Edited by Gervase Jackson-Stops

May, 1988

Dear Hopey,
Well, better very very very VERY late than never, don't you think?

Love,

Paul
x x x

The Treasure Houses of Britain

Five Hundred Years of Private Patronage and Art Collecting

National Gallery of Art, Washington · Yale University Press, New Haven and London

The exhibition was made possible by a generous grant from Ford Motor Company

Organized by the National Gallery of Art with the collaboration of the British Council,
the exhibition was supported by indemnities from Her Majesty's Treasury
and the U.S. Federal Council on the Arts and Humanities.
British Airways has been designated the official carrier of the exhibition.

Designed by Derek Birdsall RDI

Edited by Mary Yakush and Frances Smyth
Typeset in Monophoto Van Dijck by Jolly & Barber Ltd, Rugby, Warwickshire, England
Printed in Italy by Amilcare Pizzi, s.p.a., Milan

Frontispiece: Rembrandt, *An Old Woman Reading, 1655* (Drumlanrig Castle),
The Duke of Buccleuch and Queensberry, KT

Exhibition dates at the National Gallery of Art: November 3, 1985–March 16, 1986

Cover illustration:
A pair of wood carvings from a door case,
*c.*1769, by Luke Lightfoot (Claydon House, The National Trust, Verney Collection)

Library of Congress Cataloging in Publication Data
Main entry under title:

The Treasure Houses of Britain

 Catalogue of a loan exhibition held at the National
Gallery.
 Bibliography: p.
 Includes index.
 1. Art patronage——Great Britain——Exhibitions.
2. Art——Private Collections——Great Britain——Exhibitions.
I. Jackson-Stops, Gervase. II. National Gallery of
Art (U.S.)
N5245.T74 1985 707'.4'0153 85–11584
ISBN 0–300–03504–7
ISBN 0–300–03533–0 (pbk.)

Contents

Introduction

J. Carter Brown
Director
National Gallery of Art

Castle Howard, Yorkshire, from the south east

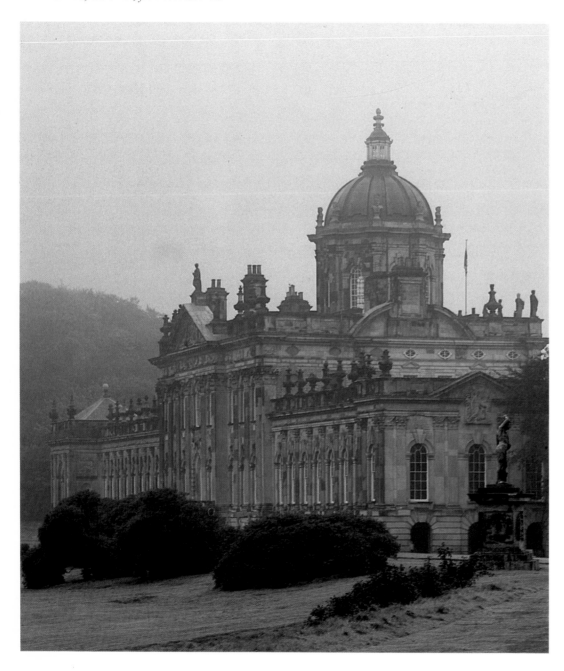

"It is in the country that the Englishman gives scope to his natural feelings. He breaks loose gladly from the cold formalities and negative civilities of town; throws off his habits of shy reserve, and becomes joyous and free-hearted. He manages to collect round him all the conveniences and elegancies of polite life, and to banish its restraints. His country seat abounds with every requisite, either for studious retirement, tasteful gratification, or rural exercise. Books, paintings, music, horses, dogs, and sporting implements of all kinds, are at hand. He puts no constraint, either upon his guests or himself, but in the true spirit of hospitality provides the means of enjoyment, and leaves everyone to partake according to his inclination."

So an American visitor to England, Washington Irving, described the world of the British country house, a way of life that has hardly changed in the century and a half since his *Sketch Book* was published. The very words "country house" are a wonderful example of English understatement. To us they may conjure up pictures of holiday retreats, cottages by the sea or in the mountains, places of escape. To the British they bring to mind a very different picture: the mellow red brick of a Tudor manor house reflected in its moat; the domes and statues, cupolas and turrets, of one of Sir John Vanbrugh's baroque palaces rising out of the mist; or the portico of a Palladian mansion seen across a lake at sunset, deer grazing by the water's edge. A deeply romantic picture this may be, painted in the golden light of Constable and Turner, but it shows what a central place the country house still holds in the British national consciousness, and what dreams of Elysium it continues to offer in an egalitarian twentieth century.

That spirit of hospitality noted by Irving has if anything increased. More than 850 country houses over the length and breadth of England, Wales, Scotland, and Northern Ireland now throw open their doors to the public for most of the summer months, and some of them all the year round. Why is it that these buildings exert such fascination, and what is it about English country house life that makes it so civilizing an experience for owners and visitors alike?

First it is because they have always been real centers of life of a community. The English country house was, and is, the background for political life, for agriculture and sport (those twin passions of the English squire), for the social round of county balls and family gatherings, and, above all, for collecting.

In the last five hundred years, apart from one short period of civil war in the seventeenth century, when the medieval churches suffered far more than the great houses, Britain has enjoyed peace at home and has been able to fight its wars abroad rather than on native soil. This and the rule of primogeniture, allied to a deep respect for tradition and a belief in evolution rather than revolution, has meant the survival of family art collections to a degree unequaled anywhere else in Europe. More than that, the development of patronage—the direct commissioning of works of art from native or immigrant artists and craftsmen—into a truly cosmopolitan form of connoisseurship in the eighteenth and nineteenth centuries is at the heart of our own response to the art of the past. In many ways the country houses of Britain can be seen as some of the oldest and longest-running museums in the world. Standing in John Nash's picture gallery at Attingham or in Jeffrey Wyatville's sculpture gallery at Chatsworth, we seem already to be in the world of the public collection: from Sir Robert Smirke's British Museum to our own West Building by John Russell Pope, which bears more than a passing resemblance to a great Palladian country house like Kedleston. Yet these rooms in turn have a long pedigree, back to Vanbrugh's great corridors at Castle Howard lined with antique sculpture in the mid-eighteenth century, back to the picture and sculpture galleries seen in Daniel Mytens' portraits of Lord and Lady Arundel in the seventeenth century (nos. 49 and 50), and still further to the long gallery at Hardwick hung with family portraits against Elizabethan tapestries—a place for exercising the body as well as improving the mind.

Not just a legacy in the architectural sense, this history of the country house is also one of developing attitudes and changing tastes which form part of our common cultural heritage. The origins of Mount Vernon as a self-sufficient estate can be found way back in the Washington family's modest English country houses: Sulgrave Manor in Northamptonshire and Washington Old Hall in County Durham. The cultured atmosphere of Thomas Jefferson's Monticello, as much as its Palladianism, finds a spiritual ancestor in Lord Burlington's Chiswick (no. 140). For more than half the period covered by this exhibition, from the time of the 1st Lord Baltimore (no. 62) to John Montresor's map of New York (no. 364) made only just before the Declaration of Independence, the country house tradition has belonged to both

our countries, and since then its unique contribution to Western culture is also one with which, like Henry James, we can feel the strongest affinity.

Knowing that the contents of British country houses, taken together, would outweigh the holdings of almost any national museum in the world, it had long been a dream of mine to mount an exhibition which would show something of these riches for the first time to an international audience. And what better time to choose than 1985, the 500th anniversary of the Tudor Succession—the moment at which the defensive, inward-looking castle began for the first time to become the domestic, outward-looking country house, open to the influences of the continental Renaissance, and when the nobility, no longer constantly on the move, began to settle in one main family seat and to collect works of art with an eye to future generations? A random selection of "treasures" drawn from British private collections would not have done justice to this great theme, and the intention from the beginning was to try to separate the many layers of taste that they represent, and to show in a broadly chronological way how they were formed, and how the synthesis of nineteen or twenty generations of art collecting that is the essence of so many British houses was achieved.

Everything in the exhibition was to come directly from a country house, and if possible from a collection formed at the particular period under examination; only in a very few rare cases were objects included which were intimately connected with a house but are no longer there, and these only where it was impossible to find an alternative and only from a British collection. The freedom allowed by the design of the Gallery's East Building enabled us to design rooms specially around the objects, some more evocative of real country house interiors than others, but all giving an impression of the taste of the period in question, the crowded picture hanging, the sumptuous sideboard arrangements of silver and silver-gilt, the sculpture galleries, libraries, and bedchambers that make a visit to such a house a constantly varied voyage of discovery.

The scale of an exhibition should follow its content and purpose. The National Gallery of Art has mounted many exhibitions of a highly focused nature, based on a single artist, or even a small body of work within the output of an artist. In *The Treasure Houses of Britain* we have decided to take on a subject whose sweep demands a very broad canvas. For half a millennium, the British country

house owners have made of these great castles and houses, often with their surrounding parks, works of art in their own right, filled with priceless objects, either commissioned or collected. They have become, as it were, vessels of civilization. As the houses themselves can be transported only photographically, it is these objects, and the history of their assembly, that form the subject of this undertaking.

The resulting exhibition is a collaboration to a highly complex degree. The generous sponsorship by the Ford Motor Company of this exhibition and its accompanying catalogue marks a particularly enlightened example of contemporary patronage, for which all of us involved with the show on both sides of the Atlantic are extremely grateful. To Philip Caldwell, former Chairman and Chief Executive Officer of the Ford Motor Company, and his successor, Donald Petersen, go our heartfelt thanks as well as to their Board of Directors, and to Walter Hayes, Vice Chairman, Ford of Europe, and to Robert Taub and the many other executives of that corporation who have helped in this show. To Mrs. Henry Brandon and the able staff of Rogers and Cowan in Washington and London we are also very grateful.

From the public sector, we are equally indebted to our working partners in the U.S. Congress, in particular the Chairmen of our two Appropriations Committees, Senator James McClure and Congressman Sidney Yates, and to their staffs; and to a variety of British and American governmental entities, particularly our colleagues at the British Council, who have been involved as partners in this project since its inception. We wish especially to thank Julian Andrews, the Director of the British Council's Fine Arts Department, who has overseen a myriad of practical details on the British side and Mr. Lyon Roussel, since retired, with whom the original discussions of this show took place. The indemnity generously offered by Her Majesty's Government for the large majority of the objects loaned to the exhibition was arranged through the British Council, with the support of the Secretary of State for Foreign and Commonwealth Affairs, Sir Geoffrey Howe; while the rest were covered by a United States government indemnity granted through the Federal Council on the Arts and Humanities.

British Airways agreed to be the official carriers of the exhibition and we are especially grateful to its Chairman, Lord King, and John Meredith, General Manager of the Americas, for their help in

this undertaking. We wish also to acknowledge the assistance of the British Tourist Authority. The two Ambassadors, Sir Oliver and Lady Wright in Washington, and Mr. and Mrs. Charles Price in London, and their respective staffs, have also taken a keen and helpful interest.

Gervase Jackson-Stops, Architectural Adviser to the National Trust in London, was appointed curator of the exhibition in April 1983. His extraordinary knowledge, energy, persuasive charm, literary gifts, and passionate dedication to the cause of the British country house have provided the mainspring of this undertaking. A special debt of gratitude is due to the Director-General of the Trust, Angus Stirling, and the Historic Buildings Secretary, Martin Drury, for allowing him a leave of absence for a longer period than was first envisaged and for all their other help.

From the outset Mr. Jackson-Stops has worked closely with the National Gallery's Chief and Assistant Chief of Installation and Design, Gaillard F. Ravenel and Mark Leithauser, who helped both to select the objects and to create appropriate settings for them, on a scale never before attempted by the Gallery for a single show. Their powers of visualization and sense of the project as an exhibition have been indispensable. Dodge Thompson, Chief of Exhibition Programs at the Gallery, tracked every aspect of the undertaking from the beginning. The exhibition office set up in London was run with the invaluable and devoted assistance of Jonathan Marsden and Anne Chandos-Pole, who worked extraordinary hours and showed a total commitment to the project. Cameran Greer of the National Gallery commuted between Washington and London and also provided a crucial link. Mary Suzor, Registrar at the National Gallery of Art, with David Fuller, Philip Blackman, Lady Anne Seymour, and Susan Martin at the British Council, were responsible for the complicated logistical planning and for the organization of the packing and transport. Research work in family archives was undertaken by the Hon. Georgina Stonor, and in libraries, by Nina Drummond. Members of the Gallery's own staff, too numerous to list here, have given extra measures of dedicated hours to this extraordinarily complex effort.

We wish to make special mention of the valuable preparatory work carried out by John Harris, A.W. Mellon Lecturer in the Fine Arts at the Gallery in 1981, and the highly knowledgeable Curator of the Drawings Collection of the Royal Institute of British Architects. The members of Mr. Jackson-Stops' Advisory Committee, many of whom also contributed essays or catalogue entries, were also of the greatest assistance in the initial selection of objects. In this context a particular debt of gratitude is owed to Francis Russell, who helped to choose and catalogue the lion's share of old master and English eighteenth- and nineteenth-century pictures; to St. John Gore, who was responsible for pictures from National Trust houses; to Sir Brinsley Ford for advice on the Grand Tour, to Sir Oliver Millar for seventeenth-century pictures, and to Sir Roy Strong for sixteenth-century portraits and miniatures.

A Committee of Honor was formed in 1983, and we were greatly honored by Their Royal Highnesses The Prince and Princess of Wales, who graciously agreed to be our patrons. The first Chairman of the Committee was the late Lord Howard of Henderskelfe, whose own guardianship and lifelong love of Castle Howard led him to become a dedicated advocate of British country houses and their collections in general, first as a representative of the National Trust, and later as President of the Historic Houses Association. A member of our steering committee until his death in November 1984, his interest in this exhibition was profound, and we honor his memory with a deep sense of gratitude.

The exceptionally generous response to our requests from owners can be judged by the long list of lenders on page 8, and to all of them we offer our thanks, not only for taking part in this exciting venture, but for their patient acceptance of the less than exciting paperwork, and the visits from appraisers, conservators, packers, and photographers that were an inevitable part of the process. The contributions made by our house-owning lenders go far beyond the deprivation to their houses and to visitors of the treasures they have lent. Beyond the basic costs of packing and transportation borne by the borrower, there are burdens that often represent direct and indirect costs to the lender. We are therefore doubly grateful to our lenders, particularly those who have lent very large numbers of objects. They are in fact donors to the financial viability of this exhibition as well as the *sine qua non* of its content.

Of those major lenders who agreed to serve on the Committee of Honor, and to whom we are specially indebted for their kindness, the Duke of Devonshire, Lord Gibson, the Chairman of the National Trust, the Duke of Northumberland, the Duke of Buccleuch, and the Marquess of Tavistock deserve special mention, while the Hon. Simon Howard and the directors of the Castle Howard Collection have added to the loans which had already been generously agreed by Lord Howard of Henderskelfe.

Lord Charteris of Amisfield, Chairman of the National Heritage Memorial Fund, who succeeded Lord Howard as Chairman of the Committee of Honor, has promoted the cause of the exhibition with the greatest enthusiasm. Commander Michael Saunders-Watson and Terry Empson of the Historic Houses Association, and Lord Montagu of Beaulieu, have also taken the keenest interest in the progress of this enterprise over a long period, and have gone out of their way to be helpful in countless ways.

The distinguished Conservation Panel formed for the exhibition consisted of Norman Brommelle, formerly Head of Conservation at the Victoria and Albert Museum; Herbert Lank, formerly director of the Hamilton Kerr Institute at Whittlesford; and David Winfield, Surveyor of Conservation to the National Trust. Much additional help came from Dr. Ian McClure, the present director of the Hamilton Kerr Institute, and his staff, who undertook much of the work on the pictures and braved fog, snow, ice, and numbing cold on their rounds of inspection. Mary Goodwin, Helen Lloyd, Jane Matthews, Trevor Proudfoot, Hermione Sandwith, and Sheila Stainton of the National Trust, and Helen Ackroyd, Simon Bobak, John Bull, Phoebe Clements, Alec Cobbe, John Dick, Briony Eastman, Simon Folkes, Rupert Harris, John Hart, John Hartley, Lucilla Kingsbury, Judith Larney, Paul Levi, William McHugh, Claire Meredith, Viola Pemberton-Piggott, Nicholas Pickwoad, Diana Reeves, Hugh Routh, James Robinson, Christine Sitwell, and Peter Smith also carried out inspections, or undertook conservation work. Mervin Richard, Exhibitions Conservator, and Ross Merrill, Chief of Conservation at the National Gallery, made constant visits to London, assisted by David Bull, Head of Painting Conservation, to coordinate with these conservators and to supervise packing arrangements with George Scott of Pitt and Scott and Roy Pateman of Wingate and Johnston.

Specially commissioned photography for the exhibition was expertly carried out by James Pipkin on five visits to Britain, covering the length and breadth of the country, while photography for the catalogue was organized by Anne Binney and Celia de la Hey from the London exhibition office. Particular thanks are due to Mark Fiennes, Angelo

Hornak, and John Bethell for undertaking long journeys, often in the worst weather conditions and at very short notice. In addition, John Hammond of the Victoria and Albert Museum, Emma O'Reilly and Olive Waller of *Country Life*, Lisa Simmons of the National Trust, and Mrs. Newby of the Paul Mellon Centre provided helpful production assistance.

The editing of the catalogue has been accomplished by Mary Yakush, Editor, with Frances Smyth, Editor-in-Chief, at the National Gallery of Art. We are grateful to John Nicoll, Yale University Press, for his careful management of the production of the book, and to Derek Birdsall for his fine design.

Members of the staff of the two British National Trusts, who have been unfailingly helpful, include David Learmont and Christopher Hartley (National Trust for Scotland); Martin Drury, Dudley Dodd, Warren Davis, Sarah Grundy, Martin Trelawny, Jennifer Hunt, Lisa Simmons, Sukie Hemming, Louella Whitefield, and Maggie Grieve (National Trust Head Office, London); National Trust regional staff including Susie Gore (Cornwall), Hugh Meller (Devon), Merlin Waterson and John Maddison (East Anglia Region), John Chesshyre and Andrew Barber (East Midlands Region), Peter Miall (Kent and East Sussex Region), Julian Gibbs and Belinda Cousens (Mercia Region), Christopher Rowell and Edward Diestelkamp (North Wales Region), Susan Denyer (North West Region), Roger Whitworth (Northumbria Region), Jeffrey Haworth (Severn Region), Christopher Beharrell (Southern Region), Christopher Wall (Thames and Chilterns Region), and Tony Mitchell (Wessex Region).

We are also grateful to museum directors, who, in addition to Sir Roy Strong, already mentioned, include Christopher Gilbert of Leeds City Art Galleries, John Jacob of The Iveagh Bequest, Kenwood, Brian Loughborough of Nottingham Castle Museum and Art Gallery, John Morley of Brighton Museum and Art Gallery (also in his present post as Keeper of Furniture and Interior Design at the Victoria and Albert Museum), Colin Thompson, formerly Director of the National Gallery of Scotland, Arnold Wilson of Bristol City Museum and Art Gallery, and Dr. John Hayes of the National Portrait Gallery.

We especially thank the administrators of all participating National Trust houses; the curators, administrators, and archivists of private houses who have been of particular help include: Dr. John Martin Robinson and Roland Puttock (Arundel Castle), Leslie Harris and Edward Paine (Kedleston), William Hugonin (Alnwick Castle), Brian Nodes (Blair Castle), Paul Duffie (Blenheim Palace), Major James Warrick (Boughton House), Major Claude Rebbeck (Bowhill), Mr. and Mrs. Jonathan Culverhouse and Dr. Eric Till (Burghley), Pat Huby (Carlton Towers), Brandon Stuart Barker (Castle Ashby), Judy Sladden and Edmond Lamb (Castle Howard), Peter Day and Michael Pearson (Chatsworth), Lt.-Comm. R.A. Hutcheson and Miss Lorna MacEchern (Drumlanrig Castle), Christopher Spicer (Euston Hall), Hazel Gage (Firle Place), Col. T.D. Lloyd-Jones (Glamis Castle), David Legg-Willis (Goodwood House), Robert Webster (Haddon Hall), Barbara Baker (Harewood House), Robin Harcourt Williams (Hatfield), Michael Taylor (Hever Castle), Frederick Jolly (Holkham), Michael Drummond-Brady (Hopetoun), Percy Baldwin (Houghton), Michael Urwick Smith (Luton Hoo), Jacques Koopman (Mereworth), Rory Wardroper (Newby Hall), Hanne Mason (private collection), Elizabeth Steele (Raby Castle), Joan Wilson (Stratfield Saye), John Saville (Syon), Oliver Beck (Tabley), Hubert Rigg (Towneley), John Keyworth (The Bank of England), Martin Westwood (Warwick Castle), Frances Bird (West Wycombe), Anthony Pelly (Wentworth Woodhouse), Tom Carter (Westminster Collection), Veronica Quarm (Wilton House), and Lavinia Wellicome (Woburn Abbey).

Others who have been helpful in a variety of different ways include: the Hon. Edward Adeane; the Hon. Charles Allsop; Sir Geoffrey Agnew; Lady Amory; Clive Aslet; the Hon. Sir John Baring; Marcus Binney; Gaye Blake-Roberts; Simon Blow; Jonathan Bourne; Mr. and Mrs. B. Rionda Braga; Lady Alicia Bridges, John Brooke-Little (Norroy and Ulster King of Arms); Mary, Duchess of Buccleuch; Lady Caroline de Cabarrus; Caroline Carr and other volunteers from the Victoria and Albert Museum Diploma Course; Michael Cartwright Sharp; George Clarke; Frances Collard; Mrs. Norman Colville; Howard Colvin; John Cornforth; Louise Corrigan; Jane Cunningham; Lady Victoria Cuthbert; Caroline Davidson; Lavinia Davies; Theodore Dell; the Duchess of Devonshire; the Marchioness of Dufferin and Ava; the Dowager Lady Egremont; Guy Evans; Mrs. Henri Frankfort; David Freeman; Kenneth Garlick; Wilbur E. Garrett; Christopher Gatiss; Christopher Gibbs; the Hon. Hugh Gibson; Phillippa Glanville; the Knight of Glin; Lady Mary Gore; the Earl of Gowrie; Gilbert M. Grosvenor; Mr. Charles Guggenheim; Dennis Haynes; Dr. Ivan Hall; Henry Harpur-Crewe; John and Eileen Harris; Lady Harrod; Francis Hawcroft; Linda Heathcoat-Amory; Tom and Mirabel Helme; Gavin Henderson; Christian, Lady Hesketh; Laura Hesketh; Terence Hodgkinson; Lady Iliffe; Tim Jackson-Stops; Jasper; Derek Johns and Philip Harari; Donald King; Viscountess Lambton; Dr. Edwin Land; Laura Lang; Lady Victoria Leatham; Mr. and Mrs. James Lees-Milne; Rupert Lord; Professor Th.H. Lunsingh Scheurleer; Neil McGregor; Arline Meyer; James Miller; the Hon. Patrick Lindsay; J.G. Links; Gregory Martin; Timothy J. McCann; Professor H.D. Miles; David Mlinaric; Charles Sebag-Montefiore; the Hon. Mrs. Morrison; Lord Neidpath; John Nevinson; Dr. Nicholas Penny; Professor Sir John Plumb; Graham Reynolds; the Hon. Matthew Ridley; William P. Rieder; the Hon. Mrs. Roberts; Michael Robinson; the Earl of Rocksavage; the Countess of Rosebery; the Hon. Lady Rowley; the Hon. Sir Steven Runciman; Sir Sacheverell Sitwell, Bart.; Lady Scott (Valerie Finnis); Tim Schroder; Lady Shaw-Stewart; John Somerville; Stephen Somerville; Dr. Marion Spencer; Sir Tatton Sykes, Bart.; Christopher Sykes; the Hon. Stephen Tennant; Lady Vestey; Peter Waldron; Richard Walker; Dr. David Watkin; Gillian Wilson; Professor John Wilton-Ely; Sir Marcus Worsley, Bart.; Melissa Wyndham; and the Marchioness of Zetland.

Last but not least, our greatest debt of gratitude remains to British country house owners past and present, of whose culture and humanity, scholarship and lack of pomposity, it can be said (in the words of Sir Christopher Wren's famous epitaph in St. Paul's), *si monumentum requiris, circumspice*— "if you seek a monument, look about you." It is to our lenders and to everything they and their forbears have accomplished in collecting, commissioning, preserving, and exhibiting these precious objects of the world's heritage, that this exhibition and its catalogue are gratefully dedicated.

Temples of the Arts
Gervase Jackson-Stops

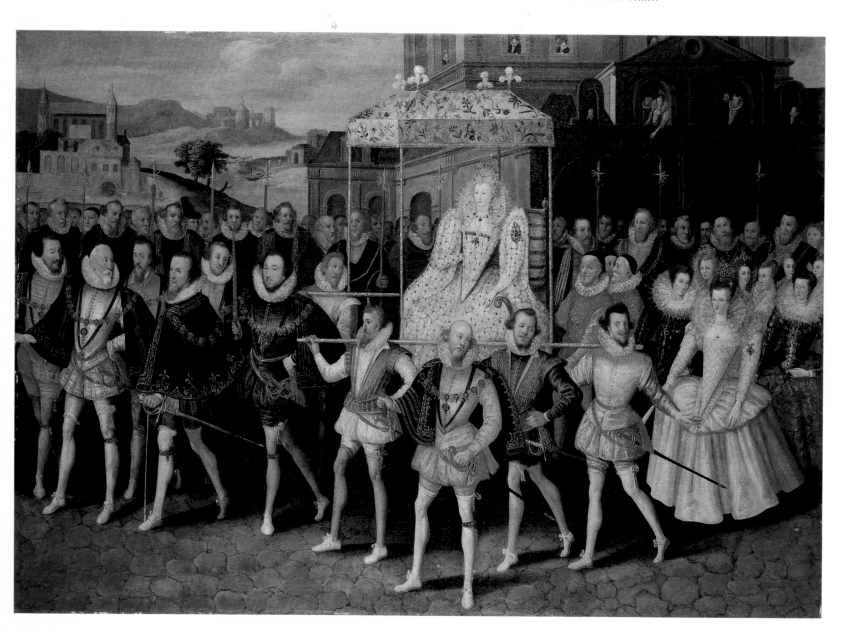

The country houses of Britain have an air of inevitability about them, as if they had grown imperceptibly over the centuries of their own accord: in stone, in brick, or in timber according to their locality. From the air, their green parks ringed with woodlands and dotted with lakes have become a natural part of the landscape, and looking down over a great mansion like Knole in Kent, more like a medieval village than a house, it would come as little surprise to find that another courtyard had sprung up overnight, that a few more pepperpots had crowned the improbable skyline of a Scottish castle like Glamis, or that a few more gable ends had jutted out over the moat of a half-timbered manor house like Little Moreton. At one with their settings, built from the very rock or clay on which they stand, or from the forests which once surrounded them, these remarkable buildings may appear to be the result of organic growth, and their history may be seen in terms of social and economic development, as has increasingly been the case. Yet they remain collective works of art created by individuals more various in their characters, their motives, and their circumstances than it would be possible to imagine.

Who were these people, and why was the building of a country house, its furnishing, its decoration, its collections—the one passion they had in common—so central to their lives? Why would Bess of Hardwick (no. 31), four times a widow, embark in her seventies on an Elizabethan prodigy house on a scale to rival the greatest castles of the Middle Ages? Why would the jocular Earl-Bishop of Bristol (no. 196) spend his last years designing and building a great country house at Ickworth in the form of an oval rotunda bigger than the Pantheon, though the Mediterranean sun appealed to him infinitely more than the cold and damp of Suffolk?

Simple pride of possession, or a desire for immortality, is only part of the answer. An Englishman's home may be his castle; he may not share the nomadic temperament of Middle Eastern races, or an interest in the abstract values of Far Eastern cultures; his deep roots in the land of his ancestors may also express a search for permanence, as a natural reaction against a notoriously undependable climate. But there are other just as powerful considerations which are less often put forward to explain the phenomenon of the country house. One is the intense curiosity that is at the heart of the English character and that has made country house visiting something of a national pastime.

In 1984, historic houses in Britain attracted a record attendance of over forty-five million, of which foreign visitors accounted for only twenty per cent. While this figure would have amazed their seventeenth- and eighteenth-century owners, it is true that many houses have been open to the public since the day they were built. When the 1st Duke of Marlborough came down to Blenheim to view progress on the work in 1711, only six years after its foundation, it was found necessary to post men at every doorway "to keep people back from Crowding in with my Lord Duke," while "little pallasadoes to keep people from the glass" were fitted outside the windows.[1] Over a hundred years later that other savior of his nation, the Duke of Wellington, was obliged to post a notice at the front door of Stratfield Saye reading: "Those desirous of Seeing the Interior of the House are requested to ring at the Door of entrance and to express their desire. It is wished that the practice of stopping in the paved walk to look in at the windows should be discontinued."[2]

In general houses would be shown to almost anyone who applied if well-dressed and mounted, though the housekeepers deputed to take people round often demanded large tips and were a mine of misinformation. Lady Beauchamp Proctor, who visited Blickling Hall in Norfolk in 1772, accompanied by "a very dirty housemaid with a duster in her hand," found that the owners "had breakfasted, and My Lord's horses stood at the door, though the servant told us he was gone out. We saw no other traces of her Ladyship than two or three workbags and a tambour; I believe we drove her from room to room, but that we could not help." By this date the "Tour of Norfolk," usually including Houghton, Holkham, Blickling, Felbrigg, and Raynham, had become almost as obligatory as the Grand Tour itself, and when Lady Beauchamp Proctor arrived at Holkham at ten in the morning, "the servant told us we could not see it for an hour at least, as there was a party going round . . . we were obliged to be shut up with Jupiter Ammon [one of Lord Leicester's antique statues], and a whole tribe of people, till the housekeeper was ready to attend us."[3]

At Kedleston an elegant hotel for visitors, designed by James Paine, was built overlooking the park at the same time as the house, and at Chatsworth the 5th Duke of Devonshire held "open days" when dinner was provided for anyone passing by. In 1844, his son was reported to allow "all persons whatsoever to see the mansion and grounds every day in the year, Sundays not excepted, from 10 in the morning till 5 in the afternoon. The humblest individual is not only shown the whole, but the Duke has expressly ordered the waterworks to be played for everyone without exception." By 1849, when the Midland Railway was opened as far as Rowsley, three miles away, 80,000 people were visiting the house during the summer.[4]

It may have been the royal progresses of Elizabeth I (fig. 1) that not only inspired the great houses of her courtiers—like Sir John Thynne's Longleat, Sir Christopher Hatton's Holdenby, or Sir William Cecil's Burghley—but also instituted the custom of country house visiting. A conscious reversion to medieval precedent, the queen's idea was primarily to save money, and to recoup some of the debts which Henry VIII incurred by maintaining the court constantly at the royal palaces of Hampton Court, Nonsuch, and Whitehall. But it also stimulated an intense competition among her subjects: a mania for building that was to last until the Civil War among the powerful men who accompanied the sovereign from house to house.

In the late seventeenth century, the diaries of John Evelyn, the notebooks of Robert Hooke and Sir Roger Pratt, and the travel journals of Celia Fiennes, show that visits to houses were an accepted practice among the gentry as much as the aristocracy, while the publication of guidebooks such as Daniel Defoe's *Tour thro' the Whole Island of Great Britain* (1724–1726) brought the fashion to a still wider audience. A particularly important aspect of such tours was the rivalry that they inspired among owners, and the wish to emulate not just the achievements of the friends with whom they might have stayed but the houses or possessions of total strangers. Thus an inveterate sightseer like the Duchess of Northumberland set out to see as many rival family seats as possible before and during her own remodeling of Alnwick Castle in the gothick style, and Syon in the classical, begun by James Paine and Daniel Garrett but continued by Robert Adam. To make sure she should miss nothing in her observations, she begins one of her travel journals in 1760 with a long questionnaire. Starting with "what is the situation of the House good or bad sheltered or exposed," she goes on to "who was the Architect," "Is the place chearful melancholy romantic wild or dreary," "Is there a fine Collection of Pictures. . . . Are there chiefly Landskips Portraits or historical," "Is the Furniture rich plain neat mean Elegant Expensive," and ending, after over 150 similar queries, "How much

Figure 2
Joseph Wilton, Sir Hugh Smithson, later 1st Duke
of Northumberland (1714–1786), before 1766
(background) *among antique busts in the hall at Syon
Park, Middlesex*

Figure 3
John Jackson, The 5th Earl of Carlisle and His Son
in the Long Gallery at Castle Howard, *c. 1810.
A grouping of early family portraits with antique and
modern busts*

Figures 4 & 5
*Grand Tour interiors: (left) the Harlequin Room at
Ribston Hall, Yorkshire, with copies of Old Masters
fitted into plasterwork frames by the architect John Carr
of York, about 1770; (right) the Cabinet at Felbrigg
in Norfolk, with Busiri's views of the Roman Campagna,
as hung by William Windham after his return from
Italy in 1743*

meat wine malt liquor coals charcoal corn butter do they usually consume."[5] It may well have been the sight of objects like the "very pretty inlaid Card Tables made by Linnel" in the drawing room at Kedleston in 1765 that persuaded her to patronize the same cabinetmaker, John Linnell, at Syon—just as Lady Beauchamp Proctor was taken with "a most elegant little Birmingham vehicle to hold the rusks," evidently a silver dish from Matthew Boulton's Soho Manufactory, that was produced with the cups of chocolate at Holkham, adding "I made Mr. Fetch-and-carry [the footman] tell me where it was bought, and am determined to have one."[6]

Rivalry, friendly or unfriendly, was obviously at the heart of country house building. But the collecting instinct also sprang from more positive, intellectual roots. A didactic purpose is already found in late sixteenth-century series of portraits of kings and queens, or family ancestors, whose virtues and traditions were supposed to inspire their descendants. By the late eighteenth century this didactic purpose was expressed in connoisseurship rather than patronage, dealing with the history of art instead of the history of family or nation. The Earl-Bishop of Bristol was anticipating the

museum philosophy of the late nineteenth century when he wrote in 1796 that he wished "to have few pictures but choice ones, and my galleries to exhibit an historical progress of the art of Painting both in Germany and Italy, and that divided into its characteristical schools—Venice, Bologna, Florence, etc."[7] Just as the Elizabethans looked back to the medieval world as an ideal age of chivalry and valor, and expressed this in so much of their art, so the Georgians, educated in the classics, looked back still further to the antique world as the font of modern civilization. There were naturally political reasons for these attitudes. A sixteenth-century nobleman like Lord Lumley (see page 62) deplored the passing of both the feudal system and the Catholic faith, and sympathized with a system of government that had long since passed. An eighteenth-century Whig like Lord Leicester (see page 25) would have supported Jonathan Richardson's claim that "there is no nation under heaven which we do not excel . . . since the best times of the ancient Greeks and Romans."[8] The classical statues and busts brought back from Italy were matched in English collections by contemporary busts of politicians like Fox and

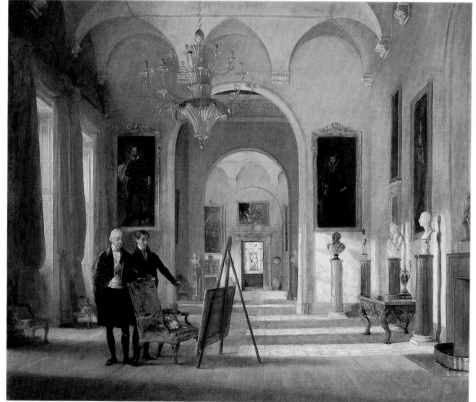

Pitt, dressed in Roman togas, to stress the origin of parliamentary democracy in the age of Plato and Aristotle (figs. 2 and 3).

The gradual change from patronage to connoisseurship as the driving force can be seen in several stages. Early country houses were on the whole built to a pattern that had evolved through the Middle Ages and that had little to do with their contents, which were largely movable. For these older houses, later owners often commissioned paintings, sculpture, or furniture to suit a certain position in a certain room, from an equestrian portrait at the end of a long gallery, to the miniatures hung in a cabinet or closet. Only very rarely were rooms formed with certain objects in mind, as in the case of Bess of Hardwick's two sets of Flemish tapestries which dictated the dimensions of the long gallery and High Great Chamber at Hardwick in 1589. In the late seventeenth century, Van de Velde overdoors or Grinling Gibbons overmantels were ordered to given dimensions, as part of the decoration of new panelled rooms in houses like Ham and Belton.

The real change came in the early eighteenth century, however, when Lord Burlington and his friends revived the taste for old masters, so briefly seen in England in the circle of Charles I before the Civil War. Many of the great Palladian houses built in the following years were conceived specially to contain pictures and sculpture that had already been bought on the Grand Tour. But the setting still remained more important than the individual work of art. If there were not enough antique statues to occupy the niches of a Wyatt gallery or an Adam tribune, then modern copies of famous examples in the Uffizi or the Vatican Museum were bought to fill the gaps. Symmetry was everything, and William Holbech went so far as to split his antique busts so as to provide pairs of matching heads in roundels for his new hall at Farnborough in Warwickshire in the 1750s.[9] In just the same way Henry Hoare of Stourhead was unable to find another old master to match his monumental Carlo Maratta *Marchese Pallavicini and the Artist*, and thus commissioned Mengs to paint a *Caesar and Cleopatra* as a pendant in 1759: two canvases which remain the lynchpins of the balanced hanging in his son's picture gallery, completed in 1802.

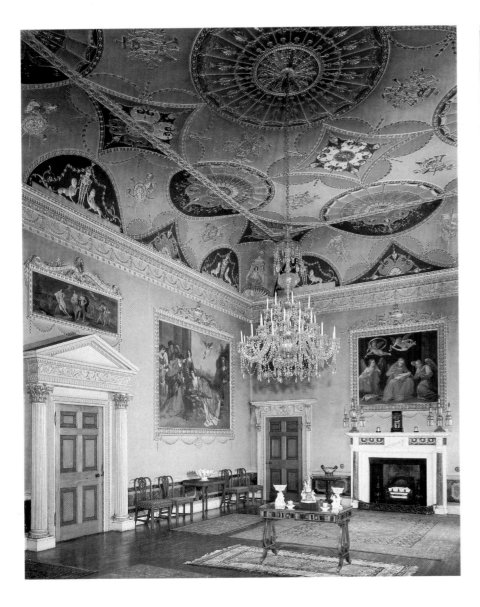

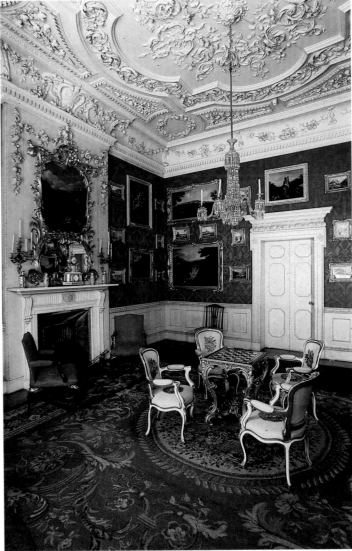

Sets of pictures, like the four Vernets, six Giordanos, and eight Devises at Uppark, were particularly popular with English buyers for this reason. But copies were just as acceptable, and these could be expanded or reduced in size to form companions at will. As Richardson put it "a copy of a very good picture is preferable to an indifferent original; for there the invention is seen almost intire, and great deal of the expression, and disposition, and many times good hints of the colouring, drawing and other qualities."[10] A very different point of view prevails today when copies are generally despised, and pictures are "read" individually, without regard to their balance and harmony in a scheme of decoration. Yet this explains the crowded hanging still to be seen in so many British country houses, with pictures in two or even three tiers, the larger-scale above the smaller, hung against the crimson damask that Sir Joshua Reynolds habitually used for the galleries of the Royal Academy. The Harlequin Saloon at Ribston in Yorkshire is a perfect example of this taste, with its vast copies of Guido Reni's *Rape of Helen* and Guercino's *Death of Dido* by the Polish artist, Franciszek Smugliewicz, fitted into uniform plasterwork frames by the architect John Carr of York (fig. 4).[11] But the Cabinet at Felbrigg (fig. 5), still arranged with Busiri's views of the Roman Campagna, exactly corresponding with their owner William Windham's diagrams of 1751, remains one of the most evocative of country house interiors at a time when patronage and connoisseurship walked hand in hand.

The idea that works of art of previous generations represented an excellence unattainable in the present—the passion for "antiques" and "masterpieces" that still obsesses us today—came only gradually during the nineteenth century, as the Industrial Revolution advanced, and the lines between art and manufacture became blurred. On the other hand, while the Duke of Bridgewater, the Marquess of Westminster, or William John Bankes of Kingston Lacy were acquiring their finest old masters, and while Lord Hertford was buying his most magnificent eighteenth-century French furniture, a patron like the 3rd Earl of Egremont was not only concentrating entirely on the work of native artists and sculptors, but commissioning from Turner in 1828 a series of four pictures, two commemorating his financial interest in the Chichester Canal and the Chain Pier at Brighton, and two of Petworth Park, representing his agricultural interests, to be fitted into the

panelling of the Carved Room at Petworth below the full-length portraits of his seventeenth-century ancestors.[12] Series of pictures continued to dominate country house collections right up to Burne-Jones' *Legend of the Briar Rose* installed in the Saloon at Buscot, though it is significant that far from being commissioned works, these were purchased by the 1st Lord Faringdon only after they had been exhibited at Agnew's Bond Street gallery in 1890. Artists by this time sold almost all their work through exhibitions, and to have painted canvases "by the yard" would have been considered demeaning.

By and large, the great collectors of the eighteenth century were the sons and grandsons of the great builders. It was the 2nd Duke of Devonshire who acquired the old master drawings and the cream of the pictures now at Chatsworth, the house his father had virtually rebuilt with the help of Talman and Archer. It was the 4th and 5th Earls of Carlisle who furnished Vanbrugh's echoing corridors at Castle Howard with antique sculpture, mosaics and marble tables brought back from Italy. It was the 2nd Earl of Egremont who filled the baroque house at Petworth with the Claudes and Cuyps, the Ruysdaels and Hobbemas, that were later to influence Turner. Not only were these heirs to great inheritances spared the cost of the vast building operations that had beset their fathers, but their culture stemmed from the easy assurance that wealth and social position had given them from their schooldays. Like Horace Walpole at Eton, an "Ariel in slit shoes," they could afford to wear their learning lightly, and to fraternise with artists, architects, and writers who were their intellectual but not their social equals.[13] Walpole's friendship with the poet Gray, an unlikely alliance between the son of a Prime Minister and the son of a scrivener, would have been unthinkable in pre-Revolutionary France. In the same way, William Kent, the apprentice coach-painter from Hull, could converse with Lord Burlington on equal terms. "Your building at Chiswick is very pretty & ye obelisk looks well," he reports to Burlington in the 1740s, "I lay there the other night but tho' I love it, was too melancholy for want of im I wish to see."[14]

John Fleming has shown how Robert Adam's career was built on the friendships he made with young noblemen on the Grand Tour during his time in Italy from 1754 to 1757.[15] After a visit to Nostell Priory in 1772 he could write "I will not pretend to describe what I feel in regard to Sir

Rowland Winn & Lady Winns friendship, it surpasses all I can say," and four years later, "we had a glorious lunch of your excellent venison yesterday when we remembered with much pleasure the founders of the feast."[16] Recalling a typical day in the life of Sir Joshua Reynolds, his early biographers, Leslie and Taylor, describe how "at four the painter dines with one of the oldest and most intimate of his friends, Mr. John Parker, one of the Members for Devon and afterwards Lord Boringdon [fig. 6]. Sir Joshua has known him from a boy; they are of about the same age. On the President's visits to Devonshire, Mr. Parker is always one of his hosts; Sir Joshua shoots and hunts with him, and advises him about purchases for his gallery, for Mr. Parker loves pictures as well as country sports, and is bent on having a good collection in his house at Saltram."[17]

One of the most convivial meeting places for patrons, artists, and architects was the Society of Dilettanti, founded by Sir Francis Dashwood and others in 1733. Horace Walpole remarked that the nominal qualification for membership was having been in Italy and the real one having been drunk in Rome.[18] But despite the flippant tone of some of the Society's deliberations, it sponsored highly influential publications such as Stuart and Revett's *Antiquities of Athens*, and Sir Joshua's two great conversation pieces, painted at the moment of Sir William Hamilton's induction (fig. 7), give a vivid impression of the intimacy that prevailed in this cultured and creative circle.

The ideal of the dilettante, a word only used in a disparaging sense at a much later period, was bound to appeal in a country where the amateur tradition had such deep roots. Lord Burlington was by no means the first aristocrat to take up architecture for instance; the Earl of Chesterfield's famous letters to his son make it clear that this was one of the accomplishments only to be expected in a "gentleman of parts," along with a thorough knowledge of music, literature, philosophy, painting, and much else. Over a hundred years earlier, the 9th Earl of Northumberland (known as the "Wizard Earl" for his interest in alchemy) had spent part of his imprisonment in the Tower of London after the Gunpowder Plot making detailed plans for the rebuilding of his houses at Syon and Petworth, based on a remarkable knowledge of Italian Renaissance forms.[19] Roger North's advice in his essay *On Building*, "be your owne architect or sitt still," was followed by many later country house owners—like John Chute of The Vyne in

Hampshire, whose "Grecian theatric staircase" of 1770 (actually based on the stage sets of the Bibiena family) provides one of the most arresting *coups d'oeil* in English architecture.

The achievements of home-grown artists and sculptors, wood carvers, and potters, also provide a continuous thread through country house collections. Sir Nathaniel Bacon's paintings at Gorhambury (see no. 65) set a standard in the early seventeenth century that it would be hard to equal, but in the late eighteenth Lady Diana Beauclerk's romantic subject pictures and Mrs. Damer's animal sculptures (no. 225) are highly accomplished, even if Horace Walpole's comparisons with Raphael and Michelangelo now seem laughable. The flower paintings of Beckford's friend, William Courtenay, are still at Powderham Castle; the Countess of Waterford's bold Pre-Raphaelite visions are at Blickling and Wallington; and Violet, Duchess of Rutland's exquisite pencil portraits, sometimes almost the equal of Ingres, can be found at Belvoir, Haddon, and other houses associated with the "Souls" in the early part of this century. The tradition continues today in the paintings of country house interiors by Sir Edmund Fairfax-Lucy and the Hon. Hector MacDonnell. Ladies' pastimes might not normally be considered the province of high art, but the embroidery produced by Bess of Hardwick and her attendants (no. 34) rivals some of the finest painting of the period, like the japanning of furniture by many amateurs in imitation of Chinese lacquer in the late seventeenth century. At Erddig, in a remote corner of North Wales, a lady's maid Elizabeth Ratcliffe not only produced

Figure 6
Sir Joshua Reynolds, John Parker, 1st Lord Boringdon, *c. 1765/1768 (The National Trust, Saltram, Devon). One of the artist's closest friends, portrayed as the archetypal English country squire*

Figure 7
Sir Joshua Reynolds, The Society of Dilettanti, *1777/1779 (Society of Dilettanti, London). One of Reynolds' two groups painted to commemorate the election of Sir William Hamilton, who is seated in the center, pointing to his newly published book on antique vases. The Society was an important meeting place for country house owners, artists, architects, and scholars*

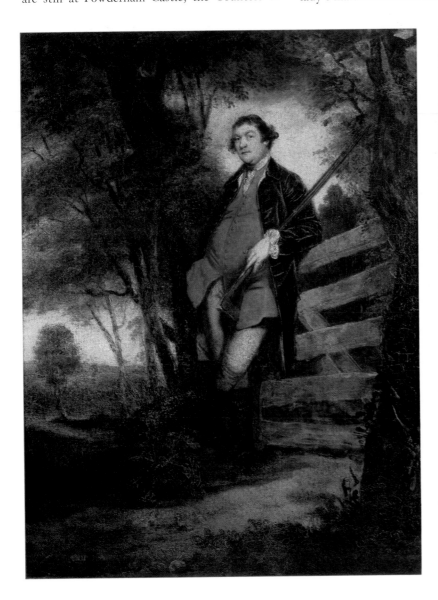

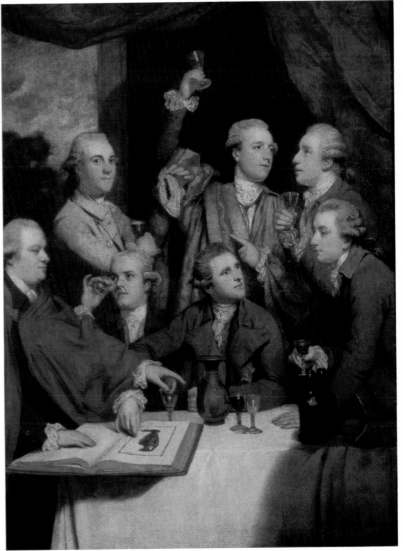

brilliant cut-paper pictures, and copies of paintings and drawings between 1765 and 1780, but also made large-scale models of the Temple of the Sun at Palmyra and a Chinese pagoda like Sir William Chambers' at Kew, entirely covered in mother-of-pearl and mica.[20]

Sir Edmund Elton's "Sunflower Pottery" at Clevedon (see no. 568) represented a scientific as well as an artistic achievement in the late nineteenth century, a reminder that the barriers between these disciplines are of comparatively recent origin. An eighteenth-century virtuoso like William Constable, of Burton Constable in Yorkshire, could be a friend of Rousseau and Voltaire, yet passionately interested in botanical specimens and natural history, carrying out early experiments with electricity and air pumps in between his researches into genealogy and heraldry. Perhaps the most significant of country house "discoveries" was the virtual invention of photography by William Henry Fox Talbot at Lacock in the 1830s. His misty calo-types of family and friends in stove-pipe hats and crinolined dresses on the lawns in front of the Abbey may represent a scientific advance, but they also opened the way to the artistic achievements of Lewis Carroll, Julia Margaret Cameron, and Cecil Beaton, the country house photographer *par excellence*.

If the history of the British country house and its collections is to be seen in terms of people rather than statistics, faces rather than forms, it is in English literature that its essence is distilled: in the world of Pope and Prior at Wimpole and Cirencester, Thomson's evocation of Hagley Park in *The Seasons*, Jane Austen's Northanger Abbey, Disraeli's Brentham, Tennyson's Locksley Hall and Trollope's Gatherum Castle—perhaps most poignantly of all in Virginia Woolf's *Orlando*, whose magic can still be breathed at Knole, as the dusty pages of the manuscript still lie open in the hall and "the great wings of silence beat up and down the empty house." Only in fiction would one expect to find owners like the reclusive Duke of Portland, whose vast underground rooms still survive at Welbeck; Bulwer Lytton who received Percy Fitzgerald at Knebworth in "a sort of repaired chamber, where we saw an Eastern potentate sitting on luxurious cushions, with dreamy eyes and reposeful manner smoking a chibouk"[21] (fig. 8); the 3rd Earl of Egremont who made "the very animals at Petworth . . . happier than in any other spot on earth"[22] (fig. 9) or Sir Roger Newdigate of Arbury (no. 329), who became Sir Christopher Cheverel in George Eliot's novel *Mr. Gilfil's Love Story*: ". . . in walking through these rooms, with their splendid ceilings and their meagre furniture, which tell how all the spare money had been absorbed before personal comfort was thought of, I have felt that there dwelt in this old English baronet some of that sublime spirit which distinguishes art from self indulgence."[23]

Just as touching as any of these benevolent ghosts is the penniless Miss Jones of Chastleton in Oxfordshire, that most beautiful of Jacobean manor houses, who told Sacheverell Sitwell and a party of visitors in the 1930s that the family had "lost their money in the war"—not the First World War, as it turned out, but the Civil War three hundred years before. Poverty and pride have been the mainstay of the British country house over the last five hundred years as much as wealth and ambition. That so many of them remain loved and lived-in family homes is a measure of the fierce and irrational loyalty to the past that they inspire, a loyalty that can only bode well for the future.

Figure 8
E.M. Ward, Edward Bulwer-Lytton in His Study, *1854 (The Hon. David Lytton-Cobbold, Knebworth House, Hertfordshire). A romantic novelist like his political ally Disraeli, Bulwer-Lytton remodeled his family house at Knebworth as a "Tudorbethan" extravaganza of towers and battlements, gables and mullions*

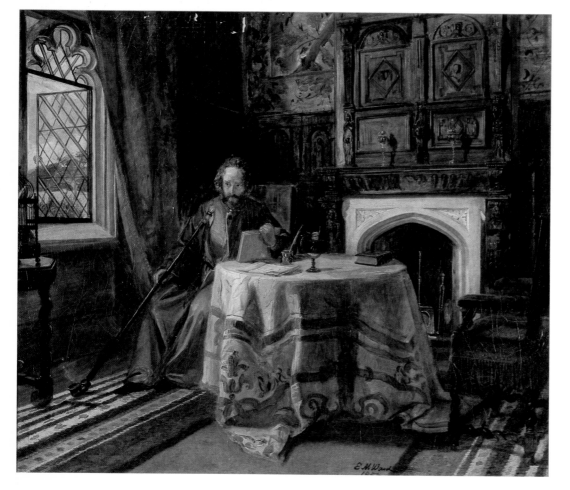

NOTES

Short references are given in full in the Bibliography

1. David Green, "Visitors to Blenheim," *Country Life*, 10 March 1950, 648
2. Lees-Milne, 1975, 8
3. R.W. Ketton-Cremer, *Norfolk Assembly*, 1957, 193–195
4. Devonshire 1982, 86
5. Victoria Percy and Gervase Jackson-Stops, "The Travel Journals of the 1st Duchess of Northumberland – II," *Country Life*, February 1974, 250
6. Ketton-Cremer, *Assembly*, 195
7. Childe-Pemberton 1925
8. Jonathan Richardson, "A Discourse on the Science of a Connoisseur" in *The Works of Mr. Jonathan Richardson*, 1773, 242
9. Information kindly given by Dr. Hansgeorg Oehler, University of Cologne
10. Richardson, "Essay on the Art of Criticism," *Works*, 1773, 226
11. Gervase Jackson-Stops, "Ribston Hall, Yorkshire," *Country Life*, 18 October 1973, 1143, fig. 3
12. Evelyn Joll, "Painter and Patron: Turner and the Third Earl of Egremont," *Apollo*, May 1977, 378
13. Lord David Cecil, *Two Quiet Lives*, 1948, 87
14. MSS at Chatsworth; information kindly given by Mr. John Harris
15. Fleming 1962
16. Gervase Jackson-Stops, *Nostell Priory*, 1973, 7
17. C.R. Leslie and T. Taylor, *Life of Sir Joshua Reynolds*, 1865, 2: 11–12
18. Lionel Cust, *History of the Society of Dilettanti*, 1898, 36
19. Gervase Jackson-Stops, "The Building of Petworth," *Apollo*, May 1977, 325, fig. 2
20. Merlin Waterston, "Elizabeth Ratcliffe: an Artistic Lady's Maid, *Apollo*, July 1978, 56–63
21. Percy Fitzgerald, *Memories of Charles Dickens*, 1913, 21
22. Strachey and Fulford 1938, 3:398
23. George Eliot, "Mr. Gilfil's Love Story" in *Scenes from Clerical Life*, 1858

Figure 9
J.M.W. Turner, Petworth Park, Tillington Church in the Distance, *c. 1828 (Tate Gallery, London).*
The 3rd Earl of Egremont, Turner's greatest patron, must be the figure who has just left his chair on the left and is walking into the sunset, followed by his dogs

The Power House
Mark Girouard

Figure 1
Figure 1
George Garrard, The Building of Southill, *1803*
(Samuel Whitbread, Esq., Southill Park, Bedfordshire).
A fortune made by the family brewery enabled the
Whitbreads to build one of the finest Regency houses in
England, designed by Henry Holland

Figure 2
Holkham Hall, Norfolk, begun by Thomas Coke, 1st
Earl of Leicester in 1734 and completed by his widow in
1764. The epitome of a great Palladian house that was
also an expression of political power

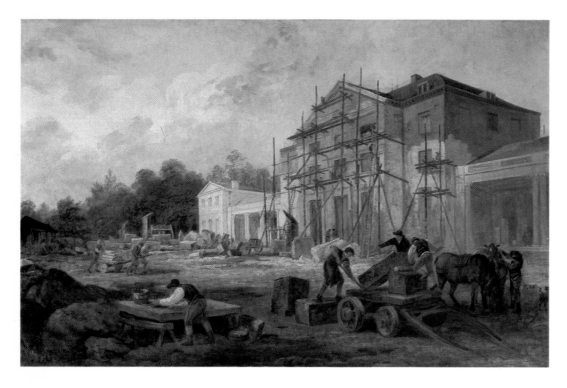

Who lived in country houses, and why did they live in them? A country house, and its surrounding estate, had four main functions, as far as its owners were concerned. It provided an income, it provided power, it provided prestige, and it provided a pleasant way of life. The ways in which these functions were fulfilled varied from century to century, but the actual functions existed from the Middle Ages, and still exist today, although the element of power has shrunk to a shadow of what it was at its prime.

At its prime it was formidable. Country houses were lived in by the people who effectively ran the country, and who owned the greater part of it. In 1873 (the first occasion for which accurate records are available) four-fifths of the acreage of Great Britain (including Scotland and Wales) was owned by less than seven thousand people, the great majority of whom were country house owners. At a local level, they dominated the countryside. From the sixteenth century the counties, the main administrative units of local government, were run by the JPs (Justices of the Peace) who also presided over the local courts. JPs were appointed in each county by the Lord Lieutenant, who was the personal representative of the sovereign, and who was invariably a titled country house owner. The JPs were almost always either country house owners, or clergymen of the established church, who had the same point of view, and often came from the same families.

But country house owners were equally entrenched in national government. By the eighteenth century they provided at least eighty per cent of the members of the House of Commons and virtually the entire House of Lords. The government executive was chosen exclusively from the two houses, as it still is. Membership of the House of Lords was hereditary, and that of the House of Commons was based on election by a very limited franchise of (in the eighteenth century) about 284,000 people. The proportion of members from country houses decreased in the course of the nineteenth century, when the franchise was extended as a result of agitation from the new industrial towns, but because of their wealth and prestige they still effectively ran the government; country house owners formed a majority in every British cabinet until 1906.

The two other principal factors in the equation of power were the towns and the king. But the towns were very much a minority of the population until the nineteenth century, and all but a handful

were dominated by local country house owners, who were often also substantial owners of town property. The king was, of course, immensely important. Until England was gradually transformed into a constitutional monarchy in the nineteenth century, he was the executive head of the government. But he had to rule through someone, and his instruments of rule were the country house owners. They were always in a position to influence or exert pressure on him as a result—and even, as happened in the Glorious Revolution of 1688, to replace him.

The majority of owners lived in their country houses because they had inherited them. But the attractions and perquisites of country house ownership were so powerful and obvious that there was always a steady infiltration of newcomers. Lawyers, judges, merchants, manufacturers, soldiers or sailors rich with prize-money, royal servants and the children of royal mistresses, owners of sugar plantations in the West Indies, the "nabobs" who made fortunes working for the East India Company, all, at various times and in varying proportions, invested in a country house and a country estate, and set up as country gentlemen.

Among the families whose collections are represented here, for instance, the Cokes of Holkham descend from a famous sixteenth-century lawyer; and the Hoares of Stourhead were bankers. The Whitbreads of Southhill (fig. 1) owned one of the biggest London breweries (and are still brewers). Harewood House was built and furnished in the 1760s by Edwin Lascelles on the basis of a fortune made in trading and sugar planting in the West Indies. At much the same time Sir Lawrence Dundas, the ancestor of the Marquesses of Zetland, of Aske, built up an even bigger fortune by supplying food and clothing to the army. The 1st Duke of Richmond, of Goodwood, was the son of one of Charles II's many mistresses. The Cavendishes, Dukes of Devonshire, and Russells, Dukes of Bedford, descend from government officials who were granted monastery lands, or bought them up cheap, at the time of the Dissolution of the Monasteries in the 1530s.

A country house owner, of course, owned more than a country house. The essential definition of a country house is a house in the country with a substantial amount of land attached to it. Land was the basis both of prestige and power. A country house estate had to generate enough income to support the house and to keep its owner in the style of a gentleman. At the upper level, some noblemen owned several hundred thousand acres, or even (in Scotland, and including much barren land) over a million acres. A thousand acres was usually accepted as the lower limit that would support an estate, although some country houses got by with a little less. Before Benjamin Disraeli became leader of the Conservative Party in the House of Commons in 1846 a dilemma had to be solved. He was incontestably the most able man in the party, but he neither owned a country house nor had the money with which to buy one. It was inconceivable in the 1840s for the Conservatives to be led by someone who did not live in a country house. Accordingly, the family of the Duke of Portland floated a loan, on the strength of which Disraeli bought Hughenden Manor in Buckinghamshire along with an estate of 750 acres—just large enough to make Hughenden acceptable as a country house, and Disraeli acceptable as a party leader. On the basis of this purchase he went on to become Prime Minister in 1868.

The income from country house estates was always mainly derived from the rents paid by tenants and tenant farmers. Most country houses have usually had a "home-farm" that was not let, and from which fresh food was supplied to the house, but although there were always important exceptions, few owners farmed for profit, even if they sometimes played an active part in encouraging their tenant farmers to improve their farms. But on the whole, they just collected their rents. For a long time the ownership of land was the only secure form of investment; until proper fire insurance was developed there was an element of

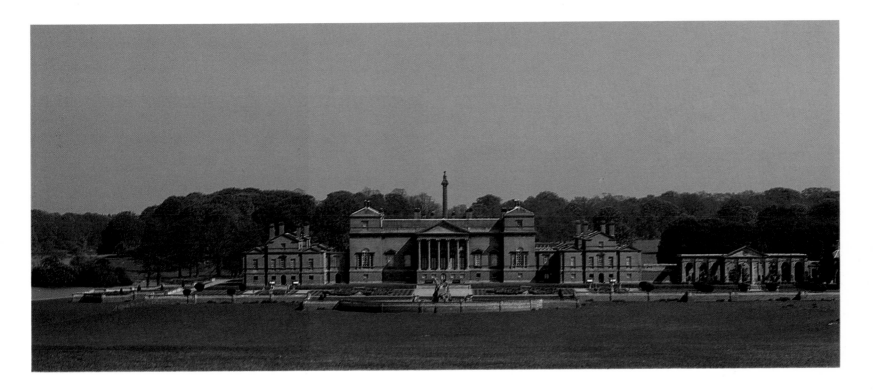

risk in owning buildings, and the stock market did not exist. It was not until the eighteenth century that government bonds or shares in the East India Company became an important alternative, to be followed by shares in the new canal companies, and then, in the nineteenth century, in the railways.

But none of these brought the prestige and power that came with the ownership of land. Ownership of an estate of several thousand acres involved more than a source of steady income. In the first place, with the land came tenants. In the Middle Ages a combination of tenants and the actual household of a country house could be turned into an armed fighting force, and as there was no permanent standing army until the seventeenth century, the miniature private armies of country house owners were extremely important. This function largely faded out in the course of the seventeenth century, but tenants who had the right to vote could still contribute to the power of their landlords by voting for them or their nominees in both parliamentary and borough elections. Since voting was open, it was taken for granted that they would vote as their landlords directed; otherwise they were in trouble.

Ownership of an estate of any size usually also carried with it the right to appoint the rector or vicar in one or more parishes; these church "livings," as they were called, were often comfortably endowed, and could provide a safe berth for a younger son. It very often included ownership, or part ownership, of a town that returned one or more members to Parliament on the basis of a small electorate, so that with a little judicious management the landowner or his nominee could rely on being returned as a member. Any substantial landowner was automatically created a Justice of the Peace, and was in the running to be chosen as one of the two Members of Parliament for his county, a more prestigious way of entering Parliament than as the member for a small borough.

The power that came automatically with ownership of land could be used as a basis on which to construct a more formidable empire. Most country house owners were very conscious of what they called their "interest." "Interest" was the whole structure of friendship, alliance, or support that a country house owner could build up in all ranks of society by entertaining people, finding jobs for them, giving custom to shopkeepers and innkeepers, creating local employment, spending money lavishly in the neighborhood, judiciously increasing his property, marrying his sons and daughters to the right people, or just being affable in the right place at the right time. An ambitious man could cultivate and increase his interest until a partial stake in appointing one member of Parliament had become complete control of several, and half the jobs in the county, or even the country, were under his control. As his interest increased he was in the position to ask the king or the leaders of the government for a rise in rank: a gentleman would angle for a baronetcy, a baronet for a peerage, and a peer for a step up in the peerage; if his interest was sufficiently large, he would get what he wanted.

But he also put himself in the running for more obviously substantial perquisites. The patronage that a king or ministers could deploy in favor of friends, relatives, or someone whose support was worth having could range from a monopoly in the sale of vinegar or soap to the right to collect the customs in a particular town, or from an important and very well paid job at court or in the government to a sinecure that was often equally well paid but involved no work at all, or work that could be handed over to a deputy for a small fraction of the salary. Horace Walpole lived comfortably, maintained a London house and built his Thames-side Gothic extravaganza, Strawberry Hill, on the strength of his salary as Chief Usher, Clerk of Estreats, and Comptroller of the Pipe in the Exchequer, without ever having to go near an office. Thomas Coke was created Lord Lovel in 1728 and made Postmaster General, with a large salary, in 1733, on the basis of the estates he had inherited from his rich lawyer-grandfather and the fact that he managed the electoral interests of the Prime Minister, Sir Robert Walpole, in Norfolk. The perquisites of being postmaster helped to pay for his magnificent new house at Holkham (fig. 2). On the strength of his wealth, house, and political position he was created Earl of Leicester in 1744. Holkham became a center of the Whigs in East Anglia, and was much used for political entertaining: in 1788, for instance, a huge party was given there to celebrate the centenary of the Glorious Revolution of 1688, which had ejected James II from the throne. At this period the Coke interest was also fostered by regular "open days," at which any Norfolk gentleman who sent in his name was entertained for the day, and often for the night as well. Similar open days were held at many big eighteenth-century houses.

The advantages of a property were concisely referred to in letters of the time, especially in the eighteenth century. In 1729, for instance, Lord Stratford wrote to his wife about arranging a marriage for his daughter with a Scottish peer. The bait was to be a large property in Suffolk, carrying with it the right of presentation to three livings, the "moral assurance" of being able to appoint two members of Parliament in the adjacent borough of Aldeburgh; moreover, in the neighborhood were two more "poor boroughs in both of which I could have a great influence would I but give myself any trouble." All this would make the proposed bridegroom "so considered at court that with the kind promises the Queen had made you, and the interest he has with having been her page, I doubt not but on marrying our daughter he might easily be made an English peer during his father's life" (British Library Add. MSS 22226, fols. 427–429.)

A country house could play a vital role in the creation of interest. In their different ways both an old house, if sufficiently historic and adequately brought up to date, and an imposing new house gave their occupants an aura of power and position, and both could be used for entertaining people of all social ranks, from the king downward. Holkham and its magnificent interiors played a part in the aggrandizement of the Cokes, just as the equally magnificent Kedleston played a part in the aggrandizement of the Curzons.

The Curzon story was not one of complete success, however; the power game had its dangers. In the eighteenth century the Curzons led the Tories in Derbyshire, and the Cavendishes led the Whigs. The two families made one of the political deals by which eighteenth-century landowners saved themselves election expenses; for many decades one of the two county members was a Cavendish, and the other a Curzon, and the elections were not contested. In the first half of the eighteenth century the Tories were without political power, however, having supported the Stuart kings; the Cavendishes dominated the county both socially and politically, the Dukes of Devonshire were almost automatically appointed Lord Lieutenants of the county, and the splendor of Chatsworth (fig. 4) both symbolized and buttressed their position. In the mid-eighteenth century Sir Nathaniel Curzon of Kedleston began to work both for a peerage and for the leadership of the county. The rebuilding of Kedleston on a scale as magnificent as that of Chatsworth was part of his campaign (fig. 3). He was only partially successful. Sir Nathaniel was created Lord Scarsdale in 1761, but failed to obtain the appointment of Lord Lieutenant when it came vacant in 1764. Moreover the Curzons, although rich, were not nearly as rich as the Cavendishes, and the new Kedleston was a bigger house than they could afford. Their property in London had to be sold to help pay for the rebuilding of Kedleston, and even so they were never able to finish it. In the nineteenth century they sank into relative insignificance, from which they were rescued by the combination of

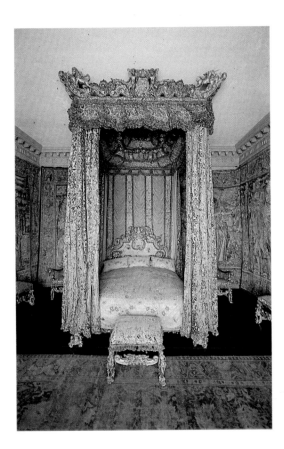

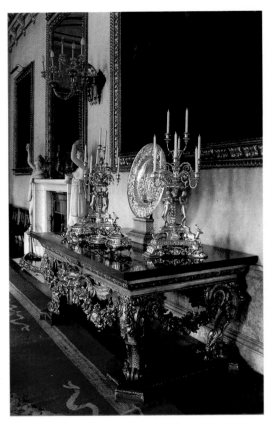

the brilliant achievements of George Nathaniel Curzon (Viceroy of India 1898–1905, Earl and Marquess Curzon; see no. 580) and his marriage to Mary Leiter, the daughter of Levy Leiter, the Chicago millionaire. But Lord Curzon only had daughters: his marquessate and earldom did not survive him, and his American money went to his daughters, leaving Kedleston once more too grand for its estate. This is the background to recent hopes that the house may be acquired for the nation through the National Heritage Fund; such were the ups and downs of one family and house in the power and money stakes.

Country house contents played their parts in these stakes just as much as everything else. A royal portrait that was a gift from a reigning monarch, like the portraits of Queen Elizabeth at Hardwick and Hatfield, would be prominently displayed and served as a certificate of royal support and approval. Some of the most splendid objects in country houses were perquisites of royal service. The Lord Chamberlain of the Household and the Groom of the Stole had the right to the entire contents of the royal apartment of a king or queen on their death, and could also take outdated or worn (but often still very handsome) royal furniture for their own use. On this basis the 6th Earl of Dorset, who was Lord Chamberlain under William III, was able to stock up his great house at Knole with superb seventeenth-century furniture, much of which is still there, including no less than three magnificent state beds (fig. 5). The equally grand bed from Calke Abbey (no. 375) was another court-

ier's perquisite: it came by way of Lady Caroline Harpur, of Calke, who was Lady in Waiting to Princess Anne, the eldest daughter of George II. The Princess married Prince William of Orange in 1734 and went off to Holland, leaving her bed behind her.

The great collections of gold and silver plate, which accumulated in the strong-rooms of rich families, were for show as well as use (besides acting, in pre-bank days, as a useful financial reserve, readily convertible into cash). At grand dinners, apart from the salts, dishes, goblets, ewers and bowls which were actually put to use, a great sideboard known as the buffet would be piled high with as much gold or silver plate as could be got onto it, merely to make a splendid demonstration of the wealth of the family (fig. 6).

The gorgeous late seventeenth- or early eighteenth-century dressing-table sets (see nos. 108 and 124) were not, of course, on show at dinners. But in the seventeenth century bedrooms and dressing rooms were not private rooms. People received visitors in their bedrooms, christenings took place in them, corpses were laid out in them, and people filed through to pay their respects: for all these reasons, bedrooms of important people were furnished for grandeur, rather than intimacy. Bedrooms became more private in the course of the eighteenth century, but dressing rooms remained rooms in which both men and women received visitors on into the early nineteenth century, and were often larger than the adjoining bedroom as a result.

An important feature of country houses in the

sixteenth, seventeenth and eighteenth centuries were what were known as "lodgings" or later on as "apartments." An apartment normally consisted of two to five rooms, depending on its importance, and formed a self-contained suite assigned to one person. A grand apartment could be made up of an ante chamber, withdrawing chamber, bed chamber, and one or more closets, in enfilade one after the other. The closets were the only really private rooms in the sequence: they were small rooms for prayer, study, and writing, or for receiving one or two important visitors, and were often furnished with small but sumptuous pieces of furniture and small but valuable pictures.

Every country house had what was known as the "best" or sometimes the "state" lodgings or apartment, kept in readiness for royal, or very important visitors, and furnished with as much magnificence as the owners could afford. In 1598, for instance, the great sea-dog table from Hardwick (no. 32) was in the withdrawing chamber of the best lodgings there. When no grand visitor was in residence, the best withdrawing chamber was often used for receiving guests; in the course of time it had become detached from the best bedchamber and became the drawing room, the formal reception room used by the family.

There were, of course, constant changes in the planning, furnishing, and lifestyle of country houses over the centuries. A fashion that first became important in the seventeenth century was the formation of collections of pictures and sculpture; these could be distributed all over the main

rooms and the best apartment, but a great collection also produced specialized picture galleries and sculpture galleries, just as the long galleries of the sixteenth and early seventeenth centuries had developed partly as a result of the new fashion for collecting family portraits, or portraits of important friends and connections.

Roughly speaking, there was a gradual move away from ostentation and formality to the elegance prized in the later eighteenth century (figs. 7 and 8) and on to the comfortable upholstery and relative informality of houses designed or adapted for the great house parties of Victorian and Edwardian days (fig. 9). The house party was an eighteenth-century development that reached its apogee in the next century: instead of entertainment by means of huge (and often drunken) dinners, or the punctiliously formal reception of one or two important people, large numbers of guests came for several days or even weeks, lived a relaxed life together, and were given the freedom of the house, its park, stables, coverts, billiard room, and library.

House party life called for a new kind of planning, which involved large numbers of communal reception rooms, and led to the corresponding decline of the apartment. They also necessitated large numbers of servants: but whereas in the Middle Ages or the sixteenth century when households were even larger, servants were on permanent display as evidence of the power of the family, in Victorian and Edwardian days they were kept out of sight as much as possible, by means of a complicated system of back stairs and passages.

However, the search for power, status, and influence continued, in spite of changing fashions. A famous collection of classical sculpture or Italian pictures could add to the status of a family just as much as the sight of fifty mounted servants in livery escorting a country house owner as he rode in the neighboring town: and inviting cabinet ministers or heiresses to agreeable house parties could increase political influence or bring money into the family as effectively as the formal reception of a great man or a rich parent in the stately enfilade of an apartment.

Of course, important though power and status were in the country house story, they were not the whole story, nor were any but a minority of country house owners only motivated by ambition and self-interest. Behind country house life lay a set of principles that were important even if not always lived up to. An independent, property owning landed class was seen as the right and natural

ruling class, but their power and privileges were recognized as bringing corresponding duties. Even ambitious families were often socially rather than politically ambitious: a title and local prestige was the summit of their ambitions. And pleasure was at least as important an element in country house life as power. There were many comfortable, unambitious country house families who lived pleasantly on independent incomes, hunted, shot, looked after their dependants, did their duties as JPs without becoming involved in politics, bred prize cattle, invited people to stay because they liked them, not because they would be useful to them, and collected pictures or statues for pleasure not status. The country house world was full of variety, as the contents of the houses make clear.

Figures 7 & 8
The "Cedar Parlour" and the "Modern Living Room" from Humphry Repton's Fragments . . ., *published in 1816. The contrast in style shows the revolution in taste and manners which took place in the Regency period*

Figure 9
The drawing room at Sandringham, Norfolk, in 1889. The crowded arrangement is typical of late Victorian country house interiors

Portraiture and the Country House
Oliver Millar

Figure 1
Petrus Christus, Edward Grimston, *1446 (on loan*
from the Earl of Verulam to the National Gallery,
London). The portrait was painted while Grimston was
ambassador to the Burgundian court

Figure 2
Hans Memling, The Virgin and Child with Sir
John Donne of Kidwelly and His Wife as Donors,
formerly at Chatsworth (National Gallery, London).
Sir John wears the Yorkist order of Suns and Roses

The portraits in the country houses of Great Britain provide, collectively and individually, a source of inexhaustible richness for British history in the economic, social, religious, literary, and political fields. To the art historian they are an essential source for the history of patronage, connoisseurship, and style; and in their own right they tell us much about life, appearance, and manners in the past and about the fortunes of a family. A little group of portraits and a handful of silhouettes, "a collection of family profiles thought unworthy of being anywhere else," like those in the old schoolroom of Jane Austen's *Mansfield Park*, can be as eloquent as the riches of a collection such as that at Welbeck, where there are nearly a thousand portraits of every imaginable type and size.

The earliest English portrait collections were founded in the first half of the sixteenth century; but two masterpieces of European fifteenth-century portraiture form a prologue. In 1446 Edward Grimston, ambassador at the Burgundian court, sat for Petrus Christus; his descendant acquired Gorhambury during the Commonwealth and, although the

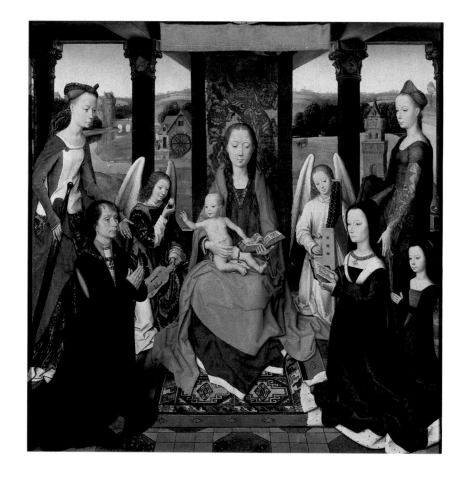

portrait has been for many years on loan to the National Gallery in London, it still belongs to the family (fig. 1). A few years later Sir John Donne of Kidwelly in Warwickshire commissioned from Hans Memling in Bruges the votive triptych (fig. 2), which passed by descent to Lord Burlington and his son-in-law the 4th Duke of Devonshire, and would still be in the library at Chatsworth if death duties had not taken such a fearful toll after the death of the 10th Duke in 1950. Edward Grimston holds the collar of SS as emblem of his duty to the House of Lancaster, and both Sir John Donne and his lady wear the collar of the Yorkist order of Suns and Roses: symbols of loyalty in a time of civil war as eloquent as the colors and sashes painted by William Dobson in the 1640s.

The origins of the oldest collections of portraits can be found at a time when, as a result of the dissolution of the monasteries and a massive re-distribution of royal property, a vast amount of land passed into private hands and it was becoming safe to live in a house rather than a castle. Like-nesses of the shrewd and ambitious Tudor "new men" still mark the beginnings of collections of portraits which, kept up to date until our own time, illustrate a family's ability to survive. The portrait of Sir William Cavendish, for example, one of Henry VIII's agents for the dissolution of the monasteries, son of a minor court official and father of the 1st Earl of Devonshire, hangs in the Long Gallery at Hardwick. Sir William Cecil, whose father had gained substantial plunder at the dis-solution, is at Burghley. In a more modest context, the visitor to Lamport is still greeted in the entrance hall by John Isham, a rich mercer and Merchant Adventurer, who bought the manor in 1560. The contrasting notes struck in such "founders" por-traits by heraldic display and reminders of mortality are heard repeatedly through the centuries; and galleries of painted portraits have their counter-parts in many displays of carved busts and effigies in parish churches near a great house: at Lydiard Tregoze, for example, Chenies (see page 60, fig. 2), Fawsley, Bottesford, Exton, or Kedleston.

The oldest collections of which records survive contained, apart from portraits of the family, like-nesses of famous men and women at home or on the Continent; and very often portraits of kings and queens, which may commemorate associations of crucial importance in a family's rise to greatness. Later they illustrated an association with the Crown through loyal service, friendship, or bastard blood.

The most spectacular of the early collections

was formed by Lord Lumley (no. 20), who had been impressed by those he had seen in Italy. It was described in a famous inventory (no. 346) and fragments of it survive in the collection of the Earl of Scarbrough. It contained many portraits of the Lumley family, and of contemporaries both English and foreign, and an extensive series of royal por-traits, among which was the famous cartoon, "Doone in white and blacke by Haunce Holbyn" (fig. 3), which eventually passed into the Devon-shire collection but left Chatsworth, with the Memling, in the 1950s. For many years it hung in the Long Gallery at Hardwick, the most magnificent room of its kind to survive (fig. 4): designed as a place of exercise or reception and to display a set of Flemish tapestries and a collection of portraits, of which to judge from the inventory of 1601 there were originally about forty that had been col-lected by Bess of Hardwick. An early arrange-ment of portraits can be seen in the background of Mytens' *Countess of Arundel* (no. 50); and some-thing of the richness of a Jacobean gallery is sug-gested by the series of portraits formerly in the collection of the Earls of Suffolk and now at Ranger's House, Blackheath (see no. 54). The room that Celia Fiennes saw at Euston in 1698, occupied by a billiard table and "hung with outlandish pictures of Heroes," must have been a late example of a gallery of worthies—sprinkled with a few vil-lains—of which the best surviving example is the set found in the Brown Gallery at Knole. On a more modest scale, this could be compared with the portraits that pack the contemporary *Galerie des Illustres* in the château of Beauregard on the Loire.

The most important surviving set of the standard icons of early kings and queens is at Hatfield, where the later portraits illustrate the fluctuations in the political and economic fortunes of a great family over a long period. There are still two famous portraits of Elizabeth I (one of which may have longed to Burghley, see no. 48), fine full-lengths of James I and Charles I, and a portrait of an am-bassador who had paid his respects to the 1st Earl of Salisbury; the 2nd Earl stands proudly in the hunting field with his father's new house in the background (fig. 5). An awkward moment in the course of the family's long subsequent obscur-ity is illustrated in a full-length of the 5th Earl, hurriedly daubed over an otherwise incriminating portrait of the Duke of Monmouth. At the end of the eighteenth century the collection came splen-didly to life again. The marchioness was painted

in a magnificent full-length in a landscape by Reynolds; the marquess sat for Romney and, some twenty years later, for Beechey. He displays his wand of office as Lord Chamberlain; and George III gave him a version of his portrait by Beechey with Hatfield specially painted in the background to commemorate a royal visit in 1800. After the conclusion of the Napoleonic Wars the restored Charles X of France gave to the marchioness—herself painted at length by Lawrence—a version of his state portrait by Gérard; and her son com-missioned from Wilkie a full-length of the Duke of Wellington. This heroic phase reached a climax when the Kaiser, the King of Siam and the Duke of Naples gave their portraits to the 3rd Marquess, three times Prime Minister, and Richmond painted his fine full-length of the marquess in a thoughtful mood and a scholarly context, and his wife and eldest son in a Rubensian vein by a sundial in the park (fig. 6).

Although a number of collections must have been broken up in the Civil War and Interregnum, loyalty to king or Parliament is still demonstrated in several houses. Devotion to the king is displayed in Dobson's portraits at Castle Ashby and Rousham; but the picture at Antony of the king at his trial probably records a regicide's approval of the event. Lord Craven's devotion to the Queen of Bohemia and her family used to be demonstrated in an extra-ordinarily rich collection of portraits at Combe Abbey and Hampstead Marshall. Happily the National Trust secured in 1968, in the course of the break-up of this collection, a group of portraits, by Honthorst and others, representative in micro-cosm of the vanished Craven splendors, and these have been appropriately placed at Ashdown House, the hunting lodge, high on the Berkshire downs, which the earl is thought to have built for the Winter Queen as a refuge from plague-ridden London. The collections of portraits at Goodwood and Euston have their origins in less troubled times, when the restored Charles II had begun, in Dryden's words, to "scatter his Maker's image through the Land." At Euston there were a series of royal portraits from Henry VII, "by the Scottish race," to William and Mary. A handful survive in the house with a number of portraits of the Duchess of Cleveland, including the one "in a Sultaness dress" seen by Celia Fiennes.

A full-length of Frederick, Prince of Wales, in a superb frame, hangs at Raby, probably as wit-ness to the sitter's love for a member of the family; and versions of Allan Ramsay's state portraits of

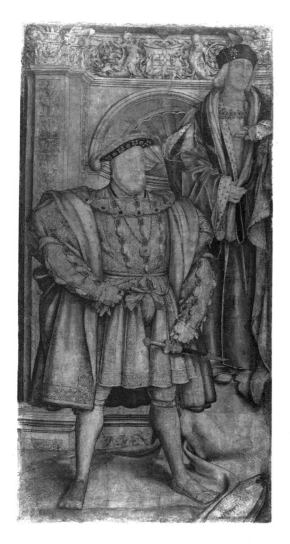

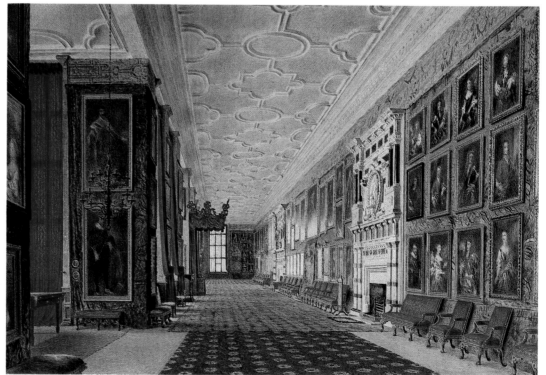

Figure 3
Hans Holbein, Cartoon of Henry VIII, with his father
Henry VII, *1536–1537, formerly at Hardwick
(National Portrait Gallery, London)*

Figure 4
William Hunt, The Long Gallery at Hardwick,
*1828, watercolor (The Trustees of the Chatsworth
Settlement). The unrivaled series of family portraits still
hang against sixteenth-century Flemish tapestries*

George III and Queen Charlotte hang in fine carved frames in many houses as evidence that an ancestor had served the king in the diplomatic service. Such portraits were issued to ambassadors along with the canopies of states and the sets of silver and gold plate that remain in many country houses. When George IV made his famous visit to Edinburgh in 1822, he stayed at Dalkeith Palace and subsequently commissioned for the Duke of Buccleuch from Wilkie a derivation of the portrait of himself in the "complete Highland costume" in which he had appeared at the Levée held at Holyroodhouse, where the Young Pretender had danced more than "seventy years since." British collections still bear evidence of attachment to the Pretenders' cause, or of optimism in the hearts of their advisers in Paris or Rome: the huge group by Mignard, for instance, of the family of James II in exile, which was at St. Germains at the king's death and is now at Swynnerton; or the interesting set of Jacobite portraits at Stanford Hall, which includes one of the finest later portraits of Prince Charles Edward, painted in Rome by Pecheux in 1770.

The arrival of Van Dyck at the court of Charles I in 1632 is the most important moment in the history of the English portrait. The portraits he painted in England are closer in spirit to the work of Gainsborough than to portraits in the Jacobean tradition. Among the artist's most generous or demanding patrons were the Earls of Pembroke, Northumberland, and Strafford, who laid the foundations of great collections of family portraits. The 4th Earl of Pembroke's huge family group still dominates the Double Cube Room at Wilton (fig. 7); the 10th Earl of Northumberland's portraits of his family and friends are now divided between Petworth, Syon, and Alnwick. The 1st Earl of Strafford's gallery contained full-lengths of the king and queen as symbols of the authority that he wielded and which is so superbly expressed in Van Dyck's full-length of the earl himself. In the early nineteenth century an imaginative artist like Haydon could be excited, thanks to the enlightened patronage of Lord Egremont, by living among fine old portraits. Staying at Petworth in 1826, he dined "with the finest Vandykes in the world," and, lying in bed at night "saw the old Portraits trembling in a sort of twilight, I almost fancied I heard them breathe."

The most splendid portrait gallery ever put together by a statesman in England was formed by the Earl of Clarendon after the Restoration, to some

extent as a commentary on his own great history of his times. The collection, and the ideas behind it, illustrate the seventeenth-century interest in the art of portraiture in general, in literature as well as painting. As in a written "character" the "fame and merit of persons" would be preserved in a portrait; and those at Clarendon House of sitters of an older generation would have provided yet another example of the importance attached to the historical portrait as example and illustration. In both aspects of Clarendon's collection is to be found the concept, in embryo, of a National Portrait Gallery.

A feature of Clarendon's collection were the fine uniform frames, like those in the gallery at Ham, which also date from the early 1670s (fig. 10). At a slightly later date the Earl of Sunderland, whose name is particularly associated with these auricular style frames (see no. 100), hung in his gallery at Althorp a series of portraits by Lely of some of the most famous and beautiful ladies of the time. A number of important pictures have been removed from this room, but it is still the "enchanted scene" loved by Walpole, "which a thousand circumstances of History and Art endear to a pensive spectator," with a range of seventeenth-century portraits leading the eye up to Van Dyck's double portrait of the Earls of Bristol and Bedford (fig. 8).

Portraits and patronage can illustrate political history. Michael Dahl was a favorite with the Tories and there are large groups of portraits by him at Badminton and Muncaster. Kneller's famous set of portraits of the Kit-Cat Club, all of the same size and uniformly framed, illustrate the "social centre of the aristocratic Whigs," and are now divided between the National Portrait Gallery in London and its northern outpost, Beningbrough Hall near York. When Sir Robert Walpole, who appears as a young man in the Kit-Cat Club, set about filling Houghton with pictures, he acquired or commissioned a number of family portraits and set over the fireplace in his library a fine version of Kneller's state portrait of George I; but he also enriched his splendid new house with a famous series of Van Dycks (many of them now in The Hermitage, Leningrad), which had been assembled by the father of the Marquess of Wharton, the most energetic party politician among the Lords of the Whig Junto, who are painted in an immense group portrait at Ombersley.

From the time of Lord Lumley, the more serious accumulators of portraits—including the Bedfords,

Lord Wharton, and the younger Earl of Strafford—had applied distinctive inscriptions or little *cartellinos* on their portraits. These help the student to establish a distinguished pedigree for portraits now widely dispersed and enable an owner with a strong family sense, such as the late Duke of Norfolk, to acquire a portrait of a famous ancestor that is authenticated, as a likeness, by unimpeachable evidence.

In the aftermath of the Napoleonic Wars the most important galleries of contemporary portraits were assembled by the Duke of Wellington and Lord Londonderry, but both of them were designed for their houses in London. Sir Robert Peel's "Gallery of Statesmen" at Drayton Manor has been dispersed; but at Haddo Lord Aberdeen is still surrounded by Metternich, Canning, Castlereagh, Bathurst, Pitt, and Peel—all specially copied after Lawrence—the Marquess of Abercorn and M. Guizot, and the series is continued in a series of marble busts by Chantrey. In the "Gallery of Friendship" which Disraeli composed at Hughenden are the portraits of those whom he had known and loved in the course of his life. The queen gave

Figures 5 & 6
The continuing tradition of family portraiture: (left) George Geldorp, William Cecil, 2nd Earl of Salisbury, *1626, showing Hatfield House in the background; (right) George Richmond*, The 3rd Marchioness of Salisbury and her Son, *c. 1873–1877. Both pictures are still at Hatfield, in the collection of the present Marquess*

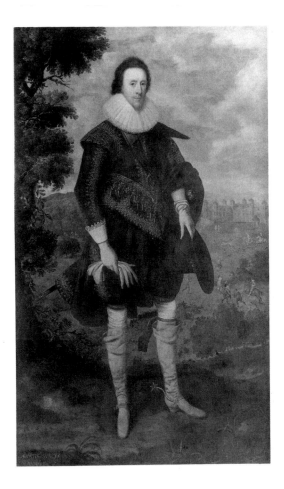

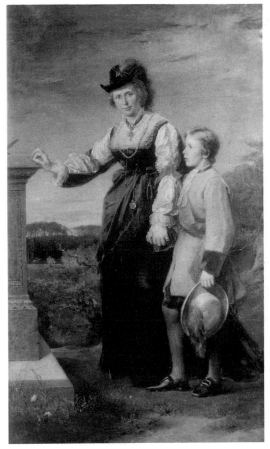

Disraeli a copy of her portrait recently painted by Von Angeli. In asking his friends for their likenesses, Disraeli was at the end of a great tradition. In 1609 Lord Salisbury had asked a friend for his portrait: "to be placed in the gallery I lately made for the pictures of sundry of my honourable friends, whose presentation thereby to behold will greatly delight me to walk often in that place where I may see so comfortable a sight."

Of collections enriched through marriage and inheritance, with successive deposits of portraits, a good example is at Audley End, where the portraits were, until recently, hung exactly as they had first been placed on their arrival from Brome Hall, Billingbear and other houses. The Cornwallis ancestors from Brome, which came as a result of a marriage in 1819, were skied in the hall or hung above the cases of stuffed birds in the picture gallery. One can still find groups of portraits of families, whose own seats have long since disappeared, in collections linked to them by marriage. The original collections built up by the Brydges, Stanley, or Capel families, for example, were dispersed long ago; but there are still important holdings of portraits of these families, as a result of marriage in the seventeenth century, at Woburn, Blair Castle and Badminton. The most remarkable surviving example of an accumulation of portraits from many sources is the Portland collection at Welbeck, where to a comparatively small nucleus of Bentinck portraits has been added, through inheritance, a wealth of portraits of the Cavendish, Talbot, Pierrepont, Holles, Vere, Harley, and Wriothesley families.

By the end of the eighteenth century many of the old long galleries and their contents were in a neglected state. Lord Torrington, writing in 1793, mourned the passing of the long gallery "which we now never make part of a new building—altho' the finest sitting room in summer, and the finest walking room in winter." He had been shocked by the state into which the long gallery at Powis had fallen and noted the same neglect at Rycote and Hardwick, where the pictures "are much neglected, and many in great decay; tho' yet restorable"; and at Coombe Abbey he noted that in a narrow, low, gallery all the pictures had been "shamefully clean'd." In the eyes of many owners, older portraits were no doubt falling out of fashion, but from the early years of the eighteenth century they were of increasing interest to such men as Loveday, Pennant and Musgrave, all of them keen travelers with a special interest in antiquities and genealogy—but above all to George Vertue and Horace Walpole, whose tireless, accurate, and unflaggingly enthusiastic note-taking laid the foundations for the study of the British portrait. Their concern that the identities of many portraits in the Wriothesley section of the Portland collection had been lost in the passing of time is characteristic. Vertue noted that the list made with the help of an old lady of the family had been rendered valueless because, when the portraits had been taken down, no note had been made of the relevant numbers so it had become "hard and past the power of knowledge to ascertain their names." Walpole told a friend, "they are only sure that they have so many pounds of ancestors in the lump." To both men a particular place of interest and delight was the gallery at Woburn: "in reality only the Corridore shut up: but it contains a most valuable collection of portraits of great persons from the reign of Henry 8th to the Revolution, particularly of the families of Russel and Bridges." Happily Woburn still contains one of the largest collections of

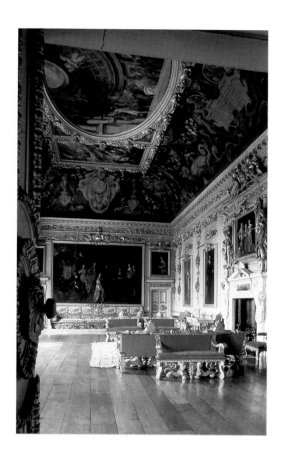

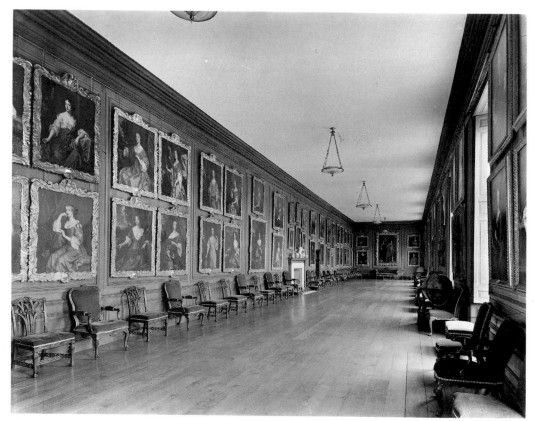

English portraits painted before the arrival of Van Dyck.

A revival of interest in Van Dyck, and a re-interpretation of his style in rococo terms, took place in the early years of the eighteenth century. At Sudbury Hall, for example, it is instructive to come down from the long gallery into the saloon (fig. 9), a superb interior in which Wright's portrait of the builder of the house is set in over the door and in which, in the mid-eighteenth century, family portraits were set into the paneling. A number of these, particularly those by Vanderbank and Hudson, are dressed in costumes familiar from the work of Van Dyck and Rubens, a popular convention seen in many portraits throughout the eighteenth century, but especially at this period in the work of Hudson: for instance, in the portraits now at Powderham Castle which he painted for the Courtenay family or in his full-length of the Duchess of Ancaster, perhaps in a dress worn at a ball at Ranelagh, which fits so well with the new decoration of the state drawing room at Grimsthorpe. The great Duchess of Marlborough was insistent that, in composing full-lengths of her beloved granddaughter, the Duchess of Bedford,

and her husband, the artist should depend on "the help of Vandyke's postures and clothes," especially as illustrated in a portrait belonging to her other grandchildren at Althorp. The enthusiasm for Van Dyck in the rococo period is less subtle than the reinterpretation of his work later in the century by such painters as Cotes, Reynolds, and, above all, Gainsborough, whose worship of Van Dyck is expressed more profoundly than by simply putting a sitter into a Van Dyck costume. In the neoclassical period admiration of the artist may have been even further aroused by the pictures coming onto the market as a result of the continental war. It is significant that a full-length of the young Lord Courtenay was painted by Cosway, always closely in touch with the London art market, in a Van Dyck costume of black and gold, for the place of honor over the mantelpiece in his new Music Room at Powderham. Architects like Flitcroft and Kent had already set portraits into the walls of the rooms they were designing in houses such as Ditchley or Rousham, where portraits in fitted plasterwork frames are part of the decoration; and Kent himself may have altered the original disposition of the pictures in the Double Cube Room at Wilton (fig. 7).

Figure 7
The Double Cube Room at Wilton House, near Salisbury, looking toward Van Dyck's huge group portrait, showing the 4th Earl of Pembroke and his family

Figure 8
The long gallery at Althorp, Northamptonshire, as it was in 1960. The portraits by Lely, Kneller, Van Dyck, and others, many of them in "Sunderland frames," culminate in Van Dyck's double portrait of the Earls of Bristol and Bedford at the far end

Figures 9 & 10
Portraits upstairs and downstairs: (left) seventeenth- and eighteenth-century Vernons in the Saloon at Sudbury in Derbyshire, set into carved wooden "tabernacles" of the 1680s; (right) the servants' hall at Erddig in North Wales, with portraits of housekeepers and gamekeepers, gardeners and carpenters, dating back to the 1720s

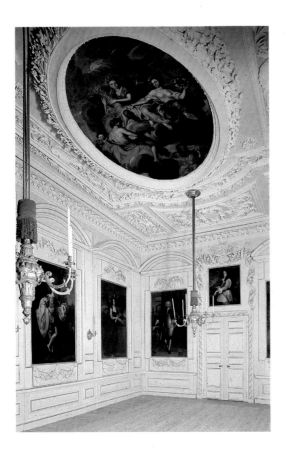

The steady accumulation of new family portraits, and the purchase by many patrons of continental pictures, must have caused owners to relegate their older pictures to a disused gallery, to upper rooms, even to the attics, or to pack them tight on a staircase. When John Loveday saw Belvoir in 1735, he admired the uninterrupted succession of family portraits: "what family can show so fine a series of Portraits belonging to it?" When Lord Torrington saw the house sixty years later there were, in addition to "a most superb Collection" of old portraits, splendid examples by Reynolds and Gainsborough and recently acquired continental masterpieces to be hung up in the great dining room and long gallery. One of the most beautiful interiors to survive from the later eighteenth century is Robert Adam's gallery at Harewood with, down the main wall, the range of portraits by Gainsborough, Romney, Lawrence, and Reynolds among others. The frames of the splendid full-lengths by Reynolds of Lady Worsley and the Countess of Harrington still have their delicate neoclassical enrichments carved by Thomas Chippendale.

In the fine new interiors of the Regency and early Victorian periods, lavishly upholstered and enriched with carving and gilding, there was no room for portraits which had been painted for a quieter setting. In Jane Austen's *Persuasion* the Musgroves at Uppercross are found, "like their houses," in a state of alteration, perhaps of improvement: "Oh! could the originals of the portraits against the wainscot, could the gentleman in brown velvet and the ladies in blue satin have seen what was going on. . . . The portraits themselves seemed to be staring in astonishment." The impression gained from Waagen and from contemporary watercolors is that only the most valuable or illustrious early portraits, notably those by Holbein and Van Dyck, with perhaps some dashing examples by Lely, were considered fit to hang with later portraits by Reynolds, Gainsborough, Hoppner, Romney and Lawrence, perhaps also with Venetian sixteenth-century portraits or seventeenth-century old masters. Special rooms were arranged in order to house particularly rich collections of portraits by a single painter, like those rooms at Knole and Althorp that were arranged with groups of por-

Figures 11, 12 & 13
Group portraits often depicted sporting scenes: from left to right, attributed to Edward Pierce, The 4th Earl of Pembroke and His Son Hunting, *c. 1640, from the dado of the Single Cube Room at Wilton; David Allan,* The 4th Duke of Atholl and His Family, *1780 (The Duke of Atholl, Blair Castle, Perthshire); and Francis Wheatley,* The Return from the Shoot, *1788, showing the 2nd Duke of Newcastle returning from a day's sport at Clumber (Graves Art Gallery, Sheffield)*

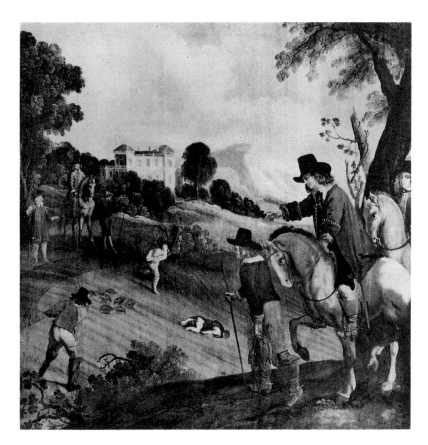

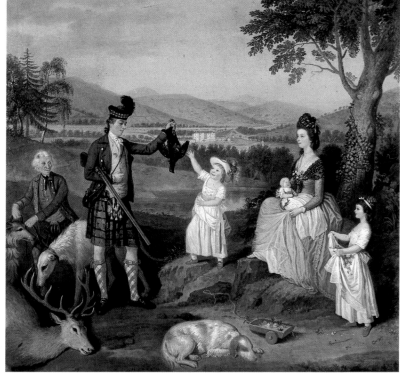

traits by Reynolds, though not until some years after the painter's death. Many houses must by now have looked like Thackeray's Bareacres Castle, "with all its costly pictures . . . the magnificent Vandykes; the noble Reynolds pictures; the Lawrence portraits, tawdry and beautiful"; but there were still unnumerable old-fashioned houses like Queen's Crawley, its great hall hung with old portraits, "some with beards and ruffs, some with huge wigs and toes turned out; some dressed in long straight stays and gowns, that look as stiff as towers, and some with long ringlets, and, oh my dear! scarcely any stays at all."

So far the portraits considered here have been life-size and frequently of a formal nature, set in patterns and with overtones of authority which, although almost unrecognizably transformed by Van Dyck in the 1630s, can in essence be traced back to the sixteenth century. Small-scale portraits (apart from miniatures) were, however, produced for patrons in the seventeenth century, and the same period saw the beginning of the conversation piece and the sporting portrait. The 4th Earl of Pembroke and his son are depicted *à la chasse* on one of the panels of the dado in the Single Cube Room (fig. 11); and in 1670 Tilborch painted *The Tichborne Dole* (no. 71) for Sir Henry Tichborne.

From the time of William III and Queen Anne a vast number of portraits in an out-of-doors setting were produced. The sporting portrait was developed principally by Wootton and Tillemans who recorded their patrons in front of their houses and gardens, in the hunting field, shooting, or at ease in the open air. The enormous canvas at Ragley, painted by Wootton for Lord Conway in 1714, is the ancestor of many such pictures. Of Wootton's works the largest holding is, perhaps understandably, at Badminton, where there are some thirty pictures by him; and he is seen on a large scale at Althorp and Longleat. He was not particularly competent or understanding as a portrait painter—indeed, an important head was often entrusted to a specialist—and an immeasurable gulf separates him in this respect from Stubbs, who painted farm bailiffs, hunt servants, huntsmen, grooms, jockeys, stable lads, trainers, agricultural laborers, and even soldiers, as well as his patrons, with a combination of reserve and sympathy that has never been equaled. The earliest portrait of an English farm laborer may be a life-size full-length, perhaps by Francis Barlow, at Clandon. There are portraits of eighteenth-century servants at Chirk and Dudmaston; but the most celebrated are those at Erddig:

of workers on the estate and in the garden and of members of the domestic staff (fig. 10). Commissioned by various members of the family, accompanied by "Crude Ditties" written about their subjects by their masters, the portraits as a whole are a unique illustration of the relations between an eccentric family and the men and women who worked for it. A set of portraits of the servants at Deene Park, painted for Mr. Edmund Brudenell by Richard Foster, is perhaps the most recent variation on this theme.

The sporting portrait was inevitably an immensely popular genre with owners of country houses. It was a permanent reminder of "good acquaintance and generous society," the essence of the sport they loved. Single portraits on horseback, shooting parties, groups of huntsmen at breakfast before the meet, whole hunts or riding parties, like that by R.B. Davis at Plas Newydd, continue to be painted up to the present day. Among the finest sporting portraits were those of members of the Derby Hunt, painted by Joseph Wright for Francis Mundy of Markeaton Hall. After this period the most competent painter of sporting

pictures was Sir Francis Grant, who specialized in life-size equestrian portraits, many of them painted to be given to Masters of Foxhounds by members of their hunts or as a present from a sitter's constituents or tenants. In Scotland an eighteenth-century outdoor scene, such as David Allan's entrancing little picture, at Blair, of the 4th Duke of Atholl showing his family a blackcock (fig. 12), is the precursor of Landseer's *Death of a Hart in Glen Tilt* (no. 535) in which the same duke presides over the disemboweling of the animal: perhaps the finest of all Highland sporting pieces. A combination of the honesty Raeburn displays in his portraits of Highland chiefs with Landseer's sense of romance could have produced the portrait, described by Scott, of Fergus MacIvor and Waverley at Tully-Veolan "in their Highland dress, the scene a wild, rocky, and mountainous pass, down which the clan were descending in the background."

The conversation piece, which has its roots in Dutch and Flemish genre painting and small-scale group portraiture in the previous century, enabled patrons from a fairly wide range in society to commission informal likenesses of themselves, their

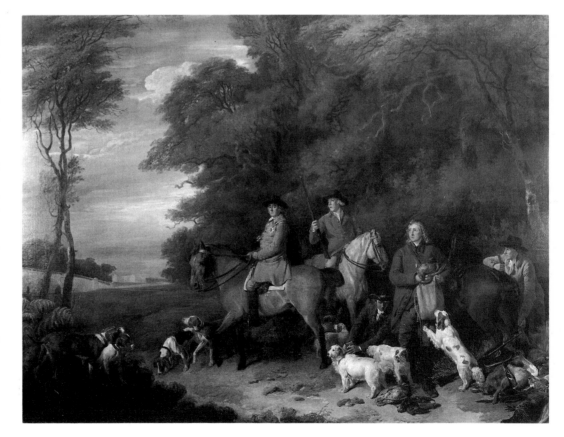

families, and servants, engaged in everyday domestic life, indoors or out, and usually in the clothes they actually wore. Specialists in this genre were providing, in other words, portraits more relaxed and less overbearing than the big full-length likenesses in which the sitter was often painted in fanciful dress or ceremonial robes and against a conventional artifical background. The setting of Philip Mercier's life-size double portrait of the 1st Marquess of Rockingham with his daughter is thoroughly conventional, and the curtain behind is held back so that he can point to the rebuilt Wentworth Woodhouse, but the same artist had also painted a small picture of Sir John Brownlow and his family, in the manner of Watteau, playing with a swing in the grounds of Belton (no. 166). The settings devised by some painters are not always accurate. Dandridge, Arthur Devis, or Edward Haytley, for instance, present their sitters in contemporary costume, even if it is sometimes the favorite Van Dyckian fancy

dress, and with contemporary furniture in use; but their backgrounds, whether interior or landscape, are often imaginary or generalized. Nevertheless, such pictures as the Braidshaighs in front of Haigh Hall, with its formal walks and its stretch of water with a boating party, or Sir Roger Newdigate in his newly gothicized library at Arbury (no. 329), are entrancing illustrations of civilized country house life in the mid-eighteenth century.

A conversation piece can often record a particular event or aspect of a patron's life. John Mortimer, for instance, painted William Drake of Shardeloes and his family discussing the plans for his new house with the Adam brothers. Wheatley portrayed Lord Aldborough with his family reviewing his regiment of volunteers in the grounds of Belan Park, and the 2nd Duke of Newcastle, who preferred a country life to political activity, ambling back to Clumber, his spaniels at his heels, after a day's shooting (fig. 13). The master of the genre was

undoubtedly Zoffany. It can be said of him, as it was of Stubbs: "Every object in the picture was a Portrait." His lively touch and enchanting color, and his unfailing accuracy, applied to the landscapes, interiors and still life that he records, as well as to the figures, give a peculiar charm and vitality to his pictures. The masterpieces of portraiture on this scale were, however, painted by artists who did not specialize in it. Gainsborough's portrait of Mr. and Mrs. Andrews in the stubble fields on their Suffolk estate; Stubbs' group of the Melbourne and Milbanke families; Joseph Wright's portrait of Mr. and Mrs. Coltman preparing for the hunt; and Copley's brilliant *Sitwell Children* of 1786 (fig. 14) are in their different ways so beautifully painted, so sympathetic, amusing and evocative— as well as being such subtle pieces of social commentary—that they are among the masterpieces of British portraiture.

There is little evidence of how such pictures were hung by those who had commissioned them.

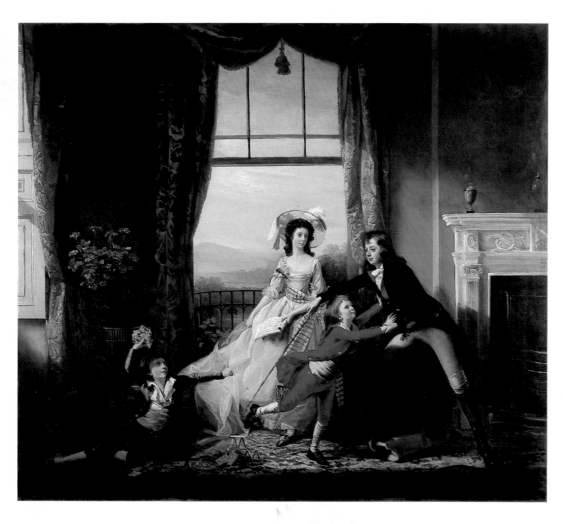

Some, of course, were intended for a patron's London house. In Reinagle's picture of Mrs. Congreve with her daughters in a London drawing room (c.1780, National Gallery of Ireland, Dublin) the family portraits are carefully depicted in a symmetrical "hang." Below two early portraits on the main wall are two little portraits of a sporting nature, by a painter such as Sawrey Gilpin. In the center of the wall is a picture, presumably of Mr. Congreve and his son, very much in the manner of Wheatley.

From the end of the seventeenth century patrons who wanted, or perhaps could only afford, a smaller form of portrait rather than a life-size image, could go to specialists in other media. In the previous century portrait painters had often worked in pastel, a medium first used in the seventeenth century by such painters as Faithorne and Ashfield. Pastels by Hoare, and above all by Francis Cotes, often in their original carved frames, are among the best of their time, lively in character, the ladies frequently in a form of fancy dress. The very good series of pastels by Hoare at Wilton, for instance, includes one of Miss Wrettle dressed up as "Rembrandt's Mother" (on the basis of a famous picture in the house) and the Countess of Pembroke, drawn with a Cupid. Cotes' pastels are sound studies of character and painted with a fresh touch, ravishing color, and mastery of a difficult medium.

The most intimate form of portrait was, of course, the miniature. Since the sixteenth century miniatures had been painted as particularly precious symbols of affection, to be worn over the heart or kept in a private place. They were frequently set, in the earlier periods, in enameled or jeweled cases, with devices conveying particular messages worked on the outside of the case (no. 47); later such miniaturists as Cosway and Engleheart enriched the back of a miniature with exquisitely wrought arrangements of jewels, enamel, and patterns made from the hair of the sitter. Single miniatures, or little groups of them, can still be seen in old-fashioned vitrines, standing on wobbly tables by the fireplace, lying beside faded campaign medals, curling photographs, and bits of Victorian jewelry. In the crowded display of family relics at Blair Castle, for example, Samuel Cooper's brilliant miniature of the Marchioness of Atholl could easily be missed. From the time of Charles I, moreover, miniatures were collected as works of art and kept in specially planned cabinet rooms, hanging on the wall or laid in drawers. A remarkable survival is the Green—originally the Fine—Closet at Ham which contained a large number of little portraits,

many in ebony frames and a number of them hanging there to this day. The great collections of miniatures at Belvoir and Burghley, family and historical portrait galleries in microcosm, were founded in the seventeenth century. At Welbeck many of the miniatures were framed for Lord Oxford, in frames of pear-wood stained black, by Bernard Lens. The fine collection of the Duke of Buccleuch was principally formed at the time when the last good miniatures were being painted before the art was effectively destroyed by the camera.

Many of the collections considered so far were formed by families who had thrived on royal favor and had perhaps, in the sixteenth century, been generously rewarded with grants of Church or Crown land. The origins of some very important collections, however, can be traced to success in very different fields, including business or industry. At Southill, the beautiful house created by the second Samuel Whitbread, Reynolds' portrait of his father, the founder of the great brewery in Chiswell Street, was placed over the fireplace in the library. Above the bookcases were the portraits of "the principal clerks in the late Mr. Whitbread's brewery." Those by Romney include Mr. Delafield, the head clerk, and those by Gainsborough and Dupont include Samuel Green, "for many years my principal brewer." At almost the same period that George Garrard was painting views of the Brewery in London and Mr. Whitbread's Wharf, and a scene of the building of Southill (see page 22, fig. 1), Joseph Wright was painting Mr. Arkwright's cotton mills by night and by day. For the great industrialist, who had been born into a poor family in Preston, Wright painted a splendid full-length, "alone in his glory, in a style which would remind his descendants of his years of struggle, not of the squire he finally consented to become," with his hand resting beside a model of his famous spinning frame. In contrast, Arkwright's son, daughter-in-law, and children, in Wright's beautiful groups, and the younger Whitbread painted by Gainsborough in 1788, seem to belong without effort to the leisured gentry.

Other collections illustrate distinguished service on land and sea: at Melford Hall and Ickworth, with fine naval portraits by Romney and Gainsborough (no. 483); or at Plas Newydd and Stratfield Saye with their many portraits associated with Lord Uxbridge and the Duke of Wellington. The presence of a great writer can still be felt in a house: Tennyson, in Watts' portrait, at Eastnor Castle (no. 557); Pope at Stanton Harcourt; Prior

Figure 14
John Singleton Copley, The Sitwell Children, *1786 (Reresby Sitwell Esq., Renishaw Hall, Derbyshire). One of the American artist's most brilliant conversation pieces, painted during his time in England*

Figure 15
G.F. Watts, Lady Margaret Beaumont and Her Daughter, *1862 (The Viscount Allendale, Bywell Hall, Northumberland)*

Figure 16
Sir Edwin Landseer, The 7th Duke of Beaufort, *1839–1842 (The Duke of Beaufort, Badminton, Gloucestershire). Painted in the romantic spirit of the Eglinton Tournament*

Figure 17
John Singer Sargent, Lady Elizabeth Bowes-Lyon (Her Majesty Queen Elizabeth the Queen Mother), *charcoal on paper, 1923 (The Earl of Strathmore, Glamis Castle)*

Figure 18
Glyn Philpot, The Countess of Dalkeith (Mary, Duchess of Buccleuch and Queensberry), *1921 (The Duke of Buccleuch and Queensberry, KT, Bowhill House, Selkirk)*

at Welbeck; Scott at Abbotsford; Bulwer-Lytton at Knebworth (see page 20, fig. 8). The 6th Earl of Dorset assembled many of the portraits of men of letters in the Poets' Parlour at Knole. An interesting series of portraits survives at Narford, placed by Sir Andrew Fountaine himself over the bookcases in his library: an example of a popular practice exemplified in the past, on a grander scale, in such houses as Cassiobury and Wrest Park; but the sitters in Sir Andrew's series include historical figures and painters as well as writers and scientists. Roman Catholic families would obviously be inclined to patronize artists of the same persuasion: Michael Wright or Benedetto Gennari for instance. Cardinal Newman, who had received his cardinal's hat after a recommendation made by the 15th Duke of Norfolk in private audience with the pope, and who had exercised so profound an influence on the duke and his predecessor, is commemorated by Millais' portrait at Arundel, painted in 1881. It hangs close to the full-length of Cardinal Philip Howard, painted in Rome, and to Lord Lumley's portrait of St. Philip Howard, on whose example the saintly 14th Duke had modeled his life.

In many country houses there is a special interest in portraits painted abroad: not just members of the family on the Grand Tour (see pages 40–49), but those who went into exile or merely preferred living abroad for a while. The portraits painted in Italy of Sir Philip Sidney have long since disappeared, but a young man at Plas Newydd, standing full-length with the Piazzetta behind in a portrait signed by Leandro Bassano, may be English; and diplomats or officers serving in the Low Countries, and royalist exiles living there during the Interregnum, sat for such painters as Honthorst, Moreelse, Miereveld, Hanneman, and Lievens. Perhaps the most beautiful portraits of English men or women compelled to live abroad are those of the ladies of the Throckmorton family, all members of the Order of Blue Nuns at the Augustinian Convent in Paris and all painted by Largillière in 1729. In the same year Sir Robert Throckmorton sat for the painter for the superb portrait—a masterpiece of the early rococo style—at Coughton Court (no. 148). There is always something arresting in portraits of the English seen through French eyes: in, for example, Greuze's refined and gentle portraits of Campbell Scott and of Lord Carlisle, painted in Paris in 1768, and now at The Hirsel and Bowhill respectively.

In the Victorian period many of the leading portrait painters did not work principally, as so many of their predecessors had done, for owners of country houses; and some of the more interesting aspects of Victorian portraiture are not fully represented in the country house collections. The "Victorian vision of Italy" is evoked in portraits by Lord Leighton, including his full-length *Countess Brownlow* at Belton, and by G.F. Watts, who stayed for nearly four years in Florence with Lord and Lady Holland, while the former was minister of the Court of Tuscany. He subsequently painted for them, in Florence and in London, a number of portraits of literary, political and social figures—Panizzi, Thiers, Guizot, Princess Lieven, and the Countess of Castiglione—and produced, mainly during these Florentine years, a famous group of pencil drawings of the Hollands' friends and acquaintances. He also painted a remarkable Giorgionesque self-portrait, dressed up in a suit of armor that a guest had worn at a fancy dress ball, and with the Casa Ferroni in the background. He later produced some of the most timeless portraits to be found in country house collections, like those of Sir John and Lady Ramsden at Muncaster, exceptionally fine in execution and sensitive in mood while his full-length at Bywell of *Lady Margaret Beaumont and Her*

Daughter is one of the most enchanting of British portraits (fig. 15).

The medieval note—heard most clearly in the preparations for the Eglinton Tournament—is struck by Landseer in his sketch of the 7th Duke of Beaufort in armor (fig. 16) and, on a more elaborate scale, by Maclise in his watercolor of the family of Sir Francis Sykes, in medieval costume, descending a winding staircase as if to take part in a tournament. A more eccentric—indeed escapist—historical mood is felt in the remarkable pictures painted by Rebecca Orpen of "the four friends of Baddesley," singly and in their library, one of them, Marmion Ferrers, dressed up to demonstrate his reputed likeness to Charles I. The fashionable Victorian painters were faced, in Millais' words, with "the horrible antagonism of modern dress," and just at a time when the portraits of Gainsborough and Romney were so much admired. Millais himself said that in the possession of such pictures "the happy owner lives daily in the best society. They give an air of distinction to the house. They decorate and harmonise with plate and furniture of the same period." Some painters, constrained to work in a modern idiom, were even more deeply influenced than Millais by the great European portrait painters of the past, by the "severer" manner of the great Venetians, Velasquez or Rembrandt. The eighteenth-century painters inevitably influenced their nineteenth-century successors. At The Hirsel, for example, there are two contemporary portraits by George Richmond; but there is also a copy by him of a famous Gainsborough of the Duchess of Montagu (no. 472) and an unfinished portrait, attributed to Gainsborough, which Richmond made attempts to finish.

Although one can sometimes be brought up short in a country house by a portrait by Collier, Orpen or Orchardson, as one can later be by Oswald Birley, it is the portraits by Sargent that most effectively capture, with their brilliant and original variations on historic themes, the mood of the *fin-de-siècle*, of the end of the great age of the country house. Sargent's portraits of Lord Dalhousie (no. 569), for example, or his great full-length of the Duchess of Portland, are assured, amused, and brilliantly painted images in the tradition of Van Dyck, Gainsborough, and particularly Lawrence. His huge group of the family of the Duke of Marlborough (no. 570) is, in scale, setting, costumes, and in its expression of authority, a conscious reworking of Reynolds' vast group of the family, painted several generations earlier, which

hangs opposite in the Red Drawing Room at Blenheim. But as a formal statement, in architectural and dynastic terms, its origins go back further: to Hudson's large canvas of the 3rd Duke and his family, to the Closterman of the 1st Duchess with her children and thence, like all such compositions in this country, to Van Dyck's *Pembroke Family* at Wilton. With all its historical and artistic associations, however, there is in this great composition, and in *The Acheson Sisters* at Chatsworth, a combination of wit and sheer style that makes a unique contribution to the history of the country house portrait. Sargent's portrait drawings—of Vita Sackville-West, Evan Charteris, Lady Diana Manners, or the then Lady Elizabeth Bowes-Lyon (fig. 17), for instance—are the last consistently good drawings of their kind to be done in England. In a different way Glyn Philpot's portrait of the young *Countess of Dalkeith* (fig. 18) painted in 1921, or of *Lady Melchett* (1927), slumped at the base of an oriental screen, are among the most subtly brilliant society portraits painted, within the older conventions, between the two wars; and the pictures in his later style—his *Lady Benthall* of 1935, for instance—brilliantly conjure up the world of the country house, of an afternoon, perhaps, at Anthony Powell's Stourwater Castle, on the eve of the Second World War.

The standard in some of the oldest collections has been well maintained, especially at Hatfield where there is a characteristic charm and stylishness in so many of the recent portraits, and at Althorp, where portraits by Augustus John, William Nicholson, and William Orpen now hang near those by Frank Holl and G.F. Watts. The most interesting contemporary portrait painters have not painted many country house portraits, although one of the most recent portraits at Althorp is the Rodrigo Moynihan of the present earl, painted to celebrate his coming of age; and the Graham Sutherland of Lord Iliffe (no. 578) is a notable addition to the collection he has formed at Basildon. By now many collections cover a very long time span. No less than nineteen generations separate a recent portrait of Lord Verulam from the Christus of his forbear. The most strikingly original family portraits commissioned for a country house in modern times are those painted by Lucien Freud for the present Duke of Devonshire (fig. 19); if the Memling and the Holbein had not been taken from the collection after the late duke's death, the collection at Chatsworth would surely now be unsurpassed, in age and quality, by any private collection in the world.

Figure 19
Lucien Freud, Lady Elizabeth Cavendish, *1950*
(*The Trustees of the Chatsworth Settlement*)

The Englishman in Italy
Brinsley Ford

Though it is uncertain when the expression "The Grand Tour" was first used, it was certainly current in the seventeenth century, when men such as Inigo Jones and John Evelyn visited Rome on their travels and looked at the antiquities with a new awareness. Richard Lassels, whose travel book was published in 1670, writes that no one can understand Livy and Caesar so well as the man who has made "the Grand Tour of France and Giro of Italy." Lassels' book covered three long voyages into Flanders, six into France, five into Italy, and one into Germany and Holland. Properly speaking, the Grand Tour would have included all these countries. But, of course, not everyone could afford the time or the money to visit them all, and for many it consisted simply of a visit to France and Italy.

The Grand Tour did not really get under way until the beginning of the eighteenth century when it became a necessary part of a gentleman's education. In the 1770s Dr. Johnson planned to go to Italy but he never got there. He always regretted this and said to Boswell, "Sir, a man who has not been in Italy is always conscious of an inferiority, from his not having seen what it is expected a man should see. The grand object of travelling is to see the shores of the Mediterranean."

In his fascinating book *British Art and the Mediterranean* (1948) Professor Wittkower points out that Lord Shaftesbury was the teacher of the new generation at the beginning of the eighteenth century and set the standards for subsequent Grand Tourists. In his famous book entitled *Characteristicks of Men . . .*, published in 1711, Shaftesbury preached the unity of morality and taste and declared that "the Science of *Virtuoso's*, and that of *Virtue* itself, become, in a manner, one and the same." Thus the acquisition of taste became an important ingredient of general education and true taste could only be acquired in Italy. Wittkower goes on to explain how Shaftesbury's ideas were developed by the painter Jonathan Richardson, who defined the rules of connoisseurship to be learned in Italy, and published in 1722 a popular guide to those monuments that every gentleman was expected to study. Under Richardson's influence travelers became more responsive toward the masterpieces they encountered. Such then was the impetus that brought young Englishmen on the Grand Tour to Italy in ever-increasing numbers, numbers which, although they fluctuated according to the political situation and were greatly reduced when wars broke out on the Continent, reached their zenith in the second half of the eighteenth century.

Once it had been decided that a young man should complete his education by being sent on the Grand Tour, the choice of a governor or bear leader became all important. The race of governors was subjected to a great deal of ridicule and abuse in the eighteenth century. This was chiefly aimed at the men who made it their profession. Of these the most famous bear leader was Dr. James Hay (fig. 2) who, between 1704 and 1729, conducted no fewer than eight, and possibly more, young Englishmen to Italy. But there were many distinguished men who took on the role as their only means of seeing foreign countries. Joseph Spence, Professor of Poetry at Oxford, paid three visits to Italy as governor to young Englishmen. Edward Holdsworth, the Virgilian scholar, accompanied five young men on the Grand Tour between 1719 and 1740. And it would be possible to cite countless other examples.

The actual journey to Italy was a memorable event in the lives of a great many Englishmen. It was probably the greatest adventure in the careers of most English artists. When compared with the changes that have taken place in this century, the speed of travel had changed relatively little from the days of Julius Caesar until the reign of George IV, or indeed until the advent of the railways. It has been said, with what truth it might be difficult to determine, that Trajan and Sir Robert Peel, both traveling at their utmost speed, covered a distance equivalent to that between Rome and London in almost exactly the same time.

In the eighteenth century the time taken from England to Italy might vary from three weeks to several months according to the route chosen and the places visited. There were three traditional ways of making the journey: by sea, by land and sea, and by land. All three ways presented dangers and discomforts. The artist Jonathan Skelton, who went by sea from England to Leghorn in 1757, complained that he was tossed for forty days by what he describes as the most "furious Levanters" (or east winds), added to which they twice nearly fell into the hands of the French, and when finally they reached their destination they had to undergo sixteen days in a *lazaretto*, which he complained was as bad as a prison.

Some people traveled through France to Marseilles, and from thence in a *tartane* or *felucca* to Genoa. These were sailing boats, and when there was no wind were usually rowed by ten sailors. The architect Robert Adam made the journey from Nice to Genoa in a *felucca* in January 1755, hoping

Figure 2
Pier Leone Ghezzi, Dr. James Hay as a Bear-Leader, pen and ink (British Museum). Hay conducted no fewer than eight, and possibly more, young Englishmen round Italy between 1704 and 1729

Figure 3
David Allan, The Arrival of a Young Traveller in Rome, *pen and ink, 1775 (Royal Collection; reproduced by gracious permission of Her Majesty Queen Elizabeth II). The scene is the Piazza di Spagna with the Caffè degli Inglesi, a famous meeting place for English artists, and an inn named the Ville de Londres on the right*

Figure 4
John 'Warwick' Smith, SS. Trinità dei Monti, *watercolor, c. 1779 (British Museum). The English quarter in Rome was centered on the Piazza di Spagna, below the church*

that it would be provided with a fire in the cabin as he dreaded the cold air of the sea at this time of the year.

The traveler who decided to make the entire journey by land traveled south by Paris to Lyons, and thence over the Mont Cenis Pass into Italy and to Turin. Crossing the Mont Cenis was one of the most exciting and dreaded experiences on the Grand Tour. Travelers equipped themselves for it as modern explorers would for the North Pole. The poet Gray says that he and Walpole went "as well armed as possible against the cold with muffs, hoods and masks of beaver, fur boots and bearskins." The richer travelers were carried over the pass by relays of men in what was known as the "Alps machine," which had a back and arms and a board on which to put your feet.

The painter Northcote, who made a bargain with a *vetturino* to take him from Lyons to Genoa for nine guineas, had to make the ascent of Mont Cenis on a mule, which was, of course, cheaper than being carried by men. On the mountain Northcote followed the example of his *vetturino* and pulled a night cap over his eyes. This behavior would certainly have seemed inexplicable to Ruskin, but Northcote was a portrait painter, and was perhaps only displaying in a somewhat exaggerated manner an attitude of indifference toward Alpine scenery.

Many travelers felt or affected a horror of the Alps. At the beginning of the century Addison wrote that the Alps filled the mind with an agreeable kind of horror. In 1765 John Wilkes wrote to a friend that the "Appenines are not near so high or so horrible as the Alps." On the other hand Gray's appreciation of mountain landscape was, as Wyndham Ketton-Cremer (1964) has pointed out, "almost Wordsworthian" and "at that time [1739] unique."

Once the Grand Tourists had arrived in Italy there were various ways of proceeding. William Beckford traveled in such style, with three carriages for his retinue, with outriders and relays of spare horses, that he was mistaken for the Emperor of Austria traveling incognito and was honored with an imperial bill. Many travelers used the posting system, which meant going in either their own or hired chaises and taking on fresh relays of horses at every posting stage. An alternative but slower and more economical way of traveling was by *vetturino*, whereby you made a bargain, as Northcote had done, to take you from one place to another for a set sum. The *vetturino* paid all the bills and avoided disputes with landlords and postillions.

The inns were all hideously uncomfortable, and insects which multiplied under the conditions of dirt and squalor were a perpetual source of torment to English travelers. In 1796 Miss Betsey Wynne, aged seventeen, was alarmed to read on the walls of the inn where she and her sister were staying a notice in English describing it as "Bugg Hall" with the warning that you were likely to be robbed. The beds were so "monstrously dirty" that they had not the courage to sleep in them and they spent the night lying on chairs without undressing. After all the adventures and discomforts of getting to Italy, it is small wonder that the exhausted traveler reached the comparative comfort of the cities with a great sense of relief.

It was an important feature of the Grand Tour to be present at certain famous events: the Carnival before Lent at Rome, Naples, or Venice; religious ceremonies at Rome during Holy Week; and Ascension Day at Venice. It follows that as Rome was the climax of the whole tour, and as most people chose to visit the south during the winter months, it was usual to start the tour of Italy in the autumn and to travel from Florence by slow stages down to Rome and Naples, and then to take in Venice on the way back. These are the four cities that I propose to visit in these pages.

At Florence the central figure of English life

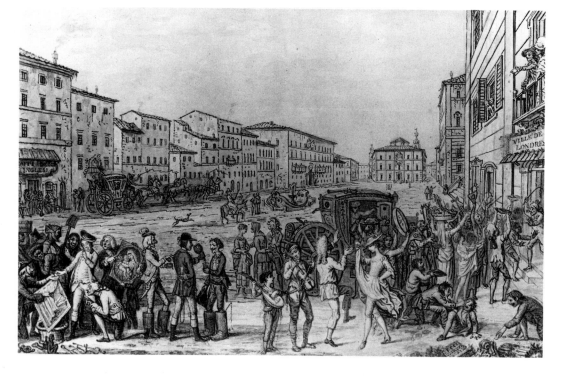

was the British Resident, Sir Horace Mann, now chiefly remembered for his correspondence with Horace Walpole. In Zoffany's famous picture of the Tribuna in the Uffizi, which was painted for George III between 1772 and 1778, he is shown standing on the right at the foot of the *Medici Venus* wearing the Order of the Bath of which he was so proud (fig. 1). Mann came to Florence in 1738 as assistant to Charles Fane, the British Resident, whom he succeeded in 1740, and he remained there for forty-eight years until his death in 1786. He lived at the Palazzo Manetti, where he kept open house. Standing near Mann with his hand on Titian's *Venus of Urbino* is that remarkable character Thomas Patch. Having studied painting under Joseph Vernet in Rome, he was expelled from the Papal City for homosexual practices and fled to Florence where he painted views of the city and caricature groups of the English on the Grand Tour. Not the least remarkable thing about Patch was that he was one of the first Englishmen to appreciate the earlier Italian painters. In 1770 he published a volume containing twenty-four engravings after the Masaccio frescoes in the Brancacci chapel in the church of the Carmini. Also present in this picture, on the extreme left, next to the statue of *Cupid and Psyche*, is the most famous of all Anglo-Florentines—Lord Cowper, the subject of a famous portrait by Zoffany (no. 178). In the painting of the Tribuna he is looking at the Raphael Niccolini-Cowper *Madonna* which is being shown to him by Zoffany himself. He subsequently acquired this picture, which his descendants sold to the National Gallery in Washington. Lord Cowper lived in Florence for a great many years and was known to all English travelers. All the other English depicted in this canvas were making the Grand Tour.

The *Medici Venus*, seen on the right in Zoffany's picture, is represented here by a bronze copy by Soldani (no. 216). The statue, which is shown surrounded by a group of gaping admirers, is now thought to be a first-century BC copy of the bronze original derived from the Cnidian Venus of Praxiteles. It was one of the most revered of all statues in the eighteenth century. People went into ecstasies over it. Joseph Spence paid her about a hundred visits and a century later the poet Samuel Rogers was to be seen every morning about midday seated opposite her. The writer Kotzebue, who dared to assert that the ladies' maids in Berlin were more attractive, was branded as a "great fool."

Thomas Patch's caricature groups were extremely popular. One of his largest groups shows a gathering of young Englishmen round the *Medici Venus* and other famous statues from the Tribuna, which are placed in an imaginary setting. A picture from Dunham Massey, the *Punch Party at Hadfield's* (no. 197), shows another group at a favorite inn after the day's sightseeing. Horace Walpole, who formed his friendship with Mann when he was in Florence with the poet Gray in 1740, thought the city "infinitely the most agreeable of the places he had seen since London," and fifty years later he still looked back fondly to his visit, recalling "the delicious nights on the Ponte di Trinità of Florence, in a linen nightgown and a straw hat, with improvisatori, and music, and the coffee houses open with ices." On their visit to Florence young English travelers would have been tempted to buy a scagliola table top (no. 172), a *pietra dura* casket (no. 202), or to commission a marble vase, a chimneypiece, a copy of an antique statue from Francis Harwood, or an adaptation of an admired Renaissance group from Vincenzo Foggini (no. 214).

Some travelers hurried through Rome on their way to spend the winter in Naples, where Sir William Hamilton played very much the same part as Sir Horace Mann played in Florence. Hamilton was appointed envoy extraordinary to the Court of Naples in 1764, a post he held until the end of the eighteenth century. Sir William's first wife, Catherine Barlow, died in 1782. Four years later he invited his nephew's mistress Emma Hart to join him in Naples, and having married her was destined to become one of the most famous cuckolds in history, which was hard on one of the most civilized of men. He formed two great collections of Greek vases and sponsored two of the most beautiful books produced in the eighteenth century—d'Hancarville's *Antiquités Etrusques, Grècques et Romaines*, 1766–1767 (no. 362), and his own *Campi Phlegraei*, 1776. Sir William's official residence was the Palazzo Sessa, but he also had two small villas in the country outside Naples, one to the north at Posillipo, and the other south of the city at Portici, close to the royal palace.

Every Grand Tourist of any consequence would have been entertained at the Palazzo Sessa, although the parties held there under the two Lady Hamiltons were of a very different character. Ann Miller, writing at the time, describes the first Lady Hamilton's musical assemblies, which she gave once a week, as "rendered perfect by her elegant taste and fine performance; it is called an Accademia di Musica; and I suppose no country can produce a more complete band of excellent performers." Those who were entertained by

Emma were expected to admire her *tableaux vivants*, that series of classical poses which later achieved much celebrity and were known as her "Attitudes." Goethe gives a wonderful account of her performance, which enchanted him, in his *Italienische Reise*.

The beauty of the Bay of Naples and its islands has been captured for us by artists like Thomas Jones. Naples must have been a paradise for travelers in the eighteenth century. There were countless delightful expeditions to be made, many of them by boat, to Posillipo, to Virgil's tomb, to Baiae, to Capri, and sometimes further afield to Paestum. Of course the crowning expedition of all was the ascent of Vesuvius. Sir William Hamilton was called upon to make twenty-two ascents as guide to visiting royalty and grandees; the volcano appears in the background of David Allan's portrait of Sir William and his first wife. The eccentric Earl Bishop of Bristol chose to have it in the background of his portrait by Madame Vigée Le

Brun (no. 196). It was an appropriate choice, for as well as being interested in volcanoes, he caused eruptions wherever he went.

Besides Vesuvius, there were the wonderful performances at the San Carlo Opera House, visits to Pompeii and Herculaneum to see the latest discoveries, events such as the ceremony of the Liquefaction of the Blood of Saint Gennaro (at which if the blood failed to liquefy the Protestant spectator was in danger of being lynched), and the unending spectacle of the contrasts of Neapolitan life with *lazzaroni* walking stark naked about the shore while the ladies, with their daughters and serving maids, contemplated "the singular spectacle," Dr. Moore writes, "with as little apparent emotion as the ladies in Hyde park behold a review of the Horseguards." To these attractions, which drew the young men on the Grand Tour to Naples, one should add drinking, gaming, and whoring.

The arrival of a young traveler in Rome during the Carnival of 1775 is shown in an entertaining drawing by David Allan (fig. 3). On the right is an inn, the Ville de Londres, where the latest arrivals stayed until they could find lodgings. The Spanish Steps leading up to SS Trinità dei Monti are just visible beyond the inn on the right. The signboard on the building on the left is inscribed *Caffè degli Inglesi*. This was the meeting place of all the English artists. Among the many amusing characters in this drawing is an English virtuoso. With his back turned to a picture of the *Madonna and Child*, he hands a coin to an old ruffian who pulls aside a curtain and allows him to leer through his quizzing glass at a picture that would certainly not have found a place on the walls of the Vatican gallery.

The Piazza di Spagna was the center of the English quarter. The English lodged either in palaces or houses in the streets leading off it or in the streets leading from the Piazza di Trinità at the top of the Spanish Steps. In this piazza was the English coffee house. The most memorable description of it is in the *Memoirs of Thomas Jones*. He was ushered into it on the day of his arrival in November 1776. After naming the nineteen artists he met there, some of whom were old acquaintances from London, he describes the interior as a "filthy vaulted room, the walls of which were painted with Sphinxes, Obelisks and Pyramids, from capricious designs of Piranesi, and fitter to adorn the inside of an Egyptian-Sepulchre than a room of social conversation". The English coffeehouse was a center of news and hotbed for gossip. A number of

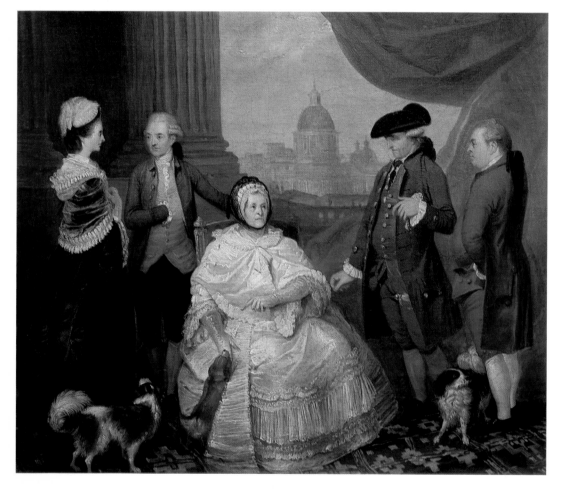

English artists used the coffee house as their headquarters in Rome, and among them was Richard Wilson who lived almost next door. It was still flourishing in 1776 when Jacob Moore, who enjoyed great fame as a landscape painter, had his study and painting room above it.

The three most famous houses where the English lodged were all on the Pincian Hill and close to the church of SS. Trinità dei Monti, which is the subject of a drawing by Warwick Smith in the British Museum (fig. 4). These houses were popular for a number of reasons. They were near to the Piazza di Spagna, yet away from its noise. The air was considered the best in Rome, the views were splendid, and the artists were attracted to the district by its associations with the past.

It was the good fortune of the English artists that they were able to take rooms in the Palazzo Zuccari, which is one of the buildings on the right of the church. The palace was built by Federico Zuccari in about 1590, and was intended, among other purposes, to provide accommodation for homeless artists. Some of the attractions that an apartment here held for an English artist are described by Jonathan Skelton in his first letter from Rome, dated 11 January 1758:

> I have taken a very handsome Lodging on the Trinita del Monte on one of ye Finest Situations about Rome. It commands almost the whole City of Rome besides a good deal of ye Country. The Famous Villa Madama (where Mr. Wilson took his View of Rome from which I always thought his best Picture) comes into my View. I shall have the finest opportunity of painting Evening Skies from my Painting-Room that I could almost wish,—surely I shall be inspired as I am going to live in the Palace of a late Queen, and in the same Apartments that Vernet had (when he was here) and within 80 or 100 yards of ye House where those Celebrated Painters Nicolo and Gasper Poussin lived! I am to pay £6 a year for my Lodgings, and I can have them furnished for £4 a year more as well as I shall desire.

Once the young Englishman had settled into his lodgings the first thing to be done was to find a good cicerone or antiquarian to show him the sights of Rome. This profession of guide lecturer was not a very lucrative one, and in consequence it was often combined with art dealing. Until about the middle of the eighteenth century the Italians had the field to themselves. It was only as the influx of English visitors increased that English artists, turned antiquarians, took their place. The most famous of the cicerones in the first half of the

eighteenth century was Francesco de Ficoroni, the author of *Le Vestigia e Rarità di Roma*.

The first English artist of note to embark on the profession of antiquarian was James Russel, who had arrived in Rome in January 1740 to study painting and had entered the studio of Francesco Imperiale. Today, if he is remembered at all, it is not as an artist but as the author of *Letters from a Young Painter Abroad to his Friends in England*, published in 1748. His only known painting was done in Rome in 1744. It represents William Drake of Shardeloes and the two distinguished scholars Dr. Townson and Edward Holdsworth, who accompanied him as tutors on the Grand Tour. The artist has depicted himself leaning against the table on the left. Unfortunately the name of the palazzo is not recorded.

On Russel's death in 1763, the two rivals for the position of principal antiquarian to the English travelers were Colin Morison and James Byres. There are a number of striking parallels between their careers. Both came to Rome as students of painting in the 1750s, both were associated with Anton Raphael Mengs, both switched from one branch of art to another and were not really successful in either, both became antiquarians and dealers, and both spent most of their lives in Rome.

Morison was a distinguished classical scholar and acted as antiquarian to Boswell, whose enthusiasm for the ruins on the Palatine was such that he suddenly broke into Latin. Morison replied in the same language, and thenceforth they decided to speak Latin continually while viewing antiquities. The effort seems to have proved too much for their tempers and their relations became somewhat strained.

James Byres soon captured the position of principal antiquarian, and he was to become one of the dominant figures in Rome in the second half of the century. He was painted by Maron, and also, with his family, by the Polish artist Smuglewicz (fig. 5). In October 1764 Byres had the privilege of conducting Edward Gibbon and his friend William Guise on the tour of Rome. Under Byres' direction the sightseeing proved so arduous that Gibbon had no strength left for the journal that he had kept on the journey from Geneva to Rome.

The Duke of Hamilton was among the many rich young men on the Grand Tour to whom Byres acted as cicerone. On his visit to Rome in 1775 he was painted by Gavin Hamilton on a hill overlooking the Forum, with his tutor, the witty Dr. John Moore, and with the latter's son, Ensign John

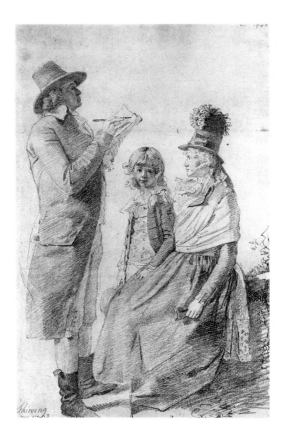

Moore, the future hero of Corunna (fig. 6). In his account of their time in Rome, Dr. Moore writes, "our mornings are usually spent in visiting the antiquities, and the paintings in the palaces. On these occasions we are accompanied by Mr. Byres, a gentleman of probity, knowledge and real taste." Later in his book he says that "what is called a regular Course with an antiquarian generally takes about 6 weeks; employing three hours a day, you may in that time visit all the churches, palaces, villas, and ruins worth seeing in or near Rome." He follows this with the warning that the labor will be of little use unless the most interesting things are revisited and reflected on at leisure, and he mentions, as an example of folly, the case of the young Englishman who ordered a post-chaise and four horses to be ready in the morning and saw everything in two days. Many instances could alas be quoted of the philistinism of the English. As a special mark of favor Cardinal Allesandro Albani, who acted as protector of the English, was able to persuade the great German scholar Winckelmann to take a young English nobleman on a tour of Rome. Winckelmann complained that Lord Balti-

more refused to spend more than ten minutes in the Villa Borghese. Nothing gave him any pleasure except Saint Peter's and the *Apollo Belvedere*. Even worse was his experience with the Duke of Gordon who, Winckelmann says, showed scarcely any signs of life as he sat in his carriage while he, Winckelmann, explained to him with the choicest expressions and the noblest images the beauties of the ancient works of art. Henceforth he resolved never to undertake this duty unless the person was worthy of it and sympathetic to him.

James Byres continued to act as antiquarian until the 1790s, but some people, especially those with families, were unwilling to subject themselves to the rigors of his course, and, as shown in the drawing of 1792 by Alexander Skirving (fig. 7), preferred to do their sightseeing on their own. During the thirty-five years that Byres spent in Rome, he sold many works of art to the young milords whom he had conducted on the tour of the city. One of his earliest purchases was Poussin's *Assumption* (now in the National Gallery, Washington), which he purchased for Lord Exeter in 1764.

Some twenty years later, in 1785, Byres crowned his art dealing activities with one of the major coups of the eighteenth century. This was the purchase for £2,000 from the Bonapaduli family of Poussin's *Seven Sacraments*, which he sold to the Duke of Rutland. One of this series is now in Washington, one was destroyed by fire, and the other five remain at Belvoir Castle. In the conspiracy that led to Byres' acquisition of these pictures, he proved himself as great a master of duplicity as his rival, Thomas Jenkins. Permission to export these pictures had been refused in the past, and since then the regulations had been tightened rather than relaxed. Byres arranged with the owners, the Bonapaduli brothers, for the Poussins to be copied "with the greatest secrecy." As soon as each copy was completed it was hung in place of the original. By November 1785 the originals were all in Byres' possession, and by August 1786 they had reached England. It was important that the deception should not be discovered by the papal authorities as it might have imperilled Byres' legitimate business of exporting works of art. The Bonapaduli palace was visited by foreigners solely on account of these pictures, and Byres had been in the habit of showing them to Englishmen attending his courses so it was part of the bargain that Byres should continue to bring visitors to the palace and to show the copies as if

Figures 8 & 9
The classical landscapes of Claude were of immense influence on English gardens laid out in the "picturesque taste." This view across the lake to Flitcroft's Pantheon at Stourhead in Wiltshire (left) was based on paintings like Claude's Coastal View of Delos with Aeneas, *1672 (National Gallery, London, right)*

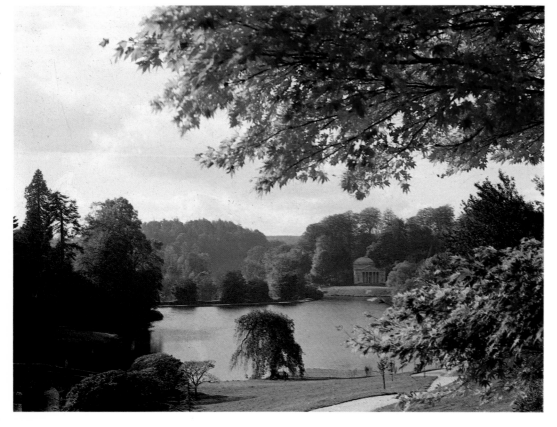

they were the originals.

Byres' most important purchase "in the virtù way" was made in about 1780, when he bought what is now known as the Portland Vase. This famous Roman cameo glass vase, which probably dates from the reign of Augustus, had long been one of the treasures of the Barberini family. It was sold to Byres by Donna Cornelia Barberini-Colonna partly to pay for her heavy losses at the card table. Byres showed the vase to Sir William Hamilton, who later told Josiah Wedgwood that he had paid the £1,000 that Byres had asked for it without any hesitation (see no. 427). Sir William brought the vase to England in 1783, and sold it to the Duchess of Portland, whose son later deposited it in the British Museum where it was smashed into more than 200 pieces by a drunken Irishman in 1845. It has since been miraculously restored.

The artist most loved by all the Englishmen on the Grand Tour was not Poussin but Claude Lorrain. His works were eagerly collected by them from the early part of the eighteenth century onward. His paintings evoked for them the scenery of the places they had visited, the Roman Campagna, the Alban lakes, and the seaports on the Neapolitan coast.

One of the most celebrated of all Claude's pictures, *The Landing of Aeneas in Latium* (no. 309), belonged to the Princes Altieri, father and son, who were both blind, and who, fearful that it and its companion picture might be confiscated by the French when they invaded Rome in 1798, sold the pictures to two English artists, Robert Fagan and Charles Grignon. The latter, meeting Nelson at Palermo, so impressed the admiral with the importance of the pictures that he arranged for a convoy to escort the small vessel on which they were being taken to England. On arrival there the paintings were sold to William Beckford.

The influence of Claude's paintings on English taste was immense. His classical landscapes were emulated by Wilson and Turner, and imitated by a host of minor artists. Admiration for his work led to the invention of the "Claude Glass," which was used by landscape painters to obtain from a natural scene the effect of a picturesque, idealized "Claudian" view. Even the English landscape, as at Stourhead in Wiltshire, was transformed to resemble that of a Claude painting (fig. 9) with temples, the focal points of vistas, on different sides of the lake (fig. 8). The artist upon whom Claude's mantle fell in the Rome of the middle of the eighteenth century was appropriately christened Claude Joseph

Vernet. Unlike that third-rate Scottish artist Jacob More, described by Sir Joshua Reynolds as "the best painter of air since Claude," Vernet was an extremely gifted artist. The two pictures here, a *Shipwreck* and a *Coast Scene* (nos. 200 and 201), come from Uppark, in Sussex, and were ordered from Vernet either by Sir Matthew Fetherstonhaugh or his brother-in-law, Benjamin Lethieullier, when they were in Rome in 1751. Both sat for Batoni, and Sir Matthew purchased from him that entrancing picture of a girl in white with a dove and a sheaf of lilies representing *Innocence*.

Byres' principal rival in Rome as a purveyor of works of art was Thomas Jenkins who dealt chiefly in antique sculpture, but he had a flourishing business in selling faked intaglios and cameos made for him in part of the Colosseum, and the sculptor Nollekens recalls that as a young man he saw the men at work and was given a handful of false gems to say nothing of the matter.

The taste for classical marbles goes back to the first quarter of the seventeenth century when Charles I and the Earl of Arundel were forming their collections. Mytens' portrait in this exhibition shows the latter in his sculpture gallery (no. 49), the first recorded in England. The collecting of ancient marbles reached its zenith in the eighteenth century, which Adolf Michaelis describes as the "golden age of classic dilettantism." It was then that the great collections of ancient marbles were formed and galleries, such as that designed by Robert Adam for Newby Hall (fig. 10), were built to contain them. The classical style of so many English eighteenth-century country houses was conceived as a particularly appropriate setting for the display of Roman sculpture. The trade for supplying the statues was largely in the hands of three men: Thomas Jenkins, the history painter, Gavin Hamilton, whose portrait group of the Duke of Hamilton has already been mentioned (fig. 6), and who undertook a number of very successful excavations; and the most famous of all restorers, Bartolomeo Cavaceppi. Most collectors were not much interested in the mutilated fragments as they came out of the ground, and indeed Lord Tavistock had declared that he would "not give a guinea for the finest torso ever discovered." In consequence, collectors got what they wanted—a complete statue—and, although certified as such by Jenkins, it might consist of a head of Venus stuck onto the

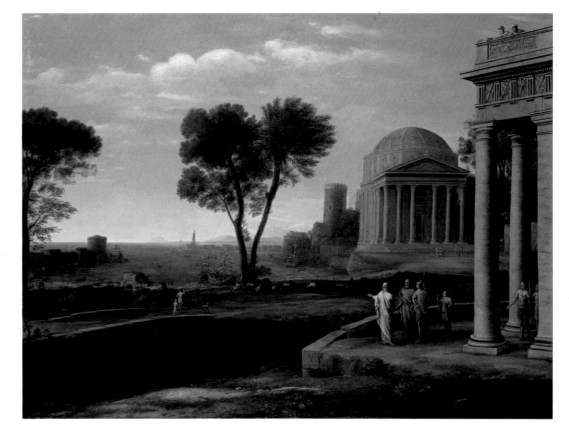

Figure 10

The sculpture gallery at Newby Hall, Yorkshire, designed by Robert Adam in 1767. The Barberini Venus, bought by William Weddell from the dealer Thomas Jenkins, can be seen through the arch, in one of the niches of the rotunda

Figure 11

The workshop of Bartolomeo Cavaceppi, the foremost restorer of antique sculpture in Rome, from the frontispiece to his Raccolta d'antiche statue, *published in 1769*

Figure 12

Rosalba Carriera, Charles Sackville, Earl of Middlesex (later 2nd Duke of Dorset), *pastel, 1737 (The Lord Sackville, Knole, Kent). The portrait was commissioned in Venice in 1737, and shows the earl dressed for the carnival, wearing a mask on his hat*

body of another goddess with the missing parts, a nose, a toe, or a hand, supplied by some restorer (fig. 11). Among the many pieces of antique, and not so antique, sculpture thought to have been through Cavaceppi's hands, two of the most engaging are included in this exhibition: Lord Clive's cat (no. 224) and the so-called "Dog of Alcibiades" (no. 243). The latter was considered by Horace Walpole among the five chief statues of animals from antiquity. One of the principal collectors of ancient marbles in England was Charles Towneley, who is shown in his sculpture gallery in a painting by Zoffany (no. 213). Prominent on the table is a bust of Clytie, which he called his wife, and lovingly took with him when he vacated his house during the Gordon riots.

The number of Englishmen who had their portraits painted in Italy in the seventeenth century is few, but Carlo Maratta's portrait of Sir Thomas Isham is a good example (no. 138). However, in the course of the eighteenth century it became more and more common for an Englishman on the Grand Tour to have his portrait painted in Rome to commemorate his visit to Italy. These evoke the spirit of the Grand Tour far better than words. It was usual for the artist to include some well-known monument or statue in the background, and an early example of this fashion is Antonio David's portrait of George Lewis Coke, which is signed and dated 1735. In the second half of the eighteenth century the two great rivals in Rome were Raphael Mengs and Pompeo Batoni. Although they prided themselves on being primarily history painters, they both painted portraits of Englishmen on the Grand Tour. The total number of Englishmen painted by Mengs does not amount to more than about two dozen, whereas Batoni must have painted more than two hundred.

It is of particular interest to compare their portraits of the same young man, especially when they were painted in the same year and when different facets of his character are revealed. Mengs' half-length portrait of Lord Brudenell in this exhibition (no. 174) is one of two of him painted by the artist in 1758. There is a rather solid Teutonic heaviness about the other, a full-length at Boughton in which the German artist has brought out the studious side of his sitter, depicting him book in hand, with a bust of Cicero on the table. Batoni's portrait of Lord Brudenell, which was

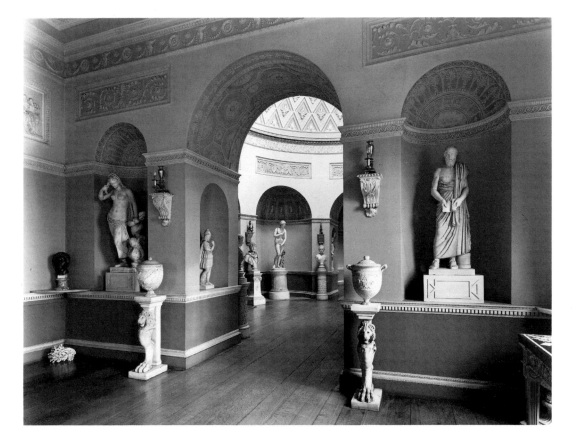

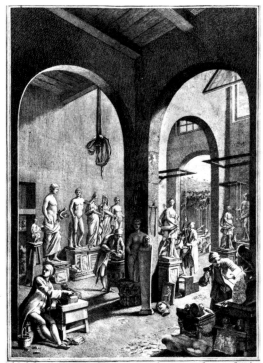

Studio di Bartolomeo Cavaceppi, ove sono state restaurate le Statue contenute nella presente Raccolta.

painted the same year, is in striking contrast (no. 173). It is distinguished by Italian elegance and refinement, and shows the young man with a fiddle under his arm and holding the score of a violin concerto by Corelli. It can hardly be doubted that Lord Brudenell instructed both artists how he was to be portrayed. While in Naples Lord Brudenell bought a number of pictures of the city by Antonio Joli, including that of the Palazzo Reale (no. 175), and also views of the environs of Naples.

One of the most remarkable of all Batoni's portraits, and certainly the one with the greatest panache, is that of General Gordon in the uniform of the Queen's Own Royal Regiment of Highlanders (no. 176). He stands like some Nordic conqueror beside a statue of Minerva and against the background of the Colosseum. Another unusual portrait by Batoni in this exhibition is his enchanting painting of the three-year-old Louisa Grenville (no. 199), who later became Countess Stanhope. In its original frame, it is one of Batoni's rare portraits of children, and, as the late Anthony Clark so perceptively observed, it is "as if a plain statement by Hogarth had been perfected by Fragonard." Another rival to Batoni was the Viennese painter Anton von Maron, who studied in Rome under Mengs. He painted a number of English people of which the portrait of Peter Du Cane, dated 1763, in the Birmingham Art Gallery, is his finest. Among the English artists studying in Rome there were many who painted portraits of their compatriots. The most successful was Nathaniel Dance, whose groups of Englishmen (no. 198) were much in demand.

The last of the four cities that every Grand Tourist visited was Venice. Unlike Rome where so many chose to be painted against a Roman background, I know of only one eighteenth-century portrait of an Englishman with a Venetian background. This is the portrait of Samuel Egerton painted by Bartolomeo Nazzari in 1733 (no. 177). Across the Grand Canal can be seen the Dogana and beyond that, across the Giudecca Canal, is Palladio's church of the Redentore. Samuel Egerton was apprenticed in 1729 to the famous Joseph Smith, and it was no doubt on his advice that the portrait was commissioned.

Joseph Smith, contemptuously described by Horace Walpole as "The Merchant of Venice," was established in the city by 1709 but he did not attain the post of consul until 1744. He held the post until 1760, and died in Venice in 1770 at the age, it is said, of ninety-six. Although socially, and

in matters of honesty, he was not the equal of Sir Horace Mann or of Sir William Hamilton, he came to occupy in Venice much the same position that they held in Florence and Naples. Today he is chiefly remembered as the patron of Canaletto, and the wonderful collection of this artist's work, which he sold to George III, is still in the Royal Collection. The two paintings by Canaletto in this exhibition which come from Tatton Park (nos. 167 and 168), were bought by Smith for his friend Samuel Hill, the uncle and guardian of Samuel Egerton. Joseph Smith also patronized other Italian artists including Rosalba, and he was doubtless responsible for obtaining her commissions to do pastel portraits of the English on the Grand Tour. One of her finest portraits is that of Lord Middlesex (fig. 12), who was later to become the second Duke of Dorset. He is wearing masquerade dress and it will be noticed that he is wearing his mask in his hat. The portrait was made in Venice in 1737, and it may well have been there that he formed his passion for opera which he tried to promote on his return to England.

Smith lived in what is now known as the Palazzo Mangilli-Valmarana, which he got Visentini to rebuild for him in 1750. It is not far from the Rialto and opposite the Pescheria. Separated from it by the Rio SS. Apostoli is the Cà da Mosta, which in the eighteenth century was the famous inn, the Leone Bianco, where many of the English stayed. Consul Smith kept open house and on his walls were to be seen paintings not only by Canaletto and Rosalba but by Sebastiano and Marco Ricci and Zuccarelli, so that it could be said that he acted as agent for these artists.

Most travelers planned their tour of Italy so as to be in Venice to witness the great Ascension Day ceremony when the Doge embarked at the Molo, and was rowed in the Bucintoro to the mouth of the Lido, where he cast a ring, blessed by the Patriarch, into the sea as a symbol of the union between Venice and the Adriatic. Venice was the link between Europe and the Orient and the spectacle on the waterfront of Turks, Albanians, Levantines, and Greeks in their national costumes must have been endlessly diverting. Besides the Ascension Day ceremony there were countless other spectacles such as the boat race on the Grand Canal, and the feast day of Saint Roch, when the Doge heard mass at the church and then visited the Scuola San Rocco (no. 170). It would be interesting to know how many Englishmen before Ruskin appreciated the wonderful visionary paintings of Tintoretto that

adorn its interior. For those who were musical, Venice must have been a paradise, for in addition to the opera there were concerts in the palaces and also at the four hospitals, the Ospedaletto, the Mendicanti, the Pietà, and the Incurabili, which were really more conservatories than convents, where orphans and love children were taught such sweet music that, as Rousseau says, "it has not its like in Italy, nor in the rest of the world."

It is difficult to imagine what English country houses would be like without the treasures that were brought back from Italy on the Grand Tour—without the views of Venice and the *capricci* by Panini, which recall the Roman monuments (nos. 182 and 183), without the classical statues and busts that adorn so many halls, and without the countless Italian pictures that are so well represented here. It can only be said that they would lose much of the unique character and charm that makes visiting them so enjoyable and rewarding an experience.

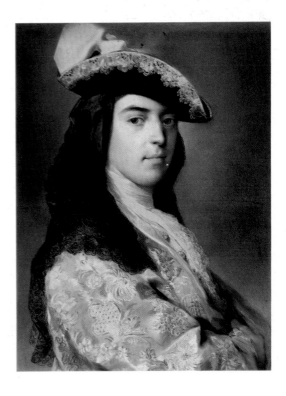

The British as Collectors

Francis Haskell

Figure 1
The First George Room (formerly the state dressing room) at Burghley House, Northamptonshire. The collection of Italian seventeenth-century pictures assembled by the 5th Earl of Exeter (c. 1648–1700) was one of the first to be acquired specifically for a house in the country, rather than in London

In his brave and eloquent protest against General Bonaparte's plans to remove the principal master-pieces of art from Italy, the French theorist Quatremère de Quincy wrote in 1796 that "England is the image of what Europe would become if the dismemberment which I fear were actually to occur. That nation has no centralized, dominant collection despite all the acquisitions made by its private citizens who have naturally retained them for their private enjoyment. What is the result? These riches are scattered through every country house; you have to travel in every county over hundreds of miles to see these fragmented collections: so that I can think of nothing less useful for Europe, or even for the arts of England itself, than what England already possesses. . . . Let us hope that one day these collections will be happily reunited and restored to the world of learning."[1]

At much the same time August von Kotzebue, the German dramatist (whose *Das Kind der Liebe* it was hoped to perform as *Lovers' Vows* in Mansfield Park, that most famous of fictional country houses), wrote that an ancient sculpture taken to the English countryside from Italy might just as well never have been excavated.[2]

But Quatremère had been to England only briefly, and Kotzebue not at all. They could not know that already access to the main collections was tolerably liberal and indeed that catalogues had often been compiled for the benefit of the many visitors who came to see them. Moreover, the great country houses with their magnificent parks, luxurious furnishings, collections of paintings, drawings, and sculpture; porcelain, coins, and medals, and their growing number of legends—about royal visitors or eccentric ancestors—had succeeded in recreating that context of beauty and historical associations which Quatremère rightly understood as the most evocative feature of Rome itself. Scattered through the remote countryside, they fulfilled (for an admittedly limited public) some of the functions we now ask of museums, libraries, and even concert halls. And they still do. Despite a hundred years of almost uninterrupted decline, decay, and destruction, the country houses of Great Britain—most of which are obviously far more accessible now than they were at the end of the eighteenth century—help to compensate for the fact that (with the rarest of exceptions) our provincial museums cannot compare in quality with their equivalents in the United States, Germany, Italy, and elsewhere, which have been built up in such very different circumstances.

But this was not always the case. The British country house collection is by no means coterminous with British art collecting. The vast numbers of masterpieces that came to this country during the reign of Charles I mostly remained in London—at Whitehall, Arundel House, York House—and when art collecting resumed on a serious scale in the second half of the seventeenth century it was once again to London that most of the famous sculpture and paintings were sent.

Nonetheless, the most remarkable collection formed after the restoration of the monarchy consisted chiefly of Italian seventeenth-century pictures assembled by the 5th Earl of Exeter, which were from the first intended to be hung at Burghley, the mansion in Northamptonshire which had originally been built by his ancestor William Cecil, Queen Elizabeth's great minister (fig. 1). Like other houses this was also decorated with lavish frescoes by the fashionable (but mediocre) Antonio Verrio. The "prodigious numbers of pictures by Carlo Maratti, Giuseppe Chiari, Carlo Dolce, Luca Jordano, & Philippo Laura," which he apparently bought during the course of three separate visits to Italy were said to "infinitely exceed all that can be seen in *England*, and are of more Value than the House itself, and all the Park belonging to it." What little we know of Lord Exeter's cheerful character confirms the tradition that "his scandalous Life, and his unpaid Debts . . . [caused] him to be but very meanly spoken of in the town of Stamford." More revealing is the fact that, like so many later important collectors, he was a man whose political affiliations led him to break with the court and with London society.[3]

Blenheim (unlike Marlborough House in London) was also designed to have a grand picture gallery from the first, and in 1707 we find the great Duke of Marlborough writing impatiently to his wife to ask her to store his pictures (which included magnificent Rubenses and Van Dycks) until it should be ready to receive them.[4] The grandiose taste reflected at Burghley and Blenheim is in fact similar enough to what could be seen at much the same time in some of the castles of Austria and South Germany.

There were certainly other fine country collections in the early eighteenth century—Lord Derby's pictures at Knowsley in Lancashire were especially engraved for a volume published in 1728—but they were unusual. In general the country house was still decorated essentially with tapestries, frescoes by imported French and Italian painters, and—above all—by family portraits. These could, of course, be of outstanding quality. The great Van Dycks of the Pembroke family, for instance, were originally installed at Durham House, the London mansion which had been leased by the family, but they were taken to Wilton (two or three years after the execution of Charles I with whom the Pembrokes had once been so closely—and now, no doubt, embarrassingly—associated), where they were placed in a room specially designed for them.[5] But, despite the presence in England of a number of greatly admired Holbeins and Van Dycks, few families could boast so splendid a heritage; and the average collection of country house portraits was already, as it has often remained, of greater interest to the antiquarian than to the aesthete.

A family which owned a London establishment tended to keep its finest possessions there. As late as 1766 it could be said of Chatsworth that it "has very little in it that can attract the eye of the Connoisseur. . . . The Pictures are few in number and indifferent," whereas at the family's London residence, Devonshire House in Piccadilly, "the collection of pictures with which this house is adorned, is surpassed by very few others either at home or abroad."[6] Similarly most of the best pictures acquired by Sir Robert Walpole, Prime Minister between 1722 and 1743, were—during his term of office—kept in London, but when he resigned he took them to his splendid house of Houghton in Norfolk (which had been completed only a few years earlier) and the greenhouse was turned into a gallery to accommodate them (see no. 363): this was certainly the most famous country house collection of pictures in Great Britain until it was sold to Catherine the Great of Russia in 1779.[7]

In fact the 1730s witnessed the first stages in the gradual dispersal of art collections from London to the country—and hence the beginning of that surprising phenomenon which has so fascinated visitors ever since and which has led to the present exhibition. In 1732, for instance, Sir Andrew Fountaine (no. 238)—one of the most distinguished connoisseurs and arbiters of taste during the early eighteenth century—decided to give up his London house in St. James' Place and move his collections to his country seat of Narford in Norfolk. As well as pictures he owned a large number of coins and medals, and he also assembled many splendid pieces of Italian majolica which, in the words of a scornful contemporary who visited Narford, were "set out upon shelves like a shop."[8] A year later the even more famous Lord Burlington suffered a political setback and moved his paintings and drawings from his mansion in central London to his Palladian "villa suburbana" at Chiswick (no. 140): withdrawal from politics or life at court, which could be justified poetically as Horatian "retirement," certainly played an important role in the creation of the country house collection.

The removal from London in the 1730s and early 1740s of the Burlington, Fountaine, and Walpole collections may have set a fashion, though the actual motives for such dispersals varied greatly. General (later Field Marshal) Wade, for instance, one of the heroes of the wars against Louis XIV, was, like Marlborough, a keen collector of paintings—but no Blenheim was assigned to him and it was said that when he found he could not fit his Rubens cartoon of *Meleager and Atalanta* into the house in London which had been designed for him by Lord Burlington he was forced to sell it to Sir Robert Walpole who sent it to Houghton.[9] And already much earlier, when two members of the Wentworth family were engaged in intense rivalry to secure supremacy in their native county of Yorkshire, one of them (Lord Raby) had written, "I have great credit by my pictures, and find that I have not thrown my money away. They are all designed for Yorkshire, and I hope to have a better collection there than Mr. Watson."[10]

However varied the reasons, there can be little doubt that by the end of the 1760s a vast exodus of collections had taken place from London to the country. It was probably in that decade that Mr. Paul Methuen moved his splendid paintings from Grosvenor Square to a specially constructed gallery at Corsham Court in Wiltshire (fig. 2), a house which he is said to have bought for that very purpose;[11] and already more than ten years earlier Thomas Coke (Lord Leicester) took his very fine collection of statues, paintings, books, and drawings from Thanet House in Great Russell Street to Holkham Hall in Norfolk, where they too were accommodated in purpose-built galleries and cabinets which were superbly enriched by a great campaign of acquisitions in Italy and elsewhere.[12] The wonderful collection of antique engraved gems and cameos acquired by the 3rd Duke of Marlborough in this period, and indicated in Reynolds' portrait group of him and his family, was also kept at Blenheim (rather than London), and great libraries, like great collections of pictures, were increasingly to be found in the country.

Guides and catalogues to country house collections were published in growing numbers, and as early as 1760 a visitor to one seat in Wiltshire found it "surprising" that so few pictures were to be seen in it.[13]

There were drawbacks to the fashion. In 1787 Sir Joshua Reynolds wrote to the Duke of Rutland of his disappointment that Poussin's *Seven Sacraments*, which he had helped to buy for him, were to be sent to Belvoir, the Duke's country house. "I hear people continually regret that they are not to remain in London; they speak on a general principle that the great works of art which this nation possesses are not (as in other nations) collected together in the capital, but dispersed about the country, and consequently not seen by foreigners, so as to impress them with an adequate idea of the riches in virtu which the nation contains. . . ."[14]

When Reynolds wrote this letter, many very remarkable works of art were, indeed, to be found in British country houses; but because of the legendary wealth and extravagance of their purchasers it is worth noting how comparatively limited in scope these actually were. Not a single one of what we would now consider the most celebrated

Roman antiquities had been acquired, although the Jenkins Venus at Newby and the "Alcibiades' Dog" at Duncombe (no. 243) were extremely highly prized in their day, and if we consider those Italian artists who were most highly esteemed during the eighteenth century—Raphael, Titian, Correggio, Annibale Carracci, Domenichino, and Guido Reni—we find that they too were poorly represented. It is true that there was hardly a significant collection which did not claim to own one or more pictures by some or all of these masters, and that such claims are almost as important to the student of taste as a knowledge of what actually was to be seen in England. Nonetheless, looking back from our vantage point, it is easy to discern that—if we omit those belonging to the royal family, which constitute rather a special case—few important and authentic pictures by the masters of the Italian Renaissance and Bolognese school hung on British walls (when compared with what could be seen in Paris, Dresden, Vienna, or Madrid) between the dispersal in the 1640s and 1650s of the collections which had been built up by the courtiers of Charles I and the influx of masterpieces following the disturbances caused by the French Revolution. Titian's *Vendramin Family* (now in the National Gallery, London) was probably the finest picture in England: it had been acquired by the 10th Earl of Northumberland from Van Dyck. The only significant Raphael was the early *Ansidei Madonna* (now in the National Gallery, London), which was bought in Italy in 1764 for Lord Robert Spencer and given to his brother, the Duke of Marlborough, who kept it at Blenheim. General Guise had a number of pictures by Annibale Carracci which, after his death in 1765, left London for Christ Church in Oxford. And Sir Robert Walpole owned a very celebrated Guido Reni (*The Virgin and the Doctors of the Church*), whose export the pope had wished to prevent.[15] This was kept at Houghton until the sale of 1779 and is now in The Hermitage.

It would, of course, be very simple to add a number of pictures to this list, but it remains true that major works by those considered to be the major artists were only very rarely available to even the most spendthrift "milordi." In compensation, other painters were exceptionally well represented. Portraits by Van Dyck constitute a special case, but the Rubenses to be seen in England also included some masterpieces, as did the Rembrandts. The fourteen Poussins calculated to have been in Britain between 1714 and 1766[16] (that is before

the purchase of the Rutland *Sacraments*) included paintings of the caliber of *The Crossing of the Red Sea* (now in the National Gallery of Victoria, Melbourne) and *The Adoration of the Golden Calf* (now in the National Gallery, London), which both belonged to Sir Jacob Bouverie (as did Guido Reni's *Rape of Europa*—now in the Mahon collection, London) and were probably kept in London but taken to Longford Castle in Wiltshire when, in 1761, they were inherited by Bouverie's son, the Earl of Radnor.

And although there had been some pictures attributed to Aelbert Cuyp in British collections well before 1764 when Lord Bute's magnificent *River Landscape with Horseman and Peasants* was first recorded (in the form of an engraving), it was this picture which, according to Benjamin West, inspired the fashion for him[17] and it was not long before most of his finest works had been accumulated by British collectors (see no. 316). Works by other Dutch landscape painters were acquired with equal enthusiasm.

Salvator Rosa was particularly admired and collected (see nos. 312 and 314). Thirty-five engravings after pictures by him then in England were published in the 1770s, and it is perhaps surprising to discover that the most celebrated works by him in England—works so celebrated in fact that they alone sufficed to draw attention to the country houses in which they were to be seen—were not landscapes but figure paintings: *The Allegory of Fortune* (now in the J. Paul Getty Museum, Malibu), which hung in the Duke of Beaufort's mansion, Badminton in Somerset; and *Belisarius* (now in a private collection) which was said to have been given to Lord Townshend by Frederick the Great and which was displayed in a room at Raynham Hall in Norfolk specially decorated for the purpose.

But, of course, the most famous of all masters whose works were bought by the English in the eighteenth century was Claude, who made a decisive and lasting impact on many aspects of British taste, art, and gardening, and the most splendid group of his works was that assembled by Thomas Coke (Lord Leicester) at Holkham, where at least seven authentic paintings were to be seen in "The Landscape Room" (fig. 3). The collections at Holkham represent perhaps the most exemplary of all those to be found in the country houses of Great Britain. In and around this great Palladian house, designed partly by the patron himself with the help of Lord Burlington as well as by William Kent and the

elder Brettingham, a visitor could enjoy all the pleasures of a liberal education: the antique was recalled again and again not only in the temples and other buildings in the grounds and in the great hall, based on an ancient Roman basilica, but also in the marble figures and busts (see nos. 232 and 236), some of exceptional importance and some removed from Rome by highly questionable means, and in a large group of plaster casts after the most famous ancient sculptures. The Italian Renaissance was recalled in the form of a copy of Michelangelo's celebrated but destroyed cartoon of *The Battle of Cascina*. As well as the incomparable Claudes and other landscapes, there were major pictures by Rubens and Van Dyck, while modern Italian painting included not only the inevitable Canalettos,

but history pictures by Giuseppe Chiari, Solimena, and others (fig. 4). In the library was a superb group of old master drawings including the famous Leicester (now Hammer) codex of Leonardo da Vinci, as well as collections of manuscripts and early printed books of the very highest repute.

The revolutions and wars which devastated Europe (but not Great Britain) at the end of the eighteenth century made a huge difference to the quality and quantity of works of art to be found in British houses, but not to their character. Although it would be ludicrously exaggerated to claim that the attributions in country house catalogues to Raphael, Titian, Correggio, and other great painters which had hitherto been as fanciful as they were abundant could henceforth be relied on, it is none-

theless true that supreme masterpieces by these and others of equal standing could now be seen in England for the first time since the death of Charles I—in London, chiefly, where the Duke of Bridgewater installed his fabulous haul from the Orleans collection, but also at Attingham in Shropshire (fig. 5) where Lord Berwick kept (for a time) Titian's *Rape of Europa* (now in the Isabella Stewart Gardner Museum, Boston); or at Rokeby Hall in Yorkshire, a house rich in Greek antiquities, where J.B.S. Morritt hung Velasquez' *Venus with a Mirror* "over my chimney-piece in the library. It is an admirable light for the painting and shows it in perfection, whilst by raising the said backside to a considerable height the ladies may avert their downcast eyes without difficulty, and connoisseurs steal a glance with drawing in the said posteriors as part of the company;"[18] or at William Beckford's fantastic neo-medieval Fonthill Abbey in Wiltshire where visitors lucky enough to be admitted could admire, among countless treasures of all kinds, Raphael's *Saint*

Catherine and Giovanni Bellini's *Portrait of Doge Leonardo Loredan*. All three pictures are now in the National Gallery in London.

Pictures of comparable quality continued to be imported long after peace had returned to Europe. In one of the last bulk purchases of its kind, the 4th Duke of Northumberland in 1856 acquired the collection of Vincenzo Camuccini, the artist and dealer who lived in Rome (see nos. 494 and 495). This included *The Feast of the Gods* by Giovanni Bellini and Titian (now in the National Gallery, Washington) and other splendid Venetian pictures. The duke provided a congenial setting for them by bringing over to England the architect Luigi Canina and a team of Italian craftsmen to erect rooms in the style of the Italian Renaissance in his castle at Alnwick in Northumberland (fig. 6).

But this spectacular gesture looked to the past, and by then many collectors had self-consciously rejected such homages to traditional taste and had seen their roles more in terms of the patronage of contemporary British art. By the middle of

the century this came to be thought of as typical of the newly rich middle class which had been brought into being by the Industrial Revolution, but many precedents for it were to be found among the nobility and gentry. Thus Sir John Fleming-Leicester (later Lord de Tabley) turned to buying exclusively English pictures (such as the Turner and John Martin, nos. 520 and 521) in the very first years of the nineteenth century and divided them between his London house and Tabley Hall in Cheshire (fig. 8): the publication of a well-illustrated catalogue—an increasingly popular practice—ensured that the collection became widely known. And, above all, the 3rd Earl of Egremont (who was one of the purchasers at Lord de Tabley's sale) added a large number of works by living English artists, notably Turner, to the fine collection of old masters and antiquities which he had inherited at Petworth in Sussex. Lord Egremont also patronized sculptors, and his gallery rivaled the one designed for the Duke of Bedford at Woburn which also included antique marbles as well as others by contemporary English sculptors and, above all, Canova's famous *Three Graces* (no. 480). But by far the most important sculpture gallery of the nineteenth century was that created by the 10th Duke of Devonshire at Chatsworth (fig. 7), in which some of Canova's most impressive works were juxtaposed to others by English and German sculptors working in Rome (no. 477).

Those collectors who continued to prefer old masters often moved into the hitherto unexplored field of early Italian painting. During the 1840s and 1850s Mr. Davenport Bromley of Grosvenor Street in London was filling his country house of Wootton Hall in Derbyshire with important pictures by (or attributed to) Giotto, Simone Martini, Orcagna, Botticelli, and other masters of the early Italian Renaissance as well as a group of Spanish paintings acquired from Paris[19]—comparable with those acquired by Sir William Stirling Maxwell for Pollok House and Keir in Scotland. These pictures were distributed throughout the various rooms of the house (fig. 9), as was often the case—to the surprise and delight of many visitors who expected to find masterpieces segregated in special galleries (at Sir George Beaumont's Coleorton in Leicestershire, Constable was "almost choked in this breakfast room. Here hang 4 Claudes, a Cousins [sic] and a Swanevelt").[20] But ever since the middle of the eighteenth century galleries had been inserted into a number of houses,

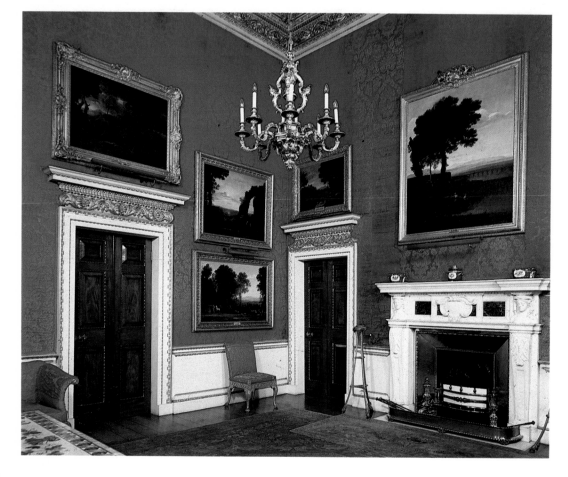

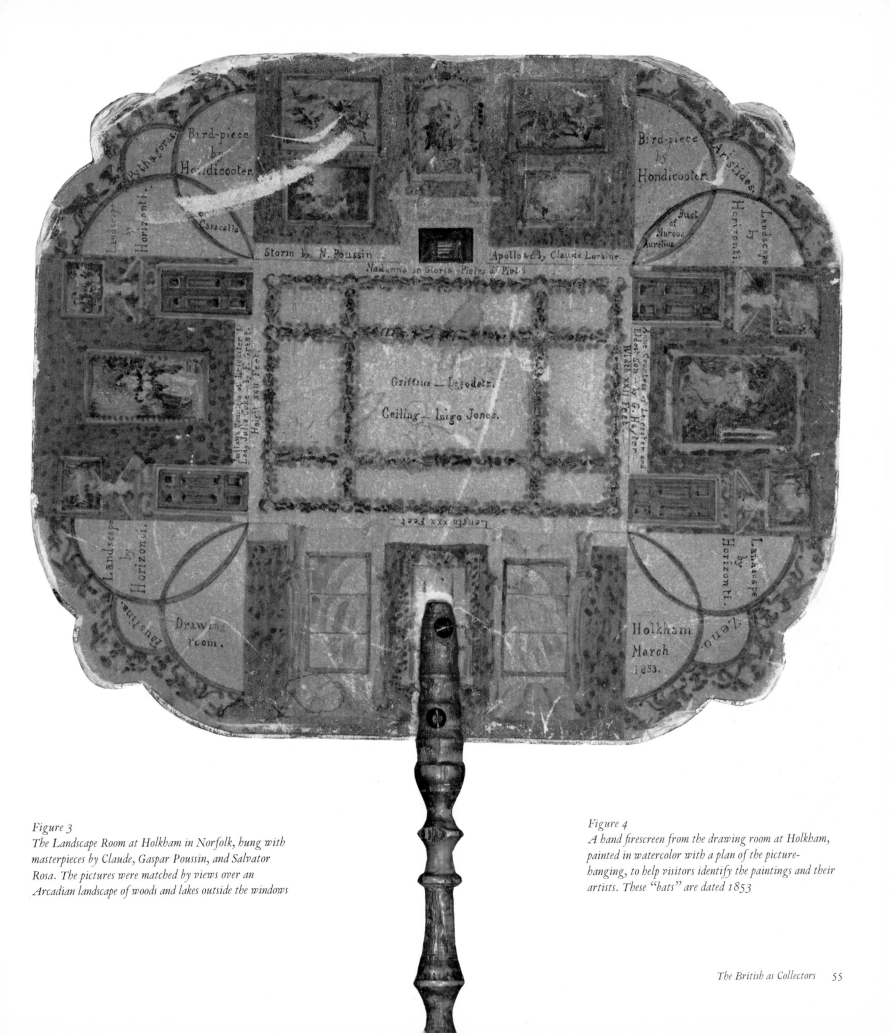

Figure 3
The Landscape Room at Holkham in Norfolk, hung with masterpieces by Claude, Gaspar Poussin, and Salvator Rosa. The pictures were matched by views over an Arcadian landscape of woods and lakes outside the windows

Figure 4
A hand firescreen from the drawing room at Holkham, painted in watercolor with a plan of the picture-hanging, to help visitors identify the paintings and their artists. These "bats" are dated 1853

particularly for the display of sculpture: most successfully at Newby Hall in Yorkshire (page 48, fig. 10) where, at much the same time that the Museo Clementino was being planned in Rome, Robert Adam devised a beautiful set of similar (small-scale) galleries for the antique figures acquired from Rome by William Weddell. Indeed, rooms such as these, where the pedestals themselves were frequently designed by the architect, often directly influenced the choice of Greek and Roman sculptures to be smuggled out of Italy or fabricated there, because the overall balance and proportions of the galleries as a whole were thought of as being at least as important as the quality of the pieces they were designed to hold.

Majolica, small bronzes, Venetian glasses, weapons, miniatures, and so on, had to some extent always been accumulated in British country houses, but it was in the nineteenth century that such objects began to form an increasingly significant proportion of what was collected, occasionally rivaling or surpassing in importance paintings, sculpture, drawings, and medals. William Beckford, whose old masters were of supreme quality, was also a passionate collector of reliquaries, agate

vases, and other curiosities (see no. 513) as had been Horace Walpole at Strawberry Hill, and—like a number of other rich Englishmen—he was able to take advantage of the great sales of the contents of the royal palaces held in France after the outbreak of the Revolution: thus out-of-date but exquisitely made furniture also became part of the British country house collection. It was probably the well-published sale in 1855 of Ralph Bernal's 4,300 "works of art of every kind and style except subject pictures of the great schools" which first drew wide attention to the appeal of *objets d'art,*[21] and among the many bidders at that sale were various members of the Rothschild family with whose great country houses around Aylesbury (fig. 11) a taste for eighteenth-century French furniture and objects of virtu came to be particularly associated (see nos. 489 and 508).

But far more characteristic than the international taste represented in these houses was the tendency of nineteenth-century collectors to look back nostalgically to their own ancestors, whether real or fabricated. The country house had long served as a repository for family portraits, and even its changing architectural styles had usually

paid homage to some vanished but evocative past. Antiquarians (from whom we derive so much of our information) had delighted to emphasize whatever historical associations could be discovered in the most improbable collections, but now it was the collections which were built up for the sake of the associations which they could recall. Sir Walter Scott's Abbotsford is the most famous example of a house designed on these principles, but all over Great Britain the accumulation of armor and tapestries and battered furniture testified to a cult of national traditions. It is tempting, in the light of hindsight, to read into the formation of such collections a tacit acknowledgment that the most creative phase of country house culture was drawing to a close: but if such was the case, it was certainly not recognized at the time.

In 1857 a huge exhibition of the *Art Treasures of the United Kingdom* was held in Manchester (fig. 10), and it revealed to the world—and indeed to the inhabitants of the United Kingdom itself—just how fantastically rich British collections then were. The French critic Théophile Thoré began his account of the exhibition[22] as follows:

Let us imagine that the Louvre had suddenly and by magic been created yesterday, and that because of some accident it was to be dispersed tomorrow. . . . The collection of pictures in Manchester is about on a level with the Louvre. The Spanish school, the Northern primitives, the German, Flemish, and Dutch pictures are even more numerous and finer. The English school can be seen only there. Only as regards the great Renaissance Italians does the Louvre surpass Manchester.

If the Duke of Sutherland had agreed to lend his Titians even this small reservation could not have been made.

"All this, collected yesterday, will be dispersed to-morrow," continued Thoré. The words sound poignantly in British ears, for they soon acquired a meaning quite different from what he had intended. Dispersals had, of course, long punctuated the accumulations, and there had been some extraordinary sales well before the general decline set in. In 1848, when the contents of Stowe were being dispersed, *The Times* wrote portentously:

During the past week the British public has been admitted to a spectacle of painful interest and gravely historical import. One of the most splendid abodes

Figure 7
The sculpture gallery at Chatsworth in Derbyshire, built by Sir Jeffry Wyatville for the 6th Duke of Devonshire, and filled with works by Canova, Thorwaldsen, and other neoclassical sculptors

Figure 8
The picture gallery at Tabley House, Cheshire, designed by Thomas Harrison in 1792 for Sir John Fleming-Leicester, later Lord de Tabley

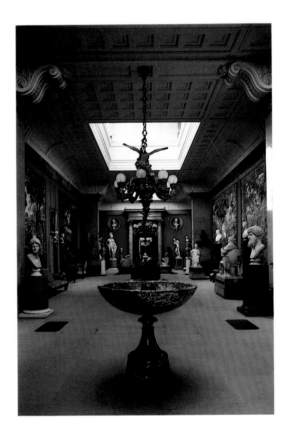

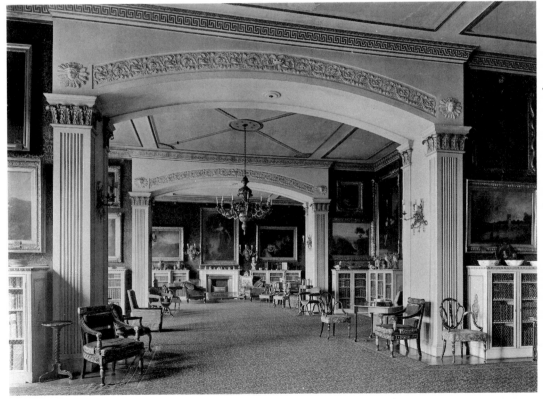

Figure 9
The library at Wootton Hall, Staffordshire, from an anonymous watercolor of about 1850 (Sir Walter Bromley-Davenport, Bart., Capesthorne). The Rev. Walter Davenport Bromley, seen with his second wife and son, was one of the pioneer collectors of Italian primitives

Figure 10
The Art Treasures of the United Kingdom exhibition held at Manchester in 1857, from a contemporary steel engraving. A French critic, Théophile Thoré, wrote "The collection of pictures is about on a level with the Louvre"

Figure 11
The Morning Room at Waddesdon Manor, Buckinghamshire. The collection of Dutch old masters, eighteenth-century British portraits, Louis Quinze furniture and Savonnerie carpets perfectly exemplifies "le goût Rothschild"

of our almost regal aristocracy has thrown open its portals to an endless succession of visitors, who from morning to night have flowed in an uninterrupted stream from room to room, and floor to floor—not to enjoy the hospitality of the Lord or to congratulate him on his countless treasures of art, but to see an ancient family ruined, their palace marked for destruction, and its contents scattered to the four winds of Heaven. We are only saying what is notorious and what therefore it is neither a novelty nor a cruelty to repeat, that the most noble and puissant prince, His Grace the Duke of Buckingham and Chandos, is at this moment an absolutely ruined and destitute man.[23]

But the contents of Stowe were not of the greatest importance and the sale was exceptional. The dispersals of the contents of Hamilton Palace in 1882 and of Blenheim in 1884 were not only of vastly greater significance, but were also symptomatic of what was to come, as was immediately recognized. "The great country houses and town mansions were looked on as permanent places of deposit for the ever-accumulating treasures of successive generations," wrote John Charles Robinson (himself a notable collector and creator of collections) in 1885.[24] But now pictures were

leaving the country houses: "a legion of clever French, German, Dutch, and Italian dealers have found England the most fruitful hunting-ground for such treasures. . . . We are, in fact, now yielding up to other countries the works of Art of which they were formerly despoiled, almost as rapidly as we acquired them. . . ." These words were written a hundred years ago; and before the intervention of American dealers.

That British country houses still contain treasures will be apparent to the reader and, still more, to those who visit the houses themselves. That they once contained a very high, not to say quite disproportionate, fraction of the movable art and artifacts of Europe has been indicated in this brief essay. The transfer of paintings and sculptures from Italian altarpieces or Spanish palaces or Greek soil to the country houses of Great Britain is one of the more remarkable episodes in the history of European taste—and economic relationships. But it is perhaps only now that we are coming to terms with the idea that old masters, antique sculpture and all the other objects amassed by British country house owners can often be seen and appreciated in these lived-in surroundings on two levels—both as individual works of art and as parts of an historic collection—better than in the regimented order of a museum gallery. Quatremère de Quincy, given a motor car, and free passes from the National Trust and the Historic Houses Association, might not be so horrified today as by the anaesthetized display of some of our public collections.

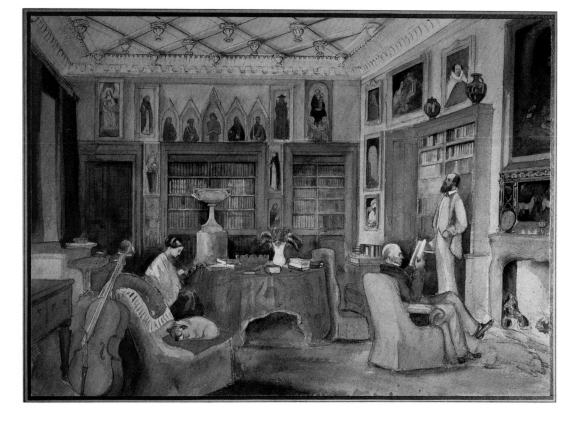

NOTES

I am extremely grateful for the great help I have received from Pascal Griener, John Harris, Christopher Lloyd, Iain Pears, Nicholas Penny, Brian and Kate Ward-Perkins; and also from Burton Frederickson and Carol Dowd of the Provenance Index of the J. Paul Getty Trust, where I was able to carry out much of the necessary research.

Short references are given in full in the Bibliography

1. *Lettres sur le préjudice qu'occasionneroient aux Arts . . . le déplacement . . . des monumens de l'art de l'Italie . . .* Paris, 1796, 48

2. Kotzebue, August von, *Erinnerungen von einer Reise aus Liefland nach Rom und Neapel,* 3 vols. Berlin, 1805, 3:23

3. See, among other references, E.K. Waterhouse, "A note on British collecting of Italian pictures in the later seventeenth century" in *Burlington Magazine,* 1960, 54–58; Daniel Defoe, *A Tour thro' the whole Island of Great Britain . . . ,* ed. G.D.H. Cole, London, 1927, 2:505–507; Vertue 1931–1932, 2:34; Toynbee 1927–1928, 58–59

4. Tipping and Hussey 1928, 90–91

5. Pembroke 1968, 60

6. Martyn 1766, 1:28–29, 41–50

7. See the lists of the pictures at London and Houghton in Vertue 1930–1955, 6:175–180, and Horace Walpole's *Aedes Walpolianae,* 3rd ed., 1767, 76

8. See "The Fountaine Collection," preface to the Christie's sale catalogue of 16 June 1884, and James Lees-Milne, *Earls of Creation,* London, 1962, 211

9. *Survey of London,* 32, part 2, North of Piccadilly, 500; and *Aedes Walpolianae,* 80

10. See Iain Pears, "The Growth of Interest in Painting in England," Ph.D. diss., Oxford University, 1984

11. Lord Methuen, *An Historical Account of Corsham Court,* Corsham, 1971, 15; Dodsley 1761, 3:83–100

12. See the preface by Christopher Lloyd to his forthcoming catalogue of the drawings at Holkham

13. Mrs. Lybbe Powys on Lord Melcombe's house, quoted in E.W. Manwaring, *Italian Landscape in Eighteenth-Century England,* 1925, 62

14. Sir Joshua Reynolds, *Letters,* ed. F.W. Hilles, 1929, 173

15. *Aedes Walpolianae,* 76–80

16. E. K. Waterhouse, "Poussin et l'Angleterre jusqu'en 1744," in *Nicolas Poussin—Colloque,* ed. André Chastel, Paris, 1960, 1:283–295

17. James Greig, *The Farington Diary,* ed. London, 1923–1928; 8:178–179 and see Simpson 1953, 39–42

18. Letter from J.B.S. Morritt to Sir Walter Scott (9 December 1820) quoted in Edgar Johnson, *Life of Sir Walter Scott,* 1970, 1:715

19. Waagen 1854, 3:371–380

20. Beckett 1968, vol. 6

21. See, as well as the sale catalogue, Redford 1888, 1:148

22. W. Burger, *Trésors d'Art en Angleterre,* 3rd ed., Paris, 1865, preface, v–vi

23. See Radford 1888, 1:138

24. John Charles Robinson, "The Gallery of Pictures by the Old Masters, Formed by Francis Cook, Esq., of Richmond", *Art Journal,* 1885, 133–137

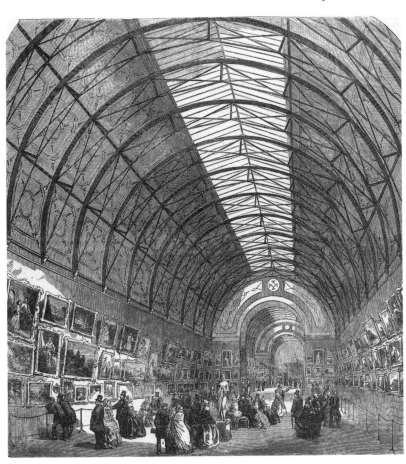

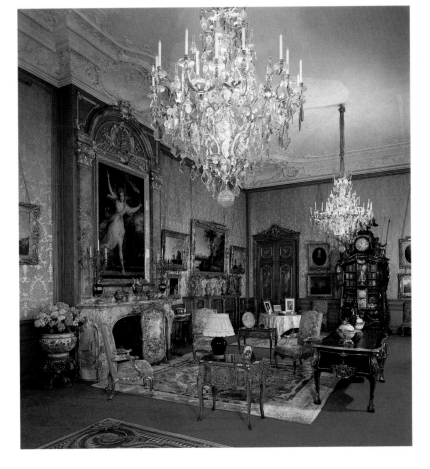

The Backward Look
John Cornforth

High up on the wall at the high table end of the Great Hall at Lumley Castle in County Durham (fig. 1), there stood until recently the equestrian figure of Edward III, better known as the Lumley Horseman (no. 1), like some monument to a *condottieri* in an Italian Renaissance church. To some eighteenth- and nineteenth-century antiquarians, this statue of the king to whom the Lumleys owed many of their ancient estates and another statue of Lyulph the Saxon, the traditional founder of the family and ancestor of the Earls of Scarbrough, were just strange old fakes, but the choice of the Lumley Horseman as one of the earliest objects in this exhibition has a double, even a triple point.

It represents the principal interest of one of the first great collectors in England, John, Lord Lumley (1533–1609), who devoted much energy to the commemoration and preservation of evidence of his family's history. But it also introduces the broader subject of the thread of historical thinking, or the backward look, which has been such a potent force in English life during the past 400 or 500 years. That thread has been encouraged by landowning families and in turn it has influenced them: indeed the development of historical think-

Figure 1
The Great Hall of Lumley Castle, County Durham, as remodeled by Sir John Vanbrugh in the early years of the eighteenth century, showing the Lumley Horseman (no. 1) high on the wall above the dais

Figure 2
The parish church of Chenies, Buckinghamshire, containing the tombs and funerary archievements of the Russell family, Earls and Dukes of Bedford since the sixteenth century

ing and the changes in approach to it over the centuries are crucial to understanding the overall balance of patronage and collecting as they are apparent in country houses.

It is, for instance, no accident that Lord Lumley was close to the first organized circle of antiquarians in England, who held regular meetings in the years after 1585 and formed what counts as the first learned society in England. That society was a natural response to the new Renaissance approach to history, and it was encouraged not only by a new awareness of national pride and self-consciousness but also by the political upheavals of the late fifteenth century, followed by the religious changes of the 1530s and 1540s. The Dissolution of the Monasteries led old families to emphasize their antiquity in the face of competition from more newly established families, who had benefited from the dispersal of church lands and who were equally keen to discover roots.

Much evidence of this resultant new interest in genealogy and pedigrees is found in the decoration of Elizabethan and Jacobean houses: in achievements of arms in carved and painted wood and plaster, over chimneys, on ceilings, and in stained glass. In Sir William Fairfax's Great Chamber at Gilling Castle in Yorkshire, for instance, the display of heraldic glass is accompanied by a broad frieze painted with trees bearing shields, each tree representing one of the wapentakes into which Yorkshire was divided and each of the 443 shields representing a family living there whose arms were recognized by the heralds in 1584. But the fascination with heraldry is expressed above all in monuments in churches, which represent the most significant field of patronage of sculpture throughout the period covered here, and that can only be experienced through exploring the village churches that so often lie in the shadow of great country houses (fig. 2). There was also a smaller circle of people that included the Elizabethan Archbishop of Canterbury, Matthew Parker, and William Cecil, the queen's faithful Secretary, who were most anxious to preserve what they could of the historical evidence scattered when the monastic libraries were broken up. Thus the interest in pedigrees and coats of arms was not just romantic or academic but was concerned with the realities of position and power and the determination of the landed class to prove their rights to their properties.

The Lumley Horseman and the history he represents also illustrate the extraordinary tenacity

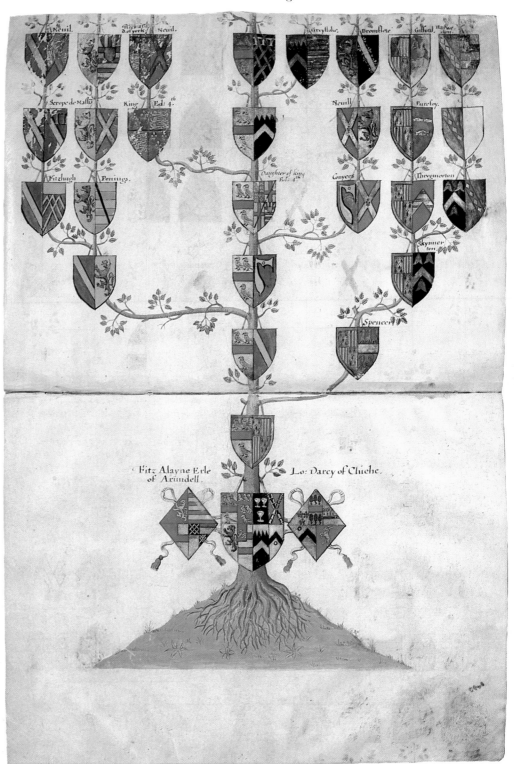

Figure 3
A page from the Lumley Inventory of 1590 (no. 346), showing part of the immense family tree which traced the ancestry of John, Lord Lumley, back through Charlemagne to Adam

Figure 4
Lulworth Castle in Dorset, built in 1608, an example of the early revival of castle architecture in England

Figure 5
Nicholas Hilliard, George, 3rd Earl of Cumberland, miniature on playing card, c.1590 (National Maritime Museum, Greenwich). An illustration of the Elizabethan courtier's nostalgia for the chivalry of the Middle Ages

Figure 6
Unknown artist, Lady Anne Clifford and Her Family, 1646 (Abbot Hall Art Gallery, Kendal). This huge triptych, from Appleby Castle in Westmorland, recently acquired for Abbot Hall with the help of the National Heritage Memorial Fund, was commissioned by the 3rd Earl of Cumberland's daughter, and shows her with other members of her family, books and portraits, in a consciously old-fashioned setting

of English landed families and their ability to stay in the saddle and still be in the race despite many near fatal falls. Lyulph was murdered before 1080; Sir Ralph de Lumley was attainted for rebelling against Richard II and died in battle; his brother, the 2nd Lord Lumley, was killed fighting for Henry V; the 6th Lord Lumley took part in the Pilgrimage of Grace, and his son was imprisoned in the Tower, convicted, and executed. John, Lord Lumley, who was the latter's son, had the title restored in 1547, but he too spent time in the Tower, and his cousin and heir fought for Charles I. In the eighteenth century the family fell on hard times, and there were sales of the family collections after the deaths of both the 4th and 5th Earls of Scarbrough in 1785 and 1807. So the Horseman with his battle-axe in hand can also be seen as representing the rough and tumble of English history that lies behind the building of great houses, the creation of spreading parks, the acquisition of marbles and pictures, and the ordering of furniture.

Feelings for land and family generally run much deeper than those for works of art. In Lord Lumley's

case the passionate concern for what the great Elizabethan antiquarian and herald William Camden describes as his "veneration for his ancestors" must have been tied up with the disturbed history of his time and the tragic history of his own family. Not only was his father executed, but his first wife was the sister-in-law of the 4th Duke of Norfolk, who was attainted and executed in 1572, and the aunt of Philip Howard, Earl of Arundel, who was attainted in 1589 and died in prison six years later (he was canonized in 1970); and Lord Lumley's own three children all died young. So it is hardly surprising that he thought so much about the commemoration of his family and the perpetuation of their reputation (fig. 3).

At Lumley the statue of Lyulph was part of a celebration of the family's association with their castle, with shields of arms in the gatehouse, eighteen more shields flanking the entrance to the Great Hall, and, within the Great Hall, the equestrian figure and fourteen portraits of the heads of all the intervening generations. In the valley, a few miles from the castle, in the church of Chester-le-Street, Lord Lumley carried out an even more

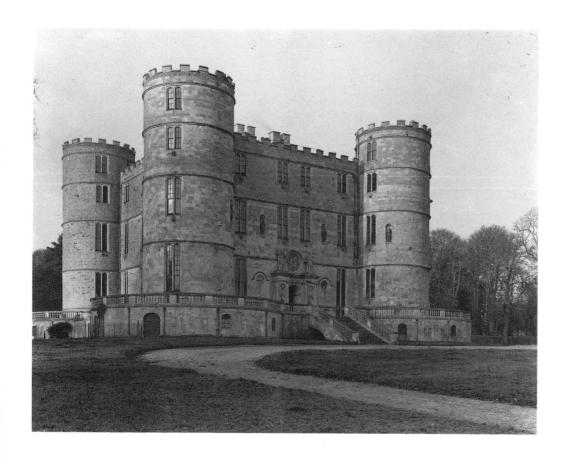

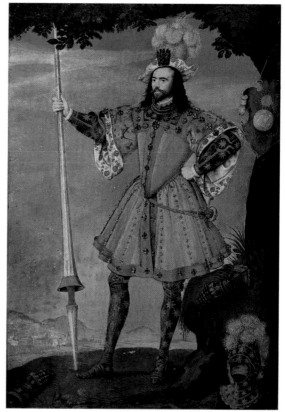

curious act of commemoration: by 1594 he had set up a series of fourteen funerary effigies, which Camden said "he had either picked out of the demolished monasteries or made new". That was not the only occasion he was concerned with monuments: in 1592 he repaired the Fitzalan Chapel at Arundel and set up a remarkable monument to the 10th, 11th, and 12th Earls of Arundel, and he also built a funerary chapel for himself at Cheam in Surrey.

Part of his collection of books and manuscripts was bought by James I. But a number of his portraits, including some probably inherited from his father-in-law, the last of the medieval line of FitzAlan Earls of Arundel, were left to his great nephew, Thomas Howard, Earl of Arundel (1585–1646), represented here by Mytens' portrait (no. 49). Lord Arundel is remembered in Horace Walpole's phrase as the "father of virtu in England," but is less widely recognized as the protector of the honor of the Howards. As John Martin Robinson has written: "Much of Arundel's own achievement—the repair and recording of ancient tombs, the erection of monuments to his relations, the

commissioning of paintings of his ancestors and events in family history, his patronage of historical scholarship was a tribute to and commemoration of the history of the Howards." That emerges in his idea of commissioning Van Dyck to paint a family group commemorating his appointment in 1640 as Captain General, with representations of Holbein's portrait of the 3rd Duke of Norfolk and the poet Earl of Surrey hanging on the wall behind him, and also his commissioning the remarkable posthumous portrait of the Earl of Surrey in an architectural setting, and Henry Lilly's *Genealogie of the Princillie Familie of the Howards*.

The concerns of Lord Lumley and Lord Arundel related not only to the world of antiquarians and heralds, but to the neo-medieval enthusiasm at the court of Queen Elizabeth that emerged in a particularly vivid form at the ceremonies associated with the annual Accession Day tilt. This revival of chivalry also found expression in portraits and miniatures, such as that of Lord Herbert of Cherbury (no. 42), as well as in the Jacobean masques performed at Court, and in the revival of castle architecture, as at Bolsover, Lulworth

(fig. 4), and Ruperra.

Heraldry to most people today is a dead language and genealogy (as opposed to one's own family tree) rather a bore. But to Lord Lumley and Lord Arundel they were both vital subjects, and the links between antiquarianism, family history, heraldic painting, portraiture, and funerary monuments were close. King Richard III had created the 1st Duke of Norfolk Earl Marshal, *ex officio* head of the College of Arms, and responsible for most of the royal ceremonial outside the walls of the palaces; and it was the 4th Duke of Norfolk who was the real founder of the College of Arms as it is known today. Although the dukedom was in suspense, Lord Arundel was made Earl Marshal in 1621: in 1633 he appointed the miniature painter Edward Norgate, Windsor Herald, just as William Segar, who painted Lord Lumley's portrait (no. 20) before 1590, was made Clarenceux King of Arms in 1597; later in 1638 Arundel made William Dugdale, the outstanding antiquarian scholar of the seventeenth century, a herald.

If the links among such subjects were close in that period, so were the links between people, and

 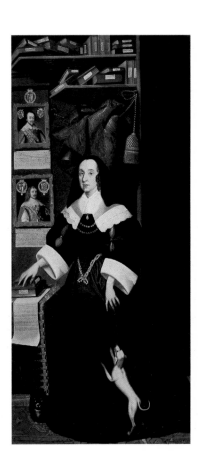

it is possible to trace some surprising ones both in districts and succeeding generations that together suggest how tight and how extensive was the web of such interests. One of Lord Lumley's contemporaries was George, 3rd Earl of Cumberland, who emerges as a figure from the neo-medieval world in Hilliard's miniature (fig. 5), and one of whose suits of armor is in the Metropolitan Museum, New York. His daughter and heir appears first as Countess of Dorset in the history of Knole—she married the 3rd Earl, the subject of one of Larkin's finest portraits (no. 54)—and then as Countess of Pembroke in the history of Wilton, where she gazes out unhappily from Van Dyck's great family group. But she is much more vividly remembered in the north of England as Lady Anne Clifford who retired to her estates in the North in 1650 and restored her castles, maintained her honors, and held court in a quasi-medieval way, progressing from castle to castle until she died at a ripe age in 1676. In the Great Chamber at Appleby Castle in Westmorland used to hang the huge triptych she commissioned in 1646 (fig. 6): the central panel shows her parents as they were in 1589 with her two brothers who died young, while on the wings she is depicted as a

girl of fifteen and as Countess of Pembroke and Countess of Dorset, with likenesses of her two husbands and representations of her favorite books, appropriately including Wotton's *Book of Architecture.*

In seventeenth-century Northamptonshire there was a strong antiquarian interest among landowners. Sir Christopher Hatton (1605–1670), the patron of Nicholas Stone at Kirby, was "a person highly affected to Antiquities" and in 1636–1639 he had facsimiles of medieval rolls of arms made at Kirby under Dugdale's direction. A mile or so across the fields at Deene lived Sir Thomas Brudenell, later 1st Earl of Cardigan, who had similar enthusiasms even before the age of twenty-one, when he compiled his first book; when he was imprisoned in the Tower of London from 1646 to 1650 he worked on transcripts of state papers. Within riding distance of both houses lies Drayton, which at that time belonged to the 2nd Earl of Peterborough (1623–1697) who returned to England at the outbreak of Civil War, went over to the king in 1643, and had to go into exile in 1645 and again in 1647. During the 1650s he probably began work with his chaplain on his *Succinct Genealogies,* a curious

work of which he printed only twenty-five copies in 1688. After the Restoration, as part of his modeling of Drayton, he commissioned for the Great Hall portraits of monarchs who had advanced the Mordaunt family, and for the King's Dining Room upstairs, portraits of the first four Lords Mordaunt painted to go with his own portrait in armor by Dobson. In the Norfolk Room he set up overdoors of knights on horseback that A.R. Dufty has shown are copied from the *Livre des Tournois,* a book of ceremonial compiled for René I, Count of Provence (1409–1480), which exists in six fifteenth-century manuscripts. The same depiction of medieval knights in armor carrying banners can be found in the Palmer pedigree from Dorney Court (no. 347) presented to Lady Anne Palmer in 1676.

Toward the end of the seventeenth century the backward look in English houses started to change character, and the sense of threat that was so strong in the earlier period died away, to be replaced by a more amused, less anxious antiquarianism. One curious figure from this world was Thomas, Lord Coningsby, whose passion for family history and the antiquity of his house, Hampton Court near

Figure 7
The north front of Hampton Court, Herefordshire, from the second volume of Colen Campbell's Vitruvius Britannicus, *1717. The house was remodeled by William Talman for Lord Coningsby about 1700*

Hereford, was tied up with a desire to see parallels between historical and modern situations. As a young man in 1680 he had voted for the exclusion of the Duke of York from the throne and later he became a supporter of William III. Apparently in the first decade of the new century he gave the north front of his house "a castle air" (fig. 7)—he was one of the first people to treat his country house in that way—and from Kneller he commissioned a huge portrait of Henry IV as Duke of Hereford standing before the walls of Coventry (fig. 8), which must have been intended to remind visitors that William III was not the first monarch chosen by Parliament.

About the time that Lord Coningsby was remodeling his house, a circle in London was discussing the founding, or refounding, of a Society of Antiquaries. The present society was founded in 1717, with Peter le Neve, one of the heralds, as president, and three people whose work had an influence that extended far beyond the society into the world of historical studies and country houses as leading members: William Stukeley as secretary, Humphrey Wanley who helped Lord Oxford amass the famous Harleian Library, and George Vertue.

Vertue was trained as an engraver and made the first collections for a history of art in England, producing a number of portraits of English kings, including King Alfred, that provided the standard eighteenth-century idea of what those people looked like.

King Alfred had a particular appeal to a Whig society, and Rysbrack was asked on several occasions to produce a bust of him. The first seems to have been for the aptly named Temple of British Worthies at Stowe about 1734, where his image was placed in the company of that of Edward, the Black Prince, Queen Elizabeth, and William III (fig. 9). The inscription attached to Alfred's bust explains exactly why he was held in such high regard: "The mildest, justest, most beneficent of Kings; who drove out the *Danes*, secured the sees, protected Learning, established Juries, crushed Corruption, guarded Liberty and was the founder of the *English* Constitution." At Kedleston the English and Roman worlds are made to meet in the lower hall, where the bust of Caesar balances one of Alfred. The most elaborate monument to him is the tower at Stourhead built by Henry Hoare in 1721–1725.

Figure 8
Sir Godfrey Kneller, Henry IV as Duke of Hereford before the Walls of Coventry, *c. 1700 (formerly at Hampton Court, Hertfordshire). In commissioning the picture, a Whig like Lord Coningsby would have been demonstrating that William III was not the first king to be chosen by Parliament*

Figure 9
The Temple of the British Worthies at Stowe in Buckinghamshire, designed by William Kent, c. 1734. The busts include those of King Alfred, and Edward, the Black Prince

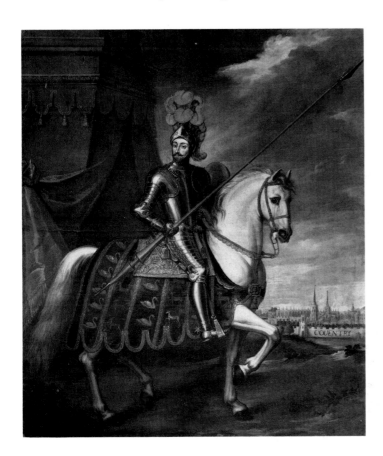

Often the concern for the past was turned to decorative effect, as at Boughton in the time of John, 2nd Duke of Montagu, father of the Lord Brudenell who was painted by both Batoni and Mengs (nos. 173 and 174). The duke married the daughter of the Great Duke of Marlborough. His mother-in-law, the formidable Sarah, and some of his contemporaries were inclined to dismiss him, but William Stukeley, who got to know him fairly late in his life, wrote after the duke's death: "we had exactly the same taste for old family concerns, genealogy, pictures, furniture, coats of arms, the old way of building, gardening, and the like. . . ." He gave the duke a mid-sixteenth-century portrait of the Wingfield family and designed for his park at Boughton a fantastic Gothick bridge that was not carried out. But there is evidence of the duke's looking backward at Boughton in the paintings he commissioned of imaginary ancestors and in the library where over the chimneypiece is a great display of the duke's arms (fig. 10). These look at first like the twin trees of Montagu and Churchill, but in fact represent his own descent through both his father and mother from Edward I, and relate his own Garter to the history of the Order. He was also the virtual refounder of the Order of the Bath, and he owned Writhe's Garter Book, which had belonged to his former neighbor, Lord Peterborough.

Stukeley's particular interest in the history of

the Druids comes to mind in a house at the opposite end of Northamptonshire, Canons Ashby. There, about 1710, a relative of the poet Dryden arranged the Great Hall with arms and armor in the old way appreciated by Stukeley and the Duke, and in the overmantel of the Jacobean Great Chamber painted armorial panels with the recently uncovered motto "Antient as the Druids".

The concern with medieval history used to emerge in a vivid way at Lyme Park in Cheshire, which Peter Legh employed Leoni to remodel in a grand Italianate style but incorporating in the Great Hall a remarkable statement of the Leghs' ancestry. According to William Dugdale the first Peter Legh carried the Black Prince's standard at Crécy. Probably in the early 1730s, this legend became the theme of the Great Hall, where a white marble chimneypiece was carved with a great sword and helmets, and portraits of Edward III and the Black Prince faced each other at either end of the room. The Black Prince, in fact, aroused a good deal of interest at that time, and one of the places where an image of him was placed was the Temple of British Worthies at Stowe, where he was described as "The Terror of Europe, the Delight of England, who preserved, unaltered, in the Height of Glory and Fortune, his natural Gentleness and Modesty."

Today antiquarian squires are very rare birds. Almost the last were Wyndham Ketton-Cremer

(1906–1969) of Felbrigg in Norfolk, the historian and biographer of Horace Walpole and Thomas Gray; and his friend Sir Gyles Isham (1903–1981) of Lamport in Northamptonshire, who as a young man was supposed to have been the most handsome of all Hamlets and later acted with Greta Garbo, but is now more widely remembered for his encouragement of local scholarship in the 1950s and 1960s. So it is difficult to determine the actual extent of antiquarian and historical interests among Georgian landowners and what influence they had on their houses. Taking the area between Oxford and Birmingham, in the second and third quarters of the eighteenth century, for instance, there was General Dormer at Rousham, Lord Guilford at Wroxton, Sanderson Miller at Radway, James West at Alscot, Sir George Lyttelton at Hagley, Lord Coventry at Croome, and Sir Roger Newdigate at Arbury.

At Rousham the style of Kent's additions were influenced by that of the original house. At Wroxton Lord Guilford consulted Sanderson Miller over his alterations, including his rearrangement of the remarkable seventeenth-century glass in the chapel. Sanderson Miller, a man of moderate means, not only gothicized his own house at Radway and built a tower and ruins on Edgehill to commemorate Charles's battle but advised a great many of his friends and neighbors, designing among other things the ruins at Hagley. James West retired to Alscot,

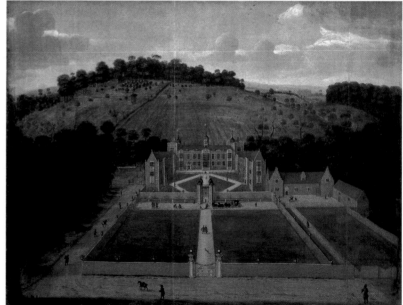

which he remodeled in the Gothick style and filled with such a huge collection of pictures (see no. 298), books, manuscripts, prints, and coins that it took fifty-five days to disperse in sales after his death in 1773. But of the Gothicists in the region the most thorough and imaginative was Sir Roger Newdigate (no. 329), who succeeded to the baronetcy in 1734 at the age of fifteen and worked on the house from 1750 to 1806. However as with so many of his contemporaries the English past was only one of his interests, for he was also concerned with developments in politics, agriculture, and industry.

The balance of Sir Roger's interests makes him an interesting comparison with William Constable (1721–1791) of Burton Constable in Yorkshire. A Catholic and so barred from public life, he devoted himself to his varied private pursuits, philosophy, natural sciences, classical arts, and family history, and as Ivan Hall has shown, the house survives now as a unique synthesis of an eighteenth-century mind. In 1747 he inherited Burton Constable and devoted many years to its remodeling and extension—all carried out in such a way as to preserve its original Elizabethan character (fig. 11), so that it would not be mistaken for the house of a new family. To that end he set up in the centerpiece of the entrance front the arms and coronet of his grandfather, the last Viscount Dunbar, who died in 1717 (fig. 12); and in the Great Hall, which

was given a new ceiling in the Jacobean style, he placed over the chimneypiece a scagliola achievement of arms with the thirty-five quarterings of the Constables. He also formed a new long gallery, where he kept his library devoted to the arts and sciences, his portraits of his ancestors (some of which he enlarged), and of Rousseau, a friend with whom he regularly corresponded, as well as his scientific instruments; his collections of fossils, gems, and medals, and his herbarium. In what he saw as a "library and Philisophical Room," family history and scientific enquiry came together.

The practice of making up sets of imaginary family portraits was fairly widespread, and they are to be encountered both at Arundel Castle and Audley End, where they appear in the Saloon, which was redecorated in two stages by Sir John Griffin (see no. 290). First, in the mid-1760s, he had the room repaneled and a new frieze put up to go with the original ceiling, and about twenty years later he commissioned Biagio Rebecca to paint a set of portraits to be inset in the paneling "to commemorate those through whom with gratitude he holds these possessions."

Although portraits have survived fairly well in country houses, nearly all country house libraries have been pillaged, and the way that they represented historical thinking is often best gleaned from old catalogues and also in the design and decoration of the rooms themselves. The library at

Figure 10
An overmantel in the library at Boughton House, Northamptonshire, carved with the family tree of the 2nd Duke of Montagu, c. 1720

Figure 11
Unknown artist, View of Burton Constable, Yorkshire, *c. 1680 (John Chichester-Constable Esq., Burton Constable). It records the original Elizabethan appearance of the house before it was altered in the eighteenth century*

Figure 12
The entrance front of Burton Constable, showing William Constable's remodeling in the mid-eighteenth century, remarkably conservative for its date and with the arms of his grandfather, the last Viscount Dunbar, as the centerpiece

Figure 13
The Great Hall at Charlecote in Warwickshire, restored by George and Mary Elizabeth Lucy in the 1840s

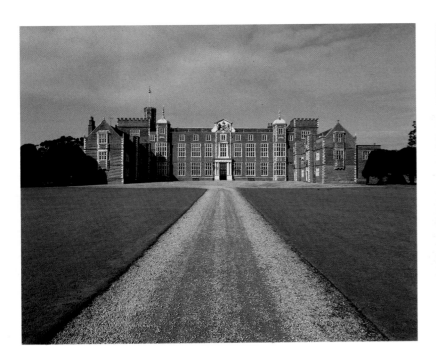

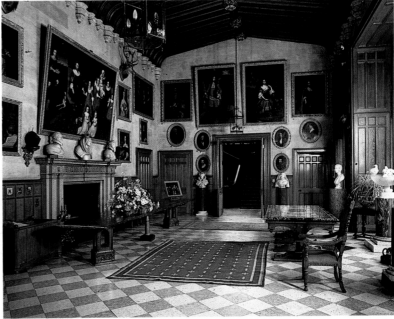

Figure 14
Peckforton Castle in Cheshire, designed by Anthony Salvin for the 1st Lord Tollemache in 1844, with the ruins of the medieval Beeston Castle on the hill beyond

Figure 15
The Great Hall at Lytes Cary in Somerset, a fifteenth-century manor house, restored by Sir Walter Jenner in 1907, and an example of the "backward look" continuing into the twentieth century

Figure 16
The view from the terrace of the old castle at Scotney in Kent. The same romantic approach that inspired Edward Hussey to build his new house looking over this view in the 1830s, inspired his grandson Christopher to become the outstanding historian and champion of British country houses in this century

Wimpole, although altered later and containing the books acquired by a later owner, is naturally associated with the great collection started by Robert Harley and continued by his son, Edward, who acquired Wimpole through his marriage and then added on the room. Both he and his father were advised by Humphrey Wanley, and when the whole collection was sold after his death, the manuscripts were bought as the nucleus of the British Museum library. That is by no means the only private library that became important to later generations of scholars; many of the eighteenth-century county histories were based on the notes and collections formed by scholarly landowners in the previous century. Perhaps that kind of spirit can be best imagined in the Gothick libraries of Horace Walpole at Strawberry Hill and Sir Roger Newdigate at Arbury and represented here by Devis' portrait of Sir Roger at his desk (no. 329).

In the second half of the eighteenth century and the nineteenth century the inspiration of the past seems to have become less strongly personal and part of a more general enthusiasm for the picturesque, Romanticism, and the Gothic Revival, and the ambition of English and American artists to establish themselves as history painters. And because the later eighteenth and nineteenth centuries are generally more familiar, less attention is devoted to them here. However, within the general mood there are many fascinating individual stories: Beckford's short-lived but influential house at Fonthill; the careful arrangement of Cotehele; Sir Samuel Rush Meyrick's collection of armor at Goodrich; George and Mary Elizabeth Lucy's restoration of Charlecote (fig. 13), and so on. A great many houses were remodeled in the Old English style or transformed into abbeys or castles, and while some families like the Grosvenors made extravagant if rather superficial play with their ancestors, others had an intense historical feeling, like the 7th Duke of Beaufort, painted by Landseer in the amor he wore at the Eglinton Tournament. So did some designers, in particular Willement, Pugin, whose Gothick library table from Eastnor Castle is included here (no. 542), and Salvin, who could re-create a castle at Alnwick for the Duke of Northumberland, or design a new one at Peckforton in Cheshire, looking across the valley to the ruins of a medieval one at Beeston (fig. 14); and, of course, Burges, who found a near-ideal patron in the 3rd Marquess of Bute for whom he transformed Cardiff Castle and designed Castell Coch (no. 565).

The new fascination exercised by Scotland, largely due to the Prince Regent's visit to Edinburgh and the reopening of the Palace of Holyroodhouse, was stage-managed by Sir Walter Scott. But this renewed concern with national identity was another aspect of Romanticism, as is clear from Raeburn's portrait of Scott, seen brooding on a Highland peak (no. 519), and Landseer's *Death of a Hart in Glen Tilt* (no. 535). By this time the "backward look" had become the spirit of a whole age, and was no longer the preserve of a cultured minority.

Rather than dwell on that age here, it may be better to look briefly at the circle of the "Souls," who spanned the late nineteenth and early twentieth centuries, to see the extent to which the feeling for the past continued to shape attitudes in Britain long after the birth of modernism. The Souls were a brilliant circle of friends in the orbit of A.J. Balfour and Lord Curzon. They came together in the late 1880s and shared many artistic and literary interests as well as a particular love of romantic country houses. So it is right that portraits of two of the group's leading women members are included here: Burne-Jones' portrait of Alberta, Lady Windsor,

later Countess of Plymouth (no. 556), whose husband owned St. Fagan's Castle, an old, gabled, manor house just outside Cardiff (no. 573), and Poynter's portrait of Mary, Lady Elcho, later Countess of Wemyss (no. 559), whose husband's family owned Stanway in Gloucestershire, a spreading, many-gabled Cotswold building of golden stone that is in many ways the epitome of the English manor house. When the Elchos went to live there in 1883 they chose wallpapers and materials by William Morris who even printed a paper himself. It was that kind of spirit that led Lord Curzon to lease Montacute in Somerset and also to preserve as ruins Tattershall and Bodiam Castles, both of which he bequeathed to the National Trust.

The Souls probably encouraged the general enthusiasm for old houses at the beginning of the century, in particular for castles, several of which were restored and brought back into use as houses, among them Allington, Saltwood, and Herstmonceaux. Americans were also infected with the idea: Lord Astor acquired Hever in Kent (no. 558), later Randolph Hearst bought St. Donat's in Wales, and Gordon Selfridge dreamed of the most fantastic castle of all, designed for him by Philip Tilden. To some extent Salvin's mantle was inherited by Lutyens as can be seen in his restoration-cum-remodeling of Lindisfarne Castle on the Northumberland coast and his design of Castle Drogo, but the great castle figure of the twentieth century was really Sir Robert Lorimer, working mainly in Scotland.

As well as the craze for castles there was another for manor houses. By 1930 many houses of medieval or Tudor origin that had gone downhill, ending up as farm houses, had acquired new owners, who not only had a love of building but of gardening and collecting (fig. 15). That thread too, is represented here, albeit indirectly, in Robert Peake's portrait of Henry, Prince of Wales (no. 56), from the remarkable collection of historical portraits at Parham in Sussex (greatly extended by Clive Pearson as part of his restoration of that house in the 1920s, 1930s, and 1950s). It may also be seen in Rex Whistler's painting of Haddon Hall, executed for the Duke of Rutland in 1933 (no. 575), a larger version of which hung in the Long Gallery there as a reminder of the sensitive restoration of that ancient house by the duke, whose mother had been a leading member of the Souls.

Rex Whistler's art epitomizes the romantic thread in that generation even if he more usually concentrates on its rediscovery of the eighteenth century, of Georgian country houses and landscapes, conversation pictures and the decorative arts. Tragically he was killed in the Second World War, but his enthusiasm did not die. Proof that it continues is seen in the glass engraving of his brother, Laurence, including those from Hever and Castle Howard (nos. 587 and 588). Out of that inter-war generation's feeling for the past grew the concept of country house preservation in Britain and the development of the National Trust's Country Houses Scheme from 1934. Today with 132 houses and 522,722 acres it is difficult to realize how personal was the inspiration of the Scheme, and how strong has been the individual commitment of members of committees and staff to that ideal. Alongside that one must not forget the intense feeling of owners for their places, in particular in the hard years after the Second World War. Few of them are as knowledgeable about heraldry or genealogy or the other antiquarian subjects that fascinated some of their forebears, but it is interesting that the Society of Antiquaries still has a number of members who own great houses.

If I had to single out one figure from recent times to represent the potency of the historical thread in the English approach, I would choose Christopher Hussey (1899–1970), whose whole philosophical, visual, and practical approach to life grew out of his grandfather's creation at Scotney Castle in Kent in the 1830s (fig. 16). Through writing about country houses over a period of fifty years, Christopher Hussey not only made a remarkable contribution to architectural history but to the general understanding and appreciation of the broad sweep of British architecture, gardening, and taste, always trying to work for a synthesis of past and present and of traditional and modern design. In his books and articles, as in his conversation, there was always a sense of a twentieth-century approach developing out of eighteenth-century ideas and their nineteenth-century expression, and of the past being a source of inspiration for the present and the future.

The Last Hundred Years

Marcus Binney and Gervase Jackson-Stops

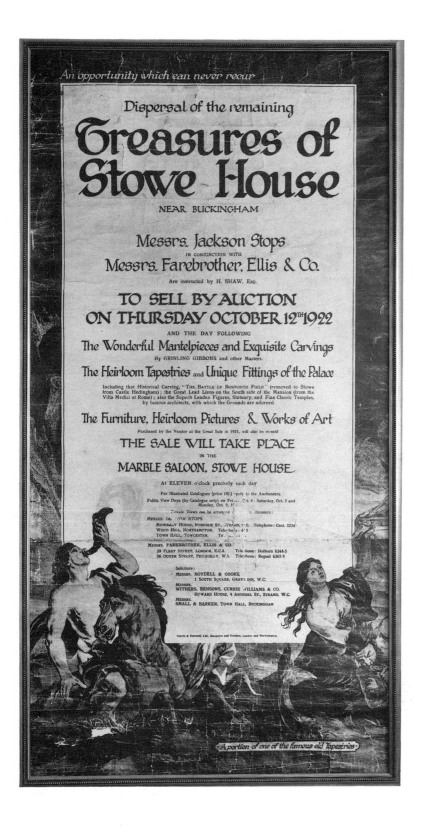

British country houses are by no means things of the past. Recent books on *The Last Country Houses* (Clive Aslet, 1982) and *The Latest Country Houses* (John Martin Robinson, 1984) show not only that they continued to be built in the Edwardian period and between the wars, but that financiers and industrialists as well as long-established families are still creating large houses for themselves in a variety of different styles—from the neo-Georgian of Sir Thomas Pilkington's Kings Waldenbury to the concrete and glass of the Duke of Westminster's new Eaton Hall. Nor are these all on a smaller scale than their eighteenth- and nineteenth-century predecessors. Sir Edwin Lutyens' Castle Drogo, left incomplete at the beginning of the Second World War is wrought as massively as a Vanbrugh house, while John Kinross' Manderston in Berwickshire, begun in 1901, is considerably larger than the Adam mansions that inspired it, with its spreading domestic offices and home farm.

At the same time a number of circumstances have combined to threaten the older country houses and their historic collections in the last hundred years. In the Indian summer of British high society before the First World War, so powerfully evoked in the Edwardian conversation pieces of Lavery and in the portraits of Sargent, Laszlo, and McEvoy, it seemed on the surface as if nothing could disturb the peaceful harmony of an established order. But already the great agricultural depression, which lasted from 1873 to 1896, the result of Free Trade and the opening up of the American Middle West, had begun to erode the estates on which the country houses depended. The introduction of death duties (a tax on capital payable by the heir) under the Liberal government in 1894 was also an ominous sign, even if it began at between one and eight per cent only, and was supposedly a temporary measure. The depression had a profound effect on the landowners' ability to maintain their collections intact even more than their estates. The philistinism encouraged by Edward VII's so-called "Marlborough House Set," in marked contrast with the cultured circle known as the "Souls," meant that many owners considered it in bad taste to talk about, even to know about, their possessions, and in these circumstances they were more likely to part with works of art than to sell land. A particular impetus to such dispersals was created by legislation culminating in the Settled Land Acts of 1882 and 1884, which allowed the Court of Chancery to authorize the sale of heirlooms by trustees, however strictly a will might have insisted on their preservation by the family.

These acts opened the way to a series of great sales: the famous Sunderland Library and many old masters from Blenheim in 1881–1883; the contents of Hamilton Palace in 1882–1883, largely consisting of treasures inherited from William Beckford's Fonthill; the majority of Sir Andrew Fountaine's collections from Narford in 1902; and many others (fig. 1). This, too, was the heyday of art dealers like Joseph Duveen, who was almost single-handedly responsible for the sale of whole series of late eighteenth-century British portraits to America. Even by today's standards, these full-length Gainsboroughs and Reynolds, Romneys and Raeburns, which grace the damask-hung walls of the Frick and Huntington Collections and a score of other museums, fetched enormous prices: in many instances enough to allow the owner to struggle on without further sales for a number of years. Nor did these pictures always leave the country. A notable collection was formed by Baron Ferdinand de Rothschild at Waddesdon to complement his magnificent French furniture, very much in line with American taste at this period; just as, between the wars, the Hon. Clive Pearson extended an impressive array of sixteenth- and seventeenth-century portraits as part of his restoration of Parham Park in Sussex.

The First World War was, however, an infinitely harder blow than anything that had gone before. Not only was a whole generation of heirs almost entirely lost on the battlefields of Flanders and the beaches of Gallipoli, often leaving houses and estates to daughters or distant cousins, but many families suffered double or treble death duties as successive sons were killed. Far from exempting the war-dead (as happened in the Second World War) Lloyd George's administration only increased the burdens, his "People's Budget" of 1909 raising the rate by thirty per cent on estates over £5,000. In the few years between 1918 and 1921 between six and eight million acres changed hands in England according to the historian F.M.L. Thompson's *English Landed Society* (1963). A transfer on this scale and in such a short space of time had probably not been equaled since the Norman Conquest. At the same time the labor force vital for the running of a great house was drying up: not only did the factory bench and the office desk offer far greater material rewards, but household service came to be considered demeaning as Ramsay Macdonald's socialist party increased in strength, finally assuming power in 1924. Henry Green's novel *Loving* (1945), based partly on Petworth, gives a haunting picture of life "below stairs" with the cavernous servants' quarters now occupied only by a butler, a housekeeper, and the two maids, who are caught waltzing together to a wind-up gramophone in the deserted rococo splendor of the White and Gold Room.

The rate of demolition of country houses accelerated sharply after the First World War. Of some 1,116 country houses in Britain destroyed between 1875 and 1975 (perhaps a quarter of the total

Figure 1
A poster for the 28-day auction of the contents of Stowe in Buckinghamshire in 1922, only one of many sales and dispersals that took place between the First and Second World Wars; the house is now a public school

Figures 2 & 3
Halnaby Hall in Yorkshire, the family home of Byron's ill-fated wife, Anne Isabella Milbanke, before and during demolition in 1952

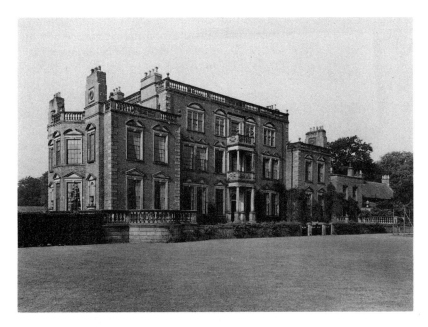

number), 63 were lost before 1918, an estimated 458 between 1918 and 1945, and 595 after 1945 (figs. 2 and 3). The many period rooms from British houses now in America—the Hamilton Palace and Woodcote Park rooms in the Boston Museum of Fine Arts; the dining room from Kirtlington at the Metropolitan Museum, New York; the drawing room from Sutton Scarsdale at Philadelphia—are poignant reminders of a disintegration that seemed as if it might be as far-reaching and as final as the rape of the French châteaux during the Revolution. During the Second World War virtually every major country house was requisitioned by the government (fig. 4). A fortunate few like Boughton were used to store great works of art from national collections but most were put to very rough use by the armed forces. No maintenance was carried out; army boots pockmarked the floors; in the worst cases paneling and staircase balustrades were sawn up as firewood during the winter. Minimal compensation was made available when the owners returned—enough perhaps to paint the windows

(if paint was available) or repair the roof over a wing. Not surprisingly many families felt it impossible to continue. Houses were sold for institutional use—to schools and hospitals—or put into the hands of the wreckers. The second great wave of destruction was soon under way, reaching a peak of seventy-five—or one every five days in 1955. The scene is well evoked in D.H. Lawrence's *Lady Chatterley's Lover*, "Now they are pulling down the stately homes, the Georgian halls are going. Fritchley, a perfect old Georgian mansion was even now, as Connie passed in the car, being demolished. It was in perfect repair; till the war the Wetherleys always lived in style there. But now it was too big, too expensive, and the country was becoming too uncongenial." Evelyn Waugh's *Brideshead Revisited* was a still more poignant lament for the passing of an age, finding an echo in John Piper's pictures of bomb-shattered buildings under lowering skies. But as Waugh put it in the second edition of *Brideshead*, published in 1960: "It was impossible to foresee in the spring of 1944 the present cult of the

English country house. It seemed then that the ancestral seats which were our chief national artistic achievement were doomed to decay and spoliation like the monasteries in the sixteenth century. So I piled it on rather, with passionate sincerity. Brideshead today would be open to trippers, its treasures rearranged by expert hands and the fabric better maintained than it was by Lord Marchmain."

Such optimism, prompted by the economic recovery of the 1950s and 1960s and the increase in tourism, may not have been wholly justified, for many more houses were still to be demolished, and many more battles still to be fought for a tax system that would not penalize the owners of historic collections. But the seeds of a revival had been sown even before the war. Under the influence of William Morris and John Ruskin, medieval and early Tudor architecture had alone been appreciated before 1914. But a new interest in the eighteenth century was stimulated by Geoffrey Scott's *Architecture of Humanism*, which appeared in 1914, and by Sacheverell Sitwell's writings, particularly *British Architects and Craftsmen* of 1945. This in turn led to the nostalgic view of the country house found in Rex Whistler's work (no. 575); the founding of the Georgian Group in 1936, the first preservation society to fight for eighteenth-century buildings; and the pioneering researches of architectural historians like John Summerson and Christopher Hussey. Queen Mary's passion for country houses, a symptom of this revival, resulted in a series of royal progresses between the wars that it is tempting to compare with those of Queen Elizabeth I. It also led to the commissioning of the famous Queen's Doll's House, now at Windsor Castle, designed for her by Sir Edwin Lutyens, and with pictures, furniture, and other *objets* made by all the leading artists and craftsmen of the day. On a less exalted level, Osbert Lancaster's *Pillar to Post* and *Home Sweet Home*, P.G. Wodehouse's portrayal of Lord Emsworth's Blandings Castle and Noel Coward's popular song "The Stately Homes of England," expressed a warm affection on the part of a wide public for a way of life that seemed doomed.

By far the most important development, however, was the birth of the National Trust's Country Houses Scheme. Founded as early as 1895 by followers of Ruskin and Morris particularly concerned with the fate of the Lake District, the Trust had until this time been more concerned with the preservation of landscape, and had acquired only a few small medieval or Tudor buildings like the fourteenth-century Clergy House at Alfriston

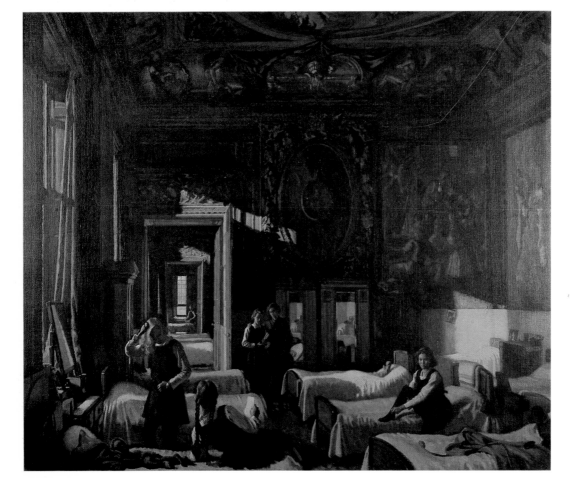

purchased for £10 in 1896. It was Philip Kerr, 11th Marquess of Lothian, a politician of radical views, who first urged the Trust to play a wider role in an important speech made at the annual meeting in 1934, outlining the perils that then confronted country houses and their collections. After long negotiations, a second National Trust Act was passed in 1937 allowing the Trust to hold land and investments to provide for the upkeep of its properties, partly on the model of the Massachusetts Reservations. Thus for the first time an owner could transfer a house to the Trust with its contents and a suitable endowment, often in the form of land, while he and his heirs could continue to live in it subject to certain conditions, which included opening to the public. The first great house and collection to come to the Trust in this way was Blickling Hall in Norfolk (fig. 5); bequeathed by Lord Lothian himself, who died while serving as ambassador to Washington in 1941. By the end of the war, the Trust had received Wallington and Cliveden, Polesden Lacey, West Wycombe and Lacock Abbey, while a number of others, including Knole, were to follow. Another very important development came in 1953 when the present Duke of Devonshire, faced with gigantic death duties on the premature death of his father three years earlier, offered Hardwick Hall with all its contents and supporting farmland to the government in lieu of death duties, to be transferred to the Trust. This "in lieu" principle was further extended at Petworth in 1963, when the late Lord Egremont gave most of the pictures, including the outstanding Van Dycks and Turners, in lieu of death duties for transfer to the National Trust, which already owned the house.

The National Trust today owns 132 major houses, and the National Trust for Scotland a further 20, regularly open to the public, of which 110 contain historic collections. The achievement is one of the great success stories of modern times, for most if not all of these houses would otherwise have been sold, abandoned or even destroyed and their collections dispersed. The concern of both organizations has been to keep families living in their old homes and not to allow them to become simply museums, but this has not always been possible to achieve. Some have preferred to move to smaller houses; others have left no direct heirs willing to carry on the connection. But a more serious limit to the Trusts' activities in recent years has been the ever-increasing size of the endowments they need to raise, in order to maintain houses "in perpetuity," the vital phrase embodied in their charters, an obligation that justifies their privileges and tax exemptions granted by Parliament. Many properties in the early days were taken on without sufficient endowment, and these are only self-supporting now through good management, with additional help from the government's Historic Buildings Council, or by drawing on the central funds raised by commercial enterprise and by the annual subscriptions of almost one and a quarter million members (1,194,000 belonging to the English National Trust and a further 130,000 to the Scottish), helped by the Royal Oak Foundation, the English National Trust's fund-raising organization in America.

Inflation, and the immensely increased cost of skilled labor in the last ten or fifteen years, has meant a widening gap between what the Trusts need to ask an owner as endowment and what he can reasonably be expected to raise. Anxious about their growing size and vast responsibilities, the Trusts also have to regard themselves more and more as an ultimate safety net, a last resort if other solutions fail. In this context, the setting up of the new National Heritage Memorial Fund has helped to give them a new, more positive role—able to save houses in a desperate plight rather than simply accept what is offered them by a rich owner.

Government aid for country houses has its origins long ago in the crisis years immediately following the Second World War. In 1948 a committee was set up under Sir Ernest Gowers, whose report, published in 1950, stressed the urgency of the situation:

> . . . our concern is to see how we can best save something of a great national heritage, an embodiment of our history and traditions, a monument to the creative genius of our ancestors and the graceful serenity of their civilisation.

Too many of Gowers' recommendations went unheeded but there was one positive outcome: the establishment in 1953 of the three Historic Buildings Councils for England, Scotland and Wales. Substantial grants became available for repairs. Castle Howard was offered £87,707 in 1958, Wardour Castle £60,000 in 1959, and very large sums (up to fifty per cent of the total required in the case of private owners, and sometimes more to charities like the National Trust) have been distributed by the Councils over the last thirty years, the principle being to stimulate a healthy partnership between private and public money and enterprise.

Figure 4
Edward Halliday, Chatsworth in Wartime, *1939 (The Trustees of the Chatsworth Settlement). The state rooms are shown in use as dormitories for a girl's school, which occupied the house during the war years. Unlike the Devonshires, many families were disinclined to move back into their country houses in the 1950s*

Figure 5
Blickling Hall in Norfolk, the first great house to be acquired by the National Trust, was bequeathed by the 11th Marquess of Lothian, who died in 1940 while ambassador in Washington. Lord Lothian had himself been one of the instigators of the Trust's Country Houses Scheme

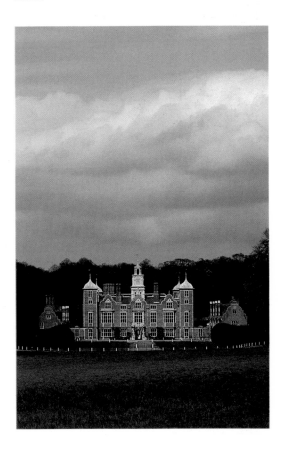

Figure 6
Leeds Castle in Kent. The foundation set up by the late Lady Baillie for the upkeep of Leeds has been the model for other private charitable trusts

Figure 7
Canons Ashby in Northamptonshire, the home of the Dryden family since the sixteenth century. The first major grant given by the National Heritage Memorial Fund after its creation in 1980 enabled the National Trust to restore and endow this romantic manor house, which was in a perilous state of decay

Figure 8
Thirlestane Castle, Berwickshire. The first house owned by a private charitable trust to receive a substantial grant for endowment from the National Heritage Memorial Fund

Out of the Second World War came another important source of succor for the country house. This was the National Land Fund set up in the budget of 1946 as a war memorial "to the memory of our dead and the use of the living for ever," with a capital sum of £50 million from the sale of surplus war stores. The Chancellor of the Exchequer, Dr. Hugh Dalton, explained ten years later that the Fund had been set up partly out of anguish at the prospect of the great estates breaking up: "It appeared to me desirable and appropriate . . . to set aside money so that, by various means, the beauty of England, the famous historical houses, the wonderful stretches of still unspoiled open country, might be preserved in the future, and increasingly become part of the heritage of us all."

During the 1950s and 1960s the Fund was used to reimburse the Treasury for tax foregone and thus allow a succession of great country houses to be accepted in payment of death duties and given to the National Trust—these included Penrhyn (1951), Ickworth (1956), Saltram (1957), Shugborough (1966), and Sudbury (1969). But by 1970 a stalemate had been reached. The National Trust felt it had over-stretched itself by accepting houses without sufficient endowments and the Treasury was steadfast in its refusal to use the Land Fund for this purpose. The crisis was first manifest over Heveningham Hall in Suffolk, a house hit by the new capital gains tax levied every fifteen years on a discretionary trust. In the absence of a suitable

purchaser who would keep the collection intact, the government finally acquired the house, but the civil servants involved were extremely aggrieved at having to take on this burden, no attempt was made to raise a proper endowment, and it had finally to be sold to a private buyer in 1981.

The economic recession of the 1970s brought a deepening of the crisis, with the new Labour government threatening to introduce a swingeing Capital Transfer Tax and Wealth Tax in 1974. The debate in the House of Lords on 26 June 1974 on the future of historic houses not only highlighted the dangers for the great houses but also the concern of owners to share their houses with the public and maintain them as heirlooms in trust for the nation at large. Lord Clark pointed out that "a wealth tax on the contents of English country houses, large and small, would in a very short time lead to their extinction," while Lord Montagu of Beaulieu was convinced "that these houses, built in the past, perhaps for the pleasure of a few, should now be available for the pleasure and education of the many. We belong to our possessions rather than our possessions belong to us. To us they are not wealth, but heirlooms over which we have a sacred trust." No less important was the emphasis on the need to keep house, contents, garden and estate intact, at a time when only heirlooms could be exempted from death duties. The point was well put by Viscount Davidson: "it is the whole entity of the house and grounds which support

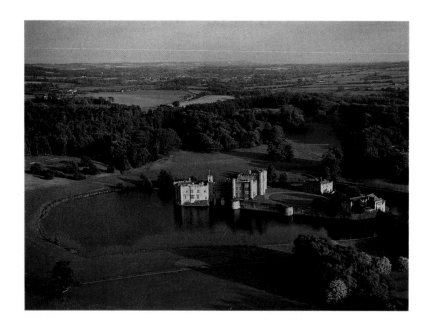

it—whether these are gardens, parkland or farmland, or a combination of all three—which matters, it is the entity of the whole estate which has grown up and been developed over the years, over the generations, which needs to be preserved."

The autumn of 1974 provided a double focus for concern with the publication of John Cornforth's *Country Houses in Britain: Can They be Saved?* and the major exhibition on *The Destruction of the Country House* held at the Victoria and Albert Museum. This was a hard-hitting show documenting in detail for the first time the 1,200 houses already lost. But it also struck an emotional chord. "We take them for granted," Roy Strong wrote in his foreword to the exhibition, "like our parish churches, the country houses seem always to have been there, since time immemorial part of the fabric of our heritage. We glimpse the park gates as we hurtle down a road, or we sense, behind some grey, mouldering stone wall, the magic of a landscape planting. . . . Alerted, we strain our eyes for a brief, fleeting glimpse of some noble pile floating in the distance. . . . The ravished eye stirs the heart to emotion, for in a sense the historic houses of this country belong to everybody, or at least everybody who cares about this country and its traditions." For some, the great hall of destruction with its rollcall of lost houses recited in funereal tones by John Harris, like the names of the fallen on a war memorial, was too much—"I could not bear to remain more than one minute," wrote a property developer who himself lived in and restored one of the most beautiful seventeenth-century houses in England.

The exhibition also provided an opportunity to show how the great houses of England stood in the national psyche. "To my further great benefit," John Ruskin wrote, "I thus saw nearly all the noblemen's houses in England in reverent, healthy delight of uncovetous admiration—perceiving, as soon as I could perceive any political truth at all, that it was much happier to live in a small house, and have Warwick Castle to be astonished at, than to live in Warwick Castle and have nothing to be astonished at." H.G. Wells expressed parallel sentiments, "it is one of my firmest convictions that modern civilisation was begotten and nursed in the household of the prosperous, relatively independent people, the minor nobility, the gentry, and the large bourgeoisie which became visibly important in the landscape of the sixteenth century, introducing a new architectural element in the towns, and spreading as country houses and

châteaux and villas over the continually more orderly countryside. Within these households, behind their screen of deer park and park walls and sheltered service, men could talk, think and write at their leisure."

Public feeling, stirred by the exhibition, was shown by the one and a half million signatures on a petition organized by the Historic Houses Association, claiming to be the largest ever presented to Parliament. Special provisions were subsequently written into the Capital Transfer Tax bill granting exemption to owners in return for a minimum of 60 days public access, and since then virtually all the great houses have opened their doors to visitors. The 1975 Act also encouraged the setting up of private charitable trusts, the most famous of these being Lady Baillie's at Leeds Castle (fig. 6), following the model of that at Ditchley, founded for the furtherance of Anglo-American relations. Since then, others including Burghley, Chatsworth, Grimsthorpe and smaller houses like Lamport have followed suit, though many owners feel that private charitable trusts need to be given far greater concessions and more flexibility before they become attractive propositions.

Despite these healthy signs, the battle over Mentmore proved that the government was still badly equipped to deal with houses and collections in danger. This splendid Rothschild house in Buckinghamshire designed by Paxton and with an outstanding collection of French furniture and pictures was offered to the nation by Lord Rosebery for the very reasonable sum of £2 million, but long delays, and the Treasury's reluctance to use the Land Fund, led to the sale of the contents in 1977. The public outcry over Mentmore resulted in firm recommendations that the Land Fund be freed from Treasury control, and this was achieved two years later when the National Heritage Memorial Fund was set up under the chairmanship of Lord Charteris of Amisfield. Quoting Sir Francis Drake, Lord Charteris wrote in the Fund's first annual report "the 'great matter' of the heritage will never be finally saved. We look forward instead to a voyage of mercy with many ports of call." The birth of this wholly independent body—the first capital fund of its kind, whose trustees are free to make their own investments, to roll over interest from year to year, and to spend capital—was a landmark in international preservation. Naturally, the support of country houses is only one part of the Heritage Fund's activities, and these have ranged in the last five years from preserving rare breeds of

bats to the salvage of Henry VIII's great warship the *Mary Rose*. But historic buildings with their contents and countryside around them have received a very large proportion of its grants.

The first to benefit was Canons Ashby (fig. 7), a Northamptonshire manor house hardly touched since the early eighteenth century, but in an advanced state of decay. The Fund's grant of a million pounds for its endowment and another half million for its repair enabled the National Trust to take the house over from the Dryden family in 1981, while still larger sums were later received by the Trust for Belton in Lincolnshire (where the house and contents were about to be sold up), and by the Scottish National Trust for Fyvie Castle in Aberdeenshire with its collections (see no. 176). The Fund has also been able to help provide endowments for private charitable trusts like that at Thirlestane Castle, Berwickshire (fig. 8), and to save outstanding works of art in historic collections, such as the Bellotto at Powis Castle (no. 193), or the fifteenth-century Flemish triptych in the chapel at Oxburgh.

Recently, the Fund has received a supplementary £5 million from the government to help with the repair and endowment of Calke Abbey in Derbyshire (fig. 9). This wonderfully untouched and atmospheric house was primarily important not for its art collections but as a document of social history, complete with its kitchens and laundries, stables, and riding school, joiner's and blacksmith's

shops, church and park—a quintessence of all that is magical about English country house life. The future of Calke seemed hopeless when its new owner, Mr. Henry Harpur-Crewe faced a tax liability of eighty per cent (over £8 million), but its rescue and transfer to the National Trust has been one of the most important successes of recent years. The state bed, apparently kept in packing cases since the eighteenth century and shown here for the first time (no. 375), together with the manuscript of Haydn's march written for Sir Henry Harpur (no. 357), are among the most spectacular of the treasures that are gradually being revealed, piled in attics, or hidden in long-forgotten drawers —fully justifying the hard-fought campaign to keep Calke intact, which still continues in the form of a public appeal.

There will undoubtedly be further challenges for the Heritage Fund to face shortly. A sum of £25 million has already been earmarked for the acquisition of Chippendale's famous furniture at Nostell Priory enabling Lord St. Oswald to meet crippling capital taxes, for the contents of Weston Park to be vested in a private charitable trust, and for Kedleston in Derbyshire. But the future of Kedleston, one of the very finest houses in England, is a long-standing problem, made worse by a complicated family trust, and it is still difficult to see how the present Lord Scarsdale's wish to present it to the nation can be achieved with the resources available. A heavy question mark likewise hangs over the future of Brodsworth in Yorkshire, with arguably the finest Victorian interior in England in the Italian classical style. On the other side of the coin, the National Trust continues to receive generously endowed properties such as Wimpole, Basildon, and most recently Kingston Lacy, with one of the finest private picture collections in England, and Ightham Mote. As well as grants from the Heritage Fund, the Trust has also received valuable help from the National Art-Collections Fund and Government grants-in-aid administered by the Victoria and Albert Museum, to acquire works of art that might otherwise be sold, or even to buy back items that left a collection many years before.

A still more important precedent has been the acceptance of certain outstanding items in private houses in lieu of tax. Thus the famous Mytens portraits of the Earl and Countess of Arundel (nos. 49 and 50) are now owned by the National Portrait Gallery but kept where they have been for many years in the drawing room at Arundel Castle; and the Van Dyck *Betrayal of Christ* (no. 264) will remain the centerpiece of the picture gallery at Corsham, though belonging to the Bristol City Art Gallery. It is of the greatest importance that this principle should be extended, and in particular that it should be accepted by the National Gallery in London.

In general, the situation in 1985 is still worrying, not least for country houses that have already lost their collections. Alternative uses, such as schools and hospitals, have rarely been successful in the long term—with the exception of Stowe, where valiant attempts are being made by the school to restore the landscape and temples to their former glory. On the other hand, residential use in smaller units has become more popular, and particularly successful conversions have been carried out by Kit Martin at Dingley, Hasells, Cullen and Gunton, and by Christopher Buxton at Charlton Park and Compton Verney. Building Preservation Trusts have been set up to save several houses *in extremis*, most notably Barlaston in Staffordshire, a masterly Palladian villa designed by Sir Robert Taylor (figs. 10 and 11). Derelict, vandalized and undermined by the extraction of

Figure 9
The drawing room at Calke Abbey, Derbyshire, hardly touched since the 1860s. After a hard-fought campaign, this atmospheric house has recently been rescued by the National Trust, with the support of the National Heritage Memorial Fund

coal, this most beautiful of Palladian villas appeared beyond reprieve when a final campaign was launched by the action group SAVE, a recent but valuable addition to the established amenity societies like the Georgian Group and the Victorian Society. In 1981 the Wedgwood company sold Barlaston to SAVE for £1, and with grants from various sources the house is now restored and will be open to the public during 1986. The rescue of Barlaston proves that literally no building can be called unsaveable—or "at the end of its useful life" as developers like to put it.

There are grounds for optimism in many other restoration programs, and in the new interest in conservation, which explains the success of the National Trust's recently published *Manual of Housekeeping*. At Hatfield, not only have the gardens been restored and replanted on the most ambitious scale, but Lady Salisbury's textile conservation workshop, following the example of that at Knole, has involved local volunteers in an immensely worthwhile cause.

British country houses are now used for an enormous range of activities, yet without destroying their lived-in atmosphere and without becoming merely institutions. Fine art courses are held at Burghley; Parnham in Dorset is the center of John Makepeace's successful furniture-making workshop and school for craftsmen; Brocket Park, Castle Ashby and Chicheley are conference centers; Cliveden has been leased by the National Trust as a luxury hotel; Warwick Castle has been acquired by Madame Tussaud's and is run as a major tourist attraction in great style; Syon has a famous garden center and Glyndebourne a famous opera house. Concerts and recitals, particularly performed on authentic instruments, are regularly held in many country houses, and the pioneers in this field were Lady Verney at Claydon and Lady Aberdeen at Haddo. Special collections of interest abound: Lacock Abbey has an exhibition on Fox-Talbot and the invention of photography; Picton Castle has a Graham Sutherland Gallery, with an important collection bequeathed by the artist; Claverton is the home of the American Museum in Britain; Castle Howard has a costume museum; Woburn and Longleat safari parks; Beaulieu a motor museum and Knebworth an Anglo-Indian exhibition.

Without any doubt, British country houses now give more pleasure to more people than at any time in their previous history. As centers of community life once again, inspiring an intense pride in the vast majority of the population, they give cause for a confident approach to the future, despite the formidable economic problems that still remain to be solved. As they continue to attract visitors from overseas in increasing numbers, it is also to be hoped that the civilizing role they have played in our national life over the last five hundred years, may be extended in the next five hundred to a still wider international audience.

Figures 10 & 11
Barlaston Hall in Staffordshire, designed by Sir Robert Taylor, 1756–1758, the main front, before and after its recent restoration by Save Britain's Heritage. Save acquired the building for £1 in 1981, and have kept it from what seemed like certain demolition

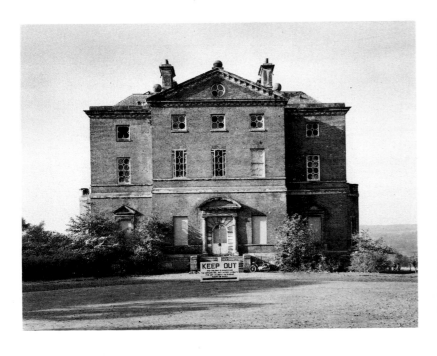

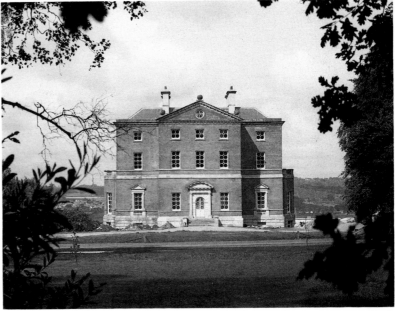

Dimensions are given in centimeters, with inches in parentheses, height before width before depth. The provenance for an object is given only where this is not obvious from the text, or where it has not always been in the same family collection. Abbreviations and short references are fully explained in the Bibliography and Exhibitions listing.—Unless a reference is provided in the text, sources for all quotations will be found in the literature immediately following the entry. New Style dates have been employed throughout, even before 1752 when the Gregorian calendar was first adopted in England and the American colonies.

Books: Books have been measured closed.
Metalwork: Gold- and silversmiths' birth and death dates are included when known. Often, however, only the date when a smith entered a mark in the Registers at Goldsmiths' Hall in the City of London, or on arrival in Britain, is known. This was the point when most goldsmiths were "made free" of the Goldsmiths' Company. Where partnerships occur, dates given are those of the duration of the partnership.

Sèvres: French descriptive titles, for example, *vase à potpourri*, are given in parentheses following the English translation. However, a title may be only one among a number of variations found in the factory records. The latter are also the source for the "active" dates of craftsmen, and the reader should note that these craftsmen may have been active elsewhere, either before or after the dates when they worked at Sèvres.

The basic titles in the British peerage—excluding those of the Royal Family—are, in order of rank, those of "Duke," "Marquess" (or "Marquis"), "Earl," "Viscount," and "Baron" (or "Lord"), which were awarded by the king in return for services rendered either to himself personally or to the public cause, and which descended from father to eldest son. In a few cases, notably in Scotland, titles can—like the Crown—pass through the female line. "Life-peerages" were only invented in 1958, and these cannot be inherited.

English peers above the rank of baron have in addition to their principal title subsidiary ones, usually those that had been conferred on their ancestors. For instance, the Duke of Devonshire is also Marquess of Hartington and Earl of Burlington. According to a longstanding usage one of these titles is usually taken as a "courtesy" title by the peer's eldest son in turn. In the case of the Cavendish family the duke's eldest son has the title of Marquess of Hartington (though this is purely a name and does not entitle him to a seat in the House of Lords); and according to the same usage, *his* eldest son has the title of Earl of Burlington.

The younger sons and daughters of dukes and marquesses are referred to as "Lord" or "Lady," followed by the given name and family name. When a daughter marries, however, she continues to use the title "Lady" but adds her husband's surname (unless he is a peer, in which case she takes his title). For instance, when Lady Elizabeth Hervey, daughter of the Earl of Bristol, married Mr. John Foster, she became Lady Elizabeth Foster, but when later she married the 5th Duke of Devonshire she became simply "Duchess of Devonshire." The title "The Honourable," followed by given name and family name, is used by the children of viscounts and barons and by the sons of earls (although the daughters of earls have the title of "Lady").

In ordinary parlance all peers—except dukes—and their wives and the bearers of courtesy titles are referred to as "Lord" or "Lady," not by their title of Marquess, Earl, Viscount, or Baron. In formal language, however, each rank has a specific qualification: a duke is "His Grace," a marquess "the Most Honourable," and other peers, by courtesy, "the Right Honourable."

Below the peerage comes "Baronet," a title created by James I, which carries the prefix "Sir" and is hereditary; and "Knight," which carries the same prefix but is not hereditary. The wives of baronets and knights bear the title "Lady" followed immediately by the family name, but without the given name: thus Sir Christopher and Lady Sykes.

The titles of most peers were derived from their estates or the county in which their biggest estates were to be found, but in the sixteenth and seventeenth centuries it was the practice that if a title became "vacant"—either because the holder had no heir, or because he was attainted and his titles were confiscated—the title would normally be allotted to any new candidate for a peerage. Thus it happened that when Baron Cavendish was made an earl he was given the earldom of Devonshire, which had fallen "vacant," although in fact he had no connection with the county of Devon. In certain cases, relatively rare before the twentieth century, newly created peers kept their family names in their titles, as, for instance, Earl Spencer and Earl Granville.

[This note is based on one written for the catalogue that accompanied *Treasures of Chatsworth: The Devonshire Inheritance,* an exhibition organized and circulated in 1978–1979 by the International Exhibitions Foundation.]

M.A.	Michael Archer
C.A.	Charles Avery
M.B.	Malcolm Baker
N.B.	Nicholas Barker
J.B.	Judith Banister
T.H.C.	T.H. Clarke
G.de B.	Geoffrey de Bellaigue
A.du B.	Anthony du Boulay
J.E.	Judy Egerton
S.F.	Susan Foister
J.F.F.	John Fuggles
C.G.	Christopher Gilbert
V.G.	Virginia Glenn
St J.G.	St John Gore
J.R.G.	Robert Guy
J.H.	John Hardy (furniture)
J.H.	John Harris (books and drawings)
W.H.	Wendy Hefford
B.H.	Brian Hillyard
D.S.H.	David Sanctuary Howard
G.J-S.	Gervase Jackson-Stops
M.J.	Michael Jaffé
S.S.J.	Simon Jervis
J.K.B.	John Kenworthy-Browne
G.L.	Gordon Lang
S.L.	Santina Levey
J.V.G.M.	John Mallet
J.M.M.	Jonathan Marsden
K.MCC.	Kenneth McConkey
O.N.M.	Sir Oliver Millar
J.N.	Lord Neidpath
A.V.B.N.	A.V.B. Norman
M.P.	Michael Pearman
N.P.	Nicholas Pickwoad
C.A.P.	Carlos Picon
A.F.R.	Anthony Radcliffe
H.C.R.L.	H.C. Robbins Landon
H.R.	Hugh Roberts
C.N.R.	Christopher Rowell
F.R.	Francis Russell
A.D.S.	Adrian Sassoon
D.S.	Diana Scarisbrick
R.S.	Rosalind Savill (porcelain)
R.S.	Robert Skelton (Indian art)
R.S.	Sir Roy Strong (pictures)
A.S.C.	Anna Somers Cocks
S.S.	Susan Stronge
C.W.	Clive Wainwright (furniture)
H.W.	Helen Wallis
E.K.W.	Sir Ellis Waterhouse
C.W.	Catherine Wills (pictures)

The introductions to each section were written
by Gervase Jackson-Stops with
the assistance of Francis Russell.

1: The Tudor Renaissance

The end of the Wars of the Roses and the accession of the first Tudor monarch Henry VII in 1485 brought a period of relative peace and prosperity to England and Wales, despite the religious disturbances and economic difficulties that were to prevail until the 1580s. Arms and armor were hung up on the walls of the great hall, rarely to be taken down again, as castles with forbidding battlements began to be replaced by outward-looking houses, characterized by huge mullion-and-transom windows and decorated with Renaissance ornament. Italian sculptors like Pietro Torrigiano, who made Henry VII's tomb in Westminster Abbey, and Giovanni da Maiano, who had a hand in the decoration of Hampton Court, first introduced this new classical language to England. But it was the arrival at the court of Henry VIII, of one of the giants of European art, Hans Holbein the younger, which laid the foundations of British portraiture. Few could approach Holbein's astonishing characterization, though a handful of portraits such as the *Unknown Lady of the Fitzwilliam Family* (no. 4), possibly by the French-born John Bettes, suggest the hand of a direct pupil.

The dissolution of the monasteries was to be of immense importance for the future of the country house, for the passing of their estates into private hands established many of the great family dynasties that have lasted until the present day: the Russells of Woburn Abbey, which was built on the site of an Augustinian priory; the Cecils of Burghley and Hatfield, the Cavendishes of Hardwick and Chatsworth, and many others. But the short-term effect of the Reformation was to cut England off from the mainstream of European art. After 1535, religious subjects, the mainstay of artists for almost one thousand years, were proscribed, and despite the arrival of immigrant or visiting painters like Hans Eworth from Antwerp, Lucas de Heere from Ghent, and Marcus Gheeraerts the elder from Bruges—as well as a fleeting visit from a painter of international renown, Antonis Mor, commissioned to paint Queen Mary I (no. 19) for his master Philip of Spain—their place was taken by portraits painted in an increasingly anti-naturalistic style, which Roy Strong has dubbed the "English icons . . . isolated, strange, exotic . . . more akin to the aesthetic of Byzantine art."

At the same time the portrait miniature far surpassed in quality and contemporary esteem all other forms of painting, and Nicholas Hilliard and his pupil and rival, Isaac Oliver, who specialized in this field, reflect more nearly than any of their contemporaries the world of Shakespeare's early plays. At the same time, the number of portraits in armor, the melancholy Lord Herbert of Cherbury (no. 42), and the Lumley Horseman (no. 1), recall the nostalgia of many Elizabethans for the medieval past, expressed at the Ascension Day tilts held in honor of the queen.

Elizabeth I's progresses, undertaken primarily to reduce the debts left by her father, encouraged her courtiers to vie with each other in the building of the splendid "prodigy houses" that date from the years after the defeat of the Spanish Armada in 1588. Large enough to entertain her considerable entourage, these towering buildings, with their main rooms on the top floor, were hung with tapestries and equipped with table carpets and cushions often elaborately embroidered by ladies of the household as well as professionals. Gold and silver dishes and ewers and elaborate jewelry and mounts for Chinese porcelain (some of the first pieces to arrive in the west) show the London metalworkers' adaptation of Renaissance ornament from Flemish and German woodcuts, while even furniture, hitherto severely practical, could take on the fantastic, mannerist forms of Jean du Cerceau and Cornelis Floris.

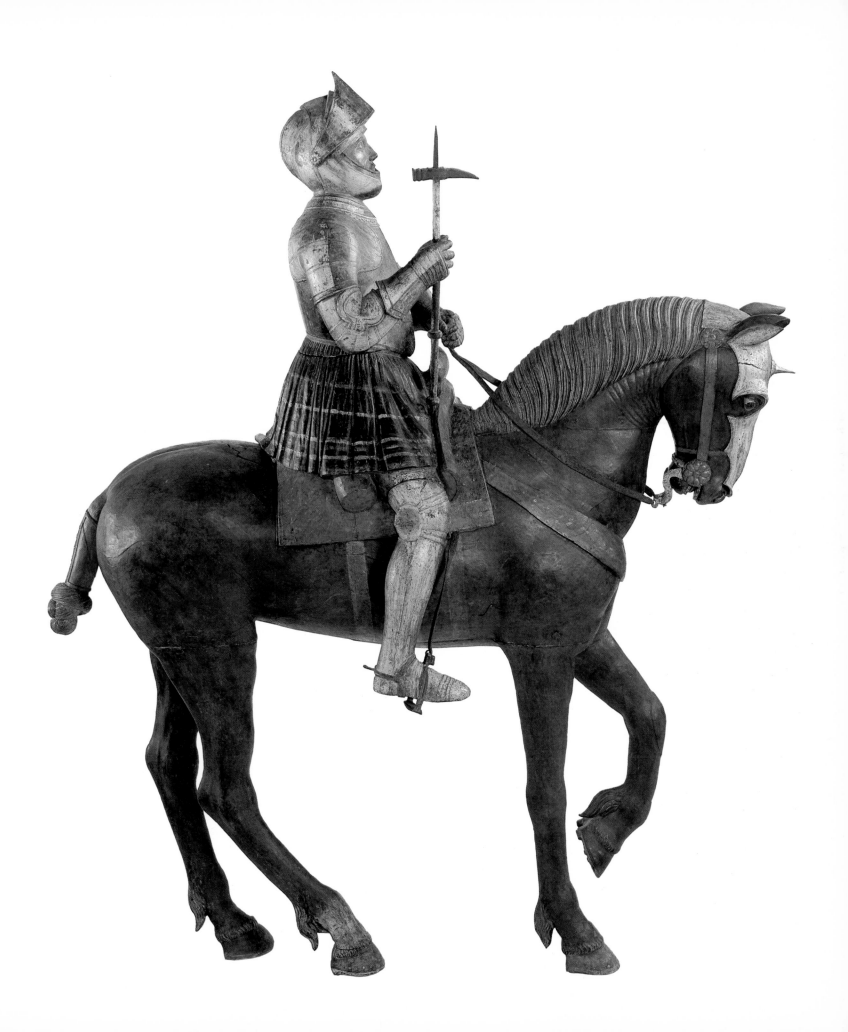

1

THE LUMLEY HORSEMAN c.1580
English
oak, painted in oils, with iron stirrups,
bridle, and axe
248.9 × 254 × 71.1 (98 × 100 × 28)

The Trustees of the Earl
of Scarbrough's Settlement

The earliest known equestrian statue in
the history of English sculpture, the
Lumley Horseman derives from Italian
Renaissance prototypes, but at the same
time exemplifies that obsession with an
idealized medieval past that was so
characteristic of Englishmen in the
Elizabethan period. The statue was
commissioned by John, Lord Lumley
(1534?–1609) (no. 20), one of the great
collectors of the age, yet even in his
own day considered something of a
learned eccentric. Sir Roy Strong has
recounted how, "out of favour at court
after his disastrous entanglements
in the Ridolfi Plot, his adherence to
the old religion excluded him from
office . . . Lord Lumley turned to his
books, his pictures and his ancestors"
(Strong 1969, 45).

The horseman, placed in a niche on
the far wall of the great hall at Lumley
Castle, above the dais, was intended to
be the culmination of a "pantheon
dedicated to the vanished glories of his
house." This progression can be traced
in the famous illustrated inventory of
his collection, drawn up in 1590
(no. 346). It began with statues of
Sir Robert and Sir Marmaduke Lumley
"who were the beginners, and laid the
foundation of this castle." These were
placed at the outer gate and followed
by the arms of all Lumley's ancestors,
carved in white marble in the inner
porch. In the courtyard beyond was a
marble fountain bearing Lumley's own
arms and those of his second wife.
Following this was the great hall itself
where the Horseman, representing
Edward III "in whose time most of this
castle was built," was flanked by small
busts of the latter's six sons, accompanied
by rather larger ones (still surviving) of
the Tudor sovereigns in whose reigns
Lord Lumley had lived.

In 1566 Lord Lumley had been sent
on a mission to Florence to recover a
debt from the Medici owed to Henry
VIII, when he succeeded in obtaining
both principal and interest. It is not
known whether he visited other parts
of Italy at this time, but the Horseman
clearly owes a debt to the celebrated
monuments of the Venetian *condottieri*,
Gattamelata in Padua and Colleoni in
Venice—by Donatello and Verrocchio
respectively—themselves influenced
by the horses of San Marco. Even
closer parallels are to be found in the
slightly later funerary monuments to
Nicola Orsini and Leonardo da Prato in
the Church of SS. Giovanni e Paolo,
immediately behind the Colleoni statue.
These are set against the wall and
framed in wide Renaissance niches with
pilasters and roundels not unlike those
depicted in the Lumley Inventory
(London, RA 1977–1979, 68,
figs. 96–99; and information from
Dr. Charles Avery). The identity of the
sculptor, who may also have carved the
alabaster pelican fountain illustrated
in the inventory (and still in Lord
Scarbrough's collection), is unknown,
though he may well have been one of a
growing number of immigrant Flemish
carvers like Maximilian Colt or
Cornelius Cuer, who later worked at
Hatfield and Knole.

The great hall at Lumley Castle was
remodeled by Vanbrugh in 1722, when
the niche that originally framed the
horseman was destroyed, and the statue
was placed on a large tapered bracket
(see no. 346), surrounded by the Segar
full-length portraits of Lord Lumley
(no. 20) and his ancestors.

Recent conservation has revealed
much of the original sixteenth-century
decoration, previously concealed under
later layers of paint and varnish. The
trompe l'oeil treatment of the armor is
particularly effective.

For a fuller account of Lord Lumley
see John Conforth's essay in this volume.

G.J-S.

Literature: Strong 1969, 45–56, fig. 33

2

THE FAMILY OF HENRY VIII: AN
ALLEGORY OF THE TUDOR SUCCESSION
c.1570–1575
Lucas de Heere 1534–1584
oil on panel
129.5 × 180.3 (51 × 71)
inscribed, at bottom, *The Qvene to
Walsingham this Tablet sente | Mark of her
Peoples and her owne contente*; on the frame,
*A face of mvch nobelitye loe in a little
roome, | Fowr states with theyr conditions
heare shadowed in a showe | A father more
than valyant. A rare and vertvvs soon. | A
zealvs davghter in her kynd what els the
world doth know | And last of all a vyrgin
qveen to Englands joy we see, | Successyvely to
hold the right and vertves of the three*

Sudeley Castle
The Walter Morrison Collection

The attribution to Lucas de Heere,
painter, avant-garde poet, and
emblematist, is now generally accepted.
De Heere fled from The Netherlands to
England to escape religious persecution
and is first recorded in the country in
1566. He remained in England for a
decade and belonged to an influential
colony of Netherlandish exiles that
included merchants, humanists, writers,
poets, painters, and engravers, all of
whom were not only dedicated to reform
in the arts but to a policy of religious
toleration. In addition they had strong
links with those in England who
supported the Protestant cause inter-
nationally: the Earl of Leicester, Sir
Thomas Gresham, and Sir Francis
Walsingham. De Heere's major patron
was Edward Clinton, Earl of Lincoln,
for whom he painted a gallery of
costume figures that was shown to the
queen. De Heere returned to the Low
Countries shortly after the Pacification
of Ghent in November 1576 and was in
the service of William of Orange and
Marnix de St. Aldegonde, leaders of the
revolt of The Netherlands against
Spain.

This painting is quite unlike anything
else produced in England at the time
but compares closely with De Heere's
signed *Solomon and the Queen of Sheba*,
1559 (Yates 1959, pl. 18 a), his illus-
trations to Jan van der Noot's *Het
Theatre* (1559), and his designs for the
pageants for the entry of Francis, Duke
of Anjou into Ghent in 1582 (Yates
1959, pl. 17b–c). The latter are
particularly close to this painting in
concept, in their mingling of allegorical
and actual historical personages in a
political denouement. Indeed the verses
on the frame place it in just such a
festival context, referring to it as
"a showe." Its rudimentary theme is a
glorification of the Protestant succession
within the house of Tudor and associ-
ation of that with peace and plenty for
the country. Henry VIII enthroned, a
"valyant" ruler, bestows the sword of
justice on his "rare and vertvous
soon," Edward VI, while his "zealvs
davghter," the Catholic Mary I, and
her Spanish husband, Philip II, bring in
their wake the god of war, Mars. In the
foreground at the right Elizabeth I
leads Peace in by the hand. Peace holds
a branch of olive and treads under the
weapons of war while behind her walks
Plenty bearing a cornucopia and, at the
same time, the queen's train.

The painting assumes knowledge of
an earlier group of *Henry VIII and His
Family*, c.1545 (Royal Collection), and,
apart from the image of Elizabeth I,
draws on available prototypes. Henry
VIII is based on the familiar Holbein
image, Edward VI apparently derives
from the type by William Scrots, and
Philip and Mary from Anthonis Mor.

Evidence for dating the picture is
provided by the cut of the queen's
dress, a type that emerged in the early
1570s. In dated instances of the
queen's portraits it is close to the 1572
miniature by Hilliard and to the
drawing of 1575 by Federigo Zuccaro
(British Museum), placing it in the
first half of that decade rather than the
second.

The inscription on the picture surface
records that it was a gift from the
queen to Sir Francis Walsingham
(1530?–1590) to mark her "content."
In the early 1570s, when Walsingham
was ambassador to Paris, he was
involved in the negotiations that led to
the Treaty of Blois, which was signed
on 21 April 1572. A year later he
returned to England and was, in
December, appointed Secretary of
State. It would be reasonable to suggest
that this picture, whose theme is peace,

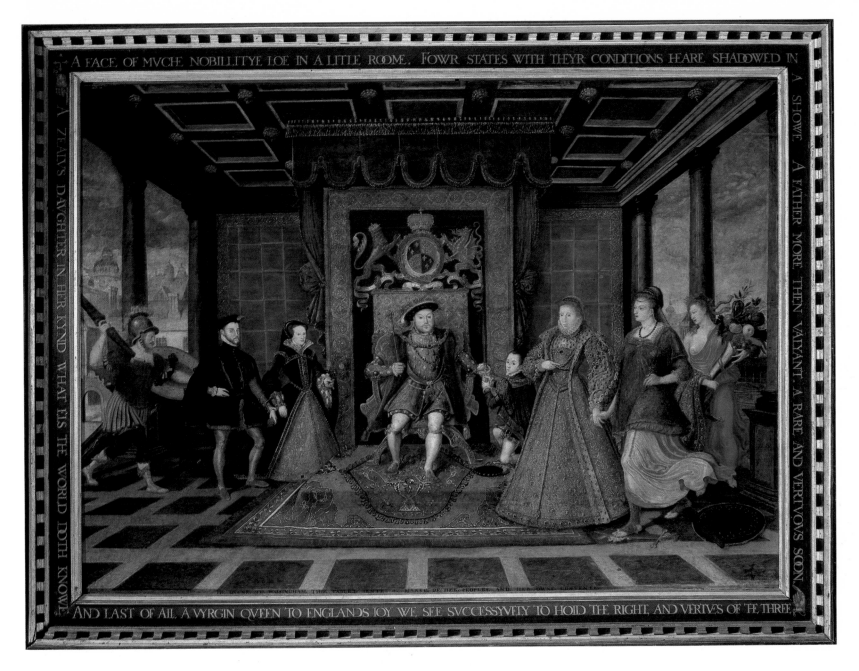

A FACE OF MVCHE NOBILLITYE LOE IN A LITLE ROOME. FOWR STATES WITH THEYR CONDITIONS HEARE SHADOWED IN A SHOWE

A ZEAL'S DAVGHTER IN HER KYND WHAT ELS THE WORLD DOTH KNOWE

A FATHER MORE THEN VALYANT. A RARE AND VERTVOVS SON.

AND LAST OF AIL A VYRGIN QVEEN TO ENGLANDS IOY WE SEE SVCCESSYVELY TO HOID THE RIGHT, AND VERTVES OF THE THREE.

specifically alludes to that treaty. In 1576 De Heere actually acted as an agent for William of Orange to Walsingham in a way that would suggest that the artist had had access to that circle at an earlier date.

The iconography stressing the virtues of the Elizabethan *pax* was a relatively new part of regal propaganda in the 1570s, though by the 1590s it had become a common form of eulogy. During that decade the picture was copied and updated twice, once as an oil painting (Yale Center for British Art, New Haven) and once in engraved form by William Rogers. R.S.

Provenance: The Walsingham family; bought from Scadbury, the Walsingham seat, in Kent, by James West; James West sale, 2 April 1773, lot 65; Sir Joshua Reynolds; Horace Walpole; Strawberry Hill sale, 17 May 1842, lot 86; J.C. Dent; and by descent to the Dent-Brocklehurst family

Literature: Vertue 1930–1955, 4: 87–88; O'Donoghue, 1894, no. 18; Cust 1913, 39–40; Auerbach 1953, 201; Strong 1963, 79, no. 82; Strong 1969, 140, no. 95; Van Dorsten 1970, 58–59; Waterschoot 1974, 68–78
Exhibitions: London, New Gallery 1890 (158); London 1902 (55); London, RA 1950 (202); London, RA 1953 (69); The Hague 1958 (56); Manchester 1965 (99); London and Leicester 1965 (20); Amsterdam 1984 (C70)

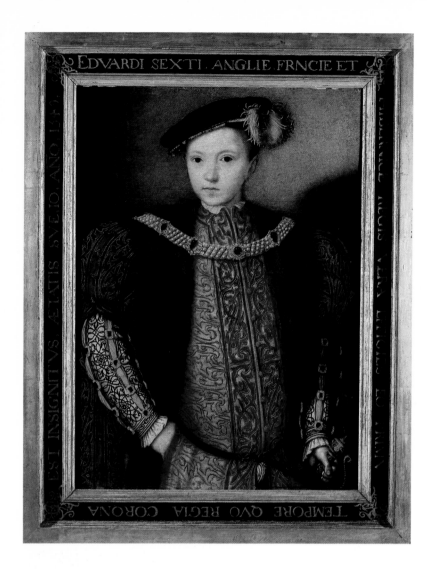

3

EDWARD VI C.1547–1549
English school
oil on panel
69.7 × 50.8 (27⅜ × 20)
inscribed, *EDVARDI SEXTI,
ANGLIE, FRNCIE ET / HIBERNICE
REGIS VERA EFFIGIES EO PRIMV /
TEMPORE QVO REGIA CORONA /
EST INSIGNITUS, AETATIS SVE, 10,
AÑO, 1549*

Loseley Park
J.R. More Molyneux, Esq.

Although the reign of the young Edward VI (1537–1553, reigned 1547–1553) was brief it was not devoid of royal portraits. Those of the king derive from two prototypes, one a full-length associated with a payment to the Flemish artist Guillim Scrots in 1551/1552. The other is a fine three-quarter length portrait in the Royal Collection (Millar 1963, 1:65) by an unidentified artist, showing Edward as Prince of Wales. That portrait, with suitable alterations such as the substitution of the collar of the Order of the Garter for the jewel with the Prince of Wales' feathers, was adapted for an image of Edward as king; a version at Petworth House bears a *cartellino* with the date 1547.

The head of the Loseley portrait follows that of the Royal Collection portrait very closely, but the costume and pose are quite distinct, and do not occur in other variants. The pose in particular suggests a deliberately less formal image. Edward is not wearing the Garter, although he does wear a heavy jeweled collar very similar to that worn by his father Henry VIII in Holbein's cartoon for the lost wall painting at Whitehall Palace. The sword that the young king holds does not recur in other portraits of Edward; the pommel is elaborately decorated and has been associated with a lost design by Holbein once in the collection of the Earl of Arundel, where it was engraved by Hollar. It has been pointed out by A.V.B. Norman, however, that the designs are dissimilar, and that a closer parallel with the sword in the Loseley portrait may be found in a masterly drawing by the Spaniard Antonio de Valdes.

In the nineteenth century the Loseley portrait carried an attribution to Holbein, but the discovery of the date of Holbein's death, 1543, made this an impossibility. The parallels with Holbein's work—the inclusion of the sitter's shadow reflected onto the green background and the precise disposition of the pattern over the surfaces of the costume—are only superficial, and do not suggest the work of a close follower.

The attribution of portraits of Edward VI is still problematic: the name of Scrots, who worked at the English court from 1546 to 1553, can only be associated with any certainty with the full-length portrait type of Edward as king. The suggestion that he also painted the portrait in the Royal Collection has not found wide acceptance and the Loseley portrait is clearly by a different hand than the latter.

The date 1549 included in the inscription on the frame should be regarded with caution, as it is inconsistent with the rest of the inscription proclaiming the portrait to be the image of Edward at the time of his coronation, in his tenth year. In fact, Edward was crowned in 1547, the date recorded on the Petworth portrait referred to above. The date on the frame was first recorded in 1859 by J.G. Nichols who later published the whole inscription in its present form (Nichols 1863).

Portraits of the English monarchs, sometimes in a series, were among the items most frequently found in the picture collections of Tudor houses. Loseley House was built in the 1560s for Sir William More (1520–1600), son of Sir Christopher More, who had been King's Remembrancer to Henry VIII and had acquired the estate. Sir William was several times a Member of Parliament as well as County Sheriff. A 1556 inventory of his possessions, taken before the building of the present house, shows that he had up-to-date tastes. He owned a collection of newly fashionable maps, but only one portrait, that of Henry VIII. The portrait of Edward VI must have entered Sir William's collection later, but the precise date is difficult to establish as the first inventory of the contents of Loseley House to list pictures individually is that of 1777, in which a reference to the portrait of Edward VI occurs. The inventories indicate that no additions were made to the collection in the seventeenth and eighteenth centuries, and it is likely that the portrait was acquired either by Sir William More or by his son Sir George (1553–1632) who held a number of important offices under James I. One possible source for the picture should be considered: Sir William More acted as the executor for the estate of Sir Thomas Cawarden,

who had been Edward VI's Master of the Revels and also Keeper of the nearby Palace of Nonsuch, built by Henry VIII. An inventory in the Guildford Muniment Room that appears to list Cawarden's goods includes several pictures, but no portrait of Edward VI. Nonsuch Palace was demolished in 1682–1688, and a number of painted panels at Loseley House have been assumed to have come to the house from Nonsuch. However, there is no documentary evidence for the transfer of these or any other items from Nonsuch to Loseley. s.f.

Provenance: First recorded in an inventory of the contents of Loseley House in 1777; and by descent
Literature: Millar 1963, 65; Strong 1969, 92, pl. 167; Norman and Barne 1980, 323, 369; Nichols 1859, 8; Nichols 1863, 20; Evans 1855
Exhibitions: London, RA Winter 1877 (184); London, New Gallery 1890 (175)

4

UNKNOWN LADY OF THE FITZWILLIAM
FAMILY c.1540–1545
artist unknown, possibly John Bettes I
oil on panel
43 × 33 (17 × 13)

Milton
The Executors of the 10th Earl
Fitzwilliam

This is one of the most distinguished paintings by an unknown follower of Holbein and epitomizes both the surprises and problems surrounding art in the mid-Tudor period subsequent to the master's death in 1543. Although clearly not by Holbein himself it derives directly, in formula and treatment, from his later court portraits such as the *Unknown Lady* (formerly called *Catherine Howard*; Toledo Museum of Art, Ohio) and *Margaret Wyatt, Lady Lee* (Metropolitan Museum, New York). In both these the picture is about half life-size and the sitter is depicted half-length, turned three-quarters to the left, with her hands clasped at the waist. The Milton *Unknown Lady* is derived directly from these and is executed in the same highly linear way in which form is suggested by the confining lines of the composition. In addition it has the same raised blue background. Judging by her dress, this portrait belongs to the 1540s, more likely the first half.

 The sorting out and attribution of pictures of this period remains a treacherous task, in the main because of their condition, for they are either in a poor state or have suffered at the hands of restorers. So far only one identifiable artist has emerged with definite Holbeinesque tricks and mannerisms and he is John Bettes I (fl.c. 1531–before 1570). A fragment of a formerly signed portrait of a man is in the Tate Gallery (Strong 1969, 1: 66). The last certain reference to him comes in 1556 and no works later than about 1550 can be attributed to him. In the present state of our knowledge it is difficult to do other than advance Bettes as a possible contender for this outstanding picture. Three other identifiable artists who also worked during the 1540s can be ruled out: the iconic Master John who

painted Mary Tudor in 1544 is far too primitive, and both Hans Eworth and William Scrots, although influenced by Holbein, were new immigrants from the Low Countries with quite different mannerisms and formulae.

 No identity has ever been suggested for this sitter. If the picture has always been in the family, and there seems no reason to doubt this, there are several candidates among the wives and daughters of the Fitzwilliams who were prominent at the court of Henry VIII. A possibility is Agnes, daughter of Sir William Sidney and wife of the third Sir William Fitzwilliam of Milton (died 1599). Agnes' eldest and only surviving brother, Sir Henry Sidney, was born in 1529. Her birth and marriage date are not known. If she was born c.1525–1530 the portrait would depict her at about the age of fifteen to twenty, in about 1545. R.S.

Provenance: The picture has belonged to the Fitzwilliam family since it was painted
Literature: Waterhouse 1969, 10
Exhibitions: London, RA 1950 (30); London and Leicester 1965 (40)

5

PAIR OF FIREDOGS OR ANDIRONS
c. 1533–1536
English
polished steel and brass,
with iron bases and sleepers
126.3 × 66 × 29 (49¾ × 26 × 11½)

Knole
The National Trust
(Sackville Collection)

Massive andirons, otherwise known as fire or brand dogs, were an essential part of the furnishings of a great hall fireplace from the mid-fifteenth century, when the idea of the central open hearth had been generally abandoned. They supported and contained the huge logs brought in by the estate woodsmen, and thus had to be heavily weighted. But they could also be highly decorative: Cardinal Wolsey's inventory of 1523–1525 lists some displaying "my Lordes armes and Cardinall hattes on the toppes," and others with dragons, lions, roses, and the arms of England.

The andirons from the great hall at Knole, among the finest early examples in existence, originally came from Hever Castle in Kent (Phillips 1929, 2: appendix V). The Hever estate had been bought in 1462 by Sir Godfrey Bullen (or Boleyn), mercer and Lord Mayor of London, and the family's rapid rise culminated in the marriage of his granddaughter Anne to King Henry VIII in 1533. The andirons are surmounted by discs, perhaps a reference to the Tudor rose, surmounted by a royal crown. These respectively bear the arms of Henry VIII and the initial *HR* (for Henricus Rex), and the falcon badge of Anne Boleyn with the initials *HA*, symbolizing their ill-fated love match. The slender bars forming the standards are supported by semi-circular arches enclosing pointed trefoils that are purely Gothic in inspiration, though there are primitive touches of Renaissance ornament in the arabesque tracery of the large drop handles (used to pull the andirons out when the ashes were being removed); similar touches are found in the curious naked figures, perhaps representing Adam and Eve, standing on corbels above them.

The andirons were probably made for Sir Thomas Boleyn (d. 1538) in the brief period between his sister's marriage and her disgrace and execution in 1536. Their later acquisition by the 1st Lord Sackville was singularly appropriate, as Knole had belonged to Henry VIII, and the buildings surrounding the outer Green Court had been built largely between 1543 and 1548 to house his attendants. G.J-S.

Literature: DEF 1924–1927, 2:
55–56, fig. 4

6

MARQUETRY CHEST c. 1585
English, probably Southwark
oak inlaid with sycamore and
other woods
78.8 × 180.9 × 77.4 (31 × 71¾ × 30½)

Arundel Castle
The Duke of Norfolk, KG

At a time when textiles, including wall hangings, table carpets, and embroideries, were by far the most important elements in the country house interior, large chests for storing these and other valuables were an essential item of furniture. Such chests were originally constructed of plain, paneled oak, but toward the end of the sixteenth century highly elaborate marquetry chests began to be made. Many were executed by German and Flemish immigrant craftsmen who, to evade the restrictions on foreigners imposed by the City of London guilds, set up their workshops in Southwark, near the southern end of London Bridge (Forman 1971, 94–120).

This example has close similarities with a famous chest in Southwark Cathedral inlaid with the arms of Hugh Offley, a prosperous leather merchant who was Sheriff of London and an alderman in 1588 (DEF 1954, 2:10, fig. 19). A third member of this group is the "great inlayde Chest" mentioned in the 1601 Hardwick inventory (and still in the house), which bears the initials *GT*, almost certainly for George Talbot, Earl of Shrewsbury (d. 1590), Bess of Hardwick's last husband. All three have architectural elements apparently taken from Vredeman de Vries' *Variae Architecturae Formae* published in Antwerp about 1560 (Jervis 1974, 29, figs. 142–157; fig. 148 has pedimented tabernacles with shell-headed niches very like those on the Arundel chest). The floral marquetry panels in arched reserves are also closely related, though there are any number of sources for these in the herbals and horticultural treatises published in Germany and the Low Countries at this period. In addition, the Southwark chest has small panels depicting a crowded arrangement of towers and spires, of a type long associated with Henry VIII's

famous palace at Nonsuch (see no. 342), though in fact this is a conventional form of decoration particularly found in the work of craftsmen from Cologne.

Hardwick is the only house in England where sixteenth-century furniture of this quality can be found in its original setting. The fine collection of English and Continental furniture of this date now at Arundel was largely acquired by the 15th Duke of Norfolk in the 1880s as part of his full-scale reconstruction of the castle, through a dealer named Charles Davis of 147 New Bond Street (Jervis 1978, 203; and information from Dr. John Martin Robinson). His bills are unfortunately too vague to identify this piece precisely ("to ten pieces fine oak furniture £2500"; "an oak chest" or "a carved Italian table" are typical entries), but in their attempt to re-create a "mansion of the ancient time" both he and the duke showed a rare discernment and knowledge. G.J-S.

Literature: Jervis 1978, 205, and pl. B (as South German)

7

MILLEFLEURS TAPESTRY WITH THE ARMS OF JEAN DE DAILLON 1481–1482
Wuillaume Desreumaulx d.1482/1483
wool and silk
360 × 280 (140 × 109½)

Montacute House
The National Trust

The millefleurs tapestry with a knight in armor was woven for Jean de Daillon, Seigneur de Lude, Governor of the Dauphiné in 1474. Jean-Bernard de Vaivre has shown that the coat of arms on the tapestry was used only by Jean I de Daillon, and only for the period between about 1450 and his death in 1481 or 1482. The heraldic wolf depicted on the banner held by the knight may have formed part of the crest of Jean de Daillon, seen only in a worn seal impression. No satisfactory solution has yet been proposed for the letters *JE* on the banner. The armor of the knight, the caparison of his horse, and the type of banner can all be found in tapestries from the time of Jean de Daillon.

In 1973–1974 a connection was made between this tapestry and documents concerning a gift of tapestries to be donated by the town of Tournai to a M. du Lude, Governor of the Dauphiné, in 1481–1482. The widow of Jean de Daillon asked for the tapestries to be delivered to herself and her children in December 1482. According to these documents, there were at least 457 square ells of tapestry in all, a sizeable set, made by the workshop of Wuillaume Desreumaulx, *tappissier* of Tournai. The discovery increases the rarity of this tapestry, as it is one of the few surviving fifteenth-century tapestries that can be precisely identified. It also shows the type of millefleurs ground being woven in at least one Tournai workshop of that date.

This tapestry has hung at Montacute House only comparatively recently. It represents a type of tapestry popular in its day. Similar pieces found their way into the hands of that avid English collector, Henry VIII, who had among his tapestries at Hampton Court, "1 odde pece of Tapistrie having on it a man pictured in harneys [ie 'harness,' meaning armor] on horsebake";

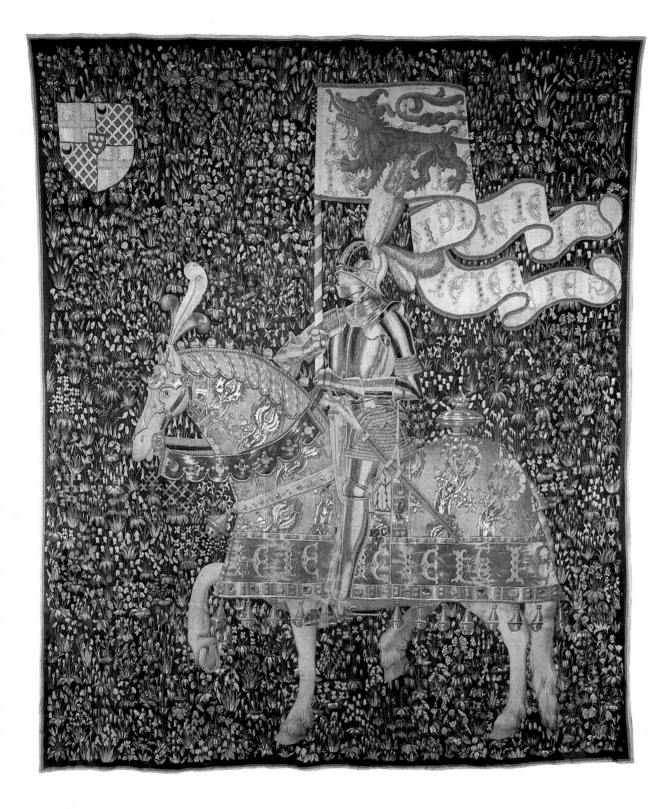

in another house owned two pieces "having a man armed on horsebake" with a "border of bells on the Top," a description of border that fits several early sixteenth-century tapestries attributed to Tournai. Besides actual personages depicted in this way, the Nine Worthies appear on horseback displaying their fictitious coats of arms on contemporary tapestries. W.H.

Provenance: Bequeathed in 1960 to the National Trust by Sir Malcolm Stewart, who acquired it in 1935 from Sir Edgar Speyer
Literature: De Vaivre 1973; De Vaivre 1974
Exhibitions: Paris and New York 1973–1974 (44)

8

ARMCHAIR c.1650
English
turned elm
139.7 × 73.6 × 48.2 (55 × 29 × 19)

Browsholme Hall
The Parker Family of Browsholme and Alkincotes

This and a similar but slightly more elaborate armchair were illustrated in the hall at Browsholme Hall, Yorkshire (now Lancashire), in a *Description* published in 1815. The prototypes can be traced back to the Romanesque period when the well-known example of about 1200 in Hereford Cathedral (see Eames 1977, 194–195, 210–211) was made. Square turned chairs should be distinguished from the triangular type, which were avidly collected by such eighteenth-century antiquarians as Richard Bateman and Horace Walpole (see Richmond-on-Thames 1980, 40). Randle Holme in *An academie or Store of Armory & Blazon* (1688, vol. 3, xiv, MSS dated 1647) shows a square "turned chaire" with uprights connecting the front seat rail to the front stretcher, a feature also present on the Browsholme chair.

However the latter is more complex, having not only arms, but also "wings" or side head rests. Although this feature would appear to make the chair very

uncomfortable, it is probable that it originated in seventeenth-century sleeping or easy chairs. Peter Thornton (1978, 196–197) has suggested that these may have developed from primitive invalid chairs. While turned chairs like the Browsholme one may have been rendered more comfortable by tie-on cushions, they are probably best considered not as functional items but as vehicles for provincial display and as examples of artisan mannerism.

This chair and its companion were almost certainly brought to Browsholme by Thomas Lister Parker (1779–1858), who inherited the house in 1794. His father had traveled with William Gilpin, the theorist of the picturesque, and while at Christ's College, Cambridge, Parker himself had known antiquarians and collectors such as Rev. Richard Buck

and Thomas Kerrick. This circle at Browsholme included Thomas Dunham Whitaker, Charles Towneley, and Walter Fawkes. An early patron of English painters—including Turner, Romney, Opie, Northcote, Callcott, Mulready, and Buckler—Parker employed Jeffry Wyatt to design a new Elizabethan-style drawing room at Browsholme in 1805. By 1824 he had overspent and had to sell the house to a cousin. His role as a pioneer in the study of English antiquities was recognized in Henry Shaw's dedication to him of *Specimens of Ancient Furniture* (London, 1836), the first book on the subject, which included a plate of a pair of bellows at Browsholme. S.S.J.

Literature: Browsholme Hall 1815, pls. 5, 7; Jervis 1980, 4–5, 21–23

9

JOINED ARMCHAIR C.1550
English
oak
$148 \times 88 \times 75$ ($58\frac{1}{4} \times 34\frac{1}{2} \times 29\frac{1}{2}$)

Cotehele
The National Trust
(Mount Edgcumbe Collection)

The great hall of a fifteenth- or sixteenth-century English manor house would look incomplete without the early panel-back chairs of massive construction that stand against rough whitewashed walls, with trophies of arms and armor above them. These chairs appear to have been used solely by the owner, his wife, or principal guests, and then only on ceremonial occasions when they dined at the high table, on a dais at one end of the hall,

or when local court hearings or rent-gatherings were held. At other times the family would, at least by the sixteenth century, have stayed in the Great Chamber on the floor above, leaving the household servants and estate workers to fill the long tables and benches in the main body of the hall.

This example is from the great hall at Cotehele in Cornwall, remodeled by Sir Piers Edgcumbe (1489–1539) and one of the finest surviving rooms of its kind in England. The chair probably dates from before 1553 when his son Richard built a new house at Mount Edgcumbe on Plymouth Sound, which replaced Cotehele as the main family seat. The elaborately carved back with a pierced floral cresting, primitive caryatids at each side, and a gadrooned rectangular panel shows the influence of Flemish pattern books, but the central medallion with a portrait head in profile is a distant echo of the Italian Renaissance. Ever since Giovanni da Maiano made his famous terracotta medallions of Roman emperors for Henry VIII's Hampton Court in 1521, this motif had been a favorite of carvers, plasterers, and decorative painters alike. Similar roundels can be found in the room from Waltham Abbey, Essex (now in the Victoria and Albert Museum), dating from about 1530, and in the parlor at Haddon Hall, Derbyshire, where the portrait heads, dated 1546, are thought to represent Sir George Vernon and his wife Margaret Tallboys.

The bearded man represented on the Cotehele chair, with a dashing plumed hat typical of the Tudor period, may simply be imaginary. While the arms in the form of serpents appear to be original, the spiral-turned front legs and stretcher and the carved seat probably date from the early nineteenth century, when Cotehele, rediscovered by a new generation of romantics and antiquarians, was meticulously restored and reopened as a summer residence by the 3rd Earl of Mount Edgcumbe.

G.J-S.

Provenance: Always at Cotehele; transferred in 1974 to the National Trust, which acquired the house in lieu of death duties in 1947

10

HALF ARMOR C.1510–1520
German
steel and leather
93 × 36 × 29 (36⅝ × 14 × 11⅜)

Penshurst Place
The Viscount De L'Isle, VC, KG

11

TWO-HANDED FIGHTING SWORD
c.1530–1540
French
steel and wood
150 × 31.8 × 17.1 (59⅜ × 12½ × 6¾)
stamped in the fuller, *IE.SVIS.CELLE.
QVI,POINT,NE.FAVLT.P;* and,
on the other side, *A.SON.MAISTRE.
CVANT.ON.LASSAVLT.N.*

Penicuik House
Sir John Clerk of Penicuik, Bart.

This two-handed sword has a steel, mushroom-shaped, octagonal pommel. Its tang-button is surrounded by acanthus tips chiseled in relief. The guards consist of a straight, octagonal-sectioned cross-guard, supporting at the center on each side of the hilt an oval side-ring, partly closed by a pair of curved bars forming a *V*, the apex of which points toward the center of the cross-guard and terminates in a knob shaped like the pommel. The cross-guard terminates at each end in a pair of baluster-shaped knobs placed end-to-end and flanking a cylindrical moulding. The center of the side-ring is decorated to match the end of the cross-guard.

The octagonal-sectioned wooden grip is bound similarly to no. 13, but the detail of the wire binding is obscured by the red and black paint. The straight, two-edged blade has a short (1.5 centimeters) ricasso with a narrow fuller at each side. A central fuller runs 41 centimeters from the hilt, and thereafter the blade is of flattened hexagonal section. A.V.B.N.

Provenance: See no. 13

12

HORSEMAN'S SWORD C.1625
British hilt, probably German blade
steel, wood, silver, and gold
108 × 24.5 × 12 (42½ × 9⅝ × 4¾)

Penicuik House
Sir John Clerk of Penicuik, Bart.

This horseman's back-sword has a fig-shaped pommel of hollow-sided octagonal shape, with the narrower end toward the blade. The spatulate ended cross-guard is slightly recurved at right angles to the plane of the blade and supports both a knuckle-guard pegged into the pommel and, at its center outside, an oval, open side-ring, and inside a smaller side-ring of the type in which the ends are turned toward the ends of the cross-guard. The whole hilt of russet steel is counterfeit-damascened with fine foliate scrolls in gold. The octagonal-sectioned wooden grip is bound with wire: a coarse, chain pattern in silver is flanked on each side by a twist of two spirally bound, steel wires, alternating with six silver twists, each in the contrary direction to its neighbor. The second group is flanked on each side by a fine chain pattern in silver. The straight, single-edged blade has a false edge. A broad central fuller is punched on each face with an unidentified mark resembling a circle between the two halves of a saltire. The short ricasso has a narrow fuller near its front edge.

If this is not the personal sword of John Clerk of Penicuik, the ancestor of the present owner, it could possibly be the "sourd with A gret gard damaskined" of the 1647 inventory of his stock in hand. He had started life as a very successful general merchant in Paris and on his return to Scotland purchased the lands of Penicuik. His eldest son John was the first baronet. A.V.B.N.

Provenance: See no. 13
Literature: Hayward 1974, 1: 142–161, figs. 1a, 1b

The close-helmet has two gorget-plates at the back of the neck, and a bevor and pointed visor pivoting at the same place on each side. The peg on the right side of the visor is for lifting it. The helmet was probably made in Innsbruck. The associated gorget consists of eight plates, from two different armors; the front lower plate later. The globose breastplate has movable gussets; to the waistplate is attached a later skirt of three lames from which hang a pair of later tassets (thigh defenses) of four movable lames. Near the neck of the breastplate to the left, the mark of the city of Nuremberg is struck. The backplate matches the breast, with separate side-wings, and a later waistplate and cullet. The decoration of both helmet and cuirass consists of plain turned edges and groups of slightly diverging shallow embossed flutes alternating with plain areas.

Although this type of crested or fluted German armor was apparently used in England (a similar helmet survives as part of a funeral achievement in a Gloucestershire parish church) there is no evidence at the present time that these particular pieces are from the original armory at Penshurst, which seems to have been slightly augmented in the early nineteenth century.
 A.V.B.N.

Exhibitions: Possibly London, Drury Lane 1888 (651), then with a pair of gauntlets

13

TWO-HANDED FIGHTING SWORD
c. 1530–1540
German blade (possibly Solingen)
steel and wood
151 × 34 × 12.9 (59⅜ × 13⅜ × 5)

Penicuik House
Sir John Clerk of Penicuik, Bart.

This two-handed sword has a steel pommel in an elongated fig shape. The narrower end of the pommel is toward the blade and its blunt end is chiseled in relief with a flower of the compositae family surrounded by a wide belt of spirally writhen flutes. The straight octagonal-sectioned cross-guard supports at the center on each side of the hilt an oval, open side-ring. The cross-guard terminates in a large spherical, spirally writhen knob at each end, and is punctuated at intervals by spirally writhen, swollen sections and others formed like two baluster-shaped moldings placed end to end. The side-rings are decorated to match. The octagonal-sectioned wooden grip is bound with steel wire, now thickly overpainted with black over a red base. A spirally bound wire is followed by a tight twist and two looser twists forming a herringbone; thereafter the pattern repeats. The grip has Turk's head ferrules. The straight, two-edged blade, with the ricasso tapering toward the tip, has two projecting lugs and a central fuller. On one side an elongated beast, with traces of copper inlay, is incised, perhaps representing the wolf of Solingen (for this type of decoration see Norman and Barne 1980, 368, fig. 21).

It seems possible that the three two-handed swords belonging to the Clerks of Penicuik were the bearing swords used in their baronial courts. On the other hand the 1647 inventory of the stock-in-hand of the merchant John Clerk (1611–1674), the ancestor of the present owner, includes: "1 tua handit sourd with A reid skabert and A crosse on the blade; 1 tua handit sourd brod Blade and reid Skabert; 1 tua handit sourd with A gray skabert." A.V.B.N.

Provenance: John Clerk of Penicuik; and by descent

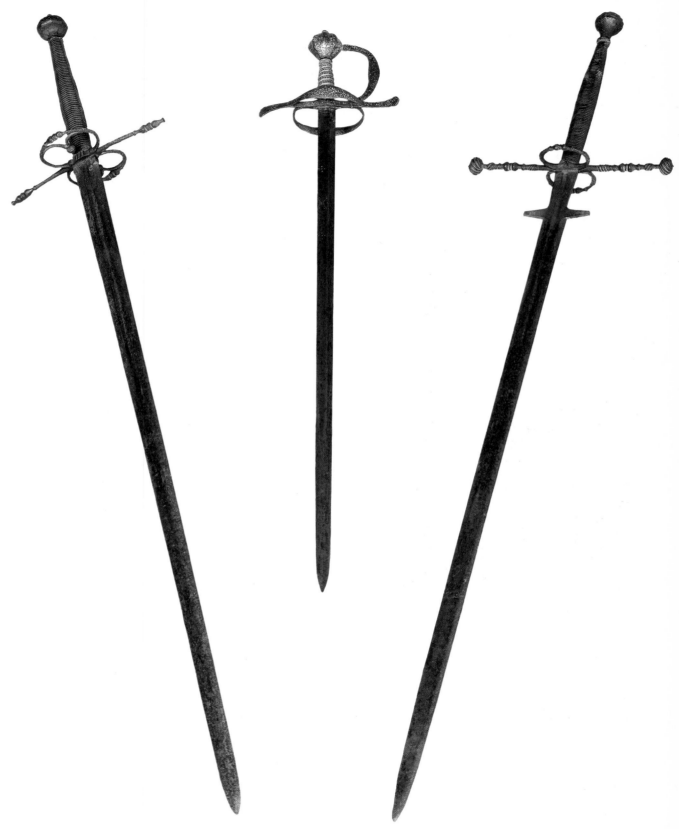

14

THE EARL OF LEICESTER'S BEARING
SWORD third quarter of the 16th
century
steel and wood
18.5 × 128.5 × 52.5 (7¼ × 50½ × 20⅝)

Penshurst Place
The Viscount De L'Isle, vc, kg

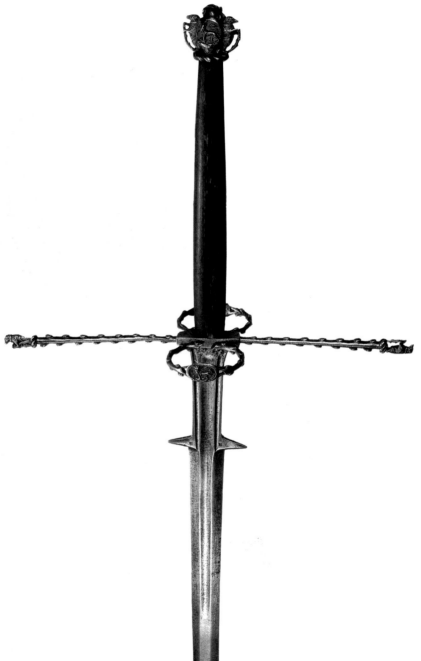

The steel pommel of this two-handed
bearing sword is chiseled in relief,
representing on each face the royal
crest of England within a garter, now
without inscription, but probably
originally of the Most Noble Order of
the Garter, flanked on each side by
a bear of Warwick charged on the
left shoulder with a crescent as a
"difference," and holding in its forepaws
a ragged staff, all chiseled in the round.
The straight cross-guard supports a
large oval, open side-ring at its center
on each side of the hilt. The rings are
wrought in relief with small projections

to resemble the branches of the ragged
staff. The ends of the cross-guard are
chiseled in the round with bears and
ragged staves as on the pommel, while
the centers of the side-rings are
chiseled in relief with the crest of
England within a garter, as on the
pommel. The straight, two-edged blade
has parrying lugs on each side near the
hilt. On both faces of each lug is an
unidentified maker's mark, a saltire
with a transverse bar at its center.
A broad fuller runs from hilt to point
flanked near the hilt by a narrow flute
on each side. A very faint inscription
may be seen on one side, both in the
fuller and the edges. It is now completely
illegible save for the following letters in
the fuller: *LYL+N ND+V MAJ+....*
The point has been broken and crudely
resharpened. The blade has also
apparently been broken at the hilt and
inexpertly hammer-welded.

This sword was intended to be
carried in procession before its owner,
Robert Dudley, 1st Earl of Leicester
(1532?-1588), Queen Elizabeth's
favorite (see no. 40). It is probably
recorded in the inventory of Leicester's
principal castle, Kenilworth, in 1583:
"A two hande sworde, with a gilt hilte
and pommelle withe ragged staves,
beares and lyons, the scabberde blacke
velvett and a case for it" (HMC 1925,
1: 292). The presence of the royal badge
suggests that the sword was connected
with a royal office, of which Leicester
held many, the highest being Protector
of the Realm, granted during the
queen's illness in 1562. A.V.B.N.

Provenance: Robert Dudley, Earl of
Leicester; his nephew Robert Sydney,
Baron Sydney of Penshurst (1603),
Viscount Lisle (1605), and 1st Earl of
Leicester of the second creation (1618);
and by descent at Penshurst
Literature: Planché 1857, 22–23; Dillon
1888, 512–513, pl. xxi; Laking 1922,
272–273, fig. 1337
Exhibitions: Manchester 1857 (22–23);
London, Drury Lane 1888 (656);
London, New Gallery 1890 (630);
London, Grosvenor 1933 (62)

15

SHIELD c. 1580
probably Milanese
steel and leather
61 (24) diam.

Eastnor Castle
The Hon. Mrs. Hervey-Bathurst

This round shield, intended for service
on foot, has a rolled edge roped
with a file, a flat rim, and a slightly
convex center coming to a low central
point, into which is screwed a sharp
spike with striated point arising from a
separate foliate washer. Around the
edge is a series of rivets to secure the
fabric lining, now missing. The surface
is pierced by four pairs of holes for the
rivets (only two of which survive) for
securing the arm-pad and braces. Only
a fragment of one leather brase survives.

The surface of the shield is etched in
low relief around the rim and in five
rays diverging from the center with
bands of trophies of arms bordered by
roping; between them are etched
shieldlike cartouches, containing scenes
from the life of Hercules, hung from
ribbons. This shield probably once
formed part of a garniture intended
possibly for the tournament, to which
purpose it would have been adapted by
means of spare parts called "pieces of
exchange." What may be the matching
armor for a lancer is also at Eastnor.

The castle was designed by Robert
Smirke in 1811 in a richly medieval
style. It is therefore surprising that the
armory so necessary for its romantic
aura was not purchased until the time
of the 3rd Earl Somers (1819–1883),
an important collector particularly of
Italian Renaissance art. A.V.B.N.

Literature: Gamber 1958, fig. 94

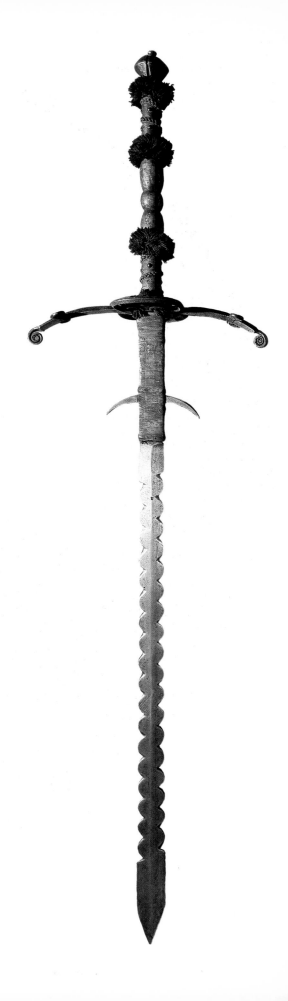

16

TWO-HANDED FIGHTING SWORD
c. 1530–1540
probably German
steel, wood, and leather
145.5 × 40.5 (53 × 15½) long

Eastnor Castle
The Hon. Mrs. Hervey-Bathurst

The steel pommel is ovoid and spirally writhen with fat ribs alternately finely roped and cross-hatched. The guards consist of a straight cross-guard supporting at its center, on each side of the hilt a large, oval, open side-ring. The knobs on the ends of the cross-guard are chiseled to match the pommel. The wooden grip covered in polishing leather is probably nineteenth century. The straight, two-edged blade has a narrow central fuller or groove, incised on one side and still containing traces of brass inlay with a series of marks. Reading from hilt to tip on one side, these are: a cross crosslet upon a mound; an open-mouthed beast, perhaps a wolf or a dog, or a comic profile head in relief wearing a "Robin Hood" hat with a feather; a circle of six small square punches with one in the center; a small illegible device; and on the flat beyond the fuller a small crozier. On the other side, reading from hilt to tip, are: a cross crosslet upon a mound; an open-mouthed beast (as above); a comic profile head wearing an open crown; a cross moline; a small letter *p*; beyond the fuller, a small crozier.

The identification of the so-called wolf mark described above has been discussed by W.M. Schmid (1902–1905, 312–317), who concludes that such short-coupled beasts may indicate that the sword was made in Passau rather than in Solingen. A.V.B.N.

17

TWO-HANDED FIGHTING SWORD C.1600
German or Swiss
steel, wood, leather, and wool
182.6 × 46.3 × 20.3 (72 × 18¼ × 8)

Eastnor Castle
The Hon. Mrs. Hervey-Bathurst

This two-handed sword has a conical
steel pommel, tapering toward the grip,
with a low, domed top crudely engraved
with scale-work. The cross-guard, of
a diamond cross-section is slightly
arched toward the blade, ending in
triple scrolls and supporting on each
side an oval, open side-ring. The wooden
grip is formed like two balusters
flanking a central ball, covered with
gilded leather and bound with gold
braid at each end, with four woolen
fringes at intervals. The straight, two-
edged blade has a long ricasso bearing a
projecting curved lug on each side.
This is followed by a flattened diamond
section, which expands gradually to
just below the tip. The cutting edges
are wavy. On each face is a small,
illegible, punched mark. The ricasso is
covered in gilded leather to make the
blade easier to hold when shortening
the sword for close-quarters work.

This type of sword was often used in
Switzerland and in the German Lands
to arm special troops, as, for example,
the men guarding the colors of an
infantry regiment. It is frequently found
in town and cantonal arsenals. Three
swords of this type from the Zurich
Zeughaus are now in the Schweizerisches
Landesmuseum (Schneider and Stüber
1980, I: nos. 156–158). A.V.B.N.

18

REDENDO HORN
Scottish
horn and silver
61 (24) long, 6 (2½) diam. at rim
incised on the horn, *IC*, above the date,
1656

Penicuik
Sir John Clerk of Penicuik, Bart.

This straight, evenly tapered, goat or
antelope horn is slightly corrugated
transversely. It is mounted at each end
with a narrow silver band, that at the
bell being edged with acanthus tips and
engraved with a strip of overlapping
leaves. A later mouthpiece resembling
that of a trumpet has been added.

The redendo horn is the means by
which the Barony of Penicuik is
held of the Crown. This mode of
tenure is first recorded in a crown
charter of 1508 (Great Seal Register
C.2/14, no. 449; letter of Dr. A. Murray,
1 March 1985), *redendo* being the first
word of the legal writ relating to it.
When the sovereign holds his or her
principal hunting on the Burghmuir of
Penicuik, until recently the last surviving
part of the ancient royal Forest of
Drumsheugh, the baron must, on request,
blow three blasts of his horn. From this
derives the crest of the present baron's
family, "a demi-huntsman winding a
horn proper," and his motto, "Free for
a blast." Earlier forms of land tenure *in
cornu*, literally covering the area of land
over which the sound of the horn could
be heard, are known from Anglo-Saxon
times: the famous Pusey Horn from
Pusey House in Berkshire (now in the
British Museum) purports to represent
a tradition established before the
Norman Conquest. A.V.B.N./G.J-S.

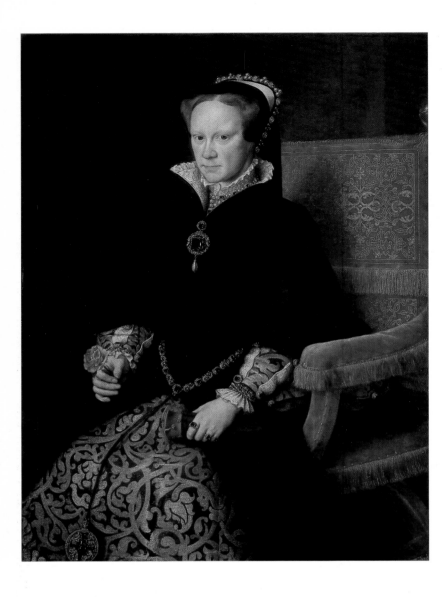

19

MARY I (1554)
Anthonis Mor 1517/1520–1576/1577
oil on panel
114.4 × 83.9 (45 × 33)
signed, *Anthonius Mor pinxit/1554*

Compton Wynyates
The Marquess of Northampton

Karel van Mander relates that Anthonis
Mor was sent to England by the Emperor
Charles V to paint Mary for her
prospective bridegroom, his son, the
future Philip II of Spain. Mor, he states,
was rewarded with a golden chain,
an annual pension of £100, and a
knighthood. No evidence has ever
emerged from English sources to confirm
this visit. It is much more likely that
Mor came over in the train of Philip
himself in July 1554 and that the three
versions of this picture were painted
after and not before the marriage.
Although not an infallible guide, Mary
wears a wedding ring and the jewel at
her throat may be the one sent to her

by Philip in June 1554: "a great diamond
with a large pearl pendant, one of the
most beautiful pieces ever seen in
the world." The frank presentation of
the careworn, thirty-eight-year-old
queen would hardly rank as a tactful
presentation of a future bride for a
husband ten years her junior. It would
seem reasonable that what Philip saw
before the match was a picture by
Eworth (Strong 1969, 87, 23) whose
interpretation of Mary's features was
far more charitable. Three versions exist
of this portrait, all signed and all of
autograph quality, but no direct com-
parison between them has yet been
made. One is in the Escorial, also the
source of this portrait of Mary I, and
a third came from the Jeningham family
of Costessy Hall, Norfolk (now in the
Isabella Stewart Gardner Museum,
Boston). Sir Henry Jeningham was Vice-
Chamberlain of the Household to Mary
and one of her most trusted advisers.
What seems to be a pendant portrait of
Philip is at Althorp (Earl Spencer).

Anthonis Mor was extensively
patronized by Philip and the visit to
England must have left some impression,
for both Lord Windsor and Sir Henry
Lee were to sit for him when passing
through the Low Countries in the 1560s.

The presentation of Mary draws on
stylistic traditions somewhat different
from that established in England by
Holbein, marrying portraiture of the
Scorel tradition to that of Northern Italy,
above all Titian. The seated formula
and the extensive chiaroscuro were quite
new in Tudor royal portraiture. This
picture therefore remains an isolated
phenomenon and one totally alien to
the iconic tradition deliberately
cultivated in the images of Mary's
successor, Elizabeth I. R.S.

Provenance: The Escorial; presented by
the king of Spain to the 2nd Lord
Ashburton, c. 1855; bequeathed to Castle
Ashby by Louise, Lady Ashburton
Literature: Strong 1969, 118, no.65;
references mainly to the Escorial version
occur in the literature on Mor: Hymans
1910, 71; Marlier 1934, 20–22;
Friedländer 1924–1937, 13: 121–122;
Strong 1969, 1: 212
Exhibitions: London, RA 1950 (200);
London, Tate 1969 (35)

20

JOHN, LORD LUMLEY 1588
Sir William Segar
oil on canvas
212.7 × 134.6 (83¾ × 53)
inscribed at the bottom,
*IOHANNES BARO DE LVMLEY
FILIVS GEORGII/A°
1588/AETATIS.54*

Sandbeck Park
The Trustees of the Earl of
Scarbrough's Settlement

John Lumley, Lord Lumley
(?1533–1609), came from an old
Catholic family. His grandfather, John,
5th or 6th Lord Lumley (1443–1544),
played a leading role in the Pilgrimage
of Grace, and although he was at first
compelled to do so, his sympathies were
in fact genuine. His father, George, was
similarly pledged; he was attainted of
treason and executed (1537) for his part
in Aske's insurrection. In 1547 John
was restored to blood and created
Baron Lumley by Parliament. He
continued in favor under Edward VI,
Mary I, and Elizabeth I until he became
involved in the Ridolfi Plot (1571), in
which Mary Queen of Catholicism was
to be restored. His part in the plot
prevented his continued advancement,
though it did not bring total disfavor:
the queen visited him in 1591 at his
house in Surrey. No full-length study of
Lumley has yet been undertaken but
recent research shows him to be a figure
of seminal importance in the cultural
history of the Elizabethan age. The
significance of his art collections is
discussed below (no. 346) but his
collecting cannot be detached from his
other areas of activity. In 1566 Lumley
traveled to Florence and all the evidence
indicates that the visit must have had a
great impact upon his attitude toward
collecting. At Nonesuch Palace, which
came to him from his father-in-law,
Henry Fitzalan, 12th Earl of Arundel,
he laid out between 1579–1591 the
first garden in England that showed
any response to the Renaissance garden
revolution. It included a grotto and
automata and had an iconographical
program. He also owned the largest
library in England, next to that of the
celebrated Dr. John Dee, and he gave to

the university libraries at Oxford and Cambridge. In 1582–1583 he founded the Lumleian Lectures on anatomy at the College of Physicians, and he was a founding member of the Elizabethan Society of Antiquaries. These aspects of Lumley's character all interconnect and are seminal for anticipating the range of intellectual and aesthetic interests of the upper classes in the seventeenth century. William Camden describes him as "a person of entire virtue, integrity and innocence, and now in his adage a complete pattern of nobility."

Genealogy was another of Lumley's passions (see no. 346). This portrait, dated 1588, is the concluding one of a series that he commissioned to decorate the great hall of his northern residence, Lumley Castle. The decor of the castle was so carefully planned that it extended as far as the castle gate. There were "statuaryes of xvien Auncestors of yor Lo: lyneally descending from the conquest unto yorself. The Statuary of Kinge Richard the seconde, delyvering the wryte of Parliament to Ralphe the first Barron of Lumley, called by him the eight yeare of his Reigne," hung together with this full-length portrait of the present holder of the title and one of his second wife Elizabeth, daughter of John, 2nd Baron Darcy of Chiche.

The series included full-length portraits of sixteen ancestors, all imaginary, and depicted successive lords standing in niches, holding shields bearing arms. Their quality is poor. However, Lord Lumley is shown standing in a niche, wearing an etched and gilt field armor of North Italian (Milanese or Brescian) manufacture that is depicted in all details with unusual faithfulness (information from Mr. A.V.B. Norman). The arms in the uppermost part of the canvas are those of Lord Lumley himself (top left) and of his two wives, Jane (d. 1576), daughter and coheir of Henry Fitzalan, Earl of Arundel, and (far right) Elizabeth (d. 1617), daughter of John, 2nd Lord Darcy of Chiche, both quartered with his own arms (information from Mr. J.P. Brooke-Little).

Although this portrait is more distinguished than those of the ancestors its quality is not particularly outstanding. This is probably due to

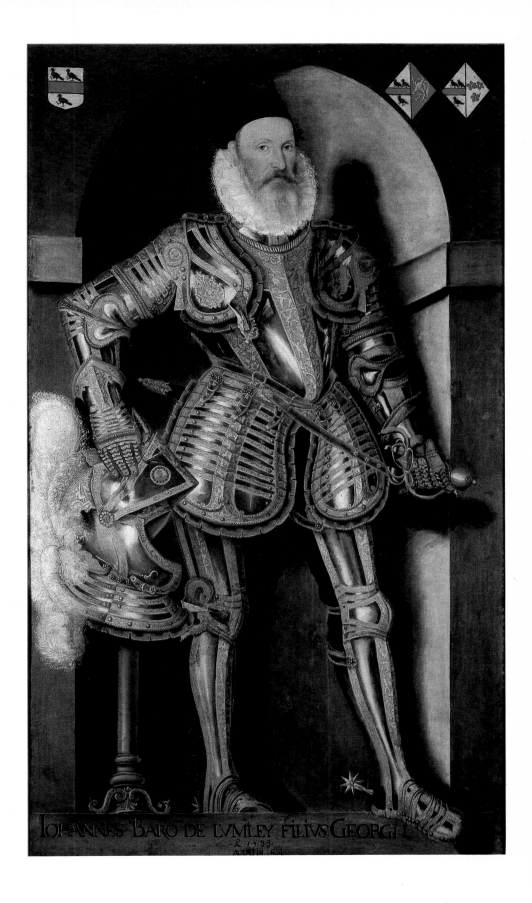

the fact that it was conceived as a decoration to be seen at a distance, hung high. That the painter has attempted the steep perspective, rare in late sixteenth-century England, is interesting. It may be that this commission for a series of full-lengths to be hung *en masse* inspired such celebrated sets as those painted for Sir Henry Lee at Ditchley in the early 1590s by Marcus Gheeraerts and, later, those by William Larkin for the Earl of Suffolk and Berkshire (now at Rangers House, Blackheath; see no. 54).

R.S.

Provenance: Not listed in the 1590 Lumley inventory; Lumley Castle, which passed to the sitter's cousin Richard Lumley, later Viscount Lumley of Waterford (1589–1661/1662), grandfather of the 1st Earl of Scarbrough; recorded in the sale of 11 August 1785, lot 34 (*Walpole Society* 1918, 6: 32); and again in the sale of 16 December 1807, lot 14; on both occasions apparently bought in
Literature: Strong 1969, 45

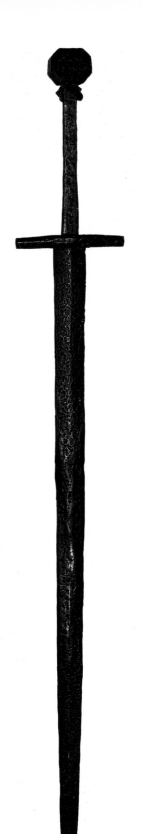

21

GUY OF WARWICK'S TWO-HANDED
SWORD 14th century
English
steel
105.7 (65½) long

The Warwick Castle Collection

This cross-hilted, two-handed sword is unusually large. Its pommel is flattened in the plane of the blade and has parallel, octagonal faces. The longer axis of the pommel is placed transversely to the main axis of the sword. The tang-button is no longer extant. The long tang is of approximately rectangular cross section, the wooden scales of its grip, and the binding of cord, leather, or wire are missing. The sword has a relatively short, straight, cross-guard of hexagonal section and a straight, two-edged blade of flattened diamond section, now with a rounded point. There is no sign of any bladesmith's mark on either blade or tang. The whole is heavily corroded but is apparently of rough construction.

The weight of this sword (15 lbs. 1 oz.) suggests that it was never intended to be a practical weapon. It may have been made as a sort of secular relic to commemorate the traditional founder of the Castle, the Saxon Guy of Warwick. Early inventories of castles sometimes include the weapons and armor of past heroes. For example, the inventory of Amboise in 1499 lists a sword called that of Lancelot of the Lake (Gay 1928, 1: 646–647). A comparable sword survives at Arundel Castle in Sussex. Tradition has it that it belonged to the Saxon founder of that castle, Bevis of Hampton (North 1978, 186–187, fig. 1). A sword with this tradition was at Warwick in 1369, according to the antiquarian William Dugdale. Thomas, 1st Earl of Warwick, who made his will in that year, left his eldest son, also named Thomas, "the Sword and Coat of mail sometime belonging to the famous Guy of Warwick." Dugdale also mentions that in 1509, when the castle was in royal hands, the king appointed one William Hoggeson to be Keeper of Guy of Warwick's Sword at a salary of tuppence a day (Dugdale 1730, 1: 396, 428).

A.V.B.N.

Literature: Grose 1786, pl. 48; Mann 1933, 158, fig. 2

22

PARTS OF A GARNITURE OF ARMOR
FOR FIELD AND TOURNEY COURSE
c. 1520–1525
German
attributed to Kolman Helmschmid of Augsburg 1470/1471–1532, with etching possibly by Hans Burgkmair the elder 1473–1531
steel and leather
185.4 × 77.5 × 53 (73 × 30½ × 21)

The Warwick Castle Collection

The cap-a-pie armor consists of a close-helmet with twin roped combs, gorget-plates, and a visor pivoted at the sides with a rounded projection below the sights; a gorget of six plates hinged on the left, with a stout roped rim at the top; a globose breastplate with movable gussets, a folding lance-rest, a waistplate, and a skirt of four overlapping lames from which hang tassets (thigh defenses), each of four lames; a backplate with a strap and buckle on the waistplate to hold it closed to the breastplate, and with a skirt of three lames; a pair of cuisses (upper leg defenses) each with two movable laminations at the top and articulated to the lower edge a poleyn (knee plate) with large oval wing outside the joint, and two narrow lames below this to connect the poleyn to the greave (shin defense); a pair of broadtoed sabatons (foot defenses) each of ten lames (several in each foot replaced); a pair of pauldrons (shoulder defenses) of three main lames, and four arm lames each, and an *haute pièce* (standing guard) on each to give additional protection to the neck; a pair of three-piece vambraces (arm defenses) each with a turning joint of Italian type in the upper cannons, a large bracelet couter (elbow defense) hung on two leathers, and a lower cannon opening on hinges to allow the entry of the forearm, and closing by means of a snap-over pin and a sneck-hook; and a pair of mitten gauntlets (thumbs replaced) with prominently roped knuckleplates. The decoration consists of roped edges followed by sunk bands containing etched decoration in low relief against the black ground, including foliate scrolls, with grotesques, birds, and human heads. A narrower, bright,

sunk band flanks the main bands on their inner side. The main surfaces are embossed with groups of shallow, slightly diverging flutes.

Although the gorget may belong to a second similar armor, it could have been intended for the missing tournament helmet of this armor, evidence for which is provided by the screw on the front of the left shoulder for the tournament reinforce. There may also have been a reinforcement at one time on the left elbow. The tourney course was a friendly duel on horseback with relatively blunt lances and swords in open lists.

This armor was purchased in Germany, presumably to add to the romantic aura of the castle's great hall, by the 2nd Earl of Warwick, before 1785, when it was illustrated in Francis Grose's *Treatise on Ancient Armour and Weapons*. It was badly damaged in the fire at Warwick Castle in 1871 and was subsequently heavily restored—the greaves and all but the lower five lames of the right sabaton were replaced, and a large, clumsy rivet was used. The attribution to Kolman Helmschmid is based on the similarity in form, construction, and decoration of this armor to two in the Waffensammlung at Vienna, respectively that of Bernard Meuting, about 1525, and that probably made for the future Emperor Ferdinand I about 1526 (Thomas and Gamber 1976, A235 and A349). Helmschmid was born in 1470/1471, the son of Lorenz Helmschmid of Augsburg, court armorer to the Emperor Maximilian I. He became a master in the Augsburg guild in 1492 and his earliest surviving work for the Emperor Charles V is an armor now in the Royal Armory at Madrid of about 1526; he died in 1532 (Gamber 1958, 73–120). The Augsburg artist Hans Burgkmair and his son are known to have decorated armors for the Emperor Maximilian I and Charles V (von Reitzenstein 1964, 70). A.V.B.N.

Literature: Grose 1786, pls. 43, 44; Mann 1937, 1:157, fig. 1

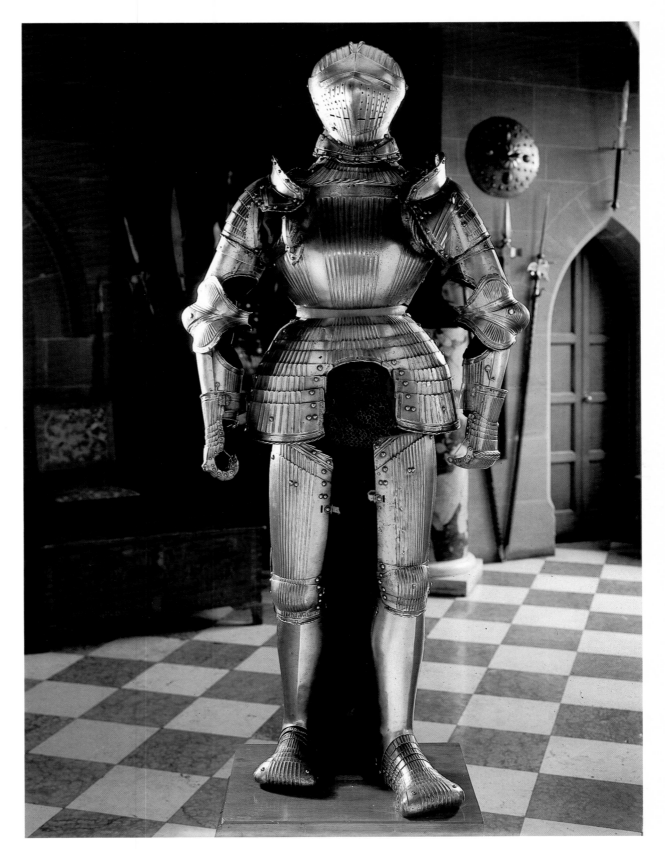

23

COMPOSITE GARNITURE OF ARMOR
FOR FIELD AND TOURNEY COURSE
Italian
partly by Pompeo della Cesa
fl.1585–1591, etched by an unknown
late 16th-century hand
steel and leather
167.6 × 76.2 × 53.3
(66 × 30 × 21) overall
signed, *POMPE*, for Pompeo della Cesa

The Warwick Castle Collection

This garniture consists of a close-helmet
for the field with gorget plates (the
lowest at the rear missing); a four-piece
gorget hinged on the left; a horseman's
breastplate of peascod form with folding
lance-rest on the right side (perhaps
associated); a skirt plate; a pair of
horseman's tassets (thigh defenses), each
of six movable lames; a pair of gauntlets
lacking the lames for thumbs and fingers;
a reinforcing plate for the left shoulder
for the tourney course; a half shaffron
(horse helmet) with a later spike on the
brow; and parts of a saddle.

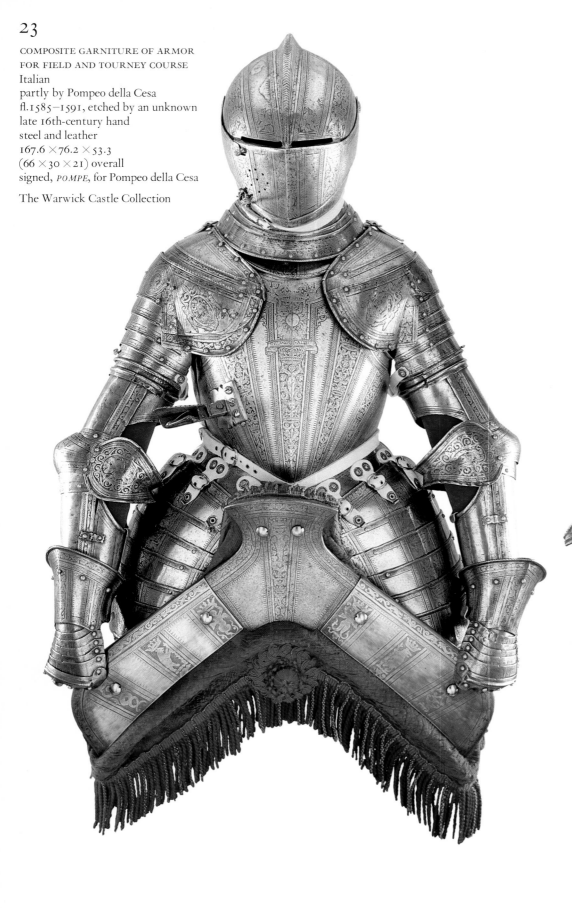

The decoration of the ensemble consists of bands of etched decoration. Some of the decoration is bright and some is blackened. It includes grotesques along the edges, and winged children, human terminal figures, lions, and grotesque beasts, all in pairs supporting coronets in the main bands. At the top of the central band of decoration on the breastplate is the signature of the maker, *POMPE*, and the emblem of the original owner. This consists of a radiant sun beneath a coronet of five fleurons supported by a pair of winged children, all above a scroll bearing the motto "NVLLA QVIES ALIBI." The two side plates of the front of the saddle, on which the decoration includes the bear and ragged staff badge of Warwick, are later replacements. The backplate is from a second armor of the same period and possibly from the same workshop, but decorated with bands including elaborate knots and oval cartouches containing grotesques, alternating with bands of trophies of arms suspended on a cord. The arms and shoulder defenses (pauldrons), which are for service on foot, are from yet another armor.

Although this armor was probably purchased by one of the Greville family to decorate the castle in the eighteenth or early nineteenth century, it is of a type occasionally depicted in English portraits of the later sixteenth century, such as that of John Shirley, dated 1588, now in the Metropolitan Museum, New York.

Pompeo della Cesa was the foremost armorer working in Milan in the last quarter of the sixteenth century. Among his patrons were Philip II of Spain, Andrea Farnese, Duke of Parma, Vincenzo I Gonzaga, Duke of Mantua, and possibly an Earl of Pembroke since parts of an armor signed by him are still at Wilton. A.V.B.N.

Literature: Thomas and Gamber 1958, 796–807

24

TARGET CROSSBOW AND WINDLASS
c. 1700
Low Countries
steel, brass, wood, bone, and hemp
$138.4 \times 81.2 \, (54\frac{1}{2} \times 32)$

Eastnor Castle
The Hon. Mrs. Hervey-Bathurst

This crossbow has a stout lath or bow of steel (with a later bow string) fixed to its wooden tiller by means of a pair of steel bow irons, one on each side. The irons also secure the steel stirrup on the front end of the tiller, making it possible to steady the bow during the spanning operation. Mortised into the top of the tiller at the front is a longitudinal brass slide for the bolts. Behind that is a bone nut to hold back the string when the bow is spanned.

The nut revolves freely except when connected to the trigger-mechanism, which is accomplished by means of a short rod inserted into a hole in the top of the stock behind the nut and in front of the later brass peep-sight. In the area of the nut the tiller is strengthened on each side by means of a steel plate shaped like a curved dolphin. The underside of the stock projects beneath the nut to improve the grip and behind this projection is a steel trigger guard.

The spanning mechanism consists of a winding box pierced with gothic fenestration, which fits over the rear end of the tiller. On each side of the winding box is a handle operating the roller for the cords. This is connected by the cords to the pulley wheels on each side of the double claw that fits over the bowstring. By rotating the cranked handles the cords are tightened and the string is drawn back until it engages the nut. The use of pulleys allows a much stronger bow than one that could be spanned by the simple strength of the human arm. The advantage of the crossbow over the longbow is that the former can be held spanned for long periods and ready to shoot, while the latter cannot.

This particular weapon was originally designed for competition shooting at targets, a favorite sport in the Low Countries where it is still practiced (see Payne and Gallwey 1903, 90–125). It was purchased recently to demonstrate the use of some crossbowmen's shields already at Eastnor and to complement the large collection of arms and armor collected by the 3rd Earl Somers (1819–1883), which fills the great hall and vestibule at Eastnor Castle.

A.V.B.N.

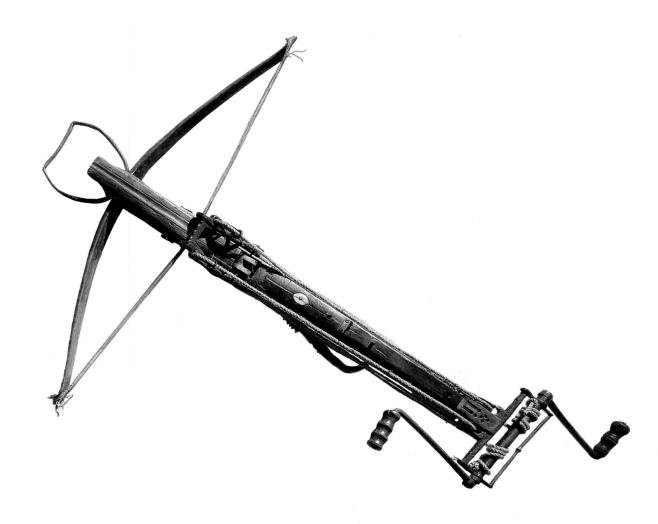

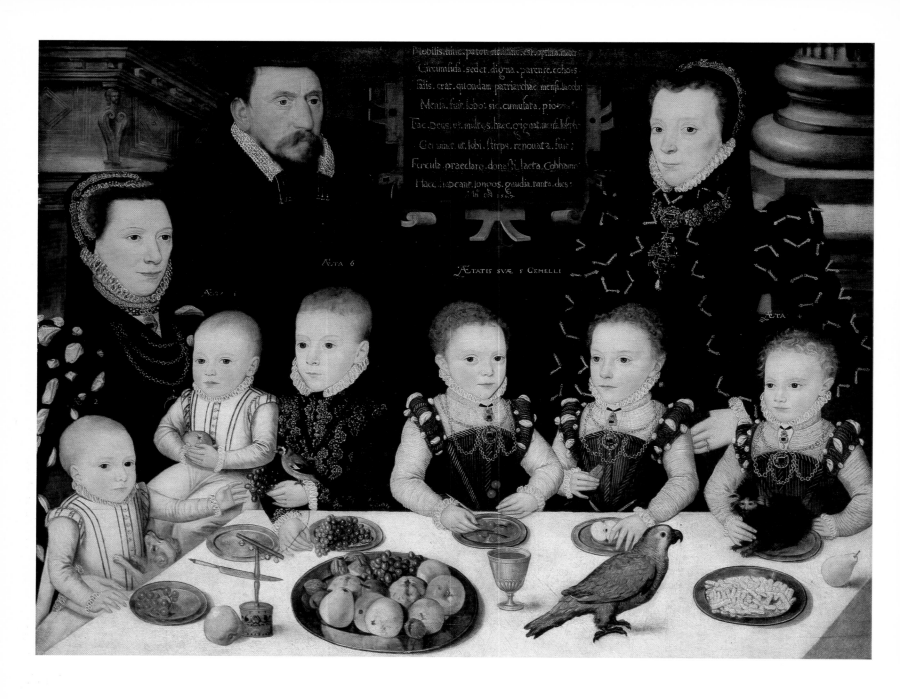

25

WILLIAM BROOKE, 10TH LORD
COBHAM, AND HIS FAMILY 1567
Master of the Countess of Warwick
oil on panel
96.6 × 124.5 (38 × 49)

inscribed *AETA I*, *AETA 6*,
AETATIS SVAE 5 GEMELLI, *AETA
4*, on the cartouche, center,
*Nobilis.hinc.pater.est.illinc.est optima.
mater/Circumfusa sedet.digna/parente/
cohors/./Talis. erat.quondam.patriarchae.
mensa.Iacobi./Mensa.Fuit.Iobo.sic.cumulata.
pio./Fac.Deus.ut.multos.haec.gignat.mensa.
Iosephos./Geminet.ut/Iobi.stirps.renovata.
fuit./Fercula.praeclaro.donasti.laeta.
Cobhamo./Haec.habeant.longos.gaudea.
tanta.dies./An.° DN. 1567*

Longleat
The Marquess of Bath

William Brooke, 10th Lord Cobham
(1527–1569), was Lord Warden of
the Cinque Ports, Constable of Dover
Castle, and Lord Lieutenant of Kent,
1558–1596. He entertained Queen
Elizabeth I twice, in 1559 and 1573 at
his house, Cobham Hall, which he
greatly enlarged. The portrait depicts
him with his second wife, Frances
(d. 1592), daughter of Sir John Newton
of Gloucestershire and Lady of the
Bedchamber to the queen. The second
lady is her sister, Johanna.

Cobham married Frances on
25 February 1559/1560 and the six
children seated around the table must
all be from this marriage. They are,

from left to right: Maximilian, age two,
with a dog jumping onto his lap;
Henry, age one, on his aunt's lap;
William, age six, with a bird on his
hand; Elizabeth and Frances, age five;
and Margaret, age four, with a pet
marmoset. As an index to mortality, it
was to be the third son, Henry, who
was to succeed his father as the 11th
Lord Cobham (d. 1619). His sister
Elizabeth (d. 1597) was to marry Sir
Robert Cecil in 1589.

The Cobham family had close con-
nections with the Thynnes of Longleat:
Francis Thynne (?1545–1608), Lan-
caster Herald and the first editor of
Chaucer, had presented Lord Cobham

with his *Perfect Ambassador*. (Francis Thynne also wrote *A Treatise of the Lords Cobham* and the *Catalogue of the Lord Wardens of the Cinque Ports*.) The dedication is signed as though from Longleat, the house of his cousin, Sir John Thynne, on 8 January 1578/1579. It is therefore likely that the picture was always at Longleat, which began to be built in the year that it was painted. Francis may also have composed the Latin eulogy casting Cobham as a kind of Tudor Jacob.

This picture is one of a group of about ten apparently by the same hand, attributed to an anonymous artist known as the Master of the Countess of Warwick. It is conceivable that this painter may prove to be one of the royal Serjeant Painters, Nicholas Lizarde, who died in 1571, a suggestion that the absence of any pictures after 1569 would support. The main stylistic source, Eworth, has been transposed into a naive, almost primitive format anticipating the insular iconic art of the high Elizabethan period. By the 1560s the abandonment of the principles of Renaissance painting as exemplified by the scientific perspective practiced by Holbein is very evident. Here the chimneypiece, cartouche, column, and table are all observed individually, with divergent lines of perspective typical of the Elizabethan vision.

The earliest secular family group in England was Holbein's painting of the family of Sir Thomas More (1526–1527) but the artist of the Cobham family portrait clearly had no knowledge of this sophisticated composition. The prototypes for this composition are Netherlandish (for example, Jan Gossaert, *The Children of King Christian II of Denmark*, ?1526/1527; Hampton Court) in which the sitters are crowded behind a table. In the instance of the Cobham group the formalized icon of separately observed images arranged like a family tree has been enlivened by the children's pets and the table laid with pewter for dessert. R.S.

Literature: Cust 1913, 35; Edwards 1934, 155–156; Strong 1969, 110
Exhibitions: London, NPG 1965 (43); London, V & A 1980 (P. 9)

26

STANDING SALT c.1610
London
silver-gilt and glass
25.4 (10) high

Woburn Abbey
The Marquess of Tavistock and the Trustees of the Bedford Estates

The most important stylistic feature of this salt is the scrollwork decoration on the foot, bowl, lid, and finial, technically very skilled. The surface of the metal was first roughly matted, and then the wires, with small vine leaves, pointed half leaves, and beaded pods, were soldered to it, using a filigree technique. Although unmarked, there is no doubt that because of this feature and the use of identical fluted spool-shaped elements and vase finials of the same silhouette, the salt is by the London maker with the mark *TYZ* in monogram, who was responsible for a small group of related pieces.

The identity of the maker is not known because the books in which goldsmiths' names and marks are registered at Goldsmiths' Hall, London, survive only from 1697 onward. He may be one of the many German and Netherlandish goldsmiths in London at the time, partly because of the high quality of the work, partly because of the use of the plump little vine leaves in the scrollwork, which are characteristically German, and partly because few English surnames begin with Z. The tall standing salt was a very English form of plate, however, in use since the Middle Ages (for instance, the salt of c.1490 at New College, Oxford), and marked the place of the host at any meal.

The earliest surviving inventory of the plate belonging to the Dukes of Bedford dates from 1819; this piece cannot be identified in it or in any later inventories, so it is uncertain when it entered the collection. It is the only piece of such antiquity, apart from an Elizabethan communion cup and paten acquired by the 9th Duke in 1872. However, by 1819, in tune with the Regency liking for lavish foreign antique plate, there were already three exquisite gold pieces of c.1700 by the

Frankfurt goldsmith, Peter Boy the elder, and two seventeenth-century German equestrian statues, in the collection. It is therefore possible that this salt may have been acquired by the early nineteenth century. The glass cylinder inside the fretted C-scrolls of the stem probably replaces a rock-crystal one. A.S.C.

Related Works: A large, fully marked standing cup with the date letter for 1611–1612 (Victoria and Albert Museum); another marked standing cup from the same year given by J. Pierpont Morgan to Christ's College, Cambridge; a small unmarked scent, or spice caster (Victoria and Albert Museum); a cup with a rock crystal bowl (Tovey Church, Shropshire) and a salt whose bowl, finial, upper section of stem, and foot are almost identical to this one (formerly Sir John Noble's collection)
Literature: Grimwade 1965, 64–65
Exhibitions: London, RA 1950 (102)

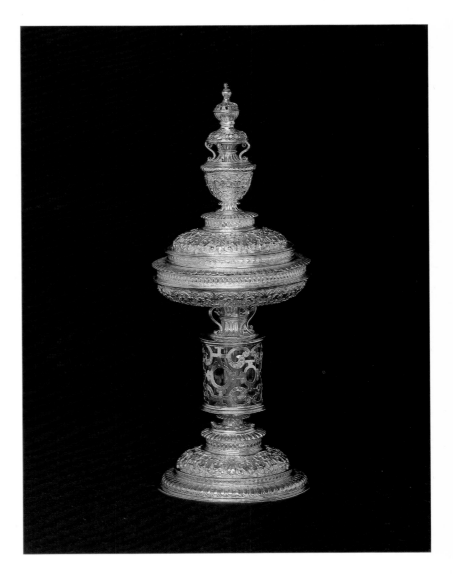

27

EWER AND BASIN 1579/1582
silver-gilt and agate
ewer: 40 (15¾) high
basin: 47.3 (18⅜) diam.
hallmark for London on both;
date letter *B* for 1579–1580
on shoulder of ewer; date letter *D* for
1581–1582 inside basin near central
boss; unidentified maker's mark on both,
three slipped trefoils within a shaped
shield

Belvoir Castle
The Duke of Rutland

This ewer is composed of four bands of
agate, and like the basin, it is gilded on
both sides. The mounts are covered in
a profusion of mannerist detail—
strapwork, swags, masks, clusters of
fruit, pecking birds, and a suspended
lobster and turtle—executed with
great clarity and crispness, and a clever
repetition and consistency of motifs.
Fish and crustacean elements dominate:
the cartouches on the shoulder are
embossed with sea centaurs fighting sea
monsters while the cast satyr handle
has a double fishtail with a naturalistic
snail on his back, and a smaller snail
riding on its back.

The matching circular basin is
decorated with twelve oval agate
plaques with convex surfaces let into
the border and well, and a circular
plaque in the center. It is embossed and
chased with the same repertory of
motifs as the ewer, the marine elements
being a turtle, lobster, sea monster, and
cuttlefish suspended by ribbons. On
both pieces the embossing is against a
finely spaced dotted ground. Originally,
the ewer was even more splendid—
for it was set with gems, indicated by
the four holes on each of the caryatid
herm figures, the shoulder, and the foot.
Both sides of the ewer and the basin are
gilt.

The grotesques, the satyr handle,
and the marine motifs are all features
that occur in Flemish goldsmiths' work
from the middle of the sixteenth century.
They parallel and perhaps originate in
the peculiar variations played on the
strapwork/grotesque theme by the
designer Cornelis Floris (1514–1575).
Marine elements such as those that
appear in this ewer and basin were
first exploited by the workshop of
the Florentine goldsmith Francesco
Salviati (1510–1563) and in the
published designs of Jacques du
Cerceau (fl. 1549–1584).

The maker of this ewer and basin
has not been identified, as the stamped
plates with the masters' marks and their
names no longer exist at Goldsmith's
Hall in London. The superior quality of
design and execution, however, make it
very probable that he was not an
Englishman. During the third quarter
of the century more and more goldsmiths
came to England from the Continent to
avoid religious persecution. Indeed,
during Queen Elizabeth's reign
(1558–1603) 150 Dutch, German, and
Flemish goldsmiths were recorded as
working in London. Because of the
ewer and basin's appearance it is very
possible that their maker was indeed a
Fleming.

Even if it were not for the fine quality
of the embossing and chasing, and of
the cast elements, the use of hardstones
puts these pieces into the top echelons
of sixteenth-century plate. Semiprecious
stone vessels were much admired around
1580, and the princely treasuries of
Europe (for example, that of the Electors
of Saxony, known as the Green Vaults,
Dresden) are full of them. In England,
however, such vessels were comparatively
rare in the sixteenth century.

This maker seems to have specialized
in mounting expensive materials. Other
works that bear his mark include the
Gibbon salt, a very handsome and
sophisticated architectural piece of
1576–1577 (his earliest dated work)
with a rock crystal body; four pieces
of Chinese porcelain, and one Siegburg
stoneware jug. The mark also appears
on a perfectly plain, very English,
covered cup of 1590–1591 with a
baluster stem, his latest dated piece.

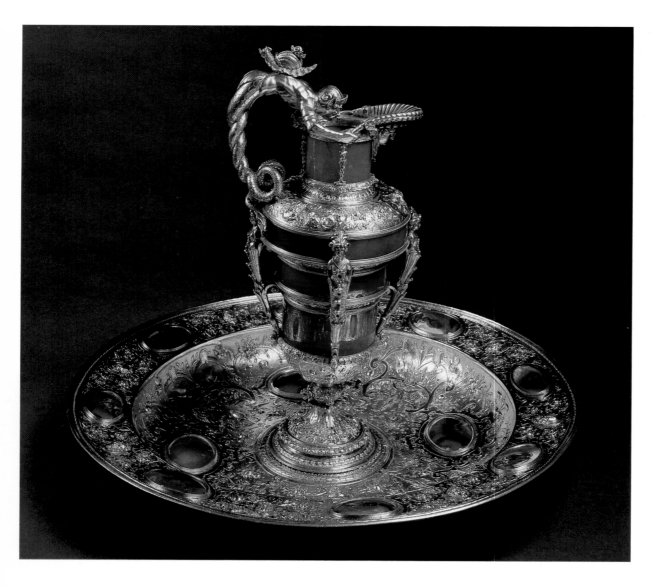

Although this ewer and basin would have functioned mainly as display plate, they would have been used for washing the hands with scented water after the meal. This was a necessary ritual as forks were still rare in the sixteenth century and were used mostly for sweetmeats.

It is uncertain when this set entered the Rutland collection, which includes no other sixteenth-century plate. The archives at Belvoir have not yet been fully explored, but I am indebted to Mrs. Stavely there for a reference dated 1841 in which the author refers to them as a "christening cup and basin." Until C.J. Jackson spotted the English hallmarks on the ewer and basin in about 1911, they were thought to be the work of the famed Florentine goldsmith and sculptor Cellini (1500–1571), to whom most elaborate, fine quality mannerist goldsmiths' work was attributed in the nineteenth century. They have always been held in high esteem by the owners, and the present duke remembers his father telling him that they were the most important works of art at Belvoir.

A.S.C.

Related Works: The Gibbon Salt, 1576–1577, Goldsmiths' Company London; a mounted Wanli pot, 1585–1586, Victoria and Albert Museum, London; a standing cup, 1585–1586, Kremlin, Moscow; a mounted Wanli bottle, c. 1580, Metropolitan Museum, New York; a mounted Wanli bowl, c. 1580, Franks Collection, British Museum, London; a covered cup, 1590–1591; Victoria and Albert Museum
Literature: Eller 1841, 330; Jackson 1911, 1:93–94; Hayward 1976, 404–405
Exhibitions: London 1862 (5746, 5742)

28

EWER AND COVER
Chinese, Ming dynasty
with english mounts dated 1589
hard-paste porcelain and silver-gilt
35.5 (14) high

Hardwick Hall
The National Trust

The pear-shaped vessel is painted in underglaze blue with lotus, peony, and lingzhi, double lozenges, lappets, floral medallions, cloud scrolls, and dots in between; the spreading foot is decorated with clouds above spreading waves, and the curved spout with flames. The silver-gilt mounts, unusually fully marked, comprise a neckmount, spout cover with chain, foliate handlemount and rim, and an inner domed section within the cover, together with a box hinge with cast thumbpiece. The inner liner, fully marked for 1589, suggests that the cover was once all of silver-gilt, and that it was replaced, perhaps in 1850, when the Tudor-style thumbpiece was added.

The earliest pieces of surviving Chinese porcelain to reach Western Europe date from the fourteenth century, but it was not until the sixteenth century that they started to arrive in any quantity, first through the Portuguese and then through the Dutch East India Company. Because of their rarity they were then sumptuously mounted in silver or silver-gilt. Bess of Hardwick (see no. 31), born in about 1520/1525, bought Hardwick from her brother in 1583 and built a new house next to the Old Hall there between about 1585 and 1590. This ewer, with its mounts dated 1589, is therefore of exactly the same date as the house. However, the only porcelain and silver object listed in the Hardwick Hall inventory of 1601 was a "purs-land Cup with a Cover trymmed with silver and guilt waying fourtene ounces," and although the contents of Chatsworth and Hardwick were constantly exchanged by the family from the earliest times, it is also possible, given its mid-nineteenth-century restoration, that this piece was purchased by the 6th Duke of Devonshire (1790–1858). The Chinese porcelain is of above average quality for

mounted pieces of the sixteenth century and probably dates from between 1560 and 1570; similar ewers of lesser quality can be found in Tehran at the Ardedil Shrine.

A.duB.

Provenance: At Hardwick from at least the time of the 6th Duke of Devonshire; and by descent; in 1959, after the death of the 10th Duke of Devonshire, the house and its contents were accepted by the Treasury in part payment of death duties and transfered to the National Trust
Literature: Boynton 1971, 35; Glanville 1984, 256

Related Works: The maker of the mounts, who cannot be identified, is recorded as having made the very fine silver-gilt mounts of 1599 on the Trenchard bowl of Jia Jing porcelain acquired by the Victoria and Albert Museum in 1983. Like the ewer, however, its earliest history is obscure. The IH marks also appear on a fine silver-mounted wooden bowl dated 1596 in the same museum, acquired in 1879

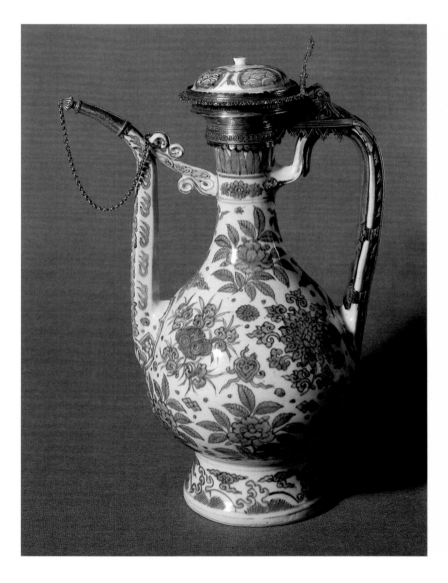

29

GOLD CROSS AND ROSARY
OF MARY QUEEN OF SCOTS 16th century
enameled gold
80 (30)

Arundel Castle
The Duke of Norfolk, KG

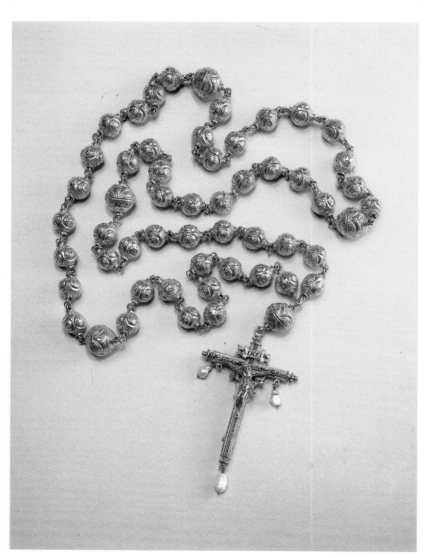

Because of its quality and pedigree, the Arundel rosary is almost certainly the one worn by Mary Queen of Scots at her girdle when she went to the executioner's scaffold at Fotheringay Castle, Northamptonshire, in 1587. She bequeathed it to Anne Dacre, who was the wife of St. Philip Howard, 13th Earl of Arundel, and both daughter-in-law and stepdaughter to the 4th Duke of Norfolk (1536–1572), as her mother, the widow of Lord Dacre, was the duke's third wife. Among other services, Anne Dacre helped Mary maintain her wardrobe during her long imprisonment, and in any case there were strong links between the queen and the Catholic Howard family; she and the 4th Duke

had planned to marry in 1570. The rosary remained in the possession of Anne Dacre's descendants, the Dukes of Norfolk, until Thomas Howard, 11th Duke (d. 1815), gave it to his cousin, Henry Howard of Corby, an antiquarian and historian who wrote the *Memorials of the Howard Family* (London 1834). Henry Howard had his wife Catherine painted wearing the rosary like a necklace, the crucifix hanging as a pendant. It was returned by his family to the 15th Duke of Norfolk, and has remained since then at Arundel, which, as the seat of the leading Roman Catholic layman in Britain, is an appropriate home for such a famous relic.

The rosary is a form of devotion traditionally ascribed to Saint Dominic (1170–1221): each of the five decades represents one of fifteen events in the life of Christ or his mother—sorrowful, joyful, and glorious—and the person praying meditates thereon while saying the Hail Mary ten times, concluding with a Gloria, and then saying an Our Father on the larger bead to commence the next decade. In the Middle Ages this aid to devotion was used so widely that the manufacture of rosaries was a thriving industry that attracted artistic skills of a high order. Methods of saying the rosary varied, as did the number and order of beads. This division into five decades subdivided by large Paternosters, however, which conforms to modern practice, is probably an early example of its type and is among the most splendid rosaries extant. D.S.

Related Works: Wooden rosary and crucifix given by Mary Queen of Scots to Sir William Herbert and now at Powis Castle (National Trust), Welshpool; also a golden rosary formerly owned by Mary Queen of Scots (Scott 1851, pl. XVIII; George Mennell collection, Newcastle)
Provenance: Bequeathed by Mary Queen of Scots to Anne Dacre, Countess of Arundel, in 1587; by descent to the 11th Duke of Norfolk (d. 1815); given to his cousin Henry Howard of Corby (descended from Anne Dacre's sister Elizabeth and her husband, Lord William Howard, half-brother of St. Philip Howard); returned to the 15th Duke of Norfolk (1847–1917) and since at Arundel Castle
Literature: Scarisbrick 1982
Exhibitions: Peterborough 1887; London 1889 (626)

30

MARY FITZALAN, DUCHESS
OF NORFOLK C. 1555
Hans Eworth fl. 1540–1573
oil on panel
88.9 × 71.2 (35 × 28)
inscribed, at right, *A⁰/AETA.SV/.16.*;
signed at bottom right, *1565/HE*

Private Collection

Hans Eworth was the most distinguished artist working in England between the death of Hans Holbein and the emergence of Gower and Hilliard at the opening of the 1570s. He came from Antwerp and the main influences on his work were Jan van Scorel and subsequently Holbein. Almost sixty pictures either bearing his monogram *HE* or generally accepted as his work have emerged. He was certainly court painter to Mary I and produced a series of distinguished portraits of her but was dropped by Elizabeth in 1558. During the last decade of his life, patronage came almost exclusively from Catholics.

The picture has been reduced very slightly to the right and the bottom of the panel. The area on the right, bearing both inscriptions, is the only one that shows signs of repainting; the rest of the panel surface is in a remarkably un-retouched state for a Tudor portrait. The inscription in the bottom right-hand corner bearing the artist's monogram and the date, both basically sound, is placed where Eworth normally adds these in other pictures, although the date 1565 is impossible. The dress is 1555 and the alteration of a 5 to a 6 in a clumsy restoration in the past is not an unusual transmutation. In 1704 the Hamilton inventory lists "A picture of the Duchess of Norfolk in Queen Elizabeth's time down to the knees" (no. 174). The combination of a Duchess of Norfolk, Hans Eworth, and the date 1555 indicate that this picture should be that listed in the inventory of John, Lord Lumley, in 1590 (see no. 346): *Mary Duchess of Northfolke, daughter to the last Earl of Arundelle (Fitzallen) doone by Haunce Eworth.* That Duchess of Norfolk was Lumley's sister-in-law, Mary Fitzalan (1540–1557). In 1555 she married Thomas Howard, 4th Duke of Norfolk (1536–1572), and it is reasonable to

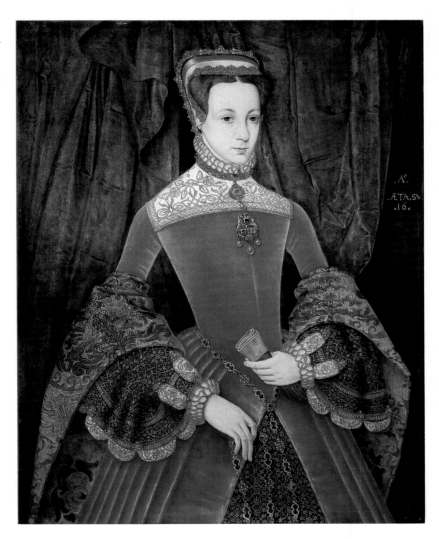

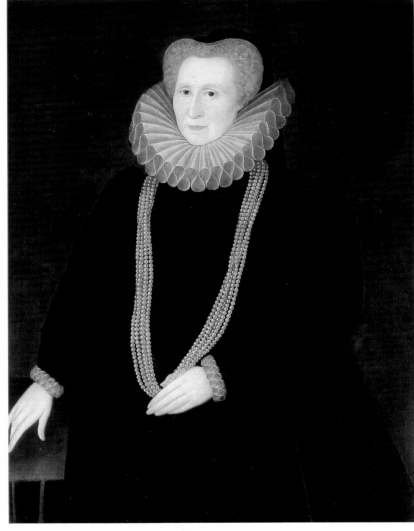

suggest that this is a marriage portrait. The second inscription on the picture gives the correct age for her in 1555 of sixteen. At the moment the lettering, due to overpainting, is cruder than that in other Eworth portraits. The duchess died in childbirth two years after marriage.

A dendrochronological examination by Dr. John Fletcher suggested that this portrait was in fact painted in 1565. All other evidence indicates that this hypothesis cannot be right. Perhaps the most telling fact is the rendering of the dress and jewelry, which is observed direct and certainly not at a remove.

The fact that this portrait turns up in the Hamilton collection in 1704, having wandered from the Lumley collection, is not surprising. There were leaks before the sales of the late eighteenth century, most notably Holbein's cartoon of Henry VIII, which had passed to the Devonshire collection by 1727. R.S.

Provenance: Possibly identical with the portrait recorded in the Lumley inventory of 1590 (*Walpole Society* 6 [1918], 26); possibly Hamilton inventory, 1704 (no. 74); recorded by Douglas Pennant as a portrait of "Mary Queen of Scots" (*Tour in Scotland, 1772* [London, 1776], 2:243); at Lennoxlove until 1984
Literature: Cust 1904, 42–43; Cust 1913, 34–35; Strong 1966, 225–226; Strong 1969, 88 (26); information communicated by Dr. John Fletcher
Exhibitions: London, NPG 1965 (5)

31

ELIZABETH HARDWICK,
COUNTESS OF SHREWSBURY
attributed to Rowland Lockey
fl. c. 1592–1616
oil on canvas
102.2 × 78 (40¼ × 30¾)

Hardwick Hall
The National Trust (Devonshire Collection)

This portrait of Elizabeth, Countess of Shrewsbury (1518–1608), popularly known as Bess of Hardwick, shows her after the death of her fourth and last husband, the 6th Earl of Shrewsbury, in 1590. She was a resolute and ambitious woman, a collector and a builder on an almost unprecedented scale, and possessed wealth affording her every indulgence. Her supreme monument is the house that she built at Hardwick, perhaps the least altered and most atmospheric of all Elizabethan "prodigy houses."

Bess was four times married, and it was her second son by her second husband, Sir William Cavendish, who succeeded to Hardwick and, after the death of his elder brother, to the Chatsworth estate, which had been bought by his father. In 1618 this son was made Earl of Devonshire, and he chose Chatsworth as the principal family seat, relegating Hardwick to the status of a secondary house. The portrait of Bess hangs in the Long Gallery, and

perhaps always did, if it is identifiable with one or other of the portraits recorded in the Gallery ("My Ladie" and "My Ladies Picture") in an inventory of the contents of Hardwick taken in 1601 (Boynton and Thornton 1971, 29). Today the visitor to this room must experience an extraordinary sense of prodigality, as did Arthur Young, on seeing the numbers of portraits displayed against the background of the famous series of Flemish tapestries that Bess had acquired from Sir Christopher Hatton. Indeed, the appearance of the room can have altered little during the course of the intervening years. The collection of pictures is characteristic of the great houses of the period in being an iconographic one: portraits of the family and of an ever more widely spreading family tree of relations, of notable personalities and royalty.

The painter of this portrait was probably Rowland Lockey (see Auerbach 1961, 254–262), an apprentice of Nicholas Hilliard. He is recorded as having worked as a miniaturist for Bess in 1592, and from 1608–1613 he was patronized by William, Lord Cavendish (later Earl of Devonshire) for whom he appears to have painted many copies of earlier pictures. Sir Roy Strong was the first to suggest the possible attribution to Lockey of a small group of portraits at Hardwick. The portraits in that group are distinguished by being painted on canvas instead of panel, and are of a rather flaccid technique. This portrait fulfills these conditions; but whether it is a copy done for Lord Cavendish after his mother's death in 1608, or one of the portraits mentioned in the 1601 inventory, must remain conjectural.

st.j.g.

Related Works: Replicas are in the National Portrait Gallery, London, and in the Portland Collection at Welbeck
Provenance: Always at Hardwick; in 1959, after the death of the 10th Duke of Devonshire, the house and its contents were accepted by the Treasury in part payment of death duties and transferred to the National Trust
Exhibitions: London, New Gallery 1890 (279); Manchester 1897 (159); Sheffield 1970

32

THE SEA-DOG TABLE c.1580
after Jacques Androuet du Cerceau I
fl.1549–1584
walnut with fruitwood and tulipwood marquetry top inset with fragments of marble
85 × 147 × 85 (33½ × 58 × 33½)

Hardwick Hall
The National Trust
(Devonshire Collection)

One of the best-documented as well as one of the most celebrated pieces of surviving Elizabethan furniture in England, the walnut "sea-dog table" is described in the Hardwick Hall inventory of 1601 as "a drawing table Carved and guilt standing uppon sea doges inlayde with marble stones and wood." It stood in the withdrawing chamber on the second (or state) floor of the house, where it remains today, and had "a carpet for it of nedleworke of the storie of David and Saule with a golde frenge and trymmed with blewe taffetie sarcenet." The word "drawing" refers to the sliding leaves that can be drawn out from under the top, and which may have been used by the Countess of Shrewsbury (better known as Bess of Hardwick; see no. 31) when showing favored guests the jewels, precious stones, and other *objets de vertu* kept in the drawers of a large cabinet that also survives in the room. Traces of gilding were found on the table during restoration at the Victoria and Albert Museum in the 1960s. The 6th Duke of Devonshire described it in the 1840s as "a wonderful old table, with sliding tops, in which the travelled curious of former days inserted, as we do now, the bits of marble they may have picked up in their Italian journeys, mounted on

chimeras, that is to say, dogs with bosoms and dolphins' tails, with garlands round their necks and ostrich feathers instead of ears."

The choice of these "sea-dogs" for the supports may be a reference to the "talbots," or dogs, which were the supporters of the arms of George Talbot, 6th Earl of Shrewsbury. Talbot was Bess of Hardwick's fourth husband; she married him in 1568 and he died in 1590. However, with the addition of wings and fishes' tails, the "sea-dogs" have been transformed into chimeras, those legendary beasts associated with the dream world who are able to fly, swim, and walk. The fact that these speedy creatures are placed on the backs of tortoises must illustrate one of those punning Latin tags so dear to the Renaissance mind: *festina lente* (make haste slowly).

The chimeras are closely based on an

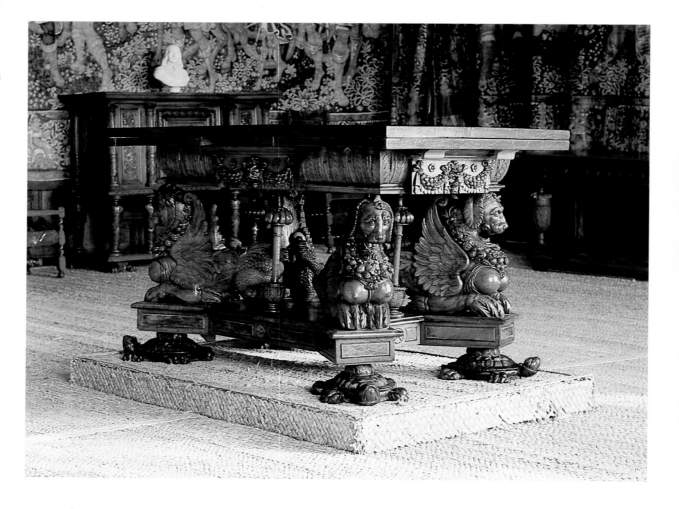

engraving by the Huguenot Jacques Androuet du Cerceau I, and the feet in the form of tortoises have been associated with another of his designs. But it cannot be said with certainty whether the table is of French or English origin. The contents of Hardwick were remarkably cosmopolitan for this early date, including Star Ushak and so-called Polonaise carpets possibly brought back from Constantinople by Bess of Hardwick's son, Henry Cavendish, in 1589; Chinese blue-and-white porcelain with English gold mounts (see no. 28); and a remarkable marquetry chest, thought to be German though inlaid with the Earl of Shrewsbury's monogram. The unrivaled collection of needlework in the house still contains examples of French embroidery (see under no. 34), and among the other contents of the Withdrawing Chamber in 1601 were "too French stooles inlayde and set with marble stones." Again, it is hard to determine whether the latter actually came from France, were merely of a French type, or were even made by French craftsmen working in England.

A drawing by the poet George Gascoigne (1525–1577), illustrating the presentation of his *Hemetes the heremyte* to Queen Elizabeth at Woodstock in 1575 (Strong 1963, 101) shows the queen sitting on a throne supported by chimeras remarkably similar in form to those of the "sea-dog table," and the suggestion has even been made that the two pieces of furniture could have been made *en suite*, and that the latter was a royal gift to the Countess of Shrewsbury (Jervis 1974, 26). G.J-S.

Provenance: At Hardwick by 1601; after Bess of Hardwick's death in 1608, inherited (with the house) by her second son William Cavendish, 1st Earl of Devonshire; and by descent to the Earls and Dukes of Devonshire until 1956, when Hardwick and its contents were accepted by H.M. Treasury in lieu of death duties, and transferred to the National Trust
Literature: Devonshire 1845, 191–193; Boynton and Thornton 1971, 10, 27; Jervis 1974, 24–26, figs. 76, 100–101; Girouard 1976, 91

33

AUTUMN FROM "THE SEASONS" c. 1611
English, Sheldon tapestry workshop
before 1570 to after 1611
wool and silk
327.6 × 406.4 (129 × 160)

Hatfield House
The Marquess of Salisbury

The four tapestries of the Seasons at
Hatfield House are based on engravings
by Marten de Vos in which Venus and
Cupid, representing Spring; Ceres,
Summer; Bacchus, Autumn; and Aeolus,
Winter, preside over the labors of the
months, with signs of the zodiac in the
sky. These signs were reversed in the
transition from engraving to tapestry,
and therefore read here from Sagittarius
to Libra, representing November to
September. The tapestry has also
transformed the plump boy-Bacchus of
the engraving into a brawny young man
and given him an entourage of wild
animals probably borrowed from a print
depicting Orpheus. Many details from
the engraving of Autumn such as the
wine press with a thatched roof and the
jagged mountains unlike anything found
in England are faithfully reproduced,
though the English workers have added
little trees outlining the mountains,
destroying their scale and the illusion
of distance. The whole perspective of
the original design has been distorted.
A stream that tops a rise as if made of
solid matter has been introduced. The
tapestry omits the traditional labor for
September, ploughing and sowing, and
instead depicts an apple harvest. At the
right, men dislodge acorns from a tree;
but their pigs have been moved to the
far left background, leaving the
November labor, feeding swine, looking
like a quarter-staff contest in front of an
oak tree.

In the border two cords entwine to
form a series of medallions each
illustrating a device, the moralizing
emblems so popular among the educated
in the sixteenth and seventeenth
centuries. A.F. Kendrick identifies
many of these devices, which have been
taken from the *Emblemata* of Alciatus,
first published in 1522, and from
Geoffrey Whitney's *Choice of Emblems*,
1586, which drew on the earlier work.
Of the twenty-nine emblems from
Whitney's book used in the four
hangings, only five are used in this
tapestry. Two in the bottom border
are, second from the left, "Post amara
dulcia" (After bitters, sweets), with a
man picking a rose; and second from
the right "Cum tempore mutamur"
(We are changed with time), showing a
baby in a cradle and a man on crutches.

The coat of arms shows the Seasons
tapestries to have been made for
Sir John Tracy of Doddington,
Gloucestershire, who married Anne,
daughter of Sir Thomas Shirley, in
1590. The date 1611, unobtrusively
woven into the tapestry of Winter,
seems to bear no relationship to
important family events. The knighthood
was conferred in 1592, and Sir John was
raised to the peerage as Viscount Tracy
of Rathcoole, County Dublin, in
1642–1643. Therefore the date
probably refers to the commencement
or end of weaving on the Sheldon looms.

William Sheldon, a country
gentleman interested in promoting
woolen manufactures, had established
tapestry workshops at Barcheston in
Warwickshire and Bordesley in
Worcestershire a few years before his
death in 1570. The workshops were
under the supervision of Richard
Hyckes (d. 1621) and his son Francis.
Both men studied classics at Oxford,
and either could have selected devices

for the borders of the Seasons tapestries.
Although Richard and Francis Hyckes
were also royal arrasworkers and may
have supplied the Crown with tapestry
as well as seeing to repairs of the Royal
Collection, most of the Sheldon tapestries
were made for local gentry like Sir John
Tracy. Doddington is some fifteen miles
from Barcheston and twenty-three miles
from Bordesley, while the pieces of
tapestry closest to the Seasons in style
and ornament are at Sudeley Castle,
Gloucestershire, about five miles from
Doddington.

The Sheldon tapestry workshops were
the first in the history of English
tapestry making to be both documented
and represented in surviving tapestries.
The Seasons tapestries are not only
unique works of art, but were the last
great set made on the Sheldon looms
before James I established a more
sophisticated manufactory at Mortlake
in 1619.

It was only in the nineteenth century
that the Seasons tapestries came to
Hatfield, after the extinction of the
Tracy peerage in 1797. They were
probably acquired by the 2nd Marquess
of Salisbury, who noted in 1866 that
they had been found in an old house in
Wiltshire. He used them to decorate
the bedroom in which Queen Victoria
slept in 1846. W.H.

Literature: Kendrick 1913; Barnard and
Wace 1928
Exhibitions: London, Lansdowne House
1929 (54, 55)

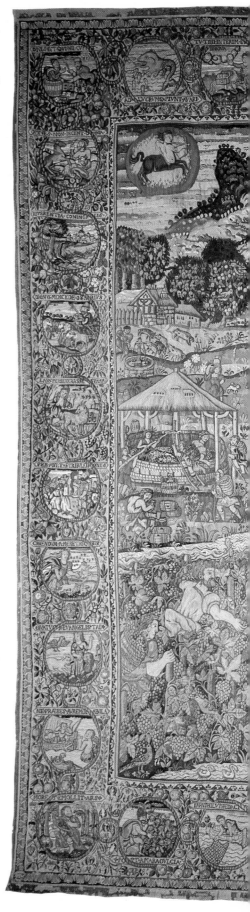

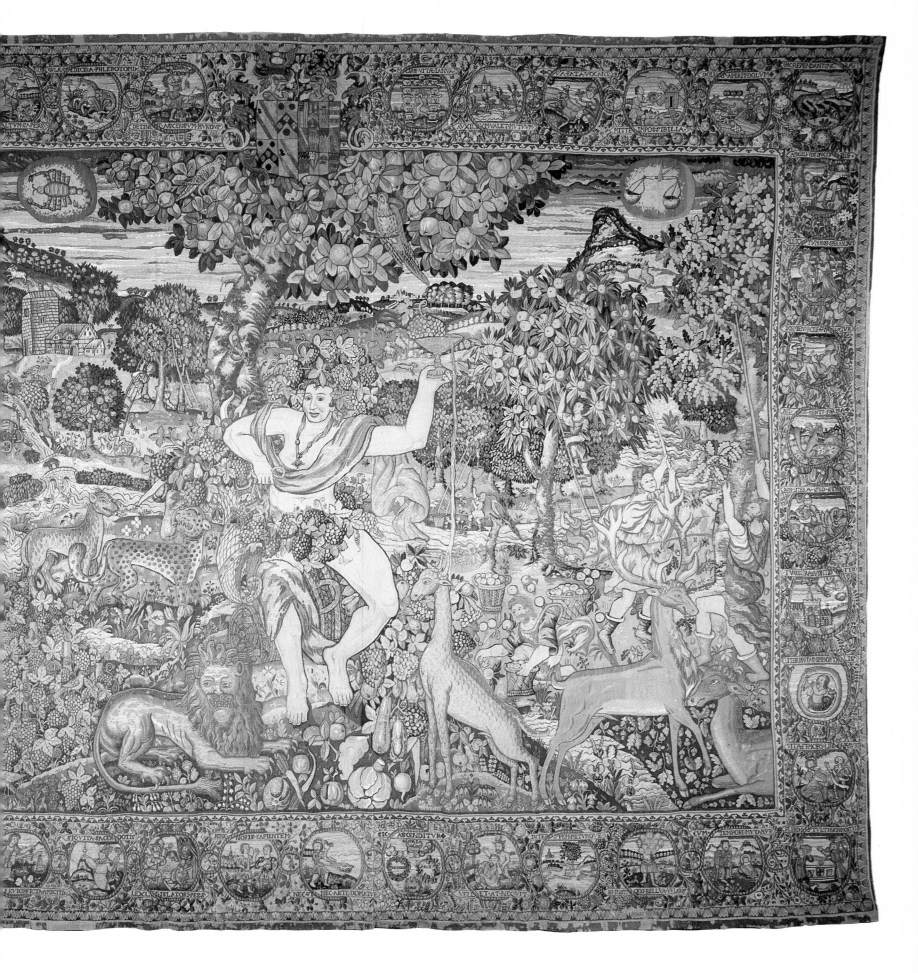

34

EMBROIDERED CUSHION COVER
late 16th century English
linen canvas with colored silks
56×117 $(22 \times 46\frac{1}{8})$

Hardwick Hall
The National Trust
(Devonshire Collection)

This cushion cover of linen canvas is embroidered with colored silks in tent and cross stitches with details in knotted stitch. In the center beneath a coronet are the arms of Talbot impaling Hardwick, supported by the Talbot dog and the Hardwick stag, commemorating the marriage in 1568 of George Talbot, 6th Earl of Shrewsbury, and Elizabeth Hardwick, better known as Bess of Hardwick (see no. 31). On either side of the shield of arms, a branching tree rises from a stylized flowery mound to fill the entire ground. The trees bear a typically Elizabethan variety of fruit

and flowers—columbine, honeysuckle, rose, marigold, pink, and cornflower, with peas and acorns. Birds perch among the branches, and in the border a scrolling stem encloses fruit and flowers.

Brightly colored textile furnishings dominated the interiors of the great houses of the sixteenth century. The tapestries, knotted carpets, and woven fabrics were produced in professional workshops but many of the embroideries were made domestically. This was certainly the case at Hardwick and Bess' other houses where she claimed, during one acrimonious exchange with her husband, that they were the work of her grooms and women with the assistance of only a single professional embroiderer. The latter would have been responsible (almost certainly with other professional assistance) for the great pictorial hangings worked with an appliqué of rich materials, for other appliqué pieces employing fabrics difficult to handle like the "long quition [cushion] of

Crimson velvett, a frett of cloth of silver with slips of nedlework in it," which was in the long gallery in 1601 and is still in the house (Boynton and Thornton 1971, 28); and for large and elaborate pieces like the embroidered bed hangings and covers. The embroiderer would also have had the job of mounting on velvet or other fabric grounds the innumerable canvas-work flowers (called slips) worked by members of the household. Hundreds of these little motifs still decorate hangings, chairs, and cushion covers in Hardwick Hall while many more, worn and reused many times, are in storage.

Standards of amateur embroidery were high in the sixteenth century and Bess and her household also tackled larger canvas-work pieces, notably cushion covers like the one shown here. Although, unlike several others surviving at Hardwick, this one cannot be identified with certainty in the 1601 inventory of the house, it may well be

one of the "too nedleworke quitions [cushions] for the windowes, whereof one with my Lord and my Ladies Armes wrought in it and lyned with Crimson sattin," which were in the best bed chamber in 1601 (Boynton and Thornton 1971, 26). The other cushion, "of Europa wrought with silke golde and silver," is more easily identifiable and it is decorated with Bess' initials oddly placed within the pictorial design, suggesting that they are the signature of the embroideress. s.l.

Provenance: Although the cushion cover has been at Hardwick since 1601, it was probably made during the 1570s or 1580s for one of Bess' other houses. Two of the related canvas-work table carpets at Hardwick are dated 1574 and 1579, a period during which Bess was still living at Chatsworth in relative peace with her husband. Accepted by H.M. Treasury in part payment of death duties on the death of the 10th Duke of Devonshire in 1959.
Literature: Nevinson 1973, 1756–1761
Exhibitions: Birmingham 1936 (985)

35

THE PALMER NEEDLEWORK c.1625
English
satin with applied canvas embroidered
with silk, silver, silver-gilt thread and
cord, and metal purl
77.5×70.5 ($30\frac{3}{8} \times 27\frac{3}{4}$)

Dorney Court
Peregrine Palmer, Esq.

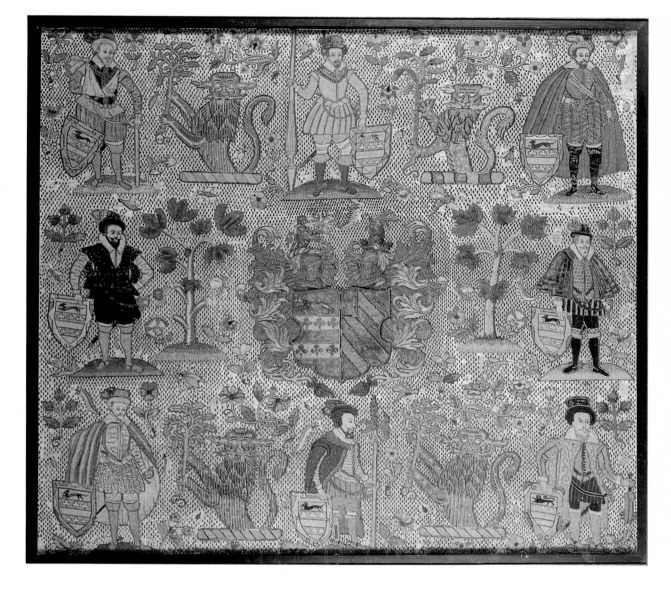

This embroidered panel with the arms of
Palmer impaling Shirley commemorates
the marriage in 1624 of Sir Thomas
Palmer of Wingham, Kent, and Elizabeth
Shirley (or Shurley) of Isfield, Sussex.
Arranged round the shield are eight
male figures, each holding a shield
emblazoned with the Palmer arms, and
between the figures are four versions of
the Palmer crest: a demi-panther rampant
issuing flames from its mouth and ears,
holding in its paws a holly branch with
leaves and berries. The remaining ground
is decorated with two stylized trees,
flowering slips, and insects.

The main motifs are embroidered on
fine linen canvas and were cut out and
applied to the cream satin ground. The
shield of arms, with its crests and
mantling, is elaborately worked with
silver and silver-gilt thread and cord
and with colored silks in laid and
couched work, partly over padding.
The other motifs are embroidered in
tent stitch, long and short stitches, and
satin and detached buttonhole stitches,
with looped pile and laid and couched
work. The ground is *semé* with silver
purl. Although the skillfully worked
shield of arms suggests a professional
hand, the other motifs and the makeup
of the panel would have been within
the reach of a skilled amateur and it is
likely that the panel was produced
within the Palmer household, possibly
with some professional help.

In its subject matter the panel
expresses one of the dominant interests
of the period: a delight in ancestry,
particularly as expressed in heraldry
and in elaborate genealogical tables.
(For a further example from the Palmer
family, an illuminated pedigree of 1672,
see no. 347.) Shields of arms appear on
many domestic embroideries of the
sixteenth and seventeenth centuries,
(see no. 34) but the Palmer embroidery
is unique in also depicting members of
the family. Although the eight figures
are all dressed in clothes of about 1590
to 1615, they probably represent five or
more generations. Sir Thomas Palmer
(1598–1656), whose marriage shield

forms the central feature, may be among
those depicted. His father, another Sir
Thomas who had died in 1608, and his
grandfather (also Sir Thomas), who
had been made a baronet in 1621 and
who died in 1625, are also probably
included. This Sir Thomas was the
youngest son of Sir Henry Palmer of
Wingham, who had fought in the wars
against France and was twice wounded
in the arm, commemorated by the sling
worn by the figure in the upper left-
hand corner. Sir Henry was one of a set
of triplets born on successive Sundays
in June 1489 and it is possible that two
other figures relate to this remarkable
birth. However, the only other figure
that can be identified with any certainty
is that in the bottom right-hand corner.
Here the Palmer greyhound on the
shield has been replaced by a lion, a
difference granted to Sir Henry's uncle,

Sir Thomas Palmer, who was knighted
by Henry VIII at the Field of the Cloth
of Gold in 1520.

The panel has not remained in the
Palmer family throughout its history
but passed to that of the Earls of
Winchilsea, probably as a result of the
marriage in 1738 between a daughter of
the then Sir Thomas and the 8th Earl.
It remained in the Winchilsea family
until about 1900 when it was purchased
by Lord Northcliffe, but following its
publication in *Country Life* he was
approached by the grandmother of the
present owner and, as a result,
generously returned it to the Palmer
family in 1910. S.L.

Literature: Barron 1802, 807;
Hussey 1924, 176–183
Exhibitions: London, Park Lane 1928 (429)

36

HENRY WRIOTHESLEY, 3RD EARL OF
SOUTHAMPTON 1603
attributed to John de Critz 1555–1641
oil on canvas
104.4 × 87 (41 × 34½)
inscribed, *IN VINCVLIS/INVICTVS./
FEBRVA: 1600: 601: 602: 603: APRI.*

Boughton House
The Duke of Buccleuch and
Queensberry, KT

Henry Wriothesley, 3rd Earl of
Southampton (1573–1624), is best
known as a patron of poets and
dramatists and as a supporter of
colonial endeavor. Thomas Nash
describes him as a "dear lover and
cherisher . . . as well of the lovers of
poets as of the poets themselves." He
was also apparently interested in
painting as Henry Peacham lists him
among those who collected pictures in
his *Graphice* (1612). The others, apart
from Henry, Prince of Wales, were the
Earls of Arundel, Worcester, Pembroke,
Suffolk, Northampton, and Salisbury as
"the principall patrons of this art."

Nothing is known of Southampton's
collection but he certainly sat for his
portrait many times. In 1594 he sat for
Nicholas Hilliard (Fitzwilliam Museum,
Cambridge) and in 1618 (?) he was one
of the earliest patrons of the Dutch
artist Daniel Mytens (Earl Spencer,
Althorp). Southampton was a leading
figure in all court festivals, appearing
regularly at the Accession Days Tilts
from 1591 onward, and, in the new
reign, became a member of the avant
garde circle of Henry, Prince of Wales,
being a challenger in the *Barriers* (1610)
and a masquer in *Oberon* (1611). Both
spectacles were designed by Inigo
Jones.

The portrait commemorates
Southampton's imprisonment in the
Tower of London from 8 February
1600/1601 to April 1603, when he was
pardoned and released by James I. The
inset of the Tower at the upper right
and the motto, "Unconquered though
in chains," commemorates this. A
second version of the portrait without
the view exists at Welbeck Abbey and
it has recently been claimed that this is
the prime version (Nottingham 1981)
although no direct comparison between
the two versions has yet been achieved.
The two versions have good provenances
via the sitters' granddaughters, both
called Elizabeth. One of them married
the owner of Boughton, Ralph, 1st
Duke of Montagu, and the other
married the 1st Earl of Gainsborough
whose granddaughter, another
Elizabeth, married Henry Bentinck, 1st
Duke of Portland, owner of Welbeck.

The picture is therefore a typical
instance of the problems that can arise
with early portraits in terms of versions
and copies. The attribution to John de
Critz, Serjeant Painter to James I, is
purely tentative. Unlike his contem-
poraries Peake and Gheeraerts there
are few works that can be remotely
connected to him with any degree of
certainty. One of them is the well-
known portrait type of Robert Cecil,
Earl of Salisbury, of which many
versions exist, the earliest bearing the
date 1599 (one dated 1602 is in the
National Portrait Gallery, London).
These are close in composition to the
Southampton portrait with the same
placing of a three-quarter-length figure
and the same formalized hand emerging
from a cloak draped around the body
like a toga. The portrait can be very
closely dated between the time of the
Earl's release from the Tower in April
1603 and his creation as Knight of the
Garter on 25 June. It was obligatory to
wear the Order at all times (except
rarely in a fancy dress context) and
its absence corroborates that the
commission must have been executed
during May and June 1603.

Southampton was famous for
wearing his hair very long. In an
unseemly brawl at court in 1598 a
certain Ambrose Willoughby "pulled
off some of the earl's locks," an action
that met with the queen's approval. He
had it cut short about 1605. R.S.

Provenance: Descended from the sitter to
Elizabeth Wriothesley, one of the three
daughters and coheiresses of Thomas
Wriothesley, 4th Earl of Southampton
(1608–1667), whose second husband
was Ralph Montagu, Earl and later 1st
Duke of Montagu; in 1767 Henry, 3rd
Duke of Buccleuch and 5th Duke of
Queensberry, married Elizabeth,
daughter and eventual heiress of
George, Duke of Montagu
Literature: Goulding 1920, 28; Strong
1964, 298; Strong 1969, 261, no. 242;
Strong 1969, 1: 298–300;
Exhibitions: Stratford-upon-Avon 1964
(19); London, Tate 1969 (173);
Nottingham 1981 (8)

37

SIR CHARLES SOMERSET
manner of George Gower d. 1596
oil on panel
96 × 68.5 (37½ × 27)

Badminton House
The Duke of Beaufort

The sitter is likely to be Sir Charles Somerset (d. 1587), sometime Standard Bearer to the Band of Gentlemen Pensioners. Sir Charles was the third son of Henry, 2nd Earl of Worcester (d. 1549), and hence the arms on the tree to the left are differenced by a mullet, the mark of a third son. The picture is undated, but the ruff is identical in form to those in a number of portraits by George Gower from the early 1570s (see Strong 1969, 169, dated 1573; 171, and also dated 1573).

This picture was considerably overpainted in the background at one time and its appearance before cleaning is recorded in Strong 1969 (63, fig. 51). As a portrait it is typical of the large number of surviving early Elizabethan paintings that remain unattributable, often on grounds of condition. It is conceivable that it is an early work by George Gower (d. 1596), who was established in London as a fashionable portraitist at the opening of the 1570s and became Serjeant Painter to the queen. The placing of the figure and the turn of the head and the eyes toward the spectator are all ingredients of his work. The landscape background, which must record a specific event in the sitter's military career, is unusual and suggests knowledge of Hans Eworth's *Thomas Wyndham* (dated 1550; private collection, UK; ill. Strong 1969, 85), which also has a tree in the background and a view of military maneuvers. But in contrast to Eworth's Flemish naturalism the portrait of Sir Charles has all the iconic ingredients typical of Elizabethan portraiture: the tree has become a symbolic tree of chivalry bearing the sitter's arms, and the landscape is schematic and symbolic, with no logical relationship in terms of actual space to the sitter. The elaborate armor and baton of command emphasize rank and status.

The remarkably splendid armor is French and relates to a series of halfsuits made for François II, Charles IX, and Henri III. In 1572 the sitter's brother William, 3rd Earl of Worcester, headed an embassy to the French court in February 1573 to act as proxy for Queen Elizabeth at the christening of the daughter of Charles IX. It is conceivable that his brother went with him and that the armor was acquired then as a royal gift. R.S.

Provenance: By direct descent to the present owners
Literature: Mann 1933, 414–417

38

GEORGE NEVILLE, 3RD LORD
ABERGAVENNY c.1535
Hans Holbein the younger 1497–1543
vellum mounted on playing card
4.9 (1⅞) diam.

Bowhill
The Duke of Buccleuch and
Queensberry, KT

Although this miniature is certainly by
Holbein, it cannot be definitely
established whether it was painted
during the sitter's lifetime or shortly
after. Holbein learned the technique of
miniature painting or limning from
Lucas Hornebolte (see no. 39) during
his second visit to England. In doing so,
however, he departed from Hornebolte's
practice, which was to work from life,
as Nicholas Hilliard was to do later.

Holbein worked up his miniatures in
the same way as his oil paintings, away
from the sitter—in his studio, where
he made use of drawings made from life
possibly with the aid of some optical
device. In the case of Lord Abergavenny
(1485–1535) the preliminary drawing
survives (Earl of Pembroke, Wilton
House) and must have been made some
time before the sitter's death, which is
thought to have been in June 1536, when
he made his will. Holbein's relatively
unsophisticated approach to the
composition as compared to his later
miniatures would suggest that, if not
made while Abergavenny was still
alive, it must have been executed very
shortly after his death.

Lord Abergavenny (d.1535) was
aged at least sixteen in 1485 when his
mother died and could have been almost
seventy or even over seventy when
Holbein drew him. He served in the
wars against France, was Constable of
Dover Castle and Lord Warden of
Cinque Ports, created Knight of the
Garter by Henry VIII, and granted the
vast estates of William, Lord Aber-
gavenny (d. 1392) in 1512.

This miniature is in good condition,
apart from minor paint losses and
discoloration and scuffing in the back-
ground. The inscription is a later
addition by Nicholas Hilliard and is
typical of his calligraphy. R.S.

Provenance: Presumably by descent from
the sitter to Mary Neville, Henry,
Lord Abergavenny's only daughter and
heiress who in 1574 married Thomas
Fane; their son, Francis, became the
1st Earl of Westmorland; and by
descent; Apethorpe sale, Christie's,
2 June 1892, lot 19; the 6th Duke of
Buccleuch, and since at Bowhill
Literature: Chamberlain 1913, 2:222;
Winter 1943, 266; Ganz 1950, 258,
no. 132; Strong 1983, 46, no. 2
Exhibitions: London, BFAC 1909
(Case C 22); London, RA 1950 (184);
London, V & A 1983 (25)

39

CATHERINE OF ARAGON c.1525–1526
Lucas Hornebolte c.1490/1494–1544
vellum mounted on card
5.4 × 4.8 (2⅛ × 1⅞)

Bowhill
The Duke of Buccleuch and
Queensberry, KT

This is the largest and most important
miniature of Catherine of Aragon
(1485–1536), Henry VIII's first queen,
and was certainly painted from life.
Two of the three others known, which
are all circular, are repetitions with
variations in the dress (Buccleuch
collection and the E. Grosvenor Paine
collection). The third (National Portrait
Gallery, London) may be a repetition,
though the dress is totally different,
and it carries an inscription presupposing
it to be a pendant to a miniature of the
king. Some works in the series of
Henry VIII bear his age and are dated
1525–1526. One of these is also
rectangular (Fitzwilliam Museum,
Cambridge), but its composition is too
different to make it a likely companion
to the present portrait. This miniature
is one of over twenty that can now be
attributed to Lucas Hornebolte, who
entered the king's service in 1525. All
those of identifiable sitters portray
members of the royal family, indicating
that at the outset the portrait miniature
was seen as a precious royal prerogative.

The Tudor art of limning or minia-
ture painting developed out of late
medieval manuscript illumination of
the Ghent–Bruges School, of which the
Hornebolte family was one of the two
foremost exponents. The techniques of
the two disciplines are identical. The
features are modeled by means of
hatching in red and gray lines over a
basic strong pink flesh color known as
the "carnation." The kinship with the
art of manuscript illumination is
particularly noticeable in the gold
highlights and the jewels indicated in
powdered gold applied over an ochre
ground. Hornebolte's miniatures all
place the sitter against a plain back-
ground of pale blue and all are
encompassed by a gold line. In this way
he established the conventions of the
Tudor portrait miniature as they were
to be inherited by Nicholas Hilliard.

This miniature is unique in his work
as it includes the sitter's hands. The
portrait formula is derived from that
evolved by Jan Gossaert, known as
Mabuse, who worked for Margaret of
Austria, Regent of the Netherlands,
among other patrons. Lucas' father,
Gerard Hornebolte, who came with
him to England, had been her court
painter. R.S.

Provenance: Conceivably the miniature
in the collection of Queen Caroline at
Kensington Palace (Vertue 1743, 22,
no. 147, 81); "Katherine of Aragon,
Queen of Spain, in a square"; first
recorded in the Buccleuch collection in
1866 with no previous history
Literature: Archaeologia 1866, 73–74;
Strong 1969, 1:40; Murdoch, Murrell,
Noon, and Strong 1982, 32–33; Strong
1983, 36, 189, no. 5
Exhibitions: London, SKM 1862 (2026?);
London, RA 1879 (F 21); London,
BFAC 1909 (Case C 15); London,
V & A 1983 (6)

40

ROBERT DUDLEY, EARL OF LEICESTER
c. 1570–1575
Nicholas Hilliard c. 1547–1619
vellum mounted on playing card
4 ($1\frac{5}{8}$) diam.

The Manor House
Stanton Harcourt
The Hon. Mrs. Gascoigne

This is the first time that this important miniature has been exhibited since 1865. Robert Dudley, Earl of Leicester (1532?–1588) and Elizabeth I's favorite, was a major patron of the arts, though more is known about his interest in literature than in the visual arts. From the mid-1560s he was building on a massive scale at Kenilworth Castle, Wanstead, and Leicester House. At Kenilworth he laid out a major, early garden complex and in 1575 he entertained the queen on a huge scale, staging a series of entertainments on the lines of the *magnificences* of the Valois court. He also appears to have been interested in paintings, having a large collection of pictures, chiefly portraits, and to have been instrumental in bringing Federigo Zuccaro over to England in 1575. Next to the queen he sat for his portrait more often than any other Elizabethan.

From the beginning of Hilliard's career in 1571, Leicester was a major supporter of the artist. In that year Hilliard prepared for him a "booke of portraitures" and probably also made two rings bearing his crest of a ragged staff. The link was close, for many of Nicholas' children were named after members of Leicester's family. All three surviving miniatures of Leicester certainly by Hilliard were painted before the artist went to France in 1576. One is dated 1576 (National Portrait Gallery, London) and a second is a pendant to one of the queen in a dress of about 1575. The Stanton Harcourt miniature is the earliest of the three and by far the most important, probably painted about 1573 or 1574. It is unique in Hilliard's oeuvre in that it has a background of a silver damask curtain. This has now oxidized so that some of the original effect of its shimmering quality as it caught the light has been lost. A Hilliard miniature of a man, in the Fitzwilliam Museum, Cambridge, dated 1574, has a green background. At about this time, then, the artist was still experimenting with backgrounds; only after he returned from France in 1578/1579 did blue become his fixed background until the 1590s. The portrait depicts the earl at about the age of forty wearing a bonnet with a gold hatband and pink and green feathers. His black doublet is heightened with gold, and there is a gold chain from which would have hung the Lesser George of the Order of the Garter. There is no doubt that this miniature, with its freshness and sense of observation and spontaneity, must have been painted *ad vivum*, as was Hilliard's normal practice. It is also in remarkably good and unfaded condition. R.S.

Provenance: A note in the hand of George Simon, 2nd Earl Harcourt (1736–1809), on the frame records that this and three other Elizabethan miniatures now at Stanton Harcourt originally came from Penshurst Place and were given to him "by the Hon. Mrs. Anson, to whom they were bequeathed by her aunt, the Hon. Lady Yonge." Penshurst was the seat of Robert Dudley's nephew, Robert Sidney, 1st Earl of Leicester of the second creation (see no. 14)
Literature: Strong 1984, 74
Exhibitions: London, SKM 1865 (1714)

41

UNKNOWN MAN c. 1610
Isaac Oliver d. 1617
vellum mounted on card
5.2 × 4.4 ($2\frac{1}{8} \times 1\frac{3}{4}$)

Ham House
The Trustees of the Victoria and
Albert Museum

This is a surprisingly little-known miniature by Oliver, considering that it has been in public ownership since 1948. It shows the artist at his most brilliant, depicting a young man burning in the flames of passion, "Alget qui non ardet" (he becomes cold who does not burn). The miniature was a standard vehicle in the etiquette of neo-Platonic courtly love for purveying an image for contemplation by the loved one. The consuming fires recur in Renaissance emblem literature. Vaenius' *Amorum Emblemata* (1608), for example, includes more than one emblem on the theme, including a salamander in the flames:

> Unhu'rt amidds the fyer the
> Salamander lives
> The lover in the fyer of love delight
> doth take
> Where lover thereby to live this
> nouriture
> What others doth destroy lyf to the
> lovers gives.

About a decade before Oliver had used the same formula, doubtless at the sitter's request, for another young man (Victoria and Albert Museum, London, P. 5–1917).

The sitter in the miniature has his hair cut short in the latest fashion and wears a cloak around his shoulders arranged in the antique manner. This is a very early instance of the adoption of classical costume in portraiture. This painting is contemporaneous with a series from the same period that includes a portrait of Prince Henry by Oliver of c. 1610–1611 (National Portrait Gallery, London), two portraits by Gheeraerts (Strong 1969, 300, nos. 306–307), and two by Larkin (Strong 1969, 315, nos. 325–326).

The miniature was probably among the "fifty-seven pictures" hung on the walls of the little Green Closet at Ham House in 1677 (Thornton and Tomlin 1980, 129), and could be that described as "My Lord of Essex of Isaac Oliver" in an inventory of two years later (no. 114). Parallels for the hanging of miniatures and small cabinet pictures in a room of this size can be found in other seventeenth-century, and earlier, country houses. R.S.

Provenance: Probably at Ham House by 1677 in the time of the Duke and Duchess of Lauderdale (though first certainly recorded in an inventory of 1911); by descent through Lionel Tollemache, 3rd Earl of Dysart, the duchess' son by her first marriage; given with Ham and its contents to the National Trust and the Victoria and Albert Museum after the death of the 9th Earl in 1935
Literature: Finsten 1981, 2: 71–73, no. 46; Murdoch, Murrell, Noon, and Strong 1981, 72
Exhibitions: London, V & A 1983 (171)

42

EDWARD HERBERT, 1ST BARON
HERBERT OF CHERBURY 1610–1614
Isaac Oliver d. 1617
vellum mounted on card
23 × 18 (9 × 7⅛)

Powis Castle
The Powis Trustees

Edward Herbert, 1st Baron Herbert of Cherbury (1583–1648), was a philosopher, historian, and diplomat, an accomplished fencer, musician, and horseman, and the author of a celebrated autobiography. From the latter we can date the miniature fairly closely, for the sitter was in England between 1610 and 1614, a period that matches his costume in this portrait exactly. It is odd that Herbert never refers to this very expensive miniature in his autobiography, which is rich in references to other portraits of himself that he commissioned. These begin with one still at Powis, attributable to Robert Peake, depicting him in his robes as a Knight of the Bath (Strong 1969, 245, no. 220). About 1610 he commissioned an equestrian portrait of himself, possibly inspired by the one of Prince Henry (see no. 56),

and in 1609–1610 he records sitting for William Larkin for the portrait now at Charlecote (Strong 1969, 315, no. 325), copies of which, he writes, were procured by the Earl of Dorset, another patron of both Oliver and Larkin, and for "a greater person," apparently the queen, Anne of Denmark. His portrait was also borrowed from Larkin by a Lady Ayres who got Oliver to paint a miniature copy of it; Herbert describes surprising her in bed contemplating it by candlelight.

This large cabinet miniature should be seen as the counterpoint to the *Three Brothers Browne* (no. 43). The style is that of Oliver painting in the manner of Hilliard, with brilliant color and broad brushstrokes. This reactionary style would have been chosen in response to the tastes of the sitter, whose known

patronage was of artists within the native tradition (Robert Peake and Larkin). The source of the composition may be more sophisticated, however, as it bears a strong resemblance to Giulio Campagnola's engraving of the river god type of Cronus. The pose can also be linked to a whole sequence of Elizabethan and Jacobean gentlemen posed in attitudes of melancholy, of which Hilliard's miniature of Henry Percy, 9th Earl of Northumberland (Rijksmuseum, Amsterdam), is the most direct prototype (c. 1590–1595). Melancholy man seeks the shade of the greenwood tree and lingers by a trickling brook, which is precisely how we see Lord Herbert. Here he is celebrated both as philosopher and knight, as exponent of both the active and the contemplative life. His shield bears a mark that seems to depict a heart rising from flames, or possibly wings, with smoke and golden sparks ascending heavenward and the motto, "Magica Sympathia." A device close to this appeared a few years later in George Wither's *Emblemes* (1635), showing a winged heart hovering above an open book upon which divine rays descend. The heart symbolizes "the Reasonable-soule" aspiring "to clime/ To *Mysteries*, and *Knowledge*, more sublime," and some such platonic ascent is intended by the device on Lord Herbert's shield. R.S.

Provenance: By descent; on the death of the 4th Lord Herbert in 1691 the miniature passed to his sister and co-heir, Florentia, wife of Richard Herbert of Oakly Park, Montgomery; their grandson became the 1st Earl of Powis
Literature: Pope-Hennessy 1949, pl. XXX; Auerbach 1961, 251, 331, no. 259; Strong 1964, 264–269; Cummings 1968, 659–666; Strong 1969, 35; Finsten 1981, 2: 91–93, no. 57; Murdoch, Murrell, Noon, and Strong 1981, 72; Strong 1983, 184–85
Exhibitions: London, SKM 1862 (2572); London, V & A 1947; London, RA 1956–1957 (600); The Hague 1958 (58); London, Tate 1969 (142); London, V & A 1983 (273)

43

THE THREE BROTHERS BROWNE
AND THEIR SERVANT 1598
Isaac Oliver d.1617
vellum mounted on card
24 × 26 (9 × 10)
inscribed at top left, *Ano Dom.1598;*
below left, to right, the ages of the
sitters, *AEtatis.21., AEtatis.24.,
AEtatis.18., Aetatis.21* (the age of the
sitter on the right); at top center,
the motto, *FIGVRAE CONFORMIS
AFFECTVS;* on a pilaster signed in
monogram, *IO*

The Burghley House Collection

This miniature depicts the three grandsons of Anthony Browne, 1st Viscount Montague (c.1528–1592), whose heir, Anthony, died five months before his father on 29 June 1592. By his wife, Mary, daughter of Sir William Dormer, he had the three sons depicted here. Anthony Maria (1574–1629) succeeded as second Viscount; John (left) married Anne Gifford and was the father of Stanislaus from whom the 9th and last Viscount Montague was descended, and William (1576–1637) (at right) became a Jesuit lay brother at the College of Saint Omer in 1613.

The Montagues were loyal Catholics who never lost the favor of the queen. The first viscount was one of the commissioners for the trial of Mary Queen of Scots and took an active part in repelling the Spanish Armada. For six days in 1591 he received the queen at Cowdray in Sussex with entertainments stressing the loyalty of both his family and the county to the crown. His grandson continued the tradition but was detained in the Fleet Prison for his vigorous speech against the new fines on Roman Catholics in 1604. He was imprisoned again, for a short time, in 1605, in the Tower of London, for suspected complicity in the Gunpowder Plot. The 2nd Viscount never occupied the public positions that his grandfather held. Cowdray was one of the leading centers of Catholicism in late Elizabethan and Jacobean England.

The miniature is Oliver's masterpiece. In 1596 the miniaturist was in Venice and, on his return to England, came into fashion, attracting a major patron in the 2nd Earl of Essex, who abandoned Hilliard. Although Oliver had been taught how to paint miniatures by Hilliard his composition and allusions were always international rather than insular. The group of brothers with arms intertwined owes something to the long tradition of depicting the Three Graces who were symbols of concord and unity (just as the motto tells us the brothers are) but may reflect more directly Du Val's engraving of the three Coligny brothers (1579). The correct perspective of the floorboards in the room is an advance on Hilliard. Oliver may have been aware of Hans Eworth's groups of Henry, Lord Darnley, and his brother

from the 1560s (both in the Royal Collection), which place the figures within a room in a very similar way. Although the figure on the right has been referred to as a servant there is no evidence for this; he is hatless, but dressed as a gentleman, and is conceivably a member of the Montague household. His arrival obviously has a symbolic significance now forgotten, relating to the fate of the Browne brothers in the year 1598.

This is one of Oliver's most subtle compositions, an essay in the handling of gray through brown into black with touches of silver (which have since blackened). The detail throughout is meticulous compared, for example, with the later miniature of Lord Herbert (no. 42, which is painted in an archaic manner recalling Hilliard). The soft *'sfumato* rendering of the faces of the young men with their dreamy looks reflects Oliver's recent visit to North Italy and his interest in Leonardo da Vinci. For the Browne family Oliver has produced a work that makes few concessions to the iconic court art of late Elizabethan England and heralds the artistic changes to come in the new century. R.S.

Provenance: By descent in the Browne family of Cowdray, Sussex; first recorded at Cowdray, c.1730 (Vertue 1930–1955; 2: 82); by the marriage of Isabella, daughter of William Stephen Poyntz of Cowdray House, in 1825, to Brownlow, 2nd Marquess of Exeter, recorded at Burghley several times (Charlton 1847, 81; Wornum ed. 1849, 1: 179; Roundell 1884, 46–47); and by descent
Literature: Foskett 1972, 1: 428, and Foskett 1979, 60; Finsten 1981, 2: 59–62, no.35; Strong 1984, 168–169, 205, no.217
Exhibitions: London, V & A 1983 (272)

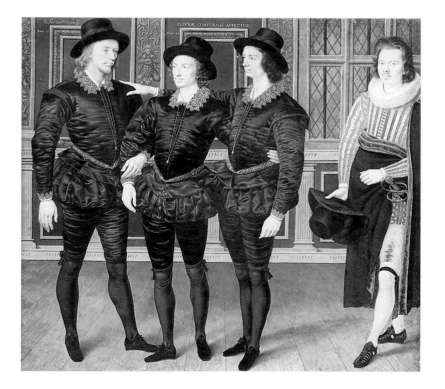

44

UNKNOWN LADY c. 1590–1593
Nicholas Hilliard c. 1547–1619
vellum mounted on playing card
5.7 × 4.6 (2¼ × 1¾)

Bowhill
The Duke of Buccleuch and
Queensberry, KT

An exceptionally fine miniature by
Hilliard, in excellent condition apart
from a little restoration at the edges
and the silver highlights, which have
oxidized black; this portrait can be
dated by the dress to just after 1590,
but preceding 1593. In that year
Hilliard, faced by the competition of
his pupil, Isaac Oliver, copied Oliver's
way of delineating hair by carefully
drawn fine lines, abandoning his own
previous technique of vigorous brush-
strokes over a ground color. The
present miniature must have been one
of the last Hilliard painted making use
of his earlier manner.

Judging from the dress and the
splendor of her jewelry, the sitter is of
high rank although unidentifiable, as
indeed most of his sitters are from this
period. The details of naturalistic still-
life are characteristic: a spray of honey-
suckle tucked into her hair, a thistle
secured to the bodice of the dress, and
a rosebud pinned to her ruff. It is
conceivable that these had some
symbolic significance for the receiver of
the portrait. R.S.

Provenance: Presumably part of the
collection formed by Walter Francis,
5th Duke of Buccleuch and Queens-
berry (1806–1884); and by descent
Literature: Kennedy 1917, pl. V;
Auerbach 1961, 140, 309, no. 125
Exhibitions: London, SKM 1862 (2037);
London, BFAC 1909 (Case C); London,
V & A 1947 (68); London, V & A 1983
(94)

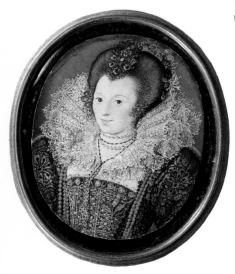

45

UNKNOWN LADY c. 1600
Nicholas Hilliard c. 1547–1619
vellum mounted on card
7.7 × 6.0 (3 × 2⅜)

Bowhill
The Duke of Buccleuch and
Queensberry, KT

This is the only miniature certainly by
Hilliard of which a second version
attributable to his pupil, Rowland
Lockey, exists (with only minor
variations; Nationalmuseum,
Stockholm). The size of the miniature
suggests that the sitter is clearly of the
highest rank, as her jewelry and dress
are only surpassed in elaboration by
those of the queen herself. Indeed the
gesture of the hand across the bodice is
repeated in a miniature of Elizabeth I of
the same date (Victoria and Albert
Museum, Ham House).

As in the case of no. 44 the hair is
painted in the tight manner of Oliver
and the background includes another
late innovation, the folded crimson
curtain. The earliest known instance of
this occurs in the miniature of the Earl
of Southampton dated 1594 (Fitzwilliam
Museum, Cambridge). The dress is off-
white, embroidered with leaves and
flowers in multicolored silk and
metallic thread over which there is a
layer of protective gauze. The inner
silk ruffle that lines the lace ruff is a
fashion typical of the turn of the
century and recurs in the portrait of
the Countess of Southampton (no. 52)
painted about the same time.

In spite of the attention to detail,
however, the miniature is a rather
awkward composition that reflects
Hilliard's retreat into the mechanical
and schematic as he grew older. R.S.

Provenance: See no. 44
Literature: Kennedy 1917, pl. 22;
Auerbach 1961, 140, 308 (123); Strong
1983, 140
Exhibitions: London, V & A 1947 (72);
London, V & A 1983 (126)

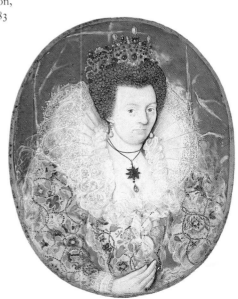

46

HAT BADGE WITH HEAD OF PIETAS
c. 1500/1550
Italian
enameled gold with onyx cameo
4.4 × 4.1 ($1\frac{3}{4}$ × $1\frac{3}{5}$)

Chatsworth
The Trustees of the
Chatsworth Settlement

This enameled gold oval hat badge is overlaid with foliage interspersed with four vases framed in a knotty branch entwined with oak leaves and acorns; it is set with an onyx cameo head of Pietas wearing a bandeau tied at the back with ribbons, and with a draped neckline. The cameo, which is contemporary with the setting, represents the personification of faithful duty to the gods, fatherland, and family, to whom the Romans dedicated a shrine in 191 BC. This head of Pietas derives from those on coins (see Kent 1978, pl. 15, no. 52; a denarius of Metullus Pius, c. 82 BC). Copied in the Renaissance period, it was worn as a badge of classical culture. The four lateral loops round the circumference of the setting would have been stitched to the upturned brim of the soft black hats worn by men at that time. In a well-known passage, Cellini (Bull 1956, 63), refers to the fashion: "Little medals of gold which were worn in the hat or cap and on these medals portraits were engraved in low or high relief and in the round." Cameos carved in high relief were well suited for setting in these ornaments. This rare survival comes from a group of wonderful Renaissance jewelry at Chatsworth, which includes the armorial signet ring of the 1st Earl of Cork. D.S.

Related Works: Hackenbroch 1979, 23: a similar brooch set with an onyx cameo of a crowned youth is in the Royal Collection, Windsor Castle
Literature: Scarisbrick 1983, 1542

47

THE GRESLEY JEWEL c. 1580
English, with Italian inset cameo
enameled gold with table-cut rubies, emeralds, pearls, and onyx cameo
with miniatures by
Nicholas Hilliard c. 1547–1619
6.9 ($2\frac{3}{5}$)

Southside House
The Pennington Mellor Charity Trust

Busts and heads of Moors were among the most common subjects for cameo cutters in the sixteenth and seventeenth centuries, combining the appeal of the exotic with an advantageous use of the layers of an onyx. The Moorish theme is reflected in the small cupids firing arrows that emerge from cornucopiae at the sides, showing traces of black enamel and obviously once blackamoors. The cupids and the male and female portraits enclosed within the pendant suggest that it was made on the occasion of a betrothal or marriage. The portrait miniatures, which are by Nicholas Hilliard, represent Catherine Walsingham (1559–1585), cousin of Sir Francis Walsingham, Secretary of State to Queen Elizabeth I, and her husband, Sir Thomas Gresley (1522–1610) of Drakelowe in Derbyshire. Her identity is established by comparison with the painting of her wearing this jewel, hung from multiple gold chains over her heart and dated 1585 (Birmingham Museum and Art Gallery). According to family tradition this pendant was a present from Queen Elizabeth on the occasion of their marriage. Despite the fact that Hilliard was the official limner to the court, the miniatures may not be original to the locket as they appear to have been slightly cut down to fit it. With its broad white enameled band set with table-cut gems the jewel is reminiscent of pendants in the British Museum and the Cabinet des Medailles, which both frame cameo portraits of Queen Elizabeth.
A.S.C.

Provenance: Reputedly by descent in the Gresley family until the late nineteenth century; Lord Wharton Collection
Literature: Auerbach 1961; Strong 1975 no. 10; Tait 1963, 150–151; Hackenbroch 1980, 296, 792–792b
Exhibitions: London, V & A 1980–1981
(46)

48

ELIZABETH I: THE RAINBOW
PORTRAIT c.1600
attributed to Marcus Gheeraerts the
younger d. 1636
oil on canvas
128.2 × 101.6 (50½ × 40)
inscribed, *NON SINE SOLE IRIS*

Hatfield House
The Marquess of Salisbury

This portrait of Elizabeth I has become
the focus of a growing and highly specu-
lative body of literature, much of it
written by iconographers who have
proposed varied interpretations: the
Queen as the Bride of Christ, as Isis,
and as a Jacobean image reflecting the
neo-Elizabethan revival centering on
Henry, Prince of Wales. In the interest
of clarity it seems sensible to treat the
picture in terms of its provenance and
date, its authorship and the circum-
stances of its painting, and its
iconography.

The earliest identifiable reference to
this picture at Hatfield is in 1719
(Vertue 1719, 1:58). Hatfield House
was built between 1607 and 1612 by Sir
Robert Cecil (1563?–1612), chief min-
ister to both Elizabeth I and James I;
several portraits of the queen belonged
to the Cecil family in the early seven-
teenth century, and it seems likely that
this must have been one of them. It was
probably initially at Salisbury House
in London and was moved to Hatfield
in the 1690s.

In the Tudor period royal portraiture
was controlled by the use of approved
images. That control broke down from
time to time as in the 1590s when
portraits of Elizabeth depicting her as
old and therefore vulnerable (the
succession was a major debate) were
destroyed by order of the Privy
Council. In or about 1593 or 1594
Nicholas Hilliard was called upon to
devise the so-called Mask of Youth,
which was a synthesis of his earlier
images of her and a total denial of the
physical reality. There are over twenty
extant miniatures by him in which this
convention appears and it was also used
by painters working in oils, including
the artist of the Rainbow Portrait. This
dates the picture to the last ten years

of the reign. The dating of the dress,
with its embroidered bodice, the
additional chin ruff, and the inner ruffle
to the ruff, points to a date of about
1600 or a little after.

No satisfactory attribution has yet
been made, although all authorities
agree that the picture belongs to the
new wave of portraiture of the 1590s
associated with the work of Marcus
Gheeraerts the younger (1561/1562–
1636) whose major patrons were the
Earl of Essex and Sir Henry Lee, the
owner of the famous Ditchley Portrait
(National Portrait Gallery, London).
Gheeraerts remains the most likely
candidate. Others are John de Critz
(c. 1552–1642), who was certainly
patronized by Cecil but whose small
identifiable oeuvre contains no works
of comparable quality, and the minia-
turist Isaac Oliver (c. 1560–1617), who
also painted in oils and was patronized
by Cecil.

Provenance and dating seem to
connect this picture with Sir Robert
Cecil. On the downfall of Essex in 1600,
it was Cecil who took on the role of
orchestrating eulogies and fêtes for the
queen in the same way that his rival
had earlier during the 1590s. Both in
December 1600 and 1602 he staged
major entertainments and he also
controlled the annual Accession Day
Tilts. For all these events he employed
an ambitious young lawyer, John Davies
(1569–1626). One entertainment could
have provided the occasion and use for
the picture, that of 1602, a contention
between a wife, a widow, and a maid,
which took place before "Astraea's
shrine," an altar decked with tapers.
The Rainbow Portrait could have been
intended to hang above that altar.
Dame Frances Yates' association of the
Rainbow Portrait with the imagery of
John Davies' *Hymnes to Astraea* (1599)
may therefore be correct. Astraea, the
Just Virgin of Virgil's *IVth Eclogue*
whose return to earth heralds the
eternal springtime of the golden age,
was an image frequently invoked to
celebrate her and certainly provides the
main theme of the portrait. The details,
however, also need to be read separ-
ately. They are as follows: (a) The
rainbow is the traditional symbol of
peace after storms. (b) The motto, "No

rainbow without the sun," associates
Elizabeth with the sun, which causes
the rainbow and brings peace to men.
(c) The golden cloak is adorned with
eyes and ears but not with mouths
(eliminating the usual misreading of it
as Fame), and is likely to refer to the
queen's use of her servants, above all
Cecil. Davies uses them in this sense:
"many things she sees and hears
through them but the Judgment and
Election [i.e. choice] are her own." (d)
The serpent on the sleeve, with its
jeweled heart hanging from its mouth
and an armillary or celestial sphere
above its head, is the traditional
symbol of wisdom. The general meaning
of this particular detail seems to be that
the queen is wise in both ruling the
passions of the heart and in reaching
decisions through the intellect (Cesare
Ripa gives a sphere as the attribute of
Intelligenza). The sphere, however, is
an emblem used in honor of the queen
as early as the 1560s and appears in
other pictures including the Ditchley
Portrait. (e) On her ruff there is a
jeweled gauntlet, a chivalrous symbol
(she bestowed her glove on a knight at
the Accession Day Tilts) referring to
her role as sovereign of her knights.
(f) The bodice is embroidered with
spring flowers—pansies, honeysuckle,
gillyflowers, and cowslips. If these
are symbolic they must allude to the
springtime Astraea brings with her
Golden Age. (g) The queen wears a
crescent-shaped jewel in her hair
alluding to the role developed first for
her by Sir Walter Raleigh in the 1580s
and part of the public imagery of the
1590s, that of Cynthia, the Moon
Goddess and Empress of the seas.

Frances Yates also noted that the
headdress and the arrangement of the
mantle derive from the figure of a *Sponsa
Thessalonica* in both Bassard's *Habitus
variarum orbis gentium* (1581) and Cesare
Vecellio's *Habiti antichi e moderni di
Diverse Parti del Mondo* (1593), a source
book heavily used by Inigo Jones for his
masque designs.　　　　　　　R.S.

Provenance: Presumably identical with
one of the pictures mentioned in the
early inventories of Hatfield and of
Salisbury House in London by the
1690s, when the contents of the latter
were moved to Hatfield (Auerbach
1971, 58); first certainly recorded by
Vertue 1950–1955, 1:58
Literature: O'Donoghue 1894, 19, no. 61;
Holland 1891, 36–37; Yates 1952, repr.
Astraea 1975, 215–219; Yates 1959,
365–366; Strong 1963, 85–86, no. 100;
Strong 1969, 299, no. 304; Auerbach and
Kingsley Adams 1971, 59–61, no. 51;
Graziani 1972, 247–259; Yates 1975,
34; Strong 1977, 50–52; Arnold 1980,
63–65; De Beauregarde 1983, 89–139;
De Beauregarde 1984, 49–62
Exhibitions: Manchester 1857 (672);
London, SKM 1866 (267); London,
New Gallery 1890 (1410B); London,
Grosvenor 1933 (206); London, NPG
1958 (no cat.); Ottawa 1967 (29)

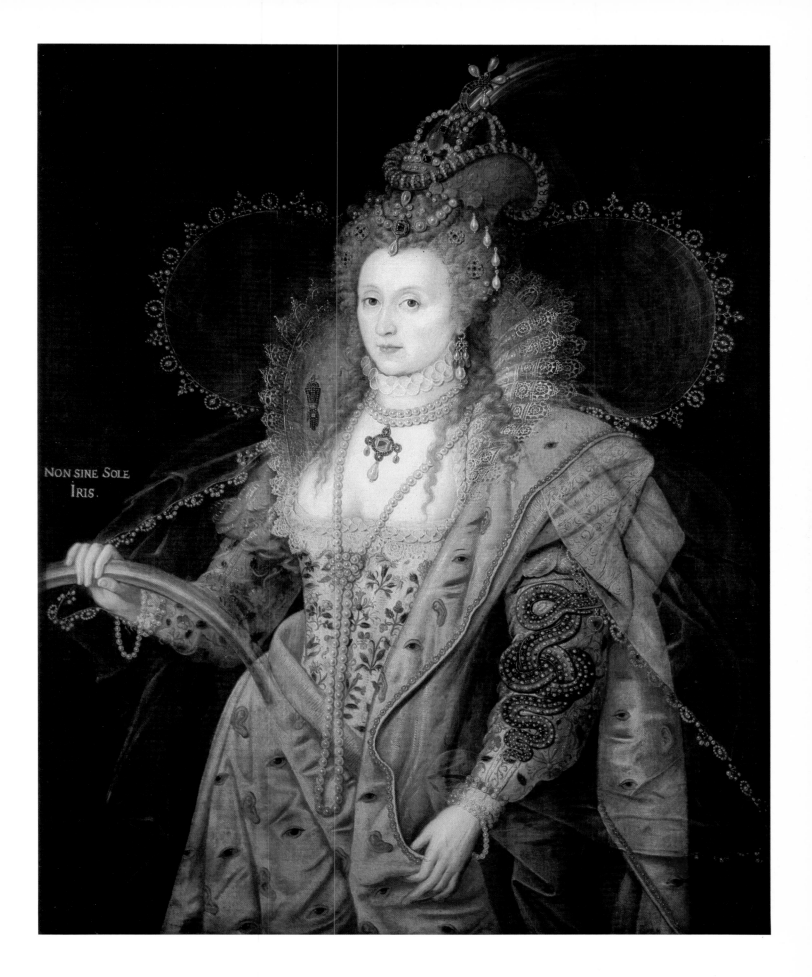

2: The Jacobean Long Gallery

Writing to ask Robert Cecil, the builder of Hatfield, for his portrait in 1609, Viscount Bindon explained that it was "to be placed in the gallery I lately made for the pictures of sundry of my honourable friends, whose presentation thereby to behold will greatly delight me to walk often in that place where I may see so comfortable a sight." The idea of the portrait gallery has its roots in renaissance Italy and it is significant that one of the earliest in England, at Lumley Castle, was probably inspired by John, Lord Lumley's embassy to Florence in 1566, when he would have seen Cosimo de' Medici's gallery of past and present worthies—copied from that of Paolo Giovio, Bishop of Nocera. Series of portraits of rulers, or of family ancestors, were soon the standard furnishing of the long galleries common to every house of the period, and indeed it is rare to find pictures listed in any other rooms. Usually these galleries were placed on the top floor with views over the formal gardens below, enabling their owners to take exercise in bad weather and in winter, under the gaze of heroes of the past, whose deeds would be an inspiration for the future.

The full-length standing portrait, probably introduced to England by Edward VI's court painter Guillim Scrots, was well suited to the increasing height of the long gallery. Series of family "costume-pieces" of this sort painted between about 1595 and 1625 still survive at Woburn and Penshurst; and most notably, the group from Charlton in Wiltshire, now at Ranger's House, Blackheath (see no. 54). The enameled brilliance of these images by John de Critz and Marcus Gheeraerts the younger, Robert Peake, and William Larkin puts them more into the category of the decorative than the plastic arts, unlike the remarkable self-portrait by Sir Nathaniel Bacon (no. 65), which shows him to have been among the only native painters of distinction before William Dobson. However, it was the arrival of two more foreign artists, Mytens in 1618 and Van Dyck in 1632, that was to transform the tradition of the gallery portrait, breathing new life into the old full-length format.

The Dutch artist, Daniel Mytens, was introduced to James I's court by Thomas, Earl of Arundel, Lord Lumley's great-nephew. The first important patron also to be a collector, called by Horace Walpole "the father of *virtù* in England," Arundel had returned from Italy with many of the antique marbles seen in the background of his own portrait by Mytens (no. 49), and it was he and his protégé Inigo Jones who encouraged the artistic patronage both of the ill-fated Henry Prince of Wales and his brother Charles I. Where Mytens' portraits have a gravity perhaps influenced by Velasquez, Van Dyck's English work has a sense of abounding life and energy, marking a return to the style of his Genoese period, influenced by Titian and Rubens—who had himself spent a short time in England in 1629–1630, devising the ceiling decoration for Inigo Jones' Banqueting House at Whitehall. Van Dyck's portraits of those in the immediate circle of the Stuart court are among his finest achievements, and his influence on English art, extending to the world of Gainsborough and Reynolds, is out of all proportion to the short period of eight years that he spent in London before his death in 1641. The court style, shown in the gilded busts of Hubert le Sueur, the Italianate *sgabello* chairs of Franz Cleyn, and the cavalier portraits of William Dobson, was not long to survive him, overwhelmed by the turmoil of the Civil War.

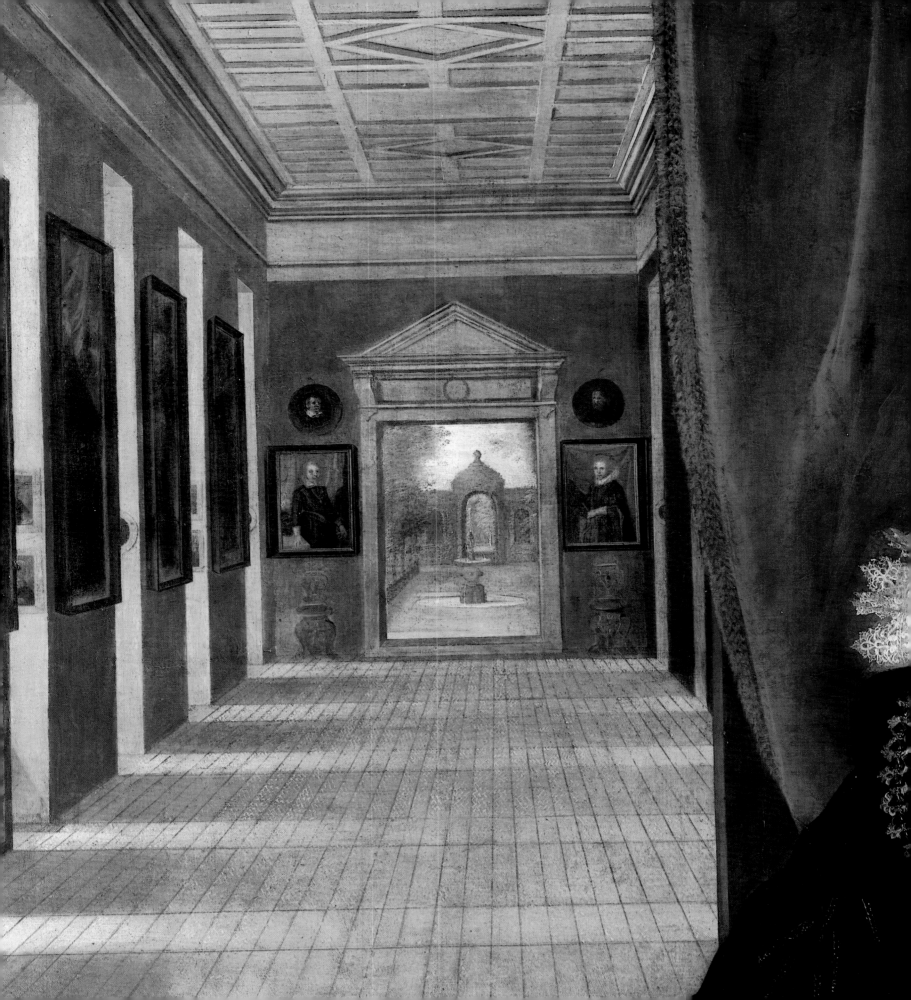

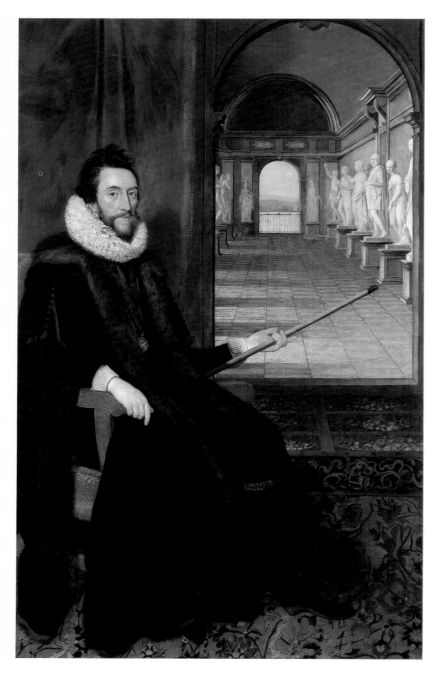

49

THOMAS HOWARD, 2ND EARL OF
ARUNDEL AND SURREY c.1618
Daniel Mytens c.1590–1647
oil on canvas
214.6 × 133.4 (84$\frac{1}{2}$ × 52$\frac{1}{2}$)

Arundel Castle
on loan from the
National Portrait Gallery, London

Thomas Howard (1590–1642) was the grandson of the 4th Duke of Norfolk, who had forfeited his lands and titles and been beheaded in 1572, and the son of St. Philip Howard, who had died in the Tower of London in 1595. He holds the baton of the Earl Marshal, the office hereditary in his family. Intelligent, austere, intensely proud of his ancestors and interested in their history, he was driven by "a single-minded attempt to restore the glory and honour of his family." He himself had been restored in blood in 1604 (he was in favor with the Prince of Wales), but not until the Restoration was his grandson restored as 5th Duke of Norfolk. Deeply devoted to the arts and learning, the earl was a lover of antiquity, a discerning patron of artists and scholars, and the first great collector in the history of connoisseurship in the British Isles. Many of his possessions are known to have been of remarkable quality; whereas, in discussing earlier collections, even those formed by Henry VIII or Lord Lumley (Arundel's great-uncle), it is difficult to assess the quality as opposed to the quantity of the works of art they assembled. Arundel was "one that Loved and favored all artes and artists in a great measure, and was the bringer of them into Englande," and in the words of Rubens, "Uno delli quatro evangelisti e soportator del nostro arte." The foreign artists he patronized included Rubens, who in 1620 painted a large group of Lady Arundel and her suite in Antwerp; Van Dyck, whom he was anxious to bring over to England in the same year; Cornelis Dieussart, Francesco Fanelli, and Wenceslaus Hollar, whom Arundel enlisted in his service in Cologne in 1636.

As a young man he had traveled in the Low Countries, and he deeply loved Italy; "the humour and manners of which nation he seemed most to like and approve, and affected to imitate." On his second and longer visit to Italy, from which he returned in 1614, he embarked on the excavation and study of classical remains, partly in the company of Inigo Jones. The marbles he acquired at that time, and those he secured in the Levant—the great assemblage collectively known as the Arundel Marbles of which a small part

survives in the Ashmolean Museum in Oxford—were set up in the gardens at Arundel House in the Strand and in the gallery there, on the first floor to which Arundel points in this picture with his Earl Marshal's baton. In the distance is a glimpse of the Thames and the Surrey shore. Arundel House was conceived by its owner almost as a museum, with a library and a fine collection of prints and gems. His collection of pictures revealed a special liking for sixteenth-century Northern painting, a taste that was not shared by Charles I or the Duke of Buckingham, his principal rivals in the collecting field. His Holbeins, probably since unequalled as a display in one collection of the works of that painter, were especially dear to him because the artist had worked for his forebears. Arundel is also the first well-documented collector in England of old master drawings (for a good modern account of the earl, see Robinson 1982).

Daniel Mytens was trained in Delft and was in London by 1618, by which time he had secured the patronage of the Arundels and, probably, of the Earl of Southampton. He was a more accomplished painter than anyone else working at the Jacobean court and he deservedly enjoyed success until the arrival of Van Dyck, although he continued to paint for the king until 1634. After his return to The Hague he continued to keep in touch with the Earl of Arundel, who in 1637 employed him to help in the acquisition of pictures and drawings. This picture and its companion may have been painted for Sir Dudley Carleton, a diplomat who knew a great deal about the arts and was helpful to collectors in London at this time. He was told by Mytens in a letter of 18 August 1618 about "those greate picteures," that Arundel was unwilling to part with, "by reason they doe leyke his honr so well that he will keep them." Arundel appears to have commissioned portraits from Mytens for Carleton "in one table": perhaps the double portrait, now in the collection of the Duke of Norfolk, in which the heads are closely related to those in these two pictures. "I wish," wrote Carleton, "he had been so happie in hitting my Lady as he hath perfectly

done your Ldp, but I observe it generally in woemens pictures, they have as much disadvantage in y^e art as they have advantage in nature."

Mytens admirably illustrates Clarendon's account of the earl: "the appearance of a great man, which he preserv'd in gate, and motion. He wore and affected a Habit very differente from that of the time, such as men only beheld in the Pictures of the most considerable men; all which drew the eyes of most, and the reverence of many towards him as the Image and Representative of the Primitive Nobility, and Native Gravity of the Nobles when they had been most Venerable." Although in both portraits the painter has not quite satisfactorily bridged the transition between the sitters in the foreground and the two important backgrounds, Mytens shows himself to be, in the solidity of his forms, far in advance of such older painters as Gheeraerts. He is also more modern in his restrained designs and freely handled paint than the artists who produced the decorative portraits now associated with Larkin. O.N.M.

Provenance: Probably always in the possession of the sitter's descendants; among a group of portraits at Arundel Castle that were handed over to the nation in lieu of death duties at the death of the 16th Duke of Norfolk in 1975 and were allowed to remain at Arundel as the property of the National Portrait Gallery, London
Literature: Hervey 1921, 143, 43; Waterhouse 1953, 36; Whinney and Millar 1957, 63; Ter Kuile 1969, 2–3, 43–44, nos. 1 and 2; Robinson 1982, 97–116
Exhibitions: London RA 1938 (8 and 28); London, RA 1960 (3 and 25); London, Tate 1972–1973 (1 and 2)

50

ALATHEIA TALBOT, COUNTESS OF ARUNDEL
Daniel Mytens c.1590–1647
oil on canvas
214.6 × 133.3 (84½ × 52½)

Arundel Castle
on loan from the
National Portrait Gallery, London

Alatheia Talbot (d. 1654); the third daughter and eventually sole heiress of the 7th Earl of Shrewsbury, married Arundel in 1606. Her inheritance transformed his financial position and was of immeasurable value in enabling him to build up his magnificent collections. "She brought to the Howards vast estates across South Yorkshire, Derbyshire and Nottinghamshire, estates rich in minerals, lead, coal and iron, and with a great house at Worksop which was to become the principal ducal seat in the eighteenth century, while the industrial town of Sheffield has formed the backbone of the family fortune ever since" (Robinson 1982).

In the background of this portrait is a gallery on the ground floor of Arundel House hung with symmetrically arranged portraits in uniform, dark frames. At the end a door opens into the garden. A number of portraits had come into Arundel's possession from his Lumley and Fitzalan forebears and they may be among the pictures dimly discernible here. The backgrounds in the two portraits illustrate two prime interests of the earl and his wife: works of art and family history.

Full-length portraits of both sitters, sometimes cited in connection with these two pictures, are at Welbeck Abbey. That of the earl is a standing full-length portrait based on a slightly later type (perhaps on the head at Boughton), and with a view of Arundel House behind. O.N.M.

Provenance etc.: See no. 49

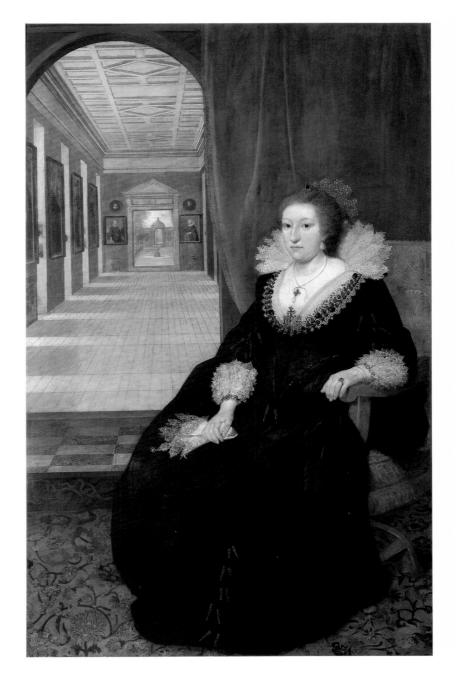

51

JOHN, LORD BELLASYS 1636
Gilbert Jackson fl. 1621–1640
oil on canvas
188 × 129.5 (74 × 51)
signed and dated, . . . *Jack/pinxit 1636*

Lennoxlove
The Duke of Hamilton and Brandon

A characteristic example of the work of
a provincial painter in the age of Van
Dyck includes a contemporary female
portrait in the background that is very
much in the style of Jackson. He worked
in different parts of the country and
had patrons in scholarly circles and
among the county gentry. Like his
contemporaries Parker and Bower,
Jackson has none of Van Dyck's mastery
of design or refinement of technique.
Unlike Van Dyck, however, he presents
an unvarnished image of his patron,
Lord Bellasys (1614–1689): he records
his very fashionable dress with scrupu-
lous accuracy and gives a comparatively
rare illustration of the sort of interior in
which Lord Bellasys may have lived.
The Salomonic column, also used in an
almost exactly contemporary full-length
portrait by Edward Bower at Dunster
Castle, is probably derived from those
in the famous Raphael tapestry cartoons
acquired by Charles I, and is particularly
appropriate for a sitter who was an
active royalist during the Civil War.

O.N.M.

Exhibitions: London, Tate 1972–1973
(143)

52

ELIZABETH VERNON, COUNTESS OF
SOUTHAMPTON C. 1600
English school
oil on panel
164 × 110.5 (64½ × 43½)

Boughton House
The Duke of Buccleuch and
Queensberry, KT

Elizabeth Vernon (1572?–c. 1655) was
the daughter of John Vernon of Hodnet
in Shropshire and Elizabeth, sister of
Walter Devereux, 1st Earl of Essex.
She was a Maid of Honor to Queen
Elizabeth I. Southampton (no. 36)
courted her "with to much familiarity"
in the autumn of 1595 so that she "almost
wept out her fairest eyes" when he left
for France in February 1598. Sometime
shortly before 30 August of that year
he secretly married her. On that date
Chamberlain, the latter writer, reports:
"Mrs Vernon is from the Court, and
lies in Essex house; some say she hath
taken a venew under the girdle and
swells upon it, yet she complaines not
of fowle play, but sayes the Erle of
Southampton will justifie it; and it is
bruted, underhand, that he was lateleie
here fowre dayes in great secret of
purpos to marry her, and effected it
accordingly." The queen was furious
and early in November he was
commanded back from France and
committed to Fleet prison. Shortly
after 8 November their daughter
Penelope was born. Southampton died
in 1624 and his wife outlived him by
more than thirty years, giving shelter
to Charles I in 1647 after his escape
from Hampton Court, being "a lady of
that honour and spirit that she was
superior to all kind of temptation."

The portrait is unique in that it
records a great Elizabethan lady at her
toilet. Two items point to a date around
the turn of the century: the ermine-
lined crimson robe laid across the stool,
which would be appropriate to her rank
as a countess and therefore subsequent
to her marriage in 1598; and the ruff
pinned to the curtain at top right,
which includes an inner ruffle of silk, a
fashion of the last few years of Elizabeth's
reign. The countess stands pulling an
ivory comb, inscribed *Menez moi douce-*

ment, through her long hair. She wears
an embroidered jacket with a zigzag
hemline adorned with spangles and pink
ribbon fastenings at the front, only the
top one of which is tied. The white lace
cuffs and collar are turned back over
her smock, beneath which she wears a
pink corset plunging in a deep *V* at the
front. Below the waist is a skirt (or
petticoat) in gold and silver of flower
sprays with a protective gauze over it.
This seems to be a very early instance
of a new style of attire without a far-
thingale, in which an embroidered
jacket was worn with a separate skirt.
It was a fashion that became all the rage
about a decade later (see Strong 1969,
330–331, nos. 354–356).

On the table stands her jewel box.
Its contents are arranged on the table
in the manner of a visual inventory.
There is a large cushion stuck full of
pins that would have been used to attach
jewels to her hair and dress. Nearby is a
triple row of pearls, two necklaces or
carcanets with ribbon fastenings, and
three pendants. Another item of jewelry
hangs from the ruff pinned to the
curtain. Janet Arnold relates it to one of
a type listed in the 1600 New Year's
Gift List: "One carcanett hanginge at a
Ruffe conteyning ix peeces of golde set
with garnetts." The three large
cushions embroidered with metallic
thread, with three tassels and the
crimson cloth fringed with gold,
remind us of the important place of
textiles in Elizabethan interior
decoration.

No satisfactory attribution has ever
been proposed for this picture, which is
painted in the native tradition of
Nicholas Hilliard and is either ignorant
of or ignores the laws of scientific
perspective and chiaroscuro. There is
no attempt to create pictorial space and
we are presented with a formalized
pattern of clothes and jewels. R.S.

Provenance: See no. 36
Literature: Goulding 1920, 28;
Wingfield-Digby 1963, 88; Strong 1969,
1:300–301
Exhibitions: London, V & A 1981 (P18)

Gheeraerts' surviving works and the one in which he comes closest in choice of costume and design to the most formal Jacobean court portraits that used to be loosely grouped under the name of the "Curtain Master." The figure rests her hand on a very grand X-frame chair of state and stands on a carpet, between curtains pulled back under a fringe.

There are seven portraits of this type in the so-called "Berkshire Marriage Set" (see no. 54). Here, however, the sitter's character is more sensitively projected, the handling is more delicate, the color more subtle, and the mood more appealing than in those rather hard, enameled images. Nor does the other painter take such conscious pleasure as Gheeraerts in details like the flowers, the patterning on the dress, or the fringes on the chair and curtains. O.N.M.

Provenance: The portrait was at Cobham Hall, in the possession of the Dukes of Richmond and Lennox (see no. 66); the sitter left many of her possessions to her nephew, the duke; by descent to the Earls of Darnley; sold Christie's, 1 May 1925, lot 22, as by Gheeraerts; the 2nd Viscount Cowdray and by descent
Literature: Millar 1963; Strong 1969, 293
Exhibitions: London, Tate 1969–1970 (162)

54

RICHARD SACKVILLE, 3RD EARL OF DORSET c.1613
attributed to William Larkin d. 1619
oil on canvas
206.4 × 122.3 (81¼ × 48⅛)
dated and inscribed, *1613, AE^{tis} sua 24/ Aut nunquam tentes: aut perfice;* a later inscription identifies the sitter wrongly as his younger brother the 4th Earl

Ranger's House, Blackheath
The Greater London Council

The 3rd Earl of Dorset (1589–1624), shown here in a very elaborate court costume, was licentious and a spendthrift. He was singled out for his spectacular costume at the marriage of Princess

Elizabeth on 14 February 1613 and it is possible that the portrait shows him dressed for this ceremony. He was the first husband of the great northern heiress Lady Anne Clifford, and the owner of Knole.

The portraits of the earl and of his younger brother are the most magnificent and the most technically accomplished of the portraits in the famous series of nine portraits (the other seven are all of female sitters) formerly at Charlton Park in Wiltshire, the seat of the Earls of Suffolk and Berkshire. However, it is not known when the portraits were collected, for whom they were originally painted, or whether they commemorate a particular event. They hang in uniform frames of about 1700, at which point the uniform later inscriptions were probably added. Although it is tempting to associate this spectacular series with a prominent Jacobean courtier such as the 1st Earl of Suffolk, there is no evidence for this, and the portraits are not recorded at Charlton before 1801.

Sir Roy Strong has argued persuasively that these and other portraits of this type were painted by William Larkin who is known to have worked for the 3rd Earl of Dorset. Larkin, however, remains a very shadowy figure, and it must be pointed out that there seems to be more than one hand at work, certainly in the Suffolk and Berkshire series as well as in portraits of this type elsewhere. The style in which the portraits are painted was a fairly short-lived one, almost a form of high Jacobean mannerism, which was soon eclipsed by that of the more up-to-date painters such as Van Somer and Mytens who came to London later in the decade (for a full discussion of the problem of authorship, see particularly Strong and Simon). O.N.M.

Provenance: At Charlton Park, Wiltshire, in an inventory of 1801; and by descent; given by Mrs. Greville Howard to the Greater London Council in 1974, as part of a collection to furnish Ranger's House, Blackheath
Literature: Waterhouse 1953, 28; Strong 1969, 323; Simon [1975], no. 3
Exhibitions: London, RA 1938 (17); London, Tate 1969–1970 (129)

53

FRANCES HOWARD, COUNTESS OF HEREFORD 1611
Marcus Gheeraerts the younger d. 1636
oil on canvas
205.7 × 129.5 (81½ × 51)
dated, *1611*

Cowdray Park
The Viscount Cowdray

Frances Howard (d. 1639) was the daughter of Thomas, Viscount Howard of Bindon. She was first married to Henry Pranell, a wealthy wine merchant; in 1601 she married the 1st Earl of Hertford, who died in 1621. Later in the same year she married Ludovick Stuart, Duke of Lennox and (later) of Richmond.

This is the most elaborate of

55

ANNE LEIGHTON, LADY ST. JOHN
c.1615
William Larkin d. 1619
oil on canvas
204.5 × 123.2 ($80\frac{1}{2}$ × $48\frac{1}{2}$)

Mapledurham House
J.J. Eyston, Esq.

This picture was first attributed to Larkin in 1969. Larkin's only certainly documented works are the two portraits of Edward Herbert, Lord Herbert of Cherbury and Sir Thomas Lucy, c.1609–1610 (both at Charlecote Park, National Trust). Larkin was probably born in the 1580s and was probably only in his middle or late thirties when he died. By then he was being patronized by the Earls of Rutland and by Anne Clifford, Countess of Dorset. His working career would therefore only have stretched from c.1605 to 1619, hence the attribution to him of a large group of pictures that use identical carpet borders and shiny silk curtains. Larkin must have been trained by an artist

within the Elizabethan tradition, conceivably even by Hilliard himself, who also died in 1619.

Although further research needs to be done, it is likely that the sitter is Anne Leighton (d. 1628), wife of Sir John St. John (d. 1648) of Lydiard Tregoze, Wiltshire. She is also depicted with her husband in the triptych celebrating the St. John family in Lydiard Tregoze church. The triptych, which was heavily overpainted, is undergoing restoration at present (information from Miss Pauline Plummer) but the resemblance to the Mapledurham portrait is apparent. Sir John set the triptych up in 1615, the date of the separate portrait. The exact connection between Anne Leighton and the Tichbornes has yet to be established. This portrait of Lady St. John is one of Larkin's late works and is unique in setting the figure against a landscape that is simultaneously both naturalistic and symbolic. In the Elizabethan period woodland settings appeared from the mid-1580s onward in response to the fashionable mode of melancholy that demanded that a person seek the shade of the greenwood tree (see Oliver's Lord Herbert, no. 42). Lady St. John is just such a melancholic: she wears the black that was *de rigueur* and crosses her hands in a gesture half-way toward the cross-armed pose best known from the famous portrait of the poet John Donne (Marquess of Lothian). Lady St. John's melancholy is of a religious kind as is made clear by the *memento mori* skull on the bank to the left. It is conceivable that the oak, a traditional symbol of immovability and strength or resolve, is also there in a symbolic capacity. R.S.

Provenance: The portrait came to Mapledurham in 1755 as part of the settlement that divided the pictures of the Tichborne family between the two daughters of Sir Henry Joseph Tichborne, Bart. (d. 1743). One of "Lady St. John" appears among the nine that passed to his daughter, Mary Agnes, wife of Michael Blount of Mapledurham. These included the famous picture entitled *The Tichborne Dole* by Gillis van Tilborch (no. 71)
Literature: Strong 1969, 324, no. 343
Exhibitions: London, Tate 1969 (131)

56

HENRY, PRINCE OF WALES c.1610
Robert Peake c.1551–1619
oil on canvas
228.8 × 218.4 (90 × 86)

Parham Park
Mrs. P.A. Tritton

This entry has been written while the picture was undergoing cleaning and restoration at the Hamilton-Kerr Institute, and the author intends to publish a fuller account with the restorer.

Henry, Prince of Wales (1594–1612), James I's eldest son, was created Prince in June 1610 and died of typhoid fever in November 1612. For a brief period of three years he presided over a brilliant court, which was a focus for the introduction into England of late mannerist culture of a type typified by Tuscany under the Grand Dukes, Prague under Rudolf II and France under Henri IV. This still-born renaissance was allied to a fiercely pan-Protestant ethic which, in political terms, reached its apogee in the marriage of his sister, Elizabeth, to the leader of Protestantism within the Holy Roman Empire, Frederick V, Elector Palatine. Besides major authors such as Ben Jonson, George Chapman, Michael Drayton, and Josuah Sylvester, who were all part of the circle, the visual arts were represented in his household by a remarkable galaxy of talent: Inigo Jones, the prince's surveyor and designer of his court entertainments; Isaac Oliver, initially his miniaturist but later his court painter; the Frenchman, Salomon de Caus, who designed and supervised the building of mannerist grottoes and fountains in his gardens; and a Florentine painter, sculptor, and architect, Constantino de'Servi.

Robert Peake was the prince's picture-maker from 1604 and it is surprising that Henry, with his avant-garde tastes in the arts, should have taken so long to replace him. Constantino de'Servi was already painting a portrait of the prince in 1611 and in the same year negotiations were entered into to secure the Dutch artist, Miereveldt. These ended in failure and led to the appointment of Oliver as the prince's painter shortly before he died. To all intents and purposes, therefore, the portraiture of the prince is by Peake and his studio assistants who were responsible for the large number of routine paintings that exist today, monuments to the enormous popularity of the heir to the throne.

Peake was a painter trained within the Hilliardesque iconic tradition of late Elizabethan art with its emphasis on the two dimensional, its use of a light palette, and its delight in spiraling, patterned surfaces. In spite of this, he was called upon to give expression to the prince's grandest aspirations, deliberately projecting his image as knight and *cortigiano*. These pictures include the two versions of him *à la chasse* (Royal Collection and Metropolitan Museum, New York) and the one of him as a warrior brandishing a sword which has recently come to light in Turin. There is no doubt, however, that this picture must rank as the most ambitious of all, and arguably as Peake's masterpiece.

Until now the picture has been covered in a late seventeenth-century repaint, which totally replaced the original background with a low-lying landscape and sky with a large tree to the right, all of which was painted in a free Titianesque manner totally belying the archaic mannerisms beneath. Prior to cleaning, the picture's Italianate features suggested both Oliver and de'Servi (who is recorded as having painted the prince's horse) as the artists. Cleaning has now established without a doubt that this picture is by Peake. The artist must, however, have been acting under direction—in response to an iconographic program compiled by someone in the prince's circle. The Turin picture, for example, is borrowed from Goltzius' engraving of Manlius Torquatus while the initial inspiration for the present canvas must be either Clouet's equestrian portrait of Henri II in the Metropolitan Museum, New York, or another version of it. The pose of both horse and rider is virtually identical but even more telling is that in both instances they are placed before a wall with a narrow foreground of foliage.

The iconography reflects the martial aspirations of the prince as well as his cultivation of the equestrian arts (he built a Riding School at St. James's in 1607–1609). In the picture we see a vivid expression of his ability to fuse imperial grandeur *à l'antique* with knightly prowess in the Elizabethan Spenserian sense. In the *Barriers* of 1610, composed by Ben Jonson, Henry was given a shield let down from heaven by King Arthur and a mighty revival of British chivalry was prognosticated under his aegis. We find this Arthurian theme reiterated in the symbolism of the *impresa* embroidered on the skirts he wears over his armor and on the horse caparison. This is a reworking of the familiar legend of the sword Excalibur, which could only be grasped from the hand arising out of the lake by the chosen knight. In this instance the sword has become the anchor of Hope and the prince's glorious future is predicted in the rising sun in the distance.

The cleaning has revealed not only a wall behind but the nude figure of winged Time bearing the prince's lance and helmet. Time's white forelocks are blown forward and tied to the favor extending backward from the prince's right arm. In this we have a rare late Renaissance instance of Time in the classical sense of Opportunity, more usually fused with Fortune and hence usually depicted as female. The prince is seizing Opportunity by the forelock. There may also be an allusion to the old Tudor theme of *Veritas Temporis Filia*, in which case it could also mean that Time reveals the Truth to come in this valiant prince.

It is conceivable that the feathers in the helmet and on the horse's head and even the dyed tail, matching those of the favor, are meant to be red, white, and blue and hence emblematic of the new Empire of Great Britain created at the union of the kingdoms by his father, James I. R.S.

Provenance: Possibly identical with "a picture at large of Prince Henry on horsebacke in armes" in the collection of Henry Howard, 1st Earl of Northampton (1540–1614), which passed to Sir Robert Cotton (1571–1631); Godfrey Williams, St. Donat's Castle; sold Christie's, 4 October 1946, lot 131
Literature: Shirley 1869, 37; Cust 1914, 347–348; Strong 1969, 338 (364); Strong 1986 (forthcoming)
Exhibitions: London, Tate 1969 (180); 1973 (58)

PAINTED HALL CHAIR c.1635
attributed to Franz Cleyn 1582–1648
walnut, painted white and gray
104 × 38.7 × 55.8 (41 × 15¼ × 22)

Lacock Abbey
Anthony Burnett-Brown, Esq.

This chair and its three companions (nos. 58–60)
are rare, early seventeenth-century examples of an
Italianate form known as the *sgabello*, quite unlike any
of the conventional forms of seat furniture that had
been made in England before the reign of James I. The
sgabello consists of cartouche-shaped boards fixed with
mortise and tenon joints to a seat that is normally
dished, with a circular depression cut into its top face.
Its earliest documented appearance in England is in
the background of Mytens' portrait of the Countess of

Arundel (no. 50), where a pair of such chairs flank
the door at the end of the long gallery leading to the
garden. The room shown is the picture gallery at
Arundel House in the Strand, designed by Inigo Jones
soon after his return from Italy with Lord Arundel in
1614, and indeed the two of them may have intro-
duced this form to England. Though usually termed
hall chairs from the early eighteenth century onward,
they seem to have been originally intended for long
galleries, lining the walls like sentinels, and this would
explain why they usually belong to very large sets.

This example, one of six, came from Holland House,
Kensington, which was built by John Thorpe for the
Cope family in 1605, but later acquired by Henry
Rich, 1st Earl of Holland. The great chamber there
was redecorated by Lord Holland soon after 1624, and
Horace Walpole, following Vertue, records that this
was carried out by the Danish-born artist Franz or
Francis Cleyn (Ilchester 1937, 15). Cleyn had spent
some time in Italy and was recommended to Charles I
by Sir Henry Wotton, the English ambassador in
Venice, and became artistic director of the Mortlake
tapestry works in 1625. His most complete surviving
rooms are the White Drawing Room and Green Closet
at Ham House, where a similar set of *sgabello* chairs
once existed. These are shown in the garden in a
painting of the 1670s by Henry Danckerts, but were
probably intended for the 1st Earl of Dysart's long
gallery and were only moved outdoors by his daughter,
the Duchess of Lauderdale, during her full-scale
refurnishing of the house after the Restoration
(Thornton and Tomlin 1980, 29, fig. 6).

Holland House was gutted by a fire-bomb in the
Second World War, but Walpole describes the Gilt
Room (the former great chamber) as having a ceiling
in "ornamented grotesque and small figures I think by
old Decleyn," as well as "two chairs, carved and gilt,
with large shells for backs . . . undoubtedly from his
designs; and . . . evidences of his taste." This is almost
certainly a reference to a pair of armchairs of *sgabello*
form (one of them now in the Victoria and Albert
Museum), which were probably made to go with the
set of single shell-backed chairs now at Lacock. The
latter appear to have been repainted several times and
now bear the rampant lion of the Talbot arms in the
central cartouche. G.J-S.

Provenance: At Holland House in the seventeenth
century; apparently given by the 2nd Earl of Ilchester
(d. 1846) to his daughter Lady Elizabeth
Fox-Strangways, wife of William Davenport Talbot of
Lacock; and by descent

PAINTED HALL CHAIR c.1635
attributed to Franz Cleyn 1582–1648
walnut, grained
124 × 39.3 × 57 (49 × 15½ × 22½)

Melbury House
Lady Teresa Agnew

This *sgabello* chair comes from a set of sixteen made for
Holland House, Kensington, and brought to Melbury
after the former was gutted by fire during the Second
World War. The chairs may well have been made for
the long gallery, while the companion set at Lacock
was intended for the Gilt Room (formerly the great
chamber). The present graining probably dates from
the nineteenth century, and the central oval is
decorated with the two lions passant of the Fox-
Strangways coat of arms. For a full discussion of the
history of these chairs, see no. 68. G.J-S.

Provenance: Probably at Holland House in the time of
Henry Rich, 1st Earl of Holland (d. 1648); by descent
through the Earls of Ilchester to the present owner,
daughter of the 8th and last Earl

59

PAINTED HALL CHAIR C.1635
attributed to Franz Cleyn 1582–1648
walnut, painted black and gold
106 × 47 × 39 (41¾ × 18½ × 15¼)

Petworth House
The Lord Egremont

One of a set of nine chairs of Italianate *sgabello* form, this has a base with grotesque heads and central garland so similar to that of no. 57 that an attribution to Franz Cleyn is also warranted. Neither these nor a companion set at Petworth, with cartouche-shaped backs decorated with the Percy crescent (see no. 60), can be identified in the inventory of 1632. They are listed, however, as "eighteene carved and gilt wood [chairs] with halfe moons" in the "lobby" in 1680 (Petworth House MSS). Both sets were evidently acquired by Algernon Percy, 10th Earl of Northumberland, one of Van Dyck's greatest patrons, whose close association with court circles would have brought him into contact with both Inigo Jones and Cleyn. The 10th Earl visited Italy in 1622, and added to the Italian books on architecture and other subjects, collected by his father, the "Wizard Earl." Any Italianate decoration he may have commissioned from Cleyn was swept away by his granddaughter Elizabeth and her husband during their remodeling of Petworth in the 1680s and 1690s. G.J-S.

Literature: Jackson-Stops 1977, 358, figs. 2, 3

60

PAINTED HALL CHAIR
attributed to Franz Cleyn 1582–1648
walnut, painted black and gold
104 × 38 × 48 (41 × 14⅞ × 18)

Petworth House
The National Trust (Egremont Collection)

This *sgabello* chair comes from a companion set to that described in no. 59. The central cartouche bears the crescent badge of the Percy family surmounted by an earl's coronet, probably that of Algernon, 10th Earl of Northumberland. The painted decoration of both chairs probably dates from the nineteenth century, though they were described in 1680 as being gilt, and the gesso ground may therefore be original. G.J-S.

61

BARBARA, LADY SIDNEY, WITH
SIX CHILDREN 1596
Marcus Gheeraerts the younger d. 1636
oil on canvas
203.2 × 260.3 (80 × 102½)
inscribed later, *1596*, with the names of
the individual sitters

Penshurst Place
The Viscount De L'Isle, VC, KG

On 23 September 1584, Barbara
(d. 1621), daughter of John Gamage of
Coity, married Robert Sidney of
Penshurst, younger brother of Sir Philip.
He was created Earl of Leicester in 1618,
and was succeeded in 1626 by his son
Robert, who was born on 1 December
1595 and is shown here seated on a
table at his mother's right (he became
the father of the sitter in no. 96). The
elder son, William, died in 1613. The

other children are Mary, Catherine,
Elizabeth, and Philippa.

The group was painted for Lord
Leicester, and Vertue (1930–1955, 5:75)
recorded the existence of a letter to
Lady Leicester from her husband in
which he desired her to go to Gheeraerts
and pay him for her picture and the
children's, "so long done, and unpaid."
This is therefore one of the few works
that can be linked to the artist by a
contemporary document, and it is among
the earliest works in his oeuvre, which
has been reconstructed principally by
Roy Strong and Oliver Millar. Despite
extensive damage, it still displays,

within the compass of an extremely
formal pattern, much of Gheeraerts'
sensitive presentation of character and
delicate treatment of detail—especially
in the lace and the jewels. No less
characteristic of the artist is the
pervading silvery tone.

A portrait of the elder son, Sir William
Sidney, also at Penshurst and painted
about 1611, can be attributed with
some confidence to Gheeraerts. O.N.M

Provenance: Always at Penshurst
Literature: Waterhouse 1953, 27; Strong
1969, 277
Exhibitions: London, Tate 1969–1970 (156)

62

GEORGE CALVERT, IST LORD
BALTIMORE 1627
Daniel Mytens c.1590–1647
oil on canvas
223.5 × 146 (88 × 57½)
signed and dated by the artist,
D. Mytens feᵗ a.⁰ 1627; inscribed later
with the sitter's name and office

Bourne Park
Lady Juliet de Chair and the Trustees
of Olive, Countess Fitzwilliam's
Chattels Settlement

George Calvert (1578/1579–1632) was
a Yorkshire gentleman, pioneer, and
close friend and political associate of
the future Earl of Strafford, for whom
this picture was painted. He was
Secretary of State from 1619 to 1625,
and was created Lord Baltimore in
1625. He became a Roman Catholic
and received from Charles I in 1632 the
grant of the colony of Maryland, which
was to be established by Catholics. He
had lived earlier in Newfoundland, and
had originally asked the king for a
grant of land north of the James River;
eventually he was granted the unsettled
land between the Potomac and the
boundary of New England. After his
death, authority over the new colony
passed to his son, Cecilius, in whose
time it was christened Maryland (see
Nye and Morpurgo 1955). There is a
copy of this picture and a series of
portraits of his descendants in the
Baltimore Museum.

This is one of the painter's master-
pieces, in which his essentially Dutch
richness of texture, fine handling of
detail, sympathetic characterization,
and solidity in modeling are combined
with a noble simplicity and elegance.
The standard accessories of the Jacobean
court portrait—the parted curtains
and the richly draped table—are
treated with a lucid sense of design and
the whole suffused in an unusually
tangible atmosphere.

This and Mytens' portrait of the
3rd Marquess of Hamilton, painted two
years later, are the finest full-lengths
painted of Englishmen before Van
Dyck's arrival in 1632. In Northern
Europe in the late 1620s it would be
hard to find portraits of greater
distinction or authority. The closest
parallels to this portrait with its fine,
swinging movement and austerely
silhouetted black figure, are possibly
Velazquez' earliest portrait of Philip IV
and his slightly later portrait of the
Infante Don Carlos (both in the Prado).
Mytens' finest works could certainly
hang beside the court portraits of
Philippe de Champaigne (1602–1674)
and not suffer in comparison. This
portrait is included in the list attached
to the will of Strafford's son, the
2nd Earl, of pictures that were to
remain at Wentworth Woodhouse as
heirlooms "with the House and the
Estate . . . My Lord Baltimore at length
a great friend of my ffathers." O.N.M.

Provenance: See no. 216
Literature: Waterhouse 1953, 37;
Whinney and Millar 1957, 63; Ter
Kuile 1969, 14–16, and 47, no. 5
Exhibitions: London, RA 1938 (52)

Sir Thomas Hanmer (1612–1678) was a page, and later Cup-bearer at the court of Charles I. A distinguished horticulturist and a collector of medals, he also made a copy of Norgate's treatise on miniature painting and was the brother-in-law of Thomas Baker, subject of a famous bust by Bernini. He probably sat for Van Dyck around 1637. In the autumn of 1638 he and his brother were granted a pass to travel for three years. Van Dyck's portrait of him passed into the possession of Lord Newport (the direct ancestor of the present owner), in whose collection it was seen by the diarist John Evelyn on 14 January 1685: "some excellent pictures, especially that of Sir Tho: Hanmers of V: Dyke, one of the best he ever painted."

In its restrained color and noble character this portrait illustrates Van Dyck's profound admiration for the work of the great Venetians, particularly Titian. The marvelous sense of poise and latent movement makes it perhaps the male equivalent of no. 64, although the touch is a shade more forceful it remains intensely nervous. Van Dyck never painted a more brilliant passage than that comprising the bent wrist, gloves, and shirt against the black of the costume. There is a slight pentimento in the lower left edge of the doublet. This portrait of Sir Thomas Hanmer is frequently compared to Cornelius Johnson's likeness of the same sitter, painted in 1631, in order to demonstrate the transforming power of Van Dyck's genius. O.N.M.

Provenance: By descent at Weston Park
Literature: Brown 1982, 211–212
Exhibitions: London, RA 1960 (5); London, Agnew 1968 (54); London, Tate 1972–1973 (103); London, NPG 1982–1983 (37)

63

SIR THOMAS HANMER c.1637
Sir Anthony van Dyck 1599–1641
oil on canvas
110.5 × 88.3 ($43\frac{1}{2}$ × $34\frac{3}{4}$)

Weston Park
The Earl of Bradford

64

ANNE CARR, COUNTESS OF BEDFORD c.1638
Sir Anthony van Dyck 1599–1641
oil on canvas
136.2 × 109.9 (53 × 43¼)

Petworth House
The Lord Egremont

Anne Carr (1615–1684) was the daughter of one of James I's favorites, Robert Carr, Earl of Somerset, and the infamous Countess of Essex. She was born while her mother was imprisoned in the Tower of London. On 11 July 1637 she married William, Lord Russell, later 5th Earl, and eventually 1st Duke, of Bedford.

This is one of the set of "four Countesses" whose portraits were painted as a series by Van Dyck. They were commissioned by the 10th Earl of Northumberland, for whom Van Dyck also painted a number of other portraits of his family and friends. The "four Countesses" particularly influenced Lely, who painted his famous series of "Beauties" for Charles II after the Restoration and also made additions to Northumberland's series after Van Dyck's death. Some of the portraits bought by the earl are conventional products of Van Dyck's "Shop of Beauty," but this picture is particularly carefully painted, with a sense of movement in the figures, draperies, and foliage with the amusing asymmetry in the face that produces a remarkable impression of movement briefly arrested. It is immeasurably more sophisticated than anything seen earlier in England and not to be seen again until the age of Watteau. Van Dyck's hurried preliminary drawing for the portrait is in the British Museum.

When the young Lord Russell had returned from his travels no less than three of the young women painted for Northumberland were mentioned as "ripe for marriage; it is thought he will settle upon one of them" The countess sat on a number of occasions for Van Dyck and her husband was painted in the magnificent double full-length (at Althorp) with Lord Digby.

The pictures were hanging at Northumberland House in London in 1671 and after the death of the 11th Earl in 1670 passed by descent, with many other Percy portraits, and Petworth House, to his daughter, the Duchess of Somerset. They have hung in the White and Gold Room at Petworth since the time of her grandson the 2nd Earl of Egremont, and, indeed, the outstanding rococo decoration of this room must have been conceived by the elder Matthew Brettingham as a suitable setting for them. In the time of the 3rd Earl of Egremont these portraits were deeply admired by artists who were patronized by the earl. They appear in Turner's drawings of interiors at Petworth; B.R. Haydon called this picture "the finest Vandyke in the world"; and the portrait of Anne Carr showed C.R. Leslie "the height to which high-bred grace and

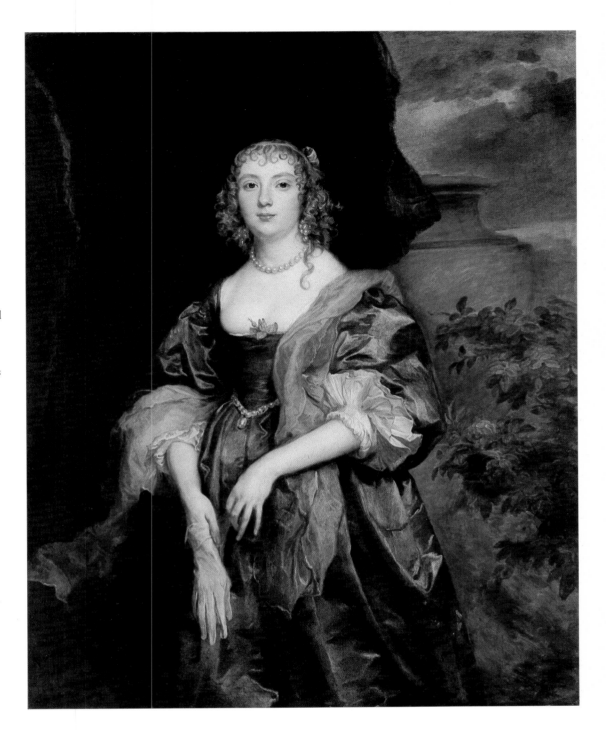

loveliness could be carried in portraiture" (Taylor 1860, 1:xxxvi, 2:146).

The beautifully carved frames of the Van Dycks at Petworth were made for the 6th Duke of Somerset by Parry Walton in 1689–1690. O.N.M.

Exhibitions: London, RA 1953–1954 (442); London, NPG 1982–1983 (41)

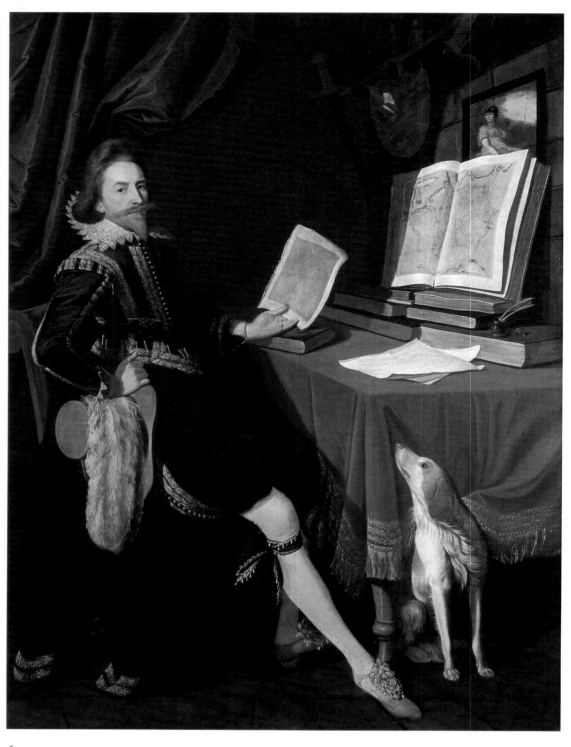

Sir Nathaniel Bacon of Culford (1585–1627) was a grandson of Sir Nicholas, the Lord Keeper, builder of the Tudor house at Gorhambury. His father, Nicholas, was half-brother to Francis and Anthony Bacon. Sir Nathaniel was the most accomplished English amateur painter of the century and he made important experiments with varnishes and pigments. In his *Compleat Gentleman* of 1622 Henry Peacham wrote that among England's noble amateurs none surpassed "Master Nathaniel Bacon of Broom in Suffolk . . . not inferior in my judgment to our skilfullest Masters."

Sir Nathaniel's surviving work consists chiefly of portraits of himself and members of his family, but the 1659 inventory of pictures at Culford Hall includes a number of family portraits in the "Inward Parlour" and, on the Great Stairs and in the Gallery, "Ten Great peeces in Wainscoate of fish and fowl &c done by Sʳ. Nath: Bacon." Apart from this picture the most important work attributed to Sir Nathaniel is *The Cook-Maid*, also at Gorhambury, a work virtually indistinguishable in detail from that of contemporary Dutch still-life painting. It should be noted that a work formerly generally accepted as Bacon's has recently been found to be signed by Jan Bloemaert. Bacon was on his way to the Low Countries in 1613. His portraits are close in design to those of other English painters who worked in the same manner; the quality of his brushwork is fundamentally Dutch. The crisp quality of his drawing, his liking for clear-cut shadows, and his individual tonality suggest that, as well as knowing the painters of The Hague, he may have looked at a painter such as Wtewael in Utrecht.

This is the artist's only known full-length portrait. It is remarkably accomplished and was presumably painted before he was created Knight of the Bath at the coronation of Charles I in 1625. The sitter's interests and pursuits—those of the *Compleat Gentleman* himself—are carefully displayed in the still life on the table: a pile of books, writing materials, a drawing in his hand, and an atlas open at a map of Northern Europe; hanging on the wall, a small picture of Minerva, and the artist's palette and sword.
Sir Nathaniel was clearly a man of cultivated tastes, "a great lover of all good arts and learning and knew good literature." The Countess of Bedford asked for his help with her garden and pictures: "Whos judgement is so extraordinary good as I know noone can tell better what is worth the haveing" (King 1983, 158–159).

O.N.M.

Provenance: The artist's daughter, Anne, married to Sir Harbottle Grimston, and by descent at Gorhambury
Literature: Waterhouse 1953, 41; Whinney and Millar 1957, 82–83; King 1983, 158–159
Exhibitions: London, RA 1956–1957 (41); London, Tate 1972–1973 (27)

65

PORTRAIT OF THE ARTIST c. 1618–1620
Sir Nathaniel Bacon 1585–1627
oil on canvas
205.7 × 153.6 (81¼ × 60½)

Gorhambury
The Earl of Verulam

LORD JOHN STUART WITH HIS BROTHER,
LORD BERNARD STUART c.1639
Sir Anthony van Dyck 1599–1641
oil on canvas
237.5 × 146.1 (93$\frac{1}{2}$ × 57$\frac{1}{2}$)

Broadlands
Lady Pamela Hicks

The subjects of this portrait were the younger sons of the 3rd Duke
of Lennox, brothers of the 4th Duke who became 1st Duke of
Richmond. Of four brothers, all of them painted by Van Dyck,
three were killed while fighting for the king in the Civil War. Lord
John (1621–1644), who died of wounds received at the battle of
Cheriton, was "of a more choleric and rough nature than other
branches of that illustrious and princely family, [and] was not
delighted with the softness of the Court . . . [but] so generally
beloved that he could not but be very generally lamented"
(Macray 1888, 3:338). His younger brother Bernard (1622–1645),
later Earl of Lichfield, who fell at Rowton Heath in command
of the King's Troop, was "a very faultless young man . . . of a
spirit and courage invincible; whose loss . . . the King bore . . .
with extraordinary grief" (Macray 1888, 4:115–116). This
picture must have been painted before the young men set off early
in 1639 for a three-year tour of the continent, and was presumably
painted for their elder brother, the duke.

No picture illustrates more clearly the revolution Van Dyck
brought about in the development of British portraiture. Infinitely
more subtle and complex in its composition than even the finest of
Mytens' portraits, it reveals Van Dyck's knowledge of Renaissance
design, that is, in the stance of the figure of the young man on the
right, which seems to be a reminiscence of Correggio. The sheer
beauty of its color (the silvery tone above all), the fluent handling,
spontaneous touch, and the sense of movement at every point—
note especially the left hand bent back on the hip and the fall of the
glove—fascinated Gainsborough, who painted both the owner
of the picture, the 4th Earl of Darnley, in 1785 and the copy of this
picture, which is now in the Saint Louis Art Museum. Van Dyck's
sense of rhythm, his marvelous combination of tension and ease,
and his air of relaxed authority and grandeur are perhaps at their
most impressive in such designs as these where the two figures are
so subtly linked—for example, in the double portrait at Althorp,
passages in the Wilton family group, or in the modello for the
Garter Procession at Belvoir Castle. There is a drawing in the British
Museum for part of the figure on the right. O.N.M.

Provenance: At Cobham Hall at the time of the death in 1672 of the
last duke of that creation; by descent to the 1st Countess of
Darnley; subsequently in the possession (at Cobham) of the Earls of
Darnley; thereafter with Sir George Donaldson, Sir Ernest Cassell,
and the Countess Mountbatten of Burma
Literature: Gluck 1931, no. 459; Brown 1982, 192, 225–229
Exhibitions: London, RA 1953–1954 (139); London, NPG
1982–1983 (44)

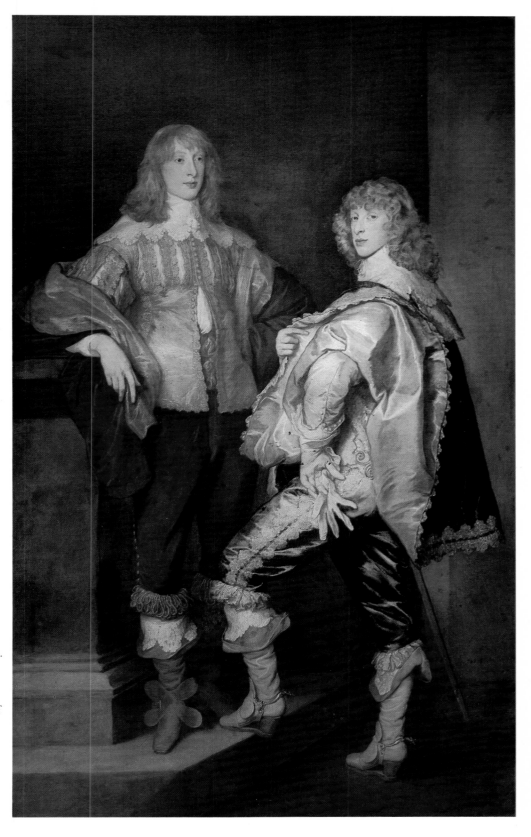

67

CHARLES I c.1635
Hubert Le Sueur c.1585–1658
gilt bronze, on touchstone pedestal
87.6 (34½) high

Stourhead
The National Trust (Hoare Collection)

The authorship and royal commissioning of the bust are proven by an entry in Abraham van der Doort's inventory (c. 1638) of the possessions of Charles I (1600–1649): "Done by the frenchman Lusheere. . .Y.owne Picture cast in brasse wth a helmett upon his head whereon a dragon (after the Auncient Roman fasshion), And a scarfe about the shouldrs soe bigg as the life beeing onely a buske, set upon a—Peddistall made of black Tutchstone" (. . . 2f II If 9, cited in Millar 1960, 70, no. 1). The gilding, strikingly revealed when the bust was cleaned at the Victoria and Albert Museum in 1978, is of considerable age, but may not be contemporary with the casting. Either Van der Doort mistook the color for polished brass, or it was added later, perhaps after the Restoration.

The bust, which was set in a window embrasure in the Chair Room of Whitehall Palace, does not appear specifically in the records of sales under the Commonwealth and was not mentioned until the early eighteenth century when George Vertue described Stourhead. A pen and wash sketch of it was made by Rysbrack, presumably in 1733 when he was employed on sculpture for the house and gardens. The image of Charles I as a helmeted warrior is unique in Le Sueur's oeuvre and probably combines a standard Renaissance reference to Mars with one to Saint George, patron saint of England, for the crest is in the shape of a snarling dragon. The image is derived from a marble bust of Charles' father-in-law, Henri IV of France, in the palace of Fontainebleau.

Le Sueur was the first of Charles' court sculptors to have been recruited abroad. Initially one of the sculptors employed in the Louvre by the French crown, Le Sueur seems to have been brought to England with Henrietta Maria, perhaps as part of a cultural dowry. He specialized in casting bronze, a craft that had hardly existed as an art form in Tudor England since the departure of Pietro Torrigiano over a century earlier. It had been greatly popularized throughout Europe in the last quarter of the sixteenth century by Giambologna, many of whose statuettes the king owned. James I and Charles I consistently failed to recruit Pietro Tacca, Giambologna's successor as court-sculptor to the Medici, and had to make do with the less distinguished Frenchman. In 1635, a far more talented sculptor from Italy, Francesco Fanelli, arrived in London and outstripped Le Sueur in his proficiency with bronze-casting. By 1636 the king had acquired a portrait bust of himself by Bernini and Le Sueur's shortcomings must have become painfully apparent. C.A.

Provenance: From the collection of King Charles I at Whitehall Palace (c.1636); Henry Hoare II of Stourhead (1705–1785), and by descent to Sir Henry Hoare, 6th Bart.; given with the major contents of Stourhead to the National Trust in 1946
Literature: Avery 1979; Avery 1982, 184–185, no. 33
Exhibitions: London, Tate 1972 (232); Brussels 1973 (78)

68

CATHERINE BRUCE, COUNTESS OF DYSART c.1635
Hubert Le Sueur c.1585–1658
gilt bronze
80 (31½) high

Ham House
The Trustees of the Victoria and Albert Museum

A daughter of Colonel Norman Bruce of Clackmannan, Catherine Bruce (d. 1649) became Lady-in-Waiting to Queen Henrietta Maria, and married the 1st Earl of Dysart before 1636. The bronze bust is undocumented but may be attributed firmly to Charles I's court sculptor, Hubert Le Sueur, by comparison with his other recorded works. Its morphology and style recall those of the female mourners on the tombs of the Duke of Richmond and Lennox and of the Duke of Buckingham (c.1634) in Westminster Abbey (Avery 1982, pls. 40b–c, 46d), and those of the Diana and mermaids on the fountain from Somerset House, now in Bushy Park, Middlesex (which appears now to be the work of Le Sueur and not of Fanelli;

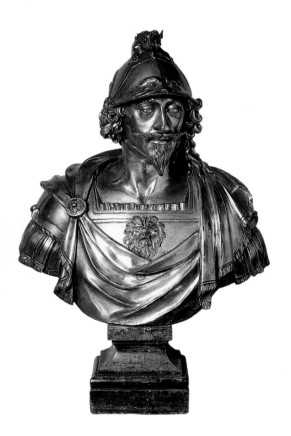

see Avery 1982, pls. 52b, 53a). The mouth, nose, and eyes also relate to Le Sueur's bust of Lady Ann Cottington in Westminster Abbey (Avery 1982, pls. 60d, 61c). The inclusion of the left arm shows Le Sueur attempting to follow Italian baroque precedents in enlarging the scope of a bust to rival painted likenesses.

The bust, which was possibly made to celebrate the sitter's marriage and subsequent elevation to the peerage, is an interesting example of a portrait made for display inside a house and not on a tomb. "One Brasse head over ye Chimney" is recorded in the White Closet in the Ham inventory of 1677, further identified as "one brasse head of her Grace's mother" in 1683 (Thornton and Tomlin 1980, 79). The room was one of those added by the architect William Samwell for the Duke and Duchess of Lauderdale in 1672–1675, and it is likely that the corner chimney-piece was specially designed at that time with a platform for the bust to stand on. The duchess (who was also Countess of Dysart in her own right) used this as her own dressing room, and it is not surprising that she should wish to keep an object of such sentimental value here. The bust was bronzed at some later date, probably in the nineteenth century, and its gilding (perhaps also dating from the 1670s) has only recently been revealed. C.A.

Provenance: Ham House, after death of the Duchess of Lauderdale in 1696, by descent to the Earls of Dysart until 1949, when given by Sir Lyonel Tollemache, 5th Bart., and Mr. Cecil Tollemache to The National Trust and the Victoria and Albert Museum, with the house and its other principal contents in 1949
Literature: Avery 1982
Exhibitions: London, RA 1956–1957 (138); Brussels 1973 (79)

69

JOHN; 1ST LORD BYRON c.1643
William Dobson 1611–1646
oil on canvas
142 × 120 (55¾ × 47)

Tabley House
Victoria University of Manchester
(Tabley Collection)

John, 1st Lord Byron (d. 1652), had as a young man fought in the Low Countries. He was a devoted and courageous royalist cavalry commander in the Civil War. For a short time he was Governor of Oxford, where Dobson had set up a studio in which he painted portraits of the king, his two eldest sons, and a number of his supporters. Byron was involved in many of the principal actions of the war and commanded the royalist forces in his native Lancashire. He later joined the court of the exiled Queen Henrietta Maria in Paris and became governor to the young Duke of York. His wife—many years younger than he—is reputed to have been one of Charles II's mistresses while in exile.

The formidable scar on Byron's face was probably the result of a wound received from a pole-axe or halberd in a night attack at Burford in January 1643. This portrait was probably painted soon after that event. It is one of Dobson's most arresting and dashingly painted pictures. The figure has been cut off at a rather awkward point and thrust into the forefront of the composition and the background is rather uncomfortably crowded: an idiosyncratic example of English baroque portraiture; in short.

Although the use of charger and page is a motif that Van Dyck had used, and though the pose of the sitter may have been influenced by one of his portraits of the Earl of Strafford, the mood here is essentially unlike that of Van Dyck. The twisted (or Salomonic) columns "entered the European artistic vocabulary" (in Dr. Malcolm Rogers' phrase) by way of *The Healing of the Paralyzed Man*, one of the Raphael cartoons (now on loan to the Victoria and Albert Museum) that were acquired by Charles I before his accession—and in England Van Dyck had used them even earlier.

The combination here of Salomonic columns and heraldic curtain is, as Dr. Rogers points out, almost certainly taken from Rubens' portrait, in Munich, of the Countess of Arundel with members of her staff. It is possible that Dobson has used the columns as symbols of the legitimacy of the royal cause (see no. 51). The columns and the curtain may in fact have been painted over a background of uninterrupted sky; the horse's mane is painted over the moldings of the nearest column; and there is an obvious change in the position of the baton. O.N.M.

Provenance: The sitter's brother-in-law, Sir Peter Leicester; by descent to Lt.-Col. J.L.B. Leicester-Warren, by whom bequeathed to the University of Manchester
Literature: Whinney and Millar 1957, 87
Exhibitions: London, NPG 1983–1984 (11)

3: Anglo-Dutch Taste and Restoration Opulence

The Civil War and Cromwell's Protectorate put an end to the building of great courtier houses like Hatfield, Audley End, and Wilton, with their spreading wings and courtyards, and the few houses built during the Commonwealth were relatively small in scale. However, the restoration of Charles II in 1660 brought a resurgence of interest in the arts and in architecture, especially stimulated by the reconstruction of London after the Great Fire of 1666. Compact "double-pile" houses of the type made popular by Roger Pratt, Hugh May, and the Dutch-born William Winde were the order of the day. Their paneled rooms, painted or grained, with marble chimneypieces and lime-washed plaster-work ceilings, sometimes decorated with garlands of fruit and flowers, give a sense of solid comfort and well-being very different from the great chambers and long galleries of Elizabethan and Jacobean "prodigy houses."

Despite constant naval wars with Holland and an uneasy peace with France culminating in the secret treaty of Dover, the cultural influence of the former nation was paramount. Flemish and Dutch artists particularly dominated the scene: the seascapes of the Van de Veldes were appreciated by those whose growing wealth was based on maritime power and overseas trade; the *trompe l'oeils* of Leemans and Hoogstraeten, and the carvings of Grinling Gibbons, fed a new appetite for baroque illusionism, allied to the scientific experiments of the newly founded Royal Society; while the country house view pictures of Danckerts, Griffier, and Siberechts show a sense of pride in the neat compartmented gardens and landscapes of Restoration England.

In the field of portraiture, Lely and Soest, Huysmans and Wissing, brought a flamboyant, sometimes even blasphemous, note to their depiction of the worldly courtiers and voluptuous beauties of Charles II's court. Sir Godfrey Kneller, who succeeded Lely as the most fashionable painter of his time, amassed such a fortune that he was able to build his own country house, Kneller Hall in Hertfordshire. The achievements of these foreigners were matched by only two native portrait painters, the Scotsman John Michael Wright and the miniaturist Samuel Cooper, though Francis Barlow produced charming pictures of birds and animals in the manner of Hondecoeter.

Dutch influence can also be seen in the marquetry furniture and tall caned chairs (or "back-stools") of the Restoration period, sometimes japanned in imitation of oriental lacquer, which was now being imported by the English and Dutch East India Companies. Blue-and-white Chinese porcelain was also copied by the Delft potters, whose wonderfully elaborate tulip vases and orange tree pots were a response to a new passion for botanical specimens, and whose wares were in turn imitated by English factories at Lambeth and Bristol.

French furniture is known to have been imported by the royal household, and by ambassadors to Louis XIV, like Ralph Montagu. But it is significant that the earliest recorded pieces of English Boulle were the work of another craftsman of Dutch or Flemish ancestry, Gerrit Jensen, whose work in this medium and in "seaweed" marquetry can be seen in many late seventeenth-century country houses.

A VIEW DOWN A CORRIDOR 1662
Samuel van Hoogstraeten 1627–1678
oil on canvas
264 × 136.5 (104 × 53¾)
inscribed, *S.V. Hoogstrat. . . ./1662*
(also dated *1662* on the map)

Dyrham Park
The National Trust (Blathwayt
Collection)

"But above all things, I do the most
admire his piece of perspective
especially, he opening the closet door
and there I saw that there is nothing
but only a plain picture hung upon the
wall." So this picture was described by
Samuel Pepys when he visited the house
of Thomas Povey in Lincoln's Inn
Fields, London, 26 January 1663. It was
painted as an illusionistic extension of
the space in which the spectator stood
and must have been the more astonishing
to the visitor to Lincoln's Inn who
would find himself confronted, on
opening the door of the closet in "the
low parler," with an unmistakably
Dutch scene. This painting is
characteristic of the illusionistic
compositions by which Hoogstraeten
(who also painted portraits) gained his
reputation in London, where he worked
from 1662 to 1667. Other Dutch artists
were preoccupied at this period with
differing forms of illusionism, perhaps
due to the influence of Carel Fabritius,
with whom Hoogstraeten was a fellow
pupil in Rembrandt's studio.
Hoogstraeten's interest in optics is
demonstrated by his celebrated
peepshow in the National Gallery,
London.

Thomas Povey (fl. 1633–1685) was
the uncle of William Blathwayt of
Dyrham. He was Treasurer to the
Duke of York in 1660 and he held
various posts connected with revenues
from the colonies. Pepys refers to the
elegance of his taste, his aptitude for
good living, and his financial maladroit-
ness. He praises his house, "so beset
with delicate pictures," his stables
with their Dutch tiles, the excellence of
his food, and his cellar stocked with
bottles (unusual, for wine then was

normally kept in cask). No doubt
Blathwayt's taste was influenced by
that of his uncle and in a deed of sale of
1693 between the two men William
Blathwayt agreed to buy for "£500 of
good English money" a quantity of
books and 112 pictures. Neither the
few pictures preserved at Dyrham today
that can be traced to Povey, nor the
acquisitions of Blathwayt himself, are
indicative of very great fastidiousness.

Dyrham is nevertheless an interesting
collection. At a moment when the arts
in England had slumped, according to
Horace Walpole, and few collections
were being formed, Blathwayt was
buying Dutch pictures by contemporary
artists, albeit minor ones—artists such
as Hondecoeter, Hendrik van Minder-
hourt, Adriaen Gael, and Abraham
Storck—to furnish the house that in
1698 he had commissioned Talman to
build. The opportunity for so doing
was presented to him when as a young
man in 1668 he became secretary to Sir
William Temple at The Hague. His
connection with the Low Countries
continued with his employment as
Secretary of War and later Secretary of
State to William III whom he accom-
panied on his campaigns in Flanders
(1692–1701). With the succession of
Queen Anne his portrait opportunities
came to an end. ST.J.G.

Provenance: Either painted in London or
Holland, the picture was first recorded
in 1663 in the house of Thomas Povey
in London when it was seen by Samuel
Pepys. It passed to Povey's nephew,
William Blathwayt of Dyrham, where
it has remained ever since, though it
was offered at auction in 1765 (William
Blathwayt sale, Thomas Joye,
18 November 1765, lot 25) and was
presumably bought in. Dyrham, with
the majority of its contents, was
acquired by the Ministry of Works in
1956 and transferred to the National
Trust
Literature: Waterhouse 1953, 77–78;
Whinney and Millar 1957, 28
Exhibitions: London, RA 1939 (160);
London, RA 1960 (153)

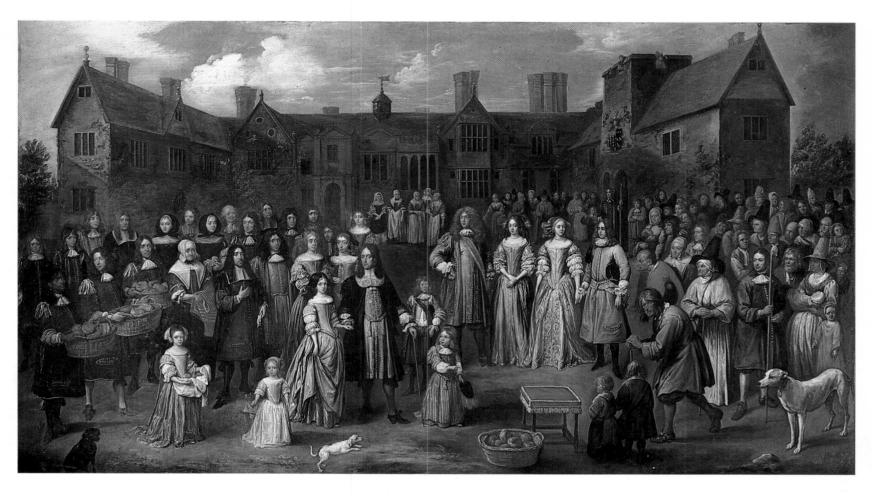

71

THE TICHBORNE DOLE 1670
Gillis van Tilborch c. 1625–c. 1678
oil on canvas
117 × 207 (46 × 81⅜)
signed and dated,
A v TILBORCH . . . 1670

Tichborne Park
Mrs. John Loudon

The scene takes place against the background of the Tudor house at Tichborne, which was demolished at the end of the eighteenth century; the present Tichborne House was built soon after 1803. The Tichborne family are known to have owned land in this part of Hampshire since the early twelfth century; and the present owner is the daughter of the 14th and last Baronet.

Sir Henry Tichborne, 3rd Baronet (d. 1689), who was a loyal supporter of the Stuarts and had been appointed at the Restoration Lieutenant of the New Forest and of the Ordnance, is about to distribute the dole. He is accompanied by members of his family. Lady Tichborne stands behind him and he holds his daughter, Frances, by the hand. The eldest son, Henry, points to the basket of loaves in the foreground. Mary Tichborne, who became a Benedictine nun at Pontoise, carries loaves in her apron. Behind her are the family chaplain, the Rev. Father Robert Hill, and the family nurse, Constantia Atkins. The two women behind her are Lady Tichborne's maid, Mrs. Chitty, and the housekeeper, Mrs. Robinson. The household and domestic staff is grouped on the left of the composition, the tenants and villagers on the right.

The ceremony of the dole, which is still enacted annually at Tichborne, originated long ago. Tradition has it that in the thirteenth century Lady Mabella Tichborne, on her deathbed, asked her husband to grant her the means of setting up a charitable bequest in a dole of bread, which would be distributed to any of the poor who went to Tichborne House on Lady Day to claim it. He agreed to give for this purpose the corn from all the land his wife could crawl round while a brand was burning. In her weakened state Lady Mabella managed to crawl around a field of twenty-three acres still known as "The Crawls."

Little is known of the contacts in England made by the Fleming Van Tilborch, but he was one of a number of lesser painters from the Low Countries who worked in England in the second half of the seventeenth century. In *The Tichborne Dole* he produced a detailed record of the appearance of a great Tudor house, of the family who lived in it, and of those who worked in it or lived in its shadow. It is of unique importance as a document of social history and as an illustration of the costumes worn at different levels in the social hierarchy of the English countryside in this period. Scenes of the distribution of bread are not uncommon in the works of such Flemish genre painters as Gonzales Coques, whose handling and subject matter influenced Tilborch.

O.N.M.

Literature: Whinney and Millar 1957, 279; Legrand 1963, 164; Harris 1979, 9, 40, 43, 52; Roberts and Crockford [n.d.]
Exhibitions: London, RA 1960–1961 (287)

Related Works: Thomas Watson, mezzotint, before 1769

Provenance: Probably de Pester, his sale, London, 1756, 1st day, lot 18, "A Storm Van der Veld," bought for 51 gns by Reynolds (Houlditch MSS, Victoria and Albert Museum, S.I, I, 72); certainly owned by Sir Joshua Reynolds by 1769; acquired by the 2nd Earl of Warwick, in the State Dressing Room at Warwick in 1815, and by descent to the 7th Earl of Warwick, his sale, Christie's, 24 May 1968, lot 78, where bought in at 200 gns; at Warwick until 1978 and on loan from the present earl to Warwick Castle since 1980

Literature: This entry draws extensively on Michael Robinson's draft entry for his catalogue of the oeuvre of the Van de Veldes, which is gratefully acknowledged; Field 1815, 197; Dugdale 1817, 406; Spicer 1844, 35; Cooke 1846; David Cordingly in London, NMM 1982

Exhibitions: London, NMM 1982 (126)

73

CALM: A STATES YACHT NEAR THE
SHORE IN LOW WATER c.1672
Willem van de Velde the younger
1633–1707
oil on canvas
63.5 × 81.2 (25 × 32)

Gosford
The Earl of Wemyss and March, KT

On the right is a States yacht at anchor with her spritsail set, flying the Dutch flag, and in front of this a barge with a trumpeter and officers; on the left is the end of a pier, off which are a *weyschuit*, a small, open vessel originally used on farms, but later on estuaries with her sail lowered; a *kaag* (a clinker-built vessel with a straight rigging) with her spritsail half lowered; and a *smalschip* (a sprit-rigged transport vessel): the sails of other vessels can be seen beyond the pier, and in the distance are other vessels. Datable about 1672, the picture is of exceptional quality and by the younger Van de Velde through-out, although the figures are worthy of his brother Adriaen who died in January 1672.

72

AN ENGLISH SHIP RUNNING ONTO
ROCKS IN A GALE c.1690
Willem van de Velde the younger
1633–1707
oil on canvas
62.2 × 77.5 (24½ × 30½)

Warwick Castle
The Earl of Warwick

This dramatic picture is one of a number of shipwrecks painted by the younger Van de Velde in the latter part of his long sojourn in England, and probably dates from about 1690. Van de Velde continued to paint and draw compositions of this kind until the end of his life and a number of the painter's pupils and followers in England would copy such works.

The picture is almost certainly the one acquired by Sir Joshua Reynolds at the sale of Mr. de Pester in 1756. It was engraved by Watson when in his possession before 1769, the year of his knighthood, as is established by the caption "From an Original Picture by Vandervelde, in the Possession of Mr. Reynolds." Reynolds may have had a particular reason for acquiring a work of this kind, as a shipwreck scene of his own, formerly in the possession of descendants of his early friend Dr. Mudge (and most recently sold at Christie's, New York, 7 December 1977, lot 102) is said to have been painted by Reynolds at Mudge's behest.

The picture cannot be identified in any of Sir Joshua's posthumous sales and is therefore likely to have been sold during his lifetime. Reynolds certainly knew George Greville, 2nd Earl of Warwick (1746–1816), at whose sale on 22 March 1793 "A Sea Storm" by the artist was bought in. Michael Robinson considers that this was the *Squall*, now at Belfast.

In addition to these two pictures the 2nd Earl also bought a large group of drawings by Van de Velde, which were sold in 1896. The picture is not in the 1809 inventory of Warwick Castle, but may then have been kept in London. Field considered it "superlatively excellent" and, no doubt recording a family tradition, stated that this was "a favourite picture" of Reynolds. F.R.

THE YACHT "MARY" AND OTHER
VESSELS UNDER SAIL OFF AMSTERDAM
1661
Willem van de Velde the younger
1633–1707 and Adriaen Van de Velde
1636–1672
oil on canvas
96.5 × 156.2 (38 × 61½)
signed on ensign of yacht on the
extreme right, *A V V 1661 and
W.V. Velde.*

The Manor House, Stanton Harcourt
The Hon. Mrs. Gascoigne

In the central foreground a state barge
of the admiralty at Amsterdam is under
oars. The yacht "Mary," presented by
the City of Amsterdam to King Charles
II in 1660, identifiable by the union
flags, ensign, and jacks and her figure-
head of a unicorn, is in the center
middle-distance. Sailing with the
"Mary" are, from the right, two
boeiers (rounded, deep-sided, sprit-
rigged vessels), a transom-sterned
bezan yacht (with fore and aft main-
sail), and behind her two bezan-rigged
yachts and a boeier; the large yacht
seen beyond these at center left flies
the ensign of the East India Company.
On the extreme right is a point of land
on the northeast bank of the harbor
basin known as the "Y," and in the
distance is seen the waterfront of
Amsterdam and three of the churches
of the city. Lying offshore are other
Dutch and English vessels.

King Charles II was restored to the
throne in May 1660 and on the 28th
of that month the city council of
Amsterdam ordered that negotiations
should be begun with the Admiralty to
purchase the yacht for presentation to
him. Converted to a standing gaff rig,
she was ready to sail on 12 August and
arrived in the Thames on the 15th.
Samuel Pepys records the king's
departure from Whitehall on that day
"to see a Dutch pleasure boat" (Latham
1970, 1:222). A number of drawings
and pictures of the "Mary" by Van de
Velde survive but none corresponds
exactly with this composition. The
elder Van de Velde was to sail on board
the "Mary," accompanying William of
Orange and Princess Mary to Holland

Although this picture only came to
Gosford in the early nineteenth century,
it is known to have been in England
before 1727. The younger Van de Velde
arrived in London with his father in the
winter of 1672–1673. By March 1673
the artist's four seascapes were being
fitted into the paneling of the Duke of
Lauderdale's bedchamber at Ham
House, where they were considered
appropriately masculine in character—
as opposed to Barlow's bird pictures in
the duchess' room (Thornton and
Tomlin 1980, 61–62). Father and son
continued to be based in London until
their deaths in 1693 and 1707 respec-
tively, and although few of their other
commissions still remain in situ, they
established a tradition of English
marine painting that was to be an
important aspect of country house

taste, particularly in those collections
formed by families with naval back-
grounds like the Herveys of Ickworth
and the Hyde-Parkers of Melford.

This picture was acquired in the
eighteenth century by the Moorheads
of Herbertshire who owned a number
of Van de Veldes. The 8th Earl of
Wemyss, who bought it in 1835,
belonged to a family with an unusual
record of collecting and whose
acquisitions represent many facets of
eighteenth- and nineteenth-century
taste. F.R.

Provenance: Possibly Thomas Coke of
Melbourne Hall, Derbyshire; his sale,
London, 19 February 1727, lot 25, or
20 February, lot 100 (the inscription
on the old stretcher recovered in 1948
reads "A Calm by ye Best Vandevelde

1727—cost £23"); acquired by the
Moorhead family whose collection is
stated in the catalogue to have been "in
the possession of the Family upwards of
a century"; by descent to W. Moorhead
of Herbertshire Castle, Stirlingshire;
his sale Tait, Edinburgh, 23 January
1835, lot 23, as a "Sea Piece, Numerous
fishing Boats, Sloops and Figures in a
Calm"; bought for 145 gns by Francis
Charteris, 8th Earl of Wemyss (1772–
1853); and by descent
Literature: This writer gratefully
acknowledges the use of Michael
Robinson's draft entry for his catalogue
of the pictures of the Van de Veldes;
Smith 1829–1842, 6:394, no. 259;
Waagen 1857, 438; Gosford 1948,
no. 238
Exhibitions: London, RA 1889 (75)

CABINET ON STAND C. 1670
English
walnut and other woods, with
needlework panels
133 × 78.5 × 45.5 (52¼ × 31 × 18)

Groombridge Place
Mrs. R. Newton

The cabinet on stand was a form of
furniture hardly known in England
before the Restoration. The diarist
John Evelyn acquired two made of
ebony in Paris during the Common-
wealth, but it was primarily in the Low
Countries, where many Royalists spent
enforced periods of exile, that the
English acquired a taste for elaborate
marquetry and veneered cabinets like
those seen in the paintings of Vermeer
and De Hooch. Whereas the interiors of
Flemish examples were often decorated
with paintings of biblical and allegorical
scenes by artists like the Van
Franckens, their English counterparts
occasionally attempted the same effect
in embroidery, a field in which
professionals and amateurs alike had
excelled since the famous *opus
anglicanum* of the Middle Ages.

The Groombridge Place cabinet
show this technique at its most
ambitious, with the embroidered panels
on the ends of the drawers and on the
backs of the cupboard doors and lid in
wonderfully fresh and unfaded condition.
The central panel represents the
finding of Moses, flanked by the Four
Elements, with the rape of Europa, and
Narcissus at the fountain below. A
shepherd and shepherdess appear on
the drawers above, and a small panel
between them is embroidered with the
coat of arms of the Haynes family. The
inside of the lid has a large rectangular
panel formerly identified as Judith and
Holofernes, but perhaps more likely to
represent Salome appearing before
Herod with the head of Saint John the
Baptist. On the insides of the doors
half-length figures of a man wearing a
silver helmet and a woman wearing a
gilt crown probably represent Charles
II and his Queen Catherine of Braganza.

The embroidery is almost entirely in
silk-wrapped metal purl, couched down
on a satin ground, with details in

in 1677, an occasion he commemorated
in a series of fifty-six drawings.

The signatures on the ensign of the
yacht on the extreme right, which
suggest that the artists may well have
sailed in it, establish that the picture is
a work of collaboration. Despite his
brilliance as a landscape and figure
painter, Adriaen van de Velde lacked
his brother's mastery at depicting
ships. That this picture is largely by
him is suggested by minor errors in the
drawing of a number of the vessels.
Thus the yacht sailing away from the
land on the right is dipping her head
into the water and the same fault
appears in a transom-sterned yacht in
the left background; of the boeiers with
white flags on the right, one is too
large, while that which partly blocks
the view of the "Mary" is too small;
the Admiralty barge also appears to be
running down the boat on its starboard
bow. These and other minor errors no
doubt resulted from Adriaen's reliance
on drawings by his father, Willem van
de Velde I. His brother Willem the
younger painted most of the ships in
the background and also probably the
sky.

That the picture was owned by
Simon, 1st Earl Harcourt (1714–1777),
is established by a reference in an
account of 1761 for "Work done . . . for
Newnham House since Octr 27th 1758,
from John Adair" (Harcourt MSS,
Bodleian Library). Adair was not only
responsible for the carving, joinery, and
gilding in the house, but also for much
of the furniture and for framing many of
the pictures including this one, which
was unfortunately reframed in the
nineteenth century.

In 1806 the picture was attributed to
the elder Van de Velde and thought to
represent the embarkation of King
Charles II at Scheveningen, a subject of
particular interest to the 1st Earl who
had attended the future wife of King
George III, Princess Charlotte of
Mecklenburg-Strelitz, on her voyage to
England in 1761. Waagen accepted the
identification and considered the picture
"more remarkable for its subject than
its beauty, as the numerous sails repeat
the same lines too often." F.R.

Provenance: In the possession of the
1st Earl Harcourt by 1758–1761; by
descent at Nuneham Courtenay until
taken to Stanton Harcourt in 1948 by
the 2nd Viscount Harcourt, father of
the present owner
Literature: This entry draws extensively
on Michael Robinson's draft for his
catalogue of the pictures of the
Van de Veldes, which is gratefully
acknowledged; [Harcourt] 1797;
[Harcourt] 1806, 23; Britton
1801–1818, 12: part 2, 276; Neale 1820,
vol.3: under no. 62; Waagen 1857, 350;
Harcourt 1880–1905, 3:235
Exhibitions: London, NMM 1982 (24)

colored silks and linen thread mainly in detached buttonhole, stem, and satin stitches. Seed pearls, coral, and loops of silk-wrapped parchment (for the wreaths) are also used as ornamentation. A bead-embroidered jewel casket in the Victoria and Albert Museum, dated 1673, displays very similar features on the front (this and other information for this entry kindly supplied by Miss Santina Levey). Its doors have marquetry ovals repeating the shape of the cartouches inside, in walnut, ebony, and sycamore, while the cornice, veneered with walnut "oysters," is fitted for jewels and lined with its original pink silk. The original "barley-twist" columns of the stand have been renewed.

The cabinet was evidently made for a son or grandson of John Haynes (d.1654), of Copford Hall, Essex, who had been first governor of Connecticut. But its present home in the drawing room at Groombridge Place in Kent, one of the most perfect surviving Restoration "gentry houses," could hardly be more appropriate. Philip Packer, who built the house, was a friend of John Evelyn and the latter records on a visit of 1674 that the old house, "built within a moate in a woody valley . . . [is] now demolish'd, and a new one built in its place." Restored with the greatest sensitivity by Mr. H. Stanford Mountain, who bought it in 1919, Groombridge now contains a collection of Charles II furniture of a quality comparable with its setting, and perfectly in harmony with the series of seventeenth-century Packer family portraits that survive in their original frames. G.J-S.

Provenance: William Haynes, Gloucester House, Highgate; sold Christie's, 1 July 1909, lot 151; with Cecil Partridge 1920; bought by Mr. H. Stanford Mountain, grandfather of the present owner
Literature: DEF 1954, 164, 166, fig. 5; Hill and Cornforth 1966, 45–46, figs. 42, 43

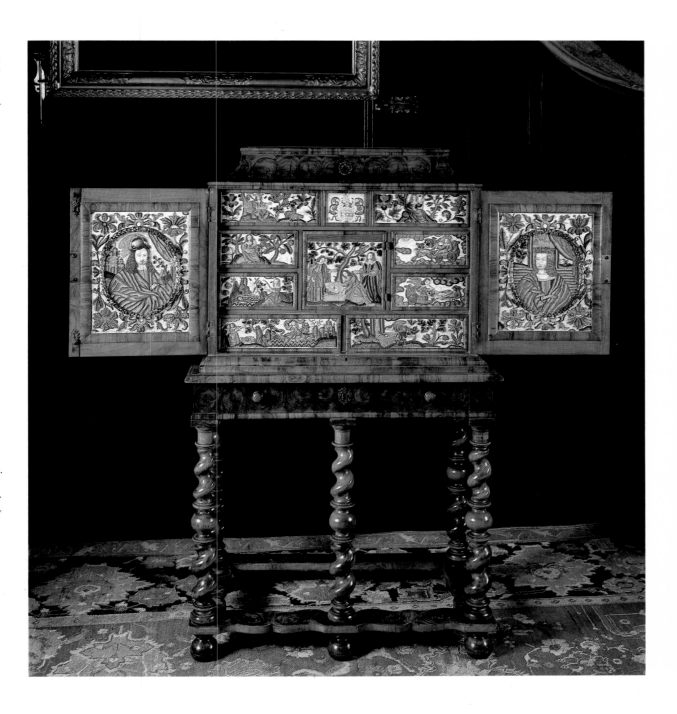

76

OLIVER CROMWELL
Samuel Cooper 1609–1672
watercolor on vellum
7.62 × 5.4 (3 × 2⅛)

Bowhill
The Duke of Buccleuch and
Queensberry, KT

This famous image of the great
Parliamentarian, statesman, and cavalry
commander was left unfinished by
Cooper as were five large studies of
heads in the Royal Collection executed
at a slightly later period. In all these
works it could be claimed that there is
nothing set down on the vellum but
what was applied while Cooper faced
his sitters. Here the collar and shoulders
are merely indicated and a square of
color has been painted around the head
so as to set it off and, presumably,
provide a guide for color in the variants
to be painted from it later. The
unfinished nature of the miniature
enhances the spontaneity of the
likeness. It is indeed one of the most
celebrated British portraits and by far
the most vivid and sympathetic
portrayal of one of the greatest
Englishmen of all time: ". . . his head so
shaped, as you might see it a store-
house and shop both of a vast treasury
of natural parts. . . . A larger soul, I
thinke, hath seldome dwelt in a house
of clay than his was" (John Maidston
in Smith 1918, 142–143). The quality
of this miniature prompted Horace
Walpole's famous claim that "if a glass
could expand Cooper's pictures to the
size of Vandyck's, they would appear
to have been painted for that propor-
tion. If his portrait of Cromwell could
be so enlarged, I don't know but
Vandyck would appear less great by
the comparison" (Wornum ed. 1888,
2:145).

The portrait cannot be closely dated.
Early in November 1650 Cooper had
"some worke for my Lo: General
Cromwell and his family to finish"
(Long 1929, 85). The problem is slightly
confused by Lely's use of Cooper's
image when he devised his quasi-official
portrait of Cromwell at some point
after he had been appointed Lord
Protector on 16 December 1653 (Lely's

signed original is now in the City Art
Gallery, Birmingham). Derivations from
the image could, in due course, depend
on either Cooper's prototype or Lely's
variant; the finished repetitions on a
miniature scale, in which the sitter is
always in armor, confusingly bear
varying dates between 1647 (at
Burghley) and 1657. It may tentatively
be questioned whether any are by
Cooper himself. Versions of the image
of the Protector, in miniature form,
were commissioned for presentation to
foreign diplomats and distinguished
servants of the state. This miniature,
"neither finished nor shaped, being
only the head" was probably in the
possession of Cooper's widow in 1683,
and fifty years later it belonged to
Cromwell's great-grandson, Sir Thomas
Frankland. In about 1862, it was
acquired from his descendants by the
5th Duke of Buccleuch. O.N.M.
Literature: Holme and Kennedy 1917,
15–16; Piper 1958, 27–41; Murdoch
1981, 110–111
Exhibitions: London, RA 1938 (784);
London, RA 1956–1957 (94); London,
Tate 1972 (221); London, NPG 1974
(36 and see also 39, 43)

77

PORTRAIT OF A LADY 1667
Samuel Cooper 1609–1672
watercolor on vellum
8.5 × 6.9 (3⅜ × 2¾)
signed by the artist, *SC* (in monogram)

Bowhill
The Duke of Buccleuch and
Queensberry, KT

This was probably among the miniatures
added to the Buccleuch collection in
the time of the 5th Duke. The identifi-
cation of the sitter with Barbara
Villiers, Duchess of Cleveland, was
suggested by Kennedy but cannot be
supported by comparison with known
portraits of that beautiful, dark-haired

lady. Hundreds of unidentified minia-
tures, however, have been endowed
with the names of the famous of their
time, and this practice continues today
to confuse the study of the subject.
Paradoxically it also debases the true
measure of Cooper's greatness, which
lies in his ability to bring us so
unforgettably into the presence of
ordinary men and women as well as
their illustrious contemporaries. For
miniatures by Cooper that do
represent the duchess, see Foskett
1974, pls. 31, 35, 66. This work is an
outstanding example of Cooper's
mature style. O.N.M.

Literature: Kennedy 1917, 18, 34
Exhibitions: London, NPG 1974 (114)

78

ELIZABETH CECIL, COUNTESS OF
DEVONSHIRE 1642
Samuel Cooper 1609–1672
watercolor on vellum
15.5 × 11.7 (6⅛ × 4⅝)
signed and dated, *Sa: Cooper/pinx. . .*
A⁰ 1642

The Burghley House Collection

A handful of miniatures by Cooper have
correctly been dated slightly earlier on
stylistic grounds, but there is no known
work by him that is signed and dated
before 1642. As in the famous miniature
of Margaret Lemon, Van Dyck's mistress
(Fondation Custodia, Institut Néer-
landais, Paris), probably painted some
five years earlier, the influence of Van
Dyck is strongly felt in the free
handling, rich atmosphere, compara-
tively large scale (for a limning), and
the composition.

The sitter (c. 1620–1689), second
daughter of the 2nd Earl of Salisbury,
married the 3rd Earl of Devonshire on
4 March 1639. She was painted by Van
Dyck and was one of the five "Count-
esses" whose portraits were painted,
as a set, for her brother-in-law the
10th Earl of Northumberland. Of these
the finest is the portrait of the Countess
of Bedford (no. 64); in the portrait of
Lady Devonshire the composition is
not unlike that devised for her here by
Cooper.

The miniature was in the collection
of pictures, drawings, and miniatures
left to her daughter by the Countess of
Devonshire herself. In the Conveyance,
dated 18 April 1690 (Burghley MSS), it
appears as, "A picture of the late Count-
esse of Devonshire by Cooper in
White." O.N.M.

Literature: Foskett 1974, 71, 89
Exhibitions: London, Tate 1972 (216);
London, NPG 1974 (12)

79

WILLIAM, LORD CAVENDISH 1644
John Hoskins c. 1590–1665
watercolor on vellum
8.9 × 7.7 (3½ × 3)
signed and dated, *IH/1644*

The Burghley House Collection

John Hoskins and his son John
(c. 1617–c. 1693), who also worked as a
miniaturist, had established a studio in
Bedford Street, Covent Garden, in or
about 1634. They were prolific and
distinguished artists, but the relation-
ship and distinction between the work
of father and son have not yet been
satisfactorily defined. Although they
(probably the father) produced a
number of copies on a miniature scale
after Van Dyck, the influence of Van
Dyck was not as effectively absorbed
by them as it was by Samuel Cooper
(see no. 78), who had probably been
their neighbor in Covent Garden since
at least 1640. By contrast with
Cooper's miniatures of the same date,
even so fine an example of Hoskins'
work as this seems slightly thin and
less atmospheric. The glimpse of
landscape in the background, with the
castle perched on a hill, had been a
feature of Hoskins' work from the time
when he had devised such passages for
the backgrounds of his copies after Van
Dyck, painted in the 1630s. Hoskins
had received an annuity of £200 from
the king in 1640, but that was
dramatically in arrears by the time of
the Restoration of Charles II.

Lord Cavendish (1641–1707) was the
first son of the 3rd Earl of Devonshire,
whom he succeeded in 1684. He had
been a pupil of Thomas Hobbes and
was one of Charles II's pages at his
coronation. He was one of the seven
signatories of the famous invitation to
the Prince of Orange, for whom he took
up arms and by whom (1694) he was
created Duke of Devonshire. In the
history of English taste he occupies a
notable position: with Talman as his
architect he rebuilt the Elizabethan
house at Chatsworth, where the state
apartments are among the most magni-
ficent in England. A distinguished team
of craftsmen, Verrio, Laguerre, Tijou,
Cibber, Jensen, and Samuel Watson

among them, was employed there, and a magnificent garden, with extensive waterworks that included the famous Cascade, was created as the essential setting for the new house.

The miniature was among those bequeathed, with a large collection of pictures, by the sitter's mother, the Countess of Devonshire, to her daughter, the Countess of Exeter. In the conveyance, dated 18 April 1690 (Burghley MSS), it appears as, "A picture of the p^re^sent Earle of Devonshire when a Child by Hoskins." With the Samuel Cooper portrait of his mother (no. 78), it comes from one of the oldest (and best documented) surviving collections of miniatures in England. O.N.M.

Exhibitions: London, Tate 1972 (199)

80

HORSEMEN CROSSING A FORD, WITH
WOLLATON HALL IN THE DISTANCE
1695
Jan Siberechts 1627–c. 1703
oil on canvas
108.5 × 143.5 ($42\frac{3}{4} \times 56\frac{1}{2}$)
signed, *J. Siberechts 1695*

Birdsall House
The Lord Middleton

Siberechts, who arrived in England from Flanders in 1673, apparently at the invitation of George Villiers, 2nd Duke of Buckingham, was the outstanding topographical painter to work in England in the late seventeenth century. His patrons included Sir Thomas Thynne—the view of Longleat of 1675 remains in the house—Henry Jermyn, 1st Lord Dover; Philip Stanhope, 1st Earl of Chesterfield; and Sir Thomas Willoughby, 2nd Bart. of Wollaton, the great Elizabethan house built for Sir Francis Willoughby in 1580–1588 by Robert Smythson. Most of his patrons wished for bird's eye views of their houses, gardens, and parks of a kind that other immigrant painters also supplied and which has a clear Flemish precedent in Jan Bruegel I's view of the Château de Mariemont, 1612 (Dijon). The prime version of Siberechts' formal bird's eye view of the house is at Birdsall and is dated 1695. An upright variant of 1697 is at Yale (Harris 1979, no. 70). This more informal view of the house, although painted over two decades after Siberechts' departure from Flanders, looks back to his original specialty, pictures of herdsmen at fords. The fine quality of the picture and the pendant *Distant View of Wollaton* suggest that strictly topographical records of gardens and parks did not permit the realization of Siberechts' full artistic potential.

Willoughby was clearly the artist's most sympathetic English patron. In addition to the Wollaton pictures he commissioned a large view of his secondary seat, Middleton Park, and a pair of smaller landscapes of more overtly Flemish character, dated 1692 and 1694. He also patronized another immigrant painter, Egbert van Heemskerk the younger, who executed six drolleries now at Birdsall. F.R.

Provenance: Painted in 1695 for Sir Thomas Willoughby, later 1st Baron Middleton; and by descent; transferred from Wollaton to Birdsall on the sale of the former in 1925
Literature: Fokker 1931, 56, 86, pl. 44a
Exhibitions: London 1937 (29)

81

VIEW OF THE THAMES WITH
SYON HOUSE
Jan Griffier I 1652–1718
oil on canvas
63.5 × 76 (25 × 30)

Syon House
The Duke of Northumberland, KG

This "bird's eye view" shows Syon House on the right with shipping on the river Thames in the foreground. A Brigittine convent, dissolved by Henry VIII and later given to the Percy family, Syon was largely rebuilt by the 9th Earl of Northumberland (known as the "Wizard Earl" for his interest in alchemy) early in the seventeenth century. Though refaced in stone in the nineteenth, the exterior still looks much as Griffier depicted it, revealing nothing of the splendid Robert Adam state rooms within. Beyond Isleworth church in the center of the picture, the avenues of Hampton Court are just discernible, and the substantial house with a hipped roof on the left is Richmond Lodge, used by Charles II and his successors for hunting in Richmond Park. Various seventeenth-century buildings appear behind the lodge. The terrace, canal, and gazebo in the foreground probably belonged to the Dutch House, later to become Kew Palace, and are thus the ancestors of the famous Botanic Gardens. The height of Richmond Hill is much exaggerated, in the manner of Griffier's Rhineland views, which were in turn inspired by his master, Herman Saftleven.

The dating of this picture is problematical, for while it is comparable in style with a capriccio view of Hampton Court and Windsor Castle painted after 1700 (now in the Tate Gallery), Griffier is said to have come to England in 1667, and is known to have painted a bird's eye view of Sudbury Hall in Derbyshire in 1681–1682 (Harris 1979, nos. 130, 133). There is no reason to doubt that he is the "Mr. Griffiere" referred to in the account books of the owner George Vernon, and the attribution gives Griffier an important place, along with Jan Siberechts and Leonard Knyff, in the development of the country-house view picture in the

late Stuart period. His sons Robert and John Griffier II continued this tradition well into the eighteenth century.

The view of Syon could also date from the early 1680s, particularly as it appears to be in the same hand as another picture in the Duke of Northumberland's collection, previously attributed to Knyff (Harris 1979, no. 84) and showing the old Percy house at Petworth before its rebuilding in 1689–1694. Both paintings could have been executed soon after the marriage of Lady Elizabeth Percy to the 6th Duke of Somerset in 1682, a period when Griffier is said to have been living on the Thames in a yacht "passing his whole time on the river between Windsor and Gravesend" (Bryan 1893,

603–604). Indeed, the young couple are more likely to have commissioned a record of Syon at this date than after 1690 when they practically abandoned the house in favor of Petworth. On the other hand, the dress of the figures in the foreground and the sash windows of the gazebo seem to suggest a later date.

At a time when it was far quicker and more comfortable to travel by river than by road, country houses on or near the banks of the Thames particularly suited those who needed to be within easy reach of Court and Parliament. These houses tended to be among the most influential in terms of architecture and decoration, even if they were not as large as the seats of the great territorial magnates further away from London. The Duke and

Duchess of Lauderdale's Ham House, only a short distance up river from Syon, still preserves some of the finest Carolean interiors in England, and this was followed in the eighteenth century by houses as important as Lord Burlington's Chiswick and Horace Walpole's Strawberry Hill. Griffier's view of Syon heralds the idea of the Thames as a second Brenta, fore-shadowing Zuccarelli's later, more openly Venetian, capriccio of Harleyford (no. 324). G.J-S.

Literature: Harris 1979, 129, no. 131

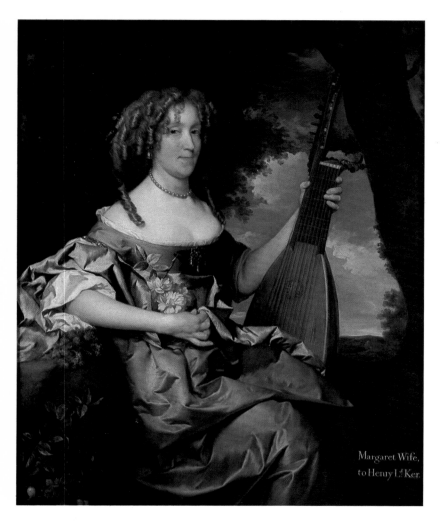

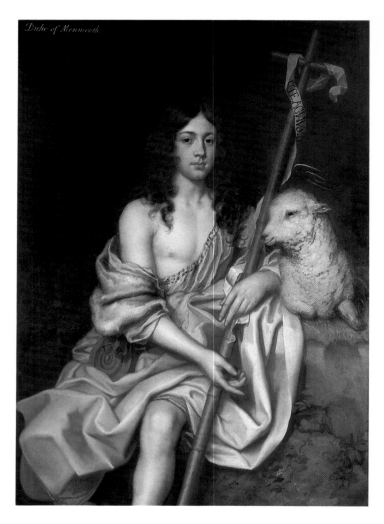

82

MARGARET, LADY KER c. 1665
Gerard Soest d. 1681
oil on canvas
125.7 × 101.6 (49½ × 40)
inscribed later with the identity of the
sitter

Floors Castle
The Duke of Roxburghe

The sitter has been identified as
Margaret Hay (d. 1681), daughter of
the 10th Earl of Erroll, who married
first, in 1638, Henry, Lord Ker, son and
heir of the 1st Earl of Roxburghe who
died in 1643; and secondly in 1644,
John Kennedy, 6th Earl of Cassilis. But,
as the picture can be dated on stylistic
grounds to around 1665, it may perhaps
represent another, younger lady.

Soest had probably come over from
Holland before the end of the Civil War
and his earliest works are somewhat
reminiscent of those of William Dobson.
His fine, atmospheric sense of color, his
grave, honest, eccentric characterization,
and his almost deliberate inelegance,
set him apart from fashionable rivals
such as Lely, whose success he could
never rival. A variant of this composition
is the signed portrait, formerly at
Yester, of Lady Margaret Hay who
later married the 3rd Earl of Roxburghe
and clasps her theorbo-lute more
purposefully. Both portraits, charming
though they are in character, are
perhaps a gloss on the statement that
by the end of his career Soest had
"grown out of humor with the public
but particularly with the ladies, which
his ruff humour coud never please."

O.N.M.

83

JAMES SCOTT, DUKE OF MONMOUTH,
AS SAINT JOHN THE BAPTIST c. 1664
Jacob Huysmans c. 1633–1696
oil on canvas
125.7 × 87.6 (49½ × 34½)
inscribed later with the identity of the
sitter

Drumlanrig Castle
The Duke of Buccleuch and
Queensberry, KT

James Scott (1649–1685), the much-
loved, illegitimate son of Charles II by
Lucy Walters, was rich, spoilt, hand-
some, vicious, and idle. At about the
time this portrait was painted Pepys
described him as a "skittish, leaping
gallant." In 1663 he married the great
heiress Anne, Countess of Buccleuch,

and was created a duke and Knight of the Garter. He had a distinguished military career, but went into exile after the discovery of the Rye House Plot. In 1685 he returned to England to lead the ill-fated rebellion against his uncle, James II, and was captured, attainted, and executed for high treason. His grandson was restored in 1743 to the duke's English honors and to the Dukedom of Buccleuch. This portrait was probably painted around 1664.

Huysmans was a Flemish painter, trained in Antwerp and influenced by the work of Van Dyck in his later Flemish period. He was in London by the summer of 1662 and, as a Roman Catholic, was much patronized by certain elements in court circles, especially by the queen, and had a studio in Westminster. Portraits of prominent—and eminently unsuitable—court figures in religious guise are not uncommon at that period and Huysmans painted the queen herself as Saint Catherine. This is a good example of his rather free, loose handling in the draperies and smooth treatment of flesh. Huysmans' compositions are often ambitious and original, in a full-blown baroque style, but he was not so accomplished an artist as Lely, although in 1664 he was described by Pepys as "the great picture drawer" who was "said to exceed Lely." The picture may have been in the possession of the young duke and his duchess and would have passed by descent. O.N.M.

Exhibitions: London, RA 1960–1961 (155)

84

DRESSING TABLE C. 1670
English
gilded and ebonized wood fitted with silver mounts
74.9 × 81.3 × 62.8 (29½ × 32 × 24¾)

Ham House
The Trustees of the Victoria and Albert Museum

This small dressing table is decorated with silver plaques embossed and chased with flowers and foliage, and overlaid with cast coronetted cyphers, with the monogram *ED* for Elizabeth Murray, Countess of Dysart (1626–1698). The table frame is supported by female caryatids—lightly clad nymphs at their toilet, with one hand holding up a festoon of gilt drapery—which may have originally been silvered but are now bronzed. Gilt laurel branches garland the acanthus scrolls on the apron, wreath the loins of the nymphs, and hang down their scroll supports, which terminate in lion feet.

The table may have been acquired as part of the embellishment of Ham House, Surrey, carried out by the Countess of Dysart shortly after the death of her first husband, Sir Lyonel Tollemache, in 1669. In the following year she succeeded in acquiring new letters patent confirming her in the title of Countess of Dysart, which she had inherited from her father William Murray, 1st Earl, who had died in 1654 (some Scottish titles descend through the female line if there is no direct male heir). A further honor came her way in 1671, when Queen Catherine of Braganza, wife of Charles II, visited her at Ham. This table formed part of the furnishings of the Green Closet, a small ornate dressing room on the principal floor, which Franz Cleyn (d. 1658), had decorated in the classical style for her father. It appears in inventories of 1677, 1679, and 1683—in the last one as "One ebony table Garnished with silver," and it was provided with a green sarsnet cover. It may originally have supported a silver and ebony dressing mirror (see Thornton and Tomlin 1980, fig. 66). The closet was originally furnished with two Japanese lacquer cabinets on low stands and a

pair of long stools, all with caryatid legs. The table is designed in the baroque style of Charles Le Brun (1619–1690), Louis XIV's *Premier Peintre*, which was transmitted to England by the engravings of the *ornemaniste* Jean Le Pautre (1618–1682). Among Le Pautre's engravings of tables in the "Antique" or "Roman" style is a table with a sphinx support, half female and half lion, both being elements that appear on this table.

The fashion for silver and silver-mounted furniture came from France, which the countess had visited on a number of occasions, and she could not have failed to have seen a great deal of it at Louis XIV's palace of Versailles; indeed, she herself owned French silver. A contemporary said that she had "a restless ambition, lived at a vast expense, and was ravenously covetous," and this table certainly epitomizes her taste for luxury. J.H.

Provenance: See no. 100
Literature: Thornton and Tomlin 1980, fig. 42; Tomlin 1982

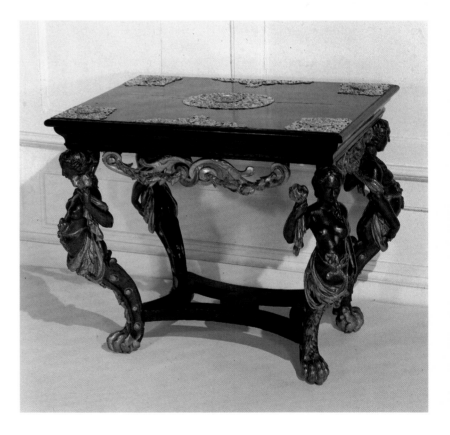

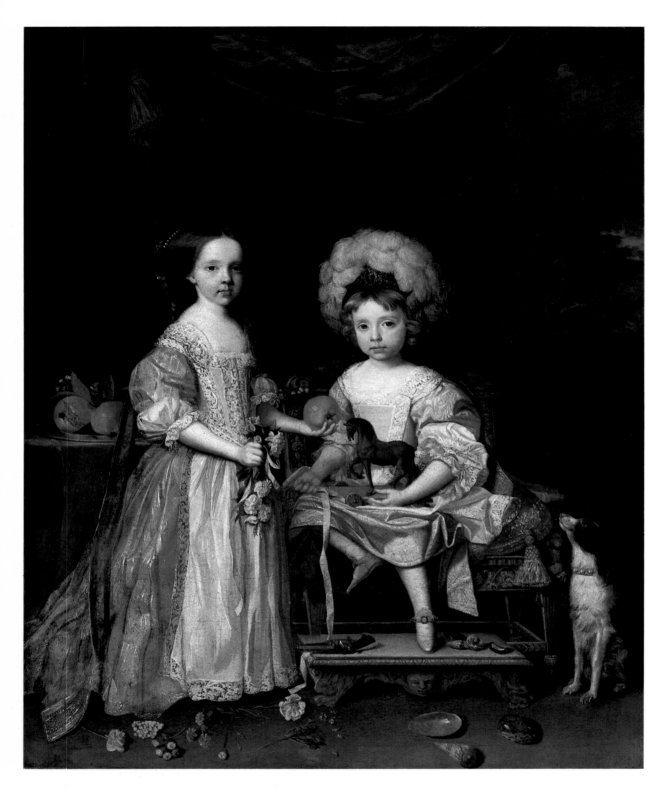

JAMES CECIL, VISCOUNT CRANBORNE,
WITH HIS SISTER, LADY CATHERINE
CECIL c. 1669
John Michael Wright 1617–1694
oil on canvas
160 × 130.8 (63 × 51½)

Hatfield House
The Marquess of Salisbury

James Cecil (1666–1694) and Lady
Catherine Cecil (c. 1663–1688) were
the two children of the 3rd Earl of
Salisbury, whom Lord Cranborne
succeeded as 4th Earl in 1683, the same
year his sister married Sir George
Downing, Bart. Probably painted in
1669 (Lord Cranborne had been born
on 25 September 1666), the two children
are in elaborate contemporary dress,
and the boy still wears a girl's frock.
Typical of Wright are the clear, cool
colors; the very sensitive character-
ization; the beautiful, slightly old-
fashioned touch in the details, especially
of the costumes and the furniture; and
an engaging lack of the assurance and
rather overbearing swagger of Lely.

Sara Stevenson and Duncan
Thompson (Edinburgh, NPG 1982)
have suggested that the still life contains
allusions which, in a light-hearted way,
could be made to apply to the children.
The pomegranate and flowers are
associated with Proserpine, the beautiful
young nymph of spring; and the pome-
granate is also associated with virginity.
Cupid, god of love, appears in the cameo
in the boy's hat; and Cupid's parents,
Venus and Mars, are perhaps referred
to by the shells and the pistol. O.N.M.

Provenance: Presumably painted for the
children's parents and to be identified
with "1 Picture of Lord Cranborne and
Lady Katherine in one frame," listed in
the Hatfield inventory of 1679/1680,
when it was hanging in the Parlour;
and by descent
Literature: Auerbach and Adams 1971,
175–176, no. 147
Exhibitions: Edinburgh, SNPG 1982 (22)

86

BUREAU C.1672
attributed to Pierre Gole c.1620–1684
marquetry of brass and pewter, with
borders of ebony inlaid with mother-of-
pearl, and gilt bronze mounts
87.6 × 89 × 55.8 (34½ × 35 × 22)

Boughton House
The Duke of Buccleuch and
Queensberry, KT

The fleurs-de-lis that appear prominently on the stretchers, and inlaid on the top of the *gradin* or writing box, have always suggested that this was a French royal piece, and this has recently been confirmed by the discovery of an exactly matching description in the *Inventaire Général* of 1718 (Lunsingh Scheurleer 1980, 390):

"Un bureau de marqueterie de cuivre sur fond d'étain, brisé par dessus en deux endroits, aiant six tiroirs par devant, un grand et cinq petits, ornés autour d'une petite moulure a feuillages de bronze doré, le bord du quarré de dessus et bordure des angles sont de nacre de perle sur fond d'ébène, porté sur huit thermes d'enfants en consoles de bois doré et argenté; long de 2 pieds 9 pouces sur 21 pouces de large et 29 de haut.

Un gradin de même marqueterie, ouvrage et ornemens à trois tiroirs fermans à clef; haut de 4 pouces sur 7 de profondeur."

The top, described as splitting into two parts, has been altered at some later date though the horizontal division is still clear. Close inspection confirms that the base was originally silvered as well as gilded, harmonizing with the brass and pewter of the marquetry, while the frames of ebony inlaid with mother-of-pearl imitate some forms of Chinese lacquer. The bureau is similarly described in the earliest inventory of Versailles, suggesting that it was acquired before about 1675. Professor Lunsingh Scheurleer has shown that only Pierre Gole was producing furniture of this type for Louis XIV, and has tentatively identified it with a bill for "un bureau en marquetery garny de plusieurs tiroirs" supplied by the cabinetmaker in 1672 at the high cost of 1,800 livres.

Pierre Gole, born in Bergen near Alkmaar, went to Paris at an early age and a document of 1656 already refers to him as "M[aitre] menuisier en ébène et ordinaire de Roi." With the sculptor Domenico Cucci he is the leading craftsman portrayed in the famous tapestry of Louis XIV visiting the Gobelins in 1667 (Château de Versailles), and he was to retain this position until his death in 1684, despite the increasing rivalry of the young André-Charles Boulle who can be said to have succeeded him as Louis XIV's leading cabinetmaker. More than twenty-five *bureaux* of different sorts (later called *bureau Mazarin*, though they date from after the cardinal's death) were made by Gole for the court and, in Lunsingh Scheurleer's words, "there is every reason to believe that the type was created in his workshop." However, that at Boughton is the only one yet to be identified, and this gives it a place of paramount importance in the history of seventeenth-century furniture.

According to family tradition, the desk was a gift from Louis XIV to Ralph, 1st Duke of Montagu, four times ambassador to France between 1666 and 1678, and a voluntary exile in Paris from 1682 to 1685 after his implication in the Duke of Monmouth's rebellion. The duke was one of the greatest patrons and supporters of Huguenot craftsmen expelled on the revocation of the Edict of Nantes, including Gole's son Cornelius (who also made furniture for Queen Mary II) in 1708, and his first cousin Daniel Marot, William III's *chef du dessin* (Jackson-Stops 1980, 245–255). Gerrit Jensen, the "sieur Janson, ébéniste a Londres" to whom Pierre Gole owed 400 livres on his death in 1684, not only supplied Montagu with a magnificent pair of metal-inlaid chests of drawers and pier glasses, which now stand in the same room as the Gole desk at Boughton, but also sent a servant "to pollish and whiten a Beuro inlaid with metal" in the duke's accounts for 1699–1700 (Boughton House MSS). There is also an important precedent for such a gift in a table and candlestands at Knole, carved by Matthieu Lespagnandelle and with tops by Pierre Gole, almost

certainly presented by Louis XIV to Charles Sackville, later 6th Earl of Dorset, ambassador in Paris in 1669 and 1670 (Jackson-Stops 1977, 1496).

Although the desk cannot be certainly identified in inventories of the Duke of Montagu's houses taken after his death, and although the bureau described in the *Inventaire Général* was sold by order of the king in 1741 (when it was bought by a certain Sieur Million for the paltry sum of 11 livres), it is possible that Gole made a replica of the latter for Louis XIV to give the duke on one of his embassies. An inventory of Gole's own goods, drawn up after his death includes, "un petit bureau de marqueterie de cuivre et d'étain, long de deux pieds huit pouces, monté sur des termes a consoles dorés avec des moulures aussi dorées . . .," showing that he must have made other very similar versions (Lunsingh Scheurleer 1980, 390, n. 66). Against this must be set the fact that the 5th Duke of Buccleuch, whose Montagu grand-mother had inherited Boughton, was

acquiring fine French furniture through the dealer and cabinetmaker E.H. Baldock in the 1830s and 1840s: not only examples by Riesener, Carlin, and others, but also earlier pieces very probably including the magnificent cabinet by André-Charles Boulle now at Drumlanrig Castle (Bellaigue 1975 and 1975a). Unless further documentary evidence emerges, the circumstances of the desk's arrival at Boughton cannot be exactly determined. G.J-S.

Provenance: First certainly recorded at Boughton in the time of the 5th Duke of Buccleuch and Queensberry (1806–1884); and by descent
Literature: Lunsingh Scheurleer 1980, 390–392, figs. 15–21

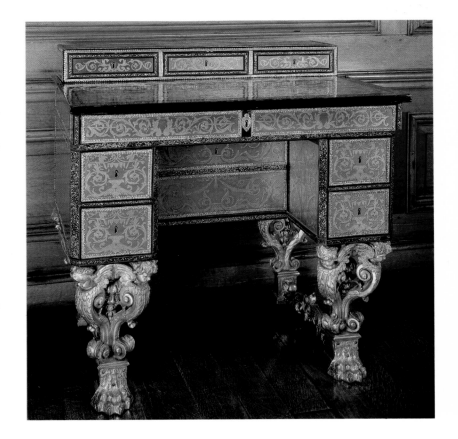

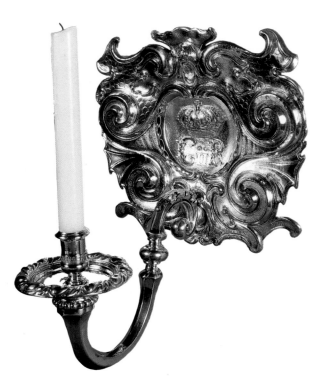

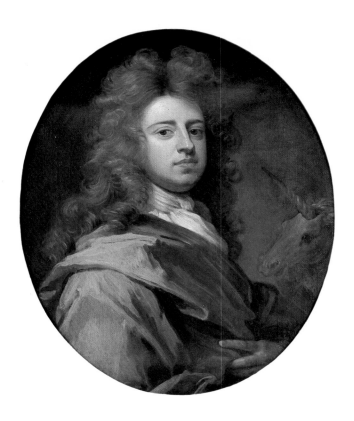

87

TWO SINGLE-LIGHT SCONCES
back plates 1668; branches c. 1690
English
silver
36.8 ($14\frac{1}{2}$) high
chased with crowned cypher *C II R* for
King Charles II

Boughton House
The Duke of Buccleuch and
Queensberry, KT

These are from a set of ten similar
single-light sconces designed and chased
in the manner of the court goldsmith
Christian van Vianen, who retired about
1661, or his son-in-law John Coquus,
with later single-light branches of formal
pattern, about 1690, bearing the
maker's mark of Arthur Manwaring.
The scrollwork and batswing design of
the back-plates is very close to the
framework of a portrait of the Dutch
silversmiths Paulus van Vianen, Hans
Van Eken, and Adriaen de Vries by the
Dutch goldsmith J. Lutma, c. 1670,
now in the Rijksmuseum, Amsterdam,
closely following the auricular style
fashionable in the early 1660s. The
sconces are unusual in that the reflector
plate in the center is chased rather than
engraved with the cypher or other armor-
ials. It is probable that, as outmoded
items from one of the royal palaces,
they were aquired about 1690 as per-
quisites by Ralph, 1st Duke of Montagu,
who was Master of the Wardrobe to
William III. The branches may have
been damaged or worn by this date,
necessitating replacement of the single-
light sconces in a later, more formal,
manner.

The maker of the back-plates, using
the mark *IN* over a bird in a heart-
shaped punch, has not yet been identi-
fied, but he was the goldsmith reponsible
for many fine pieces in the royal and
other collections of the Charles II
period. He appears to have been
associated with another Royal Gold-
smith, Robert Smythier, whose mark
appears (without full assay marks) on
six of the sconces from the same set,
as well as on a pair formerly in the
collection of the Earl of Lonsdale.
Others, apparently originally in the
royal household, were purchased in the
early 1800s by the firm of Rundell,
Bridge and Rundell. J.B.

Provenance: See no. 86
Literature: Jones 1929, nos. 221–222;
Oman 1970, 54–55, pl. 63A

88

PORTRAIT OF THE ARTIST c. 1688
Sir Godfrey Kneller 1646?–1723
oil on canvas
73 × 61 ($28\frac{3}{4}$ × 24)

The Burghley House Collection

Kneller was a member of the Honour-
able Order of Little Bedlam, which was
founded by the 5th Earl of Exeter and
held its meetings at Burghley. The
members of the Order had their
portraits painted (not all of them by
Kneller) and each member had in his
portrait the animal from which he had
received a nickname, in this case
Unicorn (see no. 90 for Porcupine); one
or two portraits of members of the
club have appeared in other collections
and the Earl of Gainsborough—
Greyhound—is also at Burghley.

Kneller arrived in London, probably
in 1676, from Germany. He achieved
success rapidly, and Lord Exeter was
among his patrons by the end of the
decade. This self-portrait, painted with
characteristic spirit and suggesting, as
always, the artist's self-confidence, was
painted around 1688. It appears in a
note dated 12 August 1690 of pictures
added to the collection at Burghley
since an inventory had been drawn up
two years earlier ("1 picture of Mr
Kneller no fframe"). Lord Exeter
patronized a number of contemporary
portrait painters and Kneller's early
work can be instructively compared at
Burghley with the work of, for example,
Lely, Wissing, Vandervaart, and Dahl.
Both this self-portrait and the portrait
of Verrio (no. 90) are in their original,
very fine, carved frames. O.N.M.

Literature: Stewart 1983, 33–34, 89,
no. 16
Exhibitions: London, RA 1960–1961
(368)

89

PLOVER SHOOTING c.1686
Francis Barlow d.1704
oil on canvas
107.9 × 130.8 (42½ × 51½)

Bereleigh
William Tyrwhitt-Drake, Esq.

Barlow was the first well-documented
English painter to specialize in animals,
birds, fish, and sporting subjects.
At Ham he was employed by the
Lauderdales to paint two canvases of
birds (one is signed and dated 1673 [?])
to be inserted above the doors in the
Volary Bedroom, which had a birdcage
outside its window; and the set of
three very big pictures of "fowle and
huntinge" now at Clandon were painted
for the hall of Denzil Holles' house at
Pyrford, where there was a famous
duck decoy or reserve.

This painting is from a series formerly
at Shardeloes in Buckinghamshire. One
of these canvases is signed and dated
16[8?]6 and six of them, in good
contemporary frames, may have been
painted originally as elements in the
decoration of a room. *Plover Shooting*,
not one of the six, is on a small scale,
and is painted with a lighter and more
delicate touch than is characteristic of
Barlow. The figures, indeed, may not
be by him and are very close in style to
Egbert van Heemskerck.

This series may have been painted
for Sir William Drake (d. 1690) or his
son, Montague Drake (d. 1698), to hang
in the original house at Shardeloes; and
perhaps the numbers of ducks and
drakes may even have been intended as
a pun on the family name. On the other
hand they could equally have been
painted for Sir Philip Tyrwhitt,
3rd Bart. (d. 1688), or his son Sir John
(d. 1741) who lived at Stainfield in
Lincolnshire. O.N.M.

90

ANTONIO VERRIO c.1688
Sir Godfrey Kneller 1646?–1723
oil on canvas
73.6 × 59 (29 × 23¼)

The Burghley House Collection

The artist is depicted here as Porcupine,
a member of the Honourable Order of
Little Bedlam (see no. 88). Probably
painted c. 1688, it is remarkably
vigorous and direct in handling and
warm-hearted in character. This work
is evidence that by this date Kneller
had become the most accomplished
painter in England, a position that was
not to be seriously challenged for the
remainder of his long career.

Verrio (1639–1707), the most
successful decorative painter of the
time, had been born in Lecce, in south-
eastern Italy, and had worked in France
before coming to London in the early
1670s. Before the Revolution his princi-
pal work was on the decoration of
Windsor Castle, in collaboration with
Hugh May and Grinling Gibbons. With
them he evolved an English baroque
decorative style that remained fashion-
able until the arrival of the painters
from Venice early in the eighteenth
century. Verrio succeeded Lely as
Principal Painter to Charles II. His
finest surviving work is at Burghley
where he worked for, and was supported
by, Lord Exeter between 1687 and 1698.
He was able, as a Roman Catholic, to
take refuge under the wing of his
patron, at a convenient distance from
the capital. At Burghley his place in the
development of baroque decorative
painting can be clearly determined. His
color schemes are light and gay and the
decorative elements thoroughly well
handled, but his figures are almost
invariably feebly drawn. He was a less
accomplished artist than Louis Laguerre

THE PRESENTATION OF A PINEAPPLE
TO CHARLES II c.1677
English school
oil on canvas
102.9 × 118.1 (40½ × 46½)

Glyn
The Executors of the late Lord Harlech

This is a little-known version of a picture in the collection of the Marquess of Cholmondeley at Houghton Hall. That painting has been described since the time of Horace Walpole as Charles II receiving the first pineapple grown in England on the grounds of Dorney Court from the hands of John Rose, Chief Gardener to the King.

Much of this iconography must be dismissed, as pineapples are unlikely to have been grown in England in the seventeenth century. The house in this painting bears no resemblance to Dorney Court, which is a rambling house on the banks of the Thames near Eton. It is perhaps more likely to have been Dorney House near Oatlands in Surrey. It is Dutch or even perhaps French in design, and the traditional attribution to Hendrick Danckerts, even for the background, cannot be sustained with any conviction.

The figures and dogs, however, are most attractively painted. John Rose—if it is he—died in 1677, and on the grounds of costume the figure of the king cannot be much earlier than that date. It is a particularly vivid likeness of the king at that late period in his life and a rare depiction of him in ordinary day dress. The composition is an early example in England of a portrait group—virtually a conversation piece—on a small scale. Nothing appears to be known of the provenance of the picture though it has a fine, apparently late seventeenth-century frame. O.N.M.

Related Works: A copy of this picture was painted in 1787 by Thomas Hewart for Ham House, and a poor copy is in the royal collection
Literature: Steegman 1962, 1:75; Praz 1971, 137, 172, 280; Harris 1979, 43, 51

whose work, especially at Chatsworth, is more distinguished than Verrio's masterpiece, the "Heaven Room" at Burghley.

His time at Burghley is unusually well documented in the archives at the house, which provide much material on the methods of a decorative painter. Among the things he left behind in 1694, while he was away at Lowther, were: "his owne his wifes & 2 sons pictures done by Sᵣ Godfrey Kneller." He also left behind him, in addition to six painted rooms and the ceiling of a huge staircase, a reputation for expensive living and for fairly scandalous behavior in the house and the neigh-

boring town of Stamford. But life must have been difficult, especially during winters in the eastern midlands, for a hot-blooded and arrogant painter from the south of Italy. He expected to consume good wine, parmesan cheese, Bologna sausages, anchovies, olives, and caviar (Burghley House MSS).

Verrio returned to the service of the Crown in the last years of the seventeenth century and worked for William III and Queen Anne at Hampton Court, where his most notable achievements were the Great Staircase and the Queen's Drawing Room.

O.N.M.

Literature: Whinney and Millar 1957, 296–302; Croft-Murray 1962, 50–60, 236–242; Stewart 1983, 33–34, 138, no. 823
Exhibitions: London, RA 1960 (49)

92

A VIEW OF EUSTON HALL
English school
oil on canvas
76.2 × 124.5 (30 × 49)

Euston Hall
The Duke of Grafton, KG

Euston was the property of Henry Bennet, Earl of Arlington, who had acquired the manor, which had belonged to the Rokewood family, in 1666. He built the house around 1666/1670 and rebuilt the church (leaving the medieval tower). Work on the church, which is seen completed in this painting, began on 21 April 1676. Very little remains of Arlington's house, but the great gates on the north approach to the mansion survive.

Arlington, a rich and prominent courtier and Lord Chamberlain from 1674 to 1685, had acquired Goring House in London (on the site of the future Buckingham House). It burned in 1674 and was immediately rebuilt. The diarist John Evelyn records (23 September 1674) the "rare pictures" and fine works of art that had been destroyed in the fire and (9–18 October 1671) his visit to Euston, where he found "that young wanton," Louise de Kéroualle, who appears to have become the king's mistress on this occasion. Colbert, the French ambassador, was also present and the entertainment was outstandingly lavish. Evelyn considered the house "a very noble pile consisting

of 4 greate pavilions after the french . . . very magnificent and commodious, as well within as without . . . the Garden handsome." Evelyn gave Arlington advice on the planning of the park. The new wall paintings in the house by Verrio (see no. 90) were among the Italian's first work in England.

Celia Fiennes visited the house in 1698 (1947, 150–151). She recorded a "good staircase full of good pictures"; a long gallery hung with a succession of full-length portraits of the royal family from Henry VII and of foreign princes; a "square" with a billiard table and some "outlandish" pictures; and contemporary family and royal portraits. She also gave a valuable description of the surroundings of the house at this early date, including the "severall rows of trees runs of a great length thro' the parke."

The picture cannot be attributed to either Thomas Wyck (d. 1667), or his son Jan, although the hunting group in the foreground is reminiscent of the latter's work. This is a good example of an increasingly popular view of the country house, accurately depicted topographically in the middle distance

and with a more freely treated foreground in which some part of the life of the owner, frequently a hunting party, is painted. (For a very full treatment of this genre, see Harris 1979.) O.N.M.

Provenance: Euston passed on Arlington's death in 1685 to his daughter and heiress, Isabella, who married the Duke of Grafton, the king's son by the Duchess of Cleveland; the picture passed to the 8th Duke of Grafton; and was given by his daughter, Lady Cecilia Howard, to the present duke
Literature: Harris 1979, 60

93

CHAIR c.1673
English
japanned beech
$128 \times 53 \times 47$ ($50 \times 20\frac{7}{8} \times 18\frac{1}{2}$)

Ham House
The Trustees of the Victoria and
Albert Museum

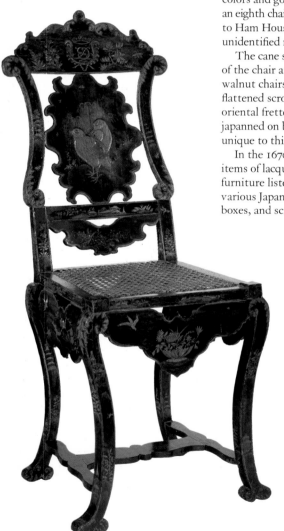

The chair, whose crest rail bears the coronetted *ED* monogram of Elizabeth Murray, Countess of Dysart and Duchess of Lauderdale (1626–1698), formed part of the furniture acquired for Ham House, Surrey, shortly after her marriage in 1672 to John Maitland, Duke of Lauderdale. It is one of a set of three chairs whose frames are japanned in imitation of Japanese lacquer with a glossy black ground decorated with gilded buildings, birds, insects, foliage, and flowers. Their ornament is executed with a total disregard for perspective and proportion, and in addition they have pairs of birds molded in low relief on their splats. A similar set of four chairs, whose splats depict oriental children at play, are japanned with colors and gold on a black ground, and an eighth chair of this pattern (presented to Ham House in 1949) bears an unidentified monogram on its crest rail.

The cane seat and tall, raking back of the chair are related to English walnut chairs of the 1660s, but its flattened scroll frame, fitted with oriental fretted cartouche panels and japanned on both front and back, is unique to this group of chairs.

In the 1670s there were over forty items of lacquered or japanned furniture listed at Ham, including various Japanese lacquer cabinets, boxes, and screens. The distinction between oriental lacquer and japanning, its European imitation, is that the former was made with the gum of the lac tree (*rhus vernicifera*), which, however, did not grow in Europe, and as the range of lacquer furniture imported by the East India Company was limited, the English cabinetmakers compromised by painting a wide range of furniture with various shellacs, resins, and varnishes to imitate the glossy effect of lacquer. *A Treatise on Japanning, Varnishing and Guilding* was published in 1688 by John Stalker, a decorative artist working in Saint James' Market. This not only gave recipes for imitating lacquer but provided patterns for the type of chinoiserie buildings, baskets of flowers, and birds chasing insects that can be seen on this chair. Artists were also advised to copy their ornament from lacquer furniture, and it is of interest to note that the pair of quails on the chair splat can also be found on a Japanese coromandel lacquer screen at Ham (Thornton and Tomlin 1980, fig. 59).

Exotic lacquer and japanned furniture were considered suitable for fashionable bedroom apartments in the late seventeenth century. This chair may be one of a set of six, *en suite* with a table, recorded in the Duchess' Private Closet in 1677 and described again two years later as having "cane bottomes" and being *en suite* with a "table painted black and gold." They also appear in the 1682 inventory as "six Japan'd backstools with cane bottomes," and with "cusheons," which matched the wall hangings of the room. As well as a tea table, the closet contained a "Japan box for sweetmeats and tea," so the "chinoiserie" chairs would have been particularly appropriate for use when the Duchess entertained friends to tea served in Chinese porcelain. J.H.

Provenance: Ham House; after death of Duchess of Lauderdale in 1696, by descent to the Earls of Dysart until 1949, when purchased by the Government and entrusted to the Victoria and Albert Museum
Literature: Huth 1971, fig. 80; Thornton and Tomlin 1980, fig. 87; Thomlin 1982

94

CANED ARMCHAIR c.1685
English
beechwood with gilded and japanned decoration
$142 \times 71 \times 62.2$ ($56 \times 28 \times 24\frac{1}{2}$)
the back posts bear impressed stamps
EW and *RH* at seat-rail level

Temple Newsam
Leeds City Art Galleries

The carved frame of this chair is partly gilded and partly japanned in the Chinese taste with floral, bird, and landscape subjects in gold on a black ground. It originally belonged to a larger suite, of which six armchairs, four side chairs, and a stool were sold in 1968 (Christie's, 23 May, lot 112), and which is thought to have been formerly at Hornby Castle in Yorkshire in the collection of the Duke of Leeds. If so, it may have formed part of the original furnishings of the 1st Duke's great house, Kiveton Park near Sheffield, designed by William Talman in 1698–1699, and demolished in 1811.

This would be a fairly late date for a type of chair which, with its carved back and seat, looks back in style to the early years of the Restoration period. The dolphins on the elaborate front stretcher and in the cresting recall the celebrated set of dolphin chairs in the White Drawing Room at Ham House, dating from the 1670s. The nautical theme may well celebrate English victories, like the Duke of York's at Sole Bay, in the Anglo-Dutch wars. On the other hand the deeply raked back and splayed arms can be paralleled by an armchair with the Cann family arms dated 1699 (DEF 1954, 1:57), and by chairs at Knole acquired by the 6th Earl of Dorset in the same decade.

The rarest feature is the japanned decoration imitating Chinese lacquer. In the Lord Chamberlain's accounts for Charles II's reign there are several references to chairs "of the China varnish," particularly made by the cabinetmaker and upholsterer Richard Price, while the carver Thomas Roberts also supplied chairs "varnisht purple" (MSS in the Public Record Office, London). Green and white grounds were also used, and a

particularly magnificent upholstered armchair of the latter type dating from about 1685 was formerly at Glemham Hall in Suffolk. The armchair exhibited here was only recently acquired for Temple Newsam, and was a particularly appropriate purchase since the house already contains the famous upholstered daybed and chairs from Kiveton (and later Hornby Castle) made by the Huguenot upholsterer Philip Guibert for the 1st Duke of Leeds. A set of seven reproduction armchairs, exactly corresponding, were made in about 1914 by Whytock and Reid of Edinburgh for Marchmont House (Christie's, 5 June 1984, lot 140), and a number of other copies are known. G.J-S.

Provenance: Possibly Duke of Leeds collection, Hornby Castle; Ronald Lee (Fine Art) Ltd. in the 1930s; Mallett & Sons (furniture catalogue 1939); trade source; bought for Temple Newsam in 1984 with the aid of grants from the government, the NACF, and a contribution from Mallet & Son
Literature: Temple Newsam draft catalogue (kindly communicated by Mr. Christopher Gilbert)
Exhibitions: London, BHF 1983, 84 (ill).

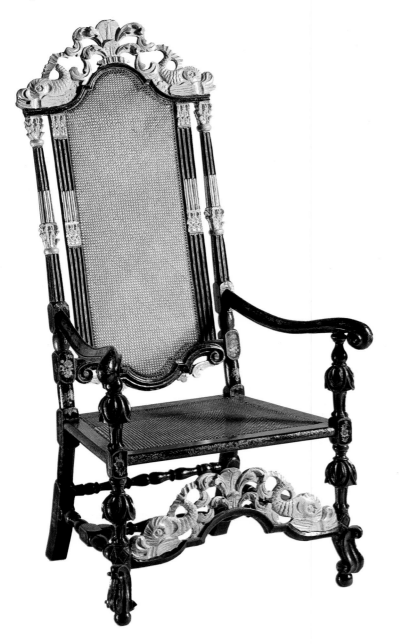

95

PAIR OF SILVER SINGLE-LIGHT SCONCES c. 1678
English
silver
45 ($17\frac{3}{4}$) high

The Burghley House Collection

This pair of sconces belongs to a set of four, revealing the finest and most elaborate craftsmanship of the period. They were probably made on the occasion of the marriage of Anne, daughter of the 3rd Earl of Devonshire and widow of Charles Lord Rich, to the future 5th Earl of Exeter in 1670, a celebrated union of which the poet Matthew Prior extolled the "Ca'ndish beauty joined to Cecil's wit." The monogram *EA* is that of the countess, below the coronet, to which the 5th Earl succeeded in 1678. Although they are unmarked, they were presumably made as a special commission for Burghley and one can only make tentative guesses about the identity of the

goldsmith. Closest in style are another set at Knole, also featuring baskets of flowers, cherubim, and scrollwork around a central monogram and coronet, but again this set of six are unmarked. The treatment of the figurework, foliage, and chasing in high relief on a matt ground and the foliage-chased branches have parallels with a set of six in the Royal Collection. The latter bear the mark of a crowned *S*, now attributed to Robert Smythier who became a freeman of the Goldsmiths Company in 1660. Through his associations with Sir Robert Vyner, principal goldsmith to Charles II, and the Jewel House (which issues plate for the royal residences, ambassadors, and the Speaker of the House of Commons) he would have been connected with the leading families of the day. J.B.

Exhibitions: Burghley 1984 (35)

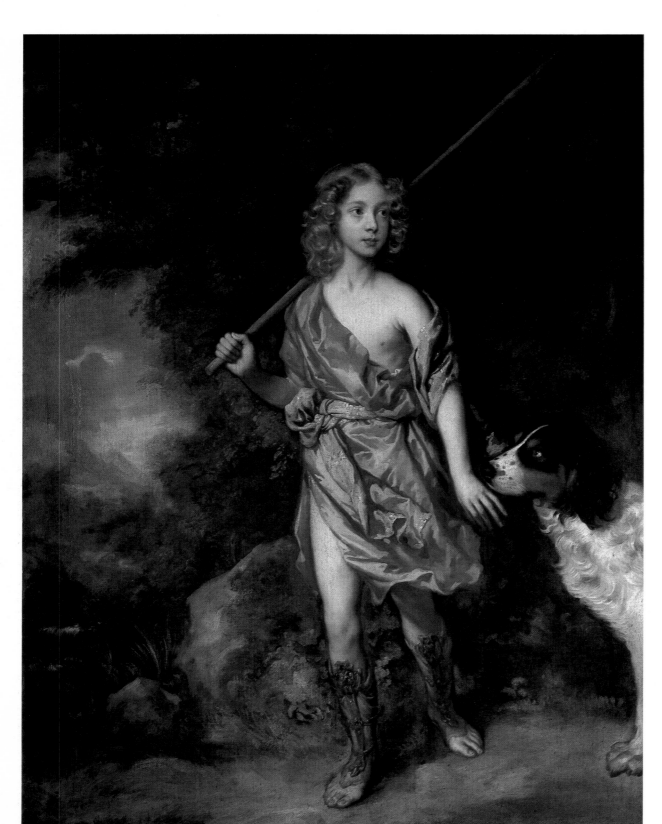

HENRY SIDNEY, EARL OF ROMNEY
Sir Peter Lely 1618–1680
oil on canvas
165.1 × 124.4 (65 × 49)
signed with the monogram, *PL*

Penshurst Place
The Viscount De L'Isle, VC. KG

A younger son of the 2nd Earl of Leicester and grandson of Barbara Gamage, Lady Sidney (see no. 61), Henry Sidney (1641–1704) was later described as "the hansomest youth of his time" at the Restoration court. He was in the household of the Duke and Duchess of York and one of the seven who, in 1688, invited the Prince of Orange to come to England.

Lely's use of the Arcadian theme was obviously influenced by Van Dyck; but more exact parallels are found in portraits and portrait groups by such painters as Gonzales Coques or Jan Mytens. A single Arcadian figure on this scale is unusual, however, at this time. Lely painted a number of portraits in this mood for the Sidney family and their relations such as the Percys and perhaps the Spencers. The picture is one of Lely's most lustrous and beautiful works, painted at a time when he gave particular attention to his landscapes. O.N.M.

Provenance: Presumed to have been painted for the sitter's parents; and by descent
Literature: Beckett 1951, no. 448; Waterhouse 1953, 60; Whinney and Millar 1957, 171
Exhibitions: London, NPG 1978–1979 (19)

97

MARY GRIMSTON c.1684
Willem Wissing 1656–1687
oil on canvas
163.8 × 113 (64½ × 44½)
inscribed later with the identity of the
sitter

Gorhambury
The Earl of Verulam

Mary Grimston (1675–1684) holds in
her lap a pomegranate, perhaps used
here, as it was by John Michael Wright
in no. 85, as a symbol of virginity. She
plucks a bunch of grapes from a dish of
fruit proffered by a black page. In the
background is a large palace.

 The daughter of Sir Samuel Grimston
of Gorhambury, Mary was betrothed to
the 2nd Earl of Essex, but died before
the marriage could take place. Painted
just before her death, this portrait is a
good example of a court style that
flourished in the reign of James II and
early in the reign of William III and of
which Wissing was the chief exponent.
It is partly influenced by the later
developments in Lely's manner but is
more crowded, elaborate, and metallic.
Kneller and Riley worked in the same
style, but Kneller always in a more
sober vein. Wissing also painted an
important group, formerly at Cassiobury,
of the young 2nd Earl of Essex with his
sister and widowed mother. O.N.M.

Provenance: Formerly at Castle Howard;
the 3rd Earl of Carlisle married in 1688
the sister of the 2nd Earl of Essex (see
above); sold at Christie's, 18 February
1944, lot 108, when it was acquired for
Gorhambury by the 4th Earl of
Verulam
Exhibitions: London, RA 1956–1957
(149)

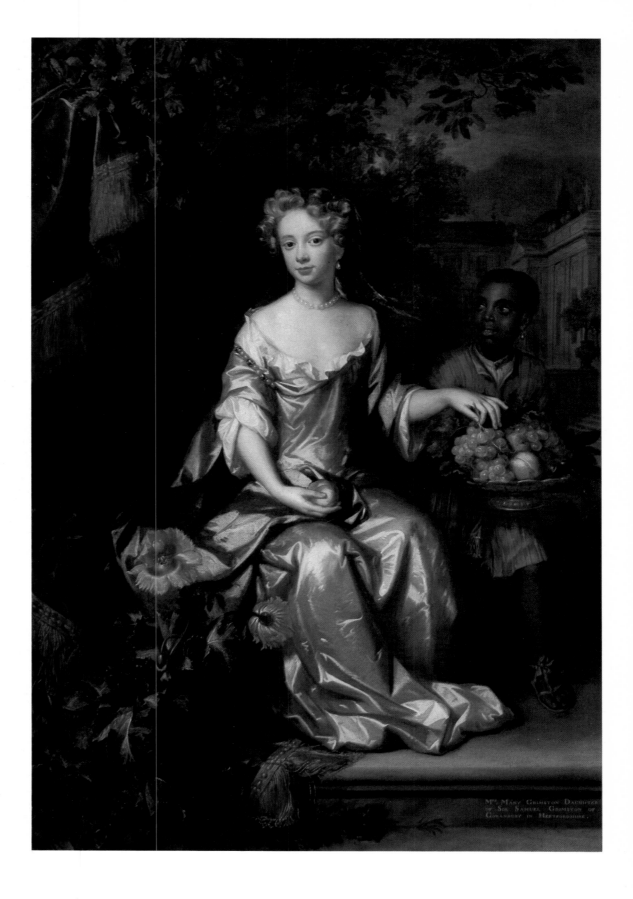

TABLE AND CANDLESTANDS c.1685
attributed to Gerrit Jensen d.1715
ebony inlaid with brass and pewter
table: 77.5 × 107.3 × 73.7
(30½ × 29 × 42¼)
stands: 116.8 (46) high

Drayton House
Lionel Stopford Sackville, Esq.

A table and a pair of candlestands, usually supplied *en suite* with a looking glass, were placed on the piers between the windows in almost all late seventeenth-century bedchambers and dressing rooms. Here they would enable the occupant to make his or her *toilette*, the face lit by day from the flanking windows, and by night from the candles, which, strengthened by their reflection in the mirror, would also help to light the room.

This set of table and stands from the state bedchamber at Drayton can be confidently attributed to Gerrit Jensen, who from about 1680 was the chief cabinetmaker employed by the court and who is the only English craftsman of the period known to have produced metal inlay furniture in the style of André Charles Boulle and his predecessor Pierre Gole. Gole indeed owed Jensen money at the time of his death in 1684 (see no. 86), and many of Jensen's pieces show that he was in direct contact with his counterparts in Paris and The Hague, in particular through the medium of Gole's cousin, Daniel Marot, who fled France at the revocation of the Edict of Nantes in 1685 and became William III's chief designer. The tapered Ionic capitals of the Drayton table supports and their flattened acanthus scroll feet can be paralleled in Marot's engravings as can the form of the torchères.

Gerrit Jensen made furniture at Drayton for both the 2nd Earl of Peterborough (1623–1697) and his daughter and heiress, Lady Mary Mordaunt, who was wife of the 7th Duke of Norfolk (until their divorce in 1700) and then of Sir John Germain, reputedly a half-brother of William III. "Mr. Johnson Cabinet Maker's bill" for various items supplied to the earl between 1679 and 1688 includes £1 "for altaring the stands inlayd with mettle" in March 1688, while a bill from another Huguenot craftsman, Philip Arbunot, made out to the Duchess of Norfolk (as she continued to be called after her second marriage), includes £2. 10. 0 for "new silvering Filigree table and new guilding ye Pillers and mending the brass and pewter of the table" in May 1703 (Drayton House MSS 2450, 2476). Both these may be references to the table and stands in the bedchamber at Drayton, which would therefore pre-date the duchess' major remodeling of the house in 1702–1704, carried out to designs by William Talman, the Comptroller of the King's Works.

G.J-S.

Provenance: Through Sir John Germain's second wife, Lady Elizabeth Berkeley, to her cousin, Lord George Sackville; and by descent
Literature: Jackson-Stops 1978, 29 (ill.)

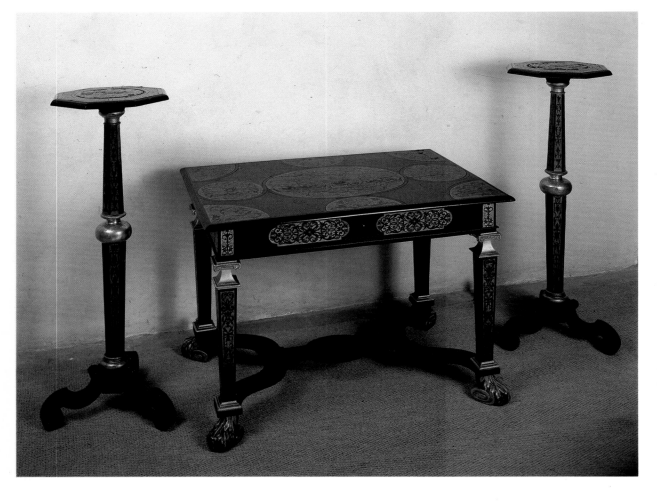

A MOTHER-OF-PEARL GARNITURE
c. 1675
probably Flemish or German
shaped leaves of mother-of-pearl, fixed
together with iron rivets
charger: 52.5 (20⅝) diam.; tankards:
32.4 (12¾) high; candlesticks: 23.5 (9¼)
high

Chicheley Hall
The Trustees of Mrs. John Nutting and
the Hon. Nicholas Beatty

The exotic oriental materials imported
in the Restoration period through the
English and Dutch East India Companies
were generally adapted to European
artifacts rather than appreciated as
works of art in their own right. Coro-
mandel and lacquer panels were thus
made into mirrors and tables of purely
English form, and Chinese export por-
celain was decorated with family coats
of arms or strange interpretations of
Western engravings (see nos 380, 381).
Mother-of-pearl was particularly prized
for its delicate pinks and greens, picked
up by candlelight. Several pieces can for
instance be seen in the famous picture
of *The Paston Treasure*, in the Norwich
City Art Gallery, painted about 1665
for Sir Robert Paston of Oxnead Hall,
and showing the riches of a collector's
cabinet at this time. John Clerk of Peni-
cuik, who was a merchant in Paris in
the 1640s, is also recorded as buying
plates and dishes in the same material,
which are still in the possession of his
family (information kindly given by
Dr. Iain G. Brown).

Catherine of Braganza's marriage to
Charles II in 1661 opened up trade with
Goa, the principal source of mother-of-
pearl, and it is possible that the pieces
of this garniture (from a larger set in-
cluding five other plates, two salts, a
box, and a ewer), were made in London
by German or Flemish immigrant crafts-
men. The shape of the tankards, in par-
ticular, can be paralleled in the work of
contemporary English silversmiths. On
the other hand, virtually identical char-
gers can be found in the Green Vault at
Dresden, in the Bayerisches National-
museum, Munich, and in the Schloss-
museum at Berlin (Pazaurek 1937, 36,
pl. 32 [2]). These, and a similar garniture
from Godmersham Park (Christie's sale,
6–9 June, 1983, 102–109), are thought
to be German in origin, and possibly
from Nuremberg, where specialists in
perlmutter abounded. G.J-S.

Provenance: Purchased by the 2nd Earl
Beatty (1905–1972); and by descent

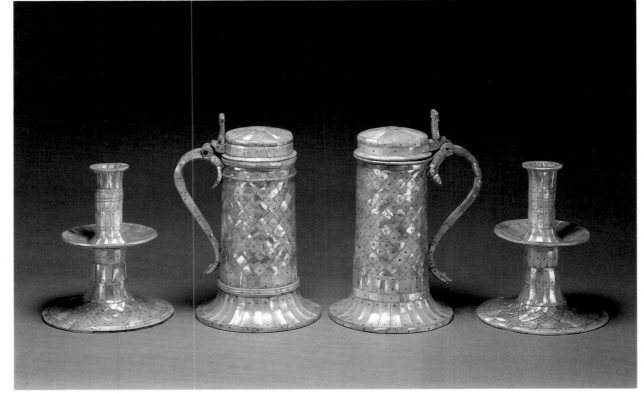

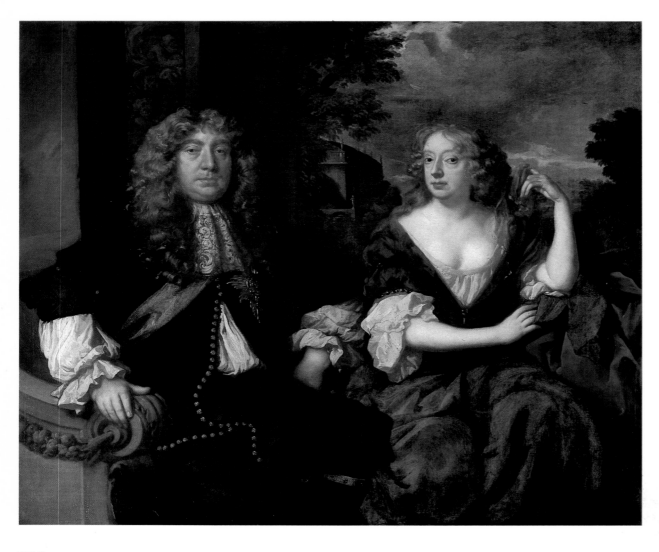

100

JOHN MAITLAND, DUKE OF
LAUDERDALE, WITH ELIZABETH,
DUCHESS OF LAUDERDALE c.1675
Sir Peter Lely 1618–1680
oil on canvas
138.4 × 165.1 (54½ × 65)

Ham House
The Trustees of the Victoria and
Albert Museum

The Duchess of Lauderdale (c.1626–1698), born Elizabeth Murray, had succeeded her father in 1655 to the Earldom of Dysart and had inherited Ham House from him. Earlier she had married Sir Lionel Tollemache who died in January 1669. In 1672 she married Lauderdale (1616–1682), who in the same year was raised to the dukedom and created Knight of the Garter. He wears the ribbon and star of the order in this painting.

In the Interregnum the Countess of Dysart had been one of Lely's most active patrons, and the portraits he painted for her at that date are among those that she later set up in the Long Gallery at Ham, where they remain to this day in their original carved frames. She was one of the most politically minded and rapacious ladies of her day, well matched with Lauderdale who as Secretary of State for Scotland from 1660 to 1680 was immensely powerful. He was also singularly violent and unattractive ("very big; His hair red, hanging oddly about him: His tongue was too big for his mouth which made him bedew all that he talked to . . . his whole manner was rough and boisterous, and very unfit for a Court"); but he was learned and clearly a man of considerable taste. He and the duchess made Ham one of the most beautiful houses of its period. Happily, it is one in which much of the splendid original decoration and much of the collections they assembled and commissioned can still be seen. On 27 August 1674, John Evelyn described it as "indeede inferiour to few of the best Villas in Italy itselfe, The House furnished like a greate Princes."

This double portrait was listed in the inventory of 1679 as hanging in the Great Dining Room at Ham: "Both ye Graces in on[e] picture wt Gilt frame." At that time it was valued at £80. It hangs in the same place today. Probably painted around 1675, it is apparently the last of a number of portraits of the Lauderdales commissioned from Lely. The rather dry pigment and cool, blond tone are characteristic of Lely's style in the last decade of his career. O.N.M.

Literature: Beckett 1951, no. 283;
Thornton and Tomlin 1980, 121–122

THE ALCHEMIST
Thomas Wyck 1616–1677
oil on canvas
126.7 × 102.7 ($49\frac{5}{8}$ × $40\frac{3}{8}$)

Ham House
The Trustees of the Victoria and
Albert Museum

Wyck was born in Beverwijk near
Haarlem, where he principally worked.
He came to England with his son, Jan,
after the Restoration, and they are
known to have been in London by the
summer of 1674. They were among the
most important Dutch painters working
in England in the later Stuart period in
the lesser genres, that is, those other
than the portrait. Their works were
often incorporated into the paneling of
interiors; and father and son worked for
the Lauderdales at Ham.

 The Alchemist is presumably the
painting that appears as no. 46 in the
"Estimate" of pictures at Ham, "A
Chymist of Old Wyck" (MSS list at
Ham House, undated, c. 1679). It was
one of the two pictures by Wyck that
were put up in the Duke's Closet and
was probably the picture that the
duke's joiner fitted into the room later
in 1674. The other, an Italianate
landscape with ruins, had been
installed slightly earlier when the
joiner removed a panel over a door in
the room in order to insert the picture.

 Thomas Wyck specialized in such
subjects as alchemists in their
laboratories, considered particularly
suitable for libraries and studies like
the Duke's Closet, Italianate harbors,
street scenes, and landscapes, all
painted in a decorative manner slightly
reminiscent of Pieter Jacobsz Laar
(Bamboccio). Good examples of his
alchemists, presumably painted for
English patrons, are at Knole and
Hatfield. Wyck was back in Haarlem at
the time of his death. O.N.M.

Literature: Whinney and Millar 1957,
282; Thornton and Tomlin 1980, 66

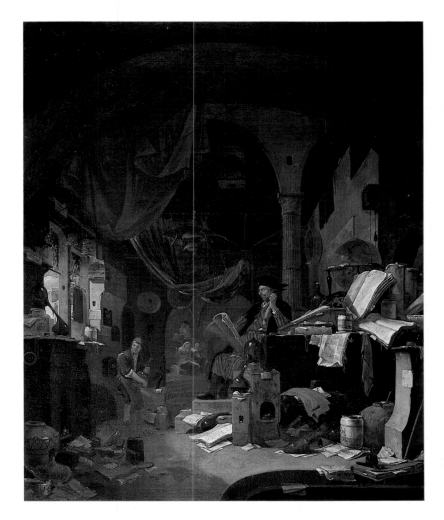

VASE WITH THE ARMS OF WILLIAM
AND MARY
Delft, Greek A factory of
Adriaen Kocks c. 1690–1700
tin-glazed earthenware
67.3 × 48.2 ($26\frac{1}{2}$ × 19)
painted on the reverse with William
and Mary's joint monogram, *RW MR*,
and at the foot with the monogram, *AK*

Erddig
The National Trust (Yorke Collection)

This large urn has a hole in the bottom,
which suggests that it was intended for
a growing plant such as a myrtle, orange,
or bay tree. The arms and initials indi-
cate that it was made for a royal palace
and this is supported by the family
tradition about its provenance. The
painting style is very close to that of a
group of pyramids and vases at Hampton
Court, all of which can also be attri-
buted to the Greek A factory. While
this vase is unique, other very different
urns of similar size are known at Chats-
worth, Dyrham, and the Schloss Favor-
ite at Rastatt. The closest parallel is
with a number of garden urns at the
palace of Het Loo in Holland (Lane
1949, pl. 14) and with engravings of
designs for such urns by the Huguenot
Daniel Marot (Archer 1983 and 1984).
It is known that Marot supplied William
III with numerous designs for gardens
and buildings, as well as interiors and
furnishings; so it is virtually certain
that he also designed an architectural
group of Delft pyramids and vases that
includes both those at Hampton Court
and the Erddig urn.

 By a family tradition at Erddig, the
vase was a gift from Queen Anne to
Dorothy Wanley who was in her service,
and from whom it was inherited by
Dorothy Hutton, the wife of Simon
Yorke of Erddig (1696–1767) (Cust
1914). This appears to be borne out by
records in the Royal Archives at Windsor
(information from Miss Jane Langton)
showing that Mrs. Dorothy Wanley
acted as wet-nurse to Queen Anne's
daughter, the Lady Anne Sophia, who
was born in May 1686 and died the
following February, and as Rocker to
Queen Anne's son, Prince William, Duke
of Gloucester. In 1702 she received a

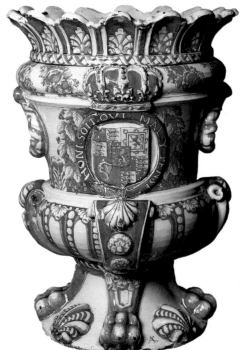

pension of £70 per annum from the queen, and it is quite likely that the vase with William and Mary's monogram, which would now have been outdated, was presented to her as a perquisite at the same moment.

Dorothy Wanley was the wife of Dr. John Hutton, Physician in Ordinary to William III from 1688 until the king's death in 1702, and the mother of Matthew Hutton, Sergeant at Arms to Queen Anne. Matthew's daughter, Dorothy Yorke (named after her grandmother) inherited the family house

at Newnham in Hertfordshire from her brother James in 1770, though the vase was brought to Erddig from her town house in Park Lane when she died in 1787 (Mallet 1978). It is listed in the Tapestry Room in an inventory of 1805, and has remained there ever since.

M.A.

Provenance: See above; given with the house and contents to the National Trust in 1973 by Mr. Philip Yorke
Literature: Archer 1975; Mallet 1978

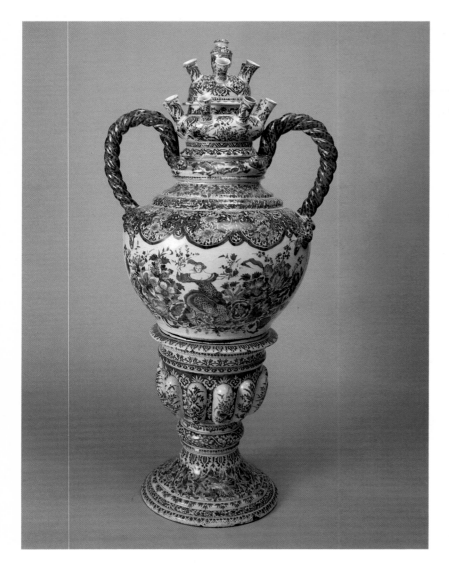

103

FLOWER VASE
Delft, Greek A factory of
Adriaen Kocks c. 1690
tin-glazed earthenware
104 (41) high
marked with the monogram *AK*

Chatsworth
The Trustees of the Chatsworth
Settlement

This flower vase is the most complete and impressive survivor of what must have been a fine collection of Delft vases, urns, and pyramids bought by the 4th Earl and 1st Duke of Devonshire (1641–1707; no. 79). Those still at Chatsworth form the largest group now in private hands. Some indication as to when they entered the house is given by an urn painted with the earl's coronet and garter, showing that it was made after 1689 but before the creation of the dukedom of Devonshire in 1694. Recent excavations in the garden roomcum-grotto built for Mary II at Het Loo (Gelderland) have brought to light fragments of a vase generally similar in form to that at Chatsworth (Erkelens 1980). Other associated fragments are painted with the arms of William III and it may therefore be inferred that all are contemporary with the grotto. The 4th Earl of Devonshire was clearly following court fashion in commissioning vases and pyramids from Adriaen Kocks.

M.A.

Related Works: No other extant flower vase is identical to that at Chatsworth in both form and painted decoration. The identical form is found in a complete state—base, body, and two tiers of nozzles—at Uppark in Sussex; in a pair of vases now in the Prinsenhof, Delft; and in a single example in the Fitzwilliam Museum, Cambridge (Glaisher Collection). An incomplete vase with the base missing is at Dyrham and another in the same condition passed through Sotheby's on 9 November 1934, lot 55 (collection Miss M. McLeod). A body section with a differing single tier of nozzles appeared at Christie's on 4 April 1977, lot 7. Two bases only are known, one in the Lady Lever Art Gallery, Liverpool, and the other in a Dutch private collection
Literature: Archer 1976

104

FLOWER PYRAMID
Delft, Greek A factory of
Adriaen Kocks c. 1690–1700
tin-glazed earthenware
130 (51) high
marked with the monogram *AK*

Dyrham Park
The National Trust (Blathwayt
Collection)

Each of the separate tiers of this flower pyramid, one of an identical pair, was intended to contain water for the cut flowers that were placed in the nozzles, which are in the form of monsters' mouths. Two sets of tiers that make up the pair of pyramids carry two different marks of identification that not only show which belong together but also indicate, when they are placed on the same side, how the painted decoration was meant to be displayed.

This pair of pyramids forms part of a fine collection of late seventeenth-century Dutch Delft at Dyrham Park. It was purchased by William Blathwayt (?1649–1717) who built the house. He had a distinguished career and became Secretary of State to William III, traveling with him to Holland every year between 1692 and 1701. In buying blue and white Delft, Blathwayt, like many others in the court circle, was following the example of Queen Mary (Lane 1949, 1950, and 1953; Wilson 1972). The 1702 inventory of the royal palace of Honselaarsdijk, for example, lists a large quantity of china including numerous Delft pyramids (Drossaers and Scheurleer 1974).

In two inventories made in 1703 and 1710, the pyramids at Dyrham are referred to as "in ye Chimney" of the "Vestibule" and in the "Best bed Chamber above stairs." Flower vases were often placed in fireplaces during the summer months (Archer 1975). They are known from the evidence of embroidered chairbacks at Doddington Hall, Lincolnshire, and Croft Castle, Herefordshire, to have been used to display cut flowers of all kinds and not exclusively for tulips as has sometimes been suggested (Archer 1976).

M.A.

Related Works: Only three other pairs of pyramids of similar shape are known, and they are decorated quite differently. One is at Lytes Cary, a house in Somerset belonging to the National Trust. Another pair were in the McLeod collection and appeared at Sotheby's on 9 November 1934 as lots 55 and 56. A third pair is in the private collection of Marchese Leonardo Ginori-Lischi in Florence. This pair has finials in the form of small urns and the Dyrham pair may once have had something similar

Literature: Archer 1975

105

FLOWER PAGODA
probably Delft, Greek A factory of
Adriaen Kocks c.1690–1700
tin-glazed earthenware
146 (57½) high

The Castle Howard Collection

This flower pyramid consists of a pagoda of five stories, each of which has a roof with six upward and outward pointing nozzles for holding cut flowers. Each nozzle is in the form of a monster with open mouth, scaly breast, wings, and claw feet. The lowest story of the pagoda is an open pavilion with twisting marbled columns, a checkerboard floor, and painted trophies on the narrow, internal walls. Steps from the pavilion descend on the backs of winged sphinxes, which are supported by a horizontal surface painted with an elaborate Chinese figure. They also rest on the heads of grotesque, gaping Moors who form the upper part of an open base made up of open brackets terminating in lion's paw feet. The brackets are decorated with squirrels, foliage, and Chinese figures.

This pyramid appears to be unique and is the most elaborate and fanciful in existence. Nothing is known of its history but it has probably been at Castle Howard since it was made. The subject matter of the modeled, as well as the painted, decoration is more than usually diverse. Each story of the pagoda has a small hole in the floor below each arch, which suggests that further decorations, perhaps figures, may once have stood there. The monsters' mouths also have small wire rings which, if original, may have carried pendant ornaments such as bells. M.A.

Literature: Archer 1976

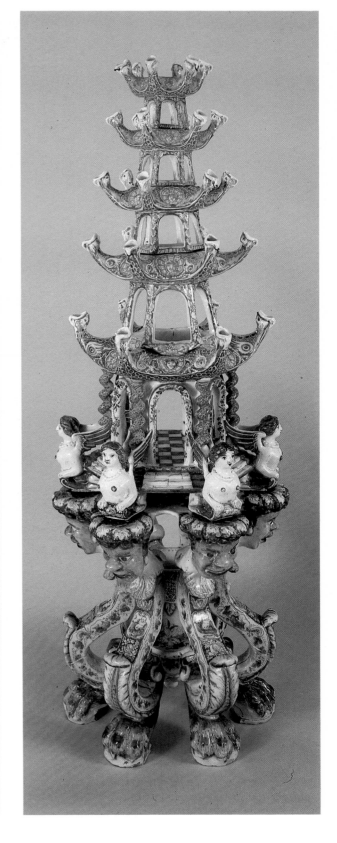

4: The Triumph of the Baroque

The reigns of William and Mary and Queen Anne, a period of almost continual war with France, paradoxically saw the height of French influence on the decorative arts in Britain. Louis XIV's Revocation of the Edict of Nantes in 1685 forced large numbers of leading Huguenot craftsmen to emigrate, and the silk and tapestry weavers, goldsmiths, upholsterers, and cabinetmakers who sought refuge in England and Holland ushered in a golden age of the decorative arts under the combined rule of the House of Orange.

The great baroque palaces of the late seventeenth and early eighteenth centuries, Petworth, Boughton, Chatsworth, Castle Howard and Blenheim, were built on a scale far exceeding the "gentry houses" of the Restoration period. Their interiors also set a new standard of luxury, shown by the magnificent buffet displays of plate laid out on sideboards in the saloon, the silver furniture often found in state bedchambers, and the monogrammed toilet sets and silver hearth furniture in dressing rooms and closets. These "rooms of state" were the setting for an elaborate ceremonial life, including the *levée* and *coucher*, formal visits paid by hosts and guests to each other's apartments, and dining in public, closely following the ritual established at Versailles and the courts of the German electors.

The allegories favored by the decorative painters of the period, Verrio, Laguerre, and Thornhill, were also used as subject matter by the tapestry weavers at Mortlake, which had entered a new period of prosperity, although the Soho workshops of the early eighteenth century preferred arabesques in the style of Jean Bérain or flower pieces like those painted by Jean-Baptiste Monnoyer for the 1st Duke of Montagu. The duke, who was a particular patron of French craftsmen, also employed Bérain's pupil (and William III's chief designer), Daniel Marot, the key figure in the spread of the Louis XIV style to Northern Europe.

Along with the brilliant colors of painted ceilings and staircases, tapestries and embroideries, gold and silver, went a taste for the exotic Orient. Collections of Chinese blue-and-white or *famille verte* were often arranged on stepped ledges above the corner chimneypieces first introduced by Wren and Talman at Hampton Court. These gave extra warmth to small dressing rooms and closets, and enabled them to share the same chimney flue as the adjoining bedchamber. Here, the expensive and fashionable pastime of taking tea was indulged and the presence of coromandel cabinets, Goanese tambour tables, or japanned furniture painted and varnished in England in imitation of oriental lacquer would have seemed particularly appropriate. Most cabinets, used for the storage of precious tea cups and bowls, were also crowned with garnitures of porcelain, and large-scale Japanese Imari pots were especially popular for this purpose.

106

CARVING OF DEAD GAME AND FISH
c. 1680–1695
Grinling Gibbons 1648–1721
limewood, on an oak backboard
157.5 × 179 (62 × 70½)

Kirtlington Park
Christopher Buxton, Esq.

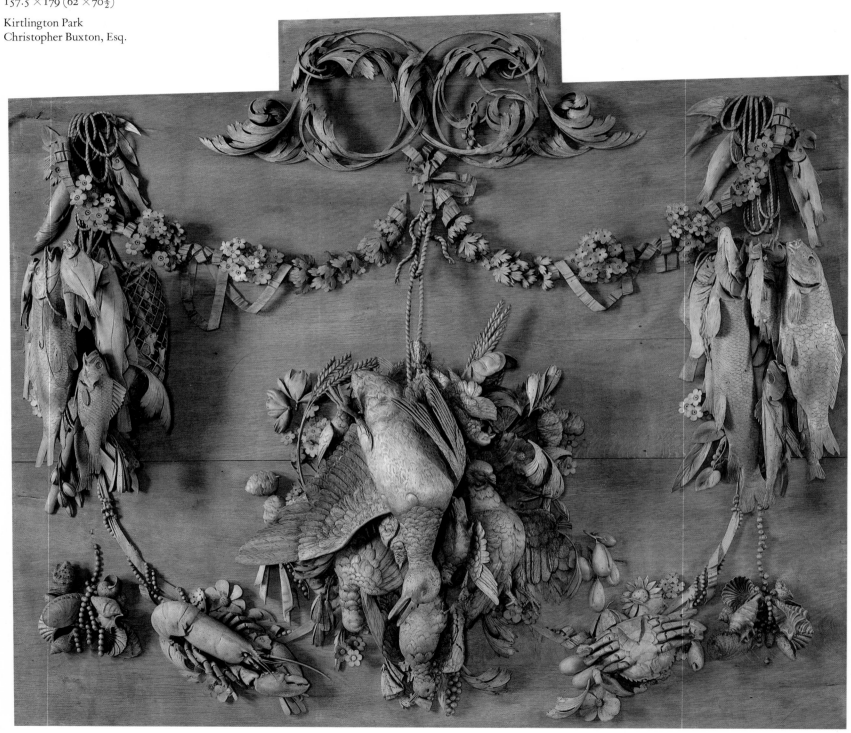

This outstanding example of virtuoso wood-carving, with mallard, partridge and woodcock, pike, trout, lobster, and crab executed almost completely in the round, bears comparison with some of the finest of Gibbons' documented work, notably the famous panel commissioned by James II after his betrothal to Mary of Modena in 1673 (now in the Estense Gallery, Modena) and the magnificent trophies in the Carved Room at Petworth dating from 1692 (Green 1964, figs. 53 and 147–152). The carving is also laminated, that is to say built up with layer on layer of relatively thin sheets of wood, in a manner characteristic of Gibbons' technique.

Grinling Gibbons was born in Holland and came to England about 1667. But his career as one of the greatest craftsmen of the age can be said to have begun on 18 January 1671, when the diarist John Evelyn discovered him carving a copy of Tintoretto's *Crucifixion* in "a poore solitary thatched house in a field" near Deptford. Within a few weeks, Evelyn had introduced him to the king, and there followed the commissions at Windsor Castle and the other royal palaces, Wren's City of London churches, including Saint Paul's, colleges at Oxford and Cambridge, and many of the larger country houses.

The Kirtlington panel is set into the overmantel of the entrance hall, where it has apparently been since the house was built by Sir James Dashwood in 1742 (see no. 352). It must however have come from the older family house known as Northbrook, which stood about a mile away near the remains of the old walled garden, and which was demolished at about the same time. This house is thought to be represented in an engraving in Blome's *The Gentleman's Recreation*, published in 1686, showing Sir Robert Dashwood, 1st Bart., with his huntsman Ralph Rawlins in the foreground, and entitled "The Death of yᵉ Hare wᵗʰ Fleet Hound" (Townsend 1922, 11). Sir Robert succeeded his father in 1682, and in the same year married an heiress, Penelope, daughter of Sir Thomas Chamberlayne. The couple may well have carried out alterations to Northbrook soon after this date, and certainly a squire of Sir Robert's ilk, famous for his sporting

interests, would be a likely patron for such an unrivaled celebration of rod and gun.

The panel must have been stained a dark color by the mid-nineteenth century, when it was described by the carver W.G. Rogers as being "worth a long pilgrimage to see . . . nearly in its virgin state, and quite capable of being recovered and brought back from its present dark state to the rich golden tone of the carvings in the Cedar Chapel at Chatsworth" (Rogers 1863, 184). Recent cleaning and repair work has effected just this transformation. Rogers also records "on the grand staircase . . . a second Gibbons panel, the subject of which is a basket of flowers and fruit, with side pendants . . . about 5 feet by 4 feet", but this no longer survives in the house. G.J-S.

Provenance: Probably commissioned by Sir Robert Dashwood (1662–1734); and by descent at Kirtlington; bought with the house by successive owners
Literature: Country Life 1912, 542–549 (ill.); Green 1964, 117, fig. 163

107

BRACKET OR TABLE CLOCK
c. 1685–1690
Jonathan Puller fl. 1683–1706
ebony case with embossed and chased silver mounts
signed below the dial and on the back plate, *Jonathan Puller Londini Fecit*
32 × 24 × 15.5 (12½ × 9⅜ × 6)

Montacute House
The National Trust

By 1675 the bracket clock had become established in England in a form that was hardly to change for a century. Early inventories generally list them in masculine surroundings such as the Duke of Lauderdale's bedchamber at Ham House, which contained "one pendulum clock garnished with silver in an Ebony case" in 1683 (Thornton and Tomlin 1980), and Lord Warrington's at Dunham Massey, which had an ebony bracket clock by George Graham (Hardy and Jackson-Stops 1978, 18). The pendulum clock had only been

used as a means of regulating clock movements for a very short while before these inventories were made, and pride was taken in the decoration of their rectangular cases (with low domed tops to contain the striking bell) made of ebony, walnut, lacquer, or even tortoiseshell. Ebony cases were generally decorated with pierced brass mounts, but the grandest, as in this case, were garnished with silver. The clock has a verge escapement and the wide-swinging "bob" pendulum generally found before the second half of the eighteenth century, when the anchor escapement and long pendulum were adopted.

Jonathan Puller was apprenticed to Nicholas Coxeter of the Clockmakers' Company in 1676, and practiced as a master clockmaker from 1683 until 1706 (Britten and Baillie 1936, 490).
 G.J-S.

Provenance: Bequeathed to the National Trust by Sir Malcolm Stewart, Bart., in 1960
Exhibitions: Brussels 1973 (136, ill. 188)

108

THE EARL OF WARRINGTON'S PLATE
1717–1749
Isaac Liger (fl. 1704–1730), Edward
Feline (fl. 1720–1749), Daniel Piers (fl.
c. 1746), James Shruder, and others
silver

Dunham Massey
The National Trust
(Stamford Collection)

pair of candlesticks, Isaac Liger 1730; 16.7 (6¾) high; pair of bowls Edward Feline: 17.8 (7) diam.; ink stand with bell and pounce-pot, Isaac Liger 1716 tray: 29.8 (11¾); toilet box Isaac Liger, 1717 12.7 (5) diam.; toilet box, James Shruder 1742 12.7 (5) diam.; shaving jug and basin, Daniel Piers 1747 jug: 17.8 (7) high, basin: 33 (13) wide; spherical soap box, Daniel Piers, and stand, Edward Feline both 1747 soap box: 11.4 (4½); stand: 15.9 (6¼) diam.; chamber pot, Daniel Piers 1747 18 (7) diam.

The Cheshire estates belonging to George Booth, 2nd Earl of Warrington (1694–1758), had been acquired by his ancestors in the mid-fifteenth century, but it was not until the early seventeenth century that the house was extended and improved, a process that was continued under his ownership. He filled the house with treasures, probably aided by the substantial dowry of his countess, Mary Oldbury, whom he married in 1704. After she had borne him one daughter they apparently lived at opposite ends of the house, and in 1739 he published a treatise on the desirability of divorce for "incompatibility of temper"

(Cockayne 1959, 12: 356). Lord Warrington's particular pride in his collection of silver is expressed in the meticulous account books, drawn up in his own hand, recording his purchases from 1701 onward. 1728 was his peak year, with 5,282 ounces recorded, but from 1732 until just before his death in 1758 he purchased some silver every year, almost all of it by Huguenot makers. His manuscript "Particular of my plate in October 1752," which also survives at Dunham Massey, reveals that he owned a total of 26,509½ ounces at that date. Only a portion of this is now at Dunham; most of it was bought back as an act of family piety by his

descendant, the last Earl of Stamford, during the series of sales held by his Foley-Grey cousins (Christie's, 20 April 1921; 28 February 1931). However, the collection includes many of the items listed in Lord Warrington's own bed-chamber in 1752 including the "trimming basin" for shaving, ewer and cover, wash ball box, hand basin, hand powder box and lid, chamber pot, hand candle-stick, a pair of candlesticks, a large and a small standish, sand box, and a "basin to wash my mouth"—many of them included in this selection.

Lord Warrington's plate is in the main quite simply decorated, but he also commissioned some more elaborately wrought items such as toilet bowls, snuffers trays, and candlesticks, the latter from the first-generation Huguenot goldsmith Isaac Liger, first recorded as being made free of the Broderers' Company in 1704, when he also entered a mark at Goldsmiths' Hall. Liger was a highly competent craftsman, and the candlesticks here show a mastery of the fashionable octagonal style. It is possible that they were in fact made by his son John, albeit under the father's supervision. In design they are identical to a pair in a 1728 toilet service (formerly at Dunham Massey and now divided), though not gilded. Heal records the death of Isaac Liger of Hemmings Row in 1730, and on 9 December of that year John Liger entered a mark, virtually identical to Isaac's, from The Pearl in Hemmings Row, Saint Martin's Lane. Like many craftsmen of Huguenot origin he worked outside the city limits.

The pair of bowls are from an original set of six made for the earl in 1749, which are engraved with running scroll-work on the rims, and with Lord Warrington's arms on opposite sides. Their exact purpose is uncertain. Hayward (1978, 36) has surmised that they may have conformed to the earl's recorded "basin to wash my mouth," but a comparison with decorative glass and porcelain bowls makes their use in the drawing room for flowers or pot-pourris (provided from the Orangery at Dunham) more probable. The making of a set of six would also seem to bear out their use in reception rooms rather than bedrooms, especially as other toilet silver in Lord Warrington's collection is comparatively plain.

The plain inkstand has two cylindrical pots for ink and sand. Its bell is a replacement of the original, which may have been that of 1716 by the same maker (lot 3 in the 1921 sale). The standish is engraved twice with the distinctive foliate cypher, *GW* below a coronet, and this must have been for

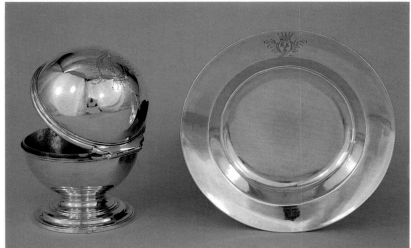

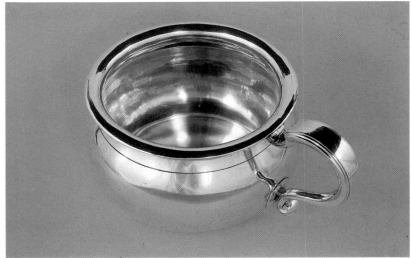

his personal use.

One of the toilet boxes is an early piece of 1717 by Isaac Liger, and is engraved with the earl's arms, while the other is by James Shruder, 1742, also engraved with the initials *GW* and the earl's coronet, and obviously made to match.

Other items of men's toilet ware represent the alliance between function and opulence that an eighteenth-century gentleman would have enjoyed at his ablutions. These include the shaving basin with its notch to fit the neck. This was almost always accompanied by a covered oval-shaped shaving jug often with a wickered handle for insulation (the recorded charge for this was usually sixpence). The spherical soap box with its plain cover, was used with a soap ball, generally accompanied by another similar pierced box for a sponge. The term "wash hand basin" appears in later records for bowls of similar dimensions, capacities, and weights.

The chamber pot is one of fourteen dating between 1714 and 1757. Twelve were allocated to the bedchambers, and two were in the parlor, or dining room. The use of silver chamber pots in the dining room was not uncommon in days of excessive drinking of both beer and wine. Dunham Massey was also exceptionally well equipped with close stools. Those in the two best bed-chambers, listed in 1758, were made of walnut with elaborate marquetry, and provided with silver pans. J.B./G.J-S.

Provenance: Many of these items were re-acquired for Dunham Massey at the Foley-Grey sales (see above). The pair of small bowls is possibly from the set of four sold at Christie's, 22 March 1948, and one of the original set of six is now in the Birmingham City Museum
Literature: Hayward 1978, 32–39; Grimwade 1976, nos. 1462, 1467

109

THE OLD PRETENDER'S WATCH 1705
Richard Vick c. 1678–1750
silver
inscribed: *Vick/London* on dial
5.5 ($2\frac{1}{8}$) diam.

Glamis Castle
The Earl of Strathmore and Kinghorne

This one-handed pocket watch with an inner and outer silver case is typical of a form that became popular in the Restoration period, when the newly founded Royal Society's promotion of scientific endeavor led to advances in timekeeping, particularly in clockmaking. The maker Richard Vick was apprenticed to Daniel Quare, perhaps the most celebrated of all makers after Thomas Tompion, from 1699 to 1702. He later became Master of the Clockmakers Company (1729) and keeper of clocks in the royal palaces, as well as watch-maker to George I (Britten and Baillie 1956, 490; Loomes 1981).

Tradition has it that the watch was left at Glamis by the Old Pretender, James II's eldest son, when he stayed at the castle with an entourage of eighty-eight (for all of whom beds were provided) at the time of the 1715 Rebellion. The Old Chevalier, as he was known by his followers, was touched for the King's Evil in the chapel—a sure sign to Jacobites that he was the rightful king, for only a true sovereign was said to be able to cure scrofula by virtue of the holy oil with which he was anointed. He presented his host, the 6th Earl of Strathmore, with a sword that is still at Glamis, but is said to have left the watch under the pillow of the Kinghorne Bed, with its early seventeenth-century embroidered hangings. It was discovered there after his departure by a maid who stole it, but whose great-great-great-granddaughter returned the watch to Glamis many years later. Living in exile at the palace of Saint-Germain, it might have been supposed that the Pretender would have had a French watch, but as the reputation of English makers was unequaled in Europe at this date it is perfectly possible that he was given this example made in London by an admirer of "the King over the Water." G.J-S.

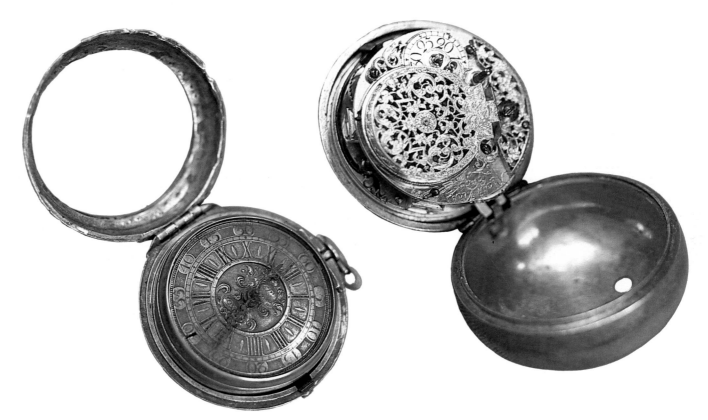

110

GARTER BADGES 17th century
English
enameled gold, onyx, paste, and crystals
9.5 ($3\frac{3}{4}$) × 5.7 ($2\frac{1}{2}$);
9.5 ($3\frac{3}{4}$) × 5 (2)
inscribed, *HONI SOIT QUI MAL*
Y PENSE

Badminton
The Duke of Beaufort

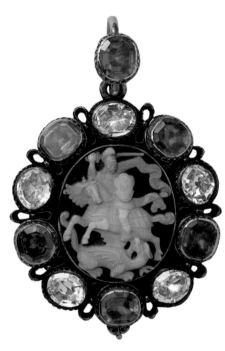

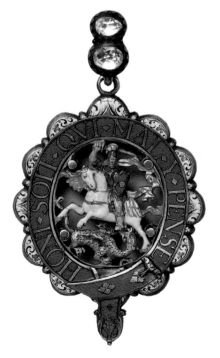

The front of one of these badges of the Order of the Garter is set with an onyx cameo of Saint George, patron of the Order, on horseback, framed in alternate red and white pastes mounted in gold and silver collets with saw tooth edges. The back of the cameo is encircled by a blue enameled Garter bearing the inscription of the Order. The cameo and white pastes are later substitutes for the original engraving and rose-cut diamonds. The cameo in the second badge of the Order is missing, but the original frame of rose-cut crystals is intact, as is the suspension loop similarly set with crystals in two silver settings, and the enameled Saint George on the back. This is enclosed within a blue garter inscribed with the same motto and bordered by seven semicircles enameled in red and white with scroll-work. Together they illustrate the style of Garter badge or Lesser George of this period, which hung from a blue ribbon worn across the chest, unlike the George attached to the Grand Collar of the Order. These two badges may descend from Henry Somerset, 3rd Marquess of Worcester (1629–1699). A staunch Tory and Member of Parliament for Monmouth, as Lord Herbert he was one of the twelve commoners deputed in May 1660 to invite the return of Charles II, a service recognized by his appointment to the Dukedom of Beaufort in 1682. The state bedchamber at Powis Castle, with its balustraded alcove in the style of Versailles, is thought to have been prepared for his reception as Lord President of Wales. D.S.

Exhibitions: London, Park Lane 1929 (802, 803)

111

GARTER 17th century
diamonds in silver, on later blue velvet
35.4 (14) long
inscribed, *HONI SOIT QUI MAL*
Y PENSE

Bowhill
The Duke of Buccleuch and
Queensberry, KT

The motto, which can be translated as "Shame be to him who thinks evil of it," is part of the insignia of the Order of the Garter, which was founded by Edward III in the mid-fourteenth century. Its membership was limited to twenty-six knights including the sovereign, as the senior British order of chivalry and counterpart to the Round Table of King Arthur. The blue Garter, which is always worn buckled around the left leg, signifies the lasting bond of friendship and honor between the members, "co-partners in peace and war, assistant to one another in all serious and dangerous exploits and through the whole course of their lives to show fidelity and friend-liness one towards the other" (see

Ashmole 1715, 124–126). Jeweled garters like this one were worn in the fifteenth century by Charles the Bold, Duke of Burgundy, who was granted the insignia in 1468, and had the black letter inscription set with hog-back diamonds. As all garter insignia had to be returned to the monarch on the death of a knight few have survived; however, another seventeenth-century one is in the Treasury of the Residenz, Munich (Twining 1960, 40). They evoke the splendor of the Garter ceremonies revived by Charles II, who conferred the Order on General Monk and Admiral Edward Montagu, who were responsible for his Restoration, on his arrival in England in 1660. The Duke of Buccleuch also owns the Badge of the Order of the Garter that belonged to General Monk, set with a cameo and framed in rose diamonds. D.S.

Exhibitions: Edinburgh 1967, 121

112

TWO-HANDED CUP AND COVER c.1725
English
silver-gilt
29×26.5 ($11\frac{1}{2} \times 10\frac{1}{2}$)

Belton House
The National Trust
(Brownlow Collection)

The two-handled cup and cover was undoubtedly the most important piece of display plate in the country house throughout the eighteenth century. This cup from Belton is almost certainly by a Huguenot smith, perhaps by David Willaume, Paul de Lamerie, or John Le Sage. The quality of the applied strapwork is particularly noteworthy: relatively simple palm leaves alternate with more elaborate, shaped straps on a finely matted ground. The features are repeated around the domed cover. The spreading foot, the leaf-capped scroll handles, and the baluster finial of the cover are relatively plain, and set off the finely engraved armorials complete with crest, supporters, and motto. The cup is engraved with the arms of John, Viscount Tyrconnel (1690–1754), created 1718, and those of the 1st Baron Brownlow, created in 1776.

The outstanding collection of silver still at Belton includes a group of William and Mary silver-gilt pilgrim bottles bearing the arms of Sir John Brownlow, builder of the house in the 1680s, and items, made principally by the royal goldsmith William Pickett, from the plate issued by the Jewel House to Lord Tyrconnel's nephew, Sir John Cust (1718–1770), who was Speaker of the House of Commons from 1761 until his death. Later, the 1st Earl Brownlow (1779–1853) was a client of the firm of Rundell, Bridge and Rundell, acquiring contemporary silver as well as a group of late seventeenth-century silver sconces from the Royal Collection. J.B.

Provenance: Probably identical with the cup and cover listed under silver-gilt in an inventory of plate at Belton taken on the death of Lord Tyrconnel in 1754 (Belton House MSS); by descent to the 7th Lord Brownlow; acquired by the National Trust in 1984 with Belton House and its principal contents

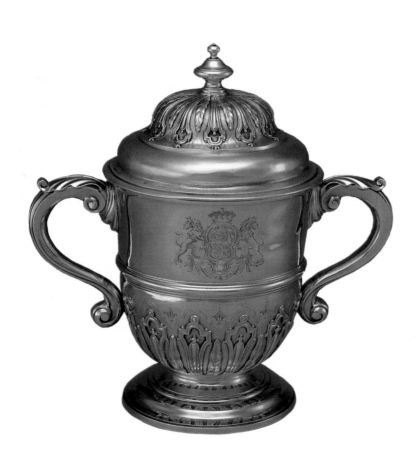

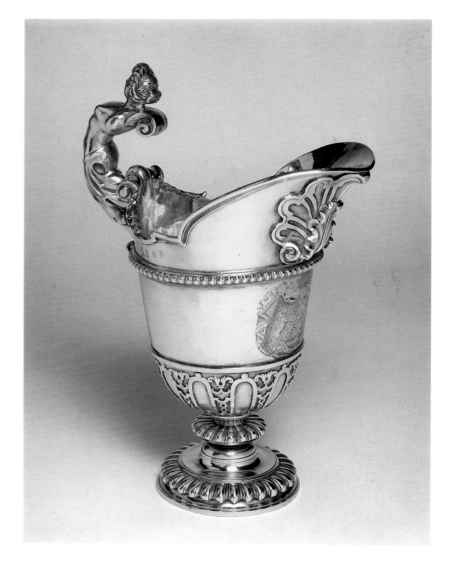

113

EWER AND BASIN
David Willaume I 1658–1741
silver-gilt
ewer: 35 $(13\frac{3}{4})$ high;
basin: 65 $(25\frac{5}{8})$ diam.

The Duke of Abercorn

The rosewater ewer with its basin was a necessity in the refined, civilized household. In the more opulent houses, where brass or pewter were eschewed, the silver or silver-gilt ewer and basin remained a major property of the plate room until the mid-eighteenth century. The Huguenot goldsmiths, in particular David Willaume, produced especially elegant large basins with helmet-shaped ewers between about 1699 and 1720.

In this example, Willaume achieved a combination of dignity and a certain esoteric exuberance in the buxom caryatid figures that form the flying scroll handle. These contrast between the bold shell motifs below the shaped lip, the gadrooned rib below, and the neat, applied strapwork at the base of the body. Ewers of this size and shape were normally accompanied by great dishes weighing 200 ounces or more. This is one of Willaume's earliest essays in the pattern that his son, David Willaume II, continued to use forty years later. The arms of the widowed Anne, Countess of Abercorn whose husband James died in 1744, were later engraved in the center of the dish in a lozenge, with those of Hamilton impaling Plumer within a drapery mantling. The countess died in 1776. J.B.

Exhibitions: Belfast 1956 (23, basin only)

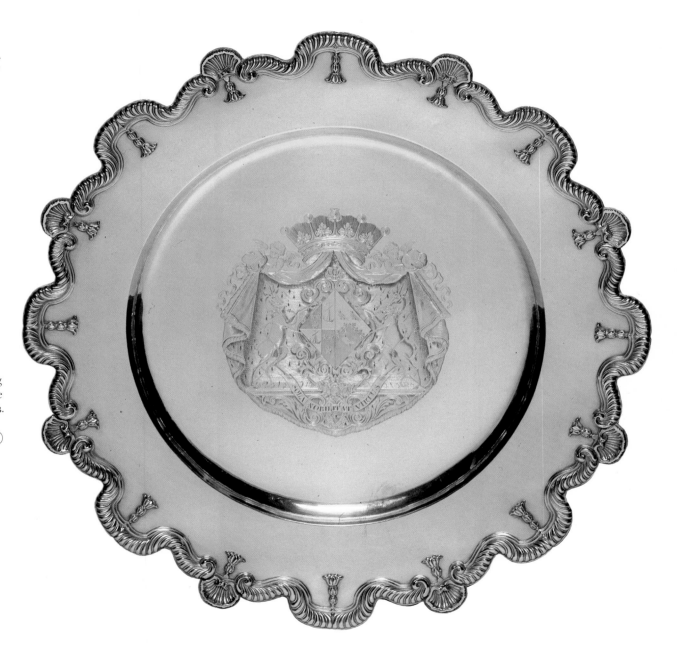

114

SIDEBOARD DISH 1683
Francis Leake
silver-gilt
58.4 (23) diam.

The Burghley House Collection

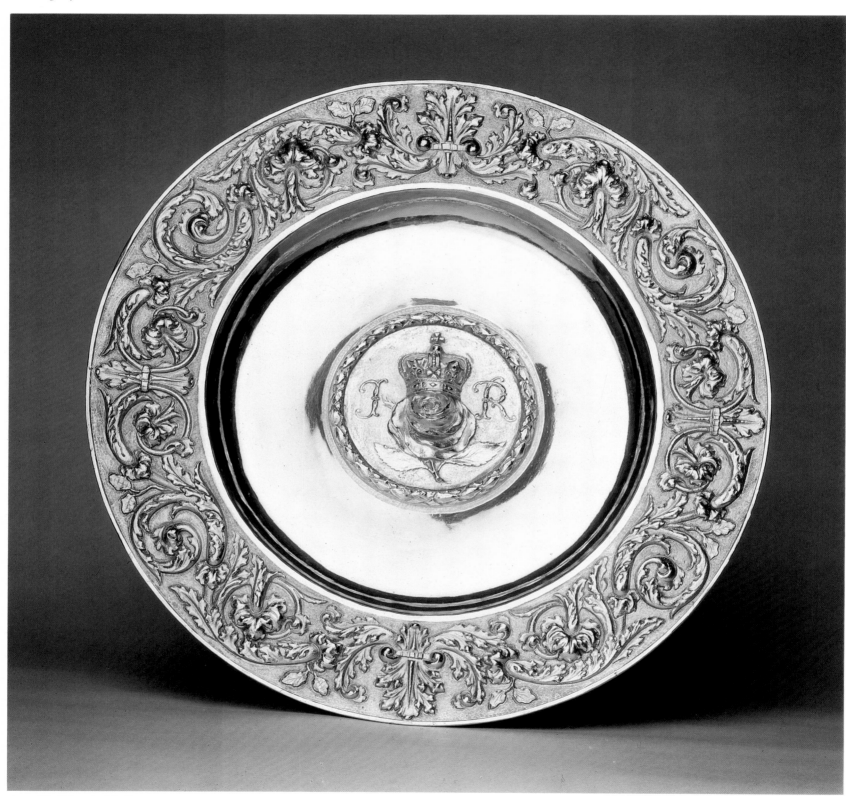

This silver-gilt sideboard dish is one of a pair of particular documentary importance. The broad rims are chased in high relief with running scrolling foliage, and the center of the well was applied slightly later with a boss chased with the Stuart rose. Below that is a royal crown between the cypher *IR* for King James II, all within a wreath.

The Earls of Exeter are the Hereditary Grand Almoners of England, and the family possess several fine pieces of silver, all but one of them basins or dishes, provided as perquisites for their service at coronations. In 1933 a reference to these 1683 dishes was discovered in the Lord Chamberlain's accounts: "May ye 13, 1685. Deliver'd to ye Earl of Exeter as Chief Almoner at his Majs. Coronation two gilt chas'd basons for his fees. pair 312.0.0" (Burghley House MSS; letter from E. Alfred Jones).

James, Duke of York, succeeded his brother Charles II in February 1685, and was crowned on 23 April. The dishes or basins were probably already in stock in the Jewel House, and only the central bosses had to be chased and applied for the coronation.

The maker Francis Leake had been apprenticed to Henry Starket, and was made free of the Goldsmiths' Company in 1655. He was brother to another goldsmith, Ralph, who was apprenticed to Thomas Vyner and became free in 1656 on the same day as Vyner's son Robert. Thomas Vyner was appointed Royal Goldsmith in 1660, and there seems little doubt that both brothers became "Vyner's men." Some of the work bearing Francis' mark has been identified from the Vyner ledgers, and much is richly chased, though Charles Oman voices doubts that Vyner in fact executed the more elaborate examples himself. Further, it is known that Wolfgang Howser was responsible for the chased Communion plate bearing Leake's mark in Auckland Palace Chapel, Durham. Other pieces bearing Leake's mark include the standing cups of 1663 in the Kremlin, the set of four standing salts in the Tower of London, a cup and cover of 1663 in the Untermyer Collection, New York, and several other cups, tankards, and other pieces.

The other Almoner's dishes in the Burghley House collection include that

of 1659, a footed salver with the maker's mark *ET*. The mark may well have been struck very shortly before the king's return on 29 May 1660—after Charles II's restoration, which became the day on which the date letter was changed each year, instead of Saint Dunstan's Day, 19 May. A second dish pertains to the coronation of Queen Anne, a large silver-gilt dish by the Huguenot goldsmith Pierre Harache of 1702, superbly engraved with the royal arms. The last, dated 1820, was made by Rundell, Bridge and Rundell, the Royal Goldsmiths. It was a large, footed basin bearing the mark of Philip Rundell, 1820, and was given as the fee at the coronation of George IV on 19 July 1821.

See also no. 115 J.B.

Literature: Oman 1970, 28–29
Exhibitions: Burghley 1984 (10)

115

EWER 1727
Benjamin Pyne d. 1732
silver-gilt
38.7 (15½) high

The Burghley House Collection

This silver-gilt ewer reflects the Huguenot manner, though it was made by one of England's most prolific native-born goldsmiths. It is almost certainly the Earl of Essex' Almoner's plate, presented as his fee (or made from the sum paid for his services) as Grand Almoner at the Coronation of George II, with whose arms it is engraved, on 11 October 1727. No record of the usual dish made for the Almoner is known for this occasion (see no. 114).

Benjamin Pyne, the son of a Devonshire gentleman, was apprenticed to the well-known medalist and goldsmith George Bowers in 1667. He must have registered his mark, *P* crowned, about 1680, one of the few pre-1697 marks to have been identified with some certainty. Pyne's work is comparable with that produced by the best of his London contemporaries and his many commissions included fine church plate, the great ewers and

dishes at the London Mansion House, the Oar Mace of Boston, Lincolnshire, and the standing cup of the Pewterers' Company of London, as well as innumerable pieces of domestic and other ceremonial silver.

Earlier in the year that Pyne made this ewer, he had resigned from the Livery of the Goldsmiths' Company and applied for the post of Beadle, which was usually awarded, if vacant, to very poor goldsmiths. The former Beadle, John Boddington, had just died, so Pyne was at once appointed. By then he was nearing seventy-five years of age, and it is said that he was also

bankrupted that year. On his death in April 1732 he was recorded as still being in debt and his daughters Mary and Ann petitioned the company for assistance as they had been left destitute and though "educated . . . not bro[t]. up to any business." Certainly the ewer must have been one of the elderly Pyne's last commissions or else it was part of the stock he sent to the office subsequently (after 29 May 1727) for assay and marking. J.B.

Exhibitions: Burghley 1984 (33)

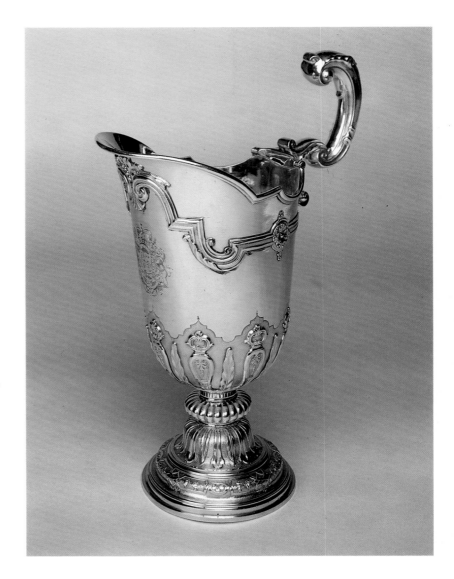

116

PILGRIM BOTTLE 1688
Adam Loofs (Loots) fl. 1682–1699
silver-gilt
48.2 (19) high

Chatsworth
The Trustees of the
Chatsworth Settlement

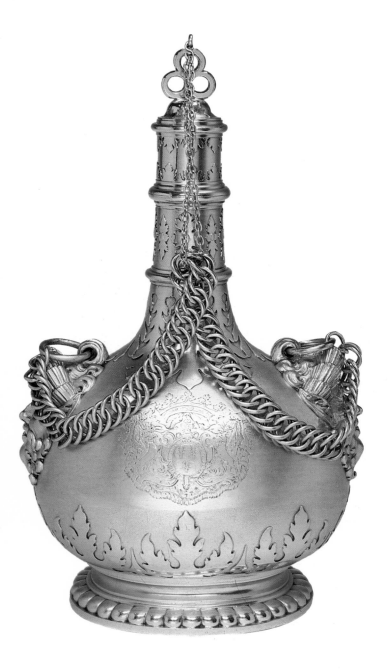

This silver-gilt pilgrim bottle dates from the year of the "Glorious Revolution" that brought William of Orange to the throne of England. This and its pair were apparently a gift from the king to the 4th Earl, created 1st Duke of Devonshire in 1694. They are extremely rare examples of this shape made by a Dutch silversmith, though other English and French examples survive. Adam Loofs was the son of Pieter Loots of Brussels and Elizabeth van den Brouck. He was made free of the Hague Goldsmiths' company in 1682, and was warden from 1687 to 1699. He was appointed Keeper of the Plate by the Stadholder William, who appears to have been partial to Loofs' French style of design, as he was to those of Daniel Marot and other craftsmen who had fled to Holland from persecution in France. The duke exhibited the same preference in his choice of other silver and silver-gilt for Chatsworth, which he rebuilt between 1685 and 1707.

These two bottles have complete marks for The Hague and the French-style mark *AL* conjoined over a hunting-horn crowned, and the two "points de remede," which were used in Paris on the finest quality silver, though their weights are marked in the Dutch style. The treatment of the masks in high relief on either side of the oval body is also very Dutch. However, French Huguenot influence can definitely be seen in the foliate cut-card ornament at the base and the bold gadrooned foot. The exact date of the presentation of the pair of bottles to the duke is unknown, but the engraving of the arms complete with the Garter and ducal coronet suggests the year of his elevation, 1694.

The magnificence of the so-called pilgrim bottles, a name derived from the medieval leather bottles carried by travelers, suits the richness of the State Dining Room at Chatsworth, the first of Talmon's new state apartments, which was completely redecorated and rehung by 1694. J.B.

Exhibitions: London, St. James's Court 1902, pl. 89; Arts Council 1964 (171a); Manchester 1979 (7); IEF 1980 (152)

117

ICE PAIL 1698/1699
David Willaume I 1658–1741
silver-gilt
25 × 25 × 22.9 (10 × 10 × 9)

Chatsworth
The Trustees of the
Chatsworth Settlement

David Willaume senior, one of the first Huguenot goldsmiths to arrive in England, was an outstanding member of the French Protestant community who enjoyed the patronage of the wealthiest clients in England. It is noteworthy that among his early clients was the 1st Duke of Devonshire, who along with Willaume could truly claim a "first" with the pair of silver-gilt ice pails, or wine bottle coolers, made for Chatsworth in 1698/1699. That was a full fifteen years before any other comparable single-bottle cooler is recorded: for instance a group of 1713/1714 by the Huguenot Lewis Mettayer, of which a pair was bequeathed in 1925 to Eton College, and others formerly in the collections of Lord Methuen and Viscount Cowdray.

These are not simple bottle holders. The whole conception is majestic, with alternating patterns of applied strapwork incorporating husks and guilloches around the base, above a spreading gadrooned foot, the plain section of the bodies engraved with the duke's arms and supporters below a running band of Vitruvian scrolls in high relief, between applied lion mask and ring handles.

Apart from a pair of ice pails made for Sir Robert Walpole in 1716 by William Lukin (Untermyer Collection, New York) nearly forty years passed before the ice pail became part of the dining furniture again, when goldsmiths such as Edward Wakelin and Thomas Heming were responsible for its revival.
 J.B.

Literature: Grimwade 1976, 703–704
Exhibitions: Manchester 1979 (8);
IEF 1980 (154)

118

GINGER JAR C. 1670–1680
English
silver, parcel gilt
43 (17) high

Private Collection

This is one of a pair of vases in the Dutch style fashionable from the time of the Restoration of Charles II in 1660 until about 1690. Such vases were used as display plate on the sideboard or on the stepped mantel shelves above a fireplace. Few such richly repoussé-chased vases bear full sets of hallmarks, since they were made on commission and therefore "not set to sale," which required assay and marking. Many were made by "Dutchmen" or other foreigners working in London, such as Jacob Bodendick, or by skilled goldsmiths who quickly mastered the art of baroque chasing to suit their fashionable patrons, craftsmen such as Thomas Jenkins, George Bowers (noted as a medallist), Robert Cooper, and Anthony Nelme.

Cupids and acanthus foliage were the chief decorative themes of such vases, which were often either gilded or part (parcel) gilt for greater effect. Often swags of fruit and foliage were applied overlaying the otherwise simple collars below the domed covers, as in this example. It is unlikely that such jars were used for anything other than decoration, since many of them are made of relatively thin gauge silver, although tall vases of a type suitable for flowers, or flask-shaped vases, are sometimes associated with these "ginger" jars, together forming a "garniture" for display. In essence these are silver versions of a garniture of Chinese porcelain jars.　　　　　J.B.

Literature: Oman 1970, 59–60
Exhibitions: London, Park Lane 1929 (220)

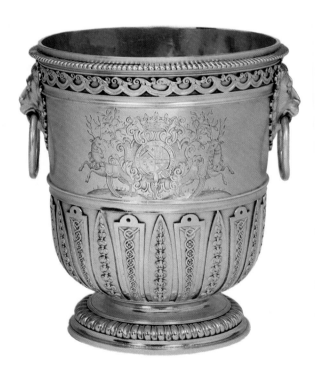

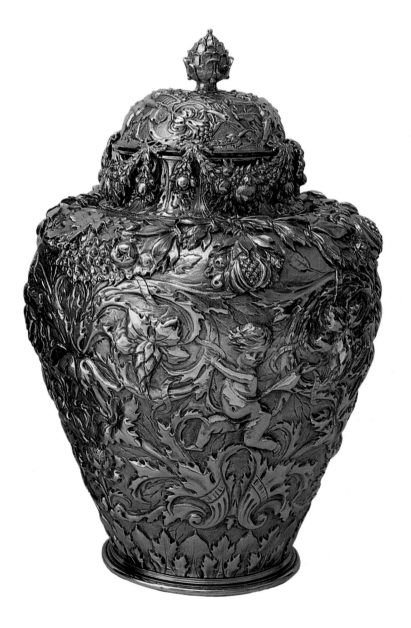

119

WINE COOLER AND FOUNTAIN 1728
Thomas Farren d. c.1743
silver
cooler: 60.9 (24) diam.;
fountain: 71.1 (28) high

The Burghley House Collection

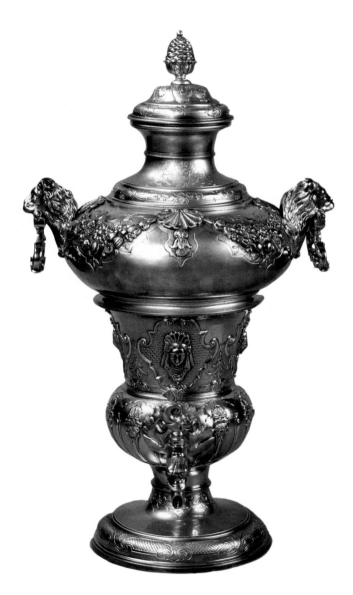

Lady Sophia Cecil, daughter of the 1st Marquess of Exeter and wife of Henry-Manvers Pierrepoint, made etchings of many of the rooms at Burghley in the years before her death in 1823. That of the dining room clearly, though perhaps somewhat amateurishly, depicts the sideboard with its grand array of buffet plate, the family's most impressive and treasured possessions in silver and silver-gilt. In the center, among the almoner's dishes and other silver is this rare wine cooler and matching fountain, both engraved with the arms of Cecil with Chambers in pretence, for Brownlow, 8th Earl of Exeter and his wife, Hannah Sophia Chambers, who married in 1724. In front on the floor, is the larger companion piece, a wine cooler of about 1710 by Philip Rollos (no. 120). The fountain, with its decorative dolphin tap and spigot, is apparently an urn for wine, which was cooled in its flasks and bottles in the matching cistern, a term strictly applicable only to the large vessels, often of brass, copper, or pewter, used for rinsing dishes during a banquet (Penzer 1957, 1; figs. 1, 2, and 3). Earlier fountains also appear to have been used for water, though by the late seventeenth century they had become

fashionable vessels for wine. Despite their widespread use, matching fountains and wine coolers have always been rare. It is interesting that those surviving in pairs are generally of smaller size than the great wine coolers, which often weighed 1,000 ounces or even as much as 8,000.

It seems likely that Farren must have inspected the earl's great Rollos wine cooler carefully, for though made perhaps twenty years later in a well-developed Huguenot style, this set has a certain kinship with the earlier piece. For example the demi-lion handles on the fountain, though of a different breed from those of Rollos, echo those of the cooler. Farren also repeats the theme of great swags festooned between masks and shells in a manner that, though typical of the later 1720s, nonetheless recalls the Queen Anne cooler. In selecting Farren as his goldsmith for these two pieces, the earl was fortunate to find a craftsman capable of producing works that were in harmony with the older treasures of his country house.

J.B.

Literature: Penzer 1957, 2:41, fig. 4
Exhibitions: London, Park Lane 1929 (406, 407); Burghley 1984 (54)

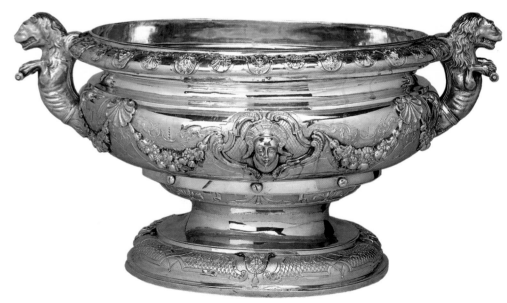

120

WINE COOLER OR CISTERN c.1710
Philip Rollos I fl. 1690–1721
silver, Britannia standard
152.4 (60) diam.

The Burghley House Collection

This great wine cooler is engraved inside with the arms of Cecil with Chambers in pretence, for Brownlow, 8th Earl of Exeter, who in 1724 married Sophia, daughter and co-heir of Thomas Chambers. Capable of holding many bottles or flasks of wine and a great quantity of ice, it is one of only about three dozen surviving English silver cisterns dating between 1667 and 1794 and notable for their immense size and weight. The weight of the present example has been variously calculated between 3400 oz. and 3690 oz. (Charlton 1847, Jones 1928).

In design this is one of the most impressive of all such cisterns, grand in scale yet conveying a sense of elegance and echoing the graceful foliate and festooned ornament of the dining room for which it was made. It is supported on four massive volute scroll feet from the base of which rise beautifully modeled griffin heads. The size and height of the heads is balanced by two splendid lions rampant, which act as handles and are also the supporters of the Cecil arms. For the relationship with the smaller wine cooler see no. 119. J.B.

Related Works: Of the four other large wine coolers made by Philip Rollos, that made for the Duke of Kingston in 1699 (The Hermitage, Leningrad), that of 1701 made for the 2nd Earl of Warrington (National Trust, Dunham Massey), and that of 1712 bearing the Royal Arms of Queen Anne after 1707 and apparently issued to the Earl of Home (British Museum), all feature handles in the form of animal supporters from coats of arms.

Literature: Penzer 1957, 3–7, 39–46
Exhibitions: Burghley 1984 (55)

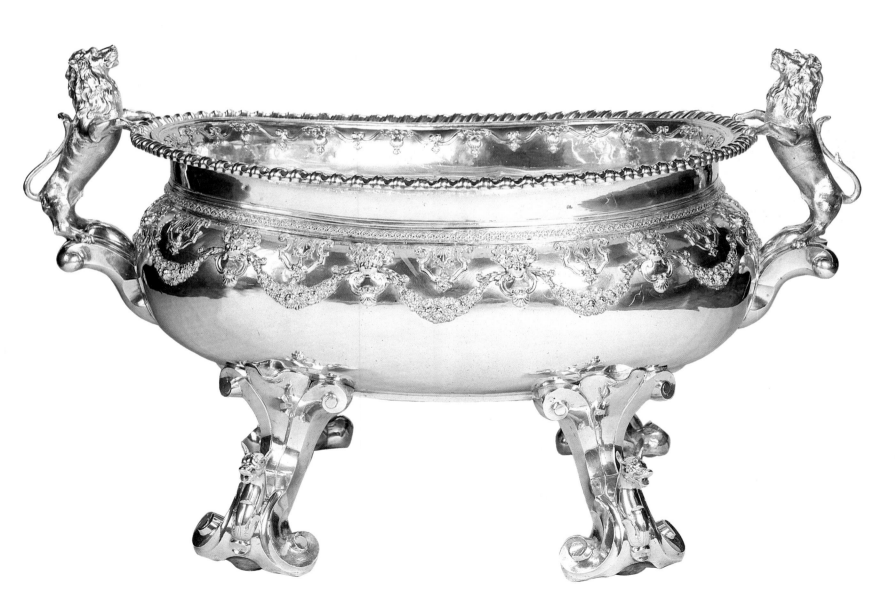

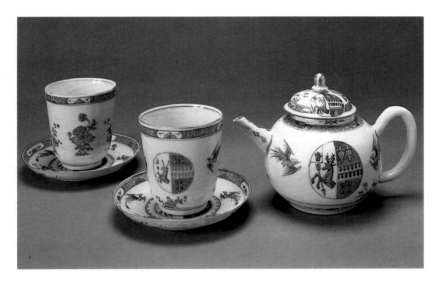

121

TEAPOT, CUPS, AND SAUCER C. 1717
Chinese, Kangxi
porcelain
teapot: 15.2 × 15.2 × 15.2 (6 × 6 × 6);
cups: 10 (4) high; saucers: 7.6 (3) diam.

Wilton House
The Earl of Pembroke and Montgomery

These pieces are from perhaps the largest *famille verte* armorial service to survive in any English country house. The service bears the arms of Decker impaling Watkins and did not come into the family of Lord Pembroke until almost a century after it was made.

The service is rich in palette and includes a variety of pieces ranging from large dishes to a tea and coffee service in which the cups are all the same shape — but those for coffee have handles and those for tea do not. There was also a companion service in underglaze blue of the same date and bearing the same arms (Griggs 1887). This and a set of similarly decorated mother-of-pearl armorial counters—perhaps the earliest such set recorded—appear never to have been at Wilton, however, and their present whereabouts are unknown.

The arms of Decker show a baronet's badge (a shield with a red hand) in the upper quarter. Sir Matthew Decker (1679–1749) was born in Amsterdam, but because of persecution moved to London in 1702. He prospered and became a director of the East India Company and later a Member of Parliament, and in 1716 was created a baronet. At his house on Richmond Green in Surrey he exercised his "truly Dutch passion for gardening," producing a pineapple to set before George I. So proud was Decker of this product that he had it painted by Caspar Netscher (DNB 1908, 5:716). He married Henrietta, daughter of the Reverend Richard Watkins, rector of a country parish in Warwickshire, and their family life is described in the *Gentleman's Magazine* (1749, 141) as "an undisturbed series of domestick comforts." The Deckers had four daughters who were painted by Johannes de Meyer in 1718 (Fitzwilliam Museum, Cambridge). In 1744 Katherine, the eldest, married the 6th Viscount Fitzwilliam whose son founded the Fitzwilliam Museum. D.S.H.

Provenance: Commissioned by Sir Matthew Decker, Bart.; his daughter Katherine, wife of the 6th Viscount Fitzwilliam (whose sister Mary married the 9th Earl of Pembroke); their son the 7th Viscount Fitzwilliam, on whose death in 1816 the principal parts of his estate passed to the 11th Earl of Pembroke and his heirs
Literature: Howard 1974, 167, 187

122

TEA TABLE ON MAHOGANY STAND
1741
David Willaume II 1693–1761
silver
64.7 × 61 (25½ × 24) diam.

Dunham Massey
The National Trust

The term "tea tables" describing large salvers or sideboard dishes is only slowly coming to be recognized in the study of the often very large circular, oblong and, by the 1770s, oval waiters—above 18 inches in diameter or length— associated with tea drinking. The first order for tea was placed by the East India Company in 1668, but coffee and chocolate remained the fashionable drinks until the early eighteenth century. The survival at Dunham Massey of two rare mahogany tripod stands with their tops shaped to take the feet of the salvers remind the historian of the original use of such silver "tables." They were often too heavy to carry about the house but were placed in the drawing-room to hold the kettle and stand, teapot, cream ewer, sugar bowl, the bowl for discarded tea leaves, and the cups and saucers. These items were associated from about 1700 onward with the kind of fashionable tea ceremony depicted in William Hogarth's painting of the Wollaston family (London, V & A 1984, B7). This salver of 1741 and its smaller companion, noted in 1752 as "a coffee table," are listed in the 1758 inventory of Dunham Massey in the Tea Room, together with "2 Mahogany Stands to set the Silver Tea and Coffee Tables on."

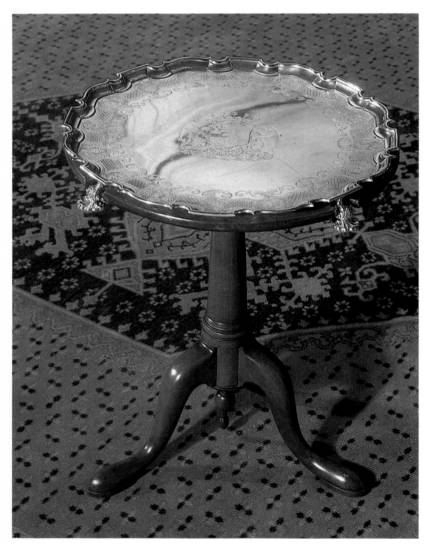

The style of the silver table is true to its date: Willaume's "pie-crust" raised rim, heavy shell feet, and flat-chased border of scrolls, foliage, and trelliswork show the development of the rococo from the earlier, more formal decoration of the Huguenot period. The table is engraved with the arms, supporters, and motto of George Booth, 2nd Earl of Warrington, impaling those of his wife Mary, daughter of John Oldbury Esq. (see no. 108).

J.B.

Provenance: With its scratch weight of 202–10, this tea table would appear to conform to the "large salver" weighing 201 oz. 4 dwt. by David Willaume, 1741, in the sale of plate from the collection of Catherine Lady Grey and Sir John Foley Grey, Bart., at Christie's, 20 April 1921, lot 46. It was purchased on behalf of the 10th Earl of Stamford by whom it was bequeathed to the National Trust with the house in 1976
Literature: Hayward 1978, 36, pl. 8

123

TEA KETTLE ON TRIPOD STAND 1725
Augustine Courtauld 1686–1751
silver
101.6 (40) high

Alnwick Castle
The Duke of Northumberland, KG

This is one of only seven such silver tripod table stands recorded, and one of only two known with an exactly contemporary kettle and lamp. The other was made in the previous year by Courtauld's master, Simon Pantin I. Such tea kettles with table stands are an indication of the importance of the tea ceremony in the English country house during the first three decades of the eighteenth century. The kettle is engraved with the arms of Seymour impaling Thynne for Algernon, Earl of Hertford, who succeeded his father as 7th Duke of Somerset in 1748. He married Lady Frances Thynne in 1713.

The scrolling supports and baluster form were used in all the known examples, but there were notable variations in the treatment of the

support for the lamp and the kettle itself. In all but two, the stand itself had a section to hold the spirit lamp, as here, or a brazier type heater, as in the Duke of Buccleuch's stand of 1717 by David Willaume. Simon Pantin's example of 1724, formerly in the collection of the Earls of Strathmore and now in the Untermyer Collection, New York, as well as that from the Gregory family collection, both feature salver tops supporting the kettle and lampstand, a form more generally used for tripod tables of wood fitted with silver salvers (see no. 122). Other tea kettles were often supplied with circular or triangular stands, now known as kettle stands, but which are rarely seen today with the original kettles. The present stand is very like one of about the same size but unmarked and perhaps slightly earlier, sold from the collection of the Marquess of Exeter in 1888 and subsequently in the collections of Col. H.H. Mulliner and of Lord Bicester.

The kettle supplied by Augustine Courtauld for Alnwick shows his mastery of a style that during the twenties gradually became more decorative, until the great flowering of the rococo in the 1730s. While most of his output was devoted to domestic wares such as coffee pots, tea-table silver, cups and covers, waiters, baskets, and so on, Courtauld's name and reputation spread abroad. He is well represented in the silver collections in The Hermitage in Leningrad and in the Kremlin in Moscow, as well as in London's Mansion House, for which he made a fine ceremonial salt in 1730.

Courtauld was of Huguenot descent—it is said that as a baby he was smuggled out of France hidden in a vegetable basket—and his work bears comparison with that of the finest of his contemporaries. His skills at casting, chasing, and piercing were passed on to his son Samuel who was apprenticed to him in 1734, and whose successors, though no longer practicing goldsmiths, remain keenly interested in the family's work and are members of the London Goldsmiths' Company to this day.

J.B.

Exhibitions: Lansdowne House 1929 (no. 164)

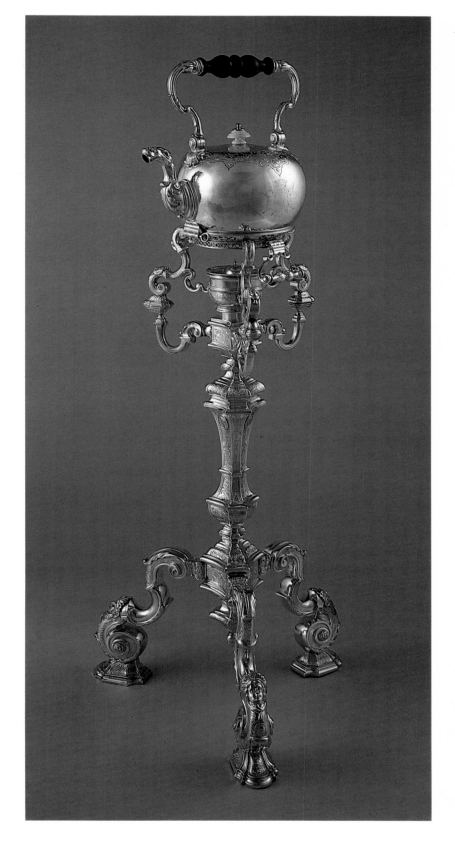

124

THE COUNTESS OF KILDARE'S
TOILET SERVICE 1698/1722
David Willaume I 1658–1741
silver-gilt
mirror 68.5 × 50.8 (27 × 20); oblong
caskets 12 × 26 × 14.3 (4¾ × 10¼ × 8⅝);
ewer 21.6 (8½) high; basin 37.4 (14¾)
wide; circular waiters 16.8 (6⅝) diam;
cylindrical toilet boxes 12.7 (5) diam.;
small cylindrical toilet boxes 7.6 (3)
diam.; porringers 8.25 × 14.6 (3¼ × 5¾);
thistle-shaped pomade pots 6.9 (2¾) high;
octagonal toilet bottles 15.2 (6) high;
candlesticks 13.9 (5½) high; candle
snuffers 13.9 (5½) wide; oblong casket
on stud feet 15.8 (6¼) wide; hair brushes
13.9 (5½) wide; octagonal "plummets"
12.7 (5) high

Luton Hoo
The Wernher Collection
Nicholas Phillips, Esq.

A large toilet service was considered a fashionable wedding present from a groom to his bride from the second half of the seventeenth century until the late eighteenth century. This example is engraved with the arms of Robert Fitzgerald, 19th Earl of Kildare (1675 –1744) impaling those of his wife Lady Mary O'Brien, daughter of the 3rd Earl of Inchiquin, whom he married in 1709. One of the larger services to have survived in its entirety, it comprises twenty-eight pieces, including a large table mirror, oblong caskets often known as comb boxes, boxes for powder and pastes of various kinds, perfume flasks, small bowls and covers "to wash chaps," an ewer, basin, salver, and pincushion. The pair of small candlesticks are provided with snuffers (probably by a specialist maker), and there are also four silver-backed brushes and a pair of interesting bottle-shaped flasks each with a hook finial. The exact nomenclature and use of the flasks has not been determined; "dressing weights" and "plummets" known to have been supplied by silversmiths have been suggested, or it is possible that they held powder and the hooks were used to fasten staylaces or buttons. Most toilet services like this one were made up of pieces of varying dates, already in stock at the silversmith's so that the order could be quickly completed. Here Willaume shows his mastery of simple formality; the pronounced gadrooned mounts contrast with the earl and countess' finely engraved armorials, complete with monkey supporters, the earl's coronet, and the family's Irish motto, "Crom a Boo." J.B.

Provenance: The 19th Earl of Kildare by descent to the 7th Duke of Leinster; sold at Christie's, 12 May 1926, to the late Sir Harold Wernher, grandfather of the present owner
Literature: Clayton 1971, 201, 317, 319

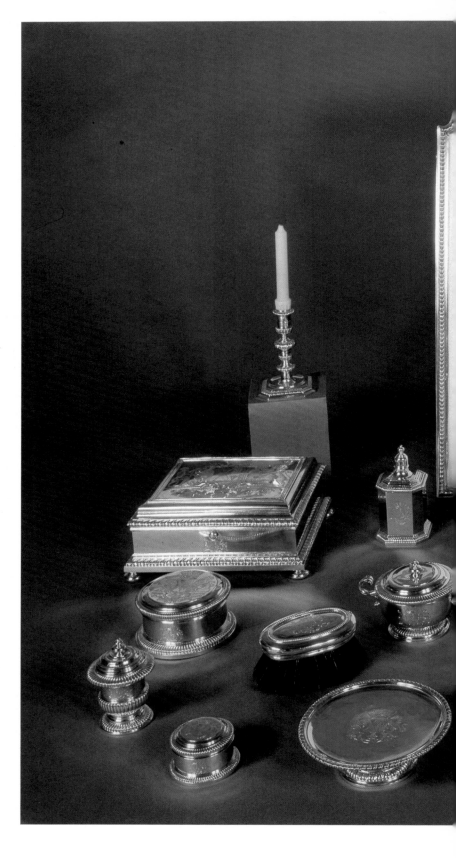

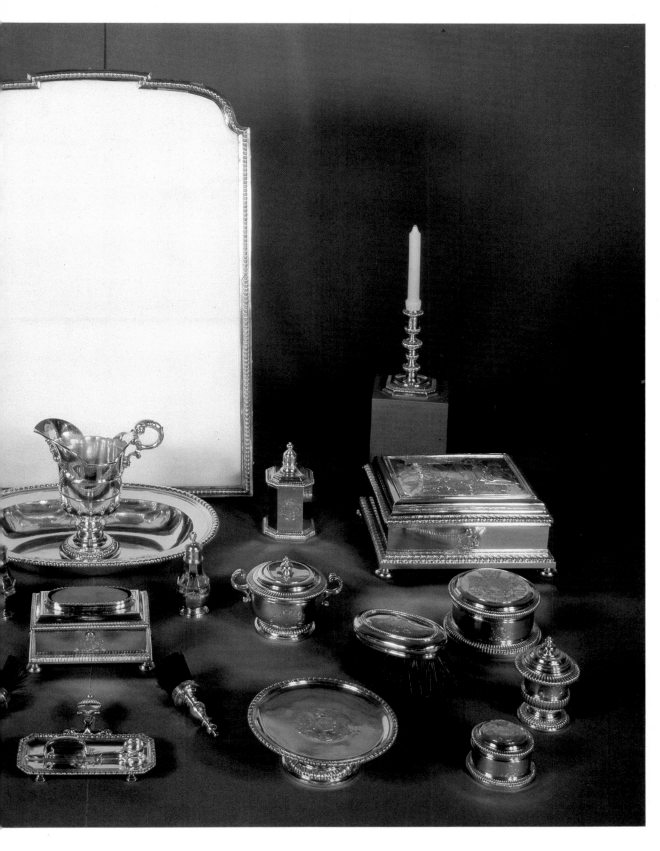

EARRINGS C. 1700
English
silver and diamonds
1.4 ($\frac{1}{2}$)

Sizergh Castle
The National Trust
(Hornyold-Strickland Collection)

These silver and rose diamond earrings
contain center stones encircled by
garlands of rose buds. According to
family tradition based on contemporary
inventories in the archives at Sizergh,
the earrings were a gift from Charles II
to Katherine Gregory (1679–1726),
daughter of Sir William Gregory (1624–
1696), Speaker of the House of Commons
and Baron of the Exchequer, on her
marriage to Philip Hoskins in 1685, and
were inherited by her only daughter,
Jane, wife of William Mathews of Burton
Court and Llangarren. Their great-
granddaughter, Alice de la Chere (1856–
1943), married Alfred Hornyold
(1850–1922), whose son Henry
Hornyold Strickland gave the earrings
to the National Trust with the contents
of Sizergh Castle. This floral and foliate
style is usually associated with jewelry
dating from 1710 to 1725; earrings of
the last quarter of the seventeenth
century were depicted in portraits and
engraved designs as pendant girandoles
or drop-shaped baroque pearls. However,
a silver pendant with a miniature of
Charles II (Christie's, 20 February 1973,
lot 180) has a similar pierced foliate
border set with rose diamonds and this
was also dated 1680 by Basil Long
(1920, 9: fig. 18). D.S.

126

A BOWL OF FLOWERS c. 1692
Jean-Baptiste Monnoyer 1634–1699
oil on canvas
95.25 × 126.3 ($37\frac{1}{4}$ × $49\frac{3}{4}$)

Boughton House
The Duke of Buccleuch and
Queensberry, KT

". . . the Lord Montagu haveing a
design to adorn his house in Bloomsbury
sent for Mr la Fosse and Baptist
flower-painter they came over just
before the driving out of K. James 2d.
& ye Revolution disturbing the
Catholicks they returned to France &
in a year or two afterwards came over
again to prosecute the work which
they jointly completed." Thus the
antiquarian George Vertue described
the circumstances in which the history-
painter Charles de Lafosse and the
flower-painter Jean Baptiste Monnoyer
first arrived in London (Vertue
1931–1932, 21). Monnoyer, generally
known in the country of his adoption
as "Old Baptiste" to differentiate him
from his son Antoine (who was in
England between 1717 and 1747), ended
his life as a Protestant, for he was buried
at Saint James, Piccadilly, in 1699
(Croft-Murray 1962, 1:258). But
Vertue's testimony suggests that his
convictions were not as strong as those

of the Huguenot painters Jacques
Rousseau and Jacques Parmentier,
whom the 1st Duke of Montagu,
several times ambassador to Louis XIV,
also brought over from France. All four
painters collaborated on a series of
panels designed by Daniel Marot for
Montagu House in Bloomsbury, rebuilt
after a fire in 1686, but not completed
until the early 1690s (Jackson-Stops
1980, 244–257). Monnoyer was also
responsible for two dozen or more
overdoor and overmantel paintings,
which, like the panels, were brought to
Boughton in Northamptonshire after
the 2nd Duke's death in 1747, when
Montagu House was acquired for the
newly founded British Museum. Here
they constitute the largest single
collection of his *oeuvre*, displayed in
ideal surroundings, since Boughton had
been remodeled at the same time as
the family's London house, clearly
under Daniel Marot's influence: a
French château ideally suited to the
most noted Francophile of his generation.

Jean-Baptiste Monnoyer, born at Lille,
is said to have been educated at Antwerp
where he may well have been trained in
the studio of a Flemish flower painter.
He was in Paris by 1665 when he was
elected an Academician, and later
worked under Le Brun both for the
Gobelins and Savonnerie manufactories,
and at Versailles, Marly, Meudon and

the Trianon (Pavière 1966, 11–12).
Monnoyer's pictures have a solid
architectural character and loose
handling which is very different from
the exquisite precision of contemporary
Dutch flower pieces, but is ideally
suited to the baroque interiors for
which they were intended. In this
overdoor, a wide gilt-bronze vase with
curious paw feet supports is placed on
a stepped ledge, reminiscent of the
corner chimneypieces for the display of
porcelain popular at this date. The effect
is pure *trompe l'oeil*, giving greater
vertical emphasis to the doorcase below,
and creating the illusion that a footman
might only recently have climbed a
ladder to create this profuse arrangement
of lilies, peonies, carnations, and
auriculas. The contemporary frames of
this picture and its pendant (no. 127)
were probably supplied by the Huguenot
carvers and gilders, John and Thomas
Pelletier, whose names constantly occur
in the Montagu House accounts
(Boughton House MSS). Their bold
architectural form may well have
matched the doorcase surrounds in the
room at Montagu House where these
paintings were first placed. G.J-S.

Provenance: Commissioned by Ralph,
1st Duke of Montagu, through his great-
granddaughter Elizabeth, wife of the
3rd Duke of Buccleuch; and by descent

127

AN URN GARLANDED WITH FLOWERS
c. 1692
Jean-Baptiste Monnoyer 1634–1699
oil on canvas
92.25 × 126.3 ($37\frac{1}{4}$ × $49\frac{3}{4}$)

Boughton House
The Duke of Buccleuch
and Queensberry, KT

Like its pendant (no. 126) this overdoor
was painted by Monnoyer for Montagu
House, Bloomsbury, with the ledge
continuing the architecture of the
doorcase below in *trompe l'oeil*. The gilt-
bronze urn is garlanded with lilac,
parrot tulips, roses, orange-blossoms,
and marigolds among other flowers.
With its frieze of dancing naiads
à l'antique, it is reminiscent of a vase
found in the still life with *objets d'art*,
fruit, and flowers, which the artist
submitted on his election to the
Académie in Paris in October 1665
(now at the Musée Fabre, Montpellier;
Pavière 1966, no. 34). The damask
curtains also recur in Monnoyer's
overdoors at Versailles (see Pavière
1966, no. 405) and may be intended to
continue the effect of a *portière* like
those seen in engravings by Daniel
Marot (Jessen 1892, 96). G.J-S.

Provenance: See no. 126

128

THE PALACE OF VULCAN, from
THE STORY OF VULCAN AND VENUS
c.1670–1680
Mortlake workshop
wool and silk tapestry
350.5 ×485 (138 ×191)
Mortlake mark at lower right

Formerly at Glemham Hall
The Trustees of the Victoria
and Albert Museum

The Triumph of the Baroque 195

In *The Story of Vulcan and Venus*, Apollo sees Mars and Venus making love and informs Vulcan, Venus' husband, who spreads a net to catch the lovers in the act and expose them to the ridicule of all the gods of Olympus. The designs were first drawn for a series of tapestries woven in Brussels in the second quarter of the sixteenth century. Five pieces of one of the Brussels sets are now in the Biltmore House in Asheville, North Carolina. Henry VIII owned a set of "7 peces of fine newe Tapestrie of the Historie of Vulcanus Mars and Venus," and it was probably this set that was copied at the tapestry workshop established by James I at Mortlake in 1619. It was not until about 1625 that the Mortlake manufactory had a resident designer; so the first two series woven both were copied from Flemish sixteenth-century tapestries in the Royal Collection and given more elaborate borders inspired by contemporary French tapestries. In 1670 Sir Sackville Crow wrote that the Vulcan and Venus series was by "Rivieres, an excellent master," but the identity of this artist remains unknown.

A document describing costs of making the first set of Vulcan and Venus tapestries in the 1620s names the Flemish craftsmen who specialized in weaving the most difficult parts of the tapestry, the faces and "nakeds." Their work can be seen in the remains of the set made for Charles I while he was still Prince of Wales, now divided between Saint James' Palace and the Victoria and Albert Museum. By the time this *Palace of Vulcan* piece was woven, some fifty years after the set made for Charles I, standards had fallen at Mortlake. Rendering of faces and hair, though vigorous, was crude by comparison with the early pieces, and so far as was possible the "nakeds" had been redrawn, clothed, to make weaving easier and cheaper. On this tapestry too, some of the smaller figures found in the piece of the same subject at Saint James' Palace have been omitted along with some of the foliage; while the columns of Vulcan's palace, decorated only with fluting, were half fluted and half covered with relief sculpture in the original. By simplifying designs of both scene and borders, and by weaving only

in wool and silk, without gold and silver thread, tapestries were produced at more competitive prices. Mortlake needed to make this particular series at a reasonable cost, because by 1670 William Benood, a former Mortlake weaver, had established a workshop in Lambeth that could offer to the Countess of Rutland Vulcan and Venus tapestries similarly modified, at only 25 shillings the ell (27 × 27 inches).

The *Palace of Vulcan* tapestry comes from a set of five formerly at Glemham Hall in Suffolk, a later home of the North family who made their fortunes largely in the second half of the seventeenth century. Sir Francis North, younger son of the 5th Baron North, was knighted in 1671 as Solicitor General, became Attorney General in 1673, Lord Chief Justice in 1682, and was raised to the peerage as Baron Guilford in 1683. His brother, Sir Dudley North, was a Turkey merchant who purchased a house in London said to have been owned by a former Lord Mayor, and whose son, Dudley, achieved the status of a country gentleman by the purchase of Glemham Hall. The younger Sir Dudley North, who married the daughter of Elihu Yale, virtually rebuilt Glemham in the 1720s. The Venus and Vulcan tapestries of the 1670s are unlikely to have been purchased by the impoverished Glemham family. Though possibly commissioned for some other house by the Norths, these tapestries may have been acquired by the first Sir Dudley with the furnishings of his London house. The set hung at Glemham, in the state bedchamber and on the stairs, in 1910. W.H.

Related Works: Pieces from similar sets survive at Drayton House and Haddon Hall
Literature: Thomson 1930, 282–283, 288–292, 302; Siple 1939

129

SILVER LOOKING GLASS, TABLE, AND STANDS 1676–1681
London
oak frames entirely covered with sheets of embossed and chased silver
looking glass: 193 × 104 (76 × 41);
table: 78.7 × 101.6 × 73.6 (31 × 40 × 29);
stands: 112 (44) high

Knole
The National Trust (Sackville Collection)

Following the precedent set by Louis XIV at Versailles and Saint-Cloud, silver furniture was made in England after 1660 until about 1710. But whereas in France almost every known piece was melted down by the king's orders in 1689 and 1709, to pay for the wars in Flanders, important pieces still survive in English collections. These include chandeliers at Chatsworth and Drumlanrig Castle and wall sconces and hearth furniture in other country houses (see nos. 87, 95 and 135). Whole suites of furniture—the familiar combination of table, mirror, and stands habitually found in baroque interiors—could also be executed in silver for state bedchambers, where display was more important than practical use, though these are now of the greatest rarity. Apart from that in the King's Room at Knole, only one other complete example survives in England: that at Windsor Castle, presented by the Corporation of London to Charles II soon after his accession. Another table and mirror at Windsor, given by the Corporation to William III, lack their candlestands, while the mirror from a third set belonging to George I is also in the Royal Collection.

It is somewhat surprising to find that the candlestands of the Knole set bear the date letter for 1676 while the table is stamped with the letter for 1680–1681 and an unknown maker's mark: *TL* with a millet above and escallop below. A possible explanation is that the smith incorporated sheets of reused silver without bothering to erase the old date letter. The mirror bears no marks at all, and this is presumably because as a specially commissioned piece, perhaps even made from silver supplied by the purchaser, it did not need to be taken to the assay office—unlike pieces held as stock or for sale. The scrolling acanthus ornament that covers every surface, interspersed with *amorini*, fruit, and flowers, is very similar in style to the large baluster vases and covers (wrongly called ginger jars) that were popular in the baroque *buffet* arrangements of the late Stuart period. In the center of the table top is a large, oval plaque showing Marsyas playing his pipes in competition with Apollo, based on a plate in Antonio

Tempesta's edition of the *Metamorphoses* of Ovid, published in Amsterdam in 1606.

All four pieces bear a monogram under an earl's coronet that has in the past been read as *FDHP*, for Frances, Countess of Dorset, and Henry Powle, Master of the Rolls, whom she married in 1679. However, close inspection reveals *FCD* as a more likely configuration, standing for the countess alone, with the *C* representing her maiden name of Cranfield. It was the practice until the present century for a lady to retain her title after a marriage with a second husband of inferior rank, and it is fitting that this magnificent set of furniture should have belonged to one of the greatest heiresses of her day. The daughter of James I's minister Lionel Cranfield, and the subject of one of Van Dyck's most beautiful full-lengths (still at Knole), she brought Copt Hall in Essex, with all its contents, and also her father's earldom of Middlesex, to the Sackville family. Whether the silver furniture was made for Copt Hall or her London house is not certain, but it was certainly in the King's Room at Knole by 1706, when an inventory was made on the death of her son, the 6th Earl. Ever since then the looking glass has hung against one of the seventeenth-century tapestries representing the story of Nebuchadnezzar, woven by Thomas Poyntz, whose main protagonists gesture toward it in a suitable mixture of amazement and disbelief. The original mirror plate has at some point in its history been replaced, but glistening in the candlelight from silver sconces and chamber sticks, and reflecting the gold and silver brocade of the great state bed on the opposite wall, the silver furniture at Knole still evokes the unrivalled splendor of English country house life in the baroque period. G.J-S.

Provenance: Commissioned by Lady Frances Cranfield, wife of the 5th Earl of Dorset (1622–1677), and by descent at Knole; acquired with the principal contents of the Show Rooms by the National Trust after the death of the 4th Lord Sackville in 1962
Literature: Phillips 1929, 2: appendix; Penzer 1961, 1:88, and figs. 2–4
Exhibitions: London, RA 1960 (429); Brussels 1973 (133–135)

130

CABINET ON STAND c. 1690
English
softwood, japanned, with polished brass
hinges and lockplate, on a silvered
limewood stand
167.6 × 123.2 × 60 (66 × 48½ × 23⅝)

Athelhampton
Sir Robert Cooke

As an answer to the many Chinese lacquer and coromandel cabinets imported to Europe in the late seventeenth century through the English and Dutch East India Companies, cabinetmakers in both countries began to produce imitation lacquer in the form of painted and varnished decoration, generally known as "japanning." John Stalker and George Parker's *Treatise on*

Japanning and Varnishing, published in 1688, was largely intended for amateurs like Lady Grisell Baillie who paid £3 for "materials to japan" in 1694, or the Countess of Bristol who in 1741 bequeathed "my cabinet, chest, large skreen and small skreen being white japan of my own work" to her son, Lord Hervey (DEF 1954, 2:270). Many professional cabinetmakers also

employed the technique. Two, however, Edward Hurd and James Narcock, claimed in 1692 to have attained "such a degree of curiosity and durableness as to equal any brought from India," in an attempt to copyright their invention for fourteen years.

The Athelhampton cabinet is of particularly high quality, decorated with oriental buildings and figures, diving cranes, and other birds and flowers in a manner very close to Stalker and Parker's engravings, and much more balanced and symmetrical than true Chinese or Japanese work. The engraved brass lock plates, hinges, and corner mounts are also very elaborate, copying those on Chinese lacquer cabinets but almost certainly made in England by a locksmith like John Wilkes of Birmingham who must have had a large stock-in-trade for cabinetmakers to choose from. But the rarest feature of the cabinet is its richly carved stand, which still preserves the original silvering, whereas others of this date have almost invariably been gilded or overpainted at a later date. In form the stand is close to contemporary Dutch examples and very similar to that of a cabinet at The Vyne, which has practically identical legs and winged cherub heads. The central figure holding a basket of fruit probably represents Ceres, but if so, the flying angels on either side present a curious mixture of Christian and pagan symbolism. Cabinets of this sort were for use in bedchambers and dressing rooms where their many small drawers were useful for keeping valuable small objects and jewelry. They were also invariably surmounted by a garniture of large porcelain, or occasionally even silver vases: hence their undecorated and somewhat abrupt, flat tops. G.J-S.

Provenance: Bought by the present owner's father as part of his restoration and refurnishing of Athelhampton in the 1920s
Exhibitions: London, Sotheby's 1983–1984 (14)

131

OVIFORM JAR, TWO BEAKERS, AND
TWO HEXAGONAL JARS c. 1670–1690
Japanese, Kakiemon
hard-paste porcelain
beaker: 47 (18½); hexagonal jars:
28 (11) high; oviform jars: 53 (20⅞) high

Woburn Abbey
The Marquess of Tavistock and the
Trustees of the Bedford Estates

Like so many of the late seventeenth-century porcelains from the Arita province of Japan; variously known as Arita, Imari, and Kakiemon, this type was unknown to native Japanese scholars before the Second World War. It has been suggested that this design is Dutch-inspired chinoiserie rather than a native Japanese idea. Large garnitures often consisting of three vases and covers and two beakers were popular in the older country houses of Europe, and are still to be found in the baroque palaces of Germany, Austria, and Hungary, as

well as in English country houses like Woburn and Blenheim, where there is a beaker very similar to this one (also 47 cm high). This and the oviform jar is from such a garniture of five pieces. A particularly fine and large collection of Kakiemon—formed by Augustus the Strong, King of Poland and Elector of Saxony between 1694 and 1705—is now in the Johanneum at Dresden. Similar vases were in the Liechtenstein Palace, Vienna, though the beaker shape is considerably rarer than the covered jar. Although most of the Kakiemon designs were copied by many of the European factories in the eighteenth century, including Meissen, Chantilly, and Chelsea, they were replaced by the cruder but showier Imari vases by 1700. From about 1690 garnitures similar to this one were exported from China in blue and white and *famille verte* and, from 1720, in *famille rose*.

The hexagonal vases or jars shown here are of the type known as "Hampton

Court Jars," as they are of a similar shape to two pairs still at Hampton Court, almost certainly collected by Queen Mary II, wife of William III. The earliest inventory, taken two years after her death in 1694, mentioned "coloured jars of six square." It is likely that the queen brought her vases over from Holland when she came to England in 1689. The earliest European record of such pieces is an account of a sale of porcelain in Holland in 1680: "The red [red painted ware was the standard term used for polychromed Japanese wares in the seventeenth century] assortment was much desired. 36 show pots for cabinets, cost price 2 florins, nine s. sold at Enkhuisen for 140 florins." These "show pots" could easily be similar to the Woburn vases, which may not have reached the collection of the Dukes of Bedford before the early 1700s. Though many Kakiemon designs were copied in European porcelain between 1720 and 1760 and many other designs derived from a mixture of

Kakiemon and Imari as well as Chinese *famille verte* and *famille rose*, few exact copies of vases were made. The most popular design was that seen in this hexagonal vase, exact copies of which were made at both Meissen and Chelsea.

A number of vases similar to the oviform one shown here are discussed by R. Soame Jenyns (1937), and one is represented in the painted ceiling of the porcelain cabinet in the Orianenberg in Brandenburg painted by Nikolai Augustin Terwesten (Reidemeister 1934, 272, pl. 8). Gladys Scott Thomson (1940, 335) records that a Mr. Henry Tombes, a "merchant in India goods," was employed by the 2nd and 3rd Dukes of Bedford to provide silks, musk, tea, arrack, cloves, nutmeg, oil, mangoes, and other goods of Far Eastern origin. A bill of his dated 6 April 1709 mentions "1 pair of Japanese jars 4£," but there is no way of connecting this document firmly with these particular jars.

A. du B.

Literature: Jenyns 1937, pl. 57B

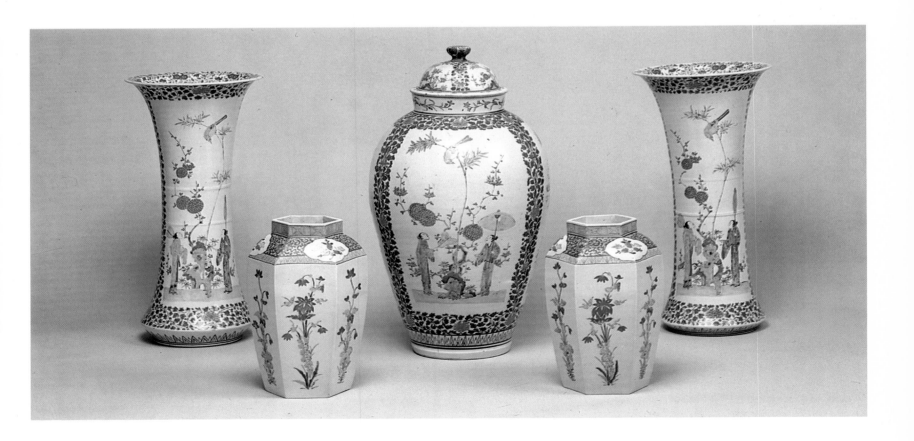

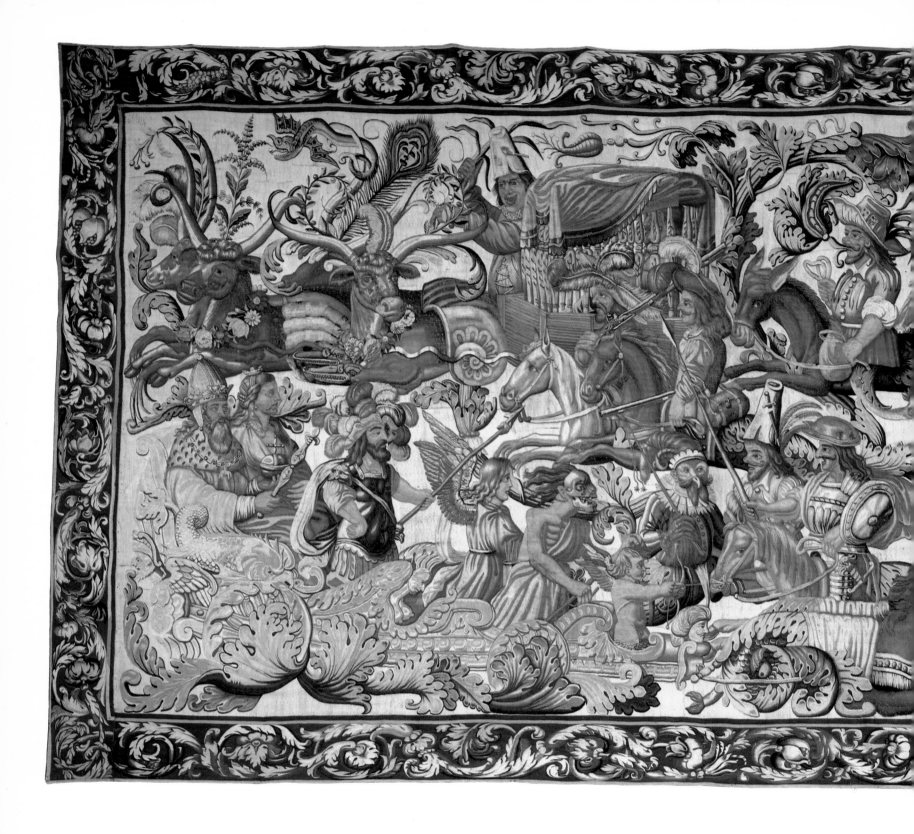

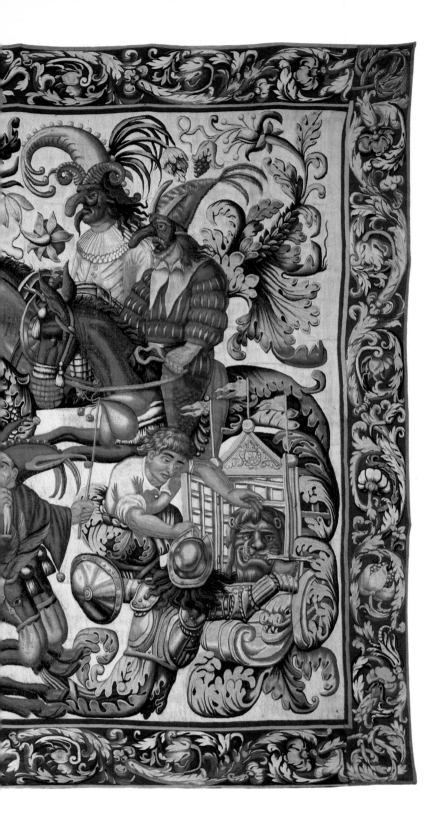

132

SCENES FROM THE STORY OF
DON QUIXOTE c.1670–1680
workshop of Francis Poyntz
fl. 1660–1684
wool and silk tapestry
269.2 × 464.8 (106 × 183)

Cawdor Castle
The Trustees of the Earl of Cawdor

This is the largest of a set of five grotesque tapestries illustrating the story of Don Quixote. It shows his encounter with the strolling players who are dressed to perform *The Parliament of Death*, his confrontation with the royal lion, and his ignominious return in a cage to his village.

Grotesque figures, half human or animal, half plant form, were common in seventeenth-century decoration, and found in plasterwork, carving, fresco, and engraving; but the size of the grotesques here, and the strange transformation of well-known characters rather than anonymous beings, makes these designs unusual. Partly for this reason, partly from the lack of any known references to such a series in the seventeenth century, tapestry historians have been uncertain as to whether this series may not have been woven in the nineteenth century. Recently re-discovered documents, however, note various sets of Don Quixote tapestries in the Royal Collection between the 1660s and 1690s, and suggest that the series was part of the stock in trade of Francis Poyntz. A Royal Warrant of January 1682/1683 ordered the purchase from Francis Poyntz of "Three peeces of Hangings of the Story of Donquixott . . . for ye State roome to His Ma^tes New Bed Chamber at Whitehall." An attribution to Poyntz is strengthened by the border design, which is almost identical to a border on another series associated with him.

Francis Poyntz held the post of yeoman arrasworker at the Great Wardrobe from the Restoration to his death in 1684. In addition to his duties of supervising the repair of existing royal tapestries, the post provided him with opportunities to supply the Crown with new sets of hangings from his own workshop. In 1678 Poyntz moved the offices of the arrasworkers of the Great Wardrobe from the Savoy to Hatton Garden, where he made tapestries signed *F.P. HATTON GARDEN*, such as the set at Hardwick Hall with playing children after paintings by Polidoro da Caravaggio. Poyntz also had a tapestry workshop in nearby Clerkenwell in the 1660s.

In a letter to the Countess of Rutland in June 1670, Sir Sackville Crow, who until recently had been in charge of the manufactory at Mortlake, wrote disparagingly of Poyntz, "take it of my credditt he hath not one good piece of painting or designe by him, besides a deare prateing fellow that knows not what good worke is." Expensive the tapestries of Francis Poyntz may have been, but a comparison of the *Don Quixote* grotesque tapestry with that of *Vulcan's Palace* (no. 128) shows that not only did Poyntz have new and exciting designs to rival the established successes of Mortlake, but the quality of the weaving in his workshop was equal if not superior at that time. Orders from the Crown reflected the truth of this, and unless Poyntz' tapestries of before 1670 were markedly inferior to those he produced later, Sir Sackville's comment must be attributed to prejudice.

W.H.

Provenance: although unsubstantiated by documentary evidence, family tradition maintains that the tapestries were given in about 1837 to the 1st Earl Cawdor (1790–1860) by his friend and contemporary Henry George, 4th Earl Bathurst of Cirencester Park. It is possible that the series were considered old fashioned by comparison to another, eighteenth-century French set of the same subject which survives at Cirencester (information kindly supplied by the Countess of Cawdor)
Related Works: The same series exists at Packington Hall, Warwickshire
Literature: Thomson 1920, 302–303, 355–359

133

AN ARMCHAIR AND TWO
SINGLE CHAIRS c.1725
English
walnut veneered and gilt-gesso frames,
with painted coats of arms and
embroidered covers
armchair: 114.3 ×68.5 ×63.5
(45 ×27 ×25); single chairs:
114.3 ×60.9 ×60.9 (45 ×24 ×24)

Stoneleigh Abbey
The Lord Leigh

This armchair, and two of a set of six
"backstools," show how baroque forms
of furniture continued to be made
for baroque houses long after Lord
Burlington's Palladian Revolution had
got under way. The backs of the chairs
are carved with the coronet and arms,
and the armchair also bears the
monogram of Edward, 3rd Lord Leigh,
and his wife, Mary Holbech of Fillongley,
whom he married in 1707 and whose
great fortune enabled him to add a huge
new wing to the old family house at
Stoneleigh. Designed by the architect
Francis Smith of Warwick and built in
1720–1724, this was in a style that
owed nothing to Colen Campbell or
William Kent but looked back to the
giant orders and vertical emphases
of Vanbrugh and Hawksmoor. The
furniture of the main rooms likewise
consisted of old-fashioned walnut and
gilt-gesso rather than the mahogany
that was soon to become *de rigueur*.

An inventory taken on Lord Leigh's
death in 1738 lists "seven fine needle
workt chairs in Walnut and Gilt frames
and Green cases" (meaning case covers to
protect the embroidery) in the drawing
room, valued at £60 (Shakespeare
Birthplace Trust, Stratford-on-Avon,
DR 18/4/9). Unfortunately there are
few surviving receipts and vouchers
among the family papers for the period
between 1710 and 1727, and it is not
possible to be certain of their maker's
identity. A pair of very similar parcel-
gilt chairs from another Francis Smith
house, Sutton Scarsdale in Derbyshire,
have recently been acquired by Leeds
City Art Gallery for Temple Newsam
House, and these are attributed to
Thomas How of Westminster, who is
described as "gentleman upholsterer"

on the contemporary lead plate engraved
with the names of all the principal
craftsmen involved there. However,
another possible candidate would be
John Pardoe of Temple Bar who supplied
gilt-gesso furniture to Lady Leigh in
the 1730s including a mirror that may
have been the "large glass sconce in a
gilt frame," also listed in the drawing
room in 1738 (Christie's sale, 15 October
1981, 106).

Apart from the rare combination of
walnut veneer and finely stamped gilt
gesso, the chairs are chiefly remarkable
for their embroidered covers in *gros-* and
petit-point. The baroque taste for allegory
and mythology is evident in the use of
scenes from Ovid's *Metamorphoses*: on
the armchair, Vulcan at his anvil is
approached by Venus; on one of the
single chairs, Leda being crowned by
Cupid welcomes the swan; while on the
other, Paris clasps Helen as the boatman
pulls away to the waiting ship and Troy
is consumed by flames. The covers
conform to the French rule that the
human figure should appear on the back
only, and not on the seat (Swain 1975,
77). The swan alone appears below the
Leda scene; an empty forge below
Vulcan and a deserted ship, with a
dinghy tethered beside it, below the
rape of Helen. The embroidery is
probably the work of professionals,
though it would also have been within
the range of a talented amateur
needlewoman like Julia, Lady Calverley,
whose similar panels at Wallington in
Northumberland, illustrating scenes
from Ogilby's edition of Virgil, are
dated 1727. One curious feature is that
the covers of the single chairs are made
with semicircular notches on the backs
and seats as if made for arms. This
suggests that they were bought as a set
and supplied to the upholsterer, rather
than woven specially for existing frames.

G.J-S.

Related Works: A set with chairs similarly
embroidered covers from Holme Lacy
in Herefordshire (Knight, Frank, and
Rutley sale, 2 March, 1910, 599)
Provenance: Commissioned by the
3rd Lord Leigh, and by descent
Literature: Thorpe 1946, 76–77,
figs. 8–10

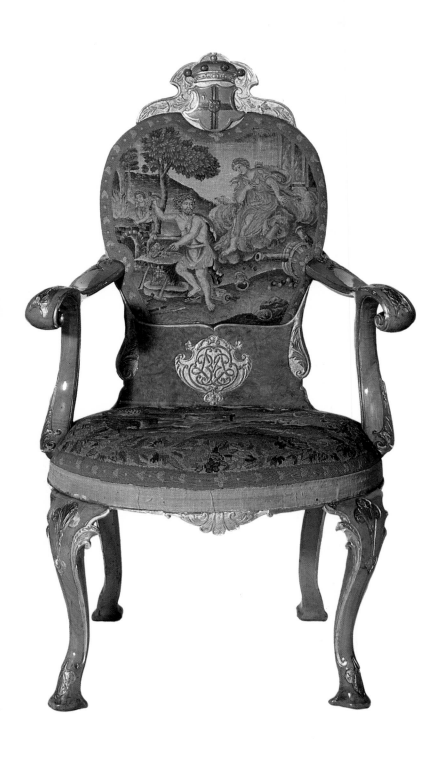
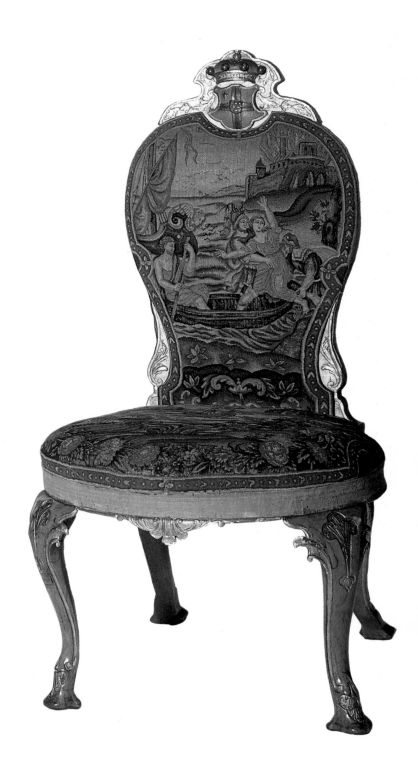

GARNITURE OF BLUE-AND-WHITE
PORCELAIN
Chinese

The Burghley House Collection

In the late Elizabethan period Chinese porcelain was collected exclusively by those in court circles and a few merchant venturers. During the first half of the seventeenth century the volume of porcelain imported to England increased, and certainly much of it survives in the great country houses. Whether it was bought in England at this time or whether it was acquired in Holland or France during the enforced exile of Royalist families during the Commonwealth Interregnum or immediately afterward is impossible to say in the absence of records. It is quite apparent, however, that by the Restoration the acquisition of china had become a craze among the fashionable. In two of William Wycherly's plays, "The Country Wife" and "The Plain Dealer" (published 1675 and 1676, respectively), there are allusions to this pastime, of which certain aspects had gained a dubious reputation. In Charles Sedley's comedy "Bellamira" (published 1683) one of the characters, Merryman, speaks of "China-houses; where under pretence of Rafling for a piece of Plate or so, you get acquainted with all the young fellows in Town."

Defoe, writing at a later date and perhaps a little inaccurately of "china-mania" as having been introduced by Queen Mary, observed, "the Queen brought in the custom or humour, as I may call it, of furnishing houses with chinaware which increased to a strange degree afterwards, piling their china upon the tops of cabinets, scrutores and every chimneypiece to the tops of the ceilings and even setting up shelves for their china ware where they wanted such places till it became a grievance in the expense of it and even injurious to their families and estates" (Rogers 1971).

Defoe's remarks about chimneypieces and the "setting up shelves" almost certainly implied stepped arrangements like this one, which is based on corner chimneypieces such as those at Burghley

House and Hampton Court and in the engravings of Daniel Marot. The architect responsible for alterations to Burghley House in the early 1690s was William Talman, Comptroller of Building and Works for William III, who was in the same period working with Marot at Hampton Court, Both interiors were reconstructed at about the same time, the former being completed by 1693, and it is interesting to reflect that the celebrated 1688 inventory of the ceramics at Burghley was drawn up as work was about to start or had just started. Almost all the pieces in this garniture can be identified either in the 1688 inventory drawn up by Culpepper Tanner, personal secretary to the 5th Earl of Exeter, or in the recently discovered "Devonshire Schedule," a list of additional items bequeathed by Elizabeth, Countess of Devonshire (see no. 78) to her daughter Anne, the 5th Earl's wife. These two are also among the earliest English documents to refer to Japanese and *blanc de chine* porcelain.

The pieces in this selection of blue-and-white from Burghley are listed individually below.　　　　G.L.

Exhibitions: Burghley 1984 (126, 127, 138, 140, 141, 146, 151, 155, 156, 157, 158)

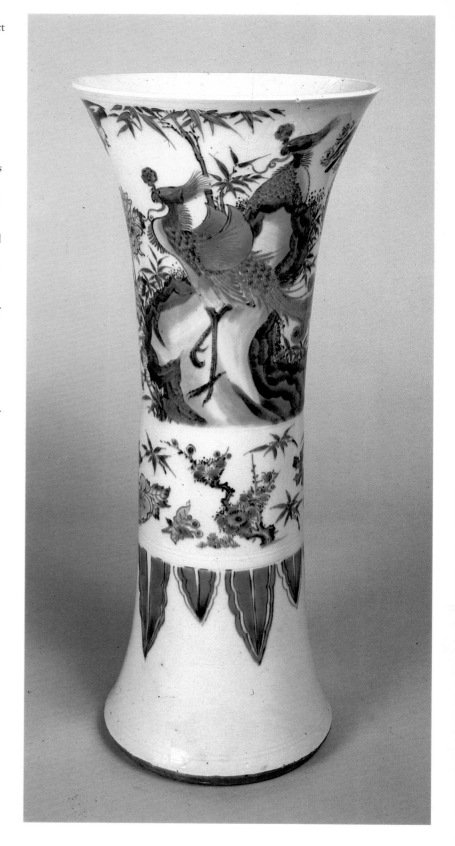

BEAKER
Transitional c. 1640
44.5 (17½) high

The form of this beaker is derived from an archaic bronze *gu*. The Devonshire Schedule lists under "Large plain China . . . A pair of large blue and white Beakers about eighteen inches high with birds and trees in blue" (for a beaker of similar type bearing the cyclical date 1640 see Kilburn 1981, pl. 65).

WINE EWER
Late Ming
16.5 × 14 (6½ × 5½) high
six-character mark of Xuande

This ewer is modeled as a mandarin duck and drake, with the female's neck entwined about her mate. The silver-gilt mounts are unmarked.

PAIR OF OVIFORM VASES AND COVERS
Transitional c. 1640
20 (8) high

These vases show a very early use of the "cracked ice" ground, which signifies the passing of winter and the approach of spring. In the reign of Kangxi (1662–1722) this motif, further embellished with prunus or hawthorn, became the most commonly used pattern for export porcelain, particularly on the ubiquitous ginger jars so beloved by Whistler and his contemporaries. These vases may be those listed in the Devonshire Schedule under "Large plain China . . . A pair of similar Jarrs blue and white about six & three-quarters in high with like covers."

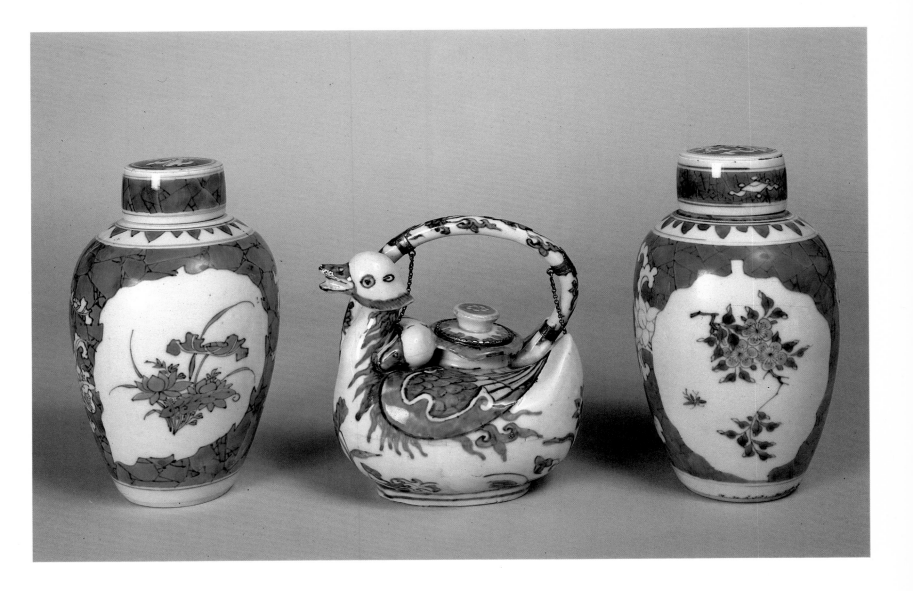

PAIR OF RECTANGULAR CANISTERS AND COVERS
Transitional c. 1640–1650
21.5 (8½) high

These are possibly the vessels listed in the Devonshire Schedule under "Large plain China . . . A pair of blue and white flatt square Bottles with hollow fflatt cover over them." The form may be based on European glass flasks used on board ship at this time. Although slab-sided flasks were made at Jingdezhen in the fourteenth century they had rounded shoulders applied with handles; this rectangular shape is not recorded prior to the Transitional period.

WINE VESSEL OR TEAPOT
Transitional c. 1640–1650
20.9 × 17.7 × 12.7 (8¼ × 7 × 5)

This vessel is listed in the Devonshire Schedule as "A Large ffour square Tea pott and a little square Top, Garnifht on the Neck handle and spout End with a Chaine to it." The silver-gilt mounts date from around 1650.

PAIR OF KENDI
Late Wanli 1573–1620
20 (8) high

It has been suggested (Sullivan 1957, 40) that this type of *kraakporselein* vessel was used for feeding infants. They are possibly the "Large plain china . . . Two pair of blue and white Dugg Bottles" listed in the Devonshire Schedule.

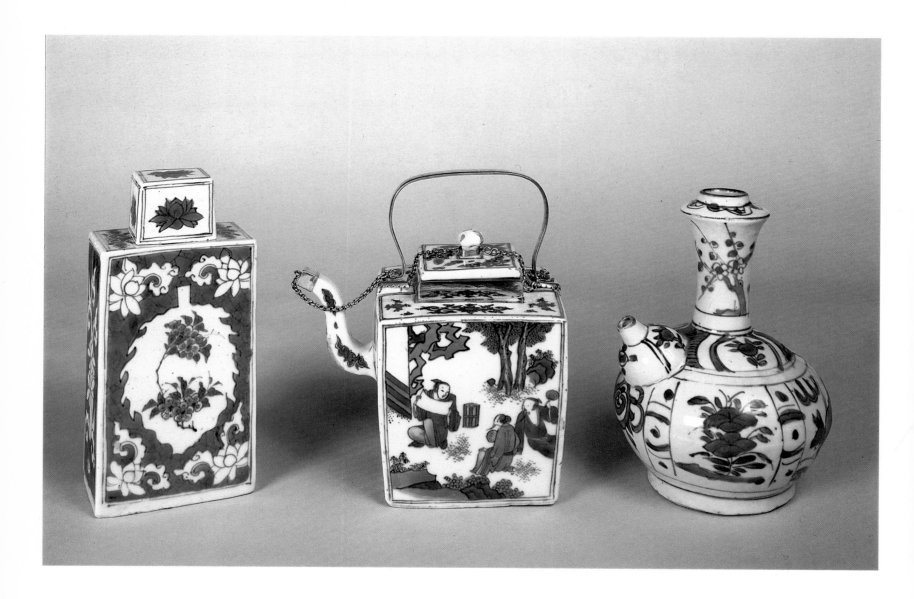

BOTTLE
Late Wanli 1573–1620
30.5 (12) high

The form may be derived from a type of Islamic metal bottle, sometimes described in early records as a "Persian flask," decorated on the neck with beads, tassels, and *ruyi* heads, the latter based on a form of the sacred *lingzhih* fungus (*polyporus lucidus*), a symbol of longevity. A bottle of this form appears in an anonymous Flemish painting of c.1620 showing the interior of an art gallery (National Gallery, London). This is the most common type of large *kraakporselein* vessel. Several examples were among a group recovered from the South China Sea by Michael Hatcher in 1983 and subsequently sold at auction (for example, Christie's, Amsterdam, 14 February 1985, lots 220–221).

BOTTLE
Late Wanli 1573–1620
28 (11) high

Of the form known as a "Persian flask" (see above), which is distinguished from the much earlier pear-shaped bottle with a flared neck or *yuhuchunping*, which has a proportionately lower and more generous belly.

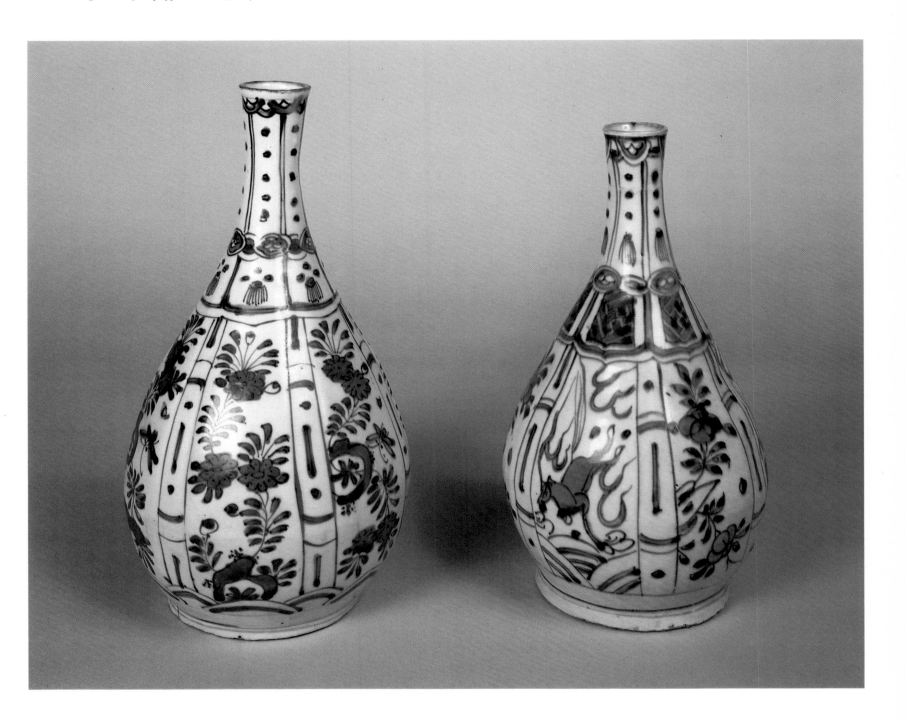

OVIFORM JAR AND COVER
Transitional c. 1640–1650
31 (12¾) high

The "cracked-ice" ground is embellished with fan- and leaf-shaped reserves enclosing vases containing lotus, fern, and other foliage on one side, and archaic vessels and scrolls on the other. Vases of this type are a feature of Dutch and Flemish still-life and interior genre paintings from 1658.

OVIFORM JAR AND COVER
Transitional c. 1640
31 (12¾) high

The two leaf-shaped reserves are painted with children at play, one showing a boy lighting a fire-cracker while his two companions cover their ears in anticipation, the other with two children attired in fancy dress and another looking on. Listed in the Devonshire Schedule under "Large plain China . . .

A small blue and white Jarr eleven inches high with a hollow fflatt cover" (the discrepancies in the measurements of this and other covered vessels in the Schedule may be explained by the supposition that they were measured without their covers).

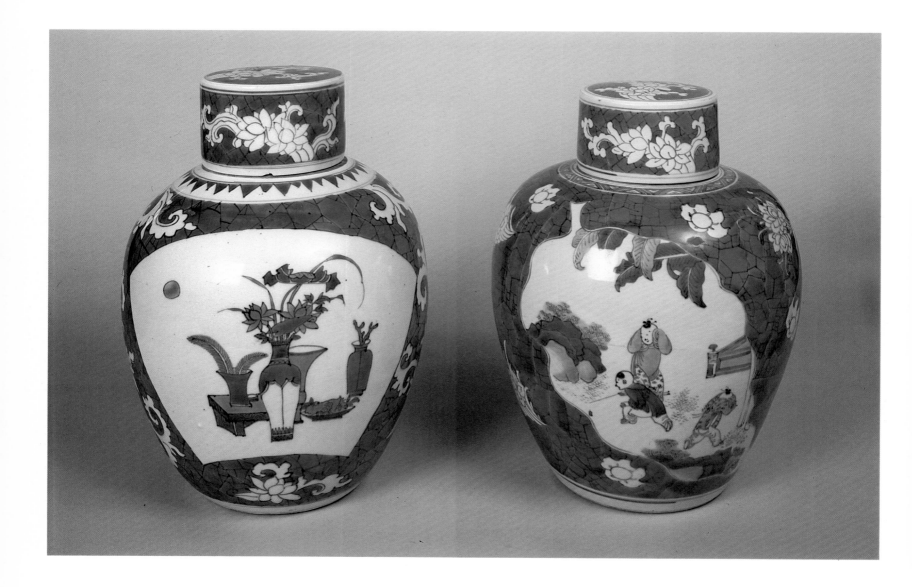

BOWL
Wanli 1575–1620
21.5 (8½) high

This bowl was reputedly presented by
Queen Elizabeth to her godchild, Sir
Thomas Walsingham, in whose family
it was retained until 1731 when it was
given to the 8th Earl of Exeter by Lady
Osborne, Walsingham's granddaughter.
While many family-held traditions
cannot be substantiated by documentary
evidence, the juxtaposition of the name
Walsingham and that of his queen
conjures up an intriguing possibility
with wide-reaching implications and
which therefore warrants further
investigation. Both were financial
backers for Sir Francis Drake's circum-
navigation, which began in 1577, and
were in effect the owners of part, if not
all of the "takings." Among the cargo
of one Spanish vessel captured off the
coast of California was a quantity of
"china," some of which was left,
presumably because it was damaged, at
Point Reyes where Drake encamped.
Among the sherds found at this site, in
what is now known as Drake's Bay,
were several pieces painted with
elements of designs that correspond
fairly closely with this bowl and with
other silver-gilt mounted pieces formerly
at Burghley House and now in the
Metropolitan Museum, New York.
The English silver-gilt mounts are of
c. 1580–1600.

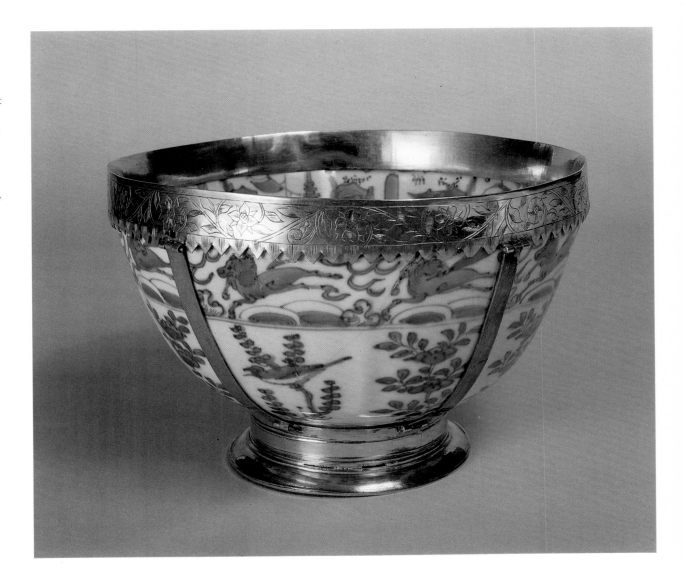

135

SET OF SILVER HEARTH FURNITURE
c. 1673
English
wood and iron with silver mounts
tongs: 81.5 (32); hearth brush: 63 (24¾);
shovel: 82 (32¼); bellows: 51.4 (20½)

Ham House
The Trustees of the Victoria and
Albert Museum

The front board of the bellows, stamped with an unidentified *SS* silversmith's mark, has an applied sheet of silver embossed and chased with scrolling acanthus foliage framing a cherubim mask and central cartouche, which is engraved with the coronet and *JEL* monogram of the Duke and Duchess of Lauderdale. John Maitland, Earl of Lauderdale, Secretary of State for Scotland, and Lord of the Bedchamber under Charles II, was elevated to a dukedom shortly after his marriage in 1672 to Countess Elizabeth Murray. To reflect his new status, Lauderdale asked the gentleman architect William Samwell (1628–1676), who had recently designed a villa for Charles II at Newmarket, to build a state apartment at his wife's home, Ham House in Surrey. It consisted of three rooms—an antechamber, bedroom, and closet—decorated in the rich baroque style of the court of Louis XIV, and whose fireplaces were all equipped with cast iron firebacks and silver hearth rods and furniture.

The state closet, the most important and most private room in seventeenth-century court ritual, contained a state couch set within a grand alcove. Everywhere in this room the duke's coronet, proclaiming the honor bestowed by Charles II, appears accompanied by palms and laurels. It is carved in the woodwork and inlaid in the floor and in scagliola (a composition of marble dust, plaster of Paris, and color pigments) on the windowsill, hearthstone, and chimneypiece frieze, which like the bellows and brush was ornamented with scrolling acanthus foliage. The apartment was renamed "The Queen's Apartment" after Catherine of Braganza's visit to Ham in 1675.

The 1679 inventory of the Queen's Bedroom lists "One Broome and one bellowes garnisht with silver," which hung from "two silver hooks" fixed in the wall on either side of the chimneypiece. In addition there were a firepan, firedogs, and fire irons, all "garnisht with silver." The antechamber was similarly equipped, but the closet contained only "One fire pan garnished with silver."

John Evelyn (1620–1706), who saw

Ham in 1678, considered it to be "furnished like a great prince's" and he may have had the house in mind when in *Mundus Muliebris, or The Ladies Dressing Room Unlock'd and her Toilet Spread* (1685), he wrote of ". . . the chimney furniture of plate for iron's now quite out of date."

J.H.

Literature: Thornton and Tomlin 1980, figs. 126, 132; Tomlin 1982
Provenance: See no. 100

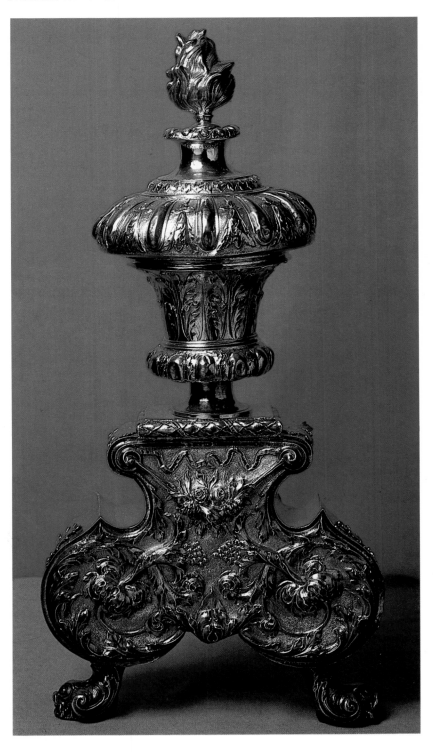

136

PAIR OF ANDIRONS c. 1680
English
silver
74.3 (29½) high

Knole
The National Trust
(Sackville Collection)

Undoubtedly the finest of the five pairs of seventeenth-century andirons, or firedogs, surviving at Knole in Kent, this pair reveal the full splendor of the best post-Restoration silverwork designed for use as well as display about the house. Placed on either side of the hearth, the great silver-faced stands conceal a slot holding the iron bar behind, on which the logs were laid, while two small creepers, with silver finials *en suite* with those of the andirons, stand between them, to support further the logs, which may not have been borne by the larger andirons.

The andirons and matching creepers are unmarked. This is perhaps not surprising, since they must have been specially made for Knole, either for the 5th Earl, Richard Sackville (1622–1677), who spent freely on decorating and furnishing the house, or for his son, the 6th Earl. The lack of a mark is not uncommon as in technical terms they "were not set to sale" under the terms of the Statute of 1423, though if sold or melted the silver would have been valued at rather less than legally "touched" plate. It is therefore impossible to do more than hazard a guess at the identity of the maker, who was certainly a craftsman of repute with skilled modelers and chasers at his command. As most comparable plate at Knole of similar date is also unmarked, the problem of identifying the maker is even greater. One possible candidate is Thomas Jenkins, maker of a pair of bowls in the collection bearing the arms of the 5th Earl, c. 1670. Another is Arthur Manwaring whose chased work is invariably very fine, or the maker who used the *TS* monogram, as on a set of twelve armorial sconces in the house. It seems likely that another pair of unmarked andirons of about the same date formerly in Lord Hillingdon's

collection were by the same hand. A further possibility is that the Knole andirons, judging by style alone, were made by the same craftsman as a pair formerly at Mentmore, maker's mark read as *GC* duplicated and reversed, *BECG* monogram but now identified as the *GB* addorsed monogram for George Bowers, "embosser in ordinary" to the king from 1661. The identification of the maker must, however, remain pure speculation.

Charles Oman suggests that such andirons and their accompanying creepers were sent from town or survived in country houses because logs rather than the coal used in London and other cities remained the chief form of heating. In the Royal Collection, for instance, the pair of about 1660/1675, also unmarked, and in a style like that of Bowers, were apparently altered and gilded in 1814–1817 by Paul Storr of Rundell, Bridge and Rundell for the Prince Regent, when they were simply described as "Two richly chased ornaments." J.B.

Literature: Evelyn 1690; Jackson 1911, I: 249/250; Phillips 1929, Appendix V; Penzer 1961, 181, pl. 13; Oman 1970, compare 61–62

137

ARABESQUE TAPESTRY 1720s
Joshua Morris, Soho workshop
wool and silk
284.5 × 189.2 (112 × 74½)

Grimsthorpe Castle
The Grimsthorpe and Drummond
Castle Trustees

"A LARGE QUANTITY OF CURIOUS, FINE, NEW HANGINGS" was "Sold by Auction by Mr. JOSHUA MORRIS, Tapistry-Maker, at his House in Frith Street, near Soho-Square" on 1 December 1726. This no doubt included some of Morris' Arabesque tapestries, of which one signed piece formerly at Perrystone Court was dated 1723. Apart from two signed series of tapestries, his advertisement, and the lawsuit that he lost in 1728 concerning the suitability of a design by William Hogarth to be woven in tapestry, little is known about Joshua Morris. M.A. Havinden established that Morris had premises in Frith Street from 1720 to 1728, when they were taken over by the upholsterer William Bradshaw who also produced tapestries. After Joshua Morris left Frith Street he may have carried on trading for a few months at the Golden Ball in Pall Mall; but in May 1729 he was bankrupt, for the Daily Post advertised the sale of "rich Tapestry Hangings, Chairs and Fire Screens . . . the Goods of Mr Joshua Morris, Tapestry-Maker," for the interest of his creditors.

The Arabesque tapestries are so called from the scrolling acanthus and strapwork frames that separate the areas of differently colored grounds. The purely decorative schemes include flower-filled urns, allegorical busts, and large exotic birds forming, with a profusion of flowers and occasionally a monkey or a squirrel, a composition balanced in mass and asymmetric in detail. Edward Croft-Murray suggests that the tapestries may have been designed by Andien de Clermont, a Frenchman working in England from about 1716 to 1756. "Designs for Screens and Chairs in Needlework or Tapestry" were included in a sale of his household furnishings and paintings. But the only comparable surviving works of this artist are some twenty years later than the tapestries, yet are distinctly more French in style. Much closer to the Joshua Morris Arabesques is a tapestry-covered sofa, formerly at Belton House, signed "Stranover" and "Bradshaw." Tobias Stranover (1684–1756), a painter of birds and flowers, was in partnership for a short time with William Bradshaw in the

Frith Street premises vacated by Joshua Morris in 1728. It is quite possible that Stranover worked for Morris before designing tapestries for William Bradshaw, and supplied the details of the Arabesque hangings if not the overall scheme.

This panel of tapestry from Grimsthorpe Castle, with flowers in a tall, golden urn standing on a marble slab, is only the central part of a much larger tapestry that originally had on either side something similar to the colorful birds perched over baskets of flowers, or smaller flower-filled urns over compartments with birds, flanking the same central portions on tapestries in the Victoria and Albert Museum and at Hagley Hall. Within the inner scrolling "frames" that edged these tapestries, the different components of the design could be rearranged to produce an almost infinite number of variations at no extra cost. As tapestry designs were cut in vertical strips to be placed beneath the warp in the low-warp loom it was easy to select different strips to join in new combinations, with a further choice of motifs to fill a plain cartouche.

The tapestries were installed in the Blue Drawing Room at Grimsthorpe in this century, having been brought from Normanton, the home of Sir Gilbert Heathcote for whom the tapestries were reputedly made. Knighted in 1702, Lord Mayor in 1710, and Member of Parliament under four monarchs from William III to George II. One of the founders of the Bank of England, he was a wealthy man for his time, with a fortune estimated at £700,000. Like many rich men, he had a reputation for parsimony, which, if true, might explain why no coat of arms was inserted in these tapestries when he was created a baronet in 1732/1733.

W.H.

Related Works: Similar sets survive at Hagley Hall near Stourbridge; Squerryes Court, Westerham; Dingestow Court near Monmouth; Victoria and Albert Museum, London; Museum of Fine Arts, Boston; Metropolitan Museum, New York

Literature: Marillier 1930, 8–12, pls. 3, 4; Havinden 1966, 516–517; Croft-Murray 1962, 1:192

Exhibitions: Lansdowne House 1929 (346, 347)

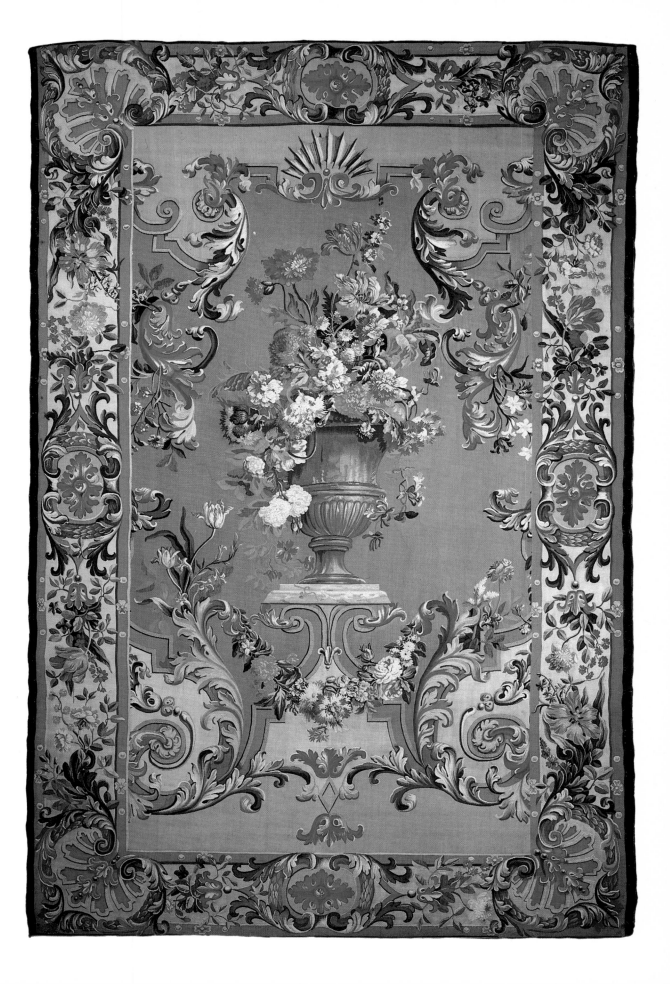

5: Lord Burlington and the Palladian Revolution

The Palladian movement, which in the early years of the eighteenth century set Britain on a different course from the rest of Europe in architecture and decoration, was to a large extent the brainchild of a single influential figure, Richard Boyle, 3rd Earl of Burlington (no. 139). He and his protégés, Colen Campbell and William Kent, found in the designs of the Italian Renaissance architect Andrea Palladio—as Inigo Jones had done a hundred years earlier—a form of classical villa whose restrained façades and rational planning ideally suited the Whig supporters of the Hanoverian Succession, and which could in turn be traced back to the writings of the Roman architect Vitruvius.

In place of the baroque vistas of Vanbrugh and Hawksmoor, Burlington proposed more static, balanced rooms—single and double cubes based on "harmonic proportions," and usually placed on a single floor or *piano nobile* in the Italian style. His own Thames-side villa at Chiswick, added to an older house, was built to Palladio's own relatively small proportions (no. 140), but later Palladian country houses like Sir Robert Walpole's Houghton and his neighbor Thomas Coke's Holkham, both in Norfolk, were built on a gigantic scale.

The main rooms of these great houses were to be hung primarily with large-scale Italian subject pictures, collected on the Grand Tour—and different aspects of Grand Tour taste are examined here and in the following five sections. Lord Burlington's passionate advocacy of Inigo Jones was precisely paralleled by his sympathy with the Italianate tastes of the great collectors of Jones' generation—King Charles I himself, Arundel, and Buckingham. Maratta's portrait of Sir Thomas Isham (no. 138) represents the increasing interest of the English in Italy in the Restoration period, but Burlington's example and the writings of Lord Shaftesbury would set the pattern of the Palladian revival. Sebastiano Ricci was employed at Burlington House and other Venetians worked in England—Pellegrini at Castle Howard and Kimbolton, Amigoni at Moor Park—while works by such artists as Luca Giordano, Solimena, Conca, and the Roman "Maratteschi" were acquired in large numbers. Kent himself had trained as a painter in their mode.

The influence of France was not wholly undermined. Largillière had studied under Lely in England, but the recusant Throckmortons sat for him in Paris. Watteau visited London about 1719–1720 to consult Dr. Mead, for whom he painted two pictures, and his follower Philippe Mercier became a favorite of Frederick, Prince of Wales, the first connoisseur of the Hanoverian line. The conversation piece, a genre that drew on both French and Dutch examples, developed an unmistakably English character because of the genius of the first great native master for over a century, William Hogarth, whose Holland House and Malpas groups (nos. 163 and 164) offer so fascinating a contrast with the work of Gravelot and Mercier. The sophisticated patrician world these record would find a provincial echo in the canvases of Devis.

Many of the pictures described in this section were originally kept in London, including the Riccis and Mercier's Tyrconnel group, while the Malpas family are apparently shown in their Arlington Street house. Although views of London had been painted in some numbers since the seventeenth century, the arrival of Canaletto raised the art of metropolitan topography to a new level. Patrons who already owned Venetian scenes commissioned pictures of London also for their country houses, and although Canaletto was evidently disappointed by the narrow market for these, his London views were the source for those of Scott and Marlow.

William Kent's furniture designs, executed by makers like Benjamin Goodison, John Gumley, and James Moore, are among his finest achievements. Their massive, sculptural quality derives partly from Italian prototypes and partly from a reinterpretation of Inigo Jones' designs, originally intended for architectural decoration. His great pier tables, settees, and chairs were conceived as part of a unified decorative scheme echoing the motifs of the plasterwork ceilings, doorcases, and chimney-pieces—often using mahogany, now being imported to England in large quantities from the West Indies.

138

SIR THOMAS ISHAM, 3RD BART. 1677
Carlo Maratta 1625–1713
oil on canvas
148.6 × 120.6 (58½ × 47½)

Lamport Hall
The Lamport Hall Trust

Thomas Isham (1657–1681) was the only son of Sir Justinian Isham, 2nd Bart., who married Vere, daughter of the 1st Lord Leigh, in 1653 and in the following year commissioned John Webb to design a precocious Palladian addition to the Tudor house his family had acquired in 1560. At his father's instance Thomas kept a diary in Latin from 1671 to 1673, which offers an unusual insight into country life in the seventeenth century (Isham 1971). He succeeded his father in 1675, and in October of the following year, after going down from Christ Church, Oxford, he set out for Italy with his cousin and tutor, the Reverend Zacchaeus Isham (1651–1705). His sojourn of some seventeen months, ten of which were spent between Rome and Frascati, was of unusual length for such an early Grand Tour. Isham's expenditure was also unusually heavy — £1,400 during the first fifteen months of his travels — and is only partly accounted for by the twenty pictures he purchased in Rome, which included the present portrait, another by Ferdinand Voet (now lost), works by Rosa, Lauri, Brandi, and Ludovico Gemignani, and copies after Raphael, Reni, Domenichino, Guercino, Poussin, Lanfranco, and Cortona. All but two of these remain at Lamport. Other acquisitions included two cabinets at 250 ducats and a marble *tazza*, also still at Lamport (Burdon 1960 and Isham and Marlow 1971, 38–40). Isham's interest in collecting was no doubt stimulated by the fact that Italian pictures and furniture could be shown to advantage in Webb's Palladian house at Lamport, but the extravagant tastes he developed meant that after his return in 1678 marriage to an heiress seemed an urgent necessity: he died of smallpox when on the point of making a suitable alliance.

"Sir Thomas's Picture Sitting done by Carlo Maratti at Rome" is recorded in a list of pictures he brought back. Maratta was generally recognized as the outstanding painter of his generation in Rome, and was patronized by several other English connoisseurs who visited that city, including the 5th Earl of Exeter and Sir Andrew Fountaine (see no. 238). The Isham portrait is of interest not least because of its presentation. Sir Thomas' gaze may be detached, but he is characterized as a connoisseur. He holds a miniature in a jeweled setting and wears a richly embroidered robe or stole, both of which he must have acquired in Rome. He also leans on a gilt baroque console table of a type Kent was to imitate in the early years of the following century. Maratta's portrait of Isham is indeed the picture in which he most closely anticipates the conventions of Grand Tour portraiture, which would reach fruition in the work of Batoni. F.R.

Provenance: Painted for the sitter; and by descent at Lamport
Literature: Burdon 1960, 5
Exhibitions: London, RA 1950 (362); Rome 1956–1957 (199); Northampton 1959 (29); London, RA 1960 (38); London, Sotheby's 1983–1984 (39)

139

RICHARD BOYLE, 3RD EARL
OF BURLINGTON 1763
George Knapton 1698–1778
oil on canvas
124.4 × 99.7 (49 × 39)
signed and dated, *George Knapton pinx
1763* on the back of the canvas, covered
by lining

Chatsworth
The Chatsworth House Trust

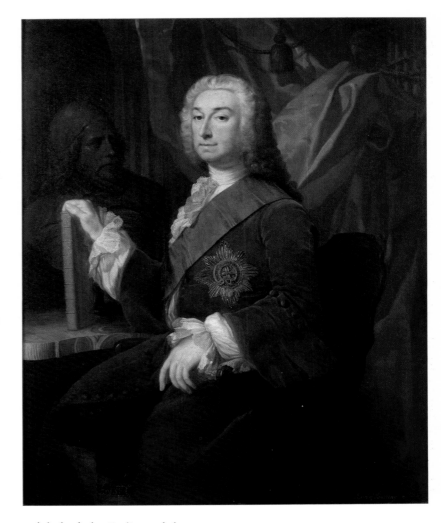

Richard Boyle, 3rd Earl of Burlington
and 4th Earl of Cork (1694–1753),
succeeded his father in 1704 and inherited
great estates in Ireland and in Yorkshire.
A prominent Whig, he was appointed
Lord Treasurer of Ireland and Lord
Lieutenant of the East and West Ridings
of Yorkshire in 1715 and became a Privy
Councillor in 1729. In 1733 he opposed
Sir Robert Walpole over the Excise Bill
and never again held office. It was only
after Burlington's Grand Tour of 1714–
1715 that architecture became his main
interest, and he quickly became the
aristocratic champion of the Palladian
cause. He returned to Italy in 1719,
mainly to study the work of Palladio at
Vicenza, and it was then that his close
association with William Kent and Colen
Campbell developed.

Burlington may have contributed to
the design of his own town establishment,
Burlington House, and, after his villa at
Chiswick established his mastery of the
Palladian idiom (see nos. 140 and 141),
he supplied projects for many of
his friends, including Lord Bruce at
Tottenham Park, Sir Robert Furness at
Waldershare, Lord Clinton at Castle
Hill, and the 2nd Duke of Richmond at
Richmond House (see no. 157). He
acquired an outstanding collection of
architectural drawings, including the
great series of masque designs by Inigo
Jones at Chatsworth and the unrivaled
assemblage of Palladio material that is
on permanent loan to the Royal Institute
of British Architects. Burlington was
also a discriminating connoisseur of
pictures.

He patronized contemporaries
including Ricci (nos. 149 and 150) and
evidently had a particular sympathy for
the Italian seicento, but also owned
portraits by Rembrandt and Hals.
Many of his acquisitions, including the
Domenichino *Madonna della Rosa*, which
at 1,500 scudi was the most expensive
picture he acquired on the Grand Tour,
are now at Chatsworth.

Knapton's portrait shows Burlington
wearing the star and riband of the Order
of the Garter, which he had received
in 1730, and celebrates his particular
veneration for Inigo Jones, who was,
with Palladio, his architectural hero.
The Rysbrack bust of Jones in the back-
ground (no. 144) is now at Chatsworth

and the book that Burlington balances
so carefully has been identified from
the binding as his own copy of Kent's
Designs of Inigo Jones, also at Chatsworth.
Based on the Jones material in
Burlington's collection and with a
supplementary group of his own designs,
this was published in 1727 at his personal
expense and constituted a manifesto of
his architectural views. F.R.

Provenance: By descent from the sitter,
through his daughter Charlotte, wife of
the 4th Duke of Devonshire
Exhibitions: London, SKM 1867 (280);
London, RA 1954–1955 (61);
IEF 1979–1980 (4)
Engravings: W.T. Mote

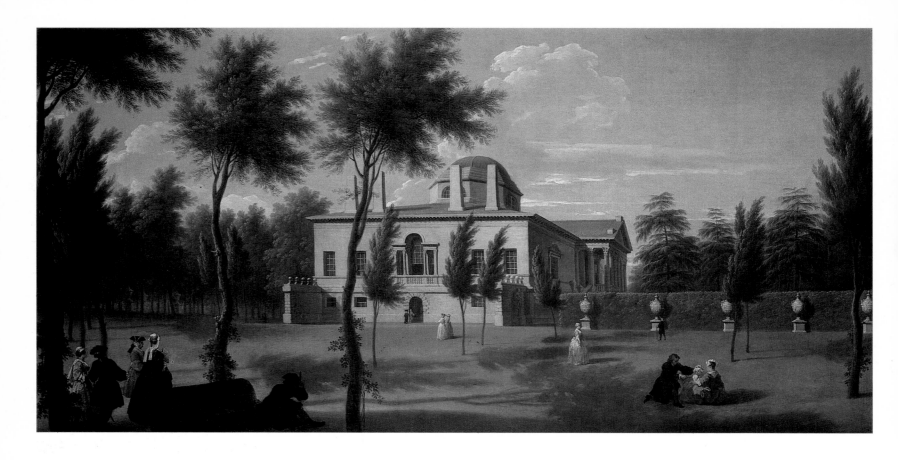

140

CHISWICK HOUSE FROM THE WEST
c. 1742
George Lambert 1700–1765
oil on canvas
73.6 × 144.7 (29 × 57)

Chatsworth
The Trustees of the Chatsworth
Settlement

This painting shows the villa at Chiswick in Middlesex, which the 3rd Earl of Burlington (no. 139) added as a wing to an older family house between about 1720 and 1729. Modeled on Palladio's celebrated Villa Capra (or Rotonda) at Vicenza, it was the first building in England since the days of Inigo Jones and John Webb to follow the principles of the great Italian Renaissance architect, and it was to have a revolutionary effect on the whole course of country house architecture in eighteenth-century England. The gardens, designed by William Kent (1685–1742), are shown

some fifteen years after the set of views by Pieter Andreas Rysbrack (no. 141), and their semi-formal lines have already been softened and "naturalized," partly by the growth of the trees but partly also in accordance with the new taste for the "picturesque."

George Lambert is one of the most important figures in the development of English landscape painting. A pupil of John Wootton, and principal scene painter at the Covent Garden Theater from 1732, he also undertook views of houses "of remarkable originality that owe little to the conventional country house perspectives of Knyff, Wootton or Tillemans but much to direct observation and perhaps to the more sensitive English views by Siberechts" (Einberg 1970, 8). Although doubt has been cast on his authorship of this picture (Harris 1979, 247, 261), it corresponds very closely with two slightly smaller pictures of Chiswick, also at Chatsworth, which are signed by Lambert and dated 1742, and with a drawing

of exactly the same composition, but without figures, in the Huntington Library (Wark 1969, 34, and fig. a). The slightly different forms of chimney found in all these are of little consequence, for Lord Burlington would probably have wished to show his original tapering obelisks even if they had had to be modified for practical reasons. The artist always seems to have relied on other painters to supply the figure groups in his pictures and Samuel Wale was employed on this work at Covent Garden. On the other hand J.B. Nichols, describing this picture as part of a set of four at Chatsworth in 1833, attributed the figures to Hogarth, with whom Lambert certainly had close associations (Nichols 1833, 366).

If further proof were needed of Lambert's hand, it can surely be found in the feathery branches of the trees, casting dappled shadows on the lawn, instead of the more conventional dark leaves or clumps of grass favored by earlier artists, and in the echoes of Gaspard

Poussin, already found in his series of Westcombe House, Blackheath, of 1732 (Earl of Pembroke, Wilton House) and Denton Hall, Lincolnshire, of 1739 (private collection). In such attempts to apply "the rules of art to the English rural scene" (Waterhouse 1978, 157) Lambert looks forward to the achievements of Richard Wilson and John Constable. G.J-S.

Provenance: See no. 139
Literature: Wark 1969, 34, fig. 9; Harris 1979, no. 277

141

THE ORANGE TREE GARDEN
AT CHISWICK c. 1729–1730
Pieter Andreas Rysbrack c. 1684–1748
oil on canvas
60 × 106.6 (24 × 42)

Chatsworth
The Trustees of the Chatsworth
Settlement

The gardens surrounding Lord Burlington's Palladian villa at Chiswick (no. 140) were almost as revolutionary in style as the house. They were begun by Charles Bridgeman at some time before 1717, when the "Bagnio," described by Colen Campbell as "the first essay of his Lordship's happy invention," was erected (Campbell 1725, 3: 8). But William Kent seems to have taken charge by the mid-1720s. These two originators of the "picturesque" manner of landscape gardening experimented with serpentine paths and rivulets, bosquets and wildernesses, very different from the long canals and parterres of a previous generation but still contained within a system of straight avenues and vistas. The horseshoe-shaped Orange Tree Garden, recently restored, is another relatively formal incident in the layout, with its descending terraces set with orange trees in tubs reminiscent of Ver-

sailles. The architectural elements are wholly Italian, however: the temple, which is a miniature version of the Pantheon with Ionic columns copied from the Temple of Fortuna Virilis, was another of Burlington's own "happy inventions," engraved by Kent and Vardy in 1736 (plate 73); while the obelisk in a pond in front of it was probably suggested to him by the Renaissance fountain, surmounted by the obelisk of Rameses II, which still stands in the center of the Piazza della Rotonda in Rome. The turkeys, pheasants, guinea fowls, and other birds depicted show that this part of the garden, encircled by a high hedge with iron gates and *clairvoyées*, was also used as an aviary. Zoffany's *Children of the 4th Duke of Devonshire*, dating from 1765 (IEF 1979–1980, 8), is set in this part of the garden, by this time devoid of orange trees and totally "naturalized," with large trees dwarfing the temple.

This picture belongs to a set of eight views of the house and gardens, probably painted about 1729 to celebrate their completion, and attributed to Pieter Andreas Rysbrack on the strength of an engraving of the *Orange Tree Garden* by Du Bosc, which acknowledges him as the artist. Rysbrack was the son of the Flemish landscape painter Pieter Rysbrack (1665–1729) and a brother of the sculptor, John Michael Rysbrack, who carried out many commissions for Lord Burlington at Chiswick, including the busts of Palladio and Inigo Jones (nos. 143 and 144). The brothers probably came to London together in 1720, and Pieter later established a reputation as a still-life and animal painter; he also produced topographical and panoramic landscapes in the manner of Tillemans. His Chiswick views set a fashion for series depicting entire garden layouts, like Balthasar Nebot's of Hartwell House, dating from 1738 (Buckinghamshire County Museum, Aylesbury).

G.J-S.

Provenance: Presumably commissioned by the 3rd Earl of Burlington, this is one of a series of eight views of the garden, of which there appear to have been two complete sets: one at Oxburgh Hall in Norfolk, inherited through Lord Burlington's sister, Lady Bedingfeld, and one at Chatsworth inherited through his daughter, who married the 4th Duke of Devonshire. Only four of the pictures in the latter set, have survived, and the *Orange Tree Garden* was purchased by the present Duke of Devonshire from Leggatt when the Oxburgh set was sold in 1952
Literature: Harris 1979, 187b and pl. 19c
Exhibitions: Nottingham 1973, 69

PIER GLASS AND TABLE 1735
John Boson, probably to designs by
William Kent 1685–1748
mirror and frame of giltwood, table of
mahogany, parcel-gilt
pier glass: 182 × 133 (71½ × 52); table:
89.5 × 151 × 80 (35¼ × 59½ × 31½)

Chatsworth
The Trustees of the Chatsworth
Settlement

This is one of a pair of pier glasses and
tables made for the Summer Parlour at
Chiswick House, which was situated
on the ground floor of the brick build-
ing between the old house and the 3rd
Earl of Burlington's new Palladian villa,
added as a wing in the 1720s. The room
was for the countess' use, and the owls
that play so prominent a part in the
design of both pieces are a reference to
the crest of her own family, the Saviles.
In the past the tables have been con-
sistently called "library writing tables,"
perhaps partly because the owl—as a
symbol of wisdom and the attribute of
Minerva—later became a standard
decorative motif in the country house
library. This furniture cannot have been
made for Lord Burlington's book room
on the ground floor of the new villa,
however, and the highly architectural
form of the tables with drawers on each
side of a central kneehole, may have
more to do with William Kent's desire
to create a whole decorative ensemble
than with any practical idea of using
them as desks. The tables are in any
case too low to write at.

In the past these pieces have been
variously attributed to William Vile and
Benjamin Goodison, both of whom are
known to have executed furniture de-
signed by Kent (Coleridge 1968, 21;
Beard 1977). But it now seems likely
that they are referred to both in a letter
written by Lady Burlington from Bath
in 1735—"I hope the Signior [Kent's
usual nickname] has remembered about
my tables and glasses" (Wilson 1984,
81)—and also in a bill for "carving
done for ye Honble Lady Burlington"
submitted by John Boson and paid on
11 September 1735. The "two Rich
Glas frames with folidge and other
ornaments" are here listed as costing
£15, and the "two Mahogany Tables
with Tearms folidge and other Orne-
ments," as well as "modles for ye Brass
work," amount to a further £20

(Chatsworth MSS no. 247.1; informa-
tion kindly supplied by Mr. Treve
Rosoman). The only other items men-
tioned in the bill are "two stands with
Boy heads" that are now also at Chats-
worth.

John Boson (or Bason) appears to
have been one of the carvers employed
on the state barge that Kent designed
for Frederick Prince of Wales in 1737
(now at the National Maritime Mus-
eum, Greenwich), and indeed the cabin
of the barge has much in common with
the Chiswick pier table: the "triumphal
arch" motif, created by the central
kneehole and the drawers with inset
roundels either side, recurs in the doors
to the cabin, with porthole windows
on either side, and the same shells,

festoons of husks, and other ornaments
can also be found. Boson also undertook
carving for the Prince of Wales at Kew,
Leicester House and Carlton House
(Duchy of Cornwall MSS). His name
occurs among the Holkham accounts
for 1732 (information from Mr. John
Hardy), once again working under
Kent's direction, and he made the stand
for Pope Sixtus V's cabinet at Stour-
head in 1742, openly modeled on a
triumphal arch and decorated with
carved reliefs representing the Pope's
architectural achievements in Rome
(Dodd 1981, 28, ill.).

The carving of the Chiswick pieces
is of the highest quality, with the acan-
thus cresting of the mirror continuing
the bird's wing effect, and the owl terms

of the table resting on lifelike claw feet.
The gilt metalwork of the handles is
also extremely finely chased by which-
ever craftsman was chosen to copy
Boson's "model." G.J-S.

Related Works: A table of similar form
but with lion-headed terms, formerly
at Rokeby Hall, is now in the Royal
Collection (Coleridge 1968, fig. 2)
Provenance: Commissioned by Lady
Dorothy Savile, daughter of the 2nd
Marquess of Halifax and wife of the
3rd Earl of Burlington; and by descent,
as no. 139.
Literature: DEF 1954, 3: colour
pl. 9; Coleridge 1968, fig. 1
Exhibitions: London, RA 1955–1956, 20,
76; IEF 1979–1980, 182

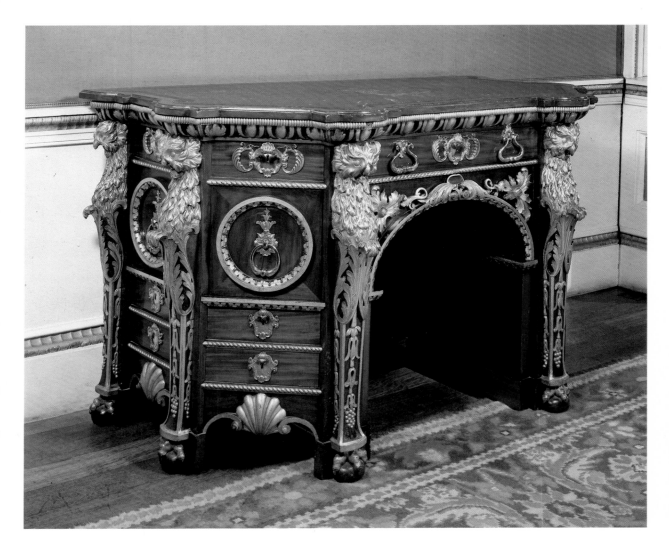

143

ANDREA PALLADIO C.1725
John Michael Rysbrack 1694–1770
marble
59.7 × 45.7 (23½ × 18)

Chatsworth
The Trustees of the Chatsworth
Settlement

Lord Burlington, for whom this bust
and that of Inigo Jones (no. 144) were
almost certainly executed, owned many
of Palladio's drawings. He published
some of them in 1730 in *Fabbriche antiche
disegnate da Andrea Palladio Vicentino e*

date in luce da Riccardo Conte di Burlington.
Kent's frontispiece to this is based on a
portrait owned by Burlington, which
apparently also served as Rysbrack's
model. This engraving is related to the
portrait of Palladio included in Leoni's
1716 English translation of the *Quattro
Libri*, engraved by Picart purportedly
after Veronese. As Wittkower (1974, 82)
has shown, however, Leoni's Palladio
bears little resemblance to the authentic
bearded Venetian known from an en-
graving after a bust portrait by Zucchi.
Instead he is shown *en negligé*, according
to the convention favored by English
patrons during the first half of the

eighteenth century. Perhaps the image
used in Burlington's portrait and the
Rysbrack adaptation of this may seem
to be a modification of the Leoni-Picart
invention to match the Van Dyck image
of Jones. Leoni's volume includes yet
another image of Palladio as a detail in
Sebastiano Ricci's frontispiece to the
work; here it is depicted in the form of
a bust in the antique manner, another
sculptural convention that enjoyed par-
ticular popularity with English patrons
(see nos. 217, 237 and 238).

Palladio was apparently a consider-
ably less popular subject than Jones.
A modified, lead version of Rysbrack's

bust, paired with a Jones, formerly
decorated the façade of a house in Pem-
brokeshire (R. Lehne Collection, Ander-
son's, New York, March 1935, lot 126)
and both statues and "Bustos large as
life" of the two architects are listed in
the catalogue of plaster casts available
from the late eighteenth-century sculptor
Charles Harris. A reduction of the
Rysbrack Palladio is also found in
Wedgwood's catalogue of 1779. M.B.

Literature: Webb 1954, 80, 102, pl. 36;
Whinney 1964, 88
Exhibitions: London, RA 1955 (84);
London, RA 1960 (165)

144

INIGO JONES c. 1725
John Michael Rysbrack 1694–1770
marble
68.6 × 48.6 (27 × 19)

Chatsworth
The Trustees of the Chatsworth
Settlement

Inigo Jones (1573–1652) and his
revered model Palladio formed the major
sources for the English neo-Palladian
style. This had been largely created by
Richard Boyle, 3rd Earl of Burlington,
and by the mid-1730s it was considered
the appropriate style for most country
houses. This bust and that of Palladio
(no. 143) originally belonged to Bur-
lington, who venerated both architects
and was himself described by the Italian
poet Maffei as "il Palladio e il Jones di
nostri tempi" (Colvin 1978, 129).

This image of Jones, bearded, wearing
a cap, and with his head turned force-
fully to the left, is based on a drawing
by Van Dyck that was owned by Bur-
lington. Together with other evidence,
this indicates that the busts were com-
missioned by him.

The Jones and Palladio busts are re-
lated to two full-length statues executed
after drawings by William Kent (the
"proper priest" to Burlington as "Apollo
of the Arts") for Chiswick Villa, which
Burlington based on Palladio's Villa
Rotonda and into which he incorpor-
ated many details derived from Jones.
Although neither busts nor statues are
signed or documented their authorship
has not been doubted, as Rysbrack's
sale of 24 January 1766 included "Two
figures of Palladio and Inigo Jones, the
original models for the figures of Lord
Burlington at Chiswick." The precise
dating of these works remains uncertain,
however, as does the order in which
they were executed. In 1732 Vertue re-
fers to the busts in the list of Rysbrack's
portraits (Vertue 1930–1955, 3:57)
and the statues were evidently in
place outside the Villa by 1728 when
they were seen by a French visitor
(Physick 1969, 79). A marble bust of
Jones and two plaster figures of both
architects were ordered by Henry Hoare
of Stourhead in 1727 and the account
was receipted by Rysbrack in April 1729
(Kenworthy-Browne 1980, 79) The
original busts executed for Burlington
must therefore date from before 1727.
Although their intended location is un-
known, their roughly finished reverses
suggest an architectural context. The

interior of the Villa was unfinished in
1727 (Wittkower 1945, no. 28) but it
is possible that they were intended for
the older Chiswick House, the façade of
which Burlington was remodeling from
1723. Whatever their precise date, the
busts are clearly from early in the career
of the Antwerp-trained Rysbrack, who
arrived in England in 1720 and soon
established himself as the preferred
sculptor of Burlington's circle. This bust
was valued highly enough by Burlington
to be shown behind him in his portrait
by Knapton (no. 139).

By the mid-eighteenth century Jones
was among the most celebrated of
English "worthies," appearing (in
another version by Rysbrack of this
bust) in the Temple of British Worthies
at Stowe. Ivory portrait reliefs of him
occur frequently in contemporary sale
catalogues and in 1747 Leak Okeover's
architect Joseph Sanderson (see no. 218)
bequeathed a "Gold ring of Inigo Jones's
Head" to a relation. Some of these
images may have been based directly
on Hollar's engraving of the Van Dyck
drawing, which was published in Jones's
Ston-heng of 1655, but others clearly
derived from Rysbrack's vivid charac-
terization. Versions of the bust exist in
various materials and the statue was
reproduced by John Cheere in plaster
(Leeds 1974, no. 64) and in ivory, for
Horace Walpole's cabinet, by Verskovis
(Webb 1954, 112). M.B.

Related Works: Among other versions
of the bust are the marble ordered by
Hoare, the stone version at Stowe
(both mentioned above), marbles (by
Rysbrack or his workshop) at the Royal
Institute of British Architects and for-
merly in the collection of Mrs. M.I.
Webb, and a late eighteenth-century
version in terracotta or composition in
the Victoria and Albert Museum. Works
related to the Chiswick statue of Jones
include a gilded terracotta model at
Wilton House (described by Webb as
plaster) that was cast in plaster by John
Cheere (Leeds 1974, 65), a variant terra-
cotta model at the Royal Instititute of
British Architects and a large plaster at
the 1st Duke of Kent's house in Saint
James' Square, London
Provenance: By descent from Lord Bur-
lington to Lord Hartington, later 4th
Duke of Devonshire
Literature: Webb 1954, 80, 102, pl. 37;
Whinney 1964, 88
Exhibitions: London, RA 1955 (63);
London, RA 1960 (166)

145

PAIR OF PEDESTALS c. 1735
probably after a design by William
Kent 1685–1742
veneered in mahogany on an oak and
pine carcass
137.1 × 30.48 × 25.4 (54 × 12 × 10)

Temple Newsam House
Leeds City Art Galleries

The rage for collecting marbles in the
early eighteenth century created a
supply of "Curious bustos and bas-
reliefs of all the most eminent emperors,
kings, generals, admirals, ministers of
state, philosophers, mathematicians,
architects, poets, and painters" to be
placed on "trusses, or pedestals or
terms," as one advertisement in the
Spectator put it. William Kent was par-
ticularly adept at providing designs for
these pedestals of a suitably architectural
character, for example at Rousham in
Oxfordshire where his patron, General
Dormer, had no less than twenty-two
bronze figures and twenty "bustos"
listed in an inventory of 1742 (Jourdain
1948, 83). The Temple Newsam ped-
estals are closely related to some in the
hall at Rousham (Lenygon 1914, fig.
275), and to a pair formerly at Canons
Ashby in Northamptonshire (private
collection, Dublin). So popular did this
form become that a similar example can
be seen in Gainsborough's portrait of
Viscountess Ligonier (Huntington
Library and Art Gallery, San Marino)
as late as 1771.

The double shells and leaf pendants
on the fronts of the shafts are typical of
Kent, while the capitals have enrich-
ments based on the metopes and tri-
glyphs of the Doric order: a classical
allusion very suitable for the display of
a marble bust. Only the long fronded
scrolls on the sides ending in a "raffled
leaf" give a mild foretaste of the rococo.
 G.J-S.

Provenance: Lady Cunard, Neville Holt,
Leicestershire; M. Harris and Sons;
bought for Temple Newsam House,
1942
Literature: Gilbert 1978, 2: no. 363 (ill.)

146

THE PELHAM CUP 1736
George Wickes 1698–1761 to a design
by William Kent 1685–1748
22-carat gold
27.9 (11)

Private Collection

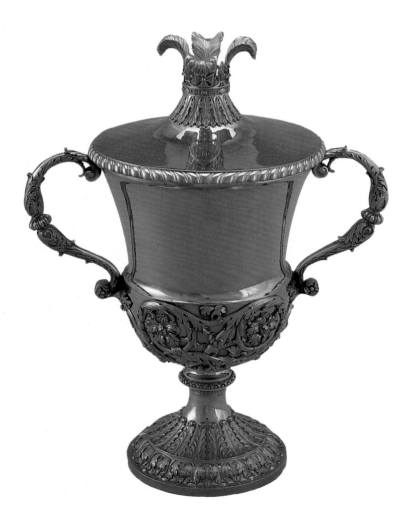

This is the original version of the cup and cover designed by William Kent, and engraved by John Vardy as a plate in *Some Designs of Mr. Inigo Jones and Mr. William Kent* (1744), where it is described as "a gold cup for Colonel Pelham." Kent's design was inherently classical at a time when the rococo was fast becoming the fashion: the formality of the acanthus-chased foliage on the base, the classical vase form with a cagework base such as might have enriched a Roman urn, the foliate handles with paterae at the terminals, and even the Prince of Wales' feathers on the finial suggest a sculptural formality that invites comparison with his designs for garden urns.

Because the cup is unmarked it was previously thought to date from much later in the eighteenth century, using the Vardy engraving as a pattern. Although a rather similar cup and cover of 1741 by John Swift (Grant-Peterkin 1981, 36–38) has now come to light, the dating of the Pelham cup might hardly have been altered, let alone confirmed, had it not been for the fortuitous survival of the ledgers of George Wickes and his successors dating from 1735 onward (Victoria and Albert Museum). In 1735 Wickes was appointed goldsmith to Frederick Prince of Wales, and it is likely that Colonel the Hon. James Pelham, who was himself appointed to the ill-fated prince's household as Private Secretary, intended the gold cup as a gift for his royal master. He resigned the post, however, in 1737. Wickes' entry dated 26 October 1736 reads: "To a gold cup 58 ozs. @ £3.15s.6d. £218.19.0d./To making £80.0.0d./To a case £2.2s.0d." The original red morocco case still survives.

Gold is sufficiently rare in English plate collections to arouse comment. As Arthur Grimwade has shown, fewer than a hundred examples dating before 1830 have survived, and the Pelham cup is substantial enough (at the 1921 sale the weight was given as 57 ounces 17 dwt., minimally less than Wickes' listing) to be of special importance. Much of the cost of the obligatory 22-carat gold (18-carat was not permitted until 1798) was paid for by the colonel's sale of over 83 ounces of gold boxes the following February to a value allowed of £314.5s.0d.

In 1755 the ledgers reveal that for the first time armorials were engraved on the cup in the shape of "2 Crests, Coronets and Garters" at a cost of ten shillings. The cup had apparently already passed to Henry Fiennes Clinton, 9th Earl of Lincoln (and later 2nd Duke of Newcastle), who had married his first cousin, the heiress Catherine Pelham, in 1744. Catherine was herself a second cousin of Colonel Pelham. A silver-gilt version of the cup, complete with the Prince of Wales' feathers, unlike other similar versions, was apparently made for the colonel by John Jacobs in that same year.

J.B.

Related Works: Cups based on the same William Kent design include: 1741 (cone finial), by John Swift; 1755 (feathers finial), by John Swift; 1763 (crown finial, christening gift from King George III), by Thomas Heming; 1769 (bud finial), by John Swift
Provenance: Colonel the Hon. James Pelham (c.1690–1761); by 1755, Henry Fiennes Clinton, 9th Earl of Lincoln; by succession to his heirs, the Dukes of Newcastle; 7th Duke's sale, Christie's, 7 July 1921, lot 84
Literature: Jones 1907, 27, pl. XXIX; Hayward 1969, 162–166; Barr 1980, 94–96
Exhibitions: London, Park Lane 1929, no. 170; London, V & A 1980–1981

147

PAIR OF CARVED AND GILT WALL
LIGHTS C.1735
design attributed to William Kent
1685–1748
pine, gilded
146 × 70 × 40 (57⅞ × 27½ × 15¾)

Knole
The National Trust (Sackville
Collection)

These magnificent wall lights or
"sconches," as they might have been
called in the eighteenth century, belong
to a set of four in the Ballroom at Knole,
bearing the coronet and star (or *estoile*)
crest of Lionel Sackville, 7th Earl and
1st Duke of Dorset (1687–1765).
Another slightly smaller set of three in
the same room are decorated with the
Order of the Garter, of which he was
made a knight in 1714. The duke seems
to have contributed little to the dec-
oration and furnishing of Knole beyond
the painted grisaille decoration in a
mildly Kentian style carried out by
Mark Anthony Hauduroy in 1723–
1724 in the King's Room and Colonnade
Room, and on the Second Staircase.
But as one of the foremost promoters of
Italian opera in England, with his friend
and political ally Lord Burlington, he
seems to have spent much time in
London, where he acquired a house in
Whitehall in 1725, extending the prem-
ises four years later (Survey of London
14, 73–74). Dorset House, as it became
known, immediately adjoined the Trea-
sury Buildings that Kent remodeled
between 1733 and 1737, later going on
to rebuild the Horse Guards, which
were completed after his death. The
Sackville papers (Kent Record Office,
Maidstone) contain few references to
this house, but it seems likely that
Kent may have been responsible for
remodeling or redecorating it in the
same decade, and that these wall lights
formed part of its contents (Jackson-
Stops 1978, 32).

The central mask, though hitherto
described as female, probably represents
the sun-god Apollo, appropriately the
source of light, often depicted with long
hair knotted above the forehead and
below the chin. The laurel garlands
below are also associated with the god,

particularly because of his love for the
nymph Daphne who was turned into a
laurel tree, while the snakes that form
the four candle-branches may allude to
his victory over the Python. The ladies
in profile wearing "Indian" feathered
head-dresses are taken from Jean Berain
—a source often used by Kent despite
his avowed preference for Italian orna-
ment—and the lion-mask holding a
ring at the top from which the whole
cartouche depends is found in carved
stone and plaster in many of his inter-
iors, including the Marble Hall at
Houghton. Parallels are also found with
a small table made for Chiswick (and
now at Chatsworth), and with the stern
of the Prince of Wales' barge, both en-
graved by John Vardy in his *Designs of
Inigo Jones and William Kent* (1744, 40,
52).

Kent was one of the first English
architects to design complete interiors,
including furniture, as part of a unified
decorative scheme. At Kensington Palace
in 1727, for instance, he was paid for
"drawing the mouldings and ornaments
for all the picture-frames, glasses etc.
for the drawing-room and for drawing
the frames, with all their ornaments,
the sconces and glasses for the gallery"
(Jourdain 1948, 82). Superbly carved as
they are, it is his genius rather than the
unknown craftsman's skill that imbues
the Knole wall lights with their par-
ticular grandeur. G.J-S.

Provenance: Commissioned by the 1st
Duke of Dorset; and by descent at
Knole; acquired by the National Trust
with the contents of the Show Rooms
in 1962
Literature: DEF 1954, 3:49, fig. 14

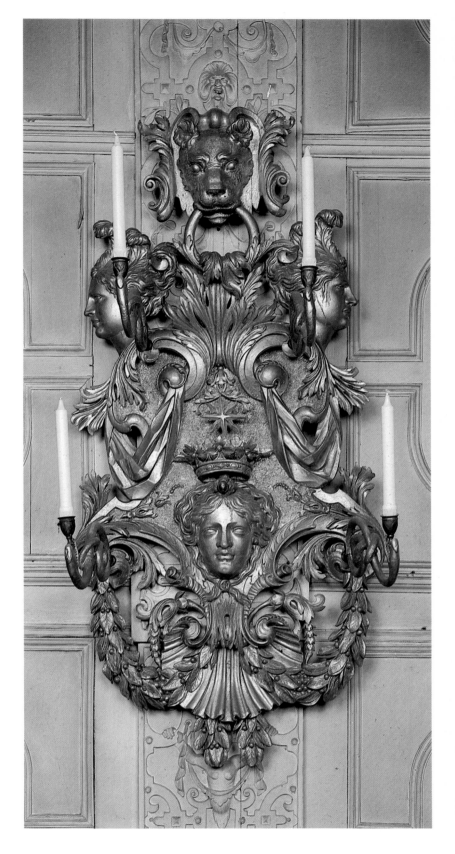

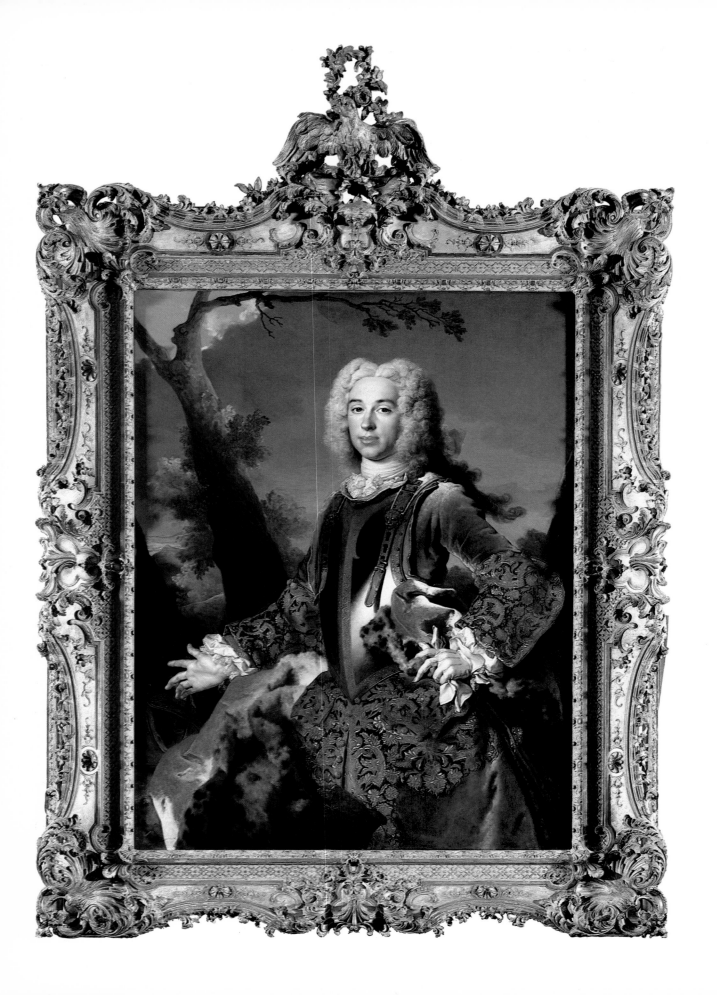

148

SIR ROBERT THROCKMORTON,
4TH BART. 1729
Nicolas de Largillière 1656–1746
oil on canvas
136.5 × 104.7 (53¾ × 47¼)
inscribed, presumably copying original
signature, on reverse, *Peint par N de
Largilliere 1729*; house inscription with
sitter's name and dates on obverse

Coughton Court
The National Trust
(Throckmorton Collection)

This portrait of Sir Robert Throckmorton
(1702–1791), whose extravagant costume
is set off by his burnished cuirass,
represents the apogee of Largillière's
mature, highly finished style. Though
the breastplate has led to the suggestion
that it could be "about the last portrait
painted of a man in armour" (Sitwell
1968, 132) its employment by the artist
is a conscious evocation of seventeenth-
century portraiture. It was painted in
Paris in 1729 and the sumptuousness of
the contemporary French carved and
gilt frame complements the panache
and technical virtuosity of the rococo
portrait.

Sir Robert, eldest son of the 3rd
baronet and grandfather of the 5th, 6th,
and 7th baronets, was born into a leading
Catholic family who, while suffering
the tribulations attendant upon their
allegiance to their faith, had at one
stage been implicated in an assasination
conspiracy—the so-called Throckmorton
Plot of 1583—with the aim of deposing
Queen Elizabeth. As a result of the
continuing recusancy of the family,
Sir Robert was in France in 1729,
when this portrait was painted and
when he was probably responsible for
commissioning from Largillière portraits
of three ladies of his family who had
become members of the Order of Blue
Nuns of the Augustinian Convent in
Paris.

Two of the portraits have been sold
in recent years: that of Elizabeth, sister
of Sir Robert (which bears on the back
of the canvas Largillière's original
signature and date, similar in style
to the inscription on the reverse of
no. 148), which was acquired by the
National Gallery, Washington, in 1964;
and that of Frances Wollascott, a cousin,
which is now in a private collection in
Australia. The third portrait is of Sir
Robert's aunt, Anne Throckmorton,
abbess of the Augustinian Convent from
1720 to 1728. Painted in a limited range
of delicate and subtle colors, it provides
a contrast with the portrait of Sir Robert,
the one ecclesiastical and discreet, the
other secular and flamboyant. It still
hangs at Coughton Court, the family
home of the Throckmortons since the
early sixteenth century and a repository
of family portraits from the sixteenth
century to the present day.

The portrait originally hung not at
Coughton, where it is first noted in an
inventory of the contents in 1855, but
at Weston, a house belonging to the
Throckmorton family in Northampton-
shire. It was seen there by Vertue who
described his visit: "To Weston a Seat
of Sr. Robert Throgmorton's his picture
½ len. by Largillière, [and] some other
Ladys by the same hand." St.J.G.

Provenance: Always in the possession of
the family. Coughton Court, excluding
the contents, was transferred to the
National Trust in 1945. The picture
was offered for sale at Christie's, London,
24 June 1964, lot 70, when it was bought
by the Ministry of Works for future
preservation at Coughton
Literature: Vertue 1930–1955, 5: 105
Exhibitions: London, RA 1956 (189);
London, RA 1968 (409); Montreal 1981
not exhibited, but see under no. 56

149

THE PRESENTATION IN THE TEMPLE 1713
Sebastiano Ricci 1659–1734
oil on canvas
83.8 × 109.3 (33 × 43)
signed, *Riccius fecit 1713*

Chatsworth
The Chatsworth House Trust

This sparkling work was painted in
1713, the year after Ricci's arrival in
London, where he spent four years
carrying out several commissions for
painted decoration. Some of these were
undertaken in collaboration with his
nephew, Marco, who had been brought
to England in 1708 by the 4th Earl of
Manchester after the latter's embassy
to Venice. The provenance of the
pictures by Sebastiano at Chatsworth
is complicated by the fact that the 3rd
Earl of Burlington (see no. 139), who
was only nineteen when this picture
was painted, and his friend the 2nd
Duke of Devonshire, whose grandson
was to marry the Earl's daughter and
heiress, are both known to have owned
works by Ricci. Thus Fougeroux
reported in 1728 that there were
"quelques tableaux" by him at both
Devonshire House and Burlington
House (1728, 77). Ricci's connection
with Burlington was well known and
Fougeroux believed that he had come
"expres d'Italie pour peindre d'Escalier
de Milord" (1728, 80). Two large
canvases painted by Ricci for the stair-
case of Burlington House remain in the
building, now the Royal Academy. The
picture collections at Devonshire
House and Burlington House were, with
that of Sir Robert Walpole, later 1st
Earl of Orford (divided between
Arlington Street and Downing Street),
the most distinguished in London, and
their character was very similar, con-
firming the fashion for the Italian seicento
that so many eighteenth-century galleries
would follow.

Ricci's facility as a *pasticheur* of
Veronese and other masters of the
cinquecento qualified him admirably for
the patronage of the leaders of the first
generation of Whig collectors. Two of
his other pictures at Chatsworth (Daniels
1976, nos. 6 and 11) are in fact direct
copies after Veronese whose *Adoration*

of the Magi, now also at Chatsworth, was in the 2nd Duke's London house by 1728. This picture is also Veronesian in conception: the figures of the Virgin, priest, and page are variants of those in Veronese's depiction of the Presentation on the outer face of the organ shutters of 1559–1560 in the church of San Sebastiano at Venice. The architecture

also recalls several prototypes by Veronese, most obviously the background of the *Family of Darius before Alexander* (National Gallery, London), then at Ca' Pisani. The woman holding a child behind the Virgin is an obvious reflection of Parmigianino, some of whose finest drawings were owned by the 2nd Duke. F.R.

Related Works: A workshop replica or early copy is in the Museo de Arte de Ponce, Puerto Rico
Provenance: Richard Boyle, 3rd Earl of Burlington, or William Cavendish, 2nd Duke of Devonshire; and by descent
Literature: Devonshire House 1813; Devonshire House 1836; Daniels 1976, 10

Exhibitions: Nottingham 1937 (20, 21); London, Agnew 1948 (4); Manchester 1948–1949; London and Birmingham 1951 (111); Arts Council 1955–1956 (27, 28); Kingston-upon Hull 1967 (61); London, Colnaghi 1978 (6, 7); IEF 1979–1980 (26, 27)

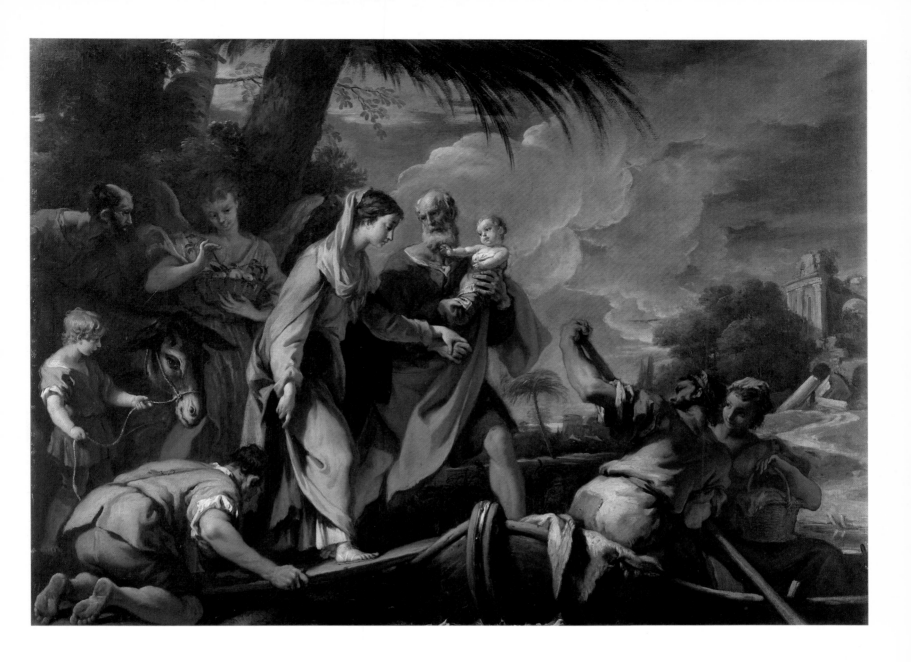

150

THE FLIGHT INTO EGYPT 1713
Sebastiano Ricci 1659–1734
oil on canvas
83.8 × 113 (33 × 44½)

Chatsworth
The Chatsworth House Trust

This picture has been generally regarded as the pendant to *The Presentation in the Temple* (no. 149). Their shared provenance and complementary subject matter certainly support the traditional connection and it is significant that, like the *Presentation*, the *Flight into Egypt* recalls works by earlier masters who would have been admired by both Lord Burlington and the 2nd Duke of Devonshire. The kneeling boy on the left was, as Daniels observes, clearly inspired

by Bassano, while the iconography has been thought, not wholly plausibly, to derive from Poussin (Osti 1951, 122). The somewhat unusual motif of Saint Joseph holding the Child appears also in the picture formerly at Springfield (Daniels 1976, no. 409), which was at Ashburnham until 1850. The Springfield painting is closely related to the Chatsworth composition and must also date from Ricci's English years. The theme of the *Rest on the Flight* was a

favorite of Ricci: in addition to the eight pictures recorded by Daniels, another formerly in an Irish collection (Russell 1978, 466, fig. 22) may also be cited.

F.R.

Provenance etc: See no. 149

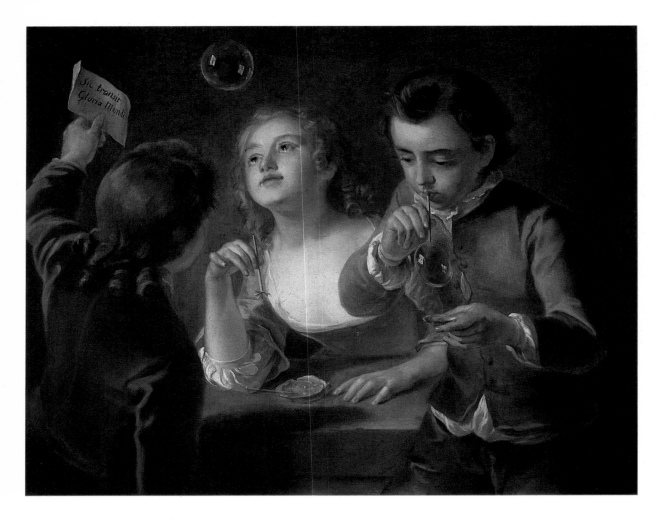

LE FAISEUR DE CHATEAUX DE CARTES
1735
Jean-Baptiste-Simon Chardin
1699–1779
oil on canvas
76 × 99 (30 × 39)

Stanton Harcourt Manor
The Hon. Mrs. Gascoigne

151

THREE CHILDREN BLOWING BUBBLES
c. 1747
Philippe Mercier 1689–1760
oil on canvas
72.4 × 91.4 (28½ × 36)
signed with initials, *PM*; inscribed on
the paper held by the boy on the left,
sic transit Gloria Mundi

Private Collection

This and the *Boy Reading to a Girl*
(Ingamells and Raines 1976–1978,
no. 213) were both apparently painted
by Mercier for the Huguenot William
le Fanu (1708–1797), who had settled
in Dublin in 1728. Mercier visited the
city in 1747 and it was probably then
that he painted Le Fanu's wife
Henriette, née Robateau de Puygibaud,
who is said to have escaped from

France hidden in a barrel of apples
(Ingamells and Raines 1976–1978,
no. 63). Evidently Le Fanu's patronage
of Mercier reflected his Huguenot
loyalties as the painter was the son of a
French Protestant tapestry worker who
had settled in Berlin.

By the time this painting was
commissioned the artist had established
a profitable practice based in York
where he kept a house from 1739 until
1751. Portraiture continued to be a
considerable source of Mercier's income,
and in Yorkshire alone, portraits by
him may still be seen at Burton Agnes,
Hovingham, Newburgh, Nostell, and
Temple Newsam. But his most inventive
works of this period are the "fancy
pictures" inspired both by Dutch
seventeenth-century models and by
Chardin. In many ways these anticipate
the art of Joseph Wright of Derby and

Henry Robert Morland. The original
ownership of surprisingly few of
Mercier's fancy pictures can be estab-
lished, but two notable examples, *The
Bible Lesson* and *Three Children in a Garden*,
acquired by Sir Robert Hildyard, 3rd
Bart., are at Flintham (Myles Hildyard,
Esq.). The identity of the children in
such pictures is unknown. F.R.

Provenance: Painted for William le Fanu;
his son Joseph le Fanu; the latter's son
Philip le Fanu, by whom sold to his
nephew William le Fanu; the latter's
son Thomas Philip le Fanu, father of
Mrs. J.T. Christie
Literature: Ingamells and Raines
1976–1978, no. 236
Exhibitions: York and London 1969 (66)

This picture, relegated to the billiard room at Nuneham Courtenay by the late nineteenth century and overlooked by scholars until it was published by David Carritt in 1974, was almost certainly exhibited at the Salon of 1735. Extensive pentimenti, most obviously in the boy's hands and in his tricorn hat, establish this as Chardin's prime version of the subject. *Une dame prenant son thé* (Hunterian Collection, Glasgow), dated February 1735 on the back of the original canvas but not exhibited until 1739, was conceived as a pendant for this picture, and was sold with it in London in 1765. *Le Faiseur de Châteaux de Cartes* was then acquired by William Fauquier (c. 1700–1788), a director of the South Sea Company and Governor of the Bank of England, who belonged both to the Society of Dilettanti, of which he was secretary and treasurer in 1771–1774, and to the Royal Society. Fauquier was an associate of the dealer John Blackwood and himself a collector on a considerable scale. In 1759 a selection of sixty-eight lots from his collection was sold at auction. The majority were of the Italian school and the representation of the eighteenth century was particularly strong, with works by Chiari, Trevisani, Garzi, Costanzi, and Luti, Orrizonte, Panini and Jolli, Solimena, Rosalba, and Canaletto. One is tempted to suppose that some of these were acquired in Italy. Fauquier was a close friend of the Harcourt family. He was consulted about the choice of the site for the new house at Nuneham in 1756 (Harcourt 1880–1905, 3:78) and his daughter Georgiana married the 1st Earl's step-nephew, the 2nd Lord Vernon whose sister married the 2nd Earl in 1765, in 1786. A number of works from Fauquier's collection, including a Lauri that he presented to Lord Harcourt, are recorded in the 1797 and 1806 Nuneham guides and it would seem that after his posthumous sale of 1789 the picture was given or sold to the 2nd Earl Harcourt (1736–1809), perhaps by Fauquier's widow, who was left a legacy in Harcourt's will of 1805.

Lord Harcourt had inherited Nuneham Courtenay in Oxfordshire, the Palladian house built in 1756–1764 by Stiff Leadbetter for his father Simon, the 1st Earl, when the latter died try-

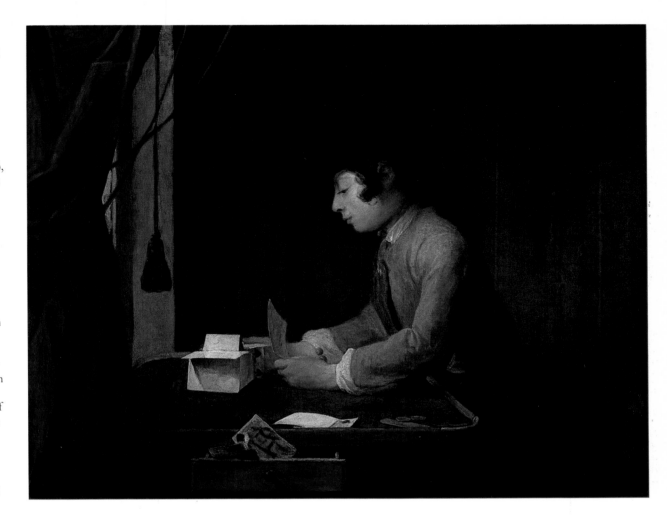

ing to rescue a favorite dog from a well in 1777. In 1781–1782 Capability Brown and Henry Holland collaborated on alterations to the house. Harcourt, who himself was an amateur artist of some distinction, added to the collection his father had formed. He was a close friend of Horace Walpole and the *Description of Nuneham-Courtenay* that he published in 1797 and 1806 was partly based on notes made of the collection by Reynolds and Walpole.

The Chardin was placed in the Eating Room, with the portrait of the 1st Earl and Countess and his brother by Reynolds, now appropriately in the dining room at Stanton Harcourt; a set of four Paninis commissioned by the 1st Earl; Occhialis of Rome, Naples, and Tivoli; and the *Boy Bitten by a Lizard* by Caravaggio that had been owned by Sir Paul

Methuen and was then attributed to Murillo. F.R.

Related Works: A partly autograph replica in which the composition is curtailed and both curtain and tassel are excluded is in the Reinhart collection at Winterthur. Chardin was to evolve five other compositions of this subject
Provenance: Possibly Comtesse de Verrue; her son-in-law Victor-Amedée, Prince de Carignan and Duc de Valentinois; his posthumous sale, Prestage's, London, 26 February 1765, lot 37, purchased for £6 by Robinson; William Fauquier, his posthumous sale, Christie's, London, 30 January 1789, lot 75, £5.15s. to Mr. Stevens (possibly bought in); George Simon, 2nd Earl Harcourt, in the Eating Room at Nuneham Courtenay by 1797 and valued

after his death in 1809 by Robert Brown at £2 (Bodleian Library, Harcourt MSS, A, 1, f. 48); and by descent at Nuneham Courtenay until taken to Stanton Harcourt in 1948 by the 2nd Viscount Harcourt, father of the present owner.

Literature: [Harcourt] 1797, 31; [Harcourt] 1806, 19; Harcourt 1880–1905, 3:247, no. 166; Carritt 1974, 502–507; Rosenberg 1979, under no. 64
Exhibitions: Probably Paris, Académie, 2 July 1735, as "Jeune garçon jouant avec des cartes"
Engravings: Pierre Filloeul, in reverse, as "Le Faiseur de Chateaux de Cartes" (Carritt 1974, fig. 3)

153

ARMCHAIR C.1731
designed by William Kent 1685–1748
mahogany, parcel gilt, upholstered in
the original silk and wool Utrecht cut
velvet
114.3 ×71.1 ×60.9 (45 ×28 ×24)

Houghton Hall
The Marquess of Cholmondeley

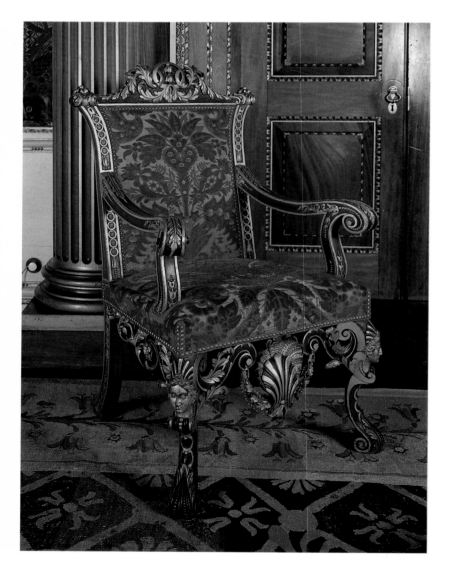

This is one of a set of twelve armchairs, four stools, and two settees, designed by Kent for the Saloon at Houghton Hall in Norfolk, the great Palladian house built by Sir Robert Walpole (1676–1745), the first Englishman to take the title of Prime Minister. The hall and saloon were finished by the end of 1731, when the Duke of Lorraine was sumptuously entertained at the house. Sir Thomas Robinson described it soon afterward as "the best house in the world for its size, capable of the greatest reception for company and the most convenient State apartments, very noble, especially the hall and saloon. The finishing of the inside is, I think, a pattern of all great houses that may hereafter be built; the vast quantity of mahogani, all the doors, window-shutters, the best staircase being entirely of that wood . . . the ceilings in the modern taste by Italians, painted by Mr Kent and finely gilt; the furniture of the richest tapestry etc; the pictures hung on Genoa velvet and damask; this one article is the price of a good house, for in one drawing-room there are to the value of £3,000 . . ." (HMC Carlisle 1897, 85).

Kent's monumental chairs, settees, and stools were intended to be placed symmetrically round the walls of the saloon, where they were the only furniture apart from the huge pier glasses and pier tables carved with life-size putti seated on shells, and a still larger console table on the wall opposite the chimneypiece supported by two sphinxes. The unity of this decorative scheme was something quite new in England, with shells a particular leitmotif appearing in the plasterwork ribs of the ceiling and the painted cove, in the doorcases and, still more appropriately, in the frame to the great Van de Velde seascape on the south wall. The double shell carved on the apron of the chairs may derive from the early seventeenth-century sgabello chair-backs by Francis Cleyn (nos. 57 and 59), which Kent would probably have attributed to his hero Inigo Jones. They also foreshadow the design of the green velvet state bed at Houghton supplied in the following year, 1732, where the gigantic shells above the headboard are a reference to the birth of Venus, whose story

is told in the surrounding tapestries. The maker is not recorded, but could have been a carver like John Boson who supplied similar parcel-gilt furniture for Chiswick (no. 142), or Benjamin Goodison who made furniture at Holkham to Kent's designs (no. 161).

The same crimson Utrecht cut velvet, with threads of yellow silk in the weft throwing up the rich color of the pattern, was used both for wall hangings and for the upholstery of the seat furniture in the saloon. This again was an important innovation, for until now great chambers or saloons had been used for dining on great occasions, and tapestries or hangings would never have been used since they retained the smell of food. Sir Robert Walpole's Marble Parlour at Houghton was one of the first state dining rooms in the modern sense, and left Kent's saloon to fulfill the true function of the *gran'salone* or reception room in an Italian palazzo. The perfect balance between the lines of the chair and the bold pattern of the damask, with a single width representing a vase of flowers in the center of the back, suggests that Kent must have designed the one to suit the other. The miraculous survival of this original upholstery is, paradoxically, due to the bankruptcy of Walpole's spendthrift grandson, who sold most of the pictures to Catherine the Great of Russia, and after whose time Houghton was shut up or let for long periods. His heirs, the Cholmondeley family, lived mostly in Cheshire until the marriage of the present Dowager Marchioness in 1913. The restoration of the house by Lord and Lady Rocksavage (as they then were) and the inheritance of much of the splendid collection of her brother, Sir Philip Sassoon, has since preserved and enhanced the grandeur of Walpole's and Kent's original conception. G.J-S.

Provenance: Made for Sir Robert Walpole; by descent through his daughter Mary, wife of the 3rd Earl of Cholmondeley
Literature: DEF 1954, 1: fig. 129; Jourdain 1948, fig. 139; Hussey 1955, 80–81, figs. 105, 107

154

ARMCHAIR c. 1720
English
gilt gesso, upholstered in the original
Genoese silk velvet
121.9 ×73.6 ×71.1 (48 ×29 ×28)

Houghton Hall
The Marquess of Cholmondeley

Mystery surrounds this magnificent chair, its three companions, and eight matching single chairs now in the Marble Parlour at Houghton. In the past the set has always been attributed to William Kent and thought to be part of his original decoration and furnishing of the room in the 1730s, like the chairs covered in Utrecht velvet in the saloon (no. 153) and those covered in green velvet originally placed in the drawing room, state bedchamber, and Cabinet Room. However, it is quite clear from their upholstery that they are not dining chairs, which would invariably have been covered with leather or horsehair at this date so as not to retain the smell of food; and matters are complicated still further by the appearance of entwined Cs in a small almond-shaped cartouche at the center of the seat rail. There is no evidence of these cartouches having been changed after 1797, when Horace Walpole's great-nephew, the 1st Marquess of Cholmondeley, inherited Houghton. Given the importance of coats-of-arms, crests, and monograms in the early eighteenth century, however, it is equally inconceivable that they were used purely as a decorative motif.

On stylistic grounds there is little to link the chairs with Kent, and much closer analogies can be drawn with the work of John Gumley and James Moore, who produced the finest gilt-gesso mirror and table frames for Chatsworth, Blenheim, and the royal palaces between 1714 and 1726. The smiling masks with feathered headdresses that swell out above the "broken" cabriole legs are derived from Jean Berain, a source Kent also favored, but like the comic snub-nosed cherub heads on the arms they are too frivolous, and the decoration generally too small-scale and exquisite in detail, to have come from the architect's drawing board. The balusters of the arms are derived from seventeenth-

century examples but tapered and "waisted" to support the scrolling arms in a baroque manner worthy of Borromini. Both their fish-scale decoration and the background of the gilt-gesso elsewhere, stamped with tiny rings, never overlapping, give a variety of light and shade to the original water-gilding, whose burnished highlights, reflecting the flames of flickering candles, must have almost given the chairs the appearance of silver-gilt. The Genoese silk velvet used to cover the backs and seats, similar to that in the saloon at Holkham, gives every appearance of being the original, and is of a type often purchased on the Grand Tour to give English houses the character of Italian *palazzi*.

As for the provenance of the chairs, two possible explanations are worth mentioning, though neither can as yet be proved. The first is that they came from Cholmondeley Hall in Cheshire, built between 1707 and 1715 for the 1st Earl of Cholmondeley. William Smith of Warwick acted as the earl's architect, but he also sought advice from Sir John Vanbrugh, and employed many of the leading craftsmen in the office of Works including the blacksmith Jean Tijou and the gardeners George London and Henry Wise (Jackson-Stops 1973). He could well have employed cabinetmakers like Gumley and Moore and, assuming that the chairs escaped being seized by the creditors of his improvident grandson, the 3rd Earl (no. 163), it is possible that they could have been brought to Houghton after the Old Hall at Cholmondeley was demolished and a new Gothic castle built there in 1801. A second theory is that they are the "4 elbow chairs" and "8 backstools" upholstered to match a state bed of "rich crimson flowered velvett (with a gold ground)" described in an inventory of the "Best Bedchamber" at Cannons in Middlesex in 1725 (Baker 1949, quoting a MSS in the Huntington Library and Art Gallery, San Marino). The owner of Cannons, James Brydges, 1st Duke of Chandos, used intertwining Cs, for instance on the balustrade of the staircase by Jean Montigny (now in the Metropolitan Museum, New York) and his lifestyle as a Maecenas of the arts would cer-

tainly justify his possession of such a magnificent set of chairs. The existence of a settee in the saloon at Houghton upholstered in the same material does not necessarily disprove this theory, since its frame does not appear to match the chairs, and its cover could have been made from the old bed-hangings. The contents of Cannons were sold when the house was demolished in 1747, but their subsequent history is difficult to discover. G.J-S.

Related Works: Two chairs identical to those at Houghton, now re-upholstered, exist in the chapel of Sir William Turner's Hospital at Kirkleatham in Cleveland (Cornforth 1977, 137, fig. 9). This chapel was reconstructed in 1742 by Cholmley Turner, a distant relation of the Cholmondeley family, but it also contains a chandelier bearing a ducal coronet said to have come from Cannons
Provenance: Not recorded at Houghton until the mid-nineteenth century; afterward by descent
Exhibitions: London, RA 1955–1956 (14)

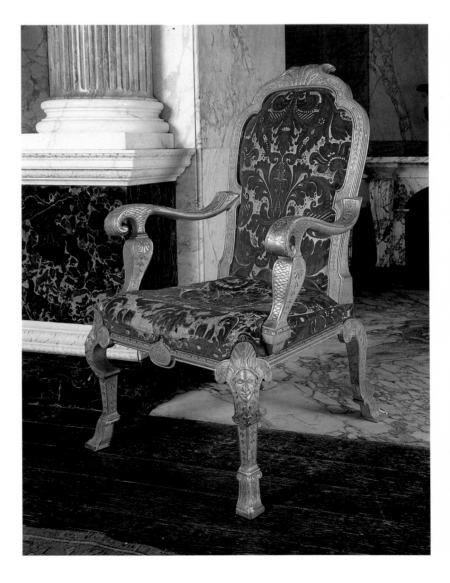

155

SIDEBOARD TABLE c.1742–1745
attributed to Matthias Lock 1740–1770,
after a design by Henry Flitcroft 1697–
1769
softwood, painted and gilded, with a
marble slab
90.8 × 228.6 × 92.7 (35¾ × 90 × 36½)

Wimpole Hall
The National Trust

The highly architectural design of this table, supported by six console brackets and with a "Vitruvian scroll" frieze, is typical of the furniture designed for Palladian country houses in the early eighteenth century. But against this austere background, the apron consists of a freely carved mask of Hercules, clothed in the pelt of the Nemean lion, won in his first labor, which hangs from great rings at either end in an entirely naturalistic style. The whole composition strongly echoes chimneypieces of the period. Its plinth molding probably matched the skirting of the room for which it was intended, and is not carried across as a platform so as to leave room for a wine cooler below. The table corresponds exactly with a pencil drawing by Matthias Lock in his folio album at the Victoria and Albert Museum (Ward-Jackson 1958, 39, fig.

48), and with a pair of tables made for Ditchley House, Oxfordshire (now at Temple Newsam). However, a schedule among the Ditchley papers records that the architect Henry Flitcroft supplied five designs for table frames there in 1740–1741 (Oxford Record Office, DIL.1/9/3a), and as virtually identical tables are to be found at Wentworth Woodhouse in Yorkshire and Wimpole Hall in Cambridgeshire—both houses where Flitcroft worked in the same decade—the likelihood is that they belong to his (somewhat repetitious) oeuvre. Lock is generally better known for his pioneering rococo designs, beginning with *A New Book of Ornaments* published in 1740, but he also produced furniture in a more solid Palladian fashion for Earl Poulett at Hinton St. George in Somerset (Coleridge 1968, figs. 93–94). It is quite possible that he was

the carver employed by Flitcroft for this series, though another candidate for the Wimpole sideboard might be Sefferin Alken, who is recorded as executing many of the carved chimneypieces and overmantels in the house (Jackson-Stops 1981, 15, 17, 25).

Flitcroft began his career in 1720 as Lord Burlington's draftsman and architectural assistant, and later became an important figure in the Office of Works, succeeding Kent as Master Mason and Deputy Surveyor in 1748, and Ripley as Comptroller of the Works ten years later. The ablest of the second-generation Palladians, "Burlington Harry" may not have had the creative genius of Kent, yet his work "has all the merits of a mature style in practised hands" (Colvin 1978, 310). His alterations to Wimpole were carried out for the 1st Earl of Hardwicke, who had bought the house

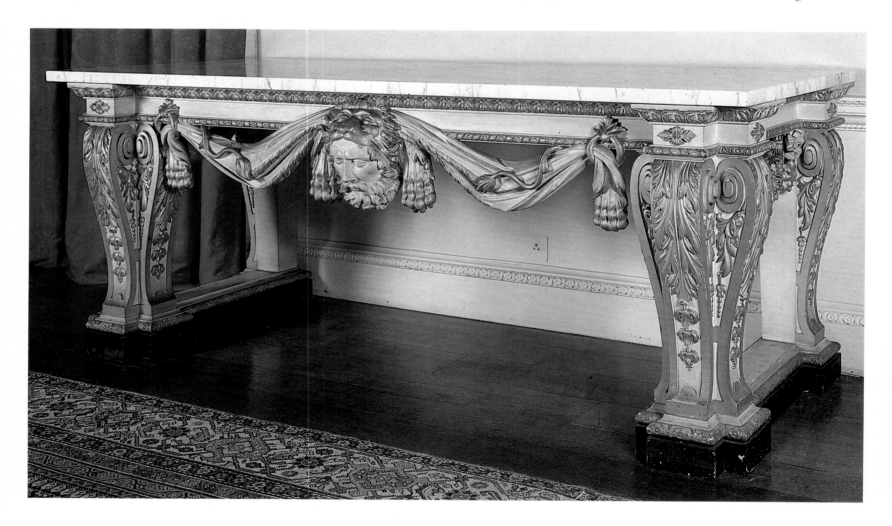

in 1740, and were completed by 1745. The sideboard now stands in the gallery, which Flitcroft created out of three smaller rooms. But like the marble chimneypiece here, with its central mask of Bacchus and festoons of vines, it probably came originally from the dining room—remodeled a century later by the 4th Earl. G.J-S.

Related Works: A pair of tables at Shugborough Hall, Staffordshire (Earl of Lichfield); one from Hamilton Palace, Lanarkshire (now in the Metropolitan Museum, New York)
Provenance: Commissioned by the 1st Earl of Hardwicke (1690–1764), and by descent to the 5th Earl; bought with the house in 1894 by the 2nd Lord Robartes (later 6th Viscount Clifden) and once again in 1938 by Captain and Mrs. George Bambridge; bequeathed by Mrs. Bambridge (the daughter of Rudyard Kipling) to the National Trust in 1976
Literature: Edwards and Jourdain 1955, pl. 82; DEF 1954, 3:124; fig. 3

156

HERCULES 1744
John Michael Rysbrack 1694–1770
painted terracotta
59.7 (23½)
signed and dated, *Mich: Rysbrack 1744*

Stourhead
The National Trust

This well-documented statuette was described by the sculptor's friend George Vertue: "Finding himself somewhat at leisure, business not being so brisk (as . . . before) he therefore set himself about a Model of Hercules." The "rule of proportion" was the antique *Farnese Hercules*, which was then in Rome. While the head resembles its prototype, the various limbs and parts of the torso were modeled from life, from different "fighting boxers" of Broughton's Amphitheatre in London and "at least seven or 8 different men," and other parts from models after the antique. The stance follows an engraving of *Her-*

cules in the Garden of the Hesperides (1646) by Pietro da Cortona, a fact which, curiously, was not noted at the time.

This figure, then, is no mere *bozzetto*, but was made with a care that recalls Italian bronze statuettes of the cinquecento. Rysbrack's practice was to paint his terracottas. The patina contributes to the appearance of bronze but it is not yet established whether the surface layer is of Rysbrack's date or later, and scarcely any original paint survives on his other terracottas for comparison.

In 1747 the artist signed an agreement with Henry Hoare of Stourhead for a full-size marble version, which was completed in 1756. The price was £300, but Hoare gave Rysbrack a gratuity of £50 "beyond ye Contract." The marble was greatly admired by Vertue, Horace Walpole, and other contemporaries. It still stands in the Temple of Hercules, more commonly known as the Pantheon, built for it by Henry Flitcroft in 1753–1754 in the Stourhead pleasure grounds. Mythological statues of the baroque period are rare in England, and this fact alone makes the Hercules singular. Rysbrack offered the terracotta for sale in 1765. Either it failed to find a buyer or, more likely, he withdrew it from the sale, for he bequeathed it in his will to Henry Hoare.

The sculptor was evidently pleased with this statuette, for it features in the portrait that Andrea Soldi painted of him in 1753 (Yale Center for British Art, New Haven). A full-size terracotta bust by Rysbrack of the *Farnese Hercules* (also at Yale), while showing certain differences, may be related to the present work. Rysbrack never went to Rome, and his versions of antique statuary were thus based on engravings or casts. J.K.B.

Provenance: Bequeathed by the sculptor to Henry Hoare, 1770
Literature: Vertue 1930–1955, 3:121–122; Kenworthy-Browne 1983; Bristol 1982 (with previous literature)
Exhibitions: London, Society of Artists 1763 (146); Bristol 1982 (72)

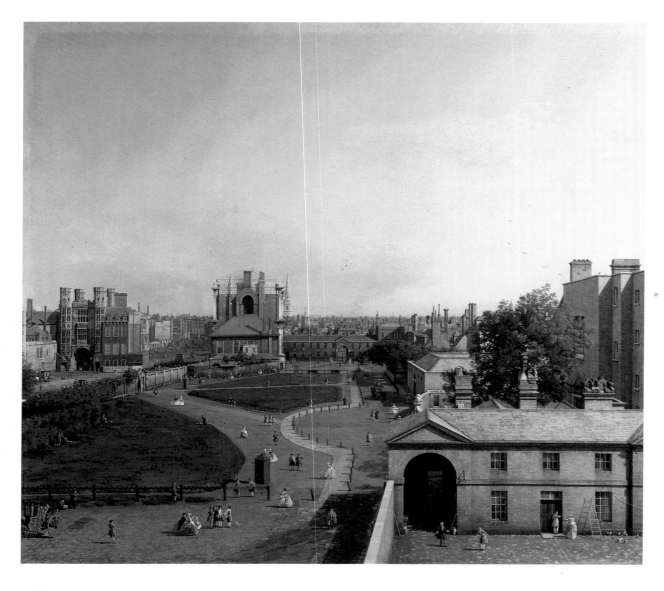

157

WHITEHALL AND THE PRIVY GARDEN
FROM RICHMOND HOUSE c. 1647
Antonio Canale, Il Canaletto
1697–1768
oil on canvas
109.2 × 119.4 (43 × 47)

Goodwood House
The Earl of March and Kinrara and the
Trustees of the Goodwood Collection

This view is taken from an upper window of Richmond House, looking north. In the foreground on the right are the stables of Richmond House and beyond them the back of Montagu House; Whitehall and the Privy Garden are divided in part by a hedge; at the far end of the garden is Inigo Jones' Banqueting House and beyond that a tower of Northumberland House and the spire of Saint Martin's-in-the-Fields. On the left is the Holbein Gate and beyond is Whitehall with the view extending to Charing Cross, and showing part of Le Sueur's equestrian statue of King Charles I. The figure just inside the gate in the foreground, wearing the riband of the Order of the Garter, is presumably Canaletto's patron, the Duke of Richmond, with a servant bowing as he approaches.

After Canaletto's arrival in London in 1746 he received commissions from several of his earlier patrons including Sir Hugh Smithson, later 1st Duke of Northumberland; Lord Brooke, later 1st Earl of Warwick; and Charles Lennox, 2nd Duke of Richmond (1701–1750). Richmond already owned the *Allegorical Tomb of Archbishop Tillotson* (see under no. 171) to which Canaletto had contributed in 1727, and in the same year he ordered a pair of Venetian views on copper (Constable and Links 1976, nos. 232, 235; both now at Goodwood; for a full account of the life of the duke see March 1911). Richmond seems to have had a particular penchant for topographical pictures, as he employed Jolli to execute three large pictures for the hall of Richmond House in 1744. One of these, an "arched piece of building thro which the view of St. George's church & ye Custom house in Venice are seen" (Croft-Murray 1962–1970, 2:226) may well have inspired Canaletto's view of London with Saint Paul's through an arch of Westminster Bridge (Constable and Links 1976, no. 412).

Richmond's commission for this view and its pendant (no. 158) was evidently prompted by a letter of 20 May 1746 from his former tutor Thomas Hill, who had just dined at the Duke of Montagu's in company with Owen MacSwinny: "Canale, alias Canaletti, is come over with a letter of recommendation from

our old acquaintance the Consul at Venice to Mac in order to [effect] his introduction to your Grace, as a patron of the politer parts, or what the Italians understand by the name of virtu. I told him the best service I thought you could do him would be to let him draw a view of the river from your dining room, which in my opinion would gain him as much reputation as any of his Venetian prospects" (Goodwood MSS 103, f. 244, West Sussex Record Office). Two drawings, taken from slightly different viewpoints, are connected with the commission. The central third of a panoramic drawing in the Blofeld collection (Constable and Links 1976, no. 754) relates to this picture, while the remaining sections are connected with the pendant (no. 158) and the *View of Whitehall* in the Buccleuch collection at Bowhill (Constable and Links 1976, no. 439). A drawing in the Onslow collection (Constable and Links 1976, no. 744) is related to the pendant. The drawing is dated to the summer of 1747 by Hayes (1958, 341). F.R.

Provenance: 2nd Duke of Richmond and by descent
Literature: Jacques 1822, 62; Mason 1839, 131, nos. 201, 202; Constable and Links 1976, nos. 424, 438
Exhibitions: Manchester 1857 (824, 831); London, RA 1930 (789, 792); London, 45 Park Lane 1938 (179, 190); London, RA 1954–1955 (18, 22)

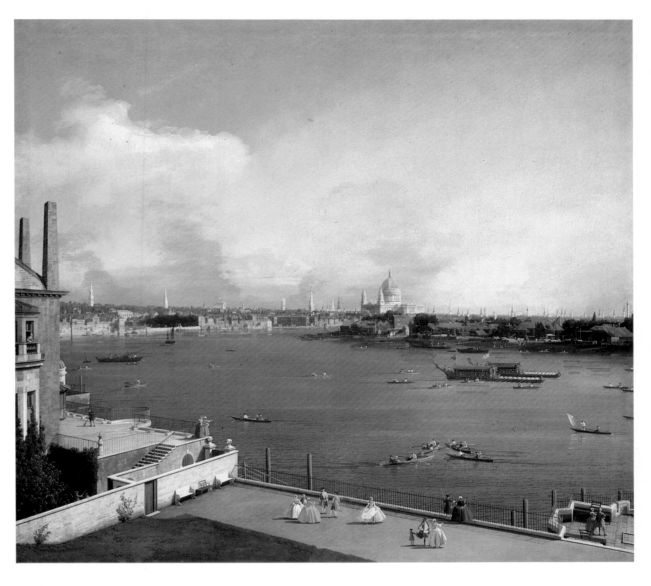

158

THE THAMES AND THE CITY OF LONDON FROM RICHMOND HOUSE
c. 1747
Antonio Canale, Il Canaletto 1697–1768
oil on canvas
106 × 117.4 (41¾ × 46¼)

Goodwood House
The Earl of March and Kinrara and the Trustees of the Goodwood Collection

The view is taken from an upper back window of Richmond House, Whitehall, looking northeast: in the foreground is the terrace of Richmond House, and to the left a corner and the terrace of Montagu House (see no. 157). North of the river the buildings include, from the left, the Savoy, Somerset House, the spires of Saint Mary le Strand, Saint Clement Danes and Saint Bride's, Saint Paul's Cathedral, and the Monument. Canaletto's view is thus in many ways a tribute to the architectural genius of Sir Christopher Wren.

This is the pendant to the view of *Whitehall and the Privy Garden from Richmond House* (no. 157) and is considered in the entry for that picture. F.R.

Provenance etc.: See no. 157

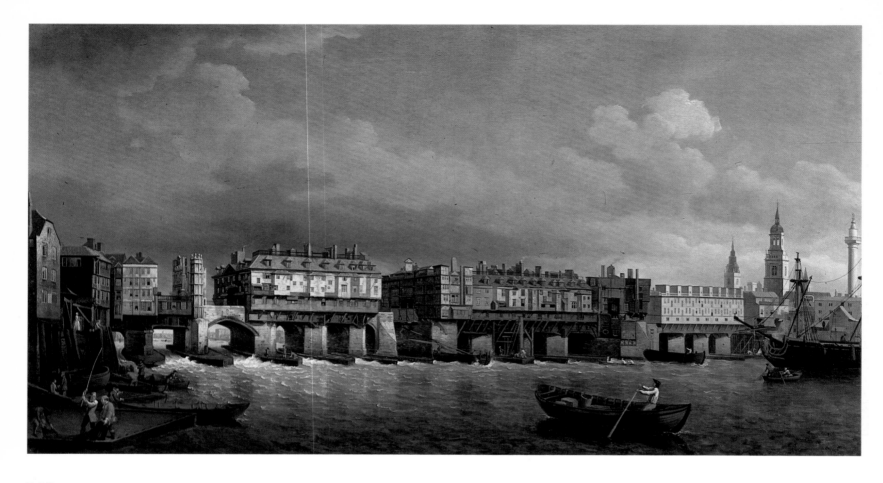

159

OLD LONDON BRIDGE 1748–1749
Samuel Scott c. 1702–1772
oil on canvas
78.7 × 149.8 (31 × 59)

Formerly at Teddesley Hall
The Governor and Company of the
Bank of England

This view is seen from Saint Olave's
Stairs on the south bank of the Thames,
looking northwest with the north bank
seen through the arches. Across the
bridge from the left are the Great Stone
Gateway, Nonsuch House, the remains
of the Old Chapel, the Piazzas, the
steeples of Saint Michael's Crooked Lane
and Saint Magnus the Martyr, and the
Monument. One of eleven versions of
Scott's view of the bridge, this picture
and its pendant, *The Building of West-
minster Bridge* (no. 160), were com-
missioned by Sir Edward Littleton,
4th Bart. (d.1812).

Scott's earliest view of the bridge,
now in the Mersey collection, was
painted in 1747, the year after a Court
of Enquiry was convened to determine
the future of the antiquated structure,
which was shortly to be condemned.
The number of versions shows how con-
siderable the demand for such pictures
was. Of the eleven pictures three remain
in the collections for which they were
commissioned: one ordered for the
Green Drawing Room at Longford by
Jacob Bouverie, 1st Viscount Folke-
stone, and paid for on 20 March 1749; a
slightly larger picture of 1753, commis-
sioned by William Windham II for the
Drawing Room at Felbrigg; and the
replica of this, of 1755, in the Moles-
worth-St. Aubyn collection at Pen-
carrow.

Sir Edward Littleton inherited Pilla-
ton Hill in Staffordshire and the baron-
etcy from his uncle and namesake in
1741–1742. He subsequently built a new
house at Teddesley, also in Stafford-
shire, now demolished, which was de-
signed by William Baker in 1757–1765,
and served as Member of Parliament for
the county in 1784–1807. The Scott
views, among the most comprehen-
sively documented of all his works, were

no doubt commissioned for Pillaton.
They are first mentioned in a letter of
28 June 1748 from the artist: "as to the
Pictures they are all over Painted and
Every Object determined but not yett
propper to be seen by everybody. how-
ever if youl doe me the Honour to call
and see them in the state thay are in I
shall take it as a Great favour." On 20
June 1750 Scott reported "Your Pictures
are now Entirely finishd. and a Case of
Wood made to Pack them up in . . . I
shall send you the two Bridges and the
head of Rembrt. with the frames." A
third, undated letter confirms that
these were dispatched to the carrier
"with a Direction to be left at your
Lodge" and, echoing so many painters'
letters, states: "I assure you they are
thought to be the two best Pictures I
ever Painted but I must beg your Pardon
for an Omission w.ch was that I forgot
to send you the two feather brushes Mr
Callivoe made for you. . . ." Isaac Colli-
voe was a restorer who also worked for
the 4th Duke of Bedford and sold pic-
tures to Lord Folkestone. The reference
is an interesting reminder of the import-
ance attached by both patron and
painter to the proper conservation of
pictures. The final letter is dated

24 July 1749. Scott's motive in writing
was to ask for payment overdue on the
two views of London, but he also re-
ported tht "the Coppy of your Hobbima
is finishd" (for the full texts of these
letters see Kingzett 1982, 45–46). Why
Scott painted a copy of Littleton's
Hobbema, itself now in the Beit Collec-
tion (Russborough, Ireland), is uncer-
tain, but the references to both this and
the Rembrandt are of interest, for these
show how closely patterns of patronage
and connoisseurship interlocked.

F.R.

Provenance: Painted for Sir Edward
Littleton, 4th Bart. (d.1812); his great-
nephew Edward John Walhouse, sub-
sequently Littleton, 1st Baron Hather-
ton; and by descent to the 4th Baron
Hatherton, Christie's, 9 June 1944, lot
94, with lot 95 (no. 160) for 3,800 gns
by Farr for the Bank of England
Literature: Kingzett 1982, 44, D
Exhibitions: Manchester 1857 (7);
London, Agnew 1951 (8); London,
Guildhall 1955 (11); British Council
1957 (64); British Council 1960 (10);
London, Guildhall 1965 (20); British
Council 1966 (49); London, Guildhall
1969 (17); British Council 1970 (29);
London, Somerset House 1977 (25)

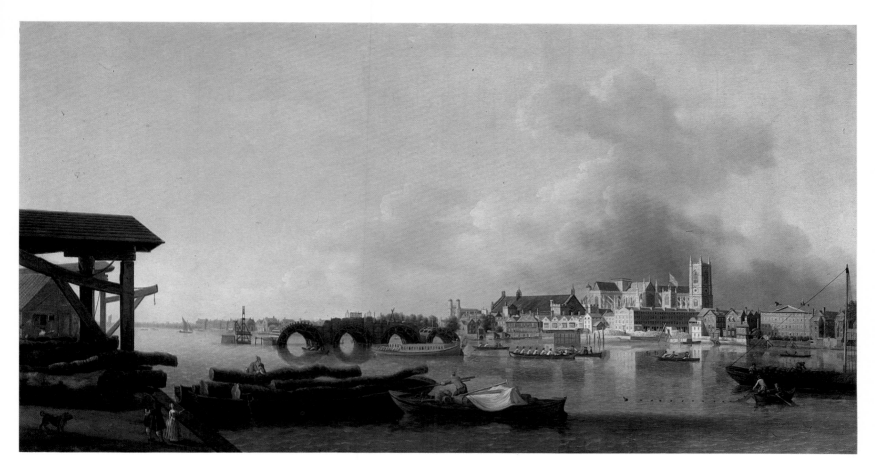

160

THE BUILDING OF WESTMINSTER
BRIDGE 1748–1749
Samuel Scott c. 1702–1772
oil on canvas
78.7 × 149.8 (31 × 59)

Formerly at Teddesley Hall
The Governor and Company of the
Bank of England

This view is from one of the timber
yards on the south (Surrey) bank of the
Thames. To the left, above Westmin-
ster Bridge, are the houses on Millbank
and the towers of Thomas Archer's
Saint John's, Smith Square; to the right
are the Palace of Westminster, West-
minster Hall, the Abbey, Manchester
Court, Dorset Court, and Derby Court.
There are a number of minor topo-
graphical inaccuracies and the position
of the northwest tower of Westminster
Abbey is distorted. Like the pendant
(no. 159) this picture was painted for

Sir Edward Littleton, 4th Bart., in
1750–1752.

The building of Westminster Bridge
had commenced in 1739 under the
supervision of the engineer Charles
Labelye. Here it is shown in the state it
had reached about May 1742, with the
two central arches turned, the timber
center for another in place, and a fourth
under construction. At the eastern end
James Vanloué's piledriving engine is
engaged in establishing the foundations
of the fifth arch (see Walker 1979).
This date for Scott's composition is con-
firmed by the unfinished houses south
of Bridge Street and in New Palace
Yard, and by the fact that only the
northern of Hawksmoor's two towers
of the west front of Westminster Abbey
is shown. (Work on the southern tower
began in 1739 but was not finished until
1744.) The barge drawing toward the
bridge, which bears the arms of the
Ironmongers' Company, is participating
in the rehearsal for the procession of

the Lord Mayor of London to West-
minster. In an annual ceremony each
November, the newly elected Lord
Mayor was conveyed by river barge to
be sworn in before the Barons of the
Exchequer in Westminster Hall. The
mayor's barge would follow that of the
livery company of which he was a
member. The Lord Mayor in 1741,
Robert Godschells belonged to the Iron-
mongers' Company. But his death in
June 1742 meant that the ceremony was
repeated on 29 June by his successor
George Heathcote. The latter was a
member of the Salters' Company, which
had no barge of its own, and therefore
borrowed the Ironmongers', so the art-
ist's original drawing could well have
been made on this occasion. Work on
the bridge proceeded rapidly, but in
1747 one pier began to sink and this
delayed its completion until 1750.
Scott's view was thus already out of
date at the time Littleton commissioned
the picture. F.R.

Related Works: Based on the drawing in
the South London Art Gallery, South-
wark (Kingzett 1982, no. D95), this is
the second of five pictures of the com-
position by Scott: the earliest of these,
dated 1747 and formerly in the Lothian
collection, is in the Metropolitan Mus-
eum, New York, and was originally the
pendant of the version of *Old London
Bridge* now owned by Lord Bearsted
Literature: Kingzett 1982, 56 (B)
Exhibitions: Manchester 1857 (6);
London, Agnew 1951 (9); London,
Guildhall 1955 (19); British Council
1957 (63); Liverpool 1958; British
Council 1960 (9); London, Guildhall
1965 (26); British Council 1966 (49);
British Council 1970 (28); London,
Somerset House 1977 (24); London,
South London Art Gallery 1978 (1)

161

SETTEE C.1735
design attributed to William Kent
1685–1748
gilt wood, upholstered in crimson
damask
109.2 × 152.4 × 81.9 (43 × 60 × 32¼)

Holkham Hall
Viscount Coke

The construction of the great Palladian house at Holkham begun in 1730 by Thomas Coke, 1st Earl of Leicester, took over thirty years, and the central block was still not roofed in 1749, the year after Kent's death. His influence, although clear in the overall design, is therefore strongest in the Family and Strangers' Wings, which were the first to be completed. This settee, with its accompanying set of four chairs, almost certainly originated in these private rooms and was probably part of the furnishing of Lady Leicester's dressing room, which Matthew Brettingham attributed to Kent in his *Plans and Elevations . . . of Holkham* (1761). Its design bears all the hallmarks of Kent's

style and is, even more than those in the Double Cube Room at Wilton (no. 162), a conscious tribute to his hero Inigo Jones. The twin cornucopiae that form the back rail, and the stiff garlands of fruit and flowers interspersed with shells below the seat, are typical of Jones' designs for Whitehall. This Bacchic theme of plenty is continued by the arms, carved in the shape of lions' or leopards' heads and resting on paw feet.

The lions' heads can also be found on the arms of a "pattern chair" supplied to Thomas Coke in 1737 by William Hallett, one of the best-known cabinetmakers of the day (Coleridge 1968, fig. 67). But another possible maker would be Benjamin Goodison of Long Acre, who supplied pieces designed by Kent for the royal palaces, and who was the principal cabinetmaker employed at Holkham from 1740 onward.

G.J-S.

Related Works: A very similar settee but with two pairs of cornucopiae on the back rail, is in the Victoria and Albert Museum (Wilson 1984, fig. 44)
Provenance: Commissioned by Thomas Coke, 1st Earl of Leicester (1697–1759); and by descent

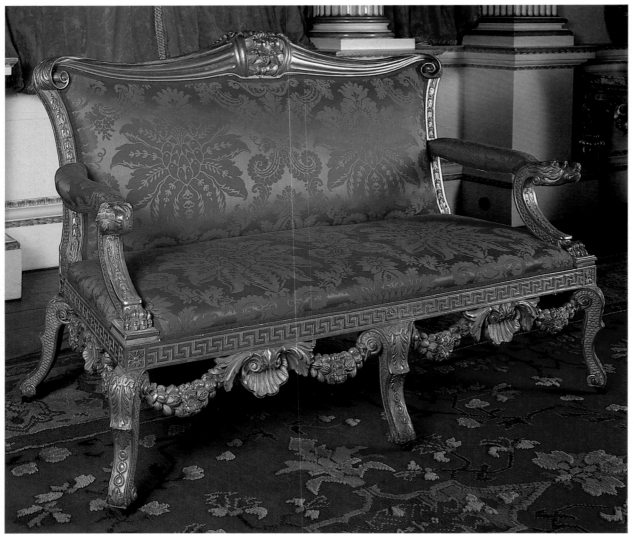

162

SETTEE C.1735–1740
design attributed to William Kent
1685–1748
gilt wood, upholstered in red velvet
110.4 × 148.5 × 68.5 (43½ × 58½ × 27)

Wilton House
The Earl of Pembroke and
Montgomery

Among the most celebrated, and most often reproduced, of all Kent's furniture designs, this settee from the Double Cube Room at Wilton is also one of the least well documented. Henry Herbert, 9th Earl of Pembroke (c. 1689–1750), who inherited Wilton in 1733, was an amateur architect of great distinction, praised by Horace Walpole as a purer Palladian than either Kent or Lord Burlington. His bridge at Wilton, built in 1736–1737, is an exact copy of a Pall-

adio design for the Rialto, and it was probably at about the same time that he commissioned six large settees for the Double Cube Room, the famous interior designed by Inigo Jones and John Webb for his ancestor, the 5th Earl, about 1652. These must have been intended to stand under the six Van Dyck full-lengths, with massive pier tables between the windows, their aprons carved with masks of Medusa and (probably) Andromeda, continuing the theme of the story of Perseus seen in Thomas de Critz' painted ceiling.

Lord Pembroke would undoubtedly have met Kent at Houghton, where he was a frequent visitor in the 1730s, designing Sir Robert Walpole's Water House in the park, and presenting him with the bronze *Borghese Gladiator*, placed on a plinth in the center of the main staircase. He also admired Kent's Shakespeare monument in Westminster Abbey to such an extent that he had a copy made for the hall at Wilton in 1743. For these reasons, as well as on stylistic grounds, the design of the furniture in the Double Cube Room can be confidently attributed to "Il Signior," as Kent's contemporaries affectionately called him. The sphinx supports with their tails turning into acanthus leaves are very similar to the supports of the great side table in the Saloon at Houghton, and the form of both seems to derive from an engraved tailpiece he made for Pope's 1725–1726 edition of Homer's *Odyssey* (Wilson 1984, fig. 32), perhaps a reminiscence of furniture he had seen during his time in Rome. However, there are also similarities with some of Inigo Jones' drawings, which Kent would have seen in Lord Burlington's collection, and it is more than likely that he conceived the settee at least in part as a conscious act of homage to the father of English Palladianism—in what was already considered one of his most celebrated shrines. The beautiful mask of Diana with the crescent moon in her hair and the exaggeratedly flattened scrolls of the arms and corners of the back are again unmistakably Kentian.

There is no mention of Kent's name in the surviving accounts at Wilton for the years 1733–1749 but he may well have been paid out of the earl's personal expenses, which are not recorded. James Pascall, the carver of an astonishing pair of rococo girandoles at Temple Newsam (Gilbert 1968, 844–848, fig. 5) received the large sum of £72.15.0 on 8 July 1737, and one "Hinchliff" was given £40 for forty yards of velvet in December 1739, while there are also payments to "Mr. Boson" (see no. 142) for a carved bedstead in January 1740. The cabinetmaker Elka Haddock and the upholsterer Samuel Jones of Saint Paul's Churchyard also received regular amounts during these years, but none of these can be singled out as the maker of the settee with any degree of certainty.

Between 1763 and 1773, the 10th Earl of Pembroke commissioned Thomas Chippendale to provide additional furniture at Wilton, probably including two much larger settees, eight feet long, some pier glasses, and a set of chairs and stools, all in a consciously Kentian style to suit the Double Cube Room (Coleridge 1968, 200). Thus the room today contains furniture and decoration of three different dates, all harmoniously designed to evoke the splendor of Italy in the seicento. G.J-S.

Related Works: Copies are to be found in many places, including a pair in the Ionic Temple at Rievaulx, Yorkshire (The National Trust)
Provenance: Though almost certainly commissioned by the 9th Earl of Pembroke, the six settees, "covered with crimson Genoa velvet," are first recorded in an inventory in 1827 divided between the Single and Double Cube Rooms at Wilton; and by descent
Literature: DEF 1954, 3:98, fig. 40

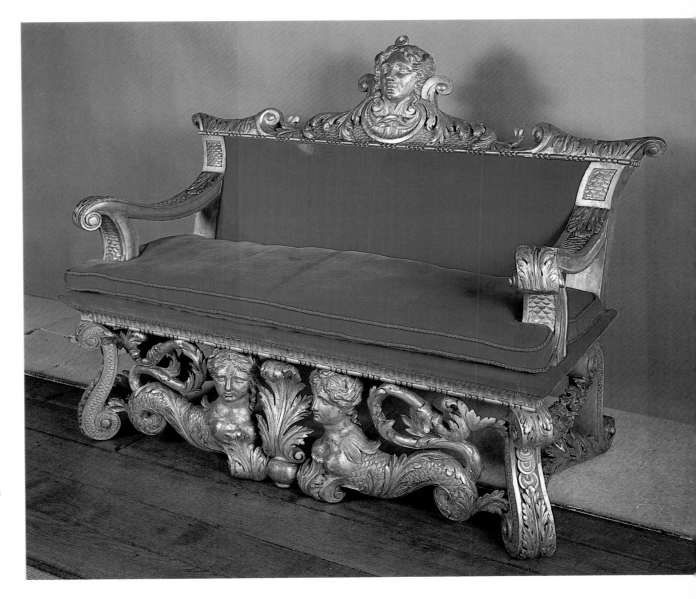

matched by financial prudence and the furniture in his London house was seized by creditors in 1746. Vertue states that Cholmondeley put prices on certain pictures and made his creditors take them at his valuation, which is confirmed by a letter of 1747 from Walpole to Mann (Lewis 1937–1983, 19: 405). Cholmondeley Castle itself, the Cheshire house remodeled by his uncle, the 1st Earl, in 1707–1715, was allowed to decay. The pictures saved from the debacle of 1746 or acquired subsequently were sold at Christie's 14–15 January 1777. The family fortunes only recovered when the son of the elder boy in the picture inherited Houghton and its Norfolk estate from his great uncle Horace Walpole, 4th Earl of Orford, in 1797. F.R.

Provenance: Painted for Viscount Malpas, subsequently 3rd Earl of Cholmondeley; and by descent
Literature: Paulson 1971, 2: 305
Exhibitions: London, Wembley 1925 (V.2); Vienna 1927 (28); London, RA 1934 (2360); Arts Council 1951 (30); London, RA 1954–1955 (32); London, Agnew 1959; London, Tate 1971–1972 (42)

163

THE CHOLMONDELEY FAMILY 1732
William Hogarth 1697–1764
oil on canvas
71 × 88.9 (28 × 35)
signed, *W. Hogarth Pinxt. 1732*

Houghton Hall
The Marquess of Cholmondeley

George Cholmondeley, Viscount Malpas (1702/1703–1770), who in 1733 succeeded as 3rd Earl of Cholmondeley, wears the riband of the Order of the Bath. He is seated by his wife Mary (1705–1731), daughter of Sir Robert Walpole, later 1st Earl of Orford, and she holds their youngest son, Frederick. Their elder son George, later Viscount Malpas (1724–1764), plays on the right with his brother Robert who balances precariously between a chair and a pile of books on a footstool, while Malpas' younger brother, James Cholmondeley, stands behind him.

The picture appears to have been commissioned in memory of Lady Malpas, who died of consumption in France on 2 January 1731. On 13 April of the following year Malpas learned that her body and possessions had been lost in a shipwreck (Paulson 1971, 2: 541, n. 6). The somewhat lifeless air of her portrait leaves little doubt that Hogarth copied an earlier likeness. Cholmondeley may himself have devised the rather unusual iconographic program with *putti* hovering above his wife. The library and picture gallery beyond certainly reflect the earl's interests. Like his contemporaries the 3rd Duke of Devonshire and the 1st Earl of Leicester, Cholmondeley was a serious connoisseur of old master drawings and, fortified no doubt by his father-in-law's example, he had also acquired a considerable collection of pictures for his house in Arlington Street, which was next door to Walpole's. Fougeroux noted in 1728 in the earl's ground floor apartment a *Venus* by Carletto Caliari, as well as a "jeune homme ceuillant des fruits" given to Caravaggio, a *Madonna* given to Leonardo, a Dughet (no. 313), and pictures by Claude, Giovanni Benedetto Castiglione, and Borgognone. Fougeroux also mentions "une jolie bibliothèque avec quelques bustes Antiques en Marbre" (1728, f. 83). Vertue in 1733 gives an amplified account (1930–1955, 4: 108–109). It therefore seems possible that Hogarth may have recorded elements of the decoration of the Arlington Street house in this picture.

Alas, Cholmondeley's taste was not

164

CONVERSATION PIECE WITH LORD HERVEY c. 1737
William Hogarth 1697–1764
oil on canvas
101.6 × 127 (40 × 50)
signed, *W. Hogarth*

Ickworth
The National Trust (Bristol Collection)

In the center of this group is Lord Hervey, who appears to be regarding a plan and elevation offered to him by Henry Fox, later 1st Lord Holland. Stephen Fox, who would become Earl of Ilchester in 1756, is seated at the left, his walking stick poised to overturn the chair on which a parson stands, gazing intently through a telescope at a church on a hill. At the right are the 3rd Duke of Marlborough and Thomas Winnington.

The central figure, John, Lord Hervey (1696–1743), was the younger son of the 1st Earl of Bristol. He married Mary Lepel, maid of honor to Queen Caroline, and their sons became successively the 2nd, 3rd (see no. 483), and 4th (see no. 196) Earls of Bristol. His activities at court as Vice Chamberlain of the King's Household and later Keeper of the Privy Seal provided the opportunity for his famous *Memoirs* and culminated in a moving account of the death of the queen. Sensitive—to judge by this section of his memoirs—Lord Hervey was capricious and waspish in the eyes of his contemporaries, and in the bitter pamphlet warfare that he carried on with Pope he was lampooned as Sporus in the latter's *Epistle to Arbuthnot*.

The sitters, with the exception of the parson who is generally thought to be Peter Wilman (or Willemin), were all leading members of the Whig party and intimates of Lord Hervey. Their combined presence is therefore understandable. What is less than clear is the explanation of the two incidents treated in the picture, the apparent rejection by Hervey of the plan that Henry Fox holds up for his inspection, and the predicament of Wilman. The fact that Fox's appointment as Surveyor of the King's Works in 1737 was owed to Hervey's influence may be significant in this context; and the tradition that the parson, whose immersion is imminent, is gazing upon the church of "Issy," a preferment in Stephen Fox's gift of which Wilman was to become incumbent in 1737, may be relevant even though it cannot be borne out by any resemblance between the church in the picture and the real church of Eisey (which was demolished in 1953). If, however, Hogarth intended to depict an actual locality, it is perhaps the garden of Water Eaton, a house near Eisey owned at that time by the Fox family. The composition has been referred to as "The Holland House Group"—anachronistically, for Lord Holland did not acquire Holland House until 1767.

Paulson suggests the autumn of 1738 as the date for this picture. This was the year in which the Duke of Marlborough's royal appointment as Lord of the Bedchamber made him a colleague of Hervey. The supposition that this

figure is not Marlborough but the 2nd Duke of Richmond is based on the fact that in a near contemporary copy of the exhibited picture (Ilchester Collection, Melbury) the sitter is shown wearing the Order of the Garter, an honor not accorded to Marlborough until 1741. However, when Horace Walpole saw the Melbury picture in 1762 he was certain that it was the Duke of Marlborough who was represented.

The collection at Ickworth is referred to under no. 196. Lord Hervey's activity as a buyer of pictures (he owned some seventy-five Dutch pictures) is all but forgotten and the only evidence of it in the house today lies in certain portraits and in a landscape by Gaspard Poussin. It is, however, by this *Conversation Piece* that he is most vividly recalled in pictorial terms.

Hogarth's assemblage of figures surpasses the usual limitations of a conversation piece in that it is an

evocation of life (or of theatricality considering the plight of the church dignitary) rather than a posed record. It can be criticized, like other early works by the artist, for a lack of cohesion in its composition. But compared with the puppetry of a Devis or the bland likenesses of most of his British contemporaries it possesses a wit and precision of handling of which Hogarth alone was capable. ST.J.G.

Provenance: By descent to the 4th Marquess of Bristol and accepted by the Treasury in lieu of death duties in 1956 together with Ickworth and most of its contents, and transferred to the National Trust
Literature: Beckett 1949, 44, pl. 95; Antal 1962, 34, 223, n. 97, pl. 73b; Paulson 1971, 7, 458, pl. 177
Exhibitions: London, Tate 1971 (98); Budapest 1972 (24); Brussels 1973 (27)

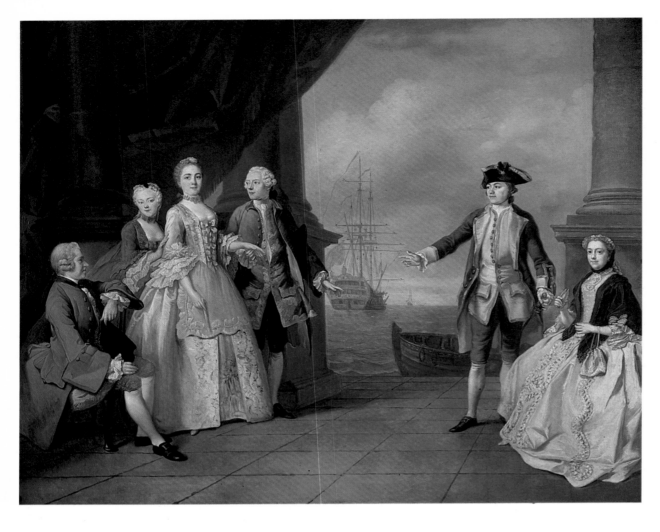

165

AUGUSTUS HERVEY TAKING LEAVE OF
HIS FAMILY 1750
Hubert Gravelot 1699–1773 and others
oil on canvas
99.1 × 124.5 (39 × 49)

Ickworth
The National Trust (Bristol Collection)

Augustus Hervey (who was to succeed
his brother as 3rd Earl of Bristol in
1775 and in turn to be succeeded by his
younger brother, the eccentric and cele-
brated Earl-Bishop of Bristol) wears the
undress uniform of a naval captain
(regulation naval uniform was first
introduced in 1748). He stands at the
right beside his mother, Lady Hervey,
wife of the memorialist John, Lord Her-
vey, and better known by her maiden
name of Molly Lepel; in the group at
the left her daughter Lepel, wife of Con-
stantine Phipps, 1st Lord Mulgrave
(who is seated at the extreme left),
stands between Mary Hervey and her
husband, George Fitzgerald. Although
traditionally called a "farewell," the
attitudes adopted by the sitters are
enigmatic, and the real subject of the
composition is obscure—whether the
presentation of the doll-like Lady Mul-
grave to her mother, or Augustus Her-
vey showing his new command to his
family. The ship in the background is
likely to be the seventy-four-gun *Prin-*

cesa, a Spanish prize taken in 1740 and
Hervey's first post ship (Erskine 1953,
96).

The attribution of the painting also
presents problems: the composition
lacks cohesion in design and harmony
in color which, when considered together
with the different techniques employed,
points to the involvement of more than
one artist. It had always been attributed
to Zoffany until Staring rediscovered
an undated letter from Gravelot to Lady
Hervey that had been published by the
Goncourts (1906, 2:278–281). This
letter had been written by the artist in
answer to criticisms of his picture,
which he alleged had been made by
Lady Hervey in Mme. Geoffrin's salon,
and included the information that
"M. Liotard devoit peindre les six têtes
à dix louis chacune. Je fis marché avec
vous à trente pour trouver la disposition
du tableau et le finir."

Although Gravelot, who was
engaged to paint the figures of George
Fitzgerald and his wife, made it plain

that portraiture was not his forte, he
also painted Lady Hervey's head "qu'à
la vérité je me comptois pas finir, et j'ai
disposé le tableau." He sent the painting
to her unfinished, at her own request,
but at the time of writing Gravelot had
received nothing in payment. The delay
was partly due to the fact that Augustus
Hervey had failed to return, as he had
promised, with his uniform and with an
exact design for the ship (which Gravelot
had laid in). The artist employed an
assistant: "Si j'ai remis le tableau à
quelqu'un pour l'avancer c'a été dans
l'envie de remplir mes engagements, et
après que M. Boucher m'a assuré que je
m'addressois bien."

According to Staring the only portrait
heads connected with Zoffany are those
of Lord Mulgrave and Augustus Hervey,
and these, with Lady Mulgrave, may
have been done from portraits by Liotard;
possibly Zoffany, Staring adds, finished
the picture and somebody like Dominic
Serres painted the sea and ship.

Further examination of the techniques
employed seems to reveal that the figures
of Mr. and Mrs. Fitzgerald, painted in a
rather facile, Watteau-like technique, are
distinct from any other feature of the
picture. This, together with Gravelot's
testimony, indicates that they surely
must be his work. The head of Lady
Hervey, although Gravelot mentions
that she gave him two sittings, is
unrelated to the Fitzgerald heads and
seems to be by the same artist who
painted Augustus Hervey. Both figures
are distinguished by being laid in in
gray. It is possible, but not certain,
that the same artist was responsible for
the figures of Lord and Lady Mulgrave
(Lord Mulgrave, seated on an English
chair, is the only character to recall
something of the style of Liotard). Who
then was the English artist responsible
for the other figures? Mr. Horace Buttery,
who cleaned the picture in 1958 suggested
that it was Hayman, an opinion with
which this writer concurs and which is
supported by the qualified authentication
of Waterhouse (1981, 148). Accessories
were presumably the work of Gravelot's
anonymous assistant. Staring's assump-
tion that Serres could have painted the
ship is not impossible, given the fact
that Augustus Hervey was later to
employ him as a recorder of his naval
exploits.

The date of the picture, according to
Staring, is probably late in 1750. All
the sitters were in Paris at that time.
The 1st Earl of Bristol (father-in-law of
Lady Hervey) died on 20 January 1751,

and this may be one reason why the picture was left unfinished in Paris and why Augustus Hervey failed to return. Whereas the proportions of the composition recall Hogarth's group of Lord Hervey and his friends (no. 164), it is improbable that the Hogarth ever came into Lady Hervey's possession and the likelihood of her commissioning a pendant to it is therefore remote.

ST.J.G.

Provenance: Always in the possession of the family until Ickworth and its contents were transferred through the Treasury to the National Trust in 1956 following the death of the 4th Marquess of Bristol
Literature: Staring 1932; Edwards 1961, 8–10
Exhibitions: Arts Council 1960(6); Brussels 1973(21)

166

VISCOUNT TYRCONNEL WITH HIS
FAMILY c.1725–1726
Philippe Mercier 1689–1760
oil on canvas
64.8 ×75.6 (25½ × 29¾)
signed, *Ph. Mercier Pinxit*

Belton House
The National Trust
(Brownlow Collection)

The artist has portrayed himself sketching a group of figures traditionally identified as: at the left, Viscount Tyrconnel; on the swing, Miss Dayrell; seated behind her, Lady Tyrconnel, and next to her William Brownlow; pulling the cord attached to the swing, Savile Cockayne Cust, and at the right, Mr Dayrell, father of the girl on the swing (Cust 1909, 191–192). In the background is Belton in Lincolnshire, the house built for Sir John Brownlow, 3rd Bart., between 1685 and 1688. Probably designed by William Winde, it is a building that may be said to epitomize the "double-pile" country house in the late seventeenth century.

Sir John Brownlow, 5th Bart. (1690–1754), son of Sir William, 4th Bart., was created Viscount Tyrconnel and Baron Charleville in the peerage of Ireland in 1718. In 1712 he married his first wife, a cousin, Eleanor Brownlow, who is seen with him in this portrait. William Brownlow, who also appears, was his brother. His sister Anne, the eventual heiress of Belton and the

Brownlow estates, had married Sir Richard Cust, 2nd Bart., whose step-brother was the Savile Cockayne Cust supposedly represented here. Francis Dayrell, of Shudy Camps, Cambridge-shire, married Elizabeth (née Sherard), niece by marriage of Sir John Brownlow, 3rd Bart. No particular event occurred to bring their families together at the time this picture was painted, and it seems strange that Dayrell's daughter, traditionally said to be the girl on the swing, should be the focal point of the composition. She was later to cause a family scandal by eloping with a Mr. Crop of Surrey in 1751.

Two factors combine to date the portrait between 1725 and 1726. The Order of the Bath worn by Lord Tyrconnel was conferred on him in May 1725; and the death of William Brownlow (always assuming that the sitter is correctly identified) occurred in July 1726. This would place the picture with the earliest of such portrait groups to be painted in England.

Mercier was a prominent figure among a number of French painters and engravers who came to England in the years of peace that followed the War of the Spanish Succession. The new current of French taste was to leave its impression on English art, and in combining por-traiture with the *fête champêtre* type of composition of Watteau, Mercier became responsible for the introduction of the conversation piece into England. Figures, no longer pastoral and anony-mous, were engaged in modish pursuits and, conveying a Gallic elegance, became the models for the English rococo. Mercier benefited socially from his relationship with Frederick, Prince of Wales (the son of George II), whose official painter he became in 1729, and the commission for the Belton family group was no doubt due to the friend-ship that existed between the Prince and Lord Tyrconnel.

If Lord Tyrconnel's professional activities as a politician were scarcely remembered beyond his own lifetime, we know him today as the first member of the family to be recognized as a collector. At his death in 1754 some eighty pictures that he had acquired are recorded, including Italian and Dutch works as well as family portraits. A number of these still survive at Belton. (see Russell 1984).

ST.J.G.

Provenance: By descent to the present Earl Brownlow; acquired by the National Trust, 1983
Literature: Ingamells and Raines 1976–1978, 17, no.16
Exhibitions: London, RA 1954–1955 (443); London, V & A 1984 (C2)

6: Souvenirs of Italy

For the owner of a country house, the Grand Tour was the indispensable climax of his education, the sequel to Eton or Westminster, Oxford or Cambridge, in which his classical education would be completed by the experience of Italy. Grand Tour patronage had many manifestations, and topography and portraiture are particularly explored here, together with Italian and English rococo furniture.

The development of Italian topographical painting in the eighteenth century was dominated by foreign visitors' demands for visual records that were also works of art. No painter was more proficient at supplying these than Canaletto who came to depend substantially on orders submitted through the English Consul in Venice, Joseph Smith: no less than twenty-two Venetian views (now grouped together in the dining room at Woburn) were supplied for Bedford House (see nos. 169 and 170) and smaller sets were acquired for many other collections. Despite his gifts, Canaletto's nephew Bellotto was not to be patronized by the English to the same extent, and Guardi also would be largely overlooked.

Early in the century, the visitor to Rome could call on the services of Vanvitelli or Busiri as *vedutisto*. By the 1730s Panini—whose classical *capricci* complemented collections of antiquities in the hands of patrons such as Lord Carlisle—built up a considerable English clientele. Vernet, whose father-in-law Mark Parker dealt in pictures, was clearly aware of the potential of British patronage, supplying modern counterparts to the seaports of Claude and Tempesta's coastal scenes. Some milords had particular requirements—thus Lord Brudenell ordered views of southern Italy from Jolli (no. 175)—while others retained traveling draftsmen. Later in the century the discoveries at Pompeii and Herculaneum drew more visitors to Naples and the tourists acquired local views by both Italian and Northern artists, including Hackert.

The handful of portraits painted by Maratta was the harbinger of a rich harvest. From about 1710 Rosalba Carriera rendered many visitors to Venice in her exquisite pastels. In Rome, Trevisani, David, and Masucci portrayed occasional tourists, paving the way for Batoni who over forty years painted some two hundred British sitters. Batoni's masterpiece of 1758, the portrait of *Lord Brudenell* (no. 173), makes a revealing contrast with the picture of the same sitter by his rival Mengs (no. 174), while the kilted *General Gordon* (no. 176), the most spectacular of his full-lengths, shows how effectively portraiture could evoke the spirit of the Grand Tour. Many of Batoni's early sitters were satirized in Rome by the young Reynolds, whose caricature groups influenced those Patch would paint of the transient English colony at Florence. Naples also was a center for portraiture. Solimena painted several visitors, as did Angelica Kauffmann in the 1760s: but the most compelling work of the kind is that of the Earl Bishop of Bristol by Madame Vigée le Brun (no. 196), an early refugee from Revolutionary France, the conquests of which would disrupt the pattern of the Grand Tour itself.

The consignments of pictures and sculpture, coins and cameos shipped from Livorno, or Leghorn, as the English called it, also contained furniture, textiles, and ceramics, marble pedestals and *scagliola* table tops, cut-velvets and damasks from Genoa (like those that survive at Holkham and Houghton), *pietra-dura* caskets from Florence, *Lattimo* glass plates decorated with views of Venice, or Doccia dinner services. Much English rococo furniture of the period shows an awareness of Italian forms, most notably the famous Linnell settees in the drawing room at Kedleston (no. 194) whose sinuous merfolk recall the writhing chairs and candlestands of the Venetian carver, Andrea Brustolon. But French influence too can be seen in the *bombé* commodes of Pierre Langlois and John Cobb, with their floral marquetry in the Louis XV style, and in tapestry-covered chairs by Paul Saunders and William Bradshaw, imitating the designs of Beauvais.

167

THE DOGE'S PALACE AND RIVA DEGLI
SCHIAVONI, VENICE 1730
Antonio Canale, Il Canaletto
1697–1768
oil on canvas
58.4 × 101.6 (23 × 40)
marked C in bottom left corner

Tatton Park
The National Trust (Egerton
Collection)

This view looks eastward along the
Riva degli Schiavoni. The column of
Saint Mark is at the left and the Ponte
della Paglia is visible between the
Doge's Palace and the prisons. It extends
along the high, uncompleted façade of
the church of the Pietà and beyond that
are the dome and campanile of San Pietro
di Castello. The huddle of small wood
and plaster buildings beyond the prisons

has an interesting history. After the
murder of Doge Vitale Michiel in 1172
it was decreed that the assassin's house
on the Riva should be razed to the
ground and that no stone building should
ever be constructed on the site. "Only
in 1948," writes John Julius Norwich
(1977), "were the authorities at last
persuaded to set the old tradition aside;
and even now, as we glance up at the
façade of the Danieli Royal Excelsior
Hotel, some of us may wonder whether,
in a slightly different and even more
disagreeable form, the old curse does
not linger still over the spot where Vitale
Michiel met his death eight centuries
ago."

Like no. 168, its companion, this
picture came to Tatton as the result of
a commission negotiated by Joseph
Smith for his friend Samuel Hill
(Chaloner 1950, 164). St.J.G.

Related Works: In Constable's catalogue
of the works of Canaletto, the Tatton
painting is regarded as the prime orig-
inal. In the revised edition by Links a
new version of the subject is listed,
formerly in the collection of the Earls
of Jersey and now privately owned,
"painted at about the same time . . .
but of higher quality in the treatment
of figures and architecture." Despite the
severity of a past relining, there is a
true brilliance of handling in the Tatton
view. A drawing in the Royal Collection
at Windsor may be a preparatory study
although the viewpoint is slightly
different. A similar drawing at Darm-
stadt, which omits the temporary hut
constructed adjacent to the Ponte della
Paglia and seen in both the Windsor
drawing and in the present picture, is
dated March 1729. A good studio ver-
sion of the painting is in the National
Gallery, London. Parker (1948, no. 9,

pl. 7) notes the unusual feature in all
these views of the lion column appearing
at the left of the corner angle of the
Doge's Palace, instead of at the right
where it appears in most compositions
Provenance: By descent from Samuel
Hill, who commissioned the picture, to
his nephew Samuel Egerton; thereafter
at Tatton, until its bequest to the
National Trust by the 4th Lord
Egerton, 1958
Literature: Constable and Links 1976,
no. 111
Exhibitions: Manchester 1960 (133);
Hull 1967

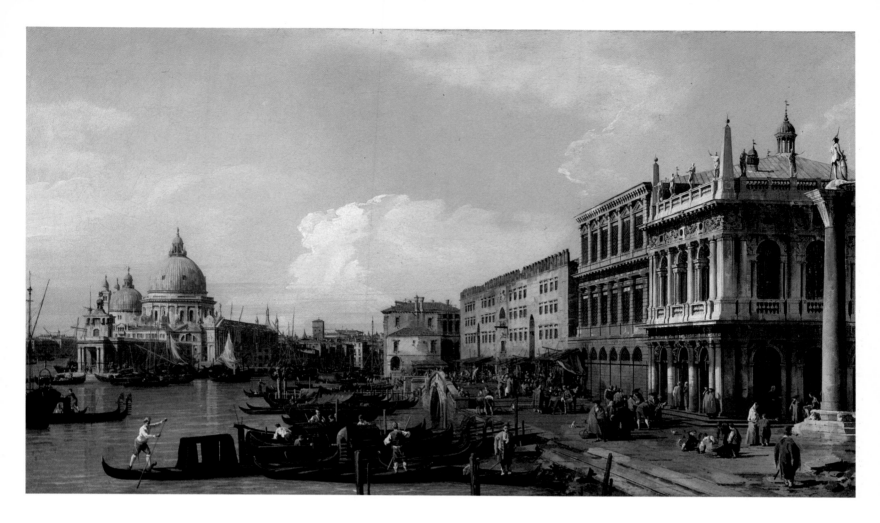

168

THE GRAND CANAL FROM THE
PIAZZETTA, VENICE 1730
Antonio Canale, Il Canaletto
1697–1768
oil on canvas
58.4 × 101.6 (23 × 40)
marked *C* in bottom left corner

Tatton Park
The National Trust (Egerton
Collection)

On the left is Santa Maria della Salute;
on the right the column of Saint
Theodore and next to it, the Libreria,
Zecca, and the Granai (State Granary),
which was demolished in Napoleonic
times and is today the site of the Giardi-
netto Reale. The low building beyond
is the restored Magistrato della Farina,
which now serves as the Capitaneria di
Porto. The rectangular tower in the
distance, which no longer exists, was
once a feature of Palazzo Venier della
Torresella.

This picture and no. 167 are those
referred to by Joseph Smith, later the
English Consul in Venice, and Samuel
Egerton (see no. 177) in letters written
to Samuel Hill, Egerton's uncle and
guardian who was responsible for instal-
ling him as apprentice to Smith in 1729.
Persistence was evidently required when
dealing with Canaletto: Smith wrote to

Samuel Hill, 17 July 1730, "At last I've
got Canal under articles to finish your
2 pieces within a twelvemonth"; and
Samuel Egerton to Samuel Hill, 15 Dec-
ember 1730, "(Smith) has att last pre-
vailed with Canal to lay aside all other
business till he had finished the 2 pic-
tures you order'd when you were last
here."

The commissioning of a work this
early in Canaletto's career is far from
commonplace. It anticipates the time
when Canaletto came almost to sym-
bolize the close relationship that had
for long existed between English trav-
elers and Venice—so that to have
acquired a view by Canaletto as a result
of an Italian trip was as fashionable as it
was to have commissioned a portrait
from Batoni. Neither studio assistance
in much of his production nor the later
disdain of Ruskin can disguise the fact

that Canaletto, in his autograph pic-
tures, captured the enchantment of the
city of Venice and transformed a detailed
view into a work of art.

For a note on the Tatton collection,
see Nazzari's portrait of Samuel Egerton
(no. 177), who played a role in the
acquisition of this painting and its
companion for his uncle ST.J.G.

Related Works : A preparatory drawing
showing part of the composition—the
Salute is omitted—is in the Royal
Collection at Windsor. For this and two
other drawings, one in the Pennsylvania
Academy of the Fine Arts, Philadephia,
and the other, dated 1729, in the De
Burlet collection
Provenance: See no. 167
Literature: Constable and Links 1976,
no. 197

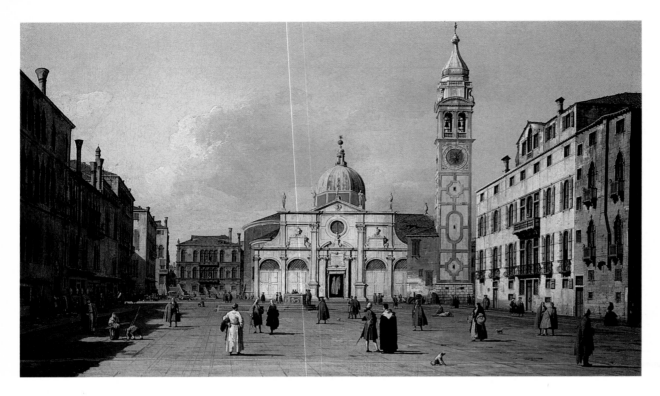

later term the "Venetian constitution," established in Britain by the "Glorious Revolution" of 1688. Thus Bedford's son Lord Tavistock wrote teasingly in 1763 to his friend the Earl of Upper Ossory, who also belonged to a committed Whig family, telling him what to do in Italy, "I had forgot to desire you to study a little the constitution of the republic of Venice, in order to inspire you to a proper dread of aristocracy; I am sure it is very useful for an Englishman" (Wiffen 1833, 2: 541).

F.R.

Related Works: Many of the Woburn pictures are similar to views by Canaletto engraved by Visentini: in no case is the correspondence absolute and the print of this subject differs in a number of respects (Constable and Links 1976, E, nos. III, VIII). Studies for the composition are at Windsor (Constable and Links 1976, nos. 604–605) and a series of related diagrammatic sketches are in a sketchbook in the Accademia, Venice (Constable and Links 1976, C, no. XVIII, f. 36v, 37r, and v, 38r and 39r). Versions of this picture are in the possession of the Earl of Cadogan and in an Italian private collection (Constable and Links 1976, nos. 279–280): the latter, and a pendant of the Scuola di San Rocco may correspond with a pair formerly in the collection of William Beckford at Fonthill

Literature: Woburn 1868, no. 354; Scharf 1877, 1889, and 1890, no. 346; Constable and Links 1976, no. 278

Exhibitions: Arts Council 1950b (14, 10); Arts Council 1950 (15, 11); Paris 1960 (239); Venice 1967 (57, 60)

169

CAMPO SANTA MARIA FORMOSA, VENICE after 1732
Antonio Canale, Il Canaletto 1697–1768
oil on canvas
46.9 × 80 (18½ × 31½)

Woburn Abbey
The Marquess of Tavistock and the Trustees of the Bedford Estates

The Campo is seen from the north, with the church and campanile of Santa Maria Formosa, and to the left Palazzo Malipiero-Trevisani: in the shadow on the left are Palazzo Donà and Palazzo Vitturi.

This and the view of the Scuola di San Rocco (no. 170) are from the celebrated series of twenty-four Venetian views acquired by John Russell, 4th Duke of Bedford (1710–1771). As Lord John Russell, he visited Venice on the Grand Tour before his marriage in 1731 and it is generally assumed that the pictures were commissioned at this time, possibly through Consul Smith. It is, however, highly unlikely that, as a younger son, he would have been in a position to place an order of such magni-

tude until after he succeeded his brother in October 1732. The duke was certainly in correspondence with Consul Smith, the likely intermediary for the commission, in 1734, but the pictures are not otherwise documented, although a drawing of July 1732 connected with the *Piazzetta, looking North* from the series is inscribed "per inghiltera" (Constable and Links 1976, no. 551). Two of the canvases are of larger format and of these *The Regatta on the Grand Canal* (Constable and Links 1976, no. 348) is datable after 1735 as the arms and colors of Doge Alvise Pisani who succeeded in that year (d. 1741) are introduced (Levey 1953, 356). The date of 1730–1731 often advanced for the series must thus be too early. Although only Consul Smith and the still unidentified original owner of the set of twenty-one Venetian views (formerly in the Hervey collection at Langley Park) patronized Canaletto on a comparable scale in Venice, it is interesting to note that Bedford was not one of the former clients who employed the painter in England.

The pictures were originally kept not at Woburn, but in Bedford House on the family's great Bloomsbury estate,

where they hung in the large dining room and the adjoining small eating room, until the house was demolished in 1800. They were then transferred to the "new eating room" in Flitcroft's southwest tower at Woburn, the former library designed by Sir William Chambers, which had been remodeled by Henry Holland. This would be alternatively known as the Drawing Room (Dodd 1818, 56–57), the Venetian Drawing Room (Parry 1831, 38–39, and Woburn 1850, 156–157) and the Canaletti Room. (For Holland's scheme for the room see Stroud 1966, 110.) Dr. Waagen apparently did not realize that the pictures had been moved, as he commented that they were painted "expressly" for the room at Woburn; he considered the two large works of "extraordinary beauty" (Waagen 1838, 3:343).

That the duke wished to have a series of views of a city with so many memorable sites and buildings is not surprising. Nonetheless it is tempting to suppose that the predilection of the great Whig families for works of the kind was influenced, consciously or not, by their commitment to what Disraeli would

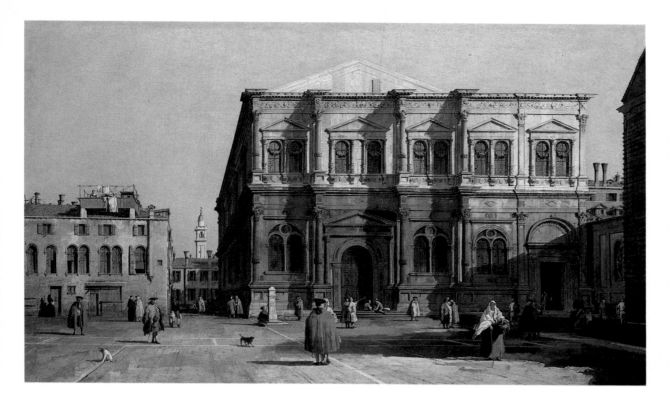

170

THE SCUOLA DI SAN ROCCO, VENICE
after 1732
Antonio Canale, Il Canaletto 1697–1768
oil on canvas
47 × 80.3 (18½ × 31½)

Woburn Abbey
The Marquess of Tavistock and the
Trustees of the Bedford Estates

The Scuola is seen from the north, with
the façade of the church of San Rocco
on the right. In the distance to the left
of the Scuola is the campanile of San
Pantaleone.

Like the view of Campo Santa Maria
Formosa (no. 169), this belongs to the
series of views of Venice painted for
John, 4th Duke of Bedford, and is
considered in the entry for that picture.
This view is related to the one engraved
by Visentini but the viewpoint of the
print is higher and taken from further
to the left, while the figures are different.

F.R.

Related Works: An autograph version
corresponding more closely with
Visentini's engraving except in the
treatment of the façade of the church is
in an Italian private collection
(Constable and Links 1976, no. 328)
Literature etc.: See no. 169

171

AN ALLEGORICAL TOMB IN HONOR
OF JOHN, LORD SOMERS c.1726
Antonio Canale, Il Canaletto 1697–1768
Giovanni Battista Cimaroli fl.1718–1733
Giovanni Battista Piazzetta 1683–1754
oil on canvas
279.4 × 142.2 (108 × 71½)

Private Collection

John, 1st Lord Somers (1650–1716) was
called to the Bar in 1676 and was an
eloquent champion of the Whig cause
during the Trial of the Seven Bishops
in 1688. William III appointed him in
succession, Solicitor General, Attorney
General, and in 1697, Lord Chancellor,
an office he resigned in 1700. He was
a member of the Kit-Cat Club and a
collector on a considerable scale (see
no. 314). A portrait of him by Lely and
two by Kneller are at Eastnor Castle.

The figures of Justice and Peace that
surmount the tomb, and the robes,
mace, woolsack, and purse in the
foreground allude to Somers' Lord
Chancellorship, while the sword is that
of the Sergeant-at-Arms. In a letter of
8 March 1726 the painting is described:

"That of Ld Sommers is a sacrifice or
Religious Ceremony (at his monument)
in Acknowledgment of the service done
the Church for his pleading the cause of
the Bishops etc" (Goodwood MSS,
West Sussex Record Office, Chichester).

This is one of a series of pictures of
allegorical tombs made to commemorate
champions of the Protestant cause and
architects of the Whig Settlement.
These "Monuments to the Remembrance
of a Set of British Worthies" were
commissioned in Italy by Owen
MacSwinny (c. 1684–1754), an Irish
entrépreneur who had left England as a
result of his bankruptcy in 1713 and
went to live with Consul Smith in Venice
in 1720. Conceived as a speculation, the
project involved at least sixteen painters,
all Venetian or Bolognese. Some, like
Balestra, Creti, and the Riccis were
already well known, but others were of
the new generation, including not only
Canaletto himself but Piazzetta and
Pittoni, neither of whom would be
seriously taken up by English patrons.
Of the twenty-four allegories executed,
ten were sold to the 2nd Duke of
Richmond whose father-in-law, the 1st
Earl of Cadogan, was included in the
series. They hung in the dining room at
Goodwood but were removed when
this was redecorated at the end of the
century, and were finally sold at
Christie's, 26 March 1814, lots 46–51,
for a total of £91 8s. 6d. Although this
picture was never at Goodwood, it is
mentioned in MacSwinny's letter to the
duke of 8 March 1726: "The perspective
and landscape are painted by Canaletto
& Cimeroli The figures by Geo: Battista
Piacotta" (Goodwood MSS, West Sussex
Record Office, Chichester).

MacSwinny issued a pamphlet about
the series and commissioned a set of
engravings to complement it. This was
discontinued, however, after eight of
the compositions had been engraved,
presumably because MacSwinny had
succeeded in selling the rest of the series
to Sir William Morice, a connoisseur
about whom surprisingly little is known.
Morice was expected by Consul Smith
at Venice in July 1730 (Chaloner 1950,
162), when he also sat for Rosalba
Carriera, who like Canaletto had a close
connection with Smith: her pastel
portrait of him is now at Pencarrow. By

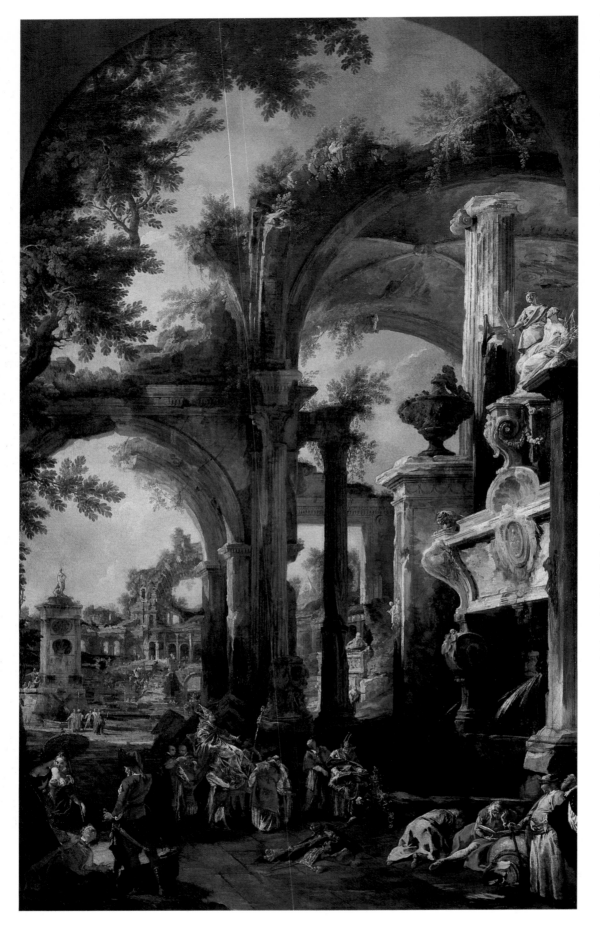

what may be more than a coincidence the Duke of Richmond rented Sir William Morice's London house in 1733 while Richmond House was being rebuilt (March 1911, 1:241).

The figures in this picture are clearly by Piazzetta whose study for the man with a staff on the extreme right is in the collection of Janos Scholz, New York (Mariuz and Palluchini 1982, no. 32B). As Watson argues, the role of Cimaroli was limited, and Canaletto's was the dominant contribution. Canaletto was also employed on the slightly later *Allegorical Tomb of Archbishop Tillotson* (private collection, Constable and Links 1976, no. 517), which was acquired by the duke and is also mentioned in MacSwinny's letter of 8 March 1726. These are the earliest pictures in which Canaletto can be shown to have worked for a British client. His technique in both is characterized by a freedom that would be lost in so many of his later topographical paintings. F.R.

Related works: A monochrome oil sketch formerly at Harewood was sold at Christie's, 2 July 1965, lot 103. This was evidently intended to be engraved in connection with MacSwinny's pamphlet promoting the pictures
Provenance: Painted for Owen MacSwinny, from whom probably acquired by Sir William Morice 3rd and last Bart. of Werrington in Devon, in or soon after 1730; purchased by the 14th Baron Windsor, later 1st Earl of Plymouth, c. 1880, and by descent at Hewell Grange (see no. 556) until 1946
Literature: Watson 1953, 362–365; Croft-Murray 1970, 241; Constable and Links 1976, 516; Mariuz and Palluchini 1982, no. 32
Exhibitions: Birmingham 1953 (165); London, RA 1955–1956 (129)

172

CONSOLE TABLE 1754–1755
English, with a Florentine scagliola top
by Petro Belloni
painted and gilt wood frame
top signed, *D.Pet.° Belloni/Vallumbros.ᵃ*
A. Florent.ᵃ F./A.D. 1754
83 × 170 × 87 (32½ × 67 × 34½)

Uppark
The National Trust
(Meade-Fetherstonhaugh Collection)

This is one of a pair of rococo tables,
with scagliola tops ordered by Sir
Matthew Fetherstonhaugh of Uppark
in Sussex when he was in Italy on the
Grand Tour between 1750 and 1752.
Entries in his account books suggest
that they were sent back to England in
1755 through the agency of Joseph
Smith, the English Consul in Venice
(see nos. 167 and 168).

Don Petro Belloni was a monk at
the monastery of Vallombrosa near
Florence, and an assistant to the abbot,
Don Enrico Hugford—born in Italy in
1697, but thought to be of Irish descent.
Hugford had previously been a monk at
Marradi where the selenite essential for
the working of scagliola was quarried,
and it was he who, more than any other,
advanced the art from "being merely a
cheap and easily worked substitute for
marble and mosaic to a medium of such
refinement that landscapes and figures
could be depicted in it" (Fleming 1955,
106–110). His brother Ignazio acted as
an art dealer and cicerone to traveling
English milords, and may well have
earned commissions both for the abbot
(examples of whose work survive at
Penshurst Place) and for his assistant
Belloni. It is significant that the three
known commissions for Don Petro's
table tops came from travelers who were
in Rome together between 1750 and
1752: Sir Matthew Fetherstonhaugh and
Joseph Leeson of Russborough (both of
whom appear in Reynolds' caricature
School of Athens in the National Gallery,
Dublin), and Leeson's Irish neighbor
Ralph Howard of Shelton Abbey,
County Wicklow (Coleridge 1966,
184–187). The three are further linked
by their patronage of Pompeo Batoni
and Claude-Joseph Vernet (see no. 200).
In a letter to Horace Walpole from

Florence dated 5 June 1747, Sir Horace Mann reveals that Leeson had already been waiting three years for his scagliola (Lewis 1955, 414)—and he was to wait another three, since the one slab that survives in the Beit Collection at Russborough is dated 1750. Sir Matthew was evidently slightly luckier in having to wait only three or four years.

Belloni's table tops are all similar in design, with a central landscape panel derived from engravings after Visentini, Locatelli, or Salvator Rosa, within an elaborate cartouche. The exquisite rendering of flowers, birds, and animals in the borders, with caterpillars, butterflies, and other insects in the space between, fully explains why Sir Matthew Fetherstonhaugh and his friends were prepared to be so patient. The table frame may well have been supplied by John Bladwell of Bow Street, Covent Garden, a subscriber to the first edition of Chippendale's *Director* in 1759, whose name occurs several times in Sir Matthew's account books during this decade. Bladwell supplied similar white and gilt mirror frames (among many other pieces) to another noted Grand Tour collector, William Windham of Felbrigg, in 1752 (London, V & A 1984, L27). It is probable that the scagliola tables were intended for the saloon at Uppark, where their combination of flowers and animals would have been perfectly in keeping with the set of tapestry-covered armchairs depicting Aesop's Fables, also attributed to Bladwell (no. 180). G.J-S.

Provenance: Commissioned by Sir Matthew Fetherstonhaugh, 1st Bart. (d. 1774); and by descent; given to the National Trust in 1954 with the house and some of its contents by Admiral the Hon. Sir Herbert Meade-Fetherstonhaugh
Literature: Coleridge 1966, 184–187, 3
Exhibitions: Wildenstein 1982 (58), fig. 59

173

JOHN, LORD BRUDENELL 1758
Pompeo Batoni 1708–1787
oil on canvas
96.5 × 71.1 (38 × 28)
inscribed on the back of the canvas by a later hand, *John, Marquis of Monthermer, son to George Duke of Montagu ob. 1770, aet 35:/by Mengs*

Boughton House
The Duke of Buccleuch and
Queensberry, KT

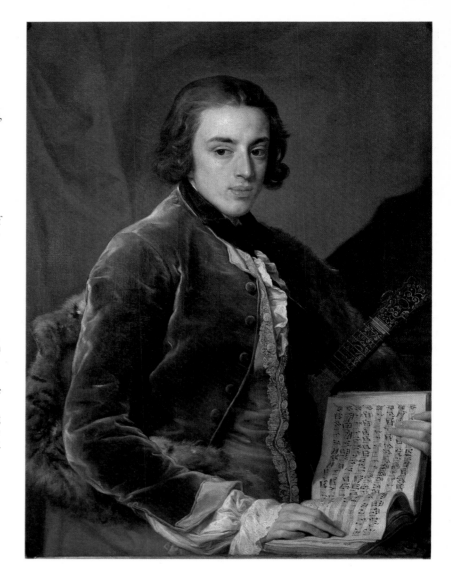

John, Lord Brudenell, later Marquess of Monthermer (1735–1770), was the only son of George Brudenell, 4th Earl of Cardigan by his wife Mary, daughter of John, 2nd Duke of Montagu. The Dukedom of Montagu was revived for Lord Cardigan in 1766 and thereafter Brudenell was given the courtesy title of Marquess of Monthermer. Educated at Eton, he was sent to study in Paris in 1751, accompanied by his tutor Henry Lyte (1727–1791) (for an account of their tour see Fleming 1958). After some three years in Paris they traveled to Italy, visiting Rome briefly in the spring of 1756 *en route* for Naples, whence they made an exceptionally thorough exploration of the classical sites of southern Italy and Sicily. Brudenell's visit to Naples led to his commissioning views of the city and elsewhere from Jolli (see no. 175). Brudenell returned to Rome early in 1758 and, as Lyte's letters to Lord Cardigan show, soon began to acquire marbles and pictures through the *cicerone* Thomas Jenkins, spending over £2,000 on such acquisitions in 1758 alone.

On 1 March 1758 Lyte reported to Cardigan, "Mengs and Pompeio have both begun my Lord Brudenell's portrait, the former a full-length and the other a half-length. They have promised to finish them out of hand and they will both be fine pictures, the more so as there is a great emulation between those two celebrated painters" (Fleming 1958, 136–137). A subsequent letter of 21 June establishes that the pictures were ready for dispatch by the next convoy—a precaution necessitated by the outbreak of the Seven Years' War. Like the Batoni, Mengs' full-length is now at Boughton, but the latter also painted a half-length of a different composition at Beaulieu (no. 174) and another of Henry Lyte, now in the collection of Sir Brinsley Ford.

Of the two Boughton pictures, the Mengs shows Brudenell reading by a bust of Cicero, a dignified and formal image. Batoni's characterization is more vital: Brudenell holds a manuscript score of Corelli's Sixth Sonata, Opus 5, his mandolin under his arm. The portrait achieves a refinement of technique in the description of Brudenell's sumptuous dress and in the observation of his features, which the painter was never to surpass. No doubt the challenge of so direct a competition with his closest rival aroused the artist, and in this connection it is of interest that none of the other Englishmen who sat for both painters—Sir Brook Bridges, William Fermor, and the 4th Duke of Manchester —was a patron on a comparable scale to Brudenell. The duke may well have seen these two portraits, as the two were distant cousins and Manchester's childless uncle, the 2nd Duke, had married Lord Brudenell's aunt.

Brudenell was in Venice in 1760. After his return to England he became, in 1761, Member of Parliament for Marlborough, a pocket borough of his uncle Lord Bruce, and a year later the barony

of Montagu of Boughton was revived in his favor. He continued to add to his collection, which was kept at Montagu House in London and achieved some fame. Elected to the Society of Dilettanti in 1761, he attended the banquet in 1769 that followed the first assembly of the newly founded Royal Academy. He never married, and as a result of his death from consumption in 1770 Boughton and Montagu House were inherited by the sons of his sister Elizabeth, Countess of Dalkeith, later Duchess of Buccleuch. F.R.

Related Works: A reduced copy, formerly at Dalkeith, is at Bowhill
Provenance: By descent through the sitter's sister Elizabeth, wife of the 3rd Duke of Buccleuch
Literature: Boughton 1832 (not numbered) as Batoni; Scott 1911, 13, no. 30, as Mengs; Clark 1985, 202
Exhibitions: London, RA 1954–1955 (298); Rome 1959 (38); Lucca 1967 (32); London, Kenwood 1974 (87); London, Kenwood 1982 (13)

174

JOHN, LORD BRUDENELL 1758
Anton Raphael Mengs 1728–1779
oil on canvas
95 × 71.2 (39 × 29)

Palace House, Beaulieu
The Lord Montagu of Beaulieu

This portrait of Lord Brudenell, which offers so revealing a contrast to that of the sitter by Batoni (no. 173), must marginally postdate both that and Mengs' full-length of the sitter at Boughton. Those portraits were begun before 1 March 1758 and were finished by the following June. The assertive pose and strong color of this portrait suggest a deliberate reaction to Batoni's more delicate likeness.

The anonymous translator of the 1796 London edition of d'Azara's *The Works of Anthony Raphael Mengs* wrote, "Mengs has done but few pictures for England except copies." In fact the artist painted over two dozen portraits of British sitters, and at the time this picture was commissioned was Batoni's leading rival in this as in other spheres. The characterization—so very different from that seen in the full-length—may be compared with that of other Grand Tour portraits by Mengs, including the slightly later pastel of William Burton, later Conyngham (private collection; Russell 1978, pl. 5). Mengs' portraits in this format, including those of Robert Stewart, later 1st Marquess of Londonderry (Mount Stewart, the National Trust; Russell 1978) and Thomas Robinson, later 1st Lord Grantham (Newby Hall. R.E.J. Compton, Esq.; Cornforth 1979, 1914), are indeed more assured and more refined in execution than those on a larger scale. Brudenell was the only English traveler to sit for two portraits by Mengs; for his patronage see no. 262. In Lord Brudenell's time Beaulieu was occupied by his aunt, whose husband Edward Hussey-Montagu was created Lord Beaulieu in 1762; it is, however, fitting that his portrait and so many of the landscapes he commissioned on the Grand Tour should now hang together at Palace House. F.R.

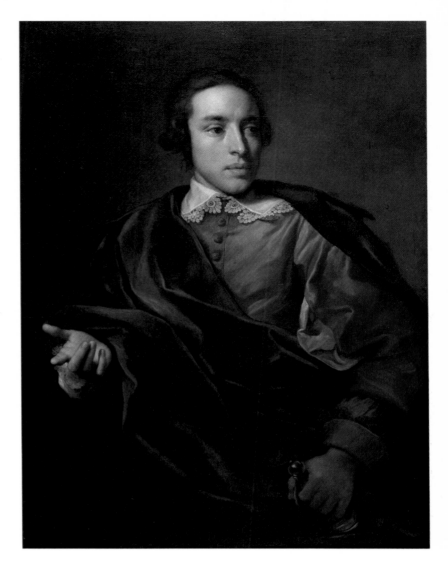

Provenance: By descent through the sitter's sister, Elizabeth, wife of the 3rd Duke of Buccleuch, her younger son Henry, Lord Montagu of Boughton (d. 1845); his great-nephew Henry, 1st Lord Montagu of Beaulieu; and by descent
Literature: Russell 1978, 16

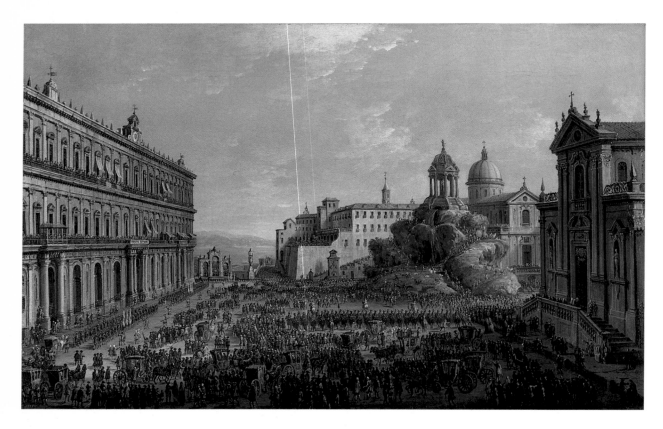

175

PALAZZO REALE, NAPLES C. 1759
Antonio Jolli c. 1700–1777
oil on canvas
49.5 × 77.4 (19½ × 30½)
inscribed on the reverse, *Palazzo Reale
con la cuccagna a S.Spirito.
p.Milord Brudenell. Jolli fe. 17--*

Palace House, Beaulieu
The Lord Montagu of Beaulieu

This view was commissioned by Lord
Brudenell, the subject of portraits by
Batoni and Mengs (nos. 173 and 174),
as part of a series showing towns he had
visited on the Grand Tour. On the left
is the façade of the Palazzo Reale, begun
in 1600/1602 by Domenico Fontana for
the Viceroy Ferrante di Castro. The
composition derives in part from that
engraved as plate 12 of Vincenzo dal
Re's *Narrazione delle Solennea Reali Feste*,
published in Naples in 1748.

Jolli, who was born at Modena, had a
peripatetic career as a painter of
decorative frescoes and theater scenery,
of *capricci* and *veduti*. He worked in

London from 1744–1748, where he
executed schemes for both Chesterfield
House and Richmond House adjoining
Montagu House, which Brudenell's
mother inherited. In the 1750s he was
again working in Italy. After a visit to
Naples he was in Venice in October
1754, Naples in 1759, and Venice again
in 1760. His movements intersected
those of Lord Brudenell, who may have
employed him as early as 1754, at several
points. Like Vanvitelli at the beginning
of the century, Jolli had traveled
more widely than most other Italian
topographical painters. Thus he was
able to supply views not only of Naples
but also of many of the other towns
Brudenell visited. Of the sixteen pictures
of approximately the same format as
the present example now at Beaulieu,
eight including the present example are
of Naples and two of Messina, while
Agrigento, Palermo, Malta, Florence,
Tarascon, and Avignon, which Brudenell
no doubt saw *en route* for Genoa in
1754, are represented by single views.
Eleven more were sold in 1958—these
comprised views of San Remy, Naples

from Ischia, Messina, Marsala, Catania,
Syracuse (two), Trapani, Venice, and
Stra (two) (Christie's, London, 2 May
1958, lots 43–51)— and three in 1973,
views of Agrigento, Palermo, and Messina
(Christie's, London, 11 April 1975, lots
60–62). Eight others are at Bowhill:
pairs of views of Naples during the
Carnival and the Bay of Naples of the
same format, and large canvases of the
Bay of Naples, Paestum, Agrigento, and
Pola. While in Naples Brudenell also
commissioned the large view of Vesuvius
by moonlight by Carlo Bonavia dated
1757 and now at Beaulieu. The pendant
to this, a Neapolitan coastal scene in
the manner of Vernet, is at Bowhill.

F.R.

Provenance: See no. 174

176

COLONEL WILLIAM GORDON
Pompeo Batoni 1708–1787
oil on canvas
259 × 187.5 (102 × 74)
signed and dated on block below column
base at lower left, *POMPEIUS BATONI
PINXIT/ROMAE ANNO 1766*; and by
a later hand, on architectural fragment
at lower right, *Genl. The honble. John
William Gordon*

Fyvie Castle
The National Trust for Scotland
(Forbes-Leith Collection)

William Gordon of Fyvie (1736–1816)
was the second suviving son of William,
2nd Earl of Aberdeen; his mother was
Aberdeen's third wife, Anne daughter
of Alexander, 2nd Duke of Gordon.
Commissioned in the 11th Regiment of
Dragoons in 1756, he became Lieutenant
Colonel of the 105th Regiment of Foot
in 1762, Colonel in 1777, and General
in 1778. A close friend of the 4th Duke
of Marlborough, in whose interest he
was elected Member of Parliament for
Woodstock in 1767, Gordon later sat
for Heytesbury, and was from 1775
until 1812 Groom of the Bed
Chamber.

Gordon's first cousin and nephew,
Alexander, 4th Duke of Gordon, had in
1764 commissioned Batoni to paint the
splendid full-length portrait formerly at
Gordon Castle and now at Goodwood
(London, Kenwood 1982, no. 22). The
Fyvie picture was no doubt com-
missioned in emulation of Batoni's
portrait of the duke, who is shown
standing with his charger and hounds
after a shooting expedition in the Roman
Campagna. Here Batoni reverts to his
more usual Grand Tour props: the
view of the Colosseum that appears in
portraits of Lord Charlemont and
William Weddell (both in the Yale
Center for British Art, New Haven);
the statue of Roma in the Palazzo dei
Conservatori, which is found, with
various changes, in a number of Batoni's
pictures and is here adapted to the pose
of the Capitoline *Seated Agrippina*; and
the fragments of a frieze with a griffin
that is used, often in the same position,
in over a dozen of the full-length
portraits.

What gives the Fyvie picture so distinguished a place in the sequence of Batoni's portraits of this format is the dramatic energy of the pose and the splendid depiction of Gordon's uniform, which is that of the 105th Regiment of Foot with the Huntly tartan. Batoni was accustomed to his patrons' vagaries of dress. He painted many of his sitters in Van Dyck costume and masquerade clothes, but this portrait, with its plaid, is unique. James Boswell, who saw a good deal of the sitter in Rome, made a note in his diary on 18 April 1765, "Yesterday morning saw Batoni draw Gord. drapery" (Brady and Pottle 1955), which suggests that the artist may have taken particular care with the costume. The characterization must have been due to the sitter who may have been aware of such a work as Richard Waitt's *Champion to the Laird of Grant* (Earl of Seafield). It was no doubt Batoni who saw how the plaid could be exploited in a classical guise, presented like a Roman toga, and who rolled down Gordon's hose in imitation of antique buskins.

This picture was one of a number of Gordon family portraits at Fyvie, bought with the castle by Alexander Forbes-Leith, later Lord Leith (1847–1926), and his American wife, Mary January, heiress to a St. Louis steel fortune. Their restoration of this spectacular early seventeenth-century castle was accompanied by the formation of a remarkable picture collection including a major group of portraits by Raeburn, and notable works by Romney, Lawrence, and others. F.R.

Provenance: By descent from the sitter to Sir Maurice Gordon Duff, Bart.; sold with Fyvie Castle in 1889 to Alexander Forbes-Leith, later Lord Leith; by descent to Sir Andrew Forbes-Leith, 3rd Bart., by whom sold with the contents of Fyvie to the National Trust for Scotland, 1984
Literature: Brady and Pottle 1955, 66; Clark 1985, 298
Exhibitions: Edinburgh 1966 (1); Aberdeen 1975 (11); London, Kenwood 1982 (23)

177

SAMUEL EGERTON C. 1732
Bartolommeo Nazzari 1699–1758
oil on canvas
218.4 × 157.4 (86 × 62)
signed, *Bartolo Nazari Fece in Venezia*

Tatton Park
The National Trust (Egerton Collection)

Samuel Egerton (1711–1780) stands in a conventional setting of terrace and column above the Grand Canal; behind him, featured as a backcloth, is the Dogana and beyond, on the Giudecca, the Church of the Zitelle. This rare portrait of an Englishman in Venice was probably painted in 1732 (Chaloner 1950, 169) during the time when Egerton was working in the city as an apprentice in a merchant's house.

The merchant was none other than Joseph Smith, better known as Consul Smith—which he became in 1744—the impresario of Canaletto and the founder of a collection that was particularly renowned for the contemporary art it contained. Smith's pictures, acquired by George III in 1762, brought to the Royal Collection an unrivaled group of works by Canaletto. Samuel Egerton, whose period of apprenticeship had begun in 1729, was thus advantageously placed, had he wished to augment the collection of pictures at Tatton, a house to which he succeeded on the death of his elder brother in 1738. However, apart from this portrait his collecting activities seem to have been confined to the intermediary role that he played in the acquisition of two early works by Canaletto (nos. 167 and 168) for his uncle and guardian, Samuel Hill.

Samuel Hill was not sanguine about buying pictures in Italy. He wrote from Rome in 1738 to his cousin Thomas Hill, "as to good original pictures I think theres nothing more cetain than yt they are not to be bought in this country, for no man here parts with a picture or statue till he has sold his wife and everything else yt can bring him any money." So it is that at Tatton the bulk of the collection is owed to two later members of the family: Wilbraham Egerton (1781–1856) and his grandson, also called Wilbraham, who became 2nd Baron and 1st and last

Earl Egerton of Tatton (1832–1909). Their tastes developed on similar lines, with a predominant interest in classical Italian pictures together with an appreciation of the Dutch school. To the elder Wilbraham, whose acquisitions were the most notable of the two, must be credited the outstanding work of art in the collection, Van Dyck's early altarpiece of the *Martyrdom of Saint Sebastian*, painted for San Giacomo degli Spagnuoli in Rome. ST.J.G.

Related Works: The small sketch for the portrait of Samuel Egerton in the Correr Museum in Venice, which had been attributed both to Alessandro and Pietro Longhi, was correctly identified as the work of Nazzari when the finished picture was first exhibited in 1960 (Pignatti 1960, 39)
Provenance: Always at Tatton until bequeathed to the National Trust by the 4th Lord Egerton, 1958
Literature: Watson 1959–1960, 267
Exhibitions: London, RA 1960 (207)

178

GEORGE, 3RD EARL COWPER
Johan Zoffany 1730/1735–1810
oil on canvas
142.2 × 111 (56 × 43¾)

Firle Place
The Trustees of the Firle Estate Settlement

Lord Cowper (1738–1789) is depicted here in a landscape, perhaps in the grounds of the Villa Palmieri, raising his hat to shield his face from the Italian sun; in the background is a view of Florence. The grandson of Queen Anne's Lord Chancellor and a member of a prominent Whig family, Cowper had arrived in Italy on the Grand Tour in 1759. He eventually decided to settle in Florence, where he was a well-known social figure and gave lavish supper parties and musical entertainments. He assembled a distinguished collection of pictures, carried out scientific experiments, and was a friend of the Grand Duke of Tuscany, through whose influence he was, in 1778, created a Prince of the Holy Roman Empire. In

1775 he married in Florence—there is a companion portrait by Zoffany of his wife at Firle Place—where he remained until his death.

When Zoffany was sent out to paint his celebrated picture of the Tribuna of the Uffizi for Queen Charlotte, it was natural that Cowper should be asked to facilitate the task. On 23 June 1772 Lady Spencer wrote from London to Cowper, "I have the Queens Commands to recommend Zoffani a Painter & a very ingenious Man to your Lordships protection, Her Majesty sends him to Florence & wishes to have him admitted into the Great Dukes Gallery this I have no doubt will be a sufficient Motive for your Lordships gaining him every advantage in your power, but I cannot in justice to the Man help adding that he has uncommon Merit and has distinguish'd himself very much in his style of Portrait Painting."

In assisting Zoffany in practical ways in Florence, Cowper was hoping to ingratiate himself with George III. Through Zoffany he attempted to interest the King in two works by Raphael that he had found in Florence: a *Self-Portrait*, which the King accepted and which is still at Hampton Court; and the "Niccolini-Cowper" *Madonna*, which remained in Cowper's hands and is now in the National Gallery, Washington (Andrew W. Mellon Collection).

This is one of three portraits painted of Cowper during his long absence from England. Cowper of course figures prominently in the *Tribuna of the Uffizi*, gazing at the Raphael *Madonna* as if to encourage the king to acquire it; and Zoffany painted a conversation piece in which he appears with members of his wife's family. The earl was a member (*lucumone*) of the Accademia Etrusca and of the Accademia di Belle Arti in Venice; in the Accademia Etrusca at Cortona is a portrait of him by Fabrini in the robes of the Bavarian Order of Saint Hubert. On a visit by Cowper to London in 1786, Horace Walpole was amused to see, at a concert at Mrs. Cosway's, "an English Earl who had passed thirty years at Florence, and is more proud of a pinchbeck principality and a paltry Order from Wirtemberg, than he was of being a peer of Great Britain, when Great Britain *was* something."

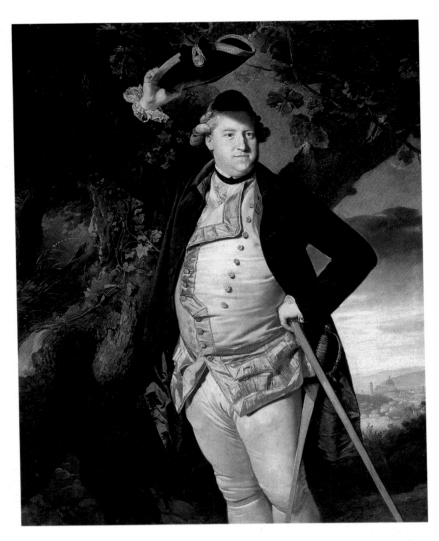

In Zoffany's oeuvre his life-size portraits are almost invariably arresting, individual in pose and character, and as fresh in touch as his more familiar conversation pieces. F.R.

Provenance: After the death of the 7th Earl Cowper without issue in 1905, the collections at Panshanger passed to his niece, Lady Desborough. This picture was in that part of the collection, which ultimately passed to her younger daughter, the late Viscountess Gage
Literature: Millar 1966
Exhibitions: London, NPG 1976 (77)

179

ARMCHAIR 1736
William Bradshaw d.1775
mahogany, upholstered in Soho tapestry
$111.7 \times 80 \times 77.5 \ (44 \times 31\frac{1}{2} \times 30\frac{1}{2})$

Chevening
The Trustees of the Chevening Estate

This is one of a suite originally comprising twelve armchairs and two sofas (of which eleven chairs and one sofa survive), supplied by William Bradshaw to the 2nd Earl Stanhope (1714–1786) for the Carved Room at Chevening House, Kent, in 1736/1737. Lord Stanhope's commission to Bradshaw is recorded in four surviving bills totaling £1326 1s. 3½d. (now in the Kent County Record Office, ref. U1590/A20a), and involved the redecoration and refurnishing of all the principal rooms of John Webb's mid-seventeenth-century house. The greatest expenditure was reserved for the drawing room, Tapestry Room, and Carved Room, the chairs appearing in the latter as: "12 Large mahogany [sic] Elbow Chairs on Castors finish'd with gilt Nails and fringe & holland Check 65.–.–/ Cases . . . @ 5.8.4 pʳ Chair 2 Large Sofoys Dº. & Cases & mohair to the Cheeks 29.13.10/ 12 Yds Lutestring in Scarves . . . @ 6/6 3.18./– 5 Ells of Tapestry to the Elbows @ 42/– 10.10–/" They were sent in eight packing cases costing an additional £7 6s. The mohair for the sofas was for some reason left off and Bradshaw was obliged to send "A Man on Horseback into the Country with the Mohair" at an additional cost of £1 14s. The chairs and tapestry survive in remarkable condition, only lacking the holland cases and castors mentioned in the account. The low and rectilinear carriage of the chairs probably indicates Bradshaw's desire (understandable in view of his reputation as the leading Soho tapestry maker) to make them principally as a vehicle for the display of his tapestry.

William Bradshaw moved into the newly vacated tapestry workshops of Joshua Morris in Frith Street, Soho, in 1728 and was joined there in 1730 by the bird and flower painter Tobias Stranover,

some of whose designs Bradshaw used for tapestries. In 1732 Bradshaw moved to 27 Soho Square. Five years later he is recorded supplying furniture and tapestries to Lord Folkestone at Longford and in 1740 to Lord Leicester at Holkham. From 1752 Bradshaw occupied 60 Greek Street, Soho, and by 1755 his relative George Smith Bradshaw had taken over the premises in partnership with Paul Saunders, thus continuing the Soho tapestry tradition in the same premises to the end of the eighteenth century (Survey of London 1966, 33: 106, 151, 189; 34: 517.)

Lord Stanhope continued to bring the interiors of Chevening up to date, particularly after his marriage in 1745, and employed a number of leading London cabinetmakers including Gordon and Tait, Samuel Norman, and Ince and Mayhew. H.R.

Literature: Hill and Cornforth 1966, 25, fig. 20
Exhibitions: Canterbury 1984, 54, and pl. 16

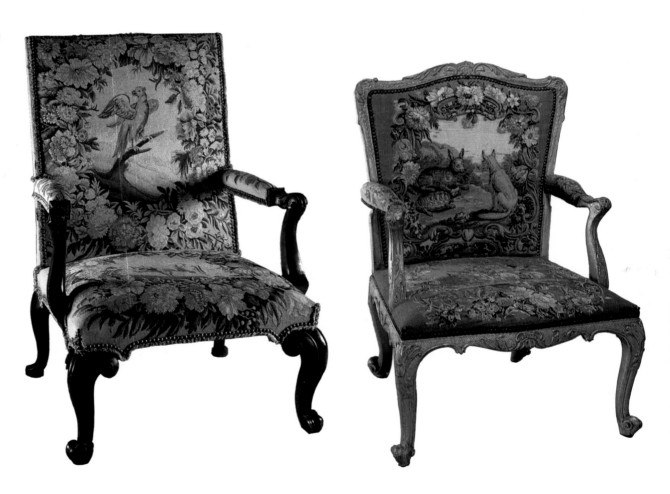

180

ARMCHAIR c. 1755–1760
attributed to John Bladwell, fl. 1725–
1768, the tapestry from the London
workshop of the Danthon family
gilt wood, the back, seat, and arms
upholstered with tapestry
107 × 74 × 71 (42 × 29 × 26)

Uppark
The National Trust
(Meade-Fetherstonhaugh Collection)

Englishmen passing through Paris on
their way to Italy in the 1740s and
1750s must have seen and admired the
tapestry covers for sets of chairs sup-
plied by the Gobelins and Beauvais
manufactories, and several of them were
later to order chair covers *en suite* with
Boucher tapestries from Neilson's work-
shop (no. 259). However, a number of
weavers in London (often of French
extraction, like Peter Parisot of Ful-
ham), were able to offer similar wares
much less expensively, and just as La
Fontaine's Fables were a popular sub-
ject in France, so Francis Barlow's illus-
trations to Aesop, first published in
London in 1666, were frequently used
as a basis for their designs. This example
comes from a set comprising eight arm-
chairs and a settee in the saloon at
Uppark, each with a back representing
a different Aesop fable set in three dif-
ferent rococo surrounds, and with seats
of three different floral patterns, all
fixed with the original brass-headed
nails. Here, the hare and the tortoise
are depicted about to begin their famous
race, under starter's orders from the
fox.

The set was bought by Sir Matthew
Fetherstonhaugh, 1st Bart., as part of
the refurnishing and redecoration of the
house begun after his return from the
Grand Tour in 1752, and the frames are
likely to have been made by John Blad-
well who provided him with other
pieces, which probably included the
frames for Pietro Belloni's two scagliola
table tops (no. 172). Their ornament of
acanthus-lapped trellis picks up the
theme of the floral tapestry borders,
but it is interesting that the fashion for
wide backs, tapering outward toward
the back-rail, prevailed despite the
narrower dimensions of the tapestry
cartouche.

The cover of one of the chairs is
signed *Danthon*, the name of a family of
Huguenot weavers working in London
from before 1707, first in Spitalfields
and then in Soho. This signature also
appears on two firescreen panels of
about the same date; one in the Victoria
and Albert Museum of a pheasant in a
landscape with classical ruins, and
another at Hopetoun House of a rabbit
in a floral cartouche similar to the
Uppark chairs (Hefford 1984, figs. 15b
and 16a). Sir Matthew's account books
record payments for tapestry to Paul
Saunders in 1761 and to a Mr. Browne
in 1760. Saunders was himself a weaver
with premises in Greek Street, Soho;
after a brief partnership with the up-
holsterer William Bradshaw in 1756 he
supplied seat furniture and tapestries
for Holkham, Petworth, and other
houses. While it is possible that he sub-
contracted work to the Danthon family,
it is perhaps more likely that Mr. Browne
acted as their agent. G.J-S.

Provenance: See no. 172
Literature: Coleridge 1967, 161, fig. 10;
Hefford 1984, 103–112, fig. 16b
Exhibitions: London, V & A 1984, L29

181

COMMODE 1760
Pierre Langlois fl. 1759–1781
marquetry of various woods with
ormolu mounts
84 × 144 × 63.5 (33 × 57 × 25)

Woburn Abbey
The Marquess of Tavistock and the
Trustees of the Bedford Estate

This commode is in the French rococo
style with serpentine forms and a bombé
front and sides. The ormolu corner
mounts are decorated with scrolling
acanthus foliage and the ormolu apron
mount is in the Louis XIV style, depict-

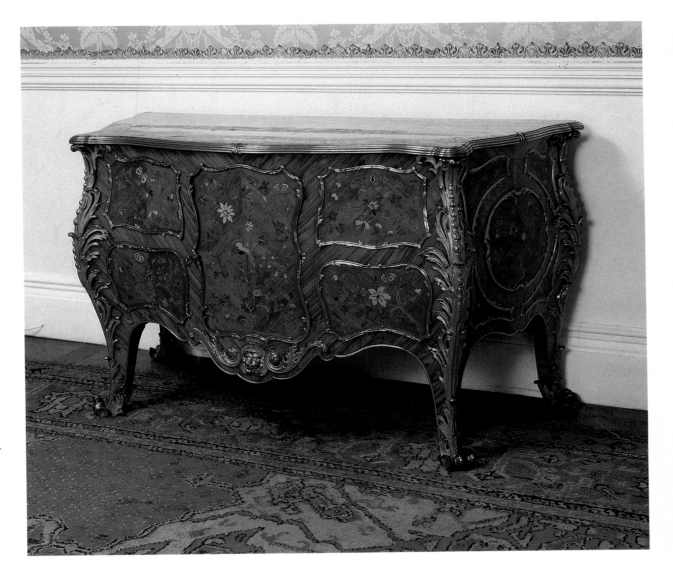

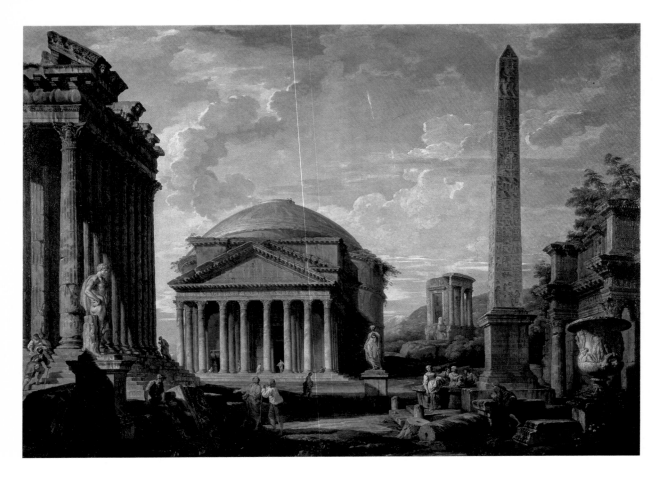

A ROMAN CAPRICCIO
WITH THE PANTHEON 1740
Giovanni Paolo Panini 1691–1765
oil on canvas
122 × 139.7 (48 × 55)

The Castle Howard Collection

This *capriccio*, order from Panini *en suite* with the *Capriccio with the Arch of Septimius Severus* and other pictures, shows from the left: the Farnese Goddess with the wreath, the Pantheon, the Temple of the Sybil at Tivoli, the Obelisk of Augustus, and the Medici Vase.

Related Works: Many of the buildings and sculptures are introduced from the same viewpoints in other *capricci.* A signed *capriccio* of 1727 with the Pantheon and the Temple at Tivoli in the same positions is at Houston (Kress Collection), and a variant of this was with Frost and Reed. The left section of the *Capriccio with the Pantheon* at the Walker Art Gallery, Liverpool, corresponds with the present picture. The same composition recurs but with less space to the left of the Pantheon in the *capriccio* of 1739 commissioned by the 1st Earl Harcourt and formerly at Nuneham Courtenay, Christie's, 19 January 1974, lot 186
Provenance: See no. 183

ing an acanthus-winged Zephyr or a "puffing wind" mask. There are ormolu framed marquetry panels at the front and sides, inlaid with birds and butterflies among flowering branches concealing four drawers and a central compartment fitted with a door on the front. The marquetry top incorporates a trophy of musical instruments surrounded by a pastoral garland and including bagpipes and a theatrical mask, suspended from a ribbon.

The commode was supplied to John Russell, 4th Duke of Bedford (1710–1777), by the French emigré *ébéniste* Pierre Langlois (fl. c. 1759–1781), who receipted his bill for "A large Inlay'd Commode Table" on 18 December 1760. During the late 1750s the duke and his duchess, Elizabeth, decorated a two-room apartment at Woburn Abbey, Bedfordshire, in the Louis XV style. Its white and gold plasterwork and woodwork, with *boiseries* in the French manner

rarely found in an English country house, were partly inspired by engravings in Jacques-François Blondel, *De la Distribution de Maisons de Plaisance* (vol. 2, 1738). The commode probably stood under the pier glass in the French bedroom, where it was intended to serve as an ornamental table rather than for the storage of clothes.

Pierre Langlois had arrived in London in the late 1750s and at a time when the war with France prevented the importation of luxury goods and furniture from Paris, he enjoyed considerable success with his French style furniture. A floral marquetry chest of drawers together with the other pieces of French style furniture were engraved on his elaborate trade card advertising his premises in Tottenham Court Road. The card, written in both French and English, stated that he specialized in "Toutes sortes de commodes, secretaries, encoignures, et autres meubles

inscrutez de fleurs en bois et marqueties garnies de bronzes dorez," translated as "Makes all sorts of Fine Cabinets and Commodes made and inlaid in the Politest manner. . . ." Langlois also specialized in japanned and painted commodes as well as ones fitted with moulded lacquer or *pietra dura* (hardstone mosaic) panels. The marquetry panels on the front of the Woburn commode are treated as decorative panels, and its prototype may have been just such a japanned commode incorporating Italian *pietra dura* plaques (repr. Thornton and Rieder 1972, fig. 5). J.H.

Literature: Thornton and Rieder 1971, 283–288; Thornton and Rieder 1972, 105–112; London, V & A 1984, L53

183

A ROMAN CAPRICCIO WITH THE ARCH
OF SEPTIMIUS SEVERUS 1740
Giovanni Paolo Panini 1691–1765
oil on canvas
122 × 139.7 (48 × 55)

The Castle Howard Collection

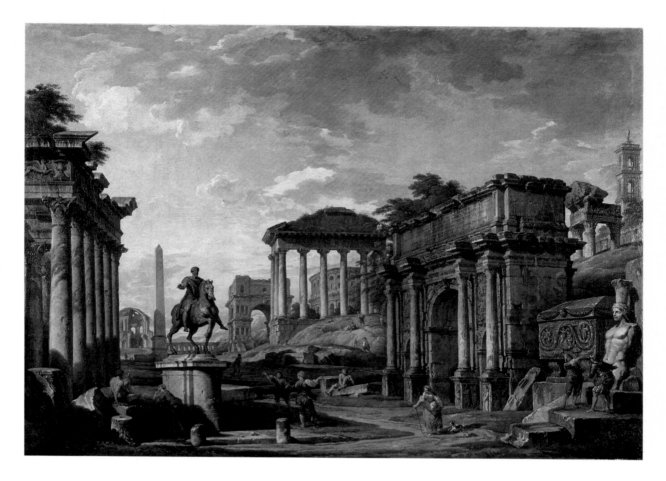

This *capriccio* shows, from the left, the
Temple of Antonius and Pius, the so-
called Temple of Minerva Medica, the
statue of Marcus Aurelius, the Arch of
Titus, the Temple of Saturn through
which the Colosseum is glimpsed, the
Arch of Septimius Severus, and the
Temple of Vespasian.

There are three other pictures of this
format by Panini at Castle Howard:
no. 182, and views of the Colosseum
and the Forum, as well as a larger pair of
upright *capricci*. The latter and the view
of the Forum are also dated 1740 and
apart from the Forum the pictures are
all in identical Kentian frames with
borders of Greek key design and eared
corners. Three Zuccarellis that now
hang with the Paninis in the Museum
Room are framed *en suite*, and may have
formed part of a single decorative scheme.

Although many pictures by Panini
and from his productive workshop were
in English collections, his relationship
with Grand Tour patrons is surprisingly
ill-documented. The pictures at Castle
Howard were evidently ordered by the
4th Earl of Carlisle (1694–1758) during
his second visit to Rome, and are typical
of an English milord's desire to bring
back souvenirs of all the monuments of
classical antiquity he most admired—not
necessarily in the form of straightforward
topography, but grouped together
according to the principles of the
picturesque. Carlisle, who had gone on
the Grand Tour in 1714–1715, set out
again for Italy in 1738, probably because
of the failing health of his son. He
was in Rome in the spring of 1739,
in Florence in June, and sailed from
Leghorn in July, returning to England
in November (information from Sir
Brinsley Ford). Letters from Michele
Lopez in Rome to Carlisle show that
Panini had promised to have the pictures
ready within a few days of 23 February
1740 but on 8 July he was still being
pressed to deliver these (Castle Howard
MSS, J 12/12/1 and 3). For Panini to

take a year to fulfill such an important
commission was normal: Lord Mansel
was in Rome in 1740 and no doubt
then ordered the pictures for which his
former bear leader, Dr. Clephane, paid
150 *scudi* on 16 February 1742 (Rose of
Kilravock MSS, National Library of
Scotland, GD 125/33/7).

The 4th Earl's contribution at Castle
Howard is inevitably overshadowed by
that of his father who had had the
courage to select Vanbrugh as his
architect. The 4th Earl's taste was more
conventional, formed on the model of
his Yorkshire neighbor, Lord Burlington.
The latter's protégé Daniel Garrett
was employed to add the steps round
Hawksmoor's great Mausoleum in
1737–1742 at the instance of Carlisle's
brother-in-law, Sir Thomas Robinson,
a Palladian architect in his own right
who completed the west wing at Castle
Howard in 1753–1759. Like many sons of
builders, Carlisle inherited a house that
offered space for collecting, and his

second Italian tour was certainly
productive. Letters survive to document
his purchases of antiquities from
Francesco de Ficoroni and Belisario
Amadei whom he evidently briefed
when in Rome, and his Paninis were
complemented by views of Venice.
Three of these purchases—the great
picture of the Bacino in the Museum of
Fine Arts, Boston, and the fine pair of
views of the Piazzo San Marco and the
Piazzetta in the National Gallery,
Washington—were by Canaletto.
Perhaps because Carlisle disliked Consul
Smith, he acquired other views of Venice
through the younger Antonio Maria
Zanetti. The first of a series of letters
from the latter to the earl dated 3 June
1740, shows that these were by a
painter "qui est le plus bon homme
du monde, et qui en est aussy abil, que
Cannalletto, au quel presentment on
paye seulement le nom, et la renomee"
(Castle Howard MSS, J 12/12/18). This
accounts for the inferior quality of the

ten views of Venice destroyed in the
1940 fire. It is revealing that his son the
5th Earl (see no. 482), who was on the
Grand Tour at the time of his father's
death, wrote from Rome on 19 June
1758, "My longing to see my own
collection of *virtu* at Castle Howard is
Wonderful" (Jesse 1843–1844, 2:308).

When the Duke of Rutland visited
Castle Howard, the Paninis were divided
between four rooms ([Rutland] 1813,
92, 99, and 100), but Waagen on his
visit in 1835 noted three of the set in
the Museum Room where they still hang,
remarking that these were "some of his
finest works" (Waagen 1838, 3:207).

F.R.

Provenance: Commissioned by the 4th
Earl of Carlisle; and by descent through
the Hon. Geoffrey Howard, younger son
of the 9th Earl
Literature: Carlisle 1837, 48, 56;
Ibbotson 1851, 26

184

VIEW OF THE COLOSSEUM, WITH THE
ARCH OF CONSTANTINE 1716
Gaspare Vanvitelli, Il Occhiali 1653–1736
oil on canvas
56 × 108 (22 × 43)

Holkham Hall
Viscount Coke

This picture, for which fifty crowns
were paid on 17 July 1716 (Holkham
MSS 734), is one of seven by the artist
that were acquired in Italy by Thomas
Coke (1697–1759), who in 1744 was
elevated to the Earldom of Leicester.
Of the other works by Vanvitelli he
purchased, a view of Piazza San Pietro
dated 1715 and one of Venice from the
Bacino, undated but executed in Rome
as an inscription attests, are of the same
size (Briganti 1966, nos. 59 and 174). A
signed view of the Castel Sant' Angelo
of the same dimensions by Hendrick
van Lint, Il Studio (mistakenly attributed
to Vanvitelli by Dawson 1817, 125,
no. 246 and exhibited London, J. Fielding
1977, no. 1), was evidently intended to
hang *en suite*.

Coke went on an extensive Grand
Tour in 1712–1718, accompanied by
his tutor Dr. Thomas Hobart. With a
surplus income of roughly £10,000 a
year, he was able to indulge a precocious
taste for collecting in many spheres:
pictures, drawings, sculpture, and,
above all, books and manuscripts. His
acquisitions were altogether exceptional,
both in number and range. Vanvitelli and
Benedetto Luti were the two artists in
Rome with whom Coke's dealings were
closest and his accounts show that a
silver basin was paid for on 11 September
1716 for presentation to each. The
development of Coke's interest in
landscape painting, which led to the
acquisition of a series of masterpieces
by Claude and others, was no doubt
spurred by his patronage of Vanvitelli.
His opinion of the painter is surely
echoed in Brettingham's comment:
"The Justness of Occhiali's Perspective
Views, and the fine glow of his Flemish
colouring, are Excellencies perhaps not
to be met with in the Works of any
other Painter" (1773, 10). Coke's later
acquisitions were made quite specifically
with his great scheme for Holkham in
mind. Plans for the house were considered
from soon after his return in 1718, but
it was not until 1734 that the foundations
were dug, and the project remained
unfinished at Leicester's death and
was completed by his widow. In 1817
this and three other Vanvitellis and the
Van Lint were, with the exceptional

pair of Venetian views on copper by
Canaletto, in the closet to the State
Bedchamber. The room also contained
Garzi's *Cincinnatus at the Plough*, the
background of which, in Brettingham's
words, is "closed with a View of the
Modern Buildings, upon the Capitol
Hill;" Maratta's *Judith*, a portrait of
Rubens' daughter; and a much admired
Madonna, wrongly given to Raphael. By
1817 the Garzi, the Maratta and the
"Raphael" had been replaced by two
Gaspards and a Wouvermans, and the
closet had taken on the air of being
a more intimate counterpart to the
Landscape Room with its great sequences
of classical landscapes of the seicento.
Subsequently the Vanvitellis and
the Canalettos were moved to Lady
Leicester's boudoir, where a third
Canaletto, the *Bucintoro at the Molo*,
had always been inset in the overmantel
designed by Kent. F.R.

Provenance: Commissioned by Thomas
Coke, later 1st Earl of Leicester, and by
descent at Holkham
Literature: Brettingham 1773, 8; Dawson
1817, 125, no. 248; Holkham 1913, 3,
no. 156; Briganti 1966, 178, no. 31
Exhibitions: London, J. Fielding 1977 (5);
s'Hertogenbosch/Haarlem 1984–1985
(82)

185

VIEW OF POMPEII 1799
Jacob Philipp Hackert 1737–1809
oil on canvas
118 × 163 (46½ × 64½)
signed and dated, *Filippo Hackert dipinse
1799*

Attingham
The National Trust (Berwick Collection)

The view, looking toward Castellamare
and the Sorrentine Peninsula, encompasses
the excavated area of Pompeii as it
appeared at the end of the eighteenth
century. The large, open space in the
center is the theater; to the left is the
Triangular Forum and adjacent to it
the Barracks of the Gladiators and the
Quadriporticus. At the extreme left is
the Odeum or small theater, and on the
right, behind its screening wall, is the
best preserved and worst plundered of
the shrines of Pompeii, the Temple of
Isis.

The discovery of Pompeii was made
in 1748, ten years after that of
Herculaneum. The excavations, which
proceeded fitfully, unsystematically,
and unscientifically, were the subject of
criticism in the eighteenth century. Sir
William Hamilton censured the dilatory
approach of the excavators, observing
that seldom were more than ten or
twelve men employed on the site, and
Hackert's picture seems to confirm
Hamilton's impression of the limited
labor force and slow pace of the work.

By the time Hackert painted this
picture his position at the court of Naples
had advanced from court painter, a post
to which he was appointed in 1785, to
something approaching that of a major-
domo of the arts. A favorite of King
Ferdinand IV and his Austrian wife,
Maria Carolina, Hackert was also the
subject of a biography by Goethe. He
was patronized by English travelers,
and admired for the realism and detail
of his style. If for this reason his
reputation subsequently suffered a
decline, it is the precision of detail and
the exactitude with which he describes
the life of a bygone age that makes this
so rich a document. The husbandry of
the period, the vines garlanded as they
still are today in that part of Italy, and
the carriages on the dusty road are all

painstakingly recorded. One of nine paintings by Hackert at Attingham today, it is moreover in an immaculate state of preservation that can have changed little since it left the artist's easel.

Among English houses, Attingham Park in Shropshire is perhaps unique in retaining the flavor of Neapolitan patronage of the early nineteenth century. This individuality is due to the purchases of furniture and pictures by William Hill, later 3rd Lord Berwick. Having been Minister at the Court of Sardinia for seventeen years, he occupied the

same post at Naples from 1824 until 1833 when, following the death of his elder brother, he returned to England. His character—by then he had become "a middle-aged sybarite"—is described by Sir Harold Acton (1961, 6). A professed admirer of Hackert, Lord Berwick was responsible for bringing the majority of the paintings by this artist to Attingham, though *The View of Pompeii* was acquired by his elder brother. The 2nd Lord Berwick had traveled extensively in Italy as a young man in company with the Reverend Edward Clarke, the author in 1763 of

the first English guide to Spain. He bought extravagantly, and to house his collection he commissioned Nash to design for Attingham one of the earliest top-lit picture galleries in an English house. By 1827 his debts forced him to dispose of more than 300 pictures. Among them were two works by Hackert, the *Pompeii* and the *Lake of Arno* (that is the *Avernus* at Attingham today). It can be assumed that these were bought in by his younger brother who succeeded him as 3rd Lord Berwick in 1832. st.j.g.

Provenance: Acquired by the 2nd Lord Berwick and sold by him; Robins, 30 July 1827, lot 55, when it was either bought in or acquired by the 3rd Lord Berwick; thereafter at Attingham, which passed to the National Trust in 1968 by the will of the 8th Lord Berwick
Exhibitions: London, RA 1960 (243); Manchester 1961 (193)

SIDEBOARD DISH 1761
William Cripps d. 1767
silver-gilt
66 (26) diam.

Chatsworth House
The Trustees of the Chatsworth
Settlement

One of a set of three, this dish is flanked
by a smaller (51cm) pair displayed on
the buffet of the State Dining Room
at Chatsworth. Magnificently embossed
and chased in the center, it combines
the mid-eighteenth-century taste for
classical ruins developed on the Grand
Tour with an unusual revival of late
seventeenth-century baroque scroll-
work in the treatment of the broad rim
(compare, for example, the Almoner's
Dish of 1683 from Burghley House, no.
114). The pattern here, however, is a
somewhat looser and freely spaced
rendering of what was a standard form
of decoration after the antique, and cor-
responds with some of Robert Adam's
early designs (see for example his draw-
ing for the Painted Breakfasting Room
at Kedleston, 1759, no. 359). The
composition, a *capriccio* of the Forum at
Rome, is taken from an engraving by
Francis Vivares published in 1755, after
a drawing by Giovanni Paolo Panini.

The splendor of this buffet plate
testifies to the skill of the goldsmith,
William Cripps, a man who emulated
the standards of his master, the
Huguenot David Willaume the younger.
Cripps became a freeman of the Gold-
smiths' Company in 1738 and entered
his mark in 1743. Thirty-six dessert
plates made by him and bearing the
royal cypher also survive at the house;
these may have come as perquisites to
the 4th Duke of Devonshire, who served
as Lord Chamberlain to George III.

J.B.

Provenance: Probably commissioned by
William, 4th Duke of Devonshire
(1720–1764); and by descent
Exhibitions: Manchester 1979 (15)

TWO LATTIMO PLATES 1741
Venetian
glass enameled in red monochrome
23 (9) diam.

The Vyne
The National Trust (Chute Collection)

One of these glass plates is based on an
etching in Luca Carlevaris' *Le fabriche, e
Vedute di Venetia*, published in 1703:
plate 47, entitled "Veduta della Piazza
di S. Marco verso il Canale." Today
this square is known as the Piazzetta,
and the view shows on the left the
Doge's Palace, on the right Sansovino's
Library, with the columns of Saint Mark
and Saint Theodore at the water's edge.
The second plate is based on a view by
Canaletto from Visentini's *Prospectus
Magni Canalis Venetiani* of 1735 (plate
IV), entitled *Hinc ex Platea S.Viti*. This
series of engravings was reissued as Part
1 of *Urbis Venetiarum Prospectus Celebriores,
ex Antonni Canal Tabulis XXXVIII. Aere
Expressi ab Antonio Visentini* in 1742. A
preparatory drawing is in the Museo
Correr, Venice, and a more finished
drawing is in the British Museum, while
Canaletto's painting is in the Royal
Collection (Constable 1976, 184). The
plate shows, on the left, the Palazzo
Corner, built by Sansovino in 1537; on
the right a part of the Campo San Vio
with a flank of the Palazzo Barbarigo.
Further to the right is the dome of
Santa Maria della Salute. Beyond the
entrance of the Grand Canal, on the
skyline, is the Riva degli Schiavoni.

The opaque white glass, known in
both Italy and England (since at least
1711) as *lattimo*, has the appearance
of porcelain. When first blown and
enameled in the late fifteenth and early
sixteenth centuries in a variety of shapes
and in considerable quantity, it was
intended as a counterfeit of Chinese
porcelain. In the eighteenth century,
with the reinvention of hard-paste por-
celain at Meissen in 1710, there was a
slight revival of interest in *lattimo* as a
substitute for porcelain. Most pieces
seem to have been enameled in colors at
the glass house of the Miotti family at
the sign of "Al Gesu."

The complicated history of these
and other red monochrome plates has

been the subject of brilliant detective research by Robert Charleston (1959), and is the sole basis of the following notes. Three young Englishmen on the Grand Tour—Horace Walpole, the Earl of Lincoln, and John Chute—were in Venice in June and July 1741, each with a companion (respectively Gray, Joseph Spence, and Francis Whitehead). Like most tourists, they visited the glass houses of Murano, where Horace Walpole bought "a set of handles for dessert knives and forks of the false lapis lazuli which pleased extremely, and cost mighty little." Each of the three also ordered for prompt delivery "two dozen plates of Venetian glass:

each plate has a different view of Venice, drawn in red" (Walpole 1774). Such plates were available only through special order and each commissioned different Venetian views, probably with the help of the English Consul Joseph Smith. The prints used were mostly the etchings of Marieschi of 1703 or engravings by Visentini after Canaletto.

Of the three sets, each of 24 *lattimo* plates, two have been dispersed; examples can be found in museums throughout Europe and America. Only The Vyne still has as many as sixteen out of the original twenty-four. Horace Walpole's set was offered for sale in

four lots of six plates each in his post-humous sale of 1842; these were lots 41 to 44, sold on 7 May at an average of £3–10–0 a lot. They had cost him more in Venice, the equivalent of £37–6–0. Of the Lincoln set, we know only that "Nine Plates with Venetian scenes in red" were sold by Christie's in the Clumber auction of 19 October 1937, as lot 76.

Horace Walpole seems to have brought his two dozen plates with him in his baggage. John Chute remained abroad until 1746, and inherited The Vyne in 1754, when they are likely to have been put on view. Here they were seen by the diarist Mrs. Lybbe Powis,

who in September 1780 remarked that "at the Vine are numberless curiosities among which a series of finest delf, much more valuable than any china, each plate with a different view of Venice." T.H.C.

Related Works: British Museum; Victoria and Albert Museum; National Museum of Wales; Moritzburg Museum, Halle; Kunstgewerbemuseum, Berlin; Corning Museum of Glass
Literature: Charleston 1959; Charleston 1963

CONSOLE TABLE C.1750
attributed to Thomas Johnson
1714–c.1778
gilded pine wood with a Sicilian jasper
slab
76 × 129 × 68 (30 × 50¾ × 26¾)

Corsham Court
The Methuen Collection

While the rococo never caught on as an architectural style in England, Palladian country houses in the mid-eighteenth century were often furnished with the most extravagant interpretations in gilded wood, plaster, and ormolu of the "natural landscapes" that were the current rage. This table from the Octagon Room at Corsham is supported by a gnarled tree whose leaves and branches merge with stylized acanthus and a frieze of lambrequins. Water gushes from below its roots, falling over the mouth of a cavern formed in the rockwork base. A pier glass in the house, designed *en suite*, has yet more twisting branches, and a cascade and grotto on which an exotic bird perches. In the hands of French designers like Oppenord and even Gravelot such naturalism would have been unthinkable, and it is probable that the Italian plasterers who flocked to England at this period, together with designers like Gaetano Brunetti, helped to introduce such entertaining images, even if the abstract c and s scrolls that provided the structural basis of the style came from Paris. The first-hand experience of English patrons on the Grand Tour must also have encouraged them to find native carvers who could equal the skills of the Venetian Andrea Brustolon or the Genoese Domenico Parodi.

Many of the elements of the Corsham table can be found in Matthias Lock and Henry Copland's *New Book of Ornaments*, published in 1752 (particularly plate 2), but still closer parallels can be drawn with one of the frames for consoles illustrated in plate 24 of Thomas Johnson's *Collection of Designs* (1758). Documented examples of Johnson's work as a carver are virtually unknown, for he seems always to have found others to retail his furniture. However, the upholsterer George Cole of Golden Square to whom Paul Methuen (1723–1795), the owner of Corsham, paid large sums in 1761 and 1763, could well have been an agent of this sort. Several of the pieces he supplied here and for the Duke of Atholl at Blair Castle are close to designs by Johnson, but are more than mere pattern-book copies (Hayward 1964, 36–37). They are also of such high quality that they justify an attribution to one who was renowned as one of the finest carvers as well as one of the most individual designers of his day.

G.J-S.

Related works: A similar table at Curraghmore in Ireland (Marquess of Waterford) is illustrated in Girouard 1967, fig.6
Literature: DEF 1954, 3: 297, fig. 54
Exhibitions: London, V & A 1984 (L20)

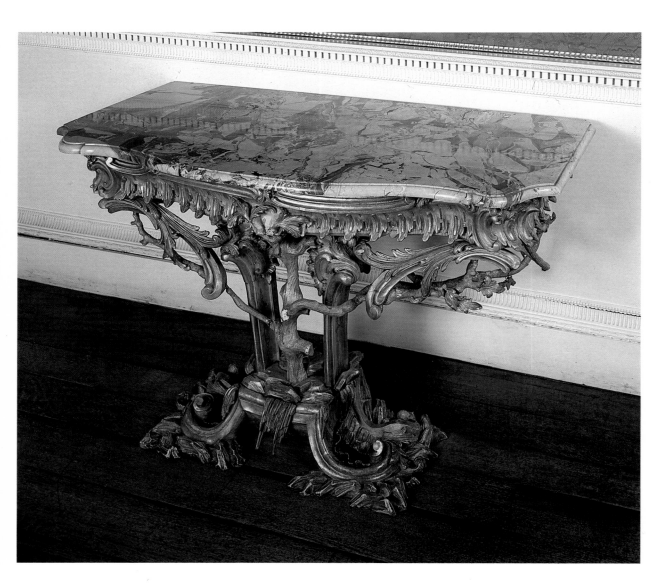

189

**THREE CARVED FIGURES OF
LUCRETIA, CICERO, AND CLEOPATRA**
Southern Italian, last quarter of the
17th century
boxwood
Lucretia: 34.5 (13½) high
Cicero: 37 (14½) high
Cleopatra: 35 (13¾) high

The Burghley House Collection

These are three from a series of eight
boxwood statuettes of classical subjects
that first appear in the 1688 inventory
of the contents of Burghley House
(information kindly supplied by Dr. Eric
Till): "My Ladyes Dressing Roome . . .
2 figures carved in Box being a
Cleopatra & a Pallace [i.e. Pallas
Athena, or Minerva] by ———";
"My Ladyes Closett . . . 2 figures in
Box, a Venus, a Lucretia by ———";
"The Best Bedd Chamber4 carved
figures in Box a Alexander, a ———, a
———, & a ——— done by
———." It is interesting to note that
the countess kept the female figures in
her own apartments. Some if not all the
statuettes were in the Jewel Closet
adjoining the State Bedchamber and
Dressing Room in 1735, when the trav-
eler and diarist John Loveday described
"some very curious carving in wood
here some miniature Statues in Box are
esteemed master-pieces" (Markham
1984, 202). Six of them are, however,
shown on the Piranesi chimneypiece in
the bedchamber in Lady Sophia Cecil's
etching of 1817 (Cornforth 1978, fig.
13), and the group has remained there
ever since—a fascinating juxtaposition
of Grand Tour purchases almost a
hundred years apart.

The 5th Earl of Exeter (1647–1700)
succeeded to the title in 1678 and there-
after traveled extensively in France and
Italy, collecting works of art of every
description. In 1679–1681 and
1683–1684 he visited Rome, Florence,
Venice, and Naples, spending much time
at the court of Cosimo III de'Medici,
Grand-Duke of Tuscany. Inscriptions
under the bases of the *Alexander*
(*A.27.D. Gennaie incominciate questa
figura*) and the *Minerva* (*A. primo Aprile*)
are most unusual, in that they appear
to give the dates when their carving

began (27 January and 1 April), though
unfortunately the years are omitted. Of
the cities visited by the 5th Earl, Naples
seems the most likely place of purchase,
for no such carvings in wood are known
elsewhere. This would also coincide with
the tradition in the house that they
came from Palermo, whence they may
well have been exported for sale to
mainland Italy. C.A.

Related Works: Victoria and Albert
Museum, *Alexander* and *Julius Caesar*
(169/170–1864) (catalogued as "early
18th century North German"); Staat-
liche Museen Preussischer Kulturbesitz,
Berlin-Dahlem (12/76)

POPE CLEMENT XIV 1771
Christopher Hewetson 1739–1798
marble
81 (31¾) high
inscribed, *CLEMENS XIV PON. M. MDCCLXXI*

Beningbrough Hall
The National Trust

Born in Ireland, Hewetson was in Rome by 1765, where he spent his whole career in the circle of the early neo-classicists. He carved portrait busts of several of them, Winckelmann, Mengs, and Gavin Hamilton, as well as of British ladies and gentlemen on the Grand Tour. The present bust of Clement XIV is the earliest of four versions, all of which are now in England, having been acquired by Grand Tourists, many of them on the advice of Gavin Hamilton. This was almost certainly the case with the version now in the Victoria and Albert Museum, London (signed and dated 1773), which came from the Talbot Collection at Margam Castle, Glamorgan, for Hamilton is known to have supplied classical statuary to Thomas Mansell Talbot. The bust at Gorhambury (signed and dated 1772) was given by the pope to the father of Harriet Walter, wife of the 3rd Viscount Grimston, when on the Grand Tour, and left to Gorhambury in her will. Another version at Ammerdown, Somerset, is believed by Lord Hylton to have been acquired in Paris between 1815 and 1835.

The Beningbrough bust appears to have been acquired by Giles Earle and his wife Margaret Bourchier, the niece and heiress of John Bourchier, who built the house in about 1710–1716. The Earles were in Rome toward the end of 1770 (Burney 1773, 299), and the dealer and *cicerone* James Byres reported in a letter to Sir William Hamilton of 20 May 1771 that they were staying at Cardinal Albani's villa at Castel Gandolfo (Chichester-Constable MSS, East Riding County Record Office; information kindly supplied by Sir Brinsley Ford). They may well have had audiences with the pope at his summer palace at Castel Gandolfo, since another letter refers to them still being at the Villa Albani in December of the same year. Piranesi later dedicated a plate in his *Vasi candelabri cippi* of 1778 to Lady Margherita Earle, almost certainly a reference to her, although she was not the daughter of a peer. She and her husband are known to have spent long periods abroad (Price and Ruffhead 1973, 18) and were probably living in Rome at this period.

Clement XIV, pope from 1769 to 1774, planned, but did not live to carry out, a radical extension of the Vatican Galleries (the part now called the Museo Pio-Clementino) and acquired much antique statuary for it from Gavin Hamilton and Thomas Jenkins, the principal British dealers living in Rome. It was almost certainly through them he was introduced to Hewetson. The present bust is the prime version, and in it the sculptor admirably conveys through the fleshy, lined features and keen sideways glance something of the pope's strength of character and vision. The wrinkles on the surface of his satin robe and the way the stole pulls away from the knotted cord brilliantly suggest movement. C.A./G.J-S.

Provenance: Bequeathed by Margaret Earle (d. 1829), with Beningbrough Hall and its contents, to a cousin, the Rev. and Hon. William Payan Dawnay (later 6th Viscount Downe); sold with the house to the 10th Earl and Countess of Chesterfield, 1917; acquired by the Treasury in 1957 in partial payment of death duties and transferred to the National Trust
Literature: Hodgkinson 1952–1954, 43, pl. XVII; Whinney 1971, 110
Exhibitions: Brussels 1973 (76)

PAIR OF PEDESTALS early 18th century
English
white Carrara marble, partly veneered with Sicilian jasper
136 × 30 × 26 (53½ × 11¾ × 10¼)

Wilton House
The Earl of Pembroke and Montgomery

The antique statuary amassed by Thomas Herbert, 8th Earl of Pembroke, between 1690 and 1730, which still fills James Wyatt's Cloisters at Wilton, formed one of the earliest and most celebrated Grand Tour collections of its day (see no. 233). The antiquarian John Loveday who visited the house in 1731 thought that "Lord Pembroke excels all others in Busts," finding that "most of them stand on Marble pedestals" (Markham 1984, 99). The extraordinary variety of these pedestals, executed in every sort of Italian marble—Volterra, Siena, *porto venere*, *brèche violette*, porphyry, and many others—suggest that he and his son, the 9th Earl, ordered quantities of these materials to be shipped back to England with their antique busts, and probably had the pedestals made up by an English sculptor. On the other hand, the 2nd Earl of Egremont, who was acquiring ancient marbles for Petworth through the agency of Gavin Hamilton in Rome in the 1750s, had whole pedestals, as well as marble table tops and their carved wooden frames, shipped back from Leghorn (Petworth House MSS). G.J-S.

Provenance: Acquired by the 8th or 9th Earl of Pembroke; and by descent

192

CARLO ANTONIO DAL POZZO,
ARCHBISHOP OF PISA c.1620
Gianlorenzo Bernini 1598–1680
marble
82.5 ×68.5 (32½ × 27)
inscribed, on rim at back of bust,
CAR. ANT. PVTEVS PIS.ARCH., and
on socle, *CA. PVT./ARCHIEP./PISAN.*

The Castle Howard Collection

This bust and its socle are inscribed in
Latin with abbreviated forms of the
name of the sitter, Monsignor Carlo
Antonio dal Pozzo (1547–1607), who
became Archbishop of Pisa in 1582.
Born of a noble Piedmontese family, he
studied law in Bologna and later met
Cardinal Ferdinando de'Medici, a near
contemporary, in Rome. When the
latter succeeded to the Grand Duchy of
Tuscany in 1587, Carlo Antonio became
his Special Counsellor and hence one of
the three most powerful men in Tuscany.
He was deeply involved with the exten-
sive repairs to the Cathedral of Pisa
necessitated by a disastrous fire in 1594,
notably with the three new pairs of
bronze doors executed under the aegis
of Giambologna. Carlo Antonio took
great interest in the education of his
first cousin's elder son, Cassiano dal
Pozzo (1588–1657), who was to become
a celebrated antiquarian, collector, and
friend of foreign artists in Rome, notably
Nicolas Poussin. Cassiano or his younger
brother, a namesake of the archbishop,
may have commissioned this bust in
gratitude in about 1620, judging from
stylistic analogies between it and other
datable portraits such as those of Mon-
signor Pedro de Foix Montoya and
Cardinal Saint Robert Bellarmine (both
c. 1621–1623), as well as Cardinal
Agostino Valier and Monsignor Fran-
cesco Barberini (National Gallery,
Washington). Those busts, like this
one, were both posthumous, and are
examples of Bernini's supreme skill in
evoking a lifelike appearance in por-
traits of people he had never set
eyes on.

 This bust is recorded in 1688 and
1689 by visitors to the Dal Pozzo palace
in Via Chiavari in Rome, though it had
been listed in 1682 among Bernini's
works by his biographer Baldinucci.

The heirs of Cassiano's younger
brother, Carlo Antonio, began to sell
off the collection after his death in 1689,
and the bust was probably purchased
by Henry Howard, later 4th Earl of
Carlisle, some time after he first visited
Rome in 1717. The 4th Earl acquired
much classical statuary for Castle
Howard—the great house built for his
father by Vanbrugh—most of it placed
in the long corridors flanking the great
hall (see no. 229). The bust, whose
authorship and identity were shortly
forgotten, may thus have been the
second of the three major works by
Bernini now in England to be imported.
The first was the bust of Thomas Baker
that was carved in Rome, probably
about 1637 and certainly before 1642
(Pope-Hennessy 1964, 601–606; Vic-

toria and Albert Museum). Despite a
papal embargo this was probably brought
to England by the sitter and in any case
was there by 1682, when it featured in
the sale of Sir Peter Lely's collection.
Bernini's *Neptune* (also in the Victoria
and Albert Museum), purchased from
Jenkins in Rome by Sir Joshua Reynolds
for 700 guineas, did not arrive in London
until 1787. C.A.

Provenance: Cassiano dal Pozzo, Rome;
Carlo Antonio dal Pozzo, Rome; Henry
Howard, 4th Earl of Carlisle (1694–
1758), probably acquired in Rome after
1717; and by descent
Literature: Rinehart 1967; Lavin 1985

193

A VIEW OF VERONA FROM THE PONTE
NUOVO c. 1745–1747
Bernardo Bellotto 1720–1780
oil on canvas
132.5 × 229.5 (52¼ × 91)

Powis Castle
National Trust (Powis Collection)

The river Adige at Verona is the central element in this composition, with buildings lining its banks and the distance dominated by the Visconti stronghold, the Castel San Pietro. The tower on the west bank (at left) is that of Sant' Anastasia; on the extreme right of the east bank is Palazzo Murari. The wooden constructions anchored in the river are watermills.

The picture was probably in England at an early date, on the assumption that it is related to an inscribed drawing at Darmstadt ("copia del quadro de la vista stando sun ponte novo verso il Castello di Verona di Bernardo Belloto detto il Canaletto per Ingilaterra"). It was purchased by Lord Clive, the victor of Plassey, in 1771, as by Canaletto, and not until after its appearance at the Royal Academy in 1904 was it recognized as being by Bellotto. It was probably painted in Verona, where the artist lived from 1745 until his departure for Dresden two years later, and it is a work that has a place at the summit of Bellotto's art.

The presence of the picture at Powis is due to the fact that Clive of India's son Edward (later to become 1st Earl of Powis of the 2nd creation) married the sister of the last earl of the Herbert line and succeeded to the Powis estates. The collection of pictures formed by Clive, the result of a rapidly conducted campaign during the closing years of his life, has largely been dispersed (Bence-Jones 1971) but the Bellotto remains at Powis, an almost solitary witness of Clive of India's once considerable collection and one of the few subject pictures in a house whose walls are preponderantly hung with family portraits. St.J.G.

Related Works: A slightly smaller version of the composition, differing in certain details, is at Dresden (Koszakiewicz 1972, no. 99, believes that it was probably painted when the artist had left Verona and had settled in Saxony) and a copy by Marlow is in the Courtauld Institute Gallery, London (Koszakiewicz 1972, Z329). The drawing at Darmstadt, described above, reflects more precisely our picture than it does the Dresden one (Koszakiewicz 1972, no. 100). A companion picture, of

strikingly original composition, which shows the view looking from the river toward the bridge, was sold at Christie's, London, in 1970 (General Sir George Burns sale, 26 November, lot 30).

Provenance: First recorded in 1771 in Lord Clive's London house, no. 45 Berkeley Square, before passing to his son Edward; by 1798 at Powis Castle where it has since remained. (The picture has in the past been wrongly associated with a view of Verona by Canaletto that was in the Fleming sale, Christie's, London, 22 March 1777, lot 48, bought by Lord Cadogan.) Although Powis was transferred to the National Trust in 1952, the Bellotto remained in the ownership of the family. It was offered for sale in 1981 when it was acquired by the National Trust with the assistance of the National Heritage Memorial Fund, the National Art Collections Fund, a Victoria and Albert Museum grant-in-aid, and private contributions
Literature: Fritzsche 1936, 27–28, 106
Koszakiewicz 1972, 2:79, 98;
Exhibitions: London, RA 1904 (68);
London, RA 1930 (768)

194

SOFA c.1762–1765
John Linnell 1729–1796
gilt pine wood upholstered in blue damask
123.1 × 337.8 × 104 (48½ × 133 × 41)

Kedleston Hall
The Viscount Scarsdale and the Trustees of the Kedleston Estate

One of four monumental giltwood sofas from the drawing room at Kedleston in Derbyshire, this and its pair, made for the end walls of the room, are slightly smaller than the two flanking the chimneypiece, and differ in their details. Instead of the triton and sea nymph whose tails entwine with those of dolphins at either end, the larger pair are each supported by a merman and mermaid emerging from bulrushes, the former with a conch and the latter with a shell lyre. The medallions in the centers of the backs are carved with profile heads of Juno wearing her usual diadem and veil, and her messenger and handmaiden Iris, portrayed with wings in her hair—and previously misidentified as Mercury—together with Bacchus and Hercules. The upholstery is a modern copy of the original, matching the wall hangings of the room, which the Duchess of Northumberland described in 1766 as being "hung with very fine pictures on blue damask."

The genesis of the design of these magnificent pieces of furniture is a complicated one and, although they arrived at the house in July and August 1765 when local men were paid for "gluing bits on" after their long journey from London, goes back at least seven years. Nathaniel Curzon, created 1st Lord Scarsdale in 1761, started to reconstruct his old family house at Kedleston in the 1750s, employing Matthew Brettingham the elder and then James Paine, who were largely responsible for the Palladian entrance façade with its two flanking pavilions. The drawing room was one of the first interiors in the main block to be tackled at a time when Curzon's precocious interest in neo-classicism, stimulated by the Grand Tour, had encouraged him to approach James "Athenian" Stuart for new designs. In 1758 the Danish artist and sculptor

Michael Henry Spang made an ambitious design for a painted ceiling probably intended for the drawing room, which celebrated England's "Year of Victories" against the French with seahorses and merfolk, and a conquering Britannia (supported by Neptune and Mars) surveying two globes symbolizing British naval and territorial successes (Hardy and Hayward 1978, 263, fig. 2). In the following year Spang also made a large-scale model of the warship *Victory*, which was to be launched in 1765 and was later to become Nelson's flagship, and this still survives at Kedleston, together with four of his marble chimneypieces. This maritime theme was to survive in the decoration of the drawing room—despite the arrival of Robert Adam on the scene in December 1758, his dismissal of Stuart's designs as "pityfulissimo," and his replacement of Spang's idea for a fresco by neo-classical grotesques and anthemia in plaster-work, with dolphins playing only a subsidiary role.

A number of drawings for the sofas by the cabinetmaker John Linnell survive in the Victoria and Albert Museum (Hayward 1980, figs. 236–240, 243), but the original conception may derive from a far more chaste neo-classical design for a settee with caryatid supports by Adam, dated 1762 and inscribed "Design of a Sofa for Lord Scarsdale, and also executed for Mrs. Montagu in Hill Street" (Sir John Soane Museum; Harris 1963, fig. 98). This early in his career, and working in a room whose main features were not of his making, the architect was evidently prepared to make a suggestion to his client, but to see it substantially altered in execution by the cabinetmaker. Not one to waste a good idea, however, Adam then offered the design to another client, Mrs. Montagu (the original "blue-stocking") who had a pair made for her London house— one of which appears to survive in the Philadelphia Museum of Art.

Linnell's drawings for the Kedleston sofas show a gradual move away from Adam's original idea to an altogether more baroque, *mouvementé* composition, reminiscent of the work of the great Venetian carver Andrea Brustolon. Horace Walpole, as so often, put his finger on it when he described them in

1768 as "settees supported by gilt fishes and sea gods absurdly like the King's coach" (Toynbee 1927–1928, 64). George III's famous coronation coach was designed by Sir William Chambers and carved by Joseph Wilton in 1760, but at the same time Linnell had produced a rival proposal for it, also decorated with triton and mermaid caryatids; significantly, he dedicated his engraving to Lord Scarsdale (Hayward 1980, fig. 148). The use of palms, found in both versions of the coach, is also reminiscent of the design of the state bedroom furniture at Kedleston, composed entirely of palm trees and their branches, and again more likely to have come from Linnell's drawing board than Adam's.

"Tho very magnificent I think these frames rather too heavy," wrote the

Duchess of Northumberland on seeing the settees in 1766. Over two hundred years later, one is more apt to share the excitement of Samuel Wyatt who, as executant architect, supervised the unwrapping of the first one to arrive in August 1765. "The sofa arrived safe," he reported to Lord Scarsdale, "and it is certainly as elegant a piece of furniture as ever was made and as well executed. The gilding is by far the best done of any I ever saw, [and] it suits the place in point of size well" (Hardy and Hayward 1978, 265–266). G.J-S.

Literature: DEF 1954, 3: 96, fig. 57; Harris 1963, 89–91, fig. 101; Hardy and Hayward 1978, 262–266, figs. 1, 8; Hayward 1980, 21–22, 60–61, 111, figs. 241–242, 244–247

195

PAIR OF GIRANDOLES
English, after a design by
Thomas Chippendale 1718–1779
giltwood
144.8 × 68.5 (57 × 27)

Plas Newydd
The Marquess of Anglesey

As the hours for dinner and supper grew later in the eighteenth century, and evening entertainments became more frequent, the demand for sconces, girandoles, and appliqué wall-lights increased, giving rococo furniture designers the excuse for some of their wildest flights of fantasy. Compared with some of the concoctions illustrated in Matthias Lock and Henry Copland's *New Book of Ornaments* of 1752 or Thomas Johnson's *Collection of Designs* of 1758, where natural forms combine in riotous contortions with but little attempt at perspective, these girandoles are controlled and elegant, examples of what Hogarth called the "serpentine line of beauty." In his preface to the third edition of *The Gentleman and Cabinet-Maker's Director* of 1762, Thomas Chippendale concluded "Upon

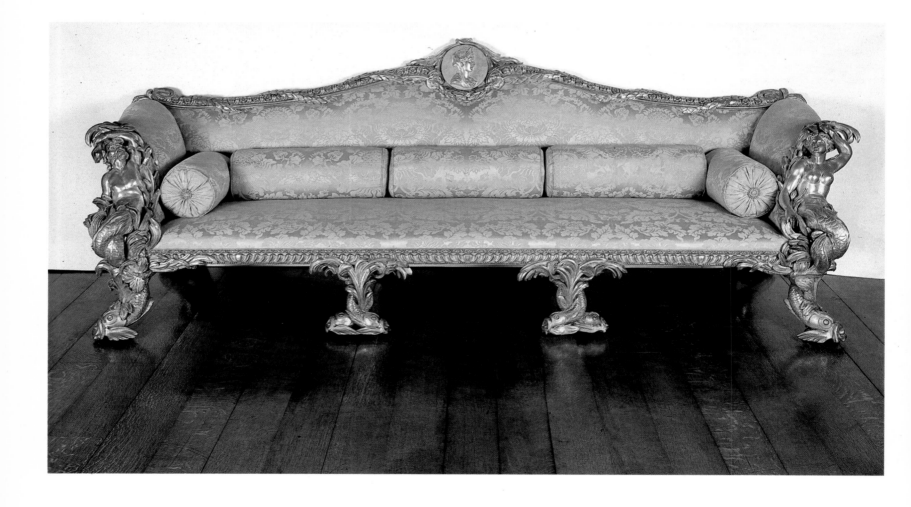

the whole, I have here given no Design but what may be executed with Advantage by the hands of a skilful Workman, though some of the Profession have been diligent enough to represent them (especially those after the Gothick and Chinese Manner) as so many specious Drawings, impossible to be worked after by any Mechanick whatever."

The design of these girandoles is taken from plate 178 of this edition. Indeed, it would be hard to find a more literal translation of any of Chippendale's designs, the anonymous "skilful Workman" having more commonly borrowed crestings, finials, and drops from several plates at a time. The only minor departure is the balustrade; while the design preserves this one "architectural" element, even this has been dissolved in the finished work into a row of vestigial S-scrolls. Other surviving girandoles are more or less closely derived from this engraving, including the pair formerly at Woodcote Park, Surrey (and now in the Woodcote Park Room in the Museum of Fine Arts at Boston) and another pair on the London art market in 1967 (archives of the Department of Furniture and Woodwork, Victoria and Albert Museum).

Plas Newydd (New Place in Welsh), overlooking the Menai Straits between the Isle of Anglesey and the mainland of Wales, owes its present castellated appearance to Sir Nicholas Bayly, Bart. and his son, who became Lord Paget of Beaudesert and, in 1784, Earl of Uxbridge. By the early nineteenth century the house had been completely remodeled by James Wyatt, working in his Gothic style, and the Lichfield architect, Joseph Potter.

More recently, in the 1930s, the 6th Marquess of Anglesey (heir to the title originally won on the field of Waterloo) employed Rex Whistler (see no. 575) to decorate a new dining room on the ground floor with *trompe l'oeil* harbor scenes, which mirror the actual view of the Menai Straits. It was probably the 6th Marquess who acquired these girandoles for Plas Newydd, where they hang in Lady Anglesey's Bedroom, also redecorated in the 1930s by Sibyl Colefax. G.J-S./J.M.M.

Literature: Edwards 1955, 244

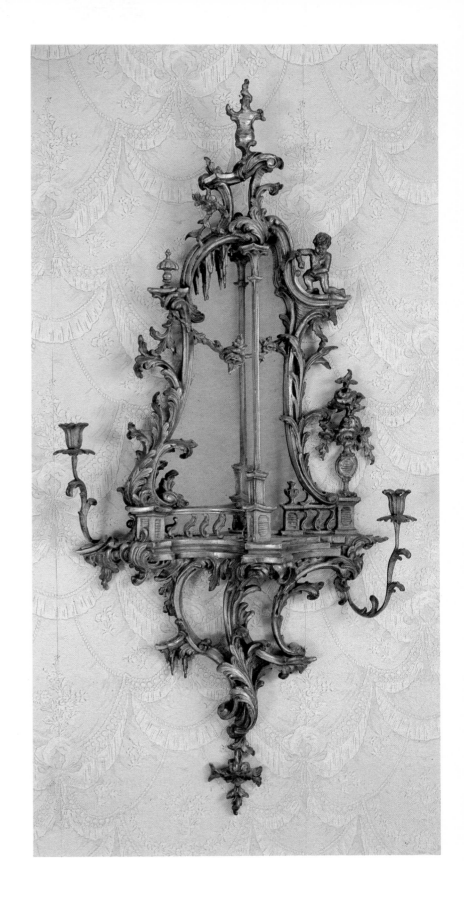

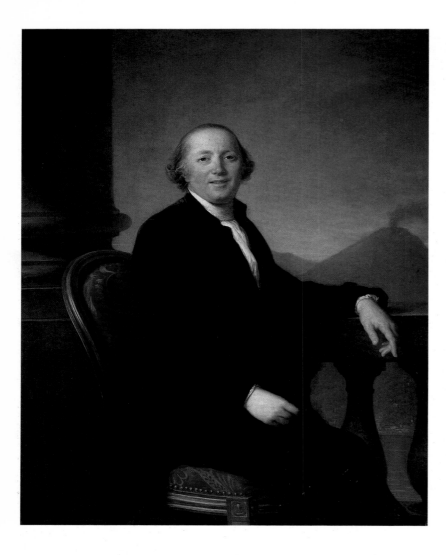

196

FREDERICK AUGUSTUS HERVEY,
4TH EARL OF BRISTOL 1790
Elizabeth-Louise Vigée Le Brun
1755–1842
oil on canvas
100.3 ×74.9 (39½ ×29½)
signed and dated, *L.E. Vigeé le Brun
1790*

Ickworth
The National Trust (Bristol Collection)

Traveler, builder, and patron of the
arts, the 4th Earl of Bristol (1730–1803)
was during the course of his capricious
and eccentric life, a focus of attention.
Ironically, while his travels are com-
memorated by the many hotels through-
out Europe that bear the name of Bristol

and his buildings by the highly
individual monument of Ickworth
(Downhill in Northern Ireland is in
ruins), what should have been his most
magnificent legacy—his collection of
works of art—has disappeared almost
without trace. In this portrait he is
seated on a terrace, with Vesuvius in
the background. He appears affable and
convivial, a state no doubt stimulated
by his daily exercise ascending the
volcano.

Frederick Augustus, fourth son of
Lord Hervey (see no. 176), succeeded
his brother the admiral (see no. 483) as
4th Earl of Bristol in 1779 and in 1798
inherited the barony of Howard de
Walden. By his wife, Elizabeth, daughter
of a Suffolk neighbor Sir Jermyn Davers,
4th Bart., he was the father of the future

Marquess of Bristol and of Lady Elizabeth
Foster, the famous beauty, whose second
husband was the 5th Duke of Devonshire.
As a younger son, the 4th Earl entered
the church and was consecrated Bishop
of Derry in 1768. This preferment may
have been due to nepotism, for his
brother the 2nd Earl was at this time
Lord Lieutenant of Ireland—"a man
whose stately manners and delicate
form," according to Horace Walpole,
"were ill-adapted to please so rude and
turbulent a people as the Irish."
However, the bishop carried out his
responsibilities with generosity and
tolerance, taking up residence in his
see, unlike many other absentee clergy.
It is, however, less for the discharge
of these episcopal duties that he is
remembered than for his activity as a
collector and patron, an activity that
by 1792 had become an insatiable pre-
occupation with a didactic purpose.

In March of that year he wrote to his
daughter Lady Erne: "My own collection
is forming from Cimabue thro' Raphael
and delicious Guido down to Pompeio
Battoni, the last of the Italian school—
and in Germany from Albrecht Durer's
master down to Angelica—but I have
no good Rafael, nor any satisfactory
Guido, but a Correggio that is invaluable
and two Claudes . . ." (Hervey family
MSS, Ickworth, quoted in Childe-
Pemberton 1925). In a letter to Sir
William Hamilton on 26 January 1798,
it is clear that he was not particularly
interested in the early pictures except
as illustrations of the didactic theme
that he was pursuing: "they are chiefly
Cimabue, Giotto, Guido da Siena, Marco
da Siena and all that old pedantry of
painting which seemed to show the
progress of art at its resurrection"
(Hervey MSS, as above). Two months
later Lord Bristol was arrested by the
French and confined at Milan, and his
entire collection was confiscated.

Shortly afterward he wrote to his
daughter Elizabeth, describing the extent
of his collection—mosaic pavements,
"sumptuous" chimneypieces, and old
masters "without end" . . . "first rate
Titians and Raphaels, dear Guido's, and
three old Caraccis—Gran Dio che tesoro"
(Hervey MSS, as above). During his
captivity in Milan the artists of various
nationalities in Rome joined in sending a

remonstrance (there were 343 signatures)
to Haller, the administrator of the
finances of the Republican armies in Italy,
asking that the collection be restored to
their patron. It was finally redeemed
for £10,000 under an arrangement with
the Directory. Within a week of pay-
ment the collection was again plundered,
but probably only part of it was lost on
this occasion. In 1797 the Earl Bishop
had written to William Roscoe (whose
gift of early Italian pictures is now in
the Walker Art Gallery, Liverpool),
offering him any statues, books, or
pictures that he might like; and in 1802,
Roscoe, in a letter to his wife, remarked
of certain purchases that they were "as
usual part of Lord Bristol's celebrated
importation" (Compton 1960, 27).

That Lord Bristol was continuing to
buy pictures as late as 1802 is clear
from the export records of that year
(Ashby 1913, no. 8). Sadly, however,
his intention to establish a gallery in
the rotunda at Ickworth, the vast neo-
classical mansion that he planned in
consultation with his architect Francis
Sandys (and which was never finished
in his lifetime), with a view to providing
an historical and didactic survey of the
history of European painting, was never
to be fulfilled. Only the bas-relief
decorations on the exterior, designed
by Flaxman, remain as a symbol of his
patronage.

Madame Vigée twice painted Lord
Bristol: first in Rome in 1789 and a year
later, the present picture, in Naples. In
her memoirs (1867, 1:193) she mentions
"un nouveau portrait de Lord Bristol
que je retrouvai à Naples et dont on
peut dire qu'il passait sa vie sur le
Vésuve, car il y montait tous les jours."
Vesuvius was also chosen as a back-
ground by Angelica Kauffmann for
her portrait of the 2nd Viscount
Palmerston at Broadlands, painted in
1764. Its appearance here is particularly
appropriate, as Sir Brinsley Ford has
observed (1974, 430), for in addition to
his interest in volcanoes, this energetic
cleric caused eruptions wherever he
went. ST.J.G.

Provenance: See no. 176
Literature: Helm 1915, 114, 189–190
Exhibitions: London, RA 1960 (180),
and 1968 (712); Chicago 1981 (57)

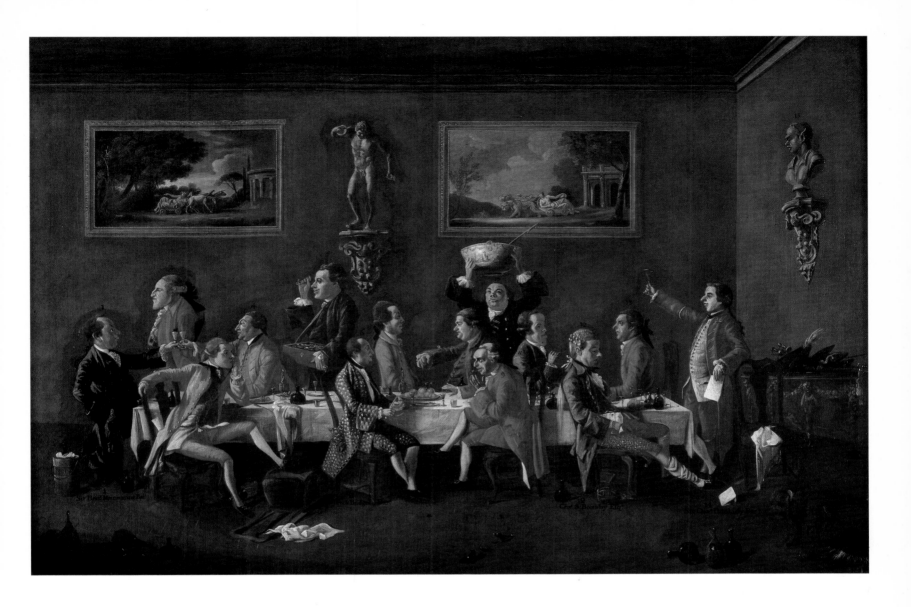

197

A PUNCH PARTY: A CARICATURE
GROUP WITH LORD GREY 1760
Thomas Patch 1725–1782
oil on canvas
114.3 ×172.7 (45 ×68)
signed and dated, *FLORENCE 1760*
PATCH PINXIT; inscribed with names
of sitters

Dunham Massey
The National Trust (Stamford
Collection)

The fourteen figures are designated by numbers and are identified as follows: *1 Sir Hen^y Mainwaring Bart 2 Earl Cowper 3 Visc^t Torrington 4 Rev^d Jona^n Lypyeatt 5 Lord Grantham 6 Sir Brook Bridges Bart 7 Ja^s Whyte Esq^r 8 Jacob Houblon Esq^r 9 Earl of Moray 10 Mr Hadfield the landlord 11 Earl of Stamford 12 Chas. S. Boothby Esq^r 13 Sir John Rushout Bar^t 14 Sir Cha^s Bunbury Bar^t*. On the wall at the right the artist has introduced a caricature bust of himself with the ears of a faun. That the inscribed names were added later for Lord Stamford is evident from the fact that at the time the group was assembled neither he (then Lord Grey),

Moray, nor Grantham had succeeded to their titles.

Thirteen men of fashion are engaged in various activities around a table— one, Lord Grantham, is carrying a peddler's tray filled with cameos from which Lord Grey has evidently acquired the example he wears on his finger. But their principal concern is with drinking the punch provided by the innkeeper, Charles Hadfield. The spirit of the party is echoed by the furnishing of the room: on the wall hang paintings of *Bacchus* and *Silenus* and between them is a replica of the *Dancing Faun* in the Uffizi, standing, as does the bust of Patch, on a socle

decorated with the Medici arms.

Hadfield's inn was known as Carlo's and was near Santo Spirito on the left bank of the Arno. It flourished as a fashionable meeting place for the English visitor in Florence until Hadfield's death in 1776, after which it was carried on by his widow.

Lord Grey made his tour of Italy, in company with his friend and country neighbor Sir Henry Mainwaring, in 1760. Before arriving in Florence they were painted together in Rome by Nathaniel Dance. (A miniature copy of 1760 by Teresa Mengs, but not the original, is at Dunham Massey today.) Their

appearance in the present work suggests that they shared a certain degree of artistic enterprise, for this is the earliest known of Patch's caricature groups of Anglo-Florentine society, "of high sociological, though not very high artistic, interest" (Waterhouse 1981, 269). Patch had arrived in Florence, after an enforced departure from Rome, in 1755. Here he painted views of the city, formed an appreciation of early Italian painting (selecting examples to engrave), and found his chief market in the type of caricature group for which Reynolds had set a precedent. Thereafter he was to fulfill a consistent demand, catering in a coarse style and in his own particular vein of ribald humor and fancifulness to this aspect of eighteenth-century taste—which, since the Dunham Massey picture is merely referred to as a "caricature" in a nineteenth-century inventory, may have met with the disdain of a later generation. ST.J.G.

Related Works: A second work by Patch, the companion to this picture, is a depiction of four Englishmen of eccentric appearance—Lord Stamford, Sir Henry Mainwaring, and two friends, who have just disembarked at Pola after having made the crossing from Venice.

Provenance: Presumably commissioned by, or acquired by, Lord Grey in Florence in 1760 (who succeeded as 5th Earl of Stamford in 1768); the Earls of Stamford until the death of the 10th and last Earl in 1976 when Dunham Massey and its contents passed by bequest to the National Trust
Literature: Watson 1940, 32, no. 1 pl. 9
Exhibitions: London, RA 1960 (183); Manchester 1960 (229)

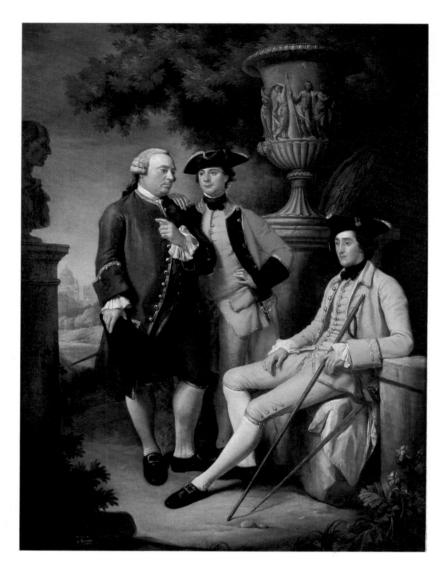

198

CHARLES, LORD HOPE, THE HON.
JAMES HOPE, AND WILLIAM ROUETT
1762
Nathaniel Dance 1735–1811
oil on canvas
96.5 × 72.4 (38 × 28½)

Hopetoun House
The Earl of Hopetoun

Charles, Lord Hope (1740–1766), elder son of the 2nd Earl of Hopetoun, and his younger brother James, later 3rd Earl (1741–1816), who wears the uniform of the 3rd (Scots) Guards, are shown with their tutor, the Reverend William

Rouett, who had been professor of Oriental Languages and Church History at Glasgow. In the background is the dome of Saint Peter's.

Unlike so many of the English portrait painters of his generation Dance was brought up in an artistic milieu, for his father, George Dance the elder, was a successful architect. Nathaniel arrived in Rome in May 1754 and was in Italy for almost a dozen years, studying and building up a connection with English travelers that would later stand him in good stead. By 1758 he was in a position to secure a first commision for the Scottish architect Robert Mylne and was also "acquainted with my Lord

Brudenell" (see no. 173) "and all the English Cavaliers in Rome" (Ford 1960, 51). While still in Rome in the early 1760s, Dance painted a pioneering neo-classical work, now lost, *The Death of Virginia,* and three pictures of subjects from the *Aeneid.* He also made a series of Grand Tour conversation pieces elaborated from patterns evolved by his first master Francis Hayman, but of a more classical character. These include the *Earl of Stamford and Sir Henry Mainwaring* of 1760 (see under no. 197; private collection); *Sir James Grant of Grant with Mr. Mytton, the Hon. Thomas Robinson and Mr. Wynn* (prime version at Cullen); *Lord Warkworth and the Rev. Jonathan Lippyatt* of 1763 (Alnwick); and *William Weddell with His Servant and the Rev. William Palgrave* (National Trust, Upton). The urn in the Hopetoun picture was also used for the Warkworth portrait. The two are notably similar in execution, echoing Dance's experience of Batoni, for whose portrait of George Craster of Craster he had supplied the pendant in 1762.

The Hope brothers were committed patrons of Dance, who also painted full-length portraits of both in 1763 that have always been at Hopetoun ([Goodreau] 1977, figs. 3 and 4). James Hope is also shown in the uniform of the Scots Guards, which he had entered in 1758, with the Temple of the Sybil at Tivoli in the distance, while Lord Hope is seen with his setter and spaniel on a sporting expedition near an aqueduct in the Campagna. The Hopetoun pictures were no doubt commissioned after the brothers returned to Rome from Naples in January 1763. On the 15th of that month they dined with James Adam, the younger son of William Adam, who was first employed at Hopetoun by the 1st Earl in 1723, and whose brother Robert had himself traveled in Italy with their uncle, the Hon. Charles Hope. Their decision to be painted in Rome was no doubt influenced by the fact that his uncle had sat for Mengs (the portrait is now lost) while their great uncle, the 2nd Marquess of Annandale, who collected many of the paintings still at Hopetoun in Italy in 1718–1720, had been painted by Andrea Procaccini. This portrait group was evidently painted for, or for presentation to, Rouett, who

owned land at Auchindrennan and lived at the house he renamed Bel Retiro on the west shore of Loch Lomond. F.R.

Provenance: William Rouett of Auchindrennan; his daughter Louisa, first wife of Admiral John Rouett Smollett (d. 1842); and by descent through the latter's son by his second marriage, Alexander Smollett of Bonhill to Major P.T. Telfer Smollett, MC, DL, of Bonhill; his sale Christie's, 13 March 1970, lot 78, where bought by Leggatt for Lord Hopetoun
Literature: Fleming 1962, 286, 375; [Goodreau] 1977 [3–6]
Exhibitions: Glasgow 1911; Helensburgh 1954 (19); London, RA 1960 (145); London, RA 1968 (7)

199

LOUISA GRENVILLE, LATER COUNTESS STANHOPE 1761
Pompeo Batoni 1708–1787
oil on canvas
104.2 ×67.3 (41 ×26½)
inscribed, *Louisa Grenville / Pompio Battone / pinxit / Roma* on the reverse of the original canvas, relined in 1934

Chevening Park
The Trustees of the Chevening Estate

Louisa Grenville (1758–1829) was the only child of the Hon. Henry Grenville (1717–1784), 4th son of Hester, Countess Temple. In 1781 she married Charles Stanhope, Viscount Mahon, later 3rd Earl Stanhope. Lord Mahon had previously married her first cousin Hester, daughter of William Pitt, 1st Earl of Chatham by his wife, Lady Hester Grenville. In 1761 Grenville was appointed ambassador to the Porte at Constantinople and traveled to the Levant by way of Italy. This portrait is first mentioned in a letter of 27 November 1761 from the *cicerone* Thomas Jenkins to Sir Henry Mainwaring, for whom he had acted in Rome: "Pompeo Batoni has made a pretty Picture of Miss Grenville, its intended for Lord Temple" (Dunham Massey MSS).
 Portraits of children are rare in Batoni's oeuvre, and the Chevening portrait was an independent commission in that neither of Louisa Grenville's

parents sat for the artist. In this respect it was unlike that of John Damer at Drayton, painted about 1750 *en suite* with portraits of his parents, Joseph Damer, later 1st Lord Milton and 1st Earl of Dorchester, and Lady Caroline Damer (L.G. Stopford Sackville, Esq., Drayton). The three-year-old girl, whose height and mature appearance belie her age, no longer wears an infant's frock but is attired in a costly dress of apricot silk. She holds a terrier puppy that had presumably been brought with the family from England. The beautifully controlled tonal scheme anticipates two of Batoni's most successful portraits of Englishwomen, *Georgiana, Countess Spencer* of 1764 at Althorp, and *Lady Mary Fox* of 1767 at Melbury. The exceptional frame, which suggests the importance the family attached to the picture, was supplied after it had reached England.
 In 1786 the sitter's husband, who was painted in turn by Ramsay, Liotard, Prud'hon, and Gainsborough, succeeded his father at Chevening, the Jonesian house remodeled after the 1st Earl acquired it in 1715. Stanhope was at first a political adherent of his cousin and brother-in-law by his first marriage, to William Pitt the younger, but he later became an enthusiastic advocate of revolutionary France. He inherited his father's scientific bent.
 Between 1786 and 1796 the main block of Chevening was recased with the assistance of Wyatt, but evidently on lines laid down by Stanhope himself; their alterations were swept away in the recent restoration. By 1859 the Batoni already hung in its present place in the recess of the drawing room. F.R.

Provenance: Painted for, or for presentation to, the sitter's uncle Richard Grenville, 2nd Earl Temple (1711–1779); presumably returned to the sitter, and by descent through the issue of her husband, Charles, 3rd Earl Stanhope by his first marriage, to the 7th Earl Stanhope, by whom Chevening was bequeathed to a private charitable trust (the house is now an official residence of the Foreign Secretary)
Literature: Chevening 1859, 10; Clark 1985, no. 238
Exhibitions: London, Agnew's 1963 (40); London, Kenwood 1982 (15)

200

COAST SCENE: EVENING 1751
Claude-Joseph Vernet 1714–1789
oil on canvas
97.4 × 134.6 (38½ × 53)
signed and dated, *Joseph Vernet f Romae 1751*

Uppark
The National Trust
(Meade-Fetherstonhaugh Collection)

This picture and no. 201 belong to a set of four coastal views, each representing a different time of day. Together with two *River Landscapes* that are at Uppark today, they are presumably the paintings commissioned from the artist by "M.Latheulier Anglois" in 1751. They are recorded in Vernet's *Livre de Verité* ("Commandes Ouvrages qui me sont ordonnez"): "Pour M.Latheulier Anglois six tableaux toile d'empereur. Quatres doivent representer des sujets de marines et les quatres

parties du jour; les deux autres des paysages avec des cascades, etc.; le prix est de trois cents ecu romains chaqu'un promis pour la fin d'avril 1751."

This "M. Latheulier" must be Benjamin, brother of Sarah Lethieullier who married Sir Matthew Fetherstonhaugh of Uppark. A year later Sir Matthew, no doubt influenced by his brother-in-law, himself ordered from Vernet a further set, "deux marines et deux paysages à ma fantasie" for completion by July 1752. These are no

longer at Uppark, if they were ever there, and Vernet's preoccupation with his final return from Rome to France in 1753 may have prevented him from honoring his commission. What are preserved in the house are copies by Vernet's talented pupil Lacroix de Marseilles of four paintings from the Lethieullier series, dated 1751. So exact are these copies in every detail of brushwork that were it not for the signatures it would be impossible to distinguish them from the master's works.

Sir Matthew bought Uppark in Sussex in 1747 and two years later he set out on a prolonged Grand Tour with his new wife. The pictures he bought on this journey form the nucleus of the collection, which still remains in the house. Among his most felicitous acquisitions was the set of early portraits (1750–1751) by Batoni of himself, his wife, and various relations who had evidently traveled with him or had joined him in Rome. "No tolerable pictures," remarked Horace Walpole when he visited Uppark in 1770. What could have been the cause of so crabbed a response on the part of this enlightened visitor? For Uppark, which is not a large house, contains a collection of predominantly Italian pictures that in proportion to its size is unsurpassed. In this discreetly beautiful setting, mellowed but hardly changed by time, the contents today are much the same as they would have been in 1770. St.J.G.

Provenance: Painted for Benjamin Lethieullier, and presumably at Uppark from an early date; by descent until 1965, when the picture was acquired by H.M. Treasury in partial payment of death duties and transferred to the National Trust
Literature: Ingersoll-Smouse 1926, 1: 61, nos. 330–331
Exhibitions: London, Kenwood 1976 (30, 31)

201

SHIPWRECK: MIDDAY 1751
Claude-Joseph Vernet 1714–1789
oil on canvas
99.1 × 134.6 (39 × 53)
signed and dated, *Joseph Vernet Roma 1751*

Uppark
The National Trust
(Meade-Fetherstonhaugh Collection)

This is the pendant to the *Coast Scene: Evening* (no. 200), from a set of four marine views at Uppark, and is considered in the entry for that picture.
St.J.G.

Provenance, etc: See no. 200

CASKET ON STAND c.1741–1754
Grand Ducal workshops, Florence; the
stand attributed to William Vile
d.1767
casket of ebony with panels of *pietre
dure* mounted in ormolu and encrusted
with semiprecious stones; stand made
of pine, gilded
casket: 30 × 44.5 × 38.6 (11$\frac{3}{4}$ × 17$\frac{1}{2}$ × 15)
stand: 79 × 56 × 53 (30$\frac{3}{4}$ × 22 × 20$\frac{3}{4}$)

The Vyne
The National Trust (Chute Collection)

John Chute (1701–1776) was the tenth
and youngest child of Edward Chute
and Katharine Keck, and the great-
grandson of Chaloner Chute, Speaker of
the House of Commons, who purchased
The Vyne in Hampshire in 1653, and
who commissioned Inigo Jones' pupil
John Webb to design the first Palladian
portico built onto an English house.
John inherited this taste for Italian
architecture to the full, and was later to
design a new staircase behind Webb's
portico based on the theater designs of
the Bibiena family (McCarthy 1975–
1976, 75–77). But as a younger son he
initially saw no prospect of inheriting
The Vyne and from 1722 to 1754 lived
principally abroad. It was while staying
with Horace Mann, the English Consul
in Florence, between 1741 and 1745
that Chute made friends with Horace
Walpole and the poet Thomas Gray,
later becoming a member of the Straw-
berry Hill "Committee of Taste," and
it must have been at this period too
that he acquired the *pietra dura* casket.

By the death of Anna Maria
de'Medici in 1743, the golden age of
Florentine craftsmanship had passed
and the Grand Ducal workshops had
been dismantled, with the sole exception
of the Opificio delle Pietre Dure, which
continued to produce cabinets, reli-
quaries, and jewel caskets in a baroque
style that had hardly changed since the
late seventeenth century. The panels of
the casket at The Vyne, its ormolu
mounts, and the fruits carved in the
round in the concave molding of the
lid, are directly comparable with designs
by the last great director of the work-
shops, Giovanni Battista Foggini (for
instance a *pri-dieu* of 1706; Detroit and
Florence 1974, 194). Florentine *pietra
dura* was highly prized by the more
discerning English milords on the Grand
Tour, and some spectacular acquisitions
were made, including the so-called
"Sixtus V Cabinet" at Stourhead pur-
chased by Henry Hoare II, and the table
from the Villa Borghese bought by
William Beckford for Fonthill, and now
at Charlecote Park.

Writing from Rome after the death
of his brother Francis in 1745, John
Chute was "not able to find the least
comfort in being one horrid step nearer
to a mouldering estate" (Lewis 1973,

35, 58). However, he seems to have
been on good terms with his last sur-
viving brother Anthony until 1751
(when they quarreled seriously) and it
seems likely that this casket was sent
back to The Vyne as a gift from him in
the late 1740s. In 1752, two years before
Anthony Chute's death and John's suc-
cession, the cabinetmaker William Vile
was paid seventeen shillings "for repair-
ing a stone cabinett" at The Vyne and
it is thought that he also supplied the
carved and gilt rococo stand, which is
of the highest quality (Coleridge 1963,
215).

Vile and his partner, the upholsterer
John Cobb, had premises near Chippen-
dale's on the corner of Saint Martin's
Lane and Long Acre from 1750 to 1765
(Heal 1953, 189), supplying many pieces
to the Royal Household, as well as to
Strawberry Hill and The Vyne over a
number of years. The superb quality of
Vile's carving and the individual char-
acter of his designs can be appreciated
in the horned satyrs' heads on this
stand. These obviously derive from the
diminutive ormolu corner mounts on
the casket, and the trellis and floral
garlands all contribute to an outdoor
"garden" theme that is at the heart of
English rococo design. G.J-S.

Related Works: A similar stand for a
lacquer casket, also attributed to William
Vile, is in the Earl of Radnor's collec-
tion at Longford Castle (Coleridge
1968, fig. 26)
Provenance: Casket purchased by John
Chute c.1741–1745, and by descent;
bequeathed by Sir Charles Chute, Bart.,
to the National Trust in 1956
Literature: Coleridge 1963, 214–216,
fig. 1
Exhibitions: Brussels 1973 (144);
Wildenstein 1982 (65)

203

MEDAL CABINET IN THE FORM OF A
TEMPLE c.1765
attributed to George Sandeman
1724–1803
mahogany, the exterior veneered
in broomwood
58.4 × 58.4 × 67.3 (23 × 23 × 26½)

Blair Castle
The Duke of Atholl

James Murray (1729–1774), the son of
the attainted Jacobite general Lord
George Murray, may have spent some
time in Italy before his marriage to his
cousin Charlotte in 1753. His brother,
Captain Murray RN, was taken to see
the Grand Duke's apartments in Flor-
ence by Sir Horace Mann in 1765 (infor-
mation kindly supplied by Sir Brinsley
Ford). James succeeded his uncle (and
father-in-law) as 3rd Duke of Atholl in
1764, and later commissioned the famous
Zoffany family group (no. 327). Earlier,
in 1758, he commissioned a remarkable
bureau-bookcase veneered in broom-
wood from a furniture maker in Perth
named George Sandeman. Murray called
this his "Plantaginet Cabinet," doubt-
less a reference to broom, whose generic
name is *planta genista*, the badge of the
House of Plantagenet; but it was also
the ancient badge of his own family,
and this explains why he later com-
missioned Sandeman to make a whole
suite of furniture for Blair Castle in this
unusual wood, including two card
tables and a fire screen, which still
survive (Coleridge 1968, 158–160, figs.
404–406).

A peculiarity of the documented
bureau-bookcase is its "secret" built-in
medal cabinet, which pulls out between
the pigeonholes (Coleridge 1968, fig.
405). Murray's collection of coins and
medals, which he may have begun in
Italy, obviously outgrew this compara-
tively modest nest of drawers and he
must have returned to the cabinetmaker
in the following decade to request a
larger one. This was made in the form
of a temple, with a portico based on one
of the most familiar sights of the Roman
Forum, the Portico of Octavia, other-
wise known as the Temple of Septimius
Severus (see no. 183)—a source also
used by Robert Adam in 1761 for his

remodeled entrance front of Osterley
Park. The façade pulls forward on
runners to reveal a mahogany interior
with tiers of small drawers lined with
baize, and of exactly the same form
as those in the bureau bookcase. The
Venetian windows on the sides of the
cabinet are more conventionally Pallad-
ian, but the same combination of fea-
tures occurs for instance on the front of
Penicuik House, designed by Sir John
Clerk probably with the help of James
Adam in 1761. Sandeman, who is re-
corded as having been in London in
1749, may well have been given draw-
ings by an architect to work from, but

his technical skill—for instance in the
tesselated pavement under the portico
—shows how accomplished provincial
cabinetmakers could be at this date. No
bill for the temple survives but James
Cullen was paid £1.19.6 in 1771 for
"polishing and repairing and fixing a
new lock and key to a Temple Cabinet,"
which suggests that it had been made
some years earlier (Blair Castle MSS).

The collecting of cameos and intag-
lios, coins and medals, was an important
aspect of Grand Tour taste, though few
now survive in the houses for which
they were intended. Sir Rowland Winn
commissioned Chippendale to make an

elaborate coin cabinet in the library at
Nostell Priory in 1767, soon after his
Grand Tour, and William Vile also made
a celebrated cabinet inlaid with ivory
for George III's collection in 1761
(London, V & A 1984, L60). However,
the Atholl cabinet sums up, better than
any other, that passionate interest in
the antique world that lay behind the
study of such small but precious
objects. G.J-S.

Literature: Coleridge 1960, 100, 101

204

PORTRAITS OF LOUIS XII AND ANNE
OF BRITTANY c.1500
French
sardonyx cameo in gold pendant
2.8 × 1.8 (1⅜ × ¾)

Chatsworth
The Trustees of the Chatsworth
Settlement

This double-sided sardonyx cameo
bears on its obverse a portrait of Louis
XII of France (1462–1515) wearing a
crown over his cap, and the collar of
the Ordre de Saint Michel over his robe.
On the reverse is a portrait, also carved
from the white layer of the sardonyx, of
Anne of Brittany (1477–1514) whom
he married in 1499. She wears a coronet
over her veil, and a pearl choker and
gold collar with a pendant. Both por-
traits relate to the gold medal by Nicholas
Leclerc (active in Lyons 1487–1507)
and Jean de Saint Priest (active in Lyons
1490–1516), presented by the City of
Lyons to Queen Anne when she entered
it for the second time in 1500, and also
reproduced in bronze (compare Hill
and Pollard 1967, 527).

French royal portraiture on gems can
be traced back to the thirteenth century
when portraits of rulers were engraved
for use as seals (Boardman and Scaris-
brick 1977, no. 187, chalcedony intaglio
head). This art continued to flourish
under the patronage of Charles V and
his brothers, who commissioned numer-
ous masterpieces (compare Kagan 1973,
no. 12, cameo portrait of Charles VII).
Such heads of kings and queens, indi-
vidually executed in precious materials
by the exacting technique of gem en-
graving, are the post-classical counter-
parts of the portraits of the rulers of
antiquity. As such, they were highly
prized by British collectors in the
eighteenth century as an accompani-
ment to antique cameos and intaglios
acquired on the Grand Tour. D.S.

Related Works: Portraits of Louis XII:
Fortnum 1877, 13, ruby cameo, and
Kagan 1973, no. 22, sardonyx cameo;
double-sided cameo portraits: Dalton
1915, nos. 336, 367, identified as
François I of France and his wife,
Eleanor of Portugal
Provenance: Not recorded in Natter's
1761 catalogue of the Devonshire cabi-
net; possibly acquired by the 6th Duke
of Devonshire; and by descent.
Exhibitions: London, SKM 1873, 104
(344)

205

DUKE LUDWIG X OF BAVARIA 1538
German
chalcedony cameo in silver pendant
2.7 × 2.8 (1 × 1⅛)
inscribed, *LH,* and dated *1538*

Chatsworth
The Trustees of the Chatsworth
Settlement

This double-sided chalcedony cameo
bears on its obverse a portrait of
Ludwig X (1495–1545) who succeeded
as Duke of Bavaria in 1516, bearded,
wearing a cap and fur-lined coat, and
facing in profile toward the right, with
a lion clasping him round the shoulder.
The reverse is an amulet, with a
Tau cross cameo inscribed across the
arms with the magical formula
ANANISAPTA DEI; on the upright,
EMMANUEL; and as a continuous band
within the outer strap, *IHS TETHA-
GRAMMATHON 1538.* Below the arms
of the cross the initials *LH* probably
stand for Ludwig Herzog. The portrait
of Duke Ludwig corresponds with that
on a medal struck in 1536 (Hill and
Pollard 1967, no. 600), and the lion is
the heraldic emblem on the Wittelsbach
family, hereditary rulers of Bavaria.
Because of its use in the early Christian
church as a consecration cross, the Tau
form was considered a particularly
powerful symbol, and this belief was
reinforced by the text from the Vulgate,
Ezekiel IX: 4, where the elect are identi-
fied by the sign of the Tau on their
foreheads. Each of the words of the
inscription has its own magical prop-
erty, *ANANZIPATA* being a charm
against falling sickness; *IHS,* the Greek
monogram of the name Jesus; and
TETRAGRAMMATON (with its
various spellings) a cabalistic word of
power signifying the name of Jehovah.
The latter two words both protected
the wearer from sudden death. The
stone, chalcedony, also had its intrinsic
apotropaic significance and was believed
to bring victory. Joan Evans (1922),
discusses all these aspects of magical
gems, inscriptions, and symbols of their
survival beyond the Renaissance, quot-
ing Jacob Wolff's *Curiosus Amuletorum
Scrutator,* published in Frankfurt in
1693, which illustrates (page 182) a
Tau cross amulet with inscription,
similar to the one shown here, *TETRA-
GRAMMATON EMMANUEL
ANANIZAPTA DEI.* The monochrome
portrait has the effect of a grisaille
painting and its realism is proof of the
flowering of glyptics in the north at
this period and the close relationship
with the art of the medalist. D.S.

Provenance: See no. 204; recorded in the
1761 Chatsworth manuscript cata-
logue (Natter 1761, drawer 3, no. 22)

206

DOUBLE PORTRAIT, 15th century
Italian
onyx cameo in an English enameled
gold pendant
$2 \times 1.6 \left(\frac{3}{4} \times \frac{5}{8} \right)$

Formerly at Castle Howard
Private Collection

This onyx cameo shows two heads, one of a man seen from the side and another of a woman facing toward the front, as if viewed from a window. His curly hair is fastened in a band tied at the back; her smooth ringlets fall down to the shoulders and she wears a dress with a collar and necklace. The sixteenth-century setting is a plain gold rim linked by four small white enamel rectangles to an outer frame. The frame is enameled with black chevrons divided by four green rectangles simulating emeralds. This design is repeated on the reverse with white chevrons and blue rectangles simulating sapphires, framing an enameled coat of arms: *Paly Silver and Gules a Bend Silver*, for the family of Langford. The Langfords, who lived in the counties of Derby, Leicester, Nottingham, Shropshire, and Worcestershire, were a large family, and inadequate geneaological records make it impossible to establish which branch owned this

jewel. The cameo represents a type found in other Renaissance engravings of illustrious men and women juxtaposed, for instance Alfonso Duke of Ferrara and Lucretia de'Medici (compare Babelon 1897, no. 953), who are both shown in profile. The interest of this cameo lies in the unusual pose.

Henry Howard, 4th Earl of Carlisle (1694–1758), who formed a superb collection of gems at Castle Howard, was a great connoisseur who corresponded with all the cognoscenti of Europe, exchanging sets of impressions and information. Letters still at Castle Howard from A.M. Zanetti in Venice and the dealers Belisario Amidei and Francesco de'Ficoroni of Rome describe the methods used to make aquisitions on his behalf, and the watch kept over the collections of the Roman princely families, the source of many magnificent objects. D.S.

Provenance: Langford family in the sixteenth century; 4th Earl of Carlisle, whose collection of gems was sold to the British Museum in 1890, with the exception of this and the following two pieces (nos. 207, 208), which were acquired by the present owner by private treaty from the Castle Howard Collection earlier in this century

207

CUPID TAMING THE LION 16th century
Alessandro Cesati fl. 1534–1564
sardonyx cameo in gold and diamond
pendant
$2 \times 1.7 \left(\frac{3}{4} \times \frac{5}{8} \right)$
inscribed, *ALEXAND E (POIEI)*, in
Greek letters, below groundline

Formerly at Castle Howard
Private Collection

This sardonyx cameo shows Amor, viewed from behind, as he prepares to mount a lion and grasps its mane. He is watched by two nymphs, one naked, the other clothed in fluttering draperies and holding a tambourine in her outstretched hand. The cameo is set in a late seventeenth-century style gold pendant with a molded rim; its back is "pounced" (or stippled) with overlaid acanthus leaves and the suspension loop has a diamond cluster below it.

This celebrated gem by Alessandro Cesati, who followed a peripatetic career in Italy, though known as Il Grechetto on account of his birth in Cyprus, is mentioned by Giorgio Vasari in his *Lives of the Most Eminent Painters,*

Sculptors and Architects: "but far beyond all others in grace, perfection and versatility has soared Alessandro Cesati surnamed Il Greco, who has executed cameos in relief and gems in intaglio in so beautiful a manner as well as dies of steel in incavo and has used the burin with such supreme diligence and with such mastery over the most delicate refinements of his art that nothing better could be found . . . there may also be seen many other stones engraved by him in the form of cameos . . . another in which is a lion" (Vere 1912–1914, 85). This composition, which is not based on a classical model but is Cesati's own design, is proof of his creative spirit as is the eloquence with which he has utilized the five layers of the sardonyx. D.S.

Provenance: See no. 206

208

HEAD OF A GORGON first half of the
18th century
Italian
sardonyx in contemporary jeweled
pendant
$3 \times 3 (1\frac{1}{4} \times 1\frac{1}{4})$
inscribed, *DIOSK(OURI) DOU*, in
Greek letters

Formerly at Castle Howard
Private Collection

This sardonyx cameo is carved with a
mask of a gorgon, its hair standing on
end and eyes wide open in horror, within
a border of reserved black and blue
layers. It is inscribed in Greek letters to
each side of mask, *DIOSK(OURI) DOU*,
the name of a gem engraver patronized
by the Emperor Augustus. This signa-
ture on a cameo of this style is impos-
sible to accept as ancient, and O.M.
Dalton (1915, lxxii) estimates that
between fifty and sixty gems in the
collection signed with the names of the
great artists of antiquity were formerly
accepted as genuine, some of them, for
example no. 54 in that volume, inscribed
DIOSKOURIDES. The publication by
von Stosch of *Antiquae Gemmae Caelatae*
(Amsterdam, 1724), which illustrated
such signatures, stimulated the produc-
tion of forgeries. Names were sometimes
added to ancient gems, but in most
cases entirely new works were created.
The Earl of Carlisle did in fact own an
ancient intaglio signed *DIOSKOURIDES*
(ill. Vollenweider 1966, pl. 66, no. 3).
The setting is a gold rim framed in a
garland of rose buds set with pale pink
rubies and four brilliant cut diamonds,
tied at the top below the suspension
loop with a ribbon, similarly set. This
setting exemplifies the eighteenth-
century taste for color and sparkle in
jewelry applied to the framing of a
cameo of classical inspiration. D.S.

Related Works: Another cameo of the
same model is in the Metropolitan
Museum, New York (Richter 1956, no.
387)
Provenance: See no. 206

209

MELEAGER AND ATALANTA C.1550
Italian
sardonyx cameo in gold pendant
$4.2 \times 3.6 (1\frac{5}{8} \times 1\frac{3}{8})$

Chatsworth
The Trustees of the Chatsworth
Settlement

This sardonyx cameo shows the maiden
Atalanta seated on a rock covered with
drapery. The hero and huntsman Mel-
eager leans on his spear in front of her,
having been brought to her by Amor
who holds his bow in his right hand.
There are two hunting dogs to the left,
a sleeping dog in the foreground, a hunt-
ing horn at Meleager's feet, and a quiver
and the head of the Calydonian boar
beside Atalanta.

The virtuoso use of the tints of the
multilayered sardonyx gives the cameo
a pictorial quality, with the yellow
boar's head, dogs, hunting horn, and
hair, and the white figures presented
against the transparent brown ground.
The cameo is not signed, but the
smooth plasticity of the figures and the
skillful condensing of humans, animals,
and objects onto the small surface of
the sardonyx indicate that this must be
the work of a great master, probably an
Italian. It demonstrates how the Renais-
sance engraver reinterpreted themes
from mythology. The sixteenth-century
patron who commissioned this work
would have appreciated the classical
iconography as well as the allusion to
hunting, the principal sport of the ruling
class of the time. The gem is recorded
in Lorenz Natter's manuscript catalogue
of the Chatsworth cabinet (1761, drawer
2, no. 24) as "Tres bon ouvrage du
temps de Lorenzo de Medici." D.S.

Related Works: Eichler and Kris 1927,
nos. 173, 174, both cameos, and mid-
sixteenth-century Italian
Literature: See no. 220

210

YOUTH CARRYING A BULL
2nd half of the 1st century BC
Anterotos
aquamarine intaglio in later gold
pendant
$2.4 \times 1.6 (1 \times \frac{5}{8})$
inscribed, *ANTEROTOS*, in Greek
letters

Chatsworth
The Trustees of the Chatsworth
Settlement

This intaglio shows a youth, naked except for a lion's skin falling behind him, carrying a bull on his left shoulder. Since the lion's skin is an attribute of Hercules, and because of the similarity between the features of the youth and coin portraits of Augustus (63 BC–14 AD), Vollenweider (1966) suggests that this intaglio is an allegorical representation of the Emperor Augustus after the campaign in Spain. Hercules (Augustus) carries the Cretan Bull, one of the Twelve Labors as described in Horace, *Carminum*, Liber III, Ode XIV: "Caesar, O citizens, who but now was said like Hercules, to be in quest of the laurel purchased at the price of death, rejoins his household gods, victoriously returning from the Spanish shore." However, as this iconography does not occur on Roman representations of the Labors, Boardman suggests alternatives to this interpretation, pointing out that animal skins may also have been worn by mortals—Milo of Croton, the famous sixth-century BC athlete, or a processional calf carrier bringing the animal to sacrifice and feast. Anterotos, who had a shop in the Via Sacra in Rome, has succeeded in conveying the tremendous effort made by the youth as he shoulders his massive burden.

The 2nd Duke of Devonshire (1672–1729) purchased the intaglio from the Sevin collection in Paris, and the significance of the inscription had already been recognized by von Stosch (1724, pl. IX), together with others signed by engravers. The gem was noted in the manuscript catalogue of the Devonshire collection (Natter 1761, drawer 1, partition 7, no. 2, "gravure excellente") and later became even more famous through its publication by Worlidge (1764, pl. 141), and reproduction in glass by James Tassie (Tassie and Raspe 1794, no. 5754). D.S.

Related Works: Boardman 1968, no. 81
Provenance: Cabinet Sevin, Paris; though von Stosch gave this location for the gem in 1724 it had most probably entered the 2nd Duke of Devonshire's collection before this date; by descent at Chatsworth
Literature: Vollenweider 1966, 43, pl. 38, nos. 1, 3
Exhibitions: London, SKM 1873

211

GEORGE JOHN, 2ND EARL SPENCER
c.1781
Nathaniel Marchant 1739–1816
cornelian intaglio in gold brooch
2.4 × 2 (1 × ¾)
signed, *MARCHANT*, in Roman capitals

Chatsworth
The Trustees of the Chatsworth Settlement

The intaglio portrait head of George John, 2nd Earl Spencer (1758–1834), is similar to one formerly at Althorp in Northamptonshire, the home of the Spencers, and now in the British Museum (Tait 1984, no. 831). According to family tradition, the latter was a gift from Lord and Lady Lucan when their daughter Lavinia married Earl Spencer in 1781. The Spencers were patrons of Nathaniel Marchant who engraved both their portraits and other works in the Althorp collection including the portrait of William Windham, the earl's political ally, which was purchased by him at the Royal Academy Exhibition in 1795. This intaglio may have belonged to Earl Spencer's sister Georgiana who married the 5th Duke of Devonshire in 1774, or it may have been acquired by her son, William, 6th Duke of Devonshire (1790–1858). The 6th Duke made additions to the ancestral gem collection that included a cameo portrait of himself engraved in Rome by Giuseppe Girometti. The presence of this intaglio in the Chatsworth cabinet reflects family pride in the career of the 5th Duke's handsome brother-in-law.

Earl Spencer, a politician and bibliophile, was First Lord of the Admiralty in the government of William Pitt from 1794–1800 and was considered by many to have been responsible for the naval victory over Napoleon. He built up the finest private library in Europe, containing 300 volumes printed before 1501, and sixty books by Caxton, the father of English printing.

Like the great masters of antiquity, Marchant signed his work, which won him the patronage of the most aristocratic clientele and election to the Royal Academy in 1791. Miniature neoclassical portraiture of this kind was set for wear as jewelry, sometimes in signet rings, pendants, bracelet clasps, and also brooches, as here. D.S.

Literature: Forthcoming monograph on Nathaniel Marchant by Gertrud Seidmann

212

DIOMEDES WITH THE PALLADIUM
2nd half of 1st century BC
Gnaios
banded agate intaglio in gold ring
1.9 × 3.2 × 2.6 (¾ × 1¼ × 1⅛)
inscribed, *GNAIOS*, in Greek letters

Chatsworth
The Trustees of the Chatsworth Settlement

On this intaglio Diomedes, naked except for his cloak, escapes from the sanctuary at Troy. He is shown leaping over a garlanded altar and there is a statuette of a god on a column to his right. His drawn sword is in one hand, the Palladium in the other. The Palladium was a statue of Pallas Athene, three cubits high, given to the founder of Troy by Jupiter who promised that the city would be safe as long as it remained there. The intaglio illustrates the episode in the Trojan War when Diomedes contrived with Ulysses to remove the Palladium and thus ensure the Greek victory. During the reign of Augustus (63 BC–14 AD) other engravers of the Roman court school besides Gnaios interpreted this subject, since the emperor, for political reasons, compared himself with Diomedes, whose heroic exploit had brought the long war to an end.

An early work by the artist, this intaglio is still in the original gold ring setting with a convex hoop and plain rim. It is one of a distinguished group of intaglios and cameos assembled by William Cavendish, 2nd Duke of Devonshire (1672–1729), which is the most important gem collection remaining in private hands in Britain. Like his library and coin cabinet (see nos. 336 and 210), this collection demonstrates the 2nd Duke's superior learning and classical culture. The gem was recorded in the manuscript catalogue of the collection (Natter 1761, drawer 1, partition 6, no. 2) with the observation "la gravure en est fort bonne." The collection was kept in a Boulle cabinet, the pair to the coin cabinet shown in Jervas' portrait of the 2nd Duke (Chatsworth). Some of the gems are illustrated in a rare book of plates engraved by M. Gosmund, a Frenchman, between 1724 and 1730, and eighty-eight were set in the famous Devonshire Parure by C.F. Hancock in 1856. D.S.

Related Works: Cornelian intaglio, signed in Greek letters *DIOSKOURIDES*, also in the Devonshire Collection, with Diomedes in the same pose escaping from the sanctuary but with a statuette of Poseidon to the right, and a dead watchman at his feet. Other versions by Roman court engravers are discussed by Boardman (1968)
Literature: Vollenweider 1966, 45, pl. 41, nos. 1, 2
Exhibitions: London, SKM 1873 (32)

7: The Sculpture Rotunda

"Never forget that the most valuable acquisition a man of refined taste can make is a piece of fine Greek sculpture," wrote the Scottish painter, archaeologist, and dealer, Gavin Hamilton to Charles Towneley in 1779. The passion for classical sculpture lay at the very center of Grand Tour taste, and indeed collectors like Towneley (no. 213) regarded the statues and busts, the sarcophagi and bas-reliefs that they acquired in Italy for such vast sums as the standard by which all art should be judged. The number of late eighteenth-century British portraits based on the Apollo Belvedere or the Capitoline Antinous, and the number of neo-classical interiors decorated with copies of famous bas-reliefs like the roundels of the Arch of Constantine, or frescoes like the *Aldobrandini Wedding* shows how this veneration of antiquities was to have a profound effect on the art and architecture of the British country house.

The Earl of Arundel (no. 49) was the first to bring a significant collection of antique marbles back to England in the early seventeenth century, but following the sensational discoveries at Herculaneum in 1738 and Pompeii in 1748, few Englishmen on the Grand Tour could resist acquiring antique marbles and mosaics, urns and vases, terracottas and bronzes, coins and cameos, both as souvenirs and as a testimony of their superior taste in the arts, inculcated by tutors and "bearleaders" alike. The dealer Thomas Jenkins, who acted as unofficial banker to the English in Rome, was at the center of this trade, together with expatriates like Gavin Hamilton, and the two most influential propagandists for the art of Greece and Rome, Johann Joachim Winckelmann, Cardinal Albani's librarian, and the artist, engraver, and sculptor, Giovanni Battista Piranesi.

The idea of the sculpture gallery, pioneered by Lord Burlington at Chiswick, and consciously looking back to the world of Lord Arundel and Inigo Jones, was continued by Matthew Brettingham at Holkham and Petworth, by Henry Holland at Woburn, and by Jeffrey Wyatville at Chatsworth. However, Robert Adam's rotunda at Newby, and the Pantheons at Stourhead and Ince Blundell, adopted the circular form of the famous Tribuna of the Uffizi in Florence, one of the prime objects of pilgrimage on the Grand Tour. In other houses like Syon, Broadlands, and Kedleston, the entrance hall was filled with sculpture on the model of a Roman atrium, while at Castle Howard, Vanbrugh's long corridors flanking the hall became the "Antiques Passages." In many ways these interiors developed from the old portrait-hung long galleries of an earlier generation—the likenesses of gods and goddesses, and heroes and heroines of antiquity, providing a more distinguished ancestry for the country house owner than the full-length canvases of his own forefathers, often relegated to bedchambers and attics. Such a collection also underlined the political beliefs of the Whig aristocrats, who were portrayed in togas by sculptors like Rysbrack and Roubiliac at home, and Monnot and Bouchardon abroad, seeing themselves as reincarnations of the Greek and Roman senators, and representatives of a free democratic system as against the absolutism prevailing elsewhere in Europe.

Although a few Greek originals were acquired for British country house collections, like the Aphrodite head at Petworth now generally attributed to Praxiteles (no. 226), they usually contain restored Roman copies of Greek originals. In describing "the taste of English virtuosi, who had no value for statues without heads," Thomas Jenkins recorded "that Lord Tavistock would not give him a guinea for the finest torso ever discovered." The builders of houses like Holkham and Kedleston obviously needed pristine figures to decorate their new classical palaces, but more than this, completeness, elegance and vivid subject-matter were prized far above historical unity or even accuracy. Here the skills of the restorer came into play, and particularly those of Bartolomeo Cavaceppi, who owned the largest studio of the kind in Rome.

The variety and decorative effect of such acquisitions, more than their archaeological importance, were considered crucial, and this explains the sets of fine seventeenth-century bronzes or eighteenth-century marble busts after the antique with elaborate colored marble socles, the medallion heads (sometimes achieved by splitting genuine antique busts), the pairs of pedestals and candelabras, and the eagles and ibex, cats and dogs which particularly attracted the animal-loving English. The popularity of Naples later in the century, and the influence of Sir William Hamilton's treatise on vases (no. 362), led to the formation of important collections of terracotta at Nostell Priory, Charlecote, and Castle Ashby in the early nineteenth century. But the "golden age of classic dilettantism" (as Adolf Michaelis called it) was brought to an end with the French Revolution, and epitomized by the loss of the splendid collection formed by the Earl-Bishop of Bristol for his vast oval rotunda at Ickworth, partly through shipwreck, partly through confiscation. By a supreme irony the prelate's own coffin had to be disguised as the packing case for an antique statue when it was sent back to England in 1803, for the superstitious sailors refused to have a corpse on board.

Al Signor Giovanni Taylor Cavaliere Inglese
amatore delle belle arti
In atto d'ossequio il Caval.re Gio. Batta Piranesi D.D.D.

Monumento antico che si vede in Inghilterra
presso il Sig.r Giorgio Aufrere Cavaliere Inglese
nella sua Villa a Chelsea

P. MANLIO
D. DECVRIONI. LVGVDVM
NENSIVM

In Inghilterra presso Sua Ecc.za In Inghilterra presso Sua Ecc.za
Milord Palmerston Milord Palmerston

Cavaliere Piranesi inc.

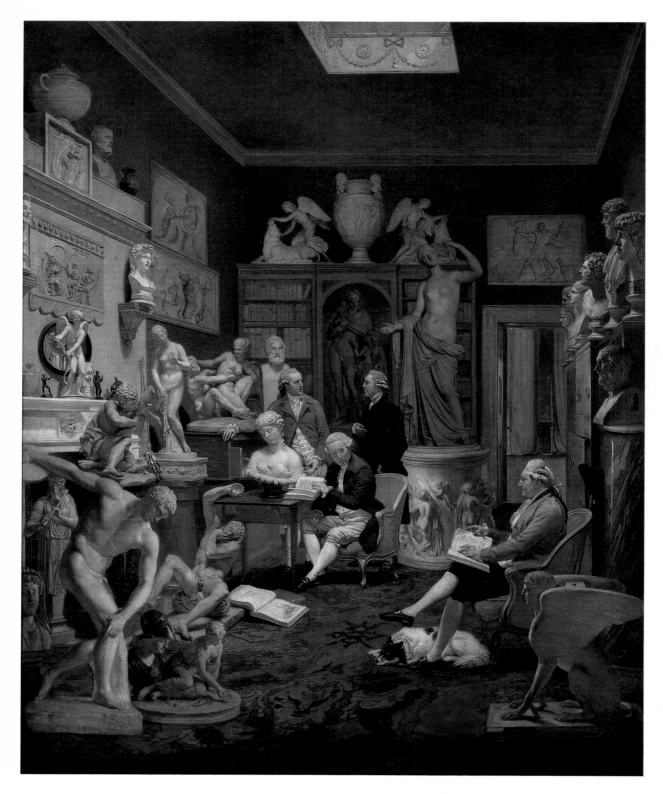

CHARLES TOWNELEY IN HIS LIBRARY
1781–1783
Johan Zoffany 1733/1735–1810
oil on canvas
127 × 99 (50 × 39)

Towneley Hall Art Gallery, Burnley

Charles Towneley (1739–1803) is seen seated in the library of his now demolished house at No. 7 Park Street (now Queen Anne's Gate), Westminster. His dog Kam, brought back from Kamchatka in 1780 by Commodore King, sits at his feet; and further back is Pierre Hugues, Baron d'Hancarville (1729–1803), the French antiquary who catalogued Towneley's collection. Behind him, on the left, is the Hon. Charles Greville (1749–1809), himself a distinguished collector, with the antiquarian Thomas Astle (1735–1803). That Zoffany was at work on the picture by 16 September 1781 is established by a letter from Towneley's sister (London, NPG 1976).

The Towneleys descend from the lay deans of Whalley Abbey who were granted land at Tunleia, near Burnley, about 1200. Like so many Lancashire gentry they adhered to the Catholic faith after the Reformation and continued to marry with other recusant families. Their refusal to conform to the established religion led to their disqualification from public office. Charles Towneley (1739–1805), who inherited at the age of three in 1741, was educated like so many English Catholics at Douai and was to make extended visits to Italy; it was in Florence that he came to know Zoffany. Towneley's major preoccupation was the formation of his great collection of marbles, which was sold after his death in 1810 to the British Museum, of which he had been a trustee, for £20,000.

As is true of the earlier portrait of Sir Lawrence Dundas in the library at Arlington Street (no. 281), Zoffany does not offer a literal account of Towneley's library. No single room in the house at Park Street was big enough to contain so many sculptures and in fact the collection was distributed throughout the house and complemented by Towneley's collection of Neapolitan views by Vanvitelli, Volaire, Antoniani, Lusieri, and others; and by other pic-

tures including the fresco fragment by Spinello Aretino now at Rotterdam that was purchased from Thomas Patch (see no. 197).

J.T. Smith, who when a student had worked for Towneley, said that the picture was "a portrait of the library, though not strictly correct as to its contents, since all the best marbles displayed in various parts of the house were brought into the painting by the artist, who made it up into a picturesque composition according to his own choice" (Smith 1828, 1:121–124).

The selection of the marbles depicted here was no doubt made by Charles Towneley himself. Many of the stars of the collection are included, among them the Towneley *Venus* and antiquities acquired through Hamilton, Jenkins, and Lyde Brown. The bust of Clytie on the table next to d'Hancarville was one of Towneley's particular favorites (he referred to her as his "wife"), and during the anti-Catholic Gordon Riots of 1780 he took her with him when he fled the house. Two of the purchases he made in 1782 are shown, the bust of Minerva on the floor and the head of Homer on a column at the right. (For an account of the collection see Cook 1985.) The picture was finished in the following year and exhibited in 1790, but in 1792 Towneley asked Zoffany to paint in a new acquisition, the version of the Discobulus discovered on the site of Hadrian's villa in the previous year, in the left foreground. Artist and patron became close friends; Zoffany later corresponded with Towneley from India while the latter was trustee of the marriage settlements of his two daughters. F.R.

Provenance: Presented by the artist to Charles Towneley of Towneley; by descent through his uncle, John Towneley (1731–1813), whose great-granddaughter Alice Mary married the 1st Lord O'Hagan; 3rd Lord O'Hagan's sale, Christie's, 19 May 1939, lot 92, when bought for 1250 gns by Burnley Borough Council for the Towneley Hall Art Gallery
Literature: Webster 1964; Cook 1985, 30–37
Exhibitions: London, RA 1790 (191); London, RA 1951; London, RA 1972 (285); London, NPG 1976 (95); Washington, NGA 1976 (134)

214

SAMSON AND THE PHILISTINES 1749
Vincenzo Foggini fl. 1730–1750
marble
233 (92) high
inscribed, *VIN ᵛˢ FOGGINI/SCVLPSIT FLO/RENTIAE/1749*

Wentworth Woodhouse
Lady Juliet de Chair and the Trustees of Olive, Countess Fitzwilliam's Chattels Settlement

The group has been catalogued by Dr. Jennifer Montagu (Detroit and Florence 1974, 80, no. 43) as follows: "In 1749 the Marquess of Rockingham instructed his eldest son Lord Malton to acquire statues in Rome for the hall of his newly reconstructed seat at Wentworth Woodhouse. Four copies after the antique carved by Roman sculptors were duly sent, but there is no specific mention of a commission to Vincenzo Foggini, who, so far as we know, was in Florence. This is presumably the 'marble groupe' that had arrived safely according to a letter of 23 January 1750 from the marquess to his son. Hugh Honour has justly described the group as virtually a pastiche of the two modern sculptors whose genius was judged at the time as worthy to rank with the antique: Michelangelo, whose projected *Samson and the Philistines* is known through many bronze copies, and Giambologna, whose marble of the same subject is now in the Victoria and Albert Museum. The gesture of the younger Philistine grasping Samson's leg is surely inspired by Michelangelo, while the upturned head of the other comes from Giambologna; Samson is a fusion of both, with his pose brought slightly closer to the *Laocoon*, a significant concession, as Honour sees it, to contemporary taste. We can also point to a strong influence in the turn of the back of the beardless Philistine from another famous antique, the *Wrestlers* in the Tribune of the Uffizi, a group also copied by G.B. Foggini.
In the late 18th century inventory of models at the Doccia factory is a 'Group of Samson, who slays the Philistines; by Foggini' (Lankheit 1982, 119, no. 4) which is known through an old photograph of a white porcelain version (W.E. Gladstone sale, Christie's, London, 23 June 1875, lot 272), in which these figures occur wrongly assembled, rising above at least four dead and dying Philistines on the ground below, making a broad-based pyramidal group. In several other entries in this inventory the name Foggini can be shown to mean the father. Although a group conceived so completely in the round would be exceptional in the work of Giovanni Battista, the thicker-set anatomy of Samson in the porcelain version leads

to the strong suspicion that the marble might well be an enlargement made by Vincenzo from a small-scale original by his father. Whoever was responsible for the conception of the carving of the marble, with its crisp and rather angular treatment of the hair and comparatively generalized anatomy, it is very different from that of Giovanni Battista and suggests that Vincenzo may have practised as a copyist of the antique."

To this account may be added that an original terracotta model of the group, reproduced in porcelain at Doccia, is in the Musée de Douai, wrongly attributed to Giambologna (Leroy 1937, 126, no. 850). As to the present monumental version in marble, the genesis of the design may conceivably go back nearly one hundred and fifty years before the date inscribed by Vincenzo Foggini.

When Pietro Tacca took over Giambologna's studio after his death in 1608, it was stated in an inventory of work in progress, "si e cominciato ad abozzare il sansone" (the roughing out of the Samson has been begun) (Watson 1977, 277). The choice of the verb *abozzare* indicates that the statue was in marble and it is probably identical with a similar item listed in the Borgo Pinti studio in 1635 (Watson 1977, 280). The project had initially been set aside due to Tacca's obligation to complete speedily the equestrian statue of King Henry IV of France, and it seems never to have been resumed. The block was still standing unfinished in the courtyard of the Grand Ducal studio a generation later, when Giambattista Foggini took over the studio from Pietro Tacca's son and successor as court sculptor, Ferdinando Tacca. In an inventory of 25 November 1687 the first two items listed are: "No 2 Bozze di Marmo di statue grande quanto il naturale, rappresentati una un Ercole e l'altra un Sanssone" (two roughed-out blocks of marble of life-size statues, one a Hercules and the other a Samson).

A decade later, on 11 February 1696, Foggini received an official order to carve out of the block a statue of Cardinal Leopoldo de' Medici for the Uffizi Gallery (Lankheit 1962, 269, doc. 258). It has always been assumed that the roughed-out marble block of Samson

was thus used to produce the statue of Leopoldo seated sideways, which is still in the Uffizi (160cm high). But if this Samson group had been designed to replace Giambologna's original, which had just been exported as a gift to Spain in 1601 (Avery 1978), it must have been pyramidal in general shape, with one of Samson's arms raised and holding the jawbone of an ass. It would only have been feasible to produce a seated figure of a cardinal from the block if the roughing-out of such an action group had scarcely begun. It seems not impossible that Foggini may have preferred to keep the roughed-out block for his personal use and that he acquired a fresh piece of marble for the portrait statue to give to the Grand Duke. If this were the case, the present sculpture may represent Pietro Tacca's original block, perhaps worked on by Giambattista Foggini, but eventually completed by his son, Vincenzo (Lankheit 1962, 226, doc. 18).

Giambologna's earlier group of *Samson and a Philistine* (now in the Victoria and Albert Museum) was given by the King of Spain to Charles I when he visited Madrid as Prince of Wales, and then in turn presented to the Duke of Buckingham. It was in Buckingham House in London, during the early eighteenth century, when Lord Malton acquired Vincenzo Foggini's version. He may have known the original or one of the several life-size casts in lead that were being produced in London in that period (for instance at Drayton and Great Harrowden in Northamptonshire, and at Chatsworth in Derbyshire). C.A.

Provenance: Acquired from the sculptor Vincenzo Foggini in Florence, by Charles, Lord Malton, later 2nd Marquess of Rockingham (1730–1782); and by descent through the heirs of his sister Anne and her husband, the 3rd Earl Fitzwilliam
Literature: Honour 1958, 224–225; Lankheit 1962, 72–73, 269, doc. 258; Watson 1973, 277–278, 280–281, 321; Lankheit 1982, 119, no. 4
Exhibitions: Detroit and Florence 1974, 80 (43)

215

THE DANCING FAUN 1711
Massimiliano Soldani Benzi 1656–1740
bronze
142 (56) high
inscribed, *MAXIMILIANVS SOLDANI BENZI FLORENTIAE 1711*

Blenheim Palace
The Duke of Marlborough

This bronze and its companion (no. 216) come from a set of full-size bronze casts after famous classical marbles in the Uffizi Gallery, Florence, made by Massimiliano Soldani in 1710/1711 for John Churchill, 1st Duke of Marlborough. The set represents the *Dancing* (or Clapping) *Faun*, the *Medici Venus*, the *Arrotino* (or Knife-sharpener), and the *Wrestlers*.

The commission is documented in a letter to the Duke of 28 April 1710 from Sir John Vanbrugh, the architect of Blenheim Palace, in which he refers to two letters recently received from Sir Henry Newton, the British Resident in Florence. Newton had obtained permission from the Grand Duke Cosimo III for the casts to be made, and had immediately set Soldani to work on them. The duchess had, however, suspended the work pending further directions from the duke. These must have been forthcoming and, as all four bronzes bear the date 1711, they were probably completed and delivered to Blenheim in that year.

Soldani had already made casts of two of these marbles, the *Dancing Faun* and the *Medici Venus*, for Johann Adam, Prince of Liechtenstein between 1695 and 1705, but for the other two statues he may have used molds prepared by the Grand Ducal sculptor Giambattista Foggini to make plaster casts for Cosimo's son-in-law, the Elector Palatine.

The four bronzes were originally installed in the hall at Blenheim Palace, but were moved out to the private garden in the present century by the 9th Duke. Believed to have been lost, they were rediscovered in 1972 by Dr. Andrew Ciechanowiecki and Miss Gay Seagrim, when these two were restored and reinstalled in the hall. The bronze is a copy of one of the most admired of the Medici marbles, which by the late seventeenth century was installed in the Tribuna of the Uffizi. Apparently a third-century copy of the lost bronze original, this marble, the head and arms of which are modern restorations, is first recorded in the mid-seventeenth century.

Soldani's considerable reputation in eighteenth-century England may be judged by the numerous ascriptions to him of bronzes in contemporary sale catalogues, not all of which are to be taken seriously (see no. 250). It is therefore surprising that examples of his work are rare in English collections. He is known to have made a set of four bronze reliefs for Lord Burlington and apart from his full-sized casts of antique marbles, which are extremely rare, he made numerous small replicas, averag-ing just over a foot high, of famous classical and modern statues. Two of these, reproducing Cellini's *Ganymede* and Michelangelo's *Bacchus*, were identi-fied by Charles Avery at Blenheim. Two more, of the *Medici Venus* and Sansovino's *Bacchus* identified by the present writer at Corsham Court, were acquired in the early eighteenth century by Sir Paul Methuen while ambassador at Turin. A.F.R.

Literature: Lankheit 1962, 23, 145, docs. 47, 339, 341; Ciechanowiecki and Seagrim 1973; Montagu in Detroit and Florence 1974, 118, no. 79; Avery 1976; Haskell and Penny 1981, 205–207
Exhibitions: Detroit and Florence 1974 (79, 80)

216

THE MEDICI VENUS 1711
Massimiliano Soldani Benzi 1656–1740
bronze
162.5 (64) high
inscribed, *MAXIMILIANVS SOLDANI BENZI FLORENTIAE 1711*

Blenheim Palace
The Duke of Marlborough

See no. 215, to which this is the companion.

The bronze is a full-size copy, with variations, of probably the most famous of all the Medici marbles, which by 1688 was installed in the Tribuna of the Uffizi in Florence. The original is thought to be a copy of the first century BC after a lost bronze statue of the early third century, of the school of Praxiteles. The most noticeable of Sol-dani's minor variations are the omission of the putti, which in the marble version rides on the dolphin, and the conversion of the bowed base of the marble into a rectangle. In an earlier full-size cast for the Prince of Liechtenstein, Soldani retained the putti on the dolphin, but in his small bronze reductions from the statue he omitted the dolphin altogether. A.F.R.

Literature etc.: See no. 215

217

JOHN, 5TH EARL OF EXETER c.1700
Pierre Etienne Monnot 1657–1733
marble
67.3 (26) high
engraved, *P.S. MONNOT/ROMA 1701*

The Burghley House Collection

Lord Exeter died in 1700 (of a surfeit of fruit) at Issy, near Paris, on his return from Rome. There his commission of sculpture from Monnot had led to the execution of one of the foremost groups of Roman late baroque sculpture to be seen in England in the early eighteenth century. According to Pascoli (1736, 2:491), Exeter visited Santa Maria del Popolo and there met Monnot, working on his bust of Cardinal Savio Millini. Following a visit to the sculptor's workshop he commissioned a monument with portraits of himself and his wife, five other large statues, and a small one. These probably included the monument in Saint Martin's, Stamford, a signed relief of the Madonna and Child, two small figures of children, an unsigned portrait of Lady Exeter, and this bust (Honour 1958). A large marble of Andromeda and the sea monster by Monnot (formerly at Burghley, now in the Metropolitan Museum, New York) may also belong to this group.

Documents relating to the Burghley Monnots have been traced by Dr. Eric Till. The bust is probably among "Ld and Ly Exeter's statues from Italy (freight) £17:10:0" mentioned in Child's bank ledger on 13 November 1706. Two further payments on 30 November 1706 and 27 March 1707 refer to the freight and storage charges for the monument, which was apparently finished by 19 March 1705 when the Duke of Shrewsbury met the sculptor "Moineau" in Rome and was told that he had been paid 6,000 crowns for it (HMC 1903, 2; part 2, 787).

Born in 1657, Monnot came to Rome about 1687. He remained there for the rest of his life, where with Rusconi and Legros (see no. 241) he became established as one of the major sculptors of late baroque Rome. Among his most notable works in Rome were the marble reliefs for the Capocaccia Chapel in Santa Maria della Vittoria, the monument to Innocent XI in Saint Peter's, and a bronze relief for the Chapel of Saint Ignatius in the Gesù. Exeter was a major patron of foreign artists, including Monnot; even more important for the sculptor was the Landgrave Karl von Hesse for whom Monnot executed the immense assemblage of sculpture decorating the Marmorbad at Kassel.

Like most of Monnot's work the Burghley Madonna relief and the Andromeda group are in a style that enjoyed some popularity among English collectors. The Andromeda was indeed reproduced in a reduced lead version at Osterley while admiration for the Exeter monument is reflected in the highly finished drawing of it by Michael Rysbrack (Eustace 1982, 115). However, the bust and monument differ markedly from Monnot's other works in their use of classicizing conventions such as the carefully reproduced antique armor and the depiction of the sitter with close-cropped hair, as in Roman Republican portraits. Such strict use of this convention for portraits of contemporary figures was highly unusual in Italy at this date and, as Honour suggests, its adoption both here and in Maratti's bust of Lord William Cecil (also at Burghley) indicated that the patron wished to be represented as an antique Roman, providing a visual equivalent to Richardson's claim that "No nation under Heaven so nearly resembles the ancient Greeks and Romans as we." The Exeter bust thus appears to anticipate that classicizing type of portrait much favored by English sitters and variously interpreted some years later by Rysbrack in his bust of Nottingham (1723), by Bouchardon in his Hervey (no. 237), and by Roubiliac in his Fountaine (no. 238). M.B.

Related Works: This bust is closely related to the reclining figure in Roman armor on the Stamford monument and is presumably based on the same terracotta model
Literature: Honour 1958, 220–221; Whinney 1964, 254

218

MARY OKEOVER C.1745
Charles Stanley 1703–1761
marble
58.4 (23) high

Okeover Hall
Sir Peter Walker-Okeover, Bart.

Mary Okeover (d. 1764) was the long-suffering and level-headed wife of the eccentric Leak Okeover, whose passion for collecting and building—most notably, the ambitious rebuilding of Okeover Hall from 1745 onward—led to his flight to France in 1751 to escape his debtors. Leaving his wife in England, he lived there as "Monsieur William Scrimshaw" until May 1753 when he returned, with his debts paid through his wife's efforts, to embark on a further building program (Oswald 1964).

Mrs. Okeover's portrait is unsigned but accompanies a bust of her husband dated 1762 and signed by Joseph Wilton. The use of the same type of socle for both, and the fact that Wilton also signed the fine monument to the couple in Okeover Church (Pevsner 1974, plate 61), would appear to support an attribution to him, even though the different treatment of the reverses indicates that the two busts were not executed as a pair. However, the correspondence between Okeover and his architect Joseph Sanderson between 1745 and 1746 reveals that the latter had engaged the Danish-born plasterer and sculptor Charles Stanley for work on the interiors. Stanley's career remains somewhat mysterious. He is best known for his plasterwork in buildings such as Langley Park, Norfolk, and the Radcliffe Camera, Oxford (Beard 1975, 247) but, having trained in Amsterdam under Jan van Logteren, he worked in England with the sculptors Peter Scheemakers and Laurent Delvaux and executed at least two monuments on his own account. His commissions at Okeover included not only a ceiling of Bacchus and Ariadne and some chimneypieces but also a "busto." This "busto" is almost certainly that of Mrs. Okeover, since a bust with the same arrangement of both drapery and hair is found on Stanley's signed monument to Charles, Lord Maynard and his ancestors, erected in 1746 at Little Easton, Essex. Since Stanley left in the same year to become Court Sculptor to Frederick V in Copenhagen—Sanderson writes in October 1746 that he "was gone off —my whole account not so much entered upon"—the bust was presumably executed before this date. The socle (which follows a pattern employed by both Roubiliac and Wilton) was therefore probably added by Wilton when he carved the portrait of Leak Okeover sixteen years later. M.B.

219

BAS-RELIEF OF A YOUNG WOMAN
1st century BC–1st century AD
Neo-Attic
marble
78.7 (31) high

Woburn Abbey
The Marquess of Tavistock and the
Trustees of the Bedford Estates

First erected as a conservatory in 1789 to designs by Henry Holland, the magnificent sculpture gallery at Woburn Abbey was adapted to its present purpose in 1820 by John Russell, 6th Duke of Bedford, who must be considered the real founder of this large and varied collection. It featured not only an abundance of ancient marbles and bronzes, but also an array of masterpieces by Antonio Canova, Sir Francis Chantrey, John Flaxman, Bertel Thorwaldsen, and Sir Richard Westmacott. The 6th Duke also arranged for some of the sculptures to be published in a sumptuous volume (the plates were drawn by Corbould and Moses, and the text prepared by Dr. Philip Hunt), which was privately printed in 1822 and limited to 180 copies. A catalogue appeared in 1828 (and was reissued, with new numbering and some additions, in 1867); and in 1900, a few years after Adolf Michaelis had published the ancient marbles, A.H. Smith of the British Museum produced his *Catalogue of the Sculptures at Woburn Abbey* (Michaelis 1882, 155–156, 721–723, 731–732, no. 100).

These early publications refer to the Woburn bas-relief of a young woman (at times whimsically nicknamed "Sappho") as a work of the fifth century BC. In the commemorative catalogue of the exhibition of Greek art mounted in 1946 at the Royal Academy in London, the relief was still dated c. 440 BC. But in fact this is a fine Neo-Attic product of Republican or early imperial times (first century BC–AD), as Lippold and Vermeule have rightly observed (Vermeule 1955, 150, with previous literature). There is a variant of the Woburn relief in the Cortile del Belvedere of the Vatican Museums in Rome (Fuchs 1959, 173, no. 26), and comparable classicizing figures are well represented in the repertory of Neo-

ATTIC RELIEF OF A GREEK GIRL.

Attic art, which employed models of
earlier periods for decorative reliefs
produced primarily for a Roman
clientele (see, for example, Fuchs 1959,
pl. 3:a–b).

We confront a young woman stepping
gracefully to the left and wearing a long,
thin garment (*chiton*) under a wide
mantle that envelops her body. Her
hair is held in a kind of cap fastened by
narrow bands. A plain, raised border
frames the composition. According to
Michaelis, the relief was engraved by
Giovanni Francesco Ferrero in Rome
probably at the beginning of the
nineteenth century (Michaelis 1882,
731, no. 100, and woodcut on page
730). C.A.P.

Provenance: Presumably purchased by
the 6th Duke of Bedford during his
travels in Italy; and by descent
Literature: Michaelis 1882, 731, no. 100,
and illustration on page 730; Smith
1900, 40, no. 69; Vermeule 1955, 150;
Vermeule and Bothmer 1959b, 347;
Fuchs 1959, 148, n. 201, 173, no. 25;
Sutton 1965, 438, fig. 3
Exhibitions: London, RA 1946 (140),
pl. 35

220

TRIUMPHAL RELIEF FROM THE ARCH
OF CLAUDIUS 1st century AD
Roman
marble
127 × 101.6 × 30.3 (50 × 40 × 12)

Hever Castle

Two heavily draped men stand in the foreground of this fragmentary Roman relief. The one on the left wears a tunic and a short veil, now visible only at the right shoulder and along the upper left arm. He holds a long pole in his right hand. The second figure is clad in a toga, and above his left shoulder and behind the ear are traces of *fasces*, the bundles of sticks (together with an axe) carried by lictors before the chief Roman magistrates. Both men were originally shown wearing laurel wreaths. In the background, carved in a low relief, is the head of a horse (once part of a quadriga), followed by two trumpeters in profile to the right. The latter are blowing into their instruments, the straight war trumpets (*tuba*) used by the Romans for giving military signals. This relief was part of a much longer composition, a ceremonial procession that moved from left to right. There can be no doubt that the theme depicted here is a triumph.

The Hever relief, which has been recently cleaned, was restored in Rome in the latter part of the sixteenth century; the entire lower portion of the panel as well as the hands of the two foreground figures are modern. These additions, however, do not detract from the importance of the sculpture, which was almost certainly unearthed in the Piazza Sciarra at Rome in about 1562. The French artist Pierre Jacques, who resided in Italy from 1572 until 1577, recorded a portion of it (the *tuba* player at right) in a drawing dated 1576 (Reinach 1902, 121, 130, pl. 63); and the entire panel (already restored) was featured in the second volume of the *Galleria Giustiniana*, published in 1631. The sculpture resurfaced in 1903 in the hands of the Roman art dealer Simonetti. A few years later it was purchased by William Waldorf Astor (later 1st Baron Astor of Hever) who at that time was the American Minister in Rome, and who assembled a considerable collection of ancient marbles around the turn of this century. (For his restoration of Hever, see no. 588.)

The relief has recently (and with good reason) been attributed to the Arch of Claudius, which is dated by inscription to the year AD 51 (Koeppel 1983, 103). The Emperor Claudius erected this arch in commemoration of the conquest of Britain; it seems to have been destroyed in the eighth century AD (Nash 1968, 1:102–103). C.A.P.

Literature: Galleria Giustiniana 1631, 2: pl. 86; Koeppel 1983, 103–109, pls. 40–43

221

BAS-RELIEF OF TWO WOODCOCKS 1834
Sir Francis Chantrey 1782–1841
marble
107.9 × 48.2 × 19.6 (42½ × 19 × 7¾)
inscribed, *Two woodcocks killed at Holkham Nov* 1830 by Sir Francis Chantrey, Sculptor*; signed and dated, *1834*

Holkham Hall
Viscount Coke

The two dead birds, which are recorded in the Holkham game book, were shot by Chantrey (a year earlier than the inscription records) on one of the many visits he made to the house late in his life. Like his earlier bust of Thomas Coke, 1st Earl of Leicester, this relief was a gift to his friend "Coke of Norfolk" who though primarily known as an agricultural reformer was also an enthusiastic patron of contemporary artists. He commissioned from Chantrey a copy of Roubiliac's bust of his great-uncle, who had built Holkham, and a relief of William IV signing the Reform Bill, completed in 1840 (Haskell and Penny 1977), a worthy addition to one of the major eighteenth-century collections of classical sculpture in England.

A fine example of Chantrey's virtuoso carving technique, the two birds are set with more than a hint of mock solemnity within a frame of the type used for church monuments, and itself derived from the Greek stele. Although inspired by an actual event and depicted in an appropriately naturalistic manner, the relief may be related to the long-established tradition of genre paintings of dead game, some of which were indeed executed in grisaille in imitation of sculpture. English collections contained many such paintings reflecting a taste for sporting pursuits, also evident in Chantrey's relief. Other sculptural expressions of this interest include the dead birds included in some of Grinling Gibbons' carvings (no. 106) and, in France, Jean-Antoine Houdon's relief of a dead thrush, shown in the Salon of 1777 (Réau 1964, 2:59), which offers a striking but presumably unconnected precedent for Chantrey's work. The influence of this relief, however, was more literary than sculptural, inspiring the anonymous poems included in *Winged Words on Chantrey's Woodcocks* (ed. J.P. Muirhead, 1857):

"Yet true, as dying by yon oak they lay,
And in sad union sigh'd their souls away;
See, the carv'd stone their drooping wings sustains!
See! E'en in death each plumy charm remains!" M.B.

Exhibitions: London, NPG 1981 (29); London, Sotheby's 1984

222

PARIS C.1450–1500
attributed to Antonio del Pollaiuolo
1431/1432–1498
bronze
26.3 (10⅜) high

The Castle Howard Collection

This statuette was probably acquired by Henry Howard, 4th Earl of Carlisle, in Rome in the 1740s. Despite the fact that the 4th Earl built the west wing of Castle Howard in 1753–1759 with his brother-in-law Sir Thomas Robinson as architect, he spent much of his time in Italy. There he collected antiquities and was on intimate terms with such distinguished antiquarians as Francesco Ficoroni, from whom he is known to have bought bronzes in 1740. The present bronze, like other classicizing Renaissance bronzes in the Castle Howard collection, was no doubt acquired in the belief that it was actually classical in date.

The figure represents Paris: the apple is concealed in the left hand, and a shepherd's staff would formerly have been held in the right hand. It is cast solid, and suffered from the serious casting flaws that frequently result from this practice. The left ankle has been repaired, which affects the stance of the figure, and the right forearm is bent out of alignment. Before treatment at the Victoria and Albert Museum in 1971, the bronze was suffering from corrosion and was generally of a gray-green color with only slight remaining traces of its original dark patina. This color was common to many of its companions at Castle Howard and may have been in part due to an old practice in some English houses of washing the bronzes in stale beer.

The *Paris* is one of ten known casts, which vary widely in facture and the handling of detail (especially in the faces), but all derive from the same original. The other versions are listed and fully discussed by Pope-Hennessy, and in the considerable literature relating to the model (also listed by him) there is a general consensus that it derives from an original by Antonio Pollaiuolo. Among drawings by the artist the most striking correspondences are to be found in a sheet in the British Museum of a prisoner

brought before a judge, in which the figure of a nude man, second from the right (seen from the back), closely resembles the back view of the statuette, and the head of the man immediately to his left has exactly the same treatment of the hair as in the better bronze versions.

Of all the known bronze versions this one is closest in handling to bronzes by Pollaiuolo. Some of the casts are undoubtedly German, but this is a typical Florentine version of the second half of the fifteenth century. In its details of modeling, the face of the figure is notably close to that of Antaeus in Pollaiuolo's bronze group of Hercules and Antaeus

in the Bargello, Florence, and the accentuated musculature of the chest and abdomen finds a parallel in his statuette of Hercules in the Bode-Museum, Berlin. The hair is modeled in a way peculiar to Pollaiuolo, being built up in locks overlapping one another at right angles, and the large, spoon-shaped toes with almost circular nails recur throughout Pollaiuolo's work.

A fine variant of the model carved in boxwood in The Hermitage, Leningrad, in which the right arm is lowered and the apple is held in the right hand, is proposed by Androssov as an original by Pollaiuolo, but the treatment of the detail here is alien to Pollaiuolo. The boxwood is more likely to be a North Italian carving of the early sixteenth century based upon a bronze version.

A.F.R.

Literature: Pope-Hennessy 1970, 4:8–13; Androssov 1975, 5–8

223

TERMINAL FIGURE OF A SATYR
1st century BC
Greco-Roman
bronze
69.2 (27¼) high

Woburn Abbey
The Marquess of Tavistock and the
Trustees of the Bedford Estates

According to the *Outline Engravings and Descriptions of the Woburn Abbey Marbles*, privately circulated in 1822, this bronze figure of a satyr "was found in an excavation made at Pompeii, when the Duke of Bedford [John Russell, 6th Duke, 1766–1839] visited that ancient city, in the spring of the year 1815, and it was presented to him, on the spot, by Caroline, then Queen of Naples" (Hunt 1822, pl. 21, with text on facing page). In addition, Michaelis was able to ascertain that Queen Caroline Buonaparte paid her only visit to Pompeii that year on 11 April (Michaelis 1882, 738, no. 128). The Woburn bronze featured (as plate 28) in the second volume of *Specimens of Antient Sculpture* published by the Society of Dilettanti in 1835.

The head and upper body of a young satyr are represented. The trunk of the figure terminates in a tapering shaft that rests on a base of three steps, and a mantle envelops the satyr's body as well as part of the terminating shaft. The figure, which is characterized as a satyr by its small horns, pointed ears, goat's warts on the neck, and dishevelled hair, appears with its left arm lowered, hand resting on hip, and the raised right arm flexed and pressed closely against the breast. The head is thrown back in a gesture of cheerful abandon. The sculpture is meticulously and lavishly finished: the whites of the eyes, the teeth, the small horns, and the tips of the warts are all made of silver. The pupils of the eyes, now vacant, may have originally been filled with another costly material of contrasting color.

The Woburn bronze, a freestanding figure datable to the first century BC, recalls a Greco-Roman hollow-cast herm of Dionysos (some details of which are also rendered in silver) recently on the London art market (Christie's, 28 November 1979, lot 86). It also bears comparison with an unusual group of double herms forming part of a bronze balustrade, found in one of the two large boats of the first century AD recovered from the bottom of Lake Nemi near Rome (Ucelli 1950, 220–223, figs. 241–244). C.A.P.

Literature: Hunt 1822, pl. 21, and text on facing page; Michaelis 1882, 737–738, no. 128; Reinach 1897, 523, no. 4; Smith 1900, 47, no. 84, fig. 27; Vermeule and Bothmer 1956, 349; Sutton 1965, 440–441, and fig. 2; Sutton 1984b, 329
Exhibitions: London, RA 1946 (180), pls. 68–69

CAT AND SNAKE
1st century BC/2nd century AD
Roman
marble
35.5 (14) high

Powis Castle
The National Trust (Clive Collection)

The Greeks and Romans of classical times were certainly acquainted with household cats, which were first imported from Egypt. Unlike the ancient Egyptians, however, they did not associate these felines with any god or divinity: cats do not feature often in Greek art and representations of them are even rarer in Roman art. This unusual Roman marble group showing an alert cat and a snake could date from as early as the first century BC, and should be no later than the second century of the era. There seems to be no exact ancient parallel (especially in sculpture) for the group. The representation closest to it is that on a Roman mosaic from the Casa del Fauno at Pompeii, now in the National Museum at Naples. The Pompeian panel depicts a cat attacking a bird; and a close version of this scene appears on another mosaic, also of Roman date, in the Sala degli Animali of the Vatican Museums in Rome (for both mosaics, see Pernice 1938, 161–164, pls. 62–63).

The Powis group, which is made of marble from Thasos, has recently been cleaned. The minor restorations (portions of the snake and of the feline's legs) were executed presumably in the eighteenth century when the piece was to be seen in Rome. Lord Clive (the victor of Plassey), who eventually purchased the sculpture, apparently referred to it when he wrote to his wife from Rome on 26 February 1774, "We have seen fine Churches, Statues and Pictures without Number and among other Curiosities, would you believe it an antique Cat. By the Stile I should imagine it to be the work of some Grecian Artist for it is so exquisitely fine that no Roman Statuary seems equal to such a Performance. You may imagine perhaps that I attempted to purchase it, I certainly did and can assure you I was very lavish in my Offers for your sake, but alas I fear this delightful Cat is out of the reach of Money, however I do not dispair and if I cannot succeed whilst I am here I will leave orders with my Agent to purchase the Cat if ever it is to be disposed of Coute qui coute." (Powis Castle MSS). C.A.P.

Provenance: See no. 193
Literature: Sutton 1984, 320, and fig. 18
Exhibitions: London, Wildenstein 1982, 33(66)

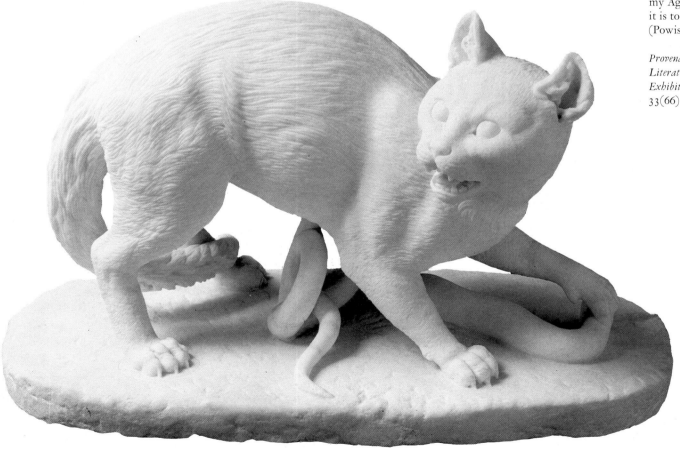

225

TWO SLEEPING DOGS c.1784
Anne Seymour Damer 1749–1828
marble
21.6 (8½) high
inscribed, *ANNA · Σ · ΔΑΜΕΡ · ΗΛΟΝΔΙΝΕΙΑ · ΕΠΟΙΕΙ*
HOC.OPUSCULUM./ROGATU. CAROLI. LENOX.RICHMONDIAE. DUCIS./CARAE.SORORIS.SUAE. MARITI./FECIT.ANNA.SEYMOUR. DAMER.

Goodwood
The Earl of March and Kinrara and the Trustees of the Goodwood Collection

This marble version of "a rough dog and a smooth one" was carved for Charles, 3rd Duke of Richmond, the husband of Mrs. Damer's half-sister, from a terracotta model in Horace Walpole's collection at Strawberry Hill. Writing to the Earl of Strafford about Mrs. Damer on 7 September 1784, Walpole comments, "I am in possession of her sleeping dogs in terra cotta. She asked me if I would consent to her executing them in marble for the Duke of Richmond—I said 'Gladly; I should like to think they should exist in a more durable material'—but I would not part with the original, which is sharper and more alive. Mr Wyat [sic] the architect saw them here lately and said, he was sure that if the idea was given to the best statuary in Europe he would not produce so perfect a group. Indeed, with these dogs and the riches I possess by Lady Di [drawings by Lady Diana Beauclerk], poor Strawberry may vie with much prouder collections" (Lewis 1973, 35, 385).

Mrs. Damer was the daughter of Francis Seymour Conway, a close friend of Horace Walpole, who had a highly exaggerated regard for her sculptural talents and bequeathed Strawberry Hill to her in his will. (On her terracotta model of a fishing eagle which stood in the Gallery at Strawberry Hill, he had the inscription added, "*non me Praxiteles finxit, at Anna Damer*"). Tutored by David Hume, she was well read in the classics (as the Greek and Latin inscriptions suggest) and learned to sculpt from Joseph Ceracchi and John Bacon. While her portraits fail to bear out Walpole's claim that she "models like Bernini [and] has excelled the moderns in the similitudes of her busts" (Lewis 1973, 25, 184), her animal sculptures reveal great charm as well as considerable technical accomplishment in the carving of the marble. As Margaret Whinney has suggested, her treatment of subjects such as this link her "on the one hand with the painters of sporting pictures, and on the other with the rising taste for rustic genre, that early form of Romanticism to be seen in the stable scenes of George Morland" (Whinney 1964, 173). Her interest in canine sculpture no doubt also reflects her personal predilections as her will specified that she be buried not only with her mallet and chisel but also with the ashes of her favorite dog.

M.B.

Related Works: The terracotta model was placed in the Little Parlour at Strawberry Hill (Walpole 1774, ii, 418). Described as "very spirited in effect under a glass case," this was sold at the Strawberry Hill sale (12 May 1842, 16th day, lot 116, to the Earl of Derby)
Literature: Gunnis 1951, 120–121; Whinney 1964, 271, no. 30

226

THE LECONFIELD APHRODITE
4th century BC
Greek
attributed to Praxiteles
marble
66 (26) high

Petworth House
The National Trust (Egremont
Collection)

The provenance and the exact date of
acquisition of the celebrated Leconfield
Aphrodite still remain to be established.
The sculpture takes its name from the
title conferred on the 3rd Earl of Egre-
mont's eldest illegitimate son, who
inherited Petworth House in 1837; how-
ever, the bust was almost certainly
acquired by Charles Wyndham, 2nd
Earl of Egremont, who between 1750
and 1760 assembled at Petworth one of
the largest and finest country house
collections of ancient marbles in Britain.
The 2nd Earl employed two agents in
Rome who secured works of art for
him: the Scottish painter and dealer
Gavin Hamilton and Matthew Bretting-
ham, son of the Earl of Leicester's exe-
cutant architect at Holkham Hall. In a
recent study, John Kenworthy-Browne
has tentatively suggested that this is
the head of Aphrodite described in
Brettingham's Rome Account Book as
an "Antique Head of Venus excellent,
Marble." Brettingham states that he
purchased this sculpture (together with
a portrait head of Julia Maesa, the sister
of Julia Domna) in 1753 from the Roman
restorer and dealer Bartolomeo Cava-
ceppi for 105 *scudi* (Kenworthy-Browne
1983a, 46, 62, 85, 132). On the other
hand, the private Account Book of the
2nd Earl of Egremont records the pay-
ment of £50 in 1755 to Gavin Hamilton
for "an antique bust of Venus" (MSS at
Petworth House), and this could
equally refer to the Aphrodite.

That the sculpture actually repre-
sents the goddess of love and beauty
can be taken for granted, given the
idealized features and the similarity of
the head to that of both the Aphrodite
of Knidos and the Venus de' Medici
type. The back of the head, including
the bundle of knotted hair, was made
separately and added on. The groove
across the top of the head must have
originally held a fillet, presumably made
of bronze. Only the nose and part of the
upper lip are restored, but most of the
surfaces have been repolished or re-
touched by the eighteenth-century res-

torer. Critics well acquainted with this
sculpture have rightly pointed out that
the head was made separately for inser-
tion in a possibly draped statue;
Margaret Wyndham notes that "this
opinion is confirmed by the appearance
of the back of the neck which is sliced
down where the moulding of the neck
ceases" (1915, 122).

The Leconfield Aphrodite featured
prominently in the first volume of *Speci-
mens of Antient Sculpture* (1809) edited
by the eminent collector and connois-
seur Richard Payne Knight. The head,
however, did not achieve its present
fame until 1888, when Adolf Furt-
wängler inspected the marble, pro-
nounced it a Greek original of the fourth
century BC, and attributed it to no less
a sculptor than Praxiteles. Furtwängler
wrote enthusiastically:
"We have reserved for the end a
very beautiful and interesting work.
This is, as I hope to be able to prove, a
real original by Praxiteles himself, a head
of his favourite goddess Aphrodite, be-
longing to his later period. . . . This
superb life-size head was found last cen-
tury. When I saw it for the first time in
1888 I was absolutely enraptured with
its beauty. . . . We are now able, in the
light of recent discovery, to say with
certainty that this is a real original
by one of the first fourth-century
artists. . . . There is only one period of
Greek art to which the hair technique
of this head can be assigned, and that is
the period of Praxiteles." (Furtwängler
1895, 343).

Furtwängler's judgment and attri-
bution have stood the test of time sur-
prisingly well. One would still like to
believe that the Leconfield Aphrodite
is a Greek original of the fourth century
BC and that it comes "presumably from
Praxiteles's school if not his hand," as
Martin Robertson has recently remarked
(Robertson 1975, 393). C.A.P.

Literature: Michaelis 1882, 616, no. 73;
Wyndham 1915, 118–123, no. 73;
Vermeule 1977, 340–343 and fig. 1;
Stewart 1977b, 195–202; Oehler 1980,
81–82, no. 82, pls. 12–15; Sutton
1984a, 312, and fig. 8
Exhibitions: London, BFAC 1903, 17–18
(22), pls. 20–22; London, RA 1946, 37
(159), pls. 47–49; London, Wildenstein
1954 [no cat.]

227

PIER TABLE c.1765
English, with an Italian (probably
Roman) top
mahogany frame, parcel gilt, with an
inlaid marble and mosaic slab
83.8 × 132 × 58.4 (33 × 52 × 23)

The Burghley House Collection

Like his great-grandfather, the 5th Earl,
who formed one of the earliest collec-
tions of Italian pictures in any English
country house (see nos. 266 and 267),
Brownlow Cecil, 9th Earl of Exeter, who
succeeded in 1754, developed a con-
suming interest in the art of the Mediter-
ranean on his visits to Italy in 1763–
1764 and 1768–1769. Most of the an-
tique sculpture now in the house was
collected by him, as was the magnificent
chimney-piece in the state bedchamber
supplied by Piranesi through Robert
Adam's agency (Kelly 1968, fig. 80).
The spectacular marble tops of this table
and its companion in the Fourth George
Room must also have been shipped back
from Leghorn, perhaps even in the same
consignment, though there is an unfor-
tunate *lacuna* in the account books at
Burghley from 1755 to the late 1760s,
which makes it impossible to be precise
about the date.

The use of marble for table tops,
following Italian precedent, only became
general in England in the early eight-
eenth century when Palladian architects
demanded it for pier tables in halls,
saloons, and drawing rooms as well as
dining parlors. No trouble or expense
was spared in procuring rare colored
marbles from Italian palaces, and for
instance the younger Matthew Bretting-
ham dispatched seven cases of marbles
in one ship destined for Holkham Hall
in 1764 (MSS at Holkham). These prob-
ably included an antique mosaic slab
now on a table in the Landscape Room,
said to have come from the Baths of
Titus, like the pair in Robert Adam's
drawing room at Syon. Other Roman
mosaics (much restored, like the antique
statuary that they accompanied) were
brought back for Castle Howard by the
5th Earl of Carlisle. Lord Exeter may
have been led to believe that his slabs,
with their geometrical design of inter-
locking circles in mosaic, were also
antique in origin, though the different
colored specimens they enclose, and the
borders of green Volterra and yellow
Siena marbles, are patently eighteenth
century.

The stand, with a carved frieze of
delicate oval paterae and legs in the
shape of classical *fasces* with lion's head
capitals and paw feet, strikes a suitably
archaeological note—with the details
perhaps taken from Desgodetz' *Edifices
Antiques de Rome* (1682), a standard pat-
tern book for neo-classical designers.
The craftsman responsible is not known,
and the earliest reference to the tables
at Burghley seems to be in 1799, soon
after the 9th Earl's death, when they
were repaired by the scagliola worker
John Augustus Richter while he was
working on the North Hall (information
kindly supplied by Dr. Eric Till).

G.J-S.

228

TWO VASES WITH COVERS c.1764/1766
Italian, after a design by
Giovanni Battista Piranesi 1720–1778
marble
47 (18½) high; 53.5 (21) high

Broadlands
The Lord Romsey

The Sculpture Hall at Broadlands, the Hampshire home of the late Lord Mountbatten, still vividly illustrates the character and tastes of his wife's ancestor the 2nd Viscount Palmerston (1739–1802). Angelica Kauffmann's portrait of Palmerston, painted in Rome on his first Grand Tour in 1764 (and still at the house) shows him with Vesuvius in the background and holding his own plan of the Temple of Paestum. But, as he wrote to a friend, "what gave me the greatest pleasure was the ancient marbles . . . I never saw a statue worth looking at till I crossed the Alps" (MSS at Broadlands). This enthusiasm, fostered by the painter and dealer, Gavin Hamilton, resulted in the purchase of £525 worth of statuary in Italy in 1764, and a further £130 worth, probably including these two vases, sent by Hamilton over the following two

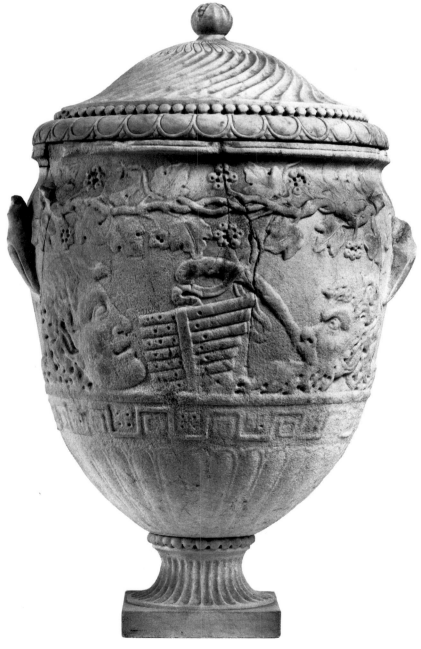

years. As with the contemporary collection of the 2nd Earl of Egremont at Petworth, the age of the pieces is variable, ranging from first-rate Roman works of the first to third centuries AD (like the huge sarcophagus panel of the Hunt of Meleager that is the centerpiece of the Sculpture Hall) to eighteenth-century "fakes," like these two vases, which Piranesi engraved for his *Vasi, Candelabri, Cippi* of 1778, dedicating the plate to "Signior Giovanni Taylor Cavaliere Inglese," although others in the book are dedicated to Lord Palmerston (Jackson-Stops 1980b, 2248–2249, fig. 9).

English patrons were a source of considerable income for the great engraver, antiquarian, and polemicist. Whole chimneypieces designed by him survive at Gorhambury in Hertfordshire, Burghley in Lincolnshire, and Wedderburn in Scotland (Rieder 1975, 582–591), while William Weddell of Newby also bought vases and urns from him for the sculpture gallery designed by Robert Adam at Newby in Yorkshire (Oehler 1981, fig. 76). While it is possible that a few small fragments of the Broadlands vases are antique (particularly the one with a frieze of pan-pipes flanked by heads of a satyr and faun), even these have been reworked to such an extent that they now represent a combination of Piranesi's scholarship and fertile imagination, far more than authentic Roman remains. Whether Lord Palmerston realized this is open to question. Though the dedications of the *Vasi* engravings are often disarmingly honest about the amount of new work carried out, most patrons preferred to think that they were buying "restorations" rather than new works of art. As to the identity of the carver responsible, Piranesi had dealings with so many—from major restorers like Cavaceppi and Pacilli, to specialist vase repairers like Cardelli and Grandjacquet (Howard 1973, 58)—that it is impossible to hazard a guess. What is certain is that designs like these were to have an important influence on a whole generation of English neoclassical architects, in particular on Robert Adam and his chief plasterer, Joseph Rose the younger, both of whom were known to Piranesi personally.

G.J-S.

229

PORTRAIT BUST OF A MAN
Roman, 2nd century AD; or after the antique
marble
93.9 (37) high

The Castle Howard Collection

The core of the collection of antiquities at Castle Howard near York was assembled in Rome during the first decades of the eighteenth century by Henry Howard, 4th Earl of Carlisle (1694–1758), who dealt primarily with the shrewd antiquarian Belesario Amadei and the learned collector and dealer Francesco de' Ficoroni. A considerable amount of unpublished Italian correspondence relating to the antique statuary (and often to engraved gems as well) is fortunately preserved in the archives at Castle Howard, together with recent transcriptions and translations of the letters.

No references to this masterly sculpture, one of the most imposing portrait busts in the collection, have been found in the eighteenth-century Italian correspondence. The provenance and date of acquisition of the marble are also uncertain. A man of about thirty years of age is depicted, with his head turned slightly to the right. He wears a tunic and fringed military cloak (*paludamentum*) fastened over the right shoulder by a round brooch resembling a four-petal flower. A portion of the tunic shows directly below the neck, emerging under the heavy folds of the fringed cloak. The supporting plaque resting above the round pedestal is unusual in that it is decorated with a scene carved in low relief, showing a winged Eros attacking a boar with a short spear.

The long, wavy hair of the figure is worked evenly throughout with a drill and a very fine chisel, and the curls are deeply undercut in order to exploit the contrast of light and dark surfaces. Carefully incised lines delineate the eye-brows and mustache as well as portions of the short beard. The irises of the eyes are similarly indicated, and the pupils are treated as a hollow circle with a narrow vertical ridge left in their upper part to suggest reflected light. All the worked surfaces are highly polished. This bust compares closely with a Roman Imperial male portrait unearthed in Rome in 1886 and now in the Museum of Fine Arts, Boston (Comstock and Vermeule 1976, 236, no. 370). That it has never been properly published presumably reflects the uncertainty among scholars about its chronology. At first glance, the bust appears to date to Antonine times (AD 138–192). Yet the unusually fine state of preservation (the sculpture is intact except for a few restored locks of hair), the lack of close parallels for the distinctive rendering of the hair, the distinctive figured relief on the supporting plaque, and, finally, the existence of a comparable portrait (also at Castle Howard) showing a richly bearded man, apparently designed as a pendant, are all factors that suggest this marble may date from the eighteenth or early nineteenth century. Regardless of its actual date, the portrait bust remains an impressive essay in antiquarian sculpture.

C.A.P.

Related works: A headless, Roman marble bust unearthed in Istanbul and now in the Archaeological Museum carries an identical scene of Eros attacking a boar, carved in low relief on the supporting plaque (Freyer-Schauenburg 1980, 119, no. 7, pl. 41:2). This parallel, which has been assigned to the Antonine period, speaks in favor of a date in the second century AD for the Castle Howard bust *Literature:* Dallaway 1800, 2:295, no. 3; Michaelis 1882, 329, no. 43

230

BUST OF A YOUNG MAN 18th century
Italian, probably Roman
marble
91.5 (36) high

Hagley Hall
The Viscount Cobham

The park at Hagley in Worcestershire, renowned in the annals of neo-classical architecture for the Temple of Theseus designed by James "Athenian" Stuart in 1758, is largely the creation of the 1st Lord Lyttelton (1709–1773), who

also erected the present Palladian house. Lord Lyttleton was to acquire a number of Roman marble sculptures in Italy as well as several contemporary copies of famous classical statues in public collections. The Hagley bust is neither Roman in date nor a straightforward copy of an ancient sculpture, but rather an accomplished eighteenth-century creation after the antique.

The young man represented appears to be about twenty years old. He wears a tunic under a metal cuirass with a leather lining that terminates in rectangular flaps at the armholes, and a

paludamentum or military cloak fastened by a large, round brooch covers most of his left shoulder. The head itself, of white Italian marble, is set into an elegant bust of variegated marble. The sculpture is surely meant to be a portrait, probably of an emperor. The features, however, are highly idealized and bring to mind Greek works of the fourth century BC, such as the so-called Meleager attributed to Skopas and preserved in numerous Roman copies (Stewart 1977, 104–107, pl. 44).

C.A.P.

231

TWO PEDESTALS
1st century AD
Roman
marble
$120 \times 67.9 \times 59.7$ ($47\frac{1}{4} \times 26\frac{3}{4} \times 23\frac{1}{4}$)
$109.8 \times 73 \times 60.9$ ($43\frac{1}{4} \times 28\frac{3}{4} \times 24$)

Newby Hall
R.E.J. Compton, Esq.

This pair of triangular Roman pedestals from the sculpture gallery at Newby Hall in Yorkshire orginally served as supports either for candelabra or for tall, decorative shafts (usually carved in imitation of vine stems and tree trunks) that were in turn surmounted by a marble basin or a finial such as a pine cone. These massive and richly embellished objects are distinctive products of the so-called Neo-Attic workshops. In terms of chronology, most extant examples range from Augustan to Hadrianic times.

Each of the triangular pedestals (also commonly referred to as tripod bases) is decorated with figures carved in low relief on all three sides. One of the bases illustrates Bacchic figures (a satyr playing the double flutes, a dancing maenad with tympanum, and a satyr holding a shepherd's crook); the other depicts two standing Victories (Nikai) as well as a seated female with a staff and a shield. One of the Victories, shown heavily draped, positions a helmet surmounting a trophy. The second Nike holds a palm branch. These archaistic and classicizing figures, derived from or

inspired by earlier Greek prototypes, were often replicated by Neo-Attic artists to satisfy the Roman demand for elegant, decorative sculpture in the grand tradition, and the relief of a dancing maenad with a tympanum is found in other Neo-Attic versions (see Fuchs 1959, 141-142, pl. 29c).

At the time of its acquisition in the eighteenth century, the pedestal with Bacchic reliefs supported a gray marble statuette of a baboon in Egyptian style (once in the Villa Mattei in Rome), which eventually ended up in the famous Pantheon at Ince Blundell Hall in Lancashire (Michaelis 1882, 355, no. 57; Ashmole 1929, 30, no. 57). Both sculptures are included in the third and last volume of the *Raccolta d'antiche statue* published by Bartolomeo Cavaceppi, the "King of Restorers," in 1772. Cavaceppi also illustrates the other triangular pedestal together with an accomplished marble statue of a heron still at Newby Hall and recently exhibited in London (Cavaceppi 1768, 1:pl. 4, and 3:pl. 53; for the heron, see London, Clarendon Gallery 1983, 78–79, no. 21).

The Newby tripod bases, which are virtually unpublished, can be traced back much earlier than the eighteenth century when they passed through Cavaceppi's vast studio. Drawings of both pedestals appear in the *Codex Coburgensis* (made shortly after the middle of the sixteenth century) as well as in the Dal Pozzo-Albani albums in the Royal Library at Windsor Castle (Vermeule 1966, 14, no. 8248, and 47, nos. 8684–8685). These albums, purchased for King George III in 1762 from Cardinal Alessandro Albani's library, come from the collection of the Commendatore Cassiano dal Pozzo (d. 1657) and his brother Antonio, who arranged for a vast selection of antiquities to be recorded by major and minor Roman artists of their time (see no. 192).

C.A.P.

Literature: Michaelis 1882, 525, no. 8, and 534, no. 41; Waywell 1978, 36, no. 8/9, and 38, no. 41; Howard 1982, 65–66, 255, nos. 1, 6, figs. 148–149

232

CAIUS JULIUS CAESAR
17th or 18th century
Italian
marble, in *verde antico* marble frame and
stand
inscribed, *C. IULIUS CAESAR*
68.6 × 45.7 (27 × 10)

Holkham Hall
Viscount Coke

Formerly in the famous London collection of the antiquarian Dr. Richard Mead, this oval relief was bought at the sale after his death in 1754 by Thomas Coke, 1st Earl of Leicester (1697–1759). Decorative roundels of this sort were immensely popular among English eighteenth-century connoisseurs, and some, like William Holbech of Farnborough Hall in Warwickshire, went so far as to split antique heads and set them within new oval mounts (information from Dr. Hansgeorg Oehler). Many other examples were bought in Italy as "restored antiques," making

particular appeal because of their subject matter (Julius Caesar being an obvious favorite), or because their colored marble backgrounds helped to enliven the decoration of entrance halls or sculpture galleries. Lord Leicester's Statue Gallery at Holkham Hall in Norfolk, which remains one of the best-preserved interiors of its kind in England, was being completed in the mid-1750s, just as the time this relief was acquired.

This portrait has been little studied, but is now rejected as an antiquity. The crisp profile and generalized treatment of detail point to a post-Renaissance date. It is generically related to a Florentine Renaissance rectangular marble relief probably of Julius Caesar in the Museum of Fine Arts, Boston, attributed by W.R. Valentiner to Mino da Fiesole.

C.A./G.J-S.

Literature: Museum Medianum 1755, 225; Michaelis 1882, 316, no. 46; Vermeule and Bothmer 1959, no. 63, 155

233

PROFILE RELIEF OF PYRRHUS
late 16th century
workshop of Francesco del Tadda
1497–1585
red porphyry, colored marbles, and
scagliola
69.8 × 53.3 × 28 (27½ × 21 × 11)
inscribed, *PYRRHVS FIL ACHIL*

Wilton House
The Earl of Pembroke and Montgomery

The rare material used for the face, and the medallic profile, point to the workshop of the greatest specialist in sculpting porphyry, Francesco di Giovanni Ferrucci, called Del Tadda. He was employed extensively by the Medici, Grand Dukes of Tuscany, from the mid-sixteenth century. He created in 1555 the porphyry and marble fountain for the first courtyard of the Palazzo Vecchio in Florence, which was crowned with Verrocchio's bronze *Cupid and Dolphin* (Allegri and Cecchi 1980, 227–229, no. 53); the massive porphyry

statue of *Justice* mounted on a column in Piazza Santa Trinità, Florence, dates from about 1580. He also produced a number of oval portrait reliefs of the Medici, for example one of Cosimo I, after 1569, now in the Victoria and Albert Museum (Pope-Hennessy 1964, 448–449, no. 479). Others, made before 1570, are in the Museo Nazionale, Florence (Florence 1980, 345–347, nos. 700–708). A similar, signed head of Christ dated 1560 is in the Rudolphinum in Prague.

Del Tadda enjoyed contrasting the smoothly buffed areas of flesh with the matt treatment of hair, carved in broad locks, as here. The different colors of portrait and background are also typical, though there is a greater variety than usual here: possibly the background would orginally have been a more somber green slab of *verde di Prato* (serpentine).

This portrait is one of a number of sculptures acquired by the 8th Earl of Pembroke (1656–1733) from the collection of Cardinal Mazarin, and the portrait of this classical hero may have been regarded as an antiquity by its early owners: a Pyrrhus "in Porphyry" was listed among a number of antique busts and bas-reliefs "above stairs" by the antiquarian John Loveday on his visit to Wilton in 1731 (Markham 1984, 540). Three years earlier, a French visitor, Fougeroux, had described the house as "a second Rome . . . the rooms (both above and below), the staircases, the corridors, are all filled with statues, busts, bas-reliefs and ancient tombs" (Fougeroux 1728. It is described in a 1778 guidebook of Wilton as "An Alto Relievo of Pyrrus, the Son of *Achilles*. It is an Oval, and has a splendid Aspect, as of a very large Gem; the Face is Porphyry, which the Cardinal *Mazarine* so much valued, as to finish his Dress with a Helmet of different coloured Marble," listed in the Cube Room, now known as the Single Cube (Kennedy 1778, 82). The crude inscription is typical of those carved on the antique statues at Wilton, apparently by a local stonemason in the early years of the eighteenth century. C.A./G.J-S.

234

COLOSSAL FOOT
2nd century BC/1st century AD
Hellenistic or Early Roman
marble
41 × 102 × 60 (16 × 40 × 23 5/8)

Chatsworth
The Chatsworth House Trust

This colossal marble foot, one of the most curious objects among the many treasures at Chatsworth, was acquired by the 6th Duke of Devonshire in 1839 from Carlo Finelli, a sculptor in Rome. In his *Handbook of Chatsworth and Hardwick*, published in 1845, the 6th Duke states that the foot "belonged to the Quirigi family at Lucca, and was long in their palace" (Cavendish 1845, 23–24). He no doubt refers to the Guinigi mansion in Lucca, which, having passed to the state in 1948, is now the Museo di Villa Guinigi. In addition, the album of sculpture accounts and correspondence in the library at Chatsworth contains Finelli's receipt in acknowledgment of the payment of 348 *scudi* for "un Piede Colossalle di marmo antico, e scoltura Greca."

Although the 6th Duke believed the colossal foot to be ancient, the sculpture has repeatedly (and without justification) been dismissed as a nineteenth-century forgery since the first decade of this century. Only recently has its authenticity been vindicated by the discovery of the matching right foot in the basement of the Antikensammlung of the Staatliche Museen in East Berlin (Picon 1983, 95–106). The Berlin foot was brought from Egypt (the exact site is not recorded) by the great Italian explorer Giovanni Battista Belzoni and acquired in Venice for the Berlin Museums in 1843 from the art dealer Pajaro, who also supplied other antiquities to Berlin. There are casts of this sculpture in the Gipsformerei of the Staatliche Museen in Berlin, and in the H.W. Sage Collection at Cornell University in Ithaca, New York (Picon 1983, 96–98).

It is clear, therefore, that the two colossal marble feet were on the Italian art market around the late 1830s and early 1840s. But the Berlin foot, if not both feet, must have left Egypt much earlier, since Belzoni died in 1823. How, when, and why the two feet became separated, one finding its way to Lucca and the other to Venice, are questions that remain unanswered.

There is no doubt that the Chatsworth foot, a left one, matches the right foot in East Berlin. Their sandals and their scale, about seven times life size, are identical. The entire statue must have stood about eleven meters high. Scale and technique (the fact that the feet were made separately for insertion) suggest that the sculpture was a cult statue, while the type of sandal indicates that it represented a woman. This kind of thong sandal with indented sole, ornate side straps, diamond-shaped clasp, and loops at the sides is well known as a female fashion from the Hellenistic period onward. The colossal foot may be assigned to Hellenistic (Ptolemaic) or early Roman times.　　C.A.P.

Literature: Cavendish 1845, 23–24; Waywell 1978, 17, no. V, 14a; Devonshire 1982, 150, and frontispiece

235

TERMINAL FIGURE OF EROS
1st/2nd century AD
Greco-Roman
marble
133.6 (53) high

Newby Hall
R.E.J. Compton, Esq.

The sculpture gallery at Newby Hall in Yorkshire was designed by Robert Adam in 1767 (after the original plans by John Carr had been rejected) to house the collection of ancient marbles that William Weddell had acquired in Italy. The greater part of this collection, which is beautifully displayed and still intact, was purchased in Rome by Weddell in the year 1765. According to a letter from the celebrated art historian Johann Joachim Winckelmann (1717–1768) to the Italian physician and diplomat Giovanni Lodovico Bianconi (one of Winckelmann's first benefactors during his Dresden days), this antique marble herm of Eros appears to have come to light in 1763, presumably in the Roman Campagna or in the capital itself. Winckelmann states that the marble (then merely an unrestored fragment) was in the possession of an Englishman living in Rome who had been fortunate to find such a figure: "Un altro inglese domiciliato in Roma ha avuto la sorte di trovare un Termine . . ." (see Michaelis 1882, 532, no. 28, with references). It has been suggested that this unnamed English expatriate was either the notorious Thomas Jenkins, the foremost antiquarian dealer of his time, or the Scottish painter Gavin Hamilton, Jenkins' close friend and constant collaborator (Michaelis 1882, 532, no. 28; Howard 1982, 65).

After passing through the restorer Bartolomeo Cavaceppi's rejuvenating hands, the lovely but battered fragment resurfaced in pristine condition, complete with a new head and neck, a pair of wings, arms holding attributes, and a stepped base for the lower part of the terminal pillar. Such is the transformed figure that appears in an engraving published by the shrewd restorer, who calls the resultant creation a "Genio femminile" (Cavaceppi 1768, 1:pl. 40). The Italian sculptor also appends a reference to Winckelmann's remarks about the piece in the second volume of his *Monumenti antichi inediti*, published in 1767. On two separate occasions the German scholar likewise mistook the statue for that of a woman or a hermaphrodite. Despite its effeminate form (note especially the modeling of the breasts), the figure at Newby is surely male and originally represented an Eros. Michaelis, among others, has observed that a stump of the right wing is ancient (Michaelis 1882, 531, no. 28). The winged god wears an animal skin tied over the left shoulder and descending diagonally toward the right hip. He holds a pitcher in his lowered right hand and a torch (now fragmentary) in the upright left. The figure's torso terminates in a slightly tapering shaft resting on a stepped base. Comparable terminal figures are well represented in Greco-Roman sculpture. They were used as garden herms, vertical posts in low balustrades, and caryatids to support the roofs of small buildings and shrines. C.A.P.

Literature: Cavaceppi 1768, 1:pl. 40; Michaelis 1882, 531–532, no. 28; Reinach 1916, 351, no. 1448 B; Waywell 1978, 37, no. 28; Howard 1982, 65, 255, no. 3, figs. 140–144

236

FORTUNA (or ISIS)
1st/2nd century AD
Roman
marble
119 (47) high

Holkham Hall
Viscount Coke

Despite the fact that it has been considerably reworked and restored, this small, marble Roman statue of a draped woman is of special interest for the history of the classical collection at Holkham Hall. The piece was acquired in May 1749 by the Earl of Leicester's agent in Rome, Matthew Brettingham the younger, who purchased it from Belesario Amadei, a leading antiquities dealer based at that time in the Piazza Navona. Brettingham secured the statue together with four other Greco-Roman marbles, all of which are still at Holkham: an Aphrodite, a Ceres (or Demeter), an Athena, and a statue of Meleager.

This group appears to have been Brettingham's first consignment of ancient sculpture to Holkham. He initially succeeded in securing an export license for the five pieces. The permit, however, was subsequently denied; and this led to a long lawsuit (it seems to have lasted until 1751) that Brettingham eventually won. It has been suggested that this statue was the principal cause of the export complications and the resulting litigation (see Kenworthy-Browne 1983a, 42, 118, 128).

The heavily draped woman wears a long, thin garment (*chiton*) under a fringed mantle that covers both shoulders and curves across the front to descend over the extended left arm. She holds a pitcher and a cornucopia (an attribute of the Italian goddess Fortuna) encircled by a snake and replete with fruit, grain, and a fillet of carded wool. The statue is known to have been restored by Bartolomeo Cavaceppi, the foremost restorer in eighteenth-century Rome (Holkham MSS, Kenworthy-rowne 1983, 128). Cavaceppi supplied the figure with attributes and a new head complete with a lotus flower at the top. This kind of head-dress figures in representations of the Egyptian goddess Isis. The Holkham statue may have been first conceived as a representation of Fortuna (Tyche), since part of the cornucopia is ancient. Michaelis suggests that the goddess was originally shown holding a steering paddle in her right hand, as a symbol of the deity's protection of seafarers. He also notes that "all antique parts [are] worked over by Cavaceppi to such a degree that it is often difficult to recognise the restorations" (Michaelis 1882, 316, no. 42).

C.A.P.

Literature: Michaelis 1882, 316, no. 42; Holkham 1913, 4 s.v. Tyche; Vermeule and Bothmer 1959a, 155; Howard 1982, 249, no. 16, figs. 71–73; Kenworthy-Browne 1983, 42, 118, s.v. Lawsuit, 128 s.v. Isis

237

JOHN, LORD HERVEY 1728–1729
Edmé Bouchardon 1698–1762
marble
76.2 (30) high
inscribed on the name plate,
JOHN.LORD/HERVEY., and around
the socle, *Edmund Bouchardon faciebat
Romae A.MDCCXXIX.*

Melbury House
Lady Teresa Agnew

Lord Hervey (1696–1743), eldest surviving son of the 1st Earl of Bristol, was a supporter of Sir Robert Walpole and a prominent figure in political and literary circles, whose *Memoirs* form a principal source of information about George II and his court. In 1720 upon his marriage to Mary Lepel, the couple were savagely attacked by Pope as "Lord Fanny" and "Sappho." With his friend Sir Stephen Fox (later Lord Ilchester) he visited Italy on account of his health between autumn 1728 and September 1729 and probably sat for Bouchardon in late 1728, when he passed through Rome on his way to Naples. In 1762 the bust was seen by Horace Walpole at Fox's house, Redlynch (1927–1928, 44), and it is likely that Hervey gave it to his friend who showed him "an affection and friendship I am as incapable of forgetting, as any nature but his is incapable of feeling" (Sedgwick 1931, 974).

Having won first prize for sculpture at the Académie in Paris, Bouchardon went to Rome in 1723. There he carved a series of outstanding busts and returned to Paris in 1732 to become one of the leading French sculptors of the mid-eighteenth century. For his portrait of Hervey, Bouchardon adopted a severely classicizing manner, already seen in his bust of the antiquarian and spy Philipp von Stosch two years earlier (Metz and Rave 1957). The truncation of the bust low across the chest, the bold depiction of the sitter with short hair and almost nude, and the form of the supporting nameplate and socle are all closely paralleled in an antique Roman type exemplified by a bust in the collection of Cardinal Albani, to whom Stosch was librarian (Jones 1926, 319). Portrayal in this classical manner was especially fitting for Hervey who prided himself on his classical learning; appropriately this bust (or the Ickworth version) is shown in a truncated and reversed form as the frontispiece to the 1778 edition of *Letters between Lord Hervey and Dr. Middleton concerning the Roman Senate.* The use of classical conventions seems to have found more general favor with English sitters, it was apparent as early as 1701, in Monnot's Earl of Exeter (no. 217), and became more common following Rysbrack's adoption of a Roman Republican type for his Earl of Nottingham in 1723. This taste may in part be explained by the view so frequently expressed in eighteenth-century England that in political and cultural life, the English were heirs to the democratic traditions and values of ancient Rome.

Bouchardon's Roman busts have a severity that anticipates late eighteenth-century neo-classical portraits and represents a type distinctly different from that developed by Rysbrack and Scheemakers. Nevertheless, many of the sculptor's sitters were British. In addition to portraits of Hervey and Stosch (who as a British government agent spying on the Pretender's court in Rome was closely connected with English and Scots in Rome), Bouchardon also executed busts of the Duchess of Buckingham, Lady Lechmere, and a "M. de Gordon," who may be the John Gordon shown on a wax medallion by the ivory carver Giovanni Battista Pozzo (in the Victoria and Albert Museum). A similar circle of British patrons seems to have been shared by Pozzo, whose medallion portraits include Stosch (anticipating Bouchardon's version), Hervey's correspondent, Conyers Middleton (Theuerkauff 1984), and the gem engraver, Lorenz Natter, whose agate medallion of Hervey closely resembles the Bouchardon portrait. M.B.

Related Works: Another (probably secondary) marble version at Ickworth (London, RA 1968, 795)
Provenance: Probably given by the sitter to Sir Stephen Fox; by descent to present owner
Literature: Kerslake 1977, 141; Baker 1985

238

SIR ANDREW FOUNTAINE 1747
Louis François Roubiliac
1702/1705–1762
marble
76.2 (30) high, including separate socle
inscribed, *AAA/FF/IIIVIR/
MDCCXLVII*, in medallion on socle

Wilton House
The Earl of Pembroke and Montgomery

A distinguished antiquarian and the
author of a study of Anglo-Saxon coin-
age, Fountaine was Warden of the
Mint between 1727 and 1753. He spent
several years in Italy and formed an
important collection of works of art
at Narford Hall, Norfolk, the ceilings
of which he had decorated in an
advanced French style by Andien de
Clermont. He was also one of Roubiliac's
earliest English patrons, having pur-
chased a marble Venus in 1738 (Mur-
doch 1983). According to Vertue
(1930–1955, 3:156–157), Fountaine
was responsible for cataloguing the col-
lection of Wilton, being "all his time
intimate and familiar with the Old Earl
of Pembroke and the late Earl to the last."

Although the terracotta model is at
Narford, this portrait was probably
commissioned by Henry, 9th Earl of
Pembroke, the "Architect Earl," who
paid Roubiliac £30 on 3rd April 1747.
It was later paired with a bust of Martin
Folkes (London, V & A 1984, S11),
purchased by Pembroke in 1749. In 1766
both busts were in the Great Room
(the Double Cube), placed respectively
on tables of lapis lazuli and red Egyptian
granite (Martyn 1766, 2:157), but by
1779 they were displayed together in a
window in the Chapel Room (Kennedy
1779, 68).

Roubiliac's marble of Fountaine re-
flects the sitter's antiquarian interests,
following the classical convention
derived from Roman portrait sculpture
that enjoyed early and widespread
popularity among English patrons from
the early eighteenth century (see no.
217). Its dramatic quality, however,
recalls that of imperial busts rather than
the Republican examples imitated by
Rysbrack. Similarly appropriate for the
marble of Fountaine is the use on the
socle of an inscription from a Roman

coin reverse, meaning "Triumvir ap-
pointed to cast and strike money in
bronze, silver and gold"; both the in-
scription and the medallion form were
derived directly from the medal of
Fountaine struck in 1744 by Jacques
Antoine Dassier. M.B.

Related Works: Apart from the terra-
cotta model at Narford, "a bust begun
for Sir *Andrew Fountaine*" was included
in Roubiliac's posthumous sale (12 May
1762, lot 82) and may have been a ver-

sion of the Wilton marble, although it
is unclear if this was a portrait of
Fountaine himself
Provenance: The bust's purchase by the
9th Earl of Pembroke is recorded in the
Wilton household account book as,
"April 3rd 1747. To Mr. Roubiliac for
the marble head of Sr A Fountaine
£30.00.00"; and by descent
Literature: Esdaile 1928, 2:90, 94, 183;
Webb 1956, 804; Whinney 1964, 111,
206
Exhibitions: London, RA 1956/1957 (199)

239

ATTIC BLACK-FIGURE HYDRIA
c. 530/520 BC
manner of the Lysippides Painter
terracotta
46.5 (18⅜) high

Charlecote Park
Sir Edmund Fairfax-Lucy, Bart.

On the body of this impressive hydria,
or water jar, within a framed panel,
Herakles is locked in combat with the
Nemean lion. This, the first of the
twelve labors the hero performed for
Eurystheus, king of Argos, is a theme
greatly favored by Attic vase painters
in the closing decades of the sixth cen-
tury BC. The present iconographic
scheme appears to have been conceived
some years earlier by the master potter-
painter Exekias. Herakles wrestles the
lion to the ground, encircling its neck
in a powerful stranglehold; with right
leg raised and foot braced against the
frame, he thrusts his full weight forward
onto the beast, while fending off with
his right hand the blow from a poised
hind paw.

Behind Herakles stands Iolaos, his
nephew and frequent aid in trouble.
Watchful and apprehensive, he holds
his master's club ready. The hero's pro-
tectress, Athena, calmly surveys the
struggle from the right, confident that
her protégé will triumph. Both figures
gesture support and encouragement
with an open hand. To fill the vacant
background, an insubstantial tree
spreads wide its branches, from which
Herakles' garment, quiver, and sword
hang. Above this scene, on the vase's
strongly articulated shoulder, a chariot
race is in progress. Two four-horse
teams course to the right, urged smartly
on by their drivers each of whom wields
a goad.

The Charlecote hydria has not pre-
viously been attributed. It may, how-
ever, be tentatively assigned to the
manner of the Lysippides Painter, whose
mature works it markedly resembles.
Sir John Beazley characterized the
Lysippides Painter as a follower of
Exekias (1956, 254–262, and 1971,
113–116; see also Burn and Glynn
1982, 32–34, and Cohen and Moon in
Moon 1979, 83–84, 91–93), at one time

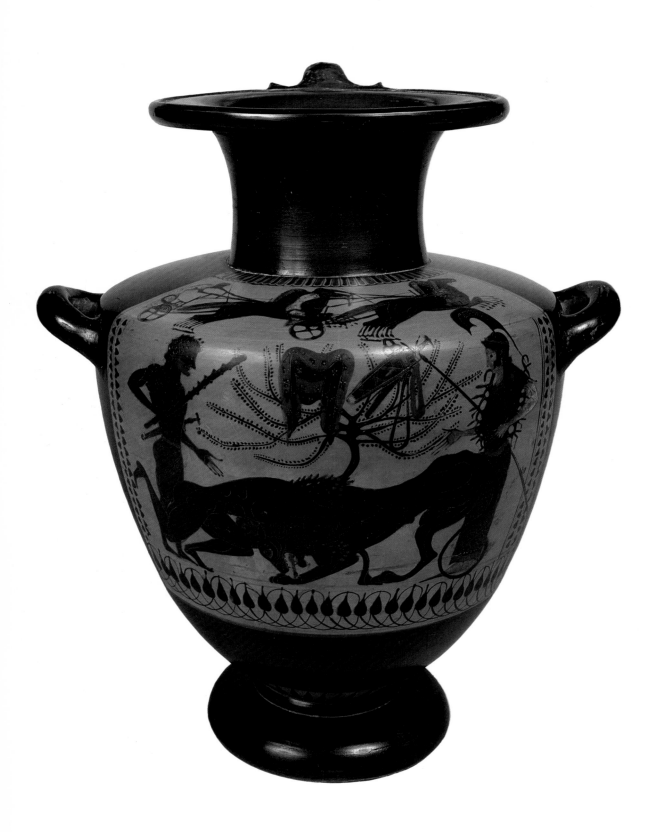

identifying him with the Andokides
Painter to whom the invention of the
red-figure technique is traditionally as-
cribed (on the Lysippides/Andokides
question see Boardman 1974, 105, and
1975, 15–16, and Cohen 1978, 1–193).

This hydria is one of a collection of
antique vases purchased in Pompeii by
George Hammond Lucy (d. 1845) and
wife Mary Elizabeth (d. 1890), on one
of two extensive tours of the continent
made in 1829 and 1841. The collection
was arranged around the cornice of the
bookcases of the library at Charlecote,
installed in 1833 to accommodate the
antiquarian's extensive purchases of
books. Lucy was above all responsible
for the rebuilding and furnishing of
Charlecote in the 1820s and 1830s in
the Elizabethan style (see no. 490).

J.R.G.

Related Works: Among works attributed
to the manner of the Lysippides Painter,
compare for example a hydria in the
British Museum (Beazley 1956, 261, no.
40, and 1971, 115) and a neck-amphora
at Berlin (Beazley 1956, 259, no. 25)
Provenance: Purchased by George
Hammond Lucy; and by descent to Sir
Montgomerie Fairfax-Lucy, 4th Bart.;
on loan to the National Trust (which
acquired Charlecote House and many
of its contents in 1945) from the present
baronet
Literature: Bothmer 1959, 149 (2);
Boardman 1978, 14–15, figs. 1a, 1b; for
the shape of the vessel see Diehl 1964,
58

240

THE NORTHAMPTON AMPHORA
c. 540 BC
probably Etruscan
terracotta
32.4 (12¾) high

Formerly at Castle Ashby
Private Collection

This famous black-figure neck-amphora, or storage vessel, was until quite recently the crowning glory of the collection of ancient vases at Castle Ashby in Northamptonshire. Across its neck, on obverse and reverse, a merman (or triton) glides over unseen waves. There are slight differences of detail in the drawing, most notably in the position of the tail fins. The triton on the obverse clasps a white dolphin in his raised right hand, a wreath in his left; his counterpart on the reverse holds a pair of wreaths, while two dolphins leap in the more ample space about him.

On the obverse, Dionysus presides over a band of reveling satyrs. The god of wine, clad in a long chiton and himation, lifts his kantharos aloft. He faces the smallest of the four satyrs, who dances to his own accompaniment on a double flute. A second one turns around to dip his oinochoe for wine into a dinos on a tall, metal stand. Behind the god, two other satyrs approach from the left: the furthest clutches a white wineskin under his arm and brandishes a drinking horn; the nearest proffers an oinochoe in his left hand and clasps a leafy spray in his right. All sport prominent wreaths, and of the satyrs, all but the wine dipper have equine feet.

The reverse transports us into a world at once less merry and more fantastic. An elaborate complex of gaily painted palmettes, tendrils, and buds divides and dominates the picture zone. Symmetrically placed to either side are naked pygmies astride imposing cranes. The *S*-shapes of the birds' long, slender necks both echo and reinforce the curvilinear patterning across the surface. At ground level we encounter two hedgehogs, a hare leaping into the vegetation for cover, and a foxlike hound who, having caught his quarry's scent, urges his master forward. It has been suggested (Boardman and Robertson 1979) that the pygmies wield their clubs not against one another in battle, but together in the hunt; their former foes, the cranes, are now subdued, and provide swift mounts for the chase. The delicate balance of the composition on this side of the vase gives one the sense of a moment caught and held forever.

This remarkable vase, the finest of its kind, is the name piece of the 'Northampton Group' of amphorae, which is closely connected with the Group of Campana Dinoi (see Cook 1981; Simon 1983, 56–57 no. 21, 180; and Hemelrijk 1984, 185–187). Although the style is recognizably East Greek, their place of manufacture has yet to be determined with certainty. Samos, North and South Ionia, the Cyclades, and Etruria have all been proposed. This last, in Boardman's view, is most probable. Etruria is the recorded provenance of the Northampton Amphora, and in all likelihood this vase was produced there by an immigrant Ionian artist. A relative newcomer to the Northampton Group, a fragmentary neck-amphora found between 1959 and 1964 at Panticapaeum in the Crimea, and mistakenly published by N. Sidorova as Clazomenian, alone shares with the Northampton vase the imposing floral complex central to one side, in this instance flanked by satyrs.

The notable assemblage of vases once at Castle Ashby was formed by Spencer Joshua Alwyne, 2nd Marquess of Northampton (1790–1851), largely during a ten-year stay in Italy from 1820 to 1830 occasioned by his wife's delicate health. While still in Rome, his collection was given notice and partly published by scholars in learned journals (see Boardman and Robertson 1979, v). In 1829 the recently founded German Institute in Rome admitted the marquess to an honorary fellowship. J.R.G.

Related Works: The famous Ricci hydria in the Villa Giulia, and a dinos (with boar hunt) in a private collection, both by Hemelrijk's Ribbon Painter (Campana Dinoi), share with the Northampton Amphora the use of a similar cable pattern
Provenance: Purchased by the 2nd Marquess of Northampton; and by descent to the present marquess, by whom sold, Christie's, London, 2 July 1980, lot 99
Literature: Shepard 1940, 19, pl. 3, fig. 21; Boardman and Robertson 1979, 1–2, pls. A, 1–3 (with previous literature; the fullest and most recent description of the vase, to which the present author is indebted)

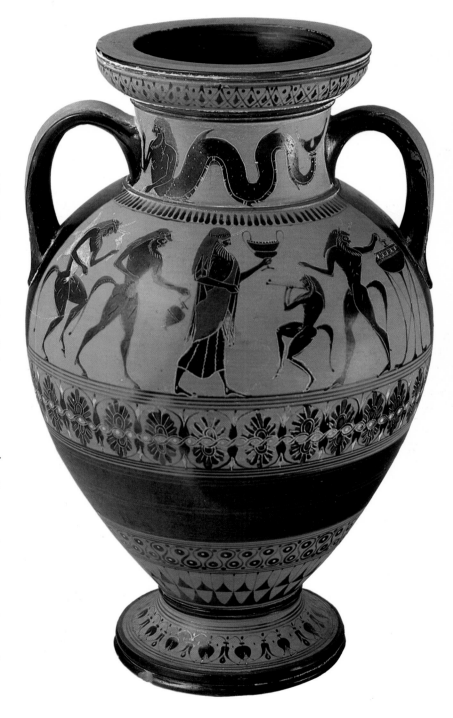

241

MARSYAS C.1715–1719
Pierre Legros II 1666–1719
marble
73.6 (29) high

Private Collection

The satyr Marsyas is shown bound to a tree, about to be flayed by Apollo, whose musical skill he unsuccessfully challenged on his pipes, shown here at his feet. Based on the account in Ovid's *Metamorphoses*, this subject was common in baroque painting and sculpture. It appeared, for example, on the vault of Annibale Carracci's Farnese Gallery. The attribution of this model to Legros is based on the description of the Dresden bronze version in the 1765 inventory of the King of Poland as by Legros, although the 1728 inventory connects it with Vinache who probably supplied it (Holzhausen 1939, 174). A number of antique sculptures of the subject were well-known in the seventeenth and eighteenth centuries, the most celebrated being that purchased by the Medici in 1584 (Haskell and Penny 1981, 262). Legros' composition appears to be an independent invention, although it is probably based on a Saint Sebastian model known in various bronze versions and now considered French.

A Parisian by birth, Legros was sent to the French Academy in Rome in 1690; he was the leading sculptor in late baroque Rome until 1715 when he returned for a period to France, allowing Rusconi to gain commissions for the majority of the Apostles in San Giovanni in Laterano. It is likely that this Marsyas dates from Legros' return to France, as it resembles in its scale those modestly sized marbles produced for display on furniture in Parisian *hôtels*. The dimensions of this particular version tally exactly with those of a "figure de marbre de LE GROS réprésentant le Satyre Marsyas" that was placed "sur la Bibliothèque" (by Boulle) in the salon of La Live de Jully and sold in 1770 (Paris, 2 May 1770, lot 151 [Souchal 1981, 2:298]). If this identification is correct, this fine marble may perhaps have been among those many works of art acquired by English collectors in France following the Peace of Amiens in 1815. However, Legros' works were already being brought to England during the early eighteenth century. Another version of the Marsyas was to be seen at Hartwell House, Buckinghamshire, by 1738 when it appeared in a view of the gardens by Balthasar Nebot (Harris 1979, 189, fig. 194f, and color pl. xx), and within a few years the sculptor's stucco relief of Tobias and Gabellus, now at Stourhead, had been placed above the library chimneypiece at Wavendon, Buckinghamshire. (Conforti 1977) M.B.

Related Works: A lost or unidentified terracotta (65 cm high) was included in the Crozat de Tiers sale, Paris, 1773, lot 1054 (Souchal 1981, 2:298); a marble version in the Victoria and Albert Museum, formerly Christie's, (20 February 1969, lot 93), 89.2 cm high. Other lost versions also probably in marble, but differing from surviving examples and from each other, are shown in Nebot's views of Hartwell (discussed above) and in an undated chalk sketch by the early nineteenth-century Cologne artist and collector Matthias Joseph de Noël (repr. as a "Männlicher Akt" by Böhn 1980, fig. 7); bronze versions, differing from each other and the marbles, are at Dresden (Staatliche Kunstsammlungen, 68 cm high; see above), Rotterdam (Stichting Hannema –De Stuers Fundatie, Hannema 1964, 104), and formerly in the collection of Anthony Blunt.
Literature: Penny 1982, 245; Baker 1985

242

ZEUS
1st century/2nd century AD
Greco-Roman
marble
81 (31⅞) high

Stourhead
The National Trust (Hoare Collection)

A mature, bearded Zeus is represented in heroic semi-nudity: in his right hand the Father of the Gods holds his powerful attribute, the thunderbolt.

Formerly the Wiltshire home of the Hoare family, Stourhead still houses one large and relatively well-known Roman marble, the so-called Livia reputed to come from Herculaneum and once in the collection of Dr. Richard Mead who died in 1754 (Vermeule and Bothmer 1956, 343, pl. 110, fig. 24). The Livia is displayed in the Pantheon, one of the buildings that grace the celebrated landscape garden at Stourhead. Unlike the Livia, this small statuette of Zeus has seldom received scholarly attention. It is about half life size and has undergone cleaning in recent years, which has made its fine state of preservation apparent once again. Only the left hand, the right arm with the thunderbolt, and part of the back have been restored. The head is ancient and evidently belongs to this statue.

This figure of Zeus adorns the entrance hall of the Palladian house together with another Greco-Roman marble of comparable scale and condition, an elegant statuette of Hera (or possibly Kore, the daughter of the corn goddess Demeter), which appears to reflect a late fifth-century BC creation (Vermeule and Bothmer 1956, 344). Neither the provenance nor the date of acquisition of the two marbles have yet been established, though it may reasonably be assumed that the statuettes were purchased together and as pendants (the Hoare Collection contained relatively few Greco-Roman antiquities). The purchase may have been made by Sir Richard Colt Hoare (1758–1838), an omnivorous collector and eminent antiquarian who resided in Italy for several years.

The prototype of the Stourhead Zeus may have been a late fourth-century BC work. The statuette has been considered a forerunner of a Hellenistic sculptural type best represented by the colossal, second-century BC marble statue of Poseidon from the island of Melos, and now in the National Museum at Athens (Vermeule and Bothmer 1956, 343–344). Vermeule attributes the prototype to the fourth-century BC sculptor Leochares and concludes that "since the support [of the Stourhead Zeus] is ancient and a short stump rather than the distinctive dolphin of the Melos statue, the original must have represented Zeus rather than Poseidon." C.A.P.

Literature: Vermeule and Bothmer 1956, 343–344, pl. 105, fig. 4

243

THE DOG OF ALCIBIADES
probably 2nd century AD
Roman after a Greek original
marble
118 (46½) high

Duncombe Park
The Lord Feversham

Variously ascribed in the eighteenth and nineteenth centuries to Phidias, Myron, Lysippos, and Leukos, this marble statue of a dog, twice lifesize, acquired great fame upon its arrival in England. At that time it earned its owner Henry Constantine Jennings (1721–1819), the nickname "Dog-Jennings." The dog is a Molossian, ancestor of the modern mastiff, and one of several breeds said in antiquity to come from Epirus in northwestern Greece.

The provenance of this statue is not known (Dallaway's statement that it was found at Monte Cagnuolo is surely wrong), but its more recent history is well documented. Jennings acquired it in Rome between 1748 and 1756 for 400 scudi (about £80) from the sculptor Bartolomeo Cavaceppi (? 1716–1799), who had restored the statue (the muzzle, left foreleg, small patches on the body, and all four sides of the plinth are new; the tip of the tail is missing, see below). Cavaceppi, the foremost restorer of his time, published an engraving of the dog in the first of his three-volume *Raccolta d'antiche statue*, where he names Jennings as the owner of the sculpture (Cavaceppi 1768, 1: pl. 6).

Something of an eccentric, Jennings liked to describe his Molossian as the "Dog of Alcibiades," a reference to the famous story of Alcibiades cutting off his dog's tail and, on hearing that all Athens felt sorry for the animal, answering that he "wished the Athenians to talk about this, that they might not say something worse of me" (Plutarch, *Life of Alcibiades*).

Talk also surrounded Jenning's Molossian, especially after it brought one thousand guineas at auction. Like Alcibiades, he was fond of horses, but his passion for racing brought him nothing but financial loss, and he was eventually forced to consign his collection to Christie's in London. On 4 April 1778, the statue was purchased by Charles Duncombe of Duncombe Park in Yorkshire (Michaelis 1882, 92–93, 294–295, no. 1) with whose family it still remains.

Winckelmann referred to this dog as a beautiful specimen, and Walpole ranked it among the five chief statues of ani-

mals from antiquity. Johnson and Burke discussed the Molossian at the Literary Club, and Boswell recorded the conversation there on the day before the sale of the dog at Christie's (for references see London, Clarendon Gallery 1983, 81–82, no. 22). Modern casts of the sculpture were available (one still stands by the canal along Fisher Row in Oxford, another copy in marble is at Hever Castle in Kent) and no doubt contributed to the animal's great fame. Nollekens' biographer states that "a mould of it belongs to Sarti, the figuremaker, a cast from which makes a most noble appearance in a gentleman's hall" (Smith 1828, 1:292; see also 2:169). In 1829 John Edward Carew executed a full-size copy in stone for the 3rd Earl of Egremont, as a memorial to one of the earl's hounds, which accidentally drowned in the lake in Petworth Park.

The sculpture is in reality a Roman copy of what must have been a famous Greek original (presumably in bronze), to judge from the considerable number of replicas extant. No other animal sculpture from the ancient world has come down to us in so many Roman copies. Besides that from Duncombe Park, there are two in the Cortile del Belvedere of the Vatican, and another pair in the Uffizi, both originally from Rome, but taken to Florence in the sixteenth century and recorded there by Vasari as early as 1568. A sixth copy, found at Castel Fusano near Ostia, and still in the Palazzo Chigi in Rome was also restored by Cavaceppi, who furnished it with feline-looking claws, muzzle, and tail; and there are four smaller versions that appear to reflect the same prototype (London, Clarendon Gallery 1983, 81–82, no. 22).

All the large replicas of the dog come from Italy, and it is not inconceivable that they are all from the same Roman workshop. These statues of dogs may well have carried some connotation that eludes us now. If its meaning and function—funerary monument, part of a group made for the Kingdom of Epirus, a dedication in a sanctuary?— cannot be determined with certainty, its date and authorship are even more difficult to establish. Cavaceppi's astonishing attribution to no less a sculptor than

Phidias ("per l'eccellenza della scultura, suppongo eser opera di Fidia") cannot be sustained. Other attributions to Myron, Lysippos, and even Leukos (about whom nothing is known except that his statue of a dog is said to have been famous) likewise carry little weight (Lysippos in particular is constantly credited by modern scholars with statues of all sorts of animals, from mastiffs to goats.) Comparisons with other representations of dogs, can however, support a date in the Hellenistic period for the prototype of the Duncombe statue. Of excellent workmanship (and in fact the best copy of the type), it has been variously dated to the late Hellenistic, or perhaps more plausibly, to the Hadrianic period.

C.A.P.

Related Works: In his heavily restored group of Dionysus with a panther at Petworth House (only the god's torso is ancient), Cavaceppi clearly used the Duncombe Park dog type as a model for the animal (Wyndham 1915, 24, no. 14, pl. 14). Bertell Thorwaldsen also copied the dog in his versions of "The Shepherd Boy," one of which was commissioned by the financier William Haldimand and is now in the Manchester City Art Gallery (Sutton 1984b, 331, fig. 12)
Literature: Cavaceppi 1768, 1: pl. 16; Michaelis 1882, 92–93, 294–295, no. 1; Vermeule 1955, 135, pl. 43;12
Exhibitions: London, Clarendon Gallery 1983, 81–82 (22), with previous literature

244

EAGLE ON ALTAR BASE
1st century AD
Roman
marble
eagle: 77.5 (30½) high

Gosford
The Earl of Wemyss and March, KT

Michaelis never saw "the grand weird-looking bird" so admired by Horace Walpole, but fortunately he recorded its history and whereabouts in his indispensable *Ancient Marbles in Great Britain* (Michaelis 1882, 486). The marble eagle came to light in Rome, in the garden of Boccapadugli near the Baths of Caracalla, reportedly in the year 1742. Cardinal Alessandro Albani, who at that time virtually controlled the antiquarian and scholarly world in Rome, brought the sculpture to the attention of John Chute (see no. 202), a friend of Horace Mann (then the British Minister in Florence) who in turn convinced Horace Walpole to buy it. Walpole acquired the eagle together with a pedestal for it (an inscribed marble cippus) for 100 *zecchini* in the summer of 1745.

From 1747 until 1842 the sculpture graced the gallery of Strawberry Hill in Middlesex, where Walpole also displayed (among other antiquities) an unusual collection of small ancient bronzes that he had purchased from Conyers Middleton, a scholar and biographer of Cicero. Among Walpole's favorite objects at Strawberry Hill were the well-known bust of Vespasian from the collection of Cardinal Ottoboni, a small bronze bust of Caligula from the excavations of Prince d'Elboeuf at Herculaneum, a basalt head of Serapis from the Barberini Palace, and of course the celebrated eagle itself, which receives mention more than once in Walpole's correspondence with Horace Mann. "There never was so much spirit and fire preserved, with so much labour and finishing," wrote Walpole in a letter of 26 June 1747 (Michaelis 1882, 486).

When the contents of Strawberry Hill were auctioned in 1842, the "glorious fowl," which had pride of place in Delanotte's engraved frontispiece to the catalogue (see no. 348), fetched

£210. Later it came into the possession of the Earl Fitzwilliam (reportedly for a far higher price), and eventually it was acquired by Lord Wemyss who seems to have obtained another ancient marble from the Walpole Collection (Vermeule 1955, 141).

The eagle, now at Gosford, near Longniddry, was published by Eugenie Strong who dated it to the first century AD. She observed that "it seems to symbolise the Augustan and Julio-Claudian age as the eagle of the SS. Apostoli does that of Trajan" (Strong 1929, 1:170). The sculpture may have originally been grouped with a statue of Zeus, with that of an emperor, or even with a representation of Ganymede. There is an Italian seventeenth-century counterpart to this piece in another English country house: the bronze eagle at Stratfield Saye acquired by the 1st Duke of Wellington at the Cardinal Fesch sale in 1816 (Vermeule and Bothmer 1959b, 344, no. 6). Notable among other ancient representations of the bird are the two large marble figures in the Palazzo dei Conservatori at Rome (Jones 1926, 63, no. 4, pl. 7, and 94, no. 31, pl. 33), the inscribed example from Turkey in the Brussels Museum (Cumont 1913, 67–68, no. 54), and the impressive bronze eagle in the J. Paul Getty Museum in Malibu (Vermeule 1981, 270, no.228). C.A.P.

Literature: Michaelis 1882, 69, 486; Strong 1929, 1:170, and fig. 206; Vermeule 1955, 141

245

EMPRESS FAUSTINA THE YOUNGER
18th century
Italian
porphyry
38 ($14\frac{7}{8}$) high

Stratfield Saye
The Duke of Wellington

This accomplished porphyry head portrays Faustina the Younger at the height of her career. Born about the years AD 125–130, she was the younger daughter of Hadrian's adopted successor, the Emperor Antoninus Pius, who betrothed her to her cousin Marcus Aurelius in AD 139. Faustina married him six years later and became Augusta after the birth of their first child in AD 146.

Many of the classical antiquities at Stratfield Saye as well as some of the marbles once at Apsley house (the family's London residence, now the Wellington Museum) were purchased in Paris by the 1st Duke of Wellington at the sale of Cardinal Fesch's collection in 1816 (Vermeule and Bothmer 1956, 332). The head of Faustina, however, is a more recent acquisition and comes from the collection of the Duke of Richmond. It was bought together with another life-size porphyry head from the same collection, a portrait of Julia Domna also at Stratfield Saye (Vermeule and Bothmer 1959b, 334, no. 4, pl. 82:33). A native of Syria, she was the second wife of Emperor Septimius Severus (reigned AD 193–211). The two sculptures clearly stem from the same workshop and seem to have been designed as pendants. In each case the neck is worked for insertion in a statue or, more likely, in a bust of contrasting color. However, these portraits are fine eighteenth-century works after the antique, rather than Roman in date. As Vermeule has rightly observed, "the Faustina in particular could easily pass as antique were not the other bust of a later period obviously by the same hand" (Vermeule and Bothmer 1959b, 344). With the antique busts acquired at the Fesch sale, they now rest on marble columns around the walls of the conservatory added to the house in 1838 by Benjamin Dean Wyatt. The columns were ordered from Naples by the 1st Duke in 1821, and were intended for the "Waterloo Palace" that was never built. In 1973 the present duke transformed the conservatory into a swimming pool, an action that would have earned the approval of his great ancestor, who was a pioneer in the use of the steam bath, plumbing and central heating (Lees-Milne 1975, 12–14). C.A.P.

Literature: Vermeule and Bothmer 1959b, 344, no. 3, pl. 82:32

246

MARK ANTONY late 1st century BC/early 1st century AD
Ptolemaic or Roman Imperial
basalt
42 (16½) high

Kingston Lacy
The National Trust (Bankes Collection)

An undated letter of the 1840s, possibly written by Lady Falmouth, among the Bankes papers at Kingston Lacy in Dorset states that "this bust was found about 1780 near the site of Canopus [in the Nile Delta, near Alexandria] and was in the collection of the late George Baldwin . . . who has represented it in a lithographic print and described it in a work prepared by him for private circulation, entitled *Baldwin's Museum.* . . ." The life-size head was featured in the second volume of *Specimens of Antient Sculpture* published by the Society of Dilettanti in 1835.

George Baldwin was an English mystical writer who traveled extensively in the Near East and in Egypt, where he served as British Consul-General during the years 1785–1796. After Baldwin's death, his possessions were disposed of at auction in London on 8 and 9 May 1828 (see Lugt 1953, no. 11737a). The basalt head was purchased for 95 guineas by William John Bankes of Kingston Lacy, who also acquired other antiquities at this sale (Michaelis 1882, 416, no. 1). A traveler and prominent antiquarian—and a friend of Byron and Rogers—Bankes also pursued a political career, having been *aide-de-camp* to the Duke of Wellington during the Peninsular War of 1808–1814. Bankes himself visited the upper reaches of the Nile and amassed a considerable number of Egyptian antiquities, among them a statue of Rameses II, a New Kingdom granite sarcophagus, a late obelisk from Philae bearing a Greek and hieroglyph inscription, erected on the lawn at Kingston Lacy in 1827, a selection of wall paintings and papyri, and a collection of about twenty stelai (Vermeule and Bothmer 1956, 330). All these survive at Kingston Lacy or are on temporary loan to museums.

Since its discovery in the late eighteenth and throughout most of the following century, this basalt portrait bust was widely held to represent the Emperor Augustus (63 BC–AD 14). Adolf Michaelis, however, argued against the traditional nomenclature, noting that the facial features as well as the arrangement of the hair differ markedly from what is seen in representations of both the youthful and the aged Augustus (Michaelis 1882, 416, no. 2). In 1956 Bernard Ashmole identified the head (on the evidence of numismatic comparisons) as a somewhat idealized portrait of the triumvir Mark Antony (d. 30 BC), a view that has been endorsed by many of the scholars who have since commented on the piece (see Toynbee 1978, 41–46, with previous literature). The shape of the bust itself, designed to stand in a niche or on a pillar, as well as the overall style of the sculpture, point to a date in late Republican or early Imperial times.

The head is in a remarkably fine state of preservation, and only the ears and small portions of the bust show any signs of damage. The painstakingly polished surfaces contribute to the dry and restrained style of this portrait, which has aptly been described as "the proud countenance of a man born to command" (Vermeule 1980, 97). Given its quality and its secure Egyptian provenance, the Kingston Lacy bust takes precedence over most Ptolemaic, Augustan, and later (especially Hadrianic) portraits in hard, colored stones. These sculptures constitute a relatively small but important group of portrait heads, some of which must have been carved outside Egypt by native sculptors who traveled with their own tools and materials. A previously unrecorded early example belonging to this series has been recently acquired by the Ashmolean Museum, Oxford (Sotheby's, London, 10–11 December 1984, lot 162). C.A.P.

Literature: Michaelis 1882, 416, no. 2; Vermeule and Bothmer 1956, 330–331, pl. 108, figs. 18–19; Johansen 1978, 76, fig. 22; Toynbee 1978, 41–46, fig. 52; Vermeule 1980, 97, fig. 136; Holtzmann and Salviat 1981, 276, n. 25
Exhibitions: Loaned to the Ashmolean Museum, Oxford, 1983–1985

8: Augustan Taste

In their pilgrimage to Rome, the inescapable goal of the Grand Tour, English milords saw themselves as Romans of the Imperial era, voyaging to Athens to seek inspiration for a new classical culture that would resurrect the glories of an older civilization on their native soil. It was in this sense that they appropriated the name of the Roman emperor Augustus, who had presided over a golden age of patronage and connoisseurship. Augustan taste, as they saw it, was intimately bound up with abstract virtues—nobility of expression, perfection of color, strength of composition—and in their choice of old masters this covered a wide range of subject matter: portraits, landscapes, and religious and mythological as well as genre scenes. The selection of pictures in this and the two following sections illustrates differing yet complementary facets of this taste and represents many of the outstanding collections of the time: six out of the seventeen visited by Fougeroux in 1728 are included, and seven out of the twenty-two from which Gambarini intended to engrave selected masterpieces after his pioneering catalogue of the Wilton pictures: those of the Dukes of Devonshire and Argyll, Lords Burlington, Egremont, Malpas, and Tyrconnel, and Sir Paul Methuen.

Old masters were often segregated from family portraits, though rigid categorization was alien to the taste of the times. Works in the Grand Manner, the almost apostolic succession from Raphael, Carracci, and Reni, to which the Romans still adhered, were thought suitable for state rooms, as at Holkham and Kedleston. Some Northern works were equally appropriate for such contexts—Van Dyck's *Betrayal* (no. 264) was installed in the picture gallery at Corsham, which remains a perfect expression of Grand Tour taste. In houses like Burghley and Wilton large numbers of small pictures were hung in cabinet rooms adjoining the great set pieces of the state apartments.

The pictures described here are all thought to have been acquired between 1680 and 1770. Many of the Italians most admired are present: Titian and Veronese, Carracci and Gentileschi, Guercino, Feti, and Dolci, together with Poussin, who was thought of as Roman rather than French. In one significant aspect eighteenth-century connoisseurs differed from their modern counterparts: copies of great pictures were thought more desirable than lesser originals and were commissioned by Henry Hoare of Stourhead and others, often from distinguished artists like Mengs and Batoni. Such favorites as Guido's *Aurora* and Raphael's Farnesina *Banquet of the Gods* were copied in paint and plaster in many English country houses.

The interiors that Robert Adam, James Wyatt, and Sir William Chambers designed to contain these collections of old masters employed a neo-classical style first introduced to Britain by James "Athenian" Stuart in the late 1750s. The vocabulary of anthemion and patera, tripod urn and winged griffin, was interpreted in exquisite plasterwork by Joseph Rose the younger, and in still more elaborate marquetry furniture by Thomas Chippendale, John Cobb, Ince and Mayhew, and other leading London cabinetmakers. French influence can be seen in some of their work, but in general a more architectural approach prevailed in the English country house, whose highly unified decorative schemes (particularly in Adam's hands) embraced everything from ceilings and carpets to barometers and door catches. Matthew Boulton's ormolu could compete with the work of the finest Parisian *fondeurs*, and his ornaments, using blue-john, the fluorite spar found in Derbyshire, were popular as far away as Russia.

The sitter in this powerful portrait has not been identified. The pose is unusual: none of Hals' other patrons chose to be painted with crossed arms—an attitude implying detachment or melancholy— which the lavish embroidery of the sleeve was clearly intended to emphasize. Waagen (1838) commented that the picture was "animated and clever, as his almost always are, but painted with much more care." It is indeed more studied in execution than many of Hals' later and more flamboyant portraits.

Pictures by Hals were in the Burlington collection at Chiswick and in that of the Duke of Devonshire at Devonshire House and this may come from either source (see no. 149). Hals was admired in the eighteenth century—Sir Robert Walpole owned the masterly *Portrait of a Man* now in the National Gallery, Washington, while the two small roundels at Longford were acquired by the 1st Earl of Radnor for 7 guineas in 1778—but his recognition as one of the greatest of Dutch masters was essentially a nineteenth-century phenomenon. The architect of the Athenaeum, Decimus Burton, owned a characteristic portrait by the artist (National Gallery, London), and *The Laughing Cavalier* (Wallace Collection, London) was acquired by Lord Hertford in Paris in 1865 for 51,000 francs, a sum only exceeded when Lord Iveagh purchased the *Pieter van den Broeke* (Kenwood) for 100,500 francs in 1888. Whistler's patron, W.C. Alexander, owned two fine portraits by Hals while the *Youth Holding a Skull* (National Gallery, London) was purchased for £3,800 in 1895 by Lord Carysfort (see no. 553). After Rembrandt, Frans Hals was moreover the Dutch painter to whom Duveen's American clients would be most susceptible.

The picture served as an overdoor in the Dining Room at Devonshire House in 1813 and 1836. Like the hall the room was hung exclusively with portraits, an arrangement for which the Bachelor Duke, who succeeded in 1811, was evidently responsible. F.R.

Provenance: Owned by either the 3rd Earl of Burlington or the 4th Duke of Devonshire in 1761; first recorded at Devonshire House in 1813; and by descent
Literature: Dodsley 1761, 2:120 or 230; Devonshire House 1813; Devonshire House 1836; Waagen 1838, 1:258; Waagen 1854, 2:94–95; Strong 1801, no. 26; Slive 1974, no. 18; Brown in London, NG 1976, with previous literature
Exhibitions: London, Whitechapel 1904 (280); London, RA 1929 (48); London, RA 1952–1953 (52); Leeds, City Art Galleries 1955 (52); Manchester 1957 (107); Haarlem 1962 (9); San Francisco, Toledo, and Boston 1966–1967 (16); London, NG 1976 (48)

247

PORTRAIT OF A MAN 1622
Frans Hals c. 1581–1666
oil on canvas
107 × 85 (42⅛ × 33½)
inscribed, *AETAT SVAE 36*
and *AN° 1622*

Chatsworth
The Chatsworth House Trust

248

PORTRAIT OF A YOUNG MAN
c.1512/1516
Tiziano Vecellio, Titian c.1480/1485–1576
oil on canvas
100.3 × 83.8 (39½ × 33)

Garrowby Hall
The Earl of Halifax

This portrait is generally recognized as one of the greatest masterpieces of Titian's Giorgionesque period and has been variously dated about 1512–1515 (Wethey), about 1515 (Valcanover), and about 1516 (Palluchini). It is the best preserved of a group of male portraits that includes the so-called *Ariosto*, formerly at Cobham and now in the National Gallery, London, and the *Jacopo Sannazaro* (Hampton Court, HM The Queen).

The picture is first recorded at Temple Newsam about 1780, when John Downman drew the copy of it in a sketchbook now at Bowood (information from the Hon. Charles Allsopp), but had presumably been acquired at an earlier date, possibly by Henry, 7th Viscount Irwin (1691–1766), for whom the Long Gallery at Temple Newsam was altered in 1738–1745. Of the furniture ordered for this room, a pair of girandoles was given to Leeds Corporation in 1922 when the house was purchased from the Hon. E.F. Lindley Wood, later 1st Earl of Halifax, and sets of seat furniture and candlestands by John Pascall have since been recovered. The 7th Viscount Irwin apparently did not acquire pictures on a comparable scale, but the collection he inherited included the *Deposition* by the Master of Saint Bartholomew (National Gallery, London), a masterpiece of the late Gothic period at Cologne that was hardly typical of the taste of the early eighteenth century when it was first recorded at Temple Newsam. A number of portraits of the Ingram family were returned to Temple Newsam by the 1st Earl of Halifax.

F.R.

Provenance: Presumably acquired for Temple Newsam in the eighteenth century, possibly by the 7th Viscount Irwin, by inheritance through Frances, a widow of the 9th Viscount Irwin (d. 1807); his daughter Elizabeth (the Hon. Mrs. Meynell Ingram), wife of Hugo Meynell of Hoar Cross, in whose possession recorded in the Temple Newsam inventory of 1808; by descent to her grandson Hugo Francis Meynell Ingram (d. 1871); his widow Emily Charlotte, daughter of the 1st Viscount Halifax; and by descent
Literature: Waagen 1854, 3:334; with previous literature; Wethey 1971, no. 115
Exhibitions: London, Grafton Gallery 1909 (84); London, BFAC 1914 (14); London, Agnew 1924 (17); London, BFAC 1937 (37); London, RA 1950 (213); York 1951 (24); Manchester 1957 (62); London, RA 1960 (68)

249

THE MYSTIC MARRIAGE OF
SAINT CATHERINE c.1560/1565
Paolo Caliari, Il Veronese 1528–1588
oil on canvas
97.7 × 161.2 ($38\frac{1}{2}$ × $63\frac{1}{2}$)

Private Collection

This overlooked work of Veronese's
early maturity may take its place as
one of the most impressive of the
painter's interpretations of a favorite
theme, though the number of canvases
of this subject by the artist makes it
virtually impossible to disentangle
their early provenance.

The 1799 Luton Hoo inventory
establishes that a group of Venetian
sixteenth-century pictures including this
and Paris Bordone's *Christ and the Centurion*

of Capernaum (Waagen 1838, 3: 373;
Richter 1883, no. 8) was then owned
by the 1st Marquess of Bute. The Luton
collection was formed by John Stuart,
3rd Earl of Bute (1713–1792), who
began to buy Dutch pictures as early as
1749–1750 and was unquestionably the
most discriminating British collector in
this field in the late eighteenth century
(see no. 307). His agent was Captain
William Baillie, who also bought pictures
for his son John, 4th Earl and 1st
Marquess (1744–1814). Best known as
a connoisseur of the Northern schools,
Baillie had a personal interest in Italian
pictures, as is shown by an undated letter
from him to the 3rd Earl recommending
that the latter's son-in-law, Sir James
Lowther (later 1st Earl of Lonsdale),
should secure the cream of the De la
Cour collection of Northern pictures

and adding, "I can accommodate him
with Italian ones" (Lowther MSS, Cum-
brian County Record Office D/LOUS/L).
Bute was also a discriminating patron
of contemporary artists and craftsmen
including Ramsay, Zoffany, and the
cabinetmaker William Vile. These almost
certainly owed their employment by
George III to the intervention of Bute,
who had been the king's tutor and was
Prime Minister in 1762–1763.

Bute employed Robert Adam at Luton
Hoo in 1766–1774 and, as at Highcliffe
in Hampshire, which Adam began for
Bute in 1773, the picture collection
contributed significantly to the impact
of the interior. Bute's observant cousin,
Lady Mary Coke, stayed at Luton in
1774 and commented both on the
number of the pictures and on the green
paper against which they were hung

(Coke 1889–1896, 4:390). The 1822
inventory establishes that the Old
Drawing Room and Lady Bute's Sitting
Room were then hung predominantly
with Italian pictures, while the great
collection of Dutch and Flemish pictures
filled much of the remainder of the
house. F.R.

Provenance: Probably purchased by the
3rd Earl of Bute; first recorded in the
collection of the 1st Marquess of Bute
at Luton Hoo in 1799 and in the Drawing
Room at Luton in 1822
Literature: Waagen 1838, 3:374
Exhibitions: London, Bethnal Green
1883 (14)

250

SAMSON AND THE PHILISTINES
early 18th century
Francesco Bertos fl. 1693–1734
bronze
88.9 × 109 (35 × 43)

Glynde Place,
The Viscount Hampden

This relief and no. 251, representing *The Flight into Egypt*, are two of a set of four bought in London in 1767 by Richard Trevor, Bishop of Durham. The bishop's account book, preserved at Glynde Place, records the transaction: "4 curious Oval Bronzes by Soldani bo[t] at Prestages Room and Porterage of heavy Metal 45.7.0." Bishop Trevor, the favorite prelate of King George II who is said to have called him "the Beauty of Holiness," inherited Glynde from his cousin, and from 1750 set about improving the old house. In 1758 he reconstructed the hall, and later installed these two reliefs there, above the twin stone fireplaces, where they still hang today.

The third relief in the series of four, representing *The Massacre of the Innocents*, was originally hung on the west wall of the hall but, having been replaced by

the great painting of Sir John Trevor and his family (c. 1635) that hangs there today, it was sold, and was acquired in 1955 by The Art Institute of Chicago. The fourth relief of the series, representing *The Entry into Jerusalem*, was inserted by Bishop Trevor into the elaborately carved overmantel of the chimneypiece in the gallery upstairs, where it still remains.

The reliefs form complementary pairs: this one of *Samson Slaying the Philistines* (the massacre of the oppressors) is the counterpart to the Chicago relief of the *Massacre of the Innocents*, while no. 251, the *Flight into Egypt*, is the counterpart of the *Entry into Jerusalem* in the Gallery at Glynde: the one an exit in flight, the other an entry in triumph.

The bronzes were sold to Bishop Trevor in 1767 as by the Florentine baroque sculptor Massimiliano Soldani, but this attribution need not be taken seriously, as a perusal of English eighteenth-century sale catalogues shows that most fine modern bronzes were then ascribed to him, just as a large number of modern marbles were given to Algardi. Among English collectors Soldani was the best-known name in bronzes, perhaps because he had enjoyed the patronage of the Duke of Marlborough

(see nos. 215–216). Unlike his reliefs, which are impeccably articulated in the Florentine tradition, these are clearly the work of an artist who had received no training in this branch of sculpture. John Pope-Hennessy was the first to recognize that the relief now in Chicago was typical of the work of Francesco Bertos, an eccentric and still somewhat mysterious sculptor of unknown origins (Wardwell and Davison 1966, 189). Bertos was recorded as active in Rome in 1693, and in 1710 and 1733/1734 in Venice and Padua, and the bronzes are typical in style but not format; for apart from a curious *ajouré* relief of the *Crucifixion* in the Victoria and Albert Museum, these are his only known reliefs. All his other works, whether in bronze or marble, are in the round.

The provenance of the reliefs before their appearance for sale at Prestage's in 1767 is not known, but they may have been in another English house, since several of the sculptor's surviving works have an English provenance, and two of his most ambitious marble groups are to be found at Newby Hall and Wilton House. A.F.R.

Literature: Oswald 1955, 1042; Wardwell and Davidson 1966, 185, 187, 189

251

THE FLIGHT INTO EGYPT
early 18th century
Francesco Bertos fl. 1693–1734
bronze
87.6 × 107.9 (34½ × 42½)

Glynde Place
The Viscount Hampden

This is the companion to the previous work and is discussed in that entry.

COMMODE AND CANDLESTANDS 1772
John Cobb d. 1778
satinwood inlaid with rosewood,
mahogany, and other woods, and with
gilt-bronze mounts; the top painted to
resemble marble
commode: 95.2 × 142.2 × 69.8
(37½ × 56 × 27½)
stands: 132 × 26.6 × 26.6
(52 × 10½ × 10½)

Corsham Court
The Methuen Collection

This is the "extra neat inlaid commode" supplied by Cobb with its matching pair of candlestands to Paul Methuen of Corsham Court in Wiltshire in 1772. Cobb's receipted account (among the Corsham MSS now at the Wiltshire Record Office) shows that they cost £63.5.0., though a further entry in Methuen's day book for 17 December of the same year records that he "pd Cobb Cabinetmaker for Commode Table &c. £72.1.0." The side panels of the commode have the owner's arms in marquetry impaling those of his wife Catherine, daughter of Sir George Cobb, 3rd Baronet, of Adderbury in Oxfordshire, and these prove that the set of furniture was a special commission and not simply bought from stock. There is unlikely to have been any connection between Mrs. Methuen's family and that of the craftsman.

While in partnership with the cabinet-maker William Vile until 1765, Cobb seems to have acted purely as an upholsterer, and both craftsmen worked in these separate capacities for the Royal Household. After that date, however, the firm continued under his name alone until 1778, becoming a byword for marquetry furniture of the highest quality. Thus, Mrs. Thrale on a visit to France in 1775, remarked that the inlaid floors at Sceaux were "finish'd like the most high prized Cabinet which Mr. Cobb can produce to captivate the eyes of his customers" (Tyson and Guppy 1932, 120). Another contemporary, J.T. Smith, recalled him as a "singularly haugty character…one of the proudest men in England…he always appeared in full dress of the most superb and costly kind, in which state he would strut through his workshop giving orders to his men" (Smith 1829–1842, 2:243). Some of Cobb's marquetry in the 1770s may well have been supplied by one Strickland who after 1778 went into partnership with Cobb's foreman Jenkins, and who was described on their trade card as "nephew to the late Mr. Vile" (Heal 1953, 176–177).

The *bombé* form of the Corsham commode, echoed by the very unusual waisted shape of the stands, has a rococo character despite its correctly neo-classical ornament of paterae, husks, and anthemia. A Louis XV influence can be felt here, and it is interesting that in 1772, the same year Cobb supplied these pieces, he was in trouble with the Commissioners of Customs for smuggling French furniture through the diplomatic bag, and had a number of pieces including "a Commode, with Marble Slab" and several "Coins" (or *encoignures*) seized from his premises at 72 St. Martin's Lane (Wills 1965). The ormolu mounts are close to those found on contemporary work by the French émigré cabinetmaker Pierre Langlois, working not far away in Tottenham Court Road (see no. 181).

The commode and stands must have always been intended to occupy their present position between the windows in the Cabinet Room at Corsham, adjoining the Picture Gallery. The prominent anthemia in the "Greek key" borders, and the delicate chains of husks, obviously derive from the monumental gilt pier glass above, designed by Robert Adam in 1771–1772 (drawings for which survive at Corsham and at Sir John Soane's Museum in London). The idea of supplying torchères to stand on either side of the commode is extremely old-fashioned for this date, looking back to seventeenth-century precedents like the silver furniture at Knole (no. 129). No comparable examples of the form survive, and it is probable that Cobb was driven to this expedient to prevent the commode (whose dimensions were dictated by the height of the dado) from being

dwarfed by the vast size of the mirror above, and the abnormally wide pier between the windows. In any event, the stands seem not to have been used for candlesticks since at least 1774, when Paul Methuen acquired the marble vases that they now support (no. 253). G.J-S.

Related Works: Three other commodes have been attributed to Cobb on the grounds of their close similarities with that at Corsham: a pair formerly in the collection of Lord Tweedmouth, slightly less wide and with floral marquetry rather than marbled tops (one now in the Victoria and Albert Museum, London; the other sold at Sotheby Parke Bernet, New York, 8 April 1961, lot 361); and a third from Holland House, now at Melbury (Lady Teresa Agnew) *Literature:* Bracket 1936; Edwards 1937; Edwards and Jourdain 1944, 35–36, pls. 56, 57; Coleridge 1968, 33–34, pls. 39, 40
Exhibitions: London, BFAC 1938 (4); London, RA 1955–1956 (361)

253

PAIR OF VASES C.1771
French
white marble with ormolu mounts
38.2 (15) high

Corsham Court
The Methuen Collection

This is the "pair of statuary marble vauses mounted in or moulu" that Paul Methuen of Corsham bought from Thomas Harrache at a cost of £18 18s. 0d. in 1774, and which are listed on the same invoice as the bronze reduction of the Laocoon (no. 254). The vases have apparently always stood on the candle-stands flanking the commode in the cabinet room (no. 252), supplied two years earlier by John Cobb.
 Josiah Wedgwood records visiting Harrache's shop in Pall Mall with Matthew Boulton in 1768 when the dealer had just returned from Paris, having "brought a great many fine things with him" (Goodison 1974, 59). The two of them "spent near twenty pounds" acquiring suitable models to copy, or pieces for which Boulton intended to

make mounts. Harrache in turn bought goods from Boulton and Fothergill to retail at a later date: the firm's ledgers for instance record the receipt of £9 4s. 6d. from him in April 1772, while "Derbyshire" vases mounted in ormolu were among the stock in trade sold at his retirement in 1778. But despite this, and despite the fact that Boulton used white marble for vases on several occasions, it is more likely that the pair at Corsham are of French origin, like so many other *objets* sold by Harrache. Neither the guilloche pattern of the bases nor the satyr mask handles can be paralleled in any documented work by Boulton, yet the former is a motif often used by Philippe Caffieri (see Eriksen 1974, figs. 236 and 459), while the latter occur as mounts to some Sèvres vases bought by Horace Walpole for John Chute in 1765–1766, one of which still survives at The Vyne in Hampshire (National Trust, Chute Collection).
 French metalworkers were easily able to undercut their English rivals after the end of the Seven Years' War in 1763, and this explains Matthew Boulton's annoyance, expressed in a letter to Wedgwood early in 1768, concerning the trade that had "lately been made out of vases at Paris. The artists have even come over to London, picked up all the old whimsical ugly things they could meet with, carried them to Paris, where they have mounted and ornamented them with metal, and sold them to the virtuosi of every nation, and particularly to Millords d'Anglaise" (Goodison 1974, 27). G.J-S.

Provenance: See no. 252

254

LAOCOON 17th century (?)
probably Italian
bronze, on a boulle socle
29.3 (11½) high

Corsham Court
The Methuen Collection

Mr. Paul Methuen acquired this bronze on 23 April 1774 for fourteen guineas from the Huguenot goldsmith Thomas Harrache at his shop at the Golden Ball and Pearl in Pall Mall, London. The bill is preserved in the Wiltshire County Record Office (Corsham House MSS, no. 5064a, file 49a), and reads as follows:

Paul Methuen, Esq.ʳ Bougᵗ of Tho.ˢ Harrache Ap.ˡ/23. 1774–

	£	s
A pair of Statuary Marble Vauses mounted in Or Moulou	18: 18:	0
A fine Antique Bronze of a Laocon	14: 14:	0
	£33: 12:	0

Rec'd the Contents in full of all Demands for Mr Harrache
 (Sgd) Sarah Moody.

On the verso of the sheet is written:

Apl 23ᵈ 1774 pd
by Draft on Croft & Co
L S D
33–12–0

According to his trade card, preserved in the British Museum (Murdoch 1983), Thomas Harrache regularly sold bronzes, together with old china and lace, in addition to his own silver and gold artifacts.

The French boulle socle on which the bronze is mounted, typical of the years c. 1690 to c. 1700, is easier to date than the bronze itself. A much larger version of the Laocoon in the Louvre is mounted on a very similar socle, though proportionately larger, and is a typical French seventeenth-century cast, with a characteristic dark red patina. The present bronze is more difficult to classify, and is not necessarily contemporary with the socle. It is a thin, flawed cast, and could well be Italian. Its description as "Antique" in Harrache's bill, does not necessarily mean that it was believed to be antique and may only refer to the subject, although its rough and flawed appearance may have encouraged such a notion.

The bronze is a free reduction from the celebrated Hellenistic marble group of the Laocoon in the Vatican, excavated on 14 January 1506 near Santa Maria Maggiore in Rome (Haskell and Penny 1981, 243–247, no. 52). Bronze reductions of the Laocoon group were very popular in France in the seventeenth and eighteenth centuries, but most of the French reductions appear to have followed Montorsoli's incorrect restoration of 1532–1533 in which the right arm of Laocoon was extended, as with the large Girardon workshop example in the Marble Hall at Houghton. This smaller bronze is unusual in having the right arm flexed back above the head. One of the only full-scale marble copies of the group still in an English country house is that at Sledmere in Yorkshire (Sir Tatton Sykes, Bart.), thought to have been executed by the English sculptor Joseph Wilton, who spent many years in Rome. For an excellent account of the Laocoon, its reproduction, and the previous literature, see Haskell and Penny 1981. A.F.R.

Literature: Murdoch 1983, 31, 32

255

LIBRARY CHAIR c. 1776/1778
attributed to Thomas Chippendale
1718–1779
mahogany with paterae and foliage in holly wood, the top rail inset with a Wedgwood basalt plaque, and the seat upholstered with the original green leather
94 × 83.8 × 53.3 (37 × 33 × 21)

Brocklesby Park
The Earl of Yarborough

Formerly at Appuldurcombe House in the Isle of Wight, this is one of a set described in an inventory of the house,

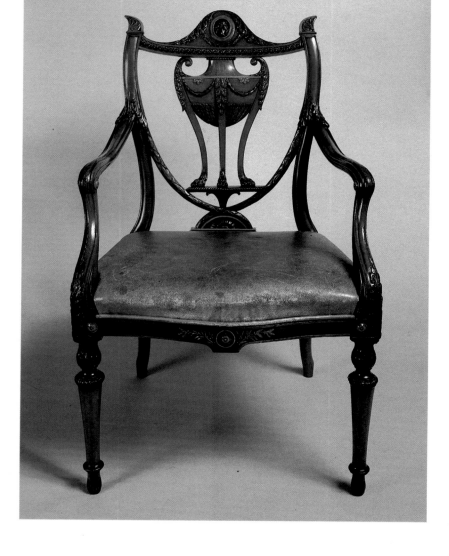

about 1730, as "8 Mahogany elbow chairs, Antique Urn back, carved & inlaid (an Author's head near the top of each back by Wedgwood) the Seats cover'd with green leather & Serge cases." The black basalt portrait medallions represent Homer, Aratus, Julius Caesar, Seneca, Shakespeare, Milton, Locke, and Pope—equating the giants of English philosophy and literature with the greatest classical authors.

Sir Richard Worsley (1751–1805) inherited the early eighteenth-century house at Appuldurcombe in 1768, and in 1775 married the step-daughter of Edwin Lascelles of Harewood, one of Chippendale's most important patrons

(see no. 265). In the early 1770s he traveled extensively in Greece and Asia Minor as well as Italy, developing a passionate interest in classical antiquities, and buying many of the marbles that still survive in the "Museum Worsleianum" at Brocklesby. Sir Richard's remodeling of the interior at Appuldurcombe, begun in 1774, was carried out in the most advanced neo-classical taste and his bank accounts show that almost all the furniture was supplied by Chippendale & Co. with whom he spent £2,638 between 1776 and 1778 (Hoare's Bank MSS, London).

The very advanced design of these chairs, with their back splats in the form of antique tripod perfume burners, their Greek anthemion terminals, and paterae in the form of smooth discs on the arms and seat rail, has been connected with the younger Thomas Chippendale (1749–1822) who played an increasingly active role in the firm during his father's declining years (Gilbert 1978, 281). However, the architect James Wyatt was responsible for the alterations to Appuldurcombe in the 1770s, and it may have been he who produced such a sophisticated design, satisfying his patron's scholarly tastes and at the same time anticipating to a remarkable degree the later furniture designs of the Regency period.

The use of Wedgwood plaques on Chippendale furniture is otherwise unknown, though other cabinetmakers— like Ince and Mayhew, Gillow and Seddon—appear regularly in Josiah Wedgwood's account books in the 1790s. Smaller-scale items by Matthew Boulton and early Broadwood pianofortes occasionally incorporate such medallions, but their use on carcass furniture was, curiously, more usual in France (particularly the work of Adam Weisweiler) and in Catherine the Great's palaces in Russia (Kelly 1965, 125–129).
 G.J-S.

Provenance: Commissioned by Sir Richard Worsley, Bart., and bequeathed with Appuldurcombe House and its contents to his niece Henrietta, wife of the 1st Earl of Yarborough; removed to Brocklesby on the sale of Appuldurcombe in 1855; and by descent
Literature: Boynton 1964, 37–58; Kelly 1965, 129, fig. 47; Boynton 1968, 352–354; Gilbert 1978, 280, figs. 152–153
Exhibitions: London, RA 1955–1956 (380)

256

ARMCHAIR c.1768
attributed to John Linnell 1729–1796,
after a design by Robert Adam
1728–1792
marquetry of various woods
with ormolu mounts
90 × 62.2 × 63.5 (35½ × 24½ × 25)

Osterley Park
The Trustees of the Victoria and
Albert Museum

This is part of a suite of marquetry
furniture comprising eight armchairs,
two writing tables, and a pedestal desk,
supplied to the banker Robert Child
(1739–1782) for the library at Osterley
Park, Middlesex, and designed in the
architect Robert Adam's neoclassical
style combined with French *goût grec*
elements. Its ornament of Vitruvian
scrolls, flutes, acanthus foliage, laurel
garlands, and rosettes repeats that of
the desk and tables. Apollo's lyre,
symbol of lyric poetry, forms the back
of the chair. It is framed within the
arched crest rail, which is inlaid with
crossed palm branches, and rests on a
plinth, decorated with pastoral ornament
of red flowers painted on a trellis ground.

Every aspect of the Osterley library,
for which Adam began providing designs
in 1766, alludes to the arts and sciences:
Greek and Roman poets are, for example,
depicted on the walls in plasterwork
medallions and inset paintings, one of
which portrays Minerva and the Muses
(the goddesses of artistic inspiration)
on Mount Parnassus, listening to Apollo,
God of Poetry and Music, playing the
lyre. An "antique" lyre also forms part
of a marquetry musical trophy inlaid on
a door of the desk, while the chair splat
is composed of a classical lyre with
pointed shoulders and fretted soundboard
holes, and bearing an ormolu medallion
of Hercules, inspired by a classical gem.
This was particularly appropriate as
Robert Child collected antique coins
and medals, and kept a medal cabinet
in the same room.

Robert Adam had designed some
mahogany "lyre-back" dining chairs for
Osterley in 1767 (Tomlin 1982, 23) and
the conception behind the library chairs
is his. But they also have a distinctly
French flavor, and the final design has

been attributed to the cabinetmaker and
upholsterer John Linnell of Berkeley
Square, London, who followed French
fashions closely and is thought to have
employed in his workshops Georg Haupt
(d.1784) and Christopher Fürlohg
(1737–c.1800), the Swedish cabinet-
makers and specialist inlayers who came
to London from Paris in the late 1760s.

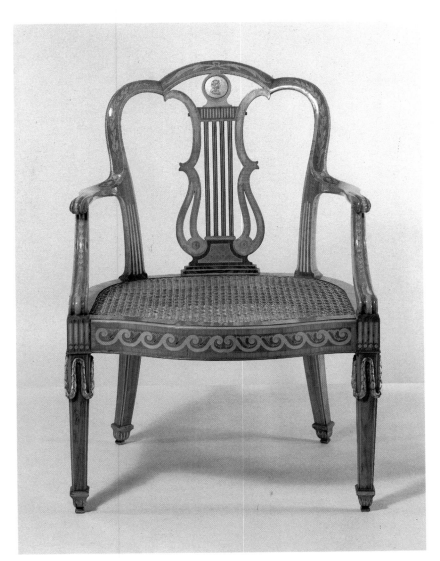

Provenance: Acquired for Osterley Park
by Robert Child (d.1782); by descent
to the Earls of Jersey until 1949, when
purchased by the Treasury and entrusted
to the Victoria and Albert Museum,
London
Literature: Hayward and Kirkham 1980,
fig. 1; Tomlin 1982a, no. F/1

J.H.

257

COMMODE 1773
attributed to William Ince and
John Mayhew fl. 1759–1803 with
Christopher Fürlohg 1737–c.1800, after
a design by Robert Adam 1728–1792
harewood with marquetry of various
woods and ormolu mounts
91.4 × 158.8 × 60.9 (36 × 62½ × 24)

Osterley Park
The Trustees of the Victoria
and Albert Museum

This is one of a pair of neoclassical
commodes designed by the architect
Robert Adam for the banker Robert
Child's neoclassical villa at Osterley
Park in Middlesex. A purely ornamental
"commode table," which is hollow
inside, it furnishes one of the window
piers of the drawing room, whose
architectural elements dictated its
semi-elliptical form and ornament.
Adam redecorated this room in the early
1770s, and its ceiling plasterwork with
octagonal compartments framing an
elliptical rosette (taken from an engraving
in Robert Wood's *Ruins of Palmyra*,
1753) provided the inspiration for
Adam's designs for both the carpet and
the commodes. In addition the commodes'
cornice, frieze, and pilaster ornaments
are taken respectively from the chair
rail, door architrave, and window shutter
ornament of the room—exemplifying
the unity of his overall scheme. Adam's
original design, dated 30 January 1773
(Sir John Soane's Museum, London),
was for a commode in his "Etruscan"
style, with a central painted medallion
of Neptune at the Court of Jupiter and
Juno. Instead the medallions on the
commodes were executed in marquetry,
from engravings after Angelica Kauffmann
(1741–1807), one representing Venus
and Cupid and the other, the chaste
goddess Diana with her hounds. These
medallions, symbolizing sacred and
profane love, in turn relate to the scenes
of the "Loves of the Gods" on the
Gobelins tapestries in the adjoining State
Ante-chamber at Osterley, which were
woven after designs by François Boucher
(1703–1770). The central marquetry
medallion is set within an ormolu oc-
tagonal frame and flanked by inlaid tri-
pods, while the oval side medallions,

depicting festive nymphs holding a tambourine and a garland, are framed by lanterns hung from ribbons. These figures were inspired by engravings of the wall paintings recently discovered at Herculaneum, a source also used for the painted "Etruscan" ornament of the state dressing room. The ormolu plaque fitted to the frieze portrays a medallion of the Empress Faustina supported by griffins.

The commodes were formerly attributed to the workshop of John Linnell (Hayward and Kirkham 1980), but have recently been reascribed to the firm of William Ince and John Mayhew, cabinetmakers of Golden Square, London (Roberts 1985). The figurative medallions are attributed to Christopher Fürlohg. J.H.

Provenance: Acquired by Robert Child (1739–1782) for Osterley Park; by descent to the Earls of Jersey until 1949, when purchased by the Treasury and entrusted to the Victoria and Albert Museum, London
Literature: Harris 1963, no. 45; Hayward and Kirkham 1980, fig. 113; Tomlin 1982a, no. F/1; Roberts 1985, 276, fig.4

258

ARMCHAIR 1765
Thomas Chippendale 1718–1779, designed by Robert Adam 1728–1792
walnut and beechwood, gilded, and upholstered in crimson damask
106.6 × 76.2 × 78.7 (42 × 30 × 31)

Aske Hall
The Marquess of Zetland

In March 1768 the Countess of Shelburne visited Lady Charlotte Dundas at her London house, 19 Arlington Street, recording in her diary that she "had vast pleasure in seeing a house, which I had so much admired, and [which is]

improved as much as possible. The apartment for company is up one pair of stairs, the Great Room is now hung with red damask, and with a few large and capital pictures, with very noble glasses between the piers, and Gilt chairs" (Coleridge 1967, 195). These chairs were certainly worthy of notice. Thomas Chippendale's invoice, dated 9 July 1765, describes them with some pride as "8 large Arm Chairs exceeding Richly Carv'd in the Antick manner and Gilt in oil Gold Stuff'd and cover'd with your own Damask—and strong castors on the feet." The reference to the "Antick [or antique] manner," the first time that Chippendale uses the phrase to describe his furniture, clearly relates to the anthemia, arabesques, and winged sphinxes or chimaeras with which the frame is carved, and to its life-like lion's paw feet. Together with "4 large Sofas exceeding Rich to match the chairs," their total cost amounted to £510.4.0, including crimson check case covers and leather outer covers. This is almost twice as much per chair as any other known to have been supplied during Chippendale's long career, and gives some indication of their exceptional quality. The original damask was presumably the same "Crimson Genoa" with which William France hung the walls of the Great Room at Arlington Street in 1764.

The normal practice at this period was for the architect to design the furniture that the French call *meublant*—that is, fixtures like pier glasses and pier tables—leaving the cabinetmaker or upholsterer to supply the *courant* or movable pieces like chairs, fire screens, and card tables. In this case, however, Sir Lawrence Dundas' architect, Robert Adam, charged £5 in 1764 for a "Design of Sopha chairs for the Salon," a colored drawing that still exists in the Sir John Soane Museum, almost exactly matching the settees as executed. Not only is this the solitary occasion on which Chippendale is definitely known to have executed one of Adam's designs, but it is also his first documented work to display a truly neoclassical character. Even though some of the designs in the third edition of his *Director* (1759–1760) are decorated with classical details, the style was still a novelty and, in

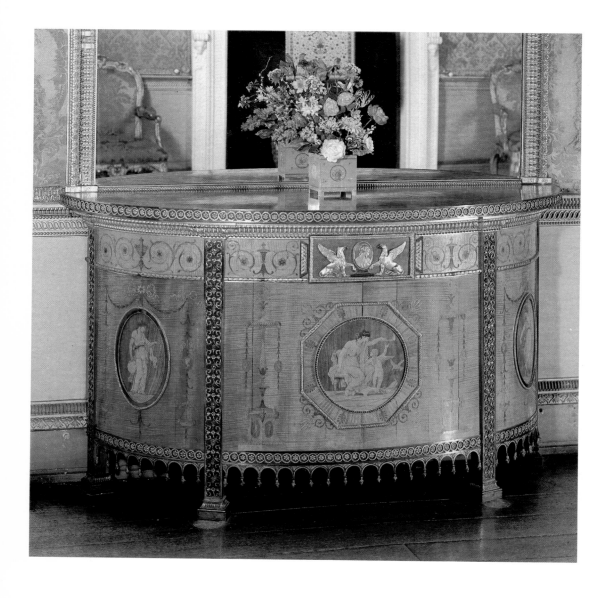

Christopher Gilbert's words, "Sir Lawrence evidently felt that only an architect-trained designer possessed the qualification to introduce it with sophistication at the level of furniture" (1978, 159).

In essence the serpentine lines of the chair frame are still rococo in feeling, and the deep apron below the seat rail even looks back to William Kent (see no. 153). Yet the architectural quality and scale of the whole composition, united with the crisp detail of the carving executed by Chippendale's craftsmen, give it an air of supreme confidence: an eighteenth-century English vision of the splendors of Imperial Rome. G.J-S.

Provenance: By descent at Arlington Street until the sale of the contents, 26 April 1934, when one sofa and four chairs were sold to Moss Harris, and their companions were taken by the Dundas family to Aske Hall; one of those sold was acquired by the Victoria and Albert Museum in 1937, and the others were re-sold at Sotheby's, 6 June 1947 and again 5 July 1963 (present location unknown)
Literature: Harris 1963, 91, fig. 101; Coleridge 1968, 195–199, figs. 15, 17; Gilbert 1978, 156–157, fig. 176

259

ARMCHAIR c.1775/1776
Thomas Chippendale 1718–1779
beechwood, gilded and upholstered in Gobelins tapestry
105.4 × 70.4 × 74.9 (41½ × 27¾ × 29½)

Newby Hall
R.E.J. Compton, Esq.

William Weddell of Newby Hall in Yorkshire was one of six Englishmen who commissioned sets of the famous tapestries made at the Gobelins factory by Jacques Neilson after designs by Boucher. All of them were patrons of Adam and four also purchased furniture from Chippendale's firm. The Earl of Coventry was the first to place an order in 1764; he was closely followed by William Weddell and Sir Henry Bridgeman of Weston Hall. The bulk of these consignments were ready for shipment in July 1767, but Sir Lawrence Dundas' tapestries for Moor Park were not completed until 1769, Robert Child of Osterley received his set in 1775, and the Duke of Portland's were woven as late as 1783. The English patrons ordered tapestry furniture covers to match their wall hangings and all the suites still preserve their original upholstery. Chippendale, however, was only responsible for furnishing one of these splendid interiors—the Tapestry Room at Newby Hall. An inventory compiled by Chippendale the Younger on Weddell's death in 1792 provides an excellent record of the original furnishing scheme, which had been completed less than twenty years earlier and confirms that, even today, few changes have occurred, making this the best preserved of all the rooms on which Robert Adam and Thomas Chippendale collaborated.

Adam's design for the Axminster carpet (Sir John Soane's Museum, London) is dated 1775, which provides a clue as to when this armchair and its eleven companions, along with two sofas and a fire-screen, were delivered to the house.

An entry in the Harewood steward's day book for 29 February 1776 records that "Chippendale has put up the Glass and now is at Newby so is Mr. Reid." Comparison with the carved and gilt chair frames Chippendale made for the state bed and dressing rooms at Harewood in 1773 (Gilbert 1978, fig. 178) reveals striking parallels of design and enrichment. Although the Newby chairs are slightly less elaborate, both models display a similar combination of lion-mask and tied-ribbon cresting, tablets on the front rails, anthemion motifs at the base of each arm supported by leaf-cup brackets, and fluted front legs headed by blocks, to mention only the most salient points. Technical features such as the existence of V-shaped cuts under the seat rails and visible back splats confirm they were made in Chippendale's workshop.

The Newby suite is memorable as the only known seat furniture by Chippendale that preserves its original upholstery. Between 1760 and 1767 Maurice Jacques and Louis Tessier, *peintre de fleurs du Gobelins*, prepared suites of designs for screen panels, the backs and seats of chairs, and sofas, representing bouquets of flowers tied by ribbons on a *damas cramoisy* ground. The majority of cartoons were contributed by Tessier and a score of floral compositions for backs, seats, and arm pads survive at the Musée des Gobelins in Paris (Fenaille 1907, 4:394–396). The panels were woven to a standard cartouche-shaped size that would fit any normal chair frame and most of the designs are repeated on other suites. William Weddell was doubtless shown these cartoons on a visit to the Gobelins manufactory. On 13 July 1769 Jacques Neilson asked Thomas Dundas to forward a small piece of tapestry included with the Moor Park consignment to "Mr. Wm Weddall Esq. Newby" (Harris 1967, 180–189), and this panel may have been intended for the pole screen that Chippendale provided. C.G.

Provenance: See no. 231
Literature: Gilbert 1978, 264–265, fig. 180
Exhibitions: York, King's Manor 1975; Leeds, Temple Newsam 1979 (49)

260

MOSES TRAMPLING ON THE
PHAROAH'S CROWN c.1643
Nicolas Poussin 1594–1665
oil on canvas
99 × 142.2 (39 × 56)

Woburn Abbey
The Marquess of Tavistock and the
Trustees of the Bedford Estates

The subject is based on a Coptic legend recorded by Josephus: the Pharoah's daughter Thermuthis delivered Moses to her father who embraced him and put his diadem on the infant's head, at which Moses pulled it off, cast it to the ground, and trampled on it.

This is the larger and apparently the earlier of Poussin's two pictures of the subject known to have been painted in the period between 1642 and 1647 at Rome. A date of 1643 has been suggested by Mahon who places the second picture, now in the Louvre, about 1644–1645.

Blunt (1967, 1:250) comments on the greater elegance of the forms, more decorative setting, and smoother handling of the Woburn picture, which was painted for Pointel, a banker from Lyons who had settled in Paris and visited Rome in 1645–1646. Pointel acquired ten pictures by Poussin, including the self portrait of 1649 in East Berlin, the Louvre *Finding of Moses*, the Louvre *Judgment of Solomon*, the National Gallery, London, *Landscape with a Man Killed by a Snake*, and the Hermitage *Landscape with Polyphemus*. Later, when it was in

the Colbert collection, the picture presumably served as pendant to the marginally smaller *Moses Striking the Rock*, now lent by the Duke of Sutherland to the National Gallery of Scotland. Both pictures were acquired by the Régent Orléans, who owned fourteen Poussins. All but one of these reached England as a result of the sale of the Italian and French sections of the Orléans collection to the Duke of Bridgewater, in partnership with the Marquess of Stafford and the 5th Earl of Carlisle (see no. 482).

The *Moses Striking the Rock* and the *Seven Sacraments* remained in the Bridgewater collection, but the other Poussins were offered for sale by the dealer Bryan, when this picture was acquired by Francis Russell, 5th Duke of Bedford (1765–1802). The duke evidently inherited the interest in the fine arts shown by his father, the Marquess of Tavistock (1739–1767), husband of Lady Elizabeth Keppel (no. 481). Tavistock bought pictures by Claude and Carracci and in a letter of 1763 to Lord Upper Ossory recommended an Italian itinerary, which shows that his own Grand Tour had not been wasted (Wiffen 1833, 2:533–542). The 5th Duke's other acquisitions included Cuyp's great view of Nijmegen (no. 316). He was a committed Whig and the subject of this picture, with its implied criticism of princes, may thus have appealed to him.

For much of the nineteenth century the Poussin was kept in the drawing room of the Bedfords' London house, where many of the finest old master pictures from the collection were hung, including five works by Cuyp, and others by Teniers, Murillo, Reni, and Claude.

F.R.

Related Works: Blunt lists a number of copies

Provenance: Probably painted for Pointel, on whose death bought by Loménie de Brienne; Cotteblanche, 1665; Jean Baptiste Colbert, Marquis de Seignelay (d. 1706), and by descent to his nephew, the Abbé de Colbert; bought by Philippe, Duc d'Orléans, Régent of France, before 1727 and by descent to Philippe, Duc d'Orléans (Philippe Egalité), by whom sold to Walkuers 1792; sold by the latter to Laborde de Méréville, 1792; bought by Bryan, 1798, for a consortium of English collectors and offered for sale by him in 1798, lot 46, when bought for 400 gns (Buchanan 1824, 1:151) by the 5th Duke of Bedford; his brother, the 6th Duke of Bedford, anonymous sale, Christie's, 6 June 1829, lot 35, bought in at 182 gns against a reserve of 400 gns, and by descent; in the Drawing Room at No. 6 Belgrave Square by 1854; from 1891 at Woburn
Literature: Smith 1829–1842, no. 19; Waagen 1854, 2:284; Scharf 1878, no. 53 (86); Blunt 1966, no. 16
Exhibitions: London, BI 1818 (14)
Engravings: E. Baudet (Andresen 1863, no. 35; anonymous, published by H. Bonnart; I. Bouillard

261

THE ADORATION OF THE MAGI
c.1635/1640
Carlo Dolci 1616–1686
oil on canvas
71.12 × 55.8 (28 × 22)

Blenheim Palace
The Duke of Marlborough

This remarkable and hitherto unpublished picture is presumably the *Adoration of the Magi* that was, as Baldinucci records, painted by the youthful Carlo Dolci for Prince, later Cardinal, Leopoldo de' Medici (Batelli 1845–1847, 5: 341). The composition reflects the influence of Dolci's master Jacopo Vignali, but his own technical gifts are wonderfully realized in the rich costumes and rigorously defined detail, qualities that were to earn him the continuing patronage of the Medici family. The exceptional finish of this picture led Waagen to suppose that it was on copper. The enlarged, but simplified, variant in the Glasgow City Art Gallery is less exquisitely wrought. In a later *Adoration of the Magi* at Burghley, the Madonna and Child are of a different design, but the three Magi and the attendant on the extreme right are modeled on this composition.

Both Passavant and Waagen, who recorded that this picture was "less affected and truer in feeling than usual," observed the special predilection of the English for Dolci, a phenomenon the more remarkable for the evident Catholic fervor of his religious work. Pictures by him were presented to King Charles II and his Queen Catherine of Braganza by Sir John Finch, who like his close friend from Cambridge, Sir Thomas Baines, himself sat for Dolci. The 5th Earl of Exeter acquired a series of works from the painter, including the variant of this composition and one of the most emphatically fervent of all his pictures, *Our Savior Blessing the Elements*; when Sir Walter Scott visited Burghley in 1826 he commented that the picture was "worth a King's ransom" (Anderson 1972, 213). Later collectors who acquired works by Dolci included Sir Paul Methuen and Henry Hoare of Stourhead. The Stourhead *Herodias* is now in the Glasgow City Art Gallery and a yet finer version (in a private collection in England) testified to the endurance of Dolci's popularity when it was sold from Ashburnham in 1850 and bought by the 2nd Marquess of Westminster for

700 guineas. In the context of the Blenheim sale of 1886, it is a comment on the taste of the times that while the most expensive of the Rubens fetched 7,200 guineas, this picture was recovered by the duke for 940 guineas while Dolci's octagonal *Madonna delle Stelle* was bought back for 6,600 guineas.

The Blenheim collection was until this sale one of the glories of England. The great Duke of Marlborough had acquired, largely by gift, an extraordinary series of pictures by Rubens, Van Dyck's equestrian portrait of King Charles I (National Gallery, London), a large number of copies of earlier pictures Teniers had made for the Archduke Frederick William, and a notable group of seicento pictures. Acquisitions continued to be made—the Ansidei altarpiece of Raphael (National Gallery, London) was a gift from the duke's brother, Lord Robert Spencer, who

bought it in 1764, and was matched by major portrait commissions carried out by Reynolds, Gainsborough, and others. Exactly when the *Adoration* was acquired remains uncertain, but Dolci's *Madonna delle Stelle* is recorded in the Grand Cabinet in 1789 when a third work by the artist, "our saviour, and Saint John," was in the Blue Drawing Room.

F.R.

Provenance: Painted for Prince Leopoldo de' Medici; first recorded at Blenheim when in the collection of the 5th Duke of Marlborough by Waagen in 1835—it was then in the duke's study but was later moved to the Small Drawing Room; Christie's, 7 August 1886, lot 646, bought in for 940 gns; and by descent
Literature: Waagen 1838, 2: 222; Waagen 1854, 3: 122–123; Scharf 1860, 44

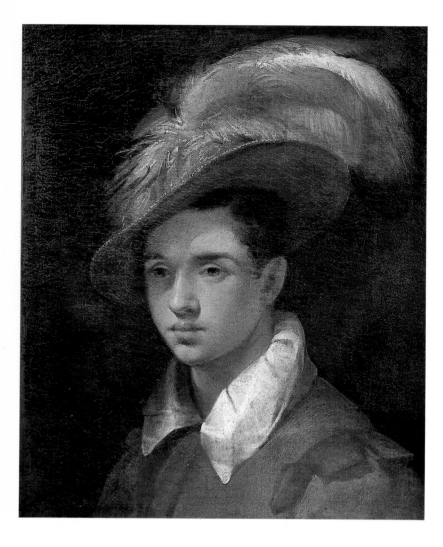

Christ Church (Posner 1971, no. 4) was acquired before 1728 by General Guise and the variant of this, now at Fort Worth (Posner 1971, no. 5), was in the Aberdeen collection at Haddo. Guise also owned the *Boy Drinking* (Posner 1971, no. 7), a version of which was at Bridgewater House, while a somewhat later picture of the same subject (Posner 1971, no. 9) was owned by Sir Abraham Hume, who purchased it in 1817 as a Titian (Hume 1824, no. 30).

This picture is first recorded in the collection of George Brudenell, 4th Earl of Cardigan (1712–1790), who married the daughter of the 2nd Duke of Montagu, and for whom the dukedom was revived in 1766. The 1770 inventory establishes that Montagu House in Whitehall contained a very considerable collection, much of which still belongs to his descendant, the Duke of Buccleuch, including the early El Greco *Adoration of the Shepherds* at Boughton and Rembrandt's *Old Woman Reading* (no. 292). For a fuller account of the collection see that entry; and for the Grand Tour acquisitions of the duke's son, Lord Monthermer, who died in 1770, see nos. 173 and 175. F.R.

Provenance: First recorded in the possession of the 1st Duke of Montagu at Montagu House in 1770; and by descent through his daughter Elizabeth, Duchess of Buccleuch
Literature: Montagu House 1898, no. 64; Posner 1971, 1: 21, and 2: no. 17
Exhibitions: Manchester 1965 (247); London, Agnew 1973 (13)

262

YOUNG MAN IN A PLUMED HAT c.1584
Annibale Carracci 1560–1609
oil on canvas
64 × 52.7 (25¼ × 20¾)

Boughton House
The Duke of Buccleuch and
Queensberry, KT

Formerly ascribed to Passarotti, to Caravaggio, and to Taddeo Zuccaro, this haunting portrait was attributed to Annibale Carracci by Benedict Nicolson at the time of the Manchester exhibition, and Posner endorses this view. He comments that the "vigorous handling and the broadly structured forms" indicate a date close to the *Crucifixion* of 1583 in the church of Santa Maria della Carità at Bologna, but argues that "a somewhat more developed feeling for the plasticity of forms suggests that it is slightly later." It indeed echoes Carracci's early experience of Venetian art. His mature style was greatly admired in England, but it is revealing that many of his secular masterpieces of this early period were secured by British collectors. The great *Butcher's Shop* of 1582–1583 at

263

PAIR OF MIRRORED APPLIQUES
c.1759/1760
attributed to Giovanni Battista Borra
1712–1786
carved and gilt wood
284.5 (112) high

Formerly at Stowe
Private Collection

This magnificent pair of wall-mirrors or appliqués belongs to a set of four made for the State Bedchamber at Stowe in Buckinghamshire as part of the extensive work on the interior of the house carried out for Richard Grenville, 2nd Earl Temple (1713–1784). Temple's architect was the Piedmontese Giambattista Borra, who had accompanied Robert Wood and James Dawkins on their celebrated tour of Asia Minor and Syria in 1750–1751, and who prepared the drawings for their two folio volumes on the ruins of Palmyra and Baalbec, published in 1753 and 1757 respectively. He seems to have spent much of this decade in England, producing highly accomplished designs for interiors at Norfolk House in London (of which the Music Room survives in the Victoria and Albert Museum) and rooms at Woburn Abbey and Stratfield Saye (Fitzgerald 1973, 10–28).

Like these, the State Bedchamber and Dressing Room at Stowe presented an unusual combination of Italianate rococo with precocious neoclassical motifs derived from Palmyra. Thus the ceiling of the bedchamber has the pattern of interconnecting octagons familiar from Wood's book (1753, pl.XIX), while the bed (now in the Lady Lever Art Gallery, Port Sunlight), which was also designed by "Signor *Borra*" according to the 1763 Stowe guidebook, was an extravagant rococo confection recalling the carvings in the Norfolk House Music Room. The appliqués consist of mirrors, waisted and shaped in a wholly Italian vein, but crowned by an urn and with swags of husks, acanthus, and paterae in a remarkably advanced neoclassical style. The whole composition is close to Borra's doorcases in the Sala da Ricevimento at the palace of Racconigi near Turin, dating from 1756–1757. The otters, rather less well carved than the rest, are the supporters of the arms of the

Dukes of Chandos, and were probably added in place of the Temple supporters by the earl's great-nephew, the 1st Duke of Buckingham, who married the Chandos heiress and added that title to his own in 1822.

Most of the carving in the State Bedchamber and Dressing Room at Stowe was carried out by the London carpenter and builder John Hobcraft of Titchfield Street (Huntington Library MSS, San Marino), but it is unlikely that he would have supplied furniture of such quality. A more likely candidate is Jean-Antoine Cuenot who was responsible for much of the exquisite carving at Norfolk House, and whose family is thought to have been in the service of the Dukes of Savoy in the late seventeenth century, suggesting a link with the Piedmontese Borra (Fitzgerald 1973, 29). Although work was begun on the two rooms in 1755, the state bed was not installed until 1759 and the curtains not hung here until the summer of 1760, when Lord Temple's newly attained Order of the Garter was interpreted in elaborate plasterwork in the center of the ceiling. Borra may already have returned to Italy by this date and by 1765 he had been superseded as the earl's architect by the Frenchman J.F. Blondel and another Italian, Vincenzo Valdre of Faenza. But his work at Stowe, much of it undertaken before Robert Adam's return to England from Rome, marks him as one of the pioneers of neoclassicism in England.

G.J-S.

Provenance: By descent at Stowe until the 1921 sale (Jackson-Stops, 4–28 July 1921, lot 2758)
Literature: Fitzgerald 1973, 13, pl. 6; Fitzgerald 1973a, 36–37, figs. 8, 10

264

THE BETRAYAL OF CHRIST c.1629
Sir Anthony van Dyck 1599–1641
oil on canvas
265.6 × 221.6 (101 × 87¼)

Corsham Court
Bristol Museum and Art Gallery

This distinguished picture probably dates from the end of Van Dyck's first Antwerp period. A large number of drawings document the evolution of the composition (Vey 1962, nos. 79–86). The first picture of this subject, notably impulsive in handling, was formerly at Petworth, and is now at the Minneapolis Institute of Arts. This was followed by a considerably larger and much more deliberately wrought canvas in the Prado, and by the Corsham picture. This differs from the earlier versions by not showing Saint Peter's attack on Malchus at the lower left, and as a result the betrayal itself is placed more centrally. The high dramatic tension of the Prado picture is not sustained but the composition gains in coherence and the Corsham *Betrayal* seems thus to be the definitive interpretation of the theme. Waagen commented, "in the luminous warm colouring it still recalls Rubens, and is of extraordinary effect" (Waagen 1857, 395).

No painter has been more consistently fashionable in England than Van Dyck, whose portraits at Wilton, Althorp, and Houghton were widely admired in the eighteenth century. But surprisingly few subject pictures of prime caliber were acquired for English collections in the eighteenth century. Of these the Corsham *Betrayal* and the *Charity*, bought in 1764 by Sir James Lowther, later 1st Earl of Lonsdale (National Gallery, London), are among the finest.

Sir Paul Methuen (1672–1757), who purchased the picture in 1747 for £100, was the son of John Methuen (1630–1706), the diplomat best known for his role in concluding the "Methuen Treaty" with Portugal in 1703. On his father's death in 1706, he succeeded him as Ambassador to Portugal, but returned to become a Lord of the Admiralty in 1709. Under King George I he received a series of appointments: in 1714 he became a Lord of the Treasury and

Privy Counsellor and in the same year Ambassador to Spain; in 1716 he became Principal Secretary of State; and from 1720 he was Comptroller of the Household, becoming Treasurer in 1725 but resigning in 1730. The heir to a not inconsiderable fortune, Methuen was greatly enriched by the various emoluments of office, which enabled him, like his younger but less long-lived contemporary, Sir Robert Walpole, to collect on a grand scale.

Sir Paul kept accounts of his annual expenses, which document the growth of the Corsham collection. In 1717 he spent 28½ guineas on frames and, in 1718, 6 guineas; in 1719 £98 7s. was spent on pictures but none were bought in 1720; in 1721 £300 was "laid out in Pictures" out of a total expenditure of £2,283 11s. 1½d. In 1722 he spent £900; in 1723, £300; in 1724, £600; in 1725, £250; in 1726 (when £300 was spent on books), £100; in 1728, £200 as well as £32 5s. for "charge on pictures from Italy"; in 1730, £900, out of a total of £2,016 14s. 5½d.; in 1732, £300; in 1733 £200 was spent on both pictures and books, in 1734, £473 and in 1735, £90 on "Pictures, Books and other Curiosities"; in 1754 £145 15s. 6d. was spent at auctions; and in 1755 £246 14s. was spent on the collection. The records for 1727, 1729, 1731, and 1736–1753 are missing or incomplete. To put these figures in perspective one should note that in the early 1720s the annual rent for the house Methuen leased from the Duke of Bridgewater was £300 and that he spent £250 for his election as MP for Brackley in 1720 and £200 in 1725, when his induction as a Knight of the Bath cost £600. When Sir Paul bought his London house in 1728 this cost £4,500, and entailed an exceptional household expenditure of just over £2,000, roughly double that of most other years.

Methuen's earliest acquisition was apparently the version of Tintoretto's *Adoration of the Shepherds*, which he bought with two works *en suite* when in Spain in 1715. He certainly took advantage of the opportunities offered by the London saleroom, buying a good copy of Caravaggio's *Tobias and the Angel* at the Duke of Portland's sale in 1722 and the large replica of Guido's Vienna *Baptism* at that of the 1st Earl of Cadogan

in 1726 (127 guineas). Other acquisitions were made at the sales of the Earl of Halifax in 1729 and the painter Charles Jervas in 1740. Methuen also patronized dealers, including George Bagna, from whom this picture was purchased. The earliest account of the colleczon is that of 1722 in Vertue's notebooks (1930–1955, 3: 10–11).

His taste was wide in range. Italian pictures inevitably predominated, with, to cite works still in the collection, the large *Sacra Conversazione* of Bonifazio Veronese, the Cortona (no. 279), three works by Dolci including the major *Institution of the Sacrament*, a Salvator Rosa, and a number of fine still lifes of a kind somewhat neglected by English connoisseurs. Methuen owned a few Spanish pictures including an early view of Mexico and a copy after Murillo, while the Northern schools were represented by the Van Dyck *Betrayal*—the *clou* of the collection as a whole—and by a large pair by Lairesse. There were also some Dutch and Flemish cabinet pictures. That Sir Paul's taste was not limited by convention is suggested by his purchase of a panel of the *Virgin and Child with Saints* in the style of Mabuse.

Methuen kept his pictures in his London house in Grosvenor Square. On his death in 1757, the collection was inherited by his cousin and godson, Paul Methuen (1723–1795), who had purchased Corsham in 1745. Methuen began to plan the reconstruction of the Elizabethan building as early as 1749 and in 1760 Lancelot "Capability" Brown was commissioned to enlarge the house. His interiors, most obviously the gallery, the Cabinet Room beyond, the state bedroom and the Octagon Room in the east wing, were specifically designed to house Sir Paul's pictures. Many though not all of these were brought from London to Corsham. The Van Dyck was evidently intended for the gallery *ab initio*, which explains its omission from Dodsley's account of the pictures in London in 1761.

Paul Methuen was keenly interested in the pictures he inherited. There are regular references in his day book of 1760–1773 to (Robert) Bonus—whose cleaning of the Guise pictures at Christ Church was so criticized by Walpole

(compare Byam Shaw 1967, 5 and 12). Bonus received £28 for "cleaning all the Pictures" in Grosvenor Street on 9 May 1765, 9 guineas on 26 April 1768, £30 on 19 April 1769, and £17 12s. on 23 December 1772. He also supplied a frame in 1773. Unlike many owners of pictures, Methuen was not dogmatic about their attribution, as the contemporary observers Dodsley and Martyn noted.

Paul Methuen's son, Paul Cobb Methuen, transferred the remainder of the collection to Corsham, where Britton lists 212 pictures divided between seven rooms. Of these 32 were in the cabinet room, 136 in the gallery, 79 in the music room, 29 in the saloon, and 17 in the dining room. A number of pictures were sold at Christie's in 1840 and at subsequent sales, and others were added as a result of the 2nd Lord Methuen's marriage to the only daughter and heiress of the Rev. John Sanford, who formed a major collection of pictures in Italy between 1815 and 1837. However, the gallery, with its splendid plasterwork by Thomas Stocking—who was at work in the room in 1763—has changed remarkably little in character since Paul Methuen's day. The recent acquisition of the Van Dyck by Bristol Museum and Art Gallery, to be kept on permanent loan to the house, is a precedent that is likely to be of the greatest importance for the future of British country house collections. F.R.

Provenance: Purchased from the dealer George Bagna for £100 on 22 May 1747 by Sir Paul Methuen, "For a large Picture of Vandycks of Our Saviour betrayed by Judas to the Jews [£] 100.0.0" (Corsham MSS); moved from Grosvenor Square to Corsham by his heir, Paul Methuen, c. 1761; by descent, acquired by HM Treasury in lieu of duty after the death of the 4th Lord Methuen in 1984, and transferred to Bristol Museum and Art Gallery to be kept in the gallery at Corsham
Literature: Britton 1806, no. 71; Smith 1829–1842, 3: Van Dyck, no. 16; Waagen 1838, 3: 102–103; Waagen 1857, 395; Methuen 1891, no. 274, and 1903, no. 227; Borenius 1939, no. 119
Exhibitions: London, BI 1857 (12); London, RA 1877 (109); London, Grosvenor 1887 (125); Antwerp 1899 (9); London, RA 1900 (30)

265

THE HAREWOOD COMMODE 1773
Thomas Chippendale 1718–1779
marquetry of various woods
with ivory on a satinwood ground;
gilt bronze mounts
96.52 × 231 × 68.5 (38 × 91 × 27)

Harewood House
The Earl and Countess of Harewood

Thomas Chippendale's commission to furnish Harewood House for Edwin Lascelles, later 1st Lord Harewood (1713–1795), was definitely the most valuable of his career, and it has been estimated that the firm's total contract exceeded £10,000. Of all the many pieces of furniture supplied for the house, this "dressing commode" was far the most elaborate, and at £86 it is also the most expensive single item of cabinet furniture recorded in any of Chippendale's bills.

The invoice, presented on 12 November 1773 (Harewood MSS, Leeds Archives Department), lists among all the rest of the furniture supplied for the State Dressing Room at Harewood, "a very large rich Commode with exceeding fine Antique Ornaments curiously inlaid with various fine woods—Drawers at each End and enclosed with foldg Doors, with Diana and Minerva and their Emblems Curiously inlaid & Engraved, a Cupboard in the middle part with a Cove Door, a Dressing Drawer in the Top part, the whole Elegantly Executed & Varnished, with many wrought Brass Antique Ornaments finely finished."

A "Damask Cover to the top" was also provided at the cost of £1, presumably made of leather stamped with a damask pattern, and possibly green to match the damask hangings of the room put up by Chippendale's men at the same time. The dressing drawer of the commode is neatly fitted with lidded and boxed compartments, wells containing glass cosmetic bottles, and comb trays, but it is the eloquent marquetry designs and high technical finish that make this commode an incomparable neoclassical masterpiece. The pictorial roundels depend heavily for their artistic effect on the contrast between light and dark materials enhanced by engraved penwork. In this respect the marquetry differs from medallions attributed to Christopher Fürlohg, which achieve a more painterly manner by combining delicately tinted and shaded elements (Streeter 1971, 418–429). There is a technical consistency about the marquetry furniture at Harewood that suggests it was not only designed by the same hand but executed in the same workshop, and since Chippendale's premises included a veneering room it is more than likely that he was wholly responsible for making as well as designing the whole piece.

Robert Adam's influence is clear, for instance in the frieze of half-paterae with garlands of husks, which appear in his design for the Kedleston sideboard as early as 1762, and in the giant patera used to form a niche or exedra, as in the organ case at Newby. The use of the Minerva and Diana medallions to suggest antique cameos can also be paralleled in his design for a commode for the Duke of Bolton in 1773 (Harris 1963, fig. 44). But Adam's last contact with Harewood seems to have been in 1771, and there is no evidence even before that date to suggest that Thomas Chippendale ever executed his designs for furniture at the house. On the contrary, in a letter to Sir Rowland Winn written in July 1767 after his first visit to Harewood, Chippendale wrote, "as soon as I had got to Mr. Laselles and look'd over the whole of ye house I found that I Shou'd want a Many designs & knowing that I

had time Enough I went to York to do them" (Nostell Priory MSS). In contrast to Adam's highly sculptural furniture, the Harewood commode—the culmination of these "many designs"—is indeed a masterpiece of the *ornemaniste*. Its two most architectural features, the concave sides and the central niche, are both likely to have been adopted for purely practical reasons: the former to allow the festoon curtains in the room to fall at night without bunching up against the sides of the commode (which filled the whole pier), and the latter to allow room for the knees when the dressing drawer was pulled out and a chair set before it. The extraordinarily refined "pilaster" strips—inset with ormolu beading and decorated with stiff acanthus leaves at the top, answered by those on the feet—are reminiscent of contemporary French furniture by Riesener, Leleu, and others, which Chippendale could have seen on his visit to Paris in 1768. Far from the naiveté of many of the *Director* engravings, and perhaps already showing his son's influence as a skilled draftsman in the St. Martin's Lane workshop, the commode justifies his reputation as the greatest cabinetmaker and furniture designer of the age.

C.G./G.J-S.

Related Works: Although undocumented, a commode at Renishaw in Derbyshire (Reresby Sitwell, Esq.) has such close affinities with that at Harewood that it has been generally attributed to Chippendale, even if the pictorial medallions are by another sub-contractor; other pieces that display stylistic parallels include the library table at Harewood, on which some of the brass mounts are duplicated, and a pair of glazed bookcases at Firle Place, probably made by Chippendale for Melbourne House in London

Literature: Simon 1907, fig. 30; Macquoid 1904–1908, pls. 56–59; Brackett 1924, 73–74; DEF 1954, 2:118, fig. 28; Edwards and Jourdain 1944, 48–49, fig. 114; Symonds 1958, 53–56; Stephenson 1968, 67–68, 72; Gilbert 1973, 3; Gilbert 1978, 195–207, figs. 232–235

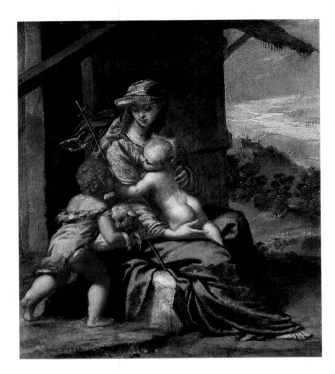

266

THE MADONNA AND CHILD WITH THE INFANT SAINT JOHN THE BAPTIST
c.1575
Ipollito Scarsella, Lo Scarsellino
c.1551–1620
oil on panel
25.4 × 22.2 (10 × 8¾)

The Burghley House Collection

This small devotional panel is one of the most enchanting in the whole oeuvre of Scarsellino, the last of the great Ferrarese painters of the Renaissance. Its immediacy and freshness are not fully matched in the version in the Hermitage, in which the figure of Saint Joseph is introduced in the background.

The picture was probably acquired in Italy by Brownlow Cecil, 9th Earl of Exeter (1725–1793), who succeeded his father in 1754 and traveled in Italy in 1763–1764 and 1768–1769. While in Naples in 1764 Exeter sat for Angelica Kauffmann; he also bought a number of pictures that complemented the collection of the 5th Earl, employing both James Byres and Thomas Jenkins as his agents in Rome (see no. 227). The picture is recorded in 1815 and 1847 as in the Chapel Room at Burghley.

F.R.

Provenance: Probably acquired by Brownlow, 9th Earl of Exeter; and by descent
Literature: Burghley 1815, 29 (as Surcello Farara); Charlton 1847, 185, no. 53; Novelli 1964, no. 179

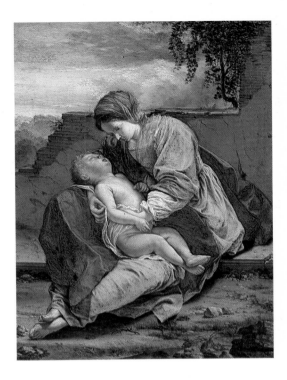

267

MADONNA AND CHILD IN A LANDSCAPE 1615/1620
Orazio Gentileschi 1563–1639
oil on copper
28.5 × 22.2 (11¼ × 8¾)

The Burghley House Collection

This exquisite devotional picture is one of the few surviving works of its kind by Gentileschi, although there is documentary evidence that he painted small works on copper. Despite its scale and the essential intimacy of the subject, this composition is conceived in the same monumental vein as far larger pictures of the period, including the Birmingham version of the *Rest on the Flight* and the altarpiece in the church of Santa Lucia at Fabriano. The rich yellow of the Madonna's dress is a color for which Gentileschi had a special predilection. Traditionally given to Castiglione, the picture was restored to Gentileschi by Denis Mahon (Bissell 1981, 168).

The painting was presented to Brownlow, 9th Earl of Exeter (1725–1793), by Pope Clement XIV (no. 190) in 1774. Exeter is known to have

commissioned copies of the frescoes by
Guido Reni in the pope's private chapel
at Monte Cavallo in that year (Father
Thorpe papers, Arundel of Wardour MSS,
information from Sir Brinsley Ford).
The earl made an extensive Italian tour
in 1768–1769, and it was no doubt
at this time that the gift was made,
as the result of a "rather curious"
incident recounted in the 1797 Burghley
guidebook: ". . . as our English nobility
have been, in general, remiss in personal
respect to his Holiness, it left the Earl a
more ample opportunity of displaying
his. This occurring on a public day,
when the Pope passed through the
streets of Rome, the Earl was pleased
to manifest the same adoration, which
he expects from all his liege subjects, on
that occasion; with which his Holiness
was so struck, that he immediately ex-
pressed a wish to return to it, by some
reciprocal instance of esteem. Now, as
the Earl well knew the effect of the
Pope's benediction, and the doctrine of
indulgencies, he neither wished for the
one, nor the other. In what way there-
fore, could his Holiness express this
esteem to a Protestant nobleman, unless
it was by some little token like the
present? As the Earl amused himself at
the Vatican, one day, he happened to
throw his eyes on this piece; and,
recollecting that he had none in his
extensive collection, by the same hand,
expressed his approbation of it. It was,
therefore, with great satisfaction, that
his Holiness heard this, which he
immediately evinced, by ordering it to
be conveyed to the Earl's lodgings, at a
very early hour, the next morning. Such
is the brief history of this piece. It was
surely as modest a favour, if it may be
called such, as a nobleman of Lord
EXETER's rank could request; and as
small a one as a Prince of GANGANELLI's
great soul could bestow."

The picture reached England in 1774.
Since at least 1815 it has hung in the
West Dressing Room, later called the
Purple Satin Dressing Room, but then,
as now, hung with blue damask. F.R.

Literature: Burghley 1797, 77–78;
Burghley 1815, 67; Waagen 1854, 3:405;
Bissell 1981, no. 39
Exhibitions: Northampton 1959; London,
RA 1960 (23)

268

PIER TABLE C.1773
English
gilt wood, with marquetry top in
tulipwood, rosewood, and satinwood
93 × 244 × 91 $(35\frac{5}{8} × 96 × 35\frac{7}{8})$

Basildon Park
The National Trust (Iliffe Collection)

The first volume of James Stuart and
Nicholas Revett's *Antiquities of Athens*,
published in 1762, was the first accurate
survey of Greek classical remains ever
to be undertaken, and was to become
the principal source book of the early
seventeenth-century Greek Revival
in England. However, its effect on
contemporary architecture was limited,
perhaps partly because of the first success
of the Adam brothers' Imperial Roman
style. The "Gusto Greco" of the 1760s
and 1770s was thus decorative rather
than structural in character, more often
found in furniture and metalwork (see
no. 461) than in buildings—except for
a few designed by the indolent Stuart
himself.

This pier table, which is one of a
pair accompanying gigantic pier glasses,
also now in the Octagon Room at
Basildon, appears to be one of the earliest
known English works of art to reproduce
the four famous caryatid figures of
the portico of the Erechtheion, on the
Acropolis in Athens. The portico, usually
known as the Propylea, only appeared
in the second volume of the *Antiquities
of Athens*, published in 1789, the year
after Stuart's death. However, the
building was engraved as plate 19 of
Le Roy's rival *Ruines des Plus Beaux
Monuments de la Grèce* of 1758, a source
used by Robert Adam, for instance in his
decoration of Syon. While it is tempting
to ascribe the design of the tables to
the great "Athenian" himself—given
Stuart's use of the highly individual
Ionic order of the Erechtheion at Thomas
Anson's town house, 15 St. James'
Square (1764–1766) and in the chapel
of Greenwich Hospital (1779–1790)—
there are others who could equally well
have been responsible. A pair of caryatid
figures without arms (and therefore
closer to the Erechtheion originals) are
for instance found supporting a table
in the third edition of Chippendale's
Director (plate 176), published as early
as 1762; the same feature occurs in a
"Glass and Table Frame for Shelburne
House" designed by Adam (Sir John
Soane's Museum; vol 20: no. 24).

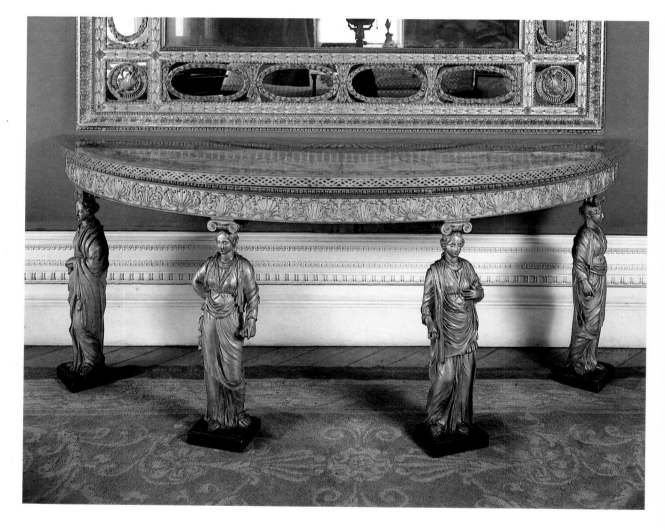

Unfortunately, very little is known about the origin of these pieces except that they were acquired by Lord and Lady Iliffe at the sale of Brockenhurst Park in Hampshire, the home of the Morant family, in 1959. The pier glasses seem likely to have been those supplied for the large sum of £316 by one Alexander Murray, mentioned in an invoice of 10 July 1773, for delivery at 17 Park Lane, the London house of Mr. Edward Morant (d. 1791). Alexander may have been a relation and partner of William Murray, recorded as a cabinet-maker in Broadway, Westminster, in the London polling lists for 1774 (Heal 1953, 123). The maker of the tables and mirror frames is not recorded, although Edward Morant's papers reveal that he bought pieces both from Thomas Chippendale and from George Seddon— also supplying the latter with mahogany from the family's Jamaican estates, which had been acquired by his great-grandfather John Morant in the late seventeenth century (*Antique Collector* 1954). The decorative designer, George Richardson, who began as Robert Adam's draftsman, also made ceiling designs for Brockenhurst in 1775. The marquetry tops of the tables inlaid in a fan design, with a border matching the very distinctive anthemion frieze, is comparable with Chippendale's work at Harewood in the early 1770s and also bears comparison with the top of the Osterley commode (no. 257) made in the same year, 1773. But unless more documents come to light, this splendid set of furniture, foreshadowing the world of Sir John Soane and C.R. Cockerell, is likely to remain among the more tantalizing mysteries of the neoclassical movement in England. G.J-S.

Provenance: By descent in the Morant family; sold with the contents of Brockenhurst Park; acquired by Lord and Lady Iliffe as part of their restoration and refurnishing of Basildon in the 1950s
Literature: Musgrave 1966, 53, fig. 104
Exhibitions: London, V & A 1962 (74)

269

SOFA C.1760
designed by James "Athenian" Stuart
1713–1788; probably executed by
Thomas Vardy
gilt wood, modern damask upholstery
96 × 211.5 × 88.9 (37¾ × 83¼ × 35)

Kenwood House
The Trustees of the Victoria and
Albert Museum

This is one of a set of four sofas and six armchairs formerly in the Painted Room at Spencer House in London, designed by James Stuart for the 1st Earl Spencer in 1759, and one of the earliest interiors in England in the new "Etruscan" taste. Lord Spencer was a leading member of the Society of Dilettanti, which had sponsored Stuart's expedition to Greece with Nicholas Revett from 1751 to 1755, resulting in the first volume of their *Antiquities of Athens*. One of the most influential books in the history of the neoclassical movement, this was finally published in 1762, and earned Stuart

the nickname by which he has been known ever since. But even before this, members of the society, including Lord Rockingham at Wentworth Woodhouse and Lord Lyttelton at Hagley, had employed him to advise on decoration and garden buildings in the new *goût grec*.

The rooms on the first floor of Spencer House, overlooking Green Park, constitute the very first fully integrated scheme of neoclassical decoration in Britain. Yet Stuart's sources are remarkably eclectic: the Painted Room itself is a *tour de force* in the ancient Roman "grotesque" or arabesque type of decoration, as revived by Raphael in the Vatican *loggie*, yet it also has a screen of columns in front of the bay window taken from the portico of the Temple of Antoninus and Faustina in the Forum, and doorcases and mirror frames inspired by the colonnade of the Incantada at Salonica—illustrated in the *Antiquities of Athens*.

The ornament of the sofas, like that of the room, is partly inspired by Grecian

architecture: the foliate scroll of the armrest is, for instance, formed like the volute of an Ionic capital, while the flutes on the seat rail correspond to those on the dado rail. Two of them have carved backs to fit between the windows in the apsed bay, while the other two stood on either side of the window opposite the chimneypiece, thus presenting their flanks to anyone entering from the Great Room next door. The winged lions carved in high relief on these flanks are the source of the sofas' unique character. Winged leopards and mythological beasts such as the sphinx and griffin (the crest of the Spencer family) ornamented some of the grander furniture at Spencer House, and in his watercolor design of 1759 for the north wall of the Painted Room (British Museum, London) Stuart proposed that guardian lions should support the tables on either side of the entrance door. Among the sources that may have provided him with inspiration for the design of the sofa are the Hellenistic marble throne flanked by

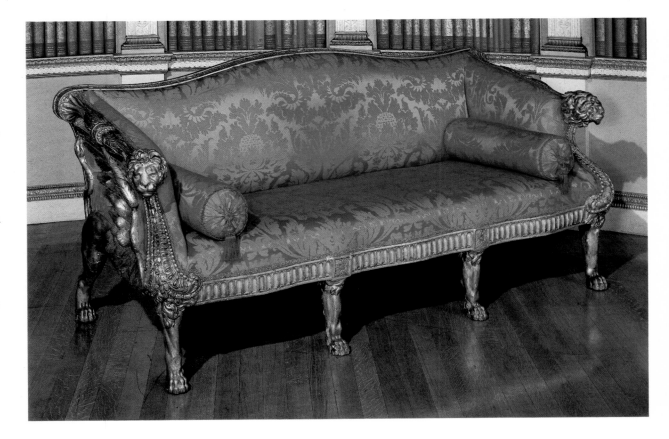

pacing lions with extended wings, which was presented to the University of Oxford in 1755 and is now at the Ashmolean Museum; a leopard with upraised tail, decorating the Bacchic frieze of the Temple of Lysicrates in Athens; and various other lion-headed marble seats that he could well have seen in Greece or in Italy.

The sofas are attributed to the specialist carver Thomas Vardy of Grosvenor Square, who collaborated with his brother, the architect John Vardy (d. 1765), in the building and furnishing of the house. A chalk sketch (Sir John Soane's Museum, London) of one end of the sofa was made by the architect Robert Adam, who, despite his scorn of Stuart's designs for Kedleston (see no. 461), acknowledged that he had "contributed greatly towards introducing the true style of antique decoration." This view was shared by Arthur Young, who described the drawing room in 1772 as "A Phoenix— the walls and ceiling are painted in compartments by Mr. Steuart in the most pleasing taste. The frames of the tables, sofas, stands etc. are all carved and gilt in the same taste as the other ornaments of the room, rich but elegant." He thought the furnishings were "astonishingly beautiful," and superior "in richness, elegance and taste" to anything he had ever seen.

J.H./G.J-S.

Provenance: By descent at Spencer House and Althorp; sold by the 8th Earl Spencer in 1977 and acquired by the Victoria and Albert Museum; on loan from the Museum to the Adam library at Kenwood
Literature: Spencer 1926, 758, fig. 6; Musgrave 1966, 197, pl. 80; Thornton and Hardy 1968, 440–451, fig. 20; Udy 1973, fig. 2; Watkin 1982, 36–38, figs. 25, 26, 30
Exhibitions: London, V&A 1972 (1658)

270

SIDEBOARD AND WINE COOLER
c. 1760/1770
English
veneered in satinwood with dark-stained softwood ornaments
table: 91.4 × 213.4 × 91.4 (36 × 83 × 36)
wine cooler: 69.9 × 81.9 × 81.9 (27½ × 32¼ × 32¼)

The Castle Howard Collection

Frederick Howard, 5th Earl of Carlisle (1748–1825), enriched his grandfather's great baroque house not only with antique sculpture and old master paintings of the finest quality (see nos. 229, 273 and 275), but also with furniture in the new neoclassical taste. Among these pieces is a commode in the French "Transitional" style, now in the gallery, which is signed in pencil inside the carcass, "Christopher Fürlohg fecit 1767," and which corresponds with a drawing among John Linnell's collection of designs at the Victoria and Albert Museum (Hayward and Kirkham 1980, 63, figs. 108–109). Fürlohg and his brother-in-law Georg Haupt were Swedish cabinetmakers who worked in Amsterdam and Paris before coming to London, where they appear to have worked for Linnell's firm. Haupt returned in August 1769 when he was appointed cabinetmaker to the King of Sweden, but Fürlohg remained in England setting up premises of his own in Tottenham Court Road by 1777 when he described himself as "Ebéniste to H.R.H. The Prince of Wales" (Heal 1953, 60).

The marquetry pattern of intersecting octagons on this sideboard and wine cooler (and a pair of pedestals of triangular section made *en suite*) is more commonly found in Sweden than in England in the mid-eighteenth century and suggests that they may also be by Fürlohg. The strictly neoclassical swags on the frieze are not unlike those in marquetry on the commode, which also has the same juxtaposition of very dark and very light woods. The 5th Earl of Carlisle's papers have unfortunately revealed few of the names of the cabinet-makers he patronized, but a large suite of bedroom chairs, two marquetry clothes presses, and a bed at Castle Howard can be attributed to John Linnell by comparison with documented furniture at Osterley of the late 1770s (Hayward and Kirkham 1980, 119–120, figs. 11, 97, 98, 140, 141). However, Ince and Mayhew (see no. 257) apparently received payments for unidentified pieces from the earl (information from Dr. Geoffrey Beard), and there are parallels also with their simple neo-classical work with dark-stained banding on a satinwood ground—like the rectangular chest commodes supplied for Croome Court as early as 1761 (Coleridge 1968, fig. 119).

G.J-S.

Literature: DEF 1954, 3:129, fig. 16

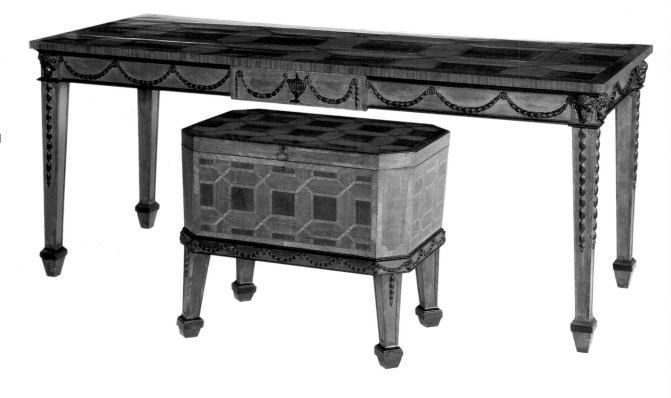

271

VASE PERFUME BURNER c. 1770/1771
Matthew Boulton 1728–1802
blue-john with ormolu support
and mounts
55.8 (22) high

Hinton Ampner House
The Executors of the late Lord Sherborne

The three griffins supporting this magnificent blue-john "egg" are of identical design to those that support Matthew Boulton's smaller-scale "Griffin Vase"—eight of which were in the catalogue of the firm's sale at Christie's in 1771, and one of which was appropriately bought by Sir John Griffin of Audley End (see no. 296). In other respects the Hinton Ampner perfume burner, pierced for the emission of incense although it no longer has a lining, has close similarities to Boulton's "Persian Vases." A pair of these bought by Sir Lawrence Dundas (and now in the Victoria and Albert Museum) displays the same pierced rim and finial, hexagonal column support, and shaped triangular base of this vase. It has been suggested (Goodison 1974, 158) that the original design for the griffins may have been given to Boulton by the architect Sir William Chambers (see no. 272), and the column support is also echoed by a drawing in Chambers' "Franco-Italian" sketchbook (Victoria and Albert Museum, Department of Prints and Drawings, 5712).

The gemstone fluorspar known as blue-john—a corruption of the French *bleu-jaune*—with its remarkable range of amethystine violets, bluish-greens, and honey yellows, was the only indigenous English material that could rival the porphyry, jasper, and malachite so much admired in Italy on the Grand Tour. Unique to a single mine at Castleton in the Peak District of Derbyshire, blue-john became world-famous from the late 1760s when the art of polishing it was perfected, using a heat process with pine resin. It was widely employed by Robert Adam and exported to France, Germany, and Russia. Indeed, Catherine the Great purchased blue-john vases, clocks, and an obelisk from Matthew Boulton between 1772 and 1774.

The collection of eighteenth-century pictures and works of art at Hinton Ampner, particularly rich in colored marbles and semi-precious stones, was put together by Ralph Dutton, 8th Lord Sherborne, author of several books on the Georgian period and one of those who contributed most to its re-evaluation and appreciation in England between the wars. The Victorian family house he had inherited was transformed in 1937 by his architect friend, the 7th Duke of Wellington, into a more suitable classical setting and modified again after a fire in 1960. He never married and on his death in 1985 generously bequeathed the house and estate to the National Trust.

G.J-S.

Provenance: Acquired by Ralph Dutton (later Lord Sherborne) in the 1930s; said to have come from the Earl of Lonsdale's collection, Lowther Castle
Literature: Goodison 1974, 157–158, figs. 89, 93

272

PAIR OF ORNAMENTS c. 1770/1775
unknown maker, after a design by
Sir William Chambers 1723–1796
ormolu, on porphyry bases
31.7 (12½) high

Hinton Ampner House
The Executors of the late Lord Sherborne

These ornaments correspond exactly with a plate entitled "Various ornamental Utensils" in William Chambers' *A Treatise on the Decorative Part of Civil Architecture* (3d ed., 1791, pl. 91), the only difference being the omission of a much larger candle nozzle and drip pan in favor of a finial, perhaps originally removable. Apart from their outstretched wings, the griffins are also very similar to those on documented vases by Matthew Boulton (see no. 271), but this could be explained if the design were among the "valuable usefull and acceptable modells" that Chambers gave Boulton in 1770, as the latter reported in a letter to his wife (Goodison 1974, 158). Another model, specifically representing a griffin, is known to have been lent by the architect to the firm in 1773. However, the chasing of the ormolu on the Hinton Ampner ornaments, though very fine, is technically quite different from that produced in Boulton and Fothergill's Soho manufactory at Birmingham, and they are evidently the work of another, unknown maker. Chambers' design was also interpreted in blue and white jasper ware by Josiah Wedgwood (Dawson 1984, fig. 45).

A constant motif found in Greek and Roman architecture, the griffin symbolizes the combined qualities of the eagle and the lion—watchfulness and courage. As such, it may have been thought a particularly appropriate ornament for a candlestick, helping to overcome the powers of darkness.

G.J-S.

Provenance: See no. 271
Literature: Goodison 1974, 158, fig. 92

273

PORTRAIT OF A MAN HOLDING
A SHEET OF MUSIC c. 1621/1623
Domenico Fetti c. 1589–1623
oil on canvas
179 × 130.8 (70½ × 51½)

The Castle Howard Collection

The sitter in this striking portrait is
shown in fanciful or theatrical dress,
holding a score and pointing to an
upturned bowl, while the youth behind
him on the right raises his finger to his
lips to call for silence. Described by
Walpole as a musician, and conjectured
by Waagen to be the artist himself, the
sitter in this portrait cannot be identified.
The arch of Palladian inspiration in the
background also appears in two of Fetti's
comparable compositions. The picture
may postdate Fetti's visit to Venice in
1621 and is one of the most deeply
personal works of his final years. An-
other version is in the Uzielli-De Mari
collection, Genoa, and a possible copy
by Stiémart was in the French royal
collection in 1715. The primacy of the
Castle Howard picture, however, is es-
tablished by *pentimenti*, notably of a
second figure in the background.

The Castle Howard inventory of
1805 establishes that the picture was
purchased in London before 1772 by
Frederick Howard, 5th Earl of Carlisle,
who had succeeded his father in 1758
(see no. 482). In 1780 the picture was
in the gallery but by 1837 it hung in
the drawing room. F.R.

Provenance: Purchased in London before
1772 by the 5th Earl of Carlisle, and by
descent at Castle Howard through the
Hon. Geoffrey Howard, younger son of
the 9th Earl
Literature: Sullivan 1780, 181; Rutland
1813, 97; Carlisle 1837, no. 31; Waagen
1838, 3:204; Ibbotson 1851, 21; Waagen
1854, 2:322; Potterton in London NG
1979, with previous literature
Exhibitions: London, RA 1938 (307);
Leeds, City Art Gallery 1949 (25);
London, NG 1979 (10)

274

DEMOCRITUS c.1635/1637
Jusepe de Ribera, Lo Spagnoletto
1591–1652
oil on canvas
154 × 119.3 (61 × 47)

Wilton House
The Earl of Pembroke and Montgomery

This noble work, overlooked until
recently by students of Ribera, represents
the philosopher Democritus, whose worn
dress alludes to the poverty he experienced
after spending his inheritance on his
journeys throughout the known world.
As Felton and Jordan observe, the
characterization is rather different from
that of Ribera's earlier and coarser
representation of Democritus in the
Prado, which is of 1630. Their dating of
1635/1637 for the Wilton picture,
with its compelling sense of form and
wonderfully controlled range of muted
tones, is fully convincing.

It is not difficult to see why this
presentation would have appealed to
Thomas Herbert, 8th Earl of Pembroke
(1656–1733), in whose possession it is
first recorded in 1728 at Durham House
off the Strand, in London. Pembroke
kept a celebrated library there, as well
as remarkable collections of ancient coins
and of drawings by the great Italian
masters. Of the pictures noted in the
house by Fougeroux, the Ribera is the
only survivor. It is significant that its
erstwhile companions were also by, or
attributed to, Italian artists—Correggio,
Tintoretto, Schiavone, Cavedone, and
Valentin ("St. Martin de Boulogne")—
whose art parallels that of Ribera in so
many ways.

Wilton was celebrated in the early
eighteenth century for its huge collection
of classical sculptures (see no. 233) and
for the great family group by Van Dyck.
The collection of Old Master pictures,
largely built up by Van Dyck's patron,
Philip Herbert, 4th Earl of Pembroke
(1584–1650), and by the 8th Earl, already
contained many of the masterpieces still
in the house—the Tintoretto *Christ
Washing the Feet of the Disciples*, from the
Eglise des Récolettes in the rue du Bac
in Paris (as Fougeroux records), the
group of putti by Rubens, and the Lucas
van Leyden *Card Players*. The visitor to

the house can still see the "quantité de petits tableaux" (Fougeroux 1728, fol. 122–127) hung very much as they were when he saw them. But, reading the catalogue made in 1731 by the Lucchese Carlo Gambarini—the earliest printed catalogue of any English private collection—one is soon aware that the balance of the collection has been affected by changing fashion, and many fine examples of seicento painting have been sold: the Luca Giordano *Neptune and Amphitrite* is at Seattle, for instance, and Castiglione's *Noah's Ark* may be the picture now at Raleigh.

When the Ribera was moved to Wilton remains uncertain: not mentioned in Cowdry's guide of 1751, it was recorded in the Corner Room in 1764 by Kennedy who described it as "very much esteemed." In 1907 it was in the Little Ante Room.　　　　F.R.

Provenance: According to Gambarini, from the collection of Cardinal de' Medici; purchased by Philip Herbert, 4th Earl of Pembroke, or by Thomas, 8th Earl, in whose possession it is recorded at Durham House in 1728; and by descent, at Wilton by 1764
Literature: Fougeroux 1728, fol. 78; Gambarini 1731; Kennedy 1764, 77; Kennedy 1769, 84; Kennedy 1786, 84; Wilton 1788, 84; Wilkinson 1907, 2:242–243; Pembroke 1968, no. 238; Felton and Jordan in Fort Worth 1983, with previous literature
Exhibitions: Fort Worth 1983 (16)

275

ERMINIA FINDING THE WOUNDED TANCRED 1649/1650
Giovanni Francesco Barbieri,
Il Guercino 1591–1666
oil on canvas
248.9 × 293.3 (98 × 115½)

The Castle Howard Collection

The picture illustrates the episode in Tasso's *Gerusalemme Liberata* in which Vafrino finds Tancred, wounded after his duel with Argante, and cries out to Erminia. Guercino's earlier treatment of the subject, painted in 1618–1619, is at Birmingham. This picture was commissioned in 1649 by Cardinal Fabrizio Savelli, the papal legate at Bologna, as a pendant to an *Erminia and the Shepherds*, begun in 1648 for the Sicilian patron Don Antonio Ruffo, which the cardinal had persuaded the painter to complete for himself. Guercino evidently worked on *Erminia Finding the Wounded Tancred* in 1650, and it was seen in his studio by the Archduchess of Mantua, to whom the legate was in turn constrained to surrender his commission. Her payment of 375 *scudi* was recorded by Guercino on 6 May 1652. The picture is one of the great masterpieces of Guercino's later period, contrasting in its more idealized forms with the earlier treatment of the subject, and yet of an equal dramatic power, for the tension of the figures is only enhanced by the poetic beauty of the landscape.

Frederick Howard, 5th Earl of Carlisle (1748–1825), who acquired this picture in 1772, was a man of unusual refinement, as the noble portrait by Sir Joshua Reynolds (no. 482) implies. He had succeeded his father at the age of ten, and after Eton and King's, Cambridge, went on the Grand Tour, accompanied for a time by Charles James Fox and Lord Fitzwilliam. In Paris he was painted by Greuze and from Turin, in one of a series of letters to George Selwyn that establish him as a letter writer of the caliber of his mother's great-nephew, Lord Byron, he announced that he would get Batoni to paint his dog Rover. His Grand Tour purchases were modest. Rover did not sit for Batoni and Carlisle evidently decided that he could not afford to have a "drawing for a coach, with antique ornaments by Piranesi" executed by his Parisian coach builder (Jesse 1843–1844, 2:201, 208, 254, 307, and 312).

Carlisle returned to England in 1769 and married the daughter of Lord Gower a year later. Recognized with Fox as being one of the best-dressed men of his day, he was also one of the most versatile: as playwright and poet, courtier and politician. His early addiction to gaming implies an extravagant side to his nature, borne out by his purchase of this picture for the exceptional sum of 500 guineas at the Lauraguais sale in 1772. At that sale Carlisle also bought Poussin's *Inspiration of a Poet* (now in the Louvre) for 200 guineas: he had a few days earlier secured Primaticcio's *Ulysses and Penelope* (Toledo Museum of Art, Ohio) for a mere 10½ guineas. In the same year he told George Selwyn that, according to his agent, he had £12,000–14,000 a year to spend: "I think that ought to satisfy me" (Jesse 1843–1844, 3:40). In July he evidently rearranged some of the pictures at Castle Howard, hanging "all my ancestors in the gallery" of Robinson's west wing (Jesse 1843–1844, 3:28).

Severe financial constraints—on a single night of gambling he lost £10,000—later forced Carlisle to retrench and in 1775 he was seriously embarrassed when Reynolds dispatched a number of pictures for which he could not afford to pay. But his affairs gradually recovered. His wife was a niece of the Duke of Bridgewater and Carlisle took an eighth share (while his brother-in-law Lord Stafford took a quarter share) in the duke's consortium that acquired the Orléans collection in 1798. Of the masterpieces thus acquired for Castle Howard, some, including the Bellini workshop *Circumcision* and the Annibale Carracci *Pietà*, were bequeathed to the National Gallery in London by Rosalind, Countess of Carlisle, in 1913. Carlisle's most remarkable picture, the Mabuse *Adoration of the Magi*, bought in 1795, was also sold to the National Gallery, but much of his collection including the Fetti portrait (no. 273), a major Gentileschi from the Orléans collection, and other works of the cinquecento and seicento, remain in the house. The Guercino has hung in the Gallery since the time of the 5th Earl.　　　　F.R.

Related Works: A workshop copy was in the possession of Barone Zezza in Rome in 1949
Provenance: Commissioned by Cardinal Fabrizio Savelli in 1649 but purchased from the artist by the Archduchess of Mantua in 1652; Comte de Lauraguais, France; his anonymous sale, Christie's, 27 February 1772, lot 70, bought for 500 gns by Mr. Dillon for Frederick Howard, 5th Earl of Carlisle; and by descent at Castle Howard through the Hon. Geoffrey Howard, younger son of the 9th Earl
Literature: Sullivan 1780, 183; Rutland 1813, 95; Carlisle 1837, no. 112; Waagen 1838, 3:208; Ibbotson 1851, 22; Waagen 1854, 3:325; Mahon in Bologna 1968, with previous literature
Exhibitions: Bologna 1968 (88); London, Agnew 1973 (36)

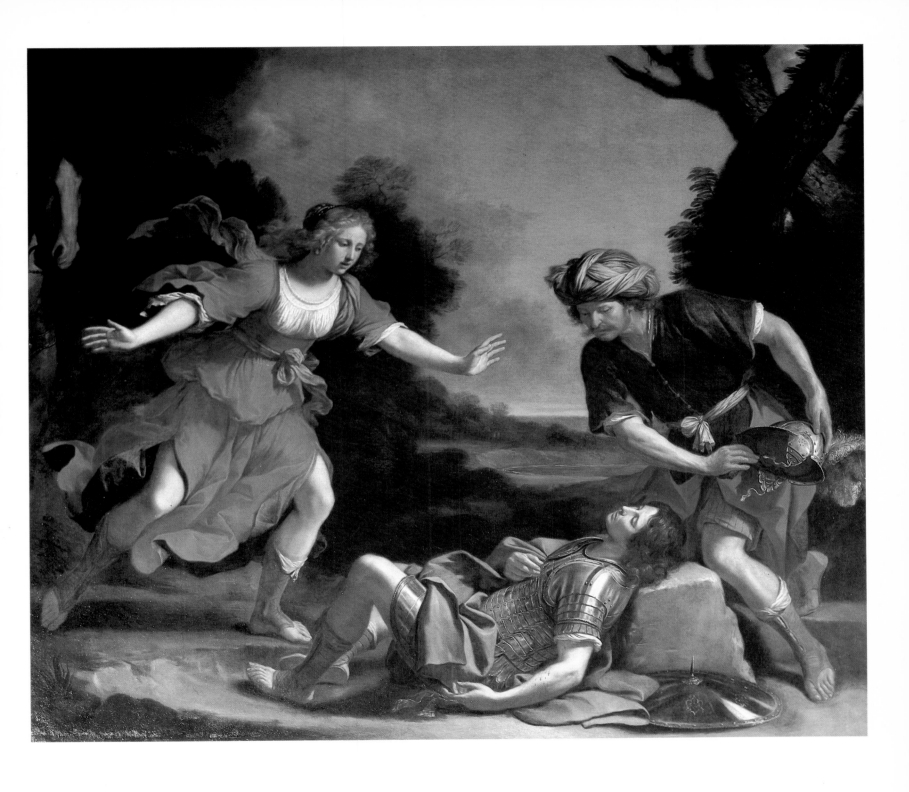

England led the world in the making of barometers and clocks, from the time of Thomas Tompion's triumphs in the late seventeenth century to the work of makers like Justin and Benjamin Vulliamy in the late eighteenth and early nineteenth centuries. Usually they were the results of collaboration between an instrument- or clockmaker and a cabinetmaker, though the latter's identity is rarely known. This barometer from Nostell Priory in Yorkshire is not only one of the finest of its kind but one of the best documented.

Work on the case was begun in June 1768 when an account sent by Thomas Chippendale to the owner of Nostell, Sir Rowland Winn, included 7s. 6d. for "a piece of strong mahogany with a hole in the Center for the Barometer frame." Swift delivery was never one of the firm's strong points, however, and on 22 October the cabinetmaker was writing to assure the irate Sir Rowland "I am Extreamly sorry that you are so Much displeased about the barometer frame...I do assure your Honour...that all the Neglect is Owing to My foreman's inatention to my Buseness...I left ye frame till I returned from france and I expected that it was nigh finished but to my great surprise there was nothing don to it" (Nostell Priory MSS). Even so, it was to be another year before the work was completed; Chippendale writes on 4 October 1769: "Mr Vullime says that the barometer is to stay in town but it is entirely finished and it shou[ld] be some care taken of it and not to be fix'd up in his open shop to be exposed." The bill for the case alone amounted to £25, and a further £1.3.0 was spent on "altering the ornaments of the barometer frame" in November 1770. These "ornaments"—including anthemia, satyr-head caryatids, rams' masks, and chains of husks—are exquisitely carved, presumably because close inspection of the dials might have revealed the kind of shortcuts the firm sometimes took with larger-scale pieces. They are also in the most up-to-date neoclassical style, evidently influenced by Robert Adam's newly completed rooms at Nostell: in particular the Top Hall, where the instrument seems always to have hung.

Justin Vulliamy, referred to in Chippendale's letter of 1769, was a well-known Swiss clockmaker who settled in London and worked in Pall Mall. He was in partnership for a time with his father-in-law Benjamin Gray, who supplied clocks to George II, and after Gray's death in 1764 carried on the business alone, benefiting particularly from the scientific interests of George III. A nearly identical barometer, with the same combination of hygrometer above and thermometer below, survives in the Royal Library at Windsor Castle, though set in a case of different design, thought to have been made by William Vile or his successor John Bradburn (Goodison 1966, pls. 14–16). G.J-S.

Literature: Macquoid 1904–1908, 3:186; Edwards and Jourdain 1955, pl. 109; Goodison 1966, 19–20, pl. 13; Coleridge 1968, 115–116, fig. 346; Gilbert 1978, 170, 189, pl. 8, fig. 34

276

BAROMETER 1768/1769
Justin Vulliamy fl. 1730–1790 and
Thomas Chippendale 1718–1779
tulipwood and other veneers on a
mahogany base with giltwood ornaments;
mechanism of polished and silvered
brass and steel
129.5 × 43 × 12 (51 × 17 × 4¾)

Nostell Priory
The Lord St Oswald

277

CANDLESTAND c. 1773
attributed to Thomas Chippendale
1718–1779
beechwood, gilded
153 × 56 × 58.4 (60 × 22 × 23)

Brocket Hall
The Lord Brocket

Sir Penistone Lamb, 1st Viscount Melbourne (1745–1828), commissioned Thomas Chippendale to supply furniture both for Melbourne House in Piccadilly, designed by Sir William Chambers, and his country seat at Brocket in Hertfordshire, begun for his father about 1760 to the designs of James Paine. One of Paine's sectional engravings of Brocket in his *Noblemen's and Gentlemen's Houses* (1783, pl. 58) shows an end wall of the saloon with a settee flanked by tall candlestands, and this splendidly architectural furniture still survives in the room today (see Tipping 1925).

Chippendale is known to have visited Brocket in August 1773, and moreover the seat furniture in the saloon—a huge set, originally comprising twelve armchairs, twelve single chairs, and four

settees—conforms to one of the cabinetmaker's standard workshop patterns at this period (Gilbert 1978, 262–263). The four candlestands, probably made to support "rich pendant lustres," which also survive in the house, have tripod bases similar to the *jardinières* or "tray pot stands" later supplied by the firm for the gallery at Harewood. But if there is little doubt that they were made by Chippendale, the possibility still remains that they were designed by James Paine, whose door frames and pier glasses in the room have exactly the same loose acanthus scrolls and chains of husks hung from bows. Paine was quick to adopt Robert Adam's neo-classical vocabulary in the 1770s, and the form of this stand is close to antique Roman prototypes such as the marble candelabrum from S. Constanza in Rome (now in the Vatican Museum) dating from the second century AD (Harris 1963, fig. 77).

In a famous letter to Lord Melbourne, written in 1773, Chambers complained that "Chippendale called upon me yesterday with some Designs for furnishing the rooms [at Melbourne House] wch upon the whole seem very well but I wish to be a little consulted about these matters as I am a Very pretty Connoisseur in furniture" (British Library MSS). Whether James Paine had the same problem at Brocket is not known, but in a period when the demarcation of responsibility between architect, upholsterer, and cabinetmaker was not firmly drawn, it is often difficult to attribute designs firmly to one or the other. G.J-S.

Provenance: By descent at Brocket to Admiral Lord Walter Kerr; bought at the sale of contents, 12–14 March 1923, by Sir Charles Nall-Cain, who also purchased the house, and was created Baron Brocket in 1933
Literature: Gilbert 1978, 262–263, fig. 381

278

CANDELABRUM 1772
Matthew Boulton 1728–1802
veneered blue-john vase with ormolu mounts and branches, the base of wood veneered with tortoiseshell
122 (48) high

Saltram
The National Trust (Morley Collection)

"I was at the exhibition of ormolu this week," wrote Mrs. John Parker of Saltram to her brother, Lord Grantham, on 9 April 1772, "there are some new things but nothing that I wished much to have, being satisfied with four of these urns you bespoke for lighting the great room" (British Library, Morley MSS). The exhibition in question was a display mounted at Christie and Ansell's saleroom by Matthew Boulton, the Birmingham metalworker described by Josiah Wedgwood in 1769 as "the first manufacturer in England," while this candelabrum and its three companions (the four "urns" referred to by Mrs. Parker) can still be seen at Saltram on elaborate carved candlestands in the corners of the saloon, one of the most spectacular of all Robert Adam's surviving interiors.

This type of candelabrum was known as the "King's vase," the first pair having been made by Boulton early in 1770 as part of a *garniture de cheminée* (with clock case) that still survives in the Royal Collection at Windsor Castle (Goodison 1974, fig. 158). These have four rather than six branches, but are otherwise identical with the Saltram candelabra. The vase itself is made of famous Derbyshire fluorspar known as blue-john (see no. 271) with a lid and stem of the same stone, while the rim is "perforated for incense"—and there is a gilt copper lining. The overall design is not unlike Boulton's earlier "caryatic" vases (Goodison 1974, fig. 76), but its much more assured neoclassical character may well be due to Sir William Chambers and to George III himself. In March 1770 Boulton reported to his wife that Chambers was making him "a drawing from a sketch of the King's for a better foot to our 4-branched vase," and there are several other features, including the satyrs and garlands, which

appear elsewhere in the architect's designs (Goodison 1974, 159). The lions' masks on the base clearly derive from the *Antichità di Ercolano* (1/3: pl. 27), published in Naples in 1767, but Boulton himself owned a copy of this work and might as easily have contributed these.

Matthew Boulton often turned specific commissions to advantage by offering ornaments of the same design to other patrons, and the "King's vase" was no exception, for a drawing of it can be found in Boulton and Fothergill's Stock Pattern Book (Goodison 1974, fig. 162a). However, the first, made with six rather than four branches, seems to have been the single example made for Lord Grantham in 1771. The latter had originally tried to buy one on the cheap by dispensing with some of the ornaments. But Boulton felt that "as that can not be done without spoiling the whole beauty of the vase it was not attempted and indeed instead of diminishing any part we have made

an addition. The branches were not thought quite so perfect as they should be and therefore we have had new ones modeled for 6 lights instead of four which in general are much better." Those ordered for his sister, of precisely the same configuration, were completed in March 1772 at a cost of £126 7s. 0d., and so pleased the Parkers that they bought a fifth two months later, which is now in the dining room at Saltram.
 G.J-S.

Provenance: By descent at Saltram; accepted with the house and contents by the Treasury in lieu of death duties and transferred to the National Trust in 1957, after the death of Edmund Robert Parker, 4th Earl of Morley
Literature: DEF 1954, 1:347, fig. 43; Goodison 1972, 35–40, figs. 35, 36a; Goodison 1974, 158–161, figs. 80–82
Exhibitions: Brussels 1973 (152)

The subject is taken from Tasso's poem
Gerusalemme Liberata, canto XIX. Erminia
is tending the wounds of Tancred who
is supported by Vafrino: on the left
is the dead Argante. The picture was
painted about 1640–1645, presumably
in Florence where Cortona was working
on the frescoes of Palazzo Pitti for much
of the period; he was, however, in Rome
from January to December 1643.

This picture was acquired by Sir Paul
Methuen (1672–1757), whose collection
is considered in detail in the entry for
the Van Dyck *Betrayal* (no. 264). Its
rococo frame, carved with garlands
of flowers, is one of the finest in the
collection and must be by a carver of
the caliber of René Duffour, who supplied
comparable picture frames to the 2nd
Earl of Egremont at Petworth in the
1750s. F.R.

Provenance: Acquired by Sir Paul Methuen;
and by descent, recorded as an overdoor
in the Dining Room on the second floor
of Paul Methuen's house in Grosvenor
Street in 1761, on the north wall of the
Gallery at Corsham in 1806, and in the
passage leading to the Boudoir in 1903
Literature: Dodsley 1761, 3: 92–93;
Martyn 1766, 2: 28; Britton 1806, 82;
Waagen 1838, 3: 103; Methuen 1891,
no. 163, and 1903, no. 261; Borenius
1939, no. 26; Briganti 1962, no. 84
Exhibitions: London, BFAC 1925 (16);
London, RA 1938 (304); London, RA
1956 (36)

279

TANCRED AND ERMINIA 1640/1645
Pietro Berrettini da Cortona 1596–1669
oil on canvas
90 × 148.9 (35½ × 48)

Corsham Court
The Methuen Collection

THE SELLING OF JOSEPH
Sebastien Bourdon 1616–1671
oil on canvas
86 × 111.7 (34 × 44)

Petworth House
The National Trust (Egremont
Collection)

This painting shows the influence of
Castiglione under whose spell Bourdon
was to fall during his visit to Rome
(1634–1637), which coincided with
Castiglione's presence in the city. It is
possible but by no means certain that
the *Joseph* was painted during this
period, for Bourdon continued to adapt
Castiglione's style even after his return
to Paris in 1637. The magnificent frame
may be one of two "in the French
taste" supplied by Samuel Norman for
Egremont House in Piccadilly, London,
in 1762 (Jackson-Stops 1980a, 1031).

Notwithstanding the great names of
Poussin, Claude, and Rubens, the
eighteenth century, in terms of English
collecting, is generally considered to be
an age dominated by the Italian school.
However, a number of collectors bought
Northern pictures, among them the 2nd
Earl of Egremont, who acquired this
picture in 1756 (Simpson 1953). It is
only comparatively recently that this
earl has been accorded his true status as
one of the founders of the great Petworth
collection, following the example of his
ancestor, the 10th Earl of Northumber-
land, who patronized Van Dyck and
bought pictures by artists as diverse as
Titian and Elsheimer. The discovery of
a small notebook containing the picture
accounts of the 2nd Earl shows him to
have been a prolific buyer from 1748
until his death in 1763, recording the
purchases of more than 150 pictures. Of
these half are Italian; the French,
Flemish, and—predominantly—the
Dutch schools comprise the remainder
(Gore 1977). His acquisitions in the
field of sculpture were even more re-
markable and the famous Petworth col-
lection of Greek and Roman antiquities
was assembled, with the assistance of
his agents Matthew Brettingham and
Gavin Hamilton in Rome, between the
years 1750–1760 (see no. 226).

Horace Walpole (letter to Sir Horace

Mann, 10 February 1758) numbered
Lord Egremont among those rich buyers
"who care not what they give" for a
picture. He refers to him (*Memoirs of the
Reign of King George II*, 80) as "son of
the great Sir William Windham, and
grandson of the Old Duke of Somerset,
whose prodigious pride he inherited more
than his father's abilities, though he
had a great deal of humour." Walpole's
final reference, again in a letter to Mann
(1 September 1763), seems to show that
this humor stayed with him until the
end, and in a beguiling account of his
last days, Walpole writes, "Everybody
knew he would die suddenly, he used
no exercise, and could not be kept from
eating, without which prodigious
bleedings did not suffice. A day or two
before he died, he said 'Well, I have but

three turtle dinners to come, and if I
survive them I shall be immortal.'"
This was not to be, and in 1763 he was
succeeded by his young son, George
O'Brien, then aged twelve, who was to
become one of the most famous patrons
of his age (see no. 547). St J.G.

Provenance: Dr. Bragge sale, 18 February
1756, lot 71; bought by the 2nd Earl of
Egremont for 95 gns (Dr. Bragge was a
collector who held a number of sales in
the 1750s; see Simpson 1953, 40);
thereafter in family ownership at
Petworth until 1957 when the contents
of the state rooms were acquired by
H.M. Treasury in part payment of death
duties and the picture was transferred
to the National Trust

9: The Dutch Cabinet

"I do not care for the Teniers you mention," the Earl of Chesterfield wrote to the dealer Solomon Dayrolles in 1748, "both my picture-rooms being completely filled—the great room with capital pictures, the cabinet with bijoux." This same relationship of large picture gallery or saloon, hung mostly with Italian old masters, and a smaller cabinet or closet adjoining, devoted to the Dutch school, can still be found in many eighteenth-century country houses like Corsham, Woburn, and Saltram. Zoffany's famous portrait of *Sir Lawrence Dundas with His Grandson in the Pillar Room at Arlington Street* also shows such a cabinet, hung with small Dutch landscapes, genre scenes, and maritime pictures (no. 281). This picture is still in the Zetland Collection, together with the Van de Cappelle seascape shown above the chimneypiece (no. 282) and some of the original Zoffoli bronzes on the mantel below, here accompanied by examples from other collections to make up the set (nos. 283–289). The careful symmetry of the hanging in this conversation piece is fanciful, for some of the pictures were hung in other rooms, but it suggests the concern of collectors with decorative effects rather than just the random acquisition of masterpieces.

Seventeenth-century Dutch painting had long been popular in Britain: many Dutch and Flemish artists worked in England and pictures were imported in large numbers from Holland, with which there were close religious, dynastic, and economic ties. The great Duke of Marlborough had a predilection for Rubens—who with Van Dyck was consistently fashionable—but Palladian taste with its emphasis on Italy inevitably made the Northern schools less fashionable. Burlington himself owned pictures by Rembrandt and Hals, but scenes from low life, "drolleries," and the like came to be segregated from the Italians. Flemish paintings predominated perhaps only in the dining room where vast pictures of birds and dead game by Snyders, De Vos, and their followers, were hung. At Kedleston, where the arrangement of the pictures in the dining room is undisturbed, such pictures were hung with Claudian landscapes and Zuccarelli pastorals.

A revival of interest in Dutch pictures, at first felt more strongly in France than in England, was championed in the mid-eighteenth century by the 3rd Earl of Bute, George III's former tutor and Prime Minister in 1762–1763. His collections at Luton Hoo and Highcliffe included masterpieces by almost every great Dutch painter except Rembrandt and Vermeer. Bute's particular liking for Cuyp was shared by the Duke of Bedford, while Lord Palmerston acquired examples of Koninck and Vermeer. Less patrician collectors of Dutch painters included the East India Company director, Sir George Colebrooke, and some Scottish country house owners, whose traditional education at the Calvinist University of Leiden may have introduced them to such pictures. Others, like William Windham of Felbrigg, made acquisitions in the Low Countries on their return from Italy on the Grand Tour. Many of the masters most admired in the eighteenth century are represented here: Rembrandt by the celebrated Buccleuch portrait (no. 292), Van Goyen and Van der Neer, Wynants, whose influence on Gainsborough was so marked, and Hobbema, while Jacob Ruysdael, Koninck, and Cuyp are included in the adjoining landscape section.

The dispersal of French collections after the Revolution meant that Dutch cabinet pictures of the highest quality were more readily available. The Prince Regent himself bought the Baring pictures, so many of which had come from France, and the remarkable Dutch collections formed by Sir Robert Peel and Lord Hertford are now respectively in the National Gallery, London, and the Wallace Collection. The early nineteenth-century collectors represented here include two bankers, Thomas Baring and Abraham Robarts; an MP, George Byng; and the owners of coal mines and slate quarries, the Duke of Cleveland and Lord Penrhyn. The enduring popularity of Dutch baroque painting can still be seen in the late nineteenth-century Rothschild houses of Waddesdon and Ascott, while the Ter Borch from Polesden Lacey (no. 293) illustrates the survival of a long tradition of connoisseurship into the present century.

281

SIR LAWRENCE DUNDAS AND HIS
GRANDSON IN THE PILLAR ROOM AT
19 ARLINGTON STREET 1769
Johan Zoffany 1733–1810
oil on canvas
102 × 127 (40 × 50)

Aske Hall
The Marquess of Zetland

Sir Lawrence Dundas (c. 1710–1781),
cadet of an ancient Scottish line, was one
of the outstanding merchant contractors
of the eighteenth century, and as
Commissary-General of the Army in
Flanders during the Seven Years War,
made a fortune of over £600,000. Created
a baronet in 1762, he was successively
MP for Linlithgow in 1747–1748,

Newcastle-under-Lyme in 1762–1768,
and Edinburgh in 1768–1781. His son
Thomas, subject of the splendid Batoni
of 1764, also at Aske, was created Baron
Dundas in 1794. The latter's heir,
Lawrence (1766–1839), seen here with
his grandfather, was elevated in 1838 to
the earldom of Zetland.

Sir Lawrence was a patron of rare
discernment. He employed Robert Adam
at Kerse, his seat in Stirlingshire (the
county his son later represented in
Parliament), at Moor Park in Hertford-
shire, and at No. 19 Arlington Street;
Capability Brown and John Carr of
York at Aske; and William Chambers
at Dundas House in Edinburgh. For
furniture he turned to Thomas
Chippendale, the leading cabinetmaker
of the day (no. 258), and he exhibited

equally fine taste in his purchase of
pictures. Wilson was commissioned to
paint a series of three large views of
Moor Park in 1765 (Constable 1953,
181, pls. 46–47); while at Arlington
Street Dundas assembled a remarkable
collection of Dutch pictures.

This picture shows Dundas in the
Library or Pillar Room at Arlington
Street, newly decorated by Adam. As
Webster points out, the chimneyboard,
so vital for the preservation of both
fabrics and pictures when the chimney
was not in use, the Turkey carpet, the
moreen curtains, pier glass, library
table, and "mahogany 2-flap table" are
all listed in the inventory of May 1768
(Zetland MSS). The library table, a
documented Chippendale piece, still
survives at Aske, though the bookcases

that were in the room have gone. Instead
of the four pictures recorded in the
inventory, eleven are shown by Zoffany
and the frames of four more are reflected
in the mirror. The arrangement of the
pictures against the beautiful blue paper
seems so inevitable that it is difficult to
believe this was altogether fanciful.
One suspects that it was based on that
of another room in the house, whence
the Zoffoli bronzes (nos. 283–288) may
also have come.

All the pictures can be identified in
the catalogue of the sale of Sir Lawrence's
collection at Greenwood's, 29–31 May
1794. Over the chimneypiece is the Van
de Cappelle, 3rd day, lot 13, still in the
collection (no. 282). This is flanked on
either side by, from the top: Cuyp's
*Inside of a Farm House, with Sheep, Goats
and Figures* and *Ditto with Figures, Cattle,
Vegetables and Farming Implements*, 1st day,
lots 21, 22 (17 gns and 10½ gns to
Hoppner); Van de Velde's *A Fresh Breeze
with Shipping* and a *Ditto Ditto*, 1st day,
lots 10, 11 (14 gns to Bollopoy and
10 gns to Holland), of which that on
the left was in the Kilmorey collection
until 1924; Pynacker's *A Beautiful Warm
Landscape with a Ferry Boat and Figures
Crossing a River*, 3rd day, lot 8 (27 gns
to Sir Matthew White Ridley), later at
Ashburnham and more recently owned
by Mrs. Alfred Brod; balanced by
Cuyp's *A View in Holland with a Boy
Tending Sheep*, 1st day, lot 17 (17½ gns
to Holland), recorded with Agnew in
1917 and subsequently with Matthiesen;
and the pair of copies of *Christ and the
Apostles* and the *Madonna and Child with
Saints and Donors* after Veronese, by an
artist akin to Teniers, but then attributed
to Veronese himself, 1st day, lots 28
and 27 (12 gns to Walton and 11 to
Colonel Smith); the latter was in the
possession of Paul Wallraf. On the right-
hand wall, Teniers' *A Corps de Garde*,
2nd day, lot 32 (50 gns to Metcalfe),
hangs above his *Journeymen Carpenters*,
2nd day, lot 36 (60 gns to Williamson).
The former (or a version of this) is at
Dulwich while the latter was at Clumber
until 1938 and was sold by Mrs. James
Teacher, Sotheby's, 21 April 1982, lot
65. (I am indebted to Charles Beddington
for tracing several of these pictures and
to Dr. Dorine van Sasse van Ysselt for
details of prices and buyers.)

Zoffany not only took liberties with the arrangement of the pictures, he also marginally reduced the scale of the Van de Cappelle in relation to the other pictures. Although the copies after Veronese were in fact half as wide as the Van de Cappelle, they seem somewhat larger in the picture. Their scale is correct, however, in relation to that of the pictures above them. Nonetheless his description of the pictures and bronzes is remarkably accurate and there is no more authentic record of contemporary taste in framing. Most of the frames were clearly English, but it can be assumed that the most elaborate, that of the Teniers *Journeymen Carpenters*, came with the picture, which (like the companion also owned by Dundas) had previously been owned by the Marquis de Granville. When the cabinetmaker William France hung the pictures at Arlington Street in March 1764, he used brass-headed nails of various sizes and weight: as Webster points out these are shown above several of the frames.

In 1771 Zoffany painted a replica of his portrait of King George III at Windsor for Dundas or his son: this cost £74 15s. The connection is intriguing because the manner in which pictures and objects from varying rooms are introduced in the picture was to be followed in Zoffany's great *Tribuna of the Uffizi*, painted for Queen Charlotte and still in the Royal Collection, and in Zoffany's portrait of Charles Towneley (No. 213).

F.R.

Provenance: Painted for Sir Lawrence Dundas, whose payment to Zoffany of 100 gns on 26 June 1770 no doubt refers to the picture; and by descent
Literature: For a detailed account see Webster in London, NPG 1976, with previous literature
Exhibitions: Leeds 1936 (33); London, RA 1954–1955 (115); Barnard Castle 1962 (11); London, NPG 1976 (56)

282

A CALM 1654
Jan van de Cappelle 1624–1679
oil on canvas
111 × 148.5 (43¾ × 58½)
signed and dated by the artist,
J V CAPPEL 1654

Aske Hall
The Marquess of Zetland

This masterpiece by the greatest of Dutch marine painters was one of the outstanding works in Sir Lawrence Dundas' collection of old master pictures, as its central position in Zoffany's portrait (no. 281) suggests. The caliber of his collection, most of which was sold by his son in 1794, was widely recognized by contemporaries: Lady Mary Coke commented in 1769 that his pictures were "very fine" (Coke 1889–

1896, 3:45). Dundas' taste for the Dutch masters was comparable in many ways with that of Lord Bute: he also owned a major work by Cuyp, the *Peasants and Cattle in a Hilly River Landscape*, which was later bought by J.J. Angerstein and is now in the National Gallery, London, and had a particular penchant for Teniers, acquiring over a dozen pictures by him, of which two appear in Zoffany's portrait.

Dutch marine painting was consistently admired in Britain—the provenance of the three Van de Veldes (nos. 72–74) illustrates this—and by the early nineteenth century Van de Cappelle was strongly represented in English collections. Of the owners of Dutch pictures who acquired works included here, Thomas Baring, George Byng, and Lord Northwick possessed notable examples of Van de Cappelle.

F.R.

Provenance: Sir Lawrence Dundas, 1st Bart. (c. 1710–1781); his son Thomas, 1st Baron Dundas (1741–1820); his sale, Greenwood's, 31 May 1794, lot 13, bought in; and by descent
Literature: Hofstede de Groot 1908–1927, 7:172, no. 52
Exhibitions: London, BI 1864 (34); London, RA 1929 (295); Leeds 1936 (14); Leeds 1947; York 1951 (11); Leeds 1958 (6); Barnard Castle 1963 (9)

283

THE BORGHESE GLADIATOR 1762/1763
Giacomo Zoffoli c.1731–1785
bronze
25 (9⅞) high
inscribed, *GIA⁰: ZOFFOLI: Fᶜ:*

Woburn Abbey
The Marquess of Tavistock and the
Trustees of the Bedford Estates

This and the following six bronzes have been chosen from three different houses to re-create the garniture of seven bronzes shown on the chimneypiece in Zoffany's famous portrait of Sir Lawrence Dundas (no. 281). Four of these (nos. 284, 285, 286 and 289) are the actual pieces depicted in the painting, and remain in the Dundas family collection at Aske together with the Van de Cappelle (no. 282) and the Chippendale library table. The *Elder Furietti Centaur* (no. 284) was sold earlier in this century but was reacquired from an American collection by the present Marquess and Marchioness of Zetland, who are attempting to re-create the full set (Zetland 1973).

All of these bronzes are from the foundry of Giacomo Zoffoli and his brother or nephew Giovanni, which flourished in Rome in the late eighteenth century. The Zoffoli owned one of the four foundries in Rome at that time that specialized in bronze reproductions after classical statuary (the others being those of Francesco Righetti, Luigi and Giuseppe Valadier, and Giuseppe Boschi), and theirs, situated above a spaghetti factory in the Via degli Avignonesi, off the Strada Felice, was the most popular among the English Grand Tourists.

The only bronze from the Zoffoli foundry that bears a date is a reduced copy of the equestrian statue of Marcus Aurelius, preserved in the Green Vaults at Dresden. This was a present from Pope Clement XIII to the Elector of Saxony and is inscribed with the date 1763. In the absence of earlier documentation for the activity of the foundry, the Dresden bronze has generally been assumed to be Giacomo Zoffoli's earliest surviving work in bronze. However, as Charles Avery has recently established, a garniture of five bronzes preserved at

Woburn, including this version of the *Borghese Gladiator* and the *Faun with a Goat* (no. 287), was brought back to England by Francis Russell, Marquess of Tavistock, on his return from the Grand Tour in 1763. The Woburn bronzes are thus contemporary with the Dresden one, and are among the earliest known productions of the foundry. They are important in showing that at this date the range of models offered by Giacomo was already quite wide. The Dresden bronze is one of only two that have so far come to light signed in cursive script *Gia.o. Zof.i. F*, whereas the others, when they are signed at all, are normally signed in upper-case letters, either *G.ZOFFOLI F.* or *G.Z.F.*, which could designate either Giacomo or Giovanni. The *Mercury* that is the centerpiece of the Woburn garniture bears the unusual cursive signature *G =Zoffoli =Romano =F.*, which we may take to be an early form used by Giacomo. The date of acquisition of the Dundas garniture is not recorded, but the Zoffany painting of 1769 proves that the bronzes must also have been among the earliest productions of the foundry.

The Zoffoli continued a tradition of bronze reductions after famous antique statues exploited in Florence by Massimiliano Soldani in the early eighteenth century (see no. 215), though there is evidence that Giacomo was not

a sculptor by training but a silversmith. The sculptor Vincenzo Pacetti records in his diary that in 1773 and 1774 he was engaged by Giacomo Zoffoli to provide reductions in clay after classical marbles (see Honour 1961; 1963). As Pacetti only began his diary in 1773, he may well have provided models for the foundry before this, and it seems to have been the regular practice of the Zoffoli to engage other sculptors to provide the models for their bronzes. Zoffoli bronzes are not found in Italy, and it would seem that their business was entirely with foreigners from Northern European countries, including Germany and Sweden. Among the most noteworthy sets in British country houses are a garniture of seven pieces at Saltram, near Plymouth, acquired by Lord Boringdon in 1793 for the splendid Adam chimneypiece in the Saloon, and a series of ten at Syon House (the most extensive set known) acquired by Hugh, 2nd Duke of Northumberland (1742–1817).

A copy of Giovanni Zoffoli's price list of 1795 is preserved in the Victoria and Albert Museum, with correspondence between the architects Charles Heathcote Tatham in Rome and Henry Holland in London. Holland was at that time engaged in the redecoration of Carlton House for the Prince Regent, and Tatham bought ten bronzes from the list on his behalf for Carlton House. Zoffoli was at

that time offering fifty-nine different reductions, and replicas of the present bronze were then priced at sixteen *zecchini romani* (£8 8s. in English money at the then current rate of exchange of 10s. 6d. to the Roman *sequin*).

This bronze is a reduction of the classical marble known as the *Borghese Gladiator*, which was in the Villa Borghese in Rome at the time of the reduction, and has been in the Louvre since 1808.

A.F.R.

Literature: Arts Council 1972, 293–295; Haskell and Penny 1981, 93, 94, 221–224, 341; Avery 1984, 97, 98

284

THE ELDER FURIETTI CENTAUR
before 1769
Giacomo Zoffoli c. 1731–1785
bronze
33.6 (13¼) high

Aske Hall
The Marquess of Zetland

This bronze is one of the actual works depicted in Zoffany's portrait of Sir Lawrence Dundas (no. 281), where it is shown second from the left on the mantel. Although the precise date of its acquisition is not recorded, the date of the painting (1769) proves it is an early work by Giacomo Zoffoli. It is a reduction of one of the two classical statues of centaurs in gray marble (*bigio morato*) excavated at Hadrian's Villa by Monsignor Furietti in 1735, and since 1765 in the Museo Capitolino.

 Reductions of the so-called "Furietti centaurs" were especially popular for chimney garnitures, since they make a perfect complementary pair, and they seem to have been sold in pairs by the Zoffoli. In Giovanni Zoffoli's price list they were priced at forty-five *zecchini romani* for the pair £23. 12s. 6d. The complementary "younger Furietti centaur" of the Dundas garniture is represented here by an example from Blenheim Palace (no. 288). A.F.R.

Related Works: Other examples at Woburn Abbey; Nationalmuseum, Stockholm; Blenheim Palace
Literature: Honour 1961, 201, 205; Haskell and Penny 1981, 94, 178, 179 (see also no. 283).

285

THE APOLLO BELVEDERE
before 1769
Giacomo Zoffoli c. 1731–1785
bronze
34.5 (13½) high

Aske Hall
The Marquess of Zetland

This bronze is another of the actual pieces depicted in no. 281 where it appears third from the left on the chimneypiece. It is a reduction from the classical marble *Apollo* first recorded before 1509, and from that year in the Vatican, where it was placed in the Belvedere by 1511. The *Apollo Belvedere* was long one of the most admired statues of antiquity, and it was correspondingly popular in Zoffoli's reductions. In Giovanni Zoffoli's price list of 1795, it is priced at sixteen *zecchini romani* or £8. 8s. A.F.R.

Related Works: Other examples at Syon House; Blenheim Palace; Victoria and Albert Museum; Nationalmuseum, Stockholm; Schloss Wörlitz, Dessau.
Literature: Honour 1961, 201, 205; Haskell and Penny 1981, 148–151 (see also no. 283)
Exhibitions: Arts Council 1972 (459)

286

MERCURY before 1769
Giacomo Zoffoli c. 1731–1785
bronze
56 (22) high

Aske Hall
The Marquess of Zetland

This bronze is another of the actual pieces depicted in no. 281, where it appears as the centerpiece of the garniture on the mantel. The figure is a reduction from the bronze *Mercury* made by Giovanni Bologna (1529–1608) for Cardinal Ferdinando de' Medici for the Villa Medici in Rome, and sent to him from Florence in 1580. The statue remained in Rome on a fountain at the Villa Medici until 1780, when it was removed by Grand-Duke Pietro Leopoldo to Florence. It is now in the Bargello. The *Mercury*, one of the most popular statues of all time, was possibly also the most reproduced. It was the only modern statue (as opposed to a classical antique) the Zoffoli included among their reductions, and it seems to have rivalled their reduction of the *Marcus Aurelius* in popularity as the centerpiece for garnitures. The version at Woburn Abbey, with the exceptional signature "G=Zoffoli=Romano=F," was acquired in 1762/1763, and proves that the *Mercury* was thus one of the earliest inclusions of Giacomo Zoffoli's productions. In Giovanni's price list of 1795, the *Mercury* is priced at twenty *zecchini romani* (£10. 5s.). A.F.R.

Related Works: Other examples at Woburn Abbey; Royal Palace, Stockholm; Schloss Wörlitz, Dessau
Literature: Dhanens 1956, 125–135; Honour 1961, 201, 205; Avery 1984, 97 (see also no. 283)

287

FAUN WITH A GOAT 1762/1763
Giacomo Zoffoli c. 1731–1785
bronze
36.5 (14⅜) high
inscribed, *GIA⁰: ZOFFOLI: Fᶜ:*

Woburn Abbey
The Marquess of Tavistock and the
Trustees of the Bedford Estates

This bronze, which takes the place of
the original version in the Dundas
garniture, was acquired in Rome by
Francis Russell, Marquis of Tavistock,
about 1762/1763, and is one of a set of
bronzes at Woburn that are among the
earliest known productions of Giacomo
Zoffoli (see no. 283).

It is a reduction from the famous statue
in *rosso antico* excavated by Monsignor
Furietti at Hadrian's Villa in 1736, and
given by Pope Benedict XIV in 1746 to
the Museo Capitolino, where it gives
its name to the *Stanza del Fauno*. The
bronze is something of a rarity among
Zoffoli's reductions, and was priced a
little higher than average. In Giovanni
Zoffoli's price list of 1795, it is priced at
twenty-two *zecchini romani* or £11. 6s.
A cast was bought by Charles Tatham
for Carlton House in that year. A.F.R.

Related Works: Another example at
Schloss Wörlitz, Dessau
Literature: Honour 1961, 205; Honour
1963, 194; Avery 1984, 97 (see also
no. 283)

288

THE YOUNGER FURIETTI CENTAUR
before 1785
Giacomo Zoffoli c. 1731–1805
bronze
36 (16⅛)
inscribed, *GIA⁰ ZOFFOLI Fᶜ ROMA*

Blenheim Palace
The Duke of Marlborough

This bronze takes the place of the
original version in the Dundas garniture
(see no. 283), which was sold in 1934.
It is a reduction of one of the two
classical statues of centaurs in gray
marble (*bigio morato*) excavated at
Hadrian's Villa by Monsignor Furietti
in 1736, and since 1765 in the Museo

Capitolino in Rome.

The bronze is one of a set of three
Zoffoli reductions at Blenheim Palace
that would have formed a small garniture,
the others being the *Elder Furietti Centaur*
and the *Apollo Belvedere* (nos. 284 and
285). The date of acquisition of the set
is not recorded, but the signature is
that of Giacomo Zoffoli, and they must
date from before his death in 1785.
 A.F.R.

Related Works: Other examples at Woburn
Abbey; Nationalmuseum, Stockholm
Literature: Haskell and Penny 1981,
178, 179 (see also no. 283).

289

THE CAPITOLINE ANTINOUS
before 1769
Giacomo Zoffoli c.1731–1785
bronze
33.8 (13⅜)

Aske Hall
The Marquess of Zetland

This bronze is one of the actual pieces depicted in no. 281 where it appears on the extreme right of the mantel. Although the precise date of its acquisition is not recorded, the date of the painting again proves it to be an early work by Giacomo Zoffoli. It is a reduction of the classical marble statue known as the *Capitoline Antinous*, excavated before 1733 at Hadrian's Villa, which, after restoration of the left arm and left leg by Pietro Bracci, was placed in the Museo Capitolino, where it remains today. In the eighteenth century the *Capitoline Antinous* was preferred by many critics to the famous *Antinous of the Belvedere*, discovered in the first half of the sixteenth century, which was also reproduced by Zoffoli, and seems generally to have been more popular with his clients. A cast of it was bought from Giovanni Zoffoli by Charles Tatham for Carlton House in 1795.

In Giovanni Zoffoli's price list it is one of the least expensive bronzes, priced at fifteen *zecchini romani* (£7. 17s. 6d.).

A.F.R.

Related Works: Other examples at Syon House; Victoria and Albert Museum; Ashmolean Museum, Oxford
Literature: Honour 1961, 198, 199, 205; Haskell and Penny 1981, 143, 144 (see also no. 283)
Exhibitions: Arts Council 1972, 294 (462)

290

CHIMNEYBOARD 1769
Biagio Rebecca 1735–1808
oil on canvas
125 × 149 (49¼ × 58½)

Audley End
The Hon. Robin Neville

This is one of five chimneyboards supplied by the artist to Sir John Griffin, later 4th Lord Howard de Walden and 1st Lord Braybrooke, and recorded in a receipt of 12 December 1769: "Twenty Guineas for painting Five Chimney Boards, and mending four full length Pictures" (Braybrooke MSS, Essex County Record Office, Chelmsford).

The chimneyboard was the commonest eighteenth-century solution to the problem of concealing the empty fireplace opening during the summer months, though few examples survive today. From the late seventeenth century it was fashionable to place a vase of flowers (often a Delft tulip vase; see nos. 103 and 104) in the hearth, but this device

was superseded by the canvas chimneyboard, often painted with a representation of flowers in a vase, though sometimes quite plain as in Zoffany's painting of the Library at Arlington Street (no. 281). However, all four of the examples that survive from the original five at Audley End are painted in grisaille, in imitation of antique bas-reliefs and vases, this one representing a tripod pedestal of Neo-Attic type (see nos. 255 and 461) flanked by oak swags "suspended" from ribbon bows. They formed part of the decorative scheme executed by Rebecca and the Florentine Giovanni Battista Cipriani in the new apartments designed for Sir John Griffin by Robert Adam in 1763–1765. The house Sir John in-

herited in 1762 from his aunt, Lady Portsmouth, was only a remnant of the Jacobean "prodigy house" of the Earls of Suffolk. He immediately set about compensating for the losses (but without enlarging the structure), employing Adam to design the new suite of apartments and Capability Brown to "improve" the park (see Drury and Gow 1984).

Biagio Rebecca worked frequently for Adam, at Kedleston, Kenwood, and elsewhere, as well as for the Wyatts and James "Athenian" Stuart. He had arrived in England from Rome in 1761 and became one of the first students of the newly formed Royal Academy in 1769. In addition to his ornamental mural painting in Adam's new rooms, his work at Audley End included a group of full-length pastiche portraits of early members of the Audley and Howard families, painted to complete a series that Sir John Griffin installed in the Saloon, and Sir John's own portrait in the robes of the Order of the Bath (Croft-Murray 1970, 258). This chimneyboard was probably painted for the library, as the ground color closely follows that of Cipriani's friezes for the room. Though the scheme was undone in 1825, the surviving elevations taken in 1781 by Placido Columbani show it as a highly coherent "temple of learning." Above the bookcases (themselves in the form of temple porticoes were Cipriani's friezes—allegories of the Arts, Sciences, Religion, and Learning—and four Coade-stone figures of vestals and sibyls stood in niches. The overmantel portrait of Sir John and overdoors of his two wives as the Cumean and Persian Sibyls after Domenichino and Guercino were supplied by Benjamin West, a life-long friend of Biagio Rebecca, whom he had met in Rome. J.M.M.

Literature: Cornforth and Fowler 1974, 229
Exhibitions: Leeds, Temple Newsam 1985 (58)

291

AN ARTIST PAINTING IN A GALLERY
HUNG WITH PICTURES c.1640
David Teniers the younger 1610–1690
oil on canvas
95.8 × 129 (37¾ × 50¾)

Raby Castle
The Lord Barnard

Teniers acted as curator to the Archduke Leopold William of whose collection he published a catalogue, the *Theatrum Pictorum*, illustrated with engravings after the originals. Many of the copies painted by the artist for this project were at Blenheim, and there are examples of his series of large views of the gallery of the archduke at Petworth and Woburn. In these it is evident that license was taken with the arrangement of the individual pictures if not with their overall effect.

Whether this picture represents a specific room in the Palace at Coudenberg is uncertain: the painter shown here at work cannot be identified, but the most prominent of the bystanders resembles Robert van den Hoecke who worked with Teniers in the archduke's service. The pictures on the floor include Van Dyck's *Samson and Delilah*

(Kunsthistorisches Museum, Vienna), Teniers' own *Landscape with a Flute Player*, and Pieter van Mol's *Portrait of a Young Man*, all from Leopold William's collection, and Correggio's *Agony in the Garden* (London, Apsley House) or a copy of this. (There is no evidence that the archduke owned such a picture.) Of the pictures on the walls only Van Dyck's so-called *Portrait of Amalia von Solms* (Vienna) (top row, third from the left) and the *Susanna and the Elders* by Cornelis Schut (second row, extreme left) are known to have been owned by the archduke.

Inscriptions on the frames of some of the pictures establish their authorship: there are pictures by Van Thulden (above the large Van Dyck) and to the right of this, a festoon of flowers of a kind that would be popular in England, by Jan Brueghel I; a landscape by Michiel Coxie (second from top row, second from left); the *Esther before Ahasueras*, protected by a curtain above the chimney piece, is by Francken; the landscape below is by G. de Wit, and the *Toper* to the left of the latter by Adriaen Brouwer. The *Forest Scene* to the left of the chimney is by Jan Brueghel I. The small number of pictures the archduke is actually known to have owned may have various explanations. Some of those shown may have been discarded by him, while others were perhaps submitted for sale, but rejected. Only a comprehensive and fully documented study of the subject will establish the precise significance of the many Flemish seventeenth-century representations of picture galleries.

This picture formed part of the remarkable collection assembled by Sampson Gideon (d. 1762), a stockbroker of Portuguese Jewish extraction, for Belvedere, the house in Kent to which a "great room" attributed to Isaac Ware was added after 1751. The house was subsequently remodeled by James "Athenian" Stuart for Gideon's son, Sir Sampson Gideon, who in 1786 was created Baron Eardley. Although relatively small, the collection was of unusual distinction, containing "none but pieces which are originals by the greatest masters, and some of them very capital" (Dodsley 1761, 1:272). The Teniers and a similar gallery scene were hung in the drawing room, where their companions

included two Murillos and the Rubens *Gerbier Family* in the National Gallery, Washington.

Twenty-one pictures from Belvedere were sent to Christie's in 1860. Of those that were sold this was the most expensive, but many of the major pictures were bought in—the most dramatic instance being that of the Murillo *Immaculate Conception* (Melbourne), which was withdrawn at 9,000 guineas, and was finally to be sold in 1945 for 460 guineas.

Henry Vane, 2nd Duke of Cleveland (1788–1864), who purchased this picture at the Belvedere sale, had inherited Raby, the great medieval castle of the Neville family, on his father's death in 1842. From 1844 until 1848 he employed William Burn on a major program of remodeling. Of Burn's interiors the opulent, octagonal drawing room, happily untouched, is the most successful, but the most ambitious was unquestionably the enlarged Baron's Hall, 132 feet in length. The Teniers was placed here by 1865 (inventory of that year at Raby, information from Mrs. Elizabeth Steele). The duke acquired a number of other Northern pictures, including two by De Hooch, which remain at Raby.

F.R.

Provenance: Victor-Amadée, Prince de Carignan and Duc de Valentinois, his sale, Paris, Poilly, 3 June *et seq* 1742, Fr 2620 (£105); presumably acquired by Sampson Gideon for Belvedere and by descent to Sir Culling Eardley, 3rd Bart.; his sale, Christie's, 30 June 1860, lot 13, bought for 440 gns by Henry Vane, 2nd Duke of Cleveland; by inheritance to his brothers, 3rd and 4th Dukes of Cleveland and to their kinsman, the 9th Baron Barnard; and by descent (Raby, no. 136)
Literature: Dodsley 1761, 1:274; Smith 1829–1842, 3:427, no. 631 (valued at £600); Waagen 1857, 278; Speth-Holterhoff 1957, 155–157
Exhibitions: London, RA 1927 (302); Bruges 1956; Barnard Castle 1963 (26)

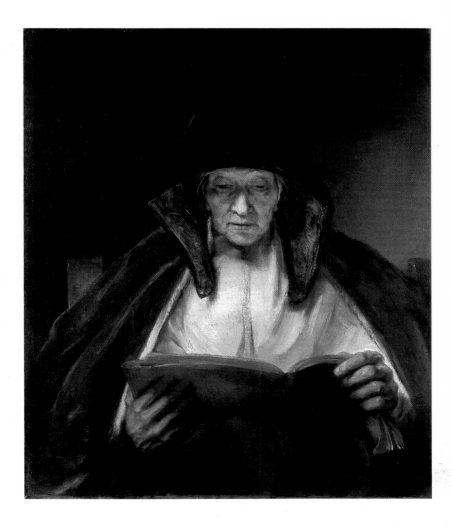

292

AN OLD WOMAN READING 1655
Rembrandt Harmensz. van Rijn
1606–1669
oil on canvas
80 × 66 (31½ × 26)
signed, *Rembrandt f 1655*

Drumlanrig Castle
The Duke of Buccleuch and
Queensberry, KT

This masterly and deeply moving picture is not a formal portrait but a study, taken from life, of an old woman intent on her book; the reflections from it illuminate her face, for her hood protects all but her nose from direct light. The text is invisible but we may surely suppose that its character is religious. The subject may be compared with a panel of 1631 in the Rijksmuseum and the noble picture of comparable date at Wilton House (Earl of Pembroke). Pictures of 1654 in The Hermitage and at Moscow may show the same model. The picture has a distinguished place among the works of Rembrandt's penultimate decade, and the bold handling of the paint anticipates his final phase.

The 1770 Montagu House inventory

establishes that this picture and the *Self Portrait* of 1659, now in the National Gallery, Washington, were purchased together for £140 by George Brudenell, 4th Earl of Cardigan (1712–1790), for whom in 1766 the Dukedom of Montagu had been revived. He and his wife, Mary, daughter of John, 2nd Duke of Montagu, were, like their son Lord Monthermer (see nos. 173 and 174), keenly interested in pictures, and it is known that the Cardigans on occasion bought pictures jointly. Their taste was evidently informed. If the Murillo *Saint John the Baptist* (Boughton) bought by Lady Cardigan in 1757 was a conventional purchase, the same could not be said of the early El Greco *Adoration of the Shepherds*, also now at Boughton. Montagu acquired a number of very distinguished seventeenth-century Dutch and Flemish pictures, including a third Rembrandt, the *Saskia as Flora* (National Gallery, London), bought after the Tallard sale at Paris in 1756, and Rubens' *Watering Place* (National Gallery, London), also from the Tallard collection. The latter was particularly admired by Gainsborough who saw it at Montagu House and wrote to David Garrick: "I could wish you to call *upon any pretence* . . . at the Duke of Montagu, not as if you thought anything of mine worth that trouble [that is, no. 472] only to see his Grace's landskip of Rubens and the four Vandykes" [that is, the set of full-lengths now at Bowhill] (Woodall 1963, 67). A hint that this picture was also of French provenance is offered by a pastel based on the head attributed to C.J.B. Hoin in the Musée Magnin, Dijon.

F.R.

Provenance: Purchased by George Brudenell, Duke of Montagu, and recorded in the 1770 Montagu House inventory; by descent through his daughter, Elizabeth, wife of the 3rd Duke of Buccleuch
Literature: Bredius 1936, no. 385
Exhibitions: London, BI 1815 (27); London, RA 1872 (179); Amsterdam 1898 (93); London, RA 1899 (8); Edinburgh 1950 (29); Amsterdam 1952 (144); London, RA 1952–1953 (178); Amsterdam 1969 (15); London, NG 1976 (90)
Engravings: James McArdell, mezzotint

293

AN INTERIOR WITH A DANCING COUPLE c.1660
Gerard ter Borch 1617–1681
oil on canvas
76.2 ×68 (30 ×26¾)

Polesden Lacey
The National Trust (Greville Collection)

A cavalier who slips a ring onto a finger of a girl's left hand is the central feature of this composition. The couple attracts the intent gaze of an old woman and a look from a girl in the background; this girl's companion is unconcerned. The subject, which on the evidence of the ring may be a betrothal, is believed by Gudlaugsson (1960) to be a figure in a dance, based on a literary precedent.

In the details of Dutch seventeenth-century genre pictures there is often a symbolic interpretation to be found by anyone who seeks for it. It occurs in some of Ter Borch's work, but as this artist is both more sophisticated and more enigmatic than many of his contemporaries, this type of analysis is not always rewarding. No such distractions occur in the present picture; its mood and effect are derived from the composure and quiet absorption of the figures, and a sense of tranquility is achieved by a restrained unity of color, almost monochromatic. The girl, as in other portraits by Ter Borch, recalls the features of his stepsister and model, Gesina. A date in the early 1660s is generally accepted on the evidence of dress; according to Gudlaugsson it is not later than 1662. But it has been observed that Gesina wears a dress that closely resembles one that she wore in a painting dated shortly after 1650 (The Hague 1974, 49).

For much of the nineteenth century the picture formed part of the great collection at Stafford House in London where it was seen by Waagen (1854, 2:71) who described it as possessing "in a high degree the decorum, refinement, elegance and romance which distinguish Terburg's pictures above all others." In the twentieth century it came into the possession of Mrs. Greville, wife of Captain the Hon. Ronald Greville, who died in 1908. Subsequently it has hung at Polesden Lacey in Surrey, the country house that from 1906 until the outbreak of the second World War was the setting for Mrs. Greville's redoubtable fame as a society hostess (Gore 1965).

The picture has been included here not only because of the Polesden Lacey association but also to represent the taste for Dutch cabinet pictures that was to engage the sympathy of English collectors (among them Lord Stafford) in the early years of the nineteenth century. It was a moment when opportunities for amassing pictures were not lacking. Threatened by the menace of Napoleon's armies, many great Continental collections were being dispersed and works of art—including the finest cabinet pictures—were being imported into Britain from the Continent on an unprecedented scale.

StJ.G.

Provenance: J. van der Marck sale, Amsterdam, 25 September 1773, lot 326; J.J. de Bruyn sale, Amsterdam, 12 September 1778, lot 8; anon. sale, "Private Property consigned from Abroad" (Crawford), Christie's, 26 April 1806, lot 11; purchased by Lord Stafford (later 1st Duke of Sutherland, Mrs. Lyne Stephens sale, Christie's, 11 May 1895, lot 347; purchased by Lesser from whom bought by William McEwen, the father of Mrs. Greville, who bequeathed Polesden Lacey and its contents to the National Trust in 1942
Literature: Gudlaugsson 1959–1960, 132–133, pl. 330; 4:183, no. 187
Exhibitions: London, RA 1929 (228); London, RA 1950 (61); The Hague 1974 (49); London, NG 1976 (13)

294

THE BURGHER OF DELFT AND HIS
DAUGHTER 1655
Jan Steen 1626–1679
oil on canvas
82.5 × 68.6 (32½ × 27)
signed, *JS*(monogram)*teen 1655*

Private Collection

Steen settled in Delft in 1654 and
owned a brewery on the Oude Delft
Canal from 1654 to 1657. This picture
demonstrates his contribution to the
development of genre painting in the
town, his debt to Karel Fabritius and
to Nicolaes Maes, and his relationship to
both Gabriel Metsu and Pieter de Hooch.

The identities of the burgher and his
daughter have not been established.
Hofstede de Groot's suggestion of Gerard
Briell van Welhouck, Burgomaster of
Delft in 1660 is not supported by the
only known portrait of Briell (Hofstede
de Groot 1908–1928, 1: Steen, no. 878).
The Oude Delft Canal is seen on the
right, crossed by a bridge with the arms
of the town; behind is the Oude Kerk
and on the left over the man's shoulder,
the Delflands Huis and the Prinsenhof.
The beggars no doubt allude to the
burgher's generosity to charity.

This picture was brought to England
by the dealer Alexis Delahante, and
subsequently acquired by Colonel
the Hon. Edward Douglas Pennant
(1800–1886) who was created Baron
Penrhyn of Llandegai in 1866. His father-
in-law, G.H. Dawkins Pennant, nephew
of James Dawkins of Palmyra fame and
heir of his cousin Richard Pennant who
had inherited a Jamaica fortune, was
responsible for the development of the
slate quarries on the Penrhyn estate:
The massive profits of these business
ventures enabled Dawkins Pennant to
build the great neo-Norman castle at
Penrhyn which was begun around 1825
after the design of Thomas Hopper.

Colonel Douglas Pennant bought
pictures on a considerable scale from
1842 onward. He acquired a few Italian
works, including a Garofalo, but was
most interested in Dutch pictures, and
bought fine examples of Maes, Cuyp,
Van der Neer, and others. His most
distinguished purchase was Rembrandt's
portrait of Catherina Hooghsaet of 1651.
This cost 740 guineas in the Saltmarshe
sale at Christie's in 1860: Penrhyn's
income in 1883 from 49,548 acres was
£71,018.

Some light on Penrhyn's attitude to
his collection is offered by his grand-
daughter's account of it. With the
exception of five portraits and a supposed
Perugino, the pictures inherited with
the house were "scattered in bedrooms,

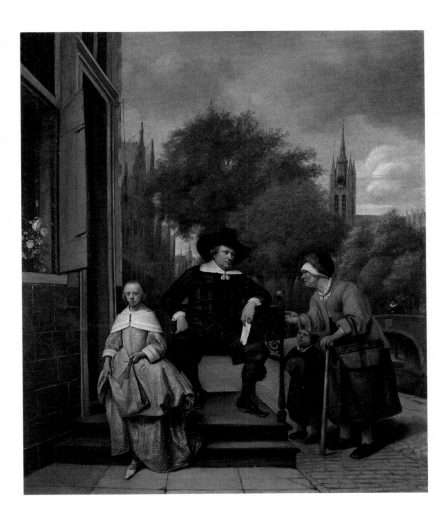

passages and servants' rooms." Penrhyn's
own acquisitions were all hung in
the two dining rooms and in his own
and his wife's sitting rooms: he "was
constantly moving the pictures...
according to the new ones he bought,"
but these were not arranged by school.
In the late 1890s the collection was
rearranged and by 1901 the more im-
portant Dutch pictures were in the
Small Dining Room (Pennant, 1902,
Introduction). F.R.

Provenance: E.M. Engelberts and Tersteeg,
Amsterdam, 13 June 1808, lot 142,
bought for 75 fls by Nieuwenhuys;
Domsert, London, 1811 bought for £88
by Charlesson; Alexis Delahante, 1814,
lot 18; bought from Nieuwenhuys by
Colonel the Hon. Edward Gordon
Douglas Pennant, later 1st Lord Penrhyn;
and by descent
Literature: Brown in London, NG 1976;
Pennant 1902
Exhibitions: London, RA 1882 (238);
London, Grafton Gallery 1911 (95);
Rotterdam 1935 (78a); London,
RA 1952–1953 (554); Aberystwyth,
Cardiff, and Swansea 1958 (4); Hague
1958–1959 (7); London, NG 1976 (103)

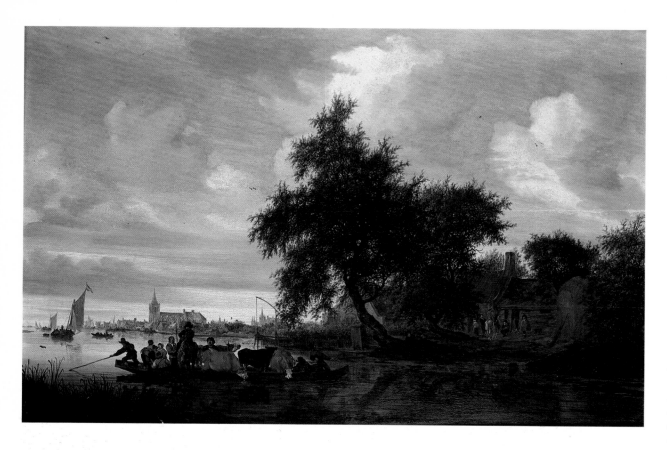

295

RIVER LANDSCAPE WITH FERRY 1633
Salomon van Ruysdael 1600/1603–1670
oil on panel
55.8 × 82.5 (22 × 32½)
signed and dated, *1633*

Private Collection

This characteristic landscape by Salomon van Ruysdael and a very similar one of much the same size were apparently first paired by Henry Blundell (1724–1810) of Ince, who had acquired the companion picture, dated 1653, at the sale of Sir George Colebrooke, 1st Bart., in 1774.

Blundell, who like his friend and neighbor Charles Towneley (no. 213) was a Roman Catholic and thus ineligible for public office, was an outstanding connoisseur. He formed a major collection of classical sculptures, housed in the Pantheon at Ince Blundell, which was added to the earlier house in 1802. The pictures he acquired were yet more remarkable. In some ways his taste was conventional—this picture might have found a place in many collections of the time—but the scale of his patronage of contemporary Italian painters was unusual and he also employed Penny, Wilson, Stubbs, and other English artists of the day. He purchased old masters in Italy from such agents as Byres, Cavaceppi, Hugford, Jenkins, and Father Thorpe. By 1803, the year in which his catalogue of the collection was published, Blundell had 197 pictures, and at the time of his death in 1810 he may have owned over 300. Some of his later acquisitions were probably owed to his association with the pioneering Liverpool collector William Roscoe, who had developed an interest in earlier schools. Despite his advanced age, Blundell was thus in the vanguard of taste when he bought such works as the Holbein *Allegory* (National Gallery of Scotland, Edinburgh), the *Journey of the Magi* by the Master of Saint Bartholomew, and other Flemish and Italian primitives, many of which remain in the present collection. Blundell's primitives eventually outnumbered his seventeenth-century Dutch pictures, although there are hints in the 1803 catalogue that these appealed to him as much as historical curiosities as for their artistic merits. His passion for collecting was to some extent shared by his son Charles Robert Blundell. The latter was an energetic buyer of both old master drawings and prints and acquired a considerable portion of Roscoe's own collection in these fields at the sales caused by the latter's bankruptcy in 1816 (see no. 332). F.R.

Provenance: Apparently purchased by Henry Blundell of Ince; his son Charles Robert Blundell (d. 1837), by whom bequeathed to his kinsman Thomas Weld, second son of Joseph Weld of Lulworth; and by descent at Ince Blundell until 1960 when the collection was inherited by the present owner
Literature: Waagen 1854, 3:252; Stechow 1938, no. 359A
Exhibitions: Liverpool 1960 (64)

296

VIEW OF THE COAST AT EGMOND
AAN SEE 1642
Jan van Goyen 1596–1656
oil on panel
63.5 × 76.2 (25 × 30)
signed and dated, *V. Goyen 1642*

Audley End
The Hon. Robin Neville

Van Goyen painted a number of views of Egmond, and this panel, with its beautifully controlled design and closely observed figures, has some claim to be the finest.

The frequency with which pictures by Van Goyen are recorded in early catalogues testifies to the artist's popularity among English collectors. Sir John Griffin (1719–1797), later 4th Lord Howard de Walden, who was created Lord Braybrooke in 1788, acquired the picture in 1771. He was not a collector on the scale of, for example, Lord Bute, but he evidently had an instinctive taste for Dutch landscapes. He inherited Audley End, the great Jacobean house of the Suffolks, in 1749 and later embarked on a series of improvements to the place. Robert Adam, who undertook the redecoration of the interior in 1762–1764 and later designed a number of garden buildings, was also responsible for the remodeling of Sir John's London house, No. 10 New Burlington Street, in 1778–1779.

In 1825–1831 the 3rd Lord Braybrooke spent over £15,000 on the redecoration of the house, in the course of which Adam's state apartments were remodeled and the present drawing room formed. Lord Braybrooke's guide of 1836 shows that the picture was already in this room, which was hung originally with red flock paper. With the exception of Pickersgill's portrait of Lady Braybrooke, clearly visible in a watercolor of 1853 owned by Lord Howard de Walden (Cornforth 1976, 103, fig. 4), the thirty-six pictures in the room were all by old masters, predominantly Dutch. Although Lady Braybrooke has long been displaced, the Van Goyen and its pendant still hang in the room, which was almost unchanged until recently.

F.R.

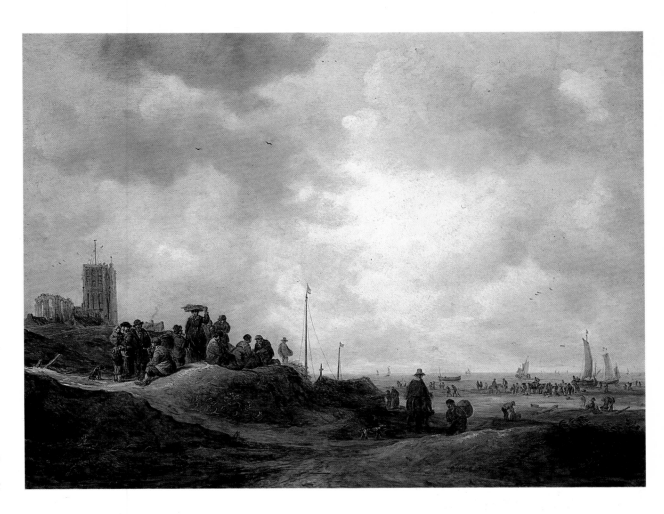

Provenance: James Ansell sale, Christie's, 6 April 1773, lot 65; bought for 20 gns by Sir John Griffin, later 4th Lord Howard de Walden and 1st Lord Braybrooke; and by descent from his cousin, the 2nd Lord Braybrooke
Literature: Audley End 1797, no. 60; Braybrooke 1836, 119; Walker 1964, no. 87; Beck 1973, no. 943
Exhibitions: London, Alan Jacobs Gallery 1977 (14)

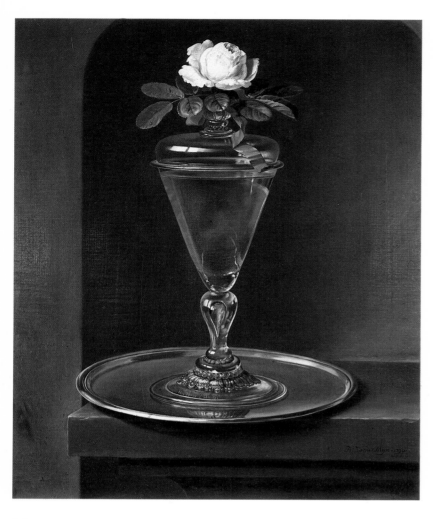

297

A ROSE IN A GLASS 1730
Herman van der Mijn 1684–1741
oil on canvas
73.6 × 62.2 (29 × 24½)
signed, *H. Vander Myn. 1730/august. 31*,
and on the foot of the glass, *un verre
d'amitié*

The Burghley House Collection

Herman van der Mijn, who was born at
Amsterdam and also worked in Antwerp
and Paris, was in London in 1727, coming
as Vertue records at the instance of
Lord Cadogan: he "got the reputation
of being a very laborious neat painter,
even to the smallest trifles in pictures"
(Vertue 1930–1955, 3:34). Vertue also
reports that he "was recommended to
Ld Exeter at Burleigh House to Clean
& repair the pictures &c or put them in
order, the sum agreed for 500 lls . . ."
(Vertue 1930–1955, 3:64). It was usual
to employ painters to act in such a
capacity, and in 1763 Walpole would
note that van der Mijn "lived long with
the last Earl," Brownlow Cecil, 8th Earl
of Exeter (d. 1754).

The inscription on the glass suggests
that Van der Mijn may have presented
the picture to Lord Exeter, for whom
he also painted a *Spaniel with Dead Game*
of 1730. Described as "A Picture of Still
Life by Vander" in the 1738 inventory,
the picture was then in the "Anti-
Room" (MSS inventory at Burghley,
fol. 86; I am indebted to John Somerville
for this reference). It was in Queen
Elizabeth's Dressing Room in 1815,
and in the North Dressing Room in
1847. F.R.

Provenance: Brownlow, 8th Earl of Exeter;
and by descent
Literature: Burghley 1815, 63; Charlton
1847, 203, no. 162; Toynbee 1927–
1928, 58

298

VASE OF FLOWERS ON A LEDGE 1704
Rachel Ruysch 1665–1750
oil on canvas
79.3 × 66.7 (31¼ × 26¼)
signed and dated, *Rachel Ruysch, 1704*

Private Collection

This unusually fine flower piece by Ruysch shows an arrangement of roses, lilies, tulips, poppies, carnations, convolvulus, iris, and other flowers in a glass bowl. There are numerous insects, and the butterfly on the cornstalk to the left is a Brindled Beauty.

Flower paintings have been popular in England since the seventeenth century: the distinguished horticulturalist Sir Thomas Hanmer (see no. 63) acquired pictures of this kind after the Restoration; these were owned by his descendants until recently, and many other early owners might be cited. This picture is believed to have been acquired by James West (1704–1772) who was MP for St. Albans in 1741–1768 and joint secretary to the Treasury from 1741 until 1762. A friend of Horace Walpole, West was a distinguished antiquary and President of the Royal Society in 1768–1772. Between 1730 and 1764 his house at Alscot was rebuilt in a Gothick style akin to that of Batty Langley by Edward Woodward of Chipping Camden, who worked under the direction of the London architects John Phillips and George Shakespear. West was a pioneer bibliophile in his enthusiasm for "black-letter" and Caxton, and was also an energetic collector in other spheres, spending liberally his income from the Treasury, the pension of £2,000 his patron the Duke of Newcastle secured for him on his resignation in 1762, and the substantial fortune inherited by his wife from her brother Sir Thomas Stevens, a successful timber merchant. The very scale of his collection may in part explain his son's decision to send much of it to Langford's auction room in 1773. The sale of the books took twenty-four days; that of the prints and drawings, thirteen; and that of the coins and medals, seven, while the majority of the pictures West acquired were merged with those of other vendors in a four-day session.

F.R.

Provenance: James West of Alscot; and by descent
Literature: Grant 1956, no. 56
Exhibitions: Birmingham 1938 (70)

299

LE MANÈGE 1654
Karel du Jardin 1622–1678
oil on canvas
50.8 × 45.72 (20 × 18)
signed, *K. DU JARDIN fec/1654*

The Lord Northbrook

This "highly-finished picture" (as it was described by Smith in the early nineteenth century) of an area for exercising horses, has long been recognized as one of the masterpieces of Du Jardin, whose reputation as a painter of animals in the eighteenth century was only surpassed by that of Paulus Potter.

Like so many pictures of the kind, it is recorded in France, and its first English owner was William Beckford, whose taste for Dutch pictures was as sound as his connoisseurship of Claude (no. 309) and the Italian masters. Beckford also owned Du Jardin's *Le Diamant*, now in the Fitzwilliam Museum, Cambridge. *Le Manège* was subsequently acquired by an extravagant nephew of the great Duke of Wellington and by the Comte, later Duc, de Morny, a close friend of Napoleon III and one of the architects of the Third Empire. Thomas Baring (1799–1873), who bought the picture in 1849, had an inherited instinct for connoisseurship. His grandfather, Sir Francis Baring, 1st Bart. (d. 1810), had formed a remarkable collection of Dutch pictures that his son Sir Thomas sold to the Prince Regent in 1814. Sir Thomas himself built up a more varied collection, including such masterpieces as the *Saint Jerome in His Study* (National Gallery, London), now generally given to Antonello da Messina but attributed until Waagen's time to Dürer; the Sebastiano del Piombo *Holy Family with a Donor* (National Gallery, London), three Claudes including the magical *Ascanius Shooting the Stag of Sylvia* (Ashmolean Museum, Oxford), a major Ribera, five Murillos, Van Dyck's great *Abbé Scaglia* (Lord Camrose), and subject pictures by Opie, Northcote, and Peters. The pictures were kept at Stratton Park in Hampshire, the neoclassical house built by the younger George Dance for Sir Francis in 1803–1806. When Sir Thomas died in 1848, he left instructions that his pictures should be sold. His

second son, Thomas Baring, MP for Huntingdon and a partner in the family bank, bought the Italian, Spanish, and French pictures at an agreed valuation and the English and Dutch works were sent to Christie's, where they fetched £11,776. 11s. Thomas Baring had himself begun to collect in the mid-1830s—in fact, it was he who gave Waagen a letter of introduction to his father—and his acquisition of forty-three pictures from the Verstolk collection in 1846 (see no. 305) no doubt explains why he did not buy his father's Dutch works. His own acquisitions were remarkable by any standard: in 1851 the dealer Chaplin, who had been the agent in the Verstolk negotiations, acquired Mantegna's *Agony in the Garden* (National Gallery, London) for him. Baring continued to add regularly to the collection until 1871, two years before his death. His nephew and heir, the 1st Earl of Northbrook (1826–1904), sold a number of outstanding pictures from the collection in the 1890s.

F.R.

Provenance: M. Montaleau, his sale, Paillet, Paris, 19 June *et seq* 1802, Fr 7020; Emler, Paris, 30 October 1809, Fr 10,001; Alexis Delahante, his sale, Phillips, 14 July 1821, bought in at 421 gns; William Beckford, Fonthill Abbey, his sale Phillips, 27th day, 15 October 1823, lot 330, bought for 290 gns by Emmerson; Hon. William Long Pole Wellesley, later 4th Earl of Mornington by 1842; his sale, Brussels, 15 June 1846, lot 6, Fr 12,300 to Warneck; Comte de Morny; his sale London, Phillips 20–1 June 1848, bought for 630 gns by Farrer by whom sold in 1849 to Thomas Baring (1799–1873); and by descent
Literature: Smith 1829–1842, 9:641, no. 10; Waagen 1854, 2:186; Northbrook 1889, no. 54; Hofstede de Groot 1908–1927, 9:275
Exhibitions: Manchester 1857 (971); London, RA 1953–1954 (386); Winchester and Southampton 1955 (12)

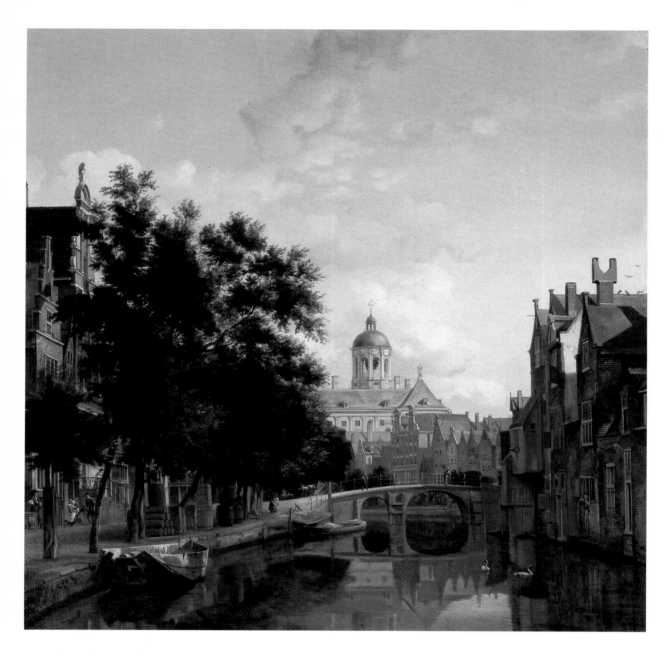

Northwick owned many Dutch pictures, but was also a discriminating collector of British painting and a particular devotee of the earlier Italian schools. The banker Abraham Robarts, who acquired the picture in or before 1834, formed a remarkable collection of Dutch seventeenth-century pictures, many of them purchased in Amsterdam where, like the Hope family, he had extensive business interests. His collection was dominated by two major Cuyps, the *Shipping on the River Maas* and the *View of Dordrecht*, and the Van der Heyden was hung with these in the drawing room at Robarts' house in Hill Street with pictures by Rubens and Teniers, Pynacker, Hobbema, Steen, and Slingelandt. The "Back Drawing Room" contained more Northern pictures and the only examples of other schools noted by Waagen, a Claude and a Murillo, while the dining room contained a Van de Velde and a Bol. The pictures here, and in the family's Regency "villa" at Lillingstone in Buckinghamshire, were of consistently high caliber and, as Waagen implies, Robarts' interest in them was shared by his wife. F.R.

Provenance: J.D. Nijman, Amsterdam, 16 August 1797, lot 102; Lord Northwick, Harrow, 1822; purchased by A.W. Robarts by 1834; and by descent
Literature: Smith 1829–1842, 5:404, no. 114 (valued at £120); Waagen 1857, 160; Hofstede de Groot 1908–1927, 8:335, no. 16; Wagner 1971, no. 10
Exhibitions: London, BI 1852 (6); London, RA 1877 (93); London, RA 1891 (61); London, RA 1929 (294); London, RA 1952–1953 (507)

300

THE NIEUWE ZIJDS VOORBURGWAL AT AMSTERDAM c.1665/1670
Jan van der Heyden 1637–1712
oil on panel
51 × 49.5 (20 × 19½)
signed, *V. Heyde*, to the left on a coping stone

Lillingstone House
D.J. Robarts, Esq.

The Nieuwe Zijds Voorburgwal is seen here from the west. A bridge crosses the canal, now filled in, and in the distance is the Dam, the Town Hall of Amsterdam, built by Van Campen. Van der Heyden was the outstanding specialist in urban topography in late seventeenth-century Holland and his work, like that of other Dutch topographical painters including Berckheyde, has long been admired in Britain. Waagen considered this a "first-rate picture" and commented

that it is "far broader and more solid" in treatment than most works by the painter. Following Smith, he attributed the figures to Adriaen van de Velde who often collaborated in this way with Van der Heyden.

The picture was owned by John Rushout, 2nd Baron Northwick (1770–1859), who assembled a vast collection of old master pictures that was subsequently kept at Thirlestane House, Cheltenham.

301

AN EXTENSIVE RIVER LANDSCAPE
c. 1665/1670
Jan Wynants 1643–1684
37.4 × 29.8 (14¾ × 11¾)
signed, *J. Wynants fec.*

Private Collection

Wynants' duneland scenes—of which
this is a fine and characteristic example—
were popular with English collectors
from the eighteenth century onward
and exercised a considerable influence
in the evolution of landscape painting
in England, not least on the development
of Gainsborough as is seen so clearly in
the early *plein air* portrait from Houghton
(no. 328).

John Staniforth Beckett (d. 1889),
son of Joseph Beckett of Barnsley and
cousin of Edmund Beckett, 1st Baron
Grimthorpe, the restorer of St. Albans
Cathedral, began to collect pictures
systematically in 1841 and continued
to buy until the end of the following
decade. His manuscript catalogue of the
collection shows that Beckett began by
commissioning a number of contemporary
works and acquiring lesser old masters,
but gradually came to concentrate on

finer examples of his favorite schools.
He owned a sketch by Rubens and a
Guardi as well as notable English works
of the eighteenth century, but had a
particular sympathy with the Dutch
school. Appropriately he left fine
examples of Cuyp and Van der Neer to
the National Gallery, London. His col-
lection is otherwise intact and offers a
revealing illustration of one facet of mid-
nineteenth-century taste in England.

F.R.

Related Works: Copies were in the
P. von Schwabach collection, Berlin,
and in the Van Bellingen sale, Brussels,
11–12 December 1923, lot 73
Provenance: Possibly in an anonymous
sale, Amsterdam, 7 November 1801,
lot 78, bought for 405 fls by J. Span;
Farrer, by whom sold to John Staniforth
Beckett, 1849; and by descent through
his niece Elizabeth, Lady Bacon, to her
son Sir Hickman Bacon, 11th and 12th
Bart.
Literature: Hofstede de Groot 1908–
1927, 8:501, no. 305, and 505, no. 327
Exhibitions: London, Guildhall 1890
(85); Norwich 1966 (57); King's Lynn
1967 (36)

302

THE SUTLER'S TENT c. 1660/1665
Philips Wouwermans 1619–1668
oil on panel
40.2 × 34.5 (15⅞ × 13½)
signed with initials,
P SL (monogram) W

Holker Hall
Hugh Cavendish, Esq.

This characteristic encampment scene
by Wouwermans was fairly judged "a
beautiful and transparent picture in his
second manner" by Waagen, whose
description of the picture can scarcely
be bettered: "On the right (sic) a tree
and a tent. A soldier close by, making
love to a *vivandière,* and a seated dog.
Two horsemen on a brown horse and
grey. In the distance a sportsman."

The picture was acquired by Sir
William Lowther, 3rd Bart. of Marske
(1727–1756), who inherited Holker
in 1743, and the great estates of his
kinsman, Sir James Lowther, 4th Bart.
of Whitehaven, in 1755, a few months
before his death. Lowther seems to have
inherited remarkably few pictures with
Holker, and acquired the collection
of portraits, topographical, and other

pictures from Whitehaven after his own
taste as a collector had matured. This
may have owed much to the influence
of his mother, Lady Elizabeth, daughter
of William Cavendish, 2nd Duke of
Devonshire. The collection sent from
London to Holker after Lowther's
premature death was not large: it only
numbered fifty-four works. But of these
several were of the highest caliber: the
great Claude *Parnassus* now at Edinburgh,
Claude's *Rest on the Flight* at Cleveland,
and the Rubens *Landscape with Cattle and
Duckshooters* at Berlin. Lowther did not
live to see the *Parnassus,* the largest of
all Claude's pictures, which was secured
for him by Thomas Patch, whom he
had met earlier in Italy (Russell 1975).
Lowther's Grand Tour yielded a pair of
Vernets, one of which survived the
Holker fire of 1870 and remains in the
house, and a caricature conversation
piece in which he appears by the young
Reynolds, to whom he later sat for
a more formal portrait. Despite his
connection with both Patch and Richard
Dalton, who were mainly interested in
seicento pictures, Lowther seems to have
had an equal interest in the Dutch school,
owning in all twenty-four pictures
by Dutch painters of the seventeenth
century. His Hobbemas and his Bloemaert
are no longer at Holker, but two
Wouvermans, three Ruysdaels, and a
Moucheron remain to give a flavor of
his connoisseurship. Described as "A
Sutler's Tent by Woverman" (a sutler
being a supplier of provisions), the pic-
ture appears as no. 18 of the posthu-
mous list of Lowther's pictures and was
kept at his house near the Horse Guards,
Whitehall (Holker MSS). Unlike
Lowther's other Wouvermans, which is
in a contemporary French frame, the
picture was evidently reframed in
England.

F.R.

Provenance: Purchased by Sir William
Lowther, 3rd Bart., and recorded at his
London house in 1756; sent 14 October
1756 to Holker and bequeathed to
Lowther's cousin Lord George Cavendish
(d. 1792); his nephew, Lord George
Cavendish, 1st Earl of Burlington;
his grandson, William, 2nd Earl of
Burlington, later 7th Duke of Devon-
shire; his grandson Victor Cavendish,
who on succeeding as 9th Duke in 1908
made over Holker to his brother Lord
Richard Cavendish; and by descent
Literature: Waagen 1857, 432; Liverpool
1906, no. 60 or 61

303

AN ITALIAN SEAPORT WITH A
FOUNTAIN OF NEPTUNE 1673
Abraham Storck c.1635–c.1710
oil on panel
25.4 × 36.8 (10 × 14½)
signed *A. Storck. Fecit 1673*

Felbrigg Hall
The National Trust (Ketton-Cremer
Collection)

Such imaginary harbor scenes as this
picture and its companion are not
uncommon in the work of Storck,
an artist who is likely to have found his
inspiration for them as the result of an
Italian visit. The paintings hang today
in the small, exquisite room at Felbrigg
Hall known as the Cabinet. Designed
by James Paine for William Windham
shortly after he had inherited the
property in 1749, its purpose was to
display the paintings, and in particular
the series of Roman views in gouache
by Giovanni Battista Busiri, which
Windham bought in Italy during the
course of his Grand Tour.

The tour made by Windham was an
unusual one. Accompanied by his
tutor, the mildly eccentric Benjamin
Stillingfleet—a botanist, naturalist,
and writer of libretti and oratorios,
whose manner of dressing led to the
assimilation into the English language

of the expression "bluestocking"—he
embarked for Paris in 1737 on a journey
that lasted until 1742. Although the
usual itinerary was followed, the most
remarkable feature of this journey was
the series of expeditions to the Alps
to explore the glaciers and valleys
around Chamonix and Mont Blanc.
These expeditions were undertaken by
Windham with a group of British
amateurs who were studying at the
Academy at Geneva in the late 1730s
and early 1740s and who styled them-
selves the "Common Room." From
1738–1740 Windham was in Italy,
after which he spent further time in
Switzerland before returning home in
1742 via Germany and Holland. It was
probably in Holland that he acquired the
Dutch and Flemish paintings in
which he showed an unmistakable
preference for marine views by Van de
Velde.

It is paradoxical that these two
beautifully preserved panels by Storck,
which fulfill so exactly William
Windham's passion for Italian views and
Dutch seascapes, should have been
collected not by him but by his kinsman
Admiral William Lukin, who succeeded
to Felbrigg in 1824. Providentially
Lukin's grandiose schemes for extending
the house were for the most part
prevented by lack of money. It
was equally fortunate that Lukin's

interference with the Cabinet was
minimal. William Windham's precise
intentions for the hanging of the room
are recorded by the wall plans that he
drew in 1764. Lukin produced a further
set of plans in 1835 demonstrating the
modest changes made to incorporate the
three paintings that he had acquired, a
seascape by Bakhuysen and the two
Storcks.

The taste of the early nineteenth
century brought a wider appreciation
of Dutch paintings. Cabinet pictures
were bought freely and began to rival
landscapes in popularity and an obsession
with verisimilitude, reflected in the work
of an artist such as Sir David Wilkie,
became increasingly evident. These
tendencies, however, are not to be found
in the collecting of Admiral Lukin, who,
other than family portraits, appears to
have limited himself to these three pic-
tures, which reflect the taste of his
forebear. STJ.G.

Provenance: Bought by Vice-Admiral
William Lukin, possibly when living in
Brussels in the early 1820s. On inheriting
Felbrigg in 1824 he changed his name
to Windham. The picture descended in
the Windham, then Ketton families at
Felbrigg until 1969 when the house, its
contents, and the estate were bequeathed
to the National Trust by Wyndham
Ketton-Cremer, biographer and historian,
and the author of *Felbrigg: the Story of a
House*
Literature: Hawcroft 1957, 216

304

AN ITALIAN SEAPORT WITH THE RUINS
OF A CLASSICAL TEMPLE 1673
Abraham Storck c.1635–c.1710
oil on panel
25.4 × 36.8 (10 × 14½)
inscribed, *A. Storck. Fecit*

Felbrigg Hall
The National Trust (Ketton-Cremer
Collection)

This is the companion picture to
no. 303, and is discussed in that entry.

305

PORTRAIT OF WILLEM VAN DE VELDE
THE YOUNGER IN HIS STUDIO
c.1665/1667
Michiel van Musscher 1645–1705
oil on panel
47.6 × 36.8 (18¾ × 14½)
signed, *Musscher/Pinxit 16 . .*

The Lord Northbrook

This is an exceptional and relatively
early work by Van Musscher, who
became a pupil of Metsu in 1665 and
was associated with Adriaen van Ostade
in 1667. Waagen commented that "in
transparency, chiaroscuro, and careful
completion [the picture] in no way falls
short of the excellence" of the latter.
The youthful artist has long been
considered to be Willem van de Velde
the younger, who was of appropriate
age in the 1660s. He is known to have
worked regularly from drawings made
on the spot by his father, whose studies
of the kind are very similar to those
laid out on the floor in the picture.
This identification was not, however,
made until the De Vos sale in 1833,
and the possibility that the subject is
Willem's brother Adriaen van de Velde
cannot be excluded. None of the land-
scapes that hang on the wall in the
characteristic ebony frames of the period
can be identified, but the plaster
statuette between the two busts above
the door is copied from the Farnese
Hercules, then in the Palazzo Farnese,
Rome, and now at Naples.

Before it came to England, this picture
had been in two of the greatest Dutch
collections, those of De Vos and Baron
Verstolk van Soelen, and the fact that
it was engraved as a frontispiece for
Smith's *Catalogue Raisonné* in 1835 confirms
its celebrity. Verstolk, who died in
1845, had formed a major collection of
seventeenth-century Dutch works. He
specialized above all in cabinet pictures
of the kind that had been so prized
since the late eighteenth century. His
drawings were sold at auction in
Amsterdam in 1847, but the dealer
Brondgeest, who had helped with the
formation of the collection, negotiated
the sale of the pictures *en bloc* through
Mr. Chaplin to a consortium of three
English bankers: Thomas Baring

(1799–1873); his fellow associate,
Humphrey St. John-Mildmay (1794–
1853), whose wife was the daughter of
Baring's uncle the 1st Lord Ashburton;
and Samuel Jones Loyd (1796–1883),
who in 1860 was created Lord Overstone
and was perhaps the most influential
English financier of the period. The col-
lection cost £26,231. Loyd took ten of
the more valuable pictures at a valuation
of £8,116; Baring secured forty-three
for £12,472; Mildmay purchased twenty
for £4,543; and Chaplin took twenty-
six for £1,100; while a single picture
was sold to King William II of Holland.
The majority of those bought by Baring
remain in the Northbrook collection,
but Mildmay's share was sold at
Christie's in 1893, largely because of
the heavy losses Baring's Bank had
suffered in South America. The pictures
acquired by Loyd were bequeathed by
his daughter, Lady Wantage, with the
collection in her London house to the
27th Earl of Crawford and are now at
Balcarres. For Baring's collection see
no. 299 F.R.

Provenance: M. Michiel von Musscher, his
sale, Zomer, Amsterdam, 21 April 1706,
lot 14, "Een Schilder in zyn Kamer,
(seer fraay) van de zelve," 10 fl; anon.

sale, Amsterdam, 21 January 1733,
lot 22, "Een Stuck van Musscher in
zijn Schilderkamer," 80 fl; Jacob de Vos,
his sale, de Vries, Amsterdam, 2 July
1833, 600 fl; Baron Verstolk van Soelen,
with a portion of whose collection
acquired in 1846 by Thomas Baring, by
whom bequeathed to his nephew, the
1st Earl of Northbrook; and by descent
Literature: Smith 1829–1842, 6:
frontispiece; Waagen 1854, 2:184;
Northbrook 1889, no. 136
Exhibitions: London, RA 1889 (134);
London, NMM 1982 (56)
Engravings: C.G. Lewis, for Smith
1829–1842

306

A WOODED RIVER LANDSCAPE
BY MOONLIGHT c.1650/1660
Aert van der Neer 1603/1604–1677
oil on panel
28.5 × 27.3 (11¼ × 10¾)

Drumlanrig Castle
The Duke of Buccleuch and
Queensberry, KT

This beautifully preserved panel is a
characteristic work, albeit on a small

scale, by a painter whose moonlight
and winter scenes were consistently ad-
mired in the eighteenth century and
represented in many collections of the
time.

Like the smaller moonlit river land-
scape, also at Drumlanrig, this panel
was in the collection of George, 1st
Duke of Montagu of the second creation
(1712–1790). The duke also owned a
larger picture by Van der Neer, now at
Boughton. For other pictures from his
collection see nos. 292 and 472. F.R.

Provenance: Presumably purchased by
George Brudenell, Duke of Montagu,
and by descent through his daughter,
Elizabeth, wife of the 3rd Duke of
Buccleuch, recorded at Montagu House
in inventories of c. 1820 and 1865
Engravings: W. Mayor, "Vue de Canal
proche de Harlem"

FIGURES DRINKING IN A COURTYARD
WITH AN ARBOR 1658
Pieter de Hooch 1629–c.1683
oil on canvas
66.5 × 56.5 (26 × 22¼)
signed, *P★D★H★/1658*

Wrotham Park
Julian Byng Esq.

This and the related *Courtyard of a House in Delft* in the National Gallery, London, have long been recognized as among the masterpieces of de Hooch's Delft period. The tablet above the archway was originally above the entrance to the Hieronymusdael Cloister in Delft, and the fact that the text here is closer to the original than that in the National Gallery picture is one of a number of factors indicating that this was the earlier of the two compositions; the differences between the two suggest that the setting is imaginary. The popularity of the composition is illustrated by the number of recorded copies (Sutton 1980, 84).

Both the Wrotham and the National Gallery pictures are first recorded in London in 1833. The latter was then owned by the Conservative politician Sir Robert Peel, whose old master pictures were almost exclusively by Dutch and Flemish artists, while this picture had been bought in Berlin by a man of wider tastes, the merchant Edward Solly, who in 1821 had sold a prodigious collection of some three thousand pictures to the Prussian government. Solly himself had a predilection for the early Italian schools and when Waagen stayed at his London house in 1835 it was of the Italian pictures that he wrote. In the sale of the Solly collection two years later, the de Hooch was purchased by George Byng of Wrotham for £535.

Wrotham was designed by Isaac Ware in 1754 for the unfortunate Admiral John Byng. George Byng (1764–1847) inherited from his father and namesake in 1789 and also followed him as MP for Middlesex, a seat he was to hold in the Whig interest for fifty-six years. Widely popular, he was described in an obituary as "neither learned, eloquent nor profound" (*Gentleman's Magazine* [1847], 309). His main

307

A WINTER SCENE ON A CANAL c.1670
Meindert Hobbema 1638–1709
oil on canvas
48.2 × 68 (19 × 27)
signed, *M. Hobbema*

Private Collection

This surprisingly little-studied picture has the distinction of being the only known winter scene by Hobbema, who no doubt sought to emulate works of the kind by Ruysdael, many of which are of similar size. The picture was apparently purchased by John Stuart, 3rd Earl of Bute (1713–1792), who was the outstanding collector of Dutch pictures in Britain in the second half of the eighteenth century. Bute's earliest recorded purchases were made in 1749/1750 and by the 1770s the collection at his Bedfordshire house, Luton Hoo, was already of unusual

distinction. With the exception of Rembrandt and Vermeer every major seventeenth-century Dutch painter was represented and there were important works by Hals, Ostade, De Hooch, Van der Neer, Ruysdael, Cuyp, and others.

In his later years Bute made further acquisitions for Highcliffe House in Hampshire: the marine collection of eighty-seven pictures, with a notable group of Dutch works, was sold at Christie's on 19 March 1796 (Russell 1984); and a further eighty pictures, the majority of which were inherited from Bute by his third and favorite son, General Sir Charles Stuart, were sold by the latter's widow at Christie's on 15 May 1841. The collection at Luton was added to by Bute's heir, the 4th Earl, subsequently 1st Marquess. Although 193 of the lesser pictures from Luton were sold by the 2nd Marquess at Christie's, 7–8 June 1822, and others were taken to Wroxton Abbey, which

his first wife inherited on her father's death in 1802, the greater part of the collection was retained, and 264 pictures were exhibited at Bethnal Green in 1882.

F.R.

Provenance: Possibly John Stuart, 3rd Earl of Bute; first certainly recorded by Smith in 1835 as the property of the 2nd Marquess of Bute at Wroxton Abbey, the seat of his wife Maria (d. 1841), elder daughter of the 3rd Earl of Guilford; her half-sister Susan, 10th Baroness North, by whose husband lent to the British Institution in 1857; their son William Henry John, 11th Baron North, his anonymous sale, Christie's, 13 July 1895, lot 62, bought for 1,450 gns by Wooton acting for the 3rd Marquess of Bute
Literature: Smith 1829–1842, 6:151, no. 104; Hofstede de Groot 1908–1927, 4:444, no. 288; Broulhiet 1938, no. 164
Exhibitions: London, BI 1857 (119)

architectural contribution at Wrotham was the enlargement of the wings in 1811. He was not the first connoisseur of the family. His great-grandfather, the 1st Viscount Torrington, had acquired an extensive group of Neapolitan pictures, while his cousin, the 3rd Viscount, was an early patron of Stubbs. From his mother's family Byng inherited two fine Van Dycks, including the *Family of Thomas Wentworth, Duke of Cleveland*. Byng was far more than a casual collector, however. Just as he weeded out twelve lesser pictures from the collection in his London house, 5 St. James's Square, on 10 April 1813, he was prepared to buy major works for substantial prices: thus at Lord Radstock's sale in 1826 he bought Giulio Romano's Spinola *Holy Family* (Russell 1982) for 890 guineas and the Parmigianino *Portrait of a Collector* (National Gallery, London) for 840 guineas. Other acquisitions included two major Murillos and the celebrated *Landscape with Diana and Her Nymphs*, of which Waagen justly wrote: "In comprehensiveness of subject, grandeur of forms, and noble and poetic feeling one of the chefs-d'oeuvre of the master [Domenichino]." That his relatively small group of Dutch pictures included a masterpiece of the caliber of the de Hooch and an exceptional Van de Cappelle offers a further testimony to the range of Byng's taste.

At the time of Waagen's visit to Wrotham, when the house had been inherited by Byng's nephew Lord Enfield, the de Hooch hung with works by Hackert, Ruysdael, Teniers, Van de Velde, the Van Dyck portrait group, and the Giulio Romano, in the "First Drawing Room." F.R.

Provenance: The Empress Josephine, Château de Malmaison, 1811, no. 67, 1814, no. 1012; Walscott [Wolschott], Antwerp; bought in Berlin "a few years" before 1833 by Edward Solly; his sale, Foster's, 31 May 1837, lot 90, bought for £535 by George Byng, MP; and by descent, through his nephew Viscount Enfield, later 1st Earl of Strafford

Literature: Smith 1829–1842, 4: no. 47; Waagen 1857, 323; Sutton 1980, no. 33
Exhibitions: London, BI 1839 (8); London, BI 1842 (187); London, BI 1856 (56); London, RA 1881 (101); London, RA 1893 (64); London, RA 1929 (311); London, RA 1938 (240); London, RA 1952–1953 (376); on long-term loan to the National Gallery of Scotland, Edinburgh, 1969–1984; Philadelphia, Berlin, and London (exh. Philadelphia only) 1984 (53)

Landscape painting has long had a particular appeal for the English, and its appreciation in the eighteenth century is closely bound up with the development of landscape gardening along "picturesque" lines, from William Kent to Capability Brown and Humphry Repton, a fashion that affected the surroundings of virtually every British country house. This in turn was reflected by a literary movement, beginning with the poetry of James Thomson, and whose later landmarks included Edmund Burke's *Inquiry into . . . the Sublime and Beautiful* of 1756, and Uvedale Price's *Essay on the Picturesque* of 1794–1795. Once again there were political overtones to these artistic tastes, for the natural landscapes admired in pictures and imitated by garden designers, were often claimed to symbolize Whig ideals of liberty and democracy, as against the rigid artificiality of formal gardens associated with foreign despotism.

Three painters, above all, were held to express the principles of the picturesque—Claude, Poussin (the work of Nicolas and Gaspard Poussin being often confused), and Salvator Rosa—as Thomson put it, "whate'er *Lorrain* light-touched with softening Hue, or savage *Rosa* dashed, or learned *Poussin* drew." Their work, first encountered by those on the Grand Tour in the early years of the century, was revered as much as the earlier Old Masters, Raphael, Titian, and the Carracci, and it is significant that Thomas Coke's Landscape Room at Holkham in Norfolk was hung entirely with their pictures, complementing the Arcadian landscape of serpentine woods and lakes outside the windows. The Holkham room was the most celebrated of its kind, but landscapes often predominated in drawing rooms like that at Nuneham Courtenay in Oxfordshire, accompanying another famous garden and park, in contrast to the heroic subject pictures hung in saloons, and the sporting scenes found in halls and dining rooms.

The immense popularity of Claude and his imitators, which owed as much to the ideal nature of his scenery as to his coloring and mastery of design, can be judged not only by the number of the artist's pictures which remain in British collections, but also by the landscape gardens, like Henry Hoare's Stourhead or Sir Francis Dashwood's West Wycombe, which were planned to give visitors on their circuit a series of three-dimensional Claudian views. Even country houses themselves, like Richard Payne Knight's Downton Castle, were built on the model of the painter's balanced but asymmetrical hill-top forts, while the poet Thomas Gray and others carried with them "Claude Glasses"—small convex mirrors acting like a camera obscura, so as to reduce a favorite view to a tiny picture, accentuating its tonal values. By contrast with these calm idyllic visions, and the nostalgia of Nicolas Poussin's *Et in Arcadia Ego*, the wildness of Salvator Rosa's torrents, bandits, and rocky landscapes evoked the pleasing horror of Burke's definition of the sublime, and encouraged for the first time an appreciation of the rugged scenery of the Alps, the Lake District, and Scotland.

As well as the Italian school, the Dutch painters, especially Ruysdael and Wynants, Cuyp and Hobbema, were admired for their picturesque qualities, and it was they who particularly influenced Gainsborough's early Suffolk landscapes, so perfectly portraying the country squire and his wife at one with their woods and wheatfields (no. 328). Zoffany's Atholl group (no. 327) commemorates the duke's newly "improved" landscape at Dunkeld but uses it as a far more stylized backdrop to the action. Native painters trained in the topographical tradition of Siberechts and Tillemans had previously been little affected by the picturesque movement, though the paintings of George Lambert and William Marlow show an increasing use of props such as gnarled trees, ruined hovels, and dusty tracks in the manner of Ruysdael. For Marlow as for Joseph Wright of Derby and Richard Wilson, the first great British painter to specialize exclusively in landscape painting, experience of Italy was to prove crucial, and the influence of Vernet can particularly be felt in their subsequent work. The gradual shift from the world of reason to the world of imagination found in late eighteenth-century English literature and landscape painting can be seen as a prelude to the romanticism of Wordsworth and Coleridge, Constable and Turner.

309

THE LANDING OF AENEAS 1675
Claude Gellée, Le Lorrain 1600–1682
oil on canvas
177.8 × 227.3 (70 × 89½)
signed and dated, *Claudio. Gille. inv. fecit. ROMAE 1675*, and below the figure of Aeneas, *Larrivo d'Anea a palant(eo) al monte evantino*

Anglesey Abbey
The National Trust (Fairhaven Collection)

The subject is taken from Virgil's *Aeneid*, VIII, 79–123: Aeneas arrives with two galleys at the town of King Evander, Pallanteum beside the Tiber, on the site of the Aventine Hill; the youths of the town are alarmed and hide, but Prince Pallas, who holds a spear, greets the Trojans from a cliff and Aeneas, who holds a palm leaf, appeals for friendship; the ruins on the right of the river are of the ancient towns of Janiculum and Saturnia, which will later be pointed out to Aeneas by Evander.

This celebrated picture was commissioned in 1675 by Gasparo Albertoni, who on the election of his wife's uncle, Cardinal Emilio Altieri to the papacy as Clement X in 1670 had been nominated Prince Altieri. It was intended as a pendant to the *Father of Psyche Sacrificing at the Temple of Apollo*, painted in 1663 for Altieri's father, Don Angelo Albertoni. Altieri claimed descent from Aeneas and his arms appear as the flag of the smaller vessel. The commission was an important one—during Clement X's pontificate in 1670–1676 Altieri, as Captain of Castel Sant' Angelo and commander of the papal forces, was second in power only to his uncle. The picture is appropriately one of the key works of Claude's latter years.

The purchase of the two Claudes from Altieri's descendants in 1798/1799 was regarded as a remarkable coup and it is not without interest that two of the agents in the sale, Robert Fagan, who successfully smuggled the pictures out of Rome, and Henry Tresham, were both painters of considerable distinction. William Beckford, who acquired the pictures for 6,500 guineas (Whitley 1928, 2:358), was a connoisseur the range of whose interests was matched by the scale of an inherited West Indian fortune, and a flamboyant personality that would have been remarkable in any age. Beckford's pictures included masterpieces of many schools—from Bellini's *Doge Leonardo Loredan* (National Gallery, London) to Dutch works of the seventeenth-century masters (see no. 299). Much of the collection was dispersed at the Fonthill Abbey sale in 1823 although many of Beckford's favorites were retained and taken to his house in Bath: even before Fonthill went, pictures had been weeded out—thus the wings of Solario's

Withypool triptych (National Gallery, London; on loan to Bristol) were sold as by Ghirlandaio for 16 guineas at Christie's in 1817—but the sale of pictures of the caliber of the Claudes so soon after their acquisition was evidently occasioned by his building commitments at Fonthill, the gigantic Gothic house in Wiltshire designed for him by James Wyatt. The pair was sold for an unprecedented sum of 10,000 guineas. The market for pictures so highly priced was inevitably limited and the Altieri Claudes were in turn to be bought by two successful Bristol merchants who were fellow Members of Parliament: Richard Hart Davis and P.J. Miles, whose great collection at Leigh Court is considered in the entry for Domenichino's *Saint John the Evangelist* (no. 499).

The fashion for Claude would gradually wane as the century progressed —although such collectors as James Morrison (see no. 518) continued to acquire works by him, and the incomparable *Enchanted Castle* (National Gallery, London) was bought by Queen Victoria's financial adviser, Lord Overstone. When the Leigh Court pictures were sold in 1884, the Altieri Claudes had perceptibly fallen in popular appeal. Nonetheless their subsequent history offers a fascinating insight into the history of taste. In 1940 the two were acquired by the most recent member of the royal family to collect Old Masters, the Duke of Kent, who inherited the taste for pictures shared by so many of his ancestors—Charles I, Frederick Prince of Wales, George III, George IV, and the Prince Consort— and also something of his mother's acquisitive zest. The duke's caliber as a collector has been obscured by his early death in the war and the sale of much of his collection, including the Claudes in 1947. These were then acquired by another determined collector, the 1st Lord Fairhaven, who lavished much of the great fortune his father had made from mining and railways in the United States on Anglesey Abbey, the house he acquired in Cambridgeshire in 1926. Fairhaven's purchase may have been influenced by the pictures' royal provenance—he formed a collection of views of Windsor—but he acquired other major pictures, including Bonington's

Coast of Normandy, and also much sculpture of distinction for the large garden he laid out in the unpromising fen country. F.R.

Related Works: Ten preparatory drawings in addition to *Liber Veritatis*, no. 185, are recorded by Röthlisberger and Cecchi 1975
Provenance: Painted in 1675 for Prince Altieri and by descent, Palazzo Altieri, Rome, until 1798/1799; both this and the pendant, which have always remained together, were bought in 1799 by Charles Grignion and Robert Fagan; sold in England to Henry Tresham for William Beckford, in whose London house the pictures were exhibited in May 1799; sold by Beckford in 1808 to Harris, by whom sold to Richard Hart Davis, MP; sold with his collection to P.J. Miles, Leigh Court, Bristol c. 1813; by descent to his grandson Sir Philip Miles, 2nd Bart.; at his sale, Christie's, 28 June 1884, bought for 3,800 gns by Agnew; Captain Robert Brassey; his sale, Christie's, 3 May 1940, lot 75, bought for 700 gns by HRH the Duke of Kent; HRH The Duchess of Kent sale, Christie's, 14 March 1947, lot 29, bought for 2,100 gns by Leggatt for Huttleston Broughton, 1st Lord Fairhaven; bequeathed with Anglesey Abbey and its contents to the National Trust on his death in 1966
Literature: Buchanan 1824, 2:31–34; Waagen 1838, 3:139; Waagen 1854, 3:181; Röthlisberger 1961, no. 185; Kitson in Arts Council 1969
Exhibitions: London, RA 1871 (149); London, RA 1949–1950 (69); London, RA 1960 (149); Arts Council 1969 (37)

310

A PASTORAL LANDSCAPE: MORNING 1651
Claude Gellée, Le Lorrain 1600–1682
oil on canvas
99 × 145 (39 × 57)

The Duke of Westminster

This celebrated pastoral was painted for the Swiss military architect, Hans Georg Werdmuller (1616–1678), who presumably comissioned the pendant (no. 311) and who also acquired the *Pastoral Landscape* now at Yale (*Liber Veritatis*, no. 116) and landscapes by Rosa and contemporary Italianate Dutch masters. Generally dated 1651, *Morning* represents the painter's continuing interest in a landscape formula that derives from Domenichino, but Claude far transcends any Bolognese precedent in his sense of atmosphere and tonal harmony.

A date about 1648 is favored for *Evening* by Kitson, partly because of the position of the related drawing in the *Liber Veritatis* (British Museum, London). There seems, however, to be no technical reason for doubting the authenticity of the date on the picture and in fact (as H. Diane Russell argues in the Washington 1982 exhibition catalogue) the differences between *Evening* and this picture, which is

undoubtedly of 1651, may well be a deliberate expression of their contrasting moods: for Claude must have intended both to balance the times of day, morning and evening, and to juxtapose the serene and undisturbed pastoral mood of the former with the deeply felt nostalgia of the latter, so haunting in its allusion to the lost greatness of Rome and the inexorable passage of time implied by the instinctive motion of the herd.

Welbore Ellis Agar (1735–1805), Commissioner of Customs, who purchased the two pictures shortly after the Blondel de Gagny sale in 1776, formed an outstanding collection of Claudes, acquiring eight autograph pictures and a reduced copy of the Longford *Pastoral Landscape with the Arch of Titus* (*Liber Veritatis*, no. 82), which has only been demoted in recent times. Significantly the Longford composition also evokes the lost dignity of Rome and the Agar copy was to be entitled by Young *The Decline of the Roman Empire*. Of Agar's other Claudes, moreover, the

Pastoral Landscape with the Arch of Titus and the Colosseum, a reworking of the Longford composition, was entitled by Young *The Rise of the Roman Empire* and is also comparable in mood with *Evening*. His ownership of three such compositions cannot have been accidental.

When Agar's collection was sold in 1806 after his death, it was bought *en bloc* for 30,000 guineas by Robert, 2nd Earl Grosvenor, later 1st Marquess of Westminster, before the scheduled auction. Although *Evening* and *Morning* are not the largest of the Agar Claudes— that honor is held by the *Sermon on the Mount* (Frick Collection, New York) and the *Adoration of the Golden Calf* (Karlsruhe)—they were esteemed the most valuable in the collection at the time of the sale, as Young records in his catalogue of the Grosvenor Gallery. He further states that eight thousand pounds were offered for the two at the time of the sale by a foreign dealer. The pictures are indeed among Claude's archetypal masterpieces.

Grosvenor had inherited another Claude, the *Rest on the Flight into Egypt* (Röthlisberger 1961, no. 241) and his collection of works by the artist was matched in number, if not in quality, only by that at Holkham. His purchase of the Agar pictures caused him to refine the collection and a large number of lesser pictures was sold in 1807, when he undertook an extensive program of redecoration at Grosvenor House. The climax of the house was the gallery in which these and other works by Claude hung with the series of Rubens cartoons, acquired in 1818 (now at the John and Mabel Ringling Museum, Sarasota) and Rubens' *Adoration of the Magi* (King's College Chapel, Cambridge). The gallery was enlarged by Thomas Cundy in 1825–1827 and is the setting for the family portrait by Leslie (no. 517). Like that at Stafford House, the collection was in general open regularly to the public—visitors were only asked to wipe their feet before entering (Whitley 1928, 294). The accessibility of the Grosvenor House pictures no doubt explains why another of the Agar Claudes, *The Sermon on the Mount*, seems to have influenced John Martin, F.R.

Related Works: A finished composition drawing was in the collection of Lady Dunsany (Röthlisberger 1961, *Drawings*, 2: no. 115); Claude's *ricordo* in *Liber Veritatis*, no. 115 (British Museum, London)

Provenance: Almost certainly painted for Hans Georg Werdmuller; Blondel de Gagny sale, Rémy, Paris, 10 December *et seq.* 1776, with the pendant, lot 200, bought for 23,999 livres by Basan; Welbore Ellis Agar, by 1782; his sale, Christie's, 3 May 1806, lots 1 and 2, but bought privately before the auction by Robert, 2nd Earl Grosvenor, later 1st Marquess of Westminster; by descent at Grosvenor House until 1926 and subsequently at Eaton Hall

Literature: Young 1821, 64, 67; Smith 1829–1842, 8: nos. 115, 124, 301; Waagen 1838, 2:314; Jameson 1844, 247, no. 19, 181; Waagen 1857, 2:171; Röthlisberger 1961, no. 115, 124; Kitson 1969, 124–125; and Russell in Washington 1982, with previous literature

Exhibitions: London, BI 1834 (125 or 132, 146); London, RA 1871 (20, 29); London, BFAC 1871, 12; Birmingham 1888 (185, 193); London, RA 1932 (153, 156); Paris 1937 (73, 74); London, Hayward 1969 (24, 25); Washington 1982 (41, *Evening* only); London, Agnew 1982 (7, *Morning* only); Eaton Hall 1984 (18, 18A)

Engravings: J. Fittler, 1782 (Le Blond 33)

311

A PASTORAL CAPRICCIO WITH THE ARCH OF CONSTANTINE AND THE COLOSSEUM: EVENING 1651
Claude Gellée, Le Lorrain 1600–1682
oil on canvas
91 × 145 (38 × 57)
signed, *CLAUDE. IVF. ROMA 1651*

The Duke of Westminster

This exceptional—and exceptionally well-preserved—masterpiece was almost certainly painted as the pendant to the *Pastoral Landscape: Morning* for the Swiss military architect Hans Georg Werdmuller. The dating of the two, their role as pendants, and subsequent history is considered in the entry for *Morning* (no. 310). F.R.

Related Works: The *ricordo* in Claude's *Liber Veritatis*, no. 124 (British Museum), which is inscribed *Claudio G. i.v.f. il Sr Verdummiller todesseche* (that is, *tedesco*)
Provenance and *Literature:* See no. 310
Engravings: W. Lowry, 1782 (Le Blond, no. 7); J.H. Wright, 1809, in the *Tresham Gallery*

Like Dughet's *Storm* (no. 313) this picture was almost certainly acquired by Thomas Coke, 1st Earl of Leicester, one of William Kent's most important patrons. By 1773 it hung in the State Dressing Room at Holkham, later known as the Landscape Room, in the company of a famous group of pictures by Claude. F.R./G.J-S.

Provenance: Probably acquired by Thomas, 1st Earl of Leicester; and by descent; recorded in the State Dressing Room, later the Landscape Room in 1773, 1817, and 1835 (Waagen) and in the Red Bedroom, its present location, in 1913

Literature: Brettingham 1773, 7 (a "fine Salvator Rosa"); Dawson 1817, 3:no. 197 ("a fine Salvator Rosa"); Waagen 1838, 3:301; Waagen 1854, 3:421; Holkham 1913, 12

313

A STORM late 1660s
Gaspard Dughet 1615–1675
oil on canvas
98.4 × 134 (38¾ × 52¾)

Holkham Hall
Viscount Coke

This powerful work of Gaspard's late maturity is perhaps his most compelling treatment of the subject, with its menacing clouds and fortress struck by lightning, the trees writhing in the wind, and the peasants whose attitudes of terror echo those of Nicolas Poussin's lost *Landscape with a Storm* of 1651.

The picture is no doubt the "tres beau paysage du Guaspre" recorded by Fougeroux in 1728 in the Arlington Street house of Lord Malpas, later 3rd Earl of Cholmondeley (no. 163) (Fougeroux 1728, fol. 83). Vertue also noted a work by the artist in Cholmondeley's collection in 1736 and the picture was engraved in 1742 while still in his possession. The earl's extravagance was such that in 1746–1747 the contents of the Arlington Street house were sold, and as one of the better-known pictures in the collection this

312

A ROCKY LANDSCAPE 1640s
Salvator Rosa 1615–1673
oil on canvas
99 × 109.2 (39 × 43)

Holkham Hall
Viscount Coke

This little-known but unusually well-preserved picture evidently dates from the 1640s and is comparable with the *Landscape with a Bridge* now in the Palazzo Pitti, Florence. Landscapes of the kind enjoyed a considerable vogue in England in the eighteenth and early nineteenth centuries, when Salvator Rosa came to be identified with the "sublime" and Claude with the "beautiful," in Burke's definition of the picturesque. As Uvedale Price, who owned a number of exceptional drawings by Rosa, wrote in his *Essays on the Picturesque* (1794): "In no other masters are seen such abrupt and rugged forms —such sudden deviations both in his figures and landscapes; and the roughness and broken touches of his pencilling admirably accord with the objects they characterize." The influence of such pictures on the development of English landscape gardening was immense. As early as the 1730s, William Kent was planting dead trees in Kensington Gardens to heighten the similarity to Salvator's landscapes, while the young Horace Walpole, traveling through the Alps with Thomas Gray, found a delicious horror in the "precipices, mountains, torrents, wolves, ramblings, Salvator Rosa. . . ." Later garden designers such as Capability Brown and Humphry Repton on the whole preferred the calmer compositions of Claude and Poussin, but Salvator Rosa continued to be imitated in more consciously literary settings like Thomas Shenstone's celebrated garden at The Leasowes in Worcestershire, and even inspired passages in Thomson's *Seasons* (Hussey 1967, 46, 66, 95, 130).

was almost certainly among those taken over at the earl's valuation by his creditors. It may well have been acquired by Thomas Coke, 1st Earl of Leicester (1697–1759), at this time.

Leicester's Grand Tour acquisitions—which included a fine group of *vedute* including several Vanvitellis (no. 184), pictures by contemporary Roman masters, and a notable series of old master drawings, in addition to the Leonardo Codex (now in the Hammer collection) and other manuscripts and books—were supplemented after his return to England by further acquisitions; by the time of his death in 1759 he had formed a collection commensurate with the scheme for his great house at Holkham.

Leicester's own role in the design of Holkham, in which he drew upon the services of Kent and Brettingham, has recently been stressed (Schmidt and Cornforth 1980, 214–217) and it is clear that his pictures were acquired quite specifically with a view to the decoration of the house which, although unfinished at his death, was to constitute his monument. Leicester's taste was in every sense Palladian, and Claude was evidently the painter he most venerated. He also owned notable landscapes by Domenichino and Rosa (no. 312) and major pictures by such contemporaries as Conca and Solimena. Apart from the Titian *Venus with a Lute Player*, sold in 1931 and now in the Metropolitan Museum, New York, Leicester's picture collection happily remains intact, although the arrangement at Holkham was modified by later generations and many of the early settecento pictures have been removed from the state rooms to the bedchambers in the family and Strangers' wings.

From an early date this picture—attributed to Poussin although recognized as by Dughet when in the Cholmondeley collection—was paired with an earlier classical landscape by Gaspard. The two may well be the Poussin landscapes listed in the "State Bedchamber Apartment," later the East Drawing Room, in 1760 and 1773. Smaller works by the artist were in the following room, the State Dressing Room (later the Landscape Room), with the celebrated collection of Claudes, the Domenichino, and works by Grimaldi and Orizonte. The *Storm*

was admired by early nineteenth-century visitors to Holkham: Mrs. Dawson Turner commented, "The clouds are enough to make anybody tremble, they are so loaded"; while in 1838 Waagen, who did not question the attribution to Poussin, described the picture as "full of poetry" and commented on the clarity of its tone.　　　　　F.R.

Provenance: George Cholmondeley, Viscount Malpas, later 3rd Earl of Cholmondeley, by 1728; probably Thomas Coke, 1st Earl of Leicester; at Holkham by 1773; and by descent
Literature: Brettingham 1773, 6; Dawson 1817, 107; Waagen 1838, 3:299; Waagen 1854, 3:421; Holkham 1913, 7, no. 185
Exhibitions: London, Kenwood 1980 (19)
Engravings: John Wood, 1742, in reverse

314

EMPEDOCLES LEAPING INTO ETNA
late 1660s
Salvator Rosa 1615–1673
oil on canvas
135 × 99 (54 × 38½)

Eastnor Castle
The Hon. Mrs. Hervey-Bathurst

Empedocles, the Sicilian philosopher and mystagogue, leapt into the crater of Mount Etna to confirm the belief that he had become a god: his fate was established when one of his slippers of bronze was cast up by the volcano. Rosa's source was Diogenes Laertius, VIII, 67–69. The subject was an unusual one and Rosa's development of it is documented by a series of twelve drawings, at Leipzig, Copenhagen, Edinburgh, Berlin, and elsewhere (Mahoney 1977, nos. 80, 1–12). Rosa also executed a reduced variant in pen and ink and

wash on a panel from a packing case: this is now in the Uffizi (Mahoney 1977, no. 80, 13). Both the drawings and the picture are of the late 1660s.

Few pictures represent more dramatically the facet of Rosa's art that appealed to his English audience in the late eighteenth and early nineteenth centuries. His *terribilità*, the tempestuous mood with which the painter's very name would become synonymous, so that Julia Mannering in Sir Walter Scott's *Guy Mannering* (chapter 17) could gush to her confidant that the scenery near Mervyn Hall had "All the wildness of Salvator here, and there the fairy scenes of Claude." Such a picture as John Martin's *The Bard* (Laing Art Gallery, Newcastle), illustrating Thomas Gray's Pindaric ode, owed its ultimate inspiration to models of this kind.

John, Lord Somers (1651–1716), the Whig Lord Chancellor (see no. 171), formed a large collection of pictures of

various schools. No inventory survives, but many pictures owned by his descendants, including Ter Brugghen's magical *Concert* (National Gallery, London) are thought to have been acquired by him. Many of the Somers pictures, including the Rosa, were re-framed about 1780. The collection was by no means a static one and Charles, 3rd Earl Somers (1819–1883), was to make substantial additions (see no. 557). F.R.

Provenance: Thought to have been owned by John, Lord Somers, and certainly in the possession of his descendant by c.1780 when many pictures in the collection were reframed in the same fashion; and by descent
Literature: Salerno 1963, 145
Exhibitions: Birmingham 1934 (278); London, Hayward 1973 (44)

315

ET IN ARCADIA EGO c.1629/1630
Nicolas Poussin 1594–1665
oil on canvas
101 × 82 (39¾ × 32¼)

Chatsworth House
The Trustees of the Chatsworth Settlement

This deeply poetic picture has long been recognized as a masterpiece of Poussin's early maturity and shows how haunted he was by his experience of the early mythologies of Titian and more specifically by the *Bacchus and Ariadne* (National Gallery, London), then in the Palazzo Aldobrandini, Rome. It is dated between mid-1629 and the latter part of 1630 by Mahon, and Blunt places it before 1631. Both this picture and its pendant, representing *Midas Washing at the Source of the Pactolus* (Metropolitan Museum, New York), were in the collection of Cardinal Camillo Massimi (no. 492) (Blunt 1966, no. 165). The title *Et in Arcadia Ego* is traditional and here retained for that reason: Blunt preferred *The Arcadian Shepherds* for both this and the later, more classical picture of the subject in the Louvre.

Although first certainly recorded at Devonshire House (see no. 247) in 1761, the picture may well have been acquired at an earlier date. The *Holy Family*, sold in 1981 and now owned jointly by the J.P. Getty Museum, Malibu, and Mr. Norton Simon, has hitherto not been documented in the collection earlier than 1766. It was seen at Devonshire House in 1728 (Fougeroux 1728, fol. 77), and was thus probably acquired by the 2nd Duke. That *Et in Arcadia Ego* was also in England well before the 1760s is suggested by the inclusion of a drawing of it in Thomas Hudson's portrait of the Hon. Elizabeth Yorke (d. 1760)—who in 1748 married Admiral Lord Anson—now at Crichel. The Louvre picture was also much admired in England: it inspired George Keate's poem *The Monument of Arcadia*, published in 1775, and a bas relief after the composition was executed by Scheemakers for Thomas Anson's garden at Shugborough F.R.

Provenance: Cardinal Camillo Massimi (d. 1677), by whom bequeathed to his brother Fabio Camillo Massimi; apparently sold in the late seventeenth century and acquired by Mme. de Housset, from whom it was acquired by her relation Loménie de Brienne; first recorded in the collection of the 4th Duke of Devonshire at Devonshire House in 1761; and by descent
Literature: Dodsley 1761, 2:227; Devonshire House 1813; Smith 1829–1842, 8: Poussin, no. 278; Passavant 1833, 71–72; Devonshire House 1836; Waagen 1838, 1:255; Hazlitt 1844, 199; Waagen 1854, 2:93; Strong 1901, no. 29; Blunt 1966, no. 119
Exhibitions: Paris 1960 (19); IEF 1979-1980 (31); Edinburgh 1981 (5)
Engravings: Ravenet, 1763 (Andresen 1863, no. 418)

316

THE VALKHOF AT NIJMEGEN
mid-1650s
Aelbert Cuyp 1620–1691
oil on canvas
101 × 147.3 (40 × 58)
signed, *A cuyp*

Woburn Abbey
The Marquess of Tavistock and the Trustees of the Bedford Estates

This celebrated picture shows the great fortress of the Valkhof at Nijmegen from the opposite bank of the Waal, the tributary of the Rhine that flows through Holland. Because of its strategic position on the last ridge of raised ground before the river reaches the more level plain of Holland, Nijmegen has been fortified since Roman times, and the same geological factors made it a favorite subject of Cuyp. A reduced version of this composition with different figures is in the John Herron Art Institute, Indianapolis. Reiss suggests that the picture may have been cut down by some two inches at the top.

Cuyp's fame in England was established by the great river landscape that was purchased by the 3rd Earl of Bute in or before 1764 through the agency of Captain William Baillie. However, Horace Walpole, in a letter to Sir Horace Mann, shows that one of the first pictures by the artist to attract attention in the saleroom was "a view of Nimeguen, a clear warm picture equal to Claude," which fetched 290 guineas in the sale of Sir George Colebrooke in 1774 (Lewis

1937–1983, 23:569). Colebrooke was a connoisseur of considerable stature who sold his collection because of the failure of his business. The picture was bought by Dr. Chauncey, himself a dealer-cum-collector, and it is tempting to identify it with the Woburn Cuyp, not least because Richard Rigby (1722–1788), in whose possession this is first certainly recorded, emerges as a patron of both Robert Adam and Reynolds in the same decade.

Originally in the circle of Frederick Prince of Wales, Rigby was the leader of the supporters of the 4th Duke of Bedford's interest in the House of Commons, and himself sat from 1754 to 1788 as MP for the Russell family's borough of Tavistock. In 1768 he received the remunerative office of Paymaster-General, which he was to hold until 1782. The duke's death in 1771 did not break Rigby's connection with the family, and it was for him that Reynolds painted his group of the duke's grandsons, Francis, 5th Duke (1765–1802), as Saint George, attended by his brothers, Lords John and William Russell, with their

LANDSCAPE WITH CATTLE RETURNING
HOME early 1770s
Thomas Gainsborough 1727–1788
oil on canvas
97.8 × 125.7 (38½ × 49½)

Bowood
The Trustees of the Bowood Collection

The composition suggests that the picture is the left-hand one of a pair of companion landscapes and Gainsborough is known to have given such a pair of pictures to his friend K.F. Abel (1725–1787) in exchange for a viola da gamba (Whitley 1915, 361–362). It has plausibly been identified with no. 47 in Abel's sale: "Evening, the companion, with a drove of cattle. and a shepherd and shepherdess, dogs &c." Abel was a native of what was then Bohemia, and a later owner of this picture, Mrs. Piozzi (whose fancies need not necessarily be believed) says, in a letter of 17 October (?1807) to her eldest daughter (Bowood MSS):—"The subject Cattle driven down to drink, and the first cow expresses something of surprise as if an otter lurked under the Bank. It is a *naked* looking landscape—done to divert Abel the Musician by representing *his* Country Bohemia in no favourable Light, & the dog is a favourite's Portrait." This picture is first certainly recorded at Bowood in 1844 (Jameson 1844, 323–324), but the 3rd Marquess of Lansdowne exhibited at the British Institution in 1814 (25) a Gainsborough "Group of Cattle, in a warm Landscape," which is otherwise unknown.

The big house at Bowood was demolished in 1955, but much of the picture collection formed by the 3rd Marquess of Lansdowne (1780–1863), who was also 4th Earl of Shelburne, is now displayed in what was the orangery of a subsidiary range of rooms known as the Diocletian Wing, built by Adam in 1768/1770. There had been an earlier picture collection, but when the 3rd Marquess inherited from his half-brother in 1809 "there was not a single picture in the family mansion, except perhaps a few family portraits" (Jameson 1844, 287).

E.K.W.

cousin, Miss Vernon as Sabrina, daughter of the King of Egypt, being rescued from the dragon.

Rigby's collection of pictures was small but evidently of high caliber. At his posthumous sale the 5th Duke acquired both this landscape and Cuyp's smaller *Landscape with Cavaliers Halted, One Sketching*, which cost 130 guineas. His brother and successor, the 6th Duke (see no. 544), who also admired Cuyp, purchased the *Skaters on the Maas*, one of his finest winter scenes. The exceptional caliber of the Woburn Cuyps was recognized by Waagen though he did not see the *View of Nijmegen*, and there is no house in which the painter's work can be seen to equal advantage.

In 1831 this picture was in the drawing room at Woburn, which was hung entirely with landscapes: its companions included a Claude, a pair of Gaspard

Dughets, and a Wilson. Later in the century, when the other Cuyps in the collection were taken to London, the view of Nijmegen remained in the house.

F.R.

Provenance: Probably Sir George Colebrooke; his sale Christie's, 23 April 1774, lot 47, bought for 290 gns by Dr. Chauncey; Richard Rigby, MP, his sale Christie's 9 January 1789, lot 16; bought for 250 gns by Holland, acting for the 5th Duke of Bedford; his brother, the 6th Duke of Bedford; and by descent
Literature: Parry 1831, 201; Woburn 1868, no. 335; Scharf 1877, 1888, and 1890, no. 367; Reiss 1975, no. 127
Exhibitions: London, BI 1818 (24); Manchester 1857 (710); London, RA 1950 (34); London, RA 1952/1953 (187); London, NG 1976 (30)

Related Works: Two early replicas, both probably copies, have appeared on the market as originals since 1949; and a small version, which has doubtfully been considered a study, is in a private collection

Provenance: Probably one of a pair of pictures presented by the artist to Karl Friedrich Abel; his sale, Greenwood, 13 December 1787, lot 47; Mrs. Piozzi, who was thinking of giving it to her second daughter, Sophia, on her marriage in 1807 to Henry Merrick Hoare (Balderston 1942, 2:1082*n*.); Anon. (A banker: ? Henry Merrick Hoare) sale by H. Phillips, 2 June 1815 (no. 18, "Landscape with cattle and figures—painted for Abel"); and by descent

Literature: Waterhouse 1958, no. 953; Hayes 1982, 2: no. 110 with previous literature

Exhibitions: London, Park Lane 1936 (128); Canada and Toledo 1957–1958 (18); London, Tate 1980–1981 (115)

318

CAERNARVON CASTLE c. 1744/1745
Richard Wilson ?1713–1782
oil on canvas
77.5 × 111.7 (31½ × 44)

Harwood
The Lady Elliot of Harwood

The first of the artist's pictures of Caernarvon and indeed the earliest of his identified Welsh landscapes, this is not conceived as a topographically accurate record, unlike the later picture of the castle apparently painted for James Brydges, Marquess of Caernarvon, later 3rd Duke of Chandos (London, Cardiff, and New Haven 1982–1983, no. 118). The greatest of the famous series of castles constructed for King Edward I in his conquest of Wales, Caernarvon was very far from being the ruin of Wilson's fantasy. Taking as his model the formula of the classical landscape evolved by Gaspard Dughet and imitated by earlier English painters including Sadler, Wootton, and Lambert, Wilson, who was always to remain conscious of his Welsh origins, set out to achieve a native counterpart. The process would be taken further, significantly after his Italian sojourn, in the *Caernarvon Castle* at Cardiff and the *Summer Evening* (*Caernarvon Castle*) of about 1764–1765 (Yale Center for British Art, New Haven; London, Cardiff, and New Haven 1982–1983, no. 115). In the latter, the Eagle Tower with its three turrets, the only major feature of the building recorded accurately in the present picture, is replaced by a simpler, round tower.

Sir Charles Tennant, 1st Bart. (1823–1906), a prominent Glasgow industrialist, was MP for the city in 1879–1880 and for Peebles and Selkirk in 1880–1886. A committed Liberal, he was a trustee of the National Gallery and formed a notable collection of pictures with the help of W. Morland Agnew who catalogued it in 1896. He acquired a couple of Dutch pictures and a Rosa Bonheur, but like other collectors of similar origin he was mainly interested in British painting—buying ten paintings by Reynolds, including his *Viscountess Crosbie*; works by Gainsborough and Romney; Hoppner's *Frankland Sisters* and other portraits; eight Morlands, a major Bonington, two Turners, and examples by Constable and Etty. Among contemporary painters he patronized Orchardson, Walker, and Millais, owning the latter's portrait of Gladstone. The collection was divided between Tennant's London house, in Queen Anne's Gate, where the "Tennant Gallery" was regularly opened to the public, and his Scottish Baronial mansion, The Glen, near Innerleithen. F.R.

Provenance: Sir Charles Tennant, 1st Bart.; his daughter the Hon. Mrs. Walter Elliot, created in 1958 Baroness Elliot of Harwood

Literature: Constable 1953, 173; Solkin in 1982–1983 exhibition catalogue, with previous literature

Exhibitions: London, Cardiff and New Haven 1982–1983 (7)

319

BARMSTON CHURCH AND OLD HALL
FROM THE SOUTH c.1762/1765
William Marlow 1740–1813
oil on canvas
71.1 × 114.3 (28 × 45)

Burton Agnes Hall
Marcus W. Wickham-Boynton, Esq.

The commissioning of this picture by
Sir Griffith Boynton (see no. 320) was
an act of family piety, for the compara-
tively modest building on the left is the
Old Hall at Barmston, near Bridlington,
where his Boynton ancestors lived until
1654, when they inherited Burton Agnes.
The building must once have been
larger, but the Jacobean range shown
by Marlow still survives with its
mullion-and-transom windows and its
huge chimney-breast at the back, on
which the stacks are set diagonally.
The little Norman church of All Saints,
with its Perpendicular windows, has
hardly been changed either, and still
contains some of the Boynton family
tombs. Marlow's treatment here is in
the manner of Ruysdael and Wynants,
with much care taken over the crumb-
ling surfaces of walls, the rock-strewn
path, and the gnarled oak trees that
frame the church. G.J-S.

Provenance: See no. 320.

320

PROSPECT OF BRIDLINGTON AND
FLAMBOROUGH HEAD c.1762/1765
William Marlow 1740–1813
oil on canvas
71.1 × 114.3 (28 × 45)

Burton Agnes Hall
Marcus W. Wickham-Boynton, Esq.

This picture and its companion (no.
319) come from a set of four view
paintings commissioned from the artist
by Sir Griffith Boynton, 6th Bart.
(d. 1778), and depicting buildings
connected with his family: Burton
Agnes Hall, built in 1601 by his ancestor
Sir Henry Griffith; Scampston Hall near
Malton, which belonged to his mother's

family, the St. Quintins; Barmston where the Boyntons originated; and Bridlington, then a small seaside town only a few miles from Burton Agnes, where he owned various properties.

William Marlow is thought to have been based in York between 1762 and 1765 (after which he spent three years in France and Italy), and certainly all the topographical pictures exhibited by him at the Society of Artists during these years were painted in the county. His architectural accuracy and mastery of perspective were learned during his apprenticeship to Samuel Scott, but he also studied at the St. Martin's Lane Academy and must have paid close attention to the work of both Richard Wilson and Vernet. This distant view of Bridlington is more concerned with Sir Griffith's broad acres than with the dramatic possibilities of the coastline and the 170-foot cliff of Flamborough Head beyond the town. G.J-S.

321

A WOODED LANDSCAPE WITH A
WATERFALL early 1650s
Jacob van Ruysdael 1628/1629–1682
oil on canvas
101.6 × 127 (39½ × 50½)
signed with monogram, *JR*

Bowhill
The Duke of Buccleuch and
Queensberry, KT

This wonderfully preserved masterpiece by a perennial favorite of English collectors dates from the early 1650s. It is one of a number of works from the period in which Ruysdael explored the compositional possibilities of a distant vista framed at either side by hills and trees. The way that the rock formations and vegetation on either side are brought so close to the spectator is exceptional, as is the beauty of the distant prospect.

How this picture entered the Buccleuch collection is uncertain. It may well be the "good Ruysdael" recorded in 1768 by Walpole (Toynbee 1927–1928, 66) in the gallery at Adderbury

in Oxfordshire, the house rebuilt by John Campbell, 2nd Duke of Argyll and 1st Duke of Greenwich (1680–1743), and inherited by his elder daughter, Caroline, Countess of Dalkeith, mother of the 3rd Duke of Buccleuch. Argyll must have owned a distinguished collection, for he was included in the list of those whose pictures Gambarini planned to engrave in 1731 (Vertue 1930–1955, 19). Other pictures from Adderbury are known to have been taken to Dalkeith Palace near Edinburgh, where the Ruysdael is first certainly recorded in the possession of the 5th Duke of Buccleuch in 1835. The duke was a notable collector, particularly of French furniture and English miniatures (see nos. 86 and 76), but he also acquired many pictures. At the

Stuart of Dunearn sale in 1829 he was rash enough to ask Sir Walter Scott to act for him and thus lost the opportunity to acquire the *Avenue at Middelharnis* (National Gallery, London) by Ruysdael's closest rival, Hobbema, for Scott considered this "fitter for an artist's studio than a nobleman's collection" (Grierson 1932–1937, 11:121).

At Dalkeith the picture was hung in the gallery, with landscapes of similar format by Claude and Vernet and a number of early portraits. F.R.

Provenance: Possibly John, 2nd Duke of Argyll, and at Adderbury in 1768; at Dalkeith, in the collection of the 5th Duke of Buccleuch, by 1835; and by descent
Literature: Smith 1829–1842, 4:89, no. 283; Waagen 1854, 3:313; Stuart 1890, 48; Dalkeith 1911 (176); Slive in The Hague and Cambridge, Mass., 1982, with previous literature
Exhibitions: London, Agnew 1978 (37); The Hague and Cambridge, Mass., 1982 (15)

Provenance: Comte de Pourtales, Phillips, London, 19 May 1826, lot 59; Horatio Walpole, 3rd Earl of Orford, Wolterton Hall; his posthumous sale, Christie's, London, 26 June 1859, lot 276, bought for 380 gns by Charles Pascoe Grenfell, of Taplow Court; by descent to his grandson, William Henry Grenfell, 1st Lord Desborough (d. 1945); his younger daughter Imogen, Viscountess Gage, by whom taken to Firle
Literature: Waagen 1854, 3:436; Gerson 1935, no. 56
Exhibitions: Manchester 1857 (703); London, RA 1878 (314)

323

VIEW OF WEST WYCOMBE PARK 1781
Thomas Daniell 1749–1840
oil on canvas
70 × 109.2 (27½ × 43)

West Wycombe Park
Sir Francis Dashwood, Bart.

The south front and east portico of West Wycombe Park, shown here, were built by Sir Francis Dashwood, 1st Bart., later Lord le Despencer, in the early 1750s, possibly to his own designs though these were executed by an architectural draftsman named John Donowell. The double colonnade is rare in being based on one of Palladio's town houses, the Palazzo Chiericati in Vicenza, rather than on one of his villas, while the portico is a replica of those on the wings at Mereworth in Kent (which belonged to Dashwood's uncle, the 7th Earl of Westmorland), designed by the Palladian architect Roger Morris. The building at the left is the Temple of Apollo, also known as the Cockpit Arch, since the room above it is supposed to have been used for cock fighting, and on the hill behind the house can be seen the tower of West Wycombe Church and the mausoleum, also built by Donowell.

Thomas Daniell's view of West Wycombe encapsulates the aims and ideals of the "Picturesque" movement in English landscape gardening. The four facades of the house, all quite different in character, are screened from each other by the planting and are thus

322

AN EXTENSIVE LANDSCAPE WITH A WINDMILL 1655
Philips Koninck 1619–1688
oil on canvas
130 × 165 (51½ × 64½)
signed and dated, *P. Koninck 1655*

Firle Place
The Trustees of the Firle Estate Settlement

This characteristic panoramic landscape is a masterpiece of the painter's full maturity. Koninck's work was admired by British collectors from the mid-eighteenth century. Dr. Hunter acquired the magnificent example now in the Hunterian Museum, Glasgow, and the 2nd Viscount Palmerston owned two works by the artist. By the mid-

nineteenth century a high proportion of his larger pictures were in Britain, both in the aristocratic collections— Westminster or Derby—and in those of newer families. Thus the banker Lord Overstone bought the great picture now in the Crawford collection, while a similar work was acquired by another prominent banker, Sir Charles Mills. The Firle picture was admired by Waagen when in the collection of Horatio Walpole, 3rd Earl of Orford of the second creation (1783–1858). Lord Orford had a predilection for landscapes, acquiring the celebrated Rubens *Landscape with a Rainbow* (Wallace Collection) for 2,600 guineas in 1823. When his pictures were sold in 1859, the Rubens was bought by the Marquess of Hertford, whose agent Samuel Mawson had mentioned the Koninck in his letter of 10 May

announcing the sale (Ingamells 1981, 86). Hertford was evidently not interested in the picture, which was bought by Charles Pascoe Grenfell (1790–1867) probably because it was so similar in size to the *Landscape with a Ruin* of the same year that he had purchased at the Granville sale in 1845 for 500 guineas (this was acquired by the National Gallery, London, in 1971). Grenfell, whose fortune was based in Cornish copper mines, was the brother-in-law of Charles Kingsley and the historian J.A. Froude. Taplow Court, his house overlooking the Thames in Buckinghamshire, was remodeled by William Burn in 1855, the entrance front in the early Tudor style with Jacobean strapwork, while the garden front was inspired by French Gothic taste. At least one of the Konincks was hung in the hall. F.R.

viewed more as a series of garden buildings or "eyecatchers" than as a single architectural entity. During a walk round the grounds these would constantly re-group with other buildings and vistas to form a series of "pictures," like the landscapes of Claude and Rosa brought to life. The fact that the columns on the south front are of timber rendered with plaster, rather than of stone, is a measure of this stage-set character. The west portico or entrance front, added in 1770 by one of the pioneers of neo-classicism, Nicholas Revett, was rather more substantial. But even this was always known as the Temple of Bacchus after its prototype, the temple at Telos, and its dedication in 1771 was an excuse for a *fête champêtre* in which Sir Francis and his friends, dressed as "Bacchanals, Priests, Priestesses, Pan, Fauns, Satyrs, Silenus &c all in proper habits & skins wreathed in vine leaves," sacrificed to the god and then repaired to the lake for more "Paeans and libations" and "discharges of cannon" from several boats.

The landscape at West Wycombe was first laid out along semiformal lines, probably by a Frenchman, Maurice-Louis Jolivet, who signs a survey of the gardens dated 1752. Their completion about this time was also commemorated by a series

of four paintings by the Scottish artist William Hannan, of which many copies and engravings exist. Thomas Daniell's four views, exhibited at the Royal Academy in 1781, the year before Lord le Despencer's death, were evidently commissioned as a companion set recording the softening and "naturalizing" of the landscape in the 1770s, under the direction of Thomas Cook, a pupil of Capability Brown. Daniell's early topographical pictures, especially of Yorkshire, show a conventional debt to Claude and Ruysdael, but apart from a view of Blenheim dated 1783, he is best remembered for the paintings and aquatints of India conceived during the nine years he spent there with his nephew William, from 1785 to 1794. G.J-S.

Literature: Oswald 1933, 470, fig. 7; Jackson-Stops 1974, 1618–1621, figs. 3, 6; Harris 1979, 162, fig. 207

324

A VIEW OF MR. CLAYTON'S HOUSE AT HARLEYFORD 1760
Francesco Zuccarelli 1702–1788
oil on canvas
58.5 × 89 (23 × 35)

Squerryes Court
John St.A. Warde, Esq.

Harleyford Manor, on the Thames near Marlow in Buckinghamshire, was built in 1755 for William Clayton, later 3rd Bart., by Sir Robert Taylor, and was one of the most accomplished villas of its date. Zuccarelli places the house correctly in relation to the river but the landscape is otherwise fanciful. Only one other view of a house by the artist is recorded, a "view of a mansion and surrounding country" that was presumably painted for Lord Tylney and was in the Wanstead sale, 21 June 1822, lot 289. Zuccarelli occasionally painted English landscapes—an example is the large *View in the Lake District*, done for Sir James Lowther (Christie's, 15 July 1983, lot 34, now London, private collection)—but most of his patrons in England, where he worked intermittently in 1752–1762 and 1764–1771, commissioned *capricci* of the kind he had painted when in Venice.

There are pentimenti in the figures near the house, and the elegant couple on the lawn no doubt represent the owner and his wife.

This picture was commissioned by John Warde (1721–1775), Clayton's brother-in-law, who had in 1746 inherited Squerryes Court in Kent, purchased by his father fifteen years earlier. A man of many interests, he sat for Arthur Devis in 1749 and commissioned Stubbs to paint the Arab stallion he had purchased in Alexandria in 1762. He was also a collector and kept a manuscript *Catalogue of Pictures of my own collecting*, which remains in the house. This picture was entered in 1760 as item 64, "A view of Mr. Claytons House at Harleyford done for me by Zuccarelli £15–15–0" (Squerryes Court MSS; I am indebted to Mr. Warde for transcribing this). Of the ninety-three pictures Warde acquired, at a total cost of £692 8s., some fifty-five remain at Squerryes. Most were bought in the saleroom although Warde occasionally went to such dealers as Collivoe. He bought two major Luca Giordanos, which had been acquired in Italy by the dealer William Kent, for 18 guineas and 27 guineas, but had a particular taste for Dutch pictures, acquiring works by Van Goyen, Egbert van Heemskerck,

Hondecoeter, Jacob Ruysdael, Steenwijk, and other masters of the seventeenth century. Despite the loss of the great Frans Hals portrait group now in the Thyssen collection, the pictures at Squerryes offer an unusually balanced insight into the taste of a collector whose background was mercantile rather than aristocratic. For it was Warde's policy of building up the small estate he inherited at Squerryes that established his family's position in the county.

<div align="right">F.R.</div>

Literature: Harris 1979, no. 304
Exhibitions: London, RA 1960 (168)
Engravings: Thomas Major

325

ROCKY SCENE WITH A WATERFALL
c.1772
Joseph Wright of Derby 1734–1797
oil on canvas
80.7 × 109.2 (31$\frac{7}{8}$ × 43)

Radburne Hall
Major and Mrs. J.W. Chandos-Pole

This is the only pure landscape to survive from before Wright's Italian journey of 1773–1775. Its character is compellingly described by Nicolson: ". . . In the one pure landscape, showing a waterfall among rocks in his native Midlands, uninhabited except for three tiny *banditti* armed with spears, no attempt is made to tidy up the barbarity of nature, but the vision is rushed down on to canvas in all its incoherence, and yet makes a coherent picture. Wright had noted similar effects in the land-

scapes of Salvator Rosa he had inspected in English private collections, but the decorum of contemporary art is brushed aside in order to preserve the wildness intact. Nothing in his own work is quite comparable to this, and we recall few examples of the kind in British painting before the early nineteenth century." (Nicolson 1968, 75).

Wright's experience of Italy, above all of Naples, was to transform his conception of landscape, and his new-found vision of the south would also leave its mark on his later views of Dovedale and Matlock in Derbyshire, and of the more distant Lake District.

This picture, omitted from Wright's account book perhaps because it was not painted specifically for sale, was no doubt acquired by his patron Colonel Edward Sacheverell Pole (1718–1780) of Radburne. Pole, who had been Colonel of the 23rd Regiment of Foot, inherited the house in 1765 from his uncle German Pole, a landowner with Jacobite sympathies who built the present house. His own contribution was to commission a series of pictures for the Saloon. In 1771 Wright supplied the full-length of Pole's wife, Elizabeth, natural daughter of the 2nd Earl of Portmore, with their son Sacheverell, and Pole himself sat for a smaller portrait for the overmantel in 1772, choosing to be painted in mid-seventeenth-century armor, presumably in allusion to his uncle's sympathy for the Stuart cause. Wright also painted a series of four candlelit genre scenes as overdoors, while Pole turned to John Hamilton Mortimer for large canvases of Belisarius and Caius Major, exhibited in 1772 and 1774 respectively, and a smaller allegorical overdoor. Although Wright did not become a friend of Colonel Pole, as was the case with some of his other clients, the landscape may well have seemed a suitable gift to a patron who paid him a total of 200 guineas in 1771–1772.

<div align="right">F.R.</div>

Literature: Nicolson 1968, no. 328
Exhibitions: Possibly London, Society of Artists 1772 (371, as "A Landscape")

326

SUNSET ON THE COAST NEAR SALERNO
c. 1785/1790
Joseph Wright of Derby 1734–1797
oil on canvas
63.5 × 75.9 (25 × 29⅞)

Private Collection

This characteristic late work by
Wright is no doubt a reminiscence of
the coast near Naples and Salerno,
which he visited in 1774, although it
was evidently not intended as a strictly
topographical record. In 1783 Wright's
account book records a payment of
14 guineas toward a picture described
as "Sun Set in the Bay of Salerno": this
was evidently smaller but may well have

been of related composition. A similar
view by moonlight was in the Holden
collection at Nuthall Temple,
Nottinghamshire.

The success of Vernet and other
artists including Carlo Bonavia in
painting generalized Neapolitan coastal
scenes had established a market for
such works, which Wright was not alone
in exploiting. Nonetheless it was
unprecedented for an English artist
based in a provincial town to secure
regular patronage for pictures of this
kind. For even after Wright returned to
England, he continued to paint Italian
subjects, sometimes paired with local
scenes as with the *Convent of San Cosimato*,
painted with the pendant *View in Dove
Dale* for Thomas Gisborne in 1786 and

now at Kedleston. Those who purchased
Italian landscapes from Wright included
Sir Brooke Boothby, Edward Mundy,
and Sir Robert Wilmot, all of whom
owned substantial houses in Derbyshire.

F.R.

Provenance: Ralph Rowbotham, 1934;
purchased by the present owner,
himself a descendant of one of the
artist's patrons, c. 1950
Literature: Nicolson 1968, no. 284
Exhibitions: Derby 1934 (104); Derby
1947; Arts Council 1958; Nottingham
1964; Munich 1978

327

THE FAMILY OF JOHN, 3RD DUKE OF
ATHOLL 1765/1767
Johan Zoffany 1733–1810
oil on canvas
93.5 × 158 (36¾ × 62½)

Blair Castle
The Duke of Atholl

The picture shows John Murray, 3rd
Duke of Atholl, KT (1729–1774), with
his wife and children. The Duchess, born
Lady Charlotte Murray (1731–1805),
was also his first cousin, and, on the
death of her father the 2nd Duke, in
January 1764 inherited the Barony of
Strange and the Kingship of the Isle
of Man. John, Marquess of Tullibardine,
later 4th Duke (1755–1830) (see no.
535) holds a fishing rod in emulation of
his father's gun, and a fish; Lord James
Murray (1757–1770) perches in the
apple tree, at the foot of which is Lord
George (1761–1803), inventor of the
shutter telegraph (and ancestor of the
present duke), who touches the hand of
his younger brother, Lord William
(1762–1796), still in his infant's clothes.
Next to their mother, their elder sister
Lady Charlotte (1754–1808) holds a
wreath of roses, while Lady Amelia
(1763–1806) sits on the ground: on their
mother's lap is the youngest of the
children, Lady Jane (1764–1846). The
animal in the tree was intended to
represent a raccoon named Tom, sent
by Captain, later Admiral James
Murray, the duke's brother, from the
West Indies: he had a special cage at
Blair but as Zoffany did not visit the
house he mistakenly depicted a lemur
in his place. The family are shown in
the "policies" (grounds) of their house
at Dunkeld beside the River Tay, with,
in the distance, the pillar the duke
erected in the summer of 1764 on Craig
Vinian, which still forms part of the
estate. The artist must have used
drawings of this setting supplied by
the duke. There are pentimenti in the
legs of the duke and Lord Tullibardine,
and in the swan: a second swan to the
left of this was suppressed by the
painter.

The duchess' father, the 2nd duke,
first considered remodeling Blair in the
1720s. John Douglas submitted a

Palladian scheme in 1736 and in 1743–1744 James Winter built a new stable block. The Castle was damaged in 1746, when besieged by Jacobite forces commanded by the duke's brother Lord George Murray. The fabric was remodeled by Winter in 1747–1758, but the decoration of the major rooms was entrusted to other craftsmen. Work on the Great Drawing Room was carried out in 1754–1758 (Oswald 1949, 1437) and the Zoffany was painted for the overmantel of the marble chimneypiece, supplied from London by Thomas Carter. The Atholls visited London in the winter of 1764–1765 to negotiate the sale of the Sovereignty of the Isle of Man for which the government was to pay £70,000 with a grant of £2,000 a year for their lives: Zoffany received his first payment in June 1765 and, as Webster points out, must have finished

the heads and laid in the figures and draperies before the family went back to Scotland in August. The elder boys were at school in Kensington in January 1766 but the rest of the family did not return to London until early November. The picture was finished by 16 January 1767 when Zoffany signed the receipt for the final payment, bringing the total to 180 guineas. At the same time Atholl was in correspondence with John Mackenzie of Delvine about earlier family portraits that had been taken from Huntingtower in his grandmother's time. Mackenzie commented, "family pictures are fixtures rather than household plenishing," and although it apparently proved impossible to recover these (Atholl 1908, 4:28), such references suggest the dynastic importance the duke attached to ancestral portraits.

F.R.

Literature: Webster in London, NPG 1977
Exhibitions: London, RA 1930 (6); London, RA 1954–1955 (123); Arts Council 1960 (12); London, NPG 1977 (31)

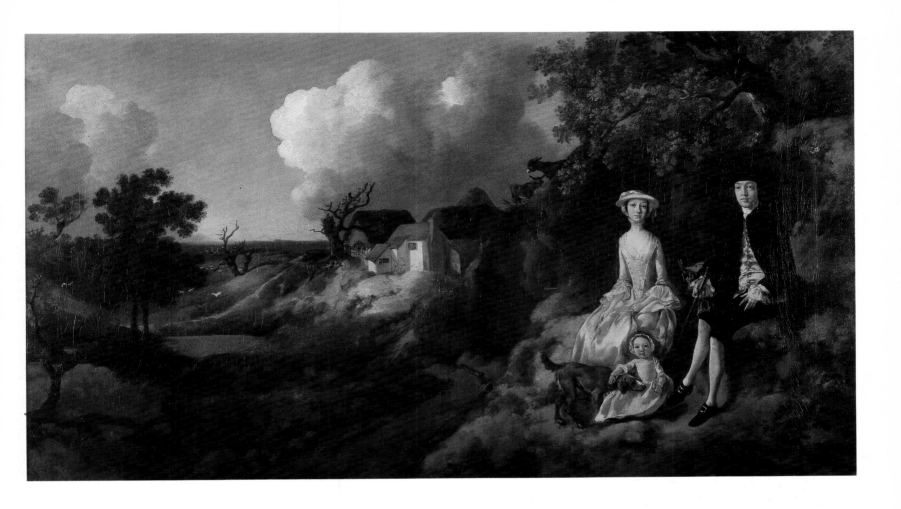

328

MR. AND MRS. BROWNE OF TUNSTALL
c.1754–1755
Thomas Gainsborough 1727–1788
oil on canvas
83.8 × 141 (33 × 55½)

Houghton Hall
The Dowager Marchioness of
Cholmondeley

John Browne is thought to have been a
wool merchant at Ipswich, and owned
property at Tunstall, near Wickham
Market, in Suffolk. His wife was Eliza-
beth Kilderbee, sister of Gainsborough's
lifelong friend Samuel Kilderbee (1725–
1813). The little girl is presumably their
elder daughter, Anna Maria (born 1753),
which provides the date for the picture.
The landscape, if not fanciful, is likely

to be in the neighborhood of Tunstall.

This picture is perhaps the most
enchanting of the half dozen or so por-
traits of Suffolk friends or neighbors, at
ease in the local landscape, painted by
the young Gainsborough at the outset
of his career. They were entirely novel
but seem to have been considered
"provincial" and were not accepted in
fashionable circles.

The original picture collection at
Houghton, formed by Sir Robert
Walpole, 1st Earl of Orford (1676–
1745), and one of the most famous in
England (see no. 349), was sold by his
irresponsible grandson to the Empress
Catherine of Russia in 1779 for £40,555.
This picture has only entered the
collection in the present century,
together with a self portrait by Gains-
borough of 1754, and a slightly earlier

painting of the artist with his wife and
daughter, again depicted in a Suffolk
landscape. E.K.W.

Related Works: The only related picture,
in both style and format, is the *Mr. and
Mrs. Robert Andrews* in the National
Gallery, London
Provenance: Passed from Mr. and Mrs.
Browne to the child in the picture,
Anna Maria Browne (1753–1795), who
in 1780 married the Rev. Nicholas
Bacon, Vicar of Coddenham; they died
without issue and the picture passed to
Mrs. Bacon's half sister, Charlotte, who
married the Rev. John Longe, also Vicar
of Coddenham; by descent through the
Longe family at Spixworth Park until
the Francis B. Longe sale, Christie's,
London, 27 July 1917, lot 141; Agnew;
Viscount d'Abernon; from whom

bought by Sir Philip Sassoon, Bart.,
1929; inherited 1939 by Mrs. David
Gubbay; from whom acquired by Sybil,
Marchioness of Cholmondeley (sister of
Sir Philip Sassoon) about 1947
Literature: Duleep Singh [1927], 2:306,
Waterhouse 1958, no. 86
Exhibitions: London, 25 Park Lane 1930
(141); London, RA 1934 (269); London,
45 Park Lane 1936 (99); Paris 1938
(224); Arts Council 1946 (18); London,
Agnew 1959 (19)

11: The Country House Library

Books were of the greatest importance to the English country gentleman in the eighteenth century. His classical education was at the root of his appreciation for the art of antiquity, just as much as his belief in political liberty. Some of the greatest English philosophers and writers, Hobbes, Locke, Pope, Gibbon, and Burke, were *habitués* of the country house, and this familiarity with men of letters in turn encouraged scientific enquiry and intellectual pursuits, even in the heartiest of sporting squires.

Among the earliest book collectors of importance were Lord Lumley, whose famous illustrated inventory of his possessions (no. 346) formed part of a collection of over a thousand volumes, and William Cecil, Elizabeth I's secretary of state, whose annotated atlases survive at Burghley, showing the discoveries of the seafarers under his protection. It was only toward the end of the seventeenth century, however, that books began to be gathered in one room, usually occupying the place of the gentleman's closet, like the Duke of Lauderdale's library at Ham and, later on, Sir Robert Walpole's at Houghton. The huge collections put together by Lord Harley at Wimpole and Thomas Coke at Holkham needed greater space, and these instead assumed the form of long galleries, designed respectively by James Gibbs and William Kent. This precedent was later followed by Robert Adam at Syon, and by Sir Christopher Sykes at Sledmere, who housed his famous library in a gallery based on the Roman Baths of Titus and Caracalla and with neoclassical plasterwork by Joseph Rose the younger complementing the writings of Greek and Roman authors on the shelves below.

Other bibliophiles of Horace Walpole's generation were becoming aware of Britain's own literary heritage, from Piers Plowman and Chaucer to Shakespeare and Ben Jonson—associating it with the triumphs of English Gothic architecture. Walpole's own library at Strawberry Hill, based on medieval tombs and doorcases, and Sir Roger Newdigate's at Arbury (no. 329) demonstrate this revival of antiquarianism, which resulted in a fashion for "Gothick" interiors even in houses which were predominantly classical. A typical mid-eighteenth-century library like Lord Warrington's at Dunham Massey contained sections on architecture and topography, natural history and botany, politics and philosophy, theology, literature, music, and genealogy—with illuminated family trees, like the Dorney Court pedigree (no. 347) playing an important role. Elaborate armorial bindings and bookplates were commissioned, and some owners like William Windham of Felbrigg themselves became proficient bookbinders. Manuscripts and family papers kept in cupboards or adjoining muniment rooms contained designs for landscapes by Capability Brown and Humphry Repton, watercolors and sketchbooks, Grand Tour maps and guides, and the occasional treasure such as the Haydn manuscript of a march commissioned by a country house owner for his volunteers (no. 357). As well as books, libraries also contained busts of philosophers or literary worthies (often a mixture of modern British and ancient classical authors), globes and telescopes, orreries and armillary spheres, and more esoteric scientific instruments like those which belonged to William Constable, the friend of Voltaire and Rousseau, still to be found at Burton Constable. Libraries in some of the greater houses like Chatsworth and Wilton had collections of Old Master prints and drawings, kept for inspection in solander boxes, but seldom framed and hung.

The collecting of rare books and foreign bindings of the past, as opposed to the building up of "working libraries," developed gradually in the eighteenth century and reached a peak in the nineteenth with the sumptuous libraries at Longleat (particularly rich in Caxtons), Alnwick, Chatsworth, and Elton. Like the reading rooms of luxuriously appointed London clubs, these interiors, increasingly planned as living rooms, give a sense of warmth and comfort that sums up a very English attitude to culture, already found in Hogarth's Malpas group (no. 163) a hundred years earlier: not as something remote and chilly to be acquired as a means to social or political advancement, but a natural and enjoyable propensity to learn about life in all its aspects.

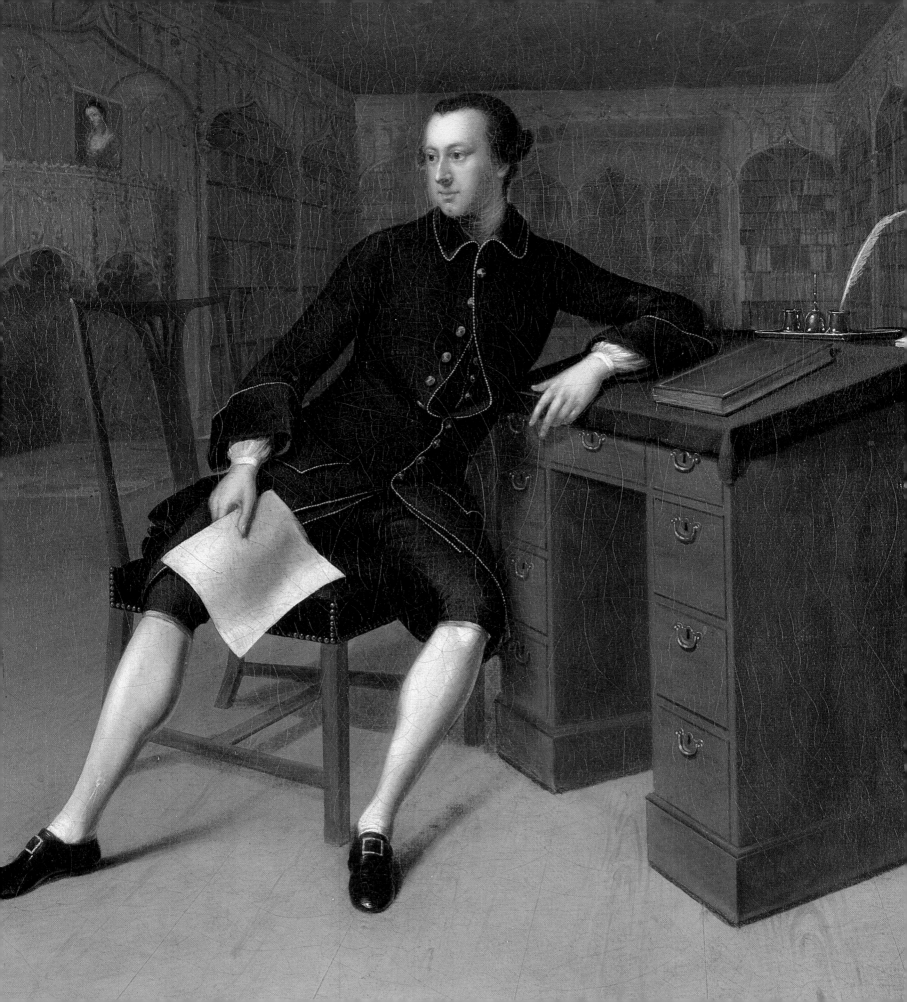

329

SIR ROGER NEWDIGATE IN THE
LIBRARY AT ARBURY HALL
1756/1758
Arthur Devis 1712–1787
oil on canvas
89 × 76.2 (35 × 30)

Arbury Hall
The Trustees of the Newdegate
Settlement

Sir Roger Newdigate, 5th Bart. (1719–
1806), was the seventh son of Sir
Richard Newdigate, 3rd Bart., and
inherited Arbury in Warwickshire at
the age of 15 in 1735. His ancestor,
John Newdigate, a cadet of the ancient
family of Newdegate, which was estab-
lished at the village of the same name in
Surrey by the time of King John, had
acquired Arbury in 1586. Roger
Newdigate went on the Grand Tour in
1738–1740 and was to become a con-
siderable expert on classical antiquities,
presenting two great antique candelabra
restored by Piranesi to Oxford Univer-
sity, where he was to endow the
Newdigate Verse Prize. At a time when
most great collectors were Whigs, Sir
Roger was a high Tory of the old school:
in 1741–1748 he was MP for Middlesex
where he had considerable estates and
from 1750 until 1780 he represented
Oxford University, whose unswerving
loyalties to the Church of England he
himself shared.

Such political sentiments and his
friendship with the architect Sanderson
Miller partly explain Newdigate's
Gothick rebuilding and redecoration of
Arbury, which this picture commem-
orates so specifically—for he is shown
holding a plan of the altered house and
seated in the library. Work on this room
was begun in 1754 and it was fitted up
a year later by William Hiorne, who
had been employed at Arbury inter-
mittently since 1748. The plasterer was
Robert Moor and the carver Benjamin
King. Devis, whose backgrounds are
usually imaginary, records Hiorne's
scheme with remarkable precision: the
canopied chimneypiece with its ogival
arches, its trefoils, pinnacles, and frieze
of animal heads, and the elaborate dec-
oration of the walls. The library desk,
so simple by contrast, which was evi-
dently supplied at the same time and
has been attributed to Chippendale, is
still in the house.

On 3 May 1756 Newdigate recorded sitting for the portrait at "Davies's" in his diary and on 10 May 1758 he sat to "finish it." Two years earlier he had paid 20 guineas for a lost double portrait with his first wife, Sophia, daughter of Edward Conyers, MP, of Copt Hall (D'Oench 1980, no. 121). Newdigate's selection of Devis, himself of Tory leanings, was no doubt due to his connection with other patrons of the painter: Mrs. John Lockwood, the sister of his first wife, sat for Devis who also worked for Edward Mundy of Allestre, whose daughter Hester was to become Sir Roger's second wife; while his Middlesex neighbor James Clitheroe, who was portrayed with his wife by Devis in 1759, was a close political associate. In 1762 Devis evidently visited Arbury, for he was paid 40 guineas for "fitting up the Pictures" in the "Parlor," now the drawing room (Nares 1953, 1211). His role was to enlarge a series of family portraits to fill the arched panels that echo the presses of the library, and set off the antiquarian detail of the chimneypiece, inspired by Aymer de Valence's tomb in Westminster Abbey.

Despite its small dimensions, this curiously provincial portrait of an informed amateur, posed rather self-consciously in the room that was so central to his existence, and holding the plan of the house that was to engage so much of his attention for over half a century, is one of the quintessential documents of eighteenth-century taste.

F.R.

Provenance: Painted for Sir Roger Newdigate, 5th Bart.; his heir, his first cousin once removed, Francis Parker, who assumed the name of Newdigate (d. 1833); his great nephew, Charles Newdegate, MP; the latter's cousin General Sir Edward Newdigate-Newdegate; his nephew Sir Francis Newdigate-Newdegate (d. 1936); his daughter the Hon. Mrs. E.A. FitzRoy Newdegate; Arbury was made over in 1950 to Mr. Humphrey FitzRoy Newdegate
Literature: D'Oench 1980, no. 120
Exhibitions: Birmingham 1934 (243); Birmingham 1953 (15); London, RA 1955–1956 (305); Preston and London, NPG 1983 (38)

330

XII CAESARES [and other works]
Venice, Aldus, 1521
C. Suetonius Tranquillus
2nd century AD
binding by Claude de Picques for Jean Grolier
octavo; dark green goatskin over paste boards
17.3 × 10.8 (6¾ × 4¼)

Blickling Hall
The National Trust (Lothian Collection)

Jean Grolier was born in Lyon, probably in 1479, the son of Etienne Grolier, the treasurer of the army in the Duchy of Milan, a post the young Grolier occupied from his father's death in 1509 until 1520. After his marriage in 1520, he settled in France and spent most of his life in Paris. In 1532, he became one of the Treasurers of France, and died in 1565. He was one of the most distinguished book collectors of his time, and his library is famous for the quality of the bindings which he commissioned for it. For about ten years, from 1538, Grolier employed the Parisian binder Claude de Picques, and the binding on the Blickling Suetonius probably dates from early in their association. This edition, like the one of 1516, was dedicated by the editor, G.B. Egnazio, to Grolier himself. The collector's name appears on the front cover, and on the back cover, his motto: *PORTIO MEA DOMINE IN TERRA VIVENTIUM.*

De Picques was born about 1510, and was established as a bookseller by 1539. By 1559, he was known as binder to the king, and it would appear that the work involved in this post caused his other clients, such as Grolier, to move on to other binders.

This example was an early arrival in England, following the dispersal of Grolier's library at the end of the seventeenth century, and was acquired by Sir Richard Ellys (1688–1742), 3rd and last Baronet of Nocton in Lincolnshire, a celebrated bibliophile. He in turn bequeathed his collections to his second cousin John Hobart, 1st Earl of Buckinghamshire, the owner of Blickling Hall in Norfolk. It was Lord Bucking-

hamshire's great-great-grandson, the 8th Marquess of Lothian, who remodeled the Jacobean long gallery at Blickling—transformed into a library in the eighteenth century—remodeling the bookcases to designs by the Arts and Crafts architect John Hungerford Pollen, in 1860–1861. This most spectacular of country house libraries now contains not only Ellys' books, but others from Gunton in Norfolk, bequeathed by the marquess' great-uncle, Lord Suffield, and some purchased by the marquess himself. Despite the sale of a few valuable items there are still approximately 12,000 volumes on the shelves, a large proportion of them published before 1700, and including some great rarities.

N.P.

Provenance: "Claudii Gueyte et Amicorum"; J. Bridges sale, 7 February 1726, lot 2644; Sir Richard Ellys; bequeathed to the 1st Earl of Buckinghamshire; and by descent at Blickling
Literature: Nixon in London, BM 1965
Exhibitions: London, NBL 1958 (88)

331

STUDIES OF SAINT JOHN THE BAPTIST
AND OF A SUPPLIANT c.1450/1455
Andrea Mantegna 1431–1506
pen and brown ink on pink prepared
paper
17.4 × 18 (6⅞ × 7)

Private Collection

Attributed in the seventeenth century to Giorgione, this drawing is one of a small group that has until recently been claimed both for Bellini and his brother-in-law Mantegna, but is now generally accepted as being by the latter and comparable in date with the frescoes of the Eremitani at Padua.

The attribution to Bellini was first made by Padre Sebastiano Resta, when it was among the sixteen volumes of drawings that he assembled for Monsignor Marchetti, Bishop of Arezzo (d. 1704). The sheet bears the number *g. 128* in Padre Resta's hand, and the entry under this number in his inventory in the British Museum (Lansdowne MSS 802) reads: "lo stimano di Giorgione, io dubito che sia de Gio. Bellini." The bishop's collection was offered for sale by his nephew in 1710 (as John Talman, son of the architect, reported to Dean Aldrich) for the equivalent of £750, and was purchased by John, Lord Somers (see no. 314). John, 2nd Earl Spencer, who owned the drawing later in the century, was a connoisseur of considerable distinction and formed a notable collection of drawings, strong in its representation of both the Italian and the Northern Schools.

William Roscoe, the Liverpool banker, in whose possession the drawing is subsequently recorded, was a pioneer in his taste for primitives, and part of his collection of early Italian pictures survives in the Walker Art Gallery, Liverpool. The fact that he did not use a collector's mark has meant that his role as a connoisseur of drawings has been largely overlooked—and his ownership of this drawing has not previously been recognized. Roscoe's collection was wide in range but included an exceptional number of drawings of the quattrocento, including another drawing then attributed to Mantegna, the ex-Gathorne-Hardy *Study of a Bird* now in the National Gallery, Washington. The drawing shown here was bought with 138 other items at Roscoe's sale in 1816 by Charles Robert Blundell, who inherited a major collection of pictures from his father, partly built up on Roscoe's advice (see no. 295), but himself bought all the old master drawings formerly at Ince Blundell. F.R.

Provenance: From the collection formed by Padre Sebastiano Resta for Monsignor Giovanni Matteo Marchetti, Bishop of Arezzo (d. 1704); his nephew Cavaliere Marchetti, by whom offered for sale in 1710; sold to John, Lord Somers (d. 1716), and dispersed at his sale, Motteux, London, 16 May 1717; George John, 2nd Earl Spencer, with his collector's mark (Lugt 1530); William Roscoe, his sale, Winstanley, Liverpool, 24 September 1816, part of lot 238, as Giorgione, bought for 19s. by Ford, for Charles Robert Blundell of Ince; and by descent, as no. 295
Exhibitions: London, RA 1960 (516); Venice 1980 (5)

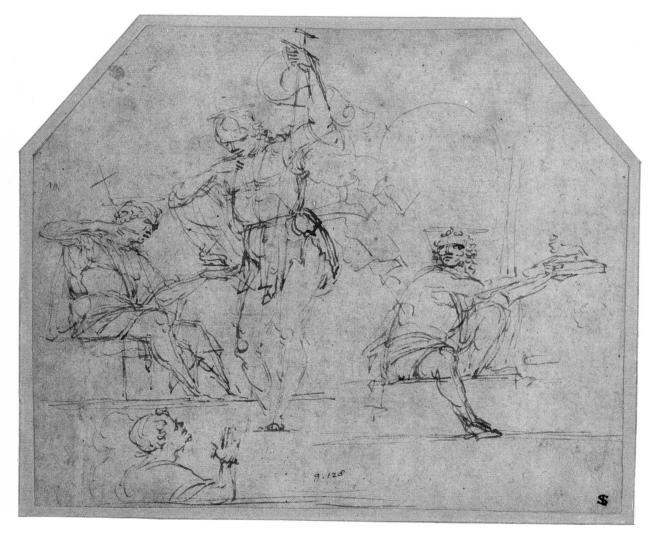

332

PORTRAIT OF AN ECCLESIASTIC
c.1513/1520
Raffaello Sanzio, Raphael 1482–1520
black, red, and white chalk
30×23.9 ($11\frac{7}{8} \times 9\frac{3}{8}$)
inscribed, *R. URB: Pl:* and *P. LEO X.*
in a seventeenth-century hand, on the
mount

Wilton House
The Earl of Pembroke and Montgomery

This penetrating likeness of a cleric,
presumably a cardinal as the red beretta
implies, is the most fully wrought por-
trait drawing of Raphael's Roman years.
Overlooked or rejected by earlier
scholars, it was first restored to Raphael
by Oberhuber (Fischel and Oberhuber
1972, 74), who compared it with heads
in the *Transfiguration*, but as Gere and
Turner argue in the British Museum
exhibition catalogue (see below) the
drawing could date from any time after
about 1513.

The drawing bears the stamp of Sir
Peter Lely, whose collection was sold in
1688 and 1694, and was presumably
acquired by Thomas Herbert, 8th Earl
of Pembroke (1656–1722). Wilton was
most celebrated for its antiquities and
pictures (see no. 274), but the old master
drawings were also of considerable dis-
tinction, excelled among country house
holdings only by those of the Devon-
shires. The greater part of the Wilton
collection was sold in 1917, when the
few framed items, including Holbein's
Lord Abergavenny and drawings by
Dolci, Luti, and Rosalba Carriera, were
retained. F.R.

Provenance: Sir Peter Lely (1618–1680),
with his executor's mark (Lugt 2092);
presumably acquired by the 8th Earl of
Pembroke; and by descent
Literature: Pembroke 1968, drawing
no. 26
Exhibitions: London, BM 1983 (141)

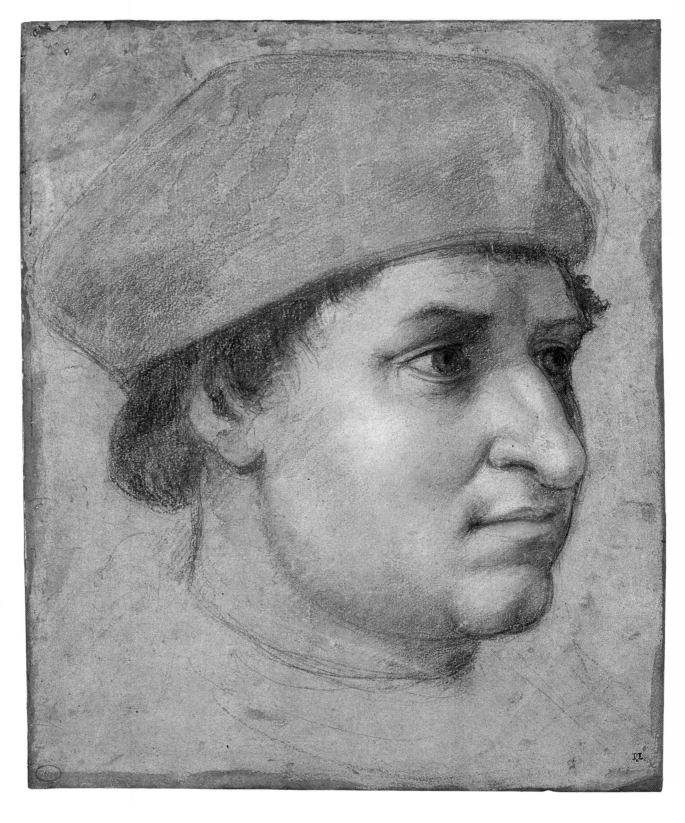

333

BIBLIA GERMANICA-LATINA
10 vols. Wittenberg, 1574 (vol. 4)
binding by Paul Droscher von
Waldenburg fl. 1581–1601
quarto; brown calf over board
21.5 × 17.5 (8½ × 7)

Elton Hall
William Proby, Esq.

The rich polychrome decoration is typical of German bindings of the latter part of the sixteenth century, and the panels showing the reformers Martin Luther and Philip Melanchthon (the former dated 1579) are two examples of several that were used by binders in the Protestant center of Wittenberg. Here, most suitably, they are found decorating a German Lutheran translation of the Bible. The initials *PD* found on the Luther panel stand for Paul

Droscher von Waldenburg, who worked in Wittenberg; he became Master in 1581 and died in 1601. One of the three putti that appear with the Christ child on the gilt roll framing the covers holds a shield bearing a horn and the initials *MI*. The identity of the owner of these initials is unknown, but he is believed to have stopped working in the latter half of the sixteenth century, after which, presumably, his roll was used by Droscher.

The bible has the bookplate of the 5th Earl of Carysfort, dated in manuscript 1898, no. 4307, and comes from the famous library at Elton that was largely his creation (see no. 335). N.P.

Provenance: 5th Earl of Carysfort; and by descent
Literature: Haebler 1928 1: 92–93

334

CRONIQUE DE SAVOIE
Lyon, 1552
Guillaume Paradin
quarto; calf binding
16.5 × 24.1 (6½ × 9½)

Dalmeny House
The Earl of Rosebery

This book, which is in a French binding, carries the royal arms of Scotland, surmounted by a crown, and monogram *Ms* (for Mary Stuart) with crowns, signifying Mary Queen of Scots (1542–1587). Of all the books known to have belonged to her this is of particular interest as the title is mentioned by Peter Young, tutor to James VI of Scotland, in a list of items from Mary's library retrieved in 1573 for the future king (British Museum; Add. Ms 34275). Moreover, its provenance suggests that it has never left Scotland since that time.

The *Cronique de Savoie* is one of many books bought by the 5th Earl of Rosebery (1847–1929) from the sale of the library of James Thomson Gibson Craig (1799–1886), an Edinburgh lawyer who spent a lifetime collecting Scottish books and fine bindings. Previous owners included Charles Kirkpatrick Sharpe (c.1781–1851), a Scottish antiquarian and friend of Sir Walter Scott, and before him, the Edinburgh legal antiquarian Thomas Thomson (1768–1852). Before that, according to Gibson Craig, the volume had long been in the library of the Hamilton family at Pencaitland House (to the east of Edinburgh), built, or enlarged, for James Hamilton, Lord Pencaitland (1660–1729). The title page has an early library shelf mark, *Df2: n2*, which has not yet been identified.

A collector of books since his schooldays at Eton, Lord Rosebery's main period of acquisition was the 1880s, the decade in which a number of sales were held: Beckford (1882–1883), Hamilton Palace (1884), Wodhull (1886), Cheney (1886), Gibson Craig (1887–1888), and Turner (1888). Historical interests were a major influence on his purchasing, as in this case, but he bought almost anything that caught his eye or imagination, and maintained large libraries at all his country residences. That at The

Durdans, near Epsom in Surrey, housed his general collections, and was described by John Buchan as "so full of rarities that the casual visitor could scarcely believe them genuine." French books and bindings were sent to join the Hebrew incunabula at Mentmore in Buckinghamshire, inherited from his wife's family, the Rothschilds, while on the Dalmeny estate he restored Barnbougle Castle as a home for his outstanding collection of books of Scottish interest. There in an austere bedroom at the top of the tower, with magnificent views each way down the Firth of Forth, he had leisure to study them during his long years in the political wilderness after 1896. B.H.

Provenance: Gibson Craig sale, Sotheby's, 10 April 1888, lot 3260; Sharpe sale, Tait & Nisbet, Edinburgh, 29 January 1852, lot 2138; Thomson sale, Tait, Edinburgh, 5 July 1841, lot 1735
Literature: Craig 1882; Warner 1893; Rosebery 1962

335

HENRY VIII'S PSALTER
London, 1544
octavo
15.2 × 10.7 (6 × 4¼)

Elton Hall
William Proby, Esq.

This copy of Thomas Berthelet's *Psalms or prayers taken out of holye scripture*, bound together with his *An exhortation unto prayer. Also a letanie*, printed in London in the same year, are steps on the way to a full liturgy in English—"understanded of the people"—which was finally accomplished in the Book of Common Prayer of 1549. Both works are printed on vellum. The first bears the inscription "remember thys wryghter wen you doe praye for he ys yours noon can say naye" in the hand of King Henry VIII: he is probably addressing Catharine Parr, his sixth and last wife, whose signature appears at the end of the second work. The

volume also bears the signatures of both King Edward VI and Queen Mary I. It was bought at the Fountains sale in 1894 by William Proby, 5th and last Earl of Carysfort (1836–1909). Lord Carysfort was a keen book collector and formed a notable library at Elton Hall that was especially strong in biblical and liturgical texts and bindings (see no. 333). J.F.F.

Exhibitions: London, Sotheby's 1983 (38)

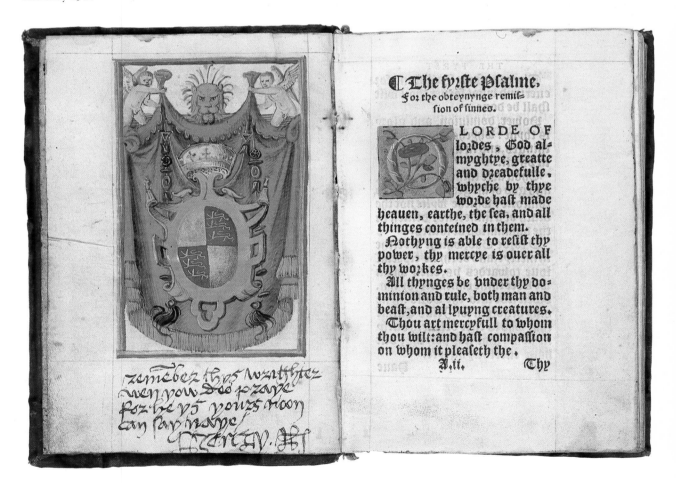

LE COSI VOLGARI
Venice, Aldus, 1514
Francesco Petrarca 1304–1374
octavo, printed on vellum and bound
by Jacques-Antoine Dérome in blue
morocco with the arms of De Mayzieu
21.6 × 15 (8½ × 6)

Chatsworth House
The Duke of Devonshire and the
Trustees of the Chatsworth Settlement

This Aldine Press Petrarch has two
illuminated title pages, one with the
device and motto of the owner at the
beginning of the Sonnets, an illuminated
border surrounding the opening page of
text, and six full-page illustrations to
the Triumphs of which this opening
shows the first, the Triumph of Cupid.
Apart from the remarkably vivid green
of this illumination, the others are
respectively drawn on blue, black,
orange, purple, and gold backgrounds.
In addition there are innumerable small
delicate illuminations in the margins of
the text. The text of Petrarch is followed
by the *Nove Imprese et Stramboti de
Messer Euriali Asculano* written on four
leaves of vellum and preceded by the
title and end page written in gilt letters
on green silk, which probably constituted
the original binding of the manuscript.
The text of the sonnets contains num-
erous small emblematic illustrations in
the margins, thought to be the work of
Vincenzo Raimondi, miniaturist to the
Sistine Chapel and sacristy from
1535–1549.

This volume appears to be a specially
printed copy of the 1514 edition with
the typographical errors corrected and
without the Aldine anchor and colo-
phon. It is described by Brunet (1842–
1844, volume 4, 545): "Un exemplaire
imprimé sur velin avec des peintures
attribuées à Giulio Clovio est indiqué
dans la *Bibliotheca Parisina, No. 328*. Il
passait pour quelqu'un des Médicis."
The attribution to Giulio Clovio, to
whom nearly all illuminations of this
period were traditionally given, can no
longer be supported. M.P.

Provenance: De Mayzieu sale 1791;
bought by John, 2nd Earl Spencer
(1758–1834, see no. 211) for £116.11s.;
given to his sister Georgiana, Duchess
of Devonshire; and by descent
Literature: This entry is based on
descriptions by J.L. Davis, Desmond
Flower, and Howard Nixon in the cata-
logues of the London exhibitions
Exhibitions: London, NBL 1953;
London, NBL 1965 (11)

THEATRUM VITAE HUMANAE
Basel, 1565
Conrad Lycosthenes
binding by Jean de Planche for
Sir Nicholas Bacon
folio; pierced pasteboard covered with
brown calf, gold tooled and painted
39.4 × 26 (15½ × 10¼)

Kingston Lacy
The National Trust (Bankes
Collection)

Jean de Planche was a Huguenot immi-
grant binder who worked in London
from 1567 until at least 1575. Born in
Dijon, the son of Jehan Desplanches, he
came to England from Rouen, and in
1572 was accused of bigamy three weeks
after marrying Helaine Couppe, the
daughter of a shoemaker at Temple
Bar. His attempts to repudiate his
previous wife, still in Rouen, on the
grounds that she was "une paillarde" (a
wanton), dragged on inconclusively for
three years. In the meantime, De
Planche continued his trade, producing
some of the most elaborate bindings of
his time for clients as illustrious as
Elizabeth I and Archbishop Parker (see
Foot 1978a, 230). The Kingston Lacy
binding, not seen in public since 1891,
is among the most elaborate produced
from his workshop, and is unique in
preserving the extraordinary extended
end bands, which are worked all round
the edges of both boards as well as
across the head and tail of the spine
(the headband itself is missing). The
arms are those of Sir Nicholas Bacon
(1510–1579), Lord Keeper of the Great
Seal from the accession of Queen Eliz-
abeth, and his motto *Mediocra Firma*
appears on the back cover. The book
has long been in the possession of the
Bankes family, and is referred to in a
letter written from Italy by William
John Bankes to his brother George in
1844:
"There are two books in the library at
Kingston Lacy that were the great
Lord Bacon's, one with a prodigiously
rich binding and the arms on the cover,
the other has in the first leaf written
'Anna Bacona. Domini Custodis Uxor'
that is to say one of the three learned
ladies, daughters of Sir Anthony Cooke,

and wife to Lord Keeper Sir Nicholas, and mother of Sir Francis Bacon. I never heard how the Chief Justice [Sir John Bankes, 1589–1644] got these, but he was of Gray's Inn, and so in his beginnings probably knew Lord Verulam" (Kingston Lacy MSS).

The second binding is also preserved at the house. N.P.

Provenance: Sir Nicholas Bacon; probably Sir John Bankes, and by descent at Kingston Lacy; bequeathed by Mr. Ralph Bankes to the National Trust with the house and its contents in 1982
Exhibitions: London, BFAC 1891 (u3)

338

THE CANTERBURY TALES
c. 1420/1430
Geoffrey Chaucer ?1340–1400
manuscript on vellum
34.9 × 25.5 (13¾ × 10)

Petworth House
The National Trust
(Egremont Collection)

The early and continuing popularity of Chaucer is confirmed by the number of manuscripts that have survived, of which this one from Petworth House is a particularly important example. Although the arms of Henry Percy, 4th Earl of Northumberland (d. 1489) appear on folio 307b, these appear to have been added at a later date. The book may have been made for the 3rd Earl (1421–1461), but the 2nd (1394–1455) is more likely: he married Eleanor Neville, daughter of Ralph, Earl of Westmoreland, and Joan Beaufort, Chaucer's niece. Yet another possibility is that it is the manuscript bequeathed

by Sir Thomas Cumberworth in 1451 to his grand-niece, whose husband acted as agent for the 4th Earl, an association that would have given opportunity for its transfer. At all events it seems likely that the volume has been in the collections at Petworth, first of the Percys, then of the Wyndhams (see no. 341), for over 400 years. J.F.F.

Literature: Manly and Rickert 1940, 1:410–414

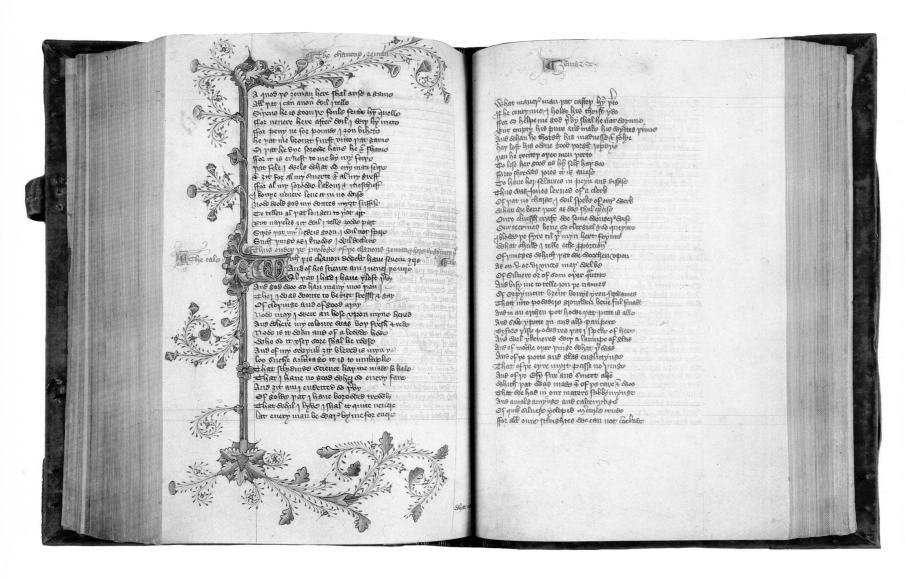

339

THE MIRROR OF THE WORLD
Westminster, 1481
William Caxton c.1422–1491
folio
25.7 × 19 (10 × 7¼)

Bourne Park
Lady Juliet de Chair and the Trustees
of Olive, Countess Fitzwilliam's
Chattels Settlement

Caxton has an assured place in the history of printing as the first Englishman to become actively involved in the new art. His reputation among English collectors has been strong since the early eighteenth century, and this is demonstrated by the numbers of his books that survive in the libraries of the great country houses such as Chatsworth and Longleat (Hellinga 1982). This book is an early treatise of simple cosmography and geography, translated from the French by William Caxton for the goldsmith Hugh Bryce, Alderman of the City of London. Caxton's source was a manuscript prose version (Bruges, c.1465) of a French poem of 1245–1246, the *Image du Monde* by Gossouin of Metz; while translating he added some information and also omitted some passages that may have offended his English patron, notably the assertion that Englishmen have tails. This book contains the first woodcut illustrations executed in England; in addition it is interesting that the manuscript captions appear in the same hand in most copies and were evidently written in Caxton's workshop.

This copy was in the collection of Thomas Cranmer, Archbishop of Canterbury, and passed with many of his books to John, Lord Lumley (no. 346), one of the first nobleman to own a substantial library. Later, on his death in 1609, a catalogue was made on the instructions of Prince Henry, who acquired most of Lumley's books. The *Mirror of the World* is not listed in this catalogue, however, and does not appear to have entered the Royal collections. It may possibly have been acquired by Thomas Wentworth, 1st Earl of Strafford (1593–1641), Charles I's favorite, and still forms part of the collection from Wentworth Woodhouse in Yorkshire, passing through his descendants the Marquesses of Rockingham. J.F.F.

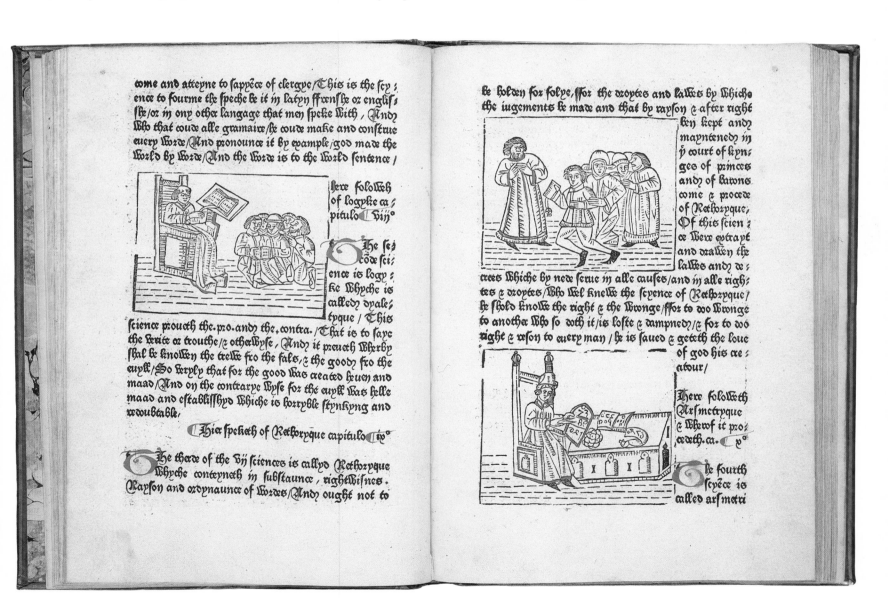

340

OPERUM ATQUE TRACTATUUM
SANCTI BERNARDI Paris, 1508
binding by the Lattice Binder
fl. 1485–1511
folio; pink-stained brown calf over oak
boards
37.9 × 27.8 (15 × 11)

Helmingham Hall
The Lord Tollemache

The Lattice Binder gets his name from
the lattice tool used on the cover of this
and other books bound by him, and the
design on this exceptionally well-
preserved binding is entirely typical of
him. He appears to have worked in
Cambridge, and, in common with a
number of other binders in the same
city, he used a pink pigment, applied
after the book was bound, to color the
calf leather found on all his bindings
(see Oldham 1952). This example shows
clearly that it was applied with a brush.
Two leaves of a scholastic theological

text in a neat, late thirteenth- or early
fourteenth-century hand, with a later
glossing text and numerous extra
glosses, are used as pastedowns inside
each board. The latest of these glosses
show that the manuscript from which
these leaves came was in use until
shortly before they were incorporated
in this binding.

The title OPERA BERNARDI, writ-
ten along the fore-edge, is an indication
of the medieval habit of storing books
flat on their shelves, with the fore-edge
outward. Modern shelving practice,
adopted in the mid-seventeenth century,
is reflected in the eighteenth-century
lettering on the spine. The title page
bears the stamp of Lionel, 4th Earl of
Dysart, a direct ancestor of the present
owner. N.P.

341

LIVRE D'ARCHITECTURE
Paris, 1582
Jacques Androuet du Cerceau I
c.1515–1585
folio; in vellum binding
41.5 × 30.2 (16¼ × 11⅞)

Petworth House
The Lord Egremont

The vellum binding of this book bears
the crescent device of Henry Percy, 9th
Earl of Northumberland (1584–1632).
Almost a thousand books from the earl's
library can be traced and it is likely
that he had many more: an enormous
number for a nobleman to own in the
first half of the seventeenth century.
Northumberland became implicated
when one of his servants was involved
in the Gunpowder Plot, and as a result
spent some sixteen years (1605–1621)
in the Tower of London. However, he
was allowed to live there in some style,
with many of his books, globes, and

scientific instruments, continuing his
scholarly work and becoming a great
friend of Sir Walter Raleigh who was
one of his fellow prisoners. His interests
lay particularly in the sciences, especially
in medicine, and his experiments in
alchemy were to earn him the nickname
of the "Wizard Earl." This reputation
was enhanced by Van Dyck's splendid
posthumous portrait at Petworth,
which shows him seated at a table and
resting his arm on a sheet of paper
covered with strange hieroglyphs and
diagrams. He was very interested, too,
in engineering, hydraulics, the art of
fortification and architecture; and the
present volume, like many in his library,
has annotations in his hand, showing
that he used it constantly.

His architectural projects included
the rebuilding of Syon in Middlesex,
which he acquired by his marriage to
Dorothy Perrot in 1594, and he drew
up a remarkably ambitious plan for a
new house at Petworth while still in
the Tower in 1615 (Jackson-Stops 1977,
325, fig. 2). In 1603 the "Wizard Earl"
wrote from Syon to Sir Robert Cecil,
"Now that I am a builder, I must borrow
out of my knowledge somewhat out of
Theobald's somewhat out of every
place of mark where curiosities are
used" (HMC, Salisbury MSS, 1930,
15:382–383). His ownership of books
by Vitruvius, Vignola, Serlio, Alberti,
Palladio, and De l'Orme shows that he
left no stone unturned in the pursuit of
such "curiosities" over the following
decades.

Jacques Androuet du Cerceau the
elder, the author of this highly influential
treatise, was the founder of a dynasty
of architects, engravers, and decorators
who worked in France in the sixteenth
and seventeenth centuries. His Premier
Livre d'Architecture, published in 1559,
portrayed fifty different town houses
or hôtels particuliers, and this was fol-
lowed by a second in 1561, depicting
architectural details, including mantel-
pieces, dormers, and cornices, while the
third and last, of 1572, consisted of
plans for country houses. Plates from
these three different works were bound
up indiscriminately in many new editions
later in the century—of which this
is one—sometimes also including
engravings from his great work, Les plus
excellents bastiments de France of
1576–1579. J.F.F./G.J-S.

Literature: Batho 1960, 15, 246

342

A VIEW OF NONSUCH PALACE 1568
Joris Hoefnagel 1542–1600
black chalk, pen and brown ink, and
watercolor heightened with white and
gold
43.2 × 53.3 (17 × 21)
inscribed, *Palatium Regium in Anglie
Regno quod appelatiur Nonciutz quasi
nusquan simile. Londini. A° 1568:2* above

Private Collection

The Palace of Nonsuch in Surrey was
built for King Henry VIII, and was one
of the first buildings in England to
demonstrate an awareness of Italian
Renaissance architecture. Work began
in 1538 and by the end of 1545 £24,536
had been spent; the building was
completed at the king's death in 1547.
The palace was demolished in 1682–
1683 when some of the painted paneling
and other fixtures were taken to Loseley
House nearby (see no. 3) This water-
color is the most accurate record of the
building, showing the south front with
its spectacular towers and unprecedented
reliefs in stucco. Hoefnagel, who traveled
extensively, was in England in 1568–1571
when he also prepared the simplified
drawing of the palace based on this
watercolor, evidently intended for the
engraver, and now in the British
Museum. The signed panel at Hatfield
House, *A Fête at Bermondsey*, in which
Queen Elizabeth I is shown attended by
courtiers, is of the same period.

This watercolor was acquired by
Alfred Morrison (1821–1897) of Fonthill,
second son of James Morrison of Basildon
(see no. 518). Like his father, Morrison
formed a notable collection of pictures
which was strong in the earlier schools
and included the Flemish altarpiece now
at Toledo, the unidentified painter of
which is known as the Master of the
Morrison Triptych. He was also in-
terested in ceramics and assembled a
remarkable series of autographs. His
wife, Mabel, daughter of the Rev.
R.S.C. Chermside, was recognized by
contemporaries as a pioneer in her taste
for antique furniture and the arrange-
ment of period rooms at Fonthill. F.R.

Literature: Colvin 1963, 4:2:196–199;
Biddle 1984, 411–416, figs. 21, 22
Exhibitions: Sutton Place 1983 (91)

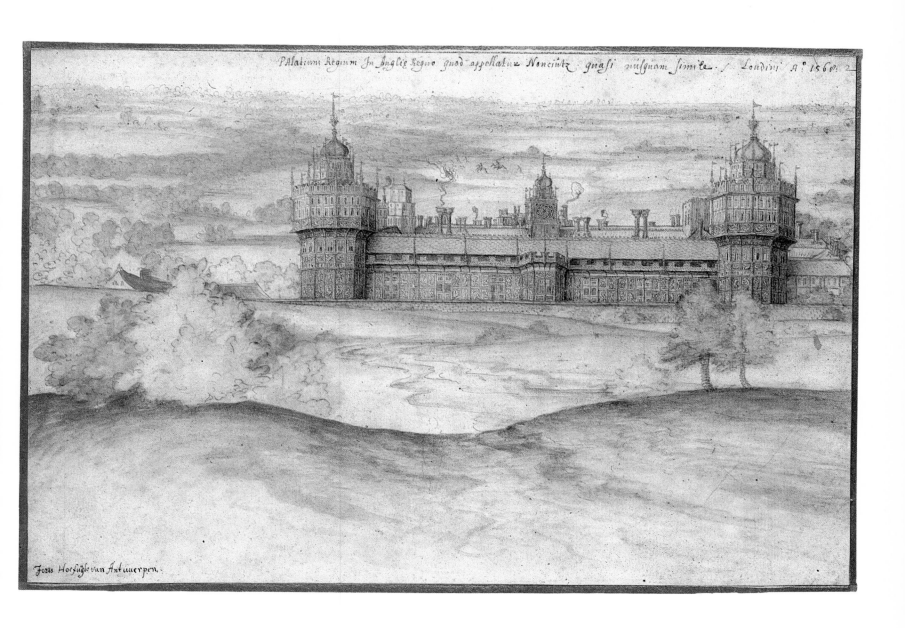

343

L'HISTOIRE DE L'ORDRE DE SAINCT
JEAN DE HIERUSALEM
Paris, 1629
Giacomo Bosio
binding by the Squirrel
Binder fl. c. 1600–1640
folio; dark brown goatskin over
pasteboard
34.8 × 23.9 ($13\frac{3}{4}$ × $9\frac{3}{8}$)

Deene Park
Edmund Brudenell, Esq.

The Squirrel Binder is so named after a pair of characteristic small squirrel tools found on some of his bindings. At least forty-three of his bindings, in addition to this one, have been identified, and several of them bear the Stuart royal arms, as here (Nixon 1970, 66; Foot 1978, 50–58). The presence of the royal arms on a binding does not necessarily imply a royal connection, and the arms are often found on books intended for non-royal customers. The inclusion on this building of the initials *CR*, however, does imply a connection with Charles I or possibly Charles II. This version of the royal arms is one of sixteen known, at least one of which was used after the Restoration. N.P.

Provenance: 3rd Earl of Cardigan (1685–1732), as indicated by bookplate; and by descent

344

THE EUCHARIST . . . A DIVINE POEM
London, 1717
Elkanah Settle (1648–1724)
binding by the Settle Binder,
black goatskin, tooled in gold
29 × 19.2 ($11\frac{3}{8}$ × $7\frac{1}{2}$)

Belton House
The National Trust
(Brownlow Collection)

Elkanah Settle (1648–1724) was a playwright and poet who, in the 1670s, was compared by some to John Dryden, though this was most probably more for political rather than literary reasons. After a period of political pamphleteering, he was appointed City Poet in 1691, but his popularity soon fell away and his income with it. In 1718, his friends procured for him a place as a poor brother in the Charterhouse. It was in an attempt to retrieve his fortunes that he began, in 1700, what has been described as a successful racket. He composed topical poems, at first on political events and later on more personal events such as birth, death, and marriage in the families of the great or wealthy. They were put into leather bindings with rather gaudy gold-tooled decoration, and embellished with the arms of a likely patron, to whom they were dispatched in the hopes of a suitable reward. Should the reward not be forthcoming and the book be returned to Settle, he had the original recipient's arms covered with a leather onlay on which were then tooled the arms of another suitable candidate (Hobson 1940, 92–96; Nixon 1978, 130, no. 57). This would appear to be the case here, where the arms of Sir John Brownlow, later Viscount Tyrconnel are tooled on an onlay, at the edge of which, on the front cover, can be seen traces of the gold-blocked arms of an unknown previous recipient.

N.P.

Provenance: See no. 112

345

ACCOUNT BOOK PREPARED FOR HENRY VIII'S BOULOGNE EXPEDITION 1544
binding by John Reynes fl. c.1493–1544
brown calf over semi-limp paste boards
41.7×31 $(16\frac{3}{8} \times 12\frac{1}{4})$

Rockingham Castle
Commander Michael Saunders-Watson

Only one other account book binding by the French immigrant binder John Reynes is recorded, dating most probably from 1508, although well over 400 printed books bound by his workshop have been identified. After his death in 1544, the signature on the animal roll (Oldham 1952, no. 432) used here (placed above the dog) was erased by the binder who took it over, and the presence of the signature on this binding shows that it comes from Reynes' workshop. On the first leaf of the book, which was bound with blank leaves, is the inscription: "Here in the Tayle of this book are writeyned the names leafe by leafe following of certen necessarie things used for the Kings p[ro]vision in his voyage to Bulleyn." This would seem to indicate that the book was prepared for Henry VIII's expedition to take Boulogne in the summer of 1544, as part of a campaign against the French agreed between Henry and the Hapsburg Emperor Charles V the previous year. Boulogne fell to Henry on 14 September 1544, but no further advance was made into French territory. Among the "certen necessarie things" to be taken were: "Wheles for grete Ordenance," "Canvas for Cartetouches," "Rammers," "Stoples for Gonnes," "Gryndestones," "Bowyers by the Daye," "fflecheres by the Daye," "Spereheedes," and "Bylls redy helved": a list, in fact, of military stores. For some reason, the book was never filled in, and was possibly appropriated by Edward Watson (an ancestor of the present owner) when he purchased Sandgate Castle, near Folkestone in Kent, in 1556; it was thereafter used by him as a commonplace book. The version of Henry VIII's arms used on this binding is otherwise unknown.

N.P.

THE LUMLEY INVENTORY 1590
John Lampton
manuscript, folio
41 × 29.5 (16⅛ × 11⅝)

Sandbeck Park
The Trustees of The Earl
of Scarbrough's Settlement

The Lumley Inventory or the "Red Velvet Book," so called on account of its binding, is the most important single document for the history of painting, sculpture, and furniture in the Elizabethan age. It not only lists the contents of the largest collection of the period but occasionally goes on to give the painter. Although much of the collection was dispersed in sales in 1785 and 1807, besides other losses prior to that date, a great number of pictures can still be identified by the *cartellini* added to them about 1590. In this way vital clues have enabled us to document the work of artists such as Hans Eworth and Sir William Segar (see nos. 20 and 30).

The collection was assembled partly through inheritance and partly through purchase and commission by John, Lord Lumley (see no. 20). It consisted of items at Nonsuch Palace, which came to him from his father-in-law, the Earl of Arundel. These may have included items such as the Holbein cartoon of Henry VIII (National Portrait Gallery, London) and "A great booke of Pictures doone by Haunce Holbyne of certyn Lordes, Ladyes, gentlemen and gentlewomen in King Henry the 8: his tyme" (Royal Collection). In addition Lumley had a house on Tower Hill in London, and Lumley Castle in the north of England, near Durham. The latter was overlaid with a decorative scheme that is recorded in some of the drawings in this manuscript, and whose mainspring was a celebration of his genealogy back to the Norman Conquest, elaborated by a collection of portraits of all the most famous people of his own era. Lumley had traveled to Florence in the 1560s and must have been influenced by the collection of *uomini illustri* assembled by Duke Cosimo I under the influence of Paolo Giovio. The Lumley collection was to be the fount of the preoccupation with portraits that is such a fundamental ingredient of the English country house.

The inventory is the work of Lumley's steward, John Lampton, and is open at a page recording some of the decoration created for the hall of Lumley Castle: "In the uppermost front of the Hall, there standeth a great statuarie on horseback, as bigg as the life, wᵗʰ in an arch of stone, in memorie of King Edward the 3 in whose time the most of this Castle was built. Wᵗʰin this arche also standeth six small pictures, in whyte marble in memorie of his six sonnes…Upon the same front there are also faire livelie statues all wrought in white marble of K Henry the 8, King Edward 6, Queen Marie and Q. Elizabeth, in whose raignes his Loᵖ lived."

The wooden horse still survives (no. 1), but not the four marble busts of the Tudor monarchs and two bas-reliefs, probably Italian, of Plato and Aristotle. Other illustrations record garden sculpture and fountains at Nonsuch, including the pelican fountain that survives at Sandbeck and a series of magnificent tables, some "of walnuttree and Markatre" and others with marble slabs, lovingly depicted in different colors, and perhaps also brought from Italy. The great series of family tombs erected by Lord Lumley at Cheam in Surrey are also shown, while the book begins with an illuminated family tree tracing his ancestry back not just to Charlemagne, but beyond him to Adam and (in gilded letters), *DEUS.*

R.S.

Literature: Cust 1918; Piper 1957; Strong 1969a, 44–45

THE PALMER PEDIGREE 1672
Roger Jenyns
illuminated manuscript on vellum,
bound in red morocco
38.7 × 25.6 (15¼ × 10)

Dorney Court
Peregrine Palmer, Esq.

Ties of blood, expressed in heraldry, were important to country house owners not just as private expressions of family pride but as public propaganda, helping to achieve power and position at a time when birth was still considered an essential prerequisite for the ownership of great estates. Many seventeenth-century family trees were of immense length and kept on rollers like those of the Percies and Sackvilles, which still survive respectively at Syon and Knole.

Others, like the pedigree at the start of the Lumley Inventory (no. 346), were in book form, with lines of descent presented horizontally, from page to page.

The Palmer Pedigree is one of the most elaborate of such books, and, with its depiction of knights in armor flourishing the banners of the "severall heiresses married into this Family," sums up a sentimental vision of the Middle Ages that was already current among

antiquarians and bibliophiles—in an age generally considered one of rational and scientific enquiry. The book is the work of a genealogist and herald, Roger Jenyns, and was painted for the twelve-year-old Lady Anne Palmer on 20 December 1672 after her return to London from France, where she had spent a year under the direction of the English Abbess of Pontoise. Lady Anne was the only daughter of Roger Palmer, Earl of Castlemaine (1634–1705), and his wife,

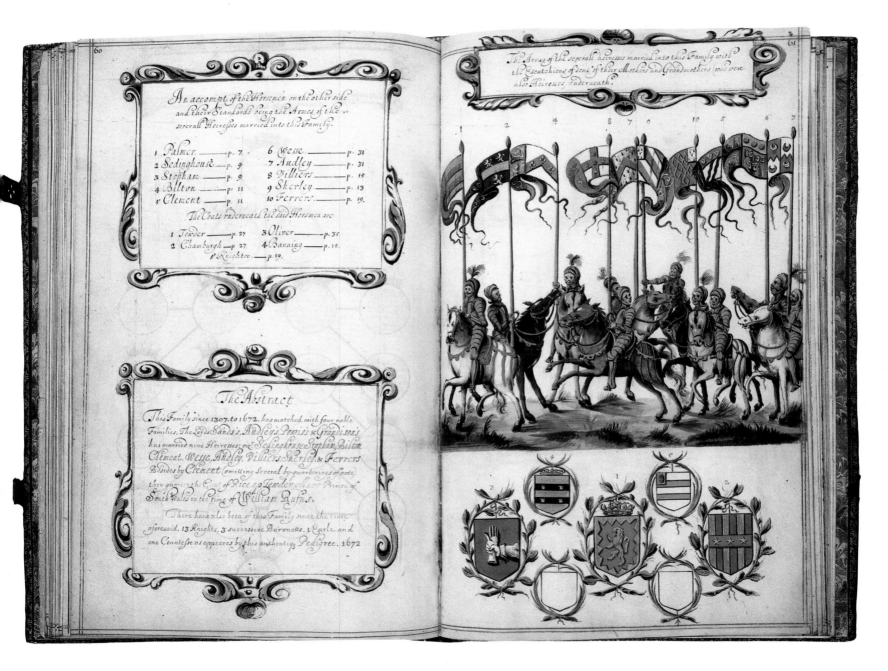

the beautiful Barbara Villiers, notorious as the mistress of Charles II, and this pedigree may have been intended as an affirmation of her true parentage when many contemporaries were convinced that she was a royal bastard. The family tree itself, as Jenyns acknowledges, is based on an earlier "Methodicall Roll" drawn up by John Philpot, Somerset Herald, in 1626 and "approved by Sir W.^m Segar Garter king of Arms" (see no. 20). It begins in 1307 with a fanciful equestrian portrait of Ralph Palmer who "Florisht in Sussex in ye Reigne of Ed: 1st and Ed: 2nd" and traces the different branches of the family, whose chief houses were at Angmering and Parham in Sussex and Wangham in Kent, and whose name traditionally derived from the early pilgrims to Jerusalem who returned carrying palms. Not just a bare list of names and dates, it also contains much fascinating biographical detail on figures like the Elizabethan Sir Thomas Palmer of Angmering—"a great House-Keeper ... he so wasted his Estate (worth £8,000 per an:) that at last he sold the House itself, and left not above £1,000 per ann:"—or his son John, who "either through the viciousness of his nature, or dejected at his Father's misfortunes got acquaintance with the Gipsies and other wandring Beggars, which way of liveing he lik'd so well, that he could never be perswaded to leave them."

Following the family tree there are full-page watercolor portraits of Lady Anne and her parents in grisaille by William Faithorne, one of the leading Restoration engravers and book illustrators—that of Lord Castlemaine inscribed by the artist as being "ad vivam." The Palmers were not generally fortunate (the extravagance shown by Sir Thomas seems to have been a recurring family weakness) and despite the earldom earned by his wife's position at court, and a long diplomatic career which took him all over Europe and to "Constantinople and then Siria, Palestine & some parts of Affriq.," Castlemaine's Catholicism was to be his undoing. In 1685 he was sent by James II on a particularly magnificent embassy to the pope, commemorated in a volume with splendid engravings of his coaches and

banquets, still to be found in many country house libraries. But with the accession of William III he narrowly escaped charges of treason, and died in comparative poverty, having paid off many of the debts of his elder brother, Sir James Palmer of Dorney Court.

Lady Anne married Thomas Lennard, Earl of Sussex, in 1675, but as they only had a daughter, the Palmer Pedigree with her other family heirlooms were left back to the Dorney Court branch. Here they have since remained, only a few miles from Windsor and the scenes of her mother's greatest triumphs.

G.J-S.

Exhibitions: London, Sotheby's 1983 (1)

348

THE STRAWBERRY HILL SALE CATALOGUE
London, 1842
George Robins
quarto
26.4 × 21.7 ($10\frac{3}{8}$ × $8\frac{1}{2}$)

Felbrigg Hall
The National Trust
(Ketton-Cremer Collection)

Horace Walpole first acquired Strawberry Hill, not far from the Thames at Twickenham, in 1747. "It is a little plaything house," he wrote, "…the prettiest bauble you ever saw… set in enamelled meadows, with filigree hedges." Over the next forty-four years his gradual reconstruction of the house in the Gothick style, using no fewer than ten architects, and his acquisition of pictures, sculpture, furniture and *objets d'art* of every period and style, occupied much of his time. By the late 1750s the villa had already become an object of pilgrimage for the fashionable world, and so great was the demand to see it that Walpole was forced to print admission tickets. It was here that he set up the famous Strawberry Hill Press, and here, in the library with its bookcases and chimneypiece based on medieval tombs and choir screens, that he conceived one of the earliest of English Gothick novels, *The Castle of Otranto.*

Walpole died at the beginning of March 1797, having only recently inherited the earldom of Orford from his spendthrift nephew. He left Strawberry Hill to Mrs. Damer (see no. 225) with £2,000 a year to keep it up, and she lived there for some time before resigning it to the Dowager Countess Waldegrave, in whom the remainder had been vested. It passed eventually to the 7th Earl for whom George Robins, the auctioneer, sold the contents in 1842. The catalogue cost 7s. and admitted up to four people to the viewing; it was available in Paris and Leipzig as well as in London. "And within," Robins proclaimed, "will be found a repast for the Lovers of Literature and the Fine Arts, of which bygone days furnish no previous example, and it would be in vain to contemplate it in times to come." It took him twenty-four days to dispose of the contents of the house. "The Renowned Marble Eagle" (no. 244) shown on the engraved title page, was sold from the Tribune as item 86 on the 23rd day. A lithograph after J.G. Eccardt's 1754 portrait of Walpole (National Portrait Gallery, London) serves as the frontispiece. This copy of the catalogue comes from Felbrigg Hall, Norfolk, and belonged at one time to Thomas Gaisford, the Greek scholar and Dean of Christ Church, Oxford.

J.F.F./G.J-S.

349

AEDES WALPOLIANAE
London, 1747
Horace Walpole 1717–1797
quarto
28.4 × 22.7 (11 $\frac{3}{16}$ × 8 $\frac{7}{8}$)

Felbrigg Hall
The National Trust
(Ketton-Cremer Collection)

As early as 1736, when he was nineteen, Walpole had compiled a manuscript catalogue of the pictures at Houghton giving their sizes and the names of the artists, perhaps inspired by the first published catalogue of pictures in any English country house, Count Carlo Gambarini's *Description of the Earl of Pembroke's pictures*, which appeared in 1731. By 1743 other pictures had been added to his father's collection and he appears to have looked at them all again. He spent most of that summer there and after Sir Robert's dismissal from office drew closer to him. He did, however, find Houghton depressing: on 20 August he told Chute, "I literally seem to have murdered a man whose name was ennui, for his ghost is ever before me" (Lewis 1973, 35, 43). His consolation was compiling this catalogue, *Aedes Walpolianae: or, a description of the collection of pictures at Houghton Hall in Norfolk*. The book is rare—Walpole variously reports having one or two hundred copies printed. He was not pleased with it, though, and he had to correct many mistakes in manuscript. These mistakes he was keen to eliminate in the second edition, which appeared in 1752. The present copy, which is the third setting of the original edition of 1747 (Hazen 1948, 29), has the author's notes in ink on the plates and comes from Felbrigg Hall, the home of Dr. Johnson's friend William Windham, a house not far from Houghton, and which in this century was to become the home of Walpole's biographer, the late Wyndham Ketton-Cremer. J.F.F./GJ-S.

Literature: Ketton-Cremer 1964, 87–89

AEDES WALPOLIANÆ:
OR, A
DESCRIPTION
OF THE
Collection of Pictures
AT
Houghton-Hall in Norfolk,

The SEAT of the Right Honourable
Sir ROBERT WALPOLE,
EARL of ORFORD.

*Artists and Plans reliev'd my solemn Hours;
I founded Palaces, and planted Bow'rs.*
PRIOR's *Solomon*.

LONDON: Printed in the Year 1747.

350

VIEW OF THE GARDENS AT WILTON
c. 1635/1647
Isaac de Caux fl. 1634–1655
engraving
37.7 × 53 ($14\frac{7}{8}$ × $20\frac{3}{4}$)

Wilton House
The Earl of Pembroke and Montgomery

English garden design in the early seventeenth century was dominated by two Frenchmen, both experts in water-works and grottoes, Salomon de Caux (c. 1577–1626) and his son or nephew, Isaac. Salomon introduced the idea of the Italianate mannerist garden to the courts of Henry, Prince of Wales, and Queen Anne of Denmark, but left England in 1614 to lay out the great garden at Heidelberg Castle for the Elector Palatine. Isaac remained in England, however, and after designing the grotto in the Banqueting House for Inigo Jones in 1623–1624 emerged

as the principal gardener to the first Caroline court. His greatest work was undoubtedly Wilton, the creation of Philip, 4th Earl of Pembroke (1584–1650), who inherited from his brother William in 1630 and began to lay out the garden between 1632 and 1636, entertaining Charles I there almost every summer. De Caux' drawing of the huge parterre, seen from the north, is in the collection of Worcester College, Oxford, and this was engraved for the *Hortus Pembrochianus* or *Le Jardin de Vuilton*, a group of twenty-six engravings that record the layout in great detail.

This engraving is taken from the terrace along the south front of the house and another drawing of similar dimensions (RIBA Drawings Collection, London) shows the opposite view back toward the house, with the famous façade as first designed about 1632, probably by De Caux in collaboration with Inigo Jones. It spanned the whole width of the garden and would have

been longer than the south front of Blenheim, but work on it was abandoned by March 1635 when Pembroke's only son, Lord Herbert, died suddenly in Italy, and his father had to return the huge wedding dowry of £25,000 paid on Lord Herbert's marriage to the Duke of Buckingham's daughter. So what was built was a new front only half the width of the garden and on the old foundations of the Tudor courtyard house. Although an engraving of Le Sueur's gladiator included in *Hortus Pembrochianus* is dated 1653, this may be an addition to the original corpus, and it is likely that all the others predate the fire of 1647 that finally put paid to De Caux's grandiose scheme for the house. At some point in the later seventeenth century both the drawing for this view and its companion of the south front were attributed to Jacques Callot, which is not surprising as De Caux uses the French convention of a foreground like stage wings with

framing trees and *staffage* at their base. The figures are very much in Callot's manner and it is certainly possible that these ornaments were added in another hand.

De Caux's sources for the garden are the standard ones in the France of Louis XIII and Cardinal Richelieu: the great parterres of the Palais de Luxembourg and of the royal gardener André Mollet. Wilton is the very first documented instance in England of the latter's characteristic *parterres de broderie*, perhaps based on those that Mollet himself made when he came to London to lay out the garden of St. James's Palace in 1629. Wilton also triumphantly proclaims the supremacy of the axial plan in seventeenth-century garden design, for the south front was intended to be centered on the wide central walk, at the end of which a series of architectural punctuations led up the hill to a triumphal arch at the top supporting an equestrian statue of Marcus Aurelius—a copy of the famous original outside the Capitol in Rome, which still survives at Wilton, crowning Sir William Chambers' entrance arch. Richelieu's garden at Reuil was similarly designed, as was Lord Weston's at Roehampton, the original site of Le Sueur's equestrian statue of Charles I, now in Trafalgar Square.

The idea of a walled enclosure divided centrally and containing groups of parterres and wildernesses became, in reduced form, the model admired and employed by other Stuart courtiers. There would be a terrace fronting the house, with the garden set at a lower level, perhaps even surrounded by the raised terrace, and a focal point might be an architectural feature of stairs that enclosed a grotto. George London developed the Wilton model even further at Longleat in 1683, making modifications that enabled this basic style of garden design to be carried through to the end of the century. J.H.

Literature: Colvin 1954, 181–190, pl. 27; Harris 1979, no. 31; Harris and Tait 1979, no. 110

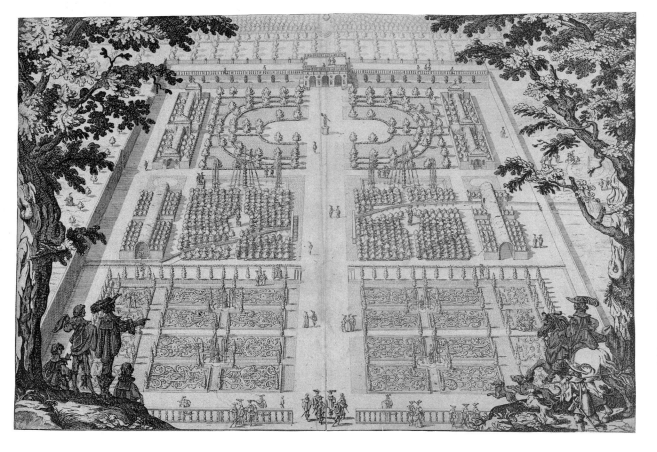

351

STOWE: A DESCRIPTION
Buckingham, 1788
Benton Seeley
octavo in calf binding
21.6 × 13.9 (8½ × 5½)
copperplate 21.2 × 40.2 (8¼ × 14¾)

Stowe
The Governors of Stowe School

From about 1720, when Richard Temple, 1st Viscount Cobham (1675–1749), commissioned Sir John Vanbrugh and Charles Bridgeman, as architect and garden designer, to turn his father's house into a princely mansion with a more than princely garden, Stowe attracted attention as one of the finest country houses in England. For thirty years Cobham continued to pour his fortune into it, particularly the embellishment of the garden, adding lakes and vistas and statues and temples (an intentional pun on the family name), until the layout extended over more than a hundred acres and became a

showplace of European renown. But it was not just the sheer size of the garden and the multitude of its temples that attracted people. Stowe was also a leading example of the new style of "natural" gardening initiated by William Kent, and in the generation when gardening mania swept England every enthusiast wanted to see the improvements that had been made. After 1733, when Cobham quarrelled with Walpole and George II and was dismissed from public office, the sophisticated visitor found a further attraction. For the ideals of the "Patriot" opposition spilled over into Cobham's gardening, so that his

construction program took on the character of a political manifesto. Thus the relish of satire was added to the satisfaction of aesthetic pleasure, and visitors walked round, notebooks in hand, taking down the details of buildings and statues, and copying out the inscriptions for their journals.

In these circumstances, it is hardly surprising that the very first comprehensive guidebook to an English country seat should have been the *Description of the Gardens of Lord Viscount Cobham at Stow*, produced by a local writing master, Benton Seeley of Buckingham, in 1744. The text for this thirty-two

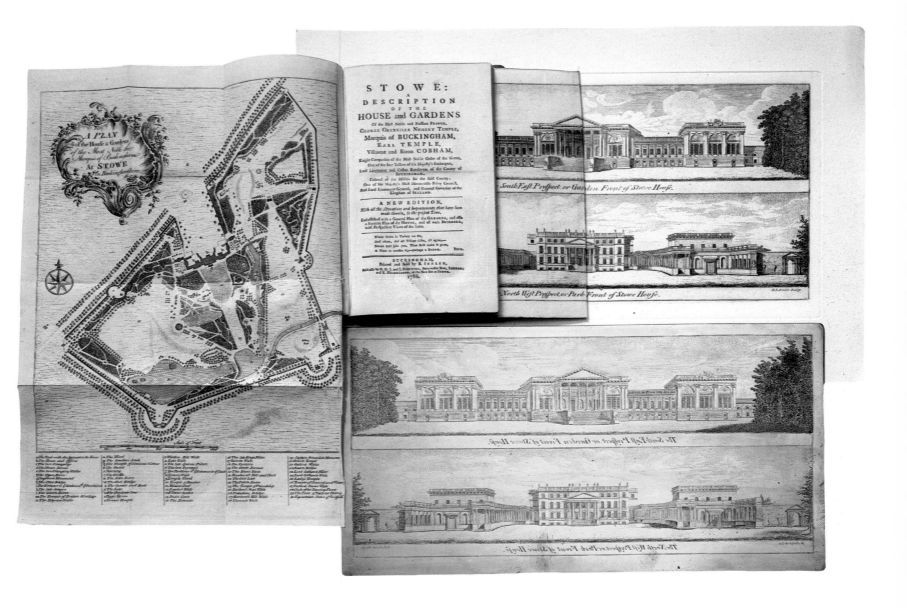

page pamphlet was based on an account in the 1742 edition of Daniel Defoe's *Tour thro' the Whole Island....* Its success led to several reprints and revisions, and two further ventures, William Gilpin's *Dialogue upon the Gardens at Stow* and a set of engraved *Views of the Temples and other Ornamental Buildings...*, published by Seeley in 1747 and 1749 respectively. In 1750, however, the London bookseller George Bickham pirated this material, amalgamating it in one octavo volume of sixty-seven pages, which he entitled *The Beauties of Stow*, a handbook that was far easier to use and that contained a brief description of the house as well as the gardens. Not to be outdone, Seeley returned to the fray, this time in partnership with another London bookseller named Rivington. Their 1759 guidebook introduced an entirely new feature, a tour of the principal rooms in the house with details of the pictures and the interior decoration; and so comprehensive was their 1763 edition (with a new elevation of the garden front, a plan of the main floor, and measured drawings of no less than twenty-one garden buildings) that Bickham was forced to retire from the contest.

This edition of 1788 hardly differs from those of the previous decade, and is shown with the original copperplate illustrating both sides of the main house, apparently first used in the previous year. By this date many great English houses and gardens were attracting visitors *en masse*—Blenheim, Hagley, Holkham, Kew, The Leasowes, and Stourhead, for example—and guidebooks were to be produced for all these before the end of the century. But the evolution of the genre at Stowe earns Seeley and his patrons Lords Cobham and Temple an important place in the whole development of tourist literature.

G.B.C./G.J-S.

Literature: Clarke 1973, 18–31; Clarke 1977, 1–11
Exhibitions: Stowe 1984 (11)

352

DESIGN FOR THE PARK AT
KIRTLINGTON 1752
Lancelot "Capability" Brown 1716–1783
pen and ink
50.8 ×64 (20 ×25½)

Kirtlington Park
Christopher Buxton, Esq.

The fame of Lancelot (called "Capability") Brown had already spread beyond the bounds of Stowe gardens in Buckinghamshire before he left that estate and settled late in 1751 as a professional landscape gardener at Hammersmith, then a village on the western edge of London. He had already been consulted by Lord Egremont at Petworth, where the new landscaping begun in 1752–1753 must be studied in stylistic relationship to Kirtlington Park, Oxfordshire, Brown's second big commission at the beginning of his career as an independent garden designer. Kirtlington was a new house in a Gibbsian style begun for Sir James Dashwood in 1742 by William Smith, but completed after Smith's death in 1747 by John Sanderson. It was probably Sanderson who recommended the employment of Brown in place of another garden designer, Thomas Greening, who also worked at Wimpole in Cambridgeshire. By 17 January 1752 Brown had been paid £100 "for work he is doing," and this included totally changing Greening's semiformal plan, which still survives at the house, and incorporates charming Chinese and Gothick alcove seats and serpentine paths through a "wilderness" recalling the work of Bridgeman and Kent. Brown's

plan instead proposed open sweeps of lawn at the front and back of the house, and plantations spreading out on the sides, all tied in with a ha-ha. A glance at this plan reveals certain hesitations on Brown's part. It is as yet ill-digested, and this is before he has mastered the art of the circumferential walk and his bolder, more sculptural, approach to the modeling of lawns, plantations, and clumps.

A myth has grown up that the English landscape garden is entirely due to Brown's invention. The reality is more prosaic, for even by the 1740s parks existed with sweeps of lawn from houses to the sides of naturalized lakes. William Kent had created a lawn from the Villa at Chiswick down to the lake's edge in 1733, and in this same year his landscaping of the hill at Esher Place would have done credit to Brown in the 1750s. Already by the 1740s a "natural" landscape was being made at Windsor Great Park by the Duke of Cumberland and Henry Flitcroft, and this, if any, may claim credit as the first landscape park designed on "picturesque" principles in England. Brown learned from these precedents and rose to be the supreme exponent. By 1783 he had more than two hundred parks to his credit, and when he died Horace Walpole wrote a little flippantly to Lady Upper Ossory, "Your Dryads must go into black gloves, Madam. Their father-in-law, Lady Nature's second husband, is dead"; but privately he wrote in his memorandum book: "Those who knew him best, or practised near him, were not able to determine whether the quickness of his eye, or its correctness, were most to be admired. It was comprehensive and elegant, and perhaps it may be said never to have failed him. Such, however, was the effect of his genius that when he was the happiest man he will be least remembered; so closely did he copy Nature that his works will be mistaken."

J.H.

Literature: Stroud 1975, 69, fig. 6c

353

THE ENGLISH MOTHS AND BUTTERFLIES
London, 1749
Benjamin Wilkes d. 1749
quarto
32.2 × 28.5 (12¾ × 11¼)

Dunham Massey Hall
The National Trust
(Stamford Collection)

This is one of the most important
eighteenth-century entomological
works produced in Britain: not only did
it provide scientists at the time with
valuable information, but since then
has proved one of the primary sources
of knowledge about the haunts and
methods of the London entomologists
themselves. It was obviously issued in
serial form: no date appears on the title
page and none of the separate "numbers"
is known to have survived. The parts
were advertised separately at 5s. each;
and the price of the whole—a large
sum—was £9 colored, or £3 13s. 6d.
uncolored. The project was supported
by what Wilkes called at the head
of the list "the subscribers to, and
encouragers of" the project. One such
was Lady Mary Booth, who married Lord
Grey of Groby, later Earl of Stamford,
in 1736. She may have been something
of a blue-stocking, and she certainly
used the book thoroughly, for it is
annotated in her hand with the names
of all the different specimens. J.F.F.

Literature: Wilkinson 1978, 90, 6–7

354

THE COURTEENHALL "RED BOOK"
1791/1793
Humphry Repton 1752–1818
manuscript volume with watercolor sketches
21.8 × 29.4 (8⅝ × 11⅝)

Courteenhall
Sir Hereward Wake, Bart.

After Capability Brown's death in 1783, Humphry Repton succeeded him as the leading English landscape gardener, exploiting the current desire for something more truly natural and more picturesque than Brown's somewhat standardized layouts with their inevitable serpentine lakes and clumps of trees. His facility as a watercolorist enabled him to illustrate his proposals by means of charming perspective views furnished with flaps, which allowed the owner to make a direct comparison between his park in its improved and unimproved condition. These sketches were usually bound together with a somewhat verbose report in a uniform binding, either of red morocco or of brown calf (as in this case), to form one of his famous "Red Books." Over seventy such books are known, and a total of nearly two hundred commissions have been listed (Stroud 1962); Repton's fame was such that he is mentioned by name in Jane Austen's *Mansfield Park*, and he figures as "Mr. Milestone" in Thomas Love Peacock's *Headlong Hall*.

The Courteenhall "Red Book" is typical of the visual and verbal blandishments with which Repton courted his clients. But it is also of particular interest in showing (as the second plate) a panoramic view of the park with the early seventeenth-century manor depicted on a flap in the foreground, which lifts to reveal the new classical house built between 1791 and 1794 on higher ground beyond. Repton's text claims that he was "consulted with regard to the stile of the house proper for Courteenhall, as well as the situation and aspect," though the building itself was "elegantly designed and executed by my ingenious friend Mr. Samuel Saxon"—a pupil of Sir William Chambers.

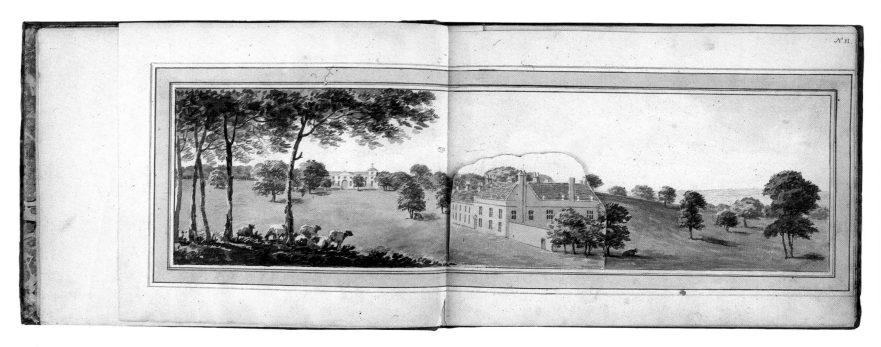

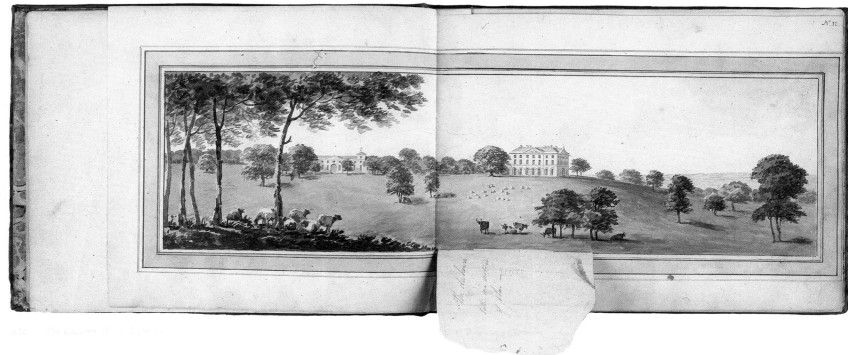

One of the oldest families in Northamptonshire, the Wakes claimed descent from the legendary Hereward the Wake, who so bravely resisted William the Conqueror after the Battle of Hastings. But their inheritance of a much larger house at Waltham in Essex meant that, in the eighteenth century, they visited Courteenhall mainly for the hunting, and this explains the palatial size of the mid-eighteenth-century stable block on the hill to the left in the "Red Book" sketch. It was thus only after a disastrous fire at Waltham in 1790 that Sir William Wake, 9th Bart. (1768–1846), decided to make Courteenhall the family's main residence, calling in Saxon and Repton to remodel the house and park respectively. The gestation of the "Red Book" was, as often, a lengthy one. Begun on 23 March 1791 "at Courteenhall," it was finished in March 1793 at "Harestreet by Romford," Repton's home in Essex, not far from Waltham, where he may first have met the Wakes. "It may be observed," he wrote disarmingly in the introduction, "that a considerable time has elapsed betwixt the date of my first visit to Courteenhall, and the completion of this volume, but … the apparent delay has I trust been of no consequence; particularly as these kind of books serve less as a guide for the execution, than as a record of the improvements, and a justification of the principles on which they are conducted."

Saxon's house still stands much as depicted in the "Red Book" while the park preserves much of Repton's planting, though there is no knowing whether his suggestions for "Lady Wake's Flower Garden" with its formal beds arranged round an oval pond, and its *corbeille*—a flower bed whimsically shaped like a giant basket—were ever carried out. It was obviously a commission that gave him cause for pride, however, for it is mentioned in both his *Sketches and Hints on Landscape Gardening* of 1796, and his *Observations* of 1803. G.J-S.

Literature: Gotch 1936, 82–83; Oswald 1939, 144–148; Stroud 1962; Carter, Goode, and Laurie 1983, 159–160, pl. 3
Engraving: By John Peltro, for William Peacock's *Polite Repository*, March 1793

355

VIEW OF THE GARDEN AT DAVENPORT
1753
Thomas Robins 1716–1770
watercolor
37.7 × 53 (14$\frac{7}{8}$ × 20$\frac{3}{4}$)

Robin Davenport Greenshields, Esq.

On 15 July 1753, the poet William Shenstone wrote to the Reverend Graves that "Mr Davenport…is laying out his environs, and…has also a painter at this time taking views round his house." These pictures were commissioned to celebrate the completion of the new landscaped gardens created for Sharington Davenport at Davenport House, Shropshire, a house built for his father, Henry, by Francis Smith of Warwick in 1726. The "painter" can be identified as Thomas Robins of Charlton Kings near Cheltenham, now recognized as the archetypal artist of the English rococo garden. The "environs" of Davenport can be seen in the foreground of this view as comprising the banks of the valley of the river Worfe that had been clothed by serpentine plantations and ornamented with follies and gazebos: an octagonal temple based on a model published by Batty Langley in 1741, a Gothick ruin, and a grotto from whose edge water gushed from a spring cascading down the bank. Turning the corner, the stream opened out to a long water, again enlivened by rococo ornaments, and these are shown in the companion view to that of the house.

Robins is thought to have been apprenticed to Jacob Portrat, a fan painter and possibly a Huguenot, who also lived in the Cheltenham area; little else is known about them except that they may both have practiced as painters on porcelain. In the history of European art there are perhaps no views that so perfectly sum up the charming artificiality of the rococo garden. The Davenport views are not entirely typical of Robins' compositional method, for they lack his usual floral frames, which give the effect of seeing the garden through a bouquet of flowers. J.H.

Literature: Harris 1978

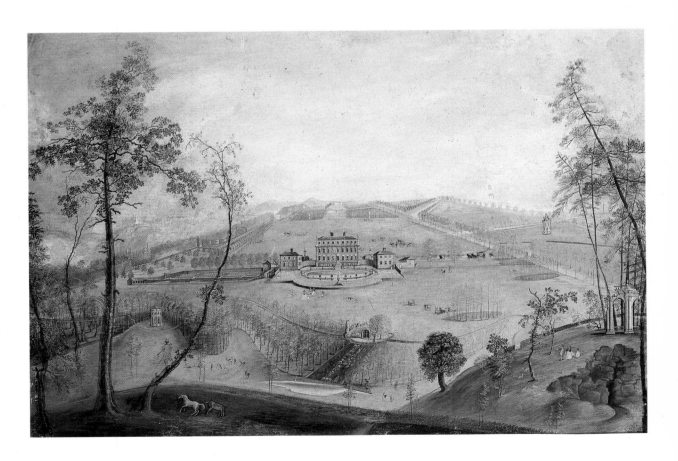

A NEW BOOKE OF TABLITURE FOR THE
BANDORA (AND) ORPHARION,
London, 1596.
William Barley
octavo
17.1 × 22.2 ($6\frac{3}{4}$ × $8\frac{3}{4}$)

Helmingham Hall
The Lord Tollemache

The orpharion was one of the technical triumphs of Elizabethan music. It was an improved version of the bandora, itself an improvement on the lute. The lute, *par excellence* the instrument of the sixteenth century, had a gentle, not penetrating, sound, limited by its six gut strings. The orpharion had six to nine pairs of wire strings, and fifteen frets against the lute's eight. Small wonder that it was christened with a combination of the names of Orpheus and Arion, the two great musicians of classical mythology.

Only two orpharions survive. One is preserved at Helmingham Hall, Suffolk, and is one of the greatest of all surviving sixteenth-century musical instruments. It was made in 1580 by John Rose (who "devised and made" the bandora in 1562). Its rounded back in the form of a scallop shell, exquisite "purfling" and inlay work, incorporating the words "Cymbalum decachordum" (a reference to Psalm 33, "sing praises unto him with the lute, and an instrument of ten strings"), the elegantly carved neck, all make it clear that this was no ordinary musician's instrument and support the legend that it was made for Queen Elizabeth herself, and given by her to Sir Lionel Tollemache who owned and enlarged Helmingham Hall substantially toward the end of the sixteenth century.

Alas, the orpharion itself is too fragile to leave its home, and it is represented here by the Helmingham Hall copy of the first printed manual of bandora and orpharion written and published by William Barley in 1596. In it he points out the difference in playing technique ("the Orpharion doth necessarilie require a more gentle and drawing stroke than the lute," otherwise its metal strings would jar together), and supplies music for it, written in the same "tabliture," or notation, as lute music.

This copy is itself an outstanding piece of a different kind of Elizabethan craftsmanship, bookbinding. The overall gilt work with its floral sprays and central panel is characteristic of the best London work at the turn of the century. The original owner whose name it bears is probably Sir Edward Stanhope (1546?–1608), chancellor of the diocese of London, a great book collector and benefactor of the library of Trinity College, Cambridge. N.B.

357

TWO MARCHES FOR THE DERBYSHIRE CAVALRY REGIMENT 1794/1795
Franz Joseph Haydn
autograph manuscript of No. 2 in C, two sheets (four pages); and printed score of three sheets with title page and five sides of music
manuscript: 24.1 × 30.5 (9½ × 12)
score: 35.5 × 30.5 (14 × 12)
signed, *di me giuseppe Haydn m.ppria*
instruments (by stave): *Tromba, 2 Corni/in C, Clarinetto/1ᵐ [Clarinetto]/ 2ᵈᵒ, Fagotto/1ᵐ, [Fagotto]/2ᵈᵒ, Serpent*

Calke Abbey
The National Trust
(Harpur-Crewe Collection)

The formation of a Derbyshire Cavalry Regiment is first mentioned in a letter from F.M. Mundy to Sir Roger Newdigate, Wednesday, 11 June 1794. A description of the "Glorious First of June"—the great naval victory by Lord Howe on 1 June 1794—is followed by: "We go on well in Derbyshire with our subscription and have determined to raise a Body of Cavalry consisting of Gentlemen and Yeomen. Sir H. Harpur, Sir Robᵗ Wilmot, Majʳ Bathurst, Capᵗⁿ Cheney and I have already offered our services" (Newdigate-Newdegate 1898, 148). From 1744 Sir Henry Harpur was Sheriff of Derbyshire, and as soon as the regiment was formed he ordered two marches for wind band from the Austrian composer Joseph Haydn, who was then in England on his second visit. Haydn composed the marches in 1795, and as the extant sources show, he took a great deal of trouble over them,

completely revising the work between the autograph manuscript and the authentic first edition. The following sources of the two marches are at Calke Abbey: "No. 1 in E flat," a score by Haydn's copyist Johann Elssler on British paper, the original manuscript performance material; and "No. 2 in C," Haydn's autograph, also the original manuscript performance material. Calke Abbey also owns the actual plates used for the authentic first edition, which Sir Henry Harpur issued privately in 1795; this edition contains not only the scores but also the piano reductions, and it is exhibited here in its final state before the actual publication. The "impressum" has been added in hand, at the bottom of the page; whereas, in the few copies (apart from that at Calke Abbey) that have survived, this "impressum" has been added by the printer.

Haydn had composed other military marches while in the service of Prince Esterházy, but during his two English sojourns of 1791–1792 and 1794–1795, he had occasion to compose not only these two marches but also another, for the then Prince of Wales (later George IV), in 1792.

Apart from the invaluable Calke Abbey sources, these marches survive elsewhere: "No. 1 in E flat" in Haydn's autograph, dated 1795 (Berlin State Library), and "No. 2 in C," also in Haydn's autograph (Burgerländisches Landesmuseum, Eisenstadt). H.C.R.L.

Literature: Hass 1950; Hoboken 1957, 541–542; Landon 1976, 260, 317–318; 488–490

THE FIRST AND CHIEF GROUNDS OF
ARCHITECTURE 1563
John Shute d. 1563
folio; with four full-page engravings
and one full-page woodcut
34.3 × 19.1 (13½ × 7½)

Chatsworth House
The Duke of Devonshire and the
Trustees of The Chatsworth Settlement

The First and Chief Grounds was the
first English book on architecture,
responding to a need in Elizabethan
England for knowledge of continental
Renaissance design. In the dedication
to Queen Elizabeth, Shute records that
he had been sent to Italy by the Duke of
Northumberland, and had made drawings
that were shown on his return to King
Edward VI. But events had blighted his
chance of advancing his book, for the
king died in 1553 and the political
upheavals associated with Mary I's
accession led to Northumberland's
execution. What the dedication demon-
strates is that the original impetus for
the work returns to the decade of the
1540s and to the powerful circle of

learned courtiers surrounding the
Protector, Edward Seymour, Duke of
Somerset, that included Sir William
Sharington of Lacock Abbey, Wiltshire;
Sir John Thynne, Somerset's steward who
superintended the building of Somerset
House between 1547 and 1552, and who
built Longleat for himself; William Cecil,
later Lord Burghley, the duke's private
secretary; and Northumberland himself,
who was the duke's brother and who
rebuilt parts of Dudley Castle in an
advanced Renaissance style.

In some ways the *First and Chief Grounds*
is disappointing, for it contains nothing
of Shute's Italian experiences, and is
merely a textbook on the Five Orders,
a free adaptation of Serlio, Vitruvius,

and Philander, with not a small spice of
North European mannerist sources
in the mythological caryatids. Had
Shute not died in 1563 another volume
may well have followed. But the book
was rendered sterile by virtue of the
popularity of the imported treatises of
the Italian, Sebastiano Serlio, and it is
significant that the ornamentation of
the pilasters in the courtyard of Kirby
Hall, Northamptonshire, attributed to
John Thorpe, is the only identifiable
use made of the book.

The book is rare: only six copies
survive. It was, perhaps, ahead of its
time. Too few people were interested
in the new Italianate architecture, and
they could as easily read about it in the
books in Italian that were readily avail-
able. It was to be some time before
interest in England was strong enough
to demand the vernacular. Shute's
work is, perhaps, more important as a
symbol of the Italianate and Renaissance
world in an age when extraordinary
freedom was used by craftsmen in the
interpretation of the classical orders. It
is a precious document in the history of
taste in Tudor England. This particular
copy has the added interest that it
is recorded in the 1742 manuscript
catalogue of Lord Burlington's library
at Chiswick. Here, consulted by the
leaders of the Palladian movement, it
can also be said to have assisted in the
rebirth of the ideals of Renaissance
architecture in eighteenth-century
England. J.H.

Provenance: See no. 139
Literature: Weaver 1912 (facsimile ed.);
Summerson 1953, 17, 20–23, pl. 12;
Wittkower 1974, 73, 100, pl. 125
Exhibitions: IEF 1979–1980 (142)

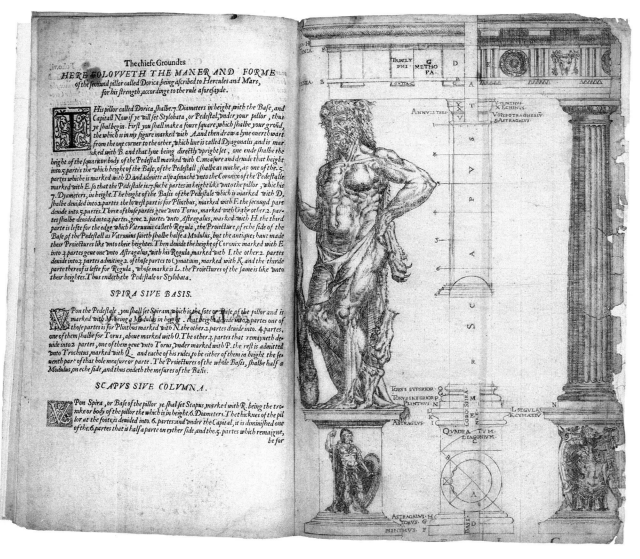

359

SECTION OF THE PAINTED
BREAKFASTING ROOM FOR KEDLESTON
HOUSE 1768
Robert Adam 1728–1792
watercolor
signed, *Adam Archt 1768*
53.3 ×67.3 (21 ×26½)

Kedleston Hall
The Viscount Scarsdale and the
Trustees of the Kedleston Estates

James Paine's Palladian plan for Kedleston was for a large central block connected to four pavilions by quadrant corridors. The northern pair was built, but by about 1765, when Robert Adam was in full charge as the 1st Lord Scarsdale's architect, the intention to build the southern pair had been abandoned. With the completion of the decoration and furnishing of the main state rooms in 1768 (though work still remained to be done on the hall and saloon), Adam produced an alternative scheme for completing the south front. This consisted of attaching corner towers with Palladian features at each end. On the principal floor these were to contain a book room beyond the library on the east, and a painted breakfasting room beyond the state dressing room on the west.

This painted breakfasting room should not be confused with the already executed breakfast room in the family pavilion. It was to have been a circular room twenty-five feet in diameter with four deep alcove niches. The painted decoration would have been extremely colorful, and, like the design for the book room, is an early example of Adam's later "Etruscan" style. The delicacy of the draftsmanship and the refinement of the overall scheme, taking

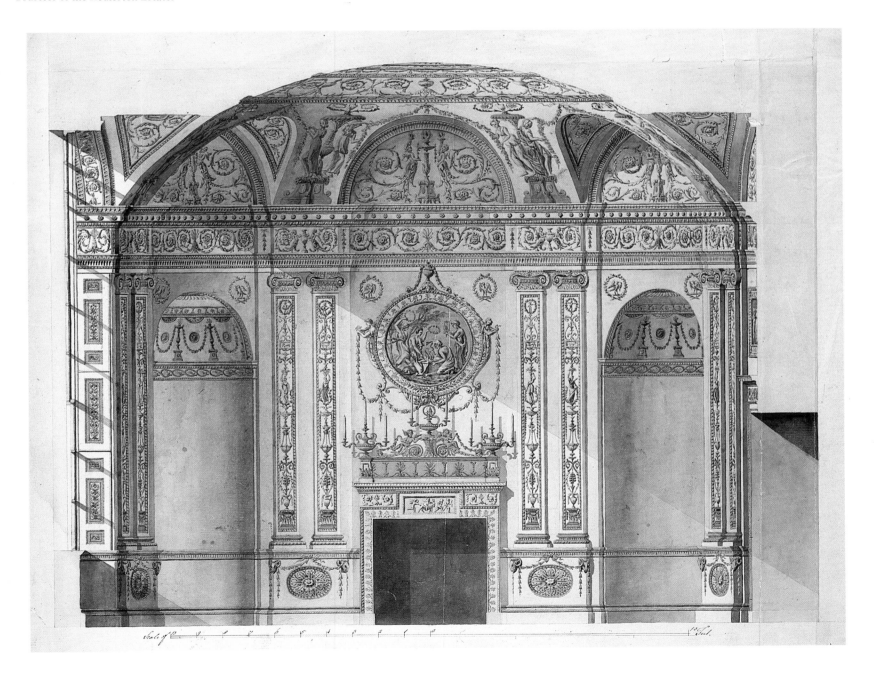

its cue from the "bronze green" tripod candelabra that appear in the niches, lunettes, and spandrels, show how well the architect was able to persuade his clients into ever greater extravagance. The strip of mirror above the chimney-piece is an interesting reversion to the early eighteenth-century idea of the "landskip glass" and may indeed be a suggestion for re-using an older plate. The roundel above has a delightful scene of a classical sacrifice, doubtless intended to be executed by Antonio Zucchi, Adam's favorite decorative painter, along with the "grotesques" on the faces of the pilasters, which recall Raphael's Vatican *loggie* more than the latest finds at Herculaneum. Unlike the filigree ornament of the Etruscan Room at Osterley, ten years later in date, this is indeed an evocation of the classical world still seen through the eyes of the Italian Renaissance. The popinjays in wreaths flanking the niches and overmantel represent the Curzon family crest.

In 1767, the year before this drawing was made, Adam had designed a circular dressing room for Harewood, twenty feet in diameter and without alcoves, but otherwise almost identical to the Kedleston room. Bolton quotes (1922, 1:177, no. 4A) a description of it as executed, and there are colored drawings in Sir John Soane's Museum (14:121; 11:148, 149), but the room no longer survives.

L.H./G.J-S.

Related Works: As well as the drawing from Kedleston there are elevations for the two walls showing the window and the door in Sir John Soane's Museum, also in full color (14:124, 125). There is also a plan (40:18), mistakenly headed (presumably by William Adam) "Plan of Saloon for Kedleston for Lord Scarsdale." It is only twenty-five feet in diameter (the saloon is forty-two feet) and it obviously refers to the breakfasting room. At Kedleston there is also a signed and dated drawing for the ceiling in full colors; and there is an incomplete, partly colored version of this in the Soane Museum (11:48) dated March 1768

360

LA MÉTHODE ET INVENTION NOUVELLE DE DRESSER LES CHEVAUX
Antwerp, 1658
William Cavendish, Duke of Newcastle
1592–1616
folio
46.2 × 32.5 (18⅛ × 12¹³⁄₁₆)

Blickling Hall
The National Trust
(Lothian Collection)

The Duke of Newcastle is said to have so loved his horses that he treated them as equals and bedded them comfortably, while in return they whinnied in expectant joy whenever he approached their stables. In 1622 he built the great Riding House at Welbeck, his country house in Nottinghamshire, and in 1625 a magnificent range of stables. This was the period of the great printed expositions of the *manège*, or the training of horses in the balletic arts. Antoine de Pluvinal and Crispin van de Passe's *Le Manège Royal* appeared in Paris in 1623, a book certainly owned and treasured by the duke because it was the most elegant exposition of the art to date. It was the model upon which he determined to base his own *Méthode et Invention Nouvelle de Dresser les Chevaux* when he was exiled in Antwerp during the Puritanical years of the 1650s. This was an achievement of the highest professionalism, and Cavendish employed the great Abraham van Diepenbeck to make the drawings, and Jacques Meurs in Antwerp to print and publish it. In matters of printing and presentation, the book was an aesthetic work, personally supervised by Cavendish as the subject closest to his heart. Cavendish wrote it in English and had it translated into French. An English edition, *A New Method and Extraordinary Invention to Dress Horses*, appeared in London in 1667; the French edition appeared in London in 1737, and was translated and published by J. Brindley as the first volume of *A General System of Horsemanship* in 1743.

Many of the duke's horses were portrayed with his castles and country houses in the background, including Ogle, Welbeck, and Bolsover, and this theme was continued after his return to Welbeck by a series of large oil paintings of his favorite horses with identifiable views seen through their legs. These still survive in the Portland collection and their composition influenced John Wootton when painting similar horses for Edward Harley, 2nd Earl of Oxford, at Welbeck in the 1720s and 1730s.

This copy of the Duke of Newcastle's "Equitation" (as it was often called) comes from the library of Sir Richard Ellys of Nocton in Lincolnshire, whose books were bequeathed to Blickling Hall, Norfolk, after his death in 1742 (see no. 330).

J.H.

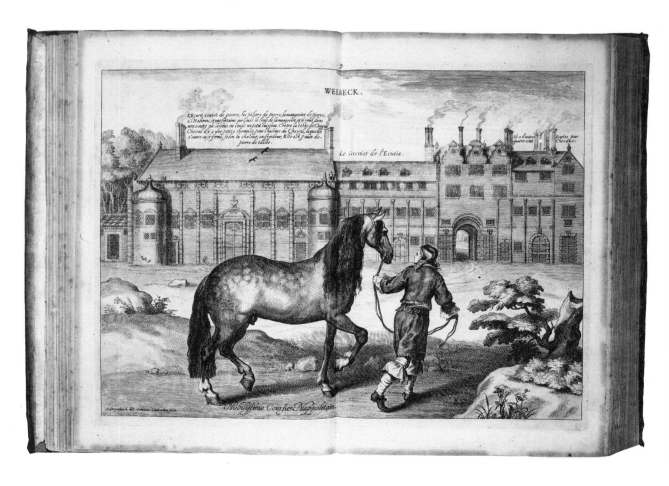

361

DYRHAM THE SEAT OF
WILLIAM BLATHWAYT ESQ.[r] 1712
Johannes Kip d. 1719
engraving
inscribed, *J. Kip Delin. et Sculp*
52 × 60.9 (20½ × 24)

Dyrham Park
W.A. Mitchell, Esq.

The tradition of the "bird's eye" view picture was brought to England in the late seventeenth century by Flemish and Dutch artists, many of whom like De Koninck (see no. 322) had climbed church towers to obtain distant prospects over their native landscapes. Among the most prolific of such artists were Johannes Kip and Leonard Knyff (d. 1720), whose collection of eighty plates entitled *Britannia Illustrata or Views of…the Principal Seats of the Nobility and Gentry of Great Britain* was first published in 1707 (Harris and Jackson-Stops 1984). Knyff appears to have prepared the drawings for all these plates and Kip to have acted as the engraver, but the second, two-volume edition of 1715 contained a number of extra views first published in 1712 in Sir Robert Atkyns' *Ancient and Present State of Glocestershire*, and for these Kip was entirely responsible. Indeed it is he rather than Knyff who produced one of the earliest known engraved "bird's eye" views of an English building—a prospect of Chelsea Hospital dated 1690—and it is significant that it was Kip whom Sir Godfrey Kneller (no. 88) chose to depict his splendid new house, Kneller Hall in Middlesex, soon after 1715 (Harris 1979, 92, pl. 104).

The volumes of *Britannia Illustrata* provide an invaluable record of the elaborate formal gardens that surrounded almost every country house in the baroque period, but which were swept away in the later eighteenth century by Capability Brown and others in their pursuit of the natural and "picturesque." It has often been said that the engravings of Kip and Knyff exaggerate, or show effects owners intended but never achieved. However, as research uncovers more about these gardens, it becomes less easy to doubt the accuracy of the engraved views.

Those at Dyrham, laid out between 1691 and about 1704 for William Blathwayt, William III's Secretary-at-War, by the Royal gardeners George London and Henry Wise, are a case in point. Little trace of their layout can now be seen in the landscaped deer park, still of great beauty, with its wide views over Bristol and the Severn estuary. Yet a long description of the garden has been recently rediscovered in Stephen Switzer's rare *Ichnographia Rustica*, published in 1718 (3:113–127), only four years after Kip's engraving, and confirming its minutest details: the long canal and cascade, the finest in England after that at Chatsworth, aligned on William Talman's orangery; the "Slope Garden" just behind the church, outside the windows of the parlor; the terraces and the "Wilderness" on the hill above them with "small Desks erected in Seats…for the sublimest Studies"; the kitchen garden and stew pond stocked with fish in the foreground; and many other features of particularly Dutch inspiration (the whole passage is reprinted in Mitchell 1977–1978, 100–108). As one of the king's closest advisers, Blathwayt had a permanent apartment at William and Mary's royal palace of Het Loo in Gelderland where he would have known Daniel Marot's famous gardens, and the superb Delft tulip vases that still survive at Dyrham (see no. 104) suggest that bulbs brought over from Holland played a large part in his planting schemes. Kip's engraving also shows the south front of the house and stable range, which are more French in style, designed by a Huguenot architect, Samuel Hauduroy, between 1693 and 1698. G.J-S.

Literature: Mitchell 1977–1978, 83–108, figs. 4, 22–30

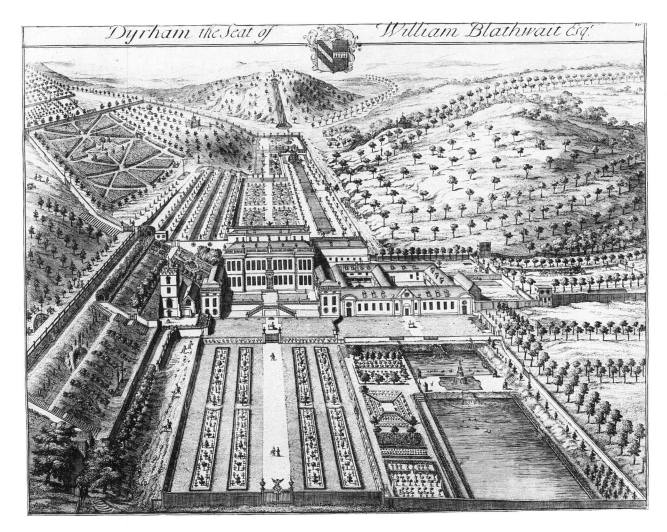

362

ANTIQUITES ESTRUSQUES, GRECQUES
ET ROMAINES, TIREES DU CABINET DE
M. HAMILTON Naples, 1766–1776
Pierre François Hugues, Baron
d'Hancarville 1719–1805
folio
48.3 × 28.8 (19 × 11⅜)

Dunham Massey Hall
The National Trust
(Stamford Collection)

Sir William Hamilton (1730–1803) was Ambassador to the Court of Naples for the exceptional period of thirty-seven years from 1764–1801, and a member of the Society of Dilettanti. No self-respecting English tourist to Italy failed to pay him a visit. His partner in this venture, D'Hancarville, is one of the most intriguing figures of the age of the Grand Tour. A philosopher turned art historian, his career was full of adventure, and his reputation not always spotless: in anticipation of D'Hancarville's visit to Florence in 1759, Johann Winckelmann warned his nephew Muzel-Stosch, "when you show him your gems, keep a close look-out to see what he is doing with his hands" (*Briefe*, 5 September 1759, quoted in Haskell 1984,

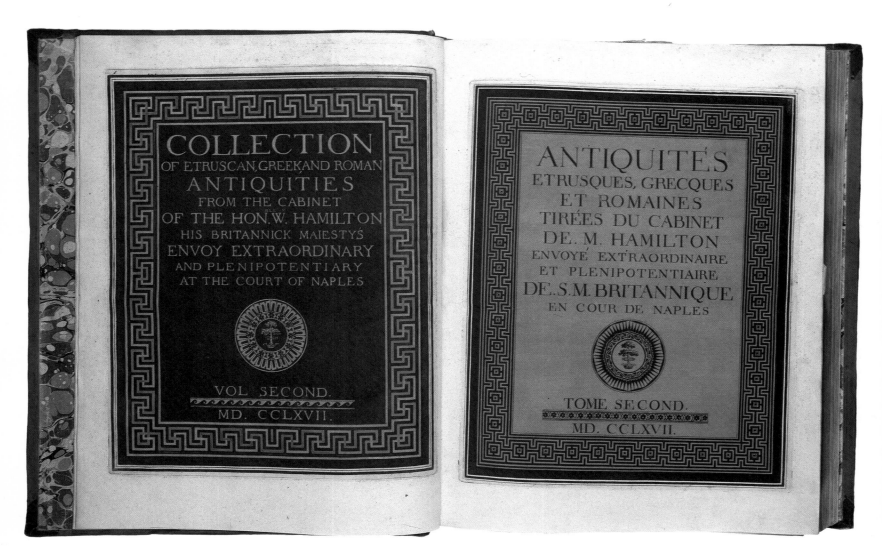

181). It is not known precisely how he came into the circle of His Britannic Majesty's Envoy Extraordinary at Naples, but the volumes that resulted from his acquaintance are the one lasting monument to his considerable scholarship. The story of their production, however, is typically colored with incident. Hamilton had originally intended only two volumes but D'Hancarville decided to enlarge it to four. The first was published in 1766, the second (this volume) in 1770, and the last two not until 1776—after a protracted dispute between patron and author.

The enormous cost of £6,000 was borne by Hamilton himself.

Despite the title, the antiquities illustrated were only partly from Hamilton's collection. D'Hancarville's text begins with references to the illustrations, but soon embarks on a lengthy discourse on the history of art in general. But it is the plates which are the most remarkable feature of the book: Hamilton wished that all the drawings should be carefully measured, in the hope of encouraging the improvement of modern English design, and these (by Giuseppe Bracci who also executed the exquisite frontispieces and vignettes) accounted for the vast cost of the book. Proof impressions of many of the plates circulated separately prior to publication, and it was these that led Josiah Wedgwood to christen his factory "Etruria" in 1769. They were fertile sources for the form and decoration of his pottery for some years. On 23 May 1786, Hamilton wrote to Wedgwood from Naples, "It is with infinite satisfaction that I reflect upon having been in some measure instrumental in introducing a purer taste of form and ornaments by having placed my collection of Antiquities in the British Museum, but a Wedgwood and Bentley were necessary to diffuse that taste so universally, and it is to their liberal way of thinking and industry that so good a taste prevails at present in Great Britain, I have always and will always do them that justice . . ." (MSS Wedgwood Museum, Barlaston). Five years after the last volume was published Hamilton gave up collecting and sold his collections to the British Museum.

D'Hancarville found his way to London, where in about 1781 he was depicted by Zoffany, cataloging the Towneley marbles (no. 213). This copy bears the bookplate of George Harry, 5th Earl of Stamford, born in 1737, the son the 4th Earl and Lady Mary Booth (see no. 353), a Fellow of the Society of Antiquaries and a discriminating collector of pictures on the Grand Tour in 1760 (see no. 197). It is not surprising that this sumptuous book should be among his collections. J.F.F./J.M.M.

Literature: Fothergill 1973, 66; Haskell 1984, 181–184

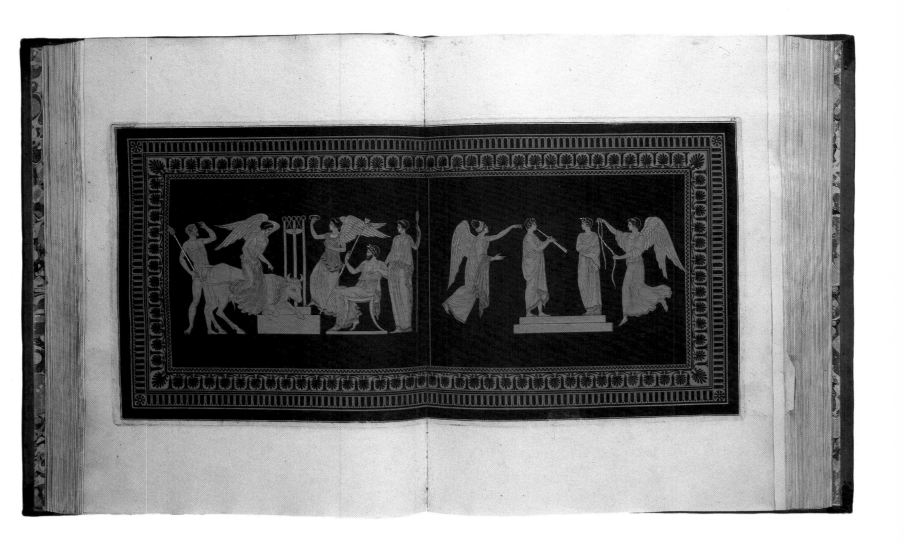

363

ELEVATION AND PLAN OF THE WEST
FRONT OF HOUGHTON HALL, NORFOLK
1735
Isaac Ware c. 1707–1766; engraved
by Paul Fourdrinier
engraving
40 × 68 (15¾ × 26¾)

The Menagerie, Horton
Gervase Jackson-Stops, Esq.

Isaac Ware, the son of a London cord-wainer, was apprenticed in August 1721 to Thomas Ripley, who in the following month succeeded Grinling Gibbons as Master Carpenter to the Board of Works. In 1722 Ripley was also appointed clerk of the works for the building of Sir Robert Walpole's great Palladian house at Houghton in Norfolk, designed by Colen Campbell. It was thus natural that many of Ware's seven apprentice-ship years should have been spent at this house. Ripley's limited capabilities caused Vanbrugh "such a Laugh … I had like to Beshit my self." But Ware was quite another matter; by 1728 he had attracted the attention of Lord Burlington, and by 1733 was the architect appointed to design the St. George's Hospital at Hyde Park Corner. In a sense he became the publicist of the Palladian, or more specifically the Burlingtonian, movement, with his *Designs of Inigo Jones and Others*, c. 1731,

and his immaculate edition of Palladio's *Four Books of Architecture* of 1738.

The Plans, Elevations and Sections, Chimney-Pieces, and Ceilings of Houghton in Norfolk appeared in 1735, ten years after William Kent had superseded Campbell as the decorator of the interior. This majestic folio commemorates the most magnificent house of its time, built by Britain's first prime minister, and must be regarded as a triumphant celebration of Campbell's architecture and Kent's idiosyncratic decoration. No less than thirteen of the plates are ascribed to Kent himself. The idea for the book may have been Ware's alone, for its innovations could hardly have been Walpole's. It is the first monograph of measured plans, elevations, and sections, together with drawings for chimney-pieces, of a country house, and was the precedent for Matthew Brettingham's *Holkham* in 1761. However, the true precedent for publishing interior

elements remains William Kent's *Designs of Inigo Jones, with some Additional Designs*, 1727. There is a curious parallel between the respective books of Ware and Brettingham. Just as the latter omits every reference to Kent on his plates, so does Ware omit Campbell's, dividing responsibility between *T. Ripley Arch.* and *W. Kent Inv.* for ceilings and chimneypieces. Ware even forgot to mention James Gibbs' responsibility for the domes of Houghton, in Lord Hervey's words "obstinately raised by the master…in defiance of all the virtuosi" (Ilchester 1950, 70). But this was a natural misdemeanor, for by 1735 Campbell and Gibbs were anathema to Lord Burlington's camp-followers.

Ware's drawings of Houghton show a high level of technical skill, particularly this one of the west front, with its explanatory ground plan shown in the foreground in steep perspective. In contrast to Vanbrugh's houses where the greatest display was always reserved for the entrance front, it is the garden front here that is framed by curving quadrant colonnades leading to the original kitchen and laundry courts. When a second edition of the book appeared in 1760 the plates, by Paul Fourdrinier, were re-engraved by his son Charles, who erased Ware's name. The plates of the first edition were reprinted by John Boydell in 1784 when he produced his folio on the Houghton pictures then in Catherine the Great's collection. J.H.

West Front of
HOUGHTON in NORFOLK

364

A PLAN OF THE CITY OF NEW YORK
AND ITS ENVIRONS 1766
John Montresor c. 1735–1816
pen and ink
74.3 × 53.9 $(29\frac{1}{4} \times 21\frac{1}{4})$

Firle Place
The Trustees of the
Firle Estate Settlement

This plan, drawn early in 1766, depicts
New York in its last years of colonial
rule, before the city was taken over by
patriots at the beginning of the American
Revolutionary War. The surveyor,
Colonel John Montresor, was appointed
Chief Engineer in America in 1775,
after twenty-one years of army service
on the North American continent. He
dedicated the plan to General Thomas
Gage (1721–1787), Commander-in-Chief
of the British Forces. In the early months
of the war the tide of events was to
turn against the British. The Provincial
Congress of New York first met in May
1775, the British troops withdrew in
June, and on 9 July 1776 patriot troops
and civilians pulled down the statue of
George III. The British forces reoccupied
the city in September 1776.

Gage, like Montresor, had come to
America with General Edward Braddock
in 1754, and had served with distinction
in the French and Indian Wars. He was
promoted to Commander-in-Chief of the
British Forces in 1763, and was held in
high esteem by the American colonists
as well as the British when in 1774 he
was appointed Governor of the Province
of Massachusetts Bay. Ordered to enforce
what the colonists regarded as coercive
acts, he found himself isolated in Boston,
protected by British troops from the
insurgent surrounding population. After
the British defeat at Bunker Hill he was
recalled to England in October 1775.
He presumably took home Montresor's
plan with his other papers to Firle Place,
where the family had lived for many
generations—a poignant reminder of
the reversals of fortune that overtook
many distinguished officers in those
tumultuous years. Montresor himself
retired to Belmont, his country house
near Throwley in Kent, where in the
1780s he commissioned the architect
John Plaw to build a pair of cottages
"in the American style," later named
New York (Colvin 1978, 642). H.W.

Literature: Cumming 1979
Exhibitions: London, NMM 1976 (190),
with previous literature

12: Chinoiserie and Porcelain

A taste for the exotic artifacts of the orient began in England as early as the sixteenth century, and by the late seventeenth the English and Dutch East India Companies were the channels by which Chinese and Japanese porcelain, embroidered silks, lacquer, and coromandel as well as spices, and (most important of all) tea, reached the households of Europe. The smaller country houses benefited as much as the larger: Elihu Yale, as Governor of Fort St. George (now Madras), sent back a lacquer screen as well as "mango atchar" or chutney to his neighbor Mrs. Edisbury of Erddig in North Wales; and coromandel screens were cut up to form the paneling of dressing rooms at manor houses like Honington Hall in Warwickshire.

By the mid-eighteenth century, imitations of Chinese lacquer in the form of japanned furniture had given way to rococo designs in which these decorative motifs had been adapted to mirror frames and pier tables, chairs and wall sconces, even to state beds like that from Badminton, now in the Victoria and Albert Museum. In contrast to the solid, symmetrical exteriors of Palladian houses, chinoiserie offered a light and insubstantial gaiety, particularly suitable for smaller rooms, where regular architectural features were dissolved: water gushes through cornices; flights of steps begin and end nowhere; oversized flowers and grasses defy the laws of perspective; and dragons, cranes, and ho-ho birds perch on branches. The engraved designs of Thomas Chippendale, Thomas Johnson, and other cabinetmakers are full of such features, and Chippendale himself was responsible for whole suites of rooms hung with hand-painted Chinese wallpaper at Nostell Priory, Harewood, and the actor David Garrick's villa at Twickenham, where Indian chintz palampores were also used. The only English designer to have a first-hand knowledge of China was Sir William Chambers, whose *Designs of Chinese Buildings* was published in 1757, but even his famous pagoda at Kew represents a European vision of Cathay rather than an accurate reconstruction.

From the late seventeenth century, British country house owners sent special orders for porcelain to China, with drawings and engravings of their family arms, hunting scenes, or even representations of their houses for the artists and enamelers to copy. This often resulted in curious images: Scottish highlanders with distinctly Chinese faces; family mottoes hilariously misspelled (the Brodies' "Unite" translated as "Untie") and heraldic colors reinterpreted in the *famille verte* or *famille noire* palette. Export porcelain also included a wide range of useful and decorative wares. Among the latter, animals, birds, and fishes were particularly popular with the British and the Germans, inspiring first of all Meissen and later Chelsea, Bow, and other models. An almost complete bestiary is to be seen here, ranging from domestic cats, dogs, and chickens to bullfinches, parrots, pheasants, and rarer wild animals like the leopard and rhinoceros on the Meissen service from Alnwick (nos. 389–390)—recalling the number of eighteenth-century country houses that had menageries in their parks, ancestors of the modern zoo.

The British milords often took in Vienna and Dresden on their way home from the Grand Tour, and Meissen porcelain was also available from London dealers. But it was Sèvres that particularly appealed to them, both before and after the French Revolution. English ambassadors to Paris rarely returned without mementoes of their stay: Louis XV presented the wife of the 4th Duke of Bedford with a famous service still at Woburn, the Duke of Richmond acquired outstanding pieces for Goodwood, and the 2nd Earl of Egremont was presented with a splendid punch bowl by his French counterpart after the signing of the Treaty of Paris (no. 402). Among the pieces directly commissioned from England, an outstanding example is the service made to celebrate George III's return to sanity in 1789 (no. 410). Later collections like those now at Firle and Boughton run parallel with the taste for French furniture developed in the 1820s and 1830s by the Prince Regent and the Marquess of Hertford.

The English factories were unable to rival the sophistication of Sèvres but the naturalistic groups of Chelsea figures including actors and masqueraders, or shepherds and shepherdesses in leafy arbors, evoke the pleasure gardens at Vauxhall and Ranelagh, where the rococo movement found its happiest expression. Josiah Wedgwood's pottery later adopted the neo-classical forms of Robert Adam's architecture, and his black-basaltes, creamware, and stoneware vases provided appropriate garnitures for the chimneypieces in Adam's interiors, like those at Saltram. Depictions of country houses and their parks on plates and tureens, later taken up by Worcester and other factories (and even in Paris), began with Wedgwood's unrivalled Frog Service made for Catherine the Great. Its quality can be judged by the few trial pieces or replicas, like the Shugborough tureen (no. 429), which survive in English collections.

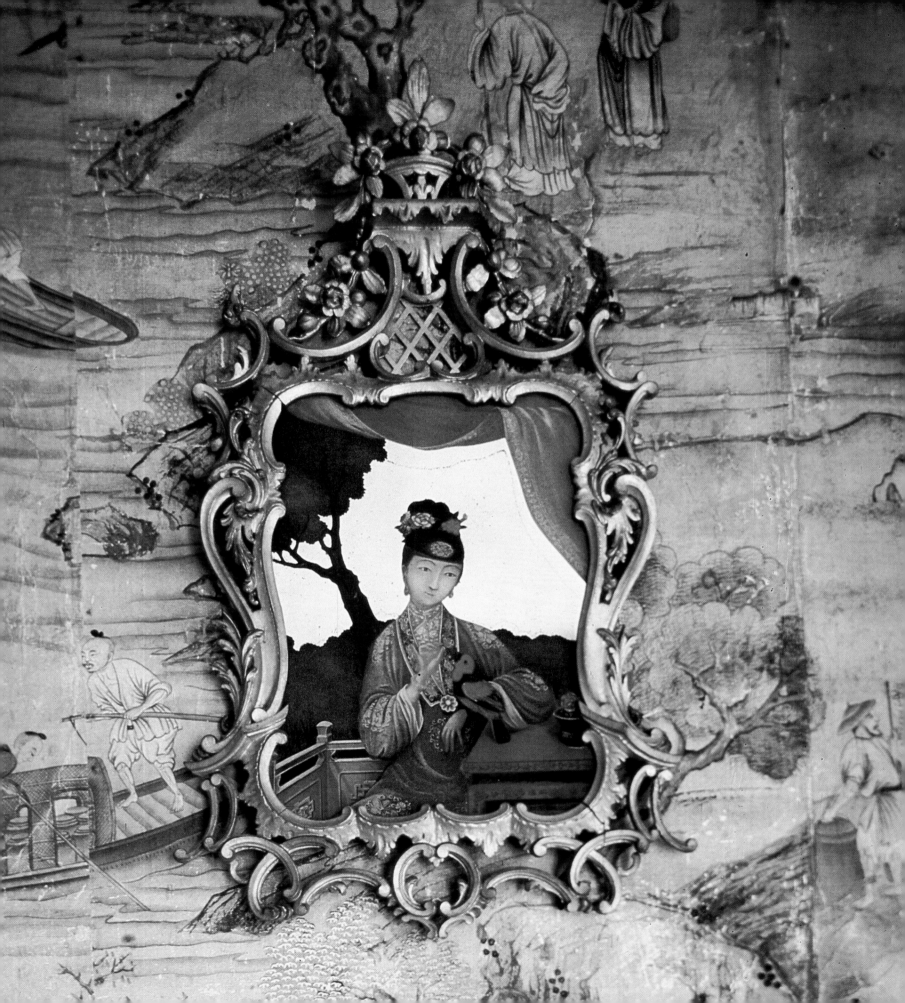

365

MIRROR PAINTING c.1756
Chinese, Qianlong, in an English frame
glass, painted in enamel colors and
silvered, in a giltwood frame
39.3 × 35.2 (15½ × 13⅞)

Saltram House
The National Trust (Morley Collection)

Saltram is richer in chinoiserie decoration than almost any English country house: no less than four rooms are hung with hand-painted Chinese wallpaper or cotton and their furniture includes a four-post bedstead and padouk-wood chairs in the "Chinese Chippendale" style, hanging shelves for the display of porcelain (including the pug dogs, no. 388), and a series of eight Chinese mirror paintings, six of which are in outstanding English rococo frames. One mirror is backed by a spare piece of wallpaper from the Chinese Dressing Room, inscribed with the date 1756 in a contemporary hand, and it is likely that they were all acquired at this time as part of Lady Catherine Parker's energetic remodeling and refurnishing of Saltram between 1750 and her death in 1758. Unfortunately none of her accounts survive, and although their beautifully carved and pierced frames have in the past been attributed to Thomas Chippendale, who later made the furniture in Adam's saloon for her son, the 1st Lord Boringdon, there are far closer parallels with two pier glasses at Felbrigg in Norfolk supplied by the carver John Bladwell of Bow Street, Covent Garden, between 1752 and 1756 (London, V & A 1984, L27). The trelliswork ornament in particular, so suitable for these charming garden scenes, is conceived in exactly the same way, combined with floral garlands and *rocailles*.

The vogue for Chinese mirror paintings developed comparatively late in England, compared with the lacquer and coromandel screens, the porcelain, and embroidered silks, which had hitherto arrived by way of the East India Company. Some of the earliest recorded are those at Shugborough brought back by Admiral Lord Anson from his famous circumnavigation (which had included a prolonged call at Canton) in 1747.

These were placed in the Chinese House, which Pennant called "a true pattern of the architecture of that nation, not a mongrel invention of British carpenters" (Hussey 1954, 1126), helping to create an atmosphere vividly conveyed by an anonymous poet of the same period— whose verses could equally well apply to the Chinese rooms at Saltram: "Here mayst thou oft in Leric Bower, secure of Mandarins despotic power . . . Safe from their servile yoke their arts command/And Grecian domes erect in Freedom's land." G.J-S.

Literature: Neatby 1977, 49–50, 63, pl. 4b

366

GOLDFISH BOWL ON STAND
c.1769/1772
Chinese, Qianlong, on a stand by
Thomas Chippendale
1718–1779
porcelain, on japanned beechwood stand
stand 40.6 (16) high;
bowl: 55.8 (22) diam.

Harewood House
The Earl and Countess of Harewood

Although the fashion for chinoiserie is particularly associated with the rococo style in England, it survived into the 1770s and beyond as a means of imparting an exotic flavor to neoclassical interiors, particularly bedrooms and dressing rooms. This splendid *famille noire* bowl, one of a pair now in the gallery at Harewood, is of a type often said to have been used for potpourri, but more likely intended for goldfish, which appear as enameled decoration on the inside, thus providing the effect of a mirror image when filled with water. The reserves on each side are painted with cockerels among the brilliantly colored flowers of the four seasons—prunus, peony, lotus, and chrysanthemum—and the use of gilding suggests a date not much earlier than 1760.

The green and gold stands for the two bowls were undoubtedly supplied to Edwin Lascelles, the builder of Harewood, by Thomas Chippendale, though probably in the period between 1769

and 1772, for which no detailed bills survive. A "pair of large enameld china cisterns on carv'd & Gilt painted Green frames," described in the 1815 inventory of Nostell Priory, are remarkably similar, and Chippendale is known to have supplied whole sets of green and gold japanned bedroom furniture to both Yorkshire houses during this period, as well as hanging "Indian paper" (actually hand-painted Chinese wallpapers) in a number of rooms. It is very probable that, like an earlier *famille rose* fish bowl at Wallington in Northumberland, those at Harewood had polished brass ring handles through the lions' masks either side, a motif repeated by Chippendale

on the stands and continued by the hairy paw feet.

The bowls were recorded in the saloon at Harewood at the time of Edwin Lascelles' death in 1795, when the stands were described as "blue and gold." However, they must originally have belonged with other green and gold japanned pieces either in the State Bedroom or the Chintz Pattern Bedroom, and the compiler of the inventory could easily be forgiven for interpreting fading turquoise as blue. G.J-S.

Literature: Gilbert 1978, 115–116, fig. 384

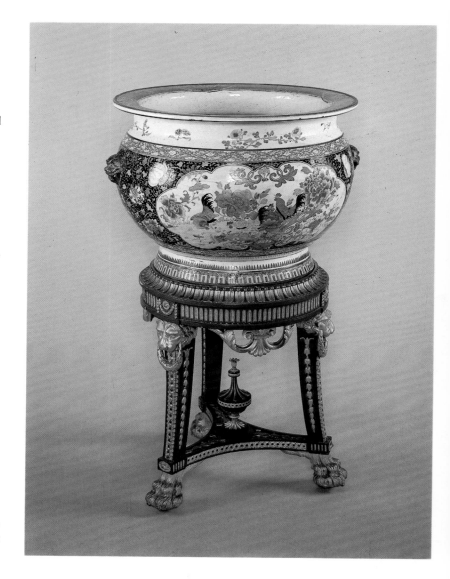

367

CANDLESTAND C.1757
Thomas Johnson 1714–1778
painted pine with iron and composition
branches and brass nozzles and drip pans
159 ×94 ×56 (62½ ×37 ×22)

Temple Newsam House
Leeds City Art Galleries

The most correct Palladian houses of
the mid-eighteenth century in England
often had interiors decorated in the
wildest rococo or chinoiserie manner.
While these styles were often favored
for bedchambers and for dressing rooms,
where they provided a particularly suit-
able ambience for tea-drinking, they
sometimes strayed into the larger
"rooms of state." This candlestand is
one of a set of four made to flank the
pier tables in the gallery at Hagley Hall,
Worcestershire, an archetypal Palladian
house designed for George, 1st Lord
Lyttelton, by Sanderson Miller between
1754 and 1760. These candlestands and
tables corresponded with other "rustic"
furnishings in the room including pier
glasses, girandoles, and wall brackets: a
decorative scheme perhaps inspired by
the views from the windows of the
gallery over the famous landscape park
at Hagley, which inspired a long passage
in Thomson's *The Seasons*, and which
was laid out with the advice of another
poet, Lord Lyttelton's neighbor George
Shenstone.

The stand is painted brown and
"stone" color to give the impression of
partly petrified wood, and the candle
branches are in the shape of gnarled oak
twigs. Every kind of aquatic ornament
appears in the carving, including a grotto
and fountain, dolphins, stalactites, and
stalagmites, which are very close in form
to those found on Chinese lacquer cabi-
nets and screens imported to England
through the East India Company. The
general form, and much of the decorative
ornament, appears in two designs for
stands published in Thomas Johnson's
150 New Designs of 1758 (plate 13), and
this whole suite of furniture is thought
to have been executed in his workshops
in Grafton Street, Soho. The winged
and feathery-tailed dolphins may well
derive from an engraving of a torchère
by François Cuvilliés, one of a series

published in Munich and Paris between
1745 and 1755 (Ward-Jackson 1958,
fig. 357), and Chippendale appears to
have adapted Johnson's design for an
engraving (plate 145) in the third edition
of the *Director* (1762). Johnson is him-
self known to have plundered the work
of other *ornemanistes* such as Daniel
Marot, Bernard Toro, and William De
La Cour, for ideas. But his pattern books,
which were among the most influential
of the period, are highly individual in
their extravagant asymmetry, often
approaching a truly oriental abstraction
of design. J.H./G.J-S.

Provenance: By descent at Hagley;
sold by the 10th Viscount Cobham,
Sotheby's, 17 March 1950, lot 134; two
of the stands are now at the Philadelpia
Museum of Art and the fourth is at the
Victoria and Albert Museum (London,
V & A 1984, L45)
Literature: Jourdain 1950, 8–10, fig. 4;
Leeds 1950, 8; Leeds 1957, 19–21;
Hayward 1964, 39–40, pl. 39; Coleridge
1968, 61–62, fig. 107; Honour 1969,
120 (ill.); Gilbert 1978, 2: 295–296,
no. 355

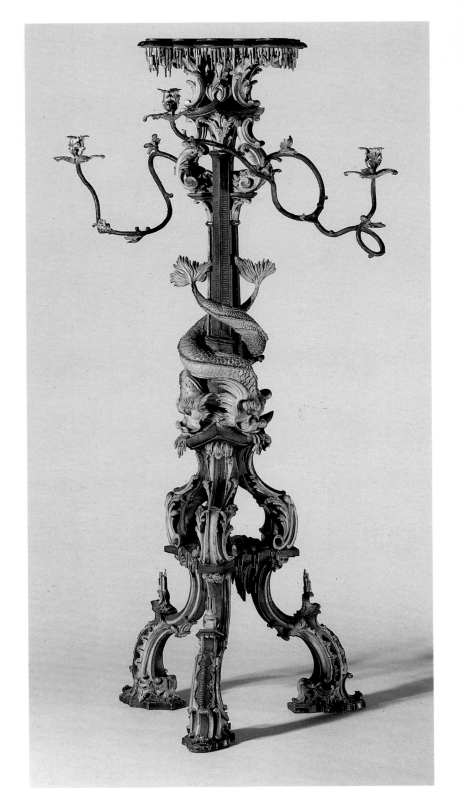

368

ARMCHAIR C.1760
English
mahogany with upholstered seat
99 × 55.8 × 58.4 (39 × 22 × 23)

Sledmere House
Sir Tatton Sykes, Bart.

The term "Chinese Chippendale" usually applied to chairs of this kind derives from the nine different patterns of "Chinese Chair" illustrated in Thomas Chippendale's *Gentlemen and Cabinet-Maker's Director* (plates 26–28 in the third edition of 1762), and from the rare documented examples of his work in this style, including the green japanned chairs in the state bedroom and dressing room at Nostell Priory of 1771. But similar examples can be found in many other pattern books of the period, like Ince and Mayhew's *Universal System* (probably also published in 1762) and Robert Manwaring's *Chair-Maker's Guide* of 1766. This particularly elaborate armchair, one of a set of four, has some similarities with one of Manwaring's engravings, first published in the *New and Genteel Designs . . . of Houshold Furniture*, by "A Society of Upholsterers, Cabinet-Makers &c." in 1760. The chairs must have been commissioned by Richard Sykes as part of the furnishing of his new house at Sledmere begun in 1751—and later rebuilt in the neoclassical style by his nephew Sir Christopher (no. 474). The high quality of the carving, a masterly combination of purely English rococo elements with the severe geometry of the Chinese fret, suggests that they were the work of a London maker, though the Yorkshire upholsterers Wright and Elwick of Wakefield (fl. 1746–1771), could easily have supplied furniture of this sort. In a letter of October 1775 Edward Elwick claimed that the firm had had "the Honour to serve most of the Nobility & Gentry in the West and North Rideing," and is said to have sent "about £3,000 of Furniture . . . into ye West Rideing . . . some Very Expensive" by water (Gilbert 1976, 38). G.J-S.

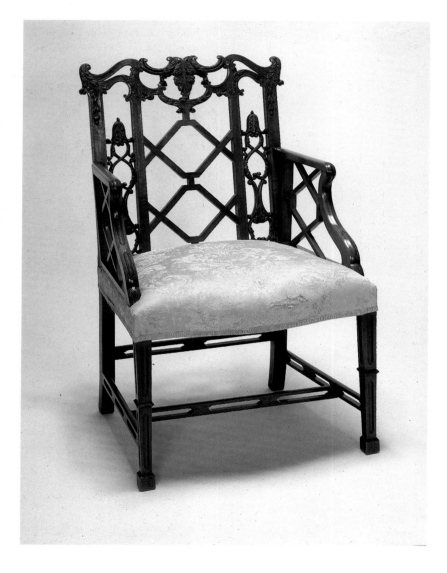

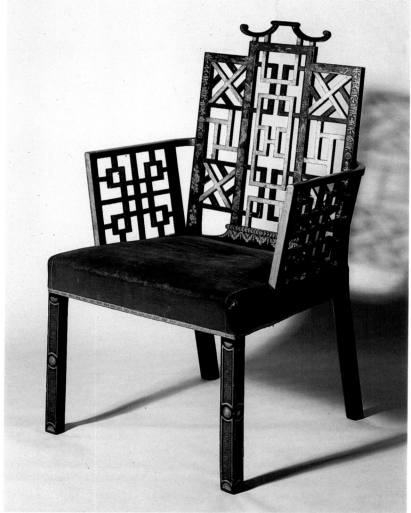

369

ARMCHAIR C.1753
William Linnell d. 1763 and John Linnell
1729–1796
beechwood, japanned
103 × 60 × 66 (40½ × 23⅗ × 26)

Private Collection

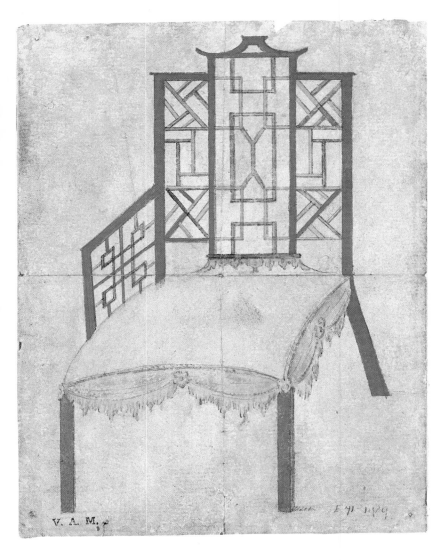

This chair comes from a set of eight forming part of the famous suite of japanned furniture supplied by William and John Linnell to the 4th Duke of Beaufort (1709–1756) for the Chinese Bedroom at Badminton House, Gloucestershire. The furnishings for this room (which was hung with Chinese painted paper) originally included the celebrated canopied bed (Victoria and Albert Museum, London), a dressing commode, and two pairs of standing shelves. Although the bills do not apparently survive, unitemized payments by the duke to the Linnell firm (in Hoare's Bank, London, ledgers) record a total expenditure between October 1752 and December 1755 of £800. This large sum must have included payments for pieces additional to the surviving japanned suite.

John Linnell's watercolor drawing for one of the chairs (Victoria and Albert Museum, London, E71 1929) indicates that a rather different color scheme was originally intended, red and blue being the dominant colors in the design rather than black and gold as executed. Traces of red can be seen under the black on the backs of some of the chairs, suggesting that the present fine japanned decoration may date from slightly later in the eighteenth century. The design of the back and legs was also modified slightly but it is not known if the elaborately swagged and fringed upholstery shown in the drawing was carried out as planned since the seat covers have been changed. The "Chinese" characters that appear on the stiles of the back, like those engraved in Sir William Chambers' *Chinese Designs* of 1757 (pl.18), are half-real and half-imaginary.

John Linnell's design for the chair (and—though no further Badminton designs survive—by implication for the rest of the suite) was one of his first major responsibilities as a designer for his father's firm. William Linnell had been among the first cabinetmakers to give concrete expression to the new vogue for chinoiserie. He had created a "Chinese" house at Woburn for the 4th Duke of Bedford in 1749 and a year earlier may have been involved in a similar scheme at Wroxton for Lord North. Other clients of the firm who had a taste for this novel form of decoration (though none so opulent as the Badminton scheme) included Mrs. Montagu in Hill Street, the 1st Lord Lyttelton, and Sir Nathaniel Curzon, 1st Lord Scarsdale. H.R.

Provenance: 4th Duke of Beaufort and by descent to the 9th Duke; his sale, Christie's, London, 30 June 1921, when purchased by the present owner. The set of chairs was divided at this sale. The other four were again sold at Christie's London 17 December 1959 (lot 28), from the collection of Lord Beatty
Literature: Hayward and Kirkham 1980, 1:106–108, fig. 4, and 2:pl. I
Exhibitions: London, Christie's 1980 (2)

370

PAIR OF CHINTZ PALAMPORES C.1770
Indian, Coromandel Coast
(northern region)
printed cotton
318.7 × 224.8 (125½ × 88½)

Flintham Hall
Myles Thoroton Hildyard, Esq.

The flowering tree motif, which dominated the design of Mughal printed cottons for over a hundred years, probably reached India through the medium of fifteenth- and sixteenth-century Persian art, itself influenced by earlier Chinese representations of the "Tree of Life" (Irwin and Brett 1970, 16–21).

These two rare eighteenth-century Indian palampores (or coverlets) are closely similar to the hangings of the famous bed supplied by Thomas Chippendale to the actor David Garrick for his Thames-side villa at Hampton near Twickenham in 1775 (now in the Victoria and Albert Museum, London). Garrick's wife, the Viennese dancer Eva Maria Veigel, had been given a bale of Indian chintz about 1771 by a group of merchants in Calcutta as a token of gratitude for some material and advice her husband had supplied for their new theater. The importing of Indian chintz was, however, strictly prohibited in England from 1700 until the early nineteenth century, as a measure of protection for native textile weavers, and in 1775 the palampores were seized by customs officials at Chippendale's workshop, where they were being made up into bed hangings and window curtains. Garrick wrote to a friend in June that year: "poor Rachel . . . had prepared paper, chairs, etc. for this favourite token of East India Gratitude" (Little and Kahrl 1963, 3:1009), and indeed Mrs. Garrick's Chinese bed-cum-dressing room at Hampton with its oriental wall-paper and green and white japanned furniture made by Chippendale had been conceived specially as a suitable setting for this material—the "unfortunate furniture which my evel stars made me deliver up into your hands," as she called it in a letter to Chippendale in 1778 (Victoria and Albert Museum MSS). It was still impounded in 1779 when an inventory was taken on Garrick's death,

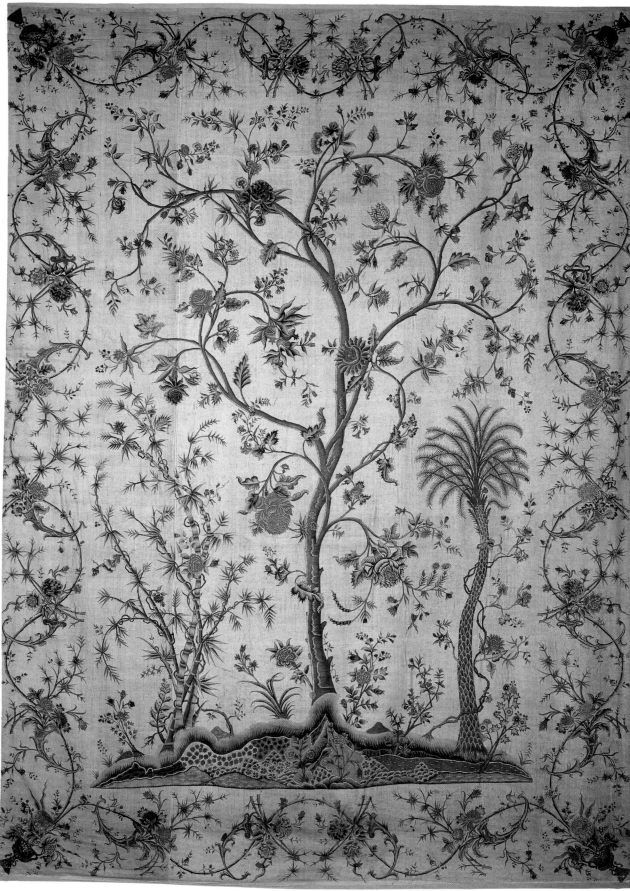

but was eventually cleared, possibly as a compassionate gesture toward his widow. The 1823 and 1864 sale catalogues of Garrick's villa (also at the Victoria and Albert Museum) reveal that the fabric was made up into bed furniture, three window curtains, a portière curtain that screened the bed alcove from the dressing room area, two coverlets and slip cases for the sofa, an easy chair, and four stool cushions.

As well as the bed and its hangings, a pair of curtains and a palampore acquired at the 1864 sale were presented to the Victoria and Albert Museum in 1906. It is uncertain whether these examples, and a third that also survives at Flintham, could have belonged to the same set, or whether they were acquired independently in the 1770s by Sir Robert D'Arcy Hildyard of Winestead in Yorkshire, many of whose possessions passed to his nephew by marriage, Colonel Thomas Thoroton of Flintham, in the early nineteenth century (Cornforth 1979a, 2455). The latter seems the more likely eventuality, since the colonel's son, Thomas Blackmore Thoroton Hildyard, who remodeled Flintham in the 1850s, adding a gigantic conservatory inspired by the Crystal Palace, so impoverished the estate that he had to spend much of the following decade abroad. G.J-S.

Literature: Irwin and Brett 1970, 80–83, pls. 32–36, and fig. 35; Gilbert 1978, 240

371

PAIR OF WOOD CARVINGS FROM A
DOORCASE c.1769
Luke Lightfoot c.1722–1789
painted pine
96.5 × 119.4 × 73.6 (38 × 47 × 29)

Claydon House
The National Trust (Verney Collection)

The rococo decoration carried out for the 2nd Earl Verney at Claydon between 1757 and 1771 was largely the achievement of a builder and carver of genius named Luke Lightfoot. Lightfoot remains one of the most mysterious figures of the period, having no other known patrons. His extraordinarily elaborate designs for the interiors of the house were all to be carried out in carved wood rather than plaster, and his finest surviving room in this manner is the North Hall. When the architect Sir Thomas Robinson saw work in progress here in 1769, he wrote to Lord Verney that "Mr. Lightfoot's design for furnishing the great Eating Room shock'd me so much and is so much the ridicule of all who have seen or heard of it that it . . . will indeed be what he expressed very justly—such a Work as the World never saw."

The great ho-ho birds perched on scrolling foliage come from the cresting of the conventional classical doorcase that once led from the North Hall through to the rotunda and ballroom beyond—demolished after Lord Verney's death. But this may not be their original position, as old photographs show them grained and standing on a sideboard. Very much in the same spirit as the ho-ho birds and C- and S-scrolls round the niches in this room, they are obviously influenced by the engravings of Thomas Johnson, though more lifelike and less stylized. It is possible that they were among the carvings Robinson advised Lord Verney to remove from Lightfoot's workshop in Southwark, having engineered the latter's dismissal in 1770, before the room was complete. It was on this occasion that Robinson reported being received by the carver "with his Hat on his head, an austere look, fierce as an eastern Monarch," going on to describe him as "a knave with no small spice of madness in his composition." G.J-S.

Provenance: By descent at Claydon; given to the National Trust with the house by Sir Harry Verney, 4th Bart., in 1956
Literature: Boynton 1966, 11–13; Jackson-Stops 1978a, 9–11
Exhibitions: London, V & A 1984 (M25)

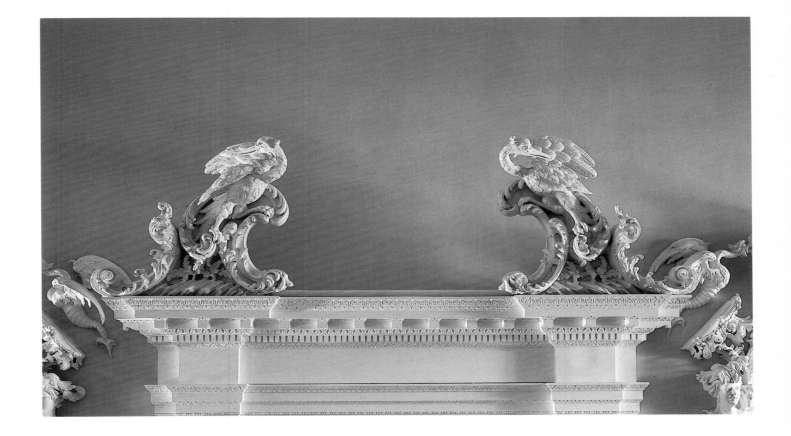

EAGLE early 18th century
Japanese, Arita
hard-paste porcelain
57.1 (22½) high

Private Collection

"Deux beaux Aigles de grandeur nat-
urelle" appear as no. 12 in the cata-
logue of the Gaignat Collection sale of
14 February 1769 and a copy embellished
with marginal sketches by Gabriel de
Saint-Aubin shows that these represent
a model similar to this one. They are
possibly the "deux oiseaux de proie"
noted in the *Livre-Journal* of the Paris
marchand-mercier Lazare Duvaux on
2 April 1751, in connection with the fur-
nishing of ormolu mounts to M. Gaignat.
Other examples are known including a
pair at Waddesdon (Ayers 1971, no. 99).
Another pair was formerly in the collec-
tion of the Hon. Mrs. Ionides (Sotheby's,
London, 2 July 1963, lot 58; Reinaecker

1956, 55). These were reputed, accord-
ing to Soame Jenyns (1965, 56), to have
belonged to the Kaiser despite bearing
the signature of Edward Raby who
worked at the Worcester and Bristol
factories and who presumably did some
repairs to the tail. Jenyns' reference
more probably refers to a pair formerly
in the Schloss Charlottenburg, Berlin,
until the Second World War.

Although white eagles appear fairly
frequently in Japanese paintings, the
surviving porcelain models have all been
found in European collections and they
must have been made expressly for
export. Faithful copies in white were
made at Meissen (see no. 373). A.du.B.

EAGLE c.1732
Meissen
hard-paste porcelain
57.1 (22½) high
factory mark of crossed swords in blue

Private Collection

This white porcelain eagle is not an original creation of a Meissen modeler, but a copy of a Japanese porcelain bird, of a type thought to have been made for export to Europe rather than for the home market (Ayers 1971; and see no. 372). The present consensus is that it is the work of J.G. Kirchner in his second term of office as modeler from 1731–1733, since J.J. Kaendler (fl.1731–1775), one of the greatest sculptors of birds and animals to work in any medium, would hardly have consented to make a copy. In its time, however, the eagle has been attributed to Kaendler himself and has been said to derive from an oriental bronze (see Johanneum 1920, lot 192).

Like most of the large figures of animals and birds ordered by Augustus the Strong (d.1733) for his Japanese Palace, this would have been decorated in "cold" colors: that is, unfired or lacquer pigments as opposed to enamels fired in the kiln. This type of ornamentation has usually deteriorated or been deliberately removed, in part because of the modern appreciation of porcelain as a worthy material. But some have retained their original "cold" colors: one in the Dresden Porzellansammlung (Reichel 1980, fig. 6); another sold in 1920 (Johanneum Duplicate sale, lot 192), with only partial coloring on the base; and a pair on the London art market in 1950, from the collection of Lord Hastings, later in the Wrightsman Collection (Sotheby's, London, 6 June 1970, lot 130; Watson 1966, 4:no. 1; Dautermann 1970, 15–17, 1A and 1B). In the chronological list of models drawn up by Johann Christian Kaendler in 1749, these eagles were given the number one.

T.H.C.

Related Works: Cited in text, but see also Nelson A. Rockefeller collection
Provenance: Sotheby's, London, 24 July 1962, lot 122, purchased by Antique Porcelain Co., from whom acquired by the present owner
Literature: Albiker 1935, figs 8, 9, and 1959, no. 216

374

PAIR OF WALL BRACKETS c.1760
English
giltwood
50.8 × 38.1 (20 × 15)

Clandon Park
The National Trust (Gubbay Collection)

Pairs of girandoles and wall brackets, asymmetrical in themselves but balancing each other on either side of a window, pier glass, or chimneypiece, were a favorite vehicle for rococo and chinoiserie ornament in the mid-eighteenth century, and are memorably caricatured by Hogarth in the second scene of *Marriage à la Mode*, where the young earl sits below an appliqué ridiculously composed of naturalistic oak leaves from which a clock, several fish, a cat, and candle branches emerge. This pair of finely carved brackets from Clandon are not quite as jagged and spiky as those that appear in Thomas Johnson's *Collection of Designs* (1758, plates 42–43), yet they are close in spirit both to these and to Johnson's brackets for console tables (plate 18). The strange creatures, half wyvern, half dragon, which emerge from typical rococo C- and S-scrolls, would have been thought particularly appropriate as supports for the Chinese porcelain figures of birds, which were in greater demand at this period than the jars and covered vases that adorned the corner chimneypieces of an earlier generation (see no. 134).

This pair of brackets comes from a remarkable collection acquired in the 1920s by Mrs. Hannah Gubbay for her house, Little Trent Park, on the Hertfordshire estate of her cousin Sir Philip Sassoon. On her death in 1968 they were generously left to the National Trust along with a number of very fine oriental porcelain birds (see nos. 383 and 384), and many other pieces of furniture, ceramics, textiles, jade, and glass, all of which are now displayed at Clandon. Unfortunately few records of Mrs. Gubbay's purchases now survive and their earlier provenance is difficult to establish.

G.J-S.

Literature: Cornforth and Jackson-Stops 1971, 1004–1008

375

STATE BED early 18th century
English with Chinese hangings
embroidery of colored silks and gold
thread close-covered on oak and pine
framework
365.7 × 182.9 × 213.4
(144 × 72 × 84) approx.

Calke Abbey
The National Trust
(Harpur-Crewe Collection)

The Calke State Bed, never before seen in public, is one of the most exciting country house discoveries of recent years. Stephen Glover's *History of the County of Derby* (1829, 2:188) provides a vital clue as to its history. "In this house, although it has never yet been put up, either for use or ornament," he writes, "is perhaps one of the most splendid state beds in the kingdom, presented on the occasion of her marriage, by 'Caroline,' Queen of George the Second, to Lady Caroline Manners (afterwards Harpur) as one of her bridesmaids." Like so many stories based on oral tradition, this is a muddled account that contains an essential element of truth. Lady Caroline, a daughter of the 1st Duke of Rutland, was not yet born at the time of Queen Caroline's marriage in 1705, but she is known to have been a bridesmaid to the queen's daughter, Princess Anne, who married the Prince of Orange in March 1734. Moreover, as her marriage to Sir Henry Harpur took place in September of that same year, only a short time after the departure of the royal couple to Holland, it would have been very natural for such a gift to be made. Many of the grandest state beds now in English country houses were acquired as perquisites (the origin of the word "perks") by courtiers at the death of a sovereign, for instance those at Knole dating from the late seventeenth century or the cut velvet bed at Hardwick thought to have been designed by John Vardy for Frederick Prince of Wales, Princess Anne's brother.

Lord Hervey describes the wedding of the Princess Royal (her title as the king's eldest daughter) in great detail in his famous *Memoirs* (Sedgwick 1984, 24–47), when St. James's Palace and Inigo Jones' chapel adjoining it were fitted up with "as much finery as velvets, gold and silver tissue, galloons, fringes, tassels, gilt lustres and sconces could give." At the *coucher* that followed, however, the Prince of Orange, who was a dwarf and a hunchback, "when he was undressed, and came in his nightgown and nightcap into the room to go to bed," made an appearance "as indescribable as the astonished countenances of everybody who beheld him. From the make of his brocaded gown, and the make of his back, he looked behind as if he had no head, and before as if he had no neck and no legs. The Queen, in speaking of the whole ceremony next morning alone with Lord Hervey, when she came to mention this part of it, said 'Ah! Mon Dieu! quand je voyois entrer ce monstre, pour coucher avec ma fille, j'ai pensé m'évanouir . . . c'est trop sotte en moi, mai j'en pleure encore.'"

Whether this was the very bed that witnessed such an extraordinary scene may never be known, for Hervey does not, unfortunately, describe the decoration of the bedchamber, and the Lord Chamberlain's accounts for these years (Public Record Office, London), while they list large numbers of beds made by the upholsterer Sarah Gilbert and joiner Henry Williams, do not contain specific references to any supplied for the wedding, or to any with Chinese embroidered hangings. In style, the upholstery of the Calke bed is old-fashioned compared with William Kent's famous green velvet bed at Houghton supplied in 1732, while the moldings of the tester and pagoda-shaped finials, and the extraordinarily elaborate headcloth with its swags, gathers, pleats, and ruched pelmet, look back to the engravings of Daniel Marot and the work of Huguenot upholsterers like Francis Lapiere and Jean Poitevin in the first decade of the century. But the embroidered bed at Houghton, which has English needlework appliqués in the Chinese style, displays many of the same characteristics only a year or two earlier, and it is easy to imagine such a confection being made for the princess whom Hervey described as "the proudest of all her proud family; and her family the proudest of all their proud nation."

Chinese needlework of this sort is notoriously difficult to date, since (like Kangxi porcelain models, which were used through the Qianlong period) there was much more continuity, and far less frequent changes of style, in oriental than in European decorative arts of the period. The silk hangings at Calke, alternately on dark blue and ivory white backgrounds, may not be quite as finely embroidered as those of the state bed at Erddig, probably supplied by John Belchier in 1720 (Hardy, Landi, and Wright 1972). But as compensation they have preserved their vivid, original colors to a remarkable degree through never having been put to use. Most beds of this period use contrasting materials for the inner and outer hangings, and it is surprising to find the two mixed in this case to achieve a particularly striking and exotic effect. The dark blue is light in weight like taffeta, and densely embroidered with flowers and birds, while the white is much heavier with a satin finish, boldly decorated with processions of figures, warriors on horseback, mandarins, and ladies in brightly colored robes, as well as dragons, birds, gazelles, and other animals. The gold thread, which at first sight suggests a later dating for the upholstery than for the bed frame, can be found in documented early eighteenth-century examples in Sweden, one of them at the Malmö Museum (Cammann 1963, 32–37, and Cammann 1974; I am indebted to Miss Verity Wilson for these references). Apart from the bed-hangings, there is a large pair of extra panels which suggests that the walls of the room where the bed originally stood may also have been hung with the same material.

Calke Abbey, an Elizabethan house built on the site of an Augustinian priory, was remodeled in the early eighteenth century by Lady Caroline's father-in-law, Sir John Harpur, 4th Bart., and it must already have had its full complement of elaborate four-post bedsteads by the time of her marriage. At any rate the Chinese bed seems never to have been erected, as Glover suggests, and indeed the timber framework (apart from the close-covered elements) may never have been brought up from London, since it would have been cheaper for the estate carpenter to make a new one than to pay the heavy cost of transport to Derbyshire. Subsequent owners of Calke displayed an increasing disinterest in public affairs, and in society in general. Lady Caroline's grandson, Sir Henry, known as the "isolated baronet," communicated with his servants only by letter, and his successors were as little inclined to make use of the state bed as he. The hangings appear to have been re-packed in 1934 during the time of the last baronet, Sir Vauncey Harpur-Crewe, and some of the smaller pieces had notes attached to them suggesting that they had been lent to an exhibition by his father, Sir John. But otherwise they remained in store continuously until the house was given to the National Trust in 1985, through the combined generosity of Mr. Henry Harpur-Crewe and the National Heritage Memorial Fund. The recent restoration of the bed at the National Trust's Levy Textile Workroom at Hughenden has been made possible by a grant from the Leche Trust, matched by money raised from the Calke Abbey Appeal. G.J-S.

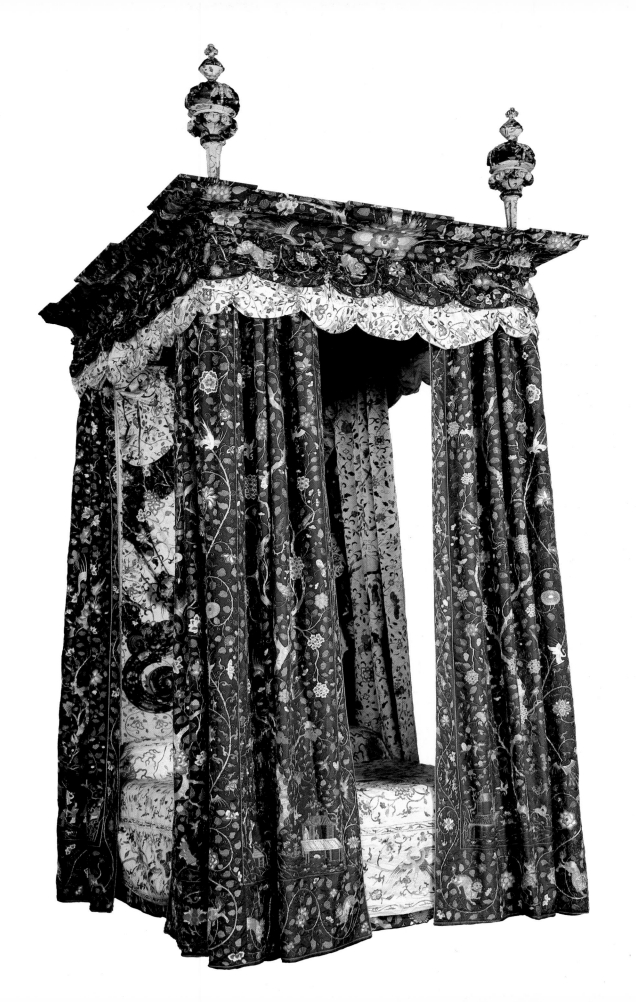

376

ARMORIAL PLATE C.1745
Chinese Export, Qianlong
22.6 (8⅞) diam.

Ugbrooke House
Colonel the Lord Clifford of Chudleigh

This plate comes from one of three Chinese armorial porcelain services made within a decade for the Lords Clifford of Chudleigh. All differ in the coloring of scrollwork and border but have the same arms and were made for Hugh, the 4th Baron (1726–1783). The design combines underglaze blue, *rouge-de-fer*, and gold in a late adaptation of the "Chinese Imari" palette. The painting in this service is particularly fine and the central armorial shows the full arms of Clifford, with a peer's helm and wyvern supporters but no coronet. The crest is repeated on the rim.

Hugh, 3rd Baron Clifford of Chudleigh, a title originally conferred on this branch of the family in 1672, married the beautiful and wealthy Elizabeth, eldest daughter of Edward Blount of Blagden, whose younger sister married the 9th Duke of Norfolk. He only survived his father by two years and when he died at an early age in 1732, his son Hugh succeeded as a minor; the latter did not marry until 1749. It is possible that this service could have been made for his coming-of-age in 1746 or possibly earlier. Like so many other Chinese services it seems probable that it was stored away in the Victorian period and sold early in this century. The present Lord Clifford was able to buy back much of the service from abroad since the Second World War and it is once again displayed in the dining room at Ugbrooke in Devon.

D.S.H.

Literature: Howard 1974, 298

377

ARMORIAL PLATE C.1743
Chinese Export, Qianlong
23.5 (9¼) diam.

Shugborough
The National Trust
(Lichfield Collection)

This plate is part of a dinner service numbering more than two hundred pieces, almost all still at Shugborough, the house for which they were made. The exact design is unique, though no less than thirty other Chinese armorial services, all copying this one to some degree, were produced within the next decade. The service was presented to Admiral Lord Anson (1697–1762) by the European merchants of Canton in gratitude for the part played by the crew of his command, the *Centurion*, in extinguishing a fire in that city.

The central design clearly derives from an original drawing, probably made by one Piercy Brett, which later formed the basis for the illustration of Tenian Island, plate XXXIV in the first edition of Anson's *Voyages*, published in 1748. The central breadfruit tree and palm are exactly as later published, but the whimsical arrangement of faithful dogs, an altar of love, cupid's bow and arrows, and shepherds' pipes speak of thoughts of home. The garland over the breadfruit tree is more likely to be a comment on the life-saving role played by the fruit when Anson's sorely depleted and starving crew reached Tenian on 18 August 1742.

The two rim panels illustrate Plymouth Sound with the ruined block house to the right and Rudyerd's Eddystone Lighthouse on the left to balance the composition. The other illustrates the anchorage at Whampoa, where trading vessels of the East India Companies anchored. As a warship however, the *Centurion* lay at Macau from early November 1742 until 11 April

1743. On the top, at the rim, is the crest of Anson; and below are the full arms, perhaps taken from a bookplate, of Anson quartering Carrier. An anchor and cable are painted on the reverse of each piece.

Descended from William Anson, an eminent Elizabethan lawyer, who purchased the estate of Shugborough in Staffordshire and whose grandson married the heiress of Charles Carrier of Wirksworth, George Anson entered the Navy at a very early age. In 1740 he was chosen to command a small fleet on a voyage of discovery and circumnavigation but his principal task was to harry the Spaniards in the Pacific. After appalling hardships, the loss of seven out of his squadron of eight, more than half his sailors, and all 259 marines who set sail, he captured the greatest Spanish prize ever taken at sea by an English captain, the annual trans-Pacific galleon bound for Acapulco from Manila. He returned triumphantly to England in June 1744.

The treasure, then valued at not less than £800,000 and worth today probably no less than £100 million, was shared: as Commander-in-Chief Anson received one eighth and as Captain an additional two-eighths of the total. His elder brother, Thomas, had inherited Shugborough in 1720 and employed the polymath architect Thomas Wright on additions to the house. On the admiral's death in 1762 his fortune was in part devoted to further improvements under the direction of James "Athenian" Stuart. These included the remarkable group of antique "monuments" in the park, some of which are depicted on Wedgwood's tureen of 1774 (no. 424), and in the design of which Stuart collaborated with Piercy Brett, the artist who accompanied the admiral on his voyage and who is credited with the design of this plate.

The dinner service provides an intimate glimpse of how things were managed day to day, for the design given to the Chinese was almost certainly dreamed up by Brett, combining their recent experiences at Tenian, their present situation and their goal, while the central scene predates by a few years the appearance of the engraving of Tenian in Anson's *Voyages*. D.S.H.

Literature: Heaps 1973; Howard 1974, 46–48, 323

378

PAIR OF TUREENS
Chinese Export, Qianlong
hard-paste porcelain
45 (17¾) high

Brodick Castle
The National Trust for Scotland
(Montrose Collection)

These tureens and covers are modeled as swimming geese with tall curved necks and folded wings. The necks are encircled with silver chains each with a grotesque pendant escutcheon engraved with a coat-of-arms and a crest of a tower. One goose has a silver eel in its beak and the other a fish, while the oval silver bases are repoussé and chased as waves with numerous fish. These mounts bear spurious eighteenth-century Rotterdam hallmarks and the maker's mark *1 B* on both bases and on one of the rims (information from Judith Banister). The tureens in the form of geese and other birds or animals are among the most spendid and spectacular of all models made for the Western market; they were designed to go with dinner services and are distinctly Western in inspiration, being based on models created in European faience and porcelain.

Brodick Castle was inherited by the Duchess of Montrose, daughter of the 12th Duke of Hamilton, who had no son. Like other works of art at Brodick, these tureens are thought to have been inherited from William Beckford of Fonthill Abbey, one of whose daughters married the 10th Duke of Hamilton (see no. 513). A.du.B.

Related Works: See Howard and Ayers 1977, 2:590, no. 615; Beurdeley 1974, no. 102

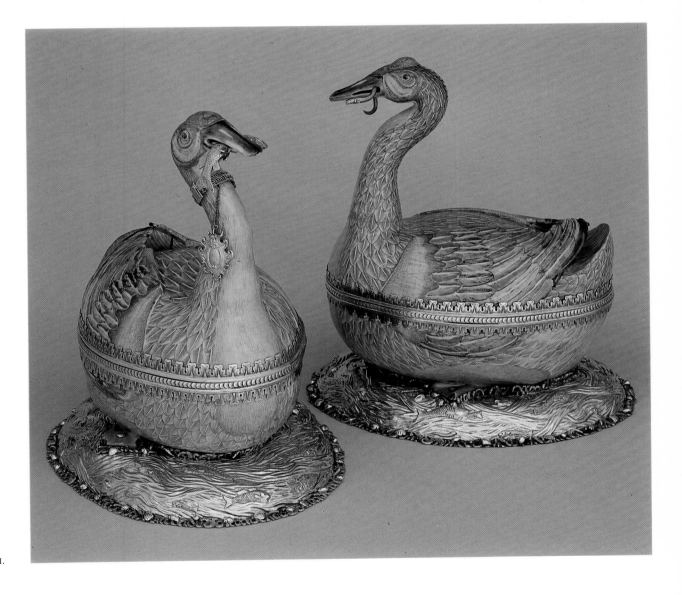

379

THE BURGHLEY BOWL c.1730/1734
Chinese Export, Yongzheng
hard-paste porcelain
29.5 ($11\frac{5}{8}$) diam.

The Burghley House Collection

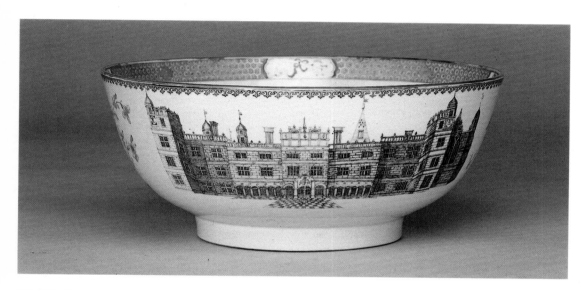

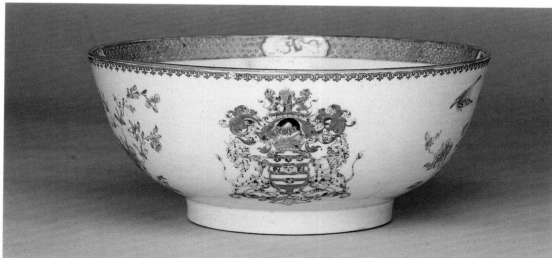

Of the thousands of Chinese export armorial wares that were shipped to England in the eighteenth century, the Burghley Bowl is exceptional on several counts. To begin with, the arms, which are those of Brownlow Cecil, 8th Earl of Exeter and his wife Hannah Chambers, whom he married in July 1724, do not appear on any other recorded pieces, suggesting that this was a special commission and never belonged to a larger service. The reverse is painted in grisaille with a view of the south front of Burghley House after an anonymous engraving of about 1715, of which there are several impressions at Burghley and another in the Victoria and Albert Museum, London. This must have been sent out to China with the drawing or bookplate for the arms. After some experimentation the grisaille technique was introduced in Chinese export porcelain in about 1728.

The remainder of the bowl is painted in *famille-rose* enamels, a palette that included pink, first used on Chinese porcelain around 1720 although it appears on German faience from about 1680. These colors supplanted the bolder *famille-verte* enamels during the reign of Yongzheng (1723–1735) when the present bowl was made. The careful execution of the flowers is among the best painting on Chinese export porcelain and is very close to that found on the contemporary "ruby-back" plates painted in the Chinese taste and beloved of nineteenth-century European collectors. The interior rim of the bowl is decorated with a band of iron-red and gold cell diaper, a form of ornament whose last recorded use is in 1734. G.L.

Related Works: Other views of Burghley House appear on Lambeth Delftware dishes dated 1745 (one in the Fitzwilliam Museum, Cambridge, and another at Burghley), Worcester porcelain of the Flight, Barr and Barr period (1813–1852), and some other pieces of blue and white Chinese export porcelain, of the early Qianlong period (1736–1795); the draftsmanship of the latter is poor and the house is unrecognizable as Burghley G.L.

Literature: Howard 1974, 943, D4
Exhibitions: Burghley 1983 (220)

380

PLATE C.1745
Chinese Export, Qianlong
19 (7½) diam.

Brodick Castle
Charles Fforde, Esq.

Four shaped vignettes of birds and
landscapes, enclosing two kilted Scottish
highlanders after European prints, appear
on this Chinese export plate. One has
been traditionally called Prince Charles'
piper (although it is not recorded that
he had one); the other is certainly a
rifleman of the same regiment. In *A
Short History of the Highland Regiment*,
London, 1743, George Bickham uses as
his frontispiece an engraving that was
certainly the source for the piper.
Bickham's frontispiece in turn copies
one of a set of four engravings sold in
London earlier in the year by John
Bowles "at the Black Horse in Cornhill."
This set commemorated four Jacobite
martyrs: Privates Farquar Shaw, Samuel
McPherson, Malcolm McPherson, and

Piper Macdonnel of the Highland Regi-
ment (the 42nd Foot) who deserted in
the Stuart cause in 1743. On 18 July the
privates were shot in the Tower while
Piper Macdonnel was sent to the penal
colony in Georgia.

The identity of Piper Macdonnel's
companion on the plate is not recorded,
but undoubtedly such plates were
made to further the Stuart cause. They
may well have come to England in 1745
or 1746 when the Jacobite uprising of
Prince Charles Edward ("Bonnie Prince
Charlie") would have made their dis-
play a dangerous luxury. The early
provenance of this plate, one of a number
made with this design, is deliberately
obscure, for ownership could, in the
decades after it was made, have caused
great embarrassment and even danger.

D.S.H.

Literature: Howard 1973, 243

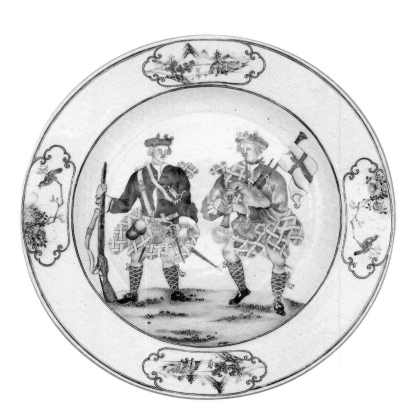

381

ARMORIAL PLATE C.1750
Chinese Export, Qianlong
22.8 (9) diam.

Berkeley Castle
The Trustees of the late
Earl of Berkeley

This plate is part of a large armorial
service surviving at Berkeley Castle,
but not originally made for the house.
The arms, almost certainly copied from
a bookplate sent to China with the
commission, are of the Lords Berkeley of
Stratton, within three sprays of Chinese
flowers and bearing the motto *Pauca
Suspexi Pauciora Despexi*.

Berkeley Castle has been in the pos-
session of the same family almost con-
tinuously since the early twelfth century
and in the fourteenth century gained
notoriety as the site of the murder of
King Edward II. In the early sixteenth
century William, 7th Lord Berkeley, was
so enraged when his brother and heir
married beneath him (to the daughter

of an alderman of Bristol) that he left
the castle and lands to King Henry VII
and his male heirs, and his successors
therefore lived in considerable poverty.
Fortunately for the family, Henry's
grandson, King Edward VI, died with-
out a male heir and the castle reverted
to the Berkeleys.

The Berkeleys of Stratton were a jun-
ior branch descended from Sir Maurice
Berkeley, a younger son in the fourteenth
century. John, 5th Lord Berkeley of
Stratton, succeeded to that title in 1740
and was Captain of the Yeomen of the
Guard and Constable of the Tower of
London before he died without an heir
in 1773. At the time of his death, much
of his property reverted to his very
distant kinsman, Frederick Augustus,
5th Earl of Berkeley, and this probably
included the Chinese dinner service from
which this plate comes. In London the
Berkeley estates included Stratton Street,
which now runs into Berkeley Street,
and Berkeley Square itself.

D.S.H.

Literature: Howard 1974, 534

382

TWO INCENSE BURNERS AND STANDS
late 17th century
Chinese, Dehua
hard-paste porcelain
incense burners: 3 (5) high
stands: 16.5
(6¼) diam.

Belton House
The National Trust
(Brownlow Collection)

The octagonal vessels are molded with three horizontal panels of scrolling flowers at the tops, floral circlets and triangles in the centers, and flatter lozenges below. The covers are pierced and molded with prunus branches and have central floral knops, each with eight similar knops round the rim. The stands have similar knops round the balustrades and are molded with sprays of flowers, each on eight cloud-scroll feet.

Blanc-de-chine ware was made near Dehua in Fujian province and was exported to Europe in large quantities at the end of the seventeenth century, though the trade waned after 1720. It is found in many country houses built before this date. The shape of these incense burners must have been very popular even if their original purpose was not realized, and in the inventory of Augustus the Strong's collection at Dresden one is described as "a hexagonal [sic] butter dish with stand." Two similar pieces are said to have been in the Treasury of Saint Mark's at Venice and passed in the late nineteenth century via the Davillier and Grandidier Collections to the Musée Guimet in Paris. They acquired the reputation of having originally been the property of Marco Polo on his return to Venice in 1295, despite the fact that they were made some four hundred years after that date. Thus the shape has been traditionally but incorrectly called the "Marco Polo Censer" (see Donnelly 1969, 76, pl. 16). Other censers of this shape are in the Mottahedeh Collection (Howard and Ayers 1977, I: 93, no. 53), in a Berlin collection (ill. Bondy 1923, pl. 189, which retains the typical "cold color" painting); and in the Victoria and Albert Museum. Much white porcelain of the late seventeenth century was painted in unfired colors particularly red and black, and gilded, but most of these unfixed "cold colors" have washed off over the years. A.du.B.

Provenance: Peregrine Cust (d. 1785), brother of Sir John Cust, Speaker of the House of Commons and owner of Belton, was a director of the East India Company and may have acquired these pieces, which are part of a large collection of oriental porcelain now at Belton. However, much of this came from another family property at Cockayne Hatley early in this century; with Belton House and much of its contents was acquired by the National Trust in 1984

383

PAIR OF CRANES
Chinese, Qianlong
hard-paste porcelain
43 (16¾) high

Clandon Park
The National Trust (Gubbay Collection)

The wing feathers of these cranes perched on rockwork are delineated with gilt details, while those on the shoulders and tails are incised and left in the biscuit. As the eighteenth century progressed, the size of the bird figures made for the European market increased, and cranes of various sizes and shapes were popular. The crane, which is native to China, is often shown in paintings as well as on Chinese wares, but figures such as these were apparently made only for export and may reflect a Western demand for such curiosities. A somewhat similar pair can be seen in a Chinese watercolor of a group of Western merchants visiting a porcelain shop, from one of a number of albums produced in Canton during the second half of the eighteenth century for export to Europe, which advanced a fanciful and romantic idea of the manufacture of porcelain in idyllic rural surroundings and ignored the industrial urban environment which actually existed (Staehelin 1965, 33). Three other pairs of cranes of varying models are in the Gubbay Collection (Jackson-Stops 1976, nos. 194, 195, and 197). A.du.B.

Provenance: See no. 374

384

PAIR OF PARROTS
Chinese, Kangxi
hard-paste porcelain
21.6 (8½) high

Clandon Park
The National Trust (Gubbay Collection)

Porcelain birds of this type, painted on the biscuit in *famille verte* enamels, appear to have been the most popular variety and were exported to Europe in large quantities. They were often used in France in the mid-eighteenth century, mounted in ormolu as table ornaments and candelabra. A.du.B.

Literature: Jackson-Stops 1976, 172

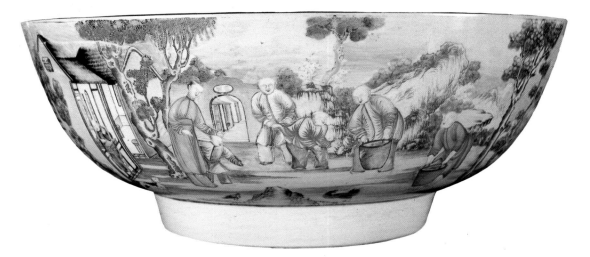

385

PUNCH BOWL c.1765
Chinese, Qianlong
hard-paste porcelain
15.8 (6¼) high 40.4 (16) diam.

Pencarrow House
Lt. Col. J.A. Molesworth-St. Aubyn

This bowl is an interesting example of those pieces of porcelain decorated with a wide variety of European scenes and copied from engravings and drawings usually taken to China by East India Company captains, who were responsible for much of the more unusual and personal trade in porcelain.

On the outside is a scene of a Chinese estate with laborers carrying baskets to a house as children strain forward to see the contents, while the decoration on the inside is completely European. Probably copied from an engraving after James Seymour (see no. 446), it displays a continuous panorama of a fox hunt from the moment when the hounds are in full cry, passing a Georgian mansion, across open fields to some cover and the death, three-quarters of the bowl later. There the huntsman holds the fox above his shoulders while the hounds bay around him. It is an exciting composition of an event that may well have taken place in Cornwall, for the house is believed to be Pencarrow, then the home of Sir John Molesworth, 4th Baronet, whose descendants have owned the bowl since it came to England and still live in the house today. At the bottom of the bowl, presumably to be discovered by those who drink deeply, is the wily prey, looking somewhat like an unusually graceful otter—perhaps intended to inspire the huntsman for another day.

In 1755 Sir John's son, also named John, married Anne Smyth of St. Audries, who died the following year; in 1762 he married Barbara, daughter of Sir John St. Aubyn. He was MP for Cornwall from 1765 and succeeded his father in the baronetcy the following year—all possible occasions for the purchase and use of such a bowl.

Pencarrow was completed by the 5th Baronet shortly after his succession and furnished in part in the Chinese taste; Chinese gray linen wallcoverings, *blanc de chine* porcelain, and Chinese lacquer

cabinets survive today. The bowl is an excellent example of those pieces of porcelain that so often link the owners of English country estates with acquaintances or relations who were captains of East Indiamen, and with the specialized workshops of Canton working to European designs. The scene on the bowl bears a passing resemblance to Pencarrow, with its rows of seven windows set in a pinkish stone rendered façade beneath a pale gray slate roof, and shows how the house must have looked in about 1765. D.S.H.

Related Works: An almost identical punchbowl is in the Victoria and Albert Museum, London (Basil Ionides bequest, C22:1951), and another was recently sold from the Dunbar Bostwick Collection (Christie's, New York, 22 May 1985, lot 94)

386

PAIR OF DISHES c. 1700–1720
Chinese, Kangxi
hard-paste porcelain
36.8 ($14\frac{1}{2}$) diam.
Lingzhi marks in blue under the bases

Clandon Park
The National Trust (Gubbay Collection)

Until the kilns at Jingdezhen were rebuilt in 1683, the Wucai (five-color) or polychrome palette for decorating Chinese porcelain included an underglaze blue, but after this date an enamel blue was substituted. These enameled wares became known in Europe as *famille verte*, a term invented by the nineteenth-century French writer Jaquemart, and were very popular in the houses of the British nobility. Dishes such as these, decorated with six large petal-shaped panels alternately painted with antiques, ladies, and children on terraces, would probably have always been for display rather than for use. A.du.B.

Provenance: See no. 374

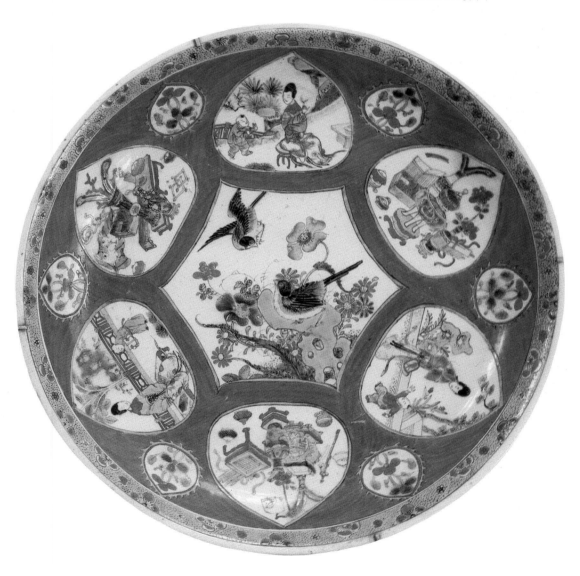

387

DISH early 15th century
Chinese
hard-paste porcelain
43 (17) diam.

Wallington
The National Trust
(Trevelyan Collection)

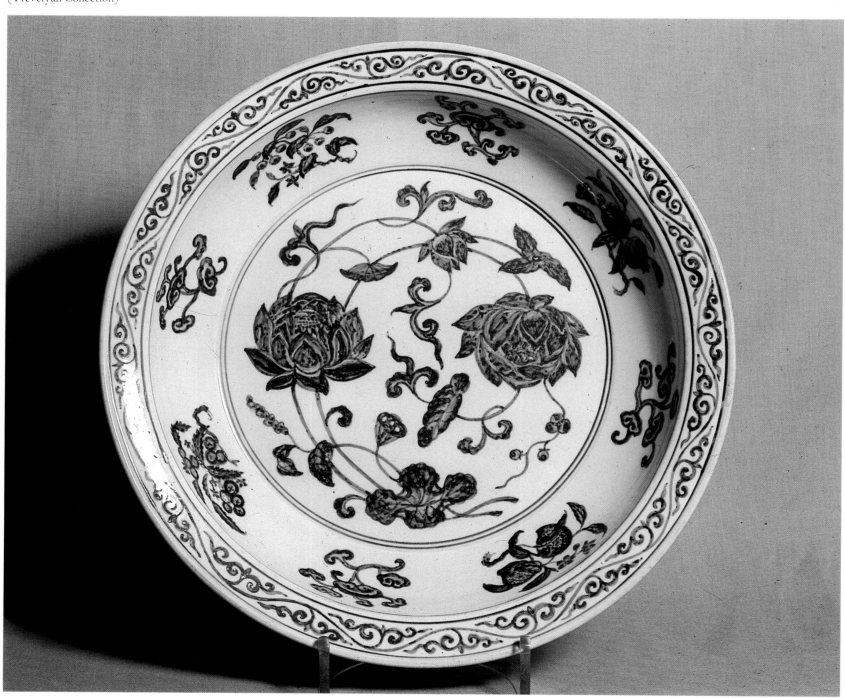

While many dishes of this shape with floral decoration still survive, the only other recorded example of this particular design is a slightly smaller dish from the collection of the late Sir John Addis, now in the British Museum, described by him (1979) as a piece in which "ceramic alchemy has combined with superb potting and masterly decoration to produce a piece of incomparable beauty."

The cavetto has eight fruit sprays below a single line, four of which are *lingzhi* interspersed by a loquat, a peach a pomegranate, and a persimmon, the stalks all pointing to the right and raggedly broken. The center is outlined by a double circle enclosing two lotus sprays with natural leaves, a bud, and a pod (accompanied by other waterplants including polygonum and sagittaria) with conventional common and tongue leaves. The reverse has a scroll of ten chrysanthemums with undulating stems. The blue, painted with a soft, wet, brush, has oxidized to black in places under a glaze of bluish tinge. The unglazed white base has traces of iron spots.

An Arabic inscription above the foot rim on the reverse, incised into the glaze with a diamond point and first noted by Michael Archer, indicates that the Wallington dish was listed in the treasury of the Mughal emperor Shah Jahan in 1628 (Archer 1970, 1139).

While the collection of oriental porcelain at Wallington was in the main brought to the house by Maria Wilson who married Sir John Trevelyan, the owner of Wallington between 1828 and 1846, it is more likely that this dish was bought in India, by Sir Charles Trevelyan who inherited Wallington in 1879, toward the end of his life. He had had a full and distinguished career in India where he married Hannah Macaulay, the sister of the historian. Another piece in the collection bears a small label inscribed "Lucknow 1859" and it is probable that this dish originally had a similar label. A.du.B.

Literature: Archer 1970, 1135

388

PAIR OF PUG DOGS c.1760
Chinese Export, Qianlong
hard-paste porcelain
25.1 (9⅞) high

Saltram House
The National Trust (Morley Collection)

The pug dog is native to China but is not a subject found on porcelain for the home market. Like other figures of birds and animals these very lifelike models were intended for export and must be based on some of those models originally made by Johann Joachim Kaendler at Meissen in the 1740s. The pug dog known as a "mops" in Germany was particularly fashionable at this time in Dresden. Indeed, after the excommunication of the Freemasons in 1738 a number of German Catholics, frightened by the Papal Bull, founded a pseudo-masonic secret society for both men and women known as the Mopsen order, whose symbol was a stuffed model of a pug dog.

Other pug dogs were copied in many of the European porcelain and faience factories as well as in England while the Chinese examples also vary considerably in detail. A very similar figure is in the Mottahedeh collection (see Howard and Ayers 1977, no. 623, 598–600).

The records that exist at Saltram are extremely scanty, but these dogs were probably acquired by John Parker, 1st Lord Boringdon (see no. 428). His surviving accounts for the years 1770–1788 show a number of purchases of china and glass, many of them from a London tradesman called Robin Stevens, who supplied many unidentified pieces of "Nankeen China," along with handkerchiefs, tea cups—and even tea. A.du.B.

Literature: Neatby 1977, 32, no. 215T

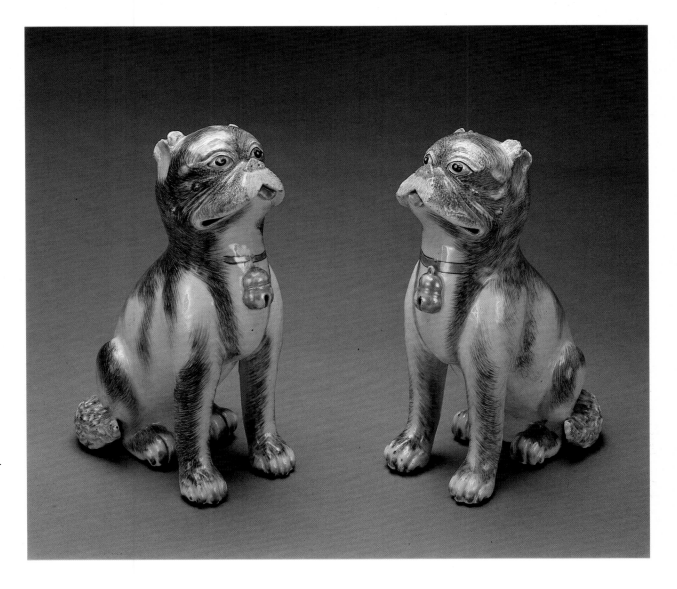

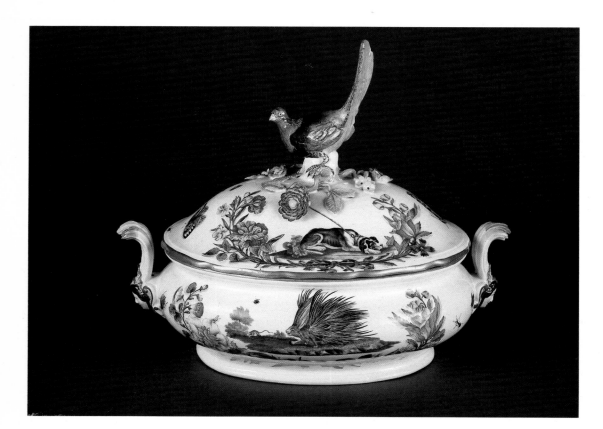

TUREEN AND CENTERPIECE FROM THE
NORTHUMBERLAND SERVICE C.1745
Meissen
hard-paste porcelain
tureen with impressed potter's numeral
26; centerpiece with factory mark of
crossed swords in blue on base and
impressed numeral 25
tureen: 34 (13¼) high
centerpiece: 43.8 × 33.7 (17¼ × 13¾)

Alnwick Castle
The Duke of Northumberland, KG

This is one of a pair of "midle Terrines,"
to quote a contemporary manuscript list
of the so-called Northumberland Service
preserved at Alnwick. Also among the
120 or so surviving pieces are a "large
terrine or marmite" and "four lesser
terrines." Their shape is typical of the
early 1740s: oval and bombé with domed
lids and handles "presenting figures of
female faces." This particular tureen
has "upon the Cover a Cock Pheasant
for the handle"; the use of miniature
birds as knops for tureen, the unusual
number of dish covers (*Glocken*), and
the extraordinary painted decoration are
the distinctive features of the service.

Clues to the dating of the tureens of
all sizes can be found in the Work
Notes (*Arbeitsberichte*) of J.J. Kaendler,
the factory's chief modeler, and in
those of his assistant Peter Reinicke.
Kaendler (fl. 1731–1775) modeled the
larger tureen in September 1742 and in
October and November 1743 he men-
tions "two new birds for the tureens of
the Hochberg service." Reinicke was
working on a "goldhammer" and turkey
for tureen covers in January 1744, and
as these birds are among those found in
the Northumberland Service, a date of
about 1745 seems appropriate.

The decoration presents an incon-
gruous mixture of brilliantly painted
swags of flowers, tied at the foot with
colored ribbons and enclosing animals
(usually after nature but sometimes
fabulous), wild, domestic, and exotic;
some as small as a lap dog, others as
large as an elephant. The flowers derive
for the most part from Weinmann's
Phytanthoza-Iconographia of 1738–1740,
while some of the insects can be traced
to engravings by Jacob Hoefnagel (1575–

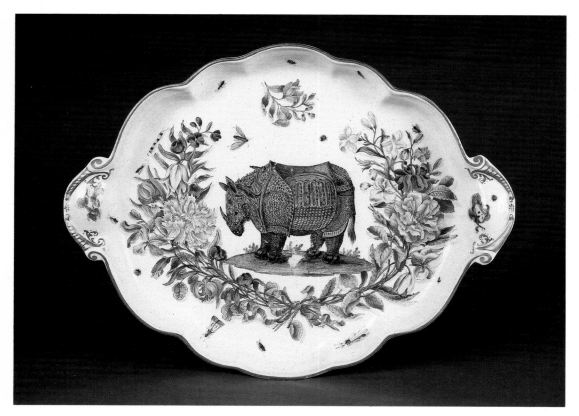

1630) after drawings by his more famous father, Georg Hoefnagel (1542–1600), published in Frankfurt in 1592 under the title *Archetypa studiaque patris* (Bastian 1983). The sources for the animals are found in a variety of prints dating from the early sixteenth century to as late as 1745. On the "midle Terrine" three of the subjects come from the set of ninety engravings, called *Entwurf einiger Thiere* by the celebrated Augsburg artist Johann Elias Ridinger. These prints were published from 1738 to 1740 (Thienemann 1856) and are named in the Alnwick manuscript list as "A Buck hound couchant tied to a thong," "a greyhound couchant," and "a Dolphin & a rat." This last is in fact a porcupine and not a dolphin—a curious error.

The large centerpiece dish from the Northumberland Service is described in the manuscript list as "a Plat Menage" and "Ein Plat de Menage." These terms seem to be of Saxon rather than French invention, although the language of the court was usually French: in France such an object would be called a *surtout*. "Four cruets & a Baskett" were originally placed on this stand. The latter held lemons and was supported on a tall stem decorated "by a Negroe and an Ape in Chaines"; the cruets were for mustard oil, sugar, and vinegar. These are all missing, except for the mustard pot (now in Schloss Lustheim, Munich, Ernst Schneider Bequest; Clarke 1975, figs. 14 a–c).

When displayed with its lemon basket and cruets, this centerpiece must have been the most imposing item in the service, apart from the large tureen. The stand by itself clearly demonstrates the discordant elements of the painted decoration of "The Grand Service for the Table of (Misnia) Dresden Porcelain, Embellished with Paintings in Miniature." Swags of flowers that are almost botanically correct, of a type called *Holzschnittblumen* or sometimes *ombrierte deutsche Blumen*, are juxtaposed with an exotic animal on an entirely different scale. As with the tureen, the flowers derive for the most part from Weinmann but it is "a Rinoceros, after Life" that is the dominant feature. It is of course based indirectly on Dürer's celebrated woodcut of 1515, which was itself derived from a drawing sent from Lisbon to

record the arrival of the first live rhinoceros in Europe on 20 May 1515. It remained the only accepted image of this beast for 230 years. (Had the centerpiece been painted two or three years later, the animal could have been drawn from life, for a live rhinoceros was to be seen in Dresden in April 1747.) The verisimilitude of Dürer's rhinoceros woodcut image seems to have deteriorated greatly by about 1745, the date of the Alnwick centerpiece, the immediate inspiration for which was probably the large porcelain model made in 1731 by Kirchner, a noted modeler at the Meissen factory (Clarke 1973, and 1976, figs. 3–6).

There is another rhinoceros in the Northumberland Service: based more closely on Dürer's woodcut; it was painted on a large, circular dish in about 1748. That dish was among the pieces lent by the original owner of the service to the Chelsea factory so that it could be copied, at the request of Sir Everard Fawkener, who had an interest in the London factory (Ilchester 1929). The Chelsea copy, on an oval dish, which reproduces every flower and insect of the Meissen original, is now in the Metropolitan Museum, New York, Untermyer Bequest (Hackenbroch 1957, 17, fig. 48).

The dinner service to which these two pieces belong was an ambassadorial gift from Augustus III, King of Poland and Elector of Saxony (ruled 1733–1763), to Sir Charles Hanbury Williams, British Envoy in Dresden from 1747 to 1755 (with an interval in Berlin in 1750–1751; see Ilchester 1928). It was accompanied by a large dessert service. Lists of each are preserved in the Holland Papers in the British Library (Add. MSS 51391 and Ilchester 1926). The two services were delivered to Williams in Dresden over a period of two years, and eventually dispatched to England for safekeeping in the hands of Williams' intimate friend, Henry Fox (later Lord Holland), husband of the former Lady Caroline Lennox (for whom see no. 396). Henry Fox displayed the two services in the library of Holland House, where they were available for study by artists of the Chelsea factory which produced copies: the knop of this tureen and the hen pheasant knop from its companion

are both found in Chelsea porcelain.

The two services remained at Holland House until about 1756, when Sir Charles' daughter, Lady Essex, arranged for their removal. We know from a letter in the Northumberland archives that the Earl (later 1st Duke) of Northumberland took part in a "Raffle for the Dresden porcelain" in 1756. Whether or not the earl won the raffle and whether, if he did, it was this Hanbury Williams dinner service that was the prize, we do not know. This theory may possibly be confirmed by the fact that in her diary under the date 18 February 1768 Lady Shelburne mentions a dinner with the Duke of Northumberland: "the dinner was very magnificent being all served on gilt plate and the Desert on the finest Dresden China I had seen. The Plates of which had cost thirty Guineas a dozen." The dessert may well have been served on plates from the dinner service. T.H.C.

Related Works: A centerpiece complete with its cruets, on a base of identical shape, was formerly at the Ducal Schloss in Tiefurt (Berling 1900, fig. 159). There is a stand alone of the same form with the arms of Hoym-von Werthen in the Ernst Schneider bequest at Schloss Lustheim, dated 1739–1740 (Rückert 1966, no. 474, pl. 118); and another with a Kakiemon design in the Victoria and Albert Museum. Two dishes, either from this service or possibly trial pieces for it, are or were in the Kunstgewerbemuseum, Köpenick, and in the Pauls-Eisenbeiss collection; two further plates are in the Seattle Art Museum and the Ducret collection
Literature: Clarke 1975
Exhibitions: Sèvres 1952

390

TUREEN, STAND, AND DISH
c. 1772/1776
Meissen
hard-paste porcelain
tureen: 25 (9¾) high
stand: 38 × 27 (15 × 10⅝)
dish: 42.3 × 31.6 (16¾ × 12⅜)
inscribed in purple script, on the inside of tureen cover, *Le Serpent et de la Lime, Le Rossignol et l'Autour;* tureen base, *l'Ane malade et le Loup, Le Lion trompeur;* stand, *L'Ane et le Loup;* dish, *Le Leopard et Le Lievre*
tureen, stand, and reinforced bases of dish and stand with factory mark of crossed swords and a star in blue; tureen also marked on biscuit with single, short, blue line; stand marked on reinforced base with two strokes in blue, a repairer's mark, and traces of a painter's mark in black, *M*; on footrim of dish, an impressed workman's mark, 5*W*, a painter's mark, *S*, and two strokes in underglaze blue

Alnwick Castle
The Duke of Northumberland, KG

This tureen, stand, and dish are from a large dinner service decorated with green *mosaik* borders and with scenes after the *Fables* of La Fontaine. The date of the service, about 1772/1776, can be deduced on the evidence of the factory marks: some pieces bear the mark of the crossed swords with a single dot, the French *Saxe au point*, associated with the so-called Academic Period (1764–1774), while others bear the mark of a star between the hilts of the two swords. This latter mark was generally adopted when Count Marcolini took over the management of the factory in 1774 (until 1811). A service of this size would have taken a long time to make.

The tureen base is oval and bombé, the cover of double-ogee outline. The handles are in the form of rams' heads with laurel festoons, heavily gilded, as is the knop of the cover. Often described as a pine cone (*Pinienzapfen*), it in fact more closely resembles a gilt pomegranate or some other fruit cupped in acanthus leaves, with a leaf rosette, also gilded, spreading onto the cover. The edges of the rims have a wave

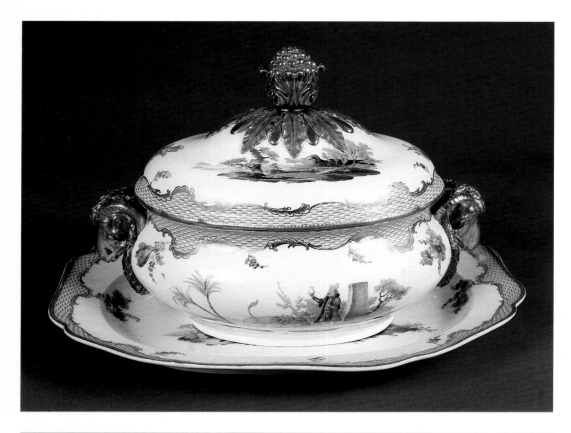

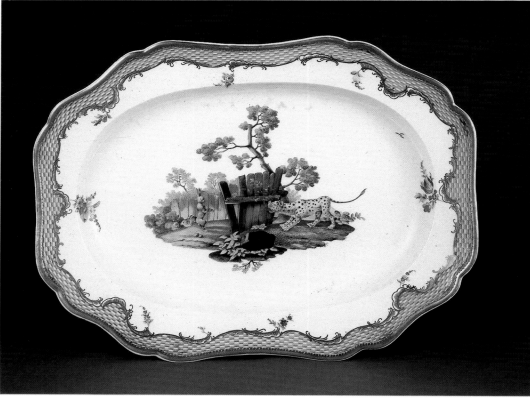

pattern, as has the oblong octagonal stand.

The source used at Meissen for decoration based on the *Fables* of La Fontaine was first published in 1746; *Fables choisies, mises en vers par M. de la Fontaine, avec un nouveau commentaire par M. Coste*, with 245 half-page vignettes engraved by Fessard after F. Chauveau and De Sève. Later editions were issued in 1759 and 1769. The engravings were adapted at Meissen in the so-called *Inselstil*, with each scene presented as though on a floating island.

The style of the tureen demonstrates the difficulty that the Meissen factory had in keeping up with changes of fashion. Despite the appointment in 1764 of a French sculptor, Acier, engaged to bring Meissen into the "new style" already established in France, the rococo was only unwillingly abandoned for the neoclassical, the Louis XV for the Louis XVI. Thus the ram's-head handles and the heavy knop only marginally reflect the new style; the shape of the tureen was hardly altered, and in the delicate gilded inner border of the *mosaik* pattern the rococo is evident. Such a mixture of styles occurs in other services of this period; for example, in the Duke of Courland Service of 1774 (with similar handles and knops) and the service with the blue border made for the Elector of Saxony, Frederick Augustus III, in 1777 (Rakebrand 1958, figs. 30–31 and 34).

The black *M* painter's mark is found on many pieces and is perhaps that of the painter J.K. Mauksch, active from 1775, particularly as a painter of landscapes (Pazaurek 1929). The *M* could also be the initial of Christoph Ferdinand Matthai, described as a "figure painter, 1st. Class" in 1775 (Berling 1900). The *S* could be the initial of Schützer, described in 1775 in the same terms as Matthai. T.H.C.

Related Works: Plates from another service with genre scenes have an identical border; two were in the Klemperer Collection (Klemperer 1928, pl. 36) and another two are in the Städtische Kunstsammlungen, Augsburg (Rückert 1966)
Literature: Reinheckel 1968

391

TUREEN AND DISH c.1730
Meissen
hard-paste porcelain
tureen: 24 $(9\frac{1}{2})$ high dish: 34.4 $(13\frac{5}{8})$
diam.

The Manor House, Stanton Harcourt
The Hon. Mrs. Gascoigne

The painted decoration of both tureen and dish are directly inspired by a rare Japanese design, while the half-barrel shape of the tureen may be an adaptation of a Japanese form. The painted decoration consists of two "banded hedges," from behind which spring, on either side, chrysanthemum sprays, yellow peonies and an unidentifiable, stylized flower. All the brilliant colors of the Kakiemon palette are included. The cock is often seen on Japanese porcelain, for example, on a picnic box in the Porzellansammlung, Dresden (Reichel 1980, color pl. 57).

The dish may have been the stand for the tureen rather than an independent dish from a dinner service. There is a comparable tureen with stand in the Porzellansammlung, Dresden, but both are decorated with chinoiseries (Handt 1956, figs. 44–45). It is rare to find both tureen and stand still together.

The absence of any mark on the glazed base of the tureen indicates that it may be one of the pieces ordered in 1729–1730 by the French dealer Lemaire, who intended to export such unmarked Meissen "Kakiemon" vessels to Paris, where they were to be sold as Japanese originals. Claus Bolz' research into this unsavory episode (1980, 24, 31, 43) includes records of the delivery to Lemaire of "two large tureens with cocks on the lids" at 30 Thaler; this was in about 1730, and in about March 1731 three others were ordered. All these were probably larger than the present example. Meissen copies of Japanese porcelain, with the mark of the crossed swords covered by a seal, were circulating in Paris as late as 1747. The finest of these copies were appreciated by a few collectors, among them the leading dealer Gersaint, who scrupulously removed the seals and praised them as equal to the originals. In his 1747 sale catalogue of the late M. Angran, Vicomte de Fonspertuis, Gersaint distinguished contemporary (1747) Meissen from "ancienne porcelaine de Saxe," by which he meant the Meissen of about 1730 with decoration after Japanese Kakiemon wares. The present covered tureen belongs to this earlier period.

That tureens with cocks as handles continued to be made at Meissen is shown by an entry in J.J. Kaendler's Work Notes (*Arbeitsberichte*) for March 1735: "kleine Hänge [sic] auf Terrine, eines grösser wie das andere auf Japanische Art mit Zierathen gefertigt" (small cocks for tureens, one larger than the other, in Japanese style with decoration), and cocks and hens are also found on some of the dish covers and small tureens in the Northumberland Service of about 1745 (see no. 3). T.H.C.

Related Works: A Meissen tureen of the same size with a hen as knop but with a "brocaded" Imari pattern is in the Schloss Lustheim, Munich, Ernst Schneider Bequest (Rückert 1966, no. 325). Four larger Japanese Imari tureens from the Dresden Porzellansammlung were sold as duplicates in 1920 (Johanneum 1920, lot nos. 1478–1481). For the pattern, see Syz 1979, no. 89. A plate with the same design as the stand is also in the Syz collection (Syz 1979, no. 84)

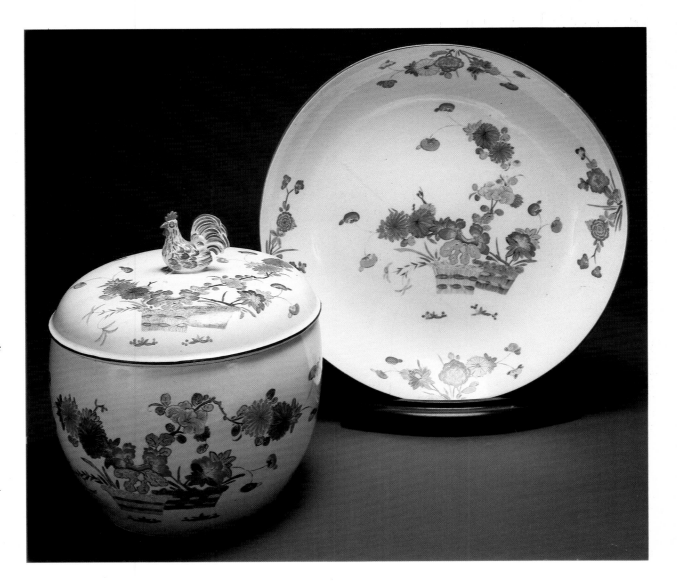

392

TWO BEAKERS C.1725
Meissen
hard-paste porcelain
factory mark on both beakers, crossed
swords in blue under the glaze; both
beakers and covers marked with a gilt
F in cursive
both 14.8 (5¾) high

Wallington
The National Trust
(Trevelyan Collection)

These covered beakers derive from forms
used in Böttger red stoneware (some-
times called *Jaspis Porzellan*). They are
probably a pair or are perhaps from a
garniture of three; however, no such set
is recorded, nor has another similar pair
yet been published. Each beaker tapers
gently outward and is surmounted by a
domed lid, which has a band of acanthus
leaves in relief matching that at the
foot. There are a number of variants of
this standard early Meissen shape (see

Rückert 1966, figs. 195–196), produced
in the early 1720s in some quantity, if
the surviving examples are a true guide.
The typical factory gilding, with drawn-
out C-scrolls and a four-petaled florette,
is characteristic of the work of Johann
Georg Funke (fl.1713–1726). (See
Rückert 1966, no. 200, for decoration.)

Each beaker has two quatrefoil
panels with quayside scenes in colors
(*Kauffahrtei*), framed in luster and gold
with additional feathery scrollwork in
purple and iron-red. Dividing the two
riverscapes are chinoiserie vignettes in
purple monochrome with egg-yellow
among the scrollwork: a rare feature.

On the side with a group of two
women and a man, concealed in the
rusticated masonry, is a capital *H*,
preceded by what appears to be part of
a capital *I*. Similar initials have been
noted on a bale in another quayside
scene on a large covered bowl with fish
handles in the Bayerisches National-
museum, attributed to Johann Georg
Heintze (Rückert 1966, no. 199).

Heintze, born in 1707, was the first
apprentice of J.G. Höroldt, chief painter
of the Meissen factory. His apprentice-
ship lasted from 1721 to 1725, the latter
being the approximate date of these two
beakers.

The precise date when these beakers
entered the Trevelyan collection is
unknown. T.H.C.

Related Works: At Waddesdon a beaker
without lid, close in style, has the factory
mark of crossed swords in blue enamel
and an *E* in gilding (see Charleston
1971, 26, for further examples). Another
has the acanthus reliefs in red and green,
and a continuous estuary scene (Seyffarth
1978, figs. 30–33), as has that from the
collection of Princess Olga of Greece,
also marked with an *F* in gold and per-
haps by the same hand as the present
two beakers (Sotheby's, 5 July 1966)
Literature: Pazaurek 1929, 28–42;
Archer 1970, 1139

393

TWO COVERED BOWLS, A TEABOWL,
AND SAUCER C.1720
Meissen
hard-paste porcelain
bowls: 9.3 (3½) diam. teabowl: 4 (1½)
high saucer: 13.5 (5¼) diam.

Ickworth
The National Trust (Bristol Collection)

Although often called pie (*Pasteten*)
dishes, these covered bowls were prob-
ably used for butter. Two are mentioned
in the Dresden Palace Inventory of 1727
as: "2 Stk runde codronierte Butter
Büchseen, 4¾ Z. hoch und 6 Z. weit"
(2 round gadrooned butter dishes, 4¾
inches high, 6 inches wide) (Menzhausen
1969, 49, no. 43). (*Z* means *Zoll*, a unit
of measurement slightly less than an
English inch.) Although the shape had
gone out of fashion in factory-decorated
pieces, it is interesting to note that
in 1731 there were still available at
the Dresden and Leipzig warehouses
"gerippte Butterbüchssen m. Deckeln"
(ribbed butter dishes with covers) with
decoration in underglaze blue, at a price
of "1 Thaler 12 Groschen" to the trade
(Berling 1900, 182). The porcelain is
about 1720, earlier than the gilding,
which was added about 1730 by one of
the *Hausmaler* or "outside decorators"
in Augsburg, of which two ateliers have
been identified as being pre-eminent—
those of the Aufenwerth and Seuter
families. Both are known to have decor-
ated white Meissen porcelain in large
quantities with gilding only. It is often
impossible to distinguish between the
workshops, particularly in comparatively
simple pieces such as covered bowls.
Some authorities believe such work was
carried out in the Meissen factory,
though this has been largely superseded.
The gilding of the flutes of the two
covered bowls is of three types: solid
gilding flanked alternately by strings of
dots and a feathery, scrolling pattern;
lacework gilding on the bands on the
upper edge of the covered bowl and the
lower edge of the lid, attempting to
imitate factory work; and burnished
gilding on the shell handles, the ball
knop, the broad horizontal bands at the
foot and where lid and base meet, and
on the interior. The borders of gilt

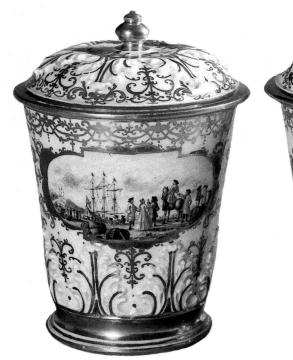
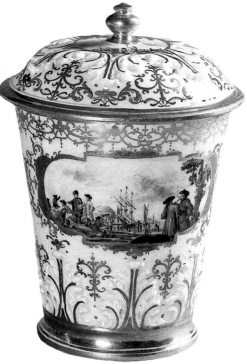

scrollwork where cover and base meet pose something of a problem in that they are very close indeed to factory work, particularly in the inclusion of the stylized four-petaled flower characteristic of the factory gilder Funke.

The tea bowl and saucer have the fluted pattern seen on the two covered bowls, and are similarly gilded, but the tea bowl, which has a burnished gilt interior, has a slightly different lacework border. It is uncertain whether this tea bowl, one of four at Ickworth, was intended to be *en suite* with the two covered bowls; one can only assume

that all were acquired at the same time.

The gilt chinoiserie on the saucer is a typical example of the exotic fantasies created by Johann Gregor Höroldt in the first years of his work for the Meissen factory. He used a wide range of enamel colors in his compositions, and many of these were copied in gilding only, the so-called *Goldchinesen* that were a specialty of the Augsburg *Hausmaler*. The saucer is a little unusual in the wide scalloped framing of the central motif. In view of the paucity of signed wares from the Aufenwerth and Seuter workshops, it

would be unwise to attribute the decoration to either. Now that a Meissen gilt chinoiserie teapot in the Virginia Museum of Fine Arts, Richmond, has been found to bear the signature of Sabina Hosennestel *née* Aufenwerth, many previously accepted attributions will need to be revised (Miller 1983, no. 41). T.H.C.

Related Works: A butter dish (or *Pastetenöpfchen*) of similar shape is in the Museum für Kunsthandwerk, Frankfurt-am-Main. But instead of vertical flutes, it is decorated with angels' heads in relief on the lids and foliate bands on the lower part; the gilt decoration is attributed to Augsburg. A covered bowl of similar shape and with shell handles, but lacking the fluting, is in the Kunstgewerbemuseum, West Berlin (Bursche 1980, no. 124)
Literature: Menzhausen 1969, 49; Ducret 1971; Frankfurt 1983, 18

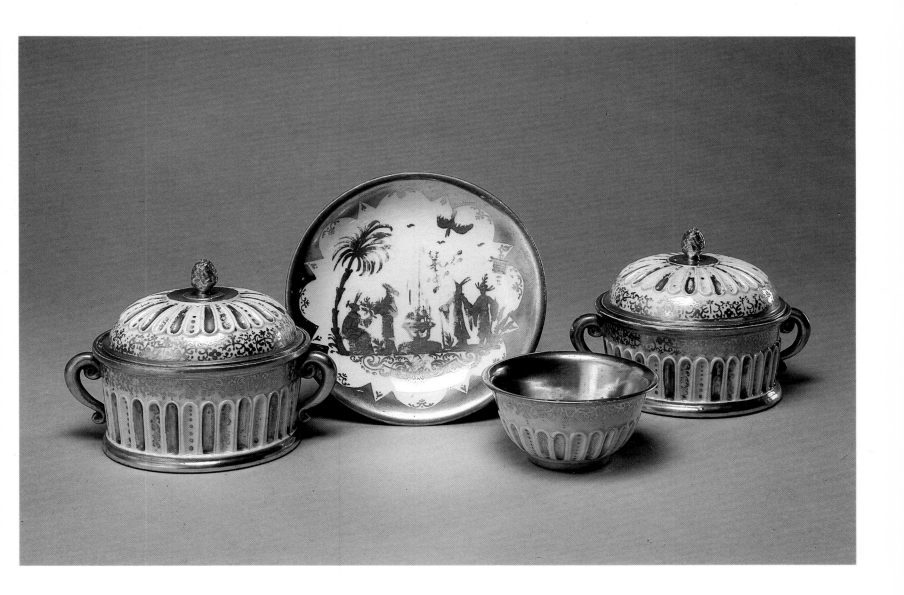

394

PAIR OF KITTENS 1736/1740
Meissen
hard-paste porcelain
10 ($3\frac{7}{8}$) and 8.5 ($3\frac{1}{3}$) high
traces of factory mark of crossed swords
in blue on one

Saltram House
The National Trust (Morley Collection)

This rare and early pair of kittens, modeled without bases, corresponds to an entry in J.J. Kaendler's Work Notes for September 1736: "2 Stück kleine Kätzgen aufs Laager in Thon poussiret, davon eine sitzend, die andere aber, wie sie einer Maus im Maule hat, vorgestellet ist" (two small kittens modeled in clay for the warehouse, one of them sitting, but the other portrayed as though it had a mouse in its jaws). Indeed, Kaendler's words precisely describe the figures.

Only a few examples of these models have survived: only one other crouching kitten, with sparse markings similar to the one shown at the lower right, is recorded, while no other pairs have been discovered (Newman 1977). There is a resemblance to an earlier pair of kittens, of which the best-known, from the Blohm Collection, is now on loan to the Hamburg Museum (Blohm 1968). These two are modeled without bases, and have been dated as early as 1720–1730. Some have only gilded decoration while others are enameled (Rückert 1966, nos. 1145–1146). T.H.C.

Related Works: Newman 1977, fig. 107
Literature: Neatby 1977, 65, pl. 6B

395

PAIR OF CATS C.1741/1745
Meissen
porcelain
17.5 ($6\frac{3}{4}$) and 18 (7) high
factory mark of crossed swords in blue
on biscuit base of one

Saltram House
The National Trust (Morley Collection)

These two cats were made in January 1741 by the factory's chief modeler, J.J. Kaendler (1706–1775), working overtime with the assistance of an apprentice. They are described in Kaendler's Work Notes as: "Eine Katze sizend von 8 Zoll hoch, und eine Maus im Rachen haltend: einer dergleichen zu vorstehender, als Compagnon." They are described slightly differently in Kaendler's *Taxa* as: "1 Katze sizend eine Maus in dem Maule haltend und damit spielend: 1 dergl. gegen jene sehend" (1 cat seated, holding a mouse in his mouth and playing with it: and 1 ditto gazing at the former). For these models Kaendler was paid a fee of "2.Thir. 12 g." (Pfeiffer 1924, 271–272).

In the modeling of the cat washing its face Kaendler seems to have been influenced by his predecessor, Kirchner, who in 1732 created a life-size cat in similar pose for the Japanese Palace of Augustus the Strong (Albiker 1935). Saxony must have been a land of dog rather than cat lovers, for the number of feline models is very small, while dozens of models of dogs of many breeds are recorded. These cats must have had a comparatively short period of popularity, for though many were mounted in ormolu in the French taste, the great *marchand-mercier* Lazare Duvaux, an important buyer of "porcelaine de Saxe," is not recorded as having ever bought any Meissen cats after December 1750. T.H.C.

Related Works: Oscar Dusendschon collection, Sotheby's, 6 December 1960, ormolu-mounted (as is usual, only the mouser has applied flowers on the base); and in numerous private collections
Literature: Albiker 1959, no. 216; Neatby 1977, 65

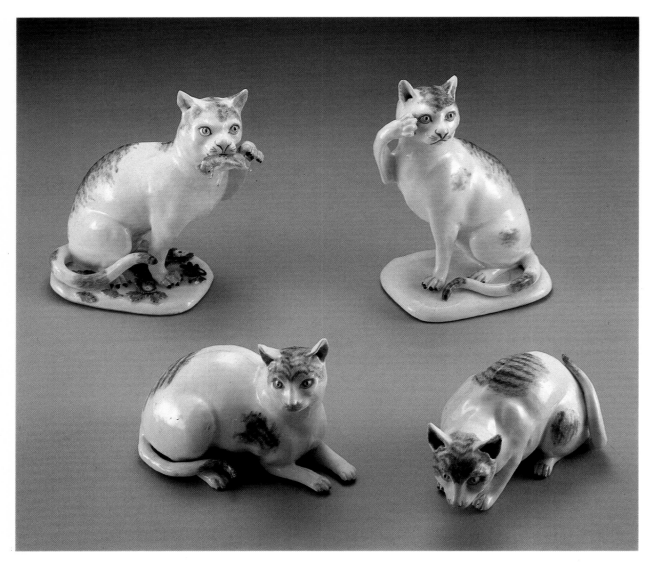

396

PORTRAIT SNUFF BOX 1748
Meissen
hard-paste porcelain
$3.4 \times 6.8 \times 5.2$ ($1\frac{1}{4} \times 2\frac{5}{8} \times 2$)

Goodwood House
The Earl of March and Kinrara and the
Trustees of the Goodwood Collection

The rectangular box has a slightly domed
lid; the base is in one piece with narrow
flutes at the corners, which hold the
Dresden gold mount as though mounted
en cage. The gold mounts are chased
with a wave pattern; the thumb-piece is
in the form of a shell flanked by foliate
scrolls. All outer surfaces are painted
with *deutsche Blumen*, naturalistic flowers
scattered haphazardly in small bouquets
and single blooms. On the inside of the
lid is a half-length portrait of Lady
Caroline Fox (1723–1774), attributed
to one of the leading Meissen painters,
Johann Martin Heinrici, active since
1741 (Beaucamp 1985).

The identity of the sitter has only
recently been established by a study of
the Holland Papers in the British Library
(Add. Mss. 51391) and the papers of Sir
Charles Hanbury Williams in the Lewis
Walpole Library of Yale University. The
social sensation of the summer of 1744
was the elopement of Lady Caroline
Lennox, eldest daughter of the 2nd
Duke of Richmond, with Henry Fox
(1704–1774), later Lord Holland. As
Horace Walpole wittily but inaccurately
commented to Sir Horace Mann, British
Resident in Florence, on 29 May:
"Mr. Fox fell in love with Lady Caroline
Lennox, asked her, was refused and stole
her. His father was a footman; her
great-grandfather a King" (quoted by
March 1911). The marriage took place
at the London home of Sir Charles
Hanbury Williams, who was appointed
British Envoy to the Court of Saxony
in 1747. When Lady Caroline gave
birth to a son in 1748, her parents
relented, and she was received back
into the family, visiting her parents at
Goodwood. To mark this reconciliation
as well as the birth of an heir, Henry
Fox commissioned his friend Hanbury
Williams to have his wife's portrait
painted on the inside of the lid of three
snuff boxes of Meissen porcelain: one

was to be of table size, another a man's
snuff box, and the third a lady's snuff
box, destined as a present for his mother-
in-law, the Duchess of Richmond.

Fox sent a portrait miniature of his
wife, Lady Caroline, to Williams. This
has just been identified as the work of
Gervase Spencer (fl. 1740–1763). In
enamel and signed and dated 1747, its
covering glass was broken in transit.
The Meissen factory made seven attempts
to get a good likeness before Hanbury
Williams was satisfied. Fox writes on
9 July 1748 that he awaits "with im-
patience Lady Caroline's picture,"
adding that one of the three boxes was
to be "a Woman's Box with her Picture
and set (which is to be a present to the
Duchess of Richmond)." "Set" in this
context refers to the box being mounted
in gold.

The first porcelain snuff box to be
completed, intended for Fox himself,
was delivered by the Meissen factory in
late June 1748, the Spencer miniature
having been delivered to the factory on
5 May. Williams was enthusiastic about
the result, writing from Dresden to Fox:
"I really think the painting equal to
Zink [Zincke, a fashionable enamel
miniaturist] & he wont do the least
head under thirty guineas." But Fox
was not so enthusiastic and tried to
cancel the order for the remaining two
boxes, although he was satisfied with
the price of £9 for the Meissen box and
£11 for the Dresden gold mounts.

Fortunately Fox's countermand was
too late. If it had been more timely the
Duchess of Richmond's reconciliation
gift would not still be at Goodwood.
The marriage of Lady Caroline to the
young politician Henry Fox was an
outstandingly happy one, and they died
within twenty-three days of each other
in July 1774. T.H.C.

Literature: Ilchester 1920; Ilchester 1928

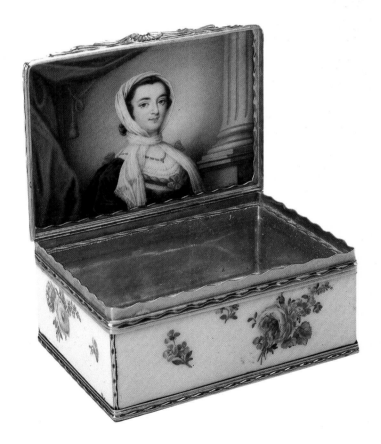

397

POTPOURRI VASE 1759
Sèvres
soft-paste porcelain mounted in ormolu
34.3 (13½) high, including mounts
factory marks of interlaced *L*s enclosing
G, the date letter for 1759; painter's
mark of Charles-Nicolas Dodin
(fl. 1754–1803)

Boughton House
The Duke of Buccleuch and
Queensberry, KT

This vase, one of a pair, consists of an upper and lower section in porcelain, four tubs of porcelain flowers, and an ormolu stand; one dolphin and the cover are ormolu replacements of original porcelain pieces. It is decorated with dark blue (*bleu lapis*) and green ground colors, and the reserves are painted with a scene by Dodin after Teniers at the front and with a spray of flowers at the back; the ground colors are highlighted with gilding. As the alternative title *vase pot pourri fontaine* implies, the model resembles a fountain, with its dolphins on plinths of green waves and gilded rockwork above a pool of water represented by the blue ground overlaid with pebble-like gilding. The potpourri vase stands in the center, its undulating form, trelliswork shoulder, and sides decorated with white and gold leaf shapes alluding to water springing from the fountain below. It combines the functions of a bulb and flower pot with those of a potpourri vase. The lower section is intended to contain water or earth and the holes flanking the dolphins are shaped to hold growing bulbs planted in winter; after flowering these were replaced with tubs of porcelain flowers so that the vases could be displayed throughout the year. The upper section is pierced with holes and was intended to contain potpourri, which would perfume the porcelain flowers.

The design is attributed to Jean-Claude Duplessis *père* (fl. 1745–1774) and the model was introduced in 1759. The figure scene at the front is taken from J.-P. Lebas' engraving (dedicated to Madame de Pompadour) of Teniers' *La Quatrième Fête Flamande*, a painting then in the collection of the Duc de Choiseul.

The Boughton vases are presumably from Madame de Pompadour's collection; "deux pots pouris à dauphins" are listed in the inventory of her porcelains at the château of Saint-Ouen in 1764 (Cordey 1939, no. 1311), and they may have been intended to flank the potpourri vase in the shape of a ship (*vase pot pourri vaisseau*) with similar decoration, which she acquired from the factory in 1759 and which is now in the Royal Collection (London; Queen's Gallery 1979, no. 55). In 1760 she bought another garniture combining the same models with rose and green ground colors and chinoiserie scenes; the *vases pot pourri à dauphins* are in the J. Paul Getty Museum, Malibu, and the *vase pot pourri vaisseau* has recently been acquired by the Louvre (Paris 1985, 132–135, no. 78).

In 1830 the 5th Duke of Buccleuch (1806–1884) bought the vases from the dealer Edward Holmes Baldock (Baldock's bills in the Buccleuch MSS, transcript kindly supplied by Geoffrey de Bellaigue). They may have come from Beau Brummell's collection in Calais, which was dispersed in 1829–1830; this suggestion arises from a reference in Captain Jesse's biography of Brummell first published in 1844, which states that Mr. Crockford, an auctioneer and the son of the owner of the famous Crockford's Club, purchased pieces from Brummell that were acquired by the Duke of Buccleuch (Jesse 1882, 2:19). It is likely that Baldock created the ormolu stand with dolphin supports, and the replacement pieces, using as an example the vase of the same model bought by George IV, another of his clients, for £50 in 1827 (London, Queen's Gallery 1979, no. 97). George IV's vase already had its mounts when it left France in 1827 and they are of a superior quality to those on the Boughton vases.

The 5th Duke of Buccleuch married Charlotte Anne, daughter of the Marquess of Bath, in 1829. Together they were keen collectors of French furniture and Sèvres porcelain, and Baldock was their chief supplier before his retirement in 1843 (Bellaigue 1975, 1:290–299; 2:18–25). R.S.

Literature: Savill 1979, 128–133
Exhibitions: London, SKM 1862
(1338–1339)

PAIR OF FLOWER POTS 1763
Sèvres
soft-paste porcelain
21 (8¼) high
factory marks of interlaced *L*s enclosing
K, the date letter for 1763; painter's
mark for Charles-Nicolas Dodin
(fl. 1754–1803)

Firle Place
The Trustees of the Firle Estate
Settlement

The circular vases are in two sections,
the upper parts, pierced with holes
in the base, fit into the lower round
bowls, which have six trelliswork
openings in the shoulder. They are
decorated with a dark blue (*bleu
nouveau*) ground overlaid with circles of gilded
dots and painted in the reserves at the
front with chinoiserie scenes and at the
back with sprays of oriental flowers by
Dodin.

The model was introduced in 1754
as a *vase à dauphin* with sculpted dolphins
at the side perhaps to commemorate
the birth of the Dauphin's son in that
year. This later, simpler version is first
listed in 1759 when it was called *vase
hollandois nouveau rond*, and its use as a
flower pot for growing plants is the
same as the *vase hollandois* (see no. 404).
The new overglaze *bleu nouveau* ground
color (later known as *beau bleu*) was
introduced in the year that this vase was
decorated, and superseded the underglaze
bleu lapis. The exotic chinoiserie scenes
are very unusual; they evolved from
the more delicate Chinese figures on a
white background found occasionally at
Vincennes and on Sèvres pieces of 1760
including a pair of vases in the J. Paul
Getty Museum, Malibu (Wilson 1978–
1979, 44–45, fig. 8). Such subjects
were a specialty of Dodin, and Ronald
Freyberger has suggested that the Firle
vases may have matched a pair of
vases hollandois nouveau ovale in the
Rijksmuseum, Amsterdam, which were
also painted by him in 1763 (Freyberger
1970–1971, fig. 3). If these four vases
did form a set there would have been
a fifth, central, vase to complete the
garniture. The Firle vases cannot be
identified in the factory's sales records
although on 25 January 1765 Louis XV

did buy a single example with a dark-
blue ground and chinoiserie scenes for
336 livres, and this price is the same as
he paid for an unspecified vase in 1763
(information kindly supplied by Tamara
Préaud). The king may have acquired
them separately but it is more likely
that they left the factory as a pair or as
a garniture of five vases.

The ormolu stands with four pairs of
hooves echo the feet of the Rijksmuseum
vases, but in addition to this the upper
section of the vases also had a stand, so
that the two halves of each vase could
be separated and displayed as four
independent items (information kindly
supplied by Deborah Gage). It is difficult
to determine when these mounts were
made; Sèvres porcelain was commonly
mounted on stands in the nineteenth
century but the practice was also popular
in the eighteenth century. The Firle
examples are almost identical to the
stand of a granite vase mounted in
ormolu during the reign of Louis XVI,

which was formerly in the Sneyd
Collection at Keele Hall, Staffordshire
(Christie's, London, 26 June 1924, lot
97), but since Ralph Sneyd's Sèvres
porcelain was occasionally copied by
Minton it is probable that he also allowed
other works of art to be used in this
way.

Many of the pieces of Sèvres now at
Firle came from the Cowper collection
at Panshanger in Hertfordshire, and
were inherited by the present Viscount
Gage's mother in the 1950s. Panshanger
was built about 1801 to designs by
Humphry Repton and his son George
Adey Repton by the 5th Earl Cowper
(1778–1837), and it was he who added
examples of Sèvres, Meissen, Chelsea,
and Worcester porcelain to the collections
of old master pictures assembled by the
2nd and 3rd Earls (see no. 178). The
China Room (*Country Life*, 11 January
1936, fig. 8) was a charming Regency
conceit with lacquer panels dividing the
shelves, which were painted to simulate

bamboo. As well as the porcelain col-
lected by the 5th Earl, it also contained
pieces inherited from the Countess' two
brothers, the 2nd Earl and 3rd Viscount
Melbourne (see no. 411), and it is not
possible from surviving documents to
determine precisely who acquired the
Dodin vases. R.S.

Provenance: In the collection of the
6th Earl Cowper by the mid-nineteenth
century; by descent to his grand-
daughter, Ethel, wife of the 1st Baron
Desbourne, and to her daughter
Alexandra Grenfell, first wife of the 6th
Viscount Gage
Literature: Lane 1955, fig.4; Watson
1966, no. 26; Freyberger 1970–1971,
31, fig. 4; Gage 1984, 92–93, figs. 4–7;
Platts 1984, fig. 5
Exhibitions: London, Dorchester House
1984 (2)

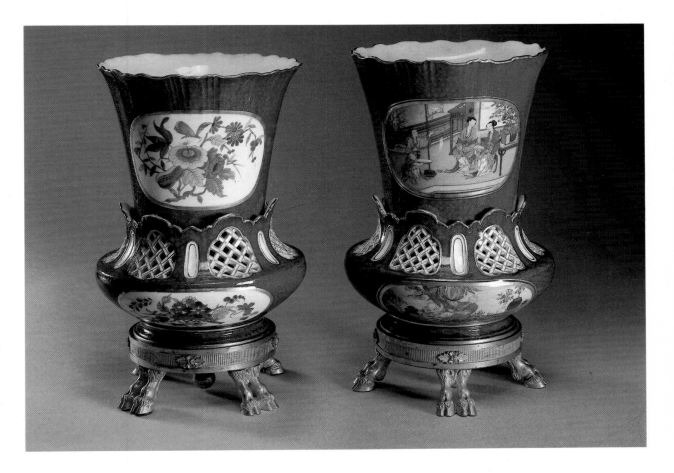

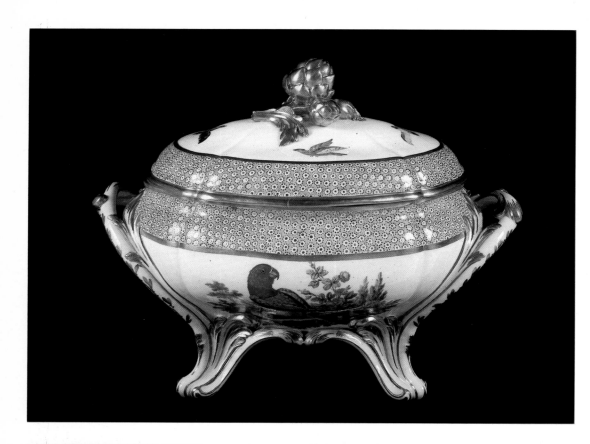

399

TUREEN AND STAND FROM THE EDEN
SERVICE 1788
Sèvres
soft-paste porcelain
tureen: 32 ($12\frac{1}{2}$) high
stand: 45.5 ($17\frac{7}{8}$) diam.
factory marks in blue of interlaced *L*s
enclosing *kk*, the date letters for 1788,
on both tureen and stand; painter's
mark in blue for Pierre-Joseph Rosset
(fl. 1753–1795) on the tureen and for
Etienne Evans (fl. 1752–1806) on the
stand; gilder's mark in gold for Etienne-
Henry Le Guay *père* (fl. 1749–1796) on
the tureen and for Henry-François
Vincent *jeune* (fl. 1753–1806) on the
stand; modeler's incised marks ·10· on
tureen and $\frac{19}{B.16}$ on the stand

Exbury House
Major Edmund L. de Rothschild

The tureen stands on four modeled legs,
which form handles to the sides. The
stand is a shallow rimmed basin in which
the legs of the tureen may rest, with
shell motifs at the handles. They are
decorated with bands of green *oeil-de-
perdrix* ground color (*fond pointillé vert*),
with blue and gold dots, and with exotic
birds in landscapes. Gilding is used to
highlight the modeling, as, for example,
on the finial of the lid.

This model of tureen, called *terrine
ordinaire*, was introduced in 1753 as part
of a dinner service made for Louis XV.
It was sometimes supplied in dinner
services along with the more common,
circular, version of this model, called
the *pot à oille*. The design of this shape
is given to Jean-Claude Duplessis
(fl. 1745–1774), who was in charge of
the modeling studios at the Manufactory.

The birds painted on these pieces
are taken from engravings published by
the Comte du Buffon from 1770 in his
Histoire Naturelle. They and all the other
pieces of this dinner service are painted
underneath with the names of the birds
depicted—on this tureen *Le Petit Ara*
and *Peruche rouge d'Amboine*, and on the
stand *Spatule Couleur de Rose, de Cayenne*.

The tureen comes from a 175-piece
dinner service dated 1784 to 1788, and
given by Louis XVI to the English
diplomat William Eden (created Lord

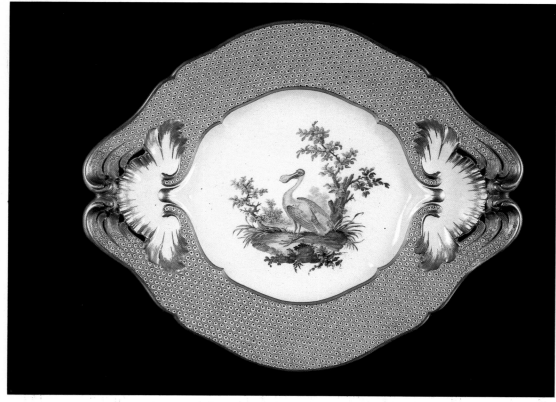

Auckland in 1793) along with other lavish presents in 1787 (though many pieces of the dinner service bear the date letters *kk* for 1788). Eden had successfully negotiated the Treaty of Navigation and Commerce, signed on 26 September 1786, between England and France (Dawson 1980, 288–297).

The service was sold after Eden's death, though a few pieces seem to have already been broken and discarded (Christie's, London, May 1814). It was purchased by Lord Yarmouth on behalf of his friend the Prince Regent (later George IV) who used it only days later at Carlton House on the occasion of a ball in honor of the Duke of Wellington. Later in the nineteenth century it passed out of the Royal Collection to the Rothschild family, possibly as a result of Baron Lionel de Rothschild's service to the Crown, and by descent to the present owner, whose gardens at Exbury are famous in horticultural circles, with some of the rarest rhodondendrons in the world. The collection now at Exbury contains other important Sèvres porcelain, and the Rothschild family must be credited for forming other spectacular collections of Sèvres in England, such as those at Waddesdon Manor and that formerly at Mentmore Towers, Buckinghamshire.　　　　　A.D.S.

Related Works: 60 other assorted pieces from the same service remain at Exbury, though a further 115 were sold in 1975 and went to collections in the United States; of these, 82 pieces, including the two circular tureens, have since entered an English private collection
Literature: Bellaigue in London, Queen's Gallery 1979–1980, 11

400

VASE 1758
Sèvres
soft-paste porcelain
19.2 (7½) high
factory marks of interlaced *L*s enclosing *F*, the date letter for 1758; painter's mark for either Jacques-François Micaud *père* (fl. 1757–1810) or Philippe Xhrowet *père* (fl. 1750–1775); incised mark *M* possibly for the *repareur* Pierre Moyé (fl. 1754–1765)

Boughton House
The Duke of Buccleuch and
Queensberry, KT

The square-shaped vase, like its pair at Boughton, has handles formed by animals' heads swallowing their tails. It is decorated with a turquoise blue (*bleu céleste*) ground, painted with sprays of flowers and fruit, and gilded with flowers.

The model is based on a Chinese Qianlong (1736–1795) prototype, probably a single vase that has not been traced, but the Sèvres version does combine features found on two Chinese vases in the Salting Bequest in the Victoria and Albert Museum, London (Savill 1979, figs. 5 and 6). The Boughton vases are the only known examples of this shape; presumably it is because so few were made that it is difficult to identify the original title of the model in the Sèvres factory records. Only one reference could describe them: on 15 June 1758 the factory presented to the painter François Boucher "2 vases d'après l'ancien" decorated with turquoise-blue ground and valued at 192 livres each. "Vases de l'ancien" were first listed in 1754 and the word "ancien" was often used to describe oriental rather than classical sources, which were called "antique." Even the turquoise-blue ground color, which Svend Eriksen associates with the reign of the Emperor Kangxi (Eriksen 1968, 28), was sometimes called "bleu ancien," so this title would be appropriate for the Boughton vases.

Boucher is the artist whose style is most associated with Vincennes and Sèvres; in 1754 and 1756 he received payments for drawings he had supplied to the factory and in 1756, 1757, and 1758 he was presented with annual gifts (Savill 1982, 1:162 and 168). The possibility that these are the vases that he was given in June 1758 is increased by a tentative identification of them in his sale catalogue of 1771 (Musier, Paris 18 February 1771, lot 839; and see Savill 1979).　　　　　R.S.

Provenance: Purchased by the 5th Duke of Buccleuch (1806–1884) from the dealer Edward Holmes Baldock (who may have acquired them from Beau Brummell's collection [see no. 397, Buccleuch MSS]; on 19 April 1831 for £45, transcripts kindly supplied by Geoffrey de Bellaigue); and by descent
Literature: Savill 1979, 130–133

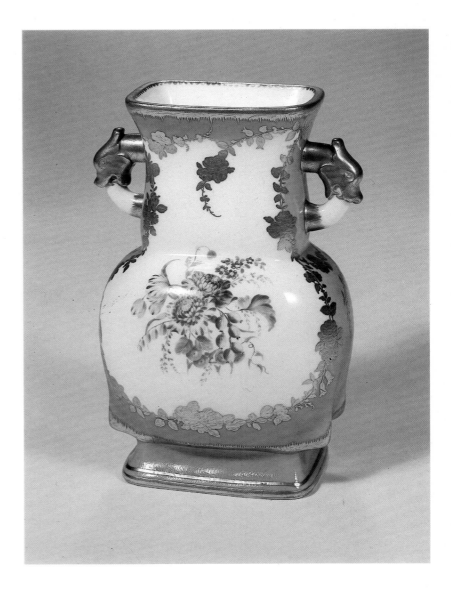

401

SUGAR BOWL AND TRAY 1779
Sèvres
soft-paste porcelain
sugar bowl: 15.3 (6) high
tray: 27 (10½) diam.
factory marks of interlaced *L*s enclosing
bb, the date letters for 1779; painter's
mark for Charles Buteux l'aîné
(fl. 1756–1782); gilder's mark for
Etienne-Henry Le Guay *père*
(fl. 1749–1796)

Woburn Abbey
The Marquess of Tavistock and the
Trustees of the Bedford Estates

The sugar bowl is attached to its oval tray and resembles a ship with a cover imitating rigging and a mast flying a trailing pennant. At either end of the bowl are chickens similar to figureheads on the prow of a ship. It is decorated with a dark blue (*beau bleu*) ground and painted in six reserves with marine trophies by Buteux, including one on the cover inscribed *Le Voyageur François* [———] *Amerique*. The gilding of leaf fronds round the reserves and swags of flowers over the ground color is by Le Guay.

Geoffrey de Bellaigue has shown that this model is based on the earlier design of the *sucrier gondole* introduced in 1757, and that the chickens were a novel and topical feature added in 1779. He has identified the bowl with the *sucrier à la Belle Poule*, which commemorated a naval encounter between England and France off the Lizard in Cornwall on 17 June 1778. This incident, the prelude to the hostilities between the two countries in the American War of Independence, involved the British frigate *Arethusa* and the French frigate *La Belle Poule*; both sides claimed victory and the French celebrated the outcome not only with the Sèvres sugar bowl but with a new hairstyle "à la Belle Poule" for ladies, and with a board game in which the winner had to succeed "de tous ses Adversaires avec la Belle Poule." The chickens' heads refer to the name of the ship, and the reference to America in the trophy on the cover illustrates French support for America during the War of Independence.

The two examples at Woburn Abbey are the only versions of this shape known to exist. They probably received biscuit firings in February and April 1779, Buteux painted the trophies in May or July that year but they do not seem to have received a final firing until July 1781. This delay may have been caused by the subsequent fate of *La Belle Poule* herself, for on 11 July 1780 she was captured by the British. They cannot be identified in the factory's sales records, and it is not known when they entered the Bedford collections at Woburn Abbey. They may have been acquired by the 5th Duke of Bedford (1765–1802), possibly through his Paris agent Dominique Daguerre (Stroud 1966, 110–111), or by the 6th Duke (1766–1839). The 5th Duke, a friend of the Prince of Wales (later the Prince Regent), commissioned Henry Holland to design the Library at Woburn, where these sugar bowls appear displayed on the chimneypiece in a painting by Lady Ela Russell of 1884 (Eriksen 1965, fig. 11). R.S.

Literature: Bellaigue 1981, 735–739

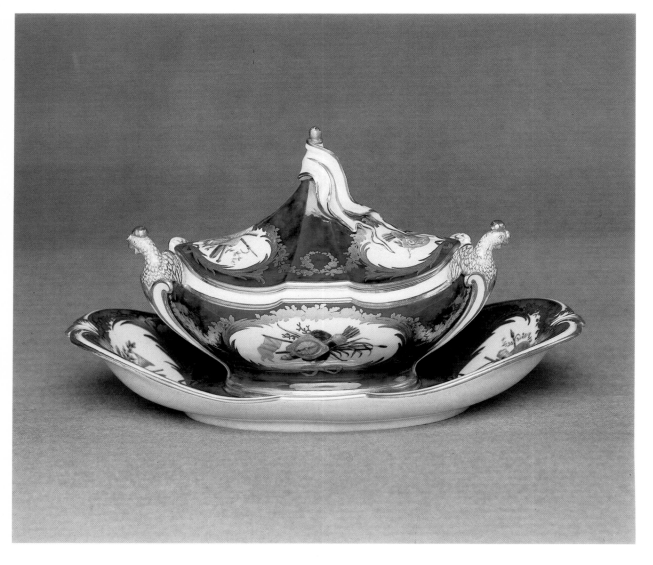

402

PUNCH BOWL 1762
Sèvres
soft-paste porcelain
34.3 (13½) diam.
factory marks of the interlaced *Ls*
enclosing *j*, the date letter for 1762;
inscribed on a piece of paper pasted to
the base, *Presented to the Earl of Egremont
Secretary of State for Foreign Affairs by the
Duc de Nivernais French Ambassador upon
the peace of 1763*

Petworth House
The Lord Egremont

The large circular bowl or *jatte à ponche*
is decorated with a dark blue (*bleu lapis*)
ground overlaid with "worm tunnel"
(*vermiculé*) gilding and painted in two
reserves with sprays of flowers includ-
ing the crown-imperial lily (*fritillaria
imperialis*), an unusual flower to find on
Sèvres of this date. The inside of the
bowl is painted with garlands of flowers
in *camaieu* blue enamel and the top edge
is gilded with lace patterns.

Punch bowls, together with a match-
ing mortar (*mortier*), were occasionally
included in the dessert section of Sèvres
dinner services and they were usually
the most expensive items after the
largest tureen. The isolated example at
Petworth is no longer part of a service.

The inscription on the punch bowl
refers to the signing, on 10 February
1763, of the Treaty of Paris, which ended
the Seven Years War between England
and France. Charles Wyndham, 2nd Earl
of Egremont (1710–1763), as the Sec-
retary of State for Foreign Affairs,
conducted the negotiations in London
with the Duc de Nivernais (1716–1798),
the French ambassador who arrived in
September 1762. Similar negotiations
took place in Paris between the English
ambassador, the Duke of Bedford, and
the French Minister for Foreign Affairs
and for his part in the peace the Duke
of Bedford received a gold snuff box
from Louis XV and his wife was pre-
sented with a Sèvres dinner service in
June 1763. This service is still at Woburn
Abbey, and includes a punch bowl with
the same external decoration, recorded
in the factory records as costing 720
livres. There is no evidence that Lord
Egremont was so fortunate; it seems

that his punch bowl was not an official
diplomatic gift but a personal present
from the French ambassador.

On 28 January 1763 the Duc de
Nivernais himself received a Sèvres
dinner service from Louis XV via the
Ministry of Foreign Affairs (Maze-
Sencier 1885, 439); a comparison of
prices with the factory's sales records
indicates that this was the service
bought in the name of the Duc de
Praslin, Secretary of State for Foreign
Affairs between October 1762 and
January 1763, as was the Bedford ser-
vice. It had a *lapis* ground and included
a punch bowl and mortar also valued at
720 livres. In the light of this evidence

it appears that the Duc de Nivernais
gave his own punch bowl to Lord
Egremont in gratitude for the part
he played in the difficult peace nego-
tiations. Lord Egremont died in the
same year that he received the punch
bowl and it was inherited by his son.
If George III had not imposed a duty
on imported china on 22 May 1775,
Petworth would also have had a Sèvres
dinner service of the mid-1770s; the
3rd Lord Egremont ordered one from
the Parisian dealer Sayde, but canceled
its delivery when the tax was introduced
(Watson 1967, 186). R.S.

Related Works: It is possible that other
pieces from the Duc de Nivernais' service
are in the Royal Collection (London,
Queen's Gallery 1979, no. 57).

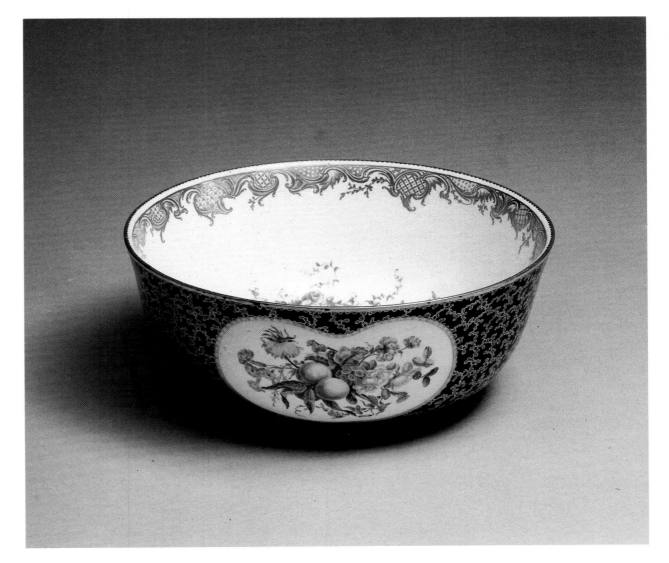

403

VASE 1776
Sèvres
soft-paste porcelain
31.1 (12¼) high
factory marks of interlaced *L*s enclosing
Y, the date letter for 1776; painter's
mark for Jean-Jacques Pierre *jeune*
(fl. 1763–1800); gilder's mark for
Boulanger *père* (fl. 1754–1784)

Harewood House
The Earl and Countess of Harewood

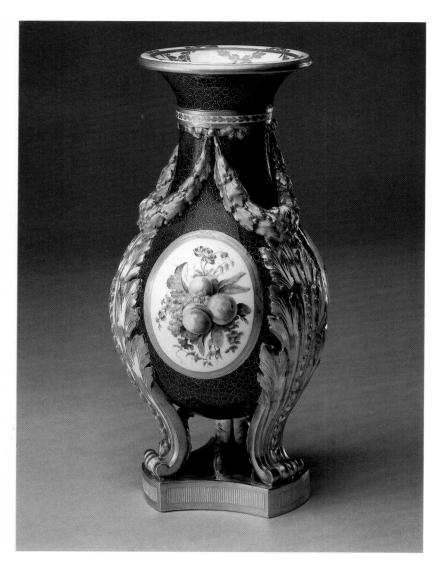

The bulbous vase is supported by a
tripod framework of acanthus leaves in
relief and scrolled feet set on a triangular
base. It is decorated with a dark blue
(*beau bleu*) ground overlaid with circles
of gilded dots; the three reserves are
painted with sprays of flowers and fruit
by Pierre, and the elaborate gilding by
Boulanger includes unusual swags within
the neck.

The model was first recorded in 1775
(London, Queen's Gallery 1979, no. 92)
and was named after Louis XV's daughter
Madame Marie-Adélaïde (1732–1800)
who was a keen patron of the factory.
This vase and its pair at Harewood,
together with a *vase du Roi* in the Wallace
Collection, formed a garniture mentioned
in the painters' and gilders' overtime
records for 1776 at Sèvres. Pierre received
60 *livres* for painting the flowers and
fruit on the three vases and Boulanger
was paid 18 *livres* for gilding the *vases de
Madame Adélaïde*.

Although the set is not described
in the factory's sales records, it is
quite possible that it was purchased
by Madame Adélaïde herself in 1777;
the entry lists three vases, one priced
at 600 livres and two at 360 *livres* each,
and these prices are identical to other
references where these two shapes are
specified. R.S.

Provenance: See no. 404
Related Works: Other pairs of this model
include one in the Royal Collection
(Queen's Gallery 1979, no. 92) and
another in the collection of the Duke of
Bedford at Woburn Abbey (Eriksen
1965, 488, fig. 7)
Literature: Tait 1966, 439, fig. 2

404

FLOWER POT 1757
Sèvres
soft-paste porcelain
19.7 (7¾) high
factory marks of interlaced *L*s enclosing
E, the date letter for 1757

Harewood House
The Earl and Countess of Harewood

This *vase hollandois*, one of a pair, is in
two sections; the upper, fan-shaped part
is pierced with holes in the base and fits
into the lower oval stand, which has
four cartouche-shaped openings in the
shoulder. It is decorated with a rose
ground interrupted with white quatrefoil
motifs forming a criss-cross pattern, the
reserve is painted with a child in a land-
scape and edged with a gilded circular
cartouche of trelliswork and sprays
of flowers. The figure painting in the
manner of Boucher may be attributed to
André-Vincent Vielliard (fl. 1752–1790).
The model was introduced in three sizes
in 1754 and this example is the second
size. A drawing showing two profile
views of this shape survives in the
archives at Sèvres and is inscribed,
*vazes ou caisse de chemine pour metre des
fleurs par ordre de Mons de Verdun le
29 mars 1754* (Eriksen 1968, 98–101),
proving that it was intended for display
on a chimneypiece and that it was
ordered by Jean-François Verdun de
Montchiroux, a major shareholder in
the Vincennes company. Lazare Duvaux's
accounts of 1758 add that the shape
was "pour mettre des fleurs en terre"
(Courajod 1873, 2: no. 3120), indicating
that the upper part would have contained
plants or bulbs growing in earth; perhaps
the term "hollandois" is connected with
a use for Dutch bulbs. The lower section
was filled with water poured through the
cartouche-shaped openings without
disturbing the plants, which absorbed
water through the holes in the base of
the upper section.

The Harewood pair was probably
included in the garniture of three *vases
hollandois* bought by the dealer Lazare
Duvaux' widow in December 1758.
They cost 432 *livres* each and flanked
an example of the first size costing
576 *livres*. The subsequent accounts of
Madame Duvaux show that she separated

the set as soon as she purchased it; the present vase and its pair were sold to the Prince de Monaco in the same month, but the center vase, which is now in the Wallace Collection, was bought by the Duchesse de Mazarin in January 1759 (Courajod 1873, 2: nos. 3313 and 3318; Verlet and Grandjean 1953, 204: Tait 1964, 477). The Harewood vases were probably acquired by Edward, Viscount Lascelles (1764–1814), son of the 1st Earl of Harewood, whom he predeceased. During the Peace of Amiens in 1802 he visited Paris specifically to attend sales of Sèvres porcelain that had resulted from the dispersal of many aristocratic properties after the Revolution. He also bought from his London agent, the china dealer Robert Fogg, but this pair cannot be identified in the bill for £600 settled with Fogg in 1807 (Mauchline 1974, 116–117). Viscount Lascelles' collection of Sèvres was already famous within a year of his death, for in 1815 Queen Charlotte came to Harewood with the Prince Regent to see it (Mauchline 1974, 119). R.S.

Literature: Tait 1964, 477, fig. 8

405

FLOWER POT 1761/1762
Sèvres
soft-paste porcelain
23.5 (9¼) high
incised mark *CN*, possibly for Séjourné
(fl. 1754–1767)

Firle Place
The Trustees of the Firle Estate
Settlement

The vase is in two sections, the upper part pierced with holes in the base and fitting into the lower oval stand on four feet, which has four cartouche-shaped openings on the shoulder. It is decorated with a rose ground overlaid with blue enamel and gilding to give a lace-patterned effect, and is painted in the reserve at the front of the upper section with a rustic scene in the manner of Teniers and in five reserves (at the sides and on the front of the stand) with landscapes.

The model is first listed in the Sèvres documents in 1758 although it may have been produced in the previous year; it was made in five sizes and this example is of the third size. It is a later variant of the *vase hollandois* of 1754 (see no. 404). The unusual decoration is only found in the early 1760s when the plain rose ground was given added novelty

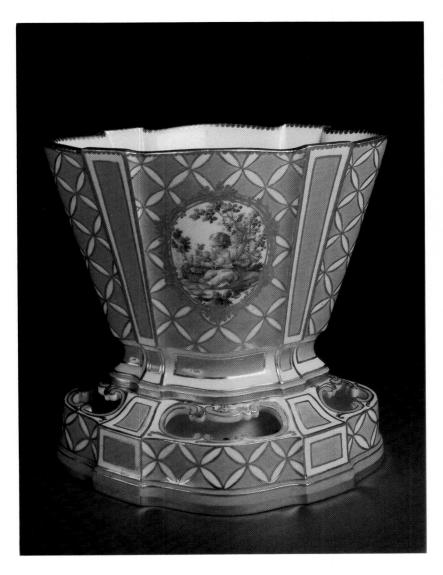

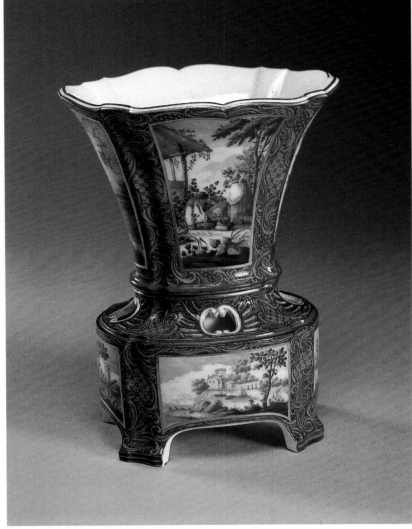

by the application of either marbling or lace patterns in blue enamel and gilding. The scene of a drunken man being rebuked by an irate lady appears on several vases between 1759 and 1762, and is taken from an ink sketch on the back of an engraving by Le Bas of Teniers' *La Quatrième Fête Flamande* in the archives at Sèvres; Carl Dauterman has suggested that it was drawn by Charles-Nicolas Dodin (1976, fig. 38). Marked vases show that in addition to Dodin, Morin, Caton, and Vielliard painted this subject, and in view of its combination with landscape scenes on the Firle vase the most likely artist is André-Vincent Vielliard (fl.1752–1790) who specialized in both types of decoration at this date.

The pair to this vase is in the Museum of Fine Arts, Boston (Gage 1984, fig. 3), painted with a scene taken from the Le Bas Teniers engraving itself, and almost identical decoration is found on a set of three vases in the Frick Collection, New York (Pope and Brunet 1974, 246–255). None of these pieces can be traced in the factory's sales records, nor is it known when the Firle vase was separated from its pair. However, since the Boston example is said to come from Lord Lincoln's collection (Lane 1955, 161) and "Mylord Lincoln" was a client of the Chevalier Lambert who handled the order of Lord Melbourne's service (see no. 411), it is possible that Lambert separated them and then sold one each to Lord Melbourne and Lord Lincoln. Alternatively the Firle vase may have been acquired in the nineteenth century by Melbourne's daughter Emily and her husband the 5th Earl Cowper (1778–1837). It remained at their home, Panshanger in Hertfordshire, until the 1950s when it was inherited by the present Viscount Gage's mother and removed to Firle.

R.S.

Literature: Lane 1955, fig. 3; Watson 1966, no. 25; Gage 1984, 93 figs. 1, 2; Platts 1984, fig. 2
Exhibitions: London, Dorchester House 1984 (13)

406

CUP AND SAUCER 1756 and after 1771
Sèvres
soft-paste porcelain
cup: 7.9 (3) high, with cover
saucer: 13.4 (5¼) diam.
factory marks of the interlaced Ls and, on the cup, D, the date letter for 1756; painters' marks on the cup for Pierre-François Yvernal (fl.1750–1759) and on the saucer for Claude-Charles Gérard (fl.1771–1825)

Firle Place
The Trustees of the Firle Estate Settlement

The cup is indented at the base and the cover has a flower knop, while the saucer has a deep tapering side. They are decorated with a dark blue (*bleu lapis*) ground, painted in the reserves with cherubs in carmine *camaieu* enamel, and gilded; the figure on the cup has his hands raised in horror as a small swarm of bees is about to attack him. The *gobelet couvert* was introduced by December 1753 and the cover could indicate that it was intended for chocolate.

Monochrome enamel scenes were especially popular in the 1750s when they complemented the smudgy underglaze *bleu lapis* ground color. Yvernal's mark occurs on examples with either carmine or blue *camaieu* decoration. The saucer is a later replacement made after Gérard's arrival at the factory in 1771; by this time such decoration was less fashionable but the painters' records (surviving from 1777) show that he did occasionally paint children in this color in the late 1770s.

The factory was constantly making replacement pieces, generally for dinner-services, but the sales records for 1756 list a cup made to replace one broken by Louis XV himself. The Firle saucer is another example of how even a cup was deemed worthy of the expense of a new saucer when it was twenty years old and not in the latest style. It is tempting to speculate that this saucer may have been commissioned by the 1st Viscount Melbourne since its date could coincide with his Sèvres service (see no. 411), but it is more likely that both pieces were acquired by his daughter Emily and her husband the 5th Earl Cowper.

R.S.

Provenance: See no. 405
Literature: Watson 1966, no. 64
Exhibitions: London, Dorchester House 1984 (5)

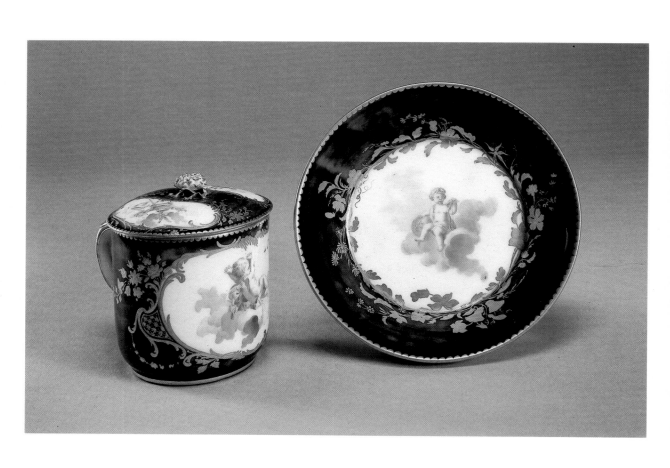

407

TRAY 1764
Sèvres
soft-paste porcelain
$17.4 \times 24.1 \left(6\frac{7}{8} \times 9\frac{1}{2}\right)$
factory marks of the interlaced *L*s
enclosing *L*, the date letter for 1764

Upton House
The National Trust
(Bearsted Collection)

The rectangular tray has pierced sides formed by a simplified Vitruvian scroll and a "harebell" motif. The painted scene is possibly by André-Vincent Vielliard (fl. 1752–1790). The model with plain sides was introduced in two sizes in 1756, and the later pierced version was first recorded in 1758; this example is of the first size. Usually it provided the tray of a small tea service, called a *déjeuner tiroir à jour*, and this piece has a matching teapot, sugar bowl, and two cups and saucers.

The scene of a boy presenting a fish to a girl is adapted from one of the panels painted by François Boucher in about 1752 for Madame de Pompadour's octagonal boudoir at Crècy and now in the Frick Collection, New York (Frick 1968, 2:8–23). It was engraved under the title *La Pesche* together with its pendant, *La Chasse*, by Jean-Baptiste Le Prince, and both subjects were freely adapted by the painters at Vincennes and Sèvres. *La Pesche* appears on dated pieces between 1754 and 1764, which often bear Vielliard's mark; another example of this model painted with the same scene is at Waddesdon Manor (Eriksen 1968, 188–189, no. 68).

The collection at Upton House, formed between the wars by Walter Horace Samuel, 2nd Viscount Bearsted (1882–1949), is particularly strong in the eighteenth-century soft-paste porcelains of Sèvres and Chelsea (see no. 416). Unlike the other Sèvres collections represented here it consists mostly of smaller, useful items rather than the dinner services and garnitures of vases that survive elsewhere. R.S.

Provenance: Sir Samuel Scott sale (Sotheby's, London, 10 July 1925, lot 46); purchased Viscount Bearsted, who presented it to the National Trust in 1948, together with Upton House
Literature: Mallet 1964, 23, no. 84
Exhibitions: London, Christie's, 1957–1958, no. 107

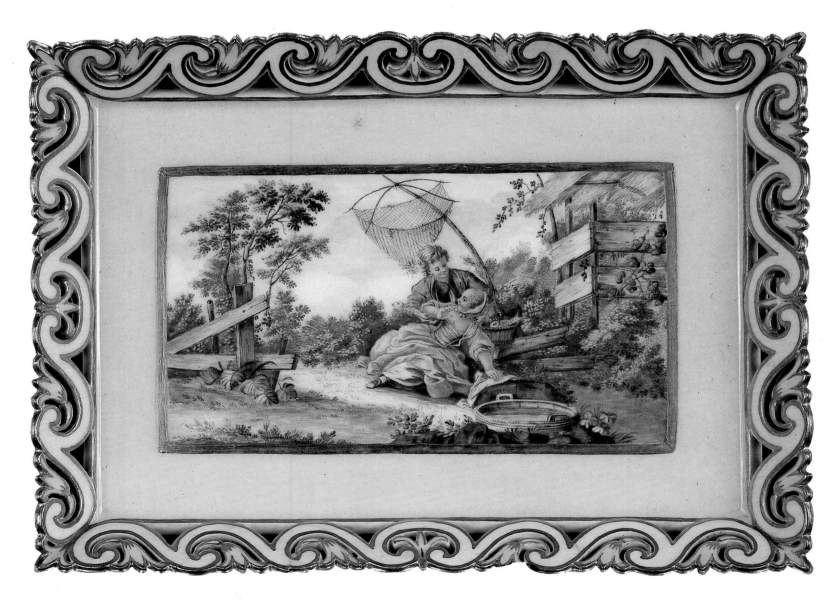

408

PART OF A TEA SERVICE 1779
Sèvres
soft-paste porcelain
tray: 48 × 36.8 (18⅞ × 14⅜);
teapot: 12.7 (5) high; sugar bowl: 11.4
(4½) high; cup: 5.7 (2¼) high;
saucer: 12 (4¾) diam.
factory marks of the interlaced *L*s
and *BB*, the date letters for 1779;
painter's mark for Pierre-André Le Guay
fils aîné (fl. 1773–1817); gilder's mark
for Etienne-Henry Le Guay *père*
(fl. 1749–1796)

Harewood House
The Earl and Countess of Harewood

The large oval tray has scrolls, acanthus leaves, and bands of laurel garlands in relief punctuating the center of the sides and at each end. The fruit knops on the covers of the teapot and sugar bowl first appear in the mid-1760s, replacing the earlier flower knops. The service, which also includes a milk jug and three more cups and saucers, is decorated with a dark blue (*beau bleu*) ground, painted with miniature scenes of rustic subjects painted by Le Guay and gilded by his father.

All the shapes except for the tray were introduced at Vincennes; they are the *théière Verdun*, the *pot à sucre Bouillard* (?), and the *gobelet et soucoupe*

litron of the third size. The tray, called *plateau Paris*, was first recorded in 1776, and was named after its designer, Daparis (fl. 1746–1797), who at this time was head of the soft-paste workshops.

This service is listed in both the painters' and the kiln records at Sèvres for 1779; seven of the eight items appear in Pierre-André Le Guay's work records on 1 April and they, together with the fourth cup and saucer, received a final firing on 3 October. They cannot be identified in the sales records but it is likely that the set cost as much as 1200 *livres*, the price paid for a similar *déjeuner Paris* in 1778.

This tea service is traditionally believed to have been presented to Queen Marie-Antoinette by the City of Paris, and the scene on the teapot of a child buying a print of Louis XVI would seem to confirm a royal connection. Perhaps it did belong to the French queen, but the idea that it was a gift from the people of her capital city probably resulted from a misinterpretation of its name. R.S.

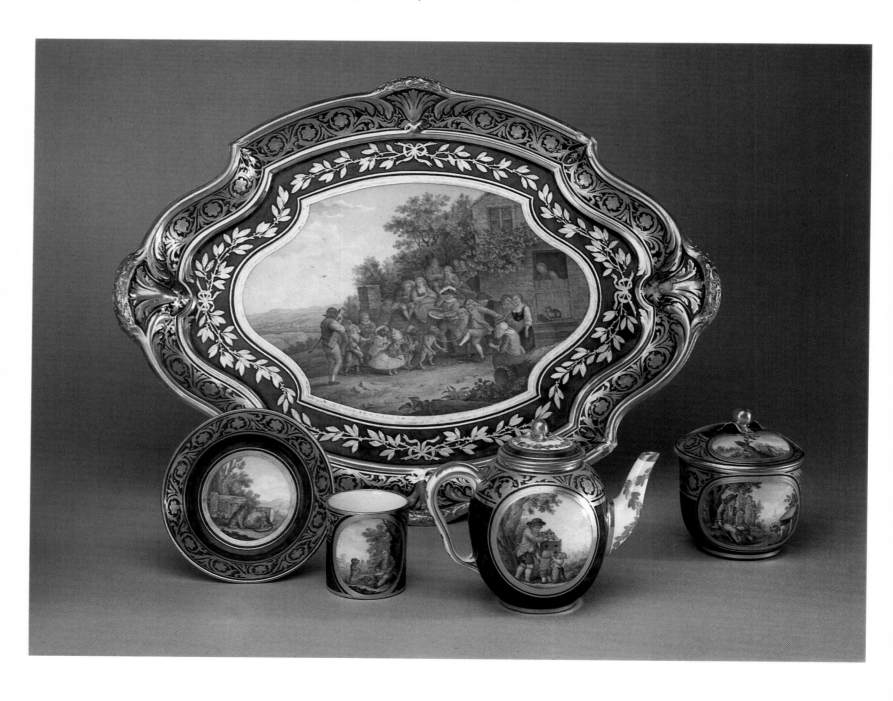

Related Works: Other *déjeuners Paris* include a hard-paste example, also dated 1779, in the Wallace Collection, London
Provenance: Possibly the "Dejunie" acquired in December 1807 by Edward Lascelles (1764–1814), son of the 1st Earl of Harewood, from his London agent, the china dealer Robert Fogg (Mauchline 1974, 116–117); by descent at Harewood.
Literature: Tait 1966, 440–441, pl. 16, and figs. 5–7

409

GARNITURE OF THREE VASES 1765
Sèvres
soft-paste porcelain
vase à couronne: 35.5 (13) high
vases Danemark à gauderon: 21.7 (8½) high
on the *vases Danemark à gauderon* only, factory marks of the interlaced Ls enclosing, on one, the date letter for 1765, and on the other that of 1766; painter's mark for Jean-Louis Morin fl. 1754–1787

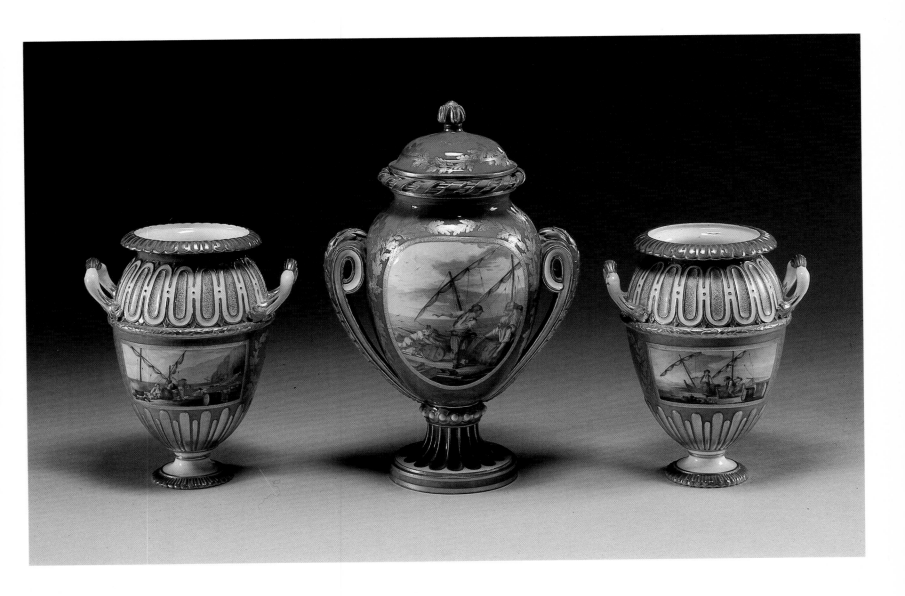

The reserves of all three vases are painted by Morin with military camp scenes on one side and harbor scenes on the other. Four different patterns of tooling are used on the gilded borders of the reserves.

The model of the *vase à couronne* (also called *vase à ruban*) was introduced in two sizes in 1763, this example (which has a replacement knop) being of the second size. The *vase Danemark à gauderon* was introduced in one size in 1764, perhaps in gratitude for Denmark's role in the Seven Years' War (1756–1763) or to celebrate the visit to Paris in that year of Joachim Godske Moltke, son of the Danish king's influential adviser. The painted scenes first appear in the late 1750s and were still popular after Morin's death in 1787. Among his other versions of the soldiers playing cards on the central vase is a flower vase of 1780 at Waddesdon Manor (Eriksen 1968, no. 109). The presence of the date letter for 1766 on one of the vases is disconcerting, but there are many such examples of inconsistency in Sèvres dating (Bellaigue 1984, 329). The three vases are recorded in the sales records at Sèvres for 12 November 1765 when the *vase à couronne* cost 720 *livres* and the two *vases Danemark à gauderon* cost 480 *livres* each. These high prices for comparatively small vases are justified by the unusual combination of both military and harbor scenes; most vases have only one reserve painted with figures and simple sprays of flowers or trophies at the back. Although they were sold for cash to an unnamed buyer, he was undoubtedly the 3rd Duke of Richmond (1735–1806) who visited the factory on the very day that the sale is recorded. He was accompanied by his wife and the Reverend William Cole, who wrote in his journal that while at the factory the duke "bespoke a service of this manufacture for their table which cost 500 pounds" (Watson 1967, 168). He must have purchased the vases on this occasion, and later received the dinner service (dated 1765–1766) which also survives at Goodwood.

The 3rd Duke of Richmond, who also held the French title of Duc d'Aubigny, was the English Ambassador Extraordinary to the court of Versailles from 1765 to 1766. He was a keen patron of

French works of art, acquiring furniture and Gobelins tapestries, and many of these pieces were bought during his time as ambassador in Paris. In 1766 he also received, as a diplomatic gift from Louis XV, a gold *boîte à portrait* valued at 15,236 *livres* (Maze-Sencier 1885, 178). At about this time he employed the architect William Chambers to rebuild his country house at Goodwood; later, he was to embark on another, much more ambitious, building program, with James Wyatt as architect, but this brought financial disaster and the new house survives incomplete. R.S.

Related Works: An almost identical garniture, but with military scenes only and with flowers in the reserves at the back, is in the Wernher Collection at Luton Hoo (*vases Danemark à gauderon*; see Brunet and Préaud 1978, 167, fig. 129)

410

PART OF A DESSERT SERVICE 1789
Sèvres
hard and soft-paste porcelain
(plates only of soft-paste) three plates: 24.4 (9⅝) diam.; five ice cream cups: 6.3 (2½) high, on a tray: 21.9 (8⅝) diam.; ice pail: 19 × 23.5 (7½ × 9¼); three preserve pots on an attached tray: 8.3 × 22.2 (3¼ × 8¾)

all the pieces bear the factory mark of the interlaced *L*s in blue; some also bear an unidentified artist's mark; the plate with the profile head, though produced in 1789, bears the date letters *MM* for 1790 and the mark of the painter Charles-Nicolas Dodin

The Manor House, Stanton Harcourt
The Hon. Mrs. Gascoigne

These pieces form part of a dessert service at Stanton Harcourt which is *en suite* with tea and coffee sets now in the possession of Her Majesty The Queen and Sir Victor Fitzgeorge-Balfour. The grisaille profile heads of King George III are restricted to eighteen plates and the inscriptions, encircling the initial G, including *Huzza the King is well* and *Viva el Rey* are restricted to the remaining plates and the components of the tea and coffee sets.

The inscriptions and the King's effigy provide the clue to the early history of this service. In the spring and early summer of 1789 celebrations were being held throughout England to mark George III's recovery from a serious bout of illness, now diagnosed as porphyria but then regarded as an attack of madness. The most lavish party was held on the 2nd June at the invitation of the Spanish ambassador, the Marquis del Campo, in the Rotunda of the Ranelagh Gardens, Chelsea. The principal guest at the gala was Queen Charlotte, who was accompanied by her daughters. Mrs. Philip Lybbe Powys records that one of the services chosen for use by the Queen was "a very curious set of Sèvres china" (Climenson 1899, 241–242).

After the gala some of the porcelain may well have been presented to Queen Charlotte, as stated by Mrs. Lybbe Powys. According to the tradition in the Fitzgeorge family the tea and coffee sets passed from Queen Charlotte to her daughter, Mary, Duchess of Gloucester, and from her to the second Duke of Cambridge. On his death, the porcelain was divided between his two sons, Sir Augustus and Sir Adolphus Fitzgeorge. When Sir Adolphus died in 1934 his portion was purchased by Queen Mary.

Elizabeth, Countess Harcourt, who also attended the gala, records in her memoirs that the Marquis del Campo

presented the bulk of the service to her and her husband the Earl Harcourt in February 1796 following his appointment as ambassador to the French Republic (Harcourt 1880, 4:267). This is confirmed in an inventory of 1830 in the Bodleian Library, Oxford, to which the writer's attention has been kindly drawn by the Hon. Georgina Stonor. In this inventory, based on one made at the time of the Earl's death in 1809, the service is described as having been presented by the Spanish ambassador.

That a Spanish ambassador should have chosen a service of Sèvres porcelain to celebrate the recovery from illness of a British monarch is indicative of the international reputation which the factory enjoyed at the time. The ambassador wanted the best and he got what was generally regarded as the best. Ironically, this high opinion of the French factory was probably not shared by the person in whose honor the service had been commissioned, namely King George III. The British sovereign,

who professed a dislike for foreign fashions, is not known ever to have bought a single piece of Sèvres porcelain. This indifference, or distaste—if such it was—for the factory's wares did not, however, extend to a complete ban on French porcelain under his roof, for he tolerated the presence in Buckingham House of an impressive collection of Sèvres assembled by his consort, Queen Charlotte. G. de B.

Literature: Bellaigue 1984, 325–331

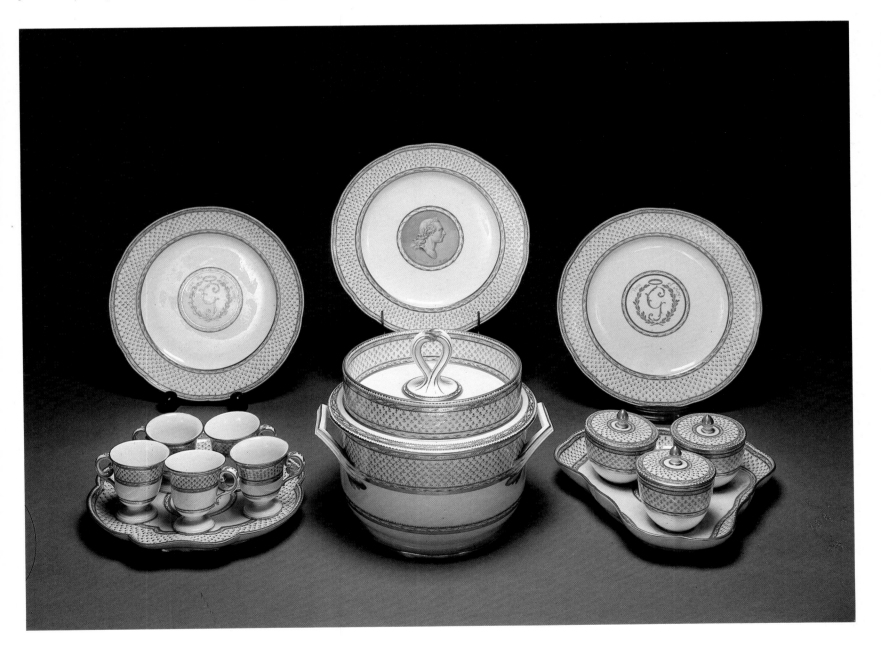

411

PLATE FROM THE MELBOURNE
SERVICE 1770
Sèvres
soft-paste porcelain
24.1 (9½) diam.
factory marks of the interlaced *L*s
enclosing *R*, the date letter for 1770;
painter's mark for Charles Buteux
l'aîné (fl. 1756–1782)

Firle Place
The Trustees of the Firle Estate
Settlement

The plate is decorated with a pale blue
dotted (*pointillé*) ground, painted with
trophies by Buteux, the factory's chief
trophy painter, and gilded. The *pointillé*
ground was added after the painted
decoration and before the gilding.

This is one of the forty-eight plates
valued at 36 *livres* each that were in-
cluded in the dessert service of eighty
pieces, costing a total of 5,197 *livres*
19 *sous*, delivered to the 1st Viscount
Melbourne's Paris agent on 20 March
1771. The principal pieces of the service
(the wine and liqueur bottle coolers,

and the sugar bowls) were also painted
with cherubs representing the arts;
such figure painting was costly so it
was usually confined to a few items.
Both the allegories and the trophies are
thought to reflect the artistic aspirations
of Elizabeth Millbanke (1744–1828)
who married Sir Penistone Lamb (1752–
1818) in 1769. The commission was
presumably placed at the factory in
1769 or 1770 to celebrate either the
marriage, or Sir Penistone's elevation
to the viscountcy of Melbourne in the
following year.

This service is a rare example of such
a commission by an Englishman. Most
of the Sèvres services acquired by the
British nobility in the eighteenth century
were either ambassadorial gifts (see
nos. 399 and 409) or bought from the
stocks held by Parisian dealers without
reference to the purchaser in the fac-
tory's documents, and in neither of
these alternatives is there evidence that
the owner had any control over the
decoration of his service. In this case
the decoration is both unusual and
personal; although *pointillé* grounds are
found in the late 1760s they are more
commonly associated with dinner
services in the 1780s including those of
Lord Eden (see no. 399) and the Duc de
Chartres, and the painted decoration
includes references to Hamlet and an
imaginary coat of arms which may
acknowledge the commission of an
English milord. Lord Melbourne's Paris
agent was the Chevalier Lambert, an
English banker and also an accepted
dealer at Sèvres, receiving a 9% discount
from the factory (see London, Queen's
Gallery 1979, no. 64). His name,
together with that of his widowed
mother (d. 1762), occurs in Lazare
Duvaux' accounts from 1754, and
before his death in 1777 their clients
included Lords Bolingbroke, Lincoln,
and probably Bristol in addition to
Lord Melbourne.

Lord and Lady Melbourne were
enthusiastic patrons of the arts; they
not only improved Brocket Park, their
country house in Hertfordshire, but
they bought Lord Holland's house in
Piccadilly in London within a month of
the delivery of their Sèvres service.
They immediately employed William
Chambers as the architect and Thomas
Chippendale to provide the furnishings
for their new London home, which was
renamed Melbourne House. It was here
that Lady Melbourne earned her
reputation as one of the leading host-
esses of her day and the Sèvres service
may have been here at this time. It was
inherited by her daughter Emily (whose
brother and second husband were the
famous Victorian prime ministers Lord
Melbourne and Lord Palmerston) and
she removed it to Panshanger in Hert-
fordshire, the country house of her first
husband, the 5th Earl Cowper. It re-

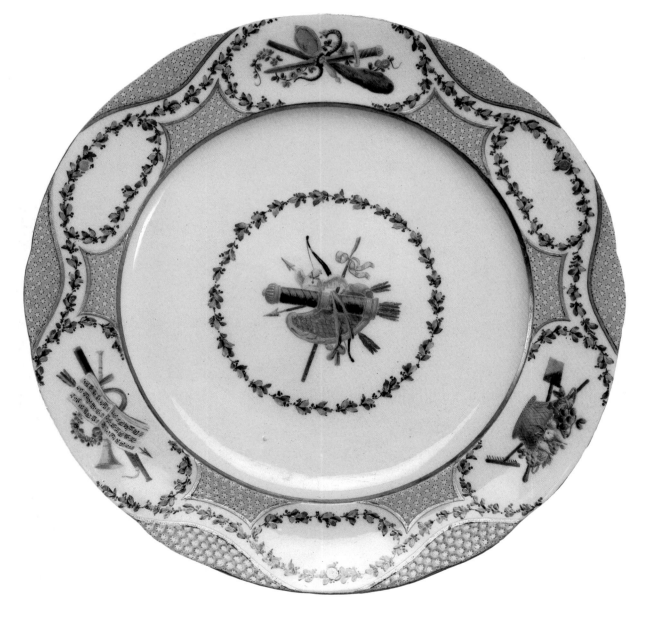

mained at Panshanger until the 1950s when it passed by descent to the present Viscount Gage's mother and was added to the collections at Firle.　　R.S.

Literature: Lane 1955, 163, figs. 8–9; Watson 1966, no. 1; Gage 1984, 89–92, figs. 8–9; Platts 1984, 1687, fig. 1
Exhibitions: London, Dorchester House 1984 (1)

412

CUP AND SAUCER　1778
Sèvres
soft-paste porcelain
cup: 7.8 (3) high
saucer: 13.3 (5 $\frac{1}{4}$) diam.
factory marks of interlaced *L*s and *AA*, the date letters for 1778; painters' marks on the cup for Jean-Baptiste Tandart *l'aîné* (fl. 1754–1803), and on the saucer for Etienne-François Bouillat *père* (fl. 1758–1810); gilders' marks on the cup for Boulanger *père* (fl. 1754–1784) and Henry-François Vincent (fl. 1753–1806)

Upton House
The National Trust
(Bearsted Collection)

The cup and saucer are decorated with a turquoise-blue (*bleu céleste*) ground overlaid with *rinceaux* scroll gilding, painted with bands of flowers, classical scenes and medallion heads in grisaille on a brown ground, and in the center of the saucer is the crowned E II monogram for Catherine (Ekaterina) II of Russia.

The form called *litron* was in production by 1752; it was made in five sizes and this example is of the second size. It was painted between 20 March and 8 April 1778 and probably received its final firing on 19 May that year.

This piece is from the tea and coffee service which was included with the dinner service and biscuit centerpiece in the magnificent service commissioned by Catherine II of Russia in 1776. It was to be for sixty people and the initial order was for 800 items. Catherine wanted the service to reflect her interest in antiquity and, except for the cups and saucers, the designs of all the shapes and their decoration were created specially for her. The ground color was

to imitate turquoise stone and the painted scenes and medallion heads were based on classical bas-reliefs and cameos some of which were taken from Louis XVI's collection and others, together with the gilding, from the Theatre of Marcellus in Rome. The factory devised a new soft-paste recipe for the service and introduced two novel techniques for its decoration: one shown on this cup and saucer was the use of transfer printing for the medallion heads (it was not to be used again at Sèvres until the nineteenth century) and the other, found only on the most important pieces, was the application of hard-paste cameo heads which were set in pre-cut recesses and secured with a gilt-copper fillet. Documents concerning the service reveal that this cup and saucer would have made eight or nine journeys to the kiln, and such painstaking manufacturing processes resulted in all the items being very expensive; each of the forty-eight cups and saucers of the second size

cost 195 *livres* and the total cost of the service was 331,317 *livres*. It was despatched for Russia in June 1779 and the factory received the final payment in 1792.

Almost all of the service, together with the silver-gilt cutlery ordered to accompany it, is still in the Hermitage Museum in Leningrad even though there was a fire in the palace in 1837 when about 160 pieces were looted. These items were brought to London in 1840 by an Italian called Ferdinando Civilotti and they were acquired by Lord Lowther (later the 2nd Earl of Lonsdale). In 1856 he sold the bulk of his pieces and some were subsequently returned to Alexander II of Russia while others were dispersed in various collections (see Savill 1982, 2:304–311).

Two cups and saucers can be traced through a number of annotated sales catalogues which name both dealers and collectors: one passed to S. Addington (1862), Lord Dudley (1886), Thomas

Goode (1895) and Durlacher (1895), and the other belonged to Rucker (1869), Lord Dudley (1886), Joseph (1886), Octavus Cooper (1910) and Stern (1910). The Upton example was in Lord Dudley's collection (Christie's London, 21 May 1886, lot 93 or 94), and it may have been purchased by the 2nd Viscount Bearsted through Stern after the Octavius Cooper sale of 1910 (Christie's, London, 3–5 May 1910, lot 169). For a note on Lord Bearsted's Sèvres collection see no. 407.　　R.S.

Literature: Mallet 1964, 24–25, no. 104, pl. 7a
Exhibitions: Possibly London, SKM 1862 (1372)

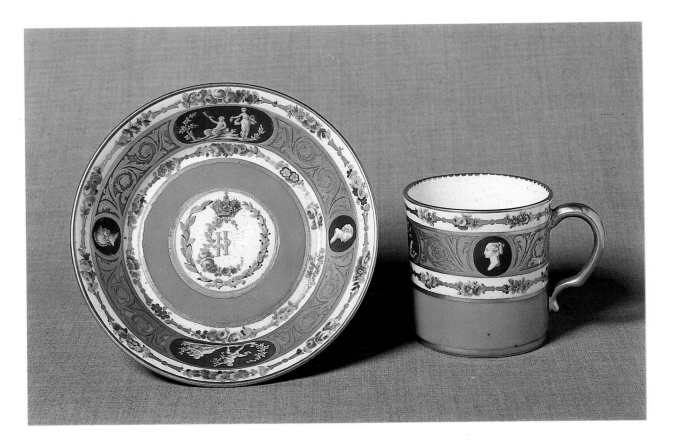

413

PAIR OF VASES AND COVERS C. 1770
Worcester
steatitic soft-paste porcelain
54.6 (21½) high
blue square seal marks under the bases

Luton Hoo
The Wernher Collection
Nicholas Phillips, Esq. and the
National Art Collection Fund

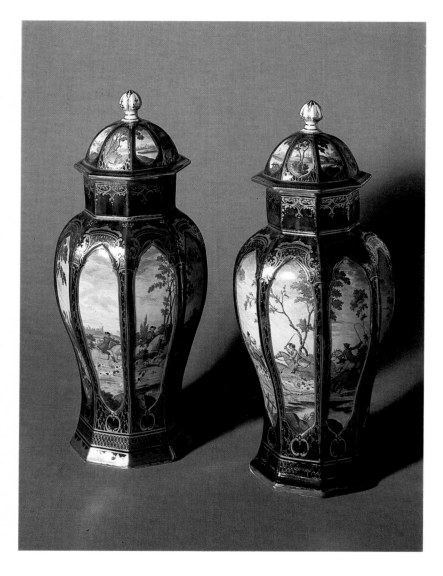

Of octagonal, slender, baluster form, the
domed covers of these vases have faceted
white gilt knops and the panels to each
side are cusped above and below in a
slightly "gothick" manner. The scenes
painted in the panels are attributed to
Jeffrey Hamet O'Neale. One has a stag
hunt, the other a fox hunt. According
to W.B. Honey (1928, 184) these are
after Wouwermans ("with delightfully
impossible horses"). The ground color
is the mazarine blue mentioned in the
1769 Worcester sale catalogues, partly
gilt with network and with elaborate
gilt cartouches enriched with scrolls,
flowers, and foliage.

These large vases are among the
grandest wares put out by Worcester
and were made in emulation of the
colored ground wares of Chelsea and
Sèvres. The more common shapes are
the circular, slender, baluster form
or the straight-sided hexagonal one.
O'Neale actually signed a number of his
paintings on large vases, including a set
of three in the Frank Lloyd Collection
in the British Museum (nos. 347 and
348), and his painting is often identifiable
by the typical red-brown rocks in
the foreground, first observed by
R.L. Hobson. O'Neale was one of the
most gifted English eighteenth-century
porcelain decorators and is particularly
famous for his copies of Francis Barlow's
version of Aesop's *Fables*, first found on
raised and red anchor Chelsea wares of
the early 1750s (although their attri-
bution to O'Neale is still tentative) and
then on Worcester wares in the 1760s
and 1770s. He was an itinerant painter
and may have worked in James Giles'
atelier in Berwick Street, London. He
must have worked in the Worcester
factory between 1765 and 1775 as both
the blue ground and the gilding of the
above vases as well as other similar
pieces are typical of that factory's
painting (Marshall 1954). A.du B.

Literature: Tapp 1951, 195

414

THREE DISHES C. 1755
Chelsea
soft-paste porcelain
26.6 (10½), 30.5 (12), and 27.3 (10¾)
diam.
red anchor marks on the reverse of each

Stanway House
The Earl of Wemyss and March, KT
and Lord Neidpath

These dishes form part of a dessert
service painted with botanical plants in
the manner traditionally associated with
Sir Hans Sloane. All the dishes have
chocolate-colored lines around the rims.
The larger one is painted with a butter
bean (*Phaseolus lunatus*), a split pea pod,
a split pod gooseberry (*Ribes grossularia*),
two small campanulas, (possibly) an
Althea, two moths, a caterpillar, and a
beetle. One of the smaller dishes had a
garden pea (*Pisum sativum*), a cut radish
(*Raphanus sativus*) and two moths. The
other dish is painted with a blue-
flowered Bignonia, a thornless purple
rose, a Chinese lantern or bladder
cherry (*Physalis alkekengi*), a butterfly, and four
other insects.

There is a reference to a porcelain
service decorated "in curious plants,
with Table Plates, Soup Plates and
Dessert Plates enamelled from Sir Hans
Sloan's plants" in a Dublin auction
announcement of July 1758. The London
sales of 1755 and 1756 do not differentiate
the types of flower painting but refer
only to "Twelve fine desart plates in
flowers, etcetera." Sir Hans Sloane was
a major Chelsea landowner and in 1722
granted a favorable lease of the site of
the Chelsea Physic Garden, in perpetuity
to the Society of Apothecaries. The
Physic Garden, no longer associated
with the Society of Apothecaries, remains
on this site in the Royal Hospital
Road. Patrick Synge-Hutchinson (see
especially *Connoisseur*, October 1958),
shows that some of the designs on
these botanical plates were taken
directly from G.D. Ehret's illustrations
to Philip Miller's *Figures of Plants*
and other books. Most of the designs
have not yet been identified and the
proximity of the Physic Garden may
have inspired the Chelsea decorators to
expand their repertory from life. Those

copying Ehret's designs always follow the illustrations in the books, which are the reverse of the original drawings, and thus Synge-Hutchinson's theory that Ehret lent his originals to the Chelsea factory loses credibility. Only two of Ehret's drawings for Philip Miller's book have been identified, as well as the "Bocconia" from *Plantae Selectae* and six plants from Ehret's *Plantae et Papiliones Rariors*. None of the Stanway dishes corresponds to these, but Ehret's production was extremely large, so their design could have come from another, lesser-known work.

<div align="right">A. du B.</div>

Provenance: Probably acquired by the 8th Earl of Wemyss; see no. 420

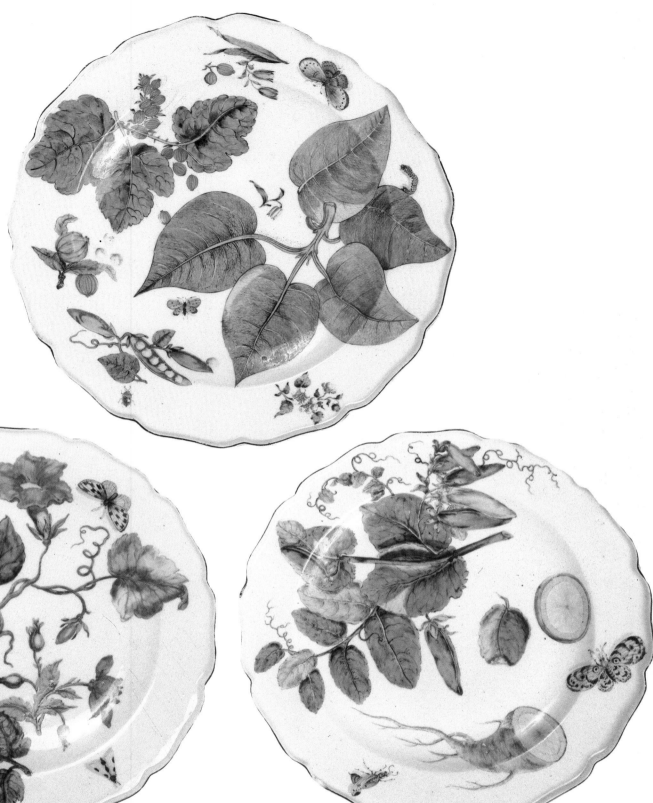

TWO FIGURES OF FISHERMEN C.1755
Chelsea
soft-paste porcelain
18.5 (7¼) high
one figure inscribed with a small red
anchor mark at the back

Saltram House
The National Trust (Morley Collection)

Both of these Chelsea figures are based
on Meissen originals modeled by J.J.
Kaendler (see Rückert 1966, no. 917).
Among the figures of fisherman that
appear in the 1755/1756 Chelsea sale
catalogues "on Monday the 10th March
1755 and the fifteen following days,

Sundays excepted," are the following:
13 March, lot 19, "Two beautiful
fishermen of two sorts with nets";
24 March, lot 7 "A fine figure of *a
fisherman* with a basket on his back . . .
2 ditto of the Italian theatre." The
fisherwoman, of which there is an
example at Colonial Williamsburg,
Virginia, is more usually paired with a
carpenter. Among the fisherman figures
sold in 1756 are, on 1 April, lot 78,
"Two beautiful fishermen each different
for ditto (a desart)."

 John C. Austin (1977, no. 120)
attributed the fisherwoman to "the
most gifted and best known of the
Chelsea sculptors," Joseph Willems, who
almost certainly executed both these

figures. The former is based on the
Meissen original that apears in J.J.
Kaendler's *Feierabendarbeit* for December
1738: "1 Fischer mit aufgewickelten
Bein Kleidern, die Fische so er gefangen,
tragt er theils in seinem Busen, Schub-
sacken und Hauden, auf den Rucken
hat er linen Kober, worinnen Krebse,
welches alles zu sehen, und nebensich
hat er ein Fischreiser liegen." The latter
is based on a slightly later model, not
made by Kaendler, of which an example
was formerly in the Gustav von Gerhardt
collection, Budapest (no. 153). A.du B.

Literature: Neatby 1977, 66–67,
no. 267T, pl. 7D

"L'AGREABLE LEÇON"
Chelsea
soft-paste porcelain
40.6 (16) high
gold anchor and incised *R.* marks

Upton House
The National Trust
(Bearsted Collection)

The subject of this group is from an
engraving by R. Gaillard after François
Boucher's painting of the same title,
signed and dated 1748 and exhibited at
the Salon in the same year. The subject
also appears on the Chelsea Foundling
Hospital Vase (Sotheby's, London,
26 November 1963, lot 69), which,
together with Gaillard's engraving,
is illustrated by J.F. Toppin (1948,
pl. 98). It was also adapted as a group
at Frankenthal by J.F. Lück with a
very different effect (repr. Hofmann
1911, 1: pl. 35, fig. 156, and 1932,
246–247, figs. 241–243). An earlier
group in which the figures were not
reversed was modeled in biscuit porcelain
at Vincennes in 1752 (Bourgeois 1913,
1: no. 313). The subject also appears as
decoration on many pieces from various
continental factories.

 L'agréable Leçon and a similar group of
The Dancing Lesson were among the largest
and most important groups made at
Chelsea during the so-called gold anchor
period. Like the earlier figures of fisher-
men (no. 415) they were probably
modeled by Joseph Willems who left
the factory in 1766. In the "Last sale
catalogue of the Chelsea Porcelain of
Mr. N. Sprimont," 15 February 1770,
lot 41 is "A very large and curious
group of a shepherd teaching a shepherd-
ess to play the flute" (£8). Another
group was in the third day's sale on
16 February, lot 46. No similar group
appears in the earlier 1761 catalogue. A
number of other examples of *L'Agréable
Leçon* survive, including one in the
Museum of Fine Arts, Boston; another
was formerly in the J.P. Morgan and
Dunlap Collections; another in the
Victoria and Albert Museum
(Rackham 1928, pl. 17, fig. 197).

 The Dancing Lesson is rarer: one group
is in the Museum of London (c. 1073)
(repr. Lane 1961, pl. 29), and another is

at West Dean House, near Chichester.

The incised *R*. mark was for many years considered to be that of the sculptor Louis François Roubiliac who did work at the Chelsea factory for a short period about twelve years before this group was modeled. It is now thought to be of an unidentified repairer. (The repairer in an eighteenth-century porcelain factory would have assembled the various pieces from the molds and produced the finished biscuit figure or group before decoration.) A.du B.

Literature: Mallet 1964, 15, no. 35

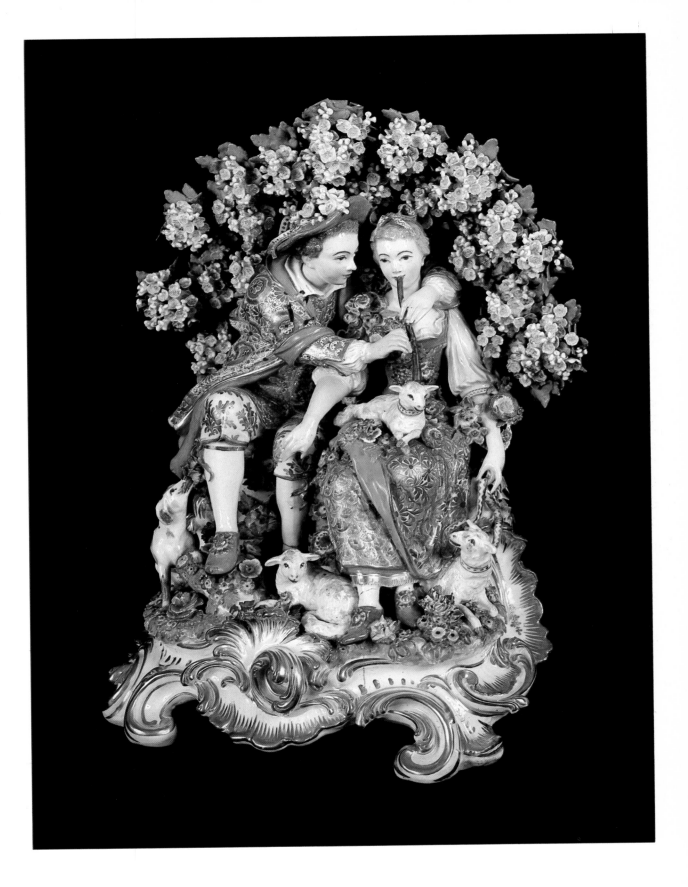

417

TWO FIGURES OF MASQUERADERS
c. 1760–1769
Chelsea, Lawrence Street Factory
soft-paste porcelain containing bone-ash
20 ($7\frac{7}{8}$) high
both marked with gold anchors at the
backs

Luton Hoo
Nicholas Phillips, Esq., and The
National Art Collection Fund

Fourteen models from the masquerader
series, with similar scroll bases and
elongated forms, have so far been
identified. They are all of about the
same size and of similar subject matter.
Eleven are at Colonial Williamsburg,

Virginia, six are at Luton Hoo, and
another is illustrated by Stoner (1955,
pl. 32). The two models shown here are
not represented at Williamsburg. It has
been traditionally suggested that these
figures commemorate a masque, held in
honor of the Prince of Wales' birthday,
in Ranelagh Gardens on 24 May 1759.
For this reason the figures are commonly
known as the "Ranelagh dancers."
However, none corresponds precisely
to those shown in the engraving by
Bowles after Maurer representing this
ball (ill. Sutton 1969, 92, fig. 2). It is
also unclear whether the figures were
intended to represent the well-to-do
in fancy dress, or mountebanks or
mummers: a figure dressed similarly
to the flageolet player (Austin 1977,

no. 137) is shown performing outside
a tavern in a drawing of 1755 by Paul
Sandby, now at Windsor Castle (Oppé
1950, pl. 114, supp. no. 431). A pair of
Chelsea "gold anchor" vases also at
Luton Hoo are painted on each side
with similar figures (Gardner 1940,
6, figs. 7 and 8). This entry draws
extensively on J.V.G. Mallet's descrip-
tion in the London, V & A 1984 exhi-
bition catalogue, which is gratefully
acknowledged. A.du B.

Related Works: Two similar figures;
illustrated Charleston and Towner
1977, pl. 9, no. 128
Exhibitions: London, V & A 1984
F43d and i)

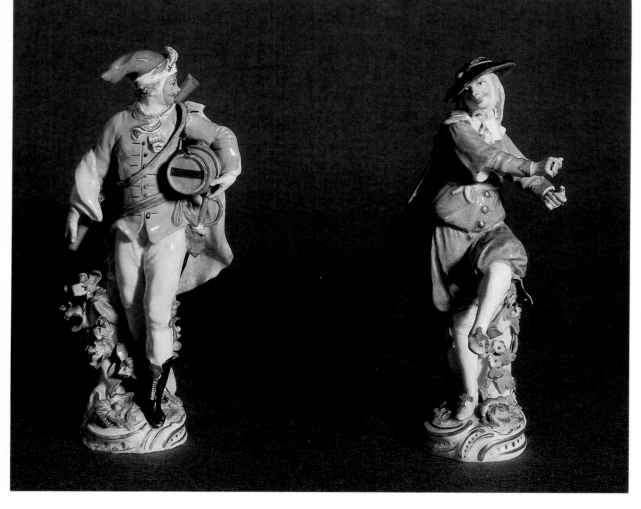

418

TWO FIGURES OF BULLFINCHES
c. 1755
Bow
soft-paste porcelain
10.7 ($4\frac{1}{4}$) and 12 ($4\frac{3}{4}$) high

Wallington
The National Trust
(Trevelyan Collection)

The birds, which are perched on rock-
work mounds with their heads turned,
one with its beak open as if singing, are
the only two colored examples of these
models so far known. They are not a
pair, however, one having been in the
house for a considerable time, possibly
since the eighteenth century, while the
other, which has a hollow base, is a
recent gift.

Other species of birds are well known
at the Bow factory and these mostly fall
into the mainstream of mid-eighteenth-
century types. While some are based on
Meissen models, the majority are native
inspirations: these bullfinches are most
lively, as are the buntings preening,
while those made eight to ten years
later appear more wooden. A pair of
buntings dating from the late 1750s,
as well as two goldfinches, are in the
Geoffrey Freeman Collection now on
display at Pallant House, Chichester
(Gabszewicz and Freeman 1982).

A.du B.

419

FIGURES OF KITTY CLIVE
AND HENRY WOODWARD
Bow
soft-paste porcelain
each 26 (10½) high

Upton House
The National Trust
(Bearsted Collection)

The source for the model of the actress Kitty Clive (née Rafter) as the "Fine Lady" in David Garrick's farce *Lethe* is an engraving by Charles Mosby published in London in 1750, which was in turn taken from a watercolor by Thomas Worlidge. The style of decoration is typical of that usually associated with William Duesbury. His "London Account Book" for 1751–1753 mentions on page 12, 24 June 1751, a "Mrs. Clive," for three shillings; and on page 27, 5 June 1752, there is a "Mrs. Clive" for five shillings. A white example in the Fitzwilliam Museum, Cambridge, is incised underneath with the date *1750* but has a pedestal base, while the majority of the figures have flat square bases like this one. The model was also copied at another factory (probably "dry-edge" Derby), with a flat, star-shaped base.

A famous beauty, who was several times painted by Reynolds, Kitty Clive

retired to a cottage on Horace Walpole's estate at Strawberry Hill, and his inventory of 1764 lists a watercolor by Worlidge entitled "Mrs. Catherine Clive, the excellent comedian in the character of FINE LADY in LETHE." She joined the cast of *Lethe* in 1749, and is said to have made her farewell appearance as the "Fine Lady" as late as 1769.

The source for the companion figure of Henry Woodward as the "Fine Gentleman" in *Lethe* is an undated mezzotint by James McArdell after Francis Hayman (Goodwin 1903, no. 103). Woodward was cast as "the Beau" in the first production of the play in 1740, but in the Drury Lane revival of 1748 he took the part of "the

Fine Gentleman." Later, in 1757, he played "Daffodil." A white example of this figure bearing the incised date *1750* is in the Untermyer Collection in the Metropolitan Museum, New York (Hackenbroch 1957, fig. 241, pl. 77), and many other white figures of Woodward are known. Colored examples like this one are rare, however, and these colors are so similar to those of a group of early Bow figures, and so unlike the wares of any other factory, that they suggest this figure was decorated in the factory rather than in William Duesbury's outside decorating shop—unlike the companion figure of Mrs. Clive. A.du B.

Related Works: Listed in Hackenbroch 1957, 168–169; Geoffrey Freeman Collection, Pallant House, Chichester (Gabszewicz and Freeman 1982, 187); Belton House, Lincolnshire
Literature: Mallet 1964, 9, no. 1

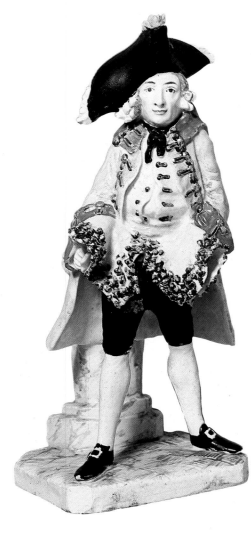

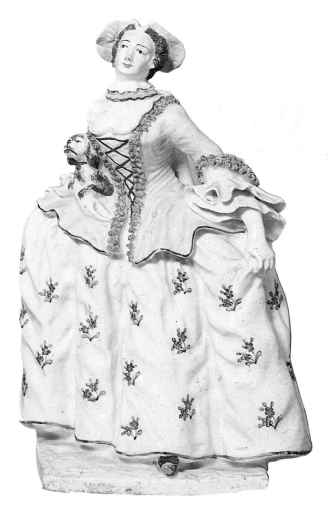

420

TUREEN AND STAND C.1755
Chelsea, Lawrence Street factory
soft-paste porcelain
tureen 26 (10¾) high stand: 49.5 (19½)
diam.
red anchor mark inside bottom of tureen

Gosford
The Earl of Wemyss and March, KT

Of all the animal, bird, and fish tureens, those modeled as boars' heads are among the rarest in the 1755 Chelsea sale catalogue. On the fourteenth day of the sale, Tuesday, 25 March, lot 90 is described as: "A beautiful tureen in the form of a BOAR'S HEAD, in a most curious dish, *with proper embellishments*." The only other example is lot 60 on 18 March. Tureens of this sort, rather differently modeled, were also produced by Paul Hannong at Strasbourg between 1748 and 1754, and other tureens in the form of animals and birds were made at German faience factories such as Höchst and Schrezheim as well as in Hungary at Hollitsch and in Portugal at Rato. Copies in Chinese porcelain were also made at a later date in various sizes up to 15¾ inches wide.

In Europe a bedecked boar's head was considered a famous delicacy from the Middle Ages onward and at The Queens' College, Oxford, it has been customary since the fourteenth century to bring in a boar's head at Christmas to the sound of a celebrated carol.

The stand "with proper embellishments" mentioned in the 1755 sale catalogue was one of the most extravagant of the "naturalistic" Chelsea products, with a quiver of arrows and a hunting hanger modeled in high relief, but the present stand, with a central stag-hunting scene, is no less evocative of the chase. The decoration is derived from a print by Johann Elias Ridinger, but in this case was almost certainly copied from the Meissen Northumberland Service, originally presented by Augustus III, King of Poland and Elector of Saxony (reigned 1733–1763) to the British Envoy in Dresden, Sir Charles Hanbury-Williams (see no. 389).

The Gosford tureen and stand are known to have been together in 1819, when Queen Charlotte's collection was sold at Christie's in London. "A TURENNE OF THE FINE OLD CHELSEA CHINA, shaped as a BOAR'S HEAD, and a capital stand of the same, finely painted with a stag hunt, flowers and insects," were bought by Lord Wemyss for £15.10s. (Nightingale 1881, *xli*). A.du B./T.H.C.

Related Works: Illustrated Gardner 1934, pl. 8 and 1942, fig. 5; Severne Mackenna 1951, pl. 41, figs. 83–84
Provenance: Queen Charlotte; her sale, Christie's, 1819, to Francis, 8th Earl of Wemyss; and by descent

421

SOUP TUREEN AND STAND
c.1755
Chelsea, Lawrence Street Factory
soft-paste porcelain
tureen: 30.4 (12) high
stand: 49.5 (19½) diam.

Grimsthorpe Castle
The Grimsthorpe and Drummond
Castle Trustees

The 1755 Chelsea sale catalogue shows that hen tureens were sold on eleven of the sixteen days of that sale, most with slightly varying descriptions, for instance, on the first day, Monday, 10 March, lot 50: "A most beautiful tureen in the shape of a HEN AND CHICKENS, *big as life*, in a curious dish adorn'd with sunflowers." In the same sale catalogue the small chicken tureens are listed together with the small sunflower dishes. While vessels in the form of animals and birds are known in various materials from an early date, and J.J. Kaendler at Meissen modeled various teapots in the form of hens and chickens during the 1730s, the Chelsea factory appears to have been the first to adapt this idea for a soup tureen. The design is taken from a print by Francis Barlow, published about 1658, which was also the source for the decoration of the inside of a punch bowl in Bristol earthenware (Bristol Museum and Art Gallery; London, V & A 1984, P12) dated 1759. Only a few other hen tureens of this model have survived including one with and one without a stand in the Victoria and Albert Museum (the latter illustrated Honey 1928, pl. 14). Another is in the Palazzo Pignatelli at Naples.

A.du B.

422

MUG 1770
Plymouth, William Cookworthy's
Factory
hard-paste porcelain
16.5 (6½) high

Saltram House
The National Trust (Morley Collection)

The delicate painting on this bell-shaped mug is of a type of decoration that has traditionally been associated with the name of Monsieur Soqui, though the only known fact about him is the statement of George Harrison (in his *Memoirs of William Cookworthy*, 1854, 48) that Cookworthy engaged "The assistance of a French artist, Mons. Soqui, whose ornamental delineations, on to articles manufactured, were extremely beautiful." Saltram House is very close to Plymouth and despite the fact that the factory only existed for two years in that city before its removal to Bristol, one might have expected a greater number of Plymouth wares to have stayed in a house with such a fine collection of porcelain. However, another Plymouth bell-shaped mug, similarly decorated with "Soqui" bird-painting, was given with several other pieces to the Museum of Practical Geology by the 2nd Earl of Morley, who inherited Saltram from his father in 1840; this is now the Victoria and Albert Museum (no. 3093–1901). A. du B.

Literature: Severne MacKenna 1946, 50; Neatby 1977, 69, no. 281

423

PAIR OF SAUCEBOATS AND STANDS
c. 1756
Chelsea, Lawrence Street Factory
c. 1745–1770
soft-paste porcelain
sauceboats 15.8 (6¼) high

Erddig
The National Trust (Yorke Collection)

The 1789 Erddig inventory records "2 Stands and two Carp Sauce Boats 6 pieces in all" (Mallet 1978, 45). Despite the fact that carp tureens without openings for spoons were made the same period in the Chelsea factory, these plaice tureens are probably the ones mentioned in the inventory, and it appears that the spoons were already missing at that date. Plaice sauceboats are first mentioned in the 1756 Chelsea sale catalogues; lot 79 of the fifth day of the sale is "a beautiful pair of *plaice sauce boats* with spoons and plates." The only known sauceboats with their spoons are a pair on loan to the National Museum of Wales, Cardiff. Others are in the Victoria and Albert Museum (London, V & A 1984, 012) and the British Museum (repr. Severne MacKenna 1951, 25 and 92, pl. 40, fig. 82). Another pair (repr. Rice 1983, 57, 202, fig. 127) are attributed to the Derby factory, which would probably place their date after 1770 when Duesbury acquired the molds and other stock of that factory.

These sauceboats were probably purchased by Simon Yorke of Erddig whose epitaph in Marchwiel church reads: "A pious, temperate, sensible Country Gentleman, of very mild, just and benevolent character as the concern at his death did best testify an advantage which Amiable Men have over great ones. He died July 28th, 1767, aged 71." A. du B.

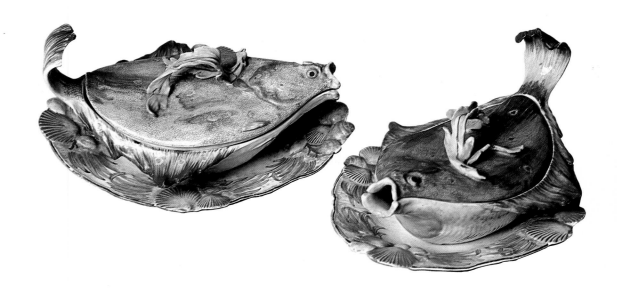

424

VASE AND COVER 1764–1768
attributed to Wedgwood
creamware
18.4 (7¼) high

Saltram House
The National Trust (Morley Collection)

The raised decoration of this covered vase is picked out in gilding over a body of creamy tone with yellowish glaze, possibly imitating the engine-turned ivory vases made in the eighteenth century. J.V.G. Mallet writes: "The attribution to Wedgwood here suggested for these ambitious un-marked creamware vases rests mainly on Wedgwood's letters. It may be objected that the vases are insufficiently classical to be Wedgwood's, but although Wedgwood was quick to adopt the neo-classical style, he was still not wholly committed to it in the period c. 1763–67 to which, if they are his at all, these vases must be assigned on the evidence of their still very creamy colour. At this early date Wedgwood did not normally use a mark.

"In his later years Wedgwood claimed that he had been the first in the Potteries to finish ware by engine-turning, the mechanical technique by which the elaborate wavy lines on these vases could alone have been cut. From the Wedgwood correspondence we learn that on 28 May 1764 Wedgwood was preparing to send 'two setts of Vases, Cream-colour, engine-turned, and printed' to the Queen, whose patronage he was sedulously cultivating. By January 1771, however, he was suffering embarrassment that some of his earliest vases, probably the kind we are discussing, were displayed on the mantelpiece of Matthew Boulton's house, and wrote to Bentley that he had offered to replace them with 'Etruscan painted ones', adding: 'the present vases are the two middle size Chetwynd Vases and 2 Orfords Cream-colour, Engine-lathed and gilt, such as you have now stow'd in the Garrat out of the way, and such a situation Mrs. Boulton has promised me for hers when we send her better'" (Neatby 1977, 62, no. 246). A.du B.

Literature: Mallet 1966, 1480, fig. 1

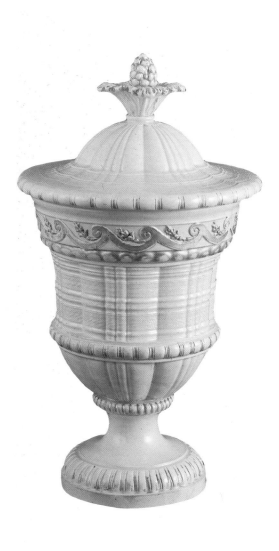

425

VASE c. 1780–1790
Wedgwood
three-color jasper
22.8 (9) high
impressed in uppercase, Wedgwood mark

Cadland Manor
The Cadland Trustees

Wedgwood began experimenting in 1773 on the development of a white biscuit body hard enough to be lapidary-polished and easily tinted. By the end of 1774 he had recorded the discovery of "a fine white terra-cotta of great beauty and delicacy" and in 1776, a finer body still, "a fine white artificial *jasper*, of exquisite beauty and delicacy, proper for cameos, portraits and bas-relief." He subsequently referred to the former as his "waxen" body. The light- and dark-blue tinted jaspers were the most popular but lilac, green, and more rarely, yellow, were also made as well as the black jasper used for the Portland vases (see no. 427). White was an uncommon ground color though Wedgwood later developed a highly porous white biscuit body with lead-glazed interior, which was also decorated in color relief. In all these wares neoclassical shapes and subjects were the most popular.

The figures are taken from models by John Flaxman senior, in turn adapted from the individual putti of the Marlborough Gem. While this vase is thought to have been in the Drummond family since the eighteenth century (see no. 426), this tri-color decoration was the speciality of Thomas Lovatt, who worked at Wedgwood from the 1860s (information from Gaye Blake-Roberts, Wedgwood Museum, Barlaston). This vase, however, does not bear his mark. A.du B.

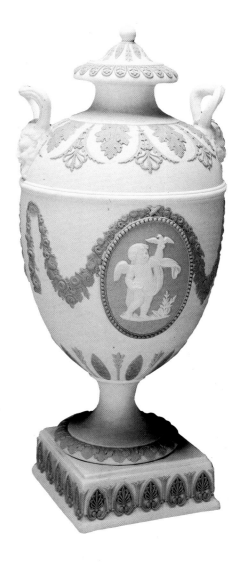

426

JUG C.1798
Wedgwood
jasper dip
19.7 (7¾) high
impressed WEDGWOOD mark under the
base

Cadland Manor
The Cadland Trustees

This jug celebrates Nelson's famous victory over the French on the night of 1 August 1798 at the Battle of the Nile, which left Bonaparte and his army stranded in Egypt in Aboukir Bay. During the second half of the eighteenth and throughout the nineteenth century, pottery and porcelain jugs, mugs, and other wares were made by Staffordshire and other manufactories in commemoration of battles won by the British navy and army.

The decoration of the jug ties it unequivocally to the Battle of the Nile. On the right a recumbent and bountiful river god (though not the famous antique group of the Nile) rests his foot on the back of a miniature sphinx; while on the left a winged female inscribes an oval tablet resting on a rostral column with the words *HAEC MUNDO PACEM VICTORIA SANCIT*. She is based on a figure of Fame who appears with her trumpet on a medallion commemorating the restoration to health of George III in 1789 (Reilly and Savage 1980, 167), but her dramatic impact is somewhat diminished by the inclusion of a tiny, mischievous crocodile that emerges from the ornate prow of a vessel to bite her shin. The profile relief bust on the front is one of the four portraits of British naval heroes (the others are Howe, Duncan, and St. Vincent) executed in 1798 by John de Vaere, chief modeler of Wedgwood's ornamental department from 1794. All the reliefs are bordered in part with rushes and convolvulus, while the shoulder has grasses and violets.

The Hon. Robert Drummond (1729–1804) was the son of the 4th Viscount Strathallan, a Jacobite killed on the battlefield at Culloden (see no. 445). A partner in the famous banking firm of Drummonds and the builder of Cadland House in Hampshire, overlooking the Solent—the scene of so many naval triumphs—he was a regular customer of the firm of Wedgwood, and the collection that survives today shows his preference for green jasper wares. In his turn Josiah Wedgwood was a client of Drummond's Bank, as a check made out by him in 1788 and preserved by the Drummond family testifies. A.du B.

Related Works: Several other Wedgwood vases and jugs include the profile bust and versions of the figure of Fame (examples in the National Maritime Museum, Greenwich, information from Miss Rina Prentice). A biscuit example of this jug is in the Wedgwood Museum, Barlaston

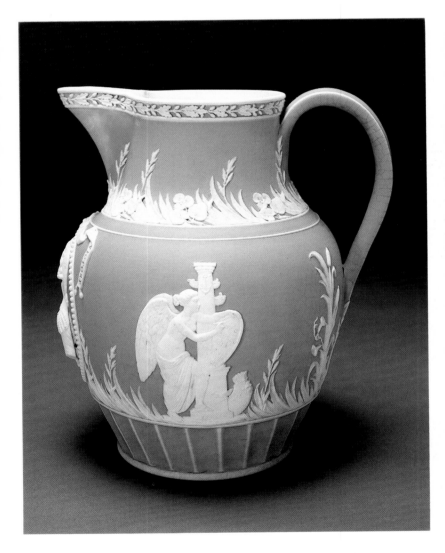

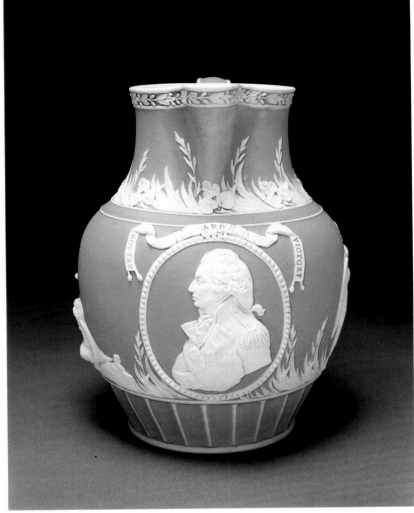

427

PORTLAND VASE c.1790
Wedgwood
jasper
26.6 (10½) high
pencilled, *no. 29*, inside lip

Nottingham Castle
Nottingham Castle Museum and Art
Gallery

This solid black jasper vase is decorated in white relief with a frieze of standing and seated male and female figures, with Cupid flying above, among columns and trees. The handles have bearded male heads at the bases and the underside of the vase has a bust portait of a man in a Phrygian cap, his finger to his lip.

The vase is a copy of a blue glass vase with white cameo relief probably made in Alexandria about 50 BC, and now in the British Museum, London. It was first recorded in the Barberini cabinet in 1642 as having been excavated by the Barberini Pope Urban VIII at that time, and was then reputed to have been used as the funerary urn of the Roman Emperor Alexander Severus and his mother, Mammea. The vase was originally of amphora shape with a longer, pointed base; either through accident or design the lower part below the frieze of figures is now missing and the circular plaque on the base is of a different glass, probably slightly later in date. This could have been added in Roman times. The Barberini vase was sold in about 1780 to the Scottish dealer James Byres for an undisclosed sum, and he in turn sold it to Sir William Hamilton for a reputed £1,000. Sir William passed it on quickly to Margaret, Duchess of Portland, in 1785 for 1,800 guineas. On her death the following year, Skinners auctioned the Duchess' effects, and the vase (lot 4155) realized 908 guineas, being bought back by the Duke of Portland in whose family it remained until it was acquired by the nation in 1945. The Duke of Portland had deposited the vase at the British Museum but it was shattered by an obscure drunkard, Lloyd, on 7 February 1845. Since then it has been twice restored and was unsuccessfully offered at auction by Christie's in 1929. The identification of the scene depicted on the vase has been the subject of much controversy; traditionally it is reputed to show Peleus and Thetis, while the bust on the base may represent Paris

(for the various interpretations see Haynes 1964).

Josiah Wedgwood borrowed the vase three days after the auction in 1786 and, after consulting Sir William Hamilton and others, spent a year discussing it with his principal modeler, Henry Webber. William Wood and William Hackwood were engaged on the drawings and designs. The next three years were spent in experimental firings and during the subsequent decade about fifty examples were made, though about fifteen of these would have been blistered or crackled. The perfect examples were sold for about thirty guineas with £2. 10s. added for a box, though Wedgwood had originally thought of £50. Not all the vases were sold immediately and Wedgwood's still had a few in stock forty years later. The Nottingham Castle example is known as the Purnell-Tite copy having belonged to Purnell B. Purnell of Stanscombe Park, Gloucestershire (Sotheby's, May 1872), and afterwards Sir William Tite, on whose death it was sold (Christie's, 1880) to Felix Joseph (through A. Wertheimer), who bequeathed it to Nottingham in 1892. Purnell was reputed to have bought it from Wedgwood in 1830.

In 1828 the glassmaker Apsley Pellatt tried to buy the few remaining vases in Wedgwood's stock and probably acquired them the following year. In 1839 an inferior edition was put out; this can be easily identified by the drapery added to the male figures. From 1880 onward copies of varying quality have been made and these usually bear an impressed mark at the side of the foot rim. Over half of the first edition of the vases are known today (listed in Dawson 1984, Appendix).

A.du B.

Literature: Mankowitz 1952; Dawson 1984, 112–125

428

OIL LAMP c.1780
Wedgwood
black-basaltes ware
36 (14) high

Saltram House
The National Trust (Morley Collection)

This vase has traditionally been referred to as the "Michelangelo" lamp but Miss Jennifer Montagu has pointed out that the bowl is copied from a Hellenistic bronze lamp of about 400 BC, while the slave figures that support it are taken from a silver-gilt crucifix by Antonio Gentile da Faenza presented to Saint Peter's, Rome, in 1582, and still preserved in the Treasury there (Montagu 1954, 380, pl. 53). The decoration of these vases was often very skillfully varied and similar examples in the Wedgwood Museum at Barlaston, Stoke-on-Trent, and the Victoria and Albert Museum (no. 4790A–1901, Jermyn Street Collection) have bodies with arabesques in relief and seated "widows" for the finials. The slaves supporting the vase were popular as motifs in English neoclassical decoration, and can be recognized supporting a globe on an ormolu clock by Matthew Boulton (Goodison 1974, front cover).

No early inventories of Saltram have been found but the overall character of the contents of the house suggests a minimum of selling or collecting since the eighteenth century. The surviving cash accounts kept for John Parker, 1st Lord Boringdon, between 1770 and 1788, include an unitemized entry for 6 June 1781 for a payment of "£18. 18s. ... to Wedgwood"; this vase together with its companion, still at Saltram, could have formed part of this purchase.

A.du B.

Literature: Mallet 1966, 1482, fig. 5; Neatby 1977, pl. 8G, and no. 206T

429

SAUCE TUREEN C.1774
Wedgwood and Bentley
creamware
19.6 (7¾) high

Shugborough Park
The National Trust
(Lichfield Collection)

This tureen, which is painted in enamels with views of the Triumphal Arch at Shugborough Park, two scenes near Ludlow Castle, and a view near Richmond Castle, is either a trial piece or a special order made after the famous Green Frog Service ordered from Wedgwood by Catherine the Great through Baxter, the Russian consul in London. In a letter to Thomas Bentley of 20 and 21 June 1774, Josiah Wedgwood wrote: "I should be glad to have a few duplicates of the Russian service sent to Etruria next Monday. The Soup Plate of L^d Gowers, & a few other *good ones*, Dishes &c., none of the pieces condemn'd to be set aside whether it be on account of their being blister'd, duplicates, or any other fault, *except poor & bad painting*, should be divided between M^r Baxter & Etruria, & we may paint more *without the Frog*, to be shewn in Greek Street" (Wedgwood MSS, Barlaston E25–18540).

The service was made of creamware, which Josiah Wedgwood called "Queen's ware" as a result of his perfection of the body and also because by 1765 he was styled "potter to the Queen." He arranged with his partner, Thomas Bentley, for the latter to open a workshop in Cheyne Row, Chelsea, where the service was decorated. Although it cost £51 8s. 4d. in its undecorated state, when it was produced in monochrome colors the cost was about £3000; the multi-colored trial pieces having proved

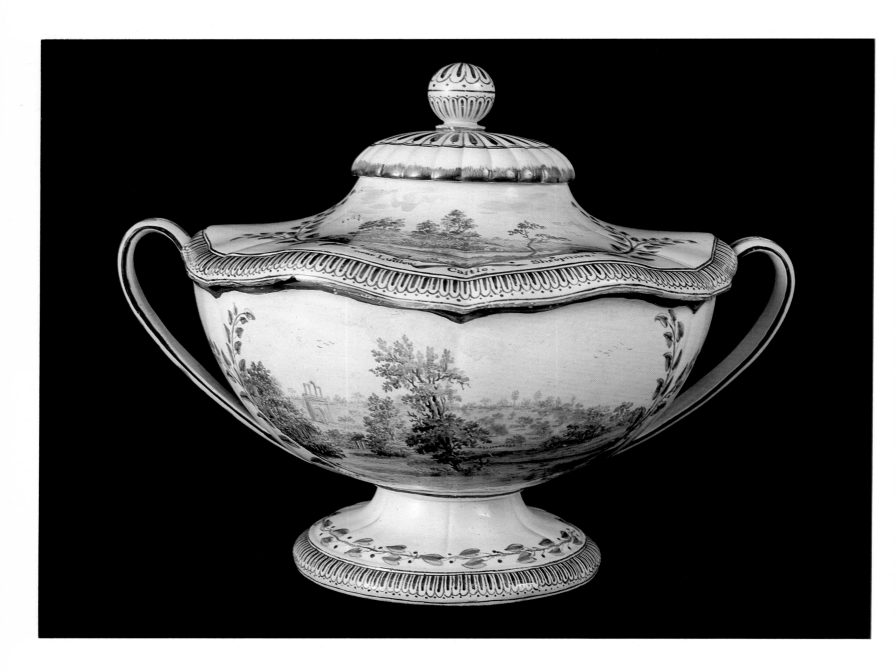

too expensive. The Russian Court is believed to have paid about £3,500. Work was begun in the spring of 1773 and continued until 1775 and it was delivered to St. Petersburg in the summer of the same year. It comprised a total of 952 pieces—50 place settings—painted in "rich mulberry" with 1,244 scenes of British country houses and landscapes. Intended for "La Grenouillère" Palace, which was called after the Finnish place-name Kekerekeksi (or "frog swamp"), the Russian service has the crest of a frog in a shield, which was not put on the Shugborough tureen. The name of the house was changed in 1780 to the Chesmensky Palace but the service remained there until 1830 when it was taken to the so-called English Palace at Peterhof. The greater part is now in The Hermitage, Leningrad.

Wolf Mankowitz reproduces part of the correspondence between Wedgwood and Lord Cathcart, the Ambassador to Russia, and with his partner Bentley. He mentions that work began on 3 April 1773 with Mrs. Wilcox and James Bakewell painting the landscapes and Nathaniel Cooper executing the borders. A week later Joseph Linley took over the borders while Mr. Wilcox worked with Cooper on the inner borders. These first items probably include this polychromed sauce tureen and cover. Wedgwood was preoccupied by the problem of finding over 1,200 different scenes; his letters mention his discussions with Mr. E. Stringer, a landscape artist and member of the Liverpool Academy who was put in charge of the Wedgwood painters. Quite a number of painters were engaged, among them John Boydell and John Pyne. In certain cases the designs were aparently taken from existing prints and drawings, but in others artists traveled about the country making sketches. In a letter dated 30 July 1773, Wedgwood writes "…I will have some real views taken and send them to you, from … Shutboro [*sic*], Ingestry Etruria and many other places. Pray have you Wilson's views from different places in Wales…" (Mankowitz 1953, 38–44). A.du B.

430

TEA SERVICE
Pinxton or Coalport (John Rose) c.1796
soft-paste porcelain
jug: 11 (4¼) high cup: 6.7 (2⅖) diam.
saucer: 13.7 (5⅜) diam.

Milton Manor House
Mrs. E.J. Mockler

Views of Milton Manor with figures, trees, and a lake, some with a dog, are painted in oval panels, and the oval baluster milk jug, of almost helmet shape, is seamed at the front and back, showing on the left side a view of the east front and on the right side, the south view. The south view is depicted on the front of the cup and, on the saucers, the east front. No engraved sources for the views are known, and they may have been painted from original sketches, but the young trees in the foreground are evidently among those planted by Bryant Barrett in 1765 (MSS records at Milton).

This service has been traditionally associated with the Pinxton factory and was reputed to have been ordered from the factory by Bryant Barrett, the present owner's ancestor, in 1796 and it does appear in an inventory of the possessions of John Richard Barrett (1771–1841). However, the shapes of neither cup nor jug correspond with other known examples of Pinxton, but are more consistent with those of John Rose at Coalport. The paste and glaze are also typical of early Coalport. John Rose bought the Caughley factory in October 1799 but had been making porcelain earlier at Coalport. Until recently much of this earlier Coalport was misattributed to other factories, particularly Chamberlain's Worcester. It was sent to London for decoration; and a watercolor of 1810 by Thomas Baxter, junior (Victoria and Albert Museum, London) shows the interior of Thomas Baxter's London decorating studio, with teaware very similar in shape to this service. A.du B.

Literature: Godden 1963

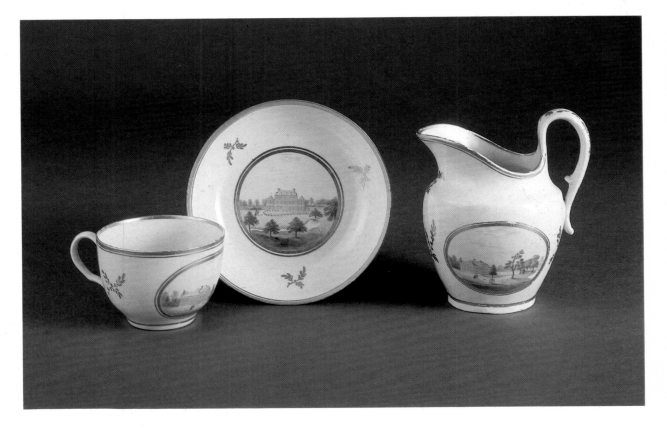

431

PAIR OF ICE PAILS AND PAIR OF
TUREENS C.1811
Worcester Barr, Flight and Barr
1807–1813
soft-paste porcelain
ice pails: 32.4 (12¾) high
tureens: 17.8 (7) high
each marked in plum, *Barr, Flight and
Barr Royal Porcelain Works Worcester.
London House, No. 1 Coventry Street*

Private Collection

The classical shape of the ice pails derives from the Warwick Vase, one of the most famous classical antiquities in any British collection (formerly at Warwick Castle; now Burrell Collection, Glasgow). One side is painted with a view of Hewell Grange in Worcestershire, the other with the arms of Other Archer, 6th Earl of Plymouth and 12th Baron Windsor, and Lady Mary Sackville, daughter of the 3rd Duke of Dorset, whom he married in 1811. The arms are surmounted by an earl's coronet with a helm above supporting the crest of a stag's head; on either side are unicorn

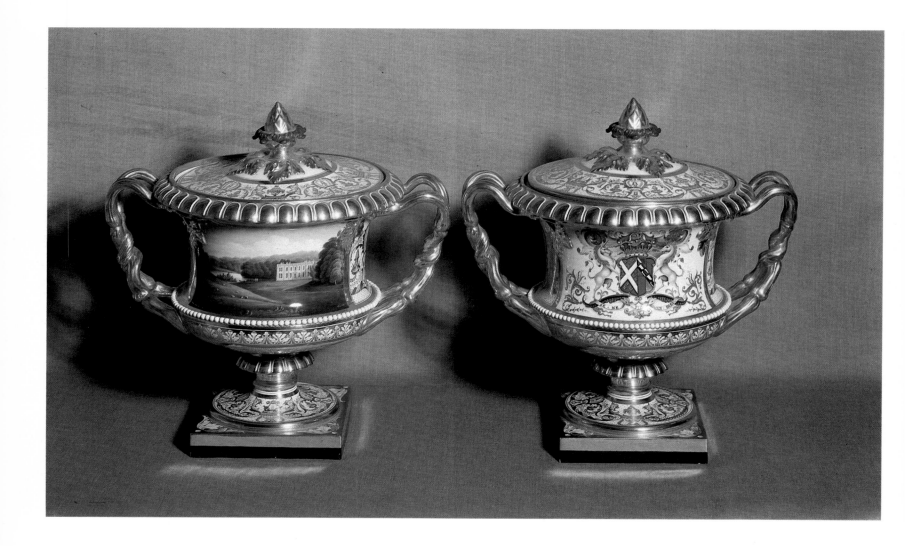

supporters; and below is the crest, *Je me fie en dieu*. The tureens, which are decorated *en suite* with views of Lake Windermere, Westmorland, and the Marina at Ryde, Isle of Wight, come from the same dessert service, and are typical of the elaborate china being made for the British aristocracy at the beginning of the nineteenth century. A combined dinner, dessert, and breakfast service made for the Prince Regent by the rival Worcester factory managed by Robert Chamberlain cost nearly £4,000 in 1811: the plates were 3 guineas each and the ice pails £31.

The fragments of the Warwick Vase were discovered by Gavin Hamilton in 1770 when a pool in the grounds of Hadrian's villa was drained. It was extensively restored by Nollekens at a cost of £300 for Sir William Hamilton who, failing to sell it to the British Museum, sold it to the Earl of Warwick. Numerous copies in bronze, porcelain, and silver were made in the early nineteenth century, and the form was eminently suitable for wine coolers.

The chief landscape painter at the Barr, Flight and Barr factory between 1807 and 1813 was Robert Brewer who with his brother John went to the Derby factory. The brothers later became teachers of drawing in the city of Derby, where John died in 1816; Robert lived until 1857. It is, however, impossible to identify with certainty the Worcester artist who painted the tureens. Solomon Cole, a painter at the Worcester factory, writing on the slightly later period of Flight, Barr and Barr (1813–1840), recorded the numbers of "… those best qualified to paint the different parts in any rich piece, and who excelled in some particular branch. One was chosen to paint the embossed parts to receive the gold, another would be engaged in laying on the gold in armorial bearings, a third would shade the gold, another would be selected to paint the supporters, varying according to the design … and another would paint the motto … on each plate of the very rich services, the names of the firm etc. were written with a pen in gold by Joseph Cotterell. He also wrote with a pen in colour…the names of the views… Then there were also Messrs. Thomas Rogers, John Barker and John Smith at the same time painting landscapes" (Godden 1966, 78–83). A.du B.

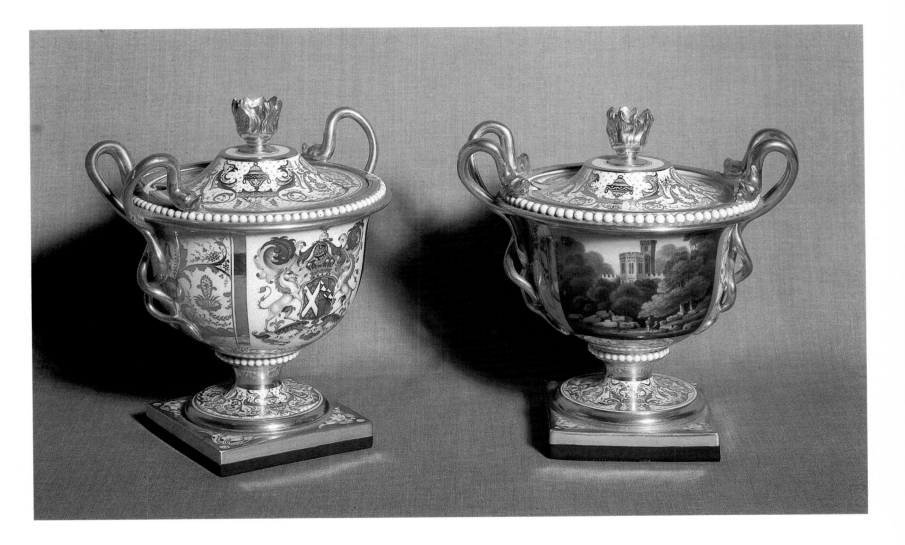

432

FOUR PLATES c.1790–1800
Stone, Coquerel and Legros d'Anisy
faience fine (creamware)
23.4 (9¼) diam.

Harewood House
The Earl and Countess of Harewood

These plates, transfer printed in sepia
with views of Harewood House, Glamis
Castle, Sandbeck, and Wentworth
Woodhouse, are from a dinner service
now comprising seventy-four pieces.
Josiah Wedgwood's famous service for
Catherine the Great of Russia (see no.
429) inspired numerous other factories
to produce services decorated with
English views, many of them taken
from the books of printed views that
had become fashionable at this period.

Transfer printing on porcelain was first
introduced at Worcester in 1753 and at
Bow about 1754, and was quite common
on Worcester and Caughley in the 1770s
and 1780s. It was the French factories
at Creil of Stone, Coquerel and Legros
d'Anisy, who specialized in the 1790s
and early 1800s in printed views both
of English and Continental scenes—
despite the war, which with the brief
intermission of the Treaty of Amiens
lasted nearly twenty years. This service
combines views in France with churches
and houses in Britain. The British views
are taken from W. Watts' "Seats of the
Nobility...," 1779: plates 71 (Glamis),
80 (Harewood), 82 (Sandbeck), and
83 (Wentworth Woodhouse); (infor-
mation from John Harris). A.du B.

Provenance: Given by the late Queen Mary
to her daughter, the Princess Royal;
and by descent to her son, the present
Earl of Harewood

433

PUNCH BOWL c.1741
probably Liverpool
tin-glazed earthenware
30.8 (12½) diam.
inscribed on the inside, *LETT US
DRINK SUCCESS TO BLACKETT
AND FENWICK*

Wallington
The National Trust
(Trevelyan Collection)

Between 13 and 19 May 1741 the
electors of Newcastle-upon-Tyne went
to the polls to vote for two Members
to represent them in Parliament. The
successful candidates were Walter
Blackett (1,453 votes) and Nicholas
Fenwick (1,231 votes) who triumphed
over Matthew Ridley (1,131) and
William Carre (638). Walter Calverley
Blackett, who lived at Wallington, was
a prominent local politician, being Mayor
of Newcastle five times and Member
for the town in seven parliaments.
Another bowl, larger but otherwise
almost identical to this one, also survives
at Wallington. The inscription and the
bacchic figure, wreathed and clothed in
vine leaves, who sits astride a barrel
holding a cup and bottle, indicates
that the bowls were used in 1741 for
dispensing punch, doubtless as an
inducement to potential voters. Four
other bowls made for elections are
known (Lipski and Archer 1984):
Southwell for Bristol in 1739 (Bristol

City Art Gallery, N 8194), Wenman and Dashwood for Oxfordshire in 1755 (Victoria and Albert Museum, c. 381–1922 and a private collection) and Harbord for Norwich in 1756 (Norwich Castle Museum, 34.1915). Besides these bowls a large number of plates was made with inscriptions relating to elections. The great majority took place in the south-west of England, which suggests that the plates came from the Delftware potteries in Bristol (see Ray 1968). They were probably used at banquets, or may have been intended as gifts and they range in date from 1753 to 1780. Although Walter Blackett must have spent a good deal of time in London and could therefore have ordered his bowls from the potteries there, it is more likely on grounds of style that they came from Liverpool, which was in any case closer. M.A.

Literature: Archer 1970, 1135

The country house owes its origin to the political power of the land-owner, but its endurance has also reflected the British passion for sport. For aristocrat and squire alike, the pattern of the year was dictated by the seasons of hunting, shooting, or the turf that in turn determined when Parliament sat. The development of sporting art closely paralleled that of portraiture and landscape: Stubbs, its outstanding exponent, achieved an equal mastery in these other spheres as can be seen in the *Grosvenor Hunt* (no. 435).

The Duke of Newcastle, one of the founding fathers of equitation in the seventeenth century, commissioned large-scale portraits of his horses (see no. 360), and his example was followed by Wootton and Stubbs, who both worked for his descendants in the eighteenth century. John Wootton, the first Englishman to specialize in sporting painting, can only fairly be judged by the vast canvases painted for the halls at Althorp, Badminton, and Longleat. George Stubbs was a painter of more exalted caliber, and the full subtlety of the pictures he painted for his principal patrons—three are represented here—can particularly be experienced when these are hung together, if no longer in the sparsely furnished billiard rooms where they were so often kept. None of Stubbs' followers could match his anatomical knowledge. His most worthy successors in the early nineteenth century were James Ward, who brought a romantic and Rubensian eye to the landscape of the hunting field and paddock, and Ben Marshall, whose observation of the hangers-on of the racing world can only be matched in the novels of his time. But it is in the sets of canvases by Ferneley at Belvoir Castle and Calke Abbey, at Deene and elsewhere, that the full meaning of hunting and the turf for owners of great houses is most clearly revealed.

Other sports were also popular. Shooting was not only enjoyed by Wootton's patrons, and Wright of Derby's, but by the milords on the Grand Tour, as Batoni and Nathaniel Dance observed. Fishing was a recreation of the sitters of Devis and Zoffany. Archery and skating are celebrated respectively by Reynolds' portrait of the Herbert brothers (Tetton House) and Stuart's of William Grant of Congalton in the National Gallery, Washington. Golf inspired no great painting, but the building of Gosford, designed by Adam for Lord Wemyss, was determined by the proximity of the links. Cricket also was widely played: the portrait from Breamore (no. 448), a rustic relation of Francis Cotes' *Lewis Cage* at Brocket, is of importance because it illustrates an aspect of provincial painting that can still be experienced in many country houses, offering a nostalgic insight into the pastimes of former generations.

Dining rooms in country houses are often where sporting pictures are gathered: the gold cups won by racehorses sometimes placed under their portraits, as in the case of Lord Scarbrough's Ben Marshall from Sandbeck (nos. 443–444); and other trophies gathered on sideboards with knife boxes, tureens, wine coolers and fountains, candelabra and plates in a continuation of the baroque buffet display. Until about 1790, when the idea of having one long dining table first came into fashion, small tables were set up for the company to eat at, and removed after the meal: hence the importance of the sideboard with its accompanying urns on pedestals, often set in a niche.

The silver and gold plate shown here covers the rococo and neo-classical periods respectively: the former still dominated by Huguenot makers like Paul de Lamerie and Peter Archambo; the latter by Paul Storr and Benjamin Smith; and with Diederich Nicholas Anderson's ormolu perfume burner and plate warmer from Kedleston (nos. 461–462) forming a link between these. Many country houses owe their finest silver to owners who were appointed ambassadors, and were thus entitled to an issue of plate from the Jewel House in London to take with them. The 3rd Earl of Bristol, who served as envoy to Turin and Madrid, is represented by the candelabra and tureen by Simon le Sage and Frederick Kandler from Ickworth (nos. 453–454); and the 3rd Lord Berwick, who was ambassador to Naples, by part of an outstanding service made by Storr and Smith for the Royal Goldsmiths, Rundell, Bridge and Rundell (no. 463).

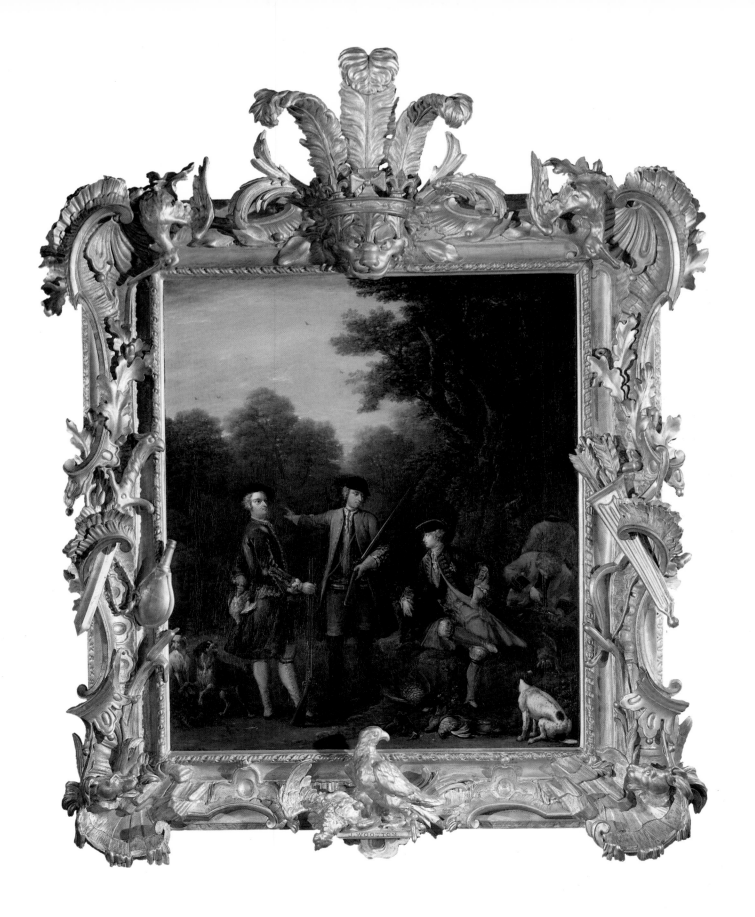

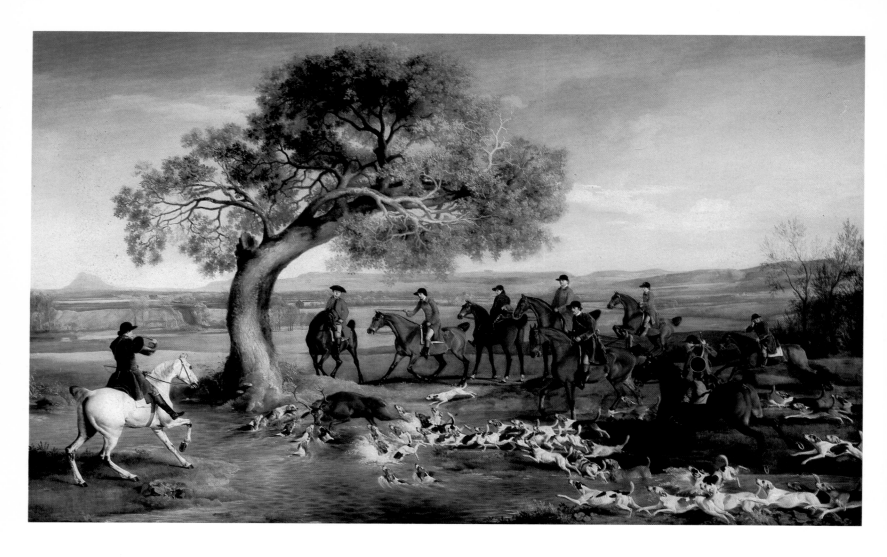

434

THE SHOOTING PARTY 1740
John Wootton 1682–1764
oil on canvas
88.9 × 74 (35 × 29)
signed and dated, *JW/1740*

Highgrove Park
Her Majesty Queen Elizabeth II
and His Royal Highness The Prince
of Wales

Frederick, Prince of Wales (1707–1751),
is shown seated in a landscape with
dogs, dead game, and two companions,
John Spencer (1708–1746) and Charles
Douglas, 3rd Duke of Queensberry
(1698–1778); two grooms in royal
livery act as loaders. The prince and
Spencer wear the prince's hunting livery,

a blue coat enriched with gold lace and
scarlet cuffs and facings, which survives
in a simplified form in the present
Windsor uniform. Spencer, father of the
1st Earl Spencer, was the favorite grand-
son of Sarah, Duchess of Marlborough,
and in 1744 succeeded her as Ranger of
Windsor Great Park; Queensberry was
Gentleman of the Bedchamber to the
Prince and Captain-General of the
Royal Company of Archers.

 The picture was almost certainly
painted for the Prince of Wales, by whom
Paul Petit was paid £21 "for a Rich
picture frame Carved with birds Richly
Ornamented neatly repair'd and Gilt in
Burnished Gold to a picture of His Royal
Highness painted by M.ʳ Wootton"
(MSS at the Duchy of Cornwall office).
Petit's statement is dated 6 October

1742. This superb rococo frame, crowned
by the Prince of Wales' feathers, is
decorated with sporting motifs, including
a knife, a bow and a quiver of arrows, a
powder flask, and game including dead
snipe and duck in the cornice and a
hawk standing astride a dead bird on
the base rail, where hounds' heads
emerge from the scrolls at the corners.

 The painting was certainly at Carlton
House in the time of George IV, who as
an enthusiastic sportsman would have
liked a portrait of his grandfather of
this type. *The Shooting Party* was among
the pictures later selected to hang in
his New Gallery (the present Corridor)
at Windsor. The small-scale sporting
group in a landscape was popularized
by Wootton from the second decade of
the century and was developed by later

painters such as Zoffany and Wheatley.
Slightly earlier, Wootton had painted
three large hunting pieces for the prince,
one of which anticipates in a number of
ways *The Grosvenor Hunt* by Stubbs
(no. 435). A version of this picture at
Drumlanrig, showing Windsor Castle
in the background, was presumably
painted for the Duke of Queensberry,
though another version was sold in
Wootton's retirement sale of 12–13
March 1761. O.N.M.

Literature: Millar 1963, no. 547
Exhibitions: Arts Council 1974–1975
(17); London, V & A 1984 (L1)

435

THE GROSVENOR HUNT 1762
George Stubbs 1724–1806
oil on canvas
149.8 × 241.3 (59 × 95)
inscribed, *Geo: Stubbs p:/1762*, on the
bank beneath the tree

The Duke of Westminster

This masterpiece, which has been
described as "the most sublime of all
English sporting pictures, a classic state-
ment as a whole and in its marvellous
detail on the very essence of hunting"
(Millar in Arts Council 1974–1975,
12), was painted for Richard, 1st Earl
Grosvenor (1731–1802), one of the
richest men in England, and one of
Stubbs' most important patrons.
Grosvenor liked to buy the work of
contemporary English painters as well
as that of the more generally approved
old masters. His passion for racing lasted
all his life, eventually nearly bankrupting
him; Horace Walpole noted that he took
his elevation to the peerage less seriously
than his preoccupation with racing,
noting on 17 March 1761 that Richard
Grosvenor "has been made a viscount
or baron, I don't know which, nor does
he, for yesterday, when he should have
kissed hands, he was gone to Newmarket
to see the trial of a racehorse."

The Grosvenor Hunt portrays Lord
Grosvenor, his younger brother Thomas
Grosvenor, his friends Sir Roger Mostyn
and Mr. Bell Lloyd, with various hunt
servants. The setting is the Cheshire
landscape seen from the saloon at
Eaton Hall, with a wide view over the
Peckforton hills, and with the ancient
fortress of Beeston Castle on the hill on
the skyline toward the left. As Mary
Spencer records (in a note in Ozias
Humphry's MS memoir, Liverpool
City Libraries, Picton Collection),
"every object in this 'Picture' was
a Portrait...." Lord Grosvenor has
generally been identified as the figure
on the left who turns to face the
spectator, the tree above him seeming
to bow in salutation, with his brother
Thomas next to him, gesturing with a
whip. But John Jacob has recently
suggested that it is Thomas Grosvenor
who faces the spectator (perhaps in his
capacity as Master of Hounds?), with

his brother on his left, a suggestion that
needs further research. The hounds are
portrayed in a state of great excitement,
having got the stag at bay on the bank
of the River Dee; the painting of the
splashes they make in the water is a
triumph of intense observation combined
with virtuoso painting.

The composition of *The Grosvenor Hunt*
appears to be derived from Oudry's
*Louis XV chassant le cerf dans la forêt de
Saint-Germain*, painted in 1730, yet there
seems no way in which Stubbs could
have seen this picture, which was in
the Cabinet du Roi at Marly, unless he
returned from Italy through France in
1754. A possible missing link is a picture
by John Wootton, *The Death of a Stag*
(Royal Collection, Millar 1963, no. 545,
pl. 203), which also owes a debt to the
Oudry, and which Stubbs could have
seen at Kew, where Horace Walpole
saw it hanging in 1761. J.E.

Provenance: Painted for Richard, 1st Earl
Grosvenor; and by descent
Literature: Young 1821, no. 2; Gilbey
1898, 33–34, 129–130; Taylor 1971,
46–47
Exhibitions: Society of Artists 1764 (112,
A hunting piece); Liverpool Art Club
1881 (94); London, Vokins 1885 (26);
London, Grosvenor Gallery 1890 (46);
London, Whitechapel 1957 (2); London,
Agnew 1970 (3); Arts Council 1974–
1975 (41); Eaton Hall 1984 (21); London,
Tate 1984–1985 (39)

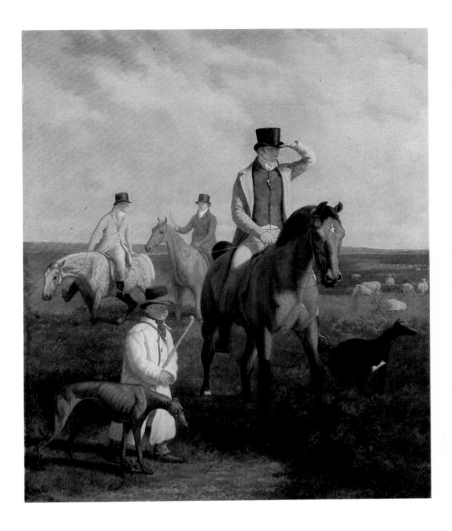

436

LORD RIVERS COURSING c.1815
Jacques-Laurent Agasse 1767–1849
oil on canvas
72.4 × 61 (28½ × 24)

Bramham Park
The Trustees of the Bramham Park
Estate

George Pitt, 2nd Baron Rivers (1751–
1828) of Stratfield Saye, Hampshire, was
Agasse's first important patron. Lady
Charlotte Percy described him in 1810
as "a pleasant and elegant man—one of
the last of that race of persons who
were the dandies of a former century"
(quoted in the *Complete Peerage*). Here
Agasse depicts his patron shading his
eyes against the sun while coursing—a
sport in which greyhounds hunt the
hare by sight, not by scent as harriers
do.

Lord Rivers bred greyhounds both
at Stratfield Saye and on his estate at
Hare Park near Newmarket, conveniently
situated for coursing meetings at both
Newmarket and Swaffham. He gave his
dogs names beginning with *P* while he
was still the Hon. George Pitt, and
with *R* after his succession in 1803 as

A WATER SPANIEL 1804
George Stubbs 1724–1806
oil on canvas
99 × 127 (39½ × 41½)
inscribed, *Geo; Stubbs pinzit/1804*,
below right forepaw

Brocklesby Park
The Earl of Yarborough

Charles Anderson-Pelham (1749–1823),
who was created 1st Baron Yarborough
in 1794, was Master of the Brocklesby
Hounds, and a dedicated breeder of
foxhounds. Over a period of thirty years,
Stubbs executed commissions that
reflected his patron's enthusiasms: he
painted Lord Yarborough's huntsman
Thomas Smith with his father, "Old"
Thomas Smith, who had been huntsman
before him; Ringwood, the premier
hound in the Brocklesby pack; Lord
Yarborough's hunters; and *An Old Pony
with the Hound Driver*, with a view of
the house at Brocklesby in the back-
ground. This portrait of a water spaniel
(catalogued by Gilbey in 1898 as *Bashaw,
a White German Poodle*) which Stubbs
painted at the age of eighty, was the
final commission he undertook for Lord
Yarborough. One of the artist's last
works, it shows that his interest in the
individuality of every living creature
was undiminished.

The English Water Spaniel, now
extinct, was part ancestor of several
sporting breeds. It was formerly an
immensely popular shooting dog,
especially in East Anglia, as were
the rather similar curly-haired Norfolk
Spaniels and White Poodles also
portrayed by Stubbs (See London, Tate
1984–1985, nos. 97, 98, 101). J.E.

Provenance: Painted for the 1st Lord
Yarborough; and by descent
Exhibitions: Liverpool 1951 (43)

the 2nd Baron Rivers. Agasse's larger
than life-size portrait of Lord Rivers'
greyhounds, *Rollo and Portia*, painted in
1805, is in the collection of the Galerie
des Beaux-Arts, Geneva, which also owns
a larger (92.7 × 71 cm) version of this
portrait of *Lord Rivers Coursing*; a third
version (125 × 94 cm) was sold at
Christie's, London, 21 November 1980,
lot 42.

Agasse first records this subject in
his manuscript record book in March
1815, as "Portrait of a G man Coursing—
begun 4 years before—Ld. Rivers.
½ length" (MSS Musée d'Art et
d'Histoire, Geneva). In 1818 he notes
that he painted a copy of it: "C. of Lord
Rvs on horse back a sporting picture
S3/4." The present picture is probably
the earlier of the two (Baud-Bovy,

writing in 1904, considered that the
1815 picture was "aujourd'hui a l'heritier
de son neveu M. Lane Fox a Bramham")
though it is possible that the Bramham
picture is a later version painted c. 1839,
when Agasse was working at the house
on equestrian portraits of the Lane Fox
family. J.E.

Provenance: Painted for the 2nd Lord
Rivers or copied by Agasse from the
picture originally painted for him; and
by descent
Literature: Baud-Bovy 1904, 148
Exhibitions: Arts Council 1974–1975 (126)

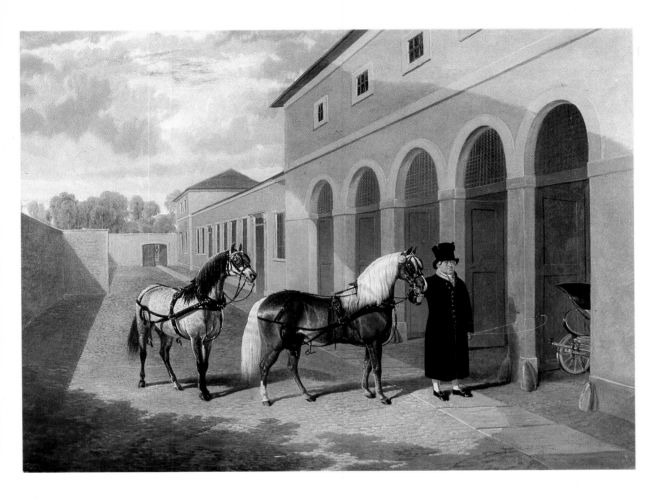

438

THE COUNTESS OF DARLINGTON'S
CARRIAGE PONIES 1823
John Frederick Herring 1795–1865
oil on canvas
66 × 90.2 (26 × 35½)
signed and dated, 1823

Raby Castle
The Lord Barnard

The initials *ED* on the ponies' harness
are those of Elizabeth, Countess of
Darlington, who married Harry Vane,
3rd Earl of Darlington, as his second
wife in 1813; she was Elizabeth Russell,
daughter of a flower seller, and had
been the mistress of Mr. Coutts the
banker. The Earl of Darlington was
passionately devoted to hunting; he
spared no expense on his kennels, and
evidently little on his stables. Herring

depicts the immaculately kept carriage
yard at Raby Castle, designed by John
Carr of York in the 1780s, with two
beautifully turned-out ponies that the
liveried coachman is about to harness
to the elegant carriage on the right
(which survives in the coachhouse at
Raby). The countess herself will prob-
ably drive them.
 Born in Surrey but brought up in
London, Herring learned to draw horses
from the driver of the London-to-
Woking coach. He later became a
coachpainter and professional driver
himself, only becoming a full-time artist
in 1821 on the advice of a discerning
passenger, Frank Hawkesworth. At the
time this picture was painted he was
working in Yorkshire, but moved to
Newmarket in 1830 and back to London
in 1833, when he received commissions
from William IV and Queen Victoria as

well as many country house owners.
His later farmyard and animal genre
scenes are somewhat sentimental, rarely
matching the direct observation and
clarity of color seen in his early work.

J.E./G.J-S.

Provenance: Presumably commissioned
by the 3rd Earl of Darlington (formerly
Viscount Barnard, who succeeded as 3rd
Earl of Darlington 1792 and was later
[1833] created 1st Duke of Cleveland
of the second creation); and by descent
Exhibitions: Arts Council 1974–1975
(176, repr., 105), and incorrectly titled
"The Duchess's Ponies"

439

STIRRUP CUP 1769
Thomas Pitts free 1744
silver
14.1 × 8.3 (5½ × 3¼)

Attingham Park
The National Trust
(Berwick Collection)

About 1770, George Forester, Squire of
Willey Hall in Shropshire, whose name
derived from the family's hereditary
post as Forester of the royal forest of
Wrekin since the time of Henry I,
established the first pack of foxhounds in
the area around this famous Shropshire
landmark. The earliest recorded silver
foxhead stirrup cups, all made by
Thomas Pitts of Air Street, Piccadilly,
London, significantly date from the
assay year 1769/1770, and all are en-
graved with the toast *Success to Fox
Hunting & Friends Round the Wrekin*.
This example and at least one other
bear the crest of Hill, for Noel Hill
(d. 1780), created 1st Lord Berwick in
1784, while another has the Talbot crest
of Forester. Later examples by Pitts
include similar inscriptions and crests,
though in other areas the toast was
often simply "Success to Fox Hunting."
The toast "all friends round the Wrekin"
was recorded as early as 1706 in *The
Recruiting Officer* by the playwright
George Farquhar. By no means restric-
ted to the hunting fraternity, it seems
rather to have been a more general
declaration of provincial solidarity,
appearing for instance on election jugs
such as the stoneware example also at
Attingham, which commemorates the
victory of the 2nd Lord Berwick in the
Shrewsbury seat in the parliamentary
election of 1794.
 The stirrup cup, originally meaning
the parting drink at a meet of foxhounds
rather than the pottery or silver cup
from which it was drunk, soon became
fashionable throughout the country
and came more and more to be made of
silver, in London and in Birmingham,
Sheffield, and Edinburgh. Silver cups
were more durable than pottery ones,
which might well fall from chilled hands
on a cold morning at the start of a run
of as much as fifty miles—as Forester's

Wrekin hunt was often known to take in. Attingham and Willey were themselves some ten miles distant from each other, though it was customary for the participants to dine together the day before and stay wherever the meet was to be held (Longrigg 1977, 124–127).

Thomas Pitts, whose mark has been identified from many pieces included in the Wakelin Ledgers and other records, must have entered his mark between 1760 and 1767, during the period of the "missing" Registers at Goldsmiths' Hall, though he is recorded working in Air Street, at The Golden Cup, from 1767, and is known as both a silversmith and chaser. His stirrup cup design in the shape of a fox mask, with ears laid back and teeth bared, remained a popular pattern for many years, though naturally silversmiths subsequently commissioned to make such cups tended to develop their own designs; some, for example, had pricked ears, while others included deep collars suitable for inscriptions.

J.B.

Provenance: Noel Hill, 1st Baron Berwick; and by descent to the 8th Lord Berwick (d. 1947), who bequeathed Attingham Park and its contents to the National Trust
Literature: Banister 1977, 1613–1614
Exhibitions: York 1969 (49); Brussels 1973 (122)

440

HUNTING HORN 1821
Paul Storr 1771–1844
silver
35.8 (14⅛) high
inscribed on the fluted stem, *This horn was presented to Mr. Patten by the Gentlemen who had the gratification of hunting with him in the winter of 1824, as a token of their respect,* and around the collar; *Storr & Mortimer Fec.*

Sandbeck Park
The Earl of Scarbrough

From earliest times, the horn played a special part in the hunt. The huntsman showed his lord a fumet (dropping) in his horn to prove that a stag had been harbored. By the later Middle Ages the horn was sounded throughout the hunt, usually on foot, and the huntsman was expected to be able to play a whole range of "motes" [sic] during the stag hunt. By the mid-eighteenth century, when fox hunting had largely superseded staghunting, the horn was used less, though sometimes bugles or French horns were played, as in Stubbs' *Grosvenor Hunt* (no. 435). The hunting squire Peter Beckford, author of a famous late eighteenth-century treatise on hunting, recommended the use of the straight English horn, although it was hardly musical. Horns made of natural material and of the curved type were still used in the hunting field after this date, though some of silver or with silver mounts were made for presentation as archery prizes.

The straight hunting horn was usually made of brass, but occasionally of silver, particularly in the nineteenth century when one or two gold examples have also been noted. The maker, Paul Storr, was by now established in his own workshop in the Soho area, but with a retail outlet in Bond Street in association with John Mortimer. It is interesting that he was by this time marking his plate with a Latin signature, in the same style used by his former employers, Rundell, Bridge and Rundell.

J.B.

Provenance: Thomas Patten (later Wilson-Patten) (1770–1827) of Bank Hall, Lancashire; by descent to his great-granddaughter Constance Ellinor Wilson-Patten, who married Osbert, third son of the 9th Earl of Scarbrough, in 1892; and by descent

441

PAIR OF SPURS 1800/1801
George Hall free 1780
18-carat gold
12 (4¾) long

Castle Fraser
The National Trust for Scotland
(Fraser Collection)

Traditionally, gold spurs are the insignia of a knight, but apart from these and the famous gold spurs made for the coronation of Charles II in 1661 and still among the Crown Jewels and Regalia in the Tower of London, no other examples appear to have survived. The royal spurs are of the pre-Norman prick type, with a point instead of a rowel, a type still being used during the thirteenth and fourteenth centuries. The engraved inscription records that the Castle Fraser spurs were presented in 1801 to Colonel Alexander MacKenzie (1758–1809, later Major General MacKenzie Fraser) by the Officers of the 78th Regiment, which he commanded. MacKenzie was appointed heir to the early seventeenth-century Castle Fraser by his aunt, Elyza, and adopted the name of Fraser. His military career, almost entirely spent abroad, was cut short by his death from Walcheren fever—a form of typhoid—in 1809, five years before he would have succeeded to Castle Fraser.

J.B.

Exhibitions: Edinburgh 1981 (3:30)

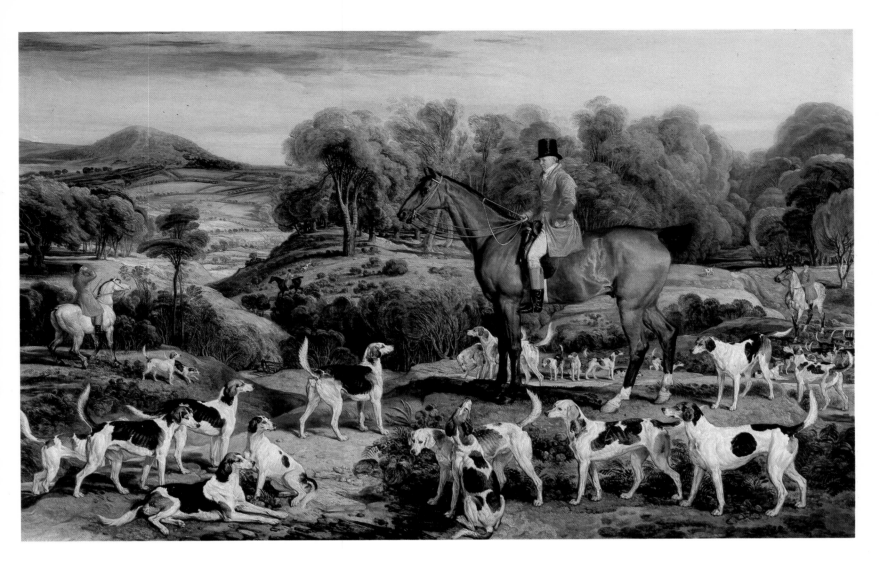

442

RALPH LAMBTON AND HIS HOUNDS
1820
James Ward 1769–1859
oil on canvas
137 × 213 (54 × 83⅞)
signed, *JWDRA* in monogram

Alnwick Castle
The Duke of Northumberland, KG

Ralph John Lambton, a member of a family settled in County Durham since the twelfth century, was Master of the Lambton Hounds there from 1804 to 1838, and became one of the best-loved sporting personalities of his day. He was his own huntsman; Longrigg notes that he "lived at the kennels and, like Lord Darlington, practically in them." The Lambton Hounds had been founded by his brother William Henry (father of the 1st Earl of Durham) in 1793, and after Ralph Lambton's retirement from the hunting field at the age of sixty-nine, he sold his hounds to Lord Suffield of the Quorn; later they were incorporated into the Durham County Hunt, where they were more at home. The rolling Durham countryside provides the background to this picture, and the artist has endowed it with a Rubensian character found in much of his earlier work.

A *Sketch for the Picture of the Lambton Hunt* appeared in Ward's own exhibition of 1841 (no. 100) and he noted in his *Descriptive Catalogue* that "The principal figure was the portrait of Mr. Ralph Lambton, as the Master of the Pack of Hounds, the greater part of which were portraits" (this is presumably the pencil and watercolor sketch reproduced by Combs 1978, 78). Ward's small portrait in oil of *Ravager*, dated 1855, the focus of his master's eye in the center of the Lambton hounds, is in the collection of Mr. Paul Mellon, and other pencil sketches for individual hounds are at Alnwick.

A mezzotint of Ward's painting by Charles Turner was published in 1821. Most people could afford to buy sporting pictures only in the form of engravings, and this became one of the most popular sporting prints of its day, finding an honored place in the dining room of that ebullient hunting man Mr. Jorrocks, the hero of Surtees' famous novel. J.E.

Provenance: By descent to Capt. William Henry Lambton of Redfield, Buckinghamshire; with Spink and Son, London, 1950; purchased by the present owner
Literature: Longrigg 1975, 108; Combs 1978, 78–79
Exhibitions: London, RA 1820 (337); London, Tate 1959 (140); Arts Council 1974–1975 (140)

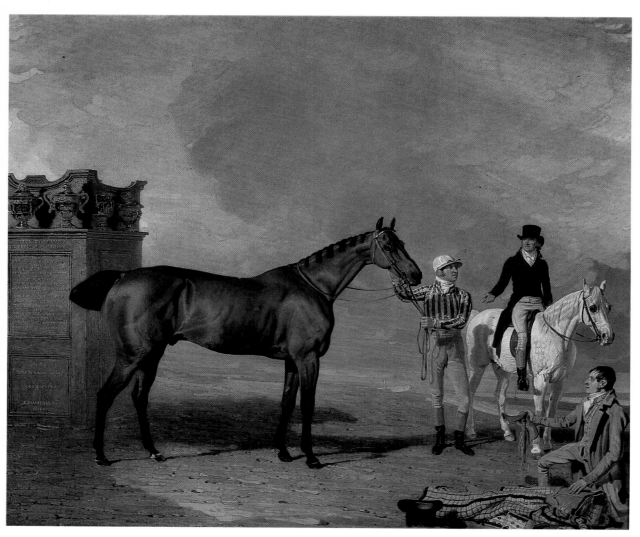

Catton, by Galumpus out of Lucy Grey, bred by Lord Scarbrough, was foaled in 1809, and took his name from the village near York where he was born. He won fourteen out of the twenty-two races in which he ran, and the four Gold Cups that he gained for Lord Scarbrough are depicted in the painting on a "monument" recording the horse's achievements; the cups themselves also survive at Sandbeck (no. 444). The inscription reads: *Catton by Golumpus|The Earl of Scarbrough|1812|He won 393 £15 at York|1813|78.10 at Preston, 105 at York|189 and 100 at Doncaster|1814|126 £5 at Newcastle|277.10 and 277.10 at Doncaster|94.10 and 157.10 at Doncaster|1815|The Cup and 86.15 178£|288.15 and 277.10 at York|The Cup and 157.10 at Doncaster|1816|The Cup 21£ 288.15 and|277.10 at York The Cup and|81 £10 at Doncaster|In all he won 21 races 3504 £5|and 4 cups|B. Marshall Pt|1816.*

Catton went to stud at Middlethorpe, near York, in 1817, but returned to racing for a few years. His most famous progeny were Tarrare (winner of 1826 St. Leger), Mulatto, Sandbeck, and Swap. Catton died at Tickhill Castle in 1833, at the age of twenty-four.

443

THE 6TH EARL OF SCARBROUGH
WITH CATTON, HIS JOCKEY, AND HIS
TRAINER 1816
Ben Marshall 1768–1835
oil on canvas
114.3 × 134.6 (45 × 53)

Sandbeck Park
The Trustees of the Earl of Scarbrough's
Settlement

The 6th Earl of Scarbrough (1757–1832), who succeeded to the title in 1807, was one of the most prominent sportsmen of his day in the north of England, with a particular enthusiasm for racing and breeding racehorses. Marshall includes his portrait on the right, on a serviceable gray hack, watching his victorious racehorse Catton. The jockey up on Catton is S. King, wearing Lord Scarbrough's racing colors (sky-blue and white stripe with a white cap); the trainer G. Nelson waits with Catton's chequered sweat-cover in the foreground at the right.

Marshall has been described as "the most professionally-minded of all English sporting painters" (Millar in Arts Council 1974–1975, 17). He wrote regularly as "Observator" and "Breeder of Cocktails" in *The Sporting Magazine*, where many of his pictures were first published, and his depiction of the racing world—especially his studies of jockeys, grooms, and trainers—are executed with the same kind of enthusiasm and vigor found in his journalism. As a contemporary wrote of Nimrod's literary style, one "can hear the horses breathe, and the silk jackets rustle, as they go by."

J.E./G.J-S.

Provenance: Commissioned by the 6th Earl of Scarbrough; and by descent
Literature: Blakeborough 1950, 3:255; Noakes 1978, 44, no. 136
Exhibitions: Richmond 1960 (41)

444

FOUR RACE CUPS WON BY
LORD SCARBROUGH'S CATTON
1813/1816
Rebeccah Emes and Edward Barnard,
partners 1808–1829, and Paul Storr
1771–1844
silver-gilt
35.5 (14) high; 43 (17);
40.6 (16); 33 (13)

Sandbeck Park
The Trustees of the Earl of Scarbrough's Settlement

These are the four cups won by the 6th Earl of Scarbrough's race horse Catton that appear in Ben Marshall's painting of the horse with his owner, trainer, and jockey (no. 443). That on the far left is the York Spring Cup of 1815, engraved with the names of the stewards, Sir William Milner, Bart., and Thomas Scarisbrick, Esq. A cup and cover of so-called campana form (referring to the bell-shaped body of the cup), it is typical of the work of the widow Rebeccah Emes and her manager Edward Barnard during this period. Unfortunately, their ledgers do not survive before 1818, but descriptions of a very similar type can be found after that date, for instance a "5 (or 6) Quart Grecian Cup and Cover Wedgd. Vine upper pt. of body twistd. dble. stalk handles, chased raffle leaves lower pt. of body, leaves on foot" (MSS, Victoria and Albert Museum, London). Emes and Barnard supplied many retailers throughout the country, often stamping their work for them, in the manner of Rundell and Bridge; sometimes it was sent for hallmarking outside London, for instance in York, where an Assay Office was still maintained.

The second cup from the left, dating from 1815, is also by Emes and Barnard, with an inscription inside the base giving the name of the retailer, John Simkinson of Doncaster. Identical horses' heads (at the top instead of the base of the handles) were used by Emes and Barnard for the Caledonian Cup of 1819, which they supplied to Robert Morton of Edinburgh, whose name is engraved around the foot as maker. The Scarbrough cup is considerably more elaborate than many others of the period; judging from the inscription on the "monument" in Marshall's picture, this must be the Doncaster Gold Cup of 1815.

The third cup from the left in Marshall's picture is a second Doncaster Gold cup won in the following year, but bearing the date mark for 1814. This was made by Paul Storr (1771–1864) while he was still with the Royal Goldsmiths, Rundell, Bridge and Rundell of Ludgate Hill, London. The laurel wreath motifs around the neck and used as a handle for the cover are tributes to the importance of the race, while there is a reminiscence of Flaxman in the chased group of three horses on the body. An exact replica of this relief was used two years later by Storr for another silver-gilt race cup of campana form (sold Christie's, London, 8 April 1970, lot 62), also using the victory wreath as a handle to the cover.

The group is completed by the York Spring Cup of 1816, which bears the York hallmarks for the year 1815–1816 and the engraved inscription "Barber & Whitwell Manuf^ts. York." There is, however, no evidence that the firm was in a position to manufacture more than the most minor pieces of silver or gold, and the cup again conforms closely to the work of one of their London suppliers, Emes and Barnard. The fine cast and chased border of cornucopiae and masks below the rim, and the flying scroll handles, are of exceptional quality, and can only be associated with one of the best London makers of the day.

J.B.

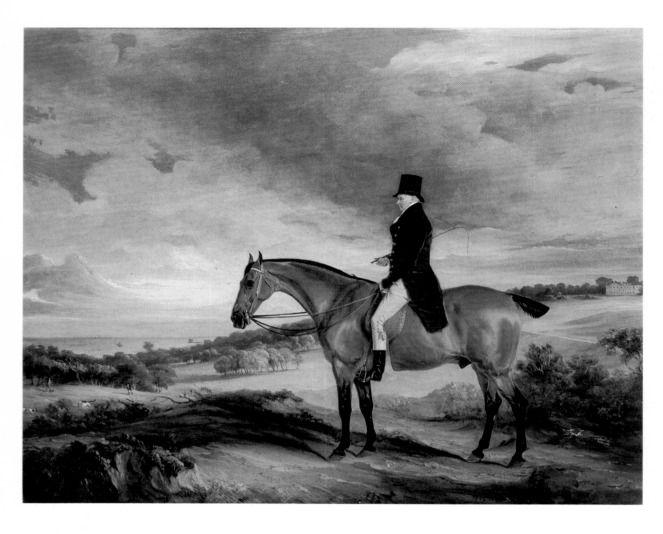

Rutland, who, recognizing the promise of the young painter, had arranged for him to be apprenticed to Ben Marshall in 1801. In 1814 Ferneley took Elgin Lodge at Melton Mowbray, and quickly built up a thriving practice working for those who lived in the Shires or visited them in the winter to hunt with the Quorn or the Belvoir. The list of his patrons reads like a roll of Regency and early Victorian society from Lord Alvanley and Beau Brummell to the Marquess of Worcester, and the pictures they ordered offer a nostalgic account of the fox-hunting world at its zenith. Many survive in context—the great *Meeting of the Quorn at Quenby* of 1823 at Norton Conyers and whole series of pictures at Keith Hall and Osberton, Deene Park and Calke Abbey. Ferneley painted several members of the Manners family and was a close friend and occasional collaborator of their favorite painter and fellow sportsman, Sir Francis Grant, who married a niece of the 5th Duke.

Drummond himself was a frequent visitor to Belvoir and Melton Mowbray, though placed in the third class among doyens of the chase by an anonymous contemporary (Paget 1931, 60). Ferneley's account books establish that the Drummonds, father and son, paid a total of 130 guineas for nine pictures between 1818 and 1831: this portrait cost 20 guineas on 3 August 1822. On the 10th of that month Ferneley wrote to his wife from London: "I sent Mr Drummonds picture of[f] yesterday. by the time I hear from him I hope to be ready for returning home" (Paget 1931, 115). Ferneley had painted Andrew Robert Drummond in 1818 and in 1823 planned to include him "in the place before Lord Brudnell in the great picture" (Paget 1931, 116). His pictures at Cadland include a version of the Belvoir Hunt and portraits of a number of horses, including Sutton and the Duke of Rutland's Cadland, which won the Derby in 1826. F.R.

Provenance: Commissioned by Andrew Berkeley Drummond; and by descent
Literature: Paget 1931, 131, no. 145

445

ANDREW BERKELEY DRUMMOND
MOUNTED ON BUTCHER AT CADLAND
1822
John Ferneley 1782–1860
oil on canvas
85.1 × 109.2 (34½ × 43)

Cadland Manor
The Cadland Trustees

Andrew Berkeley Drummond (1755–1833) was the eldest son of the Hon. Robert Drummond, younger son of the 4th Viscount of Strathallan, the Jacobite who died at Culloden in 1746. The latter's younger brother, Andrew, was the founder of the family bank and it was the success of this that enabled Robert Drummond to acquire the estate of Cadland. The house was designed by Capability Brown in 1775–1778 and enlarged by Henry Holland in 1782. Brown was responsible for the park seen here in its prime, its plantations falling away toward the Solent. The house was destroyed to make way for the oil refinery at Fawley, which opened in 1951, and its successor is some two miles away on the site of a "fishing house" in a miniature park designed by Brown.

Andrew Berkeley Drummond became a partner in Drummonds Bank in 1779. Two years later he married Lady Mary Perceval, daughter of the 2nd Earl of Egmont and sister of Spencer Perceval, the future Prime Minister who was assassinated in 1812. Drummond succeeded to Cadland on his father's death in 1804. As this picture implies, he took a close interest in the management of the estate and was also a keen sportsman: in the background a keeper is seen walking up birds.

The portrait may well have been commissioned at the instance of the Drummonds' son, Andrew Robert Drummond (1794–1865). He had ordered two pictures from Ferneley in 1818 and in 1821 married Lady Elizabeth Manners, daughter of the 5th Duke of

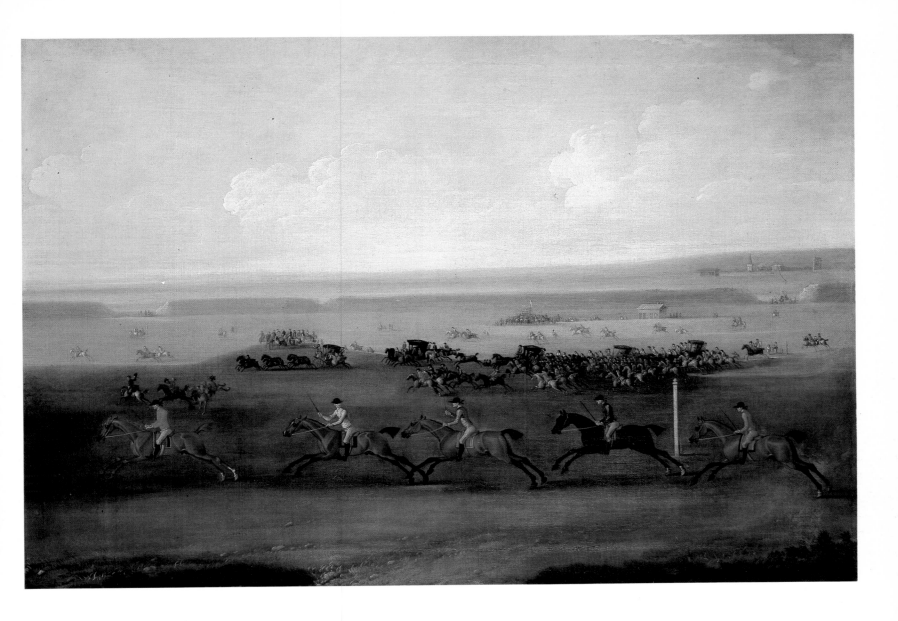

446

A RACE OVER THE LONG COURSE AT
NEWMARKET C.1731
James Seymour 1702–1752
oil on canvas
88.9 × 127.6 (35 × 50¼)

Private Collection

James Seymour, a talented amateur, who
reputedly took to painting after incurring
heavy racing debts at Newmarket,
painted a series of sporting pictures
for Sir William Jolliffe (1665–1750), a
Governor of the Bank of England and a
keen sportsman. Seymour portrayed his
patron in *Sir William Jolliffe Preparing
for the Chase* and *Sir William Jolliffe
Pursuing the Chase*; and in addition to a
series of portraits of famous racehorses
painted for Jolliffe, he painted this scene
of a race in progress at Newmarket. His
contemporaries, the more professional
artists Peter Tillemans and John Wootton,

both painted similar scenes, and it seems
probable that Seymour largely based
this painting on Tillemans. He may
have used the engraving of the latter's
*View of a Horse-Match over the Long Course
at Newmarket, from the Starting-Post to the
Stand*, published about 1720, omitting
the foreground detail, but showing the
same eager press of mounted spectators
keeping abreast of the race in the
background, and the same distant view
of the Devil's Dyke at the edge of
Newmarket Heath with the town of
Newmarket beyond. J.E.

Provenance: Painted for Sir William Jolliffe;
and through his nephew by descent to
the present owner
Literature: Hussey 1929, 126
Exhibitions: Richmond 1960 (15, as "A
Race for the King's Plate")

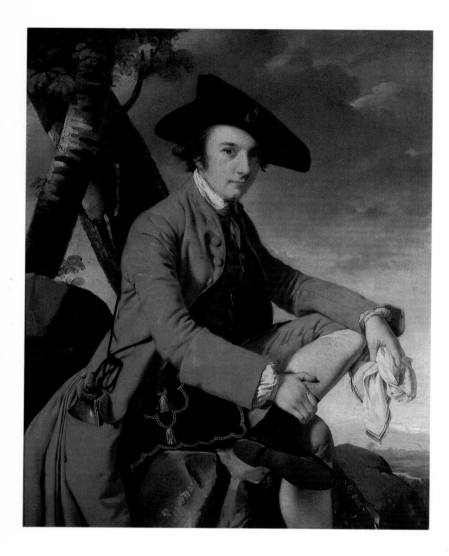

447

FLEETWOOD HESKETH 1769
Joseph Wright of Derby 1734–1797
oil on canvas
127 × 101.6 (50 × 40)

Meols Hall
Colonel Roger Fleetwood Hesketh

Fleetwood Hesketh was the son of Roger Hesketh of North Meols (1711–1791) and his wife Margaret, heiress of Edward Fleetwood of Rossall. His branch of the family had been founded by Hugh, illegitimate son of Sir Thomas Hesketh of Rufford (d. 1587), who married the heiress of North Meols, Frances, daughter of Peter Bold of Bold.

This picture and the pendant of Hesketh's wife were painted at Liverpool, where Wright was based from late in 1768 until the autumn of 1771. Although he had trained briefly under Thomas Hudson in London in 1751–1753 and again in 1756–1757, Wright's evolution as a portrait painter developed along strongly independent lines but reflects his study of prints. In this connection one may cite the parallel of John Singleton Copley who also responded to engraved sources and whose *Boy with a Squirrel* was actually thought by Reynolds to be by Wright (Nicolson 1968, 1:3–4). The survival of Wright's account book (National Portrait Gallery, London) makes it possible to follow his surprisingly rapid evolution from such unambitious early works as the Hudson-like *Nathaniel Curzon* of 1755–1756 (Kedleston) to the six Derby Hunt portraits of 1762–1763 (formerly in the Miller Mundy collection at Markeaton) and the *Shuttleworth Family* of 1764 (Leck Hall, Lord Shuttleworth). The informality of Fleetwood Hesketh's pose, resting with his gun and powder flask against a tree during a shooting expedition, shows how far Wright had moved from the stiffer mode of Hudson. The portrait recalls the Markeaton series but is obviously more assured, while the more formal pendant established the mood of a number of later works, although the balustrade that appears in this had already been used in the portrait of Robert Gwillym of Atherton of 1766 (City Art Museum of Saint Louis).

Wright's account book lists twenty-eight sitters in Liverpool: apart from the Hesketh pictures only the portrait of Thomas Staniforth (Tate Gallery) survives while that of Master Ashton is known from a copy: however, other Ashton portraits and that of Mrs. Clayton (Fitchbury Art Museum) are evidently of the same period. Taken together the portraits offer a fascinating insight of the way a visiting artist could cater for the needs of a close-knit community with strong mercantile connections. While the Heskeths had substantial ship-owning interests in addition to inherited estates, Mrs. Clayton was the proprietor of productive coal mines, the Ashtons were slave traders, and Staniforth had married into another shipping family (see Nicolson 1968, 1:99–100). Wright's customary fee for a work of this standard format was 10 guineas, the sum charged for twenty-three of the Liverpool portraits. This may be compared with Reynolds' fee of £35 at the same period. F.R.

Provenance: Commissioned by the sitter in 1769; at Rossall until the house was sold in 1844; by inheritance to Thomas Knowlys Parr, by whom bequeathed to the present owner in 1938 and subsequently at Meols (see Cornforth 1973, 209)
Literature: Nicolson 1968, 1:no. 81
Exhibitions: Southport 1951 (153)

448

THE BOY WITH A BAT:
WALTER HAWKESWORTH FAWKES
c. 1760
English School
oil on canvas
121.9 × 101.6 (48 × 40)

Breamore House
E.J.W. Hulse, Esq.

Walter Ramsden Beaumont Hawkes-worth (1746–1792) assumed the name of Fawkes on succeeding to Farnley Hall in Yorkshire under the will of his cousin Francis Fawkes in 1786. It was he who commissioned John Carr of York to remodel Farnley, and it was his son, also Walter, who later became one of Turner's greatest patrons.

Cricket, played in England since at least the thirteenth century, was a favorite sport of the English upper classes in the eighteenth century, and many country houses had their own pitches, the 3rd Duke of Dorset's at Knole being particularly famous. The fashion of portraying young men and boys holding a cricket bat started in the 1740s, and was especially employed by Thomas Hudson, as for instance in his great family group of the 3rd Duke of Marlborough at Blenheim, where the duke's eldest son on the far left carries a bat on his shoulder, and a ball on his right hand, a pose loosely based on the Apollo Belvedere (Simon and Smart 1983, no. 68, pl. 24). This portrait has in the past been attributed to Hudson, on grounds of the similarity of pose, but shows none of the latter's highly finished technique. The curved bat then used was large and heavy, weighing four or five pounds, and this stance was customary for batsmen even during play, as can be seen in engravings by L.P. Boitard and others. The hat is also of a kind seen in contemporary prints of matches, but the two stumps held in the boy's left hand are of particular interest in that they are flat pieces of wood with notches for the bails, instead of the more primitive forked twigs seen in cricketing portraits like Francis Cotes' masterly picture of *Lewis Cage as Batsman*, dated 1768 (Brocket Hall, Hertfordshire; Mead Johnson 1976, no. 255, fig. 72). The change to three round stumps only came in the late 1770s and even then took several decades to be generally adopted.

The ruined castle shown in the background of the portrait is that at Newark in Nottinghamshire, with the seven-arched bridge over the river Trent. A painting of a match at Newark by J.D. Curtis dating from 1823 (M.C.C. collection, Lord's) shows the players on the same field, which is still in use as a cricket ground. G.J-S.

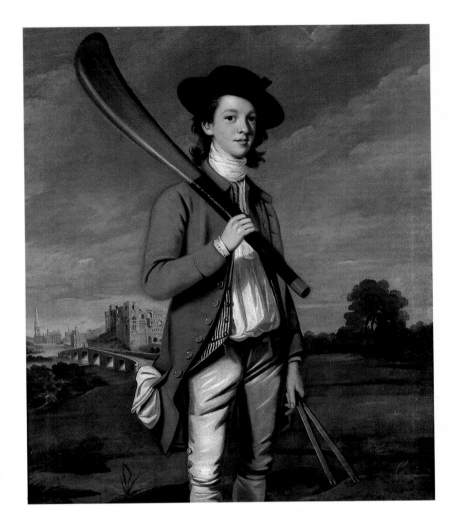

Provenance: Thomas Mason FSA of Copt Hewick, Yorkshire; his daughter Ellen, who married Henry Parr Hamilton, Dean of Salisbury (1794–1880); their daughter Katherine, who married Sir Edward Hulse, 5th Bart., in 1854; and by descent
Literature: Simon and Smart 1983, no. 70, pl. 27

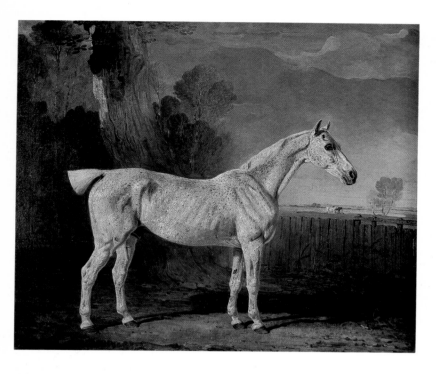

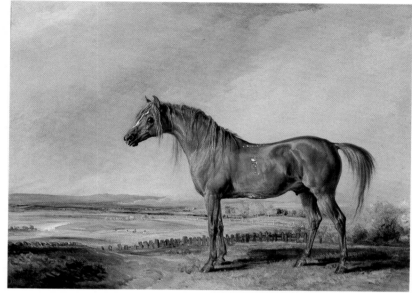

449

GRAY HORSE IN A LANDSCAPE 1815
Ben Marshall 1768–1835
oil on canvas
86.3 × 101.6 (34 × 40)
inscribed, *B. Marshall pt. 1815*

Rockingham Castle
Commander Michael Saunders-Watson

Lewis Watson, 3rd Lord Sondes
(1792–1836), and his brothers John
(later 4th Baron), Henry, and Richard
Watson, were all keen riders to hounds,
and used the old castle at Rockingham,
which was only one of many houses
owned by the family, primarily as a
hunting lodge. The 3rd Earl, who kept
his own pack, though he later became
Master of the Pytchley, commissioned
Ben Marshall to paint at least seven
canvases between about 1815 and 1817.
These included the very large painting
of *Lord Sondes and his Brothers with Their
Hounds in Rockingham Park* (still at
Rockingham Castle; Arts Council 1974–
1975, 129), and individual portraits of
some of the finest hunters in his stables,
among them this unidentified *Gray Horse
in a Landscape*. Ben Marshall, who was
born in Leicestershire, not far away from

Rockingham, was living near Newmarket
at the time these pictures were painted.
As he said to his pupil Abraham Cooper,
"the second animal in creation is a fine
horse, and at Newmarket I can study
him in the greatest grandeur, beauty
and variety" (quoted in Arts Council
1974–1975, 84). Some of his finest work
was executed in the years before 1819,
when he sustained injuries in a mail-
coach accident, which seriously impaired
his abilities as an artist. J.E./G.J-S.

Provenance: Commissioned by the 3rd
Earl Sondes; and by descent
Literature: Noakes 1978, 44, no. 129
Exhibitions: Richmond 1960 (39)

450

COPENHAGEN, THE DUKE
OF WELLINGTON'S CHARGER
c.1820/1824
James Ward 1769–1859
oil on canvas
80 × 109.3 (31½ × 43)

Alnwick Castle
The Duke of Northumberland, KG

Between 1820 and 1826, the 3rd Duke
of Northumberland purchased six
portraits of celebrated horses from Ward,
for £105 each. Two of the horses—"A
Persian Horse" and "A Cossack Horse"
—belonged to the duke himself. Two
others had carried monarchs: "Adonis,"
George III's favorite charger, and
"Nonpareil," George IV's favorite.
Two had carried opposing generals in
the Napoleonic wars: "Copenhagen, the
Horse rode by the Duke of Wellington
at the Battle of Waterloo" and "Marengo,
Napoleon Bonaparte's Barb Charger at
the Battle of Waterloo." Ward later
published these six portraits and eight
others as a series of lithographs of
"Celebrated Horses" dedicated to
George IV.
 Of all these portraits, those of

Copenhagen and Marengo, appropriately
painted at dawn and sunset, are arguably
the finest and the most romantic.
Wellington's horse, by Eclipse out of
Lady Catherine, had been bred by
General Grosvenor, who rode the mother
at the siege of Copenhagen while she
was carrying the colt. Copenhagen in
turn carried the Duke of Wellington at
the Battle of Waterloo, 18 June 1815,
and carried him for fifteen hours. Bryant
relates that "It was eleven o'clock before
the victor dismounted outside the inn
at Waterloo. As he patted the horse
which had borne him so patiently all
day, Copenhagen made his commentary
on the terrible battle through which he
had passed by suddenly lashing out and
breaking free. It took a groom half an
hour to catch him. 'There may have
been many faster horses,' Wellington
said of him, 'no doubt many handsomer,
but for bottom and endurance I never
saw his fellow.'" J.E.

Provenance: Purchased by the 3rd Duke
of Northumberland; and by descent
Literature: Grundy 1909, 45, 57–58;
Bryant 1971, 451
Exhibitions: London, RA 1824 (357);
Arts Council 1959 (371)

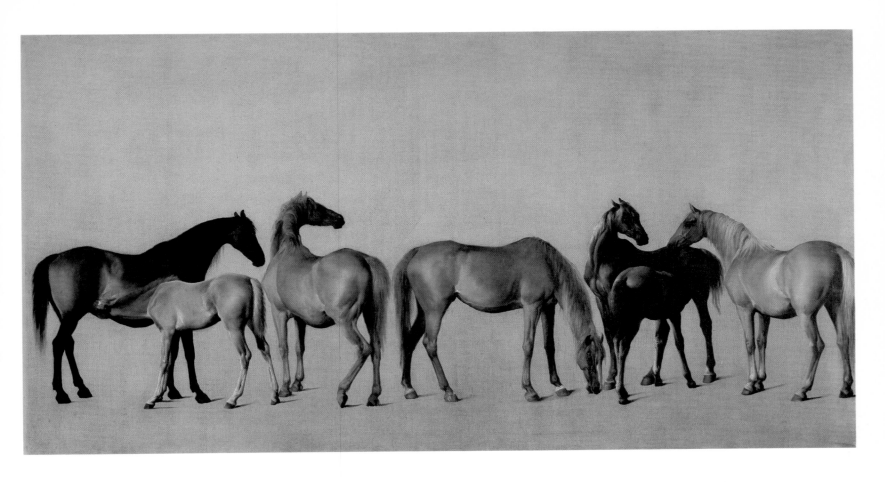

451

MARES AND FOALS WITHOUT
A BACKGROUND 1762
George Stubbs 1724–1806
oil on canvas
99 × 190.5 (39 ×75)

St. Osyth's Priory
Lady Juliet de Chair and the Trustees
of Olive, Countess Fitzwilliam's
Chattels Settlement

This is one of several pictures that Stubbs painted at Wentworth Woodhouse in Yorkshire about 1762 for Charles Watson Wentworth, 2nd Marquess of Rockingham (1730–1782), a nobleman who combined eminence in politics with enthusiasm for racing and breeding racehorses. A painting of "five brood-mares and two foles" is listed with four others for which Lord Rockingham paid a total of £194. 5s. on 15 August of that year (Constantine 1953, 237). These mares and foals would have been particular animals in his stud farm, some of them the progeny of winning sires, and themselves hoped-for winners.

Like other pictures that Stubbs painted for Rockingham, notably the life-size portrait of the racehorse *Whistlejacket*, this picture was left without a landscape background. It is not known whether the decision to leave the painting at this stage was made by the artist or his patron. But one can well imagine that the latter, who had

an important collection of classical statuary at Wentworth Woodhouse, may have appreciated the feeling of a classical Greek or Roman frieze that this simple treatment gave the picture. Stubbs in 1762 was still a little-known and untried painter. In commissioning a portrait of his mares and foals, Rockingham may have been surprised to find himself the recipient of a work of such superlative quality, and decided that the composition should be left as it was. J.E.

Related Works: The mare and foal at the left and the two mares and a foal on the far right are almost exactly repeated in Stubbs' *Mares and Foals in a River Landscape* (Tate Gallery, London), thought to have been commissioned by the 3rd or 4th Viscount Middleton in the late 1760s (London, Tate 1984–1985, 89).
Provenance: Commissioned by the 2nd Marquess of Rockingham; and by descent (see no. 214).
Literature: Taylor 1971, 14, 26–27, 206, pl. 20; Parker 1971, 55–71
Exhibitions: Probably Society of Artists 1762 (110, *A Brood of Mares*); London, RA 1879 (223); Paris 1928 (137); London, Ellis and Smith 1946 (2); Liverpool 1951 (31); London, Whitechapel 1957 (30); Richmond 1960 (18); London, Tate 1984–1985 (88)

452

SIDEBOARD, URNS ON PEDESTALS, AND
WINE COOLER 1771
Thomas Chippendale 1718–1779
rosewood, satinwood, and amboyna
with ormolu mounts
sideboard: 90.2 × 198.7 × 81.9
(35½ × 78¼ × 32¼);
pedestals and urns: 177.8 × 43.2 × 43.2
(70 × 17 × 17);
wine cooler: 72.4 × 76.2 × 58.4
(28½ × 30 × 23)

Harewood House
The Earl and Countess of Harewood

This magnificent suite of dining room
furniture, made as part of Thomas
Chippendale's most important single
commission (see no. 265), was supplied
to Harewood some time before December
1772 when the earliest of his surviving
accounts presented to Edwin Lascelles
opens with the tantalizing entry "To a
Bill Delivered £3024.19.3." Fortunately,
documentary evidence about the firm's
activities during this period exists in
a Day Work Book kept by Lascelles'
steward, Samuel Popelwell, who noted
how Chippendale's workmen at the
house spent their time from October
1769 (Gilbert 1978, 200, 213–214). This
book confirms that the dining room

was one of the first of Robert Adam's
interiors to be furnished, and entries
for 1771, such as "Fixing Window
Curtains in the Dineing room—18
hours" (15 June), "At the oil cloths for
the Sideboard in the Dineing Room—6"
(22 July), and "Covering Furniture in
the Dineing Room—6" (15 November),
make it almost certain that this suite,
with another matching sideboard, was
sent up to Yorkshire from the firm's
St. Martin's Lane workshop during the
course of the year.

Robert Adam, who was commissioned
to decorate the interiors of the house,
designed by John Carr of York in 1759,
has in the past been given the credit for

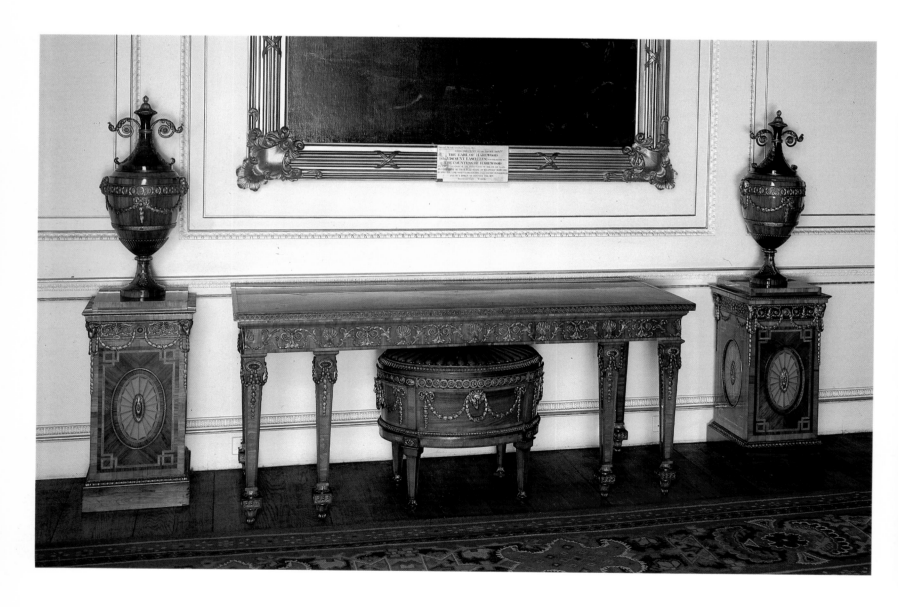

the design of much of the Harewood furniture—and at other houses where he and Chippendale collaborated, like Nostell Priory and Saltram, or Lansdowne House and 19 Arlington Street, the architect was responsible for many of the larger items such as pier glasses and pier tables, leaving the cabinetmaker to supply the rest. However, there is no evidence that this is what happened at Harewood, and the dining room suite in particular shows features markedly different from any of Adam's other known designs. The handling of the legs of the sideboard, and especially the feet, show a knowledge of contemporary French furniture, which may well be connected with Chippendale's visit to Paris in 1768. Moreover, the whole interpretation and spacing of the classical ornaments— the guilloche moldings, the anthemion and acanthus frieze, and the chains of husks suspended from oval paterae— are more decorative and detailed, and less architectural, than they would have been in Adam's hands. The satyrs' masks on the wine cooler (or cellaret) and the ormolu rams' heads at the corners of the pedestals, closely comparable with those in carved wood on the Nostell barometer (no. 276), are also echoed by the pier glasses and pier tables in the same room, for which a drawing attributed to Chippendale survives (Victoria and Albert Museum). Perhaps the most original and successful features of the whole design are the lid of the wine cooler, formed as a giant ribbed patera; and the tall, attenuated covers to the urns, which sprout acanthus scrolls that also act as handles. The sideboard pedestals supporting lead-lined urns were strictly functional, for one was equipped with racks as a plate warmer, and the other intended for rinsing glasses or utensils during meals, with a pot cupboard below.

The ormolu mounts, which are of outstanding quality, could have been produced in Chippendale's workshop, for his premises certainly contained a furnace in a small stone-flagged room, and a later bill for the "Exceeding large Brass Hall Lanthorn" at Harewood together with "6 Antique Brass Gerandoles" and a "large brass Scroll Bracket" for the staircase (26 August 1774) includes charges for "carving the various Patterns in wood....casting and afterwards Chasing them in lead and brass &c." Sophie von la Roche, who visited his rival George Seddon's workshop in 1786, reported that the latter employed "girdlers—who mould the bronze into graceful patterns" (Williams 1933, 173–175). On the other hand there were skilled ormolu workers to whom such mounts could be sub-contracted, such as Pierre Langlois' son-in-law Dominique Jean, who is thought to have made the mounts on a mahogany commode at Nostell Priory attributed to Chippendale (Gilbert 1978, 46).

Apart from the very much plainer set of sideboard, urns, and wine cooler at Paxton House in Berwickshire, made in 1776, no other comparable suites of documented Chippendale furniture exist. These pieces not only demonstrate the unique importance of the Harewood commission in the cabinetmaker's *oeuvre* but are among the finest examples of English craftsmanship in the late eighteenth century. C.G./G.J-S.

Literature: Simon 1907, fig. 30; Macquoid 1908, pls. 56–59; Brackett 1924, pl. 60; DEF 1954, 3:129, fig. 15; Edwards and Jourdain 1955, pl. 126; Symonds 1958, 56, fig. 14; Harris 1963, 104–105, no. 151; Musgrave 1966, 91, 208, figs. 136, 138; Gilbert 1973, 1–32; Gilbert 1978, 45, 200–201, figs. 350, 352, pl. 7
Exhibitions: Leeds, City Art Galleries 1930 (108—wine cooler only); London, RA 1934 (1555—pedestal and urns only); London, RA 1955–1956 (390—wine cooler only); Leeds, Temple Newsam 1968 (42—full suite); Council of Europe 1971–1972 (1646—urn and pedestal only); Leeds, Temple Newsam 1979 (30, 31—pedestal and wine cooler only)

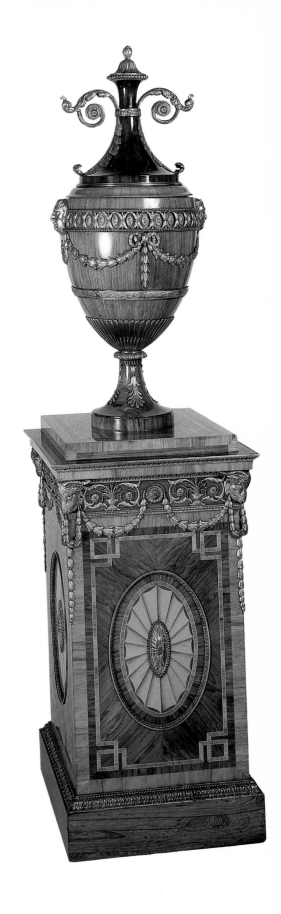

453

THREE-BRANCH CANDELABRUM 1758
Simon Le Sage entered 1754
silver
47.3 × 37 × 33 (18⅝ × 14½ × 13)

Ickworth
The National Trust (Bristol Collection)

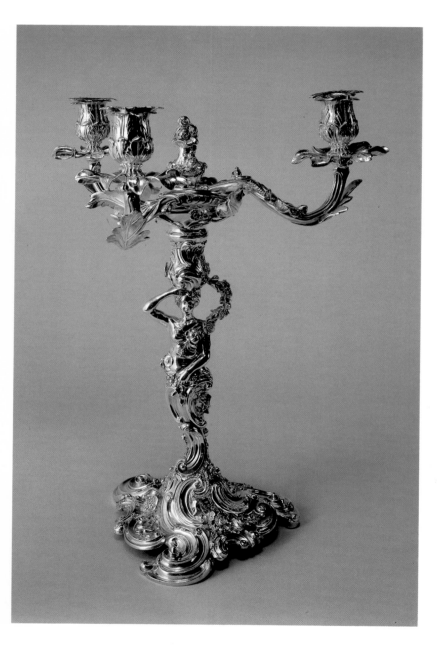

This magnificent three-branch candelabrum from a set of twelve (a fourth light can be fitted if required by removing the central finial) is engraved beneath the base with the arms of George II, and comes from a set of twelve, issued by the Jewel House as part of the ambassadorial plate of George William Hervey, 2nd Earl of Bristol, Ambassador to Madrid from 1758 to 1761. The stem is in the shape of a female term rising from the cast and chased triangular base, which is decorated with scrolls and flowers. The weight of the individual candelabra varies from 145 oz. troy to 159 oz. 10 dwt., making a grand total for the set of 1810 oz. 10 dwt. The maker, a second-generation Huguenot goldsmith, was Subordinate Goldsmith to the King from about 1754 to 1759. The son of John Hugh Le Sage and elder brother of Augustin Le Sage, he was apprenticed to his father in 1742, but as often happened among the London craftsmen, he was turned over the same day to another master, Peter Meure, who was also of Huguenot stock. Like his partner, Peter Archambo, Meure was a member not of the Goldsmiths' but of the Butchers' Company. Simon Le Sage entered two marks as largeworker at Goldsmiths' Hall on 5 April 1754, and joined his father at the Golden Cup in Great Suffolk Street, Charing Cross, London, where he followed him also as Subordinate Goldsmith to the King.

Four of the set are usually displayed on the dining room table at Ickworth, and it is unlikely that any other comparable set of mid-eighteenth century candelabra has survived. Lord Bristol had previously served as Ambassador to Turin (1755–1758), and he seems on that occasion to have taken his own plate, for during his time in Italy he commissioned two tureens (still at Ickworth) to match a pair by Frederick Kandler of 1752, engraved with the Hervey arms (no. 454), and likewise beakers and other smaller objects. The exceptionally large dinner service that accompanies the set of Le Sage candelabra, including silver-gilt salvers, soup tureens, dishes, and bowls, was issued by the Jewel House for his Spanish embassy, and reflects the far greater importance of this mission, when the embassy in Madrid must have been the scene of many splendid banquets.

Until the final issue of plate to the Duke of Wellington on being appointed Ambassador to Paris in 1814, it was generally assumed (though with some demur from the Lords of the Treasury) that such plate was a perquisite for the services of the officer of state concerned, and thus passed into his private ownership. From 1815, however, the state won the day, and Viscount Castlereagh as Foreign Secretary ruled that official residences should be permanently furnished with appropriate plate.

Lord Bristol later became Lord Lieutenant of Ireland (1766–1767) and Lord Privy Seal (1768–1770), but inordinate pride may account for the fact that he did not attain higher office. He never married, and it was left to his younger brother Frederick, the Earl-Bishop of Derry (no. 196), to rebuild the old house at Ickworth as a repository for the family's collections.

Caryatid candlesticks and candelabra are recorded in English silver from at least the end of the seventeenth century onward, and leafy branches, foliate sconces, and figures derived from classical architecture were adapted and revived by the rococo school of designers, notably the artist and gold chaser George Moser, whose pen and wash design for a candlestick (London, V & A 1984, E14) is closely allied to the design of the Hervey candelabra. In silver, similar castings appear to have been used by Paul de Lamerie for a pair of candelabra of 1748 in the collection of the Earl of Liverpool, and again four years later, when Lamerie's stock and tools had been dispersed following his death, by Frederick Kandler (for a pair in the Conway Collection, Ashmolean Museum, Oxford) though both had differing details for branches and sconces, and male instead of female terms. J.B.

Provenance: Given to the 2nd Earl of Bristol in 1758; and by descent at Ickworth until 1956 when, after the death of the 4th Marquess, the house and its principal contents were accepted by the Treasury in lieu of death duties and transferred to the National Trust
Literature: Hayward 1960–1961, 3–7; Hayward 1963, 16–22; Bury and Fitzgerald 1969, 27–29; Banister 1980, 792–794
Exhibitions: London, Christie's 1957–1958 (178); York 1969 (37); Brussels 1973 (121)

454

SOUP TUREEN 1752
Charles Frederick Kandler entered 1727
silver
$35 \times 45.7 \times 27 \ (13\frac{3}{4} \times 17\frac{7}{8} \times 10\frac{5}{8})$

Ickworth
The National Trust (Bristol Collection)

In commissioning the silversmith Charles Kandler I to make him a pair of large and richly decorated soup tureens and liners in 1752, only a year after succeeding to the title, the 2nd Earl of Bristol was continuing his father's long-established tradition of acquiring plate for the family seat at Ickworth in Suffolk. This silver, always in the newest fashion, is meticulously listed in an account book that the 1st Earl kept between 1688 and 1742 (Hervey MSS). The 2nd Earl presumably chose Kandler as his silver-smith because he no doubt approved the high rococo style of Paul de Lamerie, whom his father had often commissioned, and indeed Kandler was more than once required to make copies of Lamerie dishes and baskets at Ickworth.

The 1752 tureen, bearing the 2nd Earl's coat-of-arms on each side, was part of a great dinner service made in the early 1750s, chiefly by Kandler, who was probably a scion of the family of that name, usually spelled Kaendler, of Dresden, who modeled for the Meissen factory. Though Kandler had certainly been in London for a quarter of a century, the style of the tureens shows his expertise at modeling, and the fluted sides and the applied vegetables, fish, and shells on the cover have a kinship with porcelain of the period. The applied armorials, with their fine supporters, and the chained lynx passant holding in its dexter paw a trefoil (the Hervey crest) that forms the handle, are also superbly modeled.

The 2nd Earl was a statesman with a distinguished career as Lord Privy Seal, and as Minister at Turin from 1755 to 1758, when he was appointed Ambassador to Madrid. He supplemented his ambassadorial services issued by the Jewel House with plate that he took from Ickworth, including his Kandler tureens, which he had copied by a Turin goldsmith about 1755, though in a circular rather than oval form. On his return to England he ordered yet more Kandler silver, including a pair of superb ladles with now rather faint marks, but one showing the scratch weight of 11 oz.16 dwt., and a group of small covered bowls and stands, for sugar, or perhaps for soup.
J.B.

Provenance: George William Hervey, 2nd Earl of Bristol (1721–1775), and by descent; acquired with Ickworth by the National Trust in 1956
Literature: Penzer 1957, 39–43, 133–137, fig. 4; Inglis 1969, 1606–1607, pl. 1; Banister 1980, 792–794, pl. 7
Exhibitions: London, Christie's 1958 (172); York 1969 (36)

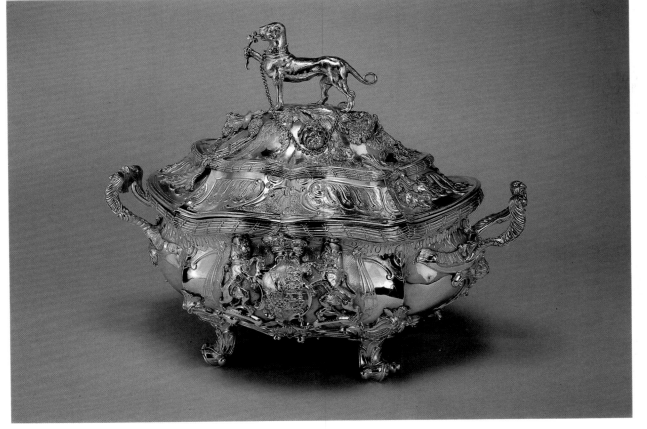

455

COFFEE JUG 1738
Paul de Lamerie 1688–1751
silver
$28 \ (11\frac{1}{4})$ high

Private Collection

Among the many English rococo coffee and chocolate jugs this example is unparalleled in its virtuosity, revealing the great goldsmith Paul de Lamerie at his most inventive and skillful. Within deceptively simple scrollwork, Lamerie has blended themes that as a rule would appear incompatible. On either side, the elongated scrolls enclose amorini chased in high relief, one facing the viewer, one with his back turned, and holding branches, apparently of coffee shrubs, against a landscape, while a third is set in the scrollwork below the handle, seemingly climbing out of the panel as he grasps his exotic plant. Below each panel foliage descends to the scrolling supports, chased with scalework and with scroll and shell feet. Shells are also repeated in different forms at the base of the handle sockets, which extend in fluid scrolls like gaping mouths along the wooden handle.

Even the engraving of the arms (Lequesne impaling Knight) contained within a rococo cartouche, in a carefully contrived space to the left of the handle, echoes the foliage and shells of the rest of the decoration. The motto, *Seek Liberty*, is given an extra flourish with the design of the ribbon scroll on which it appears. These arms are those of Alderman John Lequesne, a distinguished member of the Worshipful Company of Grocers who was, like de Lamerie, of Huguenot birth. He was knighted in 1737, and the following year elected a Director of the Bank of England. On 25 April 1738 he married Mary Knight of Hampshire, and it may have been as a wedding present for her that de Lamerie was commissioned to make this pot, as well as a similar, though unmarked, cream jug (in the same collection until 1929), a tea-kettle, lampstand, and salver (now in the collection of Mr. and Mrs. Arthur Gilbert and on display at Los Angeles County Museum), and perhaps other silver that has now been lost. Sir John was a highly successful man who, besides

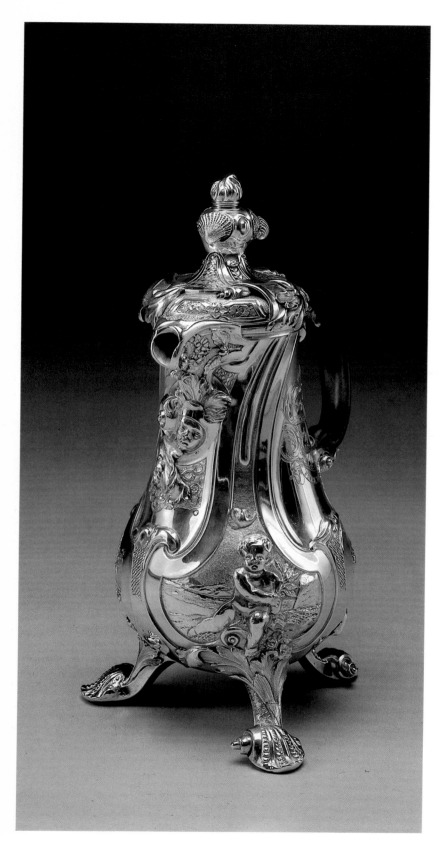

being an Alderman of Bread Street Ward in the City of London from 1735, was a Director of the Hospital of La Providence, known as the French Hospital, in St. Giles, Cripplegate. In 1739 he was chosen a Sheriff of London, but died childless in 1741 and was buried at St. Peter-le-Poer in Broad Street, now unhappily demolished. The rich grocer-banker had come a long way since 1700, when he was naturalized as a "distressed Protestant, alien born."

Even among de Lamerie's outstanding pieces, no other truly comparable pot is known. The closest, much less richly chased, is a swirl-fluted pot on three shell supports, made in the same year (which by 1964 was in the collection of the Folger Coffee Company, Kansas). Another piece, of the same year, but again less magnificent, is in the Sterling and Francine Clark Art Institute in Williamstown, Mass.; while a third, of 1737, is in the Metropolitan Museum, New York. Though the pattern is obviously of French inspiration, again no comparable French pot, even by masters such as Thomas Germain or Henri-Nicolas Cousinet, is known, and this remains one of the finest and most original examples of English rococo silversmithing. J.B.

Provenance: John Gabbitas, Esq. (Sotheby's, 27 June 1929, lot 171); the late Mrs. Anna Thompson Dodge (Christie's, 23 June 1971, lot 24); a "European collector" (Christie's, New York, 10 May 1983, lot 207)
Literature: Grimwade 1974, 51, pl. 60A, cover
Exhibitions: V & A 1984 (G7)

456

DISH FROM A DESSERT SERVICE 1738
Peter Archambo I fl.1721–1767
silver
20.6 × 20 × 3.8 ($8\frac{1}{8}$ × $7\frac{7}{8}$ × $1\frac{1}{2}$)

Levens Hall
O.R. Bagot, Esq.

An early example of the asymmetrical, high rococo style introduced by Paul de Lamerie, Paul Crespin, Frederick Kandler, and Peter Archambo himself in the 1730s, this small but heavy dish, with a scratch weight of 16 oz. 17 dwt., was probably intended as part of a dessert service, perhaps accompanied by an epergne or dessert centerpiece, for nuts, bonbons, or other small sweetmeats at the dining table. Its virtuosity is emphasized by the three putti round the rim, each heavily cast and chased: the first wreathed in bunches of grapes in Bacchic fashion, the second grasping thunderbolts, the attribute of Zeus, or Jupiter, and the third with wings and clouds swirling below. With the large conch shell on the fourth side, which also acts as a handle, these may represent the Four Elements: Earth, Air, Fire, and Water. The engraved goat's head crest of the Bagot family appears to be contemporary. J.B./G.J-S.

Related Works: A pair of similar dishes, exact copies of those at Levens, were made in 1815 at the beginning of the rococo revival period by Robert Garrard, of the same size but slightly heavier, 34 oz. 16 dwt. the pair (sold from the collection of W.C. Chappell, Esq., and described as "salvers" at Sotheby's, London, in 1972). Other dishes in the same manner were made by William Fountain in 1816

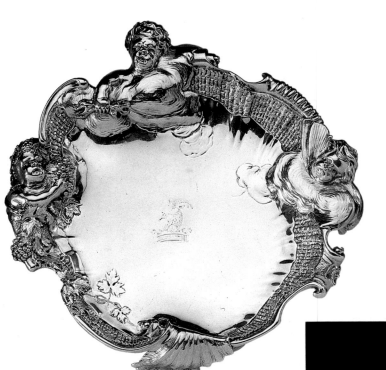

457

TABLE BASKET AND LADLE 1737
Paul de Lamerie 1688–1751
silver
40.6 (16) wide; ladle 30 (11¾) long

Woburn Abbey
The Marquess of Tavistock and the
Trustees of the Bedford Estates

This is one of a pair of baskets and
associated ladles at Woburn, engraved
with the arms of John, 4th Duke of
Bedford, and his second wife Gertrude,
daughter of John, 1st Earl Gower, whom
he married in 1737. Presumably made
in connection with this marriage, they
have now been happily restored to the
family after their theft in 1984. It is no
exaggeration to say that they are the

richest and finest of their type ever to
have been created by Lamerie. Although
unmarked, the ladle, pierced with the
duke's initials *JB* in cypher, is un-
doubtedly the work of the master. The
basket is a confection of unsurpassed
craftsmanship in the ordering of the
complex details of cast, chased, pierced,
and engraved cornucopiae, and the
baskets of flowers and Apollo masks
that decorate the rims. It seems most
likely that it was intended not for bread
or cakes as is usually thought, but for
fruit, as seen in Hogarth's group portrait
of the Graham children in the National
Gallery, London. J.B.

Literature: Grimwade 1965, 500, 502,
pl. 5; Clayton 1984, pl. 1
Exhibitions: London, RA 1950 (108)

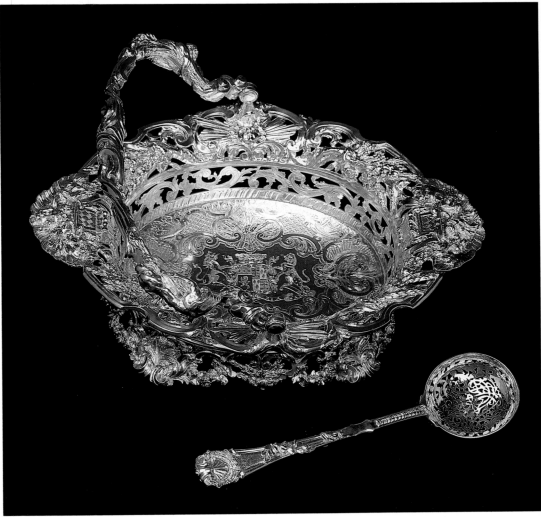

458

THE LEINSTER SERVICE 1745–1747
George Wickes entered 1722
silver
tureen on stand: 30.8 × 45.7 × 27.3
($12\frac{1}{8}$ × 18 × $10\frac{3}{4}$); épergne:
40.6 × 40.9 × 33.6 (16 × $16\frac{1}{8}$ × $13\frac{1}{4}$),
and tray: 11.4 × 68.6 × 57
($4\frac{1}{2}$ × 27 × $22\frac{1}{2}$); salver: 23.5 ($9\frac{1}{4}$)
diam.; oval sugar box: 13.9 ($5\frac{1}{2}$) high;
round condiment box: 13.9 ($5\frac{1}{2}$) high;
sauce boat: 13.9 × 19 × 9.2
($5\frac{1}{2}$ × $7\frac{1}{2}$ × $3\frac{5}{8}$); dinner plate: 25.4 (10)
diam.
engraved with the arms of James
Fitzgerald, Earl of Kildare (1722–1773,
created 1746), later 2nd Duke of
Leinster, impaling those of his wife
Emilia Mary, daughter of Charles
Lennox, 2nd Duke of Richmond

Private Collection

This group of seven pieces comes from a dinner service bearing hallmarks for 1745/1746 except for the épergne and tray, dated 1747. The survival of English silver dinner services was greatly jeopardized from the late eighteenth century by the improvements in manufacturing high-grade pottery and porcelain in England and the later development of bone china. Many earlier services must have been melted down as taste changed or certain pieces, notably plates, became worn. A few fine examples have survived, but this very large service is additionally remarkable for its documentary history: complete details are to be found in the "Gentlemen's Ledger" kept by the goldsmith George Wickes, charged to "the Rt Honble: The Earl of Kildare" between 9 February 1746/1747 and 19 August 1747 (MSS, Victoria and Albert Museum, London).

Of the original service of 170 pieces, only a few are missing—some plates and soup dishes, a pair of sauceboats, eight salts, some salad dishes, a pair of small waiters, bread baskets, "escallop"

shells, the flatware and cutlery, and the basket used with the épergne shown here. An oddly described piece from those missing was "a Machine Dish Ring" weighing 52 oz. 13 dwt., costing £24.1s. 2d., which was almost certainly an early dish-cross, a piece of plate that was used earlier in Ireland than in England. The dish ring, usually associated with Irish silver was made at least as early as the seventeenth century in England, when braziers with lampstands were also not uncommon. By the middle of the eighteenth century, however, the dish cross with extendable arms generally superseded the dish ring, the earliest example of a dish cross in English silver apparently being one of 1739 by James Shruder. Most date from about 1748 onward, and in 1756 Edward Wakelin supplied a "plate warmer 48 oz. 9 dwt." to the Marquess of Exeter, presumably the dish cross sold by the family in 1929.

Unfortunately, the Wickes' ledgers do not reveal the name of the designer of the service, though in fact the earl was charged on 27 May 1745 for a pair of "fine chas'd candlesticks and branches" of French inspiration based on an original by Thomas Germain, together with "a book of drawing and binding, 18s.6d." This may have included designs for objects from the dinner service that was presumably by then being made.

It has been suggested (Barr 1980, 87) that Wickes' associate Samuel Netherton, who had been trained in his youth by a drawing master, may have been responsible for preparing the designs used in his workshop. No doubt the firm was familiar with the many design books, both English and French, made by such artists as William de la Cour, Hubert-François Gravelot, and Juste-Aurèle Meissonnier, as well as with the latest products of contemporary London craftsmen such as Paul de Lamerie, John Hugh Le Sage, William Kidney, and others who were also adept at the more complex themes of the new rococo style. To adopt and to adapt was simply good business.

One piece of which the design origin can be traced is the canopied épergne with its dished tray. This is closely akin to the similar épergne in the Royal

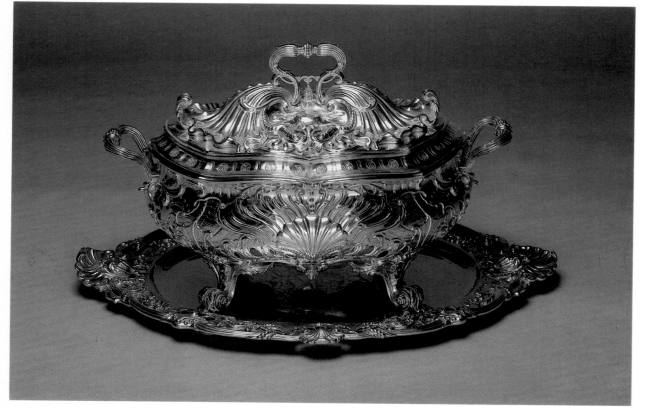

Collection made for Frederick Prince of Wales by George Wickes in 1745, and based on an engraved design by John Vardy after William Kent. The earl may well have seen the finished centerpiece during a visit to Panton Street when commissioning Wickes to make his grand service. The royal épergne has, however, been extensively altered from its original appearance, which has been compared with Meissen table arbors.

The tureen (one of a pair) displays an originality even in an age of highly innovative designs. It is of slightly bombé form, supported on four massive scroll supports, and the treatment of the shell motifs is especially interesting: those on the sides of the tureen, of fanlike form, are pierced to reveal the liner below, and those on the cover are of rich almost three-dimensional form, balancing the large shell handles to the stands, which have elaborate borders of shells and running scrollwork. Together these tureens and stands, with their dishes and ladles, weigh no less than 592 oz. 14 dwt. It is interesting that, despite their magnificent chasing, they were charged at only 7s. 6d per oz. for making, whereas the "Epargne and Basket & Table" weighing 427 oz. 16 dwt. were charged at 10s. an ounce for making, the price of silver in 1747 having fallen to 6s. an ounce.

The shell motifs and the reeded and foliate pattern of the tureen handles were repeated in neater but still opulent style on the sauceboats, of which six large examples and a pair of smaller ones survive from the original ten, and for the seventy-seven dinner and soup plates. The shaped reed and tie rims also appear on a series of waiters or salvers ranging in size from $7\frac{1}{2}$ inches to $21\frac{1}{2}$ inches in diameter. The "2 ovill and 4 Round Boxes," together weighing 83 oz. 14 dwt., were probably originally associated with the missing salad dishes, and were charged at £7. 6s. for making, £6. 1s. for the metal. They were accompanied by "2 Sugar Spoons 2 Pepper 2 Mustard Spoons," so helping to identify their purpose in preparing dressing for fresh salads in summer and for herb salads in winter. It is unlikely that they would have been placed on the épergne centerpiece, however, which would have been used for serving fruit and sweetmeats. J.B.

Provenance: James Fitzgerald, Earl of Kildare, created Duke of Leinster in 1766; Sir Harry Mallaby-Deeley; Walter J. Chrysler, Sotheby's, New York, 1960; acquired by present owner
Literature: Grimwade 1974, 32, 48, pls. 45, 95; Snodin 1977, 37–42; Barr 1980, 197–205; Hawkins 1983, 54–66
Exhibitions: Sydney 1980 (9); V & A 1984 (G23)

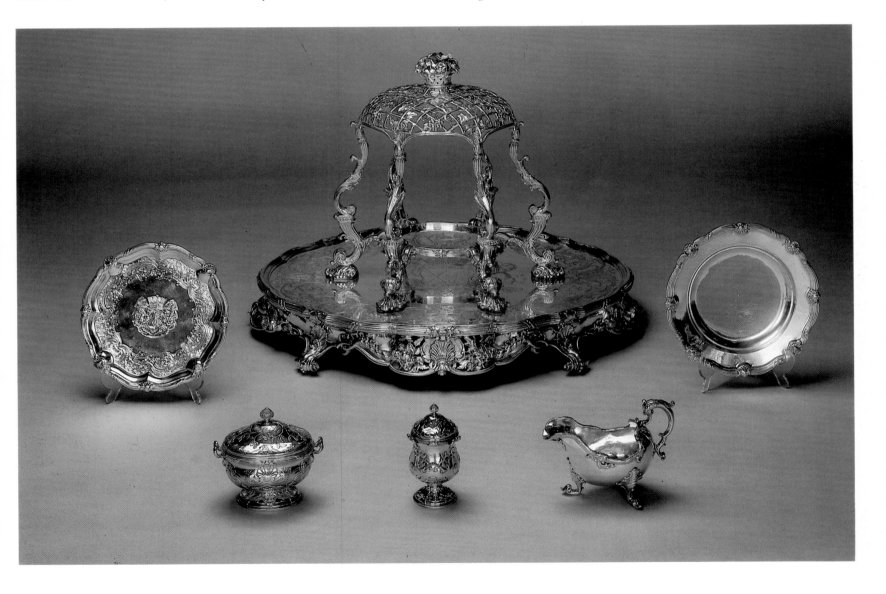

459

SILVER-MOUNTED TORTOISESHELL
PUNCH BOWL 1750
Paul Crespin 1694–1770
silver and tortoiseshell
31.7 (12½) high

Longleat House
The Marquess of Bath

This is a rare, perhaps unique, example of the combination of tortoiseshell and silver at a period when very few elaborate silver punch bowls were being made, and recalls the Renaissance love of unusual objects mounted in precious metals. It is thought that the shell is from a hawksbill turtle (*Chelone imbricata*)

from the Antilles, owned by Thomas Thynne, 2nd Viscount Weymouth (1710–1751), which he chose to have mounted by Crespin, one of the leading London Huguenot goldsmiths. The applied shield bears the Thynne arms.

Crespin must have had the shell treated by a specialist craftsman, who would have cleaned and prepared the carapace. The shell is basically brittle and horny, but it is thermoplastic and becomes pliable when immersed in boiling water, regaining its rigidity on cooling. One section can also be joined to another under heat and pressure, so that attractive patterns can be built up from the darker and lighter plates. The underbelly, apparently chiefly used here

for the cover, provided the yellowish plates known as "blond," which are not mottled. The craftsman has here adapted the contrasting parts of the upper shell to form a deep, irregularly shaped bowl that is startingly asymmetrical even by the standards of the most advanced rococo.

Though the bowl only bears the maker's mark of Paul Crespin, it cannot date from much before 1750. An inventory taken in January of that year records: "A Tortoise Shell Bowl lined with Silver. A Ladle the same" (Longleat MSS); unfortunately the latter is no longer in the collection. J.B.

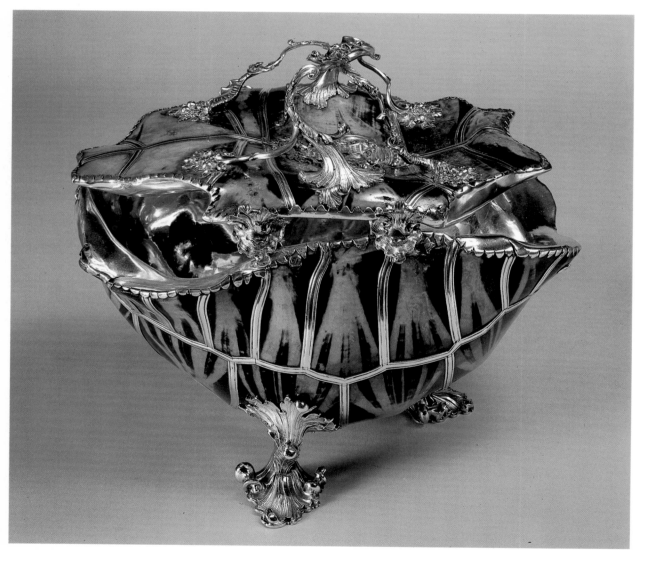

460

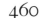

THE RICHMOND RACE CUP 1766
Daniel Smith and Robert Sharp, partners 1763–1796, after a design by Robert Adam
silver-gilt
48.26 (19)

inscribed, *Earl of Darlington: Sʳ Laurence Dundas: Stewards/Richmond 1766. Shadow, Dux, Sylvio, Royal George and Meaburn.*

Bourne Park
Lady Juliet de Chair and the Trustees of Olive, Countess Fitzwilliam's Chattels Settlement

This splendid race cup was designed by Robert Adam, whose original drawing is preserved in Sir John Soane's Museum, London, inscribed *Vase for Thomas Dundas Esqʳ. for a prize*. It was one of a series of so-called Gold Cups run for at Richmond Races, all of which appear to have been made by Smith and Sharp, the earliest recorded being those of 1764: one at Anglesey Abbey, Cambridgeshire (The National Trust), the other sold in London in 1969 and bearing the name Thomas Dundas along with that of Sir Marmaduke Wyvill, Bart., as stewards.

The races were first run in 1759 and for the first five years were all won by the Duke of Cleveland's bay horse, Dainty Days. In 1765 the course was moved from the High Moor to a new one at Whitcliffe, but the same pattern continued to be used for the Gold Cups, valued at £80. In 1766 the race was won by Lord Rockingham's horse Shadow. Royal George, recorded as finishing fourth on the 1766 cup, was owned by Thomas Dundas, Esq., MP for Richmond from 1763 to 1768, and for Stirling from 1763 to 1794, when he was created Baron Dundas. His father, Sir Lawrence Dundas, 1st Bart. (see no. 281) was the owner of two country houses: Moor Park in Hertfordshire and Aske Hall just outside Richmond in Yorkshire. The race course was laid out on part of the latter estate, and it is no wonder that the Dundas family's proprietary interest in it should have led to this commission—for they were also among Robert Adam's most important patrons.

The design of the cup illustrates the fine complexity of early English neo-

classical silver design, the form based on a classical Greek urn but enriched in typically English style with a frieze of racehorses and jockeys between beaded borders below the rim, and with oval medallions on either side, one with horses being exercised by their grooms, and the other with a race past the winning post. The spreading foot with its swirled, fluted pattern, and the twisted handles rising to caryatids and foliate scrolls, said to represent Victory, are almost rococo in manner, and were indeed abandoned by the makers for the cups of 1765 and 1768, though with less happy results than in Adam's original design. The latter was faithfully followed once again for the 1770 cup (which is still at Aske Hall, in the collection of the present Marquess of Zetland). This also bears the inscription *Wm Pickett, London, Fecit 1770*, the firm of retailers who eventually became the Royal Goldsmiths Rundell, Bridge and Rundell.

Daniel Smith and Robert Sharp were among the foremost silversmiths commissioned to interpret Adam's neoclassical designs for silver, and were responsible for many impressive pieces of domestic silver as well as race cups and other presentation pieces. Their partner Richard Carter, who entered a joint mark with them in 1778, appears to have been a younger brother of John Carter, who made candlesticks from designs by both Robert Adam and James Wyatt. J.B./G.J-S.

Literature: Rowe 1965, 35–36, pls. 6, 7, 8
Exhibitions: Canterbury 1984 (80, pl. 19)

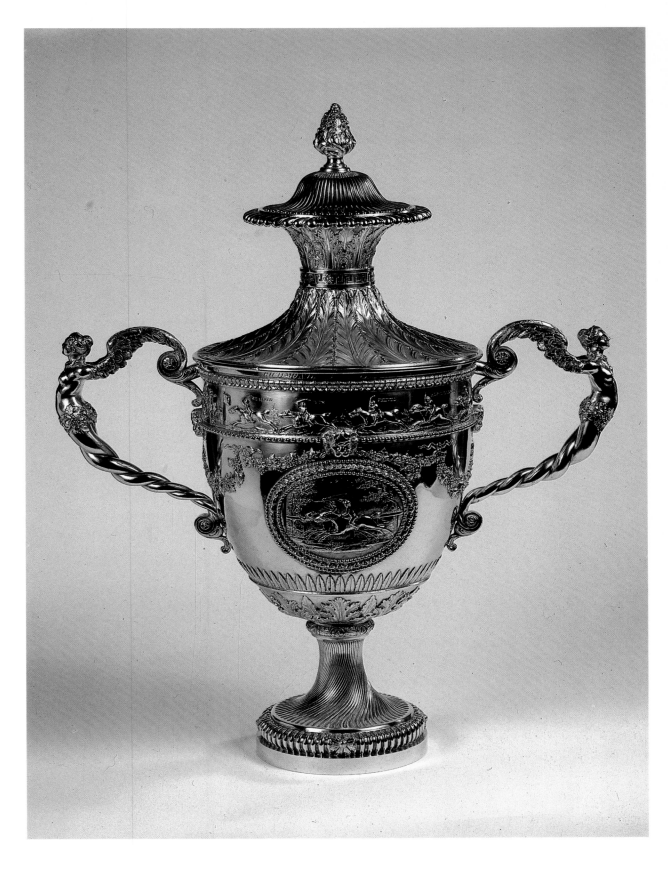

461

TRIPOD PERFUME BURNER WITH
CANDLE BRANCHES c.1760
designed by James "Athenian" Stuart
1713–1788 and attributed to
Diederich Nicolaus Anderson d.1767
gilt-bronze and marble
53.3 (21)

Kedleston Hall
The Viscount Scarsdale and the Trustees
of the Kedleston Estate

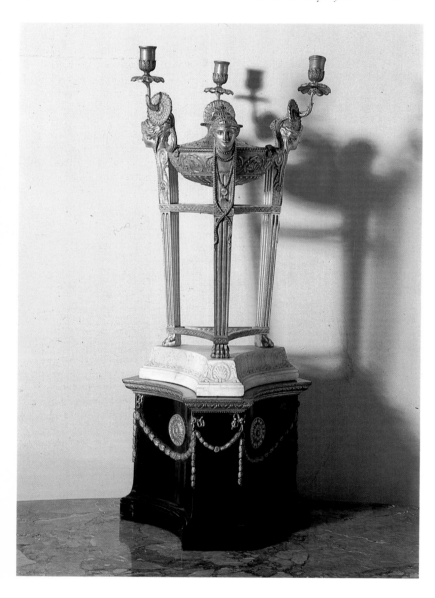

This exquisite neo-classical tripod can
be seen in a famous drawing by Robert
Adam showing the sideboard alcove of
the dining room at Kedleston, dated
1762 (Harris 1963, fig. 3), and it was
for this reason that its design used to
be attributed to Adam. However, the
Duchess of Northumberland, who visited
the house in August 1766, described
the alcove "adorn'd with a vast quantity
of handsome plate judiciously dispos'd
on Tables of beautiful Marble & of
very pretty shapes, in the midst is
M^r Stewart's Tripod." James "Athenian"
Stuart had produced designs for
Kedleston in 1758, which Sir Nathaniel
Curzon eventually rejected in favor of

Adam's (see no. 359). Two of these
sketches show tripods of this pattern,
one in the form of perfume burners, and
the other as a candelabrum (Goodison
1972, 695–704), while Stuart's design
for the Painted Room at Spencer House
(see no 269) includes almost identical
candelabra, of which a pair still survive
in the Spencer collection at Althorp.
The idea seems to have stemmed from
his attempt to reconstruct the original
tripod which was thought to have
crowned the Choragic Monument of
Lysicrates (or Tower of the Winds),
drawn for inclusion in his pioneering
Antiquities of Athens, which appeared in
two volumes in 1762 and 1789.

The tripods made to Stuart's design
in the early 1760s have often been
attributed to Matthew Boulton, but
Nicholas Goodison has shown that his
firm was not capable of producing gilt
ornaments of such size and quality at
this date. However, Diederich Nicolaus
Anderson, who made the plate warmer
for the dining room at Kedleston (no.
462) exhibited "a tripod, from an
original design of M^r Stuart's" at the
Free Society of Artists in 1761 (Gunnis
1968, 17), and was almost certainly the
maker of this example, together with
one from Wentworth Woodhouse (now
in the Victoria and Albert Museum),
where Stuart was also employed in the
late 1750s. G.J-S.

Related Works: Another tripod by
Anderson, probably made for Charles
Pelham, exists in a private collection
(Goodison 1974, 141), and several later
copies were made by Matthew Boulton
after 1771: for example a set of four
commissioned by Earl Gower (Duke of
Sutherland collection) supplied in 1777
for a total of £181.1s.6d. Three draw-
ings for the tripod, all inscribed, "for Sir
Nathaniel Curzon Bart" exist among the
Adam drawings at the Sir John Soane's
Museum, London, but these must either
be by Stuart himself, or copies of his
work, or drawings of the finished tripod
by one of Adam's draftsmen
Literature: Goodison 1972, 695–703;
Goodison 1974, 140–143, pls. 65–67

462

PLATE WARMER 1760
Diederich Nicolaus Anderson d.1767
gunmetal and ormolu, on a mahogany
parcel-gilt base
114.3 × 52.5 (45 × 20¾)
signed beneath the cover, *Diederich
Nicolaus Anderson made this plate-warmer
in 1760*

Kedleston Hall
The Viscount Scarsdale and the Trustees
of the Kedleston Estate

"The Plate warmer too in the Shape of
a Vase is extreamly handsome," wrote
the Duchess of Northumberland in
her description of the dining room at
Kedleston in 1766. The comparatively
recent discovery of the inscription
beneath the cover has revealed the full
name of this highly skilled ormolu-
worker for the first time, suggesting
also that he was an immigrant from
Scandinavia, like the contemporary
Swedish cabinetmaker Christopher
Fürlohg (Goodison 1974, 22). Both
appear to have been in the immediate
circle of Sir William Chambers, who
himself came from a Scottish merchant
family settled in Sweden; and Chambers
may even have been instrumental in
bringing them to London.

A design for the plate warmer is
among the Adam drawings at Sir John
Soane's Museum in London (vol. 23:93),
and although this is unsigned and could
be a copy by one of his draftsmen from
a lost original (see no. 461), the antique
vase design with caryatids holding hands
is very much in Robert Adam's Roman
idiom, rather than in James "Athenian"
Stuart's Greek. Placed in front of the
open fire, and with its back open, the
urn could have held a considerable stack
of plates, and somewhat compensated
for the fact that the kitchen at Kedleston
was in a separate wing, several hundred
yards away from the dining room. G.J-S.

463

THE 3RD LORD BERWICK'S
AMBASSADORIAL PLATE 1805–1818
Paul Storr 1771–1844, Benjamin Smith II
and James Smith III, partners 1808–1812,
and others
silver-gilt
candelabrum centerpiece: 54.6 (21½)
high; candelabra: 65.4 (25¾) high;
dessert stands: 30.5 (12) diam.; coasters:
13.9 (5½) diam.; decanter labels: 8 × 8
(3 × 3); teapot: 15.5 (6) high; ewer:
16 (6¼) high; sugar bowl: 16 (6¼) high

Attingham Park
The National Trust
(Berwick Collection)

These pieces form part of the Ambassa-
dorial Service issued by the Jewel House
on behalf of the crown to William Noel-
Hill, later 3rd Baron Berwick, who was
envoy extraordinary and minister
plenipotentiary to the King of Sardinia
from 1807 to 1824 (on the practice of
equipping ambassadors with plate, see
no. 453). Lord Berwick's taste for silver-
gilt is evident in the large collection
that still survives at Attingham, the
house he inherited from his brother in
1832, and it is interesting that he was
able to return for more pieces over a
long period rather than being issued
with a complete service all at once.

All the pieces would have been
ordered through the Royal Goldsmiths,
Rundell, Bridge and Rundell of Ludgate
Hill, although they were the work of
different makers. The larger-scale items
came from the Dean Street workshops
of Paul Storr, including the pair of three-
light candelabra here (1808/1810), two
of a set of six, and the candelabrum
centerpiece with a dessert basket (1814).
They are engraved with the arms of
King George III and the crest of the
Noel-Hill family. The design of the
candlesticks was originated by Storr as
early as 1798, though with rather less
elaborate foliage chasing round the bases
and stems. The very beautifully con-
trived sconces echo the anthemion
pattern of the sticks, with highly sculp-
tural honeysuckle and foliage branches.
The mixing up of sets made in any one
year seems to have been endemic at the
Jewel Office, as in this instance when
earlier branches (dated 1808) were

supplied with later candlesticks (dated
1810). It is interesting to note that
similar branches but with different sticks
were supplied by Rundell, Bridge and
Rundell in 1810 (Duke of Hamilton
sale, Christie's, London, 1919). The
Attingham candlesticks can be used
either singly (without branches), to burn
two candles only (with a detachable
pine-cone finial in the central nozzle),
or as full, three-light candelabra.

The centerpiece has two pairs of
branches and a central dessert basket
supported by caryatid figures of the
Three Graces, who stand with out-
stretched arms and hold crossed staves
with pine-cone or "thyrsus" terminals,
tied with ribbons. As embodiments of
the threefold aspect of generosity—the
giving, receiving, and returning of
gifts—these maidens must have been
thought particularly appropriate as
decoration for an ambassador's table. A
set of three similar dessert stands were
made in 1810 for the 2nd Earl of Belmore
(private collection, London) and a larger
pair were made in the same year for the
Duke of Wellington's Ambassadorial
Service (now at Apsley House, London).
The idea of making large *surtouts de table*,
including centerpieces of such massive
architectural form, came at a time when
one long table had become part of the
permanent furnishing of a dining room
for the first time—in place of the
smaller folding tables set up by footmen
in the mid-eighteenth century.

The pair of decanter coasters, from a
set of eight, is also by Storr and of a
pattern that first occurs in his work
about 1814. All the attributes of wine
and wine drinking were incorporated in
the design of these "wine slides" with
baize-covered bases so that they could
be passed smoothly and easily from guest
to guest. Here the smith has produced
a rich intertwining pattern of vine
tendrils and bunches of grapes among
which sport infant bacchanalian figures
and the leopards associated since classical
times with Bacchus, god of wine. Other
coasters of this pattern were formerly
in the collections of the Earl of Lonsdale
and the Earl of Harewood and there is a
set of twelve in the Wellington service
at Apsley House. All carry the usual
Latin inscription of "Rundell, Bridge
and Rundell aurifices regis et principis

Walliae regentis Britannias."

By the turn of the eighteenth century, plain glass was not considered suitable for use with elaborate dinner services, and so simple bottles were largely superseded by cut glass decanters. For such massive pieces, the small, plain, bottle ticket of engraved silver was hardly acceptable, and those in the forefront of fashion were quick to order cast and chased decanter labels of suitable size and weight, often gilded for an effect of greater grandeur. One of the most popular patterns was that of a finely tooled wreath of grapes and vine leaves tied at the top with a ribbon of silver and with the wine name pierced on a

swag or festoon, with fringed borders echoing the fashionable drapes of the period.

The pattern was apparently first conceived by Digby Scott and Benjamin Smith of Greenwich in 1806, goldsmiths who were almost wholly employed by the royal suppliers, Rundell, Bridge and Rundell. Indeed, at least four such labels of that date were specially made for Queen Charlotte, who had a small oval added below the upper part with her monogram in script as a personal touch on the many generous gifts she made to friends and relatives.

The dies for the wine labels were used first by Benjamin Smith who

worked on his own from 1807, then with his brother James from 1809 until 1812. After the Smiths had parted from Rundell's, the dies apparently remained the property of the Royal Goldsmiths and were used by various makers, including the smallworkers Phipps, Robinson and Phipps, who appear to have worked for Rundell's after the Smiths and Paul Storr resigned. These labels, with three others in the set of twelve, dated 1814, seem to be their only use of the pattern and were probably made for Lord Berwick's ambassadorial service to supplement an earlier group made by the Smiths. While madeira, sherry, port, and claret were

usual in almost every country house, it is interesting that the ambassador also regularly served the French Hermitage (which could be red or white) and the Portuguese Bucellas, a wine made in the Lisbon area, which had become fashionable among Wellington's officers during the Peninsular War.

Benjamin and James Smith's contribution to Lord Berwick's service included the pair of footed dessert stands of 1810, again engraved with the arms of George III. A number of similar dessert salvers have been recorded. The earliest, by Digby Scott and Benjamin Smith, made for Ernest-Augustus, Duke of Cumberland and King of Hanover, in

1805, are rather less grandly bordered, having only a single row of vine foliage, but about 1807 Benjamin Smith appears to have developed the even richer style of vine border. One pair survives with the arms of Lennox, for the 4th Duke of Richmond and Gordon, while another pair of the same year were made for Charles Duncombe, later 1st Baron Feversham, and his wife. The following year Benjamin Smith made others with the royal arms, including a pair later issued as ambassadorial plate to the Duke of Wellington, while the pattern was later continued by Paul Storr for the Royal Goldsmiths after Benjamin Smith had left the firm. The engraving

was the work of Walter Jackson, who had been apprenticed to John Thompson of Gutter Lane and whose album showing the royal and other armorials is preserved in the Victoria and Albert Museum. His distinctive, rather busy style initiated the tradition of typical nineteenth-century engraved armorials (Oman 1978, ch. 6).

All the pieces so far described belonged to Lord Berwick's dinner service, but for his embassy to Turin he was also issued a three-piece silver-gilt tea service, made by the Smiths: a cream ewer of 1805, a teapot of 1807, and a two-handled sugar bowl of 1809. These different dates once again show that the Jewel House apparently held plate ready

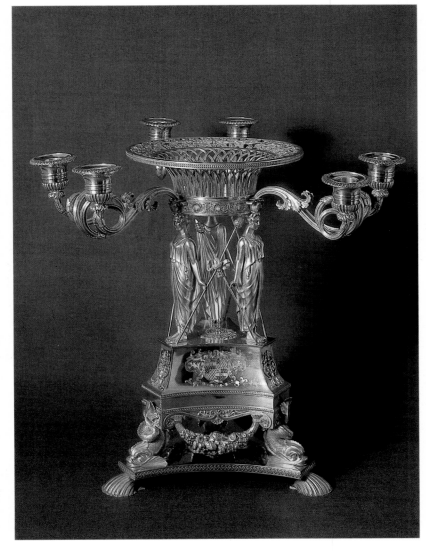

for ambassadorial issue as required, but did not necessarily keep exact sets together. The neoclassical design of the service, influenced by French styles of the period, appears to have been standard output from Lime Kiln Lane, Greenwich, from where Scott and Smith were suppliers of plate to Rundell, Bridge and Rundell, the Royal Goldsmiths, and other examples of the pattern by the same makers have been noted from 1804 to 1808. The ewer and bowl show the most pronounced French features, while the compressed circular teapot is reminiscent of an ancient Roman oil lamp. All are decorated with a finely cast, chased, and applied Greek key border within beaded edges. Among similar examples are an eight-piece double service of 1806 by Scott and Smith comprising two cream ewers, two sugar basins, and four teapots, bearing the crest of Charles Howard, 11th Duke of Norfolk (1746–1815).

Lord Berwick's plate is now displayed in the dining room at Attingham and in a new installation recently devised in the vaulted basement below the entrance hall. J.B.

Provenance: By descent at Attingham; bequeathed to the National Trust by the 8th Lord Berwick, 1953
Literature: Penzer 1954, 144, pl. 33
Exhibitions: London, Christie's 1957–1958 (189); York 1969 (51, 52, 55, 56, 58, 59) and pl. 13; Brussels 1973 (126)

464

THE DONCASTER RACE CUP 1828
Rebeccah Emes and Edward Barnard
partners 1808–1829
silver-gilt
39.4 (15½) high
inscribed, *Doncaster Races, 1828/Won by Major Yarborough's Bay Horse Laurel/The Right Honble. Lord Viscount Morpeth, The Honble John Stuart Wortley M.P. Stewards/P. Bright Doncaster, Fecit.*

Lotherton Hall
Leeds City Art Galleries

Despite the somewhat boastful inscription, Mr. Bright of Doncaster appears only to have been the retailer of this splendid cup, which was actually made by the London firm of Emes and Barnard, supplier of all the Doncaster race-cups from 1821 to 1829, and probably many later ones as well. In February 1830, their day books (Victoria and Albert Museum MSS) record that Bright was charged £4.10s.0d. for "9 fin'd drawings of the Doncaster Cups, 1821 to 1829 inclusive," and the present cup is

recorded in the following entry dated 9 September 1828:
"Mr. P. Bright
A 6 Quart antique egg shape Vase (Buckingham) beaded ovolo edge and chas'd Greek Honeys'ckle & scroll on neck under flanch vine and bays bro[t]. on body all over & leaves & hs'kles bottom, div'd. rich husk d'ble snake handles with Vine curls &c. concave fluted foot, sqre. plinth & struck collet wire (no cover.) Gilt all over. Engd. on plinth *Doncaster Races 1828* & rev. Stwd. names, Lord Morpeth, Mr. S. Wortley, MP. Wainscot Case." The total price of £142.14s.1d. included duty on 170 = 7 oz at £12. 15s. 7d., metal and making at 5/4d. and 6s. an ounce coming to £96. 8s. 6d., gilding £30, engraving £1. 10s. 0d., and the wooden case £2.

The so-called "Buckingham Vase" was a famous classical antiquity excavated by Gavin Hamilton at Hadrian's Villa in Rome in 1769, and engraved by Piranesi in his *Vasi, Candelabri, Cippi . . .* in 1778 (Focillon 1918, F614). It was acquired by George, Lord Temple, Marquess of Buckingham, and was among the best known objects in the collection at Stowe, his great house in Buckinghamshire sold in the Stowe sale of 1848 (H.R. Foster, lot 749; the vase, which measured 46 inches in height, was bought by an untraced Bond Street dealer, Town & Emmanuel, and its subsequent whereabouts are unknown).

The Piranesi engraving is detailed, but the making of the vase was nonetheless a tour-de-force of the modeler, caster, and chaser in the workshops at Amen Corner, proving that they were fully capable of competing with the Rundell and Bridge workshops, for which, indeed, they supplied finished goods from time to time.

Emes and Barnard used the design for a number of vases, wine coolers, and other silver items in the early years of the nineteenth century. Their working drawings for this cup (private collection, England, and Victoria and Albert Museum, London) show an alternative for the snake handles, perhaps proposed to make a more suitable race cup, but the Doncaster Race Committee evidently insisted on the authentic model (Udy 1978, 833). The presence among them of

Lord Morpeth, one of the two Stewards of Doncaster racecourse, suggested to Udy that he may have recommended the antique source; later 7th Earl of Carlisle, he was the heir to Castle Howard and one of the most important antique collections in England (see no. 229).

The acquisition of the cup in London in 1966 by Leeds City Art Galleries, and its subsequent display at Lotherton Hall was particularly fortunate because it joined a fine collection of silver-gilt race cups dating between 1776 and 1829, collected by the Gascoignes of Lotherton.

J.B.

Provenance: David Udy, Esq.; bought by Leeds City Art Galleries, Temple Newsam, with the aid of a government grant, 1966; transferred to Lotherton Hall, Aberford, Yorkshire
Literature: Banister 1976, 168
Exhibitions: Arts Council 1978 (316)

465

VASE AND COVER 1800
Paul Storr 1771–1844
silver-gilt
49.5 (19½) high

Woburn Abbey
The Marquess of Tavistock and the Trustees of the Bedford Estates

This vase, engraved with the arms of Francis Russell, 5th Duke of Bedford (1765–1802), is in the late neoclassical manner favored by the Adams and the Wyatts, and especially appropriate for its patron, the founder of the collection of antiquities at Woburn. It displays the particular ability at chasing and modeling silver on a large scale that must have recommended Paul Storr to the Royal Goldsmiths, Rundell and Bridge. Originally a tea urn, the tap and spigot have been removed, resulting in a piece suitable for display on a dining room buffet. The tripod form, on hoofed feet rising to caryatid sphinxes

derives ultimately from the bronze table from the Temple of Isis at Pompeii, excavated under the Bourbons in the mid-eighteenth century, and Storr may have taken the design from an etching in Piranesi's *Vasi* of 1778 (Udy 1978, 824, and figs. 33, 34). This is one of the earliest uses of Egyptian ornament in English silver; David Udy has suggested that the river goddess who reclines on the lid is symbolic of the Nile, and it is surely significant that it was in 1800

that Nelson returned from his famous victory (1978, 827, and see no. 426). The treatment of the figures, including the reclining nymph finial, the overlapping paterae of the lower molding, the pendant beads, the compressed anthemion border, and the water-leaves round the base and on the cover have all the ingredients that were to mark the finest silversmithing in the years of the Napoleonic Wars.

J.B.

Literature: Penzer 1954, 110, pl. 16; Grimwade 1965, 506, pl. 10
Exhibitions: London, RA 1950 (111)

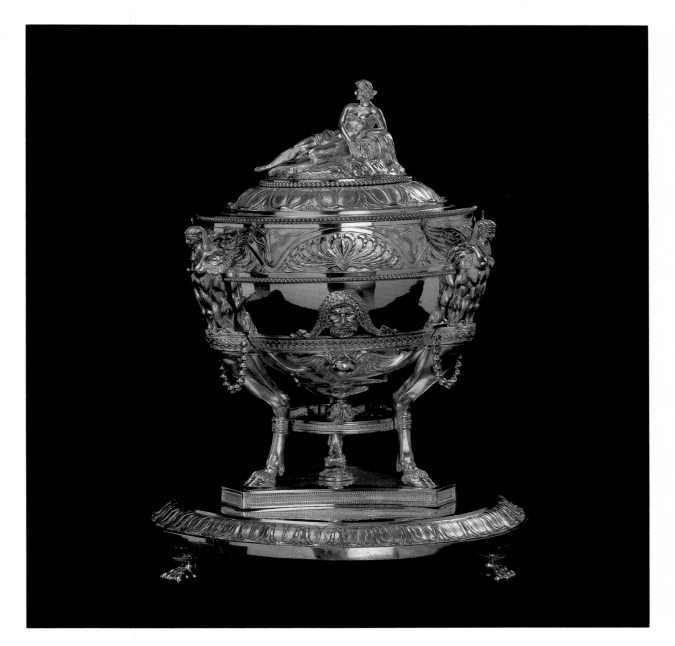

466

EGG CODDLER ON LAMPSTAND 1802
John Edwards III free 1782
silver-gilt
34.5 (13½) high

Attingham Park
The National Trust
(Berwick Collection)

The late eighteenth- and early nineteenth-century fashion for breakfasts, especially in large country houses, brought a host of useful tablewares into fashion; among the most conspicuous were the egg coddler or egg boiler. This unusually splendid one has a frame for four eggs incorporating a sand-glass timer in the handle. The flat cover of the pan is hinged on either side so that it can be completely closed during the cooking process. The pan has the twisted double serpent handles that were popular at this period, and is supported on an elegant frame with a small spirit lamp burner *en suite*. Edward's work, executed either alone or in partnership, with

William Frisbee briefly in 1791, or with his son Edward, from 1811, is often gilded though plain and elegant in design. It is likely that he undertook work for retailers in the City of London, such as Rundell, Bridge and Rundell. An identical egg coddler of the same year, also gilded, was sold from the Harcourt collection in 1961. In style it is perfectly matched to the neo-classical formality of George Steuart's house designed for Noel Hill, later 1st Lord Berwick, in 1782 and with new stairs and a gallery added by John Nash in 1805. J.B.

Provenance: See no. 463

467

SOUP TUREEN FROM THE DECCAN
SERVICE 1806
John Edwards III free 1782
silver, parcel-gilt
30.4 (12) high

Stratfield Saye
The Duke of Wellington

The Deccan Service, called after that part of southern India coterminous with the great plateau, was presented to Major General the Hon. Sir Arthur Wellesley, later 1st Duke of Wellington, by his fellow officers in the Indian Campaign of 1796–1805. The service is divided between the duke's country seat at Stratfield Saye in Hampshire and Apsley House in London, both presented to him by the nation after Waterloo. Appropriately, Indian themes dominate the design of this grand tureen-centerpiece engraved with the Wellesley arms. The richly wrought circular bowl has a frieze of victorious laurel wreaths, intertwining snake handles, and supports in the shape of heavily caparisoned elephants facing the four points of the compass. The finial on the cover is formed as an Indian with a parasol seated on a lotus-flower disc. It is not known who was responsible for the designs used for this service, though the work was carried out by four different silversmiths: William Fountain, Joseph Preedy, John Moore, and John Edwards, between the years 1806 and 1814.

The duke was especially fond of Stratfield Saye, which still contains pictures, portraits, sculpture, furniture, and other possessions that he used and loved (Cornforth 1975, 899–902, 982–985). By the 1830s he and his house were a place of pilgrimage for all who still remembered his great victories, and it is intriguing to find that a board still survives instructing visitors "desirous of seeing the Interior of the House . . . to ring at the door of entrance and to express their desire. It is wished that the practice of stopping on the paved walk to look in at the windows should be discontinued." J.B.

Literature: Oman 1973, 197–205, pl. 4;
Sulton 1975, 4–6

468

CHAMBER CANDLESTICK 1810
English
silver-gilt
17.5 (6⅞) high

Attingham Park
The National Trust
(Berwick Collection)

In many large country houses, the plate
room would display row upon row of
chamber candlesticks, each destined for
the household's bedchambers and those
of the guests. Being primarily utilitarian,
most were of simple form, incorporating
a short plain sconce, usually of baluster
form, with a plain nozzle; the base was
dished to catch liquid wax droppings
and was of generous diameter if the
householder was particularly afraid of
fire. On occasion, however, chamber
candlesticks of unusual design were
commissioned for the owner's personal
use or for traveling, following the
allegorical styles more usual in the
drawing room or the dining room.
This example uses the motif of the
snake biting its tail, the symbol of
eternity, often accompanying the figure
of Time, for it forms a circle (in this
case a figure of eight) that never ends.
Made by an unidentified London smith

in 1810, it is a silver-gilt "toy" perhaps
spotted during a visit to London by
Thomas Noel-Hill, 2nd Baron Berwick
(1770–1832). It is the sort of charming
conceit that may well have been dis-
played in the glittering windows of
Rundell, Bridge and Rundell on Ludgate
Hill or at Wakelin and Garrard's in the
West End. Lord Berwick's extravagance
was so extreme that in 1827 he was
forced to sell almost the entire contents
of the family house at Attingham, leav-
ing only small items like this as part of
the depleted inheritance of his brother,
William, who succeeded as 3rd Baron in
1832.

The maker's mark has generally been
read as *LL* in script (though inverted
it can be read as *TT* in script). So far
it has only been recorded on two other
chamber candlesticks of the same pat-
tern, dated 1810 and 1812, and on a box
of 1811, which may suggest that the
maker was a smallworker and could poss-
ibly be one Lewis Landfriede, recorded
by Grimwade as having entered marks
as a goldworker in 1801 and 1810. J.B.

Provenance: See no. 463
Literature: Grimwade 1982, no. 3723
Exhibitions: York 1969 (57); Brussels
1973 (123)

The late eighteenth century and the early nineteenth, the years of Nelson's victory at Trafalgar and Wellington's at Waterloo, saw triumphs in the artistic as well as the political field. Not only did the greatest period of English portraiture, the age of Gainsborough and Reynolds, lead to the landscape paintings of Constable and Turner, but many of the finest old masters were bought by British collectors from France, Italy, and Spain, gathered in top-lit picture galleries like those at Attingham, Somerley, and Petworth.

Portraiture has always been central to the development of painting in Britain and its pre-eminence was confirmed by a succession of native painters of genius: Ramsay, with his Italian training and French sympathies; Reynolds, whose close study of the old masters and understanding of his sitters, whether in childhood or old age, informs his every portrait; Gainsborough, the sounder craftsman and at his best, as in the portrait of the *Duchess of Montagu* (no. 472), an observer of extraordinary penetration; Romney, blunter in technique yet unrivalled as a painter of peerless complexions and shimmering satin; Hoppner, happiest when informal and in the depiction of children; Lawrence, whose flair and bravura made him the natural painter of the allied commanders after the defeat of Napoleon; and Raeburn, whose noble and romantic visions of the dignity of man offer parallels with the novels of Sir Walter Scott. Alongside their achievements, sculptors like Nollekens, Chantrey, and Campbell produced portrait busts of remarkable power, though their allegorical groups never approached the sublimity of Canova's *Three Graces* (no. 480), which the 6th Duke of Bedford installed in a specially built temple at one end of the sculpture gallery at Woburn.

While the lack of support for "history pictures" was bemoaned by some writers, the progress of the Industrial Revolution is suggested by Wright of Derby's *Iron Forge* (no. 485) and the rise of social conscience by Wheatley's moving picture of the reformer John Howard visiting a prison (no. 484). The most adventurous patron of native artists and sculptors in the early nineteenth century was another Whig aristocrat, the 3rd Earl of Egremont, the friend of Turner, Blake, Flaxman, and many of their contemporaries, but Sir John Leicester, who commissioned Turner to paint Tabley (no. 582), also collected works of the English school, including John Martin's *Destruction of Pompeii and Herculaneum* (no. 521), a match for the drama of Fuseli's scenes from Macbeth (no. 522). Constable's heroic Suffolk landscapes, perhaps more boldly innovative in their directness than any other pictures of the time, did not appeal to those with traditional tastes: *The Lock* (no. 518) was purchased by a successful haberdasher, James Morrison.

The French Revolution precipitated the sale of many of the great collections in France—that of the Dukes of Orleans was only the most celebrated—and the French invasions of Italy and Spain were yet more destructive. The British and their agents were swift to take advantage of the situation, securing seicento masterpieces from Roman palazzi, Rubens and Van Dycks from Genoa, Velasquez and Murillos from Madrid. The full measure of their achievement can best be sensed in the volumes of Waagen, and the catalogues of the loan exhibitions to the newly-founded British Institution. Many of the finest collections of old masters, like those of Earl Grosvenor, the Marquess of Stafford and J.J. Angerstein, were kept in London, where the last generation of great town houses were constructed, and were only moved to the country at a later date. C.R. Leslie's conversation piece set in the gallery at Grosvenor House (no. 517) gives a marvelous impression of the opulence of such interiors, with the Velasquez (no. 497) clearly shown in a crowded arrangement of pictures on the Pompeian red walls.

Primitives, first collected by the Earl-Bishop of Bristol, began to attract collectors like William Roscoe and his friend Charles Blundell of Ince in the early nineteenth century, but the renewal of interest in early Italian painting is also revealed by canvases of the Venetian cinquecento, the Titian from the extraordinary collection formed by William John Bankes for Kingston Lacy (no. 498), the Palma bought by the 4th Duke of Northumberland for Alnwick (no. 494), and the Tintoretto from Longleat (no. 501). That all three houses were restored or decorated in the Italianate style suggests the central role such collecting played in the taste of the early Victorian era.

The "Battle of the Styles" seen elsewhere in the architecture of the period—Grecian, Egyptian, Gothic, neo-Norman—is also reflected in the decorative arts. The eclecticism of William Beckford's collection at Fonthill, ranging from Mughal carvings to Augsburg metalwork, from Boulle and ebony furniture to majolica, Limoges and ivories, found many imitators in the early nineteenth century including the Prince Regent himself, and his friend the Marquess of Hertford. Their particular passion for the finest French furniture, easily obtainable in the aftermath of the Revolution, was shared by the Duke of Wellington, who purchased important pieces for Stratfield Saye, and was later taken up by the Rothschilds in their Buckinghamshire houses—Mentmore, Waddesdon, Halton and Ascott. Thomas Hope's refined Egyptian and Greek Revival designs, and those of his protégé, the sculptor Flaxman, meanwhile influenced a whole generation of Regency cabinetmakers and upholsterers, goldsmiths and jewelers. The latter's neoclassical tiaras set with cameos and intaglios particularly reflect the cosmopolitan brilliance of social life in the aftermath of Waterloo.

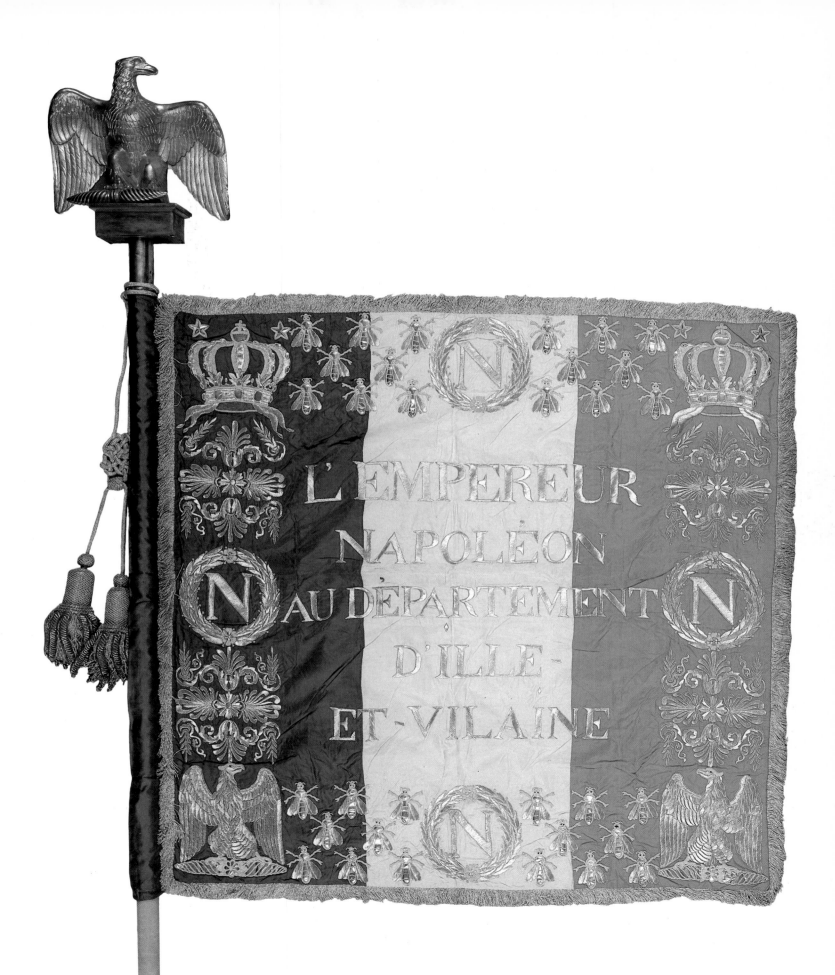

469

LADY CAROLINE SCOTT AS "WINTER"
1776
Sir Joshua Reynolds 1723–1792
oil on canvas
143.5 × 112 (56½ × 44)
inscribed at bottom left, *Lady Caroline Montagu 1777*

Bowhill
The Duke of Buccleuch and
Queensberry, KT

Lady Caroline Montagu-Scott, third daughter of the 3rd Duke of Buccleuch, was born 6 July 1774. She married in 1803 Sir Charles Douglas, 5th Bart., who became the 5th Duke of Queensberry in 1810. She died 29 April 1854.

There is no surviving sitter book for 1776 and her name does not appear in that for 1777, but J.R. Smith's mezzotint of the picture (entitled "Winter") was published 1 November 1777, and there seems little doubt that the two pictures exhibited at the Royal Academy in 1777, "(287) Ditto [that is, portrait] of a young nobleman/(288) Ditto of a young lady," were the companion portraits of Charles William Henry, Earl of Dalkeith, and Lady Caroline (Waterhouse 1941, pls. 184–185). There is a tradition (earliest source unknown) that she entered the studio in the attire seen in this picture, while Sir Joshua was painting her brother, and that he insisted on painting her. It seems to have been finished in December 1776, when it was seen in the studio by Horace Walpole (letter of 17 December 1776 to the Countess of Upper Ossory), who wrote: "But of all delicious is a picture of a little girl of the Duke of Buccleuch, who is overlaid with a long cloak, bonnet and muff, in the midst of the snow, and is perishing blue and red with cold, but looks so smiling and good-humoured, that one longs to catch her up in one's arms and kiss her till she is in a sweat and squalls." The background is perhaps taken from a picture by Aert van de Neer, but Reynolds added the woodcock.

E.K.W.

Provenance: Painted in the second half of 1776, but the payment does not appear in Reynolds' ledger until "Aug. 1783 Duke of Bucclieugh [sic] for his Son and Daughter £147"; it has remained in the family collection ever since
Literature: Graves and Cronin 1899–1901, 2:656 (as "Lady Caroline Montagu"); Waterhouse 1941, pl. 184, and 1973, pl. 58
Exhibitions: London, RA 1777 (288); Birmingham 1961 (66)

470

LADY SUSAN FOX-STRANGWAYS 1761
Allan Ramsay 1713–1784
oil on canvas
94.6 × 64.7 (37¼ × 25½)

Melbury House
Lady Teresa Agnew

Lady Susan Fox-Strangways (1743–1827) was the eldest daughter of Stephen, 1st Earl of Ilchester by his wife, Elizabeth, heiress through her mother of Melbury and the Strangways estates in Dorset. She was a bridesmaid to Queen Charlotte in 1761 and the portrait may well have been commissioned to commemorate this event. Lady Susan was a favorite of her father's younger brother Henry, 1st Lord Holland, and from about 1760 spent much of her time at Holland House, becoming the intimate friend of her uncle's sister-in-law, Lady Sarah Lennox, daughter of the 2nd Duke of Richmond (see no. 396). Lady Holland, had as Lady Georgina Lennox performed in the celebrated children's production of Dryden's *Conquest of Mexico* in 1731, recorded by Hogarth's picture now at Melbury, and she no doubt encouraged the series of amateur productions staged at Holland House in the early 1760s. Lady Susan and Lady Sarah both performed in these as did the Hollands' younger son Charles James Fox. Reynolds' great portrait of the three at Melbury dates from this period. In 1764 the Ilchesters were outraged to discover that Lady Susan had fallen in love with William O'Brien, an Irish actor who had assisted with the theatricals. After a sitting for the pastellist Catherine Read, she eloped with him: the couple settled on a tract of land in North America (Ilchester 1937, 81–82) but returned to England in 1771.

In 1760 Ramsay was appointed Principal Painter to the young King George III, evidently at the suggestion of the latter's erstwhile tutor Lord Bute. His reputation as a portrait painter was already challenged by Reynolds. This rivalry had spurred him to revisit Italy in 1757, and his portraiture was brought to a new pitch of refinement in the ensuing half-decade. In this picture the beautifully described taffeta and fastidious color, pale green and white, of the dress are matched by the delicate intimacy of Ramsay's characterization. For all her reticence, there is a hint of Lady Susan's underlying strength of will. Walpole, who saw the picture at Melbury in 1762, thought it "very good":

it is indeed one of Ramsay's finest portraits and one in which his sympathy with the France of Perronneau is most evident.

Both the Ilchesters and the Hollands were patrons of Ramsay. For the former he painted Lady Susan's younger sisters, Harriet and Lucy, while the noble portrait of Caroline, Lady Holland, begun in 1763 and finished in 1766, was intended for Holland House, as were those of her sisters, Lady Cecilia Lennox, Lady Louisa Connolly, and Emily, Countess of Kildare. With the exception of the latter portrait, now at Liverpool, these remain in the collection, as does an autograph replica of that of Mary, Lady Hervey, a close family friend.

Related Works: A study for the pose is in the National Gallery of Scotland, and a drawing for the hands in the Ashmolean Museum, Oxford, no. 2083
Provenance: Painted for the sitter's father Stephen Fox Strangways, 1st Earl of Ilchester; and by descent
Literature: Smart 1952, 83, 109, 189, 191, 209, no. 54
Exhibitions: London, Grafton 1894 (48); Paris 1909 (35); London, Grafton 1909 (101); Brussels 1929 (132); London, RA 1934 (307); London, RA 1956 (221); London, Kenwood 1958 (25); London, RA 1964 (55)

F.R.

1809, the duke eventually married Lady Betty, but he died in 1811, and she later retired to Rome, where she financed excavations in the forum and patronized contemporary artists.

She introduced her stepson, the 6th Duke of Devonshire, to Canova and the Roman artistic scene, and is thus responsible for Chatsworth having the best collection of neo-classical sculpture in England. She was devious, fascinating, and highly intelligent, and she left a diary, which was written with an eye to posterity. An intelligible (and charitable) account of the *ménage* at Devonshire House has been written by Arthur Calder Marshall (1978). E.W.

Provenance: In Reynolds' ledger, under 8 July 1788 is written, "Lady Eliz. Foster, paid by the Duke of Devonshire £51.10"; the picture has remained in the Devonshire collections, but not always at Chatsworth, ever since
Literature: Graves and Cronin 1899–1901, 1:328; Waterhouse 1941, pl. 282, and 1973, pl. 114; Marshall 1978
Exhibitions: London, RA 1788 (219), and 1934 (274); and Memorial Catalogue (159)

Ralph, 1st Duke of Montagu, in a French style, with French furnishings and decorations, in the 1690s—but her father had moved to a more modest house in the Privy Gardens, Whitehall. The original Montagu House in Bloomsbury was demolished in the 1840s, when the present British Museum was built. Horace Walpole, who later quarreled with her, wrote of her to Henry Seymour Conway (6 October 1748): "I never met a better understanding, nor more really estimable qualities: such a dignity in her way of thinking, so little idea of anything mean or ridiculous, and such proper contempt for both!"

Gainsborough clearly thought this and its companion among his best portraits, for he wrote to Garrick in 1768 (Whitley 1915, 61-62): "I could wish you to call, *upon any pretence,* any day after next Wednesday at the Duke of Montagu, because you'd see the Duke and Duchess in my *last* manner...." Gainsborough did not often have a female sitter of such pronounced character, but he measured up to it very well. The painting partly visible on the back wall is clearly a fragment of a Gainsborough landscape and shows the kind of frame he favored for such pictures. E.K.W.

Related Works: Gainsborough also painted in 1768 a companion portrait of her husband (Waterhouse 1958, no. 490) and another (30 × 25 in) portrait of the Duchess (Waterhouse 1958, no. 492), probably from the same sittings
Provenance: The Duke and Duchess of Montagu's only son, the Marquess of Monthermer (nos. 173 and 174), died without issue in 1770, and their only surviving daughter, Elizabeth, wife of the 3rd Duke of Buccleuch, thus inherited Boughton, Montagu House and Ditton in Surrey, with all their contents; the picture has been at the Buccleuch seat of Bowhill since at least the mid-nineteenth century
Literature: Whitley 1915, 62; Waterhouse 1958, no. 491
Exhibitions: London, NPG 1868; London, RA 1873; Edinburgh 1885; London, Park Lane 1936 (105); London, Tate 1980–1981 (100)

471

LADY ELIZABETH FOSTER 1787
Sir Joshua Reynolds 1723–1792
oil on canvas
74 × 62 (29½ × 25)

Chatsworth
The Trustees of the Chatsworth Settlement

Elizabeth Hervey (1759–1824) was the second daughter of the notorious Earl-Bishop of Bristol (see no. 196), one of the most compulsive collectors of old and modern works of art. She had an "international" education and injudiciously married, in 1776, John Foster, a rather drunken member of the Irish Parliament, whom she soon abandoned. Returning to England, she was befriended by Georgiana, Duchess of Devonshire, whose devoted friend

and confidante she became until the latter's death (1806). When not traveling abroad she lived at Devonshire House, and also delighted the duke, whose "distinguished characteristic" was "constitutional apathy." She bore him two children, the younger of whom, Sir Augustus Clifford, was born in May 1788. She sat for this portrait in April 1787 and it was engraved in stipple by Bartolozzi the same year. It was exhibited at the Royal Academy in 1788 (no. 219) as "Portrait of a lady." The *ménage à trois* formed by the duke, Georgiana his duchess, and Lady Betty Foster was one of the most curious social phenomena of the time and their nicknames for one another were Canis, Mrs. Rat, and Racky (from Lady Betty's worrying cough). The children, legitimate and bastard, were ultimately brought up together. Three years after Georgiana's death, in

472

MARY, DUCHESS OF MONTAGU c. 1768
Thomas Gainsborough 1727–1788
oil on canvas
125.7 × 100.3 (49½ × 39½)

Bowhill
The Duke of Buccleuch and Queensberry, KT

Lady Mary Montagu (1711–1755) was the second daughter, but principal heiress of John, 2nd Duke of Montagu (d. 1749), and Mary, the youngest daughter of the great Duke of Marlborough. She married in 1730, George Brudenell, 4th Earl of Cardigan, who was created Duke of Montagu in 1766 largely because of his wife's inheritance, which included Boughton in Northamptonshire and Montagu House in London. The latter had been built by her grandfather

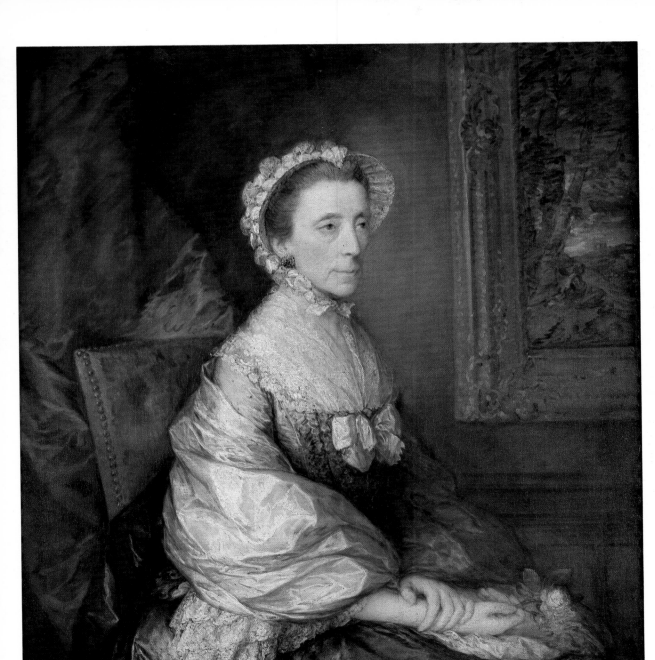

473

WILLIAM, 18TH EARL OF SUTHERLAND
1763
Allan Ramsay 1713–1784
oil on canvas
243.8 × 152.4 (96 × 60)

Dunrobin Castle
The Sutherland Trust

William Sutherland, 18th Earl of
Sutherland (1735–1766), succeeded his
father in 1750 and in 1761 married Mary,
daughter and co-heiress of William
Maxwell of Preston, Kirkcudbrightshire,
a half-length portrait of whom by
Ramsay is also at Dunrobin. In 1763
Sutherland was elected a representative
peer for Scotland. Lady Sutherland
died on 1 June 1766 and the earl
survived her by only fifteen days.
Their deaths no doubt explain why
John Adam's design of the same year
for a quadrangular stable block at
Dunrobin was not executed. In 1771
the House of Lords confirmed the
right of their daughter, Elizabeth, to
the earldom: her husband Viscount
Trentham, subsequently 2nd Marquess
of Stafford, was created Duke of
Sutherland in 1833.

Ramsay's father, the poet of the same
name, was a close friend of many of the
leading Scots of his generation, including
two notable connoisseurs, Sir David
Forbes of New Hall and Sir John Clerk
of Penicuik. More than any other major
painter of his generation, Ramsay was
brought up in the milieu of the country
house and he was to be on terms of
close and equal friendship with many
of his sitters, including the Stanhopes
of Chevening. As his father was the
first exponent of the literary revival of
eighteenth-century Scotland, so Ramsay
would become Scotland's first painter
of European standing. After his first
Grand Tour, he settled in London in
1738: many of his early patrons, the
Dukes of Argyll and Roxburgh, and
Lords Stair and Haddington, were Scots
and it was to Argyll's nephew, the 3rd
Earl of Bute, that Ramsay was to owe
his appointment as Principal Painter to
King George III. This portrait has an
important place in the sequence of his
full-lengths, following that of Norman
Macleod, 22nd of Macleod of 1747–1748

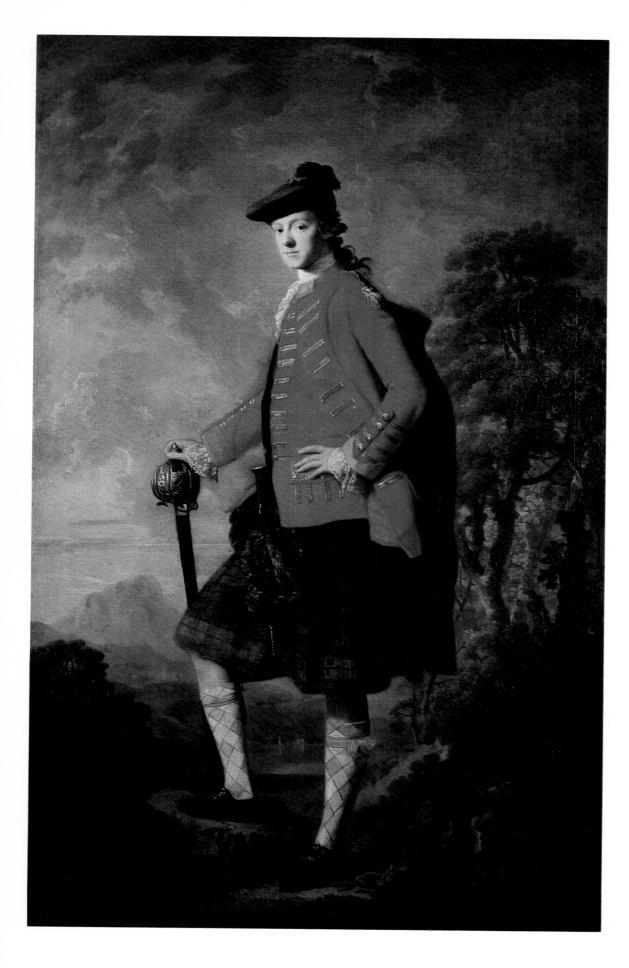

at Dunvegan, whose splendid tartan plaid does not disguise the painter's dependence on the Apollo Belvedere. The Dunrobin portrait is less theatrical, although it is an equally compelling image. The 28-year-old earl is also shown in highland dress, as Bute had been in the earliest of Ramsay's portraits of him. The artist's evident sympathy with such an expression of national sentiment explains why Walpole believed that he was himself a covert Jacobite.

The high caliber of Ramsay's full-length portraits of men of around 1760—that of the Prince of Wales, later George III, of 1757 at Mount Stuart, is the finest formal portrait of that monarch—is matched by the distinction of his portraits of women, the finest of which, like that of Lady Susan Fox-Strangways (no. 470), are almost all of a more intimate format in which his extraordinary mastery of textures could most effectively be demonstrated. Ramsay was regarded with jealousy by many of his English rivals and was consistently underrated until quite recently. As a result, many of his finest works remain in the collections for which they were painted. F.R.

Provenance: Painted for the sitter; his daughter Elizabeth, Duchess of Sutherland; and by descent at Dunrobin, no. 226
Literature: Irwin 1975, 56.

474

SIR CHRISTOPHER AND LADY SYKES
c.1786/1793
George Romney 1734–1802
oil on canvas
246.6 × 185.4 (97 × 73)

Sledmere
Sir Tatton Sykes, Bart.

Sir Christopher Sykes (1749–1801),
who succeeded his father as 2nd Baronet
in 1783, had married Elizabeth (d. 1803),
daughter of William Tatton, of Withen-
shaw, Cheshire, in 1770. Member of
Parliament for Beverley in 1784–1790,
he was an oustanding landlord, taking
a close interest in the development
and management of his considerable
Yorkshire estates. A contemporary
wrote in 1784: "Sir C. has formed, and
is forming, great designs in the planting
way which will beautify it prodigously"
(Fairfax–Blakeborough 1929). Sykes'
enclosures in the Wolds set an example
that was widely followed and his plan-
tations were extensive. He was also
responsible for the rebuilding of Sledmere
in 1787–1788.

Sykes gave Romney the unusual
number of twelve sittings for the picture
in the spring of 1786; 20, 24, 27, and 30
March; 7, 12, and 19 April; and 1, 5, 8,
13, and 17 May. Lady Sykes sat on 29
March, 3 April, and 1, 10, and 15 May,
but, as was often the case, the picture
remained unfinished in Romney's studio
for several years. The most obvious
pentimento is in the outline of Sir
Christopher's right leg. The picture
was finished by 16 May 1793 when
Romney sent the bill for 160 guineas
(Sykes MSS, Sledmere). Sir Christopher
paid in July, and the picture was dis-
patched to Sledmere on the 31st of that
month. The composition derives from
the celebrated portrait by Rubens
of the artist, his second wife, and
son, then at Blenheim and now in the
Metropolitan Museum, New York; a
copy of Earlom's mezzotint of this
remains in the house. The figures are
reversed and the action of their arms
transposed, while the place of Rubens'
offspring is taken by a favorite spaniel.

The characterization of the picture
is wholly appropriate. The Sykeses walk
arm-in-arm, he holding his spectacles,

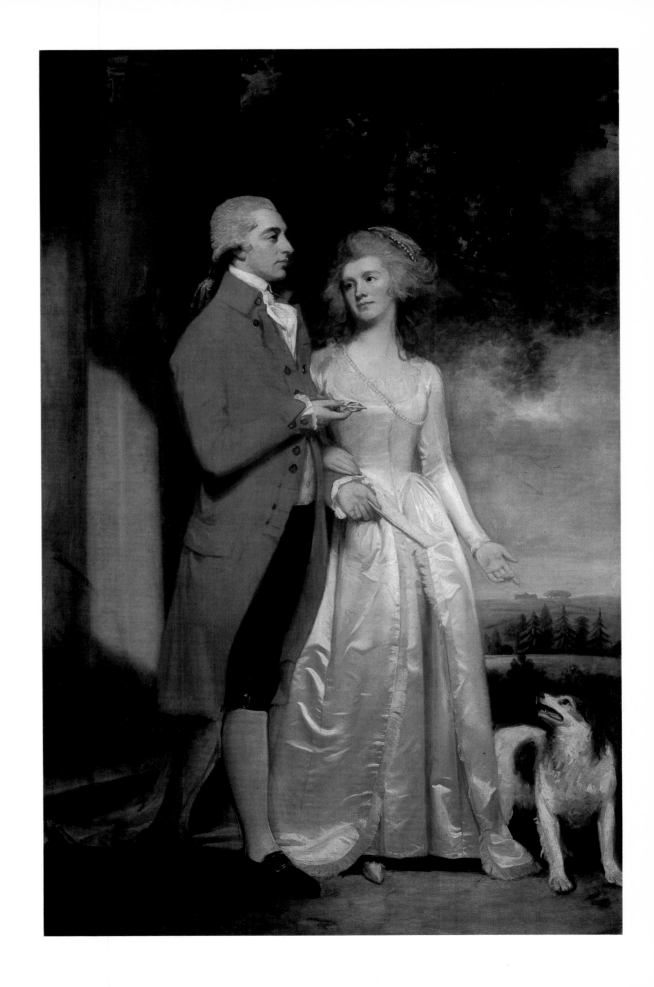

near a plantation of firs with the castle at Sledmere, an "eye-catcher" probably designed by Carr of York, in the distance. A drawing for the background recorded by Ward and Roberts in the Davies-Cooke collection (but no longer at Gwysaney) was of "a place called Maramat, near Sledmere." With the *Lady de la Pole* in the Museum of Fine Arts, Boston, and the Frick *Warwick Family*, the picture is one of the masterpieces of Romney's later years and indeed perhaps his most successful portrait group in the neo-classical vein. Few works offer a more complete view of Romney's technical abilities. The paint is handled with an impulsive brilliance; the textures, including that of Lady Sykes' wonderful dress of white satin, which reflects the splendid red of her husband's coat, are defined with extreme dexterity. The picture's soubriquet, *The Evening Walk*, first recorded in the 1920 sale catalogue, was no doubt inspired by that of Gainsborough's portrait of Mr. and Mrs. William Hallet, now generally known as *The Morning Walk*, in the National Gallery, London. This was first mentioned in *The Morning Herald* in March 1786, when Sykes began to sit for Romney, and Gainsborough's composition may well have prompted Romney to reinterpret Rubens' scheme.

F.R.

Provenance: Painted for the sitter; and by descent at Sledmere; probably always in the dining room as shown in a watercolor of 1847 by Miss Sophia Sykes; displaced after the fire in 1911 and offered by the executors of Sir Mark Sykes, Bart., at Christie's, 14 May 1920, lot 90, but bought in at 27,000 gns and returned to its former position by the present owner
Literature: Ward and Roberts 1904, 2:154; Rump 1974, 1:191–192, 2: pl. 173

475

SOPHIA AUFRERE, MRS. PELHAM
c. 1777
Joseph Nollekens 1737–1823
marble
66 (26) high
signed, *Nollekens Ft.*

Brocklesby Park
The Earl of Yarborough

Portrait busts by Nollekens are often undated as late as the 1790s; this bust was probably made around 1777, in which year the sculptor signed a bust of the sitter's father, George Aufrere of Chelsea. Sofia Aufrere (1752–1786) married in 1770 Charles Anderson Pelham (created 1st Baron Yarborough in 1794). Her lively character is well conveyed by the full-length portrait of 1771 by Reynolds (also at Brocklesby Park). Nollekens' bust is a striking work, although it demonstrates his persistent weakness in modeling the eyes. The scarf about the head and neck recalls the well-known antique statue *La Zingara* (The Gypsy Woman), then at the Villa Borghese, Rome (now in the Louvre, Paris). A scrolled tablet between bust and socle, derived from ancient Roman portrait busts, features on Nollekens' earlier works.

Charles Pelham had known Nollekens in Rome before 1770, and he became one of the sculptor's most important patrons. Apart from two early heads of Pelham himself, and later busts of his family, Pelham ordered from Nollekens over twenty portraits of politicians and writers, which were sold (inaccurately catalogued) by Christie's, London, 11 July 1929; and mythological statues of *Venus Chiding Cupid* (1778) and *Seated Mercury* (1783; both now at the Usher Art Gallery, Lincoln). On the tragic death of his wife, Pelham erected the Mausoleum in Brocklesby Park to the designs of James Wyatt, for which Nollekens carved a full-length statue of Sophia in classical dress leaning on a pedestal (Penny 1977, 51).

J.K-B.

Related Works: A marble copy by Nollekens, also undated, but of inferior quality, is also at Brocklesby
Literature: Whinney 1964, 162
Exhibitions: Arts Council 1971–1972 (412)

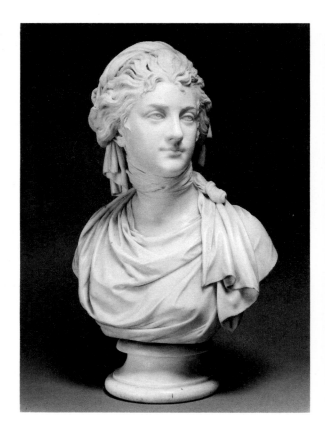

476

CHARLES JAMES FOX 1791
Joseph Nollekens 1737–1823
marble
70.5 (27¾) high
inscribed (rear), *Charles James Fox/Aged
43*, and signed, *Nollekens Ft.*; on the
socle, ten lines of laudatory verse

Southill Park
Samuel Whitbread, Esq.

Nollekens modeled this, his first bust of
Fox, in 1791 for the 4th Earl Fitzwilliam's
Mausoleum to Lord Rockingham at
Wentworth Woodhouse, Yorkshire.
However, Catherine II of Russia, who
appreciated Fox's efforts to keep peace,
acquired the first marble version (The
Hermitage, Leningrad), and Fitzwilliam
obtained the second marble. Seven
marble busts are known, including those
at Holkham (for Thomas Coke, 1792);
Yale Center for British Art, New Haven
(for Lord Robert Spencer, 1792);
Melbury (for the 3rd Lord Holland,
1793); and the present work. Another,
in the Baltimore Museum of Art,
appears to be later. The bust greatly
increased the sculptor's reputation, and
was engraved in mezzotint by William
Pether (1792). In 1801, Nollekens made
a different bust of Fox for Francis,
5th Duke of Bedford (Woburn Abbey,
Bedfordshire). More classical in style
than the present work, it proved to be
the more popular and was repeated in
marble at least thirty times.

Charles James Fox (1749–1806),
third son of the 1st Baron Holland,
had been a political disciple of Lord
Rockingham (d. 1782), whose liberal
ideals he continued. With the cry of
"Liberty" he challenged the authority
of the king, and Lord North's American
policy; he supported the French Revol-
ution (and many of its excesses) and
the abolition of slavery. A "Man for the
People," he was the finest orator in the
House of Commons but, disgusted with
Pitt's coercive government, he seldom
attended Parliament between 1792 and
1797. After Pitt's death in 1806 he held
office briefly as Foreign Minister, but
failed to conclude a peace with Napoleon.
Aristocratic and extravagant in private
life, Fox inspired a devotion among his
supporters that was best expressed at
Woburn Abbey where, in 1802, the Duke
of Bedford created a Temple of Liberty
containing the (second) bust of Fox
accompanied by six heads of his friends.

Samuel Whitbread, MP (1758–1815),
brewer and politician, attached himself
to Fox and became one the leading
Foxites. His republican politics became
wilder and his mentality increasingly
paranoid until his suicide two weeks
after the Battle of Waterloo. A man of
vanity and unfulfilled social ambition,
he is remembered chiefly for having
rebuilt Drury Lane Theatre after the
fire of 1809, and for Southill Park, his
country house, which he rebuilt from
1796 and furnished to the designs of
Henry Holland. It is not known when
he acquired the bust of Fox, which is
first recorded at Southill in 1805; he
composed the inscribed verses himself
two years earlier. The bust at Southill,
like that at Holkham, has as its pendant
another by Nollekens of the Duke of
Bedford (1802). J.K-B.

Literature: Whitbread 1951, 57
Exhibitions: London, ML 1984 (28),
with previous literature

477

PRINCESS PAULINE BORGHESE
1823/1824
Thomas Campbell 1790–1858
marble
66 (26) high

Chatsworth
The Chatsworth House Trust

Thomas Campbell, humbly born
in Edinburgh, studied at the Royal
Academy Schools in London and went to
Rome in 1818. There he remained for
twelve years, specializing in portraits of
the English visitors; the works of this
period are probably his best. In 1823–
1824 he made a colossal bust of the 6th
Duke of Devonshire (Chatsworth), and
the present bust was commissioned by
the same duke early in 1824.

Pauline Bonaparte (1780–1825),
younger sister to Napoleon, married
her second husband, Prince Camillo
Borghese, in 1803. In that year Canova
began work on a statue of the princess
reclining, *Venere vintitrice* (Villa Borghese,

Rome). Rome she found too *triste*, and her behavior in Paris usually verged on the scandalous. After 1815, with her mother and brothers Lucien and Jérôme, she lived in Rome where she is recorded in many visitors' diaries as one of the sights of the city. She was known as a flirtatious coquette with a taste for handsome English aristocrats.

The bachelor Duke of Devonshire in 1824 found the Bonapartes fascinating as survivals of a brilliant but lost dynasty. He paid much attention to Pauline, thereby shocking the English ladies. The princess, ten years his senior, he described as "curious to see, great remains of beauty." She allowed Campbell to model this bust for him, and the duke's diary, preserved at Chatsworth, records its progress. Pauline was often tiresome and capricious during the half-dozen sittings that were required. The completed bust reached Devonshire House, London, in 1827, and the duke thought it "the loveliest thing in the world, too beautiful."

On his visits to Rome between 1818 and 1824, the duke ordered many marble statues from Canova, Thorwaldsen, and their pupils for his remarkable gallery at Chatsworth. The first statue he acquired was Canova's *Madame Mère* (the Mother of Napoleon). As a pair to it, he commissioned Campbell in 1824 to make a seated statue of Pauline, for which she graciously allowed casts to be made of her hand, foot, and nose. The statue, completed in 1840, gave the sculptor much trouble, and it lacks the grace and spontaneity of the present bust.

 J.K-B.

Related Works: Seated statue of Pauline Borghese, by Thomas Campbell, also at Chatsworth
Provenance: 6th Duke of Devonshire, 1827; and by descent
Literature: Kenworthy-Browne 1971 and 1972

478

ARTHUR WELLESLEY, 1ST DUKE
OF WELLINGTON 1828
Sir Francis Chantrey 1781–1841
marble
78.7 (31) high
inscribed, *Chantrey Sc., 1828*

Petworth House
The National Trust
(Egremont Collection)

The duke (1769–1852) is shown looking to his left, with ruffled hair and dressed in broad swathes of loosely arranged classical drapery. The sitter was one of many leading figures of the early nineteenth century whose busts were executed by Chantrey, the outstanding portrait sculptor of the period. The original version of the Wellington portrait was commissioned in 1820 and finished in 1823. Another version executed for the duke and completed in the same year was seen in the sculptor's studio in 1822 by Mrs. Arbuthnott who described it as "excessively like" but compared it unfavorably to the earlier bust by Nollekens: "Chantrey's bust is too much in an attitude to please me: I think a bust sh[d] have as much expression as can be given to it by the artist but sh[d] not be in action. However, I am no judge and it is very much Chauntry's [sic] style to give a great deal of *attitude* to his busts."

The production of replicas of a bust was common practice among late eighteenth- and nineteenth-century sculptors and if a sitter was especially celebrated a large number may have been produced. Unlike most of his contemporaries, however, Chantrey did not leave such work wholly to his assistants but was himself involved in the finishing of all the versions, ensuring the high quality of each example.

The Petworth bust was commissioned by Lord Egremont in 1828 and completed by the end of the year. The bill for £157-10-0 (the same price as other versions) was paid in July 1831 according to the sculptor's ledger in the Royal Academy. Egremont was a famous patron of English artists, notably Turner, and commissioned mythological or ideal figures and groups from sculptors such as Flaxman, Nollekens, Rossi, Carew, and Westmacott. These were intended for display in the enlarged sculpture gallery where modern works were shown alongside antique sculpture mostly collected by the 2nd Earl (Kenworthy-Browne 1977). A figure of Satan was commissioned from Chantrey, probably to complement Flaxman's *Saint Michael*, but the marble version was never executed. Although the finish of Chantrey's marbles equalled that of the finest gallery sculpture, his practice relied almost entirely on the production of portrait sculpture, monuments, and public sculpture, leaving gallery subjects to those sculptors working in Rome.

 M.B.

Related Works: Three preparatory drawings at Stratfield Saye, Berkshire; four in the National Portrait Gallery; and one in the collection of David Bindman, London; plaster model in the Ashmolean Museum, Oxford; marble versions in a) Earl of Liverpool collection; commissioned by Earl of Liverpool 1820, completed 1824 (Ledger, page 122); b) Apsley House, London, signed and dated 1823, commissioned by the Duke of Wellington 1821, completed 1824 (Ledger, page 170; Avery 1975); c) HM the Queen, Windsor Castle, signed and dated 1828, commissioned 1828, completed 1829 (Ledger, page 211); d) HM the Queen, Windsor Castle, signed and dated 1835, commissioned by Lord Farnborough in 1832, completed 1836 (Ledger, page 251); e) Glasgow Museum and Art Gallery, signed and dated 1836, according to Allen Cunningham's entry in the Ledger (page 189) left by Chantrey because of a flaw in the marble and sold in 1835 [sic] to Mr. MacLellan of Glasgow; f) HM the Queen, signed and dated 1837, commissioned by William IV for a Temple at Kew, completed 1837 (Ledger, page 278); g) Belton House, Lincolnshire, signed and dated 1838, commissioned for Earl Brownlow 1836, completed 1840 (Ledger, page 278)
Literature: Jones 1849, 121; Whinney 1964, 226
Exhibitions: London, NPG 1981 (7)

479

FOUR TRICOLORS OF THE GARDE
NATIONALE 1815
French
silk embroidered with silver lace, and
with silver fringe and tassels
85×88.9 ($33\frac{1}{2} \times 35$)

Stratfield Saye
The Duke of Wellington

From the gallery of the entrance hall at Stratfield Saye hang six of the seventy-one flags presented by Napoleon to the Départements of France in 1815, and given up in tribute to the 1st Duke of Wellington on his entry into Paris after the Battle of Waterloo. Some now hang on the walls of the Plate and China Rooms at Apsley House, along with relics of the duke's many other campaigns, while others are in store. The banners are worked in silver embroidery to denote their civil origin, as opposed to the gold thread used for regimental colors, and the ornaments include the

Imperial bees, Napoleon's monogram in a laurel wreath symbolizing victory, the crown that he had placed on his own head in the presence of Pope Pius VII in 1804 (the occasion immortalized by David), and the eagle that he adopted as a symbol in imitation of the Roman legions. The heads of the staves are also ornamented with the original carved and gilt eagles.

Napoleon's presentation of the flags took place at a ceremony on the Champ de Mai, near the Invalides in Paris, and this appears on one side of each, with the name of the relevant Département on the other. The superb condition of the banners is the more remarkable because they were discovered after the Second World War, wrapped in wet tissue paper in a garden shed at Stratfield Saye, where they had been for some years. Smaller, plain tricolors are presented by the Duke of Wellington to the Queen each year on or before Waterloo Day (18 June) as a form of "rent" for the house and estate. G.J-S.

Literature: Percival 1973, 61, figs. 12, 13

480

THE THREE GRACES 1815/1817
Antonio Canova 1757–1822
marble
167.6 (66) high

Woburn Abbey
The Marquess of Tavistock and the
Trustees of the Bedford Estates

Canova, who had already made a small model of *The Graces*, was asked by the Empress Josephine in 1812 to execute a life-size version. The Duke of Bedford, visiting Rome in 1814, saw the unfinished marble and, Josephine having died that year, he wished to buy it. However, her son Eugène de Beauharnais claimed the group (now in the Hermitage, Leningrad) and Canova agreed to make another, which was completed and delivered to Woburn in 1817. The price was probably 6,000 *zecchini* (£3,000). Canova, who regarded each of his statues as unique, described this as a "replica, with alterations": the only obvious difference is that on the Woburn group the rectangular supporting pedestal was changed to a cylindrical one.

The three Graces, or Charities, daughters of Zeus, were celebrated by Greek poets as companions of Aphrodite, living on Parnassus with the Muses. Thalia stands at the center (for youth and beauty), with Euphrosyne (Milton's "Mirth") and Aglaia (elegance). In *Outline Engravings*, the duke's own account of his sculpture gallery, the goddesses are described as "almost etherial [sic] figures of delicate female beauty." The group demonstrates the qualities in Canova that pleased the aristocratic and South European temperaments; many visitors to Rome from the "puritan" north, or from America, disliked the affectation of his style, preferring the more austere works of Thorwaldsen.

The Sculpture Gallery at Woburn was originally a greenhouse, but after 1800 some marbles were brought in, and a Temple of Liberty was inserted at the east end (see no. 476). When the 6th Duke of Bedford was in Rome in 1814–1815 he acquired some important antique sculpture; at the same time he ordered the *Graces* from Canova and two bas-reliefs from Thorwaldsen, and to these modern works he later added others by Chantrey and Westmacott. Canova came to England in the fall of 1815, and was the duke's guest at Woburn where he advised on the arrangement of the sculpture. The next year a Temple of the Graces for the west end of the gallery was designed by Wyatville, in the form of a rotunda lit from above. Canova's group stood within, on a carved pedestal

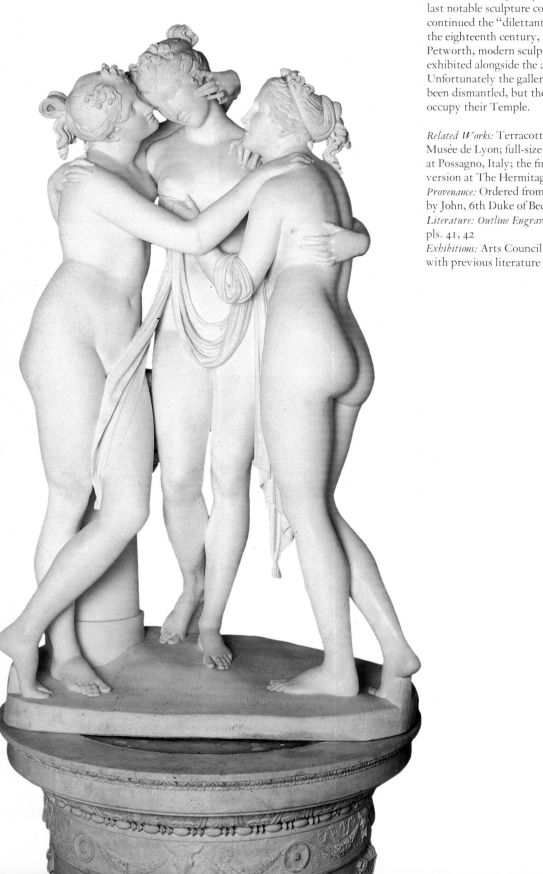

with rotating top, while two statues of the duke's infant daughters Lady Georgiana Russell (by Thorwaldsen, 1814) and Lady Louisa (by Chantrey, 1817), were placed at the entrance.

The Woburn gallery housed the last notable sculpture collection that continued the "dilettante" tradition of the eighteenth century, but as at Petworth, modern sculpture was exhibited alongside the antique. Unfortunately the gallery has recently been dismantled, but the Graces still occupy their Temple. J.K-B.

Related Works: Terracotta *bozzetto* at Musée de Lyon; full-size plaster model at Possagno, Italy; the first marble version at The Hermitage, Leningrad
Provenance: Ordered from the sculptor by John, 6th Duke of Bedford, 1814
Literature: Outline Engravings 1822, pls. 41, 42
Exhibitions: Arts Council 1972 (322), with previous literature

481

LADY ELIZABETH KEPPEL 1761
Sir Joshua Reynolds 1723–1792
oil on canvas
236.2 × 146 (93 × 57½)
inscribed, *Cinge Tempora Floribus/Suave olentis Amaraci/Adsis O Hymenaee Hymen/Hymen O Hymenaee*; *Elizabeth, Countess of Albemarle, Daughter of Admiral Keppel 1761*

Woburn Abbey
The Marquess of Tavistock and the Trustees of the Bedford Estates

In 1764 the sitter, Lady Elizabeth Keppel (1739–1768), daughter of the 2nd Earl of Albemarle (and sister of Admiral, later Viscount, Keppel) married Francis, Marquess of Tavistock, eldest son of the 4th Duke of Bedford and father of the 5th. He was killed by a fall from his horse in 1767, and she expired of "grief and decline" at Lisbon the following year. She was one of the twelve brides-maids of Queen Charlotte at her marriage to King George III on 8 September 1761, and it seems likely that the partly effaced and erroneous inscription now on the picture originally read (as on the mezzotint by E. Fisher, 1761), "Elizabeth Keppel Comitis Albemarli filia Regiis nuptiis adfuit 1761" (Smith 1878–1882, 2:498). She is shown here in the dress she wore as one of the bridesmaids, which was painted by the drapery painter Peter Toms (1748–1777), who received only twelve guineas for doing it (Edwards 1808, 54).

The Keppel family were among the staunchest of Reynolds' early patrons and Commodore (later Admiral and Viscount) Keppel had been instrumental in conveying the young Reynolds to Italy in 1750, and had sat in 1753/1754 for the full-length that established Reynolds' reputation in London. He seems to have commissioned this portrait, which appears in an undated entry (possibly 1762) in Reynolds' ledger: "Lady Elizabeth Keppell. Paid in full/by the Admiral." She sat in September 1761, soon after the royal wedding, and the maid sat in December. The picture was exhibited at the Society of Artists 1762 (no. 87) as "Whole length of a lady, one of her Majesty's bride maids."

The Latin quotation, which consists of excerpts from the Epithalamion of Manlius and Julia by Catullus (Carmina LXI), may be rendered "Crown the temples [that is, of the God Hymen] with sweet-smelling marjoram, may you be present to help, O God of marriage…" (for the motive and its significance, see Gombrich 1942). The frame of the picture does not seem to have been ready until 1765, as there is another entry in the ledger: "Frame July 4 1765. Lady Eliz. Keppell now Lady Tavistoke £42." This frame was removed when the picture came to Woburn in the early nineteenth century, and it was fitted in to the Flitcroft plasterwork of what is now the Reynolds Room— together with Reynolds' portraits of her brother, the Admiral, her husband, Lord Tavistock, her sister-in-law, later Duchess of Marlborough, and several others.

The picture is a splendid example of Reynolds' method of enhancing the status of the private portrait so that it could compete with the "history pictures" the collecting classes were bringing back from Italy. It may also have been intended as a bid for royal patronage, but George III always found Reynolds' style insufficiently domestic. The sitter's husband, Francis, Marquess of Tavistock, was the first member of the Russell family to collect old masters seriously.
 E.K.W.

Related Works: The motive of decorating a term of Hymen first appears in British portraiture in a picture of about 1731 by Pieter van Bleeck (London, Colnaghi 1983, no. 4). Reynolds himself also enlarged it into a more "historical" scene in *The Three Montgomery Sisters* (R.A. 1774; now at the Tate Gallery), which has been elaborately discussed by Gombrich 1942
Provenance: Painted in 1761 at the instigation of the sitter's brother and either given to their father, Lord Albemarle, or bequeathed to Lord Albemarle at Admiral Viscount Keppel's death in 1786; given to the Duke of Bedford by the 4th Earl of Albemarle (d. 1749), and has been at Woburn ever since
Literature: Waterhouse 1941, 76 and 1973, pl. 32
Exhibitions: London, Society of Artists 1762 (87); Arts Council 1950 (47)

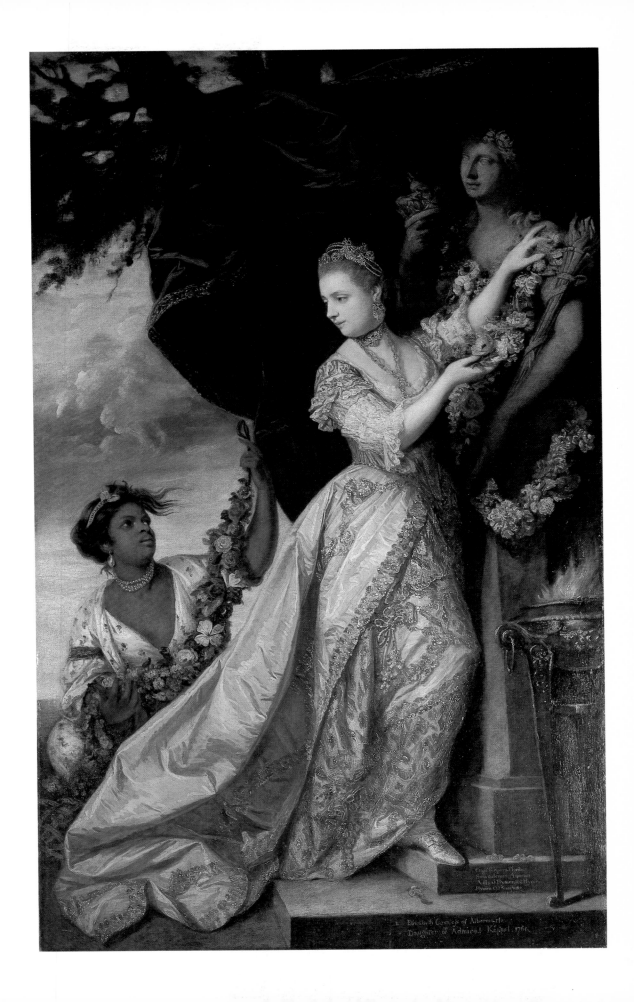

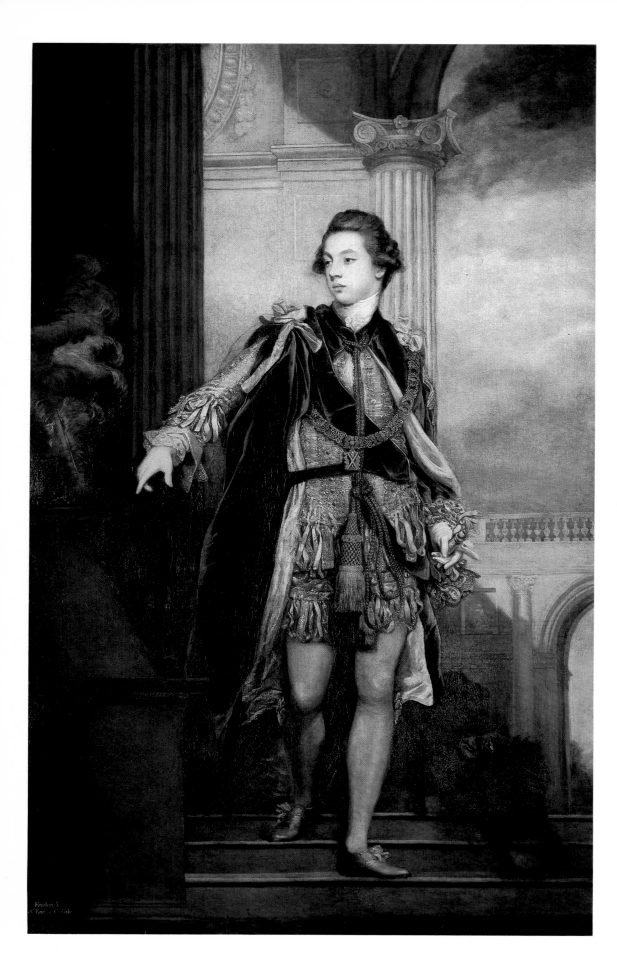

482

FREDERICK HOWARD, 5TH EARL OF
CARLISLE 1769
Sir Joshua Reynolds 1723–1792
oil on canvas
241.3 × 149.8 (95 × 59)

The Castle Howard Collection

Frederick Howard (1748–1825) was
the youngest, but only surviving, son
of the 4th Earl of Carlisle, whom he
succeeded at the age of ten. His father
had more or less finished the great house
at Castle Howard and bought a good
deal of classical statuary for it (Michaelis
1882, 60), but it was the 5th Earl, toward
the latter part of his life, who collected
most of the old masters. In this portrait
he is wearing the robes of the Order of
the Thistle, with which he was invested
by the King of Sardinia at Turin on
27 February 1768 no doubt so that he
could make a more spectacular appear-
ance at the Sardinian Court. He resigned
the Thistle on his election to the Order
of the Garter in 1793. The 5th Earl
held a number of ornamental positions,
but his best-known political activity
was his *not* making a treaty with the
Americans in 1778.

The pose, which Reynolds had used
in 1753/1754 for the portrait of Admiral
Keppel (National Maritime Museum,
Greenwich), and with which he had
first made his name, is certainly taken
from a classical statue and is generally
considered to derive from the most
famous of all eighteenth-century statues,
the Apollo Belvedere (Haskell and Penny
1981, no. 8, 148). But while Keppel is
striding along the seashore, the palace
setting here transposes the portrait into
an exercise in the style of Veronese,
appropriate to the baroque splendors of
Castle Howard. Reynolds painted Carlisle
as a boy (1757/1758); there were some
sittings in the summer of 1767 (before
he received the Thistle) that probably
came to nothing; and a half-dozen sittings
in May and June 1769 for this picture,
which was paid for in 1775, as recorded
in the artist's ledger: "Sept. 6 1775.
Lord Carlisle whole length £157.10." It
has been at Castle Howard ever since.

E.K.W.

Related Works: Also at Castle Howard (probably acquired shortly before 1800) is a Reynolds full-length of the Tahitian Omai (RA 1776), which is more overtly derived from the Apollo Belvedere, and may possibly have been bought for that reason by Lord Carlisle, who was a man of considerable artistic sensibility
Literature: Michaelis 1882, 60; Graves and Cronin 1899–1901, I: 150; Waterhouse 1941, pl. 131, and 1973, pl. 52; Haskell and Penny 1981, 148
Exhibitions: Birmingham 1961 (45), with previous literature

483

AUGUSTUS HERVEY, 3RD EARL OF
BRISTOL 1768
Thomas Gainsborough 1727–1788
oil on canvas
232.4 × 152.4 (91$\frac{1}{2}$ × 60)

Ickworth
The National Trust (Bristol Collection)

Portrayed as a naval captain, Augustus Hervey (1724–1779), who was to succeed his brother as 3rd Earl of Bristol in 1775, leans against a great anchor draped with the Spanish Ensign. Seldom in a British portrait have the incidental interest, silk flag, hazy sea, or buildings shimmering on the horizon, been realized so seriously. The distant building is the Moro fort at Havana in the siege of which Hervey took part. Present at its bombardment in 1762, he was sent home with dispatches before its capture the following year.

The 3rd Earl of Bristol, a member of a family distinguished in the eighteenth century for its eccentricity, was the son of Lord Hervey (see no. 237) and grandson of the 1st Earl of Bristol. His mother was the celebrated court beauty Mary (or Molly) Lepel, maid of honor to Queen Caroline. The career of his elder brother, the 2nd Earl, had culminated in the lord lieutenancy of Ireland; and his younger brother Frederick, the 4th Earl, was the bishop whose portrait was painted by Vigée le Brun (no. 196). He himself was a man of conquests in more than one sense. In the navy he rose to the rank of Admiral of the Blue and subsequently, from 1771–1775, he was appointed a Lord of the Admiralty.

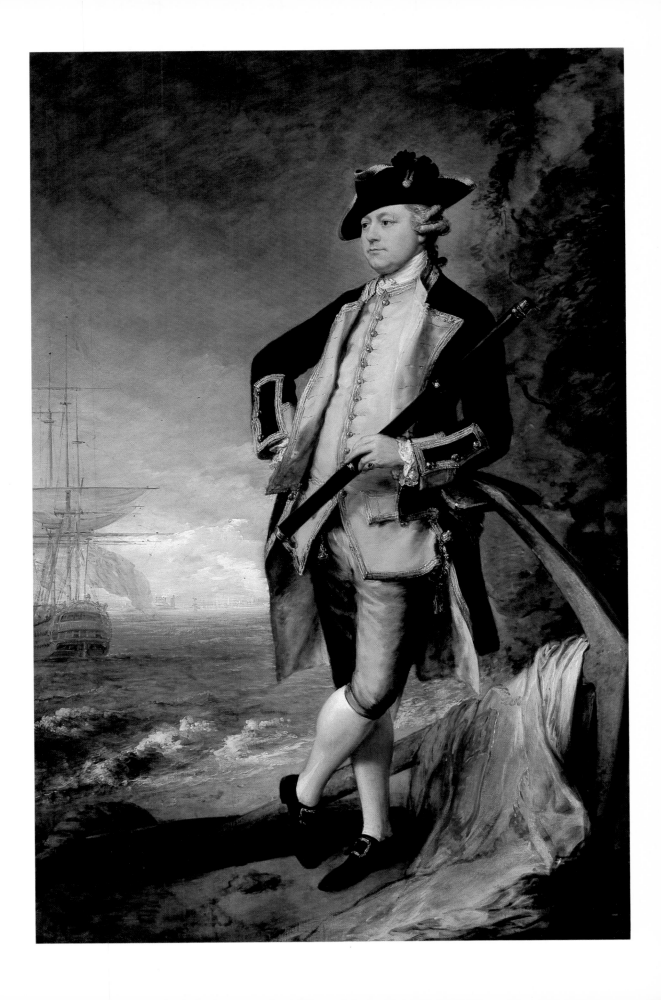

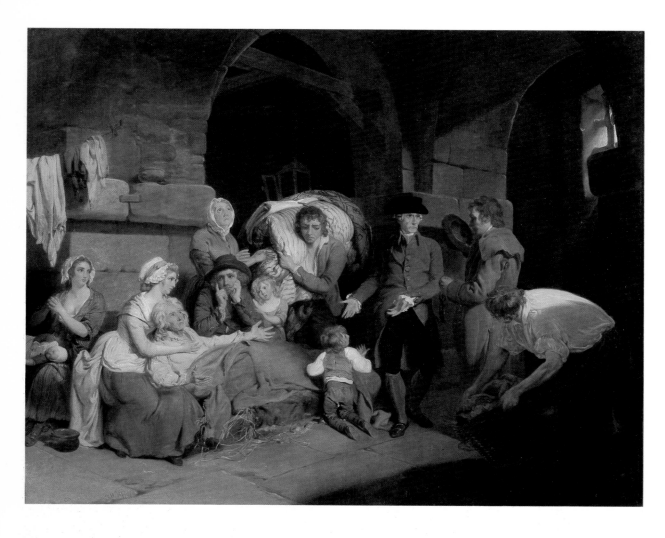

JOHN HOWARD VISITING AND
RELIEVING THE MISERIES OF A PRISON
1787
Francis Wheatley 1747–1801
oil on canvas
104.1 × 129.5 (41 × 51)
signed, *F.W. Px.t/1787*

Private Collection

John Howard (1726?–1790), philanthropist and author of *The State of Prisons* (1777) had served as High Sheriff of Bedfordshire in 1773 and his experience in this capacity made him realize a pressing need for prison reform. His tours of inspection of prisons throughout Britain led to much alleviation of suffering and his later travels through Europe only extended the range of his influence.

Howard is hearing the full catalogue of woes of the family of an elderly prisoner who lies listless on his bed. Wheatley's prisoner was obviously inspired by Greuze and indeed the whole composition reflects the influence of the French artist, whose work was widely diffused through prints. Howard himself is said to have refused to sit for a portrait and Wheatley's picture is described as the "best likeness" of him in the press advertisement for Hogg's print. Howard's death in 1790 and the publication in 1791 of William Hayley's *Eulogies of Howard, A Vision* stimulated Romney to make a considerable number of drawings of *Howard Visiting a Lazaretto* in the early 1790s in connection with a project to paint one or more pictures of the subject. Their dramatic neo-classical character was to contrast with Wheatley's more restrained narrative (see Jaffé 1977, nos. 94–100b). Nevertheless this picture foreshadows some of the "modern history pieces" attempted by British artists in the early nineteenth century.

The picture was acquired in February 1809 by Dudley Ryder (1762–1847), who had succeeded his father as 2nd Baron Harrowby in 1803 and was elevated to the earldom in July 1809. Harrowby was from 1784 until 1803 a Member of Parliament for Tiverton—a seat held in turn by his grandfather Sir Dudley Ryder, Lord Chief Justice in 1754–1756 and by his father—and

In other respects his reputation was somewhat tempestuous, and in matrimony he was both ill-served and conspicuous, for his wife was Elizabeth Chudleigh, later to become notorious as the bigamous Duchess of Kingston. After the debacle of this alliance he never remarried, but settled down with a Mrs. Nesbitt, a former model of Sir Joshua Reynolds.

The portrait is traditionally said to have been painted for the 2nd Lord Mulgrave, the nephew of Lord Bristol and then a young man of twenty-four. Certainly it was sold by his daughter in 1834. A question remains to be solved, however: what was the picture that was copied for Mrs. Nesbitt by Ozias Humphry in 1788? In that year she wrote to Humphry, instructing him to ensure that "my lords picture is put up

as it was where you took it down." Gainsborough's portrait would have escaped the entail on the contents of Ickworth and could have remained in her possession. Humphry's perfunctory copy of the head and shoulders is at Ickworth. Horace Walpole said of the Gainsborough, "very good and one of the best modern pictures. I have seen it at Lord Bristols in St. James's Square," after he had examined it at the Society of Artists Exhibition in 1768. His opinion remains as true today as it was over two hundred years ago. ST.J.G.

Provenance: Included in the so-called Joseph Robins sale at Christie's, 21 February 1834, lot 83, by an anonymous seller (Lady Murray); bought in and reappeared soon afterward in the sale room (Deacon's, 9 May 1839) when it was bought by Lockyer, an official at Greenwich. There are at Ickworth two letters from him addressed to Lord Jermyn, the future 2nd Marquess of Bristol. Lockyer offered him the portrait which he had bought for 65 gns. Lord Jermyn evidently refused it, referring the letter to his father Lord Bristol. The assumption is that it was bought by Lord Bristol
Literature: Erskine 1933, 1746–1759; Waterhouse 1958, no. 82
Exhibitions: London, SA 1768 (60); London, RA 1934 (264); British Council 1957 (10)

held a series of appointments under Pitt during whose final administration he was briefly Foreign Secretary in 1804. As President of the Council in 1812–1827, Harrowby was a significant figure in the cabinets of Lord Liverpool and Canning. His ownership of a picture with such obviously liberal connotations casts an interesting light on his political views. Although a Tory, he had been convinced by the case against slavery advanced by Wilberforce and Fox in the celebrated debate in the Commons of 1791; by 1812 he was a supporter of Catholic Emancipation; and in 1831–1832 he was a leader of the "Waverers" who facilitated the passage of the Reform Bill in the House of Lords. Harrowby was never a collector on the scale of his wife's half-brother, the 2nd Marquess of Stafford, or her brother-in-law, the 5th Earl of Carlisle (no. 482), but he acquired a number of important pictures and was a trustee of the British Museum.

F.R.

Provenance: "An eminent publisher retiring from business," his sale, Christie's, 25 February 1809 (110), bought for 38 gns by Dudley Ryder, 2nd Baron Harrowby, subsequently created 1st Earl, and by descent
Literature: Webster 1970, no. 57
Exhibitions: London, RA 1788 (31); London, BI 1849 (98); London, RA 1873 (277); Birmingham 1934 (295); London, RA 1951–1952 (39); British Council 1957–1958 (72)
Engravings: James Hogg, 1790, line engraving

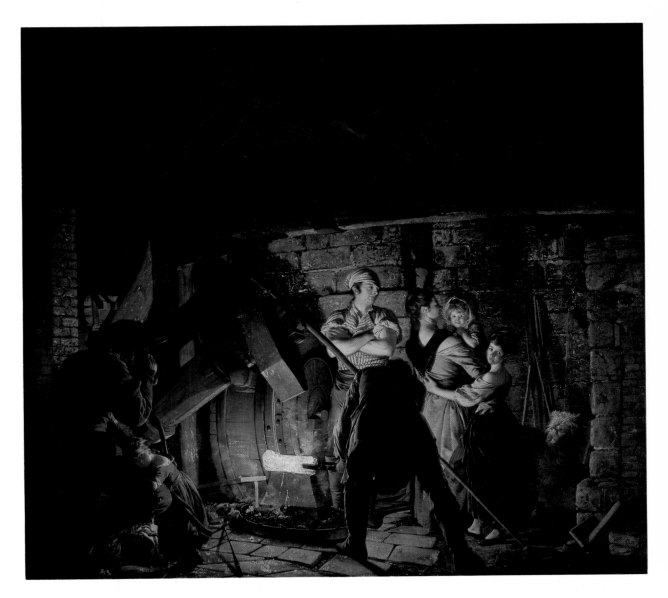

485

AN IRON FORGE 1772
Joseph Wright of Derby 1734–1797
oil on canvas
119.4 × 132 (47 × 52)
signed, *Jo. Wright/Pinx.^t./1772*

Broadlands
Lord Romsey

From the 1760s Wright had come to specialize not only in portraiture (see no. 447), but also in nocturnal and candlelit scenes, his early exploration of this genre culminating in the *Orrery* of 1764–1766 in the Derby Museum and the Tate Gallery *Experiment with an Air Pump* of 1767–1768. Many of Wright's patrons were from the world of commerce, and it was perhaps inevitable that a painter of his temperament working in an area where industrial activity was making dramatic progress should be drawn to paint such subjects. While there is a seventeenth-century Dutch precedent for these in a picture

attributed to Molenaer at Ponce, Puerto Rico (Nicolson 1968, I:51), the three versions of the *Blacksmith's Shop* of 1771, the present picture, and the *Iron Forge Viewed from Without* of 1773 (The Hermitage, Leningrad) are among the most forceful and inventive of all Wright's compositions. With its heroic interpretation of the manufacturing process, its sense of controlled power and dramatic force, the Broadlands picture can claim to be the first masterpiece inspired by the Industrial Revolution.

An Iron Forge was sold to an established member of the Whig oligarchy, the 2nd Viscount Palmerston (for a full

account of his life see Connell 1957). The entry in Wright's account book reads: "The picture of the Iron Forge to Ld Palmerston, £210" (National Portrait Gallery, London, MSS). Palmerston was a man of many interests. His career on the margin of the political world has been overshadowed by the record of his son, the future Foreign Secretary and Prime Minister. Widely read, and an acquaintance of Voltaire and De Saussure, he was keenly interested in antiquities, in natural phenomena, science and exploration. From the time of his Grand Tour in 1763–1764, picture collecting became a favorite pursuit and unlike many connoisseurs of the time he kept a catalogue with a meticulous record of his purchases (formerly at Broadlands, but misplaced by a former archivist). He patronized many contemporary artists, including Angelica Kauffmann, Gavin Hamilton, Wilson, Marlow and Hodges, Pars and Reynolds—of whose will he was to be an executor—but he also had an excellent eye for old masters. He acquired notable works by Castiglione and Cozza and other masters of the seicento, and a number of earlier pictures, including the Rocco Marconi *Christ and the Woman Taken in Adultery* (Coral Gables, Kress Collection). He owned works by many of the masters who were then in vogue—Claude, Gaspard, and Cuyp; but it was in Palmerston's choice of Dutch pictures that his taste seems most advanced. He bought the Vermeer *Woman Playing a Lute*, now at Kenwood, for £16 and owned two landscapes by De Koninck, of which one remains at Broadlands (Russell 1982, fig. 4).

An Iron Forge was not the first work by Wright to enter the collection. On 24 January 1771, Lord Palmerston bought the *Girls Playing with a Cat by Candlelight* (Nicolson 1968, I:no. 212) at Christie's for 7 guineas. *An Iron Forge* cost 200 guineas (according to Wright's account book; in the missing notebook from Broadlands the sum was given as £200), the price Wright had charged for the *Orrery*. That *An Iron Forge Viewed from Without* was sold to Catherine the Great for 130 guineas in 1774 suggests the high opinion the artist must have had of the Palmerston picture.

Lord Palmerston evidently hung his pictures with great care: at Broadlands they were arranged in six rooms and deliberately segregated from the series of family portraits which he had inherited. *An Iron Forge* was one of the twenty-five paintings that hung in the dining room in 1807, when his son made a list of the pictures. Many of the 132 pictures recorded in 1807 at Broadlands have been sold, but the surviving portion of his collection nonetheless offers a rewarding insight into Palmerston's taste. F.R.

Related Works: A copy of 1773 by H. Faber is recorded by Nicolson
Provenance: Purchased from the artist for £200 by Henry Temple, 2nd Viscount Palmerston, in 1772; by descent to his son, the 3rd Viscount (d. 1865); by inheritance to the latter's widow; her son (by her first marriage) William Cowper-Temple, 1st Lord Mount Temple; by descent to his nephew Hon. Evelyn Ashley, and to the latter's son, 1st Lord Mount Temple, father of Countess Mountbatten of Burma, and maternal grandfather of the present owner
Literature: Palmerston 1807, fol. 2; Nicolson 1968, no. 197; Russell 1982a, 224
Exhibitions: London, SA 1772 (373, as "An Iron Forge"); Brussels 1935 (1138); London, RA 1954–1955 (420); London, Tate 1958; Toronto 1984
Engravings: Richard Earlom, published by Boydell, 1 January 1773, mezzotint

486

MRS. MAGUIRE AND HER SON, WITH A NEWFOUNDLAND DOG 1805
Sir Thomas Lawrence 1769–1830
oil on canvas
164.4 × 164.4 (65 × 65)

The Duke of Abercorn

Frances Hawkins, whose secret marriage to Captain Constantine Maguire was announced in May 1805 (Gebbie, 1972, 248) was for many years the mistress of John James, 9th Earl and from 1790, 1st Marquess of Abercorn (1758–1818). Their son, called John James Hamilton by Farington in 1805, was later known as Arthur Fitzjames.

This splendid picture, exceptional both in format and character, has an important place in the sequence of Lawrence's portraits of women, which began so spectacularly with those of Queen Charlotte (National Gallery, London) and Elizabeth Farren (Metropolitan Museum, New York), both exhibited in 1790. Lawrence's brilliant technical gifts are seen at their best: with its striking informality of pose the picture offers a revealing contrast with the earlier and altogether more respectful portrait of Lady Templetown and her son in the National Gallery, Washington.

The picture was painted for Lord Abercorn, whom Lawrence described in a letter of 1803 to his sister: "…an old Jermyn Street friend—a staunch and honourable one…" (Williams 1831, 1:233). Abercorn had been an early patron of Lawrence and had sat for three portraits, of which those exhibited at the Royal Academy in 1790 and 1814 are both at Baronscourt, while the third was painted in the mid-1790s for Abercorn's neighbor, Sir John Stewart, 1st Bart., of Ballygawly (Garlick 1964, 13).

Lord Abercorn separated from his first wife in 1798 and it seems likely that his illegitimate son was born about a year later, to judge by the child's age in this picture. In 1800 he remarried, and his second wife, daughter of the 2nd Earl of Arran and widow of Henry Hatton of Clonard, in turn sat for Lawrence in about 1800. Marriage did not end the Marquess' liaison with Mrs. Hawkins, and this picture was painted for him early in 1805. Lawrence

asked Farington his opinion of it on 12 February. As a list of the painter's receipts drawn up on 14 February 1806 establishes, he was paid £50 for the picture (Garlick 1964, 270).

Lord Abercorn was understandably reluctant to allow the picture to be exhibited, but the decision in September 1805 that Mrs. Hawkins should return to Ireland evidently made it possible for this to be shown at the Royal Academy in 1806. Farington records Fuseli's admiration for the picture, which had "all that *mind* & the *pencil* could do" and showed "the most exquisite ideas of pleasure without exciting any vicious feelings" (*Farington Diary*, 7, 2546). To a man with a taste for pornography like Fuseli the picture was innocent enough, but the more narrow-minded Northcote considered that Mrs. Maguire "looked like a *whore*" and her son "as if he had been bred among the vices of an impure house" (*Farington Diary*, 7:2750). The picture's evident debt to Renaissance *tondi* of the Madonna and Child with the Infant Baptist no doubt encouraged such criticism.

If it was unusual for a married man to commission a portrait of his mistress and illegitimate child, it was doubly so to hang it. But Abercorn, who in 1789 had inherited an estate worth £20,000 from his uncle, the 8th Earl, was not a man to be ruled by mere convention. While not a major patron of the arts, and still less a collector, he was an energetic builder, employing Sir John Soane to enlarge both his Irish seat, Baronscourt, and Bentley Priory, the house he bought near Stanmore that was to become a Tory counterpart to the Whigs' Holland House. F.R.

Related Works: A preparatory drawing was claimed by Wilkie from Lawrence's executors in 1831 on behalf of Andrew Geddes (Garlick 1964, 297)
Provenance: Painted for John James, 1st Marquess of Abercorn; and by descent
Literature: Garlick 1964, 137; Levey in London, NPG 1979
Exhibitions: London, RA 1806 (91, as "A Fancy Group"); London, RA 1904; Paris 1909 (24); London, Grafton Gallery 1910 (54); Brussels 1929 (125); London, Agnew 1951 (8); London, RA 1951–1952 (198); London, NPG 1979 (22)

487

LIEUTENANT-GENERAL SIR CHARLES
STEWART, LATER 3RD MARQUESS OF
LONDONDERRY 1812
Sir Thomas Lawrence 1769–1830
oil on canvas
127 × 102 (50 × 40)

Wynyard Park
The Marquess of Londonderry

The Hon. Charles William Stewart (1778–1854), son of Robert Stewart, successively 1st Baron (1789), Earl (1799), and finally Marquess of Londonderry (1816), was the half-brother of Viscount Castlereagh, the Foreign Secretary, whom he succeeded as 3rd Marquess of Londonderry in 1822. He had a distinguished career in the army, serving as adjutant general from 1809 until 1812, when Wellington, who had long been tried by his capacity for mischief-making, secured his recall. Stewart's impetuous courage was not, however, in doubt. He is shown in this portrait in Hussar uniform and with the Peninsular Medal, which he was awarded after the Battle of Talavera in 1809. With its martial vitality, the picture anticipates the heroic air of the finest of the portraits of the allied commanders Lawrence was to paint for the Waterloo Chamber at Windsor.

Lawrence exhibited portraits of Lord Castlereagh in 1794 and 1810 and his earliest portrait of Stewart, who was to become his "constant' friend (Layard 1906, 136), was first mentioned in June of that year and was exhibited at the Royal Academy in 1811. No longer traceable, this may have been destroyed by fire at Wynyard in 1844 or, alternatively, presented to one of Londonderry's continental friends—as may well have been the case with the present portrait. This is one of two fully autograph versions of the painter's second portrait of Stewart. The other, which is signed and dated 1812, was painted for the 1st Marquess Camden. It remains at Bayham and may well be the picture exhibited and favorably received in 1813 although the present portrait has usually been so identified. Stewart's first wife, Lady Caroline, who died on 11 February 1812, is said by Miss Croft to have seen the portrait of him "in the large fur cap" at Lawrence's house, and this may establish a terminus *ante quem* for the composition (Layard 1906, 254).

An intimacy developed as a result of the sittings for these portraits. In July 1814 Stewart asked the Prince Regent, who had never patronized Lawrence, to sit for the full-length portrait exhibited in 1815 and now at Wynyard. Meyer's recently published engraving of this portrait was also shown to the prince and evidently helped to secure the commission for the heroic series of the Waterloo Chamber. Stewart was appointed Ambassador to the Court of Vienna in 1814, at the time of the Congress, and a letter of March 1816 shows the active part he himself took in arranging Lawrence's triumphant continental progress to take likenesses for the Waterloo portraits (Layard 1906, 96, 100–101): Tsar Alexander sat in Stewart's presence when at Aix-la-Chapelle for the Congress of 1818, and Lawrence stayed with his friend when he visited Vienna in the following winter. Lawrence's third portrait of Stewart was painted at Vienna in 1819; the sitter acquired this from the painter's executors in 1830 and it is now at Wynyard.

In 1819 Stewart married as his second wife, Frances Anne, daughter and heiress of Sir Henry Vane Tempest, 2nd Bart. of Wynyard, and the management and development of his wife's great estates in County Durham was to become the major preoccupation of his later years. Wynyard itself was rebuilt on a palatial scale in 1822–1828 by Philip Wyatt who made use of his brother Benjamin Dean Wyatt's abortive project for a Waterloo Palace, and although a fire of 1841 destroyed two thirds of the house, it was rebuilt by Ignatius Bonomi who adhered closely to Wyatt's design. The Wyatt brothers also remodeled Londonderry House, no. 19 Park Lane, in 1825–1828. F.R.

Provenance: Prince Troubetskoi; purchased by the 5th or 6th Marquess of Londonderry and by descent at Londonderry House and subsequently at Wynyard
Literature: Hyde 1937, 59; Garlick 1964, 131; Michael Levey in London, NPG 1979
Exhibitions: Possibly London, RA 1813 (159); London, RA 1931/1932 (184); London, RA 1934 (642); London, Agnew 1951 (20); London, RA 1968–1969 (74); London, NPG 1979 (74)
Engravings: J. Hopwood, for *Military Panorama*, London, 1813, stipple; H. Meyer, 1814, mezzotint, with the addition of the ribbon and star of the Order of the Bath, which Stewart was awarded in 1813

LADY THEODOSIA VYNER 1791
Sir Thomas Lawrence 1769–1830
oil on canvas
127 × 102 (50 × 40)

Newby Hall
R.E.J. Compton, Esq.

Lady Theodosia Vyner (1765–1822) was the fourth daughter of John, 2nd Earl of Ashburnham (1724–1812), himself a collector on a considerable scale: in June 1788 she married Robert Vyner of Gautby in Lincolnshire, who like his father and grandfather was a Member of Parliament for many years.

The picture is one of the finest in the sequence of Lawrence's early portraits of this format, following the penetrating likeness of the old Countess of Oxford exhibited in 1790 (National Trust for Scotland, Fyvie Castle) and preceding the *Lady Caroline Harbord* of 1793 in the Lothian collection. Lawrence's contributions to the Royal Academy in 1791, of which this was the most striking, were less spectacular, if less controversial than those of the previous year, and included smaller portraits of Sir Gilbert Heathcote at Grimsthorpe, Lady Emily Lennox, sister of Lady Bathurst (see no. 523), and the *Homer Reciting his Poems* formerly at Downton. Williams records that Lawrence charged 30 guineas for the picture (compare Garlick 1964, 267).

<div align="right">F.R.</div>

Provenance: By descent, through the sitter's son Henry Vyner of Newby
Literature: Garlick 1964, 190
Exhibitions: London, RA 1791 (75); York 1934 (5); Arts Council 1950; London, RA 1951–1952 (212)

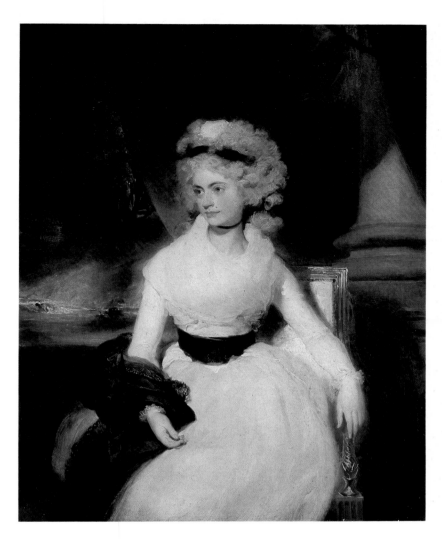

LEAN-TO SECRETAIRE c.1750
BVRB, Bernard II van Risen Burgh
fl. c.1730–c.1765
oak veneered with tulipwood, inlaid with stylized floral marquetry of kingwood; mounts of chased and gilt-bronze; drawers of mahogany, probably relined
104 × 142.2 × 67.5 (41 × 56 × 26½)
stamped, *BVRB JME* (Bernard van Risen Burgh *Jurande des Menuisiers-Ebénistes*); lock plate engraved with interlaced *LLs*

Dalmeny House
The Earl of Rosebery

Designated by the British Government in 1977 as a work of art of pre-eminent importance, this *secrétaire en pente* was included in the Mentmore sale (Sotheby's, Mentmore, 18 May 1977, lot 26). It was not sold, however, and now forms part of the furnishings of Dalmeny House.

The desk is unusually large, measuring 142 cm. in width compared with 81 cm. to 83 cm. for desks of more traditional size produced in the *BVRB* workshop. Its width is only exceeded by that of the double lean-to desk (*bureau en dos d'ane*) now in the J. Paul Getty Museum, Malibu, which measures 158.7 cm. (Paris 1974, 328–329). Indeed, as has already been pointed out in the Mentmore catalogue entry, the two desks have much in common. They have the same heavy, squat proportions and many of their mounts were evidently based on the same models. The one major difference lies in the stylized floral marquetry. On the Dalmeny desk it is more profuse and mingles with scrolling ribbons, whereas on the Getty piece the marquetry forms clearly defined bunches and sprays. Jonathan Bourne, in a recent article, has suggested that the existing marquetry on the lean-to may represent a later restoration, carried out "probably in a design differing in details to that originally there" (Bourne 1984, 410).

These possible alterations notwith-standing, the desk is an outstanding example of mid-eighteenth-century French furniture. Pierre Verlet has suggested that it could have been made

for a minister or a *fermier général* (Verlet 1967, 158). The crossed *LLs* on the lockplate has led others to believe, however, that it might have been commissioned by the French Crown (Sotheby's 1977). In the absence of any palace or château inventory mark—which would have been struck or painted on the dust board, now missing—it has not been possible to establish for whom this piece was made.

When the 5th Earl of Rosebery married in 1878 Hannah, the sole daughter and heiress of Baron Mayer Amschel de Rothschild (d. 1874), she brought as dowry Mentmore Towers,

which had been built for her father by Sir Joseph Paxton between 1850 and 1855 in the neo-Elizabethan taste. It was something of an Aladdin's cave, if we are to judge from Lady Eastlake's letter of 27 January 1872, which describes it as filled with "every sumptuous object that wealth can command." The house, she adds, "is a museum of everything, and not least of furniture, which is all in marquetry, or *pietra dura*, or *vermeille*" (Eastlake 1895, 2:224). G.de B.

Literature: Verlet 1967, fig. 123; Bourne 1984, 410, pl. 6

490

PAIR OF DWARF CABINETS 1815/1818
attributed to Edward Holmes Baldock
1777–1845
ebony with ormolu mounts and
marble top
$104 \times 95.2 \times 43$ ($41 \times 37\frac{1}{2} \times 17$)

Charlecote Park
The National Trust
(Fairfax-Lucy Collection)

This pair of cabinets was purchased by George Hammond Lucy for his seat, Charlecote Park, at the Fonthill Abbey sale of 1823. They were lots 1143 and 1144 and were each described as "A superb console of ebony wth carved door, surmounted on each side by ebony columns with or-moulu caps, bases and mouldings, and black and gold marble slab." They were in the Crimson Drawing Room, one of the most richly furnished interiors at Fonthill, which was completed in about 1818. William Beckford who had created the Abbey to house his remarkable collections had a particular penchant for ebony furniture. This, along with his spectacular black Japanese lacquer gave an effect of somber splendor to the interiors, which were hung with crimson textiles.

It is likely that these cabinets were made in the workshops of Edward Holmes Baldock, the celebrated London antiquities broker and cabinetmaker, who also specialized in making copies of elaborate French eighteenth-century furniture, as well as retailing genuine pieces (see no. 86). The front of each cabinet is made from the elaborately carved door of an early seventeenth-century French or Dutch ebony cabinet. Baldock not only provided furniture and works of art for Fonthill, but is known to have produced a number of pieces of furniture constructed from ancient fragments of carved ebony (Wainwright 1977).

These cabinets normally stand on either side of the fireplace in the drawing room at Charlecote, which contains a number of other objects also purchased at Fonthill (Wainwright 1985). William Beckford's collection was one of the most important ever formed in England, and many English country houses still contain objects and pictures purchased at the Fonthill sale of 1823 (see nos. 309 and 513). C.W.

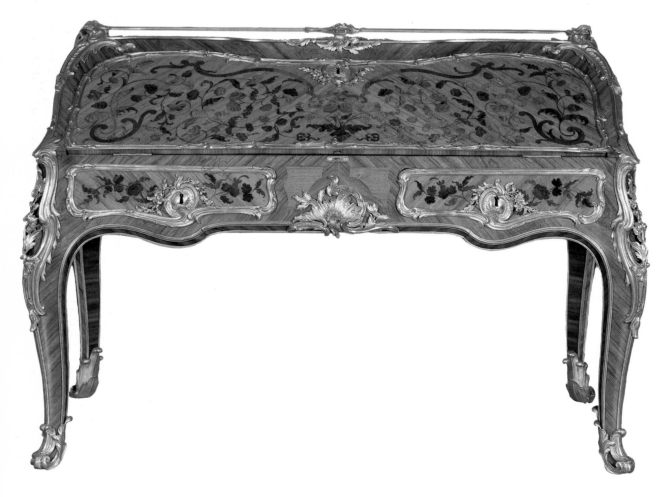

Literature: Fonthill 1823, 1144; Wainwright 1985

491

PAIR OF CANDELABRA C.1784/1785
Pierre-Philippe Thomire 1751–1843
bronze and ormolu on marble bases
101.6 × 33 (40 × 13)

Carlton Towers
The Duke of Norfolk, KG

Formerly at Broughton Hall near Skipton in Yorkshire, this magnificent pair of candelabra may have been acquired by Stephen Tempest and his wife Elizabeth on their continental tour in 1818. Several pieces of French furniture brought back from this trip, including a commode by Delorme and two pairs of large bronze and ormolu columns, survive at Broughton, together with their portraits painted in Florence by François Xavier Fabre in an uncompromisingly realistic neo-classical vein. Mrs. Tempest was a daughter of Henry Blundell, the collector of classical antiquities and builder of the famous Pantheon at Ince Blundell (see no. 331), and this may partly account for their advanced Greek Revival tastes, expressed in the remodeling of the house by William Atkinson in 1810–1813, and its furnishing by Gillows of Lancaster, only completed in 1824.

The candelabra were brought to Carlton Towers by their granddaughter Ethel Tempest, who married the 10th Lord Beaumont in 1893. A notebook written in her hand, listing the non-entailed pictures, furniture, and other objects that she had inherited, records the family tradition that they had belonged to Talleyrand (MSS at Carlton Towers; information kindly supplied by Dr. John Martin Robinson). If this is so, they are perhaps more likely to have been purchased by her father, Sir Charles Tempest, Bart., after Talleyrand's death in 1838. But without further documentary evidence, this provenance must remain unproven. The winged victories with entwined mermaid's tails are very similar to those on a table by Jacob in the Louvre, thought to have been made for a *cabinet turc* of the Comte d'Artois in the 1780s (information kindly supplied by Mr. Peter Hughes). But Thomire continued to use such motifs after the Revolution, and a pair of candelabra of this model are described in the list of objects which he submitted as collateral for a government loan in 1807, and which he forfeited in 1812. G.J-S.

Related Works: Two pairs of similar candelabra are in the offices of the President of France at the Trianon-sous-Bois (one of them possibly the pair forfeited by Thomire in 1812), and other examples are at Schloss Ludwigslust, Württemberg, the Château de Malmaison, and the Palace of Pavlovsk (I am indebted to Mr. David H. Cohen for this information)
Exhibitions: London, Sotheby's 1983

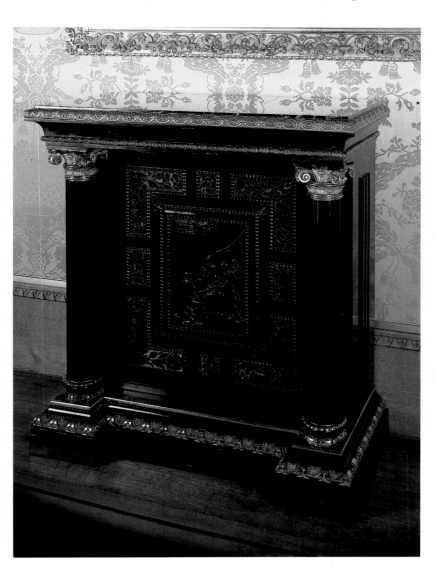

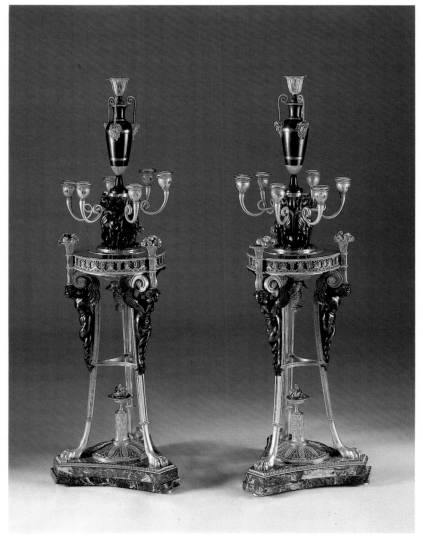

492

CARDINAL CAMILLO MASSIMI
1649/1650
Diego Velasquez 1599–1660
oil on canvas
76×61.3 ($29\frac{7}{8} \times 24$)

Kingston Lacy
The National Trust (Bankes Collection)

Camillo Massimi was painted by Velasquez in Rome during the artist's second visit to Italy (1649/1650) when his principal commission was the portrait of the Pope, Innocent X. Massimi, a member of a distinguished Roman family, was possessed of the qualities that are often associated with great Renaissance churchmen. A high-ranking member of the court of Innocent X, Papal Nuncio to Spain in 1654–1658 and Cardinal in 1670, he was also the founder of a celebrated collection of pictures, books, and antiquities, an amateur artist, and the patron and friend of Poussin (see no. 315), Velasquez, and Claude. At his death in 1677 his heir was forced to sell his collections. Among the buyers were the King of France, the Marqués del Carpio (who acquired this portrait) and

the English collector Dr. Mead, a man of classical learning and discriminating taste who died in 1754. (For an account of the cardinal's life, see Haskell 1963, 115–119; for the publication of a holograph letter from Velasquez, welcoming Massimi on his arrival in Spain, see Harris, 1960, 162–166).

"Un ritratto del medesimo cardinal [i.e. Massimi] in habito da prelato, di mano di Diego Velasio." The portrait was thus described in an inventory of Massimi's possessions taken after his death in 1677. From 1682–1687 a portrait of Massimi by Velasquez was recorded as being in the collection of Don Gaspar de Haro, Marqués del Carpio. Thereafter, for nearly three centuries, all trace of it is lost. Its rediscovery is owed to Mrs. Enriqueta Harris (1958, 279–280; 1983, 410–415) who recognized in a portrait of an ecclesiastic hanging at Kingston Lacy the features of the cardinal.

The "habito da prelato," as it was described in the Massimi inventory, is, as Mrs. Harris points out, the most unusual feature of the composition: "A costume," she writes, "in which few if any other prelates have sat for a portrait. Yet it was the official costume—a silk *sottana* and serge *soprana*, in peacock blue—of a *cameriere segreto* or *d'onore*, both being personal appointments of the Pope. Camillo Massimi was appointed *cameriere segreto* and *protonotario apostolico* by Innocent X in 1646, while he is described as *cameriere d'onore di S. Beatitudine* in an Avviso of October 1650, when he was made a canon of St Peter's, possibly the occasion of the portrait." The sitter's dress is painted in ultra-marine, a rare and costly pigment, used in Italy but scarcely ever in Spain.

During its recent restoration, the cipher of Don Gaspar de Haro, accompanied by the number *430*, was revealed on the back of the original canvas. Lists of the pictures in this celebrated collection were made in 1682 on Don Gaspar's appointment as viceroy of Naples and again in 1687 after his death, in both of which the Velasquez is numbered *430*. From then until 1819–1820, when it was bought in Bologna by William John Bankes, nothing is known of its history. Bankes, visiting Italy in those years, acquired among

other pictures the portrait of Titian (no. 498) which came from the Marescalchi Palace in Bologna. From a paper in the Bankes correspondence it is clear that the Velasquez was found in the same city, for in comparing the Spanish paintings of Velasquez with those executed in Italy Bankes remarks on the "richer tone of colour" of the latter, "like that which I purchased at Bologna."

It was in 1812 that William John Bankes set out on the journey that was to end eight years later in Bologna. His first stop was Spain, where he stayed for a time at Wellington's headquarters. His interest in Spanish art led ultimately to the creation of the Golden Room at Kingston Lacy in the 1840s, furnished with a carved, gilded, and painted ceiling and Cordoba leather hangings from a Contarini Palace in Venice. Its walls were hung with pictures by, or attributed to, Morales, Zurbaran, Murillo, Espinosa, and Velasquez. "I know of no other collection in England," wrote Waagen after visiting Kingston Lacy, "containing so many valuable pictures of the Spanish school." In this respect Bankes in 1812 was ahead of his time. It was not until after the Peninsular War that Spain, bypassed by the Grand Tourist and only occasionally visited in the eighteenth century, began to attract English visitors and—for works of art were now becoming available—collectors. By the mid-century travelers and scholars such as Richard Ford, whose *Handbook for Travellers in Spain* was published in 1848, and Sir John Stirling Maxwell, whose *Annals of the Artists of Spain* appeared in the same year, further opened the eyes of the British public to Spanish art; and in 1853 the sale in London of Louis Philippe's collection of Spanish pictures (which included the bequest of the English collector Hall Standish) provided an unprecedented opportunity for the acquisition of works of art that were by now in considerable demand. The time was not far off when there would be more paintings by Murillo in British collections, as was the case with Cuyp and Canaletto, than there were in the countries of their origin. (On the British taste for Spanish painting see Braham 1981.)
st.j.g.

Provenance: In the sitter's possession until his death in 1677; soon afterward acquired by the Spanish Ambassador at Rome, Don Gaspar de Haro, Marqués del Carpio, in whose collection it was recorded in 1682; after Don Gaspar's death in 1687 it disappeared until it was bought by William John Bankes in Bologna in 1819–1820; thereafter at Kingston Lacy until the death of Mr. Ralph Bankes in 1982, who bequeathed the house and its contents to the National Trust
Literature: Harris 1958; López-Rey 1963, no. 471; Harris and Lank 1983
Exhibitions: London, BI 1821 (48); London, RA 1902 (130); on loan to the National Gallery, London, 1983–1985

493

THE HOLY FAMILY 1670/1675
Bartolomé Estéban Murillo 1617–1682
oil on canvas
96.5 × 68.5 (38 × 28)

Chatsworth
The Trustees of the Chatsworth Settlement

Dated 1670–1675 by Angulo, this is one of the most intimate and engaging in the long sequence of Murillo's pictures of the subject. The unusually small scale may echo a Dutch prototype, and as Mena and Valdivieso point out (Madrid and London [1982-1983] 1983), the figure of Saint Joseph is reminiscent of a lost composition by Ribera, known from copies in the Museo de Santa Cruz, Toledo, and the Escorial, while the theme of the Virgin uncovering the Child derives ultimately from Raphael. However, the deceptive simplicity of the design is wholly personal, and the beautifully controlled execution marks the picture as one of the masterpieces of Murillo's full maturity.

As early as 1693 a picture attributed to Murillo was sold in London, and by 1729 the widow of Sir Daniel Arthur brought a notable group of works by the artist from Spain: these included the Woburn *Cherubs Scattering Flowers* and the Boughton *Infant Saint John*, which was purchased by Lady Cardigan, mother of Lord Brudenell (see no. 173) in 1757. Murillo quickly became popular

with the English: Sir Robert Walpole owned an *Assumption of the Virgin* and a *Flight into Egypt*, while the *Adoration of the Kings* (Toledo, Ohio) was at Belvoir by 1729. The school version of the *Madonna and Child* at Corsham was "a favourite picture of Sir Paul Methuen's" (Methuen 1891, under no. 226). John Blackwood, who sold pictures to so many collectors in the mid-eighteenth century, had a particular sympathy for Murillo, whose *Journey into Egypt* (Toledo, Ohio) was an early purchase of one of the more discriminating *nouveau riche* connoisseurs of the time, Sir Sampson Gideon. But it was less for his religious pictures than for his studies of children that Murillo was admired by eighteenth-century painters in England. Reynolds' fancy pictures of children owe much to his example and Gainsborough's copy of the *Old Woman with a Boy* at Dyrham still hangs with it in the house.

Although this picture was purchased for Devonshire House, London, in the eighteenth century, it is included here to illustrate the continuity of taste. The turmoil caused by the French occupation of Spain and the Peninsular War led to a hemorrhage of sales, and no great gallery of the early nineteenth century in Britain was complete without a Murillo. In London alone Stafford House could boast the *Santa Justa* and *Santa Rufina* (now at Dallas), Grosvenor House the *Jacob Searching for His Household Goods* (Cleveland), while there were major works in the Baring, Hertford, Heytesbury, Lansdowne, and many other collections. Murillo was to remain in high fashion throughout the nineteenth century. For example, the great *Triumph of the Eucharist* at Buscot (National Trust, Faringdon Collection) was acquired as late as 1895 by the successful banker Sir Alexander Henderson, later 1st Lord Faringdon. Changing taste in this century has led to the disposal of many works by Murillo from English collections, and this partly accounts for his splendid representation in American institutions. F.R.

Provenance: Probably purchased by the 2nd Duke of Devonshire; and by descent at Devonshire House where recorded in the East Drawing Room (the Green Room) in 1813 and 1836; and afterward at Chatsworth
Literature: Devonshire House 1813; Devonshire House 1836; Waagen 1854, 3:351; Angulo 1981, 2:187; Mena Marques and Valdivieso in Madrid and London 1982–1983, with previous literature
Exhibitions: Derby and Sheffield 1948–1949 (9); Leeds and Sheffield 1954–1955 (20); Arts Council 1955–1956 (19); IEF 1979–1981 (36); London, NG 1981 (53); Madrid and London 1982–1983 (58)

494

LADY WITH A LUTE C.1520
Jacopo Negretti, Palma Il Vecchio
1480–1528
oil on canvas
96.5 × 73.6 (38 × 29)

Alnwick Castle
The Duke of Northumberland, KG

This characteristic work of Palma's early maturity, less a portrait than a representation of an ideal of feminine beauty, has been associated with Marcantonio Michiel's description of a picture he saw in the collection of Girolamo Marcello in 1525: "La tela delle donna insino al cinto, che tiene in la mano destra el liuto e la sinistra sotto la testa, fu de Iacomo Palma" (A canvas of a woman to the waist, who holds a lute in her right hand and has her left hand under her head, by Jacopo Palma). Of Palma's surviving pictures, that at Alnwick fits the description except that it is in reverse; thus it is likely that Michiel describes a version of it. First

attributed to Palma by Crowe and Calvacaselle (1871, 2:481), the picture has been accepted as his by most critics; Mariacher implies that it may be a school work (*pace* Rylands, London, RA 1983–1984). It is in fact one of the artist's finest pictures of the type, and can be dated not long after 1520: minor pentimenti in the landscape confirm its autograph status.

The picture is first certainly recorded in the celebrated collection in Palazzo Manfrin, Venice, in 1800. It was then thought to be by Giorgione to whom a number of other works in the collection were then given. The Palazzo was visited by many of the more discriminating visitors to the city, including Byron who observed "some very fine Giorgiones" (Marchand 1973–1982, 6:213). A catalogue of the collection was published in 1856, but in the ensuing years many pictures were sold, a substantial proportion coming to England.

Algernon Percy, 4th Duke of Northumberland, who acquired this picture in 1857, had an inherited taste for the Venetian Renaissance. In the seventeenth century his ancestors had acquired two exceptional works by Titian, the double portrait of Cardinal d'Armagnac and his secretary, still in the collection, and the *Vendramin Family in Adoration*, sold to the National Gallery, London, in 1929. The duke himself, who succeeded his brother at the age of 55 in 1847, had a particular sympathy for the cinquecento. While Anthony Salvin was chosen for the great task of remodelling Alnwick Castle from 1854 onward in an appropriately medieval style, the internal decoration was entrusted to Luigi Canina, director of the Capitoline Museum, who was succeeded in 1856 by Giovanni Mantiroli. Other Italians were retained and local craftsmen were trained under them. The resulting suite of apartments, still unfinished at the duke's death in 1865, was one of the most notable statements of neo-Renaissance taste in Britain and cost a total of a quarter of a million pounds. Such an interior demanded appropriate furnishings and pictures and in 1856 the duke purchased the major collection assembled by the neo-classical painter Vincenzo Camuccini and his brother Pietro.

The most celebrated of the Camuccini pictures, the Bellini *Feast of the Gods*, is now in Washington (National Gallery, Widener Collection), and many seicento works from the collection have been sold in recent decades, but the majority of the cinquecento pictures happily remain at Alnwick, where the Sarto self-portrait, a group of Venetian portraits, and works by Garofalo, Lotto, Badalocchio, and Reni (see no. 495) still complement the 4th Duke's decoration. F.R.

Provenance: Girolamo Manfrin by 1800; by descent at Palazzo Manfrin, Venice, no. 262 of the 1856 catalogue; purchased in 1857 by the 4th Duke of Northumberland; and by descent at Alnwick
Literature: Hartshorne 1865, 60; Northumberland 1930, 575; Mariacher 1968, 82
Exhibitions: London, BFAC 1915 (62); London, Matthiessen 1939 (22); London, RA 1950–1951 (215); Manchester 1957 (65); London, RA 1983 (75)

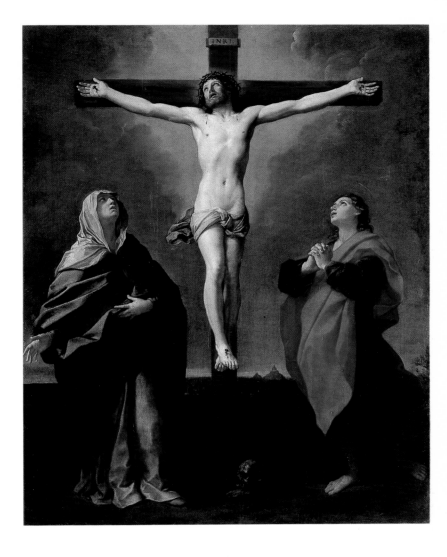

495

THE CRUCIFIXION 1625/1626
Guido Reni 1575–1642
oil on canvas
95.25 × 74 (37$\frac{1}{2}$ × 29$\frac{1}{2}$)

Alnwick Castle
The Duke of Northumberland, KG

This powerfully concentrated masterpiece is, as Malvasia was the first to recognize (1678, 2:30), related to Reni's great *Crucifixion of the Cappuccini*, now in the Pinacoteca Nazionale, Bologna (Malvasia 1678, 2:30). Painted a decade later, this picture omits the Magdalen who kneels at the foot of the cross in the altarpiece at Bologna; the figures of the Virgin and Saint John the Evangelist were also modified considerably and placed nearer that of Christ. The more rigorous intensity of this composition reflects Reni's response to the Roman

classical tradition, and accounts in turn for the iconographic influence of the picture which was to be altogether exceptional for a work of relatively modest scale, albeit accessible in a prominent Roman church. First described by Titi (1674, 333), the picture is mentioned by both Bellori and Passeri in their biographies of Guido, and in many later guide books.

The picture was acquired by Algernon Percy, 4th Duke of Northumberland, with the Camuccini collection in 1856, and was placed in the Drawing Room at Alnwick in 1856: for this purchase and the part it played in the duke's campaign for the restoration of Alnwick, see the entry for the Palma, no. 494. F.R.

Provenance: Painted for Cardinal Berlinghieri Gessi (d. 1639), by whom bequeathed to the church of Santa Maria della Vittoria, Rome, from which sold in 1801, when purchased by Pietro Camuccini; purchased with the Camuccini collection by Algernon, 4th Duke of Northumberland, 1856
Literature: Waagen 1857, 470; Hartshorne 1865, 63; Pepper 1984, no. 96
Exhibitions: London, B.I. 1856 (52); London, RA 1950–1951 (326); Bologna 1954 (32); Newcastle 1963 (67); London, Agnew 1973 (44)

496

MARCHESA CATERINA GRIMALDI
1606
Sir Peter Paul Rubens 1577–1640
oil on canvas
241.3 × 139.7 (95 × 55)
inscribed, *PETR' PAVLVS RVEBNS*
PINXIT ATQUE SINGVLARI
DEVOTIŌE ADD M.DC.V.I, partly
abraded at lower left, the fourth line
distorted possibly by an early
nineteenth-century restoration

Kingston Lacy
The National Trust (Bankes Collection)

The attribution has never been doubted except by David Wilkie in a letter to Sir Robert Peel (1 August 1839). Only the identity of the sitter is uncertain. C.G. Ratti (1780) recorded, in Genoa in the palace of Giovan Francesco Centurione, on the first floor then inhabited by Giovanbattista Grimaldi la Pietra, several portraits including "due di Dame a sedere in grandi tele, che sono i più belli, che del *Rubens* avrete fino ad ora in questa Città veduto." Both these were acquired for Kingston Lacy by William John Bankes with identifications presumably supplied by the Grimaldi family: the present one as Marchesa Isabella Grimaldi, and the companion portrait, wherein the sitter is accompanied by her dwarf and her pet dog, as Marchesa Maria Grimaldi. With these identifications they were exhibited by W.J. Bankes in 1841 at the British Institution (nos. 70 and 64). However, a note in the Bankes papers (Dorset County Record Office, kindly called to my attention by the Hon. Georgina Stonor), which is written in the hand of W.J. Bankes, reads, "TORINO/Chevr Rati Opizzone/ Conseiller d'Etat à Turin. Rue de la Providence No: 22: has the companion picture by Rubens of the pair which I purchased; portrait of a Lady full length (standing) (with a fan) the same date upon it 1606, & the age, & name of the Lady (Spinola Doria, I think)—is desirous of selling it; it was a present from the head of the Family Imperiali to his (the Chevr's) father-in-law when the Imperiali was quitting the palace in Campetto." This note would seem to fill a gap in the provenance of the *Marchesa Brigida Spinola Doria* in the National Gallery, Washington, but also, since that portrait is reputed to have been acquired for General Sir John Murray, Bart., of Clermont (Fifeshire) by 1827, it should indicate that W.J. Bankes had made his purchase in Genoa by about the mid-1820s. However, we have in his copy of Ratti (opposite page 291) his own annotation that he bought both his Rubens portraits at Genoa in 1840.

The identification of these portraits at Kingston Lacy has changed since the London exhibition of 1841: that of the woman with the dwarf and dog was changed by Ludwig Burchard (1929) to Caterina Grimaldi who in 1606 married Gianvincenzo Imperiale, an identification followed by Frances Huemer (1977) and by Justus Müller Hofstede (1977). That of the present picture was changed by John Smith (9: no. 395) to Maria Grimaldi; by Waagen (1857) to Brigida Spinola Doria (an implausible view maintained by Burchard, despite eye pigmentation and other details that differ conspicuously from those of the Washington picture); and by Müller Hofstede, first to Bianca Spinola Doria and (1977) to Veronica Spinola Doria, an opinion then shared by the present writer. More probably both the Kingston Lacy portraits represent ladies of the Grimaldi family, painted by Rubens in 1606. Much as the Washington portrait painted the same year of Brigida Spinola, who had married Giacomo Massimiliano Doria in July 1605, shows a bride in white, so the present portrait shows Caterina Grimaldi in her bridal dress; she married Gian Vincenzo Imperiale the following year when Rubens was in Genoa in the suite of Vincenzo I Gonzaga, Duke of Mantua. The letters *M.A* written on the collar of the dog in the companion portrait suggest that the identification as Maria Grimaldi and accepted by W.J. Bankes may indeed be correct. The white patch on the red hanging, otherwise unexplained, may refer to the Grimaldi arms (*fusato di rosso e di argento*). The top of the hanging appears to be blazoned according to the Pallavicini arms of Caterina's great grandfather, Francesco (*capo d'oro carica di una steccconata di nero*).

The full-length portraits of Grimaldi ladies, which were to be hung by Mr. Bankes in his saloon at Kingston Lacy, evidently excited the emulation of Van Dyck when as a young man in his twenties he saw them in Genoa; and it was through Van Dyck's active admiration that this kind of grandeur in portraiture became accessible to Carbone and other Genoese painters of the seicento. In the case of the present portrait the grandeur of the seated figure, made more splendid by the spread and fall of drapery and by the spatial order and effect of the architectural setting, is a tribute by the twenty-nine-year-old Rubens to the fresco on the Justice wall of the Stanza della Segnatura of Gregory IX, with the likeness of Julius II giving the Decretals. Raphael in Rome, as well as Tintoretto and Titian in Venice, was of the utmost importance to his development as a painter. From Moroni may have come the notion that a full-length, seated pose, was not too presumptuous a pattern of portraiture for a woman, even a woman not of royal birth.

M.J.

Literature: Huemer 1977; Jaffé 1977a; Müller Hofstede 1977
Exhibitions: London, BI 1841 (64)

497

DON BALTASAR CARLOS:
THE RIDING SCHOOL 1636
Diego Velasquez 1599–1660
oil on canvas
144 × 91 (57½ × 36½)

The Duke of Westminster

The Infant Baltasar Carlos, Prince of the Asturias (1629–1646), son of King Philip IV of Spain, is shown on his charger, performing a *levade*, near the Buen Retiro, the palace at Madrid built for the King by his favorite and first minister, Gaspar de Guzmán, Conde de Olivares and Duque de San Lucar. Philip IV and his consort, Isabella de Bourbon, observe the scene from the balcony on the right, attended by the Condésa d'Olivares and with a child, possibly the Infanta Maria Antonia (1635–1636). Immediately below is Olivares, on the point of taking the lance held out to him by a courtier, probably Alonso Martinez de Espinar, Gentleman of the Bedchamber to Prince Baltasar Carlos and Keeper of Arms; the man behind the latter is probably Juan Mateos, the Master of the Hunt. The prince is attended by a dwarf. Olivares himself held the distinguished office of Master of the Horse, and his role as mentor of the king and as instructor of the young prince is implicit in this majestic celebration of the analogy between the arts of horsemanship and monarchy. A date in the latter part of 1636 would be consistent with the prince's appearance and the proposed identification of the Infanta, who died in December of that year. There are numerous pentimenti, notably in the roof and tower of the palace and in the upper part of the prince's body: the figures of Olivares, Martinez, and Mateos overlay the wicker fence and were no doubt introduced by the artist at a late stage.

The picture is one of the earliest in the series of likenesses of the Prince by Velasquez: another equestrian portrait was painted for the Hall of the Realms in the Buen Retiro and is now in the Prado. A variant of this composition, in which the subsidiary portraits are replaced by stock figures, is in the Wallace Collection: this is now generally considered to be by Mazo.

This picture was presumably commissioned by or for presentation to the Conde Duque and was recorded by Palomino in the possession of his nephew, the Marquez de Heliche (Palomino 1724, 3, 332). It was subsequently owned by the latter's son, the Marquez del Carpio, Viceroy of Naples in 1682–1687, who added extensively to the assemblage of pictures he inherited and owned one of the greatest of all seventeenth-century collections, rich in Italian and Spanish works with an outstanding series of paintings by Velasquez including the Rokeby *Venus* (National Gallery, London), which was to reach England as a result of the turmoil caused by the French invasion and occupation of Spain. Carpio's collection must have owed much to the prestige of his viceroyal office and similarly the alienation of the picture by the family of his niece may well have been due to the influence of Cardinal Gonzaga, who subsequently acquired it, exercised as Papal Nuncio in Madrid. When the picture reached London remains uncertain. It was purchased by a remarkable connoisseur, Welbore Ellis Agar (1735–1805), brother of the Archbishop of Dublin and uncle of Welbore Ellis Agar, 2nd Earl of Normanton, who in turn formed a notable picture collection, much of which remains at Somerley. Agar's collection was famous above all for its group of landscapes by Claude (see no. 310) and its purchase *en bloc* by the 2nd Earl Grosvenor was a remarkable coup. Visible in Leslie's

conversation piece of the Westminster family in the Gallery at Grosvenor House (no. 517), the picture is recorded in 1844 by Mrs. Jameson in the dining room. Although Waagen (1838) regarded it as an autograph and "excellent repetition, very powerful and clear in the coloring" of the composition, it was overlooked by more recent critics. Its priority over the Wallace Collection version was only decisively demonstrated by Harris after the picture was restored in the mid-1970s. F.R.

Provenance: Luis de Haro, Marqués de Heliche (d. 1661), by 1647; his son Gaspar Méndez de Haro, Marqués del Carpio y de Heliche (d. 1687); sold in 1690, but recovered for the latter's brother the Conde de Monterrey (d. 1716); his daughter, wife of the 10th Duque d'Alba (d. 1739); Cardinal Silvio Valenti Gonzaga (d. 1758), Nuncio in Spain in 1736 by 1749; Welbore Ellis Agar, catalogued for his sale, Christie's, 2 May 1806, lot 22, but acquired *en bloc* with the collection by the 2nd Earl Grosvenor, later 1st Marquess of Westminster; and by descent
Literature: Young 1821, no. 142; Passavant 1833, 66; Waagen 1838, 2:315; Jameson 1844, 262, no. 84; Waagen 1854, 2:172; Harris 1976, 266–275
Exhibitions: London, BI 1819 (8); London, RA 1870 (2); London, RA 1890 (138); London, New Gallery 1895–1896 (59); London, Guildhall 1901 (127); London, NG 1981 (24); Eaton Hall 1984 (24)

498

FRANCESCO SAVORGNAN DELLA TORRE
c.1545
Tiziano Vecellio, Titian 1480/1485–1576
oil on canvas
123 × 96 (49¼ × 38⅛)

Kingston Lacy
The National Trust (Bankes Collection)

The traditional indentification as the military commander Girolamo Savorgnan must be discounted on date (he died in 1529 and the portrait is appreciably later); it is also a patrician, not a military commander, who is shown. The suggestion, first made by Fabbro (1951, 185–186), that Francesco Savorgnan della Torre is represented, is under the circumstances perfectly plausible—so long as the date of the picture is no later than 1547 when Francesco died (all authorities appear to agree that it was painted in the early 1540s), and provided that the identification is not invalidated by the inscription *CA ZORZI*, recently revealed on the back of the canvas. The Zorzi were a Venetian family owning palaces on the Rio San Giorgio dei Greci and near Santa Maria Formosa (see London, RA 1983, 122). The portrait has, however, been associated with the name of Savorgnan from the early years of the nineteenth century.

Fabbro has pointed out that the Del Torre branch of the Savorgnan family owned Palazzo di San Geremia until the death of the last male representative in 1810. Following this the palace was sold by his niece and the large collection of pictures, which included portraits ascribed to Titian, was dispersed. By 1820, when this picture was acquired by William John Bankes, it was in the possession of the Conte Marescalchi in Bologna. Before that, on the evidence of a note in Bankes' handwriting discovered recently by Mr. Anthony Mitchell among the family papers at Kingston Lacy, it was owned by the "Avvocato Galeazzi." The note reads as follows: "The elder Schiavone (whom I consider the best colourist now in Venice) tells me that he made, and still has somewhere in his possession, a small sketch or copy of the Marquis of Savorgnan by Titian

which is now at Kingston Lacy. It was at the time he copied it in the choice collection of the Avvocato Galeazzi, who sold it with three other pictures (of which one was the Judgement of Solomon by Giorgione, he cannot call to mind the remaining two) to the Conte Marescalchi for 10,000 Franks."

The *Judgment of Solomon*, the large, unfinished work that is among the greatest Venetian pictures of the early cinquecento, is now at Kingston Lacy (London, RA 1983, no. 97). Before buying it Bankes had consulted his friend Lord Byron. Byron, while admitting that he knew "nothing of pictures myself, and care almost as little," nonetheless favored its purchase (letter of 26 February 1820; see Rowse 1975).

William John Bankes (1786–1855), whom Byron called "a stupendous traveller," was also something of an explorer and was a collector on a grand scale. An early visit to the Peninsula in 1812 led to his love of Spanish art and in the course of his life he added to the seventeenth- and eighteenth-century Bankes family collection, consisting mainly of English and Netherlandish paintings and transformed it into one with a European character. It contained such masterpieces as the Velasquez and Rubens portraits (nos. 492 and 496) and the Sebastiano del Piombo/Giorgione *Judgment of Solomon*, already mentioned. On inheriting the family house of Kingston Lacy in 1835 he employed Sir Charles Barry to remodel it. As a result the style of an Italian palazzo has been superimposed upon a conventional late seventeenth-century building—a change befitting the character of the contents. Waagen (1857, 4:374–383), on his visit to the house, remarked upon the discrimination and success of Bankes' Italian and Spanish purchases. The Titian, however, was not there at the time of his visit; Waagen saw it at the British Institution Exhibition in 1856 and pronounced it "very elevated in conception."

For the last fourteen years of his life Bankes had elected to live abroad rather than to face impending charges for a breach of convention. By a curious legal anomaly a dispensation existed whereby an expatriate was permitted to set foot on English soil between the hours of

sunrise and sunset on Sundays. Bankes is said to have availed himself of this opportunity; making a practice of crossing the Channel, he would anchor his yacht in a nearby bay, bringing cartloads of works of art to add to the collection at Kingston Lacy, which was now occupied by his brother. ST.J.G.

Provenance: Possibly Savorgnan della Torre, Venice, until the death of Conte Antonio, 1810; Avvocato Galeazzi; Marescalchi Palace, Bologna; acquired 1820 by William John Bankes; thereafter at Kingston Lacy on the death of Ralph Bankes in 1982 who bequeathed the house and its contents to the National Trust
Literature: Wethey 1971, 138–139, with previous literature
Exhibitions: London, RA 1983 (122)

499

SAINT JOHN THE EVANGELIST
c.1627/1629
Domenico Zampieri, Il Domenichino
1581–1641
oil on canvas
259 × 198 (95 × 58)

Glyndebourne
Sir George Christie

This picture is a reinterpretation of Domenichino's pendentive fresco of *Saint John the Evangelist* of 1624–1625 in Sant' Andrea delle Valle, Rome. Dating from about 1627–1629, its more sculptural character already anticipates the heroic mood of the painter's surpassing masterpieces, the pendentive frescoes of 1631–1640 in the chapel of Saint Januarius in the Cathedral at Naples. First recorded in the posthumous inventory of the collection of Marchese Vincenzo Giustiniani, which was prepared in 1683, it then formed part of a series of the Evangelists (Salerno 1960, 102, nos. 169–172). The companions, Reni's *Saint Luke*, Renieri's *Saint Matthew*, and Albani's *Saint Mark*, have not been traced. Although misattributed by Sandrart to Albini, the picture was one of the most celebrated in the collection. It was mentioned in most eighteenth-century guide books and accounts of Rome and etched by Fragonard.

The *Saint John* was rumored to be for sale in March 1801 (Brigstocke 1982, 52). On 30 June 1804, James Irvine reported to William Buchanan, the Scottish dealer, that he had offered 5,000 crowns (that is, *scudi*); that 6,500 had been unsuccessfully offered by the agent of an English nobleman, and that Lucien Bonaparte, who had made other acquisitions from the collection, was negotiating its purchase for 7,000 crowns (Irvine's letter is published by Buchanan 1824, 2:154). In the event it was sent with the bulk of the Giustiniani Gallery to Paris, where, as Buchanan records, "Delahante succeeded in obtaining its separation from that collection" (1824, 2:193). Delahante brought the picture to England and it was then sold by his fellow dealer Harris to Richard Hart Davis, MP, who was rumored to have spent £100,000 on his collection (*Farington Diary*, 12:4279). This was in turn purchased *en bloc* by his friend Philip John Miles, who is said to have paid 12,000 guineas for the picture.

The son of a successful Jamaica merchant who settled at Bristol, Miles was MP for the city. Waagen correctly describes him as "a very wealthy merchant and manufacturer" and, after an hour and a half's visit to Leigh Court, considered that Miles' "capital works of the most eminent Italian, Flemish, Spanish, and French masters…would have done the highest honour to the palace of the greatest monarch in Europe" (Waagen 1838, 2:134). The range of Miles' taste was indeed remarkable. He owned such earlier Italian pictures as the Carpaccio *Adoration of the Magi* and Raphael's predella panel of *The Way to Calvary* (both National Gallery, London) in addition to a major group of works of the Bolognese school. There were pictures by Murillo and Rubens; Sweerts' heart-rending *Plague*, then given to Poussin and until recently in the Cook collection; Gaspar Dughet's great *Calling of Abraham* from the Colonna Gallery (National Gallery, London) and, not least, the Altieri Claudes (National Trust, Anglesey Abbey, see no. 309). Miles' English pictures were also of the first quality, with the Hogarth *Shrimp Girl* (National Gallery, London), and Stothard's *Canterbury Pilgrims* (Tate Gallery, London). Of the five collections for which John Young, Director of the British Institution, published catalogues in the early 1820s, Miles' was the only one not kept in London.

Miles' house, Leigh Court near Bristol, was built in 1814 by Thomas Hopper in the "the Italian style" expressly to house his collection. The entrance atrium and hall were decorated with copies of antique sculpture and the more important pictures were arranged in two rooms: like the Claudes, the Domenichino was placed in the saloon. Considered by Waagen to be one of the painter's most beautiful works, its reputation inevitably diminished as the taste for Italian pictures of an earlier generation developed: the picture's sinking fortunes in 1884 and 1899 offer as revealing an insight into the evolution of taste as the very different reception it had received earlier in the century.

F.R.

Related Works: Preparatory drawings at Windsor (Pope-Hennessy 1948, nos. 124, 126–127)
Provenance: Painted for Marchese Vincenzo Giustiniani (d. 1631), Rome, and by descent at Palazzo Giustiniani until c. 1806 when sent to Paris; brought to London by Alexis Delahante; Harris; Richard Hart Davis, MP; sold privately to Philip John Miles, Leigh Court, c. 1813; by descent to his grandson, Sir Philip Miles, 2nd Bart.; his sale, Christie's, 28 June 1884, lot 22, bought in at 700 gns; Sir Cecil Miles, 3rd Bart., his posthumous sale, Christie's, 13 May 1899, no. 19, bought in at 100 gns, but sold after the sale for 70 gns to M. Colnaghi; A.L. Christie; and by descent
Literature: Young 1822, 5; Buchanan 1824, 2:154, 193, no. 16; Waagen 1838, 2:140–141; Waagen 1852, 3:182; Reitlinger 1962, 1:44; Spear 1982, no. 100, 261–264
Exhibitions: London, RA 1950–1951 (328); Rome 1956–1957 (90); London, Agnew 1973 (28)

Bath House in London. On his death in 1864 she moved to Melchet Court in the New Forest, which was rebuilt by Henry Clutton, and he also designed Kent House, her London residence, the site of which was acquired in 1870. The decoration of her houses was lavishly but carefully thought out—Lady Ashburton suffered an "indigestion of bric-a-brac" on a visit to Mentmore in 1870 (Surtees 1984, 140)—and many of the leading artists and craftsmen of the day were engaged—Lear, Rossetti, and Watts among painters; Marochetti, Wolner, and the American Harriet Hosmer among sculptors. She also owned a considerable collection of old masters, mostly of the Italian schools, including Mantegna's *Adoration of the Magi*, a Bellini *Madonna*, and works by such artists as the Master of the Bambino Vispo, Caselli, Palmezzano, and Andrea da Salerno. Despite the recent sales of Dosso and Battista Dossi's *Pan and Echo* and the Mantegna to the J. Paul Getty Museum, few surviving collections offer as rewarding an insight into the taste for Italian pictures in mid-Victorian England. F.R.

Provenance: Possibly Casa Venier, Venice, before 1660; Louisa, Lady Ashburton, whose only child, the Hon. Mary Florence Baring, wife of the 5th Marquess of Northampton, had predeceased her; and by descent

Literature: Canova 1964, 98, fig. 120
Exhibitions: London, RA 1960 (57)

500

THE REST ON THE FLIGHT INTO EGYPT WITH SAINT JOHN THE BAPTIST, SAINT ELIZABETH, AND SAINT CATHERINE
c.1545/1550
Paris Bordon 1500–1571
oil on canvas
96.7 × 139.7 (38 × 55)

Castle Ashby
The Marquess of Northampton

This magnificent canvas is one of the less well-known masterpieces of the painter's late maturity, vibrant in color and resonant of Bordon's debt to Titian and to Palma.

King Charles II owned five pictures by the painter, whose Berlin *Chess Players* was in the possession of the Earl of Arundel. Like other Venetians of the cinquecento, Bordon was popular with collectors in Britain from the eighteenth century onward. The fine family portrait at Chatsworth was acquired by the 6th Duke of Devonshire and in the nineteenth century other portraits were at Ashridge, Longford, and Mentmore, while the celebrated *Warrior with Two Pages*, now in the Metropolitan Museum, New York, was at Eastnor. Of the pictures most closely related in style to the present work, the *Holy Family with Saint John the Baptist* was in the portion of the

Orleans collection retained by the Duke of Bridgewater while the variant of this from Keir was owned by Sir William Stirling Maxwell, the pioneer connoisseur of Spanish painting.

E.K. Waterhouse (London, RA 1960) suggests that the picture is that recorded by Boschini in Cà Venier, Venice (Boschini 1660, 334). Its subsequent whereabouts cannot be established until the nineteenth century when it was owned by Louisa, Lady Ashburton (1827–1903), one of the most remarkable women of her generation (for a sympathetic biography see Surtees 1984). Louisa Stewart Mackenzie married William Baring, 2nd Lord Ashburton, in 1858. A friend of Browning, Carlyle, Landseer, and many of the outstanding figures of the mid-Victorian era, Lady Ashburton after her marriage redecorated her husband's houses, The Grange and

501

ANGELICA AND THE HERMIT
c. 1578/1580
Jacopo Robusti, Il Tintoretto 1518–1594
oil on canvas
104 × 129.5 (41 × 51)
inscribed, *Jacomo Tentoreto*

Longleat
The Marquess of Bath

This picture, which has been somewhat overlooked until recent years, was described by Berenson as an "Allegorical couple in a garden" (1957, 1:174), but seems to illustrate Ariosto's *Orlando Furioso* in which the charms of Angelica overcame the Christian paladins and also hermits. The owl and luxuriant flowers are not specified in the text. Datable about 1578–1580, it may well be, as Palluchini and Rossi argue, that Tintoretto's son Domenico Robusti collaborated in the execution of the landscape and the flowers.

The picture was acquired by John Alexander Thynne, 4th Marquess of Bath (1831–1896), who succeeded his father in 1837. Bath evidently appreciated the schools of Tuscany from the trecento onward, acquiring a number of cassone panels and a handsome altarpiece by the Master of the Spiridion *Story of Joseph*. He evidently had a predilection for Venice, where he was to die. He bought the early Titian *Rest on the Flight* for 350 guineas at the Munro of Novar sale in 1878 and acquired several canvases of the late cinquecento for use as ceiling decorations at Longleat, where J.D. Crace undertook a major program of redecoration in the 1870s. Many Italian craftsmen were employed and the cyclopean chimneypiece of the Saloon was actually copied from one in the Doge's palace. As at Alnwick a generation earlier, Bath's acquisitions were thus closely linked with his contribution to the building.

Lord Bath was a trustee of the National Portrait Gallery in 1874–1893 and of the British Museum in 1883–1896. Described in 1885 as "the very exemplar of an immaculate, unemotional self-possessed British aristocrat" (*Society in Life*, 1885, quoted in the *Complete Peerage* 2:26), Bath's income in 1883, from just under 50,000 acres, was £81,018. His

collection of Italian pictures was small by comparison with those of Gambier Parry, now removed from Highnam Court to the Courtauld Institute; Davenport Bromley, a small proportion of whose collection survives at Capesthorne; or Lord Lindsay, most of whose pictures are at Balcarres. But it is one of the few of the period to remain intact and in its intended setting. At Longleat, moreover, the 4th Marquess' acquisitions made a fascinating contrast with another element in the collection, the Dutch seventeenth-century pictures bought in the 1840s by Beriah Botfield whose taste was conventional in many ways. Typical examples of Terborch, Netscher, van Goyen, and Lingelbach are complemented by an exceptional de Keyser and a pair of street scenes by the elusive Jacob Vrel. F.R.

Literature: Longleat, no. 21, as Palma Giovane; Palluchini and Rossi 1982, no. 391
Exhibitions: London, RA 1960 (63)

502

LOUIS DE BOURBON, LE GRAND CONDÉ
c.1707
attributed to Jerome Derbais
fl.1688–1715
bronze and gilt-bronze
86.4 (34) high

Stratfield Saye
The Duke of Wellington

This and its companion (no. 503) are from a set of nine large busts in the gallery at Stratfield Saye, acquired by the 1st Duke of Wellington soon after the battle of Waterloo to accompany his outstanding collection of Boulle furniture. These busts, which differ in date and quality, include a version of Le Sueur's Charles I (see no. 67) and the same sculptor's Henri IV, a mid-eighteenth-century bust of Louis XIV, and those of his two great commanders, Condé and Turenne, together with four early nineteenth-century heads; traditionally Napoleon and Massena, paired with two Roman emperors, one of them evidently Vitellius.

Of these, the Condé and Turenne are the finest, once attributed to Coysevox, but more likely posthumous likenesses by Jerome Derbais, who executed the marble versions at Chantilly for Henri-Jules de Bourbon, son of the Grand Condé. The entry in the accounts for 29 August 1707 reads "à Derbais, marbrier, la somme de 2400 livres pour quatres bustes...représentant fer monseigneur le Prince, un autre représentant fer M. de Turenne, sans escabellons, et deux autres bustes représentant deux Maures." The composition is reminiscent of an earlier posthumous bust of the prince by Coysevox dating from 1688, now in the Louvre (Souchal 1981, 1:179, no. 7c) though looking to the left rather than the right, broader-featured, and without Coysevox's sense of nervous tension. A considerable number of bronze casts of this model must have been made, and other examples exist in the Royal Collection at Windsor, and at the Wallace Collection in London (formerly in William Beckford's collection at Fonthill). Derbais, who was the son-in-law of the sculptor Gilles Guerin, frequently occurs in the royal accounts from 1668 to 1715, and worked at Versailles, Marly, Saint-Germain, and Fontainebleu.

Louis de Bourbon, Prince de Condé (1621–1686), became one of the most famous names in French military history from the early age of twenty-two, when he commanded the French army at the battle of Rocroy, gaining a decisive victory over the Spaniards. He later led the party of the Fronde that drove Cardinal Mazarin from power and in 1675 succeeded Turenne in the command of the army on the Rhine. G.J-S.

Literature: Mann 1931, 61–62, fig. 40; Watson 1975, 47

503

BUST OF A ROMAN EMPEROR,
TRADITIONALLY NAPOLEON c.1810
French
bronze and gilt-bronze
86.4 (34) high

Stratfield Saye
The Duke of Wellington

The inclusion of the 1st Duke of Wellington's greatest adversary in the pantheon of military commanders whose busts adorn the gallery at Stratfield Saye might seem strange, were it not for the "Iron Duke's" known respect for many of Napoleon's qualities. His London residence, Apsley House, already contained Canova's heroic nude statue of the Emperor as "pacific" Mars, presented to him by the British government in 1816, and Wellington may have viewed such trophies in the same light as the giant bust of Louis XIV captured by the 1st Duke of Marlborough at the siege of Tournai, and placed on the parapet of the south front at Blenheim.

The sculptor of this and the accompanying busts—of Napoleon's general Massena, and two Roman emperors after the antique—has not been identified. For the other busts in the series, and the circumstances of their acquisition, see no. 502 G.J-S.

Literature: Watson 1975, 47, fig. 4

504

PAIR OF PEDESTALS c.1700
French
Boulle marquetry in brass and
tortoiseshell
135.3 (53¼) high

Stratfield Saye
The Duke of Wellington

The pedestals come from a set of
four described simply as "Quatre Gaines"
in Fénéol de Bonnemaison's bill of lading
in 1818, and were evidently supplied
with the bronze and gilt-bronze busts
that they now support. Six exactly
similar pedestals are now in the Louvre,
three of these bearing the stamp of
Etienne Levasseur. However, as Sir
Francis Watson has pointed out, it is
more likely that Levasseur repaired
these pieces than that they were made
in his workshop (1975, 47). Guild
regulations required that *ébénistes*
should stamp pieces that they altered
or restored just as much as pieces
they had created. Thus the so-called
"Londonderry Cabinet" in the Wallace
Collection, which bears Levasseur's
stamp no less than eight times, is almost
certainly a restoration of a famous
seventeenth-century piece almost
certainly made by Boulle himself for
the French Crown. The Stratfield Saye
pedestals also probably date from the
reign of Louis XIV. The fringed apron
that hangs from below the frieze across
the entire upper half of the front has a
translucent tortoiseshell background
(taken from the underbelly of the turtle)
painted blue on the reverse, a feature
found on some of the finest documented
pieces, while the contrasting *premier*
and *contre-partie* Boulle marquetry is
also normal practice for the period. A
further pair of pedestals from the same
set is at Wrotham Park in Hertfordshire
(Byng collection). G.J-S.

Literature: Watson 1975, 47, fig. 4

Like the book cabinet (no. 505), these
pedestals belong to the outstanding
collection of Boulle furniture bought in
Paris by the 1st Duke of Wellington,
and much of it now grouped in the
gallery at Stratfield Saye. Here, combined
with the crowded arrangement of prints
edged with gilded wooden beading and
pasted on the walls in the 1790s during
Lord Rivers' day, these pieces present
an aspect of neo-classical taste unfamiliar
to most collectors of French furniture.

505

BOOK CABINET c.1780
Etienne Levasseur fl. 1767–1798
Boulle marquetry in brass and pewter
with glazed doors
stamped, *E. LEVASSEUR*
103.2 × 167 × 45.7 (40½ × 65¾ × 18)

Stratfield Saye
The Duke of Wellington

This break-fronted book cabinet, or
meuble à hauteur d'appui, as it would have
been called in the eighteenth century,
belongs to a series of Boulle pieces
acquired by the 1st Duke of Wellington
in Paris soon after the Battle of Waterloo,
and destined for Stratfield Saye,
the country house in Hampshire given
him by a grateful nation in 1817. It
may seem paradoxical that Napoleon's
greatest enemy should choose to fill his
house with such furniture, but ever
since the arrival of the *émigrés* at the
time of the Revolution in 1789–1790,
and the sales of the contents of the
royal palaces ordered by the Directory
in 1793, eighteenth-century French
works of art had become highly fashion-
able in England. These were the years
when the Prince of Wales and his friend
Lord Yarmouth, later 1st Marquess of
Hertford, were laying the foundations
of their great collections, and it is
significant that the latter's fifteen cases
shipped back from Paris in January
1818 contained items of "French Buhl"
(now in the Wallace Collection) directly
comparable with those at Stratfield Saye.

The duke bought over forty lots,
including richly colored marble and
mosaic tables, from the collection of
Cardinal Fesch, Napoleon's uncle, sold
in 1816, but otherwise most of his
purchases were made through the
celebrated *ébéniste* Jacob-Desmalter,
and the painter and dealer Fénéol de
Bonnemaison. It was the latter who
seems to have acquired all the Boulle
furniture including this cabinet, one of
"deux bibliothèques ou bas d'armoire"
that appear in his bill of lading, dated
July 1818. Their design goes back to an
engraving by André-Charles Boulle
himself, which was repeated in the Louis
XVI period by a number of different
makers. Variants by Joseph Baumhauer
and J.-L.-F. Delorme can be found in

the Wallace Collection, as well as a closely similar pair by Levasseur, differing only in that they have large, oval plaques of ormolu chased with classical scenes (like those on some smaller cabinets in the Wellington collection) in place of the central satyr's mask.

Levasseur was trained in the atelier of Charles-Joseph Boulle, who had continued his father's business after the latter's death in 1732. Although he is known to have made furniture in the conventional Louis XVI style—including some in the newly fashionable mahogany for the king's aunts at Bellevue—he specialized in the making and repairing of boulle furniture, a tradition carried on even after the Revolution by his son Pierre-Etienne.

G.J-S.

Literature: Watson 1975, 44–45, fig. 1

506

MANTEL CLOCK c.1805
Pierre-Philippe Thomire 1751–1843
burnished, matt ormolu with patinated figures, on a marble base
62.2 × 79.6 × 30.5 $(24\frac{1}{2} \times 31 \times 12)$

Woburn Abbey
The Marquess of Tavistock and the Trustees of the Bedford Estates

A taste for French furniture and decoration was first introduced at Woburn by John Russell, 4th Duke of Bedford (1710–1771). Appointed ambassador to the court of Louis XV in 1762, he returned with the great Sèvres service still in the house and furniture including a Régence style commode attributed to Antoine Gaudreau (Watson 1965, pl. 8)—as well as decorating rooms in the rococo style based on engravings by Blondel. His successor, the 5th Duke, employed Henry Holland to remodel several interiors in the Louis XVI style during the 1780s, and bought furniture for them through the *marchand-mercier* Dominique Daguerre between 1787 and 1791. But his younger brother, who succeeded as 6th Duke in 1802, was perhaps the most acquisitive and art-

loving member of the family. He was in Paris in 1803 during the short-lived Peace of Amiens, and purchased Italian antiquities from Napoleon in sufficient quantities to require thirty-six large cases to transport them back to Woburn.

Among the numerous late Louis XVI and Empire *bronzes d'ameublement*, which are scattered about the house (see no. 509), this magnificent clock by Thomire must be counted one of his finest acquisitions. It appears in an engraving of the Holland library at Woburn, made for *Vitruvius Britannicus* (1827), standing on the central dwarf bookcase between the windows, opposite the chimneypiece, a position it appears always to have occupied. The clock face, almost lost in the overall sculptural composition, forms the wheel of a chariot in which personifications of the Four Seasons are being drawn by lions, led by a winged *amorino*. The *rosso antico* base has a medallion of Diana the huntress, and the harvest theme must have particularly appealed to the 6th Duke, who was one of the great agricultural pioneers of his day (see no. 544), and a leading patron of George Garrard, the English animal painter and sculptor.

Thomire, the most renowned *fondeur-ciseleur* of the Louis XVI period, turned his atelier over to the manufacture of arms during the Revolution, but returned to his former profession in 1804 when he acquired the premises and business of Éloy Lignereux, Daguerre's partner and successor. By 1807 it was reported that he was employing as many as seven or eight hundred workers, and undertaking important commissions for the emperor (Watson 1966, 2: 573); the Woburn clock probably dates from the years shortly after the firm was reestablished, when the quality of chasing and gilding were at their highest. G.J-S.

Related Works: A plaster model of the *Char des Saisons* clock is in the Musée des Arts Decoratifs, Paris (15202), and other examples are in the Württembergisches Landesmuseum, Stuttgart, and in the Frederiksborg Palace, Denmark (information kindly supplied by Mr. David H. Cohen)
Literature: Watson 1965, 482–483, fig. 12

507

PORTRAIT OF THE ARTIST 1791
Elisabeth-Louise Vigée Le Brun
1755–1842
oil on canvas
99 × 80.6 (39 × 31¾)
inscribed, *L.E. Vigée Le Brun Naples 1791*

Ickworth
The National Trust (Bristol Collection)

Before going on to Naples in 1790, Mme. Vigée had spent eight months in Rome. Despite the inscription on this picture, she includes it in her *Souvenirs* as among the portraits "fait à Rome." In the text she writes, "Aussitôt après mon arrivée à Rome, je fis mon portrait pour la galerie de Florence…. Je peignis ensuite…une copie de celui que je destinais à Florence, que vint me demander lord Bristol…." Lord Bristol was of course the susceptible Earl Bishop whose portrait Mme. Vigée also painted (no. 196).

The Uffizi self-portrait of 1790 depicts the artist painting a portrait of her patroness, Marie Antoinette. In the version done for the 4th Earl of Bristol, the head of the artist's daughter Julie is substituted for that of the queen, and in the engraving by Denon it is Raphael's head that appears on the canvas.

Although Batoni, followed by Mengs, took precedence as the portrait painter most sought after by the British abroad, a number of them sat for French artists. If Mme. Vigée is encountered more frequently in British collections than other French portrait painters, it is as the result of the visit that she paid to England after the signing of the peace treaty in 1802. She records in her memoirs her impressions of the country where she spent three years. Numbed at first by the climate and the dull Sundays, she is soon carried along on a tide of social success which culminates in her painting the Prince of Wales. In her progress, she arouses the hostility of certain British artists, notably Hoppner, who in the preface to his *Oriental Tales* of 1805 dismisses her character as overwhelmingly presumptuous and her art as insipid. For the latter imputation there may be some justification; nevertheless it is instructive to compare Mme. Vigée's portrait of

the Duchess of Dorset of 1803 with Hoppner's earlier full-length of the sitter, both of which are at Knole. The former depicts an elegant and pensive lady; the latter, to quote Horace Walpole's description of another portrait at Knole, the Van Dyck school picture of Lady Middlesex, "a bouncing kind of Lady-Mayoress." (For a study of the relationship between English and French painting of the period, see Sutton 1984a) St.J.G.

Provenance: See no. 196
Literature: Vigée Le Brun 1867, 1:161–162; 2:366; Helm 1915, 114, 207; Douwes Decker 1984, no. 255
Exhibitions: London, RA 1968 (713)

DROP-FRONT SECRETAIRE C.1765
widow of Jean-François Oeben
fl. 1763–1767

oak, veneered with kingwood, purple-
wood, and tulipwood, and inlaid with
marquetry of sycamore, boxwood,
holly, ebony, and other woods, in part
stained, shaded and engraved; mounts
of bronze chased and gilded
149 × 113 × 45 ($58\frac{5}{8}$ × $44\frac{3}{8}$ × $65\frac{3}{4}$)
stamped three times, *JF-OEBEN*

Dalmeny House
The Earl of Rosebery

This *secrétaire à abattant* is one of a group
of such pieces mostly stamped by
Jean-Henri Riesener (Bellaigue 1974,
355). Following the death of Jean-
François Oeben in January 1763,
Riesener continued to work for his
master's widow as foreman, eventually
taking over the running of the workshop
in 1767 following his successful courtship
of the widow.

Two of the related secrétaires are
struck with Oeben's and not Riesener's
stamp, namely the Rosebery version
and the one in the Wernher Collection
at Luton Hoo (Watson 1960, figs. 75,
77). Svend Eriksen has suggested that
they were probably made during the
years 1763 to 1767 when Riesener was
acting as foreman for Oeben's widow
(Eriksen 1974, 318–319).

Characteristic of these secrétaires are
their ample proportions, the opulence
of their marquetry decoration, and the
high quality of their mounts. A number
were made for the French Crown. They
include a secrétaire now at Waddesdon
Manor, Buckinghamshire, which was
delivered by Riesener to Louis XVI's
private study in the Petit Trianon on 6
August 1777 (Bellaigue 1974, 348–357).
The marquetry incorporating a figure
of Silence on its drop-front is identical
to that on the Rosebery and Luton
Hoo pieces. It is likewise repeated
in the decoration of the "Stanislas"
roll-top desk (but with slightly simplified
surrounds), now in the Wallace Collection
(Watson 1956, F. 102). This desk, which
is signed by Riesener and is dated 20
February 1769 in the marquetry, is
now known to have belonged to the
Comte d'Orsay (Baulez 1981, 67). A

comparison carried out with the help of a tracing reveals that the same template must have been used for all four pieces. It is intriguing to find the original workshop pattern continuing in use over a period of some fourteen years.

It is also intriguing to find Baron Ferdinand de Rothschild buying for Waddesdon Manor, at the Hamilton Palace sale in 1884, a secrétaire so closely associated with the one his cousin Baron Mayer Amschel de Rothschild (d. 1874) had bought for Mentmore Towers. The parallels between the two collections, which do not end there, illustrate the conformity of taste of the great collectors among members of the Rothschild family. They justify the expression, "le goût Rothschild," to designate their partiality for the most refined examples of French eighteenth-century decorative arts.

G.de B.

Literature: Watson 1960, fig. 75

509

French
perfume burner of porphyry; urns of green brescia marble, with gilt-bronze mounts
perfume burner: 28 × 40.6 (11 × 16); urns: 43 (17) high

Woburn Abbey
The Marquess of Tavistock and the Trustees of the Bedford Estates

Like the Thomire clock (no. 506), this garniture of vases is shown in J.G. Jackson's view of the library at Woburn, engraved by Henry Moses for the 1827 edition of *Vitruvius Britannicus*. The porphyry *brûle-parfum* is placed in the center of Henry Holland's comparatively low, white marble chimneypiece, flanked by the green brescia urns, and with a small pair of cylindrical lapis lazuli columns between them. The group, reflected in Holland's huge overmantel mirror in the Louis XVI taste, has every indication of being acquired specially for this position by John Russell, 6th Duke of Bedford (1766–1839), either

on his visit to Paris in 1803, the year after his succession, or very soon afterward. The rich colors of the semiprecious stones, seen against the chaste white and gold of the architectural decoration, may have been specifically intended to pick up the red and green morocco bindings of the books, and the blue leather upholstery of the chairs, including some by Georges Jacob acquired by the 5th Duke.

The exquisitely chased sphinx heads on the perfume burner suggest the influence of Vivant Denon's *Voyages dans la Basse et Haute Egypte*, first published in Paris in 1802, although Egyptian elements drawn from Piranesi and others had been popular already in the Louis

XVI period. The pierced anthemion frieze set between rope moldings, like that on the base, would have allowed smoke to escape from the smoldering pastilles placed inside. The mounts on the urns are less elaborate, but similar to those found on Sèvres vases of the period. Like the clock, these pieces could possibly have come from, or been retailed by, Thomire's workshop, but the large numbers of highly skilled ormolu workers in Paris in the late eighteenth and early nineteenth century makes a more definite attribution and dating impossible.

Both the general shape of the vases, based on antique Greek pots; and the practise of cutting hardstones go back

to the Duc d'Aumont, First Gentleman of the Bedchamber to Louis XVI, who exploited his position to establish a workshop for this purpose in the Hôtel du Garde-Meubles. His posthumous sale in 1782 had many such pieces and two in the Wallace Collection (F360 and 361) are generically related to Woburn ones (information kindly supplied by Mr. Peter Hughes).

G.J-S.

Literature: Watson 1965, pl. 7; Cornforth 1978, 42, fig. 28
Exhibitions: Arts Council 1971–1972 (1761)

510

DISH C.1545
Urbino, Guido da Merlino workshop
tin-glazed earthenware
50 (19¾) diam.
inscribed, *Come li Romani sconfisere/li
Saniti sote il consulate de Valerio/Corvino
fato in botega d guido/merlino Vedi tito
livio deco/tercia ca XXIII*

Knightshayes Court
The National Trust
(Heathcoat-Amory Collection)

As the inscription records, the dish is painted with a battle of the Romans and Samnites during the Consulate of Valerius Corvinus, as described by Livy. The workshop of Guido da Merlino was claimed for Venice by some authors in the past, on the assumption that the "San Polo" named as its site was that of the Venetian district where Maestro Lodovico of Venice operated. More recently Rackham (1959, 130–131, 136) expressed doubts and Lessmann (1979, 175) has argued convincingly for Urbino. The works inscribed as executed in Guido's workshop range in date from 1542–1551 and none is signed as by his own hand, if indeed he knew how to paint. A number of hands are distinguishable among the inscribed pieces and sometimes more than one handwriting appears on the reverse of a single piece (for example, Lessmann 1979, no. 150). The *Battle of Constantine* by Raphael and his pupils, and beyond that Leonardo's *Battle of Anghiari*, probably explain the diffusion of this type of battle scene.

Elaborately decorated pieces of maiolica, especially those in the *istoriato*, or narrative style, were probably never intended for serious use but for display. Whereas the more utilitarian pieces were usually broken, these fine pieces tended to survive on display shelves, in cupboards, or hung on walls. By the early eighteenth century some large collections such as those of the Grand Dukes of Tuscany, the Electors of Saxony, and the Dukes of Brunswick were already in existence. *Istoriato* wares were at first prized as a form of painting and were sometimes framed as such and ascribed most implausibly to Raphael and other admired Renaissance painters. One of the earliest collectors in England was Sir Andrew Fountaine (see no. 238), whose collection, much added to in the nineteenth century, was displayed by his nineteenth-century heirs in a special room at Narford Hall in Norfolk, until auctioned in 1884 (Christie's, 14 June). The method used to display another collection, that of the Dukes of Buckingham at Stowe, can be seen in a watercolor painted not long before the collection was dispersed in 1848: rows of plates rested on brackets in two apse-like recesses near the windows (Cornforth 1978, 45, fig. 33).

The three pieces of maiolica shown here were acquired by Sir John Heathcoat-Amory in 1946, when the large mid-nineteenth-century collection formed by the Rev. Thomas A. Berney of Bracon Hall in Norfolk was dispersed. Though Sir John had little reverence for the Victorian architect William Burges, who had built Knightshayes Court for his grandfather, nor for John Diblee Crace, who had decorated its interior, his idea of filling the corner alcoves of the Morning Room with maiolica was in sympathy with what might have been placed there in Victorian times.

J.V.G.M.

Related Works: Rackham 1959, no. 454, pl. 207A; Giacomotti 1974, no. 1040
Provenance: The Rev. Thomas A. Berney, Bracon Hall, Norfolk; Miss Berney (sale, Sotheby's, London, 18 June 1946, lots 6, 36); Sir John Heathcoat-Amory
Literature: Rackham 1932, 214, pl. 4B; Rackham 1959, 130–131, 135, pl. 207A; Lessmann 1979, 175–181
Exhibitions: London, SKM 1862 (5299)

511

PAIR OF DRUG JARS c.1600
Urbino, probably Patanazzi workshop
tin-glazed earthenware
each 56 (22) high
one inscribed on a medallion at one
side, *VRBINO FECIT*

Knightshayes Court
The National Trust (Heathcoat-Amory
Collection)

Both jars are modeled with handles in
the shape of harpies and are painted on
either side with oval panels of mytho-
logical subjects. On the jar at the right
is a panel representing Hercules and
Omphale; on the panel on the other
side are putti, grotesques, medallions,
and a coronet on a white ground. The
jar at the left is similar, but with different
mythological scenes and without a
coronet or inscription. The scene on
one side may be intended to illustrate an
episode described by Ovid (*Metamorphoses*
II), concerning the gossiping crow
and the tales he bore back to Apollo.

Comparison with two vases (71 cm high)
that form part of a late addition to the
famous pharmacy set at the pilgrimage
town of Loreto suggests that this pair
probably once had domed covers sur-
mounted by griffins. The vases at Loreto
are thought to form part of a delivery
received from Urbino in 1631, and have
been attributed to the workshop of the
Patanazzi family there. The draftsman-
ship displayed on the present two vases
is of a somewhat higher order than that
on the Loreto pair, suggesting a slightly
earlier date. The coronet painted at the
front of the vase at the right suggests
that they came from a nobleman's rather
than from an ecclesiastical pharmacy.
Parts of the naked bodies in the mytho-
logical panels have been scraped off
and repainted, no doubt to make them
more suitable for display in the Victorian
home of the Rev. Thomas Berney.

J.V.G.M.

Provenance: See no. 510
Literature: Grimaldi 1977

512

AUTUMN and WINTER 1695
Balthasar Permoser 1651–1732
ivory
27.3 (10¾) high and 25.4 (10) high
Autumn inscribed, *BAT:P:INV;*
Winter inscribed, *B.P.v.*

Harewood House
The Earl and Countess of Harewood

The two seasons, Autumn being
personified as Bacchus, were originally
accompanied by the goddesses Flora
and Ceres (representing Spring and
Summer) now in the Herzog Anton
Ulrich Museum, Brunswick, the latter
being dated 1695. Sets of the seasons
were apparently carved by Permoser,
the outstanding late baroque sculptor
in Germany, throughout his career—
both in ivory and boxwood as well as
on a larger scale for the gardens of his
main patron, the Elector of Saxony,
in Dresden. The theme appears to
have particularly suited the sculptor's
powerful and idiosyncratic style in

which the dramatic manner of Bernini
is transformed into a variety of late
baroque that, in Permoser's smaller
works, anticipates the rococo. Thus,
while the Bacchus is based on a High
Renaissance interpretation of this subject
(by Sansovino) and the Vulcan remains
clearly Berninesque in the treatment of
beard and drapery, both figures could
in fact be successfully translated into
the rococo medium of porcelain by the
Fürstenberg factory in the 1770s. All
four figures first appear in the 1798
Brunswick inventory but may well have
been acquired in the early eighteenth
century by Herzog Anton Ulrich, of
whom Permoser executed at least one
portrait bust. In 1806 they were among
the works removed from the Brunswick
Collection to save them from the invading
Napoleonic forces. It is likely, however,
that they were in fact taken to Paris,
although Spring and Summer were later
returned to Brunswick. The Harewood
figures were probably acquired in Paris,
together with a magnificent collection
of Sèvres, by Edward Viscount Lascelles
who made a number of visits there after
1803. Ivory figures frequently served
as models for porcelain figures in the
eighteenth century, and were indeed
eventually supplanted by them, so that
the appeal of these examples to an
enthusiastic collector of porcelain is not
altogether surprising. No examples of
Permoser's work are known in England
during the eighteenth century but
contemporary English sale catalogues
suggest that there was considerable
interest in continental ivory carving as
well as the medallion portraits produced
by artists such as David Le Marchand,
active in England in the first half of the
century.

M.B.

Related Works: Among the other Seasons
by Permoser or his workshop the most
relevant are: in ivory—four seasons,
Grünes Gewolbe, Dresden (Asche
1978); Spring and Winter by a Permoser
follower, Germanisches National
Museum, Nuremberg (Asche 1978,
figs. 138–139); four seasons in Doccia
porcelain after lost ivories, Sorrento
and Karlsruhe (Asche 1978, figs. 98–
101); in limewood—Spring, Bayerisches
Nationalmuseum, Munich (Schädler
1980, fig. 1); Autumn, Kunstgewerbe

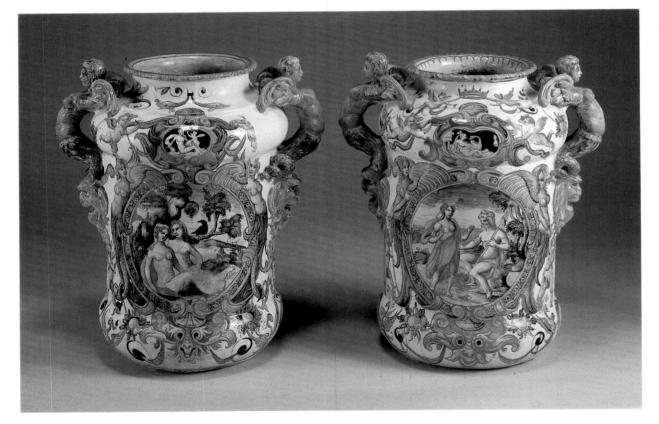

Museum, Cologne, (Schädler 1980, fig. 6); Winter, formerly Frankfurt am Main, private collection (Schädler 1980, fig. 7); in sandstone—three of four seasons included among the mythological figures formerly in the Schlosspark Schwerin, Touristengarten, Dresden; Winter by Valentin Schwarzenberger, after the Schwerin winter, Königswartha, formerly Luga, perhaps based on the Winter in limewood and related to the Harewood Winter (Asche 1978, pl. 130); Autumn by Valentin Schwarzenberger, Königswartha, formerly Luga (Asche 1978, fig. 132),

closely related to the Harewood Autumn on which it may be based. Asche suggests that the signed and dated Harewood/Brunswick set represents the culmination of Permoser's exploration of this theme in ivory but Schädler, while accepting Asche's earlier dating of the Dresden persuasively argues for a looser relationship without a clear developmental stylistic sequence
Literature: Maclagan 1931; Asche 1978, 51f
Exhibitions: Hamburg 1977, 187–188, with previous literature

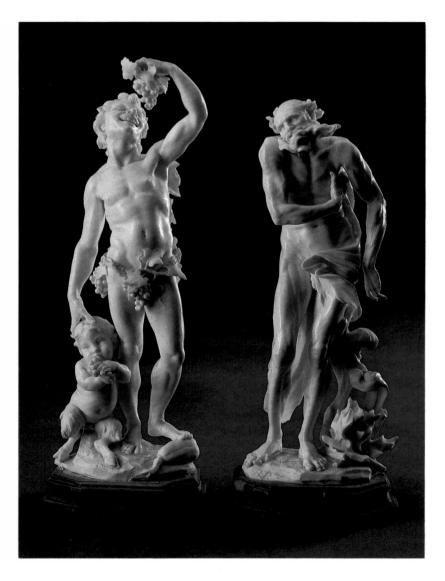

513

HARDSTONES FROM THE BECKFORD COLLECTION

Brodick Castle
The National Trust for Scotland
(Montrose Collection)

The successive collections assembled by William Beckford (1760–1844) were among the most extensive, varied, and outstanding of the many formed in England in the late eighteenth and early nineteenth centuries. The son of a Lord Mayor of London, this eccentric but very knowledgeable connoisseur, whose novel, *Vathek,* and other writings give him a minor but significant place in English literary history, inherited vastly profitable sugar estates in Jamaica, prompting Byron to describe him as "England's wealthiest son." From this income he financed not only his collecting activities but also the remodeling or building of three houses, the most spectacular being the neo-Gothic Fonthill Abbey. Like many English collectors of the period he benefited greatly from the sales in France that followed the Revolution, but the variety and richness of his collection was exceptional: alongside paintings by Raphael, Bellini, and Holbein were works commissioned from contemporary artists, among them the sculptor Moitte and the painter Benjamin West. But its greatest strength lay perhaps in the decorative arts, which ranged from French furniture, medieval enamels, and Renaissance goldsmiths' work to (appropriately for the author of the "oriental" book *Vathek*) oriental ceramics, jades, and a large group of then unfashionable Chinese and Japanese lacquer, some of it acquired from the collection of Mme. de Pompadour.

Beckford's collecting was at its height when he was furnishing Fonthill Abbey. Included here are six examples of smaller pieces acquired or made for interiors such as the Yellow Drawing Room, in which "the light is repeated by mirrors in every pier, and reflected from the gold and crystal, and precious stones of a thousand articles of virtu which fill the open armoires, or cover the marbles of the room" (Rutter 1823, 51). Many of these pieces, even if old, were mounted for Beckford by contemporary

goldsmiths. Quite contrary to contemporary practice, however, the patron apparently played a considerable part in the design of the pieces he commissioned. Intended for display in cabinets, these exquisite and mostly small objects, many of them agates mounted in gold or silver-gilt, were created in imitation of the mounted hardstones found in seventeenth-century courtly *Kunstkammern,* and together form the earliest example in English silver of the historicist use of Renaissance designs with which Beckford was evidently very familiar. They did not, however, appeal to every contemporary observer, being scathingly, if perceptively, described by William Hazlitt as "the most highly finished, the most costly and curious, of that kind of ostentatious magnificence which is calculated to gratify the sense of property in the owner and excite the wondering curiosity of the stranger" (Hazlitt 1844, 285).

Following the sale of Fonthill Abbey in 1823 many objects were sold but others were taken by Beckford to Lansdown Tower, Bath, and at his death passed to his son-in-law, the 10th Duke of Hamilton. Much of this collection was in the 1882 Hamilton Palace sale but a substantial fragment of the collection survives at Brodick Castle, a former Hamilton house on the Isle of Arran. M.B.

Provenance: William Beckford; his daughter Susan married the 10th Duke of Hamilton; by descent to Mary (d. 1957), only daughter of the 12th Duke, who married the 6th Duke of Montrose; accepted with Brodick Castle by the Treasury in lieu of death duties in 1958 and transferred to the National Trust for Scotland
Literature: Snodin and Baker 1980, 744, figs. 37, 42, and 748, fig. 48, and 825, A62, A72, A83
Exhibitions: London, Spink 1980 (B18, B20, B22, B26, B30); Salisbury 1976 (C21, C52)

BOWL AND STAND 1816
Paul Storr 1771–1844
agate with silver-gilt mounts
14 (5½) high
London hallmarks for 1816–1817

The low, oval bowl, with a silver-gilt rim, is engraved with linear arabesques; the detachable stand, with a flat base, is engraved with hatched arabesques; and a calyx form for the bowl rests on eight herm supports. It is engraved with Hamilton cinquefoils, the Beckford heron, and the Beckford version of the Hamilton oak tree crest.

The leading Regency goldsmith Paul Storr (and Rundell, Bridge and Rundell for whom he worked until 1819) received an extensive series of commissions from Beckford over a long period. The majority are in a conventional, French-inspired neo-classical manner, but this piece has arabesque ornament that recalls the sixteenth-century Grolier book bindings (see no. 330) that Beckford not only collected but imitated in his own bindings. The supports recall the use of chimeras by Netherlandish mannerist goldsmiths.

Beckford was especially partial to hardstone vessels, which apparently appealed to him on account of both their oriental associations and the virtuoso manner in which they were mounted by mannerist goldsmiths for courtly *Kunstkammern*.

COVERED BOWL ON STAND 1818
John Harris
agate with silver-gilt mounts
22 (8⅝) high
maker's mark of John Harris; London hallmarks of 1818–1819

This shallow, oval, agate bowl is mounted in silver-gilt with satyr marks at the ends; its stepped foot and domed cover are both engraved with strapwork. In both form and ornament it draws on a variety of sources, the combination of which was probably worked out by Beckford's friend Gregorio Franchi, who appears to play an important role in the design of the silver for Fonthill. The shape of the bowl and the domed foot are based on late sixteenth-century vessels while the satyr heads recall those on the celebrated late antique hardstone vase (Walters Art Gallery, Baltimore), formerly in Beckford's collection and earlier owned and drawn by Rubens. The superbly executed flat-chased strapwork on the cover is derived from sixteenth-century German sources. The maker, John Harris, was one of a number of otherwise obscure "smallworkers" and jewelers responsible for most of the mounted Fonthill pieces. Known as "the Methodist," he is mentioned in Beckford's letter to Franchi of 29 June 1819: "Now I recollect that the Methodist has in his keeping the lapis-lazuli and the gold; it wouldn't surprise me if he made off and if one heard no more of him until one read in the American Papers: 'New York, 21st Sept. 1819—Brother Harris, newly arrived from the Land of Perdition, has gladdened our hearts with much spiritual discourse etc, etc…'" (Alexander 1957).

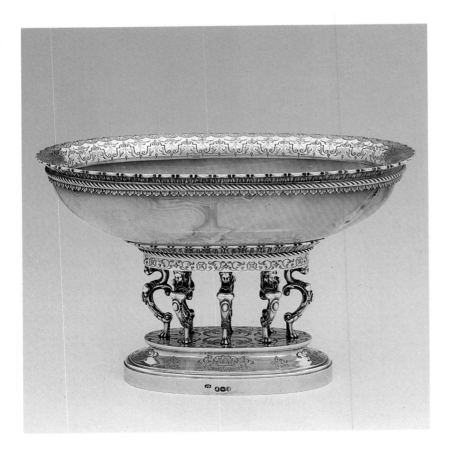

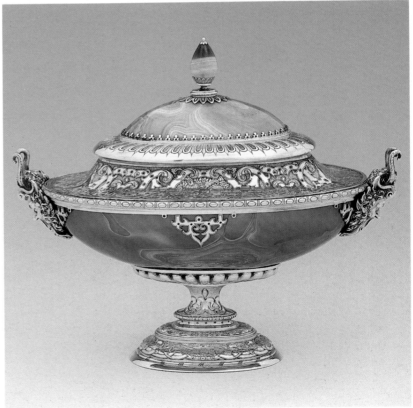

BOWL AND COVER
early 18th century
Mughal
jade set with rubies
12.1 (4¾) high

Beckford owned a number of Mughal
pieces, together with both mounted
and unmounted Indian agates. The
decorative use of precious stones appears
to have had a particular appeal for him
and is imitated on some of the silver
made for Fonthill as well in the alter-
ations made to a German Renaissance
standing cup by Veit Moringer, shown
in one of Maddox's paintings of objects
at Lansdown Tower.

LADLE 1815
Paul Storr 1771–1844
gold and jade set with rubies
13 (5) long
maker's mark of Paul Storr
London hallmarks for 1815

The ladle has an *S*-shaped stem, with a
bowl in the form of a flower and a
jade lotus finial. The form of the stem
and bowl here follow that of the earlier
Indian jade used for the finial. The
calyx shape of the bowl, however, is
characteristically designed to include
a reference to Beckford's pretended
lineage, incorporating the Hamilton
heraldic device of the cinquefoil.

SPOON c.1815/1820
English
agate with enamel mounts
13 (5¼) long

Carved with flowers and with a plaited
stem, this is one of a group of enameled
spoons, all of different and highly
imaginative design, almost certainly
made for Fonthill. Although none is
hallmarked, the decorative motifs
employed on the mounts correspond
with those found in an annotated
drawing by Franchi in the Aldridge
design album in the Victoria and Albert
Museum. The stripped and spotted
ornament on this example recalls early
seventeenth-century enameled mounts
but the parrot's head is both idiosyncratic
and bizarre.

VASE AND COVER
17th century
Italian
rock crystal with gold and enamel
mounts
13.9 (5½) high

The ovoid, crystal body is engraved
with scrollwork and gadroons, on a low
foot, and the domed cover is attached
by a chain. One of many rock crystals
at Fonthill, including examples said by
Beckford to be by Valerio di Vicenza,
this piece may possibly be identified
with "1 petite vase de christal de
roche—M^al. Decaix," included in a list
drawn up by Beckford's friend Franchi
of objects to be removed from Fonthill
in 1822 (Snodin and Baker 1980, 833).
Italian rock crystals were among the
works admired by Beckford when he
visited Florence in 1780 and wrote to
Alexander Cozens that he "flew madly
from bust to bust and cabinet to cabinet
like a Butterfly bewildered in a Universe
of Flowers" (Fothergill 1972, 89).

GOBLET early 18th century
Austrian (?), with English mounts
rock crystal; silver-gilt mounts
11 (4⅜) high
makers mark of John Harris; London
hallmarks for 1818

The faceted crystal body of the goblet
is engraved with a nymph and sea
monster. The lobed form of the foot is
based on a woodcut in H. Brosamer's
*Ein neue Kunstbuchlein von Mancherley
Schönen Trinkgeschiren* (Fulda, about
1540). Together with other pieces
commissioned by Beckford at this
period, this object illustrates his use
of Renaissance ornament, anticipating
the taste for strapwork and similar
decoration in the "Jacobethan" archi-
tecture of William Burn and publications
such as C.J. Richardson's *Architectural
Remains of the Reigns of Elizabeth I and
James I*. A number of Beckford's pieces
were indeed included as objects worthy
of emulation in Richardson's *Studies of
Ornamental Design* (1851). It may be the
goblet sketched alongside the record of
a £5 payment for "mounting a crystal
cup" included in a list dated 20 July
1818, from Franchi's accounts of pieces
bought for Beckford.

JUG
Chinese c.1710
porcelain with silver-gilt mounts
11 (4⅓) high
maker's mark of James Aldridge

The jug has an octagonal body, originally
a beaker, with a selection of the
"hundred antiques" in *famille verte*
enamels on a *café au lait* ground; silver-
gilt mounts engraved with sunflowers,
arabesques, and cinquefoils; and tendril-
form handles.

This is one of a large number of
relatively modern oriental ceramic
vessels bought and mounted for Fonthill.
Many of these were mounted as cream
jugs or basins of which no less than
forty-seven, "all different," are included
in Franchi's lists of objects removed
from the Abbey in 1822. As in some of
the other surviving examples, the form
of the lip used here is based on that
seen on sixteenth-century nautilus
cups, several of which were owned by
Beckford. A sketch of a similar jug is
indeed accompanied in one of Franchi's
by the description "a la Holbeins,"
indicating a conscious adoption of a
sixteenth-century motif.

In the engraved decoration of the
mount, Beckford has cleverly combined
motifs commonly employed on oriental
porcelain with the Hamilton cinquefoil,
an heraldic device demonstrating his
descent from the Hamilton family, which
appeared throughout the interiors of
Fonthill.

514

DISH 1569
Pierre Reymond 1513–1584
Limoges
painted enamel on copper
46.3 (18¼) diam.
inscribed, *EXODE·XVII·*, and signed,
P.R.1569

Luton Hoo
The Wernher Collection
Nicholas Phillips, Esq.

Limoges in southern France was an important center of *champlevé* enameling on copper from the twelfth century through most of the fourteenth. The craft was revived in the late 1400s but by this time the technique was painted enameling. The works of Pierre Reymond belong to the most successful decades of this revival when pieces from Limoges reflected the mannerist style evolved at the Royal Palace of Fontainebleau, and were held in great esteem by the French Court and patrons beyond France.

The subject of the decoration is taken, as the inscription indicates, from the Book of Exodus, XVII, verses 8–16: "Amalek and his people came to fight with the Israelites who, led by Moses, were on their journey from Egypt. During the battle, if Moses held up his hand, Israel prevailed, but if he let it down, then Amalek prevailed. So Aaron and Hur sat him down on a stone and held up both his hands until the going down of the sun, when Joshua and the Israelites defeated Amalek and his people."

On this dish Hur and Aaron appear immediately to the left of the central portrait boss, desperately trying to keep the aged Moses' hands aloft while the battle rages around them. Moses is more usually depicted with his arms outstretched to the sides, a posture that became a "type" for the crucified Christ. The reverse is decorated overall with strapwork, masks, and scrolls surrounding central portraits of a man and woman.

Pierre Reymond was a leading member of a family of Limoges enamelers. Over a thousand pieces by him or by his workshop survive, most of them enameled tableware: ewers, basins, tazze, salts, and dishes of various sorts. His earliest dated works were made in 1534. Among his patrons were the Bourbon family in France, for whom he executed two triptychs (one now in The Hermitage, Leningrad) and in Germany, the patrician Tücher family of Nuremberg. The tableware that he enameled for them between 1558 and 1562 includes two ewers whose goldsmith's work was fashioned by the most famous Nuremberg goldsmith of the day, Wenzel Jamnitzer, which is a testimony to the high rank of artistic production in which he shared (Germanisches Nationalmuseum, Nuremberg; Residenz, Munich).

Like most Limoges enamelers he relied heavily upon engravings for his compositions. He drew on Lucas van Leyden, Albrecht Dürer, Marcantonio Raimondi and his school, Virgil Solis, and, from the middle of the century, the illustrators of French books, such as Bernard Salomon, and the Fontainebleau school of *ornemanistes*.

Limoges enamels, together with other products of the French sixteenth century such as Palissy and Saint Porchaire pottery, were of particular interest to the French romantic movement, which was so attracted to the life and art of the sixteenth-century Valois court. From the 1850s the first collections of decorative art were being formed and these always included works of Limoges enameling. The Louvre and the Victoria and Albert Museum assembled large collections, as did the English and French branches of the de Rothschild family.

J.M.M.

Related Works: A dish of 1563 by Reymond in the Walters Art Gallery, Baltimore, its bowl decorated with scenes from Genesis, has a similar border of grotesques, possibly inspired by the engravings of Jost Amman and Cornelis Bos (Verdier 1967, no. 141)
Provenance: Baron Achille Seillière, Château de Mello, France, 1890; Martin Heckscher, Vienna, 1898; Sir Julius Wernher, Bart., 1912; and by descent

515

TAZZA c.1570/1585
silver-gilt
40 × 37.4 (15¾ × 14¾)

Luton Hoo
The Wernher Collection
Nicholas Phillips, Esq.

This is one of an original set of twelve late sixteenth-century tazze, probably acquired shortly after they were made by Cardinal Ippolito Aldobrandini, elected Pope Clement VIII in 1592, whose arms they bear. Each of the massive dishes was supported by a figure of one of the Twelve Caesars, above a shallow dish chased in relief with four scenes from his life. Cardinal Aldobrandini was a well-known collector of classical antiquities, like his nephew Cardinal Cinto Aldobrandini, owner of the celebrated fresco known as the *Aldobrandini Wedding* (discovered in 1606), and such symbolism must have had particular appeal for him.

The figures and their appropriate bowls had probably already been confused by the time of their sale in 1861, when Christie's attributed them to Benvenuto Cellini, and sold them together with "A manuscript volume," perhaps a copy of Suetonius' *Lives*.

By 1891, at least six of the bowls and their figures had been acquired by the Parisian dealer Frederic Spitzer, who gave them vase-shaped stems of grander and more mannerist design that he, and perhaps his clients, believed "improved" them.

By the time they were offered for sale by Spitzer at auction in 1893, only six had escaped his "improvements" and nearly all had emperors presiding over scenes from the lives of others. The Luton Hoo tazza shows Nero with scenes from the life of Augustus. The maker and country of origin of the set remains a subject for scholarly argument. No exact design or drawing connected with the tazze has been identified, although there are related drawings of Roman emperors by the Nuremberg master Virgil Solis. Yvonne Hackenbroch favored a German origin, but John Hayward proposed an Italian one, arguing that no other German tazze of the period were similar in treatment,

while Carl Hernmarck has suggested late sixteenth-century France as a possible source, or even itinerant German goldsmiths there or in Italy; Timothy Schroder also notes a relationship in the borders to Limoges work of the period.

<div style="text-align: right">J.B.</div>

Provenance: Cardinal Ippolito Aldobrandini; Prince Giovanni Battista Pamphili; Charles Scarisbrick, Esq., Christie's, 15 May 1861, lot 159
Literature: Hackenbroch 1950; Hayward 1976; Hernmarck 1977, 126–127, pls. 234–235; Schroder 1979, no. 26

516

DISH C.1450/1475
Spain, Valencia
tin-glazed earthenware
45.7 (18) diam.

Private Collection

The dish is painted in gold luster and blue with a vine leaf (or ivy leaf) pattern; in the center is a lion rampant, perhaps intended for the arms of Leon. The dating is that suggested for this type of leaf pattern by Van de Put (1904, 13–14, 65–67, pls. 2b and 11) largely on armorial evidence. Frothingham (1951, 128, fig. 88) shows that this type of vine or ivy leaf continued in vogue after 1465 and 1468, by reference to two armorial pieces. The taste for Hispano-Moresque lustered pottery seems to have developed slightly later than for Italian maiolica, but large numbers of pieces found their way into country house collections in the second half of the nineteenth century.

<div style="text-align: right">J.V.G.M.</div>

Provenance: Sotheby's, London 15 December 1962, lot 5 (repr. frontispiece); purchased by the present owner

517

THE GROSVENOR FAMILY 1831
Charles Robert Leslie 1794–1859
oil on canvas
101.6 × 144.7 (40 × 57)

The Duke of Westminster

One of the most ambitious of all nineteenth-century conversation pieces, this picture by the American-born Leslie, who specialized in historical and genre scenes, was painted at the time of the elevation of Robert Grosvenor, 2nd Earl Grosvenor (1767–1845), to the Marquessate of Westminster, an honor owed to his support of the Whig government of Lord Grey, on 13 September 1831; sittings are recorded in July of that year. The marquess sits at the left center with his grandson, Hugh Lupus, later 1st Duke of Westminster (1825–1899), son of Richard, Earl of Belgrave, later 2nd Marquess, who stands behind and

to the right. Beside him is his sister-in-law Lady Robert Grosvenor, daughter of Lord Cowley and niece of the Duke of Wellington; her white dress alludes to her marriage on 17 May 1831. Lady Westminster is seated at the piano: near her, on the right, is her second son Thomas, who had succeeded his maternal grandfather as 2nd Earl of Wilton in 1814, with his daughter and his wife Mary, daughter of the 11th Earl of Derby. The Westminsters' third son, Lord Robert, later 1st Lord Ebury, stands on the left in his uniform as Comptroller of the Household. Behind him is Lady Belgrave, daughter of the 2nd Marquess of Stafford, shortly to become 1st Duke of Sutherland, with her children Lady Elizabeth (later Lady Wenlock), Lady Caroline (later Lady Leigh), and Lady Evelyn Grosvenor, who are playing with a parrot. Her elder daughter Lady Eleanor (later Duchess of Northumberland), is in the foreground center, dancing with her

sister Lady Mary, subsequently Countess of Macclesfield.

The family is seen in the gallery at Grosvenor House, which was redecorated after its purchase in 1805 at a cost of £17,000 by William Porden, surveyor of the Grosvenor Estate, who was also responsible for reconstructing Eaton in the Gothic style. The gallery was intended from the first as the climax of the house. Grosvenor had inherited a substantial collection, including pictures purchased in Italy by Richard Dalton for his father the 1st Earl, whom he succeeded in 1802, and a fine series of works by Stubbs (see no. 435). The collection of Welbore Ellis Agar, celebrated for its Claudes (nos. 310 and 311), was acquired *en bloc* in 1806 and Rubens' great *Adoration of the Magi* (King's College, Cambridge) was bought at the sale of the 1st Marquess of Lansdowne in the same year. Gainsborough's celebrated *Blue Boy* (San Marino) followed in 1809. From 1806 William

Seguier (1771–1843), dealer and restorer, who was to be the first Keeper of the National Gallery, London, was given a retainer of £100 a year to attend to the collection, Young's catalogue of which was published in 1821.

Pictures had determined Porden's scheme and the acquisition in 1818 of four very large tapestry designs by Rubens was the catalyst for the extension of the gallery, undertaken by Thomas Cundy and his son at a total cost of £23,000 (Cornforth 1973, 1540). In 1827 Lady Belgrave—whose letters to her mother, the Duchess of Sutherland, offer so fascinating an account of the family—reported that Lady Grosvenor was against the project: "She even wishes the Rubenses back with their seller as the first cause of such a disturbance" (Huxley 1965, 54).

Like other large picture galleries in London houses of the period, that at Grosvenor House was intended for great evening receptions. Its opulence was matched by those at Cleveland (later Bridgewater) House and Stafford House, owned by Lady Belgrave's father; and in that at Apsley House, where part of the collection of Lady Robert's uncle, the "Iron Duke" of Wellington can still be seen.

Leslie's view shows Porden's original gallery and beyond the screen of columns, Cundy's extension: in this can be seen two of the works by Rubens, the *Abraham and Melchizedek* and *The Fathers of the Church*, which are now in the Ringling Museum, Sarasota; on the wall on the right is Velasquez' *Don Balthasar Carlos* (no. 497). F.R.

Provenance: Painted in 1831 for Robert Grosvenor, 1st Marquess of Westminster; and by descent at Grosvenor House until 1924
Literature: Taylor 1860, 2:224
Exhibitions: London, RA 1832 (121); London, Tate 1955; London, RA 1957 (378)

518

THE LOCK 1823/1824
John Constable 1776–1837
oil on canvas
152.4 × 122 (60 × 48)

Sudeley Castle
The Walter Morrison Collection

This is the fifth of Constable's series of
six large pictures of scenes on the River
Stour in Suffolk. A man is opening the
downstream gates of Flatford Lock while
a barge waits in the basin for the water
level to drop. The church in the distance
is that of Dedham. Constable intended
to finish the picture in time for the
1823 exhibition, but illness and problems
with the *Salisbury Cathedral from the
Bishop's Grounds* (Victoria and Albert
Museum, London), meant that he only
began work on it in the following
winter. By 15 April 1824 he was able to
tell his friend Fisher: "my *friends* all
tell me it is my best. Be that as it
may I have done my best. It is a good
subject and an admirable instance of
the picturesque" (Beckett 1962–1968,
6:155). On 8 May Constable was able
to tell Fisher that the picture was liked
at the exhibition and had been purchased
on the day of opening for 150 guineas.
In 1828 in a letter to Phillips the portrait
painter, he recalled that the sale was
effected "by the disinterested friendship
of [H.W.] Pickersgill" (Beckett
1962–1968, 4:280). S.W. Reynolds
planned to engrave the picture in 1824,
telling Constable that "since the days
of Gainsborough and Wilson, no land-
scape has been painted with so much
truth and originality, so much art, so
little artifice" (Beckett 1962–1968,
4:266). The engraving was not finished
but in 1825 Constable painted a second
version, now in an English private
collection. This was followed by the
horizontal variant of 1826, which he
later presented as his diploma work to
the Royal Academy.

 James Morrison (1789–1857), who
purchased this picture, was to become
an outstanding collector. The son of an
innkeeper, he had begun in 1809 to
work as a shopman for a firm of whole-
sale haberdashers; in 1814 he married
his employer's daughter and the turnover
of Todd & Co., of which he took over

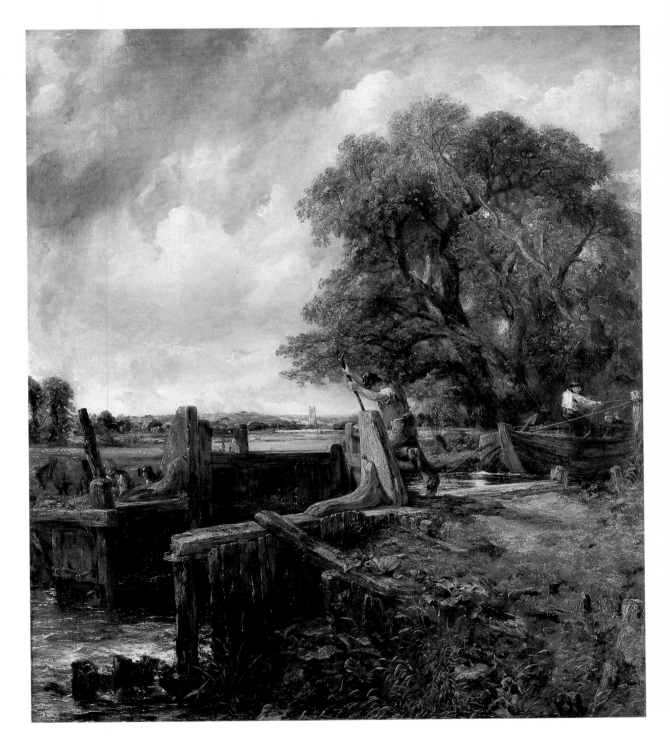

the sole direction, increased dramatically. He invested also in many other business enterprises and his acumen in such spheres was shown by his success in cornering the market in black crepe at the time of the death of George III's widow Queen Charlotte in 1821. His interest in the arts owed much to his friendship with the architect John Papworth, who was to remodel Morrison's four houses in turn—Balham Hill, No. 95 Upper Harley Street, Fonthill, and not least, Basildon, the house built by Carr for Sir Francis Sykes in 1776–1783, which was purchased in 1838 for £97,000. Soon after buying *The Lock* he told Papworth: "If I get very good things I shall become attached to the arts, if not I shall desert them for another hobby" (Gatty 1976, 249). He was not to desert the arts: he became a friend of Wilkie and Eastlake and later the partner of the dealer William Buchanan, whose own taste was in fact less rigorous than his own—for Morrison had an almost unerring eye.

The Constable was Morrison's first major purchase and subsequently he bought English pictures sporadically, although it was not until 1831 that he acquired his first old master, a Claude. Like other collectors of his generation, he was careful to segregate English pictures from his old masters. When Waagen visited Basildon, the Hall housed a collection of classical antiquities but was dominated by a large Claudian Turner. The Constable and other modern English pictures were in the Octagon, the great room designed by Carr whose scheme for its decoration was never completed and which at length was fitted up as a picture room by Papworth with an Italianate ceiling and wall coverings of purple velvet. Its erstwhile companions included Hogarth's *Punch Club*, landscapes by Wilson and Nasmyth, a Collins of 1826, Wilkie's *Confessional*, which Morrison ordered when in Rome in 1827, two works by William Hilton, Eastlake's *Flight of Francesco Carrara*, the portrait of von Humbolt, the naturalist, by Pickersgill for whom Morrison himself sat, a second Turner, and pictures by Stanfield and Webster. Many of Morrison's Dutch pictures, including works by Potter, Du Jardin, Van der Neer, Hobbema,

and Ostade were in the Oak Room, while the School Room could boast a scene from *Henry V* by Harlow and Greuze's chalk study for the head of the father in *Le Bénédiction* in the Louvre. Other old masters remained in Morrison's London house: these included masterpieces of the caliber of Claude's *Adoration of the Golden Calf* (City Art Gallery, Manchester), Poussin's *Triumph of Pan* (National Gallery, London), and Rembrandt's *Hendrickje Stoffels* (National Gallery, London), one of the outstanding works in the collection of Edward Gray of Harringay, which Morrison and Buchanan bought *en bloc* for £15,000 in 1838. The collection still contains a major Parmigianino, one of Poussin's rare landscapes, and notable Dutch pictures.

F.R.

Provenance: Purchased at the 1824 Royal Academy exhibition by James Morrison; and by descent
Literature: Reynolds 1984, no. 24.1
Exhibitions: London, RA, 1824 (180, as "A boat passing a lock"); London, BI 1825 (129, as "The Lock"); London, International Exhibition 1862 (320); London, RA 1882 (181); London, Grosvenor 1889 (85); London, New Grosvenor 1914 (102); London, Tate 1976 (227)

519

WALTER SCOTT 1808
Sir Henry Raeburn 1756–1823
oil on canvas
182.8 × 127 (72 × 50)

Bowhill
The Duke of Buccleuch and
Queensberry, KT

Walter Scott (1771–1832), the son of an Edinburgh lawyer but descendant of the Scotts of Harden, a younger branch of the Scotts of Buccleuch, was himself trained as a lawyer. His first major publication, *The Minstrelsy of the Scottish Border* (1802–1803), was followed by *The Lay of the Last Minstrel* (1809), *Marmion* (1808), and *The Lady of the Lake* (1810), which established him as the most successful poet of the day, until the advent of Lord Byron. In 1814 Scott published, anonymously, *Waverley*, the first of his novels set in Scotland, which had a profound impact on attitudes to that country, its history and landscape. Later novels, including *Ivanhoe* (1819), *Kenilworth* (1821), and *Quentin Durward* (1823) were to extend the range of his influence. Created a baronet in 1820, Scott's own social and architectural aspirations were realized in the creation of Abbotsford, his house by the Tweed, which was to become a place of pilgrimage. His bankruptcy in 1826 and the heroic efforts he made to repay his debts confirmed his popular reputation. Apart from the Duke of Wellington, no private individual of the period was more frequently portrayed.

This portrait was painted for Scott's publisher, Archibald Constable, in 1808, as is confirmed by a letter of 14 August that year to John Christian Schetky: "I sate last spring at the request of the bookseller, to Raeburn for a full-length portrait, seated under the fragment of an old tower, with Hermitage Castle in the background. Camp is also introduced, couchant, as the heralds call it. The connoisseurs think it is the best portrait Raeburn has ever done. I fancy it will be in the next Exhibition" (Schetky 1877, 62). Camp was the first of a series of favorite dogs to appear in portraits of Scott, while Hermitage Castle and the Hills of Liddesdale were an appropriate setting for the writer of the *Lay of the Last Minstrel*. A few months later Scott and Constable quarreled. "In the present circumstances," he wrote early in 1809, "I have only a parting favour to request of your house which is that the portrait for which I sat to Raeburn shall be

considered as done at my debit & for myself. It shall be of course forthcoming for the fullfillment of any engagement you may have made about engraving if such exists" (letter of 22 January 1809, Grierson 1932–1937, 2:155). Constable refused to surrender the picture, and a variant of it was subsequently painted for Scott. Now at Abbotsford, this is softer in feature and less emphatically literary.

The picture was given a mixed reception. The *Scots Magazine* for April 1809 considered it "an admirable painting, with most appropriate scenery" (71:269), and went further in October: "To say that Mr. Raeburn's portraits are admirable likenesses is the least part of the praise they deserve. The figure of Mr. Scott is in a meditating posture seated beside a ruin, with a favourite dog." The reviewer admired the "judgment displayed" by Raeburn. He also realized that the artist was a colorist of both originality and distinction, a fact that has often been overlooked: "We consider the present as a striking instance of Mr. Raeburn's scientific knowledge of the harmony of colouring; the greenish tone which pervades the whole is particularly pleasing" (71:730–731). The *Repository of Arts* (3 [18 June 1810], 36) was less appreciative: "This last of the minstrels shows how lamentably the race is degenerate, for never was a more unpoetical physiognomy delineated on canvas; we might take him for an auctioneer, a travelling dealer or chapman: in short for any character but a bard." J.B.S. Morritt of Rokeby, who knew Scott well at the time the picture was painted, told Lockhart that the "literal fidelity" of the portrait was its "principal merit." "The expression is serious and contemplative, very unlike the hilarity and vivacity then habitual in his speaking face but quite true to what it was in the absence of such excitement" (Lockhart 1837–1838, 2:183). In 1810 Turner published a mezzotint of the portrait, the sale of which Raeburn found disappointing to judge from his comments, recorded by Allan Cunningham: "The thing is damned, sir—gone—sunk: nothing could be more unfortunate: when I put up my Scott for sale, another man put up his Molyneux [a famous boxer]. You know the taste of our London beersuckers: one black bruiser is worth one thousand bright poets: the African sells in thousands, and the Caledonian won't move;—a dead loss, sir—gone, damned; won't do" (Cunningham 1830–1837,

5:255—256). In fact, the mezzotint was to be copied by several engravers and a large number of other prints are based more or less directly on it.

When the 4th Duke of Buccleuch, to whom the *Lay* had been dedicated and who had become a close friend, asked Scott to sit for Raeburn again in 1819, the novelist suggested that his protégé William Allan might produce something more satisfactory: "I am a little hesitant about Raeburn...He...has twice made a very cowderheaded person of me" (Grierson 1932—1937, 5:349). The picture was intended to hang above the chimneypiece in the new library at Bowhill, but it was never begun because of the duke's death. However, Scott did sit for Raeburn again in 1822 for two portraits, one of which was painted for the duke's brother, Lord Montagu of Boughton.

Scott was clearly delighted when the 5th Duke purchased this picture on Constable's bankruptcy in 1826. He paid 350 guineas for it and Scott wrote as if to thank him shortly afterward: "I must say I was extremely gratified by seeing Raeburns portrait...hanging at Dalkeith and feel sincerely the kindness which placed it there. One does not like the idea of being *knockd down* even though it is only in effigy" (14 December 1826, Grierson 1932—1937, 9:139—140).

F.R.

Provenance: Painted for Archibald Constable; on whose bankruptcy in 1826 acquired by the 5th Duke of Buccleuch and placed in the library at Dalkeith; and by descent
Exhibitions: Edinburgh ASA 1809 (183); London, RA 1810 (79); Leeds 1822 (1); Manchester 1857 (329); London, SKM 1868 (252); Edinburgh 1871 (49); Edinburgh 1876 (125); Edinburgh 1884 (304); Edinburgh 1901 (153); Edinburgh 1932 (31); London, RA 1939 (83); Edinburgh 1971 (5)
Engravings: C. Turner, pub. R.H. Cromek, 1810, mezzotint; A. Raimbach, pub. R.H. Cromek & J. Sharpe, 1811; R. Cooper, pub. Constable & Co. (after 1820); R.W. Dodson, pub. Carey, Lea & Blanchard; Unsigned, pub. Robins & Co., 1826; J. Horsburgh, publ. Cadell, 1837

520

TABLEY HOUSE AND LAKE:
WINDY DAY 1808
J.M.W. Turner 1775–1851
oil on canvas
91.5 × 120.6 (36 × 47½)
signed, *J M W TURNER RA*

Tabley House
Victoria University of Manchester
(Tabley Collection)

Tabley House in Cheshire, which was built by the architect Carr of York in 1761, was the seat of Sir John Leicester, created Lord de Tabley in 1826. This view of the house and a companion picture (*Tabley House: Calm Morning*) were painted in 1808. *Calm Morning* was bought by the 3rd Earl of Egremont at Lord de Tabley's sale in 1827 and is now at Petworth, though the companion remains at Tabley.

Sir John Leicester's activities as a patron of British artists have been chronicled by Douglas Hall (1962). In 1806 he had acquired a London house, no. 24 Hill Street, where in order to display his collection he constructed a gallery that he opened to the public. The sale catalogue of the contents of Hill Street following his death in 1827 shows him to have been a patron of a catholic disposition. Among the few notable omissions is Constable—curiously enough, although Constable often visited Petworth, this neglect was shared by Lord Egremont. But Sir John Leicester owned eleven works by Turner (Lord Egremont possessed twenty) and as Evelyn Joll (1977, 374) points out, these two collectors were alone among Turner's patrons in only buying oil paintings.

In the summer of 1808 Turner was staying at Tabley in order to paint the two views of the house. According to the artist Henry Thomson, who was a fellow guest—so Callcott related to Farington (*Diary*, 5:215)—Turner appeared to spend all his time fishing; but his industry was enormous and he probably did most of his painting in the early hours of the morning. His success with these views, which led to further commissions of the same sort from Lord Egremont and Lord Lonsdale, was confirmed by the favorable notices received—within the didactic terms of contemporary criticism—on their exhibition at the Royal Academy, London, in 1809. In the review of the *Morning Herald* it was observed that Turner had used Cuyp as his model. The *Monthly Magazine* considered that *Windy Day* "has an effect that ravishes as much by the novelty of its effect as by its genuine representation of truth," while the *Repository of Arts* (1:490) wrote: "… the views of Sir John Leicester's seat, which in any other hands would be merely topography, touched by his magic pencil have assumed a highly poetical character. It is on occasions like this that the superiority of this man's mind displays itself; and in comparison with the production of his hands, not only all the painters of the present-day but all the boasted names to which collectors bow sink into nothing." Evelyn Joll adds that the pale tonality of the pictures may also reflect the influence of Turner's friend and follower, Augustus Callcott, a number of whose paintings were bought by Sir John Leicester. For a fuller account of the latter's collection see no. 521.

st.j.g./g.j-s.

Provenance: See no. 521
Literature: Butlin and Joll 1977, no. 98, with previous literature
Exhibitions: London, RA 1809 (105); Manchester 1857 (292); London, RA 1881 (178); London, Whitechapel 1953 (76); Manchester 1957 (223); London, Agnew 1967 (8); London, Tate 1973–1974 (206); London, RA 1974 (150)

published a catalogue of the collection in 1819 and evidently shared his wish to foster history painting in Britain. After his death, on 7 July 1827 some eighty of the pictures from Hill Street had to be sold at Christie's. Twenty-six works from the collection were retained and remain at Tabley, but these cannot represent the full range of Leicester's taste. Several of his early acquisitions, including the Reynolds portrait, two pictures of horses by Garrard, and five works by Northcote remain, as do Lawrence's portrait of Lady Leicester and Ward's of Sir John as Colonel of the Cheshire Yeomanry, a regiment he had raised. For similar reasons George Jones' picture of the regiment exercising on Liverpool Sands was kept. Thompson's view of the lake and tower at Tabley was retained, as was the Turner of *Tabley Lake (Windy Day)* (no. 520), although the pendant, *Tabley Lake (Calm Morning)* was sold. Fuseli's *Friar Puck*, Ward's *Fall of Phaeton*, Hilton's *Mermaid*, three Opies and Leslie's *Anne Page and Slender* suggest Sir John's interest in history painting, and there are also works by such artists as Bourgeois, Callcott, and Hofland.

The charged character of Martin's composition is in obvious contrast with many of Leciester's more conventional acquisitions. The painter does not, however, aspire to the apocalyptic plane of the Russian Karl Bruillov's *Last Day of Pompeii* (Mikhailovsky Palace, Leningrad), which was admired by the ageing Sir Walter Scott, and which was to inspire Lytton's novel, *The Last Days of Pompeii* (1884). F.R.

Related Works: A watercolor of the subject by Martin was in the collection of Mrs. R.F. Wright
Provenance: Purchased from the artist by Lord de Tabley in 1826; and by inheritance until 1975 when Tabley was bequeathed to the University of Manchester by Lt.Col. F.L.B. Leicester-Warren
Literature: Feaver 1975, 55–59; Hall 1962, 84, 116
Exhibitions: Newcastle 1951 (178); London, Whitechapel 1953 (8); London, Hazlitt 1975 (16)

521

THE DESTRUCTION OF POMPEII AND HERCULANEUM 1821
John Martin 1789–1854
oil on canvas
83.8 × 121.9 (33 × 48)

Tabley House
Victoria University of Manchester
(Tabley Collection)

The rediscovery of the Roman cities of Pompeii and Herculaneum in the eighteenth century and their gradual excavation by the Neapolitan authorities had captured the public's imagination. Martin's large picture of the destruction of Pompeii and Herculaneum, measuring 64 by 99 inches, was painted in 1821 for the Duke of Buckingham. This cost 800 guineas and was included in the artist's exhibition at the Egyptian Hall in 1822; it was acquired by the National Gallery in 1869, and gravely damaged in the flood of 1928 at the Tate Gallery. This more compact treatment of the theme was acquired from the painter in 1826 by Lord de Tabley, whose payment of £50 was acknowledged in a letter of 3 July (Hall 1962, 84).

Sir John Leicester, 5th Bart. (1762–1827), who was created Lord de Tabley in 1826, succeeded to Tabley House in Cheshire, built by Carr of York for his father Sir Peter Leicester, Bart., on the latter's death in 1770. Sir John went on the Grand Tour in 1785–1786, but made no acquisitions abroad. Indeed, although he inherited Wilson's great view of Tabley (Lord Ashton of Hyde), he bought remarkably little, portraits by Reynolds and Northcote and a Gainsborough landscape apart, until 1805, when he leased No. 24 Hill Street as his London house. The former library was then remodeled as a picture gallery, probably by Thomas Cundy, and the announcement of its completion in the *Morning Post* shows that the pictures were "hung in a perfectly novel style of elegance, suspended from chains by lions' heads, splendidly gilt" (compare Whitley 1928, 106); these lions' heads still survive in the drawing room at Tabley.

Leicester only bought works by English painters and, with the exception of Wilkie and Constable, patronized every major native painter of the period, acquiring the first of his eleven Turners (see no. 520) in 1806 for £315. In 1812–1814 he acquired eight more works, and it was perhaps at this time that Thomas Harrison of Chester constructed the Picture Gallery at Tabley itself. In 1818 Sir John decided to open the Gallery at Hill Street to the public and at least seven pictures were bought; three followed in 1819, six in 1820, and one in 1821. In 1823 Leicester offered to sell the collection to the nation: the suggestion was declined and he resumed buying on a modest scale in 1824, acquiring in all some nine pictures before his death in 1827. Of these the Martin is by far the most important. Leicester may have been advised in his purchases by William Carey, who

522

MACBETH AND THE WITCHES
1793/1794
John Henry Fuseli 1741–1825
oil on canvas
167.6 × 134.6 (66 × 53)

Petworth House
The National Trust
(Egremont Collection)

In 1793–1794 Fuseli painted four scenes for Woodmason's *Illustrations of Shakespeare*, two from *Midsummer Night's Dream*, and two from *Macbeth*: the present picture (from Act I, scene 3) and *Macbeth and the Witches at the Cauldron*. The latter was bought by John Knowles, the biographer of the artist, who recalls Fuseli's observations on the two pictures: "When Macbeth meets with the witches on the heath, it is terrible, because he did not expect the supernatural visitation; but when he goes to the Cave to ascertain his fate, it is no longer a subject of terror: hence I have endeavoured to supply what is deficient in the poetry." (Fuseli is here referring to the colossal head that he introduced into the second picture.)

Macbeth, which Fuseli had translated into German early in his life, remained his favorite Shakespearean tragedy (*Farington Diary*, 2:211). He first exhibited a scene from it at the Royal Academy in 1777 (*The Weird Sisters*) and his last was shown in 1812 (*Lady Macbeth seeing the Daggers*). The subject of *Macbeth and Banquo with the Witches*, used in the Boydell Shakespeare Gallery (engraved by Caldwall, Boydell no. 37) is substantially the same as the exhibited picture. A number of other paintings of *The Three Witches* are more closely related to the Petworth design, but in reverse, than to the Caldwall engraving.

The apparition of the witches in this painting makes almost as sudden and awful an impact on the spectator as it does on Macbeth, and summarizes the characteristics of Fuseli: the mannerist style with its distorted anatomy, the romantic obsession with the idea of terror, and the need to express pictorially the images of literature. Whether or not it was wholly consonant with the taste of its purchaser, the 3rd Earl of Egremont (for whom see no. 547) is questionable, for this, to judge by the pictures he bought, generally ran on more orthodox and classical lines, though Fuseli would have argued, from his establishment post as Keeper of the Royal Academy, that his was a classical style inspired by Michelangelo. Lord Egremont bought two other paintings by Fuseli and also owned three works by Blake: a measure of the role that he played as a patron of contemporary art.

ST.J.G.

Provenance: Acquired by the 3rd Earl of Egremont, date not recorded; thereafter in family ownership at Petworth until 1957 when the house and contents of the state rooms were acquired by H.M. Treasury in part payment of death duties and transferred to the National Trust
Literature: Knowles 1831, I:189; Federmann 1927, 53, 170; Irwin 1966, 129, pl. 136; Schiff 1973, 163, 187, no. 880
Exhibitions: Detroit and Philadelphia 1968 (69); Arts Council 1973 (145)

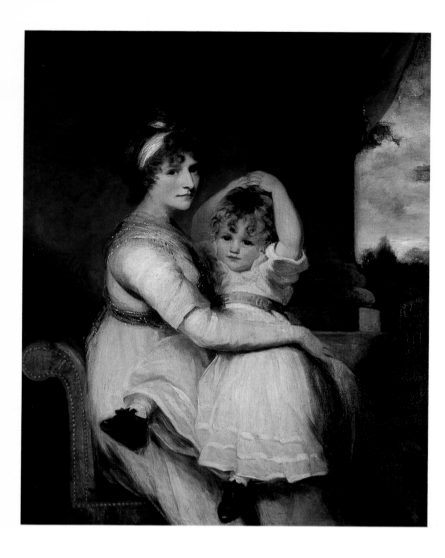

523

GEORGINA, COUNTESS BATHURST,
AND HER SON 1792
John Hoppner 1758–1810
oil on canvas
127 × 99 (50 × 39)

Cirencester Park
The Earl Bathurst

Georgina Lennox (1765–1841) was the daughter of Lord George Lennox, younger son of the 2nd Duke of Richmond (see no. 409) and his wife Lady Louisa Kerr, daughter of William, 4th Marquess of Lothian. One of the celebrated beauties of her generation, she was the first love of her cousin Lord Edward Fitzgerald, who was to play so tragic a part in the Irish rebellion of 1798. In 1789 she married Henry, Lord Apsley, subsequently 3rd Earl Bathurst, whose father, the 2nd Earl, had been Lord Chancellor in 1771–1779. His grandfather, Allen, 1st Earl Bathurst (1684–1775), the friend of Pope and Gay, was responsible for the layout of the park at Cirencester over a period of more than half a century, in a style that remained wholly impervious to the naturalism of Capability Brown.

As Lady Apsley, the sitter was painted with great sensitivity by the youthful Lawrence in 1792. The portrait was commissioned by her father, Lord George Lennox, and this may explain Lord Bathurst's decision to order a second picture after a relatively brief interval. Lady Bathurst is seen with her third son, the Hon. Peter George Allen Bathurst, who was born in 1794 and died after being innoculated for smallpox in 1796. Bathurst's choice of Hoppner was no doubt prompted by the success of the latter with portraits of a similar nature; for example, *Viscountess Duncannon and her Sons* of about 1787, in the collection of the Earl of Bessborough.

Despite its neo-classical idiom, the picture has a freshness so characteristic of a once-fashionable painter whose best work is now curiously neglected. The choice of color was probably determined by the sitter herself: as in the Lawrence, she is in a white dress and her hair tied with a white ribbon.

The Bathursts were perceptive patrons of portraitists. The 2nd Earl had sat for Dance, his countess for both Reynolds and Gainsborough, and as a boy the 2nd Earl had been painted with his brother by Dance. His daughter Louisa Georgina was portrayed as a child by Beechey and in early womanhood by Lawrence, whose gigantic portrait of the *Duke of Wellington on Copenhagen* was painted for Bathurst. The collection at Cirencester also includes a Reynolds of Lady Bathurst's father, Lord George Lennox, the unusually fine Ramsay of her mother, and Hoppner's portrait of her brother, Charles Lennox, later 4th Duke of Richmond, with a terrier. The portraits of the two families thus offer a fascinating microcosm of English painting in the reign of King George III. F.R.

Provenance: Painted for the 3rd Earl Bathurst; and by descent
Literature: Bathurst 1908, 160; McKay and Roberts 1914, 15

524

GENERAL AND MRS. FRANCIS DUNDAS
PLAYING CHESS c.1810/1812
Sir Henry Raeburn 1756–1823
oil on canvas
101.6 × 140.3 (40 × 55)
inscribed, *General and Mrs. Francis Dundas*

Arniston House
Mr. and Mrs. Aedrian Dundas Bekker

Francis Dundas of Sanson (c. 1755–1824) was the second son of Robert Dundas of Arniston, MP for Midlothian, and Lord President of the Court of Session. His elder brother was a lawyer, becoming the fifth successive head of his branch of the family to be on the bench of the supreme court, but Dundas enlisted as an ensign in the footguards in 1775, serving in America from 1777 until 1781 when he was among the officers who surrendered with Lord Cornwallis at Yorktown. Promoted to captain and lieutenant colonel in 1783, and major general in 1795, he served in the West Indies and was the commander of the troops at the Cape of Good Hope in 1796–1803, and acting governor in 1798–1799 and 1801–1803. He subsequently held command both in England and Hanover, becoming a full general in 1812 and colonel of the 71st highland infantry in 1809. His wife Eliza, was the daughter of Sir John Cumming.

Painted with Raeburn's accustomed fluency, this penetrating double portrait is datable about 1810–1812 and may well be the work exhibited in 1812 as "Portraits of a Lady and Gentleman," as is suggested in the 1981 catalogue. Raeburn's nearest approach to the conversation piece, it is conceived nonetheless in the grand manner: Mrs. Dundas watches contentedly while the general ponders his move, but his concentration only adds to the dignity of the portrait. No doubt the viewer was intended to draw a parallel between the strategy of the chessboard and the general's personal military experience.

At Arniston the picture is part of a remarkable series of portraits of one of the outstanding legal families of Scotland. The house, commenced by the general's great-grandfather, Robert Dundas, Lord Arniston in 1726 and continued by

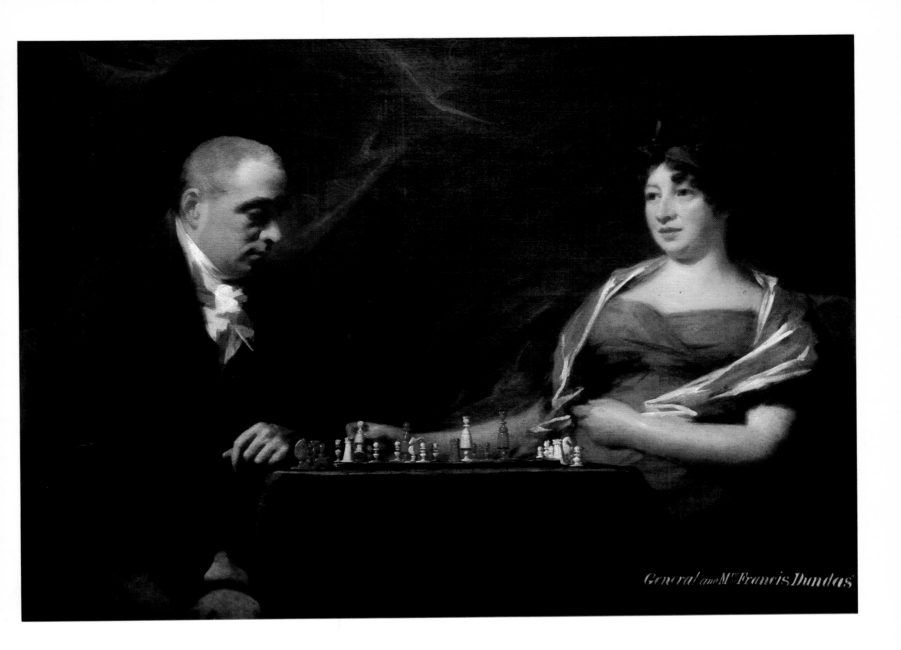

General and M^{rs} Francis Dundas

his son, was designed by William Adam, whose scheme owed much to the influence of the Dundas' neighbor Sir John Clerk of Penicuik. The young Robert Adam bought pictures in Italy for Robert Dundas, the general's father: these include Curadi's *Hagar and the Angel*, which remains in the house.

F.R.

Provenance: By descent in the family of General Dundas' elder brother, Robert Dundas of Arniston

Exhibitions: Possibly Edinburgh, ASA 1812 (109); Edinburgh 1950; Edinburgh, SNPG 1956 (19); London, RA 1956–1957 (396); Edinburgh, TRAC 1981 (21)

525

SETTEE AND ARMCHAIR c.1800/1804
Thomas Hope 1769–1831
mahogany painted black and gold with
bronze mounts
settee: 76.2 × 172.7 × 71 (30 × 68 × 28);
chair: 121.9 × 66 × 76.2 (48 × 26 × 30)

Buscot Park
The Trustees of the Faringdon Collection

This is one of a pair of couches, and one
of a set of four armchairs, made for the
Egyptian Room of Thomas Hope's
London house in Duchess Street, the
main interiors and principal contents
of which were engraved for Hope's im-
mensely influential *Household Furniture
and Interior Decoration*, published in
1807. A general view of the room,
conceived as a setting for his collection
of Egyptian antiquities "bought in
variously coloured materials such as
granite, serpentine, porphyry, and
basalt," appears as plate 8 of the book;
front and side views of one of the couches
(called settees by Hope) in plate 17;
and similar views of one of the chairs in

plate 46, in that delicate form of outline
engraving that he had learned from his
friend, the French architect, Charles
Percier.

The son of an Amsterdam banker,
John Hope, Thomas made an extended
Grand Tour of Europe, Asia, and Africa
between 1787 and 1795 before settling in
England. He acquired the house in
Duchess Street in 1799 and a country
seat, The Deepdene in Surrey, in
1807, and here he assembled the great
collections of antique sculpture and
vases (including many that had belonged
to Sir William Hamilton), the Indian
pictures, and the fruits of his patronage
of Flaxman, Thorwaldsen, and Canova,
Benjamin West, Thomas Daniell,
and Richard Westall. The furniture
accompanying these works of art was
all designed by Hope himself, using
a variety of different sources. Baron
Vivant Denon's *Voyage dans la Basse et
Haute Egypte*, published in 1802, is
acknowledged as one of the chief of
these, in the concluding section of
Household Furniture, and Denon's book,
written in the aftermath of Napoleon's

Nile campaign, undoubtedly provided
many of his ideas for the Egyptian
Room at Duchess Street, where the
colors were described as "that pale
yellow and that bluish green which
hold so conspicuous a rank among the
Egyptian pigments; here and there
relieved by masses of black and gold."
However, in describing the chairs,
Hope states that the "crouching priests
supporting the elbows are copied from
an Egyptian idol in the Vatican: the
winged Isis placed in the rail is borrowed
from an Egyptian mummy case in the
Institute [now Museo Civico] at Bologna:
the Canopuses [the small canopic vases
of the cresting] are imitated from
the one in the Capitol; and the other
ornaments are taken from various
monuments at Thebes, Tentyris, &c."

This last claim, to have incorporated
details culled from actual Egyptian
temples, cannot be substantiated;
like his novel *Anastasius*, Hope's
designs remain remarkably free of any
archaeological content and are rather
products of the European eighteenth-
century vision of Egypt. Here they are

in marked contrast to the furniture
Hope acquired for his later Egyptian
Room at the Deepdene, a copy of a
famous suite designed by Vivant Denon
for himself that imitated genuine
Egyptian chair shapes. Hope had un-
doubtedly seen the antiquities he cites
in Italy, but even here the inspiration
may have come at second hand, for
replicas of several of them—in bronze
or ceramics—were widely available
in Rome from the 1790s onwards.
These were typical of the ornaments
C.H. Tatham was procuring for the
architect Henry Holland's country house
interiors at this date (for this and much
of the following information I am greatly
indebted to Dr. Helen Whitehouse).
The canopics and crouching figures on
the chairs (both now in the Vatican
Museum; Botti and Romanelli 1951,
nos. 200, 46) and the lions on the couch,
flanking the base of the steps to the
capitol, all appear independently else-
where in *Household Furniture*, suggesting
that Hope must have owned such
replicas. The bovine and bar detail on
the back of the chair is probably based

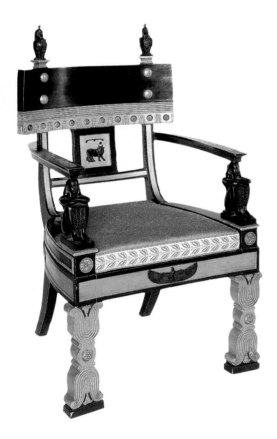

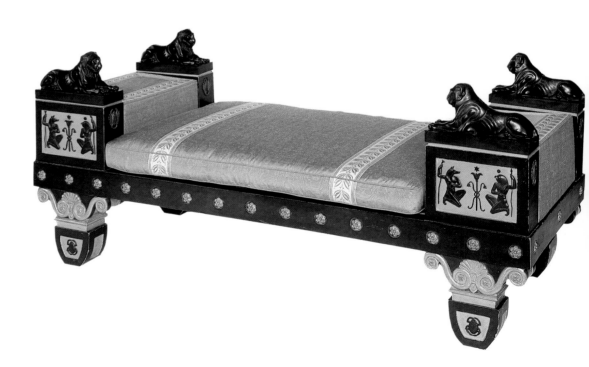

on a published inscription from an obelisk, where two signs not unlike this are a common element of the royal titulary at the top.

The figures on the couch, representing the gods Anubis, with a jackal head, and Horus, with a hawk head, are close to engravings of the *Mensa Isiaca*, a decorated bronze table top (Vatican Museum), probably of Roman rather than Egyptian origin, but a fertile source for designers, including Percier and Fontaine, ever since it was first published in the sixteenth century. Gilt-brass scorpions are attached to the sides and each foot displays the sacred beetle or scarab in bronze. By contrast, the anthemion and scroll brackets above them are pure Greek Revival, like the original form of the upholstery, thrown loosely over the sides and with a deep tassel fringe down to the floor like the covers of couches seen on Greek and Etruscan vases. A long passage in *Household Furniture* (29–30) advocates the use of bronze ornaments for their durability as well as their green patina, while the desire for permanence that was at the root of Hope's neo-classicism explains the particularly solid construction of this furniture.

Many of the pieces at Duchess Street were made by the French bronze caster Decaix, the Flemish carver Bogaert, and the sculptor Francis Chantrey, but few of Hope's accounts survive and it is not possible to attribute these pieces with any degree of certainty. The interior of the house was substantially complete by February 1804, when he invited members of the Royal Academy to visit it, issuing tickets of admission instead of inviting them "to meet company," which caused some annoyance. Admiration for the collections was unbounded, but the furniture provoked a wide range of comment, from Flaxman's tribute to Hope as "the first in this country who has produced a system of furniture, collected from the beautiful examples of antiquity, whose parts are consistent with each other"—to George Dance, whose verdict on Duchess Street was that it "certainly excited no feelings of comfort as a dwelling." G.J-S.

Provenance: Inherited from Thomas Hope by his brother William Henry Hope; by descent at The Deepdene; Christie's sale 18 July 1917, lot 306; bought by Alexander Henderson, 1st Lord Faringdon (1850–1922)
Literature: Symonds 1957, 230, figs. 15, 16; Musgrave 1961, 52, fig. 21; Watkin 1968, 115, 211, 256, figs. 39, 40; Honour 1969, 210–212 (ill.); Musgrave 1970, 5–11
Exhibitions: Arts Council 1971–1972 (1654, 1655)

526

ARMCHAIR c.1815
attributed to George Smith
fl. 1808–1828
beechwood, painted green (bronzed) with gilt details
88.9 × 68.5 × 66 (35 × 27 × 26)

The Royal Pavilion, Brighton

This chair comes from a set of ten, formerly in the Tapestry Room at Forde Abbey, Dorset, but probably made for Leigh Court, near Bristol, the neo-classical house designed by Thomas Hopper for the connoisseur and collector, Philip John Miles (see no. 499). The design corresponds closely with plate 56, dated 1 December 1804, in *A Collection of Designs for Household Furniture and Interior Decoration*, published by George Smith in 1808. Smith describes himself on the title page of this work as "Upholder Extraordinary to his Royal Highness the Prince of Wales," complimenting the latter in the text on "the elegant display of superior virtu exhibited in his palaces in Pall Mall and at Brighton."

Though he later boasted of receiving "the most flattering testimonies from Mr Thomas Hope," the only recorded testimonies are accusations of plagiarism: the title of Smith's book is a direct crib from Hope's volume of the previous year, and many of the motifs employed, such as the use of animal monopodia for chair and table legs, and the widely-spaced stars on bolt-heads here used on the seat rail, derive from a combination of Hope's design's and those in Percier and Fontaine's *Recueil des Decorations*

Interieures of 1801. But whereas Hope's expensively produced treatise, printed in a small edition, would have reached only a limited circle of *cognoscenti*, Smith's colored plates were widely available and did much to popularize and standardize the Regency style. In his later *Cabinet-maker's and Upholsterer's Guide* (1828) he is stated to be "Furniture Draughtsman to His Majesty, and principal of the drawing Academy, Brewer Street (41) Golden Square," but he evidently enjoyed considerable patronage still as a cabinetmaker, being employed "by some of the most exalted characters in the country to manufacture many of the Designs."

The slight refinement of the form of this chair compared with the published plate, suggests that it may have come from his workshop rather than being simply a pattern-book copy. Conventionalized Egyptian motifs such as the winged stars on the sides, and the sheathing of the upper parts of the legs and arms, are unashamedly combined with Greek Revival ornament like the Medusa head and anthemion scrolls on

the back rail. The caned side panels are reminiscent of the "curricle" chairs with sabre legs being produced at this period by Gillows of Lancaster. G.J-S.

Related Works: Another chair from the same set is now in the Victoria and Albert Museum; see Arts Council 1971-1972 (1656)
Provenance: Probably made for Philip John Miles of Leigh Court (d. 1845); inherited by John William Miles, his son by his second marriage, who bought Forde Abbey in 1846 with only a few of its original contents; bought early in this century by the playwright Edward T. Knoblock, one of the pioneers of the Regency Revival; purchased for the Royal Pavilion, Brighton, in 1971
Literature: Jourdain 1965, 50, fig. 81; Musgrave 1961, 95, fig. 42A
Exhibitions: Brighton 1983, 91

527

URN ON STAND 1816
workshop of George Bullock d. 1819
silver; stand, yew inlaid with ebony,
with marble top
urn 57.7 (22¾) high;
stand 92.3 (36½) high
inscribed, on base of urn, *The bones
contained in this urn were found in certain
ancient sepulchres within the long walls of
Athens in the month of February 1811,*
and *Expende-quot libras in duce summo
invenies!— Mors sola fatetur quantula sint
hominum corpuscula,* and *The gift of Lord
Byron to Walter Scott*

Abbotsford
The Faculty of Advocates, Scotland,
and Mrs. Maxwell-Scott

Sir Walter Scott himself told the story
of this urn: "I saw Byron for the last
time in 1815 . . . Like old heroes in Homer,
we exchanged gifts. I gave Byron a
beautiful dagger mounted with gold . . .
Byron sent me, some time after a large
sepulchral vase of silver. It was full of
dead mens bones, and had inscriptions
on two sides of the base…To these I
added a third inscription in these words
'The gift of . . .'" (Lockhart 1848, 40).

Scott had a stand specially made for the
urn by the London cabinetmaker George
Bullock who made several pieces of
furniture for Abbotsford and helped
with other aspects of the furnishing,
and with other work in Scotland which
included commissions from two branches
of the Murray family, at Blair and Scone
(Coleridge 1965).

The stand arrived at Abbotsford in
November 1816, and Scott wrote, "…the
very handsome stand for Lord Byron's
vase, with which our friend George
Bullock has equipped me" (Lockhart
1848, 166). A design for a stand for the
Byron urn survives among a group of
Bullock drawings (Wainwright 1977, 3,
10), though the piece was executed in a
slightly simplified form. The stand left
Abbotsford at some stage after Scott's
death, but fortunately it, or one identical
to it, was discovered in 1981 on the
antique market. It was purchased by
the Faculty of Advocates of Scotland,
with assistance from the National
Art Collections Fund and returned to
Abbotsford (see NACF 1981).

Starting with a small farmhouse,
Scott created his remarkable house at
Abbotsford with the help of several
architects, cabinetmakers, antique
brokers, and friends, in the years between
1812 and the mid-1820s. He filled it with
an interesting and important collection
of antiquities (Wainwright 1983), which
remain to this day, in the house still
inhabited by his family. Abbotsford, like
the homes of other literary figures, had
a great fascination for the visitor and
objects like this urn and stand combined
literary and artistic interest. Both the
exteriors and interiors of the house are
pioneering examples of what Scott called
the "Old Scotch Style," which was to
have influence throughout Europe and
North America. Indeed, numbers of
Americans visited Scott, including
the anonymous "… lawyer and …
unitarian preacher from New England"
(Wainwright 1977) who came in 1818,
as well as Washington Irving who wrote
a fascinating account of Abbotsford.
This stand is not in the "Old Scotch
Style" but was designed in a severely
neo-classical manner to suit both the
Grecian character of the urn and the
Greek bones that it contained. C.W.

528

TABLE c.1815
Giacomo Raffaelli 1743–1836 and
Giuseppe Leonardi fl. after 1781
gilt wood with an inlaid specimen
marble top
89.5 × 156 × 68.6 (35¼ × 61½ × 27)

Burton Constable
Mr. and Mrs. J. Chichester Constable

This is one of a pair of tables from the long gallery, Burton Constable, described in the room in 1841 as "a solid slab of marble, inlaid by Raffaelli, of Rome; it contains upwards of 150 specimens of marble, of which there is a catalogue of the species, according to Arocato Corsi's work on antient marbles. It is 4 ft. 6 in. long, and 2 ft. broad, supported by a winged and gilded sphynx, carved in solid wood by Leonardi. Another table, of the same construction; both weigh half a ton" (Poulson 1841, 2:248). A diagram of the top with a key to the different marbles—"verde di Sicilia," "Breccia d'Egitto," "Roccia del Vesuvio," and many others—also survives in the family papers, with the same attribution of the slab to Raffaelli and the stand "executed by Leonardi at Rome," probably in the hand of Sir Clifford Constable, 2nd Bart., who succeeded to Burton Constable in 1823.

Thomas Aston Clifford Constable (1806–1889) inherited a great Elizabethan house, with interiors remodeled by his cousin William Constable (1721–1791), a dilettante with an extraordinary range of interests from chemistry and botany to classical literature and philosophy. The friend and correspondent of Rousseau and Voltaire, William Constable had been on no less than three Grand Tours, acquiring, among many other treasures, a Neapolitan table top of 165 specimen marbles, granites, porphyries, and other polishable stones, for which he commissioned a frame from Thomas Chippendale (Hall 1982, 1200, fig. 11). Sir Clifford, a Catholic for whom a visit to Rome would have been a religious as well as a cultural pilgrimage, was thus following a family tradition when he purchased this table and its companion on an Italian expedition of his own, and the meticulous way in which the marbles

were "catalogued" shows that he too was interested in them for scientific reasons and not just as decorative objects.

Giacomo Raffaelli was the most celebrated mosaicist and marble inlayer in Rome in the late eighteenth century, moving to Milan to work for the Napoleonic court in 1804, but returning to Rome some time after 1814. A table top at Syon House bears his label with the address "Rue du Babuino N. 92," and his other work includes the monumental table centerpiece for the viceroy at the Villa Carlotta, Cadenabbia, and a huge mosaic mural copy of Leonardo's *Last Supper* in the Minoritenkirche, Vienna (Gonzalez-Palacios, 1984,

143–144). Giuseppe Leonardi is less well known, but a sculptor of that name won prizes at the academy in Bologna in 1781 and 1786, and was described in 1809–1811 as "custode dell'Accademia di belle arti" there, and "scultore in ornato, ed anche un poco di figura" (Tadolini 1900, 20, 22). The 6th Duke of Devonshire's *Handbook of Chatsworth*, written in 1844, refers to the pavement of the groundfloor corridors (on three sides of the courtyard) as being "composed chiefly of ancient marbles ... the work of Leonardi, a poor man, who lives at the Forum at Rome" (Devonshire 1982, 98). The winged harpies, carved as monopodiae

and placed back to back, are ultimately Piranesian in inspiration, though the ornaments between them are in a more advanced Greek Revival taste. The original gilding is in two tones, a darker bronzed finish set off against a lighter, almost silvered effect for the wings and bases.

G.J-S.

Literature: This entry is based on information generously supplied by Dr. Ivan Hall, Dr. Alvar Gonzalez-Palacios and Mr John Fleming

529

THE SHIELD OF ACHILLES 1822
designed by John Flaxman 1755–1826;
bearing the mark of Philip Rundell
silver-gilt
99 (39) diam.
inscribed on reverse, *Designed and
Modelled by John Flaxman R.A. Executed
and Published by Rundell, Bridge & Rundell,
Goldsmiths & Jewellers to His Majesty,
London MDCCCXXII*

Anglesey Abbey
The National Trust
(Fairhaven Collection)

Homer describes how the lame god Hephaestus made a great shield for the warrior Achilles: "[he] began by making a large and powerful shield, adorned all over, finished with a bright triple rim of gleaming metal and fitted with a silver baldric." Achilles' shield was conceived as a mirror of the world of gods and men, of banqueting and people fighting, of countrymen and vintners, and many others, including the king himself. Then, "finally, round the very rim of the wonderful shield he put the mighty Stream of Ocean" (Rieu 1950, 349, 353).

The achievement of Hephaestus, the god of metalworking, must have been an inspiration and a challenge to any modeler. John Flaxman, perhaps England's greatest neo-classical artist and sculptor, is said to have read and studied *The Iliad* in the original Greek, though it was also readily available in Pope's translation. He is believed to have started on this great project, perhaps as a tribute to the Duke of Wellington, as early as 1810, winning the support of the Prince Regent and his brother the Duke of York. In the event, however, it was Thomas Stothart who won the commission for a shield to be presented to Wellington by the merchants and bankers of London in 1814. This shield, even larger than Flaxman's, was made by Rundell, Bridge and Rundell's former employee Benjamin Smith in about 1822 and retailed by Rundell's competitors, Green, Ward and Green (Wellington Museum, Apsley House, London).

Meanwhile, Flaxman's work upon the various sections of the *Shield of Achilles* slowly progressed, and from time to time he received stipends from the Royal Goldsmiths who appear to have borne the whole cost of the work. Flaxman's surviving drawings are superbly detailed, appearing almost three-dimensional in their treatment. This contrasts with the outline engraving so often associated with the artist, notably in his designs for book illustrations for the *Odyssey* and the *Iliad*, and for *Paradise Lost* and *Pilgrim's Progress*. For work in the round or in relief, however, including Wedgwood jasperware, monuments, and metalwork, his drawings were more carefully detailed to assist the craftsmen undertaking the final work.

The identity of the silversmith employed by Rundell, Bridge and Rundell to make the four copies of the Achilles Shield is unknown, as is the exact date when work on them was started. A letter of 15 May 1814 to William Sotheby records "the fragments of the shield in their progress" (Huntington Library, San Marino), and it is noted by Bury and Snodin that in 1815 the Royal Goldsmiths were asking that the original size be increased. The payments continued, £100, £200, and so on, until a total of at least £825 had been paid by 1818. By then Rundell's top craftsmen, Benjamin Smith and Paul Storr, had both left to set up their own workshops and so William Pitts, son of the silversmith of that name who had been apprenticed in 1806 and who was described as "silversmith and chaser" in 1818, may have been responsible for the shields. Each is said to have taken a year to complete.

Four copies were made in silver and gilded, the first two bearing the date letter for 1821/1822, the third and fourth that of 1822/1823. All bear the sponsor's mark of Philip Rundell who was in fact apprenticed as a jeweler. The first, which has the cypher of King George IV on the reverse and remains in the Royal Collection, is described in the inventory of his brother, King William IV, as "this masterpiece of modern art." The second, the property of the Duke of York, commander-in-chief of the British Army and second brother of George IV, was sold at his death in 1827 by Christie's of London for 1000 guineas to Rundell, Bridge and Rundell, acting on behalf of his nephew the Duke of Cambridge (1819–1904). It is now in the Huntington Art Gallery, San Marino, together with a large corpus of Flaxman's work.

This example was acquired by William Lowther, 2nd Earl of Lonsdale (1757–1844), who rebuilt Lowther Hall in Cumberland as Lowther Castle, and was a regular patron of Rundell, Bridge and Rundell as well as heir to a rich collection of earlier family plate. For his poor treatment of his staff and tenantry (including his agent, William Wordsworth's father) he became known as the "Bad Earl." The fourth copy went to the Duke of Northumberland, by whose descendant it was recently sold in London for a world record price (Sotheby's, 3 May 1984, lot 124). J.B.

Related Works: Besides the four silver-gilt shields, each of which weighs between 660 and 690 ounces, several plaster casts were made. That made for the Royal Academy remains in the collection; another belonged to Sir Thomas Lawrence, PRA, and was sold at his death, and a third belonged to the family of John Gawler Bridge of the Royal Goldsmiths. One with a simulated bronze finish, from the collection of Pickersgill and Hook, was exhibited at the Heim Gallery, London, in 1976, no. 92. Several bronze casts were also made, including one for John Bridge
Provenance: 2nd Earl of Lonsdale and by descent to the 6th Earl; his sale Christie's, London, 20 February 1947, lot 136; bought by Huttleston Broughton, 1st Lord Fairhaven; bequeathed with Anglesey Abbey and its contents to the National Trust on his death in 1966
Literature: Jones 1911, 17–18, pl. 54; Wark 1970, no. 58; Bury and Snodin 1984, 274–283
Exhibitions: London, RA 1979 (187)

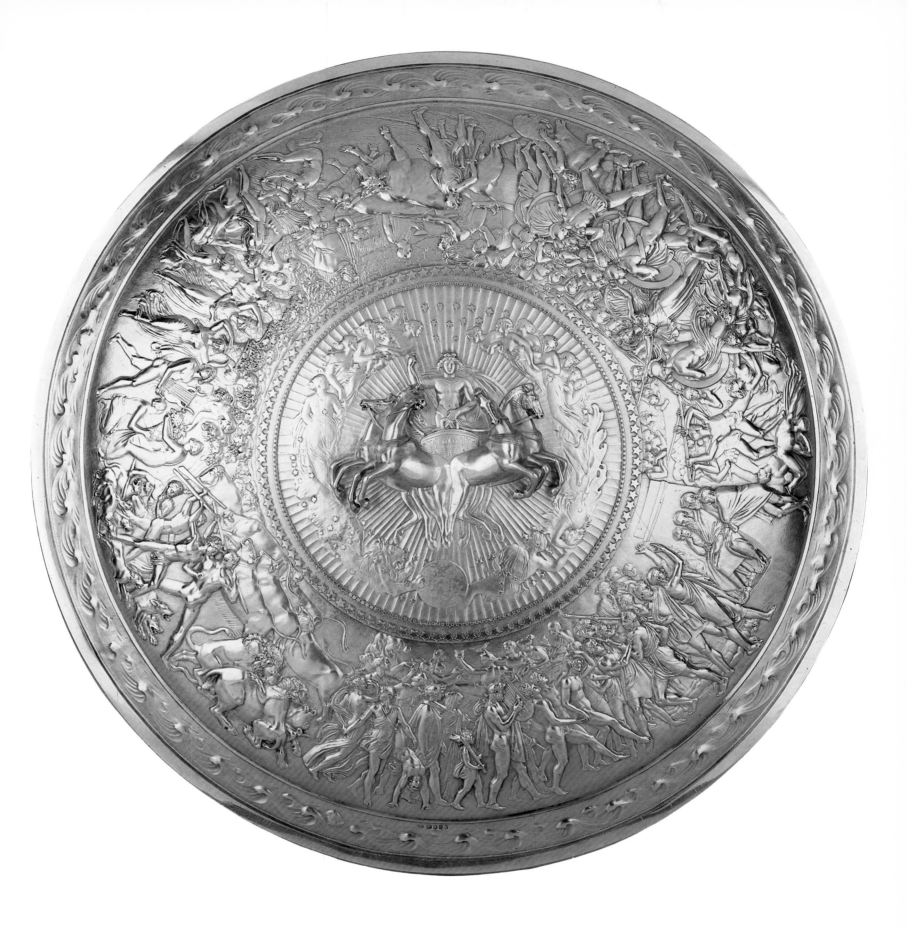

TIARA AND COMB C.1815
diamonds and pink spinels
tiara: 7×38.5 $(2 \times 14\frac{3}{4})$
comb: 3×14 $(1\frac{1}{8} \times 5\frac{1}{2})$

The Duke of Westminster

Both the tiara and comb are set transparent, and are part of a parure that includes a matching necklace and pair of pendant earrings made for the beautiful and eccentric Princess Catherine Bagration (1783–1857), widow of the gallant Prince Peter Ivanovich Bagration (1765–1812), a relation of the Empresses Catherine I and Elizabeth I, and great-niece of Prince Potemkin. The princess held court at the Congress of Vienna, after which she continued to live abroad, and refused to obey the Emperor Nicholas I's order to return to Russia in 1832, saying she could only exist in Paris. There, as in Vienna, she was famous for her political and literary salon and for her extravagant lifestyle, entertaining the aristocracy at spectacular dinners and dances in her home on the Champs Elysées. Closely connected with Russian royalty, Princess Bagration—*en grande toilette*, the tiara low on her forehead, marabout feathers waving above, and her blonde chignon pinned in place by the comb—must have seemed like a sovereign herself, radiant with light and color. The Viennese firm of Koechert supplied her with jewels, though there is no specific reference to this parure in their archives. It derives from the impressive style of jewelry originally designed to promote the Napoleonic regime and which was adopted after the fall of the Empire by the Restoration monarchy in France and other European courts including Russia. D.S.

Provenance: Purchased by the present duke from S.J. Phillips, of London, at the time of his marriage in 1978
Literature: Solodkoff 1981, pl. 241, illustrates the necklace and earrings belonging to this parure
Exhibitions: Eaton Hall 1984 (8)

TIARA AND WAIST CLASP 1823
Roman
gold and shell cameo
tiara: $6.3 \times 17.7 \times 11.3$ $(2\frac{1}{2} \times 7 \times 4\frac{1}{2})$
clasp: $1.9 \times 6.9 \times 6.3$ $(\frac{3}{4} \times 2\frac{3}{4} \times 2\frac{1}{2})$

Blair Castle
The Duke of Atholl

The tiara is curved to the shape of the head and the wide front is set with a shell cameo version of the Roman fresco painting of the first century AD known as the *Aldobrandini Wedding*, framed in a pierced border crowned with acanthus foliage rising to an apex. The rectangular double waist clasp is set with two round shell cameos, after the reliefs by Bertel Thorwaldsen (1770–1844) of the personifications of Day and Night, each framed in Greek fret with foliate scrolls in the spandrels. The design of the frames harmonizes admirably with the classical character of the shell cameos. The fresco, which had been copied or described by Rubens, Goethe, Van Dyck, and Poussin, was found on the Esquiline in 1604/1605 and was for some time in the collection of Cardinal Cinto Aldobrandini; it passed through various hands until it was purchased for the Vatican Museum by Pius VII in 1818. It derives from a Greek original depicting the preparations for a wedding, with gods and goddesses seated beside mortals and musicians and handmaidens performing sacred rites (see Helbig and Speier 1963, 360–366). Thorwaldsen's representations of Night and Day caught the public imagination and were reproduced many times in cameos, intaglios, and mosaics for jewelry and box lids.

Rome was a center for the revival of the ancient art of gem engraving that took place in the eighteenth century and that received a further stimulus with the Empire style promoted by Napoleon. Gem cutters produced versions of classical gems, ancient and Renaissance monuments, and contemporary sculpture and painting in both hardstones and shell for setting into mementoes of the Grand Tour. Lord Charles Murray, son of the 4th Duke of Atholl and his second wife Marjory, eldest daughter of the 16th

Baron Forbes, was in Rome in 1823 when he purchased the tiara and waist clasp for his mother. Shell was particularly suited for reproducing the frieze-like composition of the celebrated fresco since it was easy to carve and light to wear. In a letter home, written from Rome on Christmas Day, Lord Charles, who was to die in Greece in 1828, gives his impressions of his stay and disenchantment with "this fine country where the people although bad are worse governed and oppressed by the most grovelling superstitions." D.S.

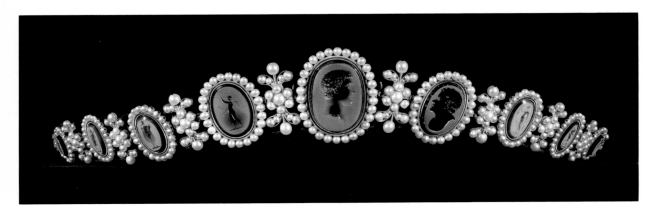

532
TIARA c.1808/1815
French and Italian
gold, pearls, and nicolo intaglios
4 × 31 (1½ × 12)

Woburn Abbey
The Marquess of Tavistock and the
Trustees of the Bedford Estates

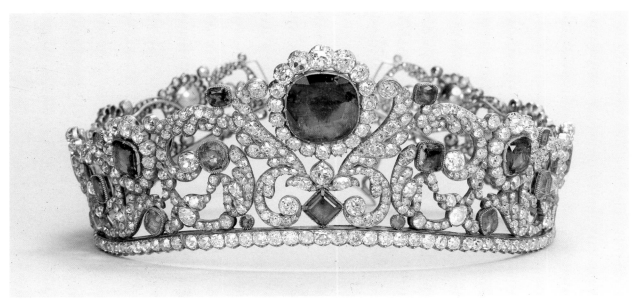

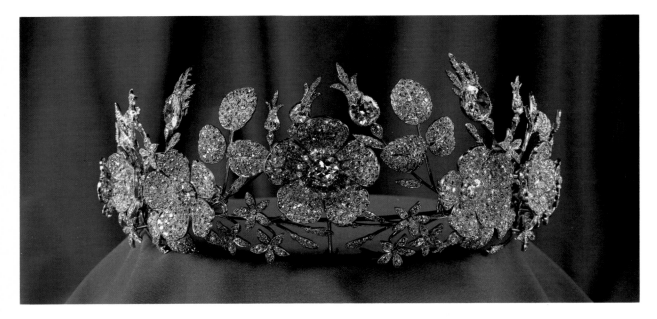

This gold and pearl tiara is set with nine nicolo intaglios of graduated size, four to each side of the central medallion. Each intaglio is framed in a double border of milled gold encircled by a frame of round white pearls and alternating with clusters of pearls between trefoils, also graduated in size from front to back. The intaglios, which are all contemporary with the setting derive from ancient gems and represent from left to right: 1. Amor, standing on the right and burning Psyche in the guise of a butterfly; 2. Omphale, walking toward the right, draped, and shouldering Hercules' club; 3. Bonus Eventus, standing facing left, with corn ears in his hair, holding a cornucopia; 4. Amor, facing left, standing; with a bow and arrow; 5. head of Hercules, facing in profile toward the right, a version of the ancient gem by Gnaios formerly in the Strozzi and Blacas collections of Rome (compare Walters 1926, no. 1892); 6. portrait of a man facing in profile toward the left, perhaps a copy of the aquamarine intaglio portrait of Pompey in the Devonshire collection (Chatsworth); 7. Venus, standing, to the left, undressing for the bath; 8. Amor, reaching up to test the tip of his arrow, bow at his feet; 9. Amor, walking to the right, whip in hand, chastising Psyche in the guise of a butterfly.

The early nineteenth-century fashion for jewels set with cameos and intaglios received a great impetus from Napoleon who, recognizing the political importance of pomp and display, commissioned the painter David to create an artistic style that could be identified with his régime. Since he considered himself heir to the Roman *imperium* this style had a strong classical character, and the jewels and costumes worn at court were designed in the same spirit. David's painting of the coronation of 1804 depicts the women of the Bonaparte family with hair dressed high, *à l'antique*, and held in place with tiaras and combs set with cameos and intaglios illustrating mythology and history. Both empresses, Josephine and Marie Louise, owned parures with engraved gems richly framed in diamonds and pearls, and so did the Bonaparte sisters. Thus the Bedford family tradition, which associates this tiara with Caroline Murat, Queen of Naples

from 1808–1815, seems well-founded, especially as the 6th Duke (1766–1839) visited Pompeii with her in 1815, when she presented him with a Greco-Roman bronze figure (no. 223). The design and workmanship of the tiara also compare with those of a diadem, now in Stockholm, made for the Empress Josephine, probably by Nitot.　　D.S.

Provenance: Queen Caroline of Naples; purchased by the 6th Duke of Bedford: c. 1817, from the former *aide de camp* of Joachim Murat, Conte de Flahaut de la Billanderie (Woburn MSS)

533

TIARA 1820
Evrard Bapst
gold, silver, emeralds, and brilliants
13 (5½) high

The Lambton Trustees

The tiara, one of the Crown Jewels of France, is of symmetrical design, with a composition of leafy scrollwork rising above a single line circlet, set with forty emeralds and 1,031 brilliants. These stones were taken from the Napoleonic parures remodeled by order of Louis XVIII after the Restoration of the Bourbon dynasty of France in 1814. In contrast to the parvenu character of the Empire of Napoleon, the Restoration monarchy sought to affirm the sacred nature of hereditary kingship, and this political purpose was manifested in a distinctive style of court art and ceremonies. Ancient symbols such as the fleur-de-lys reappeared, and the numerous court functions were organized according to traditional protocol. The tiara might have been worn by either of the two royal princesses, the wives of the king's nephews, the Duchesse d'Angoulême, or the Duchesse de Berri, always magnificently bejeweled on these occasions. It was completed in 1820 by Frédèric Bapst after a design by Evrard Bapst, son of Georges Frédèric Bapst, jeweler to Marie Antoinette, and Crown Jeweler from 1814 to 1831, and has never been altered. The rich, formal, majestic style, so characteristic of Restoration taste, also appealed to the Empress Eugénie who married Napoleon III in 1853. Court life under the 2nd Empire was particularly brilliant, and the empress wore this tiara frequently, being very fond of emeralds, which suited her fair skin and red hair. Valued at 50,000 francs, it was sold by the Third Republic with the Crown Jewels of France in 1887 for 45,900 francs, passing ultimately into the family of the present owners.

　　D.S.

Literature: Vever 1906; Twining 1960, 284; Michael 1983, 61

534

TIARA c.1840
French
gold, silver, and diamonds
8.9 × 20.3 × 15.2 (3½ × 8 × 6)

Woburn Abbey
The Marquess of Tavistock and the Trustees of the Bedford Estates

This tiara is in the form of a wreath of wild roses, jasmine, and five-petaled flowers—the leaves, buds, and petals pavé set with diamonds, and each flowerhead centered on a single large stone, mounted in silver, open-backed in gold. The wild roses are graduated in size from front to back, and are fixed to trembler springs that amplify the illusion of real flowers, as they move with the wearer. This naturalistic style originated with the French jeweler, J.B. Fossin (1786–1848) who took over the firm of Nitot, court jeweler to Napoleon in 1815, and with his son, Jules Jean Fossin (1808–1869) obtained the Royal appointment to Louis Philippe in 1831. He was the first jeweler of the Romantic period to return to nature for his motifs, reproducing bouquets of precious stones in the tradition of the eighteenth-century designers Lempereur and Pouget. The Bedford tiara is close to a design for a wild rose and jasmine tiara by Fossin in the archives of his successors, Maison Chaumet of Paris (compare Vever 1906, I:220). Anna Maria Stanhope, who in 1808 married Francis, 7th Duke of Bedford (1788–1861), was appointed to the household of Queen Victoria in 1837. Placid, gracious, and good-humored, she divided her life between her court duties at Windsor and Woburn where she lived in great state. A schedule attached to her husband's will of 1861 includes a description and drawing of the wild rose tiara and designates it one of the Russell family heirlooms.　　D.S.

15: The Highlands and the Victorian Spirit

Scottish national pride, which suffered in the Jacobite rebellions of 1715 and 1745, was never wholly crushed: Batoni's *Colonel Gordon* and Ramsay's *Earl of Sutherland* (nos. 176 and 473) still proudly wear the tartan, whose use was generally proscribed; and Scottish aristocrats like Lord Bute and Lord Chief Justice Mansfield played a prominent part in public life. However, it was the appreciation of the "picturesque" scenery of the Highlands, brought into full-blooded romantic relief by the historical novels of Sir Walter Scott, that encouraged a new passion for Scotland in the early nineteenth century. George IV's entry into Edinburgh, largely stage-managed by Scott, his re-opening of the palace of Holyrood, and his depiction by Wilkie in the full regalia of a Highland chieftain, set the pattern for Queen Victoria's almost annual visits to the Highlands. The building of Balmoral, influenced by the German *jagdschlösser* which Prince Albert had known from his youth, encouraged the construction or remodeling of many other large houses and shooting lodges in the style known as Scottish Baronial. Many of these would be hung with the works of Sir Edwin Landseer, whose pictures provide an unparalleled celebration of Victorian sporting life.

Another of the queen's favorite artists, Franz Xaver Winterhalter, painted some of the leading lights of country house society, like the Duchess of Sutherland (no. 545), the mistress of Trentham, Cliveden and Dunrobin, seen here as if receiving guests at the foot of the great staircase at Stafford House in London. Her famous *soirées*, like those described in the political novels of Trollope, were matched by the hospitality of the 3rd Earl of Egremont, who, approaching his eighties, thought nothing of entertaining 6,000 tenants with roast beef and plum pudding at one of the great fêtes in Petworth park, recorded by Witherington (no. 547).

Travelers on the continent in the period after Waterloo went further afield than the eighteenth-century Grand Tourists. Bonington's coastal scenes in Normandy, Clarkson Stanfield's Adriatic ports and, later on, Edward Lear's Corsican pine forests—as well as J.F. Lewis' watercolors of Spain, Morocco and the Middle East—show the widening horizons of British connoisseurs, who were beginning to find the French and Spanish cathedrals more exciting than the ruins of the Roman Forum.

Like the renewal of interest in Scotland, the Gothic Revival, pioneered by Augustus Welby Pugin, had its roots in a deep nostalgia for the past. In the same period as the mock-medieval Eglinton Tournament of 1837, it was only natural that neo-Norman castles such as Eastnor and Penrhyn should be hung with arms and armor, and filled with massive sideboards, billiard tables and beds whose forms derived from medieval church furnishings. The lifting of restrictions on Roman Catholics, finally achieved in 1829, and the ambitions of industrialists and *nouveaux riches* to rival old-established county families, encouraged the building of some of the most ambitious Gothic houses such as Allerton, Carlton Towers and Scarisbrick. But by the 1860s the less assertive and more comfortable "domestic Tudor" employed by Anthony Salvin, William Burn, and others had more appeal for house-builders like the Welby-Gregorys of Denton (no. 546).

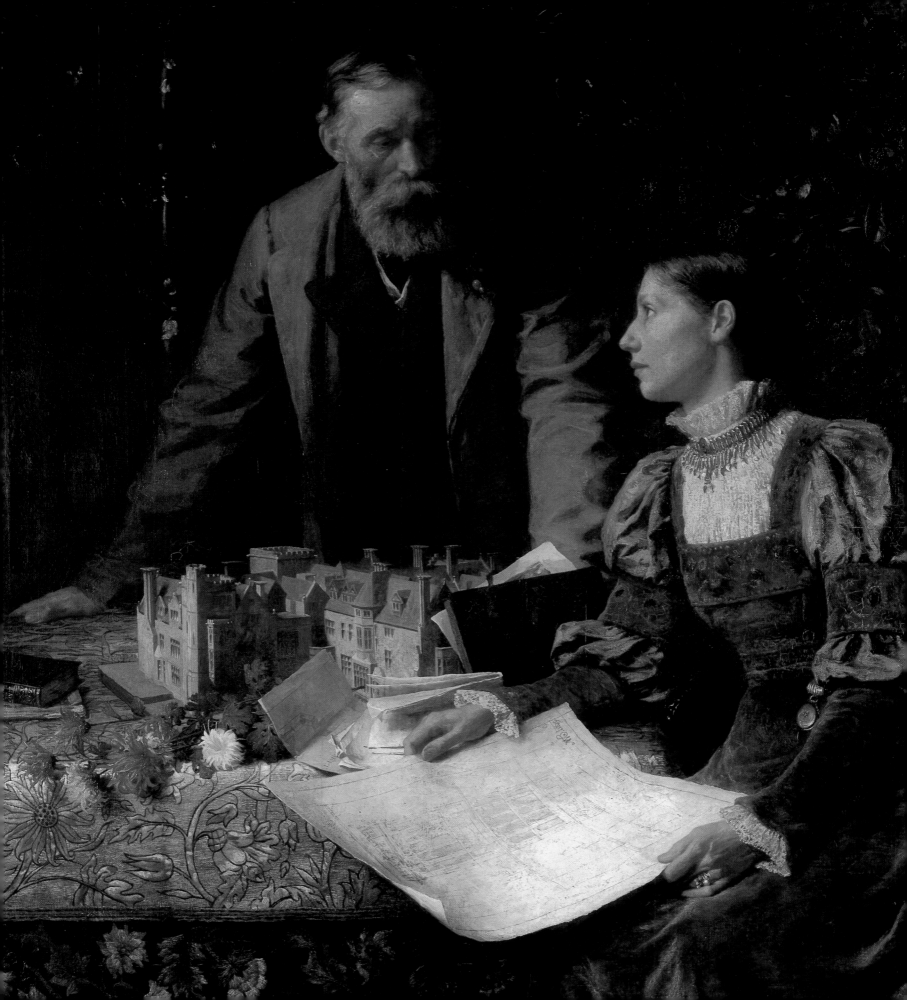

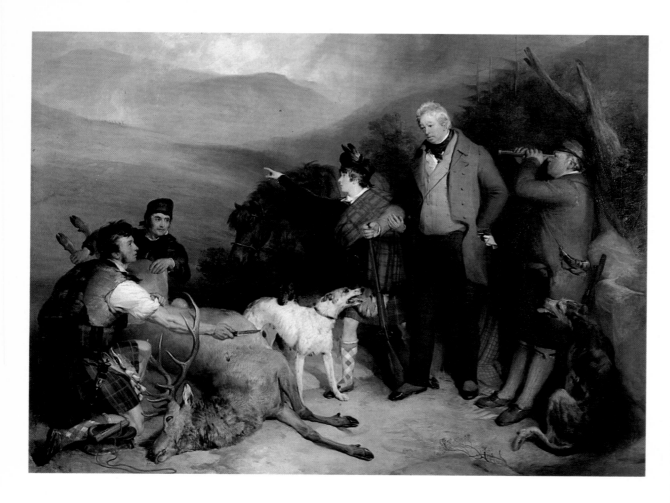

society: the old duke and young Crerar look at each other, while the attention of both the boy and the elder Crerar is held by the sight of a distant stag, far beyond the field of the spectator's vision. This presentation has obvious parallels in many of Scott's novels, in which the interdependence of lord and retainer is a consistent theme.

It would be interesting to know whether Landseer was aware of Wilkie's small panel, *The Death of the Red Deer*, which was inspired by his visit to Blair in 1817 and completed in 1821. McIntyre and the duke's piper McGregor appear in this, but the picture evidently did not meet with Atholl's approbation. It resurfaced at Christie's, 23 November 1984, lot 56, and was purchased for the present duke.

The work of his predecessors at Blair meant that Atholl had no architectural contribution to make there, but he was a builder on a considerable scale elsewhere. In 1801–1806 he employed George Steuart, the architect of Attingham, at Castle Mona, his house on the Isle of Man, and he also engaged Archibald Elliot on extensive projects at Dunkeld in 1809 and 1814–1815. At the time Landseer was working on the picture, designs were secured from Hopper for a new house at Dunkeld, and though the foundations were dug the project was abandoned on the duke's death. F.R.

Related Works: Five oil sketches, including that of the keeper Donald McIntyre (Yale Center for British Art, New Haven), and a drawing are recorded by Ormond
Provenance: Commissioned by John Murray, 4th Duke of Atholl; and by inheritance at Blair
Literature: Richard Ormond in Philadelphia and London 1981–1982
Exhibitions: London 1830 (313); Philadelphia and London 1981–1982 (36); London, Sotheby's 1984 (118)
Engravings: J. Bromley, 1833; G. Zobel, 1862

535

THE DEATH OF A HART IN GLEN TILT
1824–1830
Sir Edwin Henry Landseer 1802–1873
oil on canvas
152.4 × 200 (60 × 79)

Blair Castle
The Duke of Atholl

John Murray, 4th Duke of Atholl (1755–1830) stands, his arm held by his grandson the Hon. George Murray, later 6th Duke (1814–1864), who wears a kilt of the Atholl tartan, a sporran, the red Tullibardine plaid, and a bonnet with eagle's feathers. On the right is the Atholl head forester, John Crerar (d. 1843), as celebrated a sportsman as his master, whose son Charles holds out his knife before gralloching the hart: both he and the third keeper, Donald McIntyre, wear the Atholl tartan. The

setting is near Marble Lodge in Glen Tilt, the spectacularly beautiful valley rising eastward to the mountains of Mar, which emerges near Blair, and was to be described so enthusiastically by Queen Victoria in the *Leaves from the Journal of our Life in the Highlands*.

Landseer's first visit to Scotland in the autumn of 1824 marked a turning point in his career: henceforward he would visit the Highlands annually, staying with an expanding circle of aristocratic friends, Bedfords and Tankervilles, and many others. He visited Blair on his 1824 tour and was evidently given the commission for the picture then, as his oil studies of the duke and his keepers date from that year. In 1825 Landseer described the duke as a "fine old chieftan—but very little else" (quoted by Ormond, see below), but the marked difference in character between his oil sketch of the

subject (now at Liverpool) and the final composition may well reflect his patron's choice. As Ormond notes, the sketch was inspired by the great hunting pieces of Rubens—Landseer would have known the Ashburton *Wolf Hunt* (Metropolitan Museum, New York) that Smith imported from Paris in 1824—and foreshadowed a dramatic counterpart to the *Battle of Chevy Chase* painted for the Duke of Bedford (see no. 548). The final picture, which was completed by 1830, is more conventional, a sporting conversation piece of a kind that was surely more consistent with the aspirations of the duke, who as a boy had appeared in Zoffany's portrait group (no. 327) with the fish he had caught, and in 1780 employed David Allan to portray his own family in a sporting guise. *The Death of the Hart in Glen Tilt* is, however, more than a mere portrait group. It symbolizes the traditional loyalties of highland

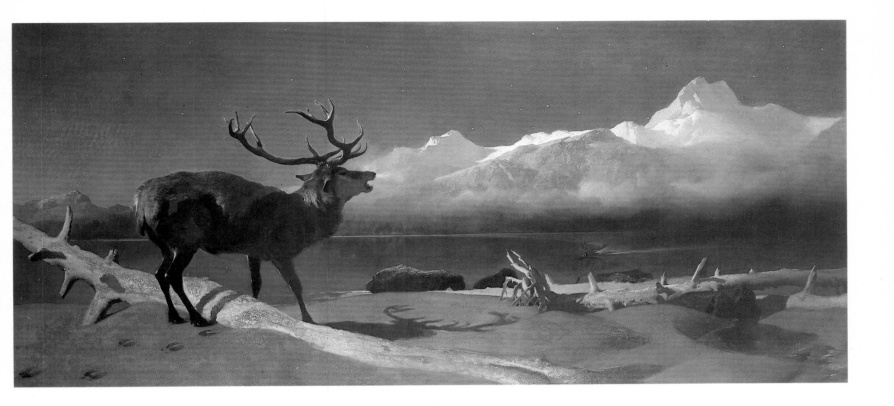

536

COMING EVENTS CAST THEIR SHADOW
BEFORE THEM: THE CHALLENGE 1844
Sir Edwin Henry Landseer 1802–1873
oil on canvas
96.5 × 211 (38 × 83)

Alnwick Castle
The Duke of Northumberland, KG

This memorable picture is, with the *Sanctuary* in the Royal Collection, one of Landseer's absolute masterpieces. The *Sanctuary*, originally bespoken by William Wells of Redleaf, a major patron of Landseer and other artists, but given by Queen Victoria to the Prince Consort in 1842, was the first of the painter's major deer subjects of the period and its success evidently encouraged Landseer to pursue a similar theme in the *Challenge*. The compositions were engraved as pendants.

The full title is taken from Thomas Campbell's *Lochiel's Warning* of 1802 in which a seer warns Cameron of Lochiel of his impending fate at Culloden: "Tis the sunset of life gives me mystical lore/And coming events cast their shadows before." The stag has come to the margin of a loch and bellows his challenge while his assailant swims from the further shore: the starlit sky is clear and a full moon is implied by the strong shadows and the silvery light that falls on the distant mountains and the skeletal tree trunks on the shore, the forms of which echo those of the challenger's antlers. The setting is perhaps intended to be Loch Laggan, but the topography is as imprecise as the theme is far-fetched, for as Ormond notes, Landseer carries his audience to the "realm of myth. We might be present at a battle between two superheroes to determine the destiny of the world, so epic is the nature of the coming struggle." Reviewers were reminded of literary parallels in Scott and Byron.

The picture was painted for Lord Algernon Percy (1792–1865), who in 1847 succeeded his brother as the 4th Duke of Northumberland. His sister Emily had in 1810 married Lord James Murray, later 1st Lord Glenlyon and their son, the Hon. George Murray, later 6th Duke of Atholl—whose son would inherit the barony of Percy on Northumberland's death—appears with his paternal grandfather in the *Death of the Hart in Glen Tilt* (no. 535). This connection with the Atholl family no doubt explains Percy's patronage of Landseer: his personal taste is represented by the Palma Vecchio (no. 494) and Reni's *Crucifixion* (no. 495). F.R.

Provenance: Painted for Lord Algernon Percy, later 4th Duke of Northumberland; and by descent through the latter's first cousin George Percy, 2nd Earl of Beverley and 5th Duke of Northumberland
Literature: Richard Ormond in Philadelphia and London 1981–1982
Exhibitions: London, RA 1844 (272); London, RA 1874 (199); London, RA 1890 (128); London, RA 1961 (74); Detroit 1968 (175); Paris 1972 (157); Philadelphia and London 1981–1982 (122)
Engravings: John Burnet, 1846; Charles Mottram, 1862; Thomas Landseer, 1872

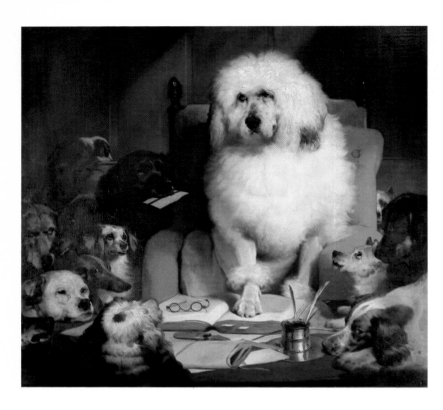

537

LAYING DOWN THE LAW: TRIAL BY
JURY 1842
Sir Edwin Henry Landseer 1802–1873
oil on canvas
120.7 × 130.8 (47½ × 51½)

Chatsworth
The Chatsworth House Trust

Dogs had been a speciality of Landseer since the outset of his career in the early 1820s: in 1824 C.R. Leslie commented that he would make himself popular at Abbotsford by painting Scott's "doggies" (Leslie 1860, 2: 157). Landseer continued to paint remarkable canine portraits but with *The Old Shepherd's Chief Mourner* of 1837 (Victoria and Albert Museum) he achieved a masterpiece—admitted as such even by Ruskin—in which the faithful hound evinces an altogether human despair at his master's death. In *Laying Down the Law* Landseer mocks the legal profession and achieves a canine counterpart to the *singeries* of the previous century, quintessentially Victorian in moral tone.

The genesis of the composition was described in a pamphlet sold with Thomas Landseer's print of 1843: "A French poodle, the property of Count D'Orsay, was resting on a table in the attitude represented by the Artist, when it was remarked by a certain noble and learned Lord who was present, and who, from having held the Seals, was certainly a competent Judge, that 'the animal

would make a capital Lord Chancellor'" (*Notes and Queries*, 20 June 1857, 482, quoted by Ormond). The poodle is the judge; the long-eared spaniel seen from behind is the clerk of the court; and the lawyers, officials, and jurors who make up the cast are represented by an improbable assemblage—the bulldog and greyhound on the left and behind, a deerhound and a bloodhound with a Blenheim spaniel, the black retriever holding the letter, and the spaniel beyond, his attention engaged elsewhere; and on the right a bull terrier, an Irish Terrier, a mastiff, and a spaniel. The Blenheim spaniel, Bony, belonged to the Duke of Devonshire and was added at the request of the Duke (letter of 26 December 1842, Victoria and Albert Museum, English MSS, 86 BR, 2, no. 86) who bought the picture. Landseer's sketch of the dog, who is cast in the role of a reporter, is also at Chatsworth. This was hung by the duke, with other canine portraits, in the South East Sitting Room at Chatsworth (Devonshire 1845, 12).

William Cavendish, 6th Duke of Devonshire (1790–1858)—the "Bachelor Duke"—succeeded his father in 1811. The very scale of the picture collection he inherited may have inhibited his activity in that direction, but he was the first of his family for over half a century to take an interest in the great collection of drawings, part of which were shown in rooms at Chatsworth—the Sketch Galleries—which Wyatville reconstructed for the purpose. The duke was particularly interested in sculpture, acquiring several major Roman works and forming a notable collection of the contemporary sculptures: he particularly admired Canova, acquiring a series of works by him including the *Endymion* and the *Madame Mère*, but also patronized Bartolini, Thorwaldsen, and Gibson. The duke was a major patron of Landseer, commissioning a large-scale historical work, *Bolton Abbey in the Olden Time*, and himself sat for the painter. He was also a builder on a considerable scale: in 1811, the year of his succession, Atkinson was employed on repairs at Lismore, the castle in Ireland inherited from the Boyle family. But Chatsworth was his major commitment. Sir Jeffry Wyatville, who was employed by the

duke's friend King George IV at Windsor, undertook a major campaign of modernization in 1820–1841, modifying the existing house and adding the vast north wing and tower: the completion of the program was celebrated by the duke's own description of Chatsworth, published in 1845, perhaps the best-written and most compelling account of any English house. Wyatville's work was complemented by the now demolished Great Conservatory at Chatsworth of 1836–1840, designed by Joseph Paxton and Decimus Burton, who also worked on the Home Farm while the estate village of Edensor was rebuilt on model lines. F.R.

Provenance: Painted for the 6th Duke of Devonshire by whom hung at Chiswick (Devonshire 1845, 12); and by inheritance at Chatsworth
Literature: This entry draws on Richard Ormond's entry in Philadelphia and London 1981–1982
Exhibitions: London, RA 1840 (311); Leeds 1868 (1396); London, RA 1874 (205); Nottingham 1959 (35); London, RA 1961 (81); Philadelphia and London 1981–1982 (140)
Engravings: Thomas Landseer, 1843; George Zobel, 1851; J.B. Pratt, 1881–1893

538

A MASTER OF HOUNDS: WILLIE, ELDEST
SON OF H. MARTIN GIBBS, ESQ. 1886
John Callcott Horsley 1817–1903
oil on canvas
134.6 × 109.2 (53 × 43)

Sheldon Manor
Major Martin Gibbs

This charming portrait of William Otter
Gibbs (1883–1960), later Colonel of the
5th Battalion, Somerset Light Infantry,
shows him at the age of three on the
steps outside the porch of Barrow Court
in Somerset, the Jacobean house that
had been restored and greatly enlarged
by his father Henry Martin Gibbs, to
designs by Henry Woodyer, about 1880
(see no. 552). A photograph taken at
the time the picture was painted shows
the artist arranging the child's pose,
with the parents watching proudly
from a distance.

The pose is ultimately derived from
the famous Holbein image of Henry VIII
(see no. 2), but a more immediate
source is Reynolds' *Master Crewe as
Henry VIII* (Lord O'Neill collection)
showing a small boy in Tudor dress,
standing with his legs akimbo, and with
two spaniels at his feet. Despite the
Pre-Raphaelites' early contempt for
"Sir Sloshua," this picture had already
inspired Holman Hunt's *The King of
Hearts*, a portrait of his nephew and
godson Edward Wilson, painted in
1862–1863 (London, Tate 1984,
no. 121), and Millais was often to use
Reynolds' prototypes—his *Hearts Are
Trumps* being a variation of Reynolds'
Three Ladies Adorning the Term of Hymen,
and depicting descendants of the original
sitters. Mezzotints of *Master Crewe* were
relatively common, but Horsley could
also have seen the picture illustrated
and described at length in Frederick
Stephens' *English Children as Painted by
Reynolds*, published in 1867 (50–51).

The artist, who generally specialized
in genre scenes and "village drama,"
was a member of the Cranbrook Colony
in Kent, with the painters Thomas
Webster, A.E. Mulready, G.B. O'Neill,
and F.D. Hardy, and became Rector of
the Royal Academy in 1875. Known as
"Clothes Horsley" for his vociferous
disapproval of naked figures, he sub-

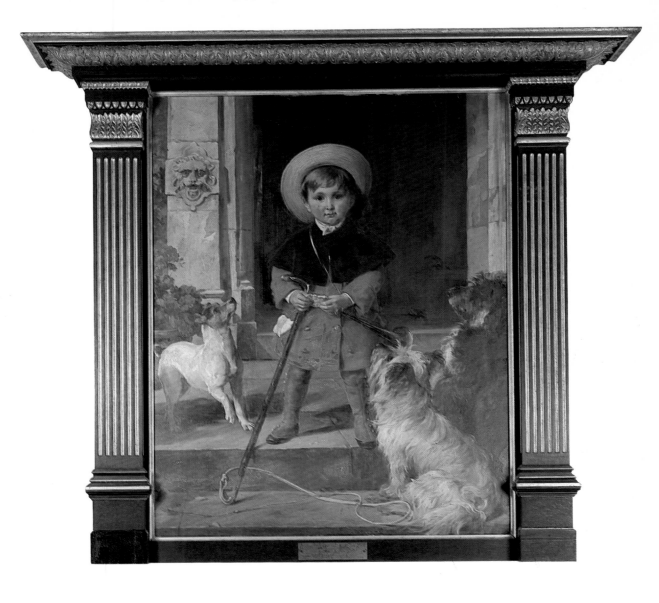

sequently inspired one of Whistler's
nudes, exhibited in 1885 under the title
Horsley soit qui mal y pense.

Considerable ingenuity is shown by
the way the child's contemporary dress
follows the shape of the Tudor costume
almost exactly: the coat reaching the
same length as the doublet, and the leg-
gings close-fitting like the tights. The
circular hat sits on the back of his head
like a halo, perhaps a rather weak visual
pun suggesting that Master Willie is a
little angel; it also emphasizes the dogs'
adoration of their master. Landseer's
influence can be felt, particularly in the

Scots terrier in the foreground, and the
nervous anticipation of the Jack Russell
on the left, about to be fed with a
biscuit. The hunting horn and crop,
together with the velvet cap seen on a
seat in the porch behind, presumably
belonged to Henry Martin Gibbs, who
in 1917 purchased Sheldon Manor in
Wiltshire for his son. The house now
contains many of the contents of Barrow
Court—which has become a Diocesan
Training Centre—though its famous
formal gardens designed by H. Inigo
Triggs about 1900 still survive. G.J-S.

Literature: I am greatly indebted to Miss
Susan Williams for generously providing
much of the information in this entry
Exhibitions: London, RA 1887 (261)

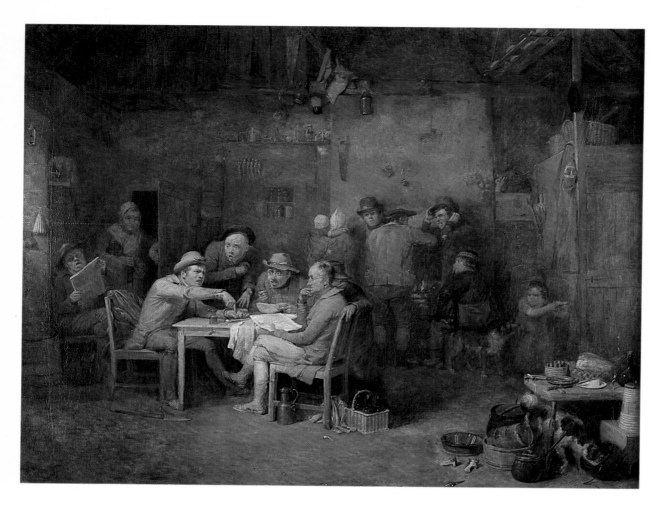

Wilkie, despite his youth and wish to please a man of such influence, countered by reminding the earl that he had not acceded to the price when this was originally quoted. The fact that two separate offers of 100 guineas had been made no doubt strengthened Wilkie's resolve, and after "a very sharp debate" Mansfield paid the sum of 30 guineas: another early patron of Wilkie, Samuel Whitbread of Southill, saw Mansfield shortly afterward and pleaded the painter's cause with "much spirit and energy" (Cunningham 1843, 1:109–110). The affair was evidently much talked of at the time, but apparently Mansfield bore no resentment. The picture was back in the painter's studio in May 1808 when it was varnished by William Seguier and was lent to Wilkie's exhibition in May 1812. Before this opened, Mansfield agreed to allow the picture to be engraved by Raimbach, which was clearly to Wilkie's advantage as the print was undertaken as a joint venture between painter and engraver.

F.R.

Related Works: Preparatory drawings are in the British Museum and the Glynn Vivian Art Gallery, Cardiff
Provenance: Painted for William, 3rd Earl of Mansfield; and by descent, at Kenwood until 1902, at Scone in 1908, at Ard Choille in 1934, at Logie House in 1951, and at Scone from 1966
Literature: This entry draws extensively on Professor Hamish Miles' draft entry for his catalogue of Wilkie's oeuvre, which the compiler gratefully acknowledges
Exhibitions: London, RA 1806 (145); London, Pall Mall 1812 (2); London, BI 1842 (118); Glasgow 1901 (282); Edinburgh 1908 (28); Rome 1911 (109); London, RA 1934 (458); London, RA 1939 (148); Paris 1951 (14)
Engravings: S.W. Reynolds, 1812, unfinished mezzotint; A. Raimbach, 1812–1813; C.W. Sharpe

539

THE VILLAGE POLITICIANS 1806
Sir David Wilkie 1785–1841
oil on canvas
57 × 74.9 (22½ × 29½)
signed and dated, *1806*

Scone Palace
The Earl of Mansfield

The subject of the picture was loosely taken from Hector MacNeill's poem, *Scotland's Skaith; or The History o' Will and Jean* of 1795. The theme is described by Cunningham: "the country tippling club, and the resolution of its members to meet oftener over their potations and politics." The man on the left of the table is apparently a caricature of Wilkie himself and both the engraver Raimbach and Cunningham state that other of the painter's early acquaintances

were portrayed in the picture. The man on the right holds the *Gazetteer*, a radical Edinburgh newspaper published in 1792–1794. Soon after January 1806, then scarcely twenty, Wilkie told his father that he had been visited by Lord Mansfield who admired his picture of Pitlissie Fair (National Gallery of Scotland, Edinburgh) and had given "directions to paint a picture for him" (Cunningham 1843, 1: 94). Even prior to the exhibition at the Royal Academy, the picture attracted considerable attention among fellow artists and led to commissions from Lord Mulgrave—who was to become one of the painter's major patrons—and Sir George Beaumont. The picture was hung advantageously at Somerset House and favorably received.

The Marquess of Stafford asked that the artist be introduced to him and

J.J. Angerstein is said to have declared that the picture "had all the sport of Teniers and the humour of Hogarth" (Cunningham 1843, 1:115). In 1830 Haydon would write that the picture "changed the whole system of Art in the domestic style." It had indeed an important place in the series of works that established Wilkie, in Sir Walter Scott's words, as the "far more than Teniers of Scotland" (Anderson 1972, 88).

Its success threw a revealing light on the relation of painter and patron. Before the exhibition Wilkie had mentioned a price of 15 guineas, at which Mansfield told him to consult his friends. Wilkie was advised that this was too little and informed the Earl on 9 May that he had been offered 30 guineas. Mansfield rejoined by stating that he was entitled to have it for 15 guineas.

540

QUEEN VICTORIA RIDING OUT WITH
HER GENTLEMEN 1840
Sir Francis Grant 1803–1878
oil on canvas
52 × 67.9 (20½ × 26¾)

Wrotham Park
Julian Byng, Esq.

Francis Grant was a Scottish painter
who became a pupil of the English
sporting artist John Ferneley, and whose
early works included several hunting
pictures in Ferneley's style. He sub-
sequently became the most fashionable
portrait painter of his time. The first
picture that he painted for Queen
Victoria, still at Windsor Castle, is
entered in Grant's sitters' book (National
Portrait Gallery, London) under May
1840, at a cost of £367 10s. It shows
the queen and members of the royal
household on one of her "ridings out,"
which according to her journals she so
greatly enjoyed. The painting exhibited
here is entered under June 1840: "Small
copy of the Queen for Honble G. Byng
£60." George Byng was a personal friend
of Grant, and there are approximately a
dozen paintings by the artist still in the
Byng family collection at Wrotham,
including the outstanding portrait of
Francis Byng as a schoolboy in Eton
dress, of 1853, and an equestrian portrait
of his father, George Byng, of 1838.

The picture is set near Sandpit Gate
in Windsor Great Park, with a view of
Windsor Castle in the distance. The
arch from which the figures emerge
seems to be imaginary; certainly no
surviving building resembles it. The
queen rides Comus, and looks toward
Lord Conyngham, who had been Groom
of the Bedchamber and Master of the
Robes, and then Lord Chamberlain.
Lord Melbourne, Prime Minister and
the young queen's chief adviser and
mentor on her accession to the throne
in 1837, rides behind her. The figures
under the arch are the Earl of Uxbridge,
Lord in Waiting, who later became Lord
Chamberlain; his brother-in-law George
Byng, later Earl of Strafford, for whom
this version was painted, and who was
Comptroller of the Household; and Sir
George Quentin, Equerry of the Crown
Stables. There is also a glimpse (clearer

in the larger painting) of Quentin's
daughter Mary, who was the lady rider
to the Master of the Horse's Depart-
ment. The bounding dogs, Islay and
Dash, are the queen's.

This was the first time that Grant
had painted Queen Victoria, but as well
as George Byng, he had already painted
Lord Melbourne in 1838, whom he
described as "most unaffected and very
agreable—I should say a thorough
good fellow and I should say likes to
think about the ladies rather than the
Canadas" (letter at Belvoir Castle,
Rutland). It was probably Melbourne
who recommended Grant to the queen.
She took extraordinary interest in the
progress of the portrait, as is illustrated
by the detailed entries in her diary from
April to October 1839 (Royal Archives,
Windsor Castle) when the picture was
being painted, recording all her own
sittings and many of Melbourne's. She

describes Grant as "very good looking
and gentleman like," and mentions
going to "the Equerries room when Lord
Melbourne was sitting to Grant . . . on
that wooden horse without head or tail,
looking so funny with his white hat
on, and holding the reins, which were
fastened to the steps. . . . Grant has got
him so like, it is such a happiness for
me to have that dear kind friend's face,
which I do like and admire so, so like,
his face, his expression, his air, his
white hat, and his cravat, waistcoat
and coat, all just as he wears it. He has
got Conyngham in also very like, and
Uxbridge and George Byng, and old
Quentin, ludicrously like."

The queen also records that the horses
were painted from life. Grant shared
with Landseer the distinction of being
the only painter in London with a studio
for animals. The fact that the queen
rides a prancing dun horse is significant

in that it seems to be a direct quotation
from a famous English royal portrait—
that of Charles I by Van Dyck in the
National Gallery in London. Grant
painted two further equestrian portraits
of Queen Victoria, in both of which he
seems aware of seventeenth-century
royal equestrian prototypes: one based on
another Van Dyck painting of Charles I
with M. de St. Antoine in attendance
(Royal Collection) and the other show-
ing the queen more dramatically,
mounted on a rearing chestnut horse;
the latter derived from Velasquez'
portraits of King Phillip IV of Spain and
Count Olivares in the Prado in Madrid.

Grant continued in royal favor until
1845, after which date he received no
further royal commissions. When in 1866
he was elected President of the Royal
Academy, the queen, despite her former
enthusiasm for the artist, wrote to the
Prime Minister Earl Russell: 'The

Queen will knight Mr. Grant when she is at Windsor. She cannot say she thinks his selection a good one for Art. He boasts of *never* having been to Italy or studied the Old Masters. He has decidedly much talent, but it is the talent of an amateur" (letter in Royal Archives, Windsor Castle). However, the queen was mistaken, as Grant became an extremely successful president, counting among his achievements the acquisition of a 999-year lease of Burlington House, still the Royal Academy's home, for a rent of one pound a year. C.M.H.W.

Related Works: The "Queen Riding out" was etched, engraved, and published first in 1841, and then again in 1843. It was reissued in 1851, updated by substituting the head of Prince Albert, the queen's husband, for that of Lord Melbourne
Provenance: Commissioned by George Byng, 2nd Earl of Strafford (1806–1886); and by descent

541

SETTEE AND TWO CHAIRS c.1850
attributed to H.F.C. Rampendahl of Hamburg
formed of antlers, with carved details, and worsted repp upholstery
settee: 109.2 × 208.3 × 91.4
(43 × 82 × 36);
chairs: 96.5 × 61 × 61 (38 × 24 × 24)
and 96.5 × 50.8 × 58.4 (38 × 20 × 23)

Osborne House
Her Majesty Queen Elizabeth II

The Horn Room at Osborne House contains an extensive suite of antler furniture, incorporating a round table, stools, and a chandelier, as well as the settee and six chairs. On the table is an album bound in antler veneer. This furniture bears a strong resemblance to "Rampendahl's Stag-horn Furniture," shown at the London 1851 exhibition by the firm of H.F.C. Rampendahl of Hamburg. Included in the exhibition were a writing bureau "inlaid with hart-horn and ivory work," a round table, a chair, a settee, and a standing candelabrum. Chandeliers incorporating antlers date back to about 1400 in Germany. Their earliest recorded usage in furniture is a chair in the deer park at Stanfort in Le Rouge's *Jardins Anglo-Chinois* of 1787. This is an *ad hoc* invention, but antlers supported on stags' heads are an integral part of a Danhauser design for a settee made in Vienna about 1830. By 1851, on the evidence of the Rampendahl exhibit at the Crystal Palace, a novelty had become an industry, and from that time on antler furniture was widespread, if not common, from Portugal to Czechoslovakia. These examples at Osborne House must have served as a pleasant reminder to Prince Albert of his childhood hunting expeditions in the Thüringerwald. S.S.J.

Literature: Jervis 1972, 93, fig. 11; Jervis 1977, 190–191, pl. A

542

TABLE 1849/1850
designed by Augustus Welby Northmore
Pugin 1812–1852; made by J.G. Crace
oak with inlay of various woods
75 × 91 × 183 (29½ × 35¾ × 72)

Eastnor Castle
James Hervey-Bathurst, Esq.

This table represents the style that Pugin adopted in his last years under the influence of the decorating firm of John Gregory Crace. From the mid-1840s Pugin was closely involved with Crace in the decoration and furnishing of the new Palace of Westminster. Pugin's own preferred style was that which he had pioneered from 1840 on and is exemplified by tough structural forms in solid oak; furniture of this type laid the foundations for the Reformed Gothic style of the 1860s. Crace, however, wished to manufacture a more ornate form of gothic furniture with polychromatic marquetry and inlay, knowing that the owners of country houses would be far more likely to employ the Pugin and Crace team to furnish their houses if they used this prettier style. Pugin, who was perpetually short of money because of his own collecting and building activities, was forced to compromise and collaborated with the firm on a number of country house schemes.

From 1847 on at Eastnor, at Leighton Hall in nearby Wales, and at Abney Hall in Cheshire interiors and furniture of a very similar type were created by them. This Eastnor table is very close to one that still survives at Abney Hall, and designs in Pugin's hand dated 1849 for one of these exist in the Prints and Drawings Department of the Victoria and Albert Museum, as are a number of designs certainly for furniture at Eastnor. The work at Eastnor continued from early 1849 to late 1850.

The forms and motifs that appear in this table and the related pieces, though not those which Pugin would have preferred, show every mark of his genius as one of the most celebrated English furniture designers of all time. These pieces also closely relate to those shown with such success by Pugin and Crace at the International Exhibition of 1851 in the Crystal Palace. C.W.

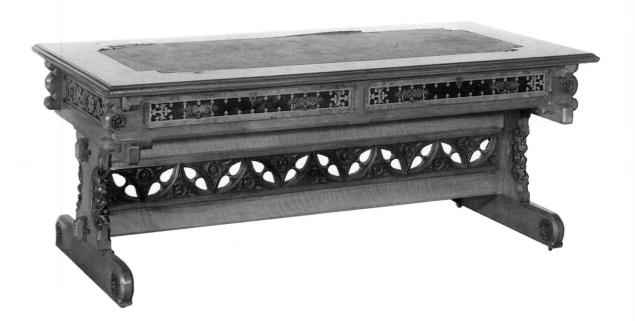

543

TWO FOUR-LIGHT CANDELABRA 1854
Herbert Minton and Co. and
R.W. Winfield and Co., after designs
by Sir Edwin Henry Landseer 1802–1873
Parian ware and silvered and gilt metal
94 (37) high

Balmoral Castle
Her Majesty Queen Elizabeth II

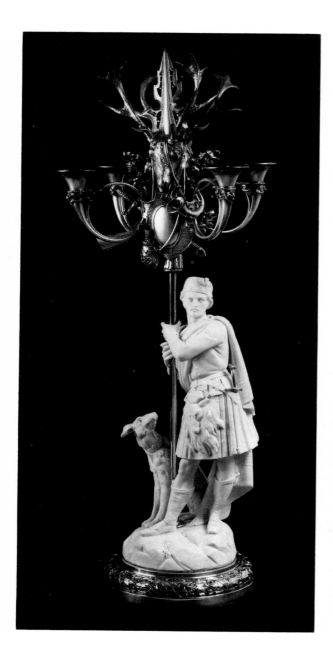
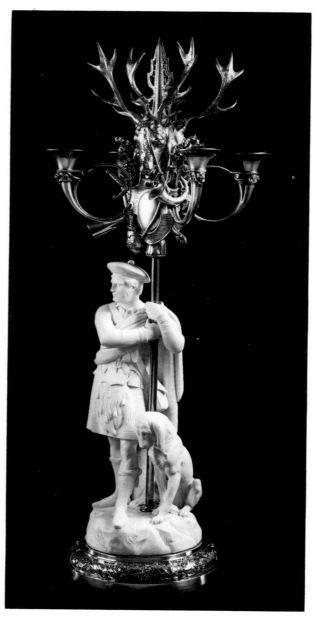

Queen Victoria and Prince Albert paid their first visit to the Highlands in 1842. They were much taken with the Highlanders, whose sturdy independence appealed to them, and they were captivated by the wild scenery, which reminded Prince Albert of Thüringia in Germany, where he had spent much of his childhood.

In 1848 they bought the lease of Balmoral Castle on Deeside, and four years later Prince Albert acquired the freehold of the Balmoral estate. Plans were immediately drawn up to Prince Albert's design for the replacement of the existing castle, which was judged too small and inconvenient. The new castle, built of grey granite in the style "of the old sturdy baronial architecture of Scotland" (*Illustrated London News*, 16 September 1854, 246), was not completed until 1856. Its building and furnishings, however, were sufficiently advanced for the queen to be able to take up residence on 7 September 1855 (Ames 1967, 101–106).

The London furniture makers, Holland and Sons, supplied most of the furniture, furnishings, and fittings in 1855. Of simple design and made principally of oak, pine, and satinwood, the wardrobes, tables, and other pieces are fitted with silver hinges that incorporate the initials *V* and *A*. The Highlands were the inspiration for the design of many of the other furnishings, notably for the carpets and some of the hangings and seat covers, which reproduce the Stuart tartan, as well as for the candelabra. The arms of the candelabra, which are in the shape of bugles, are attached to a hunting trophy incorporating a stag's head. The trophy is secured to a lance held by a Highlander, with a seated hound beside him.

The candelabra were probably designed by Sir Edwin Landseer, who was certainly responsible for the groups in Parian ware. He evidently had second thoughts about the breed of one of the hounds represented, for in a letter of 22 October 1854 to Herbert Minton he asked that the model of the hound be changed from one of a rough deer-hound to "a smooth bloodhound with pendant ears." He included in his letter a pen sketch of the bloodhound (letter from the Minton Archives, kindly communi-

cated by Miss Joan Jones).

Six pairs of candelabra of this pattern were made. They were supplied by Herbert Minton and Co. at a cost of £468 8s. The bill, which is dated August and November 1854, provides a breakdown of the cost (WRA, PP2/8/5137). The Parian ware groups each came to 6 guineas, and their models and molds amounted to a further £100. The metal fittings, which were made by Winfield (probably R.W. Winfield and Co., Birmingham) and were the most expensive item, cost £288.

The candelabra were intended for the most lavishly decorated room in the castle, the drawing room, which is situated on the ground floor. Ten stood on the white marble tops of six cabinets and pedestals of satinwood inlaid with marquetry panels, which were supplied by Holland and Sons at a cost of £437 2s. This arrangement persists to this day. The rest of the furnishings provided by Holland for this room echo the Scottish theme of the candelabra. They include a set of tartan cashmere curtains and six satinwood chairs, each carved with a thistle in the center of their pierced backs. The chairs and the other seats in the room were all covered by Holland in silk tartan poplin. G.de B.

544

SALVER 1837
designed by Sir Edwin Henry Landseer 1802–1873; made by Benjamin Preston free 1817
silver-gilt
66 × 83.8 (26 × 33)

Woburn Abbey
The Marquess of Tavistock and the Trustees of the Bedford Estates

The practical approach to enriching one's house with contemporary silver for use as well as display is clearly demonstrated by the 6th Duke of Bedford's having had a series of agricultural and farming medals, won by him and his brother the 5th Duke, made into a large oblong tray. The idea for such a piece may have been inspired by

the large silver-gilt salver given to the duke in 1807 by the agriculturalists of Great Britain. Rather unexpectedly, perhaps, the commission for the design of the 1837 salver went to Sir Edwin Landseer, particularly known for his paintings of dogs and deer, and for the modeling of the lions at the foot of Nelson's Column in London's Trafalgar Square in 1858. Landseer first came to Woburn in the 1820s, and became very closely acquainted with both duke and duchess, accompanying them on their annual visits to Scotland. The duke was one of his first patrons, commissioning the *Hunting of Chevy Chase* (Birmingham City Art Gallery) in 1826. After the duke's death in 1839, Landseer proposed to the duchess, who was twenty years his senior. Her refusal led to his first nervous breakdown in 1840 (Ormond in Philadelphia and London 1981–1982).

During his long working life Landseer himself designed several medals featuring birds and animals, and the result of his essay in silver design is a very large oblong salver or sideboard dish. Almost every inch is decorated with the attributes of farming. In the center a Roman-style plowman guides a pair of oxen, within a cartouche of paired cornucopiae. At each corner is a wheatsheaf with a trophy of farm implements, while the border is richly chased with "family" groups of farm animals boldly modeled by Edward Cotterill. At the top, below the ducal badge and coronet, are a lively group of harvesters and a sheepshearing scene that recalls George Garrard's well-known painting of 1804, *The Woburn Sheepshearing*. This annual event took place at the home farm, beginning with a public breakfast and continuing with competitions for plowing, shearing, and livestock over about five days. It was an occasion where farm workers mingled freely with peers and statesmen (as well as the 6th Duke of Bedford, Garrard's painting depicts Lord Egremont, Lord Dundee, and the Duke of Clarence).

John Russell, 6th Duke of Bedford (1766–1839), was a keen collector of sculpture and his taste encompassed Canova's *Three Graces* (no. 480) and Garrard's bronze overdoor reliefs after La Fontaine's Fables for Henry Holland's new dining room (Deuchar in London,

ML 1984, 54, 85). The duke would have been familiar with Garrard's plaster models of improved breeds of sheep and cattle, which were among the first three-dimensional representations of farm animals, and seem to be echoed in this salver. It is known that he took a close interest in the design, particularly over the placing of the portrait medallion of his brother, the 5th Duke.

Benjamin Preston, the silversmith employed for the task of making up Landseer's complicated design by the London retailers, W.H. Osborn, was a son of one Benjamin Preston, who worked in the London Assay Office, and was apprenticed in 1810 to Edward Barnard of Emes and Barnard, a firm noted at the period for their ability to produce fine copies of neoclassical designs and for the quality of their chased and cast ornament. Free of the Goldsmiths' Company in 1817, Preston did not, however, enter his own mark until 1825, when he set up in business in Coppice Row, Clerkenwell, London.
 J.B/J.M.M.

Literature: Grimwade 1965, 505, pl. 12; Grimwade 1982, 643
Exhibitions: Philadelphia and London 1981–1982 (96)

545

1849
Franz Xaver Winterhalter 1805–1873
oil on canvas
243.8 × 142.2 (96 × 56)

Dunrobin Castle
The Sutherland Trust

Lady Harriet Howard (1805–1868) was the daughter of the 6th Earl of Carlisle, and in 1823 married the 2nd Duke of Sutherland. She was Mistress of the Robes to Queen Victoria from 1837–1841, 1846–1852, 1853–1858, and 1859–1861. The queen was devoted to the duchess and on a visit to Dunrobin in September 1872 laid the foundation stone of a memorial to her.

Winterhalter, who established an international reputation as a court portrait painter, was first brought to the attention of Queen Victoria and Prince Albert by Louise, Queen of the Belgians. A portrait of the queen with her elder son, painted in Paris in 1838, had been sent over to Queen Victoria in the same year: "quite lovely . . . beautifully painted in oils by a German painter called Winterhalter." Queen Louise was

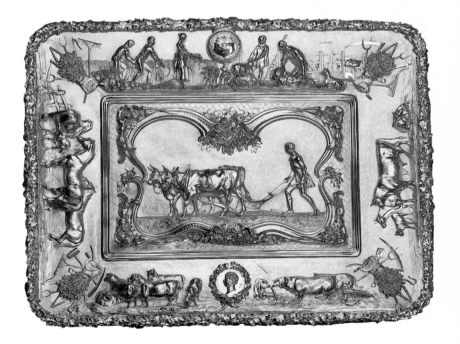

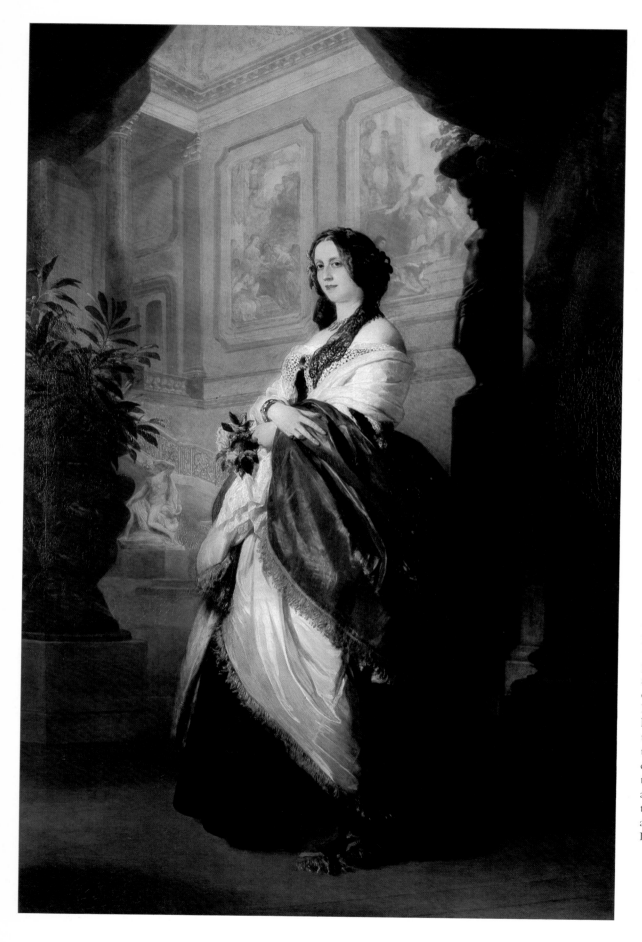

a daughter of Louis-Philippe, King of the French, by whom the painter was also extensively patronized. In the summer of 1842 he paid his first visit to London and achieved notable success with his portraits of the queen, Prince Albert, the Princess Royal, and the Duchess of Saxe-Coburg-Gotha. Thereafter Winterhalter made many visits to the English court; he remained the queen's favorite portrait painter and after his death she found it difficult to find a successor.

This portrait was painted for the Duke and Duchess of Sutherland in 1849. On 13 June the queen went to Stafford House to see, according to her Journal, "the picture Winterhalter is painting of the Duchess of Sutherland. The picture, which is far advanced, though without any background, is most successful, and a beautiful work of art. The Duchess is in a Court dress with her train over her arm, and quite 'dans le grand style.'" A copy of the head and shoulders was painted by Corden as a present from the duchess for the queen's birthday on 24 May 1851, and a version with a different background (Inveraray Castle) was probably painted for the duchess' daughter, Elizabeth, who married the 8th Duke of Argyll.

The duchess is shown standing at the foot of the stairs at Stafford House, which had been leased to the Marquess of Stafford, who became the 1st Duke of Sutherland, in 1827. The staircase hall, decorated by Barry, has been described as the most splendid of its date and kind in England. It rises to the full height of the building and the walls are decorated with copies after famous paintings by Veronese. In the time of the 2nd Duchess the house played a prominent part in the social, artistic, and political life of London, the Whig equivalent of the Tory bastion at Apsley House. Many celebrated parties were held in the house, including the ball attended by the queen on 13 June 1847. At this time it also housed the Sutherland collection of pictures (those collected by the 1st Duke when he was Earl Gower and Marquess of Stafford) in the picture gallery, described by Mrs. Jameson as "the most magnificent room in London." O.N.M.

546

THE HOUSE BUILDERS 1879
Sir Frank Dicksee 1853–1928
oil on canvas
135.9 × 152.4 (53½ × 60)

Denton House
Sir Bruno Welby, Bart.

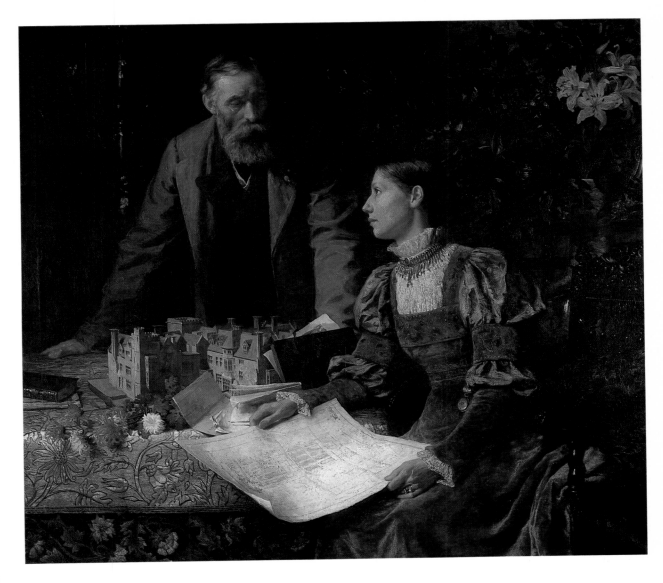

Symbolizing the aims and ambitions of the Victorian country house builders, this double portrait shows Sir William Welby-Gregory, 4th Bart. (1829–1898), and his wife Victoria, only daughter of the Earl of Wharncliffe, inspecting the model and drawings for Denton Manor, Lincolnshire, which was built for them between 1879 and 1884 by A.W. (later Sir Arthur) Blomfield. The drawing held by Lady Welby-Gregory, showing a detail elevation of the two-story oriel window over the front door, is signed with the monogram *AWB* and the date 1879. The model of the house is seen from the same angle as a perspective drawing published in *The Building News* (10 October 1879), which, however, shows the oriel only one story high and displays other minor differences in the fenestration. A folder of additional drawings conceals the immense service wings round two courtyards, occupying far more space than the family's own quarters. The house was demolished just before the Second World War, and only the stable block now remains.

Blomfield's "domestic Gothic" style looks back to Augustus Welby Pugin's country houses of the 1840s and 1850s, such as Bilton Grange in Warwickshire; a cautious and conservative approach compared to the polychrome fantasies of William Burges and S.S. Teulon, but one that must have appealed to a squire who was already fifty, and who was rebuilding his old family seat not so much to make his mark in the county as to provide a home for the pictures, furniture, and other works of art inherited from his father's cousin, Gregory Gregory of Harlaxton. Models of houses were frequently requested by patrons, from Sir Christopher Wren's Easton Neston in the 1690s to Anthony Salvin's Peckforton Castle in the 1840s and Sir Edwin Lutyens' Castle Drogo early in this century. They were particularly helpful, as at Denton, in revealing

the different grouping of elements in a rambling, irregular house, whose picturesque character would not be clear from one-dimensional plans and elevations.

Lady Welby-Gregory was one of the leading lights in the foundation of the Royal School of Art Needlework in South Kensington, and her interests are reflected in the richly embroidered tablecloth, whose stylized flowers in the manner of William Morris' textiles are complemented by a bunch of freshly picked chrysanthemums. The ebony chair in which she sits is of a seventeenth-century Goanese type, generally thought by the Victorians to

be "Elizabethan" (see a similar set in the library at Charlecote; Wainwright 1985, figs. 6, 7), while behind her is a large oriental porcelain vase with an arrangement of lilies, a particular token of aesthetic sensibility in the Pre-Raphaelite period.

According to a memoir written in 1905 after Dicksee's death, *The House Builders* caused something of a sensation when exhibited at the Royal Academy in 1880, and must have contributed to his election as an ARA the following year, at the early age of twenty-seven. Hitherto the artist had concentrated on somewhat overcharged mythological and narrative pictures, and the success

of this picture meant that "portrait commissions soon came to him in embarrassing profusion." However, it was not a field in which he wished to make a mark, and he did not exhibit another portrait at the Academy for nineteen years (Rimbault Dibdin 1905, 6). G.J-S.

Literature: Art Journal 1880, 186; *Builder,* 8 May 1880, 561; Girouard 1979, fig. 11; Franklin 1981, 30, 123, 259
Exhibitions: London, RA 1880 (40); Manchester 1887; London, SPP 1891; London, V & A 1973 (152)

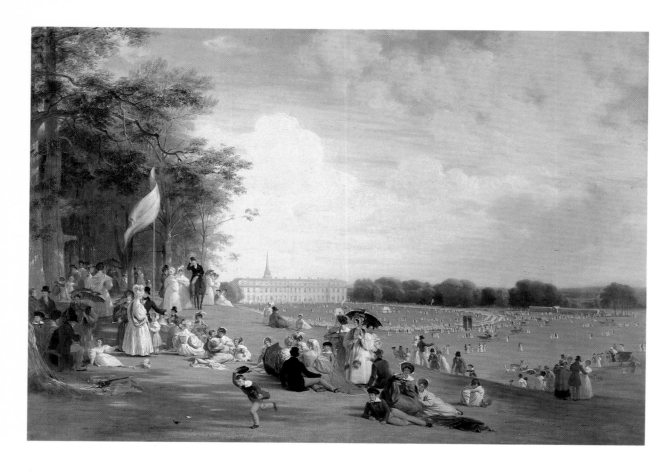

estimated that 6,000 sat down to the
great haunches of beef, the round plum
puddings, the piles of newly-baked
loaves. Neighboring squires were called
upon to perform the carving; the estate
staff and servants waited upon the
indigent guests. A band paraded, the
sky was a glorious unclouded blue, and
Greville noted that 'nothing could exceed
the pleasure of that fine old fellow'
(Strachey and Fulford 1938, 3:398).
Then the inner gates were thrown open
in order that the multitude might wan-
der as they pleased through the garden,
up to the windows of the house itself.
Later, to complete the festivities, a fire-
work display exploded over Capability
Brown's arcadian landscape." G.J-S.

Provenance: See no. 522
Literature: Sutton 1977, 320, fig. 1;
Egremont 1985
Exhibitions: London, RA 1836 (306);
London, RA 1951 (354); Brussels 1973
(71)

548

VIEW ON THE COAST IN NORMANDY
1825/1826
Richard Parkes Bonington
1801/1802—1828
oil on canvas
62.2 × 96.5 (24½ × 38)
signed, *R P Bonington*

Woburn Abbey
The Marquess of Tavistock and the
Trustees of the Bedford Estates

This exceptional picture, one of a series
of coastal scenes which Bonington
executed in France, was painted shortly
before his departure for Venice in 1826.
It is the most impressive survivor of
the considerable collection of works by
contemporary painters purchased by
John Russell, 6th Duke of Bedford
(1766—1839), and was evidently acquired
from the artist, whose studio in Paris
both the duke and Lord Holland were
advised to visit by Augustus Wall
Callcott. In a letter of 28 February 1826
to Lord Holland, his librarian Dr. Allen
reports, "Mr. Calcott . . . tells me that
Landseers picture of Chevy Chase for
the Duke of Bedford is most excellent
and superior to any thing he has yet
done. He also recommends to you and

547

A FETE AT PETWORTH 1836
William Frederick Witherington
1785—1865
oil on canvas
inscribed, *W.F.W. 1836*
83.8 × 120.6 (33 × 47½)

Petworth House
The National Trust
(Egremont Collection)

George Wyndham, 3rd Earl of Egremont
(1751—1837), famous as the patron of
Turner and many other British artists
and sculptors, is seen on horseback on
the left, beside the banner, at one of the
great annual feasts at Petworth given
for his tenantry and workers, which
took place even during the years of
deepest agricultural depression. In
the background is the south front of
Petworth House, built in the 1690s
by his ancestor the "Proud Duke"
of Somerset, with the spire of the
parish church behind. The park, one of
Capability Brown's most famous land-
scapes, is shown with the trees grown
to full maturity.

Witherington, better known for his
genre scenes of country folk in the
manner of Wilkie, shows a concourse
worthy of some of John Martin's mega-
lomanic visions. Yet records of the
event as held in 1834, and again in 1835
(when the earl was eighty-four), show

that he was not guilty of exaggeration.
The present Lord Egremont has de-
scribed the circumstances: "In May 1834
there was a great celebration in the
park, an occasion worthy of Versailles
except that the day had originated in its
instigator's charitable spirit rather than
the posturing self-glorification of the
Sun King. The earl had been in the
custom of providing the poor of Petworth
and its surrounding parishes with a
winter feast but that year the entertain-
ment was postponed until the summer
because of his temporary illness. Thus,
in May, he decided to stage the event
in the open air, in front of the great
house. Fifty-four tables, each fifty feet
long, were placed in a vast semicircle,
and two great tents erected to house
the provisions. Some 4,000 tickets were
distributed throughout the locality but
when the guns were fired to announce
the beginning of the feast, many more
were allowed in. Eventually it was

to the Duke to go to the atelier of an English artist at Paris, a Mr. Bonnington—in the Rue Mauvais he thinks—who is making a great deal of money there by small landscapes, I think which are in great request among the Parisians and from those Calcott has seen possess in his opinion great merit" (British Library, Holland House MSS 52173, 856). Both the Bedfords and the Hollands spent the winter and spring of 1825–1826 in Paris and the picture was presumably bespoken before the artist left for Venice on 4 April.

Bedford was not Bonington's only patrician patron—Countess de Grey purchased the *French Coast Scenery* and Sir George Warrender, 4th Bart., the *French Coast with Fishermen*, which the painter sent to the British Institution in 1826—but it must have been gratifying for the artist that a nobleman known both for his collection of old masters and for his support of living artists should have acquired works by him. For Bedford owned not only the landscape, but also the smaller but breathtakingly beautiful *Coast of Picardy* (Wallace Collection, London). This was, it seems, kept not at Woburn, but in London and was bought at the sale of the duke's widow in 1853 by the 4th Marquess of Hertford for 220 guineas.

Parry's Woburn guide of 1831 establishes that the duke then kept his contemporary pictures in the North Drawing Room, previously the Billiard Room, in which important Dutch and Flemish pictures had been hung, and in the adjoining Ante Drawing Room, previously the Inner Drawing Room. After the visit of Queen Victoria in 1841 these were respectively to become the State Bed Chamber and the Queen's Dressing Room. The pictures in the former (where the Bonington now hangs) included William Allan's *Assassination of the Regent Murray*, still at Woburn, commissioned by the duke at the instance of Sir Walter Scott; Landseer's *Hunting of Chevy Chase* (Birmingham City Art Gallery), and Hayter's *Trial of William, Lord Russell*. The latter was no doubt ordered as an act of family piety and was much admired by the then historian of the family, J.H. Wiffen: "The genius of Mr. Hayter, whose imaginative eye has been illuminated as

with a distinct vision of the pomp of that ill-starred tribunal and its malevolent assessors, has fixed the whole impressive scene on canvas, for the admiration of other ages as well as of our own" (Wiffen 1833; 2:271, n. 1). The Bonington was in the Ante Drawing Room with Leslie's *Proclamation of Lady Jane Grey*, Abraham Cooper's *Battle of Zutphen* (in which Sir William Russell had fallen), works by Eastlake and Severn and views of the park at Woburn by Lee and Landseer. The latter was of course the painter with whom the Bedfords were most intimately associated. He first stayed at Woburn in February 1823 and the acquaintance quickly ripened into a friendship, which resulted in a remarkable series of family portraits and other commissions. By 1829 it was rumored that he was the lover of the duchess, Georgiana (1781–1853), daughter of the 4th Duke of Gordon. F.R.

Provenance: Purchased by the 6th Duke of Bedford; and by descent

Literature: This entry draws on Marian Spencer's draft entry for the picture in her forthcoming catalogue of Bonington's oeuvre, no. 325, which is gratefully acknowledged; Parry 1831, 22; Woburn 1850, 150; Woburn 1868, no. 381; Scharf 1877, 1889, and 1890, no. 330

Exhibitions: Possibly London, Regent Street 1824 (46); ArtsCouncil 1950 Rotterdam 1955; Manchester 1957; British Council 1960 (12); King's Lynn 1961 (13); Nottingham 1965 (266); London, RA 1968–1969 (212)

Engravings: J.D. Harding, lithograph, 1 August 1830; Charles G. Lewis, published Hodgson, Boys and Graves, 1835, steel engraving

of drawings by Bonington that remains at Bowood, and fine works by Wilkie and Landseer. Appointed a Trustee of the National Gallery in 1834, he was also one of the most discriminating collectors of old masters of his generation, acquiring a notable group of Italian pictures of the cinquecento—distinguished Dutch pictures, including Rembrandt's *Mill* (National Gallery, Washington) and his late *Self-Portrait* (Kenwood, London) and the fine Gainsborough landscape (no. 317). F.R.

Provenance: Painted for the 3rd Marquess of Lansdowne; and by descent
Literature: Ambrose 1897, no. 313; Van der Merwe 1979, under no. 174

549

VIEW ON THE MEDITERRANEAN
c.1834/1845
Clarkson Stanfield 1793–1867
oil on canvas
87.6 × 116.8 (34½ × 46)

Bowood House
The Trustees of the Bowood Collection

This is one of a series of ten Italian views by Stanfield which, together with two pictures of pilgrims in Italy by C.L. Eastlake, were commissioned by Henry Petty-Fitzmaurice, 3rd Marquess of Lansdowne (1780–1863), for the dining room in the Great House at Bowood. Enlarged and redecorated by Robert Adam in 1761–1764 for the 1st Marquess, Prime Minister in 1781–1782, the Great House was demolished in 1956. In the dining room at Kedleston Adam had determined not only the

details of the decoration, but also the arrangement of the pictures, some of which are set into the walls. The yet richer scheme of the Bowood dining room, with its spectacular plaster ceiling, was also intended to be complemented by pictures, but may well have had to be adapted to accommodate Stanfield's scheme.

The commission is surprisingly little documented. The first component to be completed, *Venice from the Dogana*, was exhibited at the Royal Academy in 1833, when Turner showed his smaller *Bridge of Sighs with Canaletti Painting* (Tate, London). A letter of 17 August 1834 from Lansdowne establishes that "the pictures by Mr Stanfield" were ready for dispatch from London: a wagon was on its way but "if there is any difficulty as to room it will be sufficient to send the largest at present" (Bowood MSS; I am indebted to Lord Shelburne

for this information). Stanfield was at Bowood to help with hanging in January 1835 but it has been suggested that the series was not completed until 1845: the tradition that each canvas cost 500 guineas (Reitlinger 1962, 1:93) cannot be substantiated.

Stanfield's patron, the 3rd Marquess, had inherited Bowood on the death of his half-brother in 1809, who had previously sold much of the remarkable collection of pictures assembled by their father, the 1st Marquess. Chancellor of the Exchequer in 1806–1807, Home Secretary in 1827–1828, Lord President of the Council under Grey, Melbourne, and Russell and a member of the Cabinet without Portfolio from 1852 until 1858, Lansdowne was for over fifty years one of the most influential and respected of Whig statesmen. He was a perceptive judge of contemporary English artists, acquiring the extraordinary collection

550

THE FOREST OF BAVELLA, CORSICA
1868
Edward Lear 1812–1888
oil on canvas
91.4 × 147.3 (36 × 58)
signed with monogram, *EL*

Beaufront Castle
Aidan Cuthbert, Esq.

Lear visited Corsica in 1868 and spent the last three days of April at Bavella. On 6 May he wrote to Countess Waldegrave, whose third husband, Chichester Fortescue, later 1st Lord Carlingford, was one of his most intimate friends: "I have seen the south part of the island pretty thoroughly: the inland mountain scenery is of the most magnificent character, but the coast or edges are not remarkable. The great pine forest of Bavella is I think one of the most wonderfully beautiful sights nature can produce. The extraordinary covering of verdure on all but the tops of granite mountains make Corsica delightful" (Strachey 1911, 103). Four large and two smaller views of Bavella were used for Lear's *Journal of a Landscape Painter in Corsica* of 1870 and the drawings made on the spot were sub-

sequently worked up as the basis for full-scale pictures. Lear's love of trees is evident both in his landscapes and in his correspondence and Bavella with its spectacular pines offered perfect illustrations to the line from Tennyson's *Oenone*: "My tall dark pines that plumed the craggy ledge." The artist's great scheme for a series of two hundred landscapes illustrating Tennyson's poems was not to be fully realized, but he was at work on a large view of Bavella for plate 32 or 33 of this project in September 1873, on the eve of his departure for India, and in June 1884. A smaller oil of the subject was in the collection of Aubrey Baring and another large picture of a comparable view is known.

Lear's first patron was Edward Smith Stanley, 13th Earl of Derby, who subsidized his *Family of the Psittacidae*, with its magnificent bird plates, and for the amusement of whose grandchildren the *Book of Nonsense*, first published in 1846, was written. Knowsley was the first of a number of great houses at which the artist became an habitué: later he would stay also at Chewton and Strawberry Hill with Lady Waldegrave, at Cadland with the Drummonds, and at Stratton with the 1st Earl of Northbrook, who as Viceroy made possible Lear's visit to India in 1873–1875. Lear traveled in Sicily with Viscount Proby, brother of the 5th Earl of Carysfort (see no. 555), and was also a close friend of Lord and Lady Somers (see no. 557). The circle

of his friends was indeed so large that late in life, when he lived at San Remo and only visited London at intervals, he tried to avoid invitations to the country. Many of his friends followed the Derbys' lead in commissioning pictures: Lady Waldegrave, Monckton Milnes, Lord Northbrook, Louisa, Lady Ashburton (see no. 500), and others, though the public demand for both these and his watercolors was surprisingly precarious. Lear was an inveterate traveler and this in part explains the appeal of his watercolors to collectors of the twentieth century, who have included Dame Freya Stark and Sir Steven Runciman. F.R.

Provenance: Anon. sale, Christie's, 16 March 1973, lot 62, bought for 7,600 gns by Agnew's, by whom sold to the present owner

The Great Exhibition of 1851 held in the Crystal Palace designed by Joseph Paxton, formerly the Duke of Devonshire's gardener at Chatsworth, marked the final triumph of the Industrial Revolution in England. But its encouragement of mass-produced art for the middle classes paradoxically provoked a reaction among the intelligentsia, leading to the high aestheticism of the Pre-Raphaelite movement on the one hand, and on the other a return to the simplicity of ancient materials and techniques in the Arts and Crafts movement. Few British country houses can be said to have played a central role in either of these movements, but many of them contain pictures and sculpture, furniture and metalwork, books, textiles and wallpapers, which show their influence. On the whole, industrialists tended to be more adventurous collectors than old-established landowners, and many of their houses, like Samuel Mander's Wightwick, Lord Leverhulme's Thornton Manor and Lord Armstrong's Cragside, remain outstanding period pieces.

Sentimental narrative pictures of the order of Henry Nelson O'Neil's *Eastward Ho* and Sophie Anderson's *No Walk Today* (nos. 553 and 560), which can be regarded as the mainstream of Victorian art, are well represented in collections like Lord Carysfort's at Elton. But the only major Pre-Raphaelite artists to make a mark in country house circles after the disbanding of the Brotherhood were Millais, in his later career as a portrait painter, and Burne-Jones. The latter's Briar Rose series at Buscot are almost as ambitious in extent as William Bell Scott's murals in the central hall at Wallington, painted under the direction of John Ruskin— a close friend of Pauline, Lady Trevelyan. Patronage of such painters often accompanied an interest in collecting Italian primitives, as in the case of Lady Windsor, the subject of one of Burne-Jones' only full-length portraits (no. 556), whose husband owned a number of trecento and quattrocento pictures at Hewell Grange, like those that still survive in the Bromley-Davenport collection at Capesthorne, and those from William Graham's collection at Mells and other houses. A renewed interest in the Italian Renaissance is also evident in Burne-Jones' *Love Among the Ruins* (no. 551), and later in the bronzes of Alfred Gilbert.

Despite the occasional appearance of classical subject pictures by Frederic, Lord Leighton and Lawrence Alma-Tadema, looking forward to the marble halls of Norman Shaw and Edwin Lutyens, portraits were more in demand for family collections, which could often boast likenesses back to the sixteenth century. Fine examples by Leighton and G.F. Watts can be found in several houses, as well as society ladies in their fashionable *japonaiserie* drawing rooms and boudoirs by Richmond and Poynter, recalling the world of Gilbert and Sullivan's *Patience*.

One of the most original and inventive of all Victorian architects and decorators, William Burges, found an ideal patron in the eccentric and immensely wealthy 3rd Marquess of Bute, for whom he designed Cardiff Castle and Castell Coch in Wales. As obsessed with the decorative unity of his interiors as Robert Adam a century earlier, Burges designed every detail down to the door-knobs, tiles, and stair-rods, while his magnificent silver designed for Lord Bute (no. 565), recalling the riches of cathedral treasuries in the Middle Ages, is also interpreted with a vigor and earthy humor characteristic of the "muscular" Victorian church architects. Under the influence of Ruskin, others, like William Morris, and the potters William de Morgan and Sir Edmund Elton, sought to escape the threat of commercialism by returning to the most basic of materials and methods: block-printing of textiles with vegetable dyes, tapestry-weaving and book illustration using woodcuts. Morris' own manor house at Kelmscott in Oxfordshire is a perfect example of this return to the "simple life," though its principles were extended to much larger country houses like Clouds in Wiltshire and Rodmarton in Gloucestershire, and the communities of craftsmen formed by Ernest Gimson in Leicestershire and W.R. Lethaby in the Cotswolds. The idealism was shared in the 1890s by the circle known as the Souls, a group united by their liberal political principles and opposition to the philistinism of the Marlborough House Set, which surrounded the Prince of Wales. In many of their country houses—Stanway, Wilsford, Taplow Court and Wrest Park—the aesthetic movement lived on until the First World War.

551

LOVE AMONG THE RUINS 1894
Sir Edward Coley Burne-Jones, Bart.
1833–1898
oil on canvas
95.2 × 160 (37½ × 63)
signed, *EBJ 1894*

Wightwick Manor
The National Trust
(Bearsted Collection)

Browning's poem *Love among the Ruins* had been published in 1855 and no doubt suggested the theme to Burne-Jones when he first treated the subject in a watercolor, begun in 1870 and finished in 1873. At a later date the watercolor was sent to Paris for reproduction in photogravure, in the process of which it was damaged. Believing that it had been destroyed, Burne-Jones executed the painting in oils in 1894, though the watercolor was later restored. A note in his hand, attached to the back of the picture, describes how he came to paint it: "This oil painting of 'Love among the Ruins' is the same

design as one of the same name which I painted in watercolours twenty-one years ago, but which was destroyed in August of last year. The present picture I began at once, and have made it as like as possible to the other, and have finished it this day, April twenty-third, eighteen ninety-four." The damaged watercolor, similar to and of the same dimensions as this picture, is probably the one sold in London in 1958 (Mrs. Pollen sale, Sotheby's, 21 May, lot 118). The model for the youth has been identified by Madge Garland (*Country Life*, 8 March 1984, 604–605) as Gaetano Meo, a favorite

model for artists of the late Victorian period, who appears in works by Leighton, Dicksee, Alma-Tadema, and Madox Brown. Fitzgerald (1975, 141) notes the influence in this picture of the famous neo-Platonist story, the *Hypnerotomachia Poliphili*, when the lovers are seated among the fallen pillars and stones.

Burne-Jones' composition, which combines classical references—the result of the attraction that he felt for the art of the Renaissance after visiting Italy—with a spirit of medievalism permeated by the chivalry of the Arthurian legends, conveys an intensity

of atmosphere that is both poetic and oppressive. The closest analogy is with the famous *Briar Rose* series (Faringdon Collection, Buscot) begun in 1870 and exhibited in London to great public acclaim in 1890. The briar rose, which has a stranglehold on these compositions, is beginning to twine its way through *Love among the Ruins*. Later, Burne-Jones was to ask Lady Leighton to find for him a specimen that he might copy, "hoary . . . thick as a wrist and with long horrible spikes on it"

The picture was acquired by the 2nd Lord Bearsted, who bought the Upton estate in 1927 and between the wars formed a collection of pictures. His purchases are evidence of what it was possible, with high standards and a catholic taste, to acquire during that period. The emphasis is on old masters—the names of Fouquet, Lotto, Giovanni di Paolo, El Greco, Saenredam and Pieter Brueghel the Elder indicate their quality. In this company *Love among the Ruins* was something of an anomaly, and with the agreement of the family Burne-Jones' picture was placed on loan with the Pre-Raphaelite collection at Wightwick Manor. ST J.G.

Provenance: Mrs. Benson by 1900; G. McCullough sale, Christie's, London, 23 May 1913, lot 118; bought Charles Davis; later acquired by the 2nd Lord Bearsted, by whom presented to the National Trust with Upton and its contents in 1948; subsequently moved to Wightwick Manor
Exhibitions: Sheffield 1971 (74)

552

MARGUERITE A L'EGLISE 1860
James Tissot 1836–1902
oil on canvas
66.2 × 90.5 (26 × 35⅝)
signed, *J.J. Tissot 1860*

Sheldon Manor
Major Martin Gibbs

In 1870–1871, at the outset of his career, Tissot painted seven pictures of themes from Goethe's *Faust*, in which Marguerite's love affair with Faust

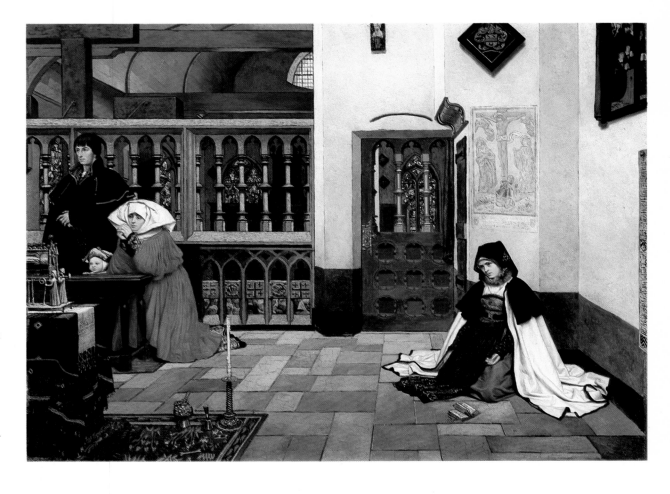

leads to such disastrous results. Three of these show Marguerite in church—the Sheldon picture, that at Dublin, and a third of vertical format now untraced (Wentworth 1984, pls. 7 and 8). Marguerite's spiritual predicament is beautifully expressed here; her abject posture contrasted so poignantly with the intent piety of the couple with their child on the left, the husband a conscious reminiscence of Rogier van der Weyden. Tissot's medievalism was more than a veneer—he had considered an architectural career and the setting, with its mural of the Crucifixion and armorial hatchment, the screen and stained glass, is observed with an archaeological precision.

Tissot's scenes from contemporary life were to enjoy a considerable vogue during his long residence in London and their success inevitably quickened interest in the painter's earlier work. When shown at the Grosvenor Gallery

in 1877 one of the pictures of Marguerite, probably this one, was renamed *Meditation*. Goupil finally sold it two years later to a purchaser who may have had rather different tastes than most of Tissot's patrons. Henry Martin Gibbs (1850–1928) was the fourth son of William Gibbs, members of whose family were among the leading patrons of the Gothic Revival. The great Gothic mansion of Tyntesfield, near Bristol, was built for his father in 1863–1866 and his mother had been brought up in a partly medieval house, Flaxley Abbey, in Gloucestershire. Gibbs himself was to buy a substantial Jacobean house, Barrow Court in Somerset (see no. 538). His family had wide mercantile interests, of which the best-known was guano, and its wealth was matched by the religious conviction of so many of its members. William Gibbs had paid for the erection of William Butterfield's chapel at Keble College, Oxford, and

his sons Anthony, who inherited Tyntesfield, and Henry Martin, gave the hall and library. Their cousin, Henry Hucks Gibbs, 1st Lord Aldenham, commissioned Sir Gilbert Scott to restore and redecorate the church and build a vicarage, school, and bridge at Clifton Hampden, Oxfordshire. F.R.

Provenance: Acquired from the artist in 1860 by Goupil, from whom purchased for 300 gns by Henry Martin Gibbs in 1879; by descent at Barrow Court until 1947 and since 1960 at Sheldon
Literature: Wentworth 1984, 22, 29, 32–34, 135–136
Exhibitions: Paris, Goupil 1861; possibly London, Grosvenor 1877 (21); London, Sotheby's 1983–1984; London, Barbican 1984–1985 (1)

553

EASTWARD HO! 1857
Henry Nelson O'Neil 1817–1880
oil on canvas
135.9 × 107.9 (53½ × 42½)

Elton Hall
William Proby, Esq.

The Indian Mutiny erupted in May 1857
and in August massive reinforcements
were raised and dispatched to the sub-
continent; here, a sergeant and other
soldiers are saying goodbye to their
wives, mothers and children who are
going down the side of a troopship,
while seamen stand by. O'Neil was one
of the more successful narrative painters
of his generation and *Eastward Ho!* was
one of his most popular works. When
the picture was shown at the Royal
Academy in the following year it was
acclaimed by both critics and public;
and but for Frith's *Derby Day* would
have been the star of the exhibition. The
success of the composition encouraged
O'Neil to paint a pendant in 1869, *Home
Again—1858*, but this did not capture
the public imagination in the same way.

Edward Aldam Leatham (1828–1800)
of Misarden Park, Gloucestershire, who
probably acquired the picture at the
1858 exhibition, inherited part of a
major Yorkshire banking fortune, and
was MP for Huddersfield from 1859 until
1886. He bought contemporary pictures,
including examples of Herring and
Couturier, and formed a distinguished
collection of the Dutch seventeenth-
century school, including works by
Berchem, Lingelbach, and Maes. For the
collection of the 5th Earl of Carysfort,
who acquired the picture in 1901, see
no. 555. F.R.

554

DAEDALUS AND ICARUS 1869
Frederic Lord Leighton 1830–1896
oil on canvas
138.2 × 106.5 (54¾ × 41⅞)

Buscot Park
The Trustees of the Faringdon Collection

Related Works: A reduced replica was in the possession of Mr. A. Glass. Another of 1861, with a companion of *Home Again*, is in the Edmund J. and Suzanne McCormick collection (Casteras 1984, no. 26). A signed canvas with a variant of the central woman with her raised arm, and in which the attitude of the baby, the girl to the left, and the woman below have been altered—with a pendant group of the same family reunited, adapted from *Home Again*—is in the Forbes Magazine collection (Forbes 1974, no. 50); a replica of this is in an English private collection
Provenance: Edward Aldam Leatham, by 1862; his son Arthur Leatham; Christie's, 18 May 1901, lot 134, bought for 200 guineas by William Proby, 5th Earl of Carysfort; and by descent
Literature: Borenius and Hodgson 1924, no. 123
Exhibitions: Paris 1857; London, RA 1858 (384); London, SKM 1862 (607); London, Guildhall, 1895 (16)
Engravings: W. T. Davey

Lord Leighton's painting of the legend of Daedalus and Icarus is an example of the interest that artists of the late Victorian period devoted to classical themes. Particularly after the Pre-Raphaelite Brotherhood's celebration of the Early Renaissance they became interested in the art of the High Renaissance and the original Greek sources: what the *Art Journal* (1871, 176–177) described as "a timely protest against vulgar naturalism, the common realism which is applauded by the uneducated multitudes who throng our London exhibitions." The writer, however, was the product of an age so permeated in its view by sentimental and anecdotal qualities that a reverence for classical art was not equalled by a corresponding degree of understanding. Watts may have unconsciously acknowledged this when, exhibiting his *Wife of Pygmalion* (now also at Buscot) at the Royal Academy in 1868, he added the subtitle "A Translation from the Greek." A cast of this head and torso, found among the Arundel marbles, always stood in his studio.

Leighton's picture, *sui generis,* achieving neither the purity of Greek art, the monumentality of the High Renaissance, nor the elegance of neoclassicism, was received at the Academy with public acclaim when it was first exhibited there in 1869, the year in which the artist was elected a full academician. To the spectator today it can perhaps be of little surprise that the ineffectual-looking youth in the painting—a figure loosely derived from the *Apollo Belvedere*—will at some stage be struck by disaster. However, what Leighton has admirably captured in the picture is the strength of the Mediterranean sunshine—whose light and heat will melt the wax on the wings of Icarus when, contrary to his father's instructions, he ventures too close to the sun. In the 1878 exhibition catalogue it is pointed out that the background is based on one of Leighton's Rhodian landscapes of 1867. A sketch for the picture is at Leighton House, London.

The first recorded owner of the picture, Alexander Henderson, created Lord Faringdon in 1916, was a railway magnate, financier, and one of the great business entrepreneurs of his age. His picture collection included European old masters, though these were surpassed in number by the Pre-Raphaelite and Victorian paintings. The majority of the nineteenth-century paintings were dispersed at the sale following his death in 1934. But a number of the old masters were bought at the sale by his grandson, the 2nd Lord Faringdon, together with certain Pre-Raphaelite works, including the celebrated series of the *Briar Rose* by Burne-Jones. The result today is that the balance of the collection at Buscot has changed, with European and eighteenth-century English paintings now in a preponderance (Gore 1966). st.j.g.

Provenance: Bought at an unrecorded date by the 1st Lord Faringdon, but at Buscot by 1907. It was included in Lord Faringdon's sale, Sotheby's, 13 June 1934, no. 117, when it was acquired by the 2nd Lord Faringdon
Literature: Ormond 1975, 88–89, 95, 96, 119, 160, no. 186, pl. 112
Exhibitions: London, RA 1869 (469); Manchester 1978 (50)

555

A DEDICATION TO BACCHUS 1889
Sir Lawrence Alma-Tadema 1836–1912
oil on panel
53.3 × 125.7 (21 × 49½)
signed, *L Alma Tadema op. CCXCIV*

Elton Hall
William Proby, Esq.

The scene is set in the court of a temple, with a view of the coast of the Gulf of Salerno with Capri on the left. The offering of a wine skin is escorted by a procession which is received by a priestess. The nearer of the dancing girls in the center is Alma-Tadema's wife, Laura Theresa.

As the artist recalled in a letter of 1903 to Lord Carysfort, this is the second version of the composition:

"The first picture of the same subject was finished on May 2nd, 1889 . . . and belongs to Baron Schroeder [now in the Museum at Hamburg]. Your picture was finished July 24th, the same year. The grouping of the figures is more or less the same in both pictures, but the figures are in many cases painted from other models. The background is quite different. The dancing girls have garlands of roses in yours, which I believe to be quite an original work of art, in which I profited by the experience gained in painting the big one" (Borenius and Hodgson 1924, 109). A letter to Carysfort from the connoisseur and writer Sir Walter Armstrong records: "Alma Tadema told me it was the best marble he ever did and the best atmosphere."

The picture was originally sold by the artist to the dealer Ernest Gambart, who did much to promote his reputation. It was kept by Gambart at Les Palmiers, Nice, where it hung in the Saloon (see Maas 1975, pl. opp. 192), and at 5,600 guineas was the most expensive picture in his sale of 1903. It was purchased for William Proby, 5th Earl of Carysfort (1836–1909), to whom the artist wrote,

saying how grateful he was that the picture had found a place in his collection and supplying the information about the picture recorded above. Carysfort, who succeeded his elder brother in 1881, traced his interest in pictures to his acquisition when at Eton of an engraving after Frith's *English Merry-making in the Olden Time*, the original of which he was to acquire at Christie's in 1892 for 430 guineas. His enthusiasm for collecting was shared by his wife, who was herself painted by Millais in 1878. Early acquisitions included a Sassoferrato and a small Claude and were followed in 1888 by Cesaro da Sesto's *Vièrge au Bas Relief* (2,400 guineas). Purchases were made every year until Carysfort's death—a Hobbema and the Luini *Boy with a Puzzle* in 1889, pictures by Berchem and Landseer in 1890, and so on. Major acquisitions included the great Frans Hals *Boy with a Skull* (National Gallery, London) in 1895; Millais' *Minuet* at 4,500 guineas in 1899; the *Madonna della Misericordia* by Genga (bought as a Ridolfo Ghirlandaio) in 1906 (£3,000); the Turner *Wreck of the Minotaur* and Constable's *Dedham Vale* of 1811 in

1907 (£3,000 and 4,900 guineas), and Sir Joshua's *Snake in the Grass* in 1909 (4,900 guineas). The Alma-Tadema was the most expensive of all Lord Carysfort's pictures, which cost a total of £76,816 13s. The earl also spent considerable sums on furniture. His estates in England and Ireland amounted in 1883 to 25,914 acres, yielding an annual income of £31,070, a substantial proportion of which was due to the development of Stillorgan, the estate inherited from the Allen family, which was gradually encroached upon by the growing city of Dublin. It is this that explains Lord Carysfort's ability to buy on so expansive a scale at a time when most of the outstanding collectors in Britain belonged to "new" families, brewers like Burton or Guinness, financiers like Cassel (see no. 66), bankers including Robert Benson, and several members of the Rothschild family.

As his grand-nephew Granville Proby argued in the preface to Borenius' catalogue, one of Carysfort's ambitions was to try to re-create the collection of his grandfather, the 1st Earl, which was sold at Christie's in 1828. The 1st Earl

was a friend and patron of Reynolds, whose fine series of family portraits had fortunately been excluded from the sale. The 5th Earl kept the collection at Glenart, his seat in Ireland. This was burnt in 1921, but fortunately the contents had already been taken to Elton, which had been acquired by the family in 1596. F.R.

Provenance: Ernest Gambart, Les Palmiers, Nice; his sale, Christie's, 2 May 1903, lot 122, where bought for 5,600 gns by Agnew for the 5th Earl of Carysfort; and by descent, through the latter's nephew
Literature: Borenius and Hodgson 1924, no. 133
Exhibitions: Chicago 1893 (57); Paris 1898
Engravings: Blanchard

556

ALBERTA, LADY WINDSOR 1893
Sir Edward Coley Burne-Jones, Bart.
1833–1898
oil on canvas
199.5 × 95.5 (78$\frac{1}{2}$ × 37$\frac{1}{2}$)
signed, EBJ 1893

Private Collection

Alberta, Lady Windsor (1863–1944), was the daughter of the diplomat Sir Augustus Paget and his wife Walburga, a close friend of the Princess Royal. She married Robert, Lord Windsor, later 1st Earl of Plymouth (1857–1923), in 1883. Famous for her pensive beauty—she was described by Cust as "delightful and very beautiful, very slow and sad" and by Lady Oxford as "an Italian primitive"—she and her husband belonged to a close-knit group of friends known as the "Souls."

This wonderfully reticent portrait is exceptional in Burne-Jones' oeuvre. It was his only attempt at society portraiture on the grand scale and indeed his only full-length. The exceptional nature of the commission may explain why the picture bears an apparent relation to a number of works of the end of the previous decade by Fernand Khnopff, the Belgian symbolist whose *Memories* of 1889 (Musée des Beaux Arts, Brussels)

was exhibited in London in 1890 (see Legrand 1967, 283). The comments of the reviewers were mixed, but Lady Paget's comments on the portrait, quoted in full by Abdy and Gere, are more appreciative: "Gay is more beautiful, but the entire impression recalls her infinitely well to her friends. The throat and hands are marvellously like, as is the girlish appearance; but her eyelids are larger and her brows have a freer sweep, and the mouth and nose are more refined in their lines, and the contours of her cheeks are fuller and her complexion much brighter, and also the master has completely ignored the rich copper shades in her hair." Lady Paget also noticed that Burne-Jones "entirely abominates" the large sleeves that were then in vogue: the artist was indeed impervious to such things and Lady Windsor's dress had nothing to do with the world of the *haute couturier*: it is rather an abstraction, as divorced from mere fashion as the costume of any of the painter's heroines.

In 1884 the Windsors began the monumental undertaking of rebuilding Hewell Grange in Worcestershire, replacing Cundy's neoclassical remodeling of an earlier house with a Renaissance mansion in the style of Montacute, designed by Thomas Gardner. Many of the interiors reflected the Windsors' taste for the Italian Renaissance and Windsor was himself a collector on a considerable scale, acquiring much Italian furniture, and a number of trecento and quattrocento pictures of the type that particularly influenced the Pre-Raphaelites. His taste is also represented here by Canaletto's *Allegorical Tomb of Lord Somers* (no. 171), which hung at the bottom of the stairs at Hewell. Burne-Jones' portrait was placed on the staircase itself. F.R.

Provenance: Painted for the husband of the sitter; and by descent, removed from Hewell in 1946, when the house was sold to the Home Office
Literature: John Christian in Arts Council 1975–1976, with previous literature; Abdy and Gere 1984, 121–123
Exhibitions: London, New Gallery 1895 (119); London, New Gallery 1898–1899 (81); Bucharest and Budapest 1972–1973 (43); Arts Council 1975–1976 (243)

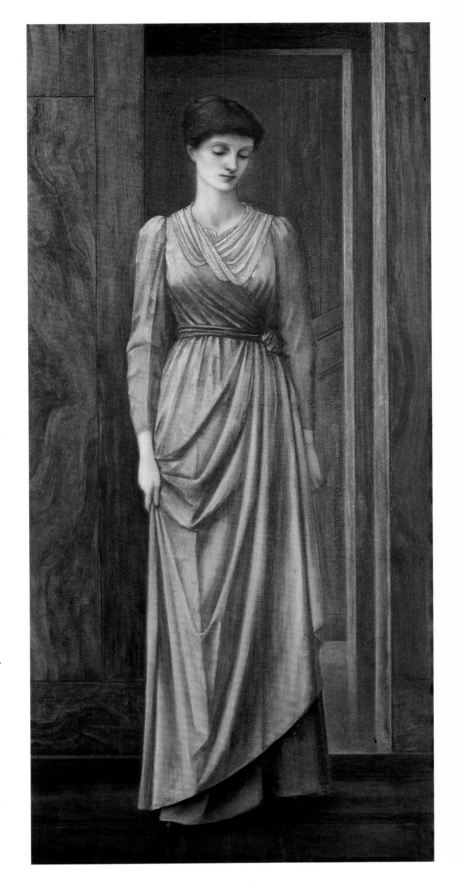

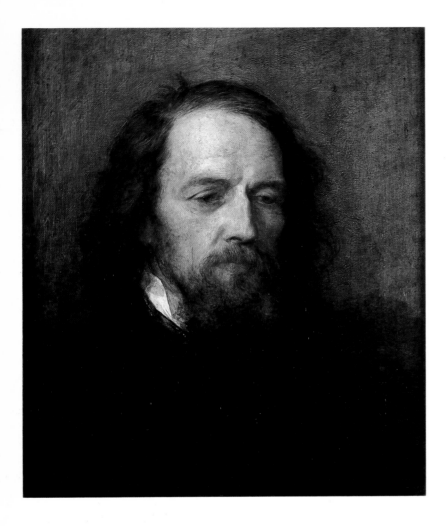

557

ALFRED, LORD TENNYSON 1858/1859
George Frederick Watts 1817–1904
oil on canvas
56.5 × 46.3 (22¼ × 18¼)
signed, *GFW*; dated *1859*

Eastnor Castle
The Hon. Mrs. Hervey-Bathurst

Alfred Tennyson (1809–1892), whose poems included *The Princess* (1847), *In Memoriam* (1850), and *Idylls of the King* (1859), was one of the great figures of the Victorian era: he was appointed poet laureate on Wordsworth's death in 1850 and was made a peer in 1884, the first occasion a poet had been honored in this way.

Watts' first portrait of Tennyson, now at Melbourne, was painted in 1857: this picture, popularly known as the "great moonlight portrait" (see Watts 1912, 1: 169) dates from 1858–1859; sittings in the summer of 1858 and March 1859 are recorded (Ormond 1973, 1: 447). During one of these Tennyson asked Watts what was in his mind when he set to work upon a portrait: the reply was to be echoed in the poem *Lancelot and Elaine*.

Watts painted four later portraits of Tennyson and executed a statue in bronze for Lincoln in 1898–1905. This picture was painted for Charles, 3rd Earl Somers (1819–1883), a close friend of the sitter. Somers' wife, Virginia, daughter of James Pattle, was the sister of the photographer Julia Margaret Cameron. The painter was an early friend of the Pattle sisters and, as Lord Eastnor, Somers is said to have seen one of Watts' portraits of his future wife and to have fallen in love with her

as a result (Watts 1912, 1: 122). Watts first visited Eastnor in 1850, and his association with the family is documented by a number of portraits still in the house: those of the future Lady Somers (1849) and of her grandmother, Madame d'Estang, her husband, their daughter Lady Henry Somerset (1871), and Mrs. Herbert Somers Cocks (1875), whose son Arthur, later 6th Baron Somers, was a godson of Tennyson. The collection also includes the double portrait of Ellen Terry and her sister of 1863–1864 and the *Time and Oblivion* of 1848.

The 3rd Earl commissioned a series of murals of the Elements for his London house, No. 7 Carlton House Terrace, in the mid-1850s: five of these were detached in 1966 and installed in the Staircase Hall at Eastnor in 1976. The Carlton House Terrace frescoes reflect Watts' study of the Venetian cinquecento. The Somerses also had a deep sympathy, shared with their close friend Robert Holford of Westonbirt, for the Italian Renaissance. The 3rd Earl supplemented the picture collection inherited from the Lord Chancellor (see no. 314) by acquiring a considerable number of early Italian pictures. These were divided between Eastnor, the castle built by Smirke for his grandfather, the London house, and Reigate Priory in Surrey, which the 1st Earl's father had acquired. A late trecento Florentine *Madonna* by a painter close to Pietro Nelli, altarpieces by Biagio di Antonio and Michele di Ridolfo Ghirlandaio, a portrait of the poet Girolamo Benivieni by Foschi, and Venetian pictures from the 3rd Earl's collection remain at Eastnor. The house is also rich in Italian furniture of the sixteenth and seventeenth centuries. F.R.

Provenance: Painted for the 3rd Earl Somers; his daughter Lady Henry Somerset; by inheritance to her cousin, Arthur, 6th Baron Somers; and by descent
Literature: Ormond 1973, 447–448
Exhibitions: London, New Gallery 1806–1807; London, Colnaghi 1860; London, Grosvenor 1882 (95); London, RA 1905 (189); Dublin 1907; London 1908; Rome 1911; Amsterdam 1936; Arts Council 1954–1955 (25); Tokyo 1972

558

LADY FREDERICK CAVENDISH
1870/1871
Sir William Blake Richmond 1842–1921
oil on panel
66 × 53.3 (26 × 21)

Holker Hall
Hugh Cavendish, Esq.

The Hon. Lucy Caroline Lyttelton (d. 1925) was the daughter of George William, 4th Lord Lyttelton and a favorite niece of W.E. Gladstone. A Maid of Honour to Queen Victoria, she married in 1864 Lord Frederick Cavendish (1836–1882), second son of the 7th Duke of Devonshire. Lord Frederick was MP for the West Riding of Yorkshire from 1865, private secretary to Gladstone in 1872–1873, and Financial Secretary to the Treasury in 1880–1882. He was appointed Chief Secretary for Ireland in 1882, but on 6 May, on the day he took the oath, he was murdered in Phoenix Park, Dublin. The brutality of the outrage contributed to a hardening of feeling in England toward the Irish question, and the defection from the Liberal party in 1888 of the Liberal Unionists, led by Cavendish's elder brother Lord Hartington, would mark the effective demise of the Whig political tradition.

Lady Frederick's diary (Bailey 1927) casts a fascinating light on the world in which she moved. A committed Liberal with a keen sympathy for deserving causes, she records both the political life of London and that of the great houses, her parents' Hagley, Gladstone's Hawarden, and the various Cavendish houses—Chatsworth where in 1864 she planned a catalogue of the pictures, Hardwick, Bolton, Lismore in Ireland, and, not least, Holker, which her husband would have inherited had he outlived his father. Her comments are sometimes trenchant; thus of Highclere in 1878 she wrote: "the castle disappoints me, having gone through the usual fate of castles, gingerbreading and gimcracking; with a late outbreak of Morris" (Bailey 1927, 2: 225). She regularly visited exhibitions and museums but did not always care for what she saw. She disliked Leighton's pictures and noted at the 1871 Academy exhibition: "young Richmond has

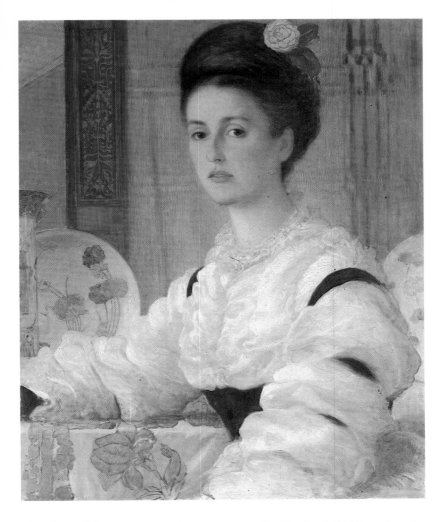

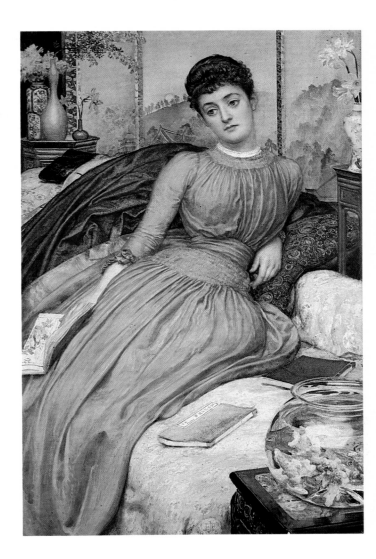

painted one of the same type: ancients playing at bowls with nothing on, which I can't appreciate" (Bailey 1927, 2:97). Rossetti also aroused her suspicions: at the home of her Derbyshire neighbors, the Cravens, in 1875 she saw "some Rossettis, very clever and with wonderful colour, but rather hateful, I think, from self-consciousness, and a sort of sensuousness; and I can't see why all his unfortunate damsels should be in such haggard and wasted ill-health" (Bailey 1927, 2: 193). She had no time for exaggeration, and on meeting Burne-Jones, of whose charm there are so many contemporary accounts, commented that he was "interesting, but desperately self-conscious" (Bailey 1927, 2: 242). The prevalence of such views in the aristocratic circles in which Lady Frederick moved explains why so few major pictures by Burne-Jones, Rossetti, and their contemporaries were acquired by the

great families that had hitherto been in the vanguard of artistic patronage.

Lady Frederick had admired an episcopal portrait by Richmond at the Royal Academy in 1865 and certainly visited the artist, presumably for a sitting, on 21 July 1870 (Bailey 1927, 2: 87). The companion portrait of Lord Frederick was exhibited at the Royal Academy in 1874, no. 721, and is also at Holker. F.R.

Provenance: By descent through the sitter's brother-in-law Lord Edward Cavendish, father of Victor Cavendish, who succeeded as 9th Duke of Devonshire in 1908 when Holker was made over to his younger brother Lord Richard; and by descent, recorded in its present position in the Library at Holker in 1906
Literature: Liverpool 1906, no. 11
Exhibitions: London, RA 1871a (530)

559

MARY CONSTANCE WYNDHAM, LADY ELCHO (later COUNTESS OF WEMYSS)
1885
Sir Edward Poynter 1836–1919
gouache
52 × 34.3 (20½ × 13⅓)

Stanway House
The Earl of Wemyss and March, KT, and Lord Neidpath

The eldest daughter of the Hon. Percy Wyndham of Clouds, Wiltshire, Conservative MP for West Cumberland (1860–1885), Mary Constance Wyndham married in 1883 Hugo Charteris, Lord Elcho, heir to the 10th Earl of Wemyss and March, and lived at Stanway House, Gloucestershire,

until her death in 1937. Her charm, humor, humanity, and vagueness are still warmly remembered there. She enjoyed a lifelong friendship with Arthur James Balfour (1848–1930), the Conservative statesman, and was a leading hostess of the "Souls," the Edwardian social and political coterie. Through her mother, Madeleine, whose close friends included the architect Philip Webb and the Burne-Joneses, she became acquainted with Edward Poynter (brother-in-law of Sir Edward Burne-Jones). He drew her three times. The first two, in red crayon on paper, are dated 11 July 1881 and 23 June 1885. The sittings for this, the gouache, took place in late 1885. The drawing was exhibited at the Grosvenor Gallery in May 1886. Lady Elcho's diary records: "Saturday 1st May 1886: Webber [Philip Webb] came. . . . We went on to Grosvenor Gallery Private View. Very hot and crowded Mr. B. J.'s blue Virgin beautiful—liked Phils [Philip Burne-Jones] 'Unfinished Masterpiece' very much. Mr. Poynters yellow sketch of me we liked."

The picture perfectly exemplifies W.S. Gilbert's satirical reference to the aesthetes of the time as "greenery-yallery, Grosvenor-Gallery." Lady Elcho, celebrated for her eighteen-inch waist, is seen reclining in a room with Chinese blue-and-white and lusterware "art pottery," a Japanese screen, bamboo furniture, and books including a volume of Japanese watercolors. The goldfish bowl in the foreground may symbolize "caged beauty" as well as merely continuing the *japonaiserie* theme. The gilt frame is original and of a type favored by both Poynter and Burne-Jones.

The son of the architect and painter, Ambrose Poynter, Edward Poynter had studied in Paris under Gleyre between 1856 and 1859, and exhibited at the Royal Academy from 1861, becoming president in 1896. He also served as director of the National Gallery in London from 1894 to 1905, the only time these two important positions have ever been held by the same man. He received a baronetcy in 1902, when Arthur Balfour became Prime Minister.

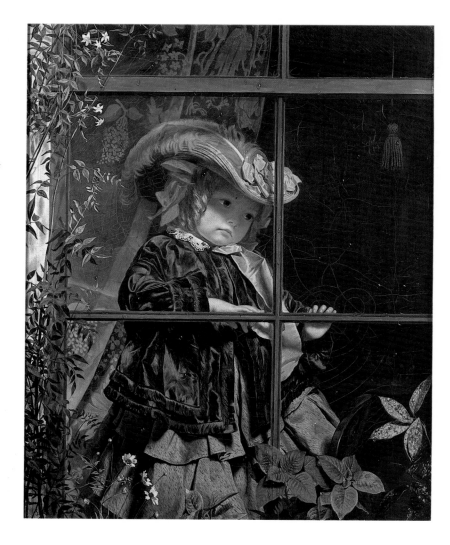

Lady Elcho was subsequently depicted with her sisters Madeleine (Mrs. Charles Adeane) and Pamela (Mrs. Edward Tennant, later Lady Glenconner) in Sargent's celebrated portrait of *The Wyndham Sisters* (Metropolitan Museum, New York). J.N.

Exhibitions: London, Grosvenor Gallery 1886; London, Bury Street Gallery 1982

560

NO WALK TODAY 1856
Sophie Anderson 1823–1898
oil on canvas
49.5 × 39.3 (19½ × 15½)

The Dower House, Boughton
Sir David Montagu Douglas Scott, KCMG

This picture of a little girl looking wistfully through a sash window is the work by which Mrs. Anderson is most widely known, and is one of the most appealing of all mid-Victorian "narrative paintings." The recent revival of the market for Victorian pictures has encouraged some commentators to suppose that these had previously fallen from critical favor more completely than was the case. Provincial museums continued to exhibit their holdings, however, and to give a single example, Burne-Jones' great *Love and the Pilgrim* was purchased by the National Art-Collections Fund in 1942 and presented to the Tate Gallery.

Sir David Scott—whose father, Lord Charles Scott, was painted as a boy by Sir Francis Grant in 1843–1844 in a pose adapted from the Reynolds of his great-aunt Lady Caroline Scott (no. 469)—began to collect Victorian pictures in the early 1920s. This canvas was purchased at that time after it had been bought in at 15 guineas in a London saleroom.

One of the pleasures of being shown the collection by its owner is the way he himself responds to their mood, and his own account of this picture is characteristic: "Look at the raindrops on the window and the flowers, jasmine and fuchsia, the fuchsia not yet in bloom, which tells us that the time of year is about July, to say nothing of the lovely clothes the little girl is wearing. How disappointed she looks as she stands there on a chair gazing out at the approaching storm—no mere passing April shower." For Sir David looks at narrative pictures in the way they were intended to be seen, as painted counterparts to the novels of the period, and with the same range of emotional expression and descriptive power. Sir David is perhaps best known as a gardener, but as a collector he takes his place in a long and distinguished sequence of diplomat connoisseurs. F.R.

Provenance: Purchased by the present owner in the early 1920s at Wallis Brothers, Pall Mall
Literature: Reynolds 1953, 84, fig. 62; and 1966, 96, 116, pl. 73
Exhibitions: London, Agnew 1961 (15); Arts Council 1962 (2); Sheffield 1968 (77)

561

SECRETAIRE CABINET
designed by George Washington Jack
1855–1932
made by Morris and Co.
mahogany with marquetry of sycamore
and various other woods
134 × 141 × 66 (52¾ × 55½ × 26)

Ickworth
The Hon. David H. Erskine

A cabinet of this design existed by 1889 when it was first illustrated (*Cabinet Maker* 1889, 115), and it is likely to have been designed and made only shortly before, for it was an advanced example of a type of Arts and Crafts furniture that only became popular in the 1890s. It is one of a number of pieces Jack designed for Morris and Company just before and after William Morris died in 1896. This design continued to be favorably reviewed; the architect Reginald Blomfield wrote of it as "a very beautiful instance of modern marquetry and indeed one of the finest pieces of furniture executed in England since the last century" (Blomfield 1896, 491). Blomfield here means that the

inspiration for this piece and especially the marquetry was the furniture of the later eighteenth century. Morris and Company at this time were manufacturing both Arts and Crafts pieces and pieces in the fashionable Neo-Georgian style and in the case of this Jack cabinet the two styles are happily combined.

This cabinet was purchased for Ickworth by Theodora, wife of the 4th Marquess of Bristol, passing to her daughter, Lady Marjorie Erskine, on her death in 1957. It was purchased directly from Morris and Company in 1906 for 98 guineas and with its Georgian characteristics would have been wholly appropriate for the celebrated neoclassical house with its

central rotunda, built for the Earl-Bishop in the 1790s (see no. 196). An identical cabinet exists in the Victoria and Albert Museum and a cabinet of this type is illustrated in the Morris and Company catalogue, published in about 1912. It is thus impossible to tell which of the two existing cabinets—indeed others may well survive—might have been illustrated in 1889. All that can certainly be said is that the Erskine cabinet was made before 1906. C.W.

Literature: Blomfield 1896, 491, ill. 488; *The Cabinet Maker* 1889, 114–115; Morris 1912, 46 (no. 353)
Exhibitions: Paris 1914; London, V & A 1934 (216)

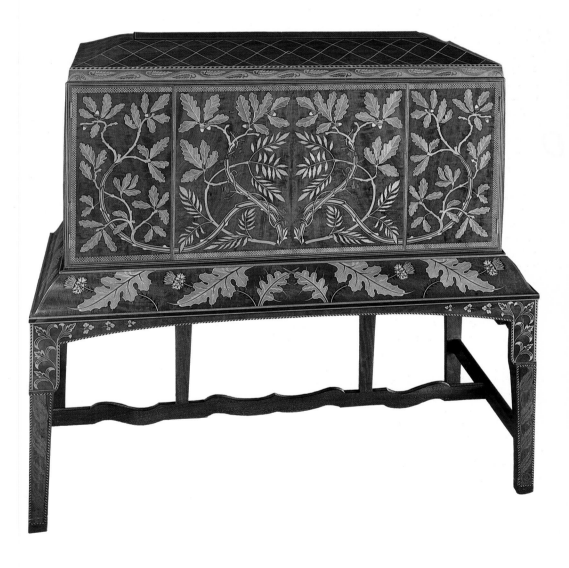

562

THE SLUGGARD c.1890/1900
Frederic, Lord Leighton 1830–1896
bronze
52.4 (20⅝) high
inscribed: top of base *Fred. Leighton*
front of base THE SLUGGARD
back of base J.W.SINGER & SONS,
FROME, SOMERSET/PUBLISHED BY
ARTHUR LESLIE COLLIE/39ᴮ OLD BOND
STREET LONDON/MAY 1ˢᵀ 1890.

Lotherton Hall
Leeds City Art Galleries

The bronze is one of an apparently
unlimited edition cast from the original
plaster sketch-model for Leighton's life-
sized bronze statue of *The Sluggard* now

at Leighton House. Staley describes the
origin of the model: "The subject had a
comical origin. Giuseppe Valona, the
model, a man of fine proportions, weary
one day of posing in the studio, threw
himself back, stretched out his arms
and gave a great yawn. Leighton saw
the whole performance and fixed it
roughly in the clay straight off." This
occurred in 1882. The clay was cast in
plaster, and the plaster then served as
the model from which Leighton worked
up the life-sized version completed
in 1885 and exhibited at the Royal
Academy in the following year. The
original title was *An Athlete Awaking
from Sleep*, and the statue was intended
as a pendant to Leighton's only other
life-sized sculpture *An Athlete Struggling*

with a Python, finished and exhibited in
1877, also now at Leighton House.

The original small plaster model
seems no longer to survive, but it is
recorded in a photograph of Leighton in
his studio taken by Ralph Robinson in
1891. In 1890 it served as the model for
the edition of bronze statuettes pub-
lished by Arthur Leslie Collie, of which
the present bronze is an example. The
bronzes were cast at Frome in the
foundry of John Webb Singer, then under
the management of his son Herbert. In
1890 Collie, an interior decorator,
embarked on an enterprise of publish-
ing bronze statuettes in response to a
demand by leading sculptors of the
time. Between then and the collapse of
this venture in 1901 due to a lack of
sufficient public interest, he published
many editions of small bronzes after
models by leading sculptors of the day,
such as Edward Onslow Ford and Hamo
Thornycroft. For these he seems in-
variably to have used the Singer foundry.
The *Sluggard* was apparently, to judge
by the number of casts which survive,
one of the most popular statuettes.
Slight differences in facture between
casts of it and differences in the form of
the inscription (in some examples the
name of the founder is omitted, and in
others only the signature and the title
appear) suggest that it was continually
cast over the entire period of Collie's
publishing venture (1890–1901) and
possibly even afterward. Produced by
the relatively inexpensive sand-casting
method (the Singer foundry also used
the more costly lost-wax method in
other cases), it was also one of the
cheapest, selling for 15 guineas. The
date May 1st 1890 inscribed on the
bronze appears on all fully inscribed
examples. It refers to the date of first
publication, and not, as has sometimes
been supposed to the actual date of
casting.

Collie's editions of bronze statuettes
were designed to fit into modern interior
decorative schemes and were aimed at
the middle classes. Although cheap in
comparison with individual works
produced at that time for the wealthy,
it seems that they were priced a little
too high for this market, and could not
stand up to the foreign, mainly French,
competition: hence the failure of Collie's
business. A.F.R.

Literature: Staley, 1906, 130, 131;
Ormond 1975, 94, 167, no. 301,
fig. 142; Beattie, 1983, 186–191, 199,
260, 59, 61

563

PAIR OF PEDESTALS C.1910
attributed to Marsh, Jones and Cribb
walnut
106 (42) high

Lotherton Hall
Leeds City Art Galleries

In 1864 John Marsh and Edward Jones acquired the furniture-making firm of Thomas Kendell, established in Leeds since the 1790s, and quickly became the leading suppliers to Yorkshire country houses, as well as opening a London branch in Cavendish Square. Their famous set of Gothic furniture made in 1866 for the son of the mill owner and philanthropist Sir Titus Salt (founder of the model town of Saltaire) is now at Lotherton, and after 1872 when Henry Cribb joined the partnership they worked for leading architects such as W.R. Lethaby and Sir Edwin Lutyens (Boynton 1967, 59–61).

A very similar pair of pedestals was specially commissioned from Marsh, Jones and Cribb by the Leeds industrialist, Sam Wilson, for the display of bronze statuettes by Alfred Gilbert in his house, Rutland Lodge, in February 1913 (Gilbert 1978, no. 368). This pair, slightly taller and with less pronounced entasis, are from the same source (bequeathed to Leeds City Art Galleries in 1925), and though not recorded in Wilson's notebooks, must surely be by the same makers—reflecting the revival of interest in neoclassicism in the Edwardian period. G.J-S.

Literature: Gilbert 1978, 303–304, no. 367

564

ICARUS C.1900
Alfred Gilbert 1854–1934
bronze
49.5 (19½) high

Sandringham
Her Majesty Queen Elizabeth II

Gilbert's original *Icarus* was commissioned in 1882 by Sir Frederick (later Lord) Leighton, President of the Royal Academy. The subject of the bronze was left to Gilbert, who chose *Icarus* because "It flashed across me that I was very ambitious: why not 'Icarus' with his desire for flight?" Now in the National Museum of Wales at Cardiff, the original statue was modeled by Gilbert in Rome and cast by the Neapolitan founder De Angelis. It was exhibited at the Royal Academy in 1884, and became a turning point in the history of English sculpture. It was twice the size of the present bronze and was apparently the only version ever made on such a large scale. Numerous half-size versions such as this one indicate the popularity of the figure. The first such bronze to be recorded was exhibited by Gilbert at the Exposition Universelle in Paris in 1889, where it won the Grand Prix; before he was declared bankrupt in 1901 and went into exile in Bruges, Gilbert executed several others for Robert Dunthorne, which were offered for sale through the Rembrandt Gallery in Vigo Street. The date the bronze was acquired for the Royal Collection is unrecorded, but the purchase was probably made by Albert Edward, Prince of Wales (from 1901 King Edward VII) about 1900. In 1892 the Prince of Wales had chosen Gilbert for a commission that was especially close to the hearts of himself and his wife Princess Alexandra, and which was to result in what is undoubtedly Gilbert's supreme masterpiece. In 1892 there occurred the tragic death, at the age of twenty-eight, of their eldest child and the prospective heir to the throne, Prince Albert Victor, Duke of Clarence. Gilbert had just completed his most famous work, the fountain of *Eros* in Piccadilly Circus, and the prince turned to him for the monument to his dead son, to be erected in the Albert Memorial Chapel at Windsor

Castle. Queen Alexandra was later to prove a loyal friend to Gilbert during his many tribulations, and it was fitting that Gilbert was chosen in his last years to erect her public memorial in London at Marlborough Gate—his last great work, completed in 1932.

The location of the bronze at Sandringham, rather than at any other royal residence, has a special significance in that Sandringham was the personal, family home of King Edward and Queen Alexandra, built by them in 1869–1871, when they were Prince and Princess of Wales. A.F.R.

Literature: Dorment 1978, 177, 178, no. 94, with previous literature; Dorment 1980; Beattie 1983, 143

565

THE CARDIFF CASTLE PLATE
designed by William Burges 1827–1881

Private Collection

This group of objects represents one of the most extraordinary episodes in High Victorian patronage. William Burges and John Patrick Crichton Stuart, 3rd Marquess of Bute, first met in 1865 when Bute was only eighteen years old.

The architect Burges, twenty years his senior, had already established a reputation—with commissions for the alterations at Gayhurst in Buckinghamshire for the 3rd Lord Carrington, the restorations at Waltham Abbey, the building of St. Fin Barre's Cathedral, Cork, and the transformation of the hall and chapel of Worcester College, Oxford, to his credit. His unexecuted designs, such as those for the Crimea Memorial Church in Constantinople,

Brisbane Cathedral, the west front of the Duomo in Florence, and the Bombay School of Art had also attracted widespread attention in the professional press. Burges' reputation was further enhanced by his numerous publications since 1850 on a wide variety of antiquarian and architectural subjects (Crook 1981).

The commission to rebuild Cardiff Castle for Lord Bute was undoubtedly the artistic opportunity of a lifetime,

and by 1866 a report on how the Norman castle could be developed had been prepared. Work began immediately after Lord Bute's coming of age, and the foundation of the first tower was laid on 12 March 1869. The building campaign continued for the rest of Burges' life and indeed was only completed in the early part of this century (Girouard 1979, 273–290). For Burges, Lord Bute was the ideal patron. Believed to be the richest man in Britain, his gross annual income

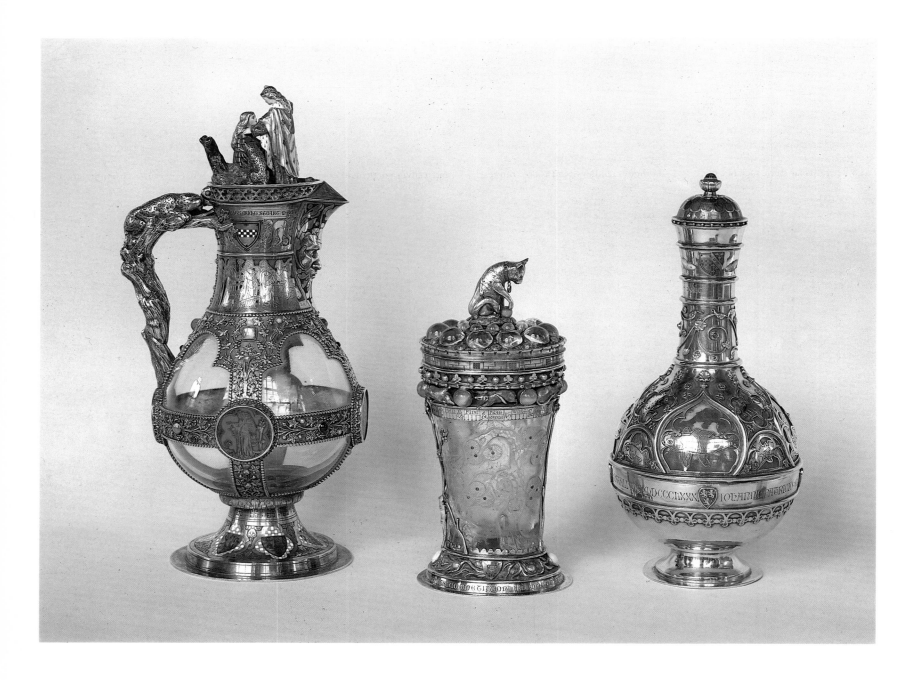

was £300,000, and when he attained his majority he had the resources to realize the most fantastic schemes that he and his architect could concoct. Intellectually there was also much common ground between the two men. Both were inveterate travelers and scholarly writers, and both shared a romantic passion for the Middle Ages. Burges became a frequent guest and was treated with great affection by Bute and Lady Gwendolen Howard, whom he married in 1872 (Crook 1970).

For Cardiff Castle and for Castell Coch, a miniature fortress like an illumination from a medieval manuscript, built only a few miles away, William Burges prepared many hundreds of designs, not only for the buildings themselves, but for the most minute details of the painted interiors, the sculpture in wood and stone, the stained glass, inlaid paneling, and even the washbasins for the principal bedrooms. To go with this fantastic mélange of the carved, the colored, and the gilded, inspired by the art of Islam and medieval Europe, the architect also designed furniture and a selection of extraordinarily exuberant silver. V.G.

Exhibitions: Cardiff and London 1981 (C48, C64, C73, C75, C76)

CLARET JUG 1869
silver-gilt, enamel, turquoise, pearls, amethysts, and glass
31.1 (12¼) high
inscribed, *JHS: PATS: CRICHT: STUART: MARCH: DE: BUTE: ME: F: F: MDCCCLXX.*; maker's mark of Jes Barkentin, London, 1869

Arguably the most spectacular piece from the group made for Cardiff Castle, this claret jug was made the year that the building was begun. It is a glass bottle mounted in silver gilt as a decanter. The round foot is chased and enameled with the arms of the Crichton-Stuart family and the body is held by straps with applied filigree of vine branches, studded with pearls and cabochon gems. On the four round bosses on the body of the vessel and around the neck are engraved and enameled scenes of the legendary career of Dionysus. The spout is a frowning male mask; the handle is a

gnarled tree trunk with a muscular leopard stalking toward the lid. On the cover, inside a gallery pierced with quadrilobes, are cast figures in medieval dress enameled in *ronde bosse*. V.G.

THE CAT CUP 1867
silver, enamel, crystal, pearls, and semi-precious stones
20.6 (8¼) high
inscribed, *WILLIAM: BURGES: IN: REMEMBRANCE: OF: THE: LAW: COURTS: COMPETITION: AD: MDCCCLXVII*; maker's mark of Jes Barkentin, London, 1867

The Cat Cup was made for Burges' personal collection of curiosities, which decorated his London homes, first at No. 15 Buckingham Street off the Strand and later Tower House, built for him in Holland Park to his own designs. The cup appears in photographs of both, taken by Francis Bedford during Burges' lifetime (Handley-Read 1966). Burges was not the first of the neo-Gothic Victorian architects to design objects on a small scale; the Medieval Court at the 1862 International Exhibition included fittings not only by him, but also by Bodley, Butterfield, Seddon, Morris, Webb, Scott, and many others.

Burges had made a particular study of thirteenth- and fourteenth-century metalwork during his extensive tours in Europe. Painstaking sketches and diagrams of objects in church treasuries from Mainz to Perugia to Aachen appear among his papers. This interest was first manifested while he worked as an "improver" in the office of Matthew Digby Wyatt for two years after 1849, helping in the production of the latter's *Metalwork and its Artistic Design* published in 1852. Burges contributed an article on damascening to this volume and over forty drawings of historical examples: English ironwork, twelfth-century vessels in the Louvre, gold and silver in the Cluny Museum, and objects in treasuries as far apart as Cologne and Pistoia. Burges maintained this passion for medieval *orfevrerie* throughout his life, and two years before his death he was triumphant over his success at sneaking in to see the great 1338 enameled silver-gilt reliquary of the *Sacro Corporale* in Orvieto Cathedral, an adventure he

briefly described in an article in the *Archaeological Journal* in 1879.

To his historicist leanings Burges added the instincts of a magpie. Widely traveled and never poor, he amassed many interesting and charming objects of all periods, both Western and Oriental. Japanese lacquer, Chinese cloisonné enamel, manuscripts, and crystal vessels—often in highly individual mounts of his own design, of which the Cat Cup is a typical example—cluttered his rooms. Burges took a carved Chinese crystal beaker and had it transformed into a vessel combining features of Suger's commissions for the altar of Saint Denis and the extravagance of early seventeenth-century German virtuoso goldsmithing; but above all he imbued it with his own sense of charming, inconsequential, childish fun. On the cover is a *ronde bosse* figure of a cat, with emeralds for eyes, playing with a coral ball; two circles of crystal cabochons and a silver battlement encircle the cat. Round the lip of the beaker, safely away from the cat, six silver mice play among cabochon gems, and on the foot are applied the architect's own imitation heraldic devices. Inside the lid is more exquisite decoration, of a cat holding a dead, defeated fox in one paw, and of scenes from the story of Puss in Boots (Pullan 1885, pl. 18).

Burges was very particular about the makers of his silver, and Jes Barkentin was one of the few he would employ. Barkentin was a Dane who began working in London in the 1860s with a Bohemian partner, Krall. At first they made domestic objects, but later they turned to church silver, making up the designs of Burges, Sir George Gilbert Scott, and L.G.F. Bodley and his circle. The Cat Cup was made to commemorate Burges' entry in the competition for the design of the new London Courts of Law, but although his designs attracted widespread admiration from his fellow architects and the press and he was paid a fee of £800, the commission finally went to G.E. Street. It was apparently Burges' custom to have a present made for himself on such occasions. The splendid decanters now in the Cecil Higgins Museum, Bedford, and the Fitzwilliam Museum, Cambridge, celebrate the publication in 1865 of *Art*

Appied to Industry and his participation in the competition for the Crimea Memorial Church in Constantinople in the same year. The Cat Cup was chosen by Lady Bute from Burges' own collection after his death in 1881. V.G.

LORD BUTE'S WATER BOTTLE 1880
silver, enamel, amethysts, semi-precious gems, and glass
26 (10¼) high
inscribed, *IOHANNI: PATRICIO: CRIC/HTON: STUART: MARCHIO/NI: DE: BUTE: UXORIS: DONU/M: NATALI: DIE: MDCCCLXXX*; maker's mark of Jes Barkentin, London, 1880

This was a birthday present to Lord Bute from his wife; the design for it, which survives in the family archive, is signed, *W. Burges/ July 1880/15 Buckingham St. Strand*, and is an example of just how precise Burges could be about what he wanted from his silversmiths. It shows an elevation, a section explaining exactly how the bottle was to fit together with an upper part that lifts away, leaving the base to serve as a cup, with further thumbnail sketches of the component parts and details of the fishes, filigree, and armorials. On the same sheet are three written estimates for the price and for a plate box to contain it.

The clear bottle is encased in silver gilt. The upper part of the body is molded around openwork ogee shapes, containing saw-pierced motifs of leaping fish with small gems set into their eyes. The neck is divided by plain molded rings into four bands—two undecorated ones with gem-set foliage tendrils, and one with swimming fishes and armorial devices in translucent enamel. The domed lid is enameled in a scale pattern and has an elaborate acorn finial set with a cabochon jewel. V.G.

CRUET 1877
silver-gilt, enamel, gems, and coral
17.8 × 25.4 × 12.7 (7 × 10 × 5)
inscribed, *IOHANNI: PATRICIO:
CRICHTON:STVART/MARCHIONI:
DE: BVTE/VXORIS: DONUM:
PRIDIE: ID: SEPTEMB: NATALI:
DIE. MDCCCLXXVII*; maker's mark
of Jes Barkentin, London, 1877

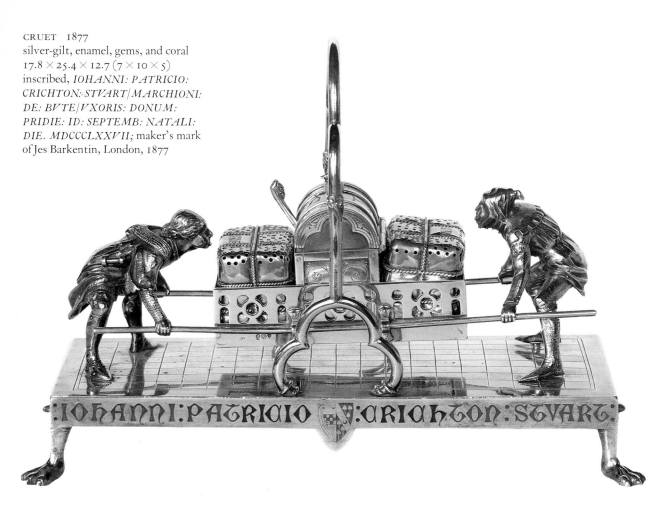

This was also commissioned by Lady Bute as a birthday present for her husband, in 1877. Drawings survive in the family archive, in the album *Orfevrerie Domestique*, and the small notebooks at the Royal Institute of British Architects datable to 1868–1877. These show that before choosing the present figures, Burges toyed with the idea of knights and clerics as supporters.

The two comical figures struggle to hold up the heavy burden of the salt, pepper, and mustard pots. They owe much to the *bas-de-page* images in thirteenth- and fourteenth-century manuscripts, which Burges avidly collected and which include numerous animal and human figures often engaged in futile labors quite irrelevant to the text above. Burges was also fascinated by medieval automata as illustrated by Villard de Honnecourt, the early thirteenth-century French "architect," the French and English facsimiles of whose sketchbook he reviewed in 1858 and 1859 respectively (Burges 1859). Even earlier, in 1857, he had carefully studied and drawn the workings of an "ancient" articulated iron hand in the Museo Correr in Venice, which he exhibited at the Archaeological Institute that year.

The cruet is made up of ten detachable sections including the mustard spoon in the shape of a tiny claw. Small *J.S.* monograms are enameled on the mustard casket, the sleeves of the figures, and elsewhere. V.G.

SOUP DISH and FISH PLATE 1868 and 1878
silver, partially gilt
soup dish: 27.9 (11) diam.; fish plate:
25.4 (10) diam.
soup dish inscribed, *JOANNES
PATRICIUS CRICHTON STUART
MARCHIO DE BUTA ME FIERI
FECIT MDCCCLXVIII*; maker's mark
of John Hardman and Co., Birmingham,
1868; fish plate inscribed, *JOANNES
PATRICIUS CRICHTON STUART
MARCHIO DE BUTA ME FIERI
FECIT MDCCCLXXIX*; maker's mark
of R. Garrard, London, 1878

The soup dish (left) is one of a set of
twenty-four designed by Burges for
Lord Bute. The drawings for the comic
characters engraved in the center of
each, inside an eight-pointed star, survive
in the family archive (Girouard 1979,
fig. 274). For Scotch Broth there is a
sheep dressed as a Highlander and for
Turtle Soup (not illustrated) there is a
city gent wearing his chain of office.

These soup dishes are *en suite* with
the eighteen fish plates, and both may
have been designed in 1867–1868
though the fish plates were not made
until ten years later. Technically much
simpler than any of the other silver
created for Cardiff Castle, the soup
dishes were made up by John Hardman
and Co. of Birmingham. Hardman's had
come to prominence as manufacturers
of ecclesiastical plate in the Gothic
style, mainly under the aegis of A.W.N.
Pugin in the 1840s and 1850s. Burges
had employed them to make several
chalices in the early 1860s including the
Beanlands Chalice (Church of Saint
Michael and All Angels, Brighton),
elaborately engraved on the foot with
the Four Rivers of Paradise, the Tree of
Life, and the Tree of Knowledge. As
enamelers, however, he found them
inadequate and said as much in *The
Ecclesiologist* in 1862. Thus, for his more
elaborate pieces he went to Barkentin
and Krall.

The fish plate (right) is one of a set
of eighteen presumably designed to go
with Lord Bute's soup plates. In the
center of each is a visual pun on the
name of a particular variety of fish.
This example, Smelt, is represented as
a fishmonger holding his nose, while
Perch, on another plate, is a winged fish
on the branch of a tree. Made ten years
after the soup plates, these were manu-
factured not by Hardmans, but by
Garrard's, the royal goldsmiths. V.G.

566

THE HON. MRS GEORGE HOWARD (later
COUNTESS OF CARLISLE) 1872
Aimé-Jules Dalou 1838–1902
bronze
52.1 (20½) high
signed, *J. Dalou, 1872*

The Castle Howard Collection

The statuette portrays Rosalind, wife
of George Howard, Liberal MP for East
Cumberland, amateur artist and patron
of the arts, who succeeded his uncle as
9th Earl of Carlisle in 1889. The sculptor
Jules Dalou, an active revolutionary
socialist who had held office under the
Paris Commune of 1871, when he was
placed in charge of the Louvre, had fled
to exile in London in the summer of 1871
after the overthrow of the Commune.
During his stay there, which lasted until
his return to Paris in 1880, George
Howard became the first, and one of the
most constant, of his English patrons.
The sources of the Howards' interest in
Dalou were twofold: both George and
Rosalind were active in left-wing English
politics and thus took a keen interest in
the community of *Communards* in exile
in London, and George as a painter had
been a pupil of Dalou's close friend
Alphonse Legros, then professor at the
Slade School. At the Royal Academy
Summer Exhibition of 1872 George
Howard bought Dalou's first English
work, the terracotta statuette *La
Boulonnaise au Rameau* (still at Castle
Howard), which relates closely to the
work of Legros. The present statuette
was commissioned immediately after
this. Later he was to commission from
Dalou terracotta busts of his wife and
his daughter May (1873) and of himself
(1877), and to acquire terracotta
maquettes from the artist. At the
division of the Howard family estates
in 1921 following the death of Rosalind,
the group of works by Dalou was
divided, but in addition to the present
work and the *Boulonnaise* two fine
maquettes are also preserved at Castle
Howard.

No direct record survives as to the
identity of the founder of the bronze,
but he would appear to have been Enrico
Cantoni, "bronze founder and moulder
for sculptors" (whose workshop at that
time was close to the studio of Dalou
in Glebe Place, Chelsea), since in 1907
the original plaster was in Cantoni's
possession at his new studio in Church

Street, Chelsea. In that year, through
the good offices of Thomas Armstrong,
the painter and former director of the
Art Division of the South Kensington
Museum (now the Victoria and Albert
Museum), a lifelong friend of the
Howards who had been present at
some of the original sittings in Dalou's
studio in 1872, the earl's permission
was obtained for a second bronze cast
to be made from this plaster by Cantoni
for the Victoria and Albert Museum;
this was delivered the following year
(Victoria and Albert Museum MSS).
No other bronze cast was ever made,
but it appears that Cantoni did make
some plaster replicas.

The statuette exploits a genre inaug-
urated by Dalou in his *Brodeuse*, exhibited
at the Paris Salon of 1870, and is the
first of a series of domestic studies that
he produced during his stay in England,
such as the *Leçon de Lecture* of 1874. The
original maquette for the latter is pre-
served at Castle Howard, and according
to a Howard family tradition, Rosalind
and Mary Howard were the models.

A.F.R.

Literature: Dreyfous 1903, 51–53;
Caillaux 1935, 127; Radcliffe 1964, 244,
245 n.3; Hunisak 1977, 137

567

VASE AND PLATE c.1888–1900
William Frend de Morgan 1839–1917
slipware and lusterware
vase: 24 (9½) high; plate: 21.5 (8½) diam.

Cragside
The William de Morgan Foundation
(on loan to The National Trust)

In the interval of approximately forty years between his abandonment of the art of stained glass and the publication in 1906 of the first of his seven novels, William de Morgan became the outstanding "art potter" of the late Victorian period. Both these pieces date from the period when he was established at the Sands End Pottery at Fulham in London.

The vase's simple shape is offset by the slip decoration of naturalistic lizards against a stylized foliate ground, painted in the palette known as "Persian colors" (more properly Turkish or Isnik) by Fred Passenger, whose mark appears on the base with that of the Fulham Pottery. With his brother Charles he was to continue producing pots to De Morgan's designs after the Sands End works closed in 1907.

The plate is unmarked, but the ruby-red luster decoration of a pair of lionesses whose tails encircle each other's necks, is highly characteristic of the Fulham period. The history and technique of luster fascinated De Morgan, and he gave a seminal paper on the subject to the Society of Arts on 31 May 1892 (reprinted in Gaunt and Clayton-Stamm 1971, 156–165): "[The technique] . . . As we now practise it at Fulham . . . is as follows: The pigment consists simply of white clay, mixed with copper scale or oxide of silver . . . It is painted on the already fused glaze with water, and enough gum arabic to harden it for handling." The pot was then packed in a closed "muffle," raised to a very low red heat, and exposed to an atmosphere of reducing smoke.

Like Edward Lear, De Morgan delighted in transforming real animals and birds into fantastic creatures, and his tiles and vessels form a delightful bestiary, from porcupines to peacocks; these two examples, the one decorated naturalistically and the other with quasi-heraldic forms, show the wide range of his designs as well as techniques.

Examples of his work in the form of tiles or vessels are to be found in countless late Victorian country houses, especially those associated with William Morris and the Arts and Crafts Movement, such as Kelmscott Manor in Gloucestershire, Ken Hill in Norfolk and Standen in Sussex. These two examples come from De Morgan's own collection at Old Battersea House in London, and are now the property of the foundation established by the will of his sister, Mrs. A.M.W. Stirling. In 1978 they were placed on extended loan to the National Trust at Cragside, the house built for the arms manufacturer Sir William, later 1st Lord Armstrong (1810–1900), by Richard Norman Shaw from 1869 to 1884. With other examples of De Morgan pottery and an important collection of paintings by his wife Evelyn, these loans compensate for the sale of much of Lord Armstrong's collection in 1910. Described by a contemporary journalist as "the palace of a modern magician," Cragside was the first house in Britain to be lit by electricity, installed by the maker Joseph Swann and powered by a hydro-electric scheme designed by Lord Armstrong himself. J.M.M.

568

THREE ELTON WARE VASES
c. 1885/1905
Sir Edmund Elton 1846–1920
pottery with luster and metallic
craquelure glazes
oviform luster vase: 26 × 16.5
($10\frac{1}{4}$ × $6\frac{1}{2}$); small metallic craquelure
vase: 17 × 8 ($6\frac{3}{8}$ × 3); tall gold
craquelure vase with curving neck and
handle: 50 × 20 ($19\frac{5}{8}$ × $7\frac{7}{8}$)

Clevedon Court
Lady Elton

"Eltonware," declared its creator, "is
the work of a Country Baronet and two
Boot Boys," but Sir Edmund Elton was
scarcely a typical fox-hunting squire. A
watercolorist, he was the grandson of
Sir Charles Elton, 6th Bart., a gifted
poet and classical scholar who was a
friend of Coleridge, Southey, Tennyson,
and Thackeray. His father was a younger
son who settled in Florence as a painter,
and Edmund only succeeded to Clevedon
Court and the baronetcy when his uncle
died without male heirs in 1883. By
this time he had already been inspired
to make ceramic tiles for churches by
watching men at work in the brickyard
at Clevedon, and had in 1881 founded
what was to become famous as the Sun-
flower Pottery. Entirely self-taught, he
and his hunch-backed assistant George
Masters were to become among the
most remarkable of the English artist-
potters, producing a bewildering pro-
fusion of shapes and styles, colors and
glazes, as the result of patient exper-
imentation.

Elton, like William Morris, William
de Morgan and Walter Crane, was in
revolt against the "tendency to general
utility and technical perfection" that
followed the Great Exhibition of 1851.
After careful study of the history of
pottery, wearing the conventional
potter's apron, designing his own kilns
and wheel and studio, he liked to regard
himself as a Pre-Raphaelite, "discarding
modern teaching, mechanical and reliable
methods, and returning to early begin-
nings." But far from focusing on the
dream of medieval order that was then
prevalent, he responded to almost every
aspect of the Aesthetic Movement: he
followed the Chinese, was influenced

by the Japanese, admired Greek models,
collected Italian pottery, and thought
himself at last an "ancient Briton." His
contemporaries lauded his oriental man-
ner on the one hand, and the "Peruvian
and Celtic" influence in his barbaric
and grotesque forms on the other.

The Sunflower Pottery, which
occupied much of the stable yard at
Clevedon, was not intended to be a
great commercial undertaking, for Sir
Edmund hardly ever repeated a single
piece. However, Elton Ware was shown
at countless international exhibitions,
winning gold medals at San Francisco
in 1894; Atlanta, Georgia, in 1895;
Brussels in 1897, Saint Louis in 1904,
and Milan in 1906—while Tiffany's
acted as his agents in New York. At the
same time he was proud that his pots
were fashioned from the silt and salt of
the Bristol channel—the clay on his
estate—and he clung tenaciously to
West Country traditions, not only in
the reproduction of its loving cups, but
in his use of colored slips under a clear
glaze—in contrast to other potteries,
which relied on colored glazes.

A particularly colorful luster vase in
this group, probably produced in the
1890s, shows a typical freedom of treat-
ment in its transformation of natural
forms. Roses, irises, and sunflowers
take on an abstracted, almost *art nouveau*
form, like his birds and serpents of the
same period, which seem to indicate
some darker torment. About 1902, Sir
Edmund began to experiment with the
production of metallic effects, using
preparations of gold and platinum in a
tar oil base. In order to avoid what he
considered the "vulgarity" of plain
gilding, he devised a method of metal-
lizing on top of a heavily crazed surface,
obtained by first coating the article
with a glaze that shrank during firing.
It was then treated with the metalliz-
ing solution and fired again at a lower
temperature in a closed kiln. The tall,
gold crackle vase with an attenuated
curving neck and handle is one of his
most ambitious pieces in this style,
while the smaller vase with a flared
neck shows an extension of this tech-
nique, in which a metallic surface is
deposited on top of a colored glaze,
which then shows through the wide
cracks—a favorite combination being
green under gold. G.J-S.

Literature: This entry is almost entirely
based on information generously sup-
plied by Lady Elton and Miss Julia Elton;
also see Lloyd Thomas 1974, 33–37;
Elton 1980, 10

The Indian summer of British country house life in the period before the First World War, so poignantly evoked in Lavery's painting of a tea party on the terrace at St. Fagan's Castle (no. 573), found in the American artist John Singer Sargent a portrait-painter of genius at the height of his powers, able to compete with the masterpieces of Lawrence, Reynolds, and Van Dyck, and on a scale worthy of the greatest country house interiors. Sargent's nationality was especially appropriate, for the fortunes of many families in the years of the agricultural depression had been saved by marriage to American heiresses: the Duchess of Roxburghe at Floors, Lady Hesketh at Easton Neston, Lady Curzon at Kedleston, and the Duchess of Marlborough at Blenheim among others. Consuelo Vanderbilt was portrayed with her husband, the 9th Duke of Marlborough, and their children in one of Sargent's most compelling set pieces (no. 570), but the artist was equally at home with the easy informality of a young aristocrat like Lord Dalhousie, symbolizing the British Raj (no. 569), or with the young Lady Rocksavage (no. 571) painted in the manner of Velasquez.

If no other painters could quite match the bravura of this technique, Ambrose McEvoy, William Nicholson, William Orpen, Philip de Laszlo, and Glyn Philpot could provide memorable society portraits either to continue a long family series, or to start new dynasties in the country houses of Sir Edwin Lutyens, Detmar Blow and Sir Robert Lorimer. Alfred Munnings' sporting pictures continued an equally long tradition, and few keen racegoers or masters of hounds failed to acquire examples of his work for their collections to accompany the Ferneleys and Grants of the previous century.

The economic difficulties that beset country houses before and after the Second World War only added to the nostalgic affection they aroused in their owners, seen so vividly in Rex Whistler's romantic view of Haddon and John Piper's dramatic gouache of a rain-soaked Harewood. Post-war portraiture has veered between the realism of Pietro Annigoni and John Merton in an Italian Renaissance style, and the more introspective character studies of Graham Sutherland and Lucien Freud, but the caricatures of Max Beerbohm and the photographs of Cecil Beaton equally deserve a place of honor for their chronicling of country house society.

Just as British houses benefited from the French Revolutionary sales, so the Russian Revolution brought at least one outstanding collection of Fabergé, now at Luton Hoo, and inherited by Lady Zia Wernher from her parents, the Grand Duke Michael of Russia and Countess de Torby. The Indian viceroys and governors also returned with works of art in the tradition of Warren Hastings and Lord Clive, whose collection still remains at Powis: these range from ivory furniture and textiles to miniatures, arms and armor, and address caskets of every conceivable shape and form. Whole rooms at Knebworth and Kedleston are filled with such booty, and at Clandeboye in Northern Ireland, the 1st Marquess of Dufferin and Ava's period as Governor-General of Canada resulted in a hall hung with snow-shoes, moose horns, furs, and eskimo canoes, while the great staircase celebrates his time in India and Burma with maharajah's thrones, narwhal tusks, miniatures, silks, and carpets.

Patronage of living artists still continues in country houses: busts by Jacob Epstein, bronze maquettes by Henry Moore, and the engraved glasses of Rex Whistler's brother Lawrence, are to be found in many private drawing rooms and studies. But while the tastes of owners are by no means confined to the past, it is the preservation of historic houses and collections, open to view by an ever-increasing public, that is now their main concern.

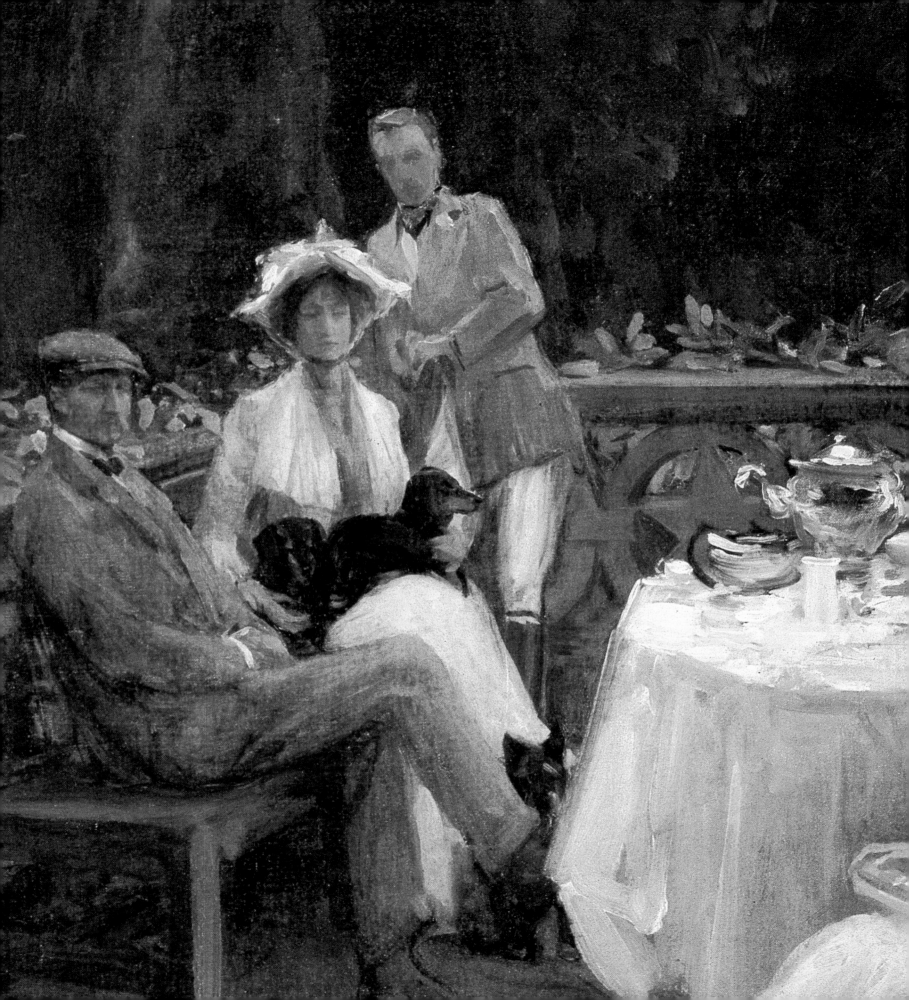

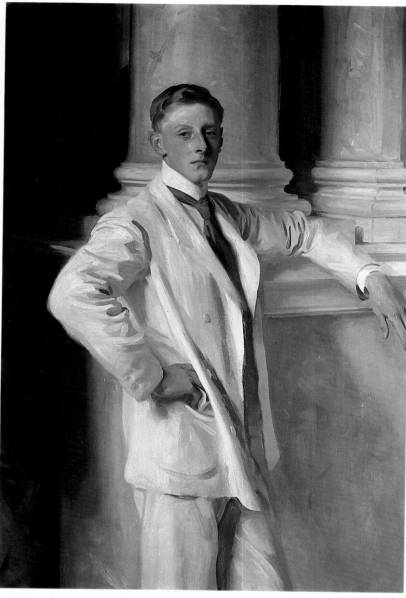

which was to become a feature of his later male portraits, notably *Lord Ribblesdale* (Tate Gallery, London) and *A.J. Balfour* (Carlton Club, London). Until this date most of his sitters had been drawn from the Edwardian plutocracy, either in Paris or in London. But for the few remaining years of his professional career, members of the British aristocracy were his main patrons, and there is a significant change in his style. His portraits were destined for their country houses, which often contained ancestors by Van Dyck, Reynolds, Gainsborough, and Lawrence, and Sargent's work had to complement these giants of the past. The column motif is just such a gesture, but the artist uses it as a foil for the extreme naturalness of the pose and costume, to produce a haunting image of youthful and patrician self-confidence, very different from the heroic attitude of an experienced administrator like *Sir Frank Swettenham*, Governor of the Malay States (National Portrait Gallery, London). The loose brushwork is powerful and expressive, as opposed to the tightness and nervous elegance of his earlier Parisian portraits, and shows the influence of Monet and his other Impressionist mentors. It recalls, too, Sargent's habit (recorded by several sitters) of charging at the canvas with his brush from a considerable distance, uttering strange oaths and imprecations, and then retiring to consider the result: a technique that resulted in an astonishing fluency and sense of energy.

The portrait was exhibited at the Royal Academy in 1900, with the sensational *Wyndham Sisters* (Metropolitan Museum, New York), when the *Spectator* commented: "Those who appreciate Mr. Sargent's art should not miss his portrait of *The Earl of Dalhousie*. The success of the realism is complete; only a real master could have succeeded in making the young face look perfectly right with the sunburn ending in a diagonal line across the forehead. This is not done to give an air of audacity to the painting but is simply the way in which a master seizes on things that help him in his characterization."

G.J-S.

569

THE EARL OF DALHOUSIE 1900
John Singer Sargent 1856–1925
oil on canvas
152.4 × 101.6 (60 × 40)

Brechin Castle
The Earl of Dalhousie

Arthur George Maule Ramsay, 14th Earl of Dalhousie (1878–1928), succeeded his father at the age of nine, and seems to have met Sargent soon after coming down from Oxford, when they were both staying at Government House—the Sultan's Palace—in Khartoum. Dalhousie had taken several trips on the Nile, and this would account for the sunburn and the tropical suit which, with the base of the giant column, combine to make this a powerful symbol of British imperial tradition. Lord Dalhousie afterward served with distinction in the South African War (1901–1902) and was wounded fighting in Flanders in the First World War.

As Ormond and Lomax point out (Leeds and London 1979), this is one of Sargent's first essays in which his subject is placed against columns or pilasters,

Literature: Downes 1925, 190; Charteris 1927, 268; Mount 1955, 436; Ormond and Lomax in Leeds and London 1979, with previous literature
Exhibitions: London, RA 1900 (44); Leeds and London 1979 (44)

570

THE MARLBOROUGH FAMILY 1905
John Singer Sargent 1856–1925
oil on canvas
signed, bottom left, *John S. Sargent 1905*
287 × 238.7 (113 × 94)

Blenheim Palace
The Duke of Marlborough

The largest family portrait group ever painted by Sargent, this is also the culmination of his great series of country house commissions, consciously rivaling the masterpieces of Reynolds and Van Dyck. The sitters are Charles, 9th Duke of Marlborough (1871–1934), and his wife, the American heiress Consuelo Vanderbilt (d. 1964), with their two sons, John (later 10th Duke) and Lord Ivor Spencer-Churchill; the dogs are Blenheim spaniels, bred on the estate since the eighteenth century, and a variation on the more usual King Charles. Sargent is said to have received 2,500 guineas for the commission (Charteris 1927, 177–178)

Like the *Sitwell Family* at Renishaw, which was painted as a pendant to an earlier conversation piece by Copley, the Marlborough group was commissioned to hang in the Red Drawing Room at Blenheim opposite Reynolds' huge portrait of *The 4th Duke of Marlborough and his Family*. A drawing by Sargent after the Reynolds group is at the Fogg Art Museum, Cambridge, Mass., but the mood of his own picture is very different, its grandeur and formality reflecting the 9th Duke's restoration of Blenheim—which included the reinstatement of Vanbrugh's forecourt, and the great parterres on the north and south fronts, laid out by the French architect, Achille Duchêne.

Preliminary studies include an oil sketch of the interior of the hall (Lousada Collection) showing the bust of the 1st Duke of Marlborough by Rysbrack, flanked by French banners captured on his campaigns, over the door to the saloon. But the other architectural elements, including the pilasters carved with military trophies in bas-relief, are entirely imaginary, and the sittings are recorded as having taken place in the artist's studio in Tite Street. Other drawings for the pictures (in the Fogg Art Museum, and in the Edward K. Perry collection, Boston) show the gradual evolution of its pyramidal composition, which the picture shares with Reynolds' much wider canvas,

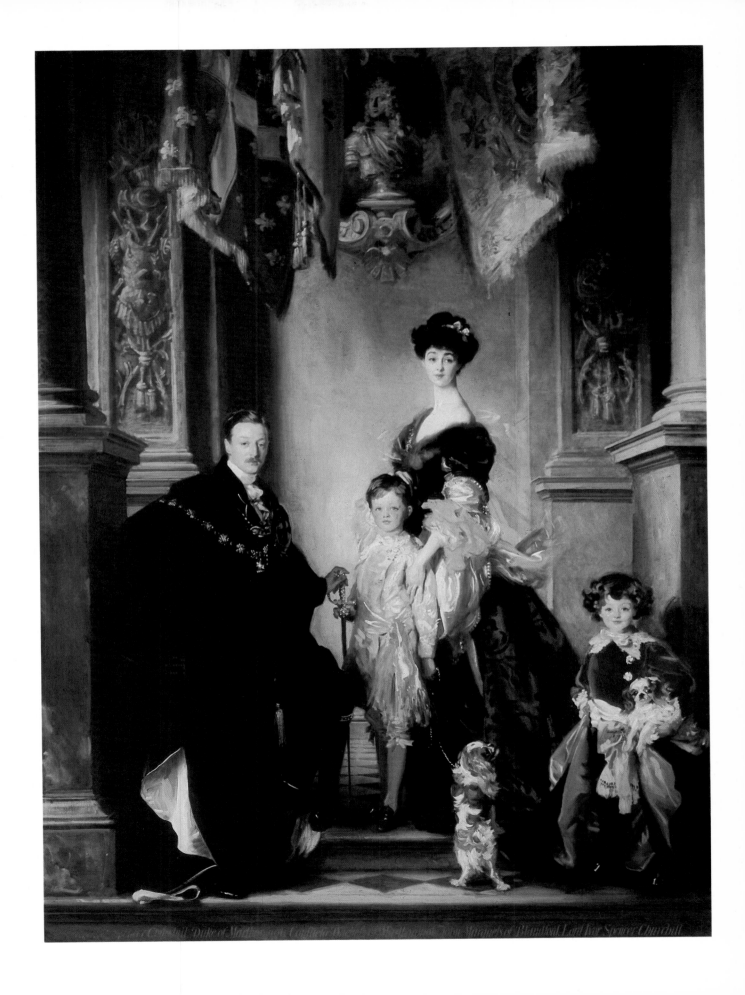

though with far greater vertical emphasis. The decisive factor was the introduction of the step, as described by the duchess in her memoirs, *The Glitter and the Gold* (Balsan 1953, 145–147): "When Sargent came to Blenheim at my husband's invitation and was told that he was to paint a pendant to a picture in which there were eight persons and three dogs, he seemed in no wise daunted ... We were therefore depicted standing in the hall with columns on either side and over our heads the Blenheim Standard, as the French Royal Standard captured at Blenheim had become known. I was placed on a step higher than Marlborough so that the difference in our height— for I was taller than he—should be accounted for. He naturally wore Garter robes. For me Sargent chose a black dress whose wide sleeves were lined with deep rose satin; the model had been used by Van Dyck in a portrait in the Blenheim collection. For my elder son he ordered a costume of white and gold—Ivor in blue velvet played with a spaniel at my side ... He had, moreover, a predilection for a long neck, which he compared to the trunk of a tree. For that aesthetic reason he refused to adorn mine with pearls, a fact that aggrieved one of my sisters-in-law, who remarked that I should not appear in public without them...."

The calm dignity of the duchess' dress and pose is in striking contrast with Boldini's portrait of Consuelo and her younger son Ivor, painted in the following year (Metropolitan Museum, New York), frankly sensuous in its treatment of high Edwardian fashion, and looking back to Fragonard rather than to Van Dyck. The marriage was not a success, and after their divorce in 1921, the duke married Gladys Deacon, another American heiress. R.O./G.J-S.

Related Works: Three later drawings of the duchess by Sargent, and a related oil portrait of the duke ($47 \times 37\frac{1}{2}$ inches), are also at Blenheim
Literature: Downes 1925, 216–217; Thesiger 1927, 2; Charteris 1927, 175, 177, 272; McKibbin 1956, 108; Mount 1969, 271–272, 445; Ormond 1970, 63–65, 252–253
Exhibitions: London, RA 1905 (256)

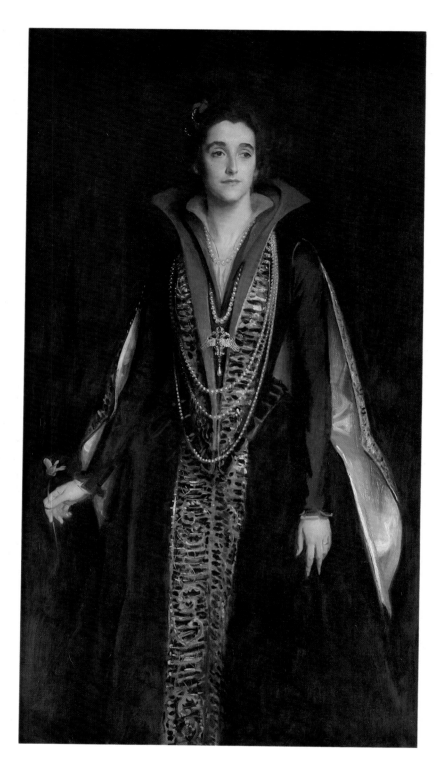

571

THE COUNTESS OF ROCKSAVAGE 1922
John Singer Sargent 1856–1925
oil on canvas
signed and dated, *John S. Sargent 1922*
161.3×89.8 ($63\frac{1}{2} \times 35\frac{3}{8}$)

Houghton Hall
The Dowager Marchioness
of Cholmondeley

Sybil, only daughter of Sir Arthur Edward Sassoon, 2nd Bart., married the Earl of Rocksavage, later 5th Marquess of Cholmondeley, in 1913. Their restoration of Houghton in Norfolk, the great Palladian seat of Sir Robert Walpole—culminating in Lady Cholmondeley's rebuilding of the staircase and *perron* on the south front in 1973, in memory of her husband—is one of the outstanding achievements of twentieth-century connoisseurship in Britain, and she remains the *doyenne* of English country house owners. Her achievement in furthering Anglo-French relations over a period of more than seventy years was recognized when, after a recent state visit to London, President Mitterand visited Houghton and invested her with the order of the Légion d'Honneur.

Brought up in Paris, Lady Cholmondeley knew Sargent from an early age and has recounted how she played piano duets with the artist as a child and was taken by him for drives in the Bois de Boulogne. Her mother, born Aline de Rothschild, was one of Sargent's closest friends and confidantes—and the subject of one of his most flamboyant three-quarter-length portraits, which also remains in the collection at Houghton (Ormond 1970, 253, fig. 96). This picture is one of only a handful painted by him after the First World War when his embargo on portraiture was almost complete. He had already come out of retirement to paint a half-length of Lady Rocksavage in 1913, which he gave her as a wedding present, and it was only his close friendship with the sitter and her brother, Sir Philip Sassoon, that led him to break his rule for a second time. He was a frequent visitor to Sassoon's house at Trent Park, near Barnet, and the latter acquired a number of his landscapes and Venetian views.

This second portrait of Lady Rock-savage is a costume piece: she is seen in a court dress of late sixteenth-century design, of purple and black silk with a richly embroidered panel down the front, and a train suspended from the shoulders, holding a single purple cyclamen in her right hand. This dress, still owned by the sitter, was especially commissioned by the artist from the great Parisian designer, Worth, and is said to have cost over two hundred pounds (Mount 1969, 434). Its Spanish character may well have been inspired by the famous Renaissance jewel worn at her breast, which belonged to Philip II's daughter Dona Maria of Austria, acquired from the convent in Madrid to which she retired, and included in the great charity exhibition of silver and jewelry organized by Sir Philip Sassoon at 25 Park Lane, London, in 1929 (no. 845). The costume emphasizes the extreme formality of the portrait, and its conscious old-master mood, particularly evoking Velásquez. The touch, however, is all Sargent, with rich, gleaming textures and powerfully modeled head and hands. According to Mount (1969, 384): "They had a 'month of sittings in the fog,' during which she spent almost the entire day at the studio with him and was amused to note that his idea of lunch for her was two whole ducks…after these sittings he announced, 'Sybil is *lovely*. Some days she is positively green,' which, strange as it may seem, bore all the marks of being intended as a compliment." R.O./G.J-S.

Literature: Downes 1925, 256; Charteris 1927, 157, 277; McKibbin 1956, 89; Mount 1969, 384, 434; no. 221; Ormond 1970, 257

572

ELIZABETH, VISCOUNTESS
CRANBORNE, LATER MARCHIONESS
OF SALISBURY 1917
Ambrose McEvoy 1878–1927
oil on canvas
101.6 × 76.2 (40 × 30)

Viscount Cranborne, MP

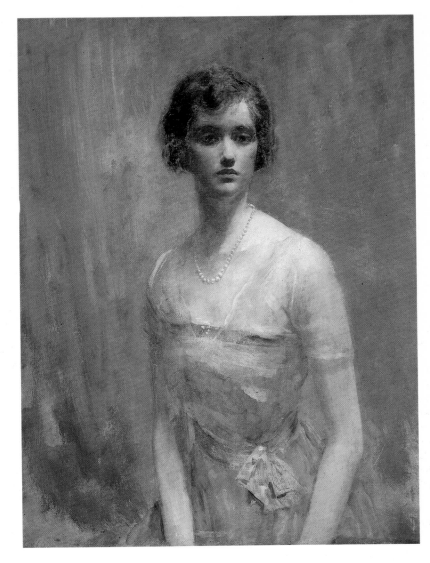

In 1915 Elizabeth Vere (1891–1982), eldest daughter of Lord Richard and Lady Moyra Cavendish, married Robert, Viscount Cranborne, who succeeded as 5th Marquess of Salisbury in 1947. True to a family tradition, Lord Cranborne was one of the outstanding political figures of his generation, serving as Leader of the House of Lords in the War Cabinet in 1942–1945 and as Lord President of the Council in 1952–1957. Lady Salisbury took a spirited interest in her husband's political life, and they shared a deep love of the houses he inherited—Hatfield, to which they moved in 1947, and Cranborne, most beautiful of Dorset manor houses. Brought up at Holker with its celebrated park, Lady Cranborne had an instinctive understanding of gardening and at Cranborne her contribution prepared the way for the far more ambitious achievement of her son and daughter-in-law.

In the year of her marriage, Lady Cranborne was drawn by Sargent (Auerbach and Adams 1971, no. 220). This portrait was commissioned in 1917 by Lord Cranborne and finished in June of that year. The choice of McEvoy was made at the suggestion of Lord d'Abernon (1857–1941), himself a distinguished connoisseur, who later published an appreciation of the artist (D'Abernon 1931, 97–101) (information from the sitter). In the years of the First World War, McEvoy became one the of the most fashionable portrait painters in London, rivaling De Laszlo in popularity. With the *Children of the 9th Earl of Sandwich* (Hon. Victor Montagu) of 1916 and the *Marquess of Crewe* (Greater London Council) of 1918, this deceptively simple likeness of one of the most beautiful women of her generation represents McEvoy at his best. F.R.

Provenance: Commissioned by Viscount Cranborne, later 5th Marquess of Salisbury; and by inheritance to his grandson
Literature: McEvoy 1919, 1: pl. 60; Auerbach and Adams 1971, no. 221
Exhibitions: London, NPS 1917; London, Morley Gallery 1974 (20)

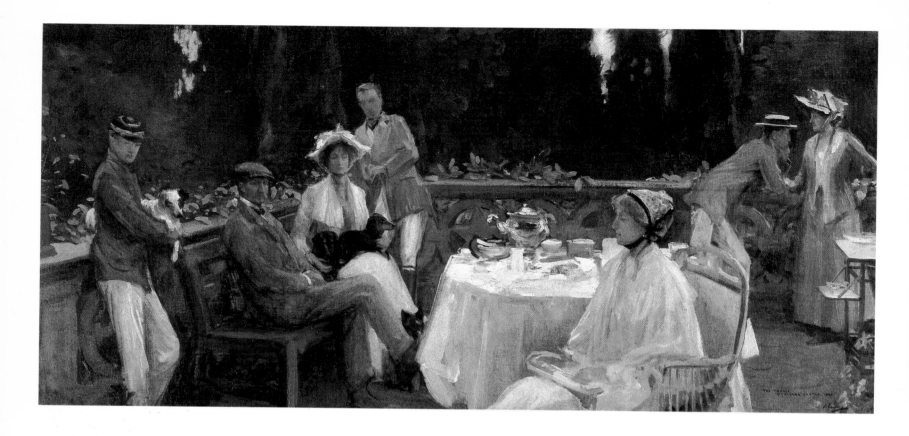

573

A FAMILY GROUP AT ST. FAGAN'S
1905
Sir John Lavery 1856–1941
oil on canvas
55.8 × 116.8 (22 × 46)
signed and inscribed,
St. Fagans Castle 1905

Private Collection

All the preconceptions about the leisurely, well-ordered existence of the Edwardian upper class seem to be embodied in Sir John Lavery's picture of Lord and Lady Windsor and their family at St. Fagan's Castle. Lavery was the doyen of this kind of conversation piece. His informal scenes of the relaxed life of English country houses, like those of Sargent, were an antidote to studio-based society portraiture. In the 1880s and 1890s, as a member of the Glasgow School, Lavery had painted scenes of this kind, but perhaps the most accomplished of these, *A Garden in France*, 1897 (Academy of Fine Arts, Philadelphia), painted at Grez sur Loing, draws successfully upon the great tradition of modern naturalistic portraiture, which had its roots in the work of Manet, Whistler, and Tissot. In *A Family Group at St. Fagan's*, Lavery has returned to the double square, horizontal format of his most famous early picture, *The Tennis Party*, 1885 (Aberdeen Art Gallery). The composition is therefore friezelike in conception,

with the main visual emphasis placed upon the figures of Lord and Lady Windsor.

The picture was painted in the year in which Robert George Windsor-Clive, 14th Baron Windsor (1857–1923), having served as Mayor of Cardiff (1895–1896) and Lord Lieutenant of Glamorgan, was created 1st Earl of Plymouth. His wife Alberta, daughter of the Rt. Hon. Sir Augustus Berkeley Paget, sits by his side; the older woman on the right is his mother-in-law, Lady Paget. In the background, leaning against the parapet, is his eldest son Other, Viscount Windsor (1884–1908); on the right is his second son Ivor, later 2nd Earl of Plymouth (1929–1943) and his daughter Phyllis; and on the left is his youngest son Archer. The setting, St. Fagan's Castle, was originally a Norman fort; in Tudor times a house was built on the site, which became the country seat of the Windsor-Clives. Later owned by Randolph Hearst, it is now the Welsh Folk Museum.

Lord Windsor had a keen interest in

art, publishing a book on Constable in 1903. How he and Lavery met is not recorded, but he may well have visited the artist's exhibition of "Cabinet Pictures," which had been held at the Goupil Gallery, London, in 1904. Though he was often regarded as the heir to Whistler in full-length portraiture, Lavery wished to extend the range of his work and to paint what came to be known as "portrait-interiors." *A Family Group at St. Fagan's* anticipates this development, which in later years took him to Wilton House, the home of the Earls of Pembroke and Montgomery, to The Wharf, Sutton Courtenay, the home of the Asquiths, to Esher Place, the home of the singer Count John McCormack, and to many other country houses.

K.MCC.

Literature: Sparrow 1911, 136, 186, as "Lord and Lady Windsor and their Family"; McConkey 1984–1985
Exhibitions: London, Grosvenor Gallery 1914 (77)

574

JAMES ROBERT DUNDAS MCEWEN
1915
Philip de Laszlo 1869–1937
oil on canvas
92.25 × 64.7 (37½ × 25½)

Bardrochat
Alexander Dundas McEwen, Esq.

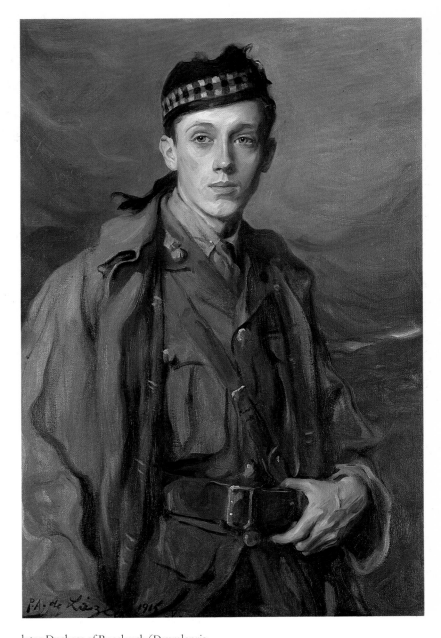

James McEwen (b. 1896), seen here in the battledress of the Royal Scots Fusiliers, was killed in an assault on the village of Bullecourt on the Somme front on 12 October 1916. His loss, with many thousands of other sons brought up in the British country house tradition, "the cream of a whole generation," was to spell the end of a way of life already being threatened by death duties and penal taxation, and a change in social attitudes that was to have profound consequences on the role of houses and estates in the twentieth century. His father, Robert Finnie McEwen, a successful Edinburgh lawyer, had acquired not only a fine William Adam house at Marchmont in Berwickshire, which he altered and extended to designs by Sir Robert Lorimer, but also a substantial shooting lodge, Bardrochat in Ayrshire, which was to have been James' inheritance as the second son. Like other fathers, McEwen published a memoir after his son's death, including many of his letters from Eton and from the front, one of the last of which, written after a brief leave, reads poignantly: "Darling Dada, I meant to have written to you before to let you know how much I gloried in those great, boisterous days on the hill. There's only one place in the world of which I could frankly say that I love it equally well on a warm sunny day, or on a black murky one with the rain pillars beating down the hillside—and that place is Bardrochat the ever-adored" (McEwen 1930, 175–176).

The frontispiece to the book reproduces the intensely romantic portrait of McEwen by Philip de Laszlo. This Hungarian-born artist is now generally remembered for his pictures of society beauties, painted over a long career, in which he was considered Sargent's natural successor. He settled in England in 1907, after a period in Munich and Paris, and made his mark with stylish portraits of sitters like the *Duchess of Portland* (1911; Welbeck Abbey), *Lady Zia Wernher* (1912; Luton Hoo) and *Lord Curzon of Kedleston* (1913; Kedleston). Although interned as an alien in 1917–1918, he quickly re-established his practice in the period between the wars, and some of his later portraits, such as that of the *Countess of Dalkeith*,

later Duchess of Buccleuch (Drumlanrig Castle) are masterpieces of their genre. A massive book on his work, published in 1925, had the distinction of including an appreciative essay by Proust's friend, the arch-aesthete Robert de Montesquiou. However, some of his most direct and moving likenesses are those of youths who were later to lose their lives in defense of their country: studies in what the 1925 volume called "the qualities of the public school spirit, tried in the fiercest of fires" (Williams 1925). G.J-S.

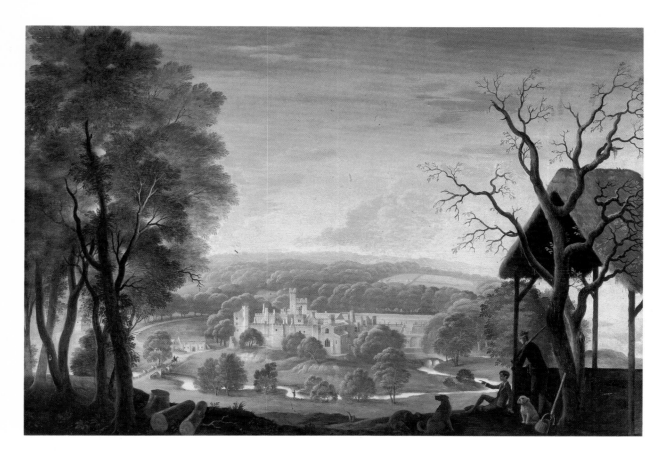

575

VIEW OF HADDON HALL, DERBYSHIRE
1932
Rex Whistler 1905–1944
oil on panel
36.8 × 56.8 (14½ × 22⅜)

Haddon Hall
The Duke of Rutland

This view of Haddon shows the medieval
house, begun in the twelfth century
and with additions made up to the
beginning of the seventeenth: a mass of
towers, battlements, chimneys, and
ancient mullion windows, rising above
the little river Wye. The scene has
changed little since 1697, when Celia
Fiennes described it as a "good old house,
all built of stone and behind it is a fine
Grove of high trees and good gardens"
(Morris 1947). By this time, the Earls
of Rutland, who had inherited Haddon
through the marriage of John Manners
with the heiress Dorothy Vernon
(d. 1584), had already made Belvoir

Castle their main residence and Haddon
had been largely abandoned. A visitor
in the early nineteenth century found
that "a gloomy and solemn silence per-
vades its neglected apartments, and the
bat and the owl are alone the inmates
of its remaining splendour" (Rhodes
1819). The restoration of the Hall
was the life's work of the 9th Duke of
Rutland (1886–1940), who approached
the task with the greatest knowledge
and sensitivity, employing skilled local
craftsmen, and entirely succeeding
in his efforts to preserve its unique
atmosphere.

As one of the finishing touches to
this great work, begun just after the
First World War, the duke commissioned
Rex Whistler, a close friend of his sister
Lady Diana Cooper, to repaint the large
panel (6 feet by 8 feet 6 inches) above
the chimneypiece in the long gallery.
This panel evidently depicted a scene
from classical history, of which only a
narrow strip down the right-hand side
remained intact, showing a curious,

thatched shelter with a half-dead tree
in front of it. Whistler was asked to
incorporate this fragment in his new
view of the house, and also to produce
this smaller panel, possibly as a trial. In
a letter to his mother dated 12 September
1932, he writes: "I sat out on the hillside
and did a painting of the scene on Sunday
afternoon, so all the *outdoor* work is
already done and this morning I walked
about with a notebook and pencil and
drew certain bits of the house in detail
and the bridges etc which were indistinct
or hidden by trees from a distance. Now
I can start on the small panel and hope
to have it done in a few days. This
afternoon I finished the imitation of
the original strip of painting on my
panel so shall be ready to begin the
rest tomorrow morning. A bit of the
summer house and some branches;
that is all that remains of the original
painting…but I have also copied it
much smaller on my little panel to scale."

The duke is himself portrayed in the
foreground on the right, carrying a gun,

and with his son Lord Granby (the
present Duke of Rutland) seated on the
ground next to him. In the larger version
the retrievers are also identified as
"Rajah" and "Quest," and the bulldog
as "Johnny Bull," while Whistler's
signature and the date 1933 appear on
one of the logs on the right. Whistler
had spent some time in Rome after
studying at the Slade from 1922 to 1926,
and the feathery trees and misty, pale
blue light show the strong influence of
Italian Renaissance painters, particularly
Primaticcio. At the same time the picture
is a powerfully nostalgic vision of the
continuity of English country house life,
at a time when its future was seriously
in doubt, and death duties and the
decline of domestic service had already
taken their toll. Its success may well
have earned the artist his most important
single commission, the huge mural in
the dining room at Plas Newydd painted
for the 6th Marquess of Anglesey and
his wife, Lady Marjorie Manners, another
sister of the Duke of Rutland. Sadly,
this panorama of sunlit Renaissance
cities, answering the scattered Welsh
farmhouses and dark woods on the
opposite side of the Menai Straits, was
finished only a few weeks before he was
killed in action in the Second World
War. G.J-S.

Related Works: A sepia ink and wash
drawing (9 × 12 inches) without the
framework of trees and shelter, and a
view of Haddon from the northeast
showing the old entrance under Peverel's
Tower and the valley beyond, are both
in the collection of the artist's brother,
Laurence Whistler
Literature: Hussey 1949, 1888, fig. 11;
Whistler and Fuller 1960, 17–18,
no. 49 (wrongly described as oil on
canvas)

576

THE DUCHESS OF DEVONSHIRE 1954
Pietro Annigoni b. 1910
oil on canvas
55.8 × 43.8 (22 × 17¼)

Chatsworth
The Trustees of the Chatsworth
Settlement

The Hon. Deborah Freeman-Mitford, youngest daughter of the 2nd Lord Redesdale, and the sister of Nancy and Jessica Mitford, and Diana Mosley, married Lord Andrew Cavendish in 1941. His elder brother, the Marquess of Hartington, was killed in action in 1944 (only four months after marrying Kathleen, sister of John F. Kennedy), and in 1950 he therefore succeeded his father as 11th Duke of Devonshire. Faced with gigantic death duties, calculated at eighty percent of the value of the estate, it seemed as if Chatsworth and its collections would have to be sold together with most of the rest of the Devonshire inheritance. But with great courage and perseverance the duke tackled these problems over a seventeen-year period, and in 1959 he and the duchess moved back into the house, which the family had left in 1930. Since then Chatsworth has been meticulously restored inside and out; the gardens have re-emerged in their full splendor, with a magnificent new greenhouse built in 1970 to replace Paxton's Great Conservatory, demolished in the 1920s; and in the development of rare breeds, the farm and gift shops, the making of garden furniture, and other commercial undertakings, Chatsworth has pioneered the way for other country houses. The Duchess of Devonshire's book *The House: a Portrait of Chatsworth*, published in 1982, with extracts from the 6th Duke's *Handbook* of 1844, is one of the most entertaining and authoritative accounts of its kind ever written.

In the book she describes being painted by Annigoni: "he demanded many sittings, and I went to his studio in Edwardes Squares every day for a month. He had done some striking portraits of dark beauties like Mary Anna Marten and Mona de Ferranti, and I realised that my colour was not his favourite. I said, 'I'm sorry about my face. I know it's not the kind you like.' He made an Italian gesture of resignation and said, 'Oh, well it doesn't matter. It's not your fault.'" As with Annigoni's famous portrait of Queen Elizabeth II in Garter Robes painted in 1955 (London, Fishmongers' Hall), the background is a highly detailed evocation of the Italian Renaissance, particularly influenced by Leonardo. In one sense this extreme realism, also found in the contemporary portraits of John Merton, can be seen as an escape from the uncertainties and horrors of the war years, and in another as a continuation of that romantic vision of the country house already seen in the work of Rex Whistler. But its popularity was also a conscious reaction against abstract art, which was increasingly the norm, and which could hardly be adapted to the requirements of a family portrait gallery. In this context Annigoni's picture makes a fascinating contrast with Lucien Freud's almost cruelly introspective portraits of the duke and duchess painted five years later in 1959 (Devonshire 1982, 121, ill.); of the latter, the duchess writes that, when it was on the public route of the house, "someone heard an old lady say to her friend, 'That's the Dowager Duchess. It was taken the year she died.'"

G.J-S

577

THE PRINCESS ROYAL ON "PORTUMNA"
1930
Sir Alfred Munnings 1878–1959
oil on canvas
signed and dated
78 × 80.5 (30¾ × 31¾)

Harewood House
The Earl and Countess of Harewood

Princess Mary (1897–1965), George V's only daughter, married Henry, Viscount Lascelles, later 6th Earl of Harewood, in 1922. Inheriting from her mother, Queen Mary, a knowledge and love of country houses and their works of art, the Princess Royal restored many of the Adam interiors at Harewood, and helped her husband acquire the Italian old masters with the fortune left him by his great-uncle, the last Marquess of Clanricarde. With the outbreak of war in 1939 the house served as a hospital, and after her husband's death in 1947, the princess and her son coped with the heavy burden of death duties and subsequent sales, keeping most of the collection intact and opening Harewood to the public for the first time in 1950.

Lord Harewood and the Princess Royal were familiar figures in the hunting field and on the racecourse in the 1920s and 1930s, and it was natural that they should have approached Munnings, the leading English sporting painter of the day, to record them for posterity. A large canvas, now hung in Lord Harewood's sitting room with works by Sargent, Lavery, and McEvoy, shows them both at a meet of the Bramham Moor Hunt, while a pendant portrays the huntsman, whippers-in, and hounds against a wide view of the Yorkshire moors. The painting of this third picture, commissioned a few years later, is recorded in some detail in the artist's autobiography, where he wrote that "the conditions under which I worked, including the weather, were the best I have ever known." The princess was to be painted on Portumna, the gray horse given her as a wedding present by the hunting women of Ireland (and called after Portumna Castle in Galway), and sittings were given during the Craven Meeting at Newmarket, where Munnings was a

guest at Egerton House, which Lord Harewood then owned. "Each morning the Princess came down to breakfast in a silk hat and habit. Soon after, with canvas, box and easel, I was ready on one of the rides of the woods surrounding the house. There was a succession of fine spring mornings, the trees not yet in leaf. The Princess rode the grey horse to the spot I had chosen and stood on the ride against a woodland background. The picture was begun and finished during the Meeting, in three sittings on three consecutive mornings. This, of the Princess Royal on the grey, is my best equestrian portrait. No horse could have stood better—no sitter was more patient" (Munnings 1951, 2:225). G.J-S.

Literature: Booth 1978
Exhibitions: London, RA 1931

578

THE 2ND LORD ILIFFE 1976
Graham Sutherland 1903–1980
oil on canvas
81.2 × 91.4 (32 × 26)

Basildon Park
The Lord Iliffe

The Hon. Langton Iliffe (b. 1908) married Renée Merandon du Plessis in 1938, and succeeded his father, the publisher and newspaper proprietor, as 2nd Baron Iliffe in 1960. In 1952 he and his wife courageously decided to buy and restore Basildon Park in Berkshire, one of the masterpieces of the architect John Carr of York, built between 1776 and 1783, but by that time unoccupied for nearly thirty years, derelict, vandalized and in most people's eyes fit only for demolition. Their repair of the house, skillfully using fittings from another ruinous Carr house, Panton in Lincolnshire, and their acquisition of appropriate pictures and furniture over a number of years must be regarded as one of the great country house success stories of the post-war period. In 1981

they generously gave Basildon to the National Trust with most of the collection and a large endowment, so as to safeguard its future in perpetuity. The house is now regularly open to the public, and Lord and Lady Iliffe continue to live in a wing.

In 1964, on Kenneth Clark's recommendation, Lord Iliffe had bought all Graham Sutherland's drawings for the Coventry Cathedral tapestry, and presented them to the city's Herbert Art Gallery and Museum. He also became a personal friend, owning a villa in the south of France, near the artist's, and not far from St. Jean Cap Ferrat, where Sutherland's celebrated portrait of Somerset Maugham had been painted in 1948. This picture of the great writer, which launched Sutherland as a portrait painter for the first time in his mid-forties, was a prelude to a series which was remarkable not for its size (he painted less than forty sitters in nearly thirty years), but for its combination of an intense psychological observation with a sense of organic unity, already found in his landscapes. Their subjects were, by choice, always creators, or "people who have wielded some degree of power or responsibility—statesmen, churchmen, industrialists, financiers, lawyers, patrons of the arts, publishers, writers, musicians" (Hayes 1977, 16). The portrait of Lord Iliffe, less grand and monolithic than the controversial *Sir Winston Churchill* (now destroyed), and less flamboyant than the full-length *Marquess of Bath* (Longleat), reveals a quiet strength of character. "I was a most difficult subject," the sitter recalled with typical modesty, "my mother used to say I had no likeness" (Berthoud 1982, 285). The seeming casualness of the pose is counterbalanced by the emphatic geometry of the design, based on interlocking squares, rectangles, and triangles, with the impression of weight increased by setting the figure deliberately low. The fiery orange of the background color particularly recalls the south of France, and the heat of those parched rock-scapes, with their bleached shells, insects, animal skulls, and twisted olive trees, which the painter found so powerful an inspiration. G.J-S.

579

VIEW OF HAREWOOD c. 1960
John Piper b. 1903
watercolor
36.8 × 56.8 (14½ × 22⅜)

Harewood House
The Earl and Countess of Harewood

In 1797, three of the greatest English watercolorists, John Varley, Thomas Girtin, and J.M.W. Turner, came to Harewood together at the invitation of Edward, Viscount Lascelles, himself an amateur painter of considerable talent. Their resulting pictures of the house and park, now gathered together with earlier views by Thomas Malton in the Princess Royal's Sitting Room, form a collection that can be matched by no other English country house. It was with this tradition of patronage in mind that the present Lord Harewood commissioned another series of watercolors from John Piper in the 1950s. The artist had already shown himself to be the leading exponent of the topographical tradition in England with his wonderfully atmospheric pictures of Renishaw in Derbyshire, painted for Sir Osbert Sitwell, and with those of Windsor, made in the early years of the war for King George VI. Of this last commission, Piper wrote to John Betjeman: "I follow unworthily in the footsteps of Paul Sandby, who did 200 water colours for George III which I am instructed to look at earnestly before starting" (MSS at University of Victoria, British Columbia; see London, Tate 1983, no. 56).

The Harewood commission, with even greater artists to match, must have seemed still more daunting, but Piper's sense of drama and gift for portraying buildings almost geologically, as if they had emerged from solid rock, alternately battered by storm and caressed by sun, resulted in some of his most notable country house portraits.

This view of the north or entrance front of Harewood around 1960 shows the house little changed since Malton's watercolors of the 1780s, except for the extra stories to the pavilions and the heavy balustrade, chimneystacks and urns on the main block, which Sir Charles Barry added to Carr of York's building in 1843. The golden Yorkshire stone, blackened by smoke from nearby Leeds, has since been cleaned. But Piper has taken obvious pleasure in the way the grime picks out the classical articulation of column and pilaster, highlighting the advance and recess of architectural masses. His partiality for leaden skies, lowering unforgettably over Vanbrugh's Seaton Delaval or Inigo Jones' Stoke Park Pavilions, led the king to commiserate with him over the bad weather he must have experienced at Windsor. But these images of country houses as embattled fortresses, powerfully resisting the hand of the demolisher and the developer, were appropriate symbols for a post-war Britain too inclined to accept the idea of progress for its own sake. G.J-S.

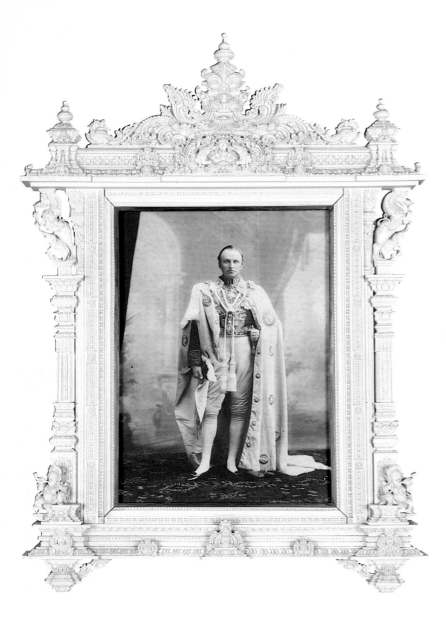

580

LORD CURZON OF KEDLESTON AS
VICEROY OF INDIA 1899/1904
Indian (Travancore)
photographic print in ivory frame
66.8 × 46 (26¾ × 18)

Kedleston Hall
The Viscount Scarsdale and the
Trustees of the Kedleston Estate

The photograph shows George Nathaniel, Marquess Curzon of Kedleston (1859–1925) robed as Grand Master of the Star of India on the occasion of the Coronation Durbar, Delhi, January 1903. The carved ivory frame employs traditional motifs from the temple architecture of South India. It takes the form of an elaborately decorated niche flanked by columns surmounted by brackets comprising lions rearing above small elephants (*yali*). Dwarf attendants (*gana*) blowing conch-shell trumpets perch on the base of each column. The tympanum of the niche comprises an auspicious lion-mask (*kirttimukkha*) spewing forth vegetation, which terminates in the tail feathers of two birds. Elephants hold up Vishnu's conch-shell emblem in the center below the mask and a small shrine containing a *shiva linga* flanks each end.

The frame can be attributed to Travancore ivory carvers and was presumably executed in 1902 as a gift to the Viceroy during the Durbar. Examples of ivory carving sent by the Maharajah of Travancore from the School of Art in Trivandrum were highly praised in the catalogue of the exhibition held in Delhi at the time of the Coronation Durbar of Edward VII.

Lord Curzon, who inherited Kedleston from his father in 1916, married two American heiresses, Mary Leiter of Washington, D.C. in 1895, and after her death Grace Monroe Hinds of Alabama. Having served as Foreign Secretary from 1919 to 1924, and afterward as Lord President of the Council, he devoted much of the remaining years of his life to the saving of Bodiam Castle in Kent, Tattershall Castle in Lincolnshire and Montacute House in Somerset, all of which later passed to the National Trust, and which encouraged the development of the Trust's Country Houses Scheme.

The Indian Museum at Kedleston contains an exhibition of silver, miniatures, ancient weapons, textiles, and other works of art collected during Curzon's time in India, while some important eighteenth-century ivory chairs and footstools elsewhere in the house were recently acquired by the National Heritage Memorial Fund for preservation in the collection. R.W.S.

Literature: Watt 1903, 185, 187–8

581

PIECES FROM
THE CLIVE OF INDIA COLLECTION

Powis Castle
The National Trust (Clive Collection)

The Clive collection of Indian art was begun by the great Lord Clive, Clive of India (1725–1744) whose victories at Arcot in 1751 and Plassey in 1757 made him a national hero and laid the foundations of Britain's Indian Empire. Robert Clive arrived in India in 1744 at the age of eighteen. For the eldest son of an impoverished country squire, it was hoped that a career as an East India Company merchant would be sufficiently lucrative to restore the family fortunes. However, Clive quickly transferred into the military branch of the service. The heroic defense of Arcot established his reputation, but it was his defeat of the Nawab of Bengal at Plassey in 1757 that created the Clive legend. Clive's subsequent annexation of Bengal marked the first stage in Britain's eventual domination of the Indian subcontinent. As well as territory for the Company, Clive amassed riches for himself. By 1771, his estates at home comprised five houses, a magnificent art collection (see nos. 193 and 224), and 20,000 acres. Rebutting parliamentary criticism of his activities in India, Clive made the celebrated remark: "When I recall entering the Nawab's Treasury at Murshidabad with heaps of gold and silver to the right and left, and these crowned with jewels, by God at this moment do I stand astounded at my own moderation!"

Clive's son, Edward, second Lord Clive (1754–1839), was appointed Governor of Madras in 1798. The following year, war was declared on Tipu Sahib, Sultan of Mysore, an implacable enemy of the British. After a swift campaign, Tipu was killed on 4 May 1799 and his capital Seringapatam, the richest city in south India, lay at the mercy of the victorious British army. There followed an orgy of looting, which left many of the soldiers richer than their officers. Choice pickings from the captured city found their way into Lord Clive's collection, including the dead Sultan's embroidered shoes, a gold tiger's head from his throne, and most extraordinary of all, his state tent

of painted chintz. Tipu's defeat was celebrated by a banquet at which Lord Clive's immediate superior, the Governor-General, remarked: "it seemed impossible there should be a great victory in this Country without Clive being concerned in it."

There have been Indian curiosities at Powis Castle since at least 1816 when a visitor was surprised to find a life-size "…model of a war elephant, entirely covered with a coat of mail and bearing a spear fastened to the forehead and swords to its tusks, which was brought home by the celebrated Lord Clive, Governor of India." Part of the elephant armor is still at Powis, together with a glittering array of Indian loot comprising seventeenth- and eighteenth-century paintings, bronzes, furniture, armor, weapons, textiles, and gold and silver encrusted with jewels.

The dagger, with a pommel in the form of a goat's head, with onyx eyes and a large ruby in gold, is one of a number of Mughal pieces in the collection. Both this and the betel nut cutters are probably those referred to in an account of Lord Clive's property made in about 1774 at his house at Claremont in Surrey, as "A curious Dagger wh Goatshead curiously carv'd large Ruby on the head and 2 Sardonyx Eyes," and "A curious pair of bettlenut Cracker," and listed again in an inventory of his Indian curiosities dated 17 March 1775 (Powis Castle MSS). Betel nut is the main ingredient of *pan* and is finely chopped before being mixed with the lime and aromatic spices that fill the betel leaf to make a quid for chewing. Wherever *pan* is used, betel nut cutters are made, and range from the sturdy and utilitarian to the more refined and decorative, as exemplified by this pair. C.N.R./S.S.

Provenance: Robert Clive, 1st Lord Clive of India, or his son Edward, 2nd Lord Clive, who married Henrietta Antonia, sister of the 2nd Earl of Powis; by descent at Powis to their great-grandson, the 4th Earl, on whose death in 1952 Powis Castle and its collections were bequeathed to the National Trust
Exhibitions: London, V & A 1982 (334, 409)

PAIR OF BETEL NUT CUTTERS C.1765
Lucknow
silver-gilt and enamel
18.5 × 5.5 (7¼ × 2⅛)

DAGGER AND SCABBARD 17th century
Mughal
enameled jade hilt, steel blade overlaid with gold
41 (16) long

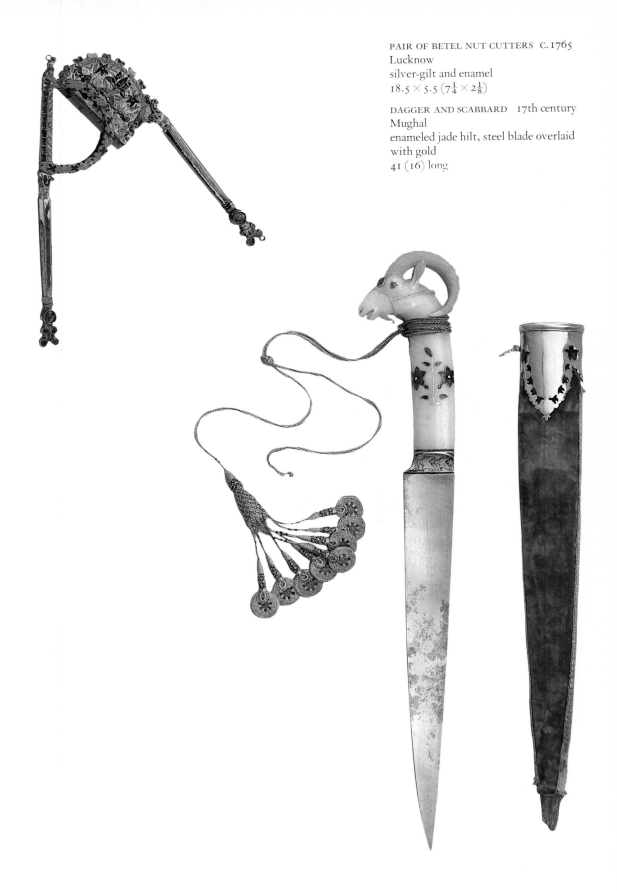

582

ADDRESS CASKET 1923
Indian (probably Calcutta)
silver on an ebony stand supported
by silver-gilt half lions
$38.7 \times 63.5 \times 30.4$ $(15\frac{1}{2} \times 24\frac{7}{8} \times 12)$

Knebworth House
The Hon. David Lytton Cobbold

The boat is a typical cargo vessel as seen in the Ganges-Brahmaputra delta near Faridpur. It has a single square sail and a woven bamboo superstructure, which is in the form of a detachable casket with a hinged lid. This contains an address from the Commissioners of the Municipal Corporation of Faridpur to H.E. the Rt. Hon. Victor Alexander Robert Bulwar [sic] Lytton P.C., G.C.I.E., Earl of Lytton, Governor of Bengal, on the occasion of his first visit to the town on 17 August 1923. There is another address (2 copies) from the Faridpur District Muslim Association of the same date. The choice of a cargo boat as an address casket is unusual and may be intended to lend extra force to the following plea in the text of the address: "My Lord, the town of Faridpur used to have the advantages of the river running through the town southwards. The complete silting up of the eastern channel and shifting of the Padma further north resulted in the silting up of the canal and thus the town being cut off from the central and southern parts of the District for the major portion of the year. This stands in the way of the expansion of the town as it blocks the development of trade and commerce." The casket was probably made in Calcutta in the year of presentation.

Lord Lytton's grandfather, the novelist Edward Bulwer-Lytton, who remodeled Knebworth in a romantic "Tudorbethan" style in the 1840s, was also a politician whose friendship with Disraeli led to his appointment as Colonial Secretary. His son, Robert, 1st Earl of Lytton, served as Viceroy of India, while the 2nd Earl continued the tradition as Governor of Bengal and later acting Viceroy. The Delhi Durbar Room at the house now contains a large collection of mementoes brought back from the sub-continent including a large silver replica of the throne of the Maharajah of Mysore, presented to the 1st Earl in 1877 when he proclaimed Queen Victoria Empress of India. R.W.S.

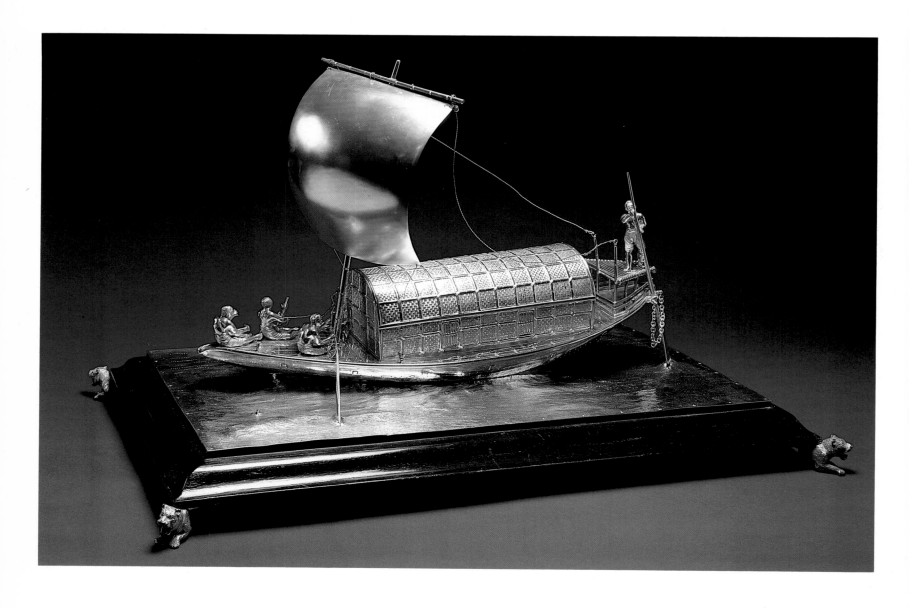

583

BUDDHA SHAKYAMUNI late 18th/
early 19th century
Burmese gold, inlaid with diamonds
and rubies
17.2 (6¾) high
inscribed on the accompanying label,
Presented to the Countess of Dufferin by
General Sir H. Prendergast, V.C., K.C.B.
and the troops of the Burmah Field Force,
Mandalay, February 1886

Clandeboye
The Marquess of Dufferin and Ava

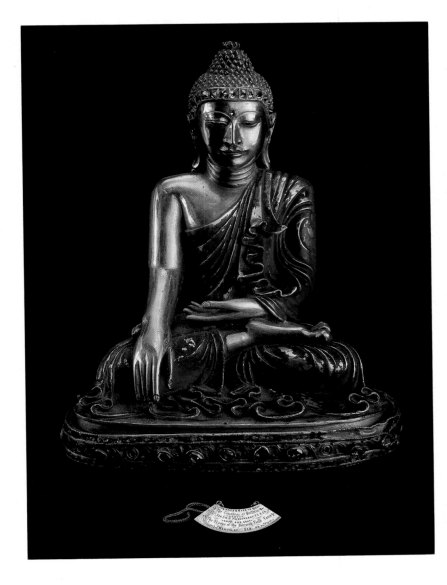

This is an extremely fine example in
gold of one of the most characteristic
forms of Buddha to be found in Burma.
He is seated in the posture known as
Bhumisparsamudra, which means "Earth
Witnessing." When the Buddha was
seated in meditation during the night
before he achieved enlightenment, he
was tempted by the demon Mara. Mara
asked him who could swear that they
had received alms from the Buddha. In
reply the Buddha touched the earth
and said the earth would bear witness
that he had given alms to such an extent
in his previous life that the earth
trembled.

This Buddha is in what is called the
Mandalay style, which dates from the
late eighteenth or early nineteenth
century. Almost all similar images are
made of gilt bronze, but this example is
exceptionally rare because it is made of
pure gold. It is supposed to have been
the personal Buddha of the Burmese
King Theebaw in his palace at Mandalay,
and was probably made for him.

Frederick, 5th Baron and 1st Earl of
Dufferin (1826–1902), was Viceroy of
India in the 1880s and annexed Burma
for the British crown in 1886 as a result
of the Burmese having concluded a treaty
with the French. However, Lord Dufferin
maintained that the country should be
treated as a separate entity from India.
In 1888 he was created a marquess and
took the title of Dufferin and Ava, Ava
being the old Burmese capital. The
Buddha was presented to his wife,
the Countess, and has been kept at
Clandeboye ever since (see Nicolson
1937).

The Buddha is hollow because it was
cast by the "lost wax" method, that is
to say a wax model was made over a
clay model and then liquid gold poured
into the mold. Religious texts, prayers,
and relics were placed inside the Buddha
and it was then sealed with a gold plate
by a Buddhist priest. A.G.

Related Works: For a similar example in
marble, see the Victoria and Albert
Museum, IM 239/1923

584

FABERGÉ FROM THE WERNHER
COLLECTION c.1892/1914
Peter Carl Fabergé 1846–1920

Luton Hoo
The Wernher Collection
Mrs. Harold Phillips and
Mrs. David Butter

No goldsmith has achieved greater
fame than Carl Fabergé, jeweller
to the Imperial Russian Court, and
although by far the greatest holdings
of his work in Britain are now in the
Royal Collection, mostly bought for
Sandringham by the Dowager Tsarina's
sister Queen Alexandra, examples can
also be found in a number of country
houses including Arundel Castle (a large
icon made for the 15th Duke of Norfolk
in 1908), Broadlands in Hampshire
(Mountbatten of Burma Collection),
and Bamburgh Castle in Northumberland
(Armstrong Collection). Outstanding
among these, both in terms of quantity
and quality, is the collection owned by
Lady Zia Wernher (d. 1977), mostly
inherited from her father Grand Duke
Michael of Russia, a grandson of Tsar
Nicholas I, and his wife the Countess
de Torby, a granddaughter of the poet
Pushkin. Lady Zia was born in 1892 and
came to England soon afterward, living
first at Keele Hall in Staffordshire, and
later at Kenwood, Hampstead (after-
ward bought by the Earl of Iveagh).
She herself married Sir Harold Wernher,
3rd Bart., and from 1948 they lived
at Luton Hoo, the country house in
Bedfordshire originally built by Robert
Adam for the 3rd Earl of Bute (see no.
307), but badly burned in 1843. Sir
Julius Wernher, who acquired it in 1903,
had made a fortune in diamond mining
in South Africa, and remodeled the house
to designs by Mewes and Davis, filling
it with a remarkable collection of old
masters, porcelain, enamels, ivories,
and other works of art, exhibiting a
taste similar to that of contemporary
American collectors such as J. Pierpont
Morgan and Isabella Stewart Gardner.

His wife, later Lady Ludlow, continued
to live at Luton Hoo from his death in
1912 until the outbreak of the Second
World War, and it was she who acquired
the first piece of Fabergé to enter the

collection, the large nephrite tray—perhaps bought at the firm's London branch, started in 1903, and subsequently at premises in Dover Street and New Bond Street, run by Fabergé's son Nicholas. All the other pieces displayed here belonged to the Grand Duke Michael and the Countess de Torby, except for the necklace of Easter eggs, which was given to Lady Zia as a child, and the so-called freedom box, bought by Sir Harold some time after 1935, and formerly at Wilton in the collection of the 15th Earl of Pembroke. (I am indebted to Mr. M. Urwick Smith, curator of the Wernher Collection, for much of the information contained here and in the following entries.) G.J-S.

DISH OR TRAY
nephrite, with handles in gold studded with rose-diamonds and inlaid with translucent red enamel
mark of the workmaster Michael Perchin
44.4×25.5 ($17\frac{1}{2} \times 10$)

About seven of these magnificent trays in nephrite and other materials are known to have been made by Fabergé, each one varying in design and size. A comparable example from the Dutch royal collection, given to Queen Wilhelmina as a wedding present from the Dutch colony in St. Petersburg in 1901, also bears the mark of Michael Evlampievich Perchin (1860–1903), one of Fabergé's most trusted and prolific craftsmen (London, V & A 1977). A peasant by origin, Perchin opened his workshop in 1886 and is thought to have made all twenty-six Imperial Easter eggs produced between then and the time of his death. The heavy rococo style of the handles looks back to Rastrelli and other St. Petersburg architects of the eighteenth century, rather than to the lighter Louis XV ornament seen in other pieces of slightly later date.

Literature: Snowman 1962, fig. 279; Bainbridge 1966, pl. 22
Exhibitions: London, Belgrave Square 1935 (527; lent by Lady Ludlow); London, V & A 1977 (P3)

FREEDOM BOX
nephrite, mounted in polished red gold and green gold; double-headed eagle in matt yellow gold with orb, scepter and parts of crown polished
mark of the workmaster Michael Perchin
24 ($9\frac{1}{2}$) high

Probably designed to hold an address or the freedom of a city presented by the Tsar, this box was traditionally given by Nicholas II to Sidney Herbert, 14th Earl of Pembroke, in 1896 when the latter was attached to the Imperial suite during a visit to Queen Victoria at Balmoral. Its neoclassical form is typical of many of Fabergé's larger pieces and reminiscent of some of the miniature versions of Louis XVI furniture that the firm also made. The shield set against the double-headed Imperial eagle depicts St. George and the dragon.

Literature: Snowman 1962, fig. 275; Bainbridge 1966, 8, pl. 8
Exhibitions: London, Belgrave Square 1935 (508; lent by the 15th Earl of Pembroke); London, V & A 1977 (P4)

THREE SPRAYS OF FLOWERS
lily of the valley with pearl and rose-diamond flowers, pearl buds, and engraved nephrite leaves: 11.4 ($4\frac{1}{2}$) high; forget-me-not with turquoise petals and rose-diamond centers, green enamel leaves: 16.5 ($6\frac{1}{2}$) high; wild strawberry with enamel fruits, split pearl, and rose-diamond flower, and nephrite leaves: 10.2 (4) high; all in rock crystal pots
base of wild strawberry engraved, *C. Fabergé St. Petersburg*

Fabergé's flower sprays, perennial favorites of the Edwardian hostess, show his work at its most precise and exquisite and would have been placed on boudoir tables and in the little Louis XV style display cases so popular at this period. Each of these sprays is removable from its rock crystal vase, made to look as if filled with water, and could thus be worn as a posy pinned at the corsage or on the lapel, in the fashion of the time. The Luton Hoo collection also boasts a gypsophila, which formerly belonged to Queen Olga of Greece. Among the most delicate and fragile of all the flowers Fabergé produced, it reacts to the slightest vibration, appearing to be in almost perpetual motion. H.C. Bainbridge, who as manager of the London branch visited the St. Petersburg workshops constantly before 1917, records that a young Russian craftsman named Kremleff specialized in the flower sprays, though he had no mark, and these could well be examples of his work, with the enameling either by W. Boitzoff or the Petroffs, Alexander and his son Nicholas (Bainbridge 1966, 126).

BELL PUSH AND CIGARETTE CASE
bell-push in scarlet and white enamel with green gold ornaments and a moonstone push-piece, on a nephrite base: 5×6.3 ($2 \times 2\frac{1}{2}$); cigarette case of silver-gilt decorated with red enamel and bands of foliage in green gold, the lid with an Imperial eagle in rose-diamonds, rose-diamond thumb piece, and match compartment: 8.3×5.7 ($3\frac{1}{4} \times 2\frac{1}{4}$)
cigarette case with the mark of the workmaster August Fredrik Hollming

Some of Fabergé's most satisfying designs were made for objects that were unknown in the eighteenth century. The invention of the electric bell meant that the old system of bell ropes and

brass wires still seen in many country houses was made obsolete, and bell pushes could now be disguised as jeweled toys or bibelots on the drawing room table. This example is comparable with one at Broadlands given by the Tsar to Princess Alice of Hesse, the mother of the late Lord Mountbatten, who later had it adapted to a form of radar, signaling from the dining room to the butler's pantry so as to dispense with the need for a cord. Cigarette cases were perhaps the most popular and numerous of all the objects made in Fabergé's workshops: in platinum, gold, silver, enamel, precious stones, or even wood, such as Karelian birch, delicately ornamented with gold. August Hollming, a Finn from Tavasthus, was a specialist in the production of these slimmer and more elegant versions of the eighteenth-century snuff box.

EASTER EGG NECKLACE
gold chain with eggs in various hardstones, gold, silver and silver-gilt, some enameled and some set with small stones
52 (21) approx.
mark of Michael Perchin on two eggs, August Hollming on five, and Erik Kollin on three

The Imperial Easter eggs, given by the Tsar to the Tsarina every year and containing exquisite "surprises"—a mechanical jewel-encrusted peacock made to strut about and spread its tail; a tiny working model of the state coach; or an extending screen of miniatures of the Imperial family—are among Fabergé's most celebrated creations. But smaller eggs of every hue, and in every medium, were sold at Easter-tide at 24 Morskaya Street, his premises in St. Petersburg, on large heart-shaped trays. This necklace is made up of eggs given to Lady Zia Wernher when young, and the fact that there are forty of them probably represents the forty days between Easter and Ascension Day, the period in which they would have been worn. Erik August Kollin (1836–1901), who was essentially a goldsmith, worked for Fabergé longer than any workmaster except for August Holmstrom, though his pieces are less often found today. It was he who made the reproductions of the Scythian Gold from the Hermitage in 1885, winning the gold medal at the Nuremberg Fine Art Exhibition; like many other craftsmen working for the firm, he was a Swedish Finn.

FIVE ANIMALS

obsidian bear with rose diamond eyes 7.5 (3) high; nephrite cock with cabochon ruby eyes and gold feet: 10 (4) high; obsidian walrus with white agate tusks and rose-diamond eyes: 7 (2¾) long; nephrite frog with diamond eyes: 9.5 (3¾) high; lapis lazuli elephant with rose-diamond eyes: 4.4 (1¾) high

Fabergé's animals, made with an unerring choice of hardstones to represent the feel of fur, feathers, or fish scales, were among Queen Alexandra's favorites. A team of artists was sent to Sandringham to make wax models not only of Edward VII's Derby winner Persimmon, his rough-haired terrier Caesar, and the queen's Pekingese, but a whole farmyard of heifers and bullocks, cocks and hens, turkeys, shire horses and even pigs—and these models were then shipped back to St. Petersburg to be

cut in Fabergé's workshop (Bainbridge 1966, 101–103). Others too found his humorous depiction of animals irresistible: Countess de Torby's particular favorites were the elephants, which form a whole series in the Luton Hoo collection. The nephrite frog is fashioned as a parasol handle, and is similar to one in the Royal Collection marked *H.W.*, for Henrik Wigström, who took over Perchin's workshop after his death in 1903 (Snowman 1979, 131 ill.). Another workmaster who specialized in executing animals in stone, but who had no mark, was the German-born Karl Woerffel.

Literature: Snowman 1962, fig. 249 (bear, cock, walrus, and frog); Bainbridge 1966, pl. 80 (bear and elephant)
Exhibitions: London, V & A 1977 (R7) (obsidian bear); New York, Cooper-Hewitt 1983 (102)

585

MADONNA AND CHILD 1951
Sir Jacob Epstein 1880–1959
lead
35 (13¾) high

Dalmeny House
The Earl of Rosebery

This is a maquette for the thirteen-foot high lead group commissioned from the sculptor by the Society of the Holy Child Jesus in Cavendish Square, London, and considered by many to be his finest monumental work. The convent occupied two identical Palladian houses on the north side of the square, built about 1770 and with a narrow lane between them that was to be spanned by a windowless bridge designed by the architect Louis Osman. The sculpture, pinned to the flat wall of this bridge, was thus to become the focal point of a grand architectural unit, and with the encouragement of Sir Kenneth Clark and the Arts Council, Epstein undertook his first commission to adorn a building for twenty years, though the fee was only a thousand pounds.

In the lead maquettes, of which three or four examples exist, the Virgin's head was based on that of his second wife, Kathleen Garman, but the nuns, who approved the design, asked that the Madonna's expression be more resigned, and in the finished group, unveiled in 1953, the head is that of the Italian pianist, Marcella Barzetti. The maquettes also show a softer modeling and less hieratic character than the final version: the Christ Child's outstretched arms, foreshadowing the Crucifixion, are less rigidly horizontal and the Virgin's stance is more protective. As with the later *Christ in Majesty* at Llandaff Cathedral, the modeling of the draperies and the feet seems to recall the Romanesque sculptures of Moissac and Chartres.

While it could hardly be said that country house patronage was central to Epstein's career, the demand for his portrait busts after the Second World War resulted in some of his finest works, including those of Gwen, Lady Melchett, of 1950, Lady Anne Tree of 1951 (formerly at Mereworth Castle), and the Hon. Robert Fermor-Hesketh (Easton Neston). G.J-S.

Provenance: Sotheby's, London, 18 July 1973; acquired by Lord Primrose, later 7th Earl of Rosebery
Literature: Buckle 1963, 340–343, 358–359, fig. 534

586

SEATED WOMAN ON BENCH 1953
Henry Moore b. 1898
bronze
20.9 × 16.5 × 13.9 (8¼ × 6½ × 5½)

The Castle Howard Collection

One of an edition of nine, this little statuette, with its subtle green patina, is in the long tradition of "cabinet bronzes," popular among English collectors since the eighteenth century and earlier. The seated female figure, a favorite subject to which the sculptor returned again and again, goes back to the Northampton *Madonna and Child* of 1943–1944, one of his first large-scale commissions. But the smooth and rounded forms of this and his other early "family" groups had, by 1952, given way to the angularity of the *King and Queen*, made for Sir Henry Keswick and placed with wonderfully dramatic effect on a Scottish grouse-moor, where they still provide one of the most unexpected of British country house experiences.

This figure of 1953 still has the finely drawn calligraphic quality of the *Reclining Figure* shown by Moore at the Festival of Britain: "the bone-smooth surface of the bronze offset with a network of fine raised lines that in some pieces run counter to the movement of the form and in other places emphasize it" (Russell 1973, 148, fig. 73). The diagonal pose of the legs recalls some of Rodin's seated figures such as the *Cybele* of c. 1889 (now Wasserman Collection, Massachusetts), but it can also be found in some of Moore's moving studies of huddled sitting and sleeping figures, taking shelter in London Underground stations during the war. According to Moore himself, these drawings had convinced him that he ought to experiment with the use of more naturalistic draperies, and "my first visit to Greece in 1951 perhaps helped to strengthen this intention. Drapery can emphasize the tension in the figure, for where the form pushes outward, such as on the shoulders, the thighs, the breasts, etc., it can be pulled tight across the form (almost like a bandage), and by contrast with the crumpled slackness of the drapery which lies between the salient

points, the pressure from inside is intensified. Also in my mind was to connect the contrast of the sizes of folds, here small, fine, and delicate, in other places big and heavy, with the form of mountains, which are the crinkled skin of the earth" (Moore 1955). As John Russell points out, this powerful analogy paradoxically "disposes altogether…of the idea that the draped statues owe anything substantial to Greek art…drapery, for Moore, was another way, and a new one, of mediating between landscape and the human body"—and a directly parallel development can be seen in the portraits of Graham Sutherland (see no. 578).

This statuette was bought by George Howard, later 1st Lord Howard of Henderskelfe (see no. 587), for his private sitting room in the family wing at Castle Howard, where it was placed alongside bronzes by Rodin, Giambologna, and Pollaiuolo, theatrical scenes by Zoffany, and a *Peasant Wedding* by Brueghel—testimony not only to his wide interest in the arts of every period, but to his love of humanity in all its forms. G.J-S.

Literature: Moore 1955, 2:no. 356

GLASS ENGRAVED WITH THE TEMPLE
OF THE WINDS, CASTLE HOWARD 1959
Laurence Whistler b. 1912
glass
inscribed, *The Temple Restored 1959*,
and on the foot, *George from Cecilia, Ela
and Charley*
22.8 × 8.9 diam. $(9 \times 3\frac{1}{2})$

The Castle Howard Collection

This goblet, blown to the artist's design,
is engraved with a moonlight view
of Sir John Vanbrugh's Temple of
the Four Winds at Castle Howard,
built in 1725–1728 and one of the
architect's last works, with Hawksmoor's
Mausoleum beyond, to the right. Made
to commemorate the restoration of the
temple, which involved the complete
reconstruction of the dome, it was a
gift to George Howard (1920–1985),
later Lord Howard of Henderskelfe,
from his wife Lady Cecilia, daughter of
the 8th Duke of Grafton, and his cousins,
the 12th Earl and Countess of Carlisle.
George Howard, who had inherited the
house and estate in 1944, made the
preservation and upkeep of Castle
Howard his life's work, also becoming
first president of the Historic Houses
Association and chairman of the British
Broadcasting Corporation.

Laurence Whistler, the younger
brother of the painter Rex Whistler
(see no. 575), and a great-great-grandson
of the silversmith Paul Storr (see nos.
463 and 465), conceived a passion for
Vanbrugh while still a schoolboy at
Stowe, and wrote one of the first full-
length biographies of the architect in
1938 (revised and enlarged in 1954). It
was while engaged on research work for
this book that he first came to Castle
Howard, becoming a close friend of the
family. By this time he had already
revived the dead art of point-engraving
on glass, encouraged by Lady Ridley of
Blagdon in Northumberland (where his
first window pane survives) and her
father, Sir Edwin Lutyens. Whistler's
romantic views of country houses, real
and imagined, not only show the highest
technical skill in this difficult medium,
but reflect a new awareness of Britain's
eighteenth-century heritage at a time
when the Georgian Group had only
recently been founded, and when so
many buildings of this period were still
threatened with decay and demolition.

G.J-S.

Literature: Whistler 1975, 29, 49, fig. 16

GLASS ENGRAVED WITH A VIEW
OF HEVER CASTLE 1960
Laurence Whistler b. 1912
glass
initialed and dated
22.8 × 8.9 $(9 \times 3\frac{1}{2})$

The Lord Astor of Hever

With its view of the medieval gatehouse at Hever by moonlight, this glass was intended as a pair to one with a daytime view, engraved three years earlier (Whistler 1959, 80). Hever in Kent is a moated fourteenth-century house, bought in 1462 by Sir Geoffrey Bullen or Boleyn, whose granddaughter, Anne, married Henry VIII. Afterward used as a farmhouse, it was acquired in 1903 by William Waldorf Astor (later 1st Viscount Astor), heir to an immense American fortune, who had come over to settle in England in 1890 and was already the owner of Cliveden in Buckinghamshire. On the marriage of his eldest son Waldorf to Nancy Langhorne in 1906, Astor decided to give Cliveden to them as a wedding present, and made Hever his home. The building was restored and enlarged by the architect F.L. Pearson with the greatest tact and sensitivity, and guest quarters provided in the form of a cluster of stone and half-timbered cottages, like a village huddled close to the walls of the castle. On his death in 1919 he left the estate to his second son John Jacob, later 1st Lord Astor of Hever, chief proprietor of *The Times* from 1922 to 1966, and it was he who commissioned this glass and its companion.

Hever was sold by the family in 1983, when a large proportion of the collection was dispersed, but the castle and gardens, which still contain important Roman and Italian Renaissance sculpture collected by William Waldorf Astor (see no. 220), are regularly open to the public. G.J-S.

Literature: Whistler 1975, 49, fig. 17

589

CIGAR HUMIDOR 1978
David Cawte b.1949
silver
16.8 (6⅝) high

Easton Neston
The Lord Hesketh

This cigar humidor, showing a continuing tradition of country house patronage, was commissioned by the Hon. John Fermor-Hesketh as a gift for his brother Alexander (who succeeded as 3rd Baron Hesketh in 1955) after his marriage in 1977 to the Hon. Claire Watson, daughter of the 2nd Lord Manton. The box, which is of silver weighing over 260 ounces and fully hallmarked, is a faithful model of Easton Neston in Northamptonshire, designed by Nicholas Hawksmoor and completed in 1702. Sir William Fermor, created Lord Lempster in 1692, initially approached Sir Christopher Wren for designs about 1685, but the final elevations, with a giant Corinthian order probably based on Louis XIV's Marly, and the highly ingenious planning of the interior, are undoubtedly due to Hawksmoor, who worked with Vanbrugh at Castle Howard and Blenheim, and who is revealed here as a figure of almost equal stature. A large part of the famous Arundel collection of antique marbles (see no. 49) was housed at Easton Neston until the mid-eighteenth century when it was bequeathed to the Ashmolean Museum, Oxford.

The house came into the Hesketh family through Lady Anna Maria Fermor, sister and co-heiress of the last Earl of Pomfret, who married Sir Thomas Hesketh, 5th Bart., of Rufford in Lancashire. Their son and grandson both married American heiresses: Florence Sharon, daughter of a senator from Nevada, and her cousin Florence Louise Breckinridge, granddaughter of General John Breckinridge, vice president of the United States. It was the first of these, Sir Thomas, 7th Bart., who restored the house and its formal gardens, which had been swept away during the late eighteenth century, and who crowned the parapet with stone lions and urns bought at the Stowe sale of 1922.

The present Lord Hesketh, a notable patron of motor racing, employed James Hunt, the future world champion, as driver for the Hesketh team, and transformed the stables at Easton Neston into a works producing highly sophisticated racing cars and, later, racing bicycles. G.J-S.

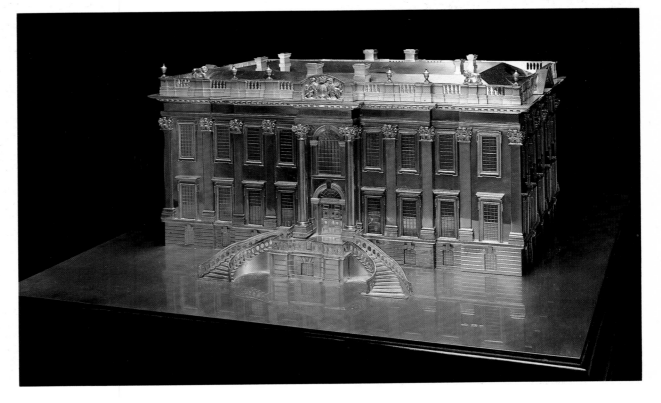

Epilogue: Life in the Country House

The history of collecting and patronage in the British country house is, above all, the history of the people who built them, and the people who lived in them, generation after generation. The long series of photograph albums that are to be found in most houses, in serried ranks on library shelves, or piled on drawing room tables for guests to leaf through on wet days or winter evenings, provide a fascinating insight into everyday life—both in the family's apartments "above stairs" and in the servants' quarters below, in parks and gardens, on lakes and grouse moors.

Some of the first photographs ever made were taken at a country house, Lacock Abbey in Wiltshire, in the 1830s and 1840s by its owner, William Henry Fox-Talbot, one of the pioneers of the new science. Since then, the camera has recorded aspects of the close-knit community life of a great household and its surrounding estate. We see tenants, farmers, game-keepers; gardeners, grooms, coachmen, and later chauffeurs; blacksmiths and estate carpenters; laundry and chamber maids, and housekeepers; cooks and their assistants; liveried footmen, valets, and all-knowing butlers; children, their nursery-maids and governesses; and the owners themselves; and finally a steady flow of guests (and their servants), house parties of visitors who joined in a variety of pursuits: shooting, fishing, and fox-hunting, dinners and amateur theatricals, cricket, and tea. Sometimes these photographs approach the high artistry of photographers like Julia Margaret Cameron and, in more recent times, Cecil Beaton—but more often they are the work of talented amateurs: members of the family, or occasionally footmen, trained to record the pursuits and pleasures of the moment.

A complete microcosm of English country house life, as well as a precious survival of Georgian craftsmanship, the celebrated Nostell Priory dolls' house, attributed to Thomas Chippendale, gives an equally vivid impression of the culture and sophistication of an eighteenth-century household, a hundred years before the dawn of photography.

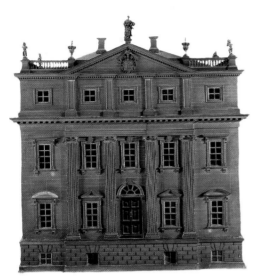

590

THE NOSTELL DOLLS' HOUSE
c. 1735/1745
attributed to Thomas Chippendale
1718–1779
carcass of oak with marble
chimneypieces and hearths; velvet,
watered silk, painted chintz, and other
textiles; walnut, mahogany, and ivory
furniture; brass, steel, silver, porcelain,
glass, and other ornaments; carved wood,
wax, and composition dolls
212 × 191.7 × 76.2 (83½ × 75½ × 30)

Nostell Priory
The Lord St. Oswald

Family tradition at Nostell Priory has always maintained that the eighteenth-century dolls' house, one of the great treasures of the collection, was made by Thomas Chippendale, and there may well be truth in this assertion. Chippendale made practically all the furniture supplied to Sir Rowland Winn, 5th Bart., Robert Adam's patron, who inherited the house in 1765, and these pieces are documented in an unrivaled series of contemporary bills, letters, and accounts. Unfortunately, the equivalent papers from the time of the 4th baronet, also called Sir Rowland, have been either lost or destroyed, and virtually the only evidence for the decoration and furnishing of Nostell in his time comes from a series of designs by his architect James Paine, and from some anonymous drawings for furniture including a bookcase, apparently referred to in letters by a York upholsterer, Robert Barker, junior, of 1763–1764 (Jackson-Stops 1974a, 24–37, figs. 10–18). The elder Barker was a subscriber to the first edition of Chippendale's *Director* (1754) and the only furniture-maker mentioned specifically as living outside London. But a much stronger reason for suspecting that Chippendale worked at Nostell in the 4th Baronet's time is provided by a drawing for the library on the north side of the house lit by a large Venetian window, which is undoubtedly in his hand and is an alternative to a scheme by James Paine (Jackson-Stops 1974, figs. 21 and 22). Neither of these drawings could possibly date from after 1765, when Robert Adam immediately enlarged this space to form a link with his proposed new pavilions, re-siting the library in an adjoining room of quite different dimensions.

In the absence of further documentary proof, recent writers have clung to the theory that Adam first introduced Chippendale to Nostell (Gilbert 1978, 169), but there are a number of pieces of earlier furniture in the house in an unashamedly rococo style, which are all comparable with engraved designs in the *Director*, and could easily be from his workshop. These include the four-post bedstead in the Amber (now the Crimson) Room (known to have been altered by him in 1767), the pier glasses here and in the Breakfast Room, and a

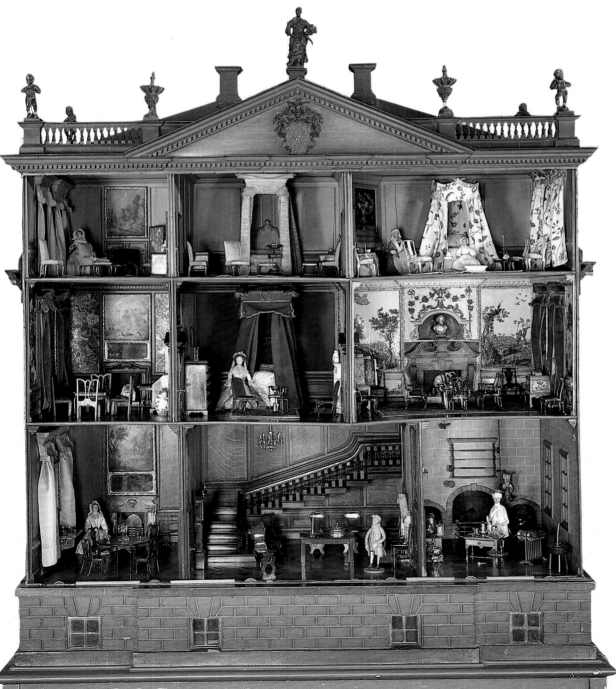

superb set of ribbon-back chairs, most of them sadly destroyed in a recent fire.

Chippendale's "missing years," from his birth at Otley (only a few miles from Nostell) in 1718, to his marriage in London in 1748, have caused much speculation. But there can be little doubt about his close links with James Paine, who may well have brought the cabinet-maker to London and introduced him to the circle of the St. Martin's Lane Academy, where he would have learned to draw from masters such as Hubert Gravelot (Fitzgerald 1968, 2–3). In his *Plans, Elevations and Sections of Noblemen's and Gentlemen's Houses*, published in 1767, Paine wrote, "at the age of nineteen I was entrusted to conduct a building of consequence in the West Riding... Nostell, the seat of Sir Rowland Winn."

Since he was born in 1717, this association with Nostell would therefore have begun about 1736. The building work, following an ambitious Palladian plan by Colonel James Moyser, a Yorkshire gentleman-architect in Lord Burlington's circle, was abnormally prolonged—perhaps because the family were relatively comfortable in the old converted priory nearby—and it was not until 1747 that Paine was giving directions as to the decoration of some of the rooms on the main floor. Even then only about half the state rooms seem to have been completed by Sir Rowland Winn's death in 1765.

Sir Rowland's arms, impaling those of his wife, Susannah Henshaw (whom he married in 1729), are carved in the pediment of the dolls' house, but this is

not to say that it definitely predates her death in 1742, for their children, Rowland, Edward and Anne, were then respectively three, two, and under one year of age—hardly old enough to play with such an elaborate toy. Of course such an elaborate construction may have been intended for the amusement of adults as much as children; but despite some old-fashioned features such as the paneling of the hall and parlor, the rectangular "landskip glasses" above some of the chimneypieces, and the baroque form of the beds, a date of about 1745 is possible in terms of the textiles and costumes, and much of the furniture.

The only other comparable dolls' house in a British collection is that at Uppark in Sussex, another house

where James Paine was almost certainly employed in the 1750s. However, this bears the arms of the Lethieuller family and was probably made for Belmont in Middlesex where Sarah Lethieullier (who married Sir Matthew Fether-stonhaugh in 1747) was brought up. The façades of the two dolls' houses have several features in common, but there are no very close parallels in Paine's known work, or in the engravings for his *Plans, Elevations and Sections of Noblemen's and Gentlemen's Houses*, and a more definite attribution cannot be advanced without further documentary evidence.

A brief tour of the dolls' house should begin in the oak-paneled entrance hall on the ground floor with its mahogany staircase and balustrade, pedimented white marble chimneypiece, and parquet floor. The footman here to greet the family's guests is dressed in the Winn livery of gray and yellow flannel, edged with braid. The overmantel painting of a King Charles spaniel and the overdoors —one of dead game and the other of a greyhound inspecting a dead hare—are typical of the sporting pictures found in many early eighteenth-century halls, like Wootton's series at Althorp and Longleat. The hall chairs are of a typical early eighteenth-century form, and the longcase clock is signed "J^no Hallifax/Barnsley," another reason for seeing the Nostell dolls' house as the work of native Yorkshire craftsmen rather than as the product of a firm of London cabinetmakers.

To the right of the hall is the kitchen, presided over by the splendid figure of the cook or steward, dressed in a tasseled cap, white linen coat with a diaper pattern (possibly cut from a tablecloth) and white stock, and holding a spoon and fork that he is about to polish with a napkin. Above the hearth is a spit mechanism with an elaborate winding gear obviously made to turn, though the roasting joints or fowls have disappeared. The dresser is magnificently arranged with silver plates, tankards, casters, and other tableware, mostly bearing a maker's mark *DB* but un-fortunately without a date letter. The dog, with a somewhat decayed black velvet coat, seems undisturbed by the glass mouse scurrying under the kitchen table.

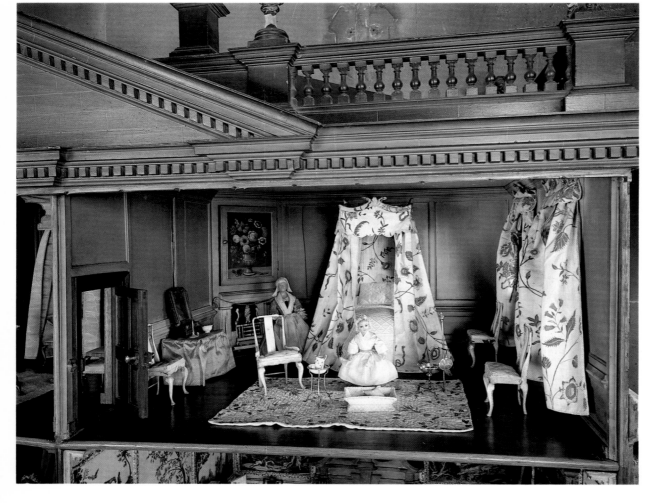

The parlor on the other side of the hall is also paneled in oak, and the gray marble chimneypiece carved with a central broken pediment and shell is not unlike some of those designed by Paine for the family and guests' bed-chambers on the second floor at Nostell. The combined overmantel picture and landscape glass are more old-fashioned in feeling, as are the valances of the blue silk window curtains. The overdoor *paysage* is in the same conventional taste as the overmantel, while the marble slab between the windows, on wrought-iron brackets, continues the theme of the chimneypiece. The mahogany gateleg table and the walnut splat-back chairs, with black horsehair seats (regularly used for eating rooms so as not to mark, or to retain the smell of food), are superbly made, and other details not to be missed include the steel fire-irons and the tiny wine glasses, with a stoppered decanter. The lady doll here looks earlier than some of her companions, and the style of embroidery on her dress is found as early as the Queen Anne period.

The drawing room on the first floor has some of the most elaborate decoration in the house. A gilt bust of a Roman emperor surmounts the chimneypiece with the demi-eagle of the Winn crest above, supporting garlands of carved and gilt fruit and flowers. The walls are decorated with cut-out engravings, colored to represent painted decoration rather than tapestries, for the scheme is continued below the dado. The pastoral scene to the left of the chimneypiece is signed "P. Mariette excu[dit]" for the Parisian engraver and publisher Pierre Mariette (1694–1774), who produced many such miniature scenes as intro-ductions or tail-pieces in his editions of La Fontaine and other classics. The cabinet and chest on stand are likewise decorated with tiny allegorical prints, but these are uncolored and mounted against gold shellac to give the impression of rare white and gold lacquer or coro-mandel. The splat-back chairs here are still more splendid than those in the parlor, with a pair of armchairs and pair of settees *en suite*, all with red velvet seats to match the window curtains. The silver tea table, the needlework carpet, in the style of an early eighteenth-

century Savonnerie, and the gilt enrich-ment of the Palladian mahogany door, add to the feeling of opulence.

The Red Velvet Bedchamber, adjoining the drawing room, is entirely hung with a red silk velvet that is remarkably unfaded. The shaped cornice of the bed and valances looks back to the engraved designs of Daniel Marot, but is also quite similar in form to the bed in the Amber Room at Nostell, for which an anonymous drawing exists in the archives (Jackson-Stops 1974a, fig. 15). The upholstered chairs made to match the bed have beautifully carved cabriole legs, and the walnut chest of drawers is made so that every drawer pulls out. The striking costume of the lady doll appears to be made from a fashionable striped dress material of the 1740s, with a lace headdress, shawl, and cuffs, while the white quilted silk coverlet is another miracle of the embroiderer's art. The white marble chimneypiece is appropriately decorated with a garniture of *blanc de chine*, and only the needlework carpet is modern.

The Red Velvet Dressing Room has a similar overmantel painting and landscape glass, but a black marble chimneypiece, and wall-panels painted and varnished to look like coromandel, with oriental lotus flowers, kingfishers, partridges, and other birds. This exotic note, very often found in dressing rooms and closets, is continued by the *famille verte* and blue-and-white porcelain. The walnut bureau-bookcase is as superbly made as the chest-of-drawers next door, and the olive green color of the paint-work (often described as "drab" in the eighteenth century) must also be original.

On the upper floor, the Chintz Bedroom is painted a soft blue that is a perfect background for the Indian chintz of the bed and window curtains, not unlike the palampores smuggled into this country for Mrs. David Garrick and seized by the customs officers at Chippendale's workshop (see no. 370), though smaller in scale and perhaps intended for a dress material. Chippendale was later to use chintz, lined with green silk, for Adam's State Bedchamber at Nostell, but this is thought to have been a Chinese hand-painted material, like the paper wall hangings that he

also supplied in 1771, and different in character from this printed cotton. The four ivory chairs look as if they can hardly date from later than the 1740s on grounds of style, yet they have thick cut-out cards below the seats, one of which reads "A/[CO]NCERT TICKE[T]/[?S]r PUGNANI." If this is a reference to the famous Turinese violinist Gaetano Pugnani (1731–1798), who was in London as conductor at the King's Theatre in 1767–1769, the cards must surely be a later reinforcement of the charming buttoned seats, rather than an original feature. The wax dolls of the little girl and her nursemaid can again be dated to the 1740s by the form of their costume, particularly the shape of the sleeves.

The Yellow Bedchamber and its dressing room, which complete the tour of the house, have bed hangings, chair covers, and window curtains of a rich yellow watered silk, once again a precious survival of an early eighteenth-century textile virtually untouched by daylight. The washstand in the bedroom is one of many in the house, some-times entirely of silver, sometimes (as here) of mahogany with a silver dish: reminders that these were far more common items of furniture than is now realized. The needlework firescreen in the dressing room is of a particularly fine stitch.

G.J-S.

Literature: Greene 1955, 118–119, figs. 74, 75

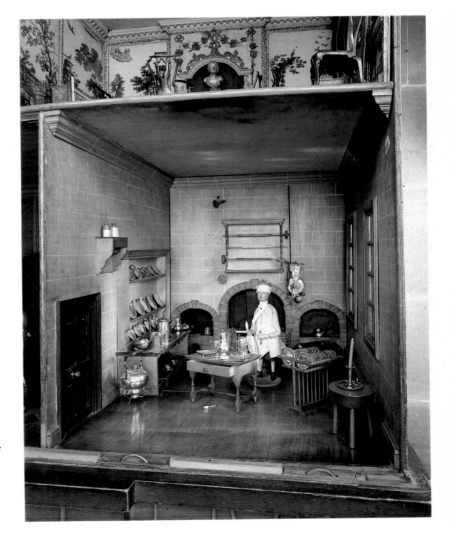

Bibliography

Abdy and Gere 1984: Abdy, Jane, and Charlotte Gere. *The Souls*. London, 1984

Abernon 1931: Abernon, Viscount d'. *Portraits and Appreciations*. London, 1931

Acton 1961: Acton, Harold. *The Last Bourbons of Naples, 1825–1861*. London, 1961

Addis 1979: Addis, J.M. *Chinese Porcelain from the Addis Collection. Twenty-two pieces of Chingtechen Porcelain presented to the British Museum*. London, 1979

Agnew 1896: Agnew, C. Morland. *Catalogue of the Pictures forming the Collection of Sir Charles Tennant, Bart., of 40 Grosvenor Square and The Glen, Innerleithen*. London, 1896

Albiker 1935 and 1959: Albiker, Carl. *Die Meissner Porzellantiere im 18 Jahrhundert*. Berlin, 1935. 2d ed. Berlin, 1959

Alexander 1957: Alexander, Boyd. *Life at Fonthill 1807–1822, with interludes in Paris and London, from the correspondence of William Beckford*. London, 1957

Allegri and Cecchi 1980: Allegri, Ettore, and Allesandro Cecchi. *Palazzo Vecchio e I Medici*. Florence, 1980

Ambrose 1897: Ambrose, George E. *Catalogue of the Collection of Pictures Belonging to the Marquess of Lansdowne, K.G., at Lansdowne House, London and Bowood, Wiltshire*. London, 1897

Ames 1967: Ames, Winslow. *Prince Albert and Victorian Taste*. London, 1967

Anderson 1972: Anderson, W.E.K., ed. *The Journal of Sir Walter Scott*. Oxford, 1972

Andresen 1863: Andresen, Andreas. *Nicolaus Poussin. Verzeichniss der nach seinen Gemälden gefertigten gleichzeitigen und späteren, kupferstiche*. Leipzig, 1863

Androssov 1975: Androssov, Sergey. "Predpolagaemoe proizvedenie Antonio Pollaiuolo." *Soobshcheniya Gosudarstvennogo Ordena Lenina Ermitazha* 40 (1975), 5–8

Angulo Iniguez 1981: Angulo Iniguez, Diego. *Murillo*. 3 vols. Madrid, 1981

Antal 1962: Antal, F. *Hogarth and his Place in European Art*. London, 1962

Antique Collector 1954: [Anon]. "Brockenhurst Park, Hampshire: The Residence of Mr. and Mrs. John Morant." *Antique Collector* 25, no. 4 (August 1954), 132–140

Archaeologia 1866: See Nichols 1866

Archer 1970: Archer, Michael. "The Making of a Ceramic Collection: Pottery and Porcelain at Wallington." *Country Life* (18 June 1970), 1135–1139

Archer 1975: Archer, Michael. "Delft at Dyrham." *National Trust Yearbook* (1975), 12–18

Archer 1976: Archer, Michael. "Pyramids and Pagodas for Flowers." *Country Life* (22 January 1976), 166–169

Archer 1983: See Exh. Amsterdam 1983

Archer 1984: Archer, Michael. "Dutch Delft at the Court of William and Mary." *The International Ceramics Fair and Seminar* (London, 1984), 15–20

Arnold 1980: Arnold, Janet. "Jane Lambarde's Mantle." *Costume* 14 (1980), 63–65

Asche 1978: Asche, S. *Baltasar Permoser*. Berlin, 1978

Ashby 1913: Ashby, T. "Thomas Jenkins in Rome." *Papers of the British School at Rome* 6, no. 8 (1913), 487–511

Ashmole 1715: Ashmole, Elias. *The history of the most noble Order of the Garter*. London, 1715

Ashmole 1929: Ashmole, Bernard. *A Catalogue of the Ancient Marbles at Ince Blundell Hall*. Oxford, 1929

Atholl 1908: Atholl, John, 7th Duke of, KT. *Chronicles of the Atholl and Tullibardine Families*. Edinburgh, 1908

Audley End 1797: *Inventory of Audley End, 1797* (MSS Audley End)

Auerbach and Adams 1971: Auerbach, Erna, and C. Kingsley Adams. *Paintings and Sculpture at Hatfield House*. London, 1971

Auerbach 1953: Auerbach, Erna. "Portraits of Elizabeth I." *Burlington Magazine* 95 (June 1953), 196–205

Auerbach 1961: Auerbach, Erna. *Nicholas Hilliard*. London, 1961

Austin 1977: Austin, John C. *Chelsea Porcelain at Williamsburg*. Williamsburg, Va., 1977

Avery 1976: Avery, Charles. "Soldani's Small Bronze Statuettes After 'Old Master' Sculptures in Florence." *Kunst des Barock in der Toskana* (Munich, 1976), 165–172

Avery 1978: Avery, Charles. *Giambologna's Samson and a Philistine*. Victoria and Albert Museum Masterpieces, Sheet 18. London, 1978

Avery 1979: Avery, Charles. "Hubert le Sueur's Portraits of King Charles I in Bronze, at Stourhead, Ickworth and elsewhere." *National Trust Studies* (1979), 128–147. Reprinted in C. Avery. *Studies in European Sculpture*. (London, 1981), 189–204

Avery 1982: Avery, Charles. "Hubert le Sueur, the 'Unworthy Praxiteles' of King Charles I." *Walpole Society* 48 (1980–1982), 135–209

Avery 1984: Avery, Charles. "Bronze Statuettes in Woburn Abbey: New Attributions to Taddeo Landini and Giuseppe de Levis." *Apollo* 119 (February 1984), 97–103

Ayers 1971: See Charleston and Ayers 1971

Babelon 1897: Babelon, E. *Catalogue des camées antiques et modernes de la Bibliothèque Nationale*. Paris, 1897

Bailey 1927: Bailey, John, ed. *The Diary of Lady Frederick Cavendish*. 2 vols. London, 1927

Bainbridge 1966: Bainbridge, H.C. *Peter Carl Fabergé*, London, 1966. First published 1949

Baker 1949: Baker, C.H., and M.I. Collins. *The Life and Circumstances of James Brydges, First Duke of Chandos*. London, 1949

Baker 1985: Baker, Malcolm. "A Piece of Wondrous Art: Giambologna's *Samson and a Philistine* and its later copies." *Antologia di Belle Arti*, N.S. 23–24 (1984), 62–71

Balderston 1942: Balderston, Katherine Canby, ed. *Thraliana; the diary of Mrs. Hester Lynch Thrale (later Mrs. Piozzi)*. Oxford, 1942

Balsan 1953: Balsan, Consuelo. *The Glitter and the Gold*. New York, 1953

Banister 1977: Banister, Judith. "Cups of the Chase." *Country Life* (21 December 1977), 1613–1614

Banister 1980: Banister, Judith. "Rococo Silver in a Neoclassical Setting." *Country Life* (4 September 1980), 792–794

Barnard and Wace 1928: Barnard, Etwell Augustine Bracher, and Alan John Bayard Wace. *The Sheldon Tapestry Weavers and Their Work*. Oxford, 1928

Barr 1980: Barr, Elaine. *George Wickes, Royal Goldsmith 1698–1761*. London, 1980

Barron 1902: Barron, Oswald. "A Needlework Picture." *Country Life* (20 December 1902), 807

Bastian 1983: Bastian, Jacques. "Drei AR-Vasen und ihre Bemalung nach Vorlangen von Johann Wilhelm Weinmann." *Keramos* 100 (April 1983), 67–82

Batelli 1845–1847: Baldinucci, Filippo. *Notizie dei professori del disegno da Cimabue in qua per le quali si dimostra come, e per chi le belle arti di pittura, scultura e architettura, lasciata la Rozzezza delle maniere greca e gotica, si siano in questi secoli ridotte all'antica loro perfezione*. ed. V. Batelli et al. 5 vols. Florence, 1845–1847

Batho 1960: Batho, G.R. "The Library of the Wizard Earl." *The Library* 15 (1960), 246–261

Bathurst 1908: Bathurst, Earl of. *Catalogue of the Bathurst Collection of Pictures*. London, 1908

Baud-Bovy 1903–1904: Baud-Bovy, Daniel. *Peintres genevois 1702–1849*. 2 vols. Geneva, 1903–1904

Baulez 1981: Baulez, C., et al. *La rue de Varenne*. Paris, 1981

Beard 1975: Beard, Geoffrey. *Decorative Plasterwork in Great Britain*. London, 1975

Beard 1977: Beard, Geoffrey. "Three eighteenth-century cabinetmakers: Moore, Goodison and Vile." *Burlington Magazine* 119 (July 1977), 478–486

Beattie 1983: Beattie, Susan. *The New Sculpture.* New Haven and London, 1983

Beaucamp 1981: Beaucamp-Markowsky, Barbara. "Rhinozeros und Panter-Thier." *Keramos* (October 1981), 17–28

Beaucamp 1985: Beaucamp-Markowsky, Barbara. *Porzellandosen europäischer Manufakturen des 18. Jahrhunderts.* Fribourg, 1985

Beauregarde 1983: Beauregarde, R. Costa de. "Isis en Angleterre. Essais d'interpretation iconographique d'un portrait d'Elisabeth I (c. 1600)." In *Influences Latines en Europe, Cahiers de l'Europe Classique et Néo-Latine 2 (1983), Travaux de l'Université de Toulouse-le Mirail.* Série A, 23:89–139

Beauregarde 1984: Beauregarde, R. Costa de. "La Dame de Coeur: Etude de quatre portraits d'Elisabeth I." *Caliban. Aspects du Théâtre Anglais. Hommage à Fernand Lagarde.* Université de Toulouse le Mirail, 21 (1984), 49–62

Beazley 1956: Beazley, J.D. *Attic Black Figure Vase-Painters.* Oxford, 1956

Beazley 1971: Beazley, J.D. *Paralipomena. Additions to Attic Black Figure Vase-Painters.* 2d ed. Oxford, 1971

Beck 1973: Beck, Hans Ulrich. *Jan van Goyen, 1596–1656.* 2 vols. Amsterdam, 1973

Beckett 1949: Beckett, R.B. *Hogarth.* London, 1949

Beckett 1951: Beckett, R.B. *Lely.* London, 1951

Beckett 1962–1968: Beckett, R.B., ed. *John Constable's Correspondence.* 6 vols. London, 1962–1968

Bellaigue 1974: Bellaigue, Geoffrey de. *The James A. de Rothschild Collection at Waddesdon Manor: Furniture, Clocks and Gilt Bronzes.* 2 vols. Fribourg, 1974

Bellaigue 1975: Bellaigue, Geoffrey de. "Edward Holmes Baldock, I." *Connoisseur* 189 (August 1975), 290–299

Bellaigue 1975a: Bellaigue, Geoffrey de. "Edward Holmes Baldock, II." *Connoisseur* 190 (September 1975), 18–25

Bellaigue 1981: Bellaigue, Geoffrey de. "Vive La France!" *Burlington Magazine* 123 (December 1981), 735–739

Bellaigue 1984: Bellaigue, Geoffrey de. "Huzza the King is well!" *Burlington Magazine* 126 (June 1984), 325–331

Bence-Jones 1971: Bence-Jones, M. "A Nabob's Choice of Art." *Country Life* (25 November 1971), 1446–1448

Berenson 1956: Berenson, Bernard. *Lorenzo Lotto.* London, 1956

Berenson 1957: Berenson, Bernard. *Italian Pictures of the Renaissance: Venetian School.* 2 vols. London, 1957

Berling 1900: Berling, Karl. *Das Meissner Porzellan und seine Geschichte.* Leipzig, 1900

Berthoud 1985: Berthoud, Roger. *Graham Sutherland. A Biography.* London, 1985

Beurdeley 1974: Beurdeley, Michel E. *Chinese Ceramics.* London, 1979

Biddle 1984: Biddle, Martin. "The Stuccoes of Nonsuch." *Burlington Magazine* (July 1984), 411–416

Bissell 1981: Bissell, R. Ward. *Orazio Gentileschi and the Poetic Tradition in Caravaggesque Painting.* University Park, Pa, 1981

Blakeborough 1949–1950: Blakeborough, J. Fairfax. *Northern Turf History.* 3 vols. London, 1949–1950

Blomfield 1896: Blomfield, Reginald. "Furniture." *The Magazine of Art* (1896), 488–491

Blundell 1803: Blundell, Henry. *An Account of the Statues, Busts, Bass-Relieves, Cinerary Urns, and other Ancient Marbles and Paintings, at Ince. Collected by H.B.* Liverpool, 1803

Blunt 1966: Blunt, Anthony. *The Paintings of Nicolas Poussin, A Critical Catalogue.* London, 1966

Blunt 1967: Blunt, Anthony. *Nicolas Poussin. The A.W. Mellon Lectures in the Fine Arts. 1958.* . . . 2 vols. London and New York, 1967

Boardman and Robertson 1979: Boardman, John, and Martin Robertson. *Corpus Vasorum Antiquorum: Great Britain, fascicule 15, Castle Ashby.* Oxford, 1979

Boardman and Scarisbrick 1977: Boardman, John, and Diana Scarisbrick. *The Ralph Harari Collection of Finger Rings.* London, 1977

Boardman 1968: Boardman, John. *The Ionides Collection.* London, 1968

Boardman 1974: Boardman, John. *Athenian Black Figure Vases. A Handbook.* London, 1974

Boardman 1975: Boardman, John. *Athenian Red Figure Vases. The Archaic Period.* London, 1975

Boardman 1978: Boardman, John. "Exekias." *American Journal of Archaeology* 82, no. 1 (1978), 11–25

Böhm, E. "Matthias Joseph De Noël (1782–1849)." *Wallraf-Richartz-Jahrbuch* 41, 1980, 159

Bolton 1922: Bolton, Arthur Thomas. *The Architecture of Robert and James Adam.* 2 vols. London, 1922

Bolz 1980: Bolz, Claus. "Hoym, Lemaire und Meissen – Ein Beitrag zur Geschichte der Dresdner Porzellansammlung." *Keramos* 88 (April 1980)

Bondy 1923: Bondy, Walter. *Kang-Hsi. Eine Blüte-Epoche der chinesischen Porzellankunst.* Munich, 1923

Booth 1978: Booth, Stanley. *Sir Alfred Munnings 1878–1959.* London, 1978

Borenius and Hodgson 1924: Borenius, Carl Tancred, and The Rev. James Vaughan Hodgson. *A Catalogue of the Pictures at Elton Hall in Huntingdonshire in the Possession of Colonel Douglas James Proby.* London and Boston, n.d. [1924]

Borenius 1939: Borenius, Carl Tancred. *A Catalogue of the Pictures at Corsham Court.* London, 1939

Boschini 1660: Boschini, Marco. *La carta del navegar pitoresco.* Venice, 1660. Reprint. 1966

Bothmer and Vermeule: See Vermeule and Bothmer

Botti and Romanelli 1951: Botti, G., and P. Romanelli. *Le Sculture del Museo Gregoriano Egiziano.* Vatican, 1951

Boughton 1832: *Catalogue of the Pictures at Boughton.* 1832

Bourgeois 1913: Bourgeois, E., and G. Lechevallier-Chevignard. *Le Biscuit de Sèvres au XVIIIe siècle.* 2 vols. Paris, 1909. 2d ed. Paris, 1913

Bourne 1984: Bourne, Jonathan. "Rothschild Furniture at Dalmeny." *Apollo* (June 1984), 406–411

Boynton and Goodison 1969: Boynton, Lindsay O.J., and Nicholas Goodison. "Thomas Chippendale at Nostell Priory."

Boynton and Thornton 1971: Boynton, Lindsay O.J., and Peter Thornton, eds. *The Hardwick Hall Inventories of 1601.* London, 1971

Boynton 1964: Boynton, Lindsay O.J., ed. and introd. "An Appuldurcombe furniture inventory." *Furniture History* (1964), 37–58

Boynton 1966: Boynton, Lindsay O.J. "Luke Lightfoot (?1722–1789)." *Furniture History* 2 (1966), 7–17

Boynton 1967: Boynton, Lindsay O.J. "High Victorian Furniture: the Example of Marsh and Jones of Leeds." *Furniture History* (1967), 54–91

Boynton 1968: Boynton, Lindsay O.J. "Sir Richard Worsley and the Firm of Chippendale." *Burlington Magazine* (May 1968), 352–354

Brackett 1924: Brackett, Oliver. *Thomas Chippendale.* London, 1924

Brackett 1936: Brackett, Oliver. "Documented Furniture at Corsham." *Country Life* (28 November 1936), 576

Brady and Pottle 1955: Brady F., and F.A. Pottle. *Boswell on The Grand Tour.* New York, 1955

Braham 1981: See Exh. London, NG 1981

Braybrooke 1836: Braybrooke, Richard. *The History of Audley End. To which are appended notices of the town and parish of Saffron Walden in the Country of Essex.* London, 1836

Bredius 1936: Bredius, A. *The Paintings of Rembrandt.* Vienna and London, 1936

Brettingham 1761: Brettingham, Matthew. *The Plans, Elevations, and Sections of Holkham in Norfolk, the Seat of the late Earl of Leicester.* London, 1761

Brettingham 1773: Brettingham, Matthew. *The Plans, Elevations, and Sections of Holkham in Norfolk, to which are added, the ceilings and chimney-pieces; . . . statues, pictures, and drawings, etc.* London, 1773

Brewer 1818: Brewer, James Norris. *Introduction to the original delineations, topographical, historical, and descriptive intituled The Beauties of England and Wales.* London, 1818

Briganti 1962: Briganti, Giuliano. *Pietro Da Cortona, o, Della Pittura Barocca.* Florence, 1962

Briganti 1966: Briganti, Giuliano. *Gaspar Van Wittel e l'origine della veduta settecentesca.* Rome, 1966

Brigstocke 1982: Brigstocke, Hugh. *William Buchanan and the 19th century Art Trade: 100 Letters to his Agents in London and Italy.* London, 1982

Britten and Baillie 1956: Britten, Frederick James, and Granville Hugh Baillie. *Old Clocks and Watches and their Makers.* 7th ed. London, 1956

Britton 1801–1818: Britton, John, and Edward Wedlake Brayley, eds. *The Beauties of England and Wales.* 19 vols. London, 1801–1818

Britton 1806: Britton, John. *An Historical Account of Corsham House in Wiltshire; The Seat of Paul Cobb Methuen, Esq. With a Catalogue of his Celebrated Collection of Pictures.* London, 1806

Britton 1808: Britton, John. *Catalogue Raisonné of the Pictures belonging to the Most Honourable Marquis of Stafford, in the Gallery of Cleveland House.* London, 1808

Broulhiet 1938: Broulhiet, Georges. *Meindert Hobbema (1638–1709).* Paris, 1938

Brown 1982: Brown, Christopher. *Van Dyck.* Oxford, 1982

Browsholme Hall 1815: [Parker, Thomas Lister]. *Description of Browsholme Hall in the West Riding of the County of York.* 1815

Brunet and Préaud 1978: Brunet, Marcelle, and Tamara Préaud, *Sèvres, des Origines à nos Jours.* Fribourg, 1978

Brunet 1842–1844: Brunet, Jacques-Charles. *Manuel du libraire et de l'amateur de livres.* 5 vols. Paris, 1842–1844

Bryan 1893: Bryan, Michael. *Dictionary of Painters & Engravers, Biographical and Critical.* 2 vols. London, 1893–1895

Bryant 1971: Bryant, Arthur. *The Great Duke.* London, 1971

Buchanan 1824: Buchanan, William. *Memoirs of Painting.* London, 1824

Buckle 1963: Buckle, Richard. *Jacob Epstein – Sculptor.* London, 1963

Bull 1956: Cellini, Benvenuto. *Autobiography.* Trans. George Bull. London, 1956

Burchard 1929: Burchard, Ludwig. "Genussische Frauenbildnisse von Rubens." *Preussische Kunstsammlungen Jahrbuch* 50 (1929), 319 ——, 1963

Burdon 1960: Burdon, Gerald. "Sir Thomas Isham: An English Collector in Rome in 1677–1678." *Italian Studies* 15 (1960), 1–25

Burges 1859: Burges, William. "Fac-Simile of the Sketch Book of Wilars de Honecort." *The Building News* (7 October 1959), 897–898

Burges 1865: Burges, William. "The Reproduction of the MS.Bib.Reg.2BVII by Messrs. Westlake and Purdue." *Gentleman's Magazine* (August 1865), 145–154

Burghley 1797: [Horn, J.]. *A History or Description . . . of Burghley House.* Shrewsbury, 1797

Burghley 1815: [Blore, Thomas]. *A Guide to Burghley House, Northamptonshire, the seat of the Marquis of Exeter; containing a catalogue of all the paintings, antiquities, &c. and with Biographical Notices of the Artists.* Stamford, 1815

Burn and Glynn 1982: Burn, L., and R. Glynn. *Beazley Addendum.* Oxford, 1982

Burney 1773: Burney, Dr. *The Journal of a Tour . . .* 2d ed. London, 1773

Bursche 1980: Bursche, Stefan. *Meissen: Steinzeug und Porzellan des 18 Jahrhunderts, catalogue of the Kunstgewerbemuseum.* Berlin, 1980

Bury and Fitzgerald 1969: Bury, Shirley, and D. Fitzgerald. "A Design for a candlestick by George Michael Moser." *Victoria and Albert Museum Yearbook* (1969), 27–29

Butlin and Joll 1977: Butlin, M., and E. Joll. *The Paintings of J.M.W. Turner.* 2 vols. New Haven and London, 1977

Byam Shaw 1967: Byam Shaw, James. *Paintings by Old Masters at Christ Church, Oxford.* London, 1967

Cabinet Maker 1889: "Furnishings at the 'Arts and Crafts.'" *The Cabinet Maker and Art Furnisher* (1889), 113–115

Caillaux 1935: Caillaux, Henriette. *Aimé-Jules Dalou (1838–1902).* Paris, 1935

Cammann 1963: Cammann, Schuyler van R. "A rare Ming textile in Sweden." *The Archives of the Chinese Art Society of America* 17 (1963), 32–37

Cammann 1974: Cammann, Schuyler van R. "A Spanish cope made from a 17th century Chinese embroidery." *Bulletin of the Malmö Museum* 310 (1974)

Campbell 1725: Campbell, Colen. *Vitruvius Britannicus, or the British Architect . . .* 3 vols. London, 1725

Canova 1964: Canova, G.M. *Paris Bordon.* Venice, 1964

Carlisle 1837: Carlisle, Georgiana, Countess of. "Descriptive catalogue of pictures." MSS Castle Howard no. H2/1/6, 1837

Carritt 1974: Carritt, David. "Mr. Fauquier's Chardins." *Burlington Magazine* 116 (September 1974), 502–509

Carter, Goode, and Laurie 1983: Carter, George, Patrick Goode, and Kedrun Laurie. *Humphry Repton, Landscape Gardener.* Norwich, 1983

Casteras 1984: See Exh. New Haven 1984

Cavaceppi 1768: Cavaceppi, Bartolomeo. *Raccolta d'antiche statue, busti, bassirilievi ed altre sculture restaurate da Bartolomeo Cavaceppi, scultore romano.* 3 vols. Rome, 1768–1772

Cavendish 1845: See Devonshire 1845

Cellini: See Bull 1956

Chaloner 1950: Chaloner, W.H. "The Egertons in Italy and the Netherlands 1720–1734." *Bulletin of the John Rylands Library* 32, no. 2 (March 1950), 157–170

Chamberlain 1913: Chamberlain, Arthur Bensley. *Hans Holbein the Younger.* 2 vols. London, 1913

Chantry Ledger: *Ledgers of Sir Francis Chantry, 1809–1823 and 1809–1841.* MSS Royal Academy of Art, London

Charleston and Towner 1977: Charleston, Robert J., and Donald Towner. *English Ceramics 1580–1830, a commemorative catalogue . . . to celebrate the fiftieth anniversary of the English Ceramic Circle, 1927–1977.* London, 1977

Charleston 1959: Charleston, Robert J. "Souvenirs of the Grand Tour." *Journal of Glass Studies* (1959), 63–82

Charleston 1963: Charleston, Robert J. "Glass Souvenirs of the Grand Tour." *Antiques* (June 1963), 665–669

Charleston and Ayers 1971: Charleston, Robert J., and John Ayers. *The James A. de Rothschild Collection at Waddesdon Manor: Meissen and Oriental Porcelain.* Fribourg, 1971

Charlton 1847: Charlton, Rev. W.H. *Burghley, the life of William Cecil, Lord Burghley . . . A Description of Burghley House . . .* Stamford, 1847

Charteris 1927: Charteris, Hon. Evan. *John Sargent.* London and New York, 1927

Chevening 1859: *Portraits and Busts in the Principal Rooms at Chevening.* 1859

Childe-Pemberton 1925: Childe-Pemberton, W.S. *The Earl Bishop.* London, 1925

Ciechanowiecki and Seagrim 1973: Ciechanowiecki, Andrew, and Gay Seagrim. "Soldani's Blenheim Commission and Other Bronze Sculptures after the Antique." *Festschrift Klaus Lankheit* (Cologne, 1973), 180–184

Clarendon 1888: See Macray 1888

Clark 1983: Clark, Anthony M. *Pompeo Batoni: A Complete Catalogue of his Works with an Introductory Text.* Oxford, 1983

Clarke 1973: Clarke, George. "The Garden of Stowe" and "Grecian Taste and Gothic Virtue: Lord Cobham's gardening programme and its iconography." *Apollo* (June 1972), 18–25, 26–31

Clarke 1973: Clarke, T.H. "The Iconography of the Rhinoceros from Dürer to Stubbs. Part I: Dürer's Ganda." *Connoisseur* 184 (September 1973), 2–13

Clarke 1975: Clarke, T.H. "Das Northumberland Service aus Meissner Porzellan." *Keramos* 70 (October 1975), 9–92

Clarke 1976: Clarke, T.H. "The Rhinoceros in European Ceramics." *Keramik-Freunde der Schweiz* (November 1976), 3–20

Clarke 1977: Clarke, George, ed. *George Bickham's "The Beauties of Stowe"* (1970). Los Angeles, 1977

Clayton 1971 and 1985: Clayton, Michael. *The collector's dictionary of the silver and gold of Great Britain and North America.* Feltham, 1971. 2d ed. Woodbridge, 1985

Climenson 1899: Climenson, E., ed. *Passages from the Diaries of Mrs. Philip Lybbe Powys of Harwick House, Oxon., 1756–1808.* London, 1899

Cockayne 1910–1959: Cockayne, George E. *The Complete Peerage of England, Scotland, Ireland, Great Britain and the United Kingdom.* 2 vols. Revised and enlarged ed. 1910–1959

Cohen 1978: Cohen, B. *Attic Bilingual Vases and their Painters.* New York, 1978

Coke 1889–1896: Coke, Lady Mary. *The Letters and Journals of Lady Mary Coke.* 4 vols. Edinburgh, 1889–1896

Coleridge 1960: Coleridge, Anthony. "George Sandeman of Perth: Cabinet-Maker." *Connoisseur* 145 (April 1960), 96–101

Coleridge 1963: Coleridge, Anthony. "18th-Century Furniture at The Vyne." *Country Life* (25 July 1963), 214–216

Coleridge, 1964: Coleridge, Anthony. "Chippendale at Wilton." *Apollo* (July 1964), 4–11

Coleridge, 1965: Coleridge, Anthony. "The Work of George Bullock, cabinet-maker, in Scotland: I." *Connoisseur* 158 (1965), 249–252; and 159 (1965), 13–17

Coleridge, 1966: Coleridge, Anthony. "Don Petro's Table-Tops: *Scagliola* and Grand Tour Clients." *Apollo* 83 (March 1966), 184–187

Coleridge, 1967: Coleridge, Anthony. "Sir Laurence Dundas and Chippendale." *Apollo* (September 1967), 190–202

Coleridge, 1968: Coleridge, Anthony. *Chippendale Furniture: The Work of Thomas Chippendale and his Contemporaries in the Rococo Taste, Vile, Cobb, Langlois, Channon, Hallett, Ince and Mayhew, Lock, Johnson, and others circa 1745–1765.* London, 1968

Colvin 1954: Colvin, Howard M. "The South Front of Wilton House." *Archaeological Journal* 111 (1954), 181–190

Colvin 1963–1982: Colvin, Howard M., ed. *The History of the King's Works.* 6 vols. London, 1963–1982

Compton 1960: Compton, M. "William Roscoe and the Early Collector of Italian Paintings." *Liverpool Bulletin* 9 (1960–1961)

Comstock and Vermeule 1976: Comstock, Mary B., and Cornelius C. Vermeule. *Sculpture in stone, The Greek, Roman and Etruscan Collections of the Museum of Fine Arts, Boston.* Boston, 1976

Conforti 1977: Conforti, Michael. "Pierre Legros and the Rôle of sculptors and designers in late Baroque Rome." *Burlington Magazine* 119 (August 1977), 556–560

Connell 1957: Connell, Brian. *Portrait of a Whig Peer, Compiled from the Papers of the Second Viscount Palmerston, 1739–1802.* London, 1957

Constable and Links 1976: Constable, W.G. Revised J.G. Links. *Canaletto 1697–1768.* 2 vols. Oxford, 1976

Constable 1953: Constable, W.G. *Richard Wilson.* London, 1953

Constable 1962: See Constable and Links 1976

Constantine 1953: Constantine, H.F. "Lord Rockingham and Stubbs; some new documents." *Burlington Magazine* 95 (1953), 237

Cook 1981: Cook, R.M. *Clazomenean Sarcophagi.* Mainz, 1981

Cook 1985: Cook, B.F. *The Towneley Marbles.* London, 1985

Cooke 1846: Cooke, Henry Thomas. *An historical and descriptive guide to Warwick Castle, Kenilworth Castle, Guy's Cliff, Stoneleigh Abbey, the Beauchamp Chapel and other places . . .* Warwick, 1846–1847

Coombs 1978: Coombs, David. *Sport and the Countryside in English paintings, watercolours and prints.* Oxford, 1978

Coote 1846: Coote, Henry T. *Present State of the Castle.* [Warwick], 1846

Cordey 1939: Cordey, J. *Inventaire des biens de Madame de Pompadour redigée après son décès.* Paris, 1939

Cormack 1970: Cormack, Malcolm, transcriber. "The ledgers of Sir Joshua Reynolds." *Walpole Society* 43 (1970), 105–169

Cornforth and Fowler 1974: Cornforth, John, and John Fowler. *English Decoration in the eighteenth century.* London, 1974

Cornforth and Jackson-Stops 1971: Cornforth, John, and Gervase Jackson-Stops. "The Gubbay Collection at Clandon." *Country Life* (29 April 1971), 1004–1008

Cornforth 1973: Cornforth, John. "Meols Hall, Lancashire—I." *Country Life* 153 (25 January 1973), 206–209; II (1 February 1973), 247–277; III (8 February 1973), 326–329

Cornforth 1973a: Cornforth, John. "Old Grosvenor House." *Country Life* 154 (15 November 1973), 1538–1541

Cornforth 1975: Cornforth, John. "Stratfield Saye House, Hampshire—I and II." *Country Life* (10 and 17 April 1975), 899–902; 982–985

Cornforth 1976: Cornforth, John. "Victorian Views of Audley End." *Country Life* (8 July 1976), 102–105

Cornforth 1977: Cornforth, John. "Kirkleatham, Cleveland—II." *Country Life* (20 January 1977), 134–137

Cornforth 1978: Cornforth, John. *English Interiors 1790–1848: the Quest for Comfort.* London, 1978

Cornforth 1979: Cornforth, John. "Newby Hall, North Yorkshire – I." *Country Life* (7 June 1979), 1802–1806; II (14 June 1979), 1918–1921; III (21 June 1979), 2006–2009

Cornforth 1979a: Cornforth, John. "Flintham Hall, Nottinghamshire – II." *Country Life* (27 December 1979), 2454–2457

Country Life 1912: "Kirtlington Park, Oxfordshire." (signed "A.D.") *Country Life* (13 April 1912), 542–549

Courajod 1873: Courajod, Louis. *Livre-journal de Lazare Duvaux, marchand-bijoutier ordinaire du Roy 1748–1758, précédé d'une étude sur le goût et sur le commerce des objets d'art au milieu de XVIII^e siècle.* 2 vols. Paris, 1873.

Cowdry 1751: Cowdry, Richard. *A Description of the Pictures, Statues, Busto's, Basso-Relievo's and other Curiosities of the Earl of Pembroke's House at Wilton.* London, 1751

Craig 1882: Craig, James Gibson. *Fac-Similes of Old Book Bindings in the Collection of James Gibson Craig.* Edinburgh, 1882

Croft-Murray 1962 and 1970: Croft-Murray, Edward. *Decorative Painting in England 1537–1837.* 2 vols. London, 1962 and 1970

Crook 1970: Crook, J. Mordaunt. "Patron Extraordinary: John 3rd Marquess of Bute." *Victorian South Wales* (1970)

Crook 1970: Crook, J. Mordaunt. *William Burges and the High Victorian Dream.* London, 1970

Crowe and Cavalcaselle 1871: Crowe, Sir Joseph Archer, and Giovanni Battista Cavalcaselle. *A History of Painting in North Italy: Venice, Padua, Vicenza, Verona, Ferrara, Milan, Friuli, Brescia; From the Fourteenth to the Sixteenth Century.* 2 vols. London, 1871

Culme 1977: Culme, John. *Nineteenth Century Silver.* London, 1977

Cumming and Rankin 1974: Cumming, W.P., and Hugh F. Rankin. *The Fate of a Nation.* London, 1975

Cumming 1974: Cumming, W.P. *British Maps of Colonial America.* Chicago, 1974

Cumming 1979: Cumming, W.P. "The Montresor-Retzer-Sauthier sequence of maps of New York City." *Imago Mundi* 31 (1979), 55–65

Cummings 1968: Cummings, Frederick. "Boothby, Rousseau and the Romantic Malady." *Burlington Magazine* 110 (1968), 659–666

Cumont 1913: Cumont, Franz. *Catalogue des sculptures & inscriptions antiques (monuments lapidaires) des Musées Royaux du Cinquantenaire.* Brussels, 1913

Cunningham 1830–1833: Cunningham, Allan. *The Lives of the Most Eminent British Painters, Sculptors and Architects.* 6 vols. London, 1830–1833

Cunningham 1843: Cunningham, Allan. *The Life of Sir David Wilkie.* 3 vols. London, 1843

Cust 1904: Cust, Lionel. *Notes on the Authentic Portraits of Mary Queen of Scots, based on the researches of the late Sir George Scharf, K.C.B.* London, 1903

Cust 1913: Cust, Lionel. "The Painter HE ('Hans Eworth')." *Walpole Society* 2 (1913), 1–44

Cust 1914: Cust, Lionel. "A Portrait called 'Henry, Prince of Wales,' by Isaac Oliver." *Burlington Magazine* 24 (1914), 347–348

Cust 1918: Cust, Lionel. "The Lumley Inventories." *Walpole Society* 6 (1918), 15–35

Dalkieth 1811: *Dalkieth Palace Collection Catalogue.* 1811

Dallaway 1800: Dallaway, James. *Anecdotes of the Arts in England.* London, 1800

Dallaway 1826: Dallaway, James. *Anecdotes of Painting in England . . .* Vol. 2. London, 1826

Dalton 1915: Dalton, O.M. *Catalogue of the Engraved Gems of the Post-Classical Periods in the British Museum.* London, 1915

Daniels 1976: Daniels, Jeffrey. *Sebastiano Ricci.* Hove, 1976

Dauterman 1970: Dauterman, Carl Christian. *The Wrightsman Collection. Porcelain.* Greenwich, Conn., 1970

Dauterman 1976: Dauterman, Carl Christian. "Sèvres Figure Painting in the Anna Thompson Dodge Collection." *Burlington Magazine* 118 (November 1976), 753–762

Dawson 1817: Dawson, J. *The Stranger's Guide to Holkham, containing a description of the Paintings, Statues, etc. of Holkham House, in the County of Norfolk; The Magnificent Seat and Residence of T.W. Coke, Esq. M.P.* Burnham, 1817

Dawson 1980: Dawson, Eileen. "The Eden Service, Another Diplomatic Gift." *Apollo* (April 1980), 288–297

Dawson 1984: Dawson, Eileen. *Masterpieces of Wedgwood in the British Museum.* London, 1984

DEF 1954: Macquoid, Percy, and Ralph Edwards. *The Dictionary of English Furniture.* 3 vols. London, 1954. First publ. 1924–1927

Denon 1802: Denon, Baron Vivant. *Voyage dans la basse et haute Egypte.* Paris, 1802

Deuchar 1984: See Exh. London, ML 1984

Devonshire House 1813: "Catalogue of the Pictures at Devonshire House, AD 1813." MSS Chatsworth

Devonshire House 1836: "Pictures at Devonshire House, Dec^r. 1836." MSS Chatsworth

Devonshire 1845: Devonshire, William George Spencer Cavendish, 6th Duke of. *Handbook to Chatsworth and Hardwick.* 1845

Devonshire 1982: Devonshire, Duchess of. *The House. A Portrait of Chatsworth.* London, 1982

Dhanens 1956: Dhanens, Elisabeth. *Jean Boulogne.* Brussels, 1956

Diehl 1964: Diehl, E. *Die Hydria.* Mainz, 1964

Dillon 1888: Dillon, Viscount. "The Sword of Robert Dudley Earl of Leicester." *Archaeologia* 51 (1888), 512–513

DNB: *Dictionary of National Biography.* Leslie Stephen, ed. 63 vols. London, 1885–1900

DNB 1975: *The Compact Edition of the Dictionary of National Biography.* 2 vols. Oxford, 1975

Dodd 1818: Dodd, Stephen. *An Historical and Topographical Account of the Town of Woburn, its Abbey, and Vicinity . . .* Woburn, 1818

Dodd 1981: Dodd, Dudley. *Stourhead.* The National Trust, London, 1981

Dodsley 1761: Dodsley, R., and J. *London and its Environs Described . . .* 6 vols. London, 1761

D'oench 1980: See Oench 1980

Donnelly 1969: Donnelly, P.J. *Blanc de Chine: The Porcelain of Tehua in Fukien.* London, 1969

Dorment 1980: Dorment, Richard. "Alfred Gilbert's Memorial to Queen Alexandra." *Burlington Magazine* 122 (January 1980), 47–54

Dorsten 1970: Dorsten, J.A. van. *The Radical Arts.* Leiden, 1970

Douglas Pennant 1902: See Pennant 1902

Douwes Decker 1984: Douwes Decker. *Portraits à l'huile de Mme Elisabeth Louise Vigée le Brun.* 1984

Downes 1925: Downes, W.H. *John S. Sargent: his Life and Work.* Boston, 1925

Dreyfous 1903: Dreyfous, Maurice. *Dalou, sa vie et son oeuvre.* Paris, 1903

Drossaers and Scheurleer 1974: Drossaers, S.W.A., and Th. H. Lunsingh Scheurleer. *Inventarissen Van de in boedels in de Verblijven van de Oranjes 1567–1795.* 's-Gravenhage, 1974

Drury and Gow 1984: Drury, P.J. and I.R. Gow. *Audley End, Essex.* London, 1984

Ducret 1971: Ducret, S. *Meissner Porzellan bemalt in Augsburg, 1718 bis zu 1750.* Vol. I. Brunswick, 1971

Dugdale 1730: Dugdale, Sir William. *The Antiquities of Warwickshire.* 2d ed. 2 vols. London, 1730

Dugdale 1817: Dugdale, Sir William. *Warwickshire; A Concise Topographical Description of the Different Towns and Villages in the County of Warwick . . .* Coventry, 1817

Duleep Singh [1927]: Duleep Singh, The late Prince Frederick. *Portraits in Norfolk Houses.* 2 vols. Norwich [1927]

Eames 1977: Eames, Penelope. *Furniture in England, France and the Netherlands from the Twelfth to the Eighteenth Century.* Leeds, 1977

Eastlake 1895: Eastlake, Lady. *Journals and Correspondence.* 2 vols. London, 1895

Edwards and Jourdain 1944 and 1955: Edwards, Ralph, and Margaret Jourdain. *Georgian Cabinet Makers.* London, 1944. 3d ed. 1955

Edwards 1808: Edwards, Edward. *Anecdotes of Painters, who have resided or been born in England.* London, 1808

Edwards 1934: Edwards, Ralph. *Early Conversation Pictures.* London, 1934

Edwards 1937: Edwards, Ralph. "Two Commodes by John Cobb." *Country Life* (22 May 1937), 574

Edwards 1955: Edwards, Ralph. "English Furniture at Plas Newydd." *Connoisseur* (1955), 240–245

Edwards 1961: Edwards, Ralph. "A problem conversation picture at Ickworth." *Apollo* (July 1961), 8–10

Egremont 1985: Egremont, Max. "The 3rd Earl of Egremont and his friends." *Apollo* (October 1985), forthcoming

Eichler and Kris 1927: Eichler, F., and Ernst Kris. *Die Kameen im Kunsthistorisches Museum.* Vienna, 1927

Einberg 1970: See Exh. London, Kenwood 1970

Eller 1841: Eller, Rev. Irvin. *The History of Belvoir Castle.* London, 1841

Elton 1980: Elton, Julia. "Eltonware at Clevedon Court." *National Trust Magazine* (Autumn 1980), 10–13

Eriksen 1965: Eriksen, Svend. "Ducal Acquisitions of Vincennes and Sèvres." *Apollo* 82 (December 1965), 484–491

Eriksen 1968: Eriksen, Svend. *The James A. de Rothschild Collection at Waddesdon Manor: Sèvres Porcelain.* Fribourg, 1968

Eriksen 1974: Eriksen, Svend. *Early Neo-Classicism in France . . .* Trans. and ed. Peter Thornton, London, 1974

Erkelens 1980: Erkelens, A.M.L.E. "Delfts Aardewerk op Het Loo." *Nederlands Kunsthistorisch Jaarboek* 31 (1980), 263–272

Erskine 1953: Erskine, David, ed. *Augustus Hervey's Journal, being the intimate account of a captain in the Royal Navy ashore and afloat, 1746–1759.* London, 1953

Esdaile 1928: Esdaile, K.A. *Louis François Roubiliac.* London, 1928

Eustace 1982: See Exh. Bristol 1982

Evans 1855: Evans, John. "Extracts from the Private Account Book of Sir William Moore." *Archaeologia* 36 (1855), 284–310

Evans 1922: Evans, Joan. *Magical Jewels of the Middle Ages and Renaissance.* Oxford, 1922. Reprint. New York, 1976

Fabbro 1951: Fabbro, C. "Un Ritratto inedito de Tiziano." *Arte Veneta.* 5 (1951), 185–186

Fairfax-Blakesborough 1920: Fairfax-Blakesborough, T. *Sykes of Sledmere, The Record of A Sporting Family and Famous Stud.* London, 1920

Farington Diary: Garlick, Kenneth, Angus MacIntyre, and Kathryn Cave, eds. *The Diary of Joseph Farington.* New Haven and London, 1978–1984

Farrer 1903: Farrer, Katherine Eusemia, and Thomas Bentley, eds. *Letters of Josiah Wedgwood.* 2 vols. London, 1903

Feaver 1975: Feaver, William. *The Art of John Martin.* Oxford, 1975

Federmann 1927: Federmann, Arnold, *Jon. H. Füssli. Dichter und Maler 1741–1825.* Leipzig and Zurich, 1927

Fenaille 1907: Fenaille, M.M. *État Général des Tapisseries de la Manufacture des Gobelins.* Vol. 4. 1907

Field 1815: Field, William *Historical and Descriptive Account of the Town and Castle of Warwick.* 1815

Fiennes 1949: Morris, Christopher, ed. *The Journeys of Celia Fiennes.* London, 1949

Finberg 1920–1921: Finberg, Hilda. "Canaletto in England." *Walpole Society* 10 (1920–1921), 1922, 75–78

Finer and Savage 1965: Finer, Ann, and George Savage. *Selected Letters of Josiah Wedgwood.* London and New York, 1965

Finsten 1981: Finsten, Jill. *Isaac Oliver. Art at the Courts of Elizabeth I and James I.* New York, 1981

Fischel and Oberhuber 1972: Fischel, Oskar, and Konrad Oberhuber. *Raphaels Zeichnungen, 9, Entwurfe zu Werken Raphaels und seiner Schule im Vatican 1551/52 bis 1520.* Berlin, 1972

Fitzgerald 1968: Fitz-Gerald, Desmond. "Chippendale's Place in the English Rococo." *Furniture History* (1968), 1–9

Fitzgerald 1973: Fitz-Gerald, Desmond. "History of the Interior of Stowe." *Apollo* 97 (June 1973), 572–585

Fitzgerald 1973a: Fitz-Gerald, Desmond. *The Norfolk House Music Room.* London, 1973

Fitzgerald 1975: Fitzgerald, Penelope. *Edward Burne-Jones.* London, 1975

Fleming 1955: Fleming, John. "The Hugfords of Florence." *Connoisseur* 136 (November–December 1955), 106–110, 197–206

Fleming 1958: Fleming, John. "Lord Brudenell and His Bear-Leader." *English Miscellany* 9 (1958), 127–141

Fleming 1962: Fleming, John. *Robert Adam and His Circle in Edinburgh and Rome.* London, 1962

Focillon 1918: Focillon, H. *Giovanni Battista Piranesi, essai de catalogue raisonné de son oeuvre.* Paris, 1918

Fokker 1931: Fokker, T.H. *Jan Siberechts, peintre de la paysanne flamande.* Brussels, 1931

Fontaine 1746: Fontaine, Jean de la. *Fables Choisies mises en vers par Monsieur de la Fontaine.* 2 vols. Paris, 1746

Fonthill 1823: *The Unique and Splendid Effects of Fonthill Abbey . . . Which Will be Sold by Auction by Mr. Phillips at the Abbey on Tuesday, the 23rd September 1823, and . . . Following Days . . .* London, 1823

Foot 1978: Foot, Mirjam M. *The Henry Davis Gift. A Collection of Bookbindings.* London, 1978

Foot 1978a: Foot, Mirjam M. "English and Foreign Bookbindings 5. A bookbinding by Jean de Planche." *The Book Collector* 27, no. 2 (Summer 1978)

Forbes 1974: Forbes, Christopher. *The Royal Academy 1837–1901 Revisited.* New York, 1974

Ford 1960: Ford, Brinsley, ed. "The Letters of Jonathan Skelton Written from Rome and Tivoli in 1758." *Walpole Society* 36 (1960), 23–82

Ford 1974: Ford, Brinsley. "The Earl-Bishop; an Eccentric and Capricious Patron of the Arts." *Apollo* (June 1974), 426

Forman 1971: Forman, Benno M. "Continental Furniture Craftsmen in London: 1511–1625." *Furniture History* 7 (1971), 91–120

Fortnum 1877: Fortnum, C.D. "Notes on some of the Antique and Renaissance gems and Jewels in Her Majesty's Collection at Windsor Castle." *Archaeologia* 45i (1877), 1–28

Foskett 1972: Foskett, Daphne. *A Dictionary of British Miniature Painters.* London, 1972

Foskett 1974: Foskett, Daphne. *Samuel Cooper 1609–1672.* London, 1974

Foskett 1979: Foskett, Daphne. *Collecting Miniatures.* Woodford, Suffolk, 1979

Fothergill 1969 and 1973: Fothergill, Brian. *Sir William Hamilton – Envoy Extraordinary.* London, 1969 and 1973

Fothergill 1972: Fothergill, Brian. *Beckford of Fonthill.* London 1972

Fougeroux 1728: Fougeroux, Pierre Jacques. "Voyage d'Angleterre d'Hollande et de Flandre, 1728." MSS Victoria and Albert Museum

Frankfurt 1983: *Deutsches Porzellan des 18. Jahrhunderts.* Museum für Kunsthandwerk. Frankfurt, 1983

Franklin 1981: Franklin, Jill. *The Gentleman's Country House and its Plan 1835–1914.* London, 1981

Freyberger 1970–1971: Freyberger, Ronald. "Chinese Genre Painting at Sèvres." *American Ceramic Circle Bulletin* (1970–1971), 29–44

Freyer-Schauenburg 1980: Freyer-Schauenburg, Brigitte. "Busten mit Reliefverziertem Indextafelchen." *Eikones. Festschrift Hans Jucker* (Bern, 1980), 118–125

Frick 1968: *The Frick Collection, II, Paintings: French, Italian and Spanish.* New York, 1968

Friedländer 1924–1937: Friedländer, M.J. *Die Altniederländische malerei.* Berlin and Leiden, 1924–1937

Fritzsche 1936: Fritzsche, H.A. *Bernardo Bellotto gennannt Canaletto.* Berg b-m, 1936

Frothingham 1951: Frothingham, A.W. *Lustreware of Spain.* New York, 1951

Fuchs 1959: Fuchs, Werner. *Die Vorbilder der neuattischen Reliefs.* Berlin, 1959

Furtwängler 1895: Furtwängler, Adolf. *Masterpieces of Greek Sculpture. A Series of Essays on the History of Art.* London, 1895

Gabszewicz and Freeman 1982: Gabszewicz, Anton, and Geoffrey Freeman. *Bow Porcelain, the collection formed by Geoffrey Freeman.* London, 1982

Gage 1984: Gage, Deborah. "Masterpieces of Sèvres Porcelain." *Antique Collector* 55, 6 (June 1984), 88–93

Galleria Giustiniana 1631: *Galleria Giustiniana del Marchese Vincenzo Giustiniani.* Vols. 1–2. Rome, 1631

Gambarini 1731: Gambarini, Carlo, Count. *A description of the Earl of Pembroke's Pictures. Now published by C. Gambarini of Lucca* London, 1731

Gamber 1958: Gamber, Ortwin. "Der italienische Harnisch im 16. Jahrhundert." *Jahrbuch der Kunsthistorischen Sammlungen in Wien* 54 (1958), 73–120

Ganz 1950: Ganz, Paul. *The Paintings of Hans Holbein.* London, 1950

Gardner 1934: Gardner, Bellamy. "Animals in porcelain." *English Ceramic Circle Transactions* 2 (1934)

Gardner 1942: Gardner, Bellamy. "Chelsea Porcelain Rarities." *Connoisseur* 110 (December 1942), 126–129

Garlick 1962–1964: Garlick, Kenneth. "A Catalogue of the Paintings, Drawings and Pastels of Sir Thomas Lawrence." *Walpole Society* 39 (1962–1964)

Gatty 1977: Gatty, Richard. *Portraits of a Merchant Prince: James Morrison 1789–1857.* Northallerton, 1977

Gaunt and Clayton-Stamm 1971: Gaunt, William, and M.D.E. Clayton-Stamm. *William de Morgan.* London, 1971

Gay 1887 and 1928: Gay, Victor. *Glossaire archéologique du moyen age et de la renaissance.* Vol. 1. Paris, 1887. Vol. 2 ed. Henri Stein. Paris, 1928

Gebbie 1972: Gebbie, John H. *An Introduction to the Abercorn Letters (as Relating to Ireland, 1736–1816).* Omagh, 1972

Gersaint 1747: Gersaint, François. *Catalogue raisonné des Bijoux, Porcelaines, . . . provenans de la Succession de M. Angram, Vicomte de Fonspertuis.* Paris, 1747

Gerson 1935: Gerson, Horst. *Philips Koninck. Ein beitrag zur erforschung des Hollandischen malerei des XVII Jahrhunderts.* Berlin, 1935

Giacomotti 1974: Giacomotti, Jeanne. *Catalogue des majoliques des Musées Nationaux.* Paris, 1974

Gilbert 1973: Gilbert, Christopher. "Chippendale's Harewood Commission." *Furniture History* (1973), 1–32

Gilbert 1976: Gilbert, Christopher. "Wright and Elwick of Wakefield 1748–1824: a Study of provincial patronage." *Furniture History* (1976), 34–50

Gilbert 1978: Gilbert, Christopher. *The Life and Work of Thomas Chippendale.* 2 vols. London, 1978

Gilbert 1978a: Gilbert, Christopher. *Furniture at Temple Newsam and Lotherton Hall.* 2 vols. London, 1978

Gilbey 1898: Gilbey, Sir Walter. *Life of George Stubbs R.A.* London, 1898

Girouard 1963: Girouard, Mark. "Curraghmore, County Waterford – III." *Country Life* (21 February 1963), 368–371

Girouard 1976: Girouard, Mark. *Hardwick Hall, Derbyshire – A History and a Guide.* London, 1976

Girouard 1979: Girouard, Mark. *The Victorian Country House.* New Haven and London, 1979

Glanville 1984: Glanville, Philippa. "Chinese Porcelain and English Goldsmiths, c.1560–c.1660." *Victoria and Albert Museum Album* (1984), 246–256

Glück 1931: Glück, G. *Van Dyck Des Meisters Gemälde. Klassiker der Kunst.* Stuttgart, 1931

Godden 1963: Godden, Geoffrey. *British Pottery and Porcelain, 1780–1850.* London, 1963

Godden 1966: Godden, Geoffrey. *An Illustrated Encyclopedia of British Pottery and Porcelain.* London, 1966

Gombrich 1942: Gombrich, E.H. "Reynolds' Theory and Practice of Imitation." *Burlington Magazine* 80 (February 1942), 40–45

Goncourt 1906: Goncourt, Edmund, et al. *L'art du dix-huitieme siècle.* Paris, 1906

Gonzalez-Palacios 1984: Gonzalez-Palacios, Alvar. *Il Tempio del Gusto.* 2 vols. Milan, 1984

Goodison 1966: Goodison, Nicholas. "Clockmaker and Cabinet-maker." *Furniture History* (1966)

Goodison 1972: Goodison, Nicholas. "Mr. Stuart's Tripod." *The Burlington Magazine* (1972), 695–704

Goodison 1972: Goodison, Nicholas. "The King's Vases." *Furniture History* (1972)

Goodison 1974: Goodison, Nicholas. *Ormolu, the Work of Matthew Boulton.* London, 1974

Goodwin 1903: Goodwin, C. *James McArdell.* London, 1903

Gore 1965: Gore, St. John. "An Edwardian Collection." *Country Life* (10 June 1965), 1410–1412

Gore 1966: Gore, St. John. "Buscot Park: The English Pictures." *Connoisseur* (January 1966), 2–6

Gore 1977: Gore, St. John. "Three Centuries of Discrimination." *Apollo* 105 (May 1977), 346–357

Gosford 1948: *Gosford Catalogue.* 1948

Gotch 1936: Gotch, J.A. *The Old Halls and Manor Houses of Northamptonshire.* London, 1936

Goulding 1920: Goulding, R.W. "Wriothesley Portraits." *Walpole Society* 8 (1920), 28

Grant 1956: Grant, M.H., Col. *Rachel Ruysch, 1664–1750.* Leigh-on-Sea, 1956

Grant-Peterkin 1981: Grant-Peterkin, Keith. "A Mystery Spanning 500 Years." *Transactions of the Silver Society* 3, no. 2 (1981), 36–37

Graves and Cronin 1899–1901: Graves, Algernon, and William Vine Cronin. *A History of the Works of Sir Joshua Reynolds.* 4 vols. London, 1899–1901

Graziani 1972: Graziani, René. "The Rainbow Portrait of Queen Elizabeth I and its Religious Symbolism." *Journal of the Warburg and Courtauld Institutes* 35 (1972), 247–259

Green 1964: Green, David. *Grinling Gibbons: his work as Carver and Statuary, 1648–1721.* London, 1964

Greene 1955: Greene, Vivien. *English Dolls' Houses of the Eighteenth and Nineteenth Centuries.* London, 1955

Gregory 1982: Gregory, Pierre. "Le Service Bleu Celeste de Louis XV à Versailles: Quelques Pièces Retrouvées." *La Revue du Louvre et des Musées de France* (1 February 1982), 40–46

Grierson 1932–1937: Grierson, H.J.C., ed. *The Letters of Sir Walter Scott.* 12 vols. London, 1932–1937

Griggs 1887: Griggs, W. *Illustrations of Armorial China.* London, 1887

Grimaldi 1977: Grimaldi, Floriano. "Musei d'Italia-Meraviglie d'Italia: Loreto, Palazzo Apostolico." Bologna, 1977

Grimwade 1965: Grimwade, Arthur. "Family Silver of Three Centuries." *Apollo* (December 1965), 498–506

Grimwade 1974: Grimwade, Arthur. *Rococo Silver.* London, 1974

Grimwade 1976 and 1982: Grimwade, Arthur. *London Goldsmiths 1697–1837, their Marks and Lives.* London, 1976. 2d ed. London, 1982

Grose 1786: Grose, Francis. *A Treatise on Ancient Armour and Weapons*. London, 1786

Grundy 1909: Grundy, C. Reginald. *James Ward, R.A.* London, 1909

Gudlauggson 1959–1960: Gudlauggson, S.J. *Geraert ter Borch*. 2 vols. The Hague, 1959–1960

Gunnis 1951 and 1968: Gunnis, Rupert. *Dictionary of British Sculptors 1660–1851*. London, 1951. 2d ed. London, 1968

Guthorn 1972: Guthorn, Peter J. *British Maps of the American Revolution*. Monmouth Beach, New Jersey, 1972

Haas 1950: Haas, Karl. "Haydn's English Military Marches." *The Score* 2 (January 1950), 150–160

Hackenbroch 1957: Hackenbroch, Yvonne. *Chelsea and other English Porcelain in the Irwin Untermyer Collection*. London, 1957

Hackenbroch 1979: Hackenbroch, Yvonne. *Renaissance Jewellery*. London, 1979

Haebler 1928: Haebler, Konrad. *Rollen und Plattenstempel des XVI Jahrhunderts*. 2 vols. Leipzig, 1928

Hall 1960–1962: Hall, Douglas. "The Tabley House Papers." *Walpole Society* 38 (1960–1962), 59–112

Hall 1982: Hall, Ivan. "William Constable I–IV" *Country Life* (22, 29 April; 6, 13 May 1982), 1114–1117; 1198–1202; 1274–1281; 1358–1361

Handley-Read 1966: Handley-Read, C. "Aladdin's Palace in Kensington." *Country Life* 139 (1966), 600–604

Handt 1956: Handt, Ingelore, and Hilde Rakebrand. *Meissner Porzellan des achtzehnten Jahrhunderts*. Dresden, 1956

Hannover 1924: Hannover, Emil. *Pottery and Porcelain. A Handbook for Collectors*. London, 1924

Harcourt 1808: Harcourt, George Simon, Earl Harcourt. *An account of the church and remains of the manor House of Stanton Harcourt in the County of Oxford*. Oxford, 1808

Harcourt 1880–1903: Harcourt, Edward William, ed. *The Harcourt Papers*. 14 vols. Oxford, 1880–1903

Hardy and Hayward 1978: Hardy, John, and Helena Hayward. "Kedleston Hall, Derbyshire – II." *Country Life* (2 February 1978), 262–266

Hardy, Landi, and Wright 1972: Hardy, John, Sheila Landi, and Charles D. Wright. *A State Bed from Erddig*. London, 1972

Harris and Jackson-Stops 1984: Harris, John, and Gervase Jackson-Stops, eds. *Kip and Knyff's Britannia Illustrata*. Facsimile ed. London, 1984

Harris and Tait 1979: Harris, John, and A.A. Tait. *Catalogue of the drawings by Inigo Jones, John Webb, & Isaac de Caux at Worcester College*. Oxford, 1979

Harris 1958: Harris, Enriquèta. "Velazquez's Portrait of Camillo Massimi." *Burlington Magazine* (1958), 279–280

Harris 1960: Harris, Enriquèta. "A letter from Velázquez to Cardinal Massimi." *Burlington Magazine* 102 (April 1960), 162–166

Harris 1963: Harris, Eileen. *The Furniture of Robert Adam*. London, 1963

Harris 1967: Harris, Eileen. "The Moor Park Tapestries." *Apollo* (September 1967), 180–189

Harris 1976: Harris, Enriquèta. "Velazquez's Portrait of Prince Baltasar Carlos in the Riding School." *Burlington Magazine* 118 (1976), 266–275

Harris 1978: Harris, John. *Gardens of Delight: the Rococo English Landscape of Thomas Robins the Elder*. London, 1978

Harris 1979: Harris, John. *The Artist and the Country House*. London, 1979

Harris 1983: Harris, Enriquèta, and Herbert Lank. "The cleaning of Velázquez's Portrait of Camillo Massimi." *Burlington Magazine* 125 (July 1983), 410–415

Hartshorne 1865: Hartshorne, C.H. *A Guide to Alnwick Castle*. London and Alnwick, 1865

Haskell and Penny 1977: Haskell, Francis, and Nicholas Penny. "Political Sculpture at Holkham." *Connoisseur* (1977), 207–209

Haskell and Penny 1981: Haskell, Francis, and Nicholas Penny. *Taste and the Antique (The Lure of Classical Sculpture 1500–1900)*. New Haven and London, 1981

Haskell 1963: Haskell, Francis. *Patrons and Painters: Art and Society in Baroque Italy*. London, 1963. 2d ed. New Haven and London, 1980

Haskell 1984: Haskell, Francis. "The Baron d'Hancarville: an adventurer and art historian in eighteenth century Europe." *Oxford and Italy, Essays in Honour of Sir Harold Acton*. London, 1984

Havinden 1966: Havinden, M.A. "The Soho Tapestry Makers." *Survey of London* 34 (The Parish of St. Anne, Soho) App. 1, 1966, 515–520, 542–543

Hawcroft 1957: Hawcroft, Francis. "Dutch Landscapes and the English Collector." *Antique Collector* (June 1957)

Hawkins, Franks, and Grueber 1885: Hawkins, Edward, Augustus Franks, and Herbert Grueber. *Medallic Illustrations of British History*. London, 1885

Hawkins 1983: Hawkins, John. *The Al Tajir Collection of Silver and Gold*. London, 1983

Hayes 1958: Hayes, John. "Parliament Street and Canaletto's View of Whitehall." *Burlington Magazine* (October 1958), 341–349

Hayes 1975: Hayes, John. *Gainsborough*. London, 1975

Hayes 1977: See Exh. London, NPG 1977

Hayes 1982: Hayes, John. *The Landscape Paintings of Thomas Gainsborough*. 2 vols. London, 1982

Haynes 1964: Haynes, D.E.L. *The Portland Vase*. London, 1964

Hayward and Kirkham 1980: Hayward, Helena, and Pat Kirkham. *William and John Linnell – Eighteenth-Century Furniture Makers*. 2 vols. London, 1980

Hayward 1960–1961: Hayward, John F. "Ambassadors' Plate." *Proceedings of the Society of Silver Collectors* (December 1960–June 1961)

Hayward 1963: Hayward, John F. "Candlesticks with Figure Stems." *Connoisseur* 152 (January 1963), 16–21

Hayward 1964: Hayward, Helena. *Thomas Johnson and English Rococo*. London, 1964

Hayward 1969: Hayward, J.F. "The Pelham Gold Cup." *Connoisseur* 171 (July 1969), 162–169

Hayward 1974: Hayward, J.F. "English Swords 1600–1650." *Arms and Armour Annual* (1974), 142–161

Hayward 1976: Hayward, J.F. *Virtuoso Goldsmiths and the triumph of Mannerism, 1590–1620*. London, 1976

Hayward 1978: Hayward, J.F. "The Earl of Warrington's Plate." *Apollo* 107 (July 1978), 32–39

Hazen 1948: Hazen, A.T. *A Bibliography of Horace Walpole*. New Haven, 1948

Hazlitt 1844: Hazlitt, William. *Criticism on Art with catalogues of the principal picture galleries of England*. 2d ser. London, 1844

Heal 1953: Heal, Sir Ambrose. *The London Furniture Makers 1660–1840*. London, 1953. Reprint, 1972

Heaps 1973: Heaps, Leo. *Log of the Centurion*. London, 1973

Hefford 1984: Hefford, Wendy. "Huguenot tapestry-weavers in and around London 1680–1780." *Proceedings of the Huguenot Society of London* 24, no. 2 (1984), 103–112

Helbig and Speier 1963: Helbig, W., and H. Speier. *Führer durch die öffentlichen sammlungen klassischer Altertumer in Rom*. Vol. 3. Tubingen, 1963

Hellinga 1982: Hellinga, Lotte. *Caxton in Focus*. London, 1982

Helm 1915: Helm, William Henry. *Vigée-Lebrun 1755–1842. Her Life, Works and a Catalogue of Pictures*. 4 vols. London, 1915

Helps 1868: Queen Victoria. *Leaves from the Journal of Our Life in the Highlands from 1848 to 1861*. ed. Arthur Helps. London, 1868

Hemelrijk 1984: Hemelrijk, J.M. *Caeretan Hydriae*. Mainz, 1984

Henmarck 1977: Henmarck, Carl. *The Art of the European Silversmith, 1430–1830*. London, 1977

Hervey 1921: Hervey, M.F.S. *The Life, Correspondance . . . of Thomas Howard, Earl of Arundel*. Cambridge, 1921

Hill and Cornforth 1966: Hill, Oliver, and John Cornforth. *English Country Houses: Caroline*. London, 1966

Hill and Pollard 1967: Hill, G.F., and G. Pollard. *Renaissance Medals from the Samuel Kress Collection*. London, 1967

HMC 1903: Historic Manuscripts Commission. *Report on the Manuscripts belonging to the Duke of Buccleuch*. 3 vols. London, 1903

HMC 1925: Historic Manuscripts Commission. *Report on the Manuscripts of Lord de L'Isle and Dudley*. London, 1925

Hoboken 1957: Hoboken, Anthony van. *Joseph Haydn: Thematisch-bibliographisches Werkverzeichnis, zusammengestelt von [A.v.H.]*. Vol. I. Mainz, 1957

Hobson 1940: Hobson, G.D. *English Bindings 1490–1940 in the Library of J.R. Abbey*. London, 1940

Hodgkinson 1952–1954: Hodgkinson, Terence. "Christopher Hewetson, an Irish Sculptor in Rome." *Walpole Society* 36 (1952–1954), 1958, 42–54

Hofmann 1911: Hofmann, F.H. *Frankenthaler Porzellan*. Munich, 1911

Hofmann 1932: Hofmann, F.H. *Das Porzellan*. Berlin, 1932

Hofstede de Groot 1908–1927: Hofstede de Groot, Cornelius. *A Catalogue Raisonné of the Works of the Eminent Dutch Painters of the Seventeenth Century based on the work of John Smith, trans. and ed. by Edward G. Hawke*. 8 vols. London, 1908–1927

Holkham 1913: *List of Statues and Busts at Holkham Hall, 1913*. London, 1913

Holland 1891: Holland, L.G. *Catalogue of the Collection of Pictures at Hatfield House*. 1891

Holme and Kennedy 1917: Holme, D., and H.A. Kennedy. *Early English Portrait Miniatures in the Collection of the Duke of Buccleuch*. London, 1917

Holme 1688: Holme, Randle. *The Academie of Armory, or a Storehouse of Armory and Blazon*. Chester, 1688

Holtzmann and Salviat 1981: Holtzmann, Bernard, and François Salviat. "Les Portraits sculptés de Marc-Antoine." *Bulletin de Correspondance Hellénique* 105 (1981), 265–288

Honey 1928 and 1977: Honey, W.B. *Old English Porcelain*. London, 1928. 3d ed. rev. Franklin D. Barret. London, 1977

Honour 1958: Honour, Hugh. "English patrons and Italian Sculptors in the First Half of the Eighteenth Century." *Connoisseur* 141 (June 1958), 220–226

Honour 1961: Honour, Hugh. "Bronze statuettes by Giacomo and Giovanni Zoffoli." *Connoisseur* 148 (November 1961), 198–205

Honour 1963: Honour, Hugh. "After the Antique: Some Italian Bronzes of the Eighteenth Century." *Apollo* (March 1963), 194–200

Honour 1969: Honour, Hugh. *Cabinet Makers and Furniture Designers*. London, 1969

Hope 1807: Hope, Thomas. *Household Furniture and Interior Decoration*. London, 1807

Howard and Ayers 1978: Howard, David Sanctuary, and John Ayers. *China for the West*. London and New York, 1978

Howard 1973: Howard, David Sanctuary. "Chinese Porcelain of the Jacobites." *Country Life* 153 (25 January and 1 February 1973), 243–244; 289–290

Howard 1973a: Howard, Seymour.

"G. B. Visconti's Projected Sources for the Museo Pio-Clementino." *Burlington Magazine* 117 (September 1975), 735–736

Howard 1973b: Howard, Seymour. "Antiquarian Handlist and the Beginnings of the Pio-Clementino." *Eighteenth Century Studies* 7 (1973), 40–61

Howard 1974: Howard, David Sanctuary. *Chinese Armorial Porcelain*. London, 1974

Howard 1982: Howard, Seymour. *Bartolomeo Cavaceppi, Eighteenth-Century Restorer*. New York and London, 1982

Huemer 1977: Huemer, F. *Corpus Rubensianum Ludwig Burchard. Portraits*. Vol. 1. Brussels, 1977

Hume 1824: Hume, Sir Abraham. *A Descriptive Catalogue of A Collection of Pictures Comprehending Specimens of All the Various Schools of Painting*. London, 1824

Hunisak 1977: Hunisak, James. *The Sculptor Jules Dalou*. New York, 1977

Hunt 1822: Hunt, Philip. *Outline Engravings and Descriptions of the Woburn Abbey Marbles*. London, 1822

Hunt 1971: Hunt, John. "Gosford, East Lothian – I and II." *Country Life* 150 (21 October and 4 November 1971), 1048–1050; 1200–1202

Hussey 1924: Hussey, Christopher. "Dorney Court, Buckinghamshire – II." *Country Life* (2 August 1924), 176–183

Hussey 1929: Hussey, Christopher. "Horses by James Seymour at Ammerdown." *Country Life* (26 January 1929), 126–129

Hussey 1949: Hussey, Christopher. "Haddon Hall, Derbyshire, IV." *Country Life* (23 December 1949), 1884–1888

Hussey 1954: Hussey, Christopher. "A Classical Landscape Park: Shugborough, Staffordshire, I." *Country Life* (15 April 1954), 1126–1129

Hussey 1955: Hussey, Christopher. *English Country Houses: Early Georgian*. London, 1955

Hussey 1967: Hussey, Christopher. *The Picturesque: Studies in a Point of View*. London, 1967

Huth 1971: Huth, Hans. *Lacquer of the West*. London and Chicago, 1971.

Huxley 1965: Huxley, Gervas. *Lady Elizabeth and the Grosvenors, Life in a Whig Family*. London, 1965

Hyde 1937: Hyde, H. Montgomery. *Londonderry House and Its Pictures*. London, 1937

Hymans 1910: Hymans, H. *Antonis Mor*. Brussels, 1910

Ibbotson 1851: Ibbotson, Henry. *The Visitor's Guide to Castle Howard, The Seat of the Rt. Hon. The Earl of Carlisle. . . .* Ganthorpe, 1851

Ilchester 1920: Ilchester, The Earl of. *Henry Fox, First Lord Holland: His Family and Relations*. 2 vols. London, 1920

Ilchester 1928: Ilchester, The Earl of. *The Life of Sir Charles Hanbury-Williams: Poet, Wit and Diplomatist*. London, 1928

Ilchester 1929: Ilchester, The Earl of. "A Notable Service of Meissen Porcelain." *Burlington Magazine* 55 (October 1929), 188–190

Ilchester 1937: Ilchester, The Earl of. *The Home of the Hollands, 1605–1820*. London, 1937

Ingamells and Raines 1976–1978: Ingamells, John, and Robert Raines. "A Catalogue of the paintings, drawings and etchings of Philip Mercier." *Walpole Society* 46 (1976–1978), 1–70

Ingamells 1981: Ingamells, John, ed. *The Hertford-Mawson Letters. The 4th Marquess of Hertford to his agent Samuel Mawson*. London, 1981

Ingersoll-Smouse 1926: Ingersoll-Smouse, F. *Joseph Vernet*. 2 vols. Paris, 1926

Irwin and Brett 1970: Irwin, John, and Katherine B. Brett. *Origins of Chintz, with a catalogue of Indo-European cotton-paintings in the Victoria and Albert Museum, London, and the Royal Ontario Museum, Toronto*. London, 1970

Irwin 1966: Irwin, David. *English Neoclassical Art: Studies in Inspiration and Taste*. London, 1966

Irwin 1975: Irwin, David, and Francina. *Scottish Painters at Home and Abroad: 1700–1900*. London, 1975

Isham and Marlow 1971: Isham, Sir Gyles, and Norman Marlow. *The Diary of Thomas Isham of Lamport (1658–81) kept by him in Latin from 1671 to 1673 at his Father's Command*. Farnborough, 1971

Jackson 1911: Jackson, Sir Charles J. *An Illustrated History of English Plate*. 2 vols. London, 1911. Reprint, 1967

Jackson-Stops and Hardy 1978: Jackson-Stops, Gervase, and John Hardy. "The Second Earl of Warrington and the 'Age of Walnut.'" *Apollo* (July 1978), 12–23

Jackson-Stops 1973: Jackson-Stops, Gervase. "Cholmondeley Castle, Cheshire – I." *Country Life* (19 July 1973), 154–157

Jackson-Stops 1974: Jackson-Stops, Gervase. "The West Wycombe Landscape." *Country Life* (27 June 1974), 1682–1685

Jackson-Stops 1974a: Jackson-Stops, Gervase. "Pre-Adam Furniture Designs at Nostell Priory." *Furniture History* (1974), 24–40

Jackson-Stops 1976: Jackson-Stops, Gervase. *The Gubbay Collection, Clandon Park, Surrey*. The National Trust, London, 1976

Jackson-Stops 1977: Jackson-Stops, Gervase. "Furniture at Petworth." *Apollo* 105 (May 1977), 358–366

Jackson-Stops 1977a: Jackson-Stops, Gervase. "A Courtier's Collection: The 6th Duke of Dorset's Furniture at Knole – I." *Country Life* (2 June 1977), 1495–1497

Jackson-Stops 1978: Jackson-Stops, Gervase. *Drayton House, Northamptonshire*. London, 1978

Jackson-Stops 1978a: Jackson-Stops, Gervase. *Claydon House*. The National Trust, London, 1978

Jackson-Stops 1980: Jackson-Stops, Gervase. "Daniel Marot and the 1st Duke of Montagu." *Nederlands Kunsthistorisch Jaarboek (Festschrift for Professor Th. H. Lunsingh Scheurleer)* 31 (1980), 244–262

Jackson-Stops 1980a: Jackson-Stops, Gervase. "Great Carvings for a Connoisseur, Picture Frames at Petworth – II." *Country Life* (25 September 1980), 1030–1032

Jackson-Stops 1980b: Jackson-Stops, Gervase. "Broadlands, Hampshire—I and II." *Country Life* (4, 11, 18 December 1980), 2099–2102; 2246–2250; 2334–2337

Jacques 1822: Jacques, D. *A Visit to Goodwood, near Chichester, the Seat of His Grace the Duke of Richmond . . .* Chichester, 1822

Jaffé 1977: See Exh. Cambridge 1977

Jaffé 1977a: Jaffé, Michael. *Rubens and Italy*. Oxford, 1977

Jameson 1844: Jameson, Mrs. (Anna Brownell). *Companion to the most celebrated private galleries of art in London. . . .* London, 1844

Jedding 1968: Jedding, Hermann. *Porzellan aus der Sammlung Blohm*. Museum für Kunst und Gewerbe. Hamburg, 1968

Jenyns 1937–1938: Jenyns, Roger Soame. "The Polychrome Wares Associated with the Potters Kakiemon." *Transactions of the Oriental Ceramics Society* 15 (1937–1938), 21–32

Jenyns 1965: Jenyns, Roger Soame. *The British Museum, Japanese Porcelain*. London, 1965

Jervis 1972: Jervis, Simon. "Antler and Horn Furniture." *Victoria and Albert Museum Yearbook* (1972), 87–99

Jervis 1974: Jervis, Simon. *Printed Furniture Designs Before 1650*. London, 1974

Jervis 1977: Jervis, Simon. "Furniture in Horn and Antler." *Connoisseur* 196 (November 1977), 190–201

Jervis 1978: Jervis, Simon. "Furniture at Arundel Castle." *Connoisseur* (March 1978), 203–216

Jervis 1980: Jervis, Simon. *Browsholme Hall*. Derby, 1980

Jesse 1843–1844: Jesse, John Heneage. *George Selwyn and His Contemporaries; With Memoirs and Notes*. 4 vols. London, 1843–1844

Jesse 1882: Jesse, Captain. *Life of Geo. Brummel*. 2d ed. 2 vols. London, 1882

Jessen 1892: [Marot, Daniel] *Das Ornamentwerk des Daniel Marot*. Ed., with prefaces, Peter Jessen. Berlin, 1892

Johanneum 1920: *Porzellan . . . aus dem Sächsischen Staatssammlungen (Johanneum)* (12 October 1920) (called colloquially the Johanneum Duplicate Sale) 1920

Johansen 1978: Johansen, Fleming. "Antike Portraetter af Kleopatra VII og Marcus Antonius." *Meddelelser fra Ny Carlsberg Glyptotek* 35 (1978), 55–81

Jones 1849: Jones, G. *Sir Francis Chantrey, R.A. Recollections of his Life, Practice and Opinions*. London, 1849

Jones 1907: Jones, Edward Alfred. *Old English Gold Plate*. London, 1907

Jones 1911: Jones, Edward Alfred. *The Gold and Silver of Windsor Castle*. Letchworth, 1911

Jones 1926: Jones, Henry Stuart, ed. *A Catalogue of the Ancient Sculptures Preserved in the Municipal Collections of Rome. The Sculptures of the Palazzo dei Conservatori*. 2 vols. Oxford, 1926

Jones 1928: Jones, Edward Alfred. *Old Silver of Europe and America from early times to the nineteenth century*. London, 1928

Jourdain 1948: Jourdain, Margaret. *The Work of William Kent, artist, painter, designer and landscape gardener. . . .* London, 1948

Jourdain 1950: Jourdain, Margaret. "Furniture at Hagley Hall." *Apollo* 51 (January 1950), 8–10

Jourdain 1965: Jourdain, Margaret. *Regency Furniture 1795–1820*. 4th ed. Revised and enlarged by R. Fastnedge. London, 1965

Kagan 1915: Kagan, J. *Western European Cameos in the Hermitage*. Leningrad, 1973

Kelly 1965: Kelly, Alison. *Decorative Wedgwood in Architecture and Furniture*. London, 1965

Kelly 1968: Kelly, Alison. *The Book of English Fireplaces*. London, 1968

Kendrick 1913: Kendrick, A.F. "The Hatfield Tapestries of the Seasons." *Walpole Society* 2 (1913), 89–97

Kennedy 1764: Kennedy, James. *A New Description of the Pictures, Statues, Bustos, Basso-Relievos and Other Curiosities of the Earl of Pembroke's House at Wilton*. 2d ed. Salisbury, 1764

Kennedy 1768 and 1769: Kennedy, James. *A Description of the Antiquities and Curiosities of Wilton House*. 3d ed. Salisbury, 1768. 4th ed., Salisbury, 1769

Kennedy 1778 and 1779: Kennedy, James. *A New Description of the Pictures, Statues, Bustos, Basso Relievos and other Curiosities in the Earl of Pembroke's House at Wilton*. 8th ed. Salisbury, 1778; 9th ed. Salisbury, 1779

Kennedy 1786: [J. Kennedy]. *A Description of the Antiquities and Curiosities in Wilton House*. 2d ed. Sarum, 1786

Kennedy 1917: Kennedy, H.A. *Early English portrait miniatures in the collection of the Duke of Buccleuch . . . Studio*, Special number. London, 1917

Kenworthy-Browne 1971: Kenworthy-Browne, John. "Pauline and the Bachelor Duke." *Country Life* 149 (28 January 1971), 208–214

Kenworthy-Browne 1972: Kenworthy-Browne, John. "A Ducal Patron of Sculptors." *Apollo* 96 (October 1972), 322–331

Kenworthy-Browne 1977: Kenworthy-Browne, John. "The Third Earl of Egremont and Neo-Classical Sculpture." *Apollo* 105 (May 1977), 367–373

Kenworthy-Browne 1980: Kenworthy-Browne, John. "Portrait Busts by Rysbrack." *National Trust Studies* (1980), 67–79

Kenworthy-Browne 1983: Kenworthy-Browne, John. "Rysbrack, Hercules and Pietro da Cortona." *Burlington Magazine* (April 1983), 216–219

Kenworthy-Browne 1983a: Kenworthy-Browne, John. "Matthew Brettingham's Rome Account Book, 1747–1754." *Walpole Society* 49 (1983), 37–132

Keramos 1980: See Bolz 1980

Kerslake 1977: Kerslake, John. *Catalogue of the Eighteenth Century Portraits in the National Portrait Gallery, London*. London, 1977

Ketton-Cremer 1964: Ketton-Cremer, R.W. *Horace Walpole. A biography*. 3d ed., London, 1964.

Kilburn 1981: Kilburn, Richard S. *Transitional Wares and their Forerunners*. Hong Kong, 1981

King 1925: King, William. *English porcelain figures of the eighteenth century . . .* London, 1925

King 1983: King, N. *The Grimstons of Gorhambury*. Southampton, 1983

Kingzett 1982: Kingzett, Richard. "A Catalogue of the Works of Samuel Scott." *Walpole Society* 48 (1980–1982), 1–134

Kitson 1969: Kitson, Michael. "The Westminster Claudes." *Burlington Magazine* 3 (1969), 754–758

Kitson 1978: Kitson, Michael. *Claude Lorrain: Liber Veritatis*. London, 1978

Klemperer 1928: Schnorr von Carolsfeld, Ludwig. *Porzellansammlung Gustav von Klemperer*. Dresden, 1928

Knowles 1831: Knowles, John. *Life and Writings of Fuseli*. London, 1831

Koeppel 1983: Koeppel, Gerhard M. "Two Reliefs from the Arch of Claudius in Rome." *Mitteilungen des Deutschen Archäologischen Instituts, Roemische Abteilung* 90 (1983), 103–109

Kozakiewicz 1972: Kozakiewicz, Stefan. *Bernardo Bellotto*. 2 vols. London, 1972

Laking 1922: Laking, Sir Guy Francis. *A Record of European armour and arms through seven ages*. 5 vols. London, 1920–1922

Landon 1960: Landon, H.C. Robbins. *Sämtliche Werke für Blasinstrumente Marsche . . . herausgegeben von H.C. Robbins Landon*. Partitur, Vienna, 1960

Landon 1976: Landon, H.C. Robbins. *Haydn: Chronicle & Works*. Vol. 3. *Haydn in England 1791–1795*. London, 1976

Lane 1949: Lane, Edward Arthur. "Daniel Marot: Designer of Delft Vases and of Gardens at Hampton Court." *Connoisseur* (March 1949), 19–24

Lane 1950: Lane, Edward Arthur. "Queen Mary II's Porcelain Collection at Hampton Court." *Transactions of the Oriental Ceramic Society* (1949–1950), 21–31

Lane 1953: Lane, Edward Arthur. "Queen Mary II's Porcelain Collection at Hampton Court." *Antique Collector* (April 1953), 72–77

Lane 1955: Lane, Edward Arthur. "Sèvres and Other Porcelain in the Collection of Viscount and Viscountess Gage at Firle Place, Sussex." *Connoisseur* 135 (April 1955), 158–163

Lane 1961: Lane, Edward Arthur. *English porcelain figures of the eighteenth century*. London, 1961

Lankheit 1962: Lankheit, Klaus. *Florentinische Barockplastik: die Kunst am Hofe der Letzten Medici*. Munich, 1962

Lankheit 1982: Lankheit, Klaus. *Die Modellsammlung der Porzellanmanufaktur Doccia*. Munich, 1982

Latham 1970: Latham, Robert, and William Matthews, eds. *The Diary of Samuel Pepys. A new and complete transcription*. 8 vols. London, 1970

Lavin 1985: Lavin, Irving. "Bernini's Bust of Cardinal Montalto." *Burlington Magazine* 127 (January 1985), 32–38

Layard 1906: Layard, George Somes. *Sir Thomas Lawrence's Letter-Bag*. London, 1906

Leeds 1950: *Leeds Art Calendar*. No. 13 (1950)

Leeds 1957: *Leeds Art Calendar*. No. 38 (1957)

Lees-Milne 1975: Lees-Milne, James. "Stratfield Saye House." *Apollo* 102, no. 161 (July 1975), 8–18

Legrand 1963: Legrand, Francine-Claire. *Les Peintres flamands de genre au XVIIe Siècle*. Paris and Brussels, 1963

Legrand 1967: Legrand, Francine-Claire. "Fernand Khnopff – Perfect Symbolist." *Apollo* 85 (April 1967), 278–287

Lenygon 1914: Lenygon, Francis. *Furniture in England from 1660–1760*. London, 1914

Leroy 1937: Leroy, Stephane. *Catalogue des Peintures, Sculptures . . . du Musée de Douai*. Douai, 1937

Leslie 1860: Leslie, Charles Robert. *Autobiographical Recollections*. 2 vols. London, 1860

Lessmann 1979: Lessmann, Johanna. *Herzog Anton Ulrich-Museum, Braunschweig, Italienische Majolika, Katalog der Sammlung*. Brunswick, 1979

Levey 1953: Levey, Michael. "Canaletto's Regatta Paintings." *Burlington Magazine* 95 (November 1953), 364–466

Lewis 1937–1983: Lewis, Wilmarth Sheldon, ed., et al. *The Yale Edition of Horace Walpole's Correspondance*. 48 vols. New Haven, 1937–1983

Lipski and Archer 1984: Lipski, L.L., and M. Archer. *Dated English Delftware*. London, 1984

Little and Kahrl 1963: Little, D.M., and G.M. Kahrl, eds. *The Letters of David Garrick*. 3 vols. London, 1963

Liverpool 1906: Liverpool, Earl of. *Catalogue of the Portraits, etc. at Holker Hall, Lancashire, in the possession of the Right Hon. Victor C.W. Cavendish, MP*. Manchester, 1906

Lloyd Thomas 1974: Lloyd Thomas, E. *Victorian Art Pottery*. London, 1974

Lockhart 1837: Lockhart, John Gibson. *Memoirs of the Life of Sir Walter Scott, Bart*. 7 vols. Edinburgh, 1837–1838

Long 1929: Long, Basil S. *British Miniaturists*. London, 1929

Long 1930: Long, Basil S. "Stuart Relics in the Possession of Major Cyril Sloane Stanley." *Collector* 9 (February 1930)

Longrigg 1975: Longrigg, Roger Erskine. *The History of Foxhunting*. London, 1975

Longrigg 1977: Longrigg, Roger Erskine. *The English Squire and his Sport*. London, 1977

López-Rey 1963: López-Rey, José. *Velasquez: a catalogue Raisonné of his oeuvre*. London, 1963

Lugt 1921: Lugt, Frits. *Les marques de collections de dessins et d'estampes*. ed. Martinus Nijhoff. Amsterdam, 1921

Lugt 1953: Lugt, Frits. *Répertoire des Catalogues de Ventes publiques intéressant l'art ou la Curiosité*. Vol. 2, *Deuxième Période, 1826–1860*. The Hague, 1953

Lunsingh Scheurleer 1980: Lunsingh Scheurleer, T.H. "Pierre Gole, ébéniste du roi Louis XIV." *Burlington Magazine* (June 1980), 380–394

Luton 1822: "Luton Hoo. Catalogue Raisonné à l'Usage de l'Amateur, 1822." MSS, Mount Stuart

Maas 1975: Maas, Jeremy. *Gambart: Prince of the Victorian Art World*. London, 1975

Macquoid 1904–1908: Macquoid, Percy. *History of English Furniture*. 4 vols. London, 1904–1908

Macray 1888: Clarendon, Earl of. *The History of the Rebellion and Civil Wars in England*. ed. W.D. Macray, 6 vols. 1888

Mahoney 1977: Mahoney, Michael. *The Drawings of Salvator Rosa*. 2 vols. New York and London, 1977

Mallet 1964: Mallet, J.V.G. *Upton House, The Bearsted Collection: Porcelain*. The National Trust, London, 1964

Mallet 1966: Mallet, J.V.G. "Wedgwood's Early Vases." *Country Life* (9 June 1966), 1480–1482

Mallet 1978: Mallet, J.V.G. "Pottery and Porcelain at Erddig." *Apollo* (July 1978), 40–45

Malvasia 1678: Malvasia, Carlo Cesare. *Felsina Pittrice. Vite de Pittori Bolognesi*. 2 vols. Bologna, 1678

Mankowitz 1952: Mankowitz, Wolf. *The Portland Vase and the Wedgwood Copies*. London, 1952

Mankowitz 1953: Mankowitz, Wolf. *Wedgwood*. London, 1953

Manly and Rickert 1940: Manly, J.M., and Edith Rickert. *The Text of the Canterbury Tales.* Chicago, 1940

Mann 1931: Mann, Sir James G. *Wallace Collection Catalogue: Sculpture.* London, 1931

Mann 1933: Mann, Sir James G. "Portrait of a Somerset in Armour." *Connoisseur* 92 (1933), 414–417

Mann 1935–1939: Mann, Sir James G. "Die alten Rüstkammerbestände auf Warwick Castle." and "Die Waffensammlung auf Warwick Castle." *Zeitschrift für historische Waffenkunde* 14 (1935–1936), 157–160; 15 (1937–1939), 49–54

March 1911: March, Earl of. *A Duke and his Friends: The Life and Letters of the 2d Duke of Richmond.* 2 vols. London, 1911

Marchand 1973–1982: Marchand, Leslie A., ed. *Byron's Letters and Journals.* 12 vols. London, 1973–1982

Mariacher 1968: Mariacher, Giovanni. *Palma il Vecchio.* Milan, 1968

Marillier 1930: Marillier, Harry Currie. *English Tapestries of the Eighteenth Century . . .* London, 1930

Mariuz and Pallucchini 1982: Mariuz, Adriano, and Rodolfo Pallucchini. *L'Opera Completa del Piazzetta.* Milan, 1982

Markham 1984: Markham, Sarah. *John Loveday of Haversham 1711–1780: The Life and Tours of an Eighteenth-Century Onlooker.* Wilton, 1984

Marlier 1934: Marlier, Georges. *Anthonis Mor Van Dashort.* Brussels, 1934

Marshall 1954: Marshall, H. Rissik. *Coloured Worcester Porcelain of the First Period (1751–1783).* Newport, Monmouthshire, 1954

Marshall 1978: Marshall, Arthur Calder. *The Two Duchesses.* London, 1978

Martyn 1766: Martyn, T. *The English Connoisseur: containing an Account of whatever is curious in Painting and Sculpture etc., in the Palaces and Seats of the Nobility and Principal Gentry of England.* 2 vols. London, 1766

Mason 1839: Mason, William Hayley. *Goodwood, its House Park and Grounds with a catalogue raisonné of the pictures in the gallery of his Grace The Duke of Richmond, KG . . .* London, 1839

Mauchline 1974: Mauchline, Mary. *Harewood House.* London, 1974

Maxwell-Scott 1888: Maxwell-Scott, Hon. Mrs. *Catalogue of the Armour & Antiquities at Abbotsford.* Abbotsford, 1888

Maze-Sencier 1885: Maze-Sencier, Alphonse. *La Livre des Collectionneurs.* Paris, 1885

McCarthy 1975–1976: McCarthy, Michael. "John Chute's Drawings for The Vyne." *The National Trust Year Book* (1975–1976), 70–80

McConkey 1984–1985: See Exh. London, Edinburgh, and Dublin 1984–1985

McEvoy 1919: *The Works of Ambrose McEvoy.* Ed. C. Johnson. London, 1919

McEwan 1930: McEwan, John H.S. *James Robert Dundas McEwan, 1896–1916. A Memoir.* Edinburgh, 1930

McKay and Roberts 1914: McKay, William, and W. Roberts. *John Hoppner, R.A. Supplement.* London, 1914

McKibbin 1956: McKibbin, David. *Sargent's Boston.* Boston, 1956

Mentmore sale: Sotheby Parke Bernet, Mentmore, Bucks. Vol. I. *Catalogue of French and Continental Furniture, Tapestries and Clocks* (May 1977), 18–20

Menzhausen 1969: Menzhausen, Ingelore. *Böttger Steinzeug/Böttger Porzellan.* Dresden, 1969

Merwe 1979: Merwe, Pieter van der. *The Spectacular Career of Clarkson Stanfield, 1793–1867.* London, 1979

Methuen 1891 and 1903: Methuen, 3d Lord. *Corsham Court.* Corsham, 1891. Rev. ed. 1903

Metz and Rave 1957: Metz, P., and P.O. Rave. "Eine neuerworbene Bildnisbüste des Barons Philip von Stosch von Edmé Bouchardon." *Berliner Museen berichte aus dem ehem. Preussischen Kunstsammlungen.* Berlin, 1957

Michael 1983: Michael, Prince, of Greece. *Crown Jewels of Britain and Europe.* London, 1983

Michaelis 1882: Michaelis, Adolf. *Ancient Marbles in Great Britain.* Trans. C.A.M. Fennell. Cambridge, 1882

Millar 1960: Millar, Oliver. "Abraham van der Doort's Catalogue of the Collections of Charles I." *Walpole Society* 37 (1960)

Millar 1963: Millar, Oliver. *Tudor, Stuart and Early Georgian Pictures in the Collection of Her Majesty The Queen.* 2 vols. London, 1963

Millar 1963a: Millar, Oliver. "Marcus Gheerarts the Younger: A Sequel through Inscriptions." *Burlington Magazine* 105 (1963), 541

Millar 1966: Millar, Oliver. *Zoffany and His Tribuna.* London, 1966

Millar 1974: See Exh. Arts Council 1974–1975

Miller 1983: See Richmond 1983

Mitchell 1977–1978: Mitchell, Anthony. "The Park and Gardens at Dyrham." *National Trust Yearbook* (1977–1978), 83–108

Montagu 1954: Montagu, Jennifer. "A Renaissance Work copied by Wedgwood." *Journal of the Warburg and Courtauld Institute* 17 (1954), no. 3–4

Montague House 1898: *Catalogue of Pictures at Montague House.* London, 1898

Moon 1979: Moon, W. *Greek vase painting in Mid-Western collections.* Chicago, 1979

Moore 1955: [Moore, Henry] *Henry Moore. Vol. II, Sculpture and Drawing, 1949–1954.* Intro. Herbert Read. London, 1955

Morris 1912: Morris & Co. *Specimens of Furniture Upholstery and Interior Decoration.* London, 1912

Morris 1912: Morris, May. *The Collected Works of William Morris.* Vol. 16. London, 1912

Morris 1934: See Exh. London, V & A 1934

Mount 1955 and 1969: Mount, Charles Merrill. *John Singer Sargent: a Biography.* New York, 1955. Reprint, New York, 1969

Müller Hofstede 1977: Müller Hofstede, J. *Rubens in Italy.* Cologne, 1977

Munnings 1951: Munnings, Alfred. *The Second Burst. An artist's Life.* Vol. 2. London, 1951

Murdoch 1981: Murdoch, J. *The English Miniature.* London, 1981

Murdoch 1983: Murdoch, Tessa. "Louis François Roubiliac and his Huguenot Connections." *Proceedings of the Huguenot Society of London* 24, no. 1 (1983), 26–45

Murdoch, Murrell, Noon, and Strong 1981: Murdoch, J., J. Murrell, P.J. Noon, and R. Strong. *The English Miniature.* New Haven and London, 1981

Museum Medianum 1755: [Mead, Dr. Richard]. *Museum Medianum.* London, 1755

Musgrave 1961 and 1970: Musgrave, Clifford. *Regency Furniture 1800–1830.* London, 1961. New ed. 1970

NACF 1981: *The National Art-Collections Fund Annual Report 1981.* London, 1981

Nares 1953: Nares, Gordon. "Arbury Hall, Warwickshire." *Country Life* (1953), 1126–1129; 1210–1213, 1414–1417

Nash 1968: Nash, Ernest. *Pictorial dictionary of ancient Rome.* 2 vols. 2d ed. London, 1968

Natter 1761: Natter, L. "Catalogue des Pierres Gravées . . . de la Collection de Monseigneur le Duc de Devonshire." Chatsworth MSS, 1761

Neale 1818–1823: Neale, John Preston. *Views of the Seats of Noblemen and Gentlemen in England, Wales, Scotland and Ireland.* 6 vols. London, 1818–1823

Neatby 1977: Neatby, Nigel, ed. *The Saltram Collection.* The National Trust, London, 1977

Nevinson 1973: Nevinson, John L. "Stitched for Bess of Hardwick. Embroideries at Hardwick Hall Derbyshire." *Country Life* (29 November 1973), 1756–1761

Newdigate-Newdegate 1898: Newdigate-Newdegate, Anne Emily, Lady. *The Cheverels of Cheverel Manor . . .* London, 1898

Newman 1977: Newman, Michael. *Die deutschen Porzellan-Manufakturen im 18. Jahrhundert.* Brunswick, 1977

Nicholas 1842: Nicholas, Nicholas Harris, Sir. *History of the Orders of Knighthood of the British Empire.* 4 vols. London, 1841–1842

Nichols 1833: Nichols, J.B., ed. *Anecdotes of William Hogarth, written by himself . . .* London, 1833

Nichols 1859: Nichols, John Gough. *A Catalogue of the Portraits of King Edward the Sixth, Both Painted and Engraved.* London, 1859

Nichols 1863: Nichols, John Gough. "Notices of the Contemporaries and Successors of Holbein." *Archaeologia* 39 (1863), 19

Nichols 1866: Nichols, John Gough. "Remarks upon Holbein's Portraits of the Royal Family of England and more particularly upon the several Portraits of the Queens of Henry the Eighth." *Archaeologia* 40 (1866), 71–88

Nicolson 1937: Nicolson, Harold. *Helen's Tower.* London, 1937

Nicolson 1968: Nicolson, Benedict. *Joseph Wright of Derby. Painter of Light.* 2 vols. London and New York, 1968

Nightingale 1881: Nightingale, J.E., FSA. *Contributions towards the History of Early English Porcelain from Contemporary Sources.* Salisbury, 1881

Nixon 1965: See Exh. London, BM 1965

Nixon 1970: Nixon, Howard M. "English Bookbindings LXXII." *The Book Collector* 19, no. 1 (Spring 1970)

Nixon 1978: Nixon, Howard M. *Five Centuries of English Book Binding.* London, 1978

Noakes 1978: Noakes, Aubrey. *Ben Marshall.* Leigh-on-Sea, 1978

Norman and Barne 1980: Norman, A.V.B., and C.M. Barne. *The Rapier and Small-Sword, 1460–1820.* London, 1980

North 1978: North, A.R.E. "Arms and Armour from Arundel Castle." *Connoisseur* 197 (March 1978), 186–194

Northbrook 1889: Weale, W.H. James, and Jean Paul Richter. *Descriptive Catalogue of the Collection of Pictures Belonging to the Earl of Northbrook.* London, 1889

Northumberland 1930: *Northumberland Catalogue.* MSS Duke of Northumberland, 1930

Norwich 1977: Norwich, John Julius. *Venice: the rise to empire.* London, 1977

Novelli 1964: Novelli, Maria Angela. *Lo Scarsellino.* Milan, 1964

Nuneham-Courtenay 1797: [George Simon, 2nd Earl Harcourt.] *A Description of Nuneham-Courtenay in the County of Oxford.* 1797

Nuneham-Courtenay 1806: [George Simon, 2nd Earl Harcourt.] *Description of Nuneham-Courtenay in the County of Oxford.* 1806

Nye and Morpurgo 1955: Nye, R.B., and J.E. Morpurgo. *A History of the United States.* London, 1955

O'Donoghue 1894: O'Donoghue, F.M. *A Descriptive and Classified Catalogue of Portraits of Queen Elizabeth.* London, 1894

Oehler 1980: Oehler, Hansgeorg. *Foto + Skulptur. Römische Antiken in Englischen Schlossern.* Cologne, 1980

Oehler 1981: Oehler, Hansgeorg. "Das Zustande-kommen Einiger Englischen Antikensammlungen im 18. Jahrhundert." *Antikensammlungen im 18. Jahrhundert.* H. Beck, P.C. Bol, W. Prinz, and H. von Steuben, eds. Berlin, 1981

Oench 1980: Oench, Ellen G. d'. *The Conversation Piece: Arthur Devis and His Contemporaries.* New Haven, 1980

Oldham 1952: Oldham, J. Basil. *English Blind-Stamped Bindings.* Cambridge, 1952

Oman 1970: Oman, Charles. *Caroline Silver, 1625–1688.* London, 1970

Oman 1973: Oman, Charles. "The Plate at the Wellington Museum." *Apollo* 98, no. 139 (September 1973), 39–48

Oman 1978: Oman, Charles. *English Engraved Silver 1150–1900.* London, 1978

Ormond 1970: Ormond, Richard. *John Singer Sargent.* London, 1970

Ormond 1971: See Exh. Philadelphia and London 1971

Ormond 1973: See Exh. London, NPG 1973

Ormond 1975: Ormond, Leonée, and Richard. *Lord Leighton.* New Haven and London, 1975

Osti 1951: Osti, O. "Sebastiano Ricci in Inghilterra." *Commentari* (1951), 119–123

Oswald 1933: Oswald, Arthur. "West Wycombe Park." *Country Life* (6 and 13 May 1933), 466–471; 494–499

Oswald 1939: Oswald, Arthur. "Courteenhall, Northamptonshire." *Country Life* (12 August 1939), 144–148

Oswald 1949: Oswald, Arthur. "Blair Castle, Perthshire-I." *Country Life* 106 (4 November 1949) 1434–1438; III (18 November 1949), 1506–1510

Oswald 1955: Oswald, Arthur. "Glynde Place, Sussex–II." *Country Life* 117 (21 April 1955), 1040–1043

Oswald 1964: Oswald, Arthur. "Okeover Hall, Staffordshire I–IV." *Country Life* 135 (23, 30 January; 12, 19 March 1964), 172–176; 224–228; 568–572; 645–649

Outline Engravings 1822: See Hunt 1822

Paget 1931: Paget, Major Guy. *The Melton Mowbray of John Ferneley (1782–1860).* Leicester, 1931

Palluchini and Rossi 1982: Palluchini, Rodolfo, and Paolo Rossi. *Tintoretto: le opere sacre e profane.* 2 vols. Milan, 1982

Palmer 1981: Palmer, Peregrine. *Guide to Dorney Court.* Dorney Court, 1981

Palmerston 1807: Palmerston, 2d Viscount. "List of Pictures and Marbles at Broadlands." MSS, Hampshire Record Office, 1807

Palomino 1724: Palomino, Antonio de Castro y Velasco. *El Museo Pictórico.* Seville, 1724

Parker 1948: Parker, K.T. *The Drawings of Antonio Canaletto in the collection of H.M. the King at Windsor Castle.* London, 1948

Parker 1971: Parker, Constance-Anne. *Mr. Stubbs the Horse Painter.* London, 1971

Parry 1831: Parry, J.D. *Guide to Woburn Abbey.* Woburn, 1831

Pascoli 1736: Pascoli, L. *Vite de Pittori, Scultori, ed Architetti moderni. . . .* Rome, 1736

Passavant 1833: Passavant, John David. *Kunstreise durch England und Belgien, nebst einem Bericht über den Bau des Domthurms zu Frankfurt am Main.* Frankfurt, 1833

Paulson 1971: Paulson, Ronald. *Hogarth: His Life, Art and Times.* 2 vols. New Haven and London, 1971

Pavière 1966: Pavière, Sydney H. *Jean-Baptiste Monnoyer 1634–1699.* Leigh-on-Sea, 1966

Payne-Gallwey 1903: Payne-Gallwey, Sir Ralph, Bart. *The Crossbow, medieval and modern, military and sporting, its construction, history, and management.* London, 1903

Pazaurek 1929: Pazaurek, Gustav E. *Meissner Porzellan-malerei des 18. Jahrhunderts.* Stuttgart, 1929

Pazaurek 1937: Pazaurek, Gustav E. *Perlmutter.* Berlin, 1937

Pelzer 1925: Sandrart, Joachim von. *Academice der Bau- 1 Bild- und Mahlerey-Kunste von 1675.* ed. A.R. Pelzer. Munich, 1925

Pembroke 1968: Pembroke, Sidney, 6th Earl of. *A Catalogue of the paintings and drawings in the collection at Wilton House, Salisbury, Wiltshire.* 1968

Pennant 1902: Pennant, Alice Douglas. *Catalogue of Pictures at Penrhyn Castle and Mortimer House in 1901.* Bangor-on-Dee, 1902

Penny 1977: Penny, Nicholas. *Church Monuments in Romantic England.* New Haven and London, 1977

Penzer 1954: Penzer, Norman Mosley. *Paul Storr.* London, 1954

Penzer 1957: Penzer, Norman Mosley. "The Great Wine Coolers, I and II." *Apollo* 66 (August 1957), 3–7; 39–46

Penzer 1957a: Penzer, Norman Mosley. "The Hervey Silver at Ickworth." *Apollo* (February and March 1957), 38–43; 133–137

Penzer 1961: Penzer, Norman Mosley. "The Plate at Knole I and II." *Connoisseur* (April and May 1961), 84–91; 178–184

Pepper 1984: Pepper, P. Stephen. *Guido Reni, A complete catalogue of His Works.* Oxford, 1984

Percival 1973: Percival, Victor. "Mementoes of the Iron Duke." *Apollo* (September 1973), 58–61

Pernice 1938: Pernice, Erich. *Die Hellenistische Kunst in Pompeji.* Vol. 6. Berlin, 1938

Pevsner 1974: Pevsner, Nikolaus. *The Buildings of England.* Staffordshire. London, 1974

Pfeiffer 1924: Pfeiffer, Max Adolf. "Ein Beitrag zur Quellengeschichte des europäischen Porzellans." In *Werden und Wirken. Ein Festgruss Karl W. Hiersemann.* Leipzig, 1924

Phillips 1929: Phillips, Charles. *History of the Sackville Family.* 2 vols. London, 1929

Physick 1969: Physick, John. *Designs for English Sculpture 1680–1860.* London, 1969

Picon 1983: Picon, Carlos Arturo. "Big Feet." *Archäologischer Anzeiger* (1983), 95–106

Picon 1983: See Exh. London, Clarendon Gallery 1983

Pignatti 1960: Pignatti, T. "Il bozzetto Egerton del Nazzari al Museo Correr." *Bolletino dei Musei Civici Veneziani* 3–4 (1960), 38–43

Piper 1957: Piper, David. "The 1590 Lumley Inventory." *Burlington Magazine* 90 (1957), 224–231

Piper 1958: Piper, David. "The Contemporary Portraits of Oliver Cromwell." *Walpole Society* 34 (1958), 27–41

Piranesi 1769: Piranesi, Giovanni Battista. *Diverse Manieri d'adornare i Cammini.* Rome, 1769

Piranesi 1778: Piranesi, Giovanni Battista. *Vasi, Candelabri, Cippi, Sarcofagi . . .* Rome, 1778

Planché 1857: Planché, James Robinson. *Some account of the armour and weapons, exhibited amongst the art treasures of the United Kingdom, at Manchester, in 1857.* London, 1857

Platts 1984: Platts, Beryl. "Sweet-scented Sèvres, the Gage Collection at Firle Place, Sussex." *Country Life* (14 June 1984), 1685–1688

Pollard 1967: Pollard, J. Graham. *A Catalogue of Renaissance Medals from the Samuel Kress Collection.* New York, 1967

Pope and Brunet 1974: Pope, John A., and Marcella Brunet. *The Frick Collection, VII. Porcelains, Oriental and French.* New York, 1974

Pope-Hennessy 1948: Pope-Hennessy, John. *The Drawings of Domenichino in the Collection of his Majesty the King at Windsor Castle.* London, 1948

Pope-Hennessy 1949: Pope-Hennessy, John. *A Lecture on Nicholas Hilliard.* London, 1949

Pope-Hennessy 1964: Pope-Hennessy, John. *Catalogue of Italian Sculpture in the Victoria and Albert Museum.* London, 1964

Pope-Hennessy 1970: Pope-Hennessy, John, with Anthony Radcliffe and Terence Hodgkinson. *The Frick Collection, illustrated catalogue 4, Sculpture, German, Netherlandish, French and British.* New York, 1970

Posner 1971: Posner, Donald. *Annibale Carracci.* London, 1971

Poulson 1841: Poulson, George. *The History and Antiquities of the Seignory of Holderness in the East-Riding of the County of York . . .* Hull, 1841

Praz 1971: Praz, Mario. *Conversation Pieces.* London, 1971

Price and Ruffhead 1973: Price, Stanley, and George Ruffhead, eds. *Three Yorkshire Villages.* Newton-on-Ouse, 1973

Price 1794: Price, Uvedale, Sir. *An Essay on the Picturesque.* London, 1794

Pullan 1885: Pullan, R.P. *Designs of William Burges.* London, 1885

Rackham 1924 and 1928: Rackham, Bernard. *Catalogue of the Schreiber Collection.* London, 1924. 2d ed. London, 1928

Rackham 1932: Rackham, Bernard. "The Berney Collection of Italian Maiolica." *Burlington Magazine* 61 (November 1932), 208–219

Rackham 1959: Rackham, Bernard. *Islamic Pottery and Italian Maiolica, Illustrated Catalogue of a Private Collection* (The Adda Collection). London, 1959

Radcliffe 1964: Radcliffe, Anthony. "Jules Dalou in England, July 1871 to April 1880." *Connoisseur* 155 (April 1964), 244–245

Rakebrand 1958: Rakebrand, Hilda. *Meissner Tafelgeschichte.* Darmstadt, 1958

Rathbone 1968: Rathbone, Perry T. *The Forsyth Wickes Collection.* Boston, 1968

Ratti 1790: Ratti, C.G. *Istruzione di quanto può vedersi di più bello in Genova in pittura, scultura ed architettura.* Genoa, 1790

Ray 1968: Ray, A. *English Delftware Pottery in the Robert Hall Warren Collection, Ashmolean Museum, Oxford.* London, 1968

Réau 1964: Réau, Louis. *Houdon, sa vie et son oeuvre.* Paris, 1964

Redford 1888: Redford, George. *Art Sales: A History of Sales of Pictures and other works of Art, with Notices of the Collections sold, Names of Owners, Titles of Pictures, Prices and Purchasers.* 2 vols. London, 1888

Reichel 1980: Reichel, Friedrich. *Altjapanisches Porzellan aus Arita in der Dresdener Porzellansammlung.* Dresden, 1980

Reidemeister 1934: Reidemeister, L. "Die Porzellan Kabinette der Brandenburgisch-Preussischen Schlosser." In *Jahrbuch der Preussischen Kunstsammlungen.* (1934)

Reilly and Savage 1973: Reilly, Robin, and George Savage. *Wedgwood, the Portrait Medallions.* London, 1973

Reilly and Savage 1980: Reilly, Robin, and George Savage. *The Dictionary of Wedgwood.* London, 1980

Reinach 1895: Reinach, Salomon. *Pierres gravées des collections Marlborough et d'Orléans, des Recueils d'Eckhel, Gori, Levesque de Gravelle, Mariette, Millin, Stosch, réunies et réeditées avec un texte nouveau.* Paris, 1895

Reinach 1897 and 1916: Reinach, Salomon. *Répertoire de las statuaire grècque et romaine.* Paris, 1897 and 1916

Reinach 1902: Reinach, Salomon. *L'Album de Pierre Jacques.* Paris, 1902

Reinaecke 1956: Reinaecke, Victor. "Fantasies of Chinese Art." *Country Life Annual* (1956), 55

Reinheckel 1968: Reinheckel, Gunther. "Plastische Dekorationsformen im Meissner Porzellan des 18. Jahrhunderts." *Keramos* 41–42 (July–October 1968)

Reiss 1975: Reiss, Stephen. *Aelbert Cuyp.* London, 1975

Reitlinger 1962: Reitlinger, Gerald Robert. *The Economics of Taste.* 3 vols. London, 1962–1970

Reitzenstein 1964: Reitzenstein, Alexander Freiherr von. *Der Waffenschmied . . .* Nuremburg, 1964

Reynolds 1953: Reynolds, Graham. *Painters of the Victorian Scene.* London, 1953

Reynolds 1966: Reynolds, Graham. *Victorian Painting.* London, 1966

Reynolds 1984: Reynolds, Graham. *The Later Paintings and Drawings of John Constable.* 2 vols. New Haven and London, 1984

Rice 1983: Rice, D.G. *Derby Porcelain, The Golden Years, 1750–1770.* Newton Abbot, 1983

Richmond 1983: Miller, J. Jefferson, II. *Eighteenth-Century Meissen Porcelain from the Margaret M. and Arthur J. Mourot Collection in the Virginia Museum.* Richmond, Virginia, 1983

Richter 1883: See Exh. London, Bethnal Green, 1883

Richter 1956: Richter, C. *Catalogue of Engraved Gems. Greek, Etruscan, and Roman.* Rome, 1956

Ridgway 1981: Ridgway, Brunilde S. *Fifth-Century Styles in Greek Sculpture.* Princeton, 1981

Rieder 1975: Rieder, William. "Piranesi at Gorhambury." *Burlington Magazine* 117 (July 1975), 582–591

Rieu 1950: Homer. *The Iliad.* E.V. Rieu, transl. London, 1950

Rimbault Dibdin 1905: Rimbault Dibdin, E. "Frank Dicksee R.A. His Life and Works." *The Christmas Art Annual* (1905)

Rinehart 1967: Rinehart, Sheila. "A Bernini Bust at Castle Howard." *Burlington Magazine* 109 (August 1967), 437–443

Roberts and Crockford: Roberts, E. and E. Crockford. *A History of Tichborne.* n.d.

Roberts 1985: Roberts, Hugh. "The Derby House Commode." *Burlington Magazine* 127 (May 1985), 275–282

Robertson 1975: Robertson, Martin. *A History of Greek Art.* Cambridge, Mass., 1975

Robertson 1978: Robertson, David. *Sir Charles Eastlake and the Victorian Art World.* Princeton, 1978

Robinson 1982: Robinson, John Martin. *The Dukes of Norfolk.* Oxford, 1982

Rogers 1863: Rogers, W.G. "Remarks upon Grinling Gibbons." *Royal Institute of British Architects Transactions* (3 June 1867), 179–186

Rogers 1971: Defoe, Daniel. *A Tour Through the Whole Island of Great Britain*, ed. Pat Rogers. London, 1971

Rosebery 1962: Rosebery, Eva. "Unfamiliar Libraries VII: Barnbougle Castle." *The Book Collector* 11 (1962), 35–44

Rosenberg 1979: See Exh. Paris, Cleveland, and Boston 1979

Röthlisberger 1961: Röthlisberger, Marcel. *Claude Lorrain: the Paintings.* 2 vols. London and New Haven, 1961

Rowe 1965: Rowe, Robert. *Adam Silver 1765–1795.* London, 1965

Rowse 1975: Rowse, A.L. "Byron's Friend, Bankes." *Encounter* (March 1975), 25

Rückert 1966: See Exh. Munich 1966

Rump 1974: Rump, Georg. *George Romney* Hildesheim, 1974

Russell 1973: Russell, John. *Henry Moore.* London, 1973

Russell 1975: Russell, Francis. "Thomas Patch, Sir William Lowther and the Holker Claude." *Apollo* 102 (August 1975), 115–119

Russell 1978: Russell, Francis. "The British Portraits of Anton Raphael Mengs." *National Trust Studies* (1978), 8–19

Russell 1978: Russell, Francis. "Another Ricci; and a New Conversation Piece by Smuglewicz." *Burlington Magazine* 120 (July 1978), 466–469

Russell 1982: Russell, Francis. "The Spinola Holy Family of Giulio Romano." *Burlington Magazine* 124 (May 1982), 297–298

Russell 1982a: Russell, Francis. "A Connoisseur's Taste: Paintings at Broadlands-I" and "Ancestral Portrait Anthology: Paintings at Broadland-II." *Country Life* 171 (28 January and 4 February 1982), 224–226; 296–298

Russell 1984: Russell, Francis. "The 3rd Earl of Bute's Picture Collection at Highcliffe." *Country Life* (26 January 1984), 226–228

Rutland 1813: Rutland, 5th Duke of, ed. *Travels in Great Britain, Journal of a tour to the Northern Parts of Great Britain.* 1813

Rutter 1823: Rutter, John. *Delineations of Fonthill and its Abbey.* Shaftesbury and London, 1823

Salerno 1960: Salerno, Luigi. "The Picture Gallery of Vincenzo Giustiniani." *Burlington Magazine* 102 (January, March, April 1960), 21–27; 93–104; 135–148

Salerno 1963: Salerno, Luigi. *Salvator Rosa.* Rome, 1963

Sandrart 1925: See Pelzer 1925

Savill 1979: Savill, Rosalind. "Two Pairs of Sèvres Vases at Boughton House." *Apollo* 110 (August 1979), 128–133

Savill 1982: Savill, Rosalind. "François Boucher and the Porcelain of Vincennes and Sèvres." *Apollo* 115 (March 1982), 162–170

Savill 1982a: Savill, Rosalind. "Cameo Fever: six pieces from the Sèvres porcelain dinner service made for Catherine II of Russia." *Apollo* 116 (November 1982), 304–311

Schädler 1980: Schädler, A. "Eine Flora-Statuette von Balthasar Permoser." *Pantheon* 38 (1980), 382–386

Scarisbrick 1982: Scarisbrick, Diana. "Treasured in Adversity: The Jewels of Mary Stuart – II." *Country Life* (10 June 1982), 1740–1742

Scarisbrick 1983: Scarisbrick, D. "Precious chain of history. The Cavendish family jewellery I." *Country Life* (9 June 1983), 1542–1544

Scharf 1860: Scharf, Sir George. *Catalogue of the pictures and works of art . . . at Blenheim.* 1860. Amplified as *Catalogue Raisonné; or a list of the pictures . . . at Blenheim.* London, 1862

Scharf 1877: Scharf, Sir George. *A Descriptive and Historical Catalogue of the Collection of Pictures at Woburn Abbey.* London, 1877

Scharf 1878: Scharf, Sir George. *Catalogue of Pictures, Miniatures and Enamels [in the Collection of the Duke of Bedford at Exeter Square].* London, 1878

Scharf 1890: Scharf, Sir George. *A . . . Catalogue of the Collection of Pictures at Woburn Abbey.* 1890

Schetkey 1877: *Ninety Years of Work and Play, Sketches from the Career of John Christian Schetkey, by his daughter.* Edinburgh and London, 1877

Schiff 1973: Schiff, Gert. *Johann Heinrich Füssli, 1741–1825 Leben und Oeuvrekatalog.* Zurich, 1973

Schmid 1902–1905: Schmid, W.M. "Passauer Waffenwesen. I. Klingenindustrie." *Zeitschrift für Historische Waffenkunde* 3 (1902–1905), 312–317

Schmidt and Cornforth 1980: Schmidt, Leo, and John Cornforth. "Holkham Hall, Norfolk." *Country Life* (1980), 214–217; 298–301; 359–362; 427–431

Schneider and Stuber 1980: Schneider, Hugo, and Karl Stuber, *Kwaffen im Schweizerischen Landesmuseum, Griffwaffen. I.* Zurich, 1980

Scott 1851: Scott, William Bell. *Antiquarian Gleanings in the North of England.* London, 1851

Scott 1911: Scott, Charles Henry Montagu Douglas. *Catalogue of the Pictures at Boughton House.* 1911

Sedgwick 1931 and 1984: Hervey, John, Lord. *Some Materials towards Memoires of the Reign of George II.* ed. Romney Sedgwick, London, 1931. New ed. 1984

Severne-MacKenna 1946: Severne-MacKenna, F. *Cookworthy's Plymouth and Bristol Porcelain.* Leigh-on-Sea, 1946

Severne-MacKenna 1951: Severne-MacKenna, F. *Chelsea Porcelain, The Red Anchor Wares.* Leigh-on-Sea, 1951

Severne-MacKenna 1952: Severne-MacKenna, F. *Chelsea Porcelain, The Gold Anchor Wares.* Leigh-on-Sea, 1952

Seyffarth 1978: Seyffarth, Richard. *Johann Gregorius Höroldt.* Dresden, 1978

Shaw Sparrow 1911: Shaw Sparrow, Walter. *John Lavery and his Work.* London, 1911

Shaw Sparrow 1931: Shaw Sparrow, Walter. *A Book of Sporting Painters.* London, 1931

Shaw 1967: See Byam Shaw, James

Shepard 1940: Shepard, K. *The Fish-Tailed Monster in Greek and Etruscan Art.* New York, 1940

Shirley 1869: Shirley, E.P. "An Inventory of the Effects of Henry Howard KG, Earl of Northampton." *Archaeologia* (1869), 37

Simon and Smart 1983: See Exh. London, Fine Art Soc. 1983

Simon 1907: Simon, Constance. *English Furniture Designers of the Eighteenth Century.* London, 1907

Simon 1975: Simon, Jacob. *The Suffolk Collection Catalogue of Paintings.* London, 1975

Simon 1983: Simon, E. *Werke der Antike im Martin-von-Wagner Museum der Universitat Wurtsburg.* Mainz, 1983

Simpson 1953: Simpson, Frank. "Dutch Paintings in England before 1760." *Burlington Magazine* 95 (7 February 1953), 39–42

Siple 1939: Siple, Ella. "A Flemish Set of *Venus and Vulcan* – II, their influence on English tapestry design." *Burlington Magazine* 74 (June 1939), 268–278

Sitwell 1968: Sitwell, Sacheverell. "Pleasures of the Senses." *Apollo* 87 (1968), 129–139

Slive 1970–1974: Slive, Seymour. *Frans Hals.* 3 vols. London and New York, 1970–1974

Smart 1952: Smart, Alastair. *The Life and Art of Allan Ramsay.* London, 1952

Smith 1828 and 1829: Smith, John Thomas. *Nollekens and His Times.* 2 vols. London, 1828. 2d ed. London, 1829

Smith 1829–1842: Smith, John. *A Catalogue Raisonné of The Works of the Most Eminent Dutch, Flemish, and French Painters. . . .* 8 vols. London, 1829–1836. Supplement, 1842

Smith 1878–1882: Smith, John Chaloner. *British Mezzotinto Portraits.* 6 vols. London, 1878–1882

Smith 1900: Smith, Arthur H. *A Catalogue of the Sculpture at Woburn Abbey.* London, 1900

Smith 1918: Smith, D. Nichol. *Characters from the Histories and Memoirs of the Seventeenth Century.* Oxford, 1918

Snodin and Baker 1980: Snodin, Michael, and Malcolm Baker. "William Beckford's Silver, I & II." *Burlington Magazine* 122 (November and December 1980), 735–748; 820–831

Snodin and Bury 1984: Snodin, Michael, and Shirley Bury. "The shield of Achilles by John Flaxman R.A." *Art at Auction* 1983–1984, 274–283

Snodin 1977: Snodin, Michael. "Silver Vases and their purpose." *Connoisseur* 194 (January 1977), 37–42

Snowman 1962: Snowman, Kenneth. *The Art of Carl Fabergé.* 1953. Reprint. London, 1962

Snowman 1979: Snowman, Kenneth. *Carl Fabergé, Goldsmith to the Imperial Court of Russia.* London, 1979

Solodkoff 1981: Solodkoff, Alexander von. *Russian Gold and Silver.* London, 1981

Sotheby's 1950: Sotheby's. *Catalogue of an Important Collection of Meissen Birds. . . . The Property of the Rt. Hon. Lord Hastings, removed from Melton Constable, Norfolk,* 1950

Sotheby's 1977: See Mentmore Sale

Souchal 1977 and 1981: Souchal, F. *French Sculptors of the 17th and 18th Centuries: the reign of Louis XIV.* A–F, London, 1977, and G–L, London, 1981

Southill 1951: Whitbread, S., et al. *Southill: A Regency House.* London, 1951

Spear 1982: Spear, Richard E. *Domenichino.* 2 vols. New Haven and London, 1982

Spencer 1926: Spencer, Earl. "Spencer House, St James's Place I & II" and "Furniture at Spencer House." *Country Life* (30 October and 6 and 13 November 1926), 660–667; 698–704; 757–759

Speth-Holterhoff 1957: Speth-Holterhoff, S. *Les Peintres Flamands de Cabinets d'Amateurs au XVIIe Siècle.* Brussels, 1957

Spicer 1844: Spicer, C.W. *History of Warwick Castle.* 1844

Staehelin 1965: Staehelin, Walter A. *Das Buch von Porzellan.* Bern, 1965

Staley 1906: Staley, Edgcumbe. *Lord Leighton of Stretton, P.R.A.* London, 1906

Stalker and Parker 1688: Stalker, John, and George Parker. *A Treatise of Japanning and Varnishing, Being a compleat discovery of those arts.* Oxford, 1688

Staring 1932: Staring, A. "Un Tableau de Conversation par Gravelot." *Gazette des Beaux-Arts* 6 (1932), 155–160

Stechow 1938: Stechow, Wolfgang. *Salomon van Ruysdael.* Berlin, 1938

Steegman 1957: Steegman, J. *A Survey of Portraits in Welsh Houses.* Vol. 1. Cardiff, 1957. Vol. 2. Cardiff, 1962

Stephen 1885–1900: See DNB

Stephenson 1968: Stephenson, Anthea. "Chippendale Furniture at Harewood." *Furniture History* (1968), 62–80

Steuart 1890: Steuart, A. Francis. *Catalogue of the Pictures of Dalkeith House.* Dalkeith, 1890

Stewart 1977: Stewart, Andrew F. *Skopas of Paros.* Park Ridge, N. J., 1977

Stewart 1977a: Stewart, Andrew F. "A Cast of the Leconfield Head in Paris." *Revue Archéologique* (1977), 195–202

Stewart 1983: Stewart, T.O. *Sir Godfrey Kneller and the English Baroque Portrait.* Oxford, 1983

Stoner 1955: Stoner, F. *Chelsea, Bow and Derby Porcelain Figures.* Newport, 1955

Stosch 1724: Stosch, P. von. *Antiquae Gemmae Caelatae.* Amsterdam, 1724

Strachey and Fulford 1938: Strachey, Lytton, and Roger Fulford, eds. *The Greville Memoirs. 1814–1816.* London, 1938

Strachey 1911: Strachey, Lady. *Later letters of Edward Lear, Author of "The Book of Nonsense" to Chichester Fortescue (Lord Carlingford) Frances, Countess Waldegrave, and others.* London, 1911

Streeter 1971: Streeter, Colin. "Marquetry Furniture by a Brilliant London Master." *Metropolitan Museum of Art Bulletin* (June 1971), 418–429

Strong 1801: Strong, S. Arthur. *The Masterpieces in the Duke of Devonshire's Collection of Pictures.* London, Munich, and New York, 1801

Strong 1929: Strong, Eugenie. *Art in Ancient Rome.* 2 vols. London, 1929

Strong 1963: Strong, Roy. *Portraits of Queen Elizabeth I.* Oxford, 1963

Strong 1964: Strong, Roy. "The Elizabethan Malady." *Apollo* 79 (1964), 264–269

Strong 1966: Strong, Roy. "Hans Eworth Reconsidered." *Burlington Magazine* 108 (May 1966), 225–233

Strong 1969: Strong, Roy. *Tudor and Jacobean Portraits.* 2 vols. London, 1969

Strong 1969a: Strong, Roy. *The English Icon.* London and New York, 1969

Strong 1975: Strong, Roy. *Nicholas Hilliard.* London, 1975

Strong 1977: Strong, Roy. *The Cult of Elizabeth. Elizabethan Portraiture and Pageantry.* London, 1977

Strong 1983: Strong, Roy. *The English Renaissance Miniature.* London, 1983

Strong 1986: Strong, Roy. *Prince Henry and England's Lost Renaissance.* London, forthcoming

Stroud 1966: Stroud, Dorothy. *Henry Holland. His Life and Architecture.* London, 1966

Stroud 1975: Stroud, Dorothy. *Capability Brown.* London, 1975

Sullivan 1780: Sullivan, R.J. *Observations made during a Tour of Parts of England, Scotland and Wales.* 1780

Sullivan 1957: Sullivan, Michael. "Kendi." *Archives of the Chinese Art Society of America.* Vol. 11. 1957

Summerson 1953: Summerson, John. *Architecture in Britain 1530–1830.* London, 1953

Surtees 1984: Surtees, Virginia. *The Ludovisi Goddess, The Life of Louisa Lady Ashburton.* Wilton, 1984

Survey of London 1966: Survey of London. (The Parish of St. Anne's Soho) 33. London, 1966

Sutton 1965: Sutton, Denys. "A Noble Heritage." *Apollo* 82 (December 1965), 437–441

Sutton 1969: Sutton, Denys. "Le Bon Ton and le Roast Beef." *Apollo* (August 1969), 90–99

Sutton 1975: Sutton, Denys. "Fruits of Victory." *Apollo* 102 (July 1975), 2–18

Sutton 1977: Sutton, Denys. "The Magic of Tradition." *Apollo* 105 (May 1977), 320–323

Sutton 1980: Sutton, Peter C. *Pieter de Hooch.* Oxford, 1980

Sutton 1984: Sutton, Denys. "The Lure of the Antique." *Apollo* 119 (May 1984), 312–321

Sutton 1984a: Sutton, Denys. "Aspects of British Collecting; XI: Paris–Londres." *Apollo* (May 1984), 334–345

Sutton 1984b: Sutton, Denys. "Amateurs and Scholars." *Apollo* 119 (May 1984), 322–333

Swain 1975: Swain, Margaret. "Pictorial Chair Covers: Some Engraved Sources." *Furniture History* 2 (1975), 76–81

Symonds 1957: Symonds, Robert W. "Thomas Hope and the Greek Revival." *Connoisseur* 140 (1957), 226–230

Symonds 1958: Symonds, Robert W. "Adam and Chippendale: A Myth Exploded." *Country Life Annual* (1958), 53–56

Syz 1979: Syz, Hans, J. Jefferson Miller II, and Rainer Rückert. *Catalogue of The Hans Syz Collection.* Vol. I. *Meissen Porcelain and Hausmalerei.* Washington, 1979

Tadolini 1900: Tadolini, Adamo. *Ricordi Autobiografici.* Rome, 1900

Tait 1963: Tait, Hugh. "Renaissance Jewellery: An Anonymous Loan to the British Museum." *Connoisseur* 54 (November 1963), 147–153

Tait 1964: Tait, Hugh. "Sèvres Porcelain in the Collection of the Earl of Harewood, I: The Early Period 1750–60." *Apollo* 79 (June 1964), 474–478

Tait 1966: Tait, Hugh. "Sèvres Porcelain in the Collection of the Earl of Harewood, III: The Louis XVI Period 1775–93." *Apollo* 83 (June 1966), 437–443

Tait 1984: Tait, Hugh. *The Art of Jewellery. A Catalogue of the Hull Grundy Gift to the British Museum.* London, 1984

Tapp 1951: Tapp, W.H. "James and John Giles and J.H. O'Neale." *English Ceramic Circle Transactions* Vol. 3, no. 5 (1951)

Tassie and Raspe 1794: Tassie, James, and R.E. Raspe. *A Descriptive Catalogue of Ancient Gems Taken From the Most Celebrated Cabinets of Europe.* London, 1794

Taylor 1860: Taylor, T., ed. *Autobiographical Recollections.* London, 1860

Taylor 1971: Taylor, Basil. *Stubbs.* London, 1971

Ter Kuile 1969: Ter Kuile, O. "Daniel Mijtens." *Nederlands Kunsthistorisch Jaarboek* 20 (1969), 1–106

Thesiger 1927: Thesiger, Ernest. *Practically True.* London, 1927

Thienemann 1856: Thienemann, Georg. A. W. *Leben und Wirken des . . . Johann Elias Ridinger, etc.* Leipzig, 1856. Reprint. Amsterdam, 1962

Thomas and Gamber 1958: Thomas B., and O. Gamber. "L'arte Milanese dell'Armatura." *Storia di Milano* 11 (1958), 698–841

Thomas and Gamber 1976: Thomas, B., and O. Gamber. *Kunsthistorisches Museum, Wien, Waffensammlungen. Katalog der Leibrustkammer.* I. *Der Zeitraum von 1500 bis 1530.* Vienna, 1976

Thompson 1963: Thompson, F.M.L. *English Landed Society in the Nineteenth Century.* London, 1963

Thomson 1930: Thomson, W.G. *A History of Tapestry.* London, 1930

Thomson 1940: Thomson, Gladys Scott. *The Russells of Bloomsbury 1669–1771.* London, 1940

Thornton and Hardy 1968: Thornton, Peter, and John Hardy. "The Spencer Furniture at Althorp." *Apollo* 87 (June 1968), 440–451

Thornton and Rieder 1971: Thornton, Peter, and William Rieder. "Pierre Langlois Ebéniste, I and II." *Connoisseur* 177 (December 1971 and February 1972), 283–288 and 105–112

Thornton and Tomlin 1980: Thornton, Peter, and Maurice Tomlin. "The Furnishing and Decoration of Ham House." *Furniture History* 16 (1980)

Thornton and Tomlin 1980: Thornton, Peter, and Maurice Tomlin. "Franz Cleyn at Ham House." *National Trust Studies* (1980), 21–34

Thornton 1978: Thornton, Peter. *Seventeenth Century Interior Decoration in England, France and Holland.* New Haven and London, 1978

Thorpe 1946: Thorpe, W.A. "Stoneleigh Abbey and its Furniture." *Connoisseur* 118 (July–December 1946), 71–78

Tipping and Hussey 1928: Tipping, H. Avray, and Christopher Hussey. *English Homes, Period IV, Vol II: The Work of Sir John Vanbrugh and his School.* London, 1928

Tipping 1925: Tipping, H. Avray. "Brocket Hall, Hertfordshire, I, II, and III." *Country Life* (4, 11 and 18 July 1925), 16–22; 60–67; and 96–103

Titi 1764: Titi, Filippo. *Descrizione Delle Pitture, Sculture e Architetture Esposte al Pubblico in Roma.* Rome, 1764

Tomlin 1982: Tomlin, M. *Ham House.* London, 1982

Tomlin 1982a: Tomlin, M. *Adam Furniture.* London, 1982

Toppin 1948: Toppin, Aubrey J. "The Origin of some Ceramic designs." *Transactions of the English Ceramic Circle.* Vol. 2, no. 10. (1948), 266

Toynbee 1927–1928: "Horace Walpole's Journals of Visits to County Seats." ed. Paget Toynbee. *Walpole Society* 16 (1927–1928), 9–80

Toynbee 1978: Toynbee, Jocelyn M.C. *Roman Historical Portraits.* London, 1978

Twining 1960: Twining, Edward, Lord. *A History of the Crown Jewels of Europe.* London, 1960

Tyson and Guppy 1932: Tyson, Moses, and Henry Guppy, eds. *The French Journals of Mrs. Thrale and Doctor Johnson.* London, 1932

Ucelli 1950: Ucelli, G. *Le Nave di Nemi.* Rome, 1950

Udy 1973: Udy, David. "The Classical Sources of English Neo-Classical Furniture." *Arte Illustrata* 52 (February 1973), 96–104

Udy, 1978: Udy, David. "Piranesi's 'Vasi,' the English silversmith and his Patrons." *Burlington Magazine* (December 1978), 820–837

Vaivre 1973: Vaivre, Jean-Bernard de. "La Tapisserie de Jean de Daillon." *Archivum Heraldicum* 87, no. 2–3 (1973), 18–25

Vaivre 1974: Vaivre, Jean-Bernard de. "L'origine tournaisienne de la tapisserie de Jean de Daillon." *Archivum Heraldicum* no. 2–3 (1974), 18–21

Van de Put 1904: Van de Put, A. *Hispano-Moresque Ware of the XV Century, a Contribution to its History and Chronology Based upon Armorial Specimens.* London, 1904

Vardy 1744: Vardy, John. *Some Designs of Mr. Inigo Jones and Mr. Wm. Kent.* London, 1744. Reprint, 1967

Vasari: See Vere 1912–1914

Verdier 1967: Verdier, P. *Catalogue of Painted Enamels of the Renaissance in the Walters Art Gallery.* Baltimore, 1967

Vere 1912–1914: Vasari, Giorgio. *Lives of the Most Eminent Painters, Sculptors and Architects.* ed. Gaston de C. Vere. London, 1912–1914

Verlet and Grandjean 1953: Verlet, Pierre and Serge Grandjean. *Sèvres. Le XVIIIe, les XIXe et XXe Siècles.* Paris, 1953

Verlet 1967: Verlet, Pierre. *French Furniture and Interior Decoration of the 18th Century.* London, 1967

Vermeule and Bothmer 1956: Vermeule, Cornelius C., and Dietrich von Bothmer. "Notes on a New Edition of Michaelis: Ancient Marbles in Great Britain, Part II." *American Journal of Archaeology* 60 (1956), 322–350

Vermeule and Bothmer 1959: Vermeule, Cornelius C., and Dietrich von Bothmer. "Notes on a New Edition of Michaelis: Ancient Marbles in Great Britain, Part III:1." *American Journal of Archaeology* 63 (1959), 139–166

Vermeule and Bothmer 1959b: Vermeule, Cornelius C., and Dietrich von Bothmer. "Notes on a New Edition of Michaelis: Ancient Marbles in Great Britain, Part III:2." *American Journal of Archaeology* 60 (1959), 329–348

Vermeule 1955: Vermeule, Cornelius C. "Notes on a New Edition of Michaelis: Ancient

Marbles in Great Britain." *American Journal of Archaeology* 59 (1955), 129–150

Vermeule 1966: Vermeule, Cornelius C. *The Dal Pozzo-Albani Drawings of Classical Antiquities in the Royal Library at Windsor Castle*. Philadelphia, 1966

Vermeule 1977: Vermeule, Cornelius C. "The Ancient Marbles at Petworth." *Apollo* 105 (May 1977), 340–345

Vermeule 1980: Vermeule, Cornelius C. *Greek Art: Socrates to Sulla, from the Peloponnesian Wars to the rise of the Julius Caesar*. Boston, 1980

Vermeule 1981: Vermeule, Cornelius C. *Greek and Roman Sculpture in America*. Berkeley and Los Angeles, 1981

Vertue 1743: Vertue, George. *Catalogue of the Principal Pictures, Statues & c. at Kensington Palace*. 1743. In Bathoe, W. *A Catalogue of the Collection of Pictures & c. belonging to King James the Second. . . .* London, 1758

Vertue 1930–1955: Vertue, George. "Notebooks." *Walpole Society*. 6 vols.: 18, 20, 22, 24, 26, 30 (1930–1955) Reprint. 1968

Vever 1906: Vever, H. *La Bijouterie Française au XIXe Siècle*. Paris, 1906

Vey 1962: Vey, Horst. *Die Zeichnungen Anton Van Dykcs*. 2 vols. Brussels, 1962

Vey 1962: Vey, H., and Gert von der Osten. *Paintings and Sculpture in Germany and the Netherlands, 1500–1600*. transl. 1969

Vigée-Lebrun 1867: Vigée-Lebrun, Marie-Louise Elizabeth. *Souvenirs*. 2 vols. Paris, 1867

Virginia 1983: See Richmond 1983

Vollenweider 1966: Vollenweider, M.L. *Die Steinschneide-kunst und ihre Künstler in spätrepublikanischer und augusteischer Zeit*. Baden-Baden, 1966

Waagen 1838: Waagen, Gustav Friedrich. *Works of Art and Artists in England*. London, 1838

Waagen 1854: Waagen, Gustav Friedrich. *Treasures of Art in Great Britain*. 4 vols. London, 1854

Waagen 1857: Waagen, Gustav Friedrich. *Galleries and Cabinets of Art in Great Britain. Supplement to Treasures of Art*. 8 vols. London, 1857

Wagner 1971: Wagner, Helga. *Jan van der Heyden 1637–1712*. Amsterdam and Haarlem, 1971

Wainwright 1977: Wainwright, Clive. "Walter Scott and the Furnishing of Abbotsford: or the Gabions of Jonathan Oldbuck Esq." *Connoisseur* 194 (January 1977), 3–15

Wainwright 1982: Wainwright, Clive. "Myth and Reality: Sir Walter Scott and his Collection – I." *Country Life* 172 (16 September 1982), 804–806

Wainwright 1985: Wainwright, Clive "Charlecote Park, Warwickshire – II." *Country Life* (28 February 1985), 506–510

Walker 1964: Walker, R.J.B. *Audley End Essex, Catalogue of the Pictures in the State Rooms*. London, 1964

Walker 1979: Walker, R.J.B. *Old Westminster Bridge, The Bridge of Fools*. Newton Abbot, 1979

Walpole 1774: Walpole, Horace. *A Description of the Villa . . . at Strawberry Hill*. Strawberry Hill, 1774

Walters 1926: Walters, H.B. *Catalogue of the Engraved Gems and Cameos, Greek, Etruscan, and Roman, in the British Museum*. London, 1926

Ward and Roberts 1904: Ward, Thomas Humphry, and W. Roberts. *Romney: a Biographical critical essay with a catalogue raisonné of his works*. 2 vols. London, 1904

Ward-Jackson 1958: Ward-Jackson, Peter. *English furniture designs of the eighteenth century*. London, 1958

Wardwell and Davison 1966: Wardwell, A., and M. Davison. "Three Centuries of the decorative arts in Italy." *Apollo* 84 (September 1966), 179–189

Wark 1969: Wark, Robert R. *Early British Drawings in the Huntington Collection*. San Marino, 1969

Wark 1970: Wark, Robert R. *Drawings by John Flaxman in the Huntington Collection*. San Marino, 1970

Warner 1893: Warner, G.F. "The Library of James VI." *Miscellany of the Scottish History Society* I (1893)

Waterhouse 1941: Waterhouse, Ellis K. *Reynolds*. London, 1941

Waterhouse 1953, 1969, and 1978: Waterhouse, E.K. *Painting in Britain, 1530–1790*. London, 1953, 1969, and 1978

Waterhouse 1958: Waterhouse, Ellis. *Gainsborough*. London, 1958

Waterhouse 1960: Waterhouse, E.K. "A Note on British collecting of Italian pictures in the later seventeenth century." *Burlington Magazine* (1960), 54–58

Waterhouse 1981: Waterhouse, Ellis. *The Dictionary of British 18th century painters in oils and crayons*. London, 1981

Waterschoot 1974: Waterschoot, W. "Even en Betekenis van Lucas de Heere." *Verslagen en Mededelingen*. Koninklijke Academie voor Nederlandse Tall-en Letterkunde, I (1974), 68–78

Watkin 1968: Watkin, David. *Thomas Hope and the Neo-Classical Idea*. London, 1968

Watkin 1982: Watkin, David. *Athenian Stuart: pioneer of the Greek Revival*. London, 1982

Watson 1940: Watson, Francis J.B. "Thomas Patch (1725–1782). Notes on his life, together with a catalogue of his known works." *Walpole Society* 28 (1940), 15–50

Watson 1953: Watson, Francis J.B. "An Allegorical Painting by Canaletto, Piazzetta, and Cimaroli." *Burlington Magazine* 95 (1953), 362–365

Watson 1956: Watson, Francis J.B. *Wallace Collection Catalogue: Furniture*. London, 1956

Watson 1959–1960: Watson, Francis J.B. "Venetian Art and Britain: A partial survey of the Royal Academy's Winter Exhibition 1959–1960." *Arte Veneta* 13–14 (1959–1960), 265–268

Watson 1960: Watson, Francis J.B. *Louis XVI Furniture*. London, 1960

Watson 1965: Watson, Francis J.B. "French Furniture at Woburn, the eighteenth and nineteenth centuries." *Apollo* (December 1965), 472–483

Watson 1966: Watson, Francis J.B. "Annotated Handlist of the Sèvres and Other European Porcelain in the Collection of Viscount and Viscountess Gage at Firle Place, Sussex." MSS, 1966

Watson 1966: Watson, Francis J.B. *The Wrightsman Collection*. 2 vols. New York, 1966

Watson 1967: Watson, Francis J.B. "Walpole and the Taste for French Porcelain in Eighteenth-Century England." In *Horace Walpole, Writer, Politician & Connoisseur, Essays on the 250th Anniversary of Walpole's Birth*. ed. Warren Hunting Smith. New Haven and London, 1967

Watson 1973: Watson, Katherine J. "Pietro Tacca." Ph.D. dissertation. Pennsylvania, 1973

Watson 1975: Watson, Francis J.B. "The Great Duke's Taste for French Furniture." *Apollo* 102 (July 1975), 44–49

Watt 1903: Watt, George. *Indian Art at Delhi, 1903, Being the Official Catalogue of the Delhi Exhibition, 1902–1903*. Calcutta, 1903

Watts 1912: Watts, Mary S. *The Annals of an Artist's Life*. 3 vols. London, 1912

Waywell 1978: Waywell, Geoffrey B. *Classical Sculpture in English Country Houses. A Hand-Guide*. XI International Congress of Classical Archaeology, London, 1978

Weale and Richter 1889: See Northbrook 1889

Webb 1954: Webb, M.I. *Michael Rysbrack, Sculptor*. London, 1954

Webb 1956: Webb, M.I. "Roubiliac Busts at Wilton." *Country Life* (19 April 1956), 804–805

Webster 1964: Webster, Mary. "Zoffany's Painting of Charles Towneley's Library in Park Street." *Burlington Magazine* 106 (July 1964), 316–323

Webster 1970: Webster, Mary. *Francis Wheatley*. London, 1970

Wentworth 1984: Wentworth, Michael. *James Tissot*. Oxford, 1984

Wethey 1971: Wethey, Harold E. *The Paintings of Titian*. 2 vols. *The Portraits*. London and New York, 1971

Whinney and Millar 1957: Whinney, M., and O. Millar. *English Art 1625–1714*. Oxford, 1957.

Whinney 1964: Whinney, Margaret. *Sculpture in Britain, 1530–1830*. London, 1964

Whinney 1971: Whinney, Margaret. *English Sculpture, 1720–1830*. London, 1971

Whistler and Fuller 1960: Whistler, Laurence, and R. Fuller. *The Work of Rex Whistler*. London, 1960

Whistler 1959: Whistler, Laurence. *Engraved Glass 1952–1958*. London, 1959

Whistler 1975: Whistler, Laurence. *The Image on the Glass*. London, 1975

Whitbread 1951: See Southill 1951

Whitley 1915: Whitley, William T. *Thomas Gainsborough*. London, 1915

Whitley 1928: Whitley, William T. *Art in England, 1800–1820*. Cambridge, 1928

Who was Who 1929: *Who was Who*. Vol. 2. London, 1929

Wiffen 1833: Wiffen, J.H. *Historical Memoirs of the House of Russell From the Time of the Norman Conquest*. 2 vols. London, 1833

Wilkinson 1907: Wilkinson, Nevile R. *Wilton House Pictures*. 2 vols. London, 1907

Wilkinson 1978: Wilkinson, R.S. "The Death of Benjamin Wilkes and the Publication of *The English Moths and Butterflies*." *The Entomologist's Record* 90 (1978), 6–7

Williams MSS: "The Papers of Charles Hanbury Williams." *Mss.* 94 vols. Yale University, Lewis Walpole Library, Vol. V.52., I.11–12

Williams 1831: Williams, D.E. *The Life and Correspondence of Sir Thomas Lawrence, Kt.* 2 vols. London, 1831

Williams 1933: Williams, Clare, ed. and trans. *Sophie in London, 1786. Being the diary of Sophie von la Roche . . .* London, 1933

Wills 1965: Wills, Geoffrey. "Furniture Smuggling in Eighteenth-Century London." *Apollo* (August 1965), 112–117

Wilson 1972: Wilson, J. "A Phenomenon of Taste; the China Ware of Queen Mary II." *Apollo* (August 1972), 116–123

Wilson 1978–1979: Wilson, Gillian. "Acquisitions Made by the Department of Decorative Arts, 1977 to Mid 1979." *The J. Paul Getty Museum Journal* 6–7 (1978–1979), 37–52

Wilson 1984: Wilson, Michael I. *William Kent*. London, 1984

Wilton 1788 and 1798: [George Richardson]. *Aedes Pembrocianae: A new Account and Description of the Statues, Busts, Reliefs, Paintings, Medals and other Antiquities and Curiosities in Wilton House*. 11th ed. Salisbury, 1788, another ed. Salisbury, 1798

Wingfield Digby 1963: Wingfield Digby, George. *Elizabethan Embroidery*. London, 1963

Winter 1943: Winter, Carl. "Holbein's Miniatures." *Burlington Magazine* 83 (1943), 266

Wittkower 1945: Wittkower, Rudolf. "Lord Burlington and William Kent." *Archaeological Journal* 102 (1945). Reprinted in *Palladio and English Palladianism*. London, 1974

Wittkower 1974: Wittkower, Rudolf. *Palladio and English Palladianism. Collected Essays*. London, 1974

Woburn 1850: *History and Description of Woburn and its Abbey*. London and Woburn, 1850

Woburn 1868: *Catalogue of Pictures, Miniatures, Drawings, and Busts at Woburn Abbey*. London, 1868

Wolff 1692: Wolff, Jacob. *Curiosus Amuletorum Scrutator*. Frankfurt, 1692

Wood 1753: Wood, R. *The Ruins of Palmyra*. London, 1753

Woodall 1963: Woodall, Mary, ed. *The Letters of Thomas Gainsborough*. London, 1963

Worlidge 1764: Worlidge, T. *A Select Collection of Drawings from Curious Antique Gems*. London, 1764

Worsley 1985: Worsley, Giles. "Nuneham Park Revisited I and II." *Country Life* (3, 10 January 1985), 16–19; 64–67

Wyndham 1915: Wyndham, Margaret. *Catalogue of the Collection of Greek and Roman Antiquities in the Possession of Lord Leconfield*. London, 1915

Yates 1952: Yates, F.A. *Allegorical Portraits of Queen Elizabeth I at Hatfield House*. Hatfield House booklet, no. 1, 1952. Reprinted in *Astraea. The Imperial theme in the Sixteenth Century*. London, 1975, 215–219

Yates 1959: Yates, Frances A. *The Valois Tapestries*. London, 1959

Yates 1959: Yates, Frances A. "Boissard's Costume Book and Two Portraits." *Journal of the Warburg and Courtauld Institutes* 22 (1959), 365–366. Reprinted in *Astraea. The Imperial theme in the Sixteenth Century*. London, 1975, 220–221

Yates 1975: Yates, Frances A. *Shakespeare's Last Plays. A New Approach*. London, 1975

Young 1821: Young, John. *A Catalogue of the Pictures at Grosvenor House, London; With Etchings From the Whole Collection Executed by Permission of the Noble Proprietor, and Accompanied by Historical Notices of the Principal Works*. London, 1821

Young 1822: Young, John. *A Catalogue of the Pictures at Leigh Court, Near Bristol; the Seat of Philip John Miles, Esq. M.P.* London, 1822

Young 1824: Young, John. *A Catalogue of Pictures by British Artists in the Possession of Sir John Fleming Leicester, Bart. with Etchings from the Whole Collection*. London, 1825

Zetland 1973: Zetland, Penelope, Marchioness of. Letter in *Country Life* (4 October 1973), 986

Exhibitions

Aberdeen 1975: *Artist and Patron in the North East: 1700–1860*. Aberdeen Art Gallery

Aberystwyth, Cardiff, and Swansea 1958: *Dutch Genre Painting*. Arts Council

Amsterdam 1898: *Rembrandt*. Stedelijk Museum

Amsterdam 1936: *Twee eeuwen Engelsche Kunst*. Stedelijk Museum

Amsterdam 1952: *Drie eeuwen Portret in Nederland*. Rijksmuseum

Amsterdam 1969: *Rembrandt 1869–1969*. Rijksmuseum

Amsterdam 1983: *Oude Kunst in de Nieuwe Kerk*. Nieuwe Kerk

Amsterdam 1984: *William of Orange Exhibition*. Rijksmuseum

Antwerp 1899: *Exposition Van Dijck*. Musée des Beaux-Arts

Arts Council 1946: *English Conversation Pieces of the Eighteenth Century*

Arts Council 1950: *Paintings and Silver from Woburn Abbey*. Royal Academy of Arts

Arts Council 1950a: *English Painting*

Arts Council 1950b: *Paintings from the Collection of the Duke of Bedford*. National Gallery of Scotland

Arts Council 1951: *William Hogarth, 1697–1764*. Tate Gallery

Arts Council 1954–1955: *George Frederic Watts, O.M., R.A., 1817–1904*. Tate Gallery

Arts Council 1955–1956: *Thirty-Five Paintings from the Devonshire Collection, Chatsworth, Lent by the Trustees of the Chatsworth Settlement*

Arts Council 1958: *Joseph Wright of Derby: 1734–1797. An Exhibition of Paintings and Drawings*. Tate Gallery

Arts Council 1959: *The Romantic Movement*. Tate Gallery

Arts Council 1960: *Portrait Groups from National Trust Collections*

Arts Council 1960: *Johan Zoffany*

Arts Council 1962: *Victorian Paintings*

Arts Council 1964: *The Shakespeare Exhibition, 1564–1964*

Arts Council 1964: *The Orange and the Rose: Holland and Britain in the age of observation, 1600–1750*. Victoria and Albert Museum, London

Arts Council 1969: *The Art of Claude Lorrain*. Hayward Gallery, London

Arts Council 1970: *Constable: The Art of Nature*. Tate Gallery

Arts Council 1972: See Council of Europe 1972

Arts Council 1974–1975: *British Sporting Painting 1650–1850*. Leicestershire Museum and Art Gallery, Leicester; Walker Art Gallery, Liverpool; Hayward Gallery, London

Arts Council 1975–1976: *The Paintings, Graphic and Decorative Work of Sir Edward Burne-Jones, 1833–1898*. Hayward Gallery, London; Southampton Art Gallery; City Museum and Art Gallery, Birmingham

Arts Council 1978: *Piranesi*. Hayward Gallery

Arts Council 1984–1985: *James Tissot*. Barbican Art Gallery

Barnard Castle 1962: *The Zetland Collection from Aske Hall*. Bowes Museum

Barnard Castle 1963: *Dutch and Flemish Painting of the Seventeenth Century, Pottery and Porcelain from Northern Collections*. Bowes Museum

Belfast 1956: *Historic Silver in Ulster*. Municipal Art Gallery and Museum

Birmingham 1888: *Collection of Paintings and Watercolours by living and deceased artists*. City Museum and Art Gallery

Birmingham 1934: *Commemorative Exhibition of The Art Treasures of the Midlands*. City Museum and Art Gallery

Birmingham 1936: *Heraldic Exhibition*. City Museum and Art Gallery

Birmingham 1938: *An Exhibition of Treasures from Midland Houses*. City Museum and Art Gallery

Birmingham 1953: *Works of Art from Midland Houses*. City Museum and Art Gallery

Birmingham 1961: *Exhibition of Works of Sir Joshua Reynolds P.R.A.* City Museum and Art Gallery

Bologna 1954: *Guido Reni*. Palazzo dell'Archiginnasio

Bologna 1968: *Mostra biennale di arte antica VII: Il Guercino*. Palazzo dell'Achiginnasio

Brighton 1983: *The Inspiration of Egypt*. Museum and Art Gallery

Bristol 1982: *Michael Rysbrack*. City Museum and Art Gallery

British Council 1957–1958: *British Painting in the Eighteenth Century*. Montreal Museum of Fine Arts; National Gallery of Canada; Art Gallery of Toronto; Toledo Museum of Art; Tate Gallery, London

British Council 1960: *British Painting 1700–1960. An exhibition prepared for the U.S.S.R.* Moscow and Leningrad

British Council 1966: *Englische Malerei der Grossen Zeit von Hogarth bis Turner*. Wallraf-Richartz Museum, Cologne

British Council 1970: *English Landscape Painting of the Eighteenth and Nineteenth Centuries*. Tokyo, National Museum of Western Art; Kyoto, National Museum of Modern Art

British Council 1972–1973: *Portretul Englez*. Muzeu de Arta and Republicci Socialiste Romania

Bruges 1956: *L'Arte Flamand dans les Collections Britanniques et la Galerie Nationale de Victoria*. Musée Communal Groeningen

Brussels 1935: *Exposition Universelle et Internationale de Bruxelles: Sections étrangères: Pays bas, France, Angleterre, Hongrie*. International Exhibition Centre

Brussels 1973: *Treasures from Country Houses of the National Trust and the National Trust for Scotland*. Palais des Beaux Arts (Europalia)

Bucharest-Budapest 1972–1973: See British Council 1972–1973

Burghley 1983: *Chinese and Japanese Export Porcelain of the 17th and 18th centuries*. Burghley House, Stamford

Burghley 1984: *Silver Exhibition*. Burghley House, Stamford

Cambridge 1977: *Drawings by George Romney from the Fitzwilliam Museum*. Fitzwilliam Museum

Canterbury 1984: *Treasures from Kent Houses*. The Royal Museum

Cardiff and London 1981: *The Strange Genius of William Burges, 'Art-Architect,' 1827–1881*. National Museum of Wales; Victoria and Albert Museum

Chicago 1893: *British Section: Fine Arts*. World's Fair

Chicago 1981: *The Golden Age of Naples*. Art Institute of Chicago

Council of Europe 1972: *The Age of Neo-Classicism*. Victoria and Albert Museum, London; Royal Academy of Arts, London

Derby 1947: *Joseph Wright of Derby*. Derby Corporation Art Gallery

Detroit and Chicago 1981: *The Golden Age of Naples*. Detroit Institute of Arts; Art Institute of Chicago

Detroit and Florence 1974: *The Twilight of the Medici: late Baroque art in Florence 1670–1743*. Detroit Institute of Arts; Palazzo Pitti, Florence

Detroit and Philadelphia 1968: *Romantic Art in Britain: painting and drawings, 1760–1860*. Detroit Institute of Arts; Philadelphia Museum of Art

Dublin 1907: *Irish International Exhibition: Fine Arts Section, British and Foreign Artists*

Eaton Hall 1984: *The Grosvenor Treasures*. Eaton Hall, Cheshire

Edinburgh 1871: *Scott Centenary Exhibition*

Edinburgh 1876: *Works of Sir Henry Raeburn, RA*

Edinburgh 1903: *Scottish National Exhibition*

Edinburgh 1950: *National Trust Exhibition*. National Trust for Scotland

Abbreviations

Arts Council: The Arts Council of Great Britain

Barnard Castle: Bowes Museum, Barnard Castle

Edinburgh, NGS: National Gallery of Scotland

Edinburgh, SNPG: Scottish National Portrait Gallery

Leeds, Temple Newsam: Temple Newsam House

London, Agnew: Thomas Agnew and Sons, Ltd.

London, BFAC: Burlington Fine Arts Club

London, BI: British Institution

London, Colnaghi: P. & D. Colnaghi and Co. Ltd.

London, Grafton: Grafton Galleries

London, Grosvenor: Grosvenor Gallery

London, Guildhall: Guildhall Art Gallery

London, Kenwood: The Iveagh Bequest, Kenwood House

London, NBL: National Book League

London, NG: National Gallery

London, NMM: National Maritime Museum, Greenwich

London, NPG: National Portrait Gallery

London, Queen's Gallery: The Queen's Gallery, Buckingham Palace

London, RA: Royal Academy of Arts (only winter exhibitions are listed for the Royal Academy of Arts)

London, SA: Free Society of Artists

London, SKM: South Kensington Museum

London, Tate: Tate Gallery

London, V & A: Victoria and Albert Museum

London, Whitechapel: Whitechapel Art Gallery

Edinburgh 1967: *Treasures from Scottish Houses.* Royal Scottish Museum

Edinburgh 1971: *Sir Walter Scott: 1771–1971. A Bicentenary Exhibition.* The Parliament House

Edinburgh 1981: *Treasures in Trust.* Royal Scottish Museum

Edinburgh, NG 1950: See Arts Council 1950

Edinburgh, NGS 1884: *Scottish National Portraits*

Edinburgh, NGS 1901: *Pictures of Sir Henry Raeburn and Other Deceased Painters of the Scottish School*

Edinburgh, NGS 1932: *Sir Walter Scott Exhibition*

Edinburgh, NGS 1981: *Poussin: Sacraments and Bacchanals*

Edinburgh, SNPG 1956: *Scottish Groups and Conversations*

Edinburgh, SNPG 1966: *Scots in Italy in the Eighteenth Century*

Edinburgh, SNPG 1982: *John Michael Wright: The King's Painter*

Edinburgh, TRAC 1981: *Masterpieces of Scottish Portrait Painting.* Talbot Rice Art Centre

Florence 1980: *Firenze e la Toscana dei Medici nell'Europa del Cinquecento.* Palazzo Vecchio: committenza e collezionismo Medici

Fort Worth 1983: *Jusepe de Ribera, Lo Spagnoletto.* Kimbell Art Museum

Glasgow 1911: *Scottish National Exhibition*

Haarlem 1962: *Frans Hals: Exhibition on the Occasion of the Centenary of the Municipal Museum at Haarlem, 1862–1962.* Frans Hals Museum

Hamburg 1977: *Barock in norddeutschland.* Museum für Kunst und Gewerbe

Heine and Haarlem 1984: *Herinneringen aan Italie kunst en toerisme in de 18e eeuw.* 's-Hertogenbosch

Helensburgh 1954: *Scottish National Exhibition*

IEF 1979: *Treasures from Chatsworth: The Devonshire Inheritance.* International Exhibitions Foundation

King's Lynn 1967: *Paintings and Watercolours from the Collection of Sir Edmund Bacon, Bt.* Fermoy Art Gallery

Kingston-upon-Hull 1967: *Venetian Baroque and Rococo Paintings.* Ferens Art Gallery

Knebworth House 1973: *Edward Bulwer-Lytton Centenary Exhibition.* Knebworth House

Leeds and London 1974: *The Man at Hyde Park Corner, Sculpture by John Cheere 1709–1787.* Temple Newsam House, Leeds, and Marble Hill, Twickenham, London

Leeds and London 1979: *John Singer Sargent and the Edwardian Age.* Lotherton Hall, Leeds, National Portrait Gallery, London

Leeds and Sheffield 1954–1955: *Paintings from Chatsworth.* Leeds City Art Galleries

Leeds 1868: *National Exhibition of Works of Art. . . .*

Leeds 1930: *English Furniture 1600–1800*

Leeds 1936: *Masterpieces from Collections in Yorkshire and Durham*

Leeds 1941: *Picture of the Month*

Leeds 1949: *Picture of the Month*

Leeds 1949: *Treasures from Yorkshire Houses*

Leeds 1955: See Leeds and Sheffield 1955

Leeds 1958: *Masterpieces from Yorkshire Houses*

Leeds 1974: See Leeds and London 1974

Leeds, Temple Newsam 1968: *Thomas Chippendale and his Patrons in the North*

Leeds, Temple Newsam 1979: *Thomas Chippendale*

Leeds, Temple Newsam 1985: *The Fashionable Fire Place 1660–1840*

Liverpool Art Club 1881: *Oil Paintings by British Artists born before 1801*

Liverpool 1906: *36th Autumn Exhibition of Modern Art.* Walker Art Gallery

Liverpool 1951: *George Stubbs.* Walker Art Gallery

Liverpool 1960: *Pictures from Ince Blundell Hall.* Walker Art Gallery

London and Leicester 1965: *Hans Eworth: a Tudor Artist and his Circle.* National Portrait Gallery, London; Leicester Museum and Art Gallery

London 1862: See London, SKM 1862

London 1889: See London, New Gallery 1889

London 1890: See London, RA 1890

London 1895: *Catalogue of the loan collection of pictures.* Corporation of London Art Gallery

London 1908: *Franco-British Exhibition: British Fine Arts Section*

London 1928: See London, Park Lane 1928

London 1930: See London, Park Lane 1930

London 1964: See Arts Council 1964

London, Agnew 1924: *Loan Exhibition of Pictures by Old Masters on Behalf of Lord Haig's Appeal for Ex-Service Men*

London, Agnew 1948: *Exhibition of Pictures from the Devonshire Collection*

London, Agnew 1951: *Loan Exhibition of Paintings by Thomas Lawrence, P.R.A.*

London, Agnew 1959: *The Houghton Pictures*

London, Agnew 1961: *Loan Exhibition of Victorian Painting: 1837–1887. In Aid of the Victorian Society*

London, Agnew 1963: *Horace Buttery: 1902–1962*

London, Agnew 1968: *Van Dyck: A Loan Exhibition*

London, Agnew 1970: *Stubbs in the 1760s*

London, Agnew 1973: *England and the Seicento: a loan exhibition of Bolognese paintings from British Collections*

London, Agnew 1978: *Dutch and Flemish Pictures from Scottish Collections*

London, Agnew 1982: *Claude Lorrain 1600–1682*

London, Alan Jacobs Gallery 1977: *Jan van Goyen, 1596–1656 Poet of the Dutch Landscape. Paintings from Museums and Private Collections in Great Britain*

London, Bethnal Green 1883: *Collection of Paintings Lent for Exhibition by the Marquis of Bute KT.* Bethnal Green Museum

London, BFAC 1891: *Exhibition of Bookbindings*

London, BFAC 1903–1904: *Exhibition of Ancient Greek Art*

London, BFAC 1909: *Early English Portraits*

London, BFAC 1914: *Pictures of the Venetian School, including works by Titian and his Contemporaries*

London, BFAC 1925: *Catalogue of an Exhibition of Italian Art of the Seventeenth Century*

London, BFAC 1937: *Pictures, drawings, furniture and other objects of art. Winter Exhibition*

London, BFAC 1938: *Winter Exhibition*

London, BHF 1983: *The Burlington House Fair.* Royal Academy of Arts

London, BI 1815: *Pictures by Artists of the Flemish and Dutch Schools*

London, BI 1818: *Pictures of Italian, Spanish, Flemish, Dutch and French Schools*

London, BI 1825: *Living Artists of the English School*

London, BI 1839: *Pictures by Italian, Spanish, Flemish, Dutch, French and English Masters*

London, BI 1841: *Catalogue of Pictures by Italian, Spanish, Flemish, Dutch, French and English Masters*

London, BI 1842: *Works of Sir D. Wilkie, R.A., together with pictures by ancient Masters*

London, BI 1849: *Pictures by Italian, Spanish, Flemish, Dutch, French and English Masters*

London, BI 1852: *Pictures by Italian, Spanish, Flemish, Dutch, French and English Masters*

London, BI 1856: *Pictures by Italian, Spanish, Flemish, Dutch, French and English Masters*

London, BI 1857: *Pictures by Italian, Spanish, Flemish, Dutch, French and English Masters with which the proprietors have favoured the Institution*

London, BI 1864: *Works of British Artists (1853–1857)*

London, BI 1865: *Bookbindings from the Library of Jean Grolier*

London, British Library 1975: *The American War of Independence 1775–1783. A Commemorative exhibition organised by the Map Library and the Department of Manuscripts of the British Library Reference Division*

London, Bury Street Gallery 1982: *The Souls*

London, Cardiff, and New Haven 1982–1983: *Richard Wilson. The Landscape of Reaction.* Tate Gallery; National Museum of Wales; and Yale Center for British Art

London, Christie's 1957–1958: *Treasures from National Trust Houses*

London, Clarendon Gallery 1983: *Bartolomeo Cavaceppi. Eighteenth-Century Restoration of Ancient Marble Sculpture from English Private Collections*

London, Colnaghi 1978: *Works by Sebastiano Ricci from British Collections*

London, Colnaghi 1983: *English Ancestors*

London, Dorchester 1984: *The Firle Sèvres Collection.* Dorchester House, The International Ceramics Fair and Seminar

London, Drury Lane 1888: *Armada and Elizabethan Relics held in the Grand Saloon of the Theatre Royal*

London, Edinburgh, and Dublin 1984–1985: *Sir John Lavery, R.A.* The Fine Arts Society, London; The Ulster Museum, Edinburgh; The National Gallery of Ireland, Dublin

London, Ellis and Smith 1946: *The Wentworth Woodhouse Stubbs Paintings*

London, Feilding 1977: *Italian Views from a Private Room in Holkham Hall.* Jocelyn Feilding Fine Art Ltd

London, Fine Art Soc. 1983: *John Player Art of Cricket.* Fine Art Society

London, Grafton 1894: *Fair Women*

London, Grafton 1909–1910: *A Catalogue of the Pictures and Drawings in the National Loan Exhibition*

London, Grafton 1911: *Old Masters in aid of the N.A.C.F.*

London, Grosvenor 1877: *Summer Exhibition*

London, Grosvenor 1882: *Winter Exhibition*

London, Grosvenor 1886: *Works of Sir John E. Millais Bt. R.A.*

London, Grosvenor 1887: *Works of Sir Anthony Van Dyck*

London, Grosvenor 1890: *Works of art illustrative of and connected with sport*

London, Grosvenor 1914: *A Retrospective Exhibition of John Lavery 1880–1914*

London, Grosvenor 1933: *The Reign of Queen Elizabeth*

London, Guildhall 1890: *Pictures.* Corporation Art Gallery

London, Guildhall 1901: *Works of Spanish Painters*

London, Guildhall 1955: *Samuel Scott, c. 1702–1772*

London, Guildhall 1969: *London Bridge in Art*

London, Hazlitt 1975: *John Martin, 1789–1854.* Hazlitt, Gooden and Fox

London, Kenwood 1958: *Allan Ramsay: 1713–1784*

London, Kenwood 1969: *Philip Mercier*

London, Kenwood 1970: *George Lambert (1700–1765)*

London, Kenwood 1974: *British Artists in Rome: 1700–1800*

London, Kenwood 1976: *Claude-Joseph Vernet*

London, Kenwood 1977: *Nathaniel Dance: 1735–1811*

London, Kenwood 1980: *Gaspard Dughet, called Gaspar Poussin, 1615–1675. A French landscape painter in Seventeenth Century Rome and his Influence on British Art*

London, Kenwood 1982: *Pompeo Batoni (1708–1787) and his British Patrons*

London, Lansdowne House 1929: *Loan Exhibition of English Decorative Art*

London, Matthiesen 1939: *Exhibition of Venetian Paintings and Drawings.* Matthiesen Gallery.

London, Museum of London 1984: *Paintings, Politics and Porter: Samuel Whitbread II and British Art*

London, Morley Gallery 1976: *Ambrose McEvoy, 1878–1927*

London, NBL 1953: *The Italian Book, 1495–1900*

London, NBL 1958: *Famous Books from Famous Houses*

London, NBL 1965: *Treasures from Private Libraries in England . . . in honour of the IV^{th} International Congress of Bibliophiles*

London, New Gallery 1889: *Exhibition of the Royal House of Stuart*

London, New Gallery 1890: *Exhibition of the Royal House of Tudor*

London, New Gallery 1895–1896: *Spanish Art*

London, New Gallery 1896–1897: *Works of G.F. Watts*

London, New Gallery 1898–1899: *Exhibition of the Works of Sir Edmund Burne-Jones*

London, New Gallery 1902: *The Monarchs of Great Britain and Ireland*

London, NG 1976: *Art in Seventeenth Century Holland*

London, NG 1979: *Venetian Seventeenth Century Painting: A Loan Exhibition from Collections in Britain and Ireland*

London, NG 1981: *El Greco to Goya: the taste for Spanish paintings in Britain and Ireland*

London, NMM 1976: *1776. The British Story of the American Revolution*

London, NMM 1982: *The Art of the Van de Veldes: Paintings and Drawings by the Great Dutch Marine Artists and Their English Followers*

London, NPE 1866: See London, SKM 1866

London, NPG 1965: See London and Leicester 1965

London, NPG 1974: *Samuel Cooper and His Contemporaries*

London, NPG 1976: *Johan Zoffany 1733–1810*

London, NPG 1977: *Portraits by Graham Sutherland*

London, NPG 1978–1979: *Sir Peter Lely*

London, NPG 1979: *Sir Thomas Lawrence: 1769–1830*

London, NPG 1981: *Sir Francis Chantrey, 1781–1841. Sculptor of the Great*

London, NPG 1982–1983: *Van Dyck in England*

London, NPG 1983–1984: *William Dobson*

London, NPS 1917: *6th Annual Exhibition.* National Portrait Society

London, Park Lane 1928: *Exhibition of Early English Needlework and Furniture*

London, Park Lane 1929: *Loan Exhibition of English Plate*

London, Park Lane 1930: *Loan Exhibition of Eighteenth Century English Conversation Pieces*

London, Park Lane 1936: *Gainsborough Loan Exhibition in Aid of the Royal Northern Hospital*

London, Park Lane 1938: *The Old London Exhibition*

London, Queen's Gallery 1979–1980: *Sèvres Porcelain from the Royal Collection*

London, RA 1870: *Old Masters, with a Collection from the Works of C.R. Leslie, R.A. and Clarkson Stanfield, R.A.*

London, RA 1871: *Old Masters and deceased Masters of the British School*

London, RA 1872: *Old Masters and deceased Masters of the British School*

London, RA 1873: *Works of the Old Masters with works of deceased Masters of the British School*

London, RA 1874: *Works of Sir E. Landseer, R.A.* Winter Exhibitions, 5th Year

London, RA 1877: *Old Masters and deceased Masters of the British School*

London, RA 1879: *Old Masters*

London, RA 1881: *Old Masters and deceased Masters of the British School, including a collection of drawings by John Flaxman, R.A.*

London, RA 1882: *Old Masters and deceased Masters of the British School*

London, RA 1887: *Works by the Old Masters and by deceased Masters of the British School, including watercolour drawings by J.M.W. Turner R.A.* Winter Exhibitions, 18th Year

London, RA 1889: *Old Masters and deceased Masters of the British School, including a special selection from the works of F. Holl, R.A. and a collection of watercolour drawings by J.M.W. Turner, R.A.*

London, RA 1890: *Works by the Old Masters and by deceased Masters of the British School including drawings and models by A. Stevens.* Winter Exhibitions, 21st year

London, RA 1891: *Old Masters and deceased Masters of the British School including a collection of watercolour drawings illustrating the progress of the art of watercolour in England*

London, RA 1893: *Old Masters and deceased Masters of the British School, including a collection of watercolour drawings, etc., by W. Blake, E. Calvert, S. Palmer and Louisa, Marchioness of Waterford*

London, RA 1899: *Works by Rembrandt*
London, RA 1900: *Exhibition of Works by Van Dyck*
London, RA 1902: *Works by Old Masters including paintings and drawings by Claude*
London, RA 1904: *Old Masters and deceased Masters of the British School, including a special selection of works by Sir T. Lawrence, P.R.A., and a collection of Sculpture and Bronzes*
London, RA 1905: *Works by G.F. Watts, R.A. and F. Sandys, also of the Design for the National Memorial to Queen Victoria by Thomas Brock, R.A.*
London, RA 1927: *Flemish and Belgian Art, A.D. 1300–1900*
London, RA 1929: *Dutch Art A.D. 1450–1900*
London, RA 1930: *Italian Art A.D. 1200–1900*
London, RA 1932: *French Art, A.D. 1200–1900*
London, RA 1934: *Exhibition of British Art: c. 1000–1860*
London, RA 1934: *Memorial Catalogue*
London, RA 1938: *Seventeenth Century Art in Europe*
London, RA 1939: *Catalogue of the Exhibition of Scottish Art*
London, RA 1946: *Greek Art. 3000 B.C.–A.D. 1945*
London, RA 1950: See Arts Council 1950
London, RA 1950–1951: *Exhibition of Works by Holbein and Other Masters of the Sixteenth and Seventeenth Centuries*
London, RA 1951–1952: *The First Hundred Years of the Royal Academy, 1769–1868*
London, RA 1952–1953: *Dutch Pictures: 1450–1750*
London, RA 1953–1954: *Flemish Art, 1300–1700*
London, RA 1954–1955: *European Masters of the Eighteenth Century*
London, RA 1955–1956: *English Taste in the Eighteenth Century, from Baroque to Neo-Classic*
London, RA 1956–1957: *British Portraits*
London, RA 1960: *Italian Art and Britain*
London, RA 1960–1961: *The Age of Charles II*
London, RA 1961: *Paintings and Drawings by Sir Edwin Landseer, R.A., 1802–1873*
London, RA 1964: *Paintings and Drawings by Allan Ramsay, 1713–1784*
London, RA 1968: *France in the Eighteenth Century*
London, RA 1968–1969: *Bicentenary Exhibition: 1768–1968*
London, RA 1972: See Council of Europe 1972
London, RA 1974–1975: *Turner 1775–1851*
London, RA 1979: *John Flaxman, R.A. Mythology and Industry*
London, RA 1983–1984: *The Genius of Venice: 1500–1600*
London, Regent Street 1834: *Exhibition of the Paintings, Drawings and Sketches of the late R.P. Bonington*
London, SA 1762: *Pictures, sculptures, models, drawings, prints etc.* Great Room, Spring Gardens, Charing Cross, Society of Arts Incorporated of Great Britain
London, SA 1763: *Paintings, sculpture, models, drawings, engravings etc.*
London, SA 1764: *Paintings, sculpture, models, drawings, engravings, etc.* Great Room, Strand
London, SA 1768: *Pictures, sculptures, designs in architecture, models, drawings, prints etc. which the Society of Artists of Great Britain have the honour to exhibit to . . . the King of Denmark at their Spring Garden Room*
London, SA 1772: *Pictures, sculptures, designs in architecture, drawings, prints etc.*
London, Seaford House 1935: *Fabergé*
London, Shepherds Bush 1908: *Franco-British Exhibition*
London, SKM 1862: *Special Exhibition of Works of Art of the Medieval Renaissance, and more recent periods on loan at the South Kensington Museum*
London, SKM 1862: *International Exhibition*
London, SKM 1866: *The First Special Exhibition of National Portraits ending with the reign of James II on loan to the South Kensington Museum*
London, SKM 1866: *National Portrait Exhibition*

London, SKM 1868: *National Portrait Exhibition*
London, SKM 1873: *Catalogue of a Loan Exhibition of Ancient and Modern Jewellery*
London, Somerset House 1977: *London and the Thames: paintings of three centuries*
London, Sotheby's 1983: *Treasured Possessions*
London, Sotheby's 1984: *The British Sporting Heritage*
London, South London Art Gallery 1978: *Drawing towards Painting: Samuel Scott*
London, Spink 1980: *Beckford and Hamilton Silver from Brodick Castle.* The National Trust for Scotland, Spink & Son Ltd.
London, SPP 1891: Society of Portrait Painters
London, Tate 1959: See Arts Council 1958
London, Tate 1969: *The Elizabethan Image. Painting in England 1540–1620*
London, Tate 1971: *Hogarth*
London, Tate 1972–1973: *The Age of Charles I*
London, Tate 1976: *Constable Paintings, Watercolours and Drawings*
London, Tate 1980–1981: *Thomas Gainsborough*
London, Tate 1982: See Philadelphia and London 1982
London, Tate 1983: *John Piper*
London, Tate 1984–1985: *George Stubbs 1724–1806*
London, V & A 1934: *Centenary of William Morris*
London, V & A 1947: *Nicholas Hilliard and Isaac Oliver, An Exhibition to commemorate the 400th Anniversary of the birth of Nicholas Hilliard*
London, V & A 1962: *C.I.N.O.A. 3rd International Art Treasures Exhibition*
London, V & A 1972: See Council of Europe 1972
London, V & A 1973: *Marble Halls: drawings and models for Victorian secular buildings*
London, V & A 1977: *Fabergé, 1846–1920*
London, V & A 1980–1981: *Princely Magnificence. Court Jewels of the Renaissance*
London, V & A 1983: *Artists of the Tudor Court. The Portrait Miniature Rediscovered 1520–1620*
London, V & A 1984: *Rococo: Art and Design in Hogarth's England*
London, Vokins 1885: *Loan Collection of Pictures by George Stubbs and Engravings from his Works.* J. & W. Vokins, Gt. Portland St., London
London, Whitechapel 1904: *Dutch Exhibition*
London, Whitechapel 1951: *Eighteenth Century Venice*
London, Whitechapel 1953: *John Martin: 1780–1854*
London, Whitechapel 1957: *George Stubbs, 1724–1806*
London, Wildenstein 1982: *Souvenirs of the Grand Tour*
Lucca 1967: *Mostra de Pompeo Batoni.* Palazzo Ducale
Madrid and London 1982–1983: *Bartolomé Estéban Murillo 1617–1682.* Museo del Prado and Royal Academy of Arts
Manchester and Minneapolis 1978: *High Victorian Renaissance.* Manchester City Art Gallery; Minneapolis Institute of Arts; Brooklyn Museum
Manchester 1857: *Catalogue of the Art Treasures of the United Kingdom collected at Manchester in 1857*
Manchester 1887: *Royal Jubilee Exhibition*
Manchester 1897: *The Royal House of Tudor.* City Art Gallery
Manchester 1957: *Art Treasures Centenary: European Old Masters.* City Art Gallery
Manchester 1960: *Private Collections.* City Art Gallery
Manchester 1961: *German Art.* City Art Gallery
Manchester 1965: *Between Renaissance and Baroque: European Art, 1520–1600.* City Art Gallery
Manchester 1978: See Manchester and Minneapolis 1978
Manchester 1979: *Treasures from Chatsworth.* Whitworth Art Gallery
Montreal Museum 1981: *Largillière and the 18th Century Portrait.* Museum of Fine Arts
New Haven 1984: *The Edmund J. and Suzanne McCormick Collection.* Yale Center for British Art

New York 1983: *Fabergé, Jeweler to Royalty.* Cooper-Hewitt Museum
Newcastle-upon-Tyne 1951: *Exhibition Recording Tyneside's Contribution to Art: Special Loan Exhibition of Works by John Martin.* Laing Art Gallery
Newcastle-upon-Tyne 1963: *Noble Patronage.* Hatton Gallery
Northampton 1959: *Sir Thomas Isham, An English Collector in Rome*
Norwich 1966: *Dutch Paintings from East Anglia*
Nottingham 1957: *Paintings and Drawings from Chatsworth (Devonshire Collection).* University Art Gallery
Nottingham 1959: *Exhibition of Victorian Painting.* University Art Gallery
Nottingham 1965: *R.P. Bonington, 1802–1828.* [supplement] *Works by Bonington's Contemporaries inserted*
Nottingham 1973: *Apollo of the Arts: Lord Burlington and his Circle.* University Art Gallery
Nottingham 1981: *Masterpieces from Great Houses in the East Midlands*
Ottawa 1967: *A Pageant of Canada. The European contribution to the Iconography of Canadian History.* National Gallery of Canada
Paris 1909: *Cent Portraits de Femmes.* Société National des Beaux-Arts
Paris 1914: *British Arts and Crafts Exhibition*
Paris 1928: *La Peinture Anglaise.* Palais du Louvre
Paris 1938: *British Painting*
Paris 1960: *Nicolas Poussin.* Musée du Louvre
Paris 1960–1961: *Le Peinture Italienne au XVIIIe Siècle.* Petit Palais
Paris 1972: *La peinture romantique anglaise et les preraphaelites.* Palais des Beaux-Arts de la ville de Paris
Paris 1973–1974: *Chefs-d'oeuvre de la Tapisserie du XIVe au XVIe siècle.* Grand Palais
Paris 1974: *Louis XV: un Moment de Perfection de L'Art Français.* Hôtel de la Monnaie
Paris 1985: *Musée du Louvre, nouvelles acquisitions de départment des objets d'art*
Paris, Boston and Cleveland 1979: *Chardin: 1699–1779.* Musée du Louvre; Museum of Fine Arts; Cleveland Museum of Art
Paris, Goupil 1861: [Tissot]
Peterborough 1887: *The Tercentenary of Mary Queen of Scots.* Peterborough Cathedral
Philadelphia and London 1981: *Sir Edwin Landseer.* Philadelphia Museum of Art; Tate Gallery
Philadelphia, Berlin, and London 1984: *Masters of Seventeenth Century Dutch Genre Painting.* Philadelphia Museum of Art; Gemäldegalerie, Staatliche Museen Preussischer Kulturbesitz, Berlin; Royal Academy of Arts
Preston and London 1983–1984: *Polite Society by Arthur Devis: 1712–1787.* Harris Museum and Art Gallery; National Portrait Gallery
Richmond 1960: *Sport and the Horse.* Virginia Museum of Fine Arts
Richmond 1980: *Masterpieces of Chinese Export Porcelain from the Mottahedeh Collection in the Virginia Museum of Fine Arts*
Richmond-on-Thames 1980: *Horace Walpole and Strawberry Hill.* Marble Hill House
Rome 1911: *International Fine Arts Exhibition.* British Section
Rome 1956: *Mostra di Pietro da Cortona*
Rome 1956–1957: *Il Seicento Europeo: Realismo, Classicismo, Barocco.* Palazzo Delle Esposizioni
Rome 1959: *Il Settecento a Roma*
Rotterdam 1935: *Vermeer – oorsprong en invloed Fabritius, de Hooch, de Witte.* Museum Boymans
Rotterdam 1955: *Engelse landschaps-childers van Gainsboro' tot Turner.* Museum Buijmans
's Hertogenbosch 1984: *Herinneringen aan Italie Kunst en Toerisme in de 18oe eeuw.* Haarlem; Heino; 's-Hertogenbosch
Salisbury 1976: *William Beckford.* Central Library
Sèvres 1951: *Les Grands Services de Sèvres.* Musée Nationale de la Céramique

Sèvres 1952: *Porcelaines de Saxe.* Musée National de Céramique
Sheffield 1968: *Victorian Paintings, 1837–1890.* Mappin Art Gallery
Sheffield 1970: *Mary Queen of Scots.* Graves Art Gallery
Sheffield 1971: *Burne-Jones.* Mappin Art Gallery
Society of Artists 1764: See London, SA 1764
Southport 1951: *Festival of Britain Exhibition of Local Art Treasures.* Atkinson Art Gallery
Stowe 1984: *The Treasure Chest – An Exhibition in the Aurelian Room.* Stowe School
Stratford-upon-Avon 1964: See Arts Council 1964
Sutton Place 1983: *The Renaissance at Sutton Place.* Sutton Place
The Hague and Cambridge, Mass. 1982: *Jacob van Ruisdael c. 1628–1682.* Mauritshuis, and Fogg Art Museum, Harvard University
The Hague 1958: *De eeuw van Shakespeare: toen Elizabeth regeerde.* Gemeente Museum
The Hague 1958–1959: *Jan Steen.* Koninklijk Museum
The Hague 1974: *Gerard Ter Borch, Zwolle 1617 – Deventer 1681.* Mauritshuis, also shown at Munster, Landesmuseum
Tokyo 1972: *British Portraits.* Museum of Western Art
Toronto 1984: *Georgian Canada. Conflict and Culture.* Royal Ontario Museum
Venice 1967: *Vedutisti Veneziani del Settecento.* Palazzo Ducale
Venice 1980: *Disegni Veneti di Collezioni Inglesi.* Fondazioni Giorgio Cini
Vienna 1927: *Meisterwerke Englischer Malerei aus drei Jahrhunderten*
Washington 1976: *The Eye of Thomas Jefferson.* National Gallery of Art
Washington 1982: *Claude Lorrain: 1600–1682.* National Gallery of Art
Wembley 1925: *The Palace of Arts* at the British Empire Exhibition, London
Winchester and Southampton 1955: *Pictures from Hampshire Houses.* Southampton Art Gallery; Winchester College Art Gallery
York and London 1969: *Philip Mercier.* City Art Gallery, York; Kenwood House, London
York 1951: *Festival of Britain: Masterpieces from Yorkshire Houses.* Corporation Art Gallery and Museum
York 1969: *Silver from National Trust Houses.* Treasurer's House
York 1975: *Neoclassicism in the North.* King's Manor

Index to Sitters, Artists, and Locations

All index references are to catalogue numbers

ACKNOWLEDGMENTS

Most of the illustrations to this catalogue have been specially commissioned and we are particularly grateful to the Ford Motor Company for assistance with this program at Petworth, Burghley, Woburn and Castle Howard. Several objects were photographed before restoration.

Other photographers include:
Derek Balmer
Beedle and Cooper
John Bethell
A.C. Cooper
Dawes and Billings
Tony Evans (Ford Motor Company)
Mark Fiennes
Hanover Studios
David Hope
Angelo Hornak
Christopher Hurst
Kershaw Studios
Horst Kolo
Layland-Ross Limited
Rowan Main
Mancktelow Photography
Duncan McNeill
Mingus Photography
Derry Moore
Erik Pelham
Pieterse-Davison International Limited
Pilgrim Press of Derby, England
James Pipkin
Joe Rock
Diana Scarisbrick
Tom Scott
Inglis Stevens Photography
Thelma Stuart
Frank Taylor
John Webb
Jeremy Whitaker
Rodney Todd White and Son
Whitehouse Studios
Derek Witty
John Wright Photography

Photographs have also been received from the following individuals, houses, museums and other institutions:
Ashmolean Museum
The Bank of England
Beaufront Castle
Palace House, Beaulieu
British Library
British Museum
Buccleuch Collection
Burghley House
Castle Howard
Chatsworth
Country Life
Courtauld Institute of Art, London
Dorney Court
Forschungsarchiv für Römische Plastik, Köln
Glamis Castle
Goodwood
Greater London Council
Holkham Hall (North Creake Photography)
Lamport Hall (Vicki Groome)
Leeds City Art Gallery
Longleat
Metropolitan Museum of Art, New York
National Galleries of Scotland
National Gallery, London
National Gallery of Art Photography Laboratory (José Naranjo, Dean Beasom, Philip Charles)
National Maritime Museum, Greenwich
National Portrait Gallery, London
National Trust, London
Raby Castle
The Royal Collection
Sotheby's
Sudeley Castle (Derek Bayes)
Temple Newsam (West Park Studios)
Tichborne Park
Victoria and Albert Museum
Westminster Collection
Lawrence Whistler
Woburn Abbey

The National Gallery of Art wishes to acknowledge the support of Messrs. S.J. Phillips of London in the preparation of no. 129, silver looking glass, table, and stands, from Knole, for the exhibition

ESSAY ILLUSTRATIONS

Temples of the Arts: *Courtesy Mr. Simon Wingfield Digby, Sherborne Castle 1; James Pipkin, 2,5; Tony Evans 3; Country Life 4; National Trust 6; courtesy Sir Brinsley Ford 7; John Bethell 8; Tate Gallery 9.*

The Power House: *The Bridgeman Art Library, courtesy Samuel Whitbread, Southill Park 1; James Pipkin 2–6; British Architectural Library, R.I.B.A., London 7,8; Reproduced by Gracious Permission of Her Majesty the Queen 9.*

Portraiture and the Country House: *National Gallery, London, courtesy the Earl of Verulam 1; National Gallery, London 2; National Portrait Gallery, London 3; National Trust 4,9,10; National Portrait Gallery, courtesy the Marquess of Salisbury 5,6; James Pipkin 7; Country Life 8,11; Courtesy the Duke of Atholl 12; Sheffield City Council 13; Courtesy Mr. Reresby Sitwell 14; Courtauld Institute of Art 16; Royal Academy, courtesy Viscount Allendale 15; Reproduced by Gracious Permission of Her Majesty Queen Elizabeth, the Queen Mother 17; National Portrait Gallery, courtesy the Duke of Buccleuch and Queensberry 18; Courtauld Institute of Art, courtesy the Trustees of the Chatsworth Settlement 19.*

Englishman in Italy: *Reproduced by Gracious Permission of Her Majesty the Queen 1,3; British Museum 2,4; courtesy Sir Brinsley Ford 5; courtesy of the Duke of Hamilton 6; courtesy Denys Oppé 7; James Pipkin 8; National Gallery, London 9; Country Life 10; Clarendon Gallery 11; Frank Mancktelow, courtesy Lord Sackville 12.*

British as Collectors: *English Life Publications Ltd. 1; James Pipkin 2,5,7; Jeremy Whitaker 3; Architectural Digest and Derry Moore 6; Country Life 8,9; Angelo Hornak 10; Waddesdon Manor 11.*

The Backward Look: *Country Life 1,2,4,7,8,13–16; A.C. Cooper 3; National Maritime Museum, Greenwich 5; Abbot Hall Art Gallery, Kendal 6; R&H. Chapman 9; James Pipkin 10; Herbert Ballard, courtesy Mr. John Chichester-Constable 11; Christopher Simon Sykes, courtesy The World of Interiors 12.*

The Last Hundred Years: *Angelo Hornak 1; Save Britain's Heritage 2,3,10,11; Courtesy of the Trustees of the Chatsworth Settlement 4; James Pipkin 5; Leeds Castle Foundation 6; National Trust 7; Country Life 8,9.*